U0114145

藝術的故事
A STORY OF ART

一

《藝術》簡詞典系列

ART JIANCIDIAN SERIES

《百官人》印章
100 OFFICIALS

《家近大禹陵》印章

A HOME NEARBY THE GREAT YU MAUSOLEUM

《東西椅》
EAST-WEST CHAIR

信 仰
【簡詞典】系列
BELIEF
jiancidian series

執 着
【簡詞典】系列
PERSISTENCE
jiancidian series

挑 戰
【簡詞典】系列
CHALLENGE
jiancidian series

超 越
【簡詞典】系列
TRANSCENDENCE
jiancidian series

藝術家：谷文達
artist: gu wenda
攝影：馬丁・舒勒
photo credit: martin schoeller

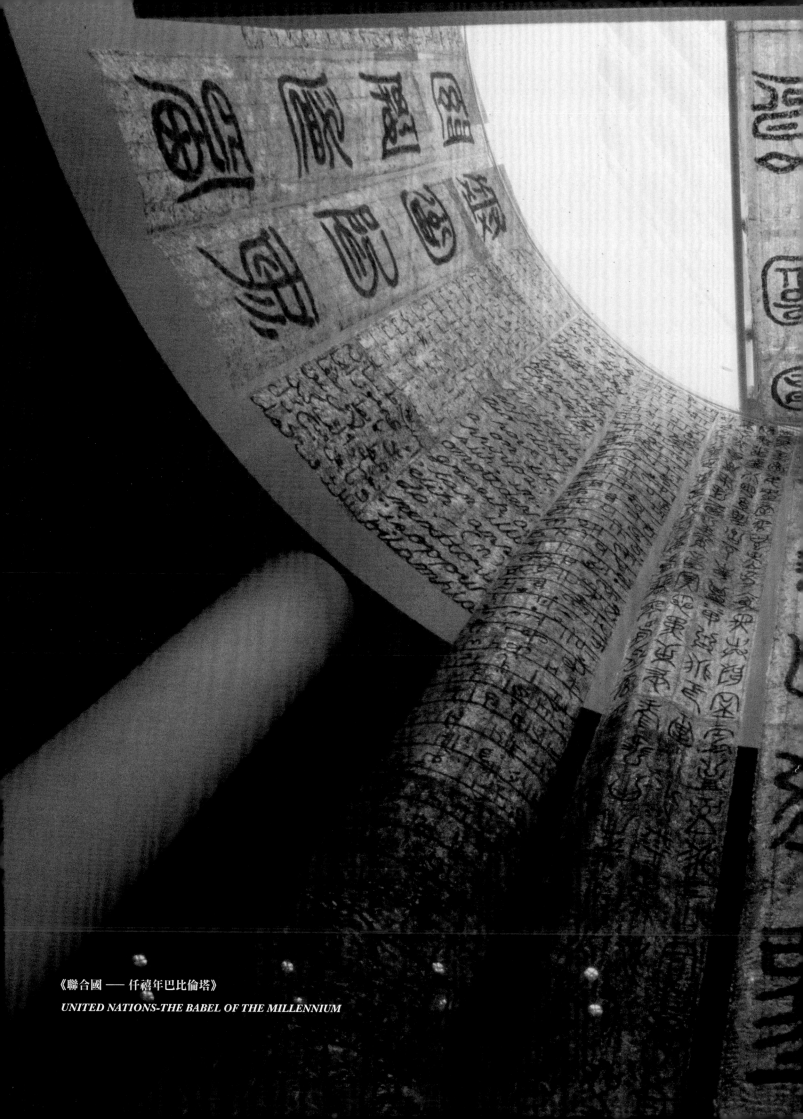

《聯合國 —— 仟禧年巴比倫塔》

UNITED NATIONS-THE BABEL OF THE MILLENNIUM

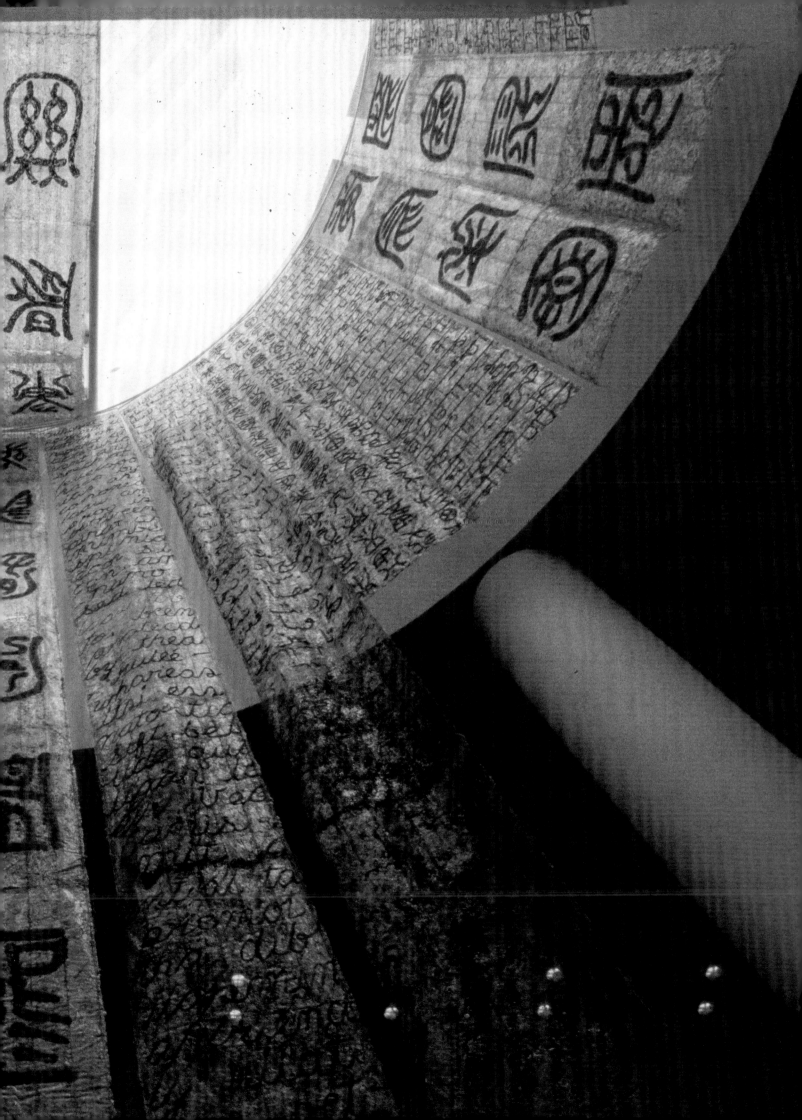

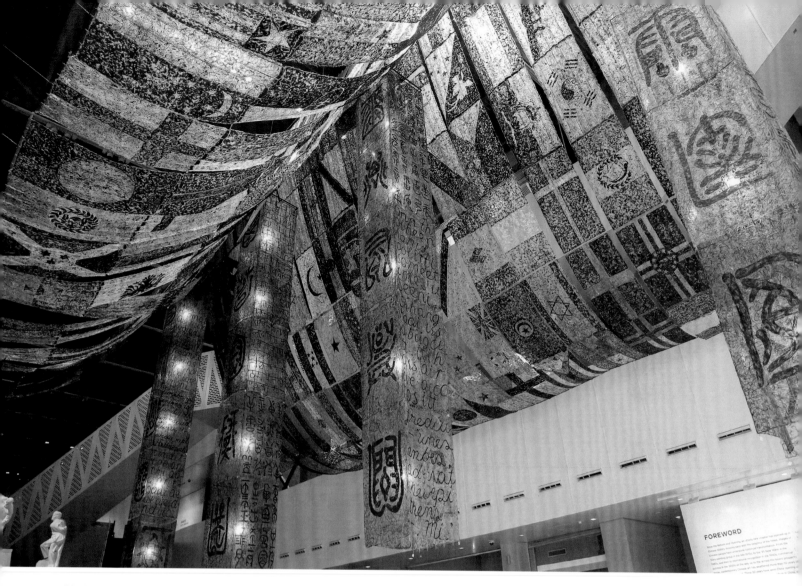

《聯合國 —— 人間》2013 年上海當代藝術博物館

UNITED NATIONS—MAN AND SPACE AT THE SHANGHAI POWER
STATION OF ART MUSEUM, 2013

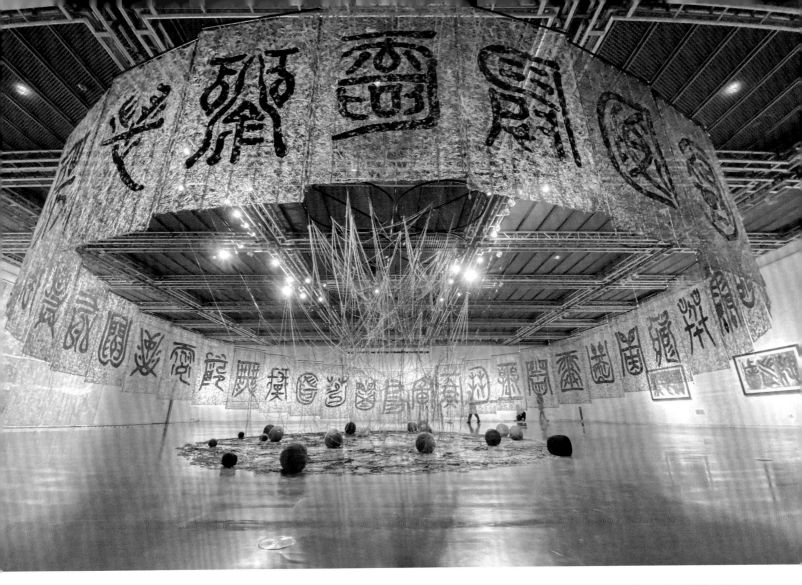

《聯合國 —— 庚子年的項鏈》

UNITED NATIONS—GENGZI'S NECKLACE

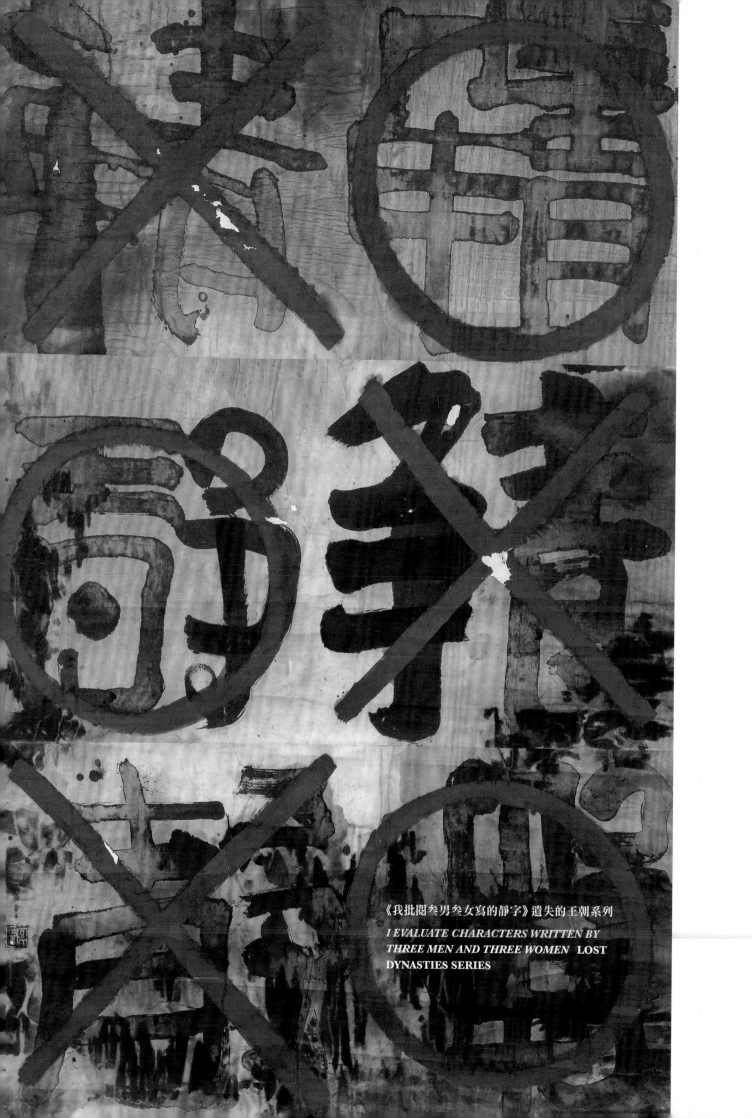

《我批閱叁男叁女寫的靜字》遺失的王朝系列
I EVALUATE CHARACTERS WRITTEN BY THREE MEN AND THREE WOMEN LOST DYNASTIES SERIES

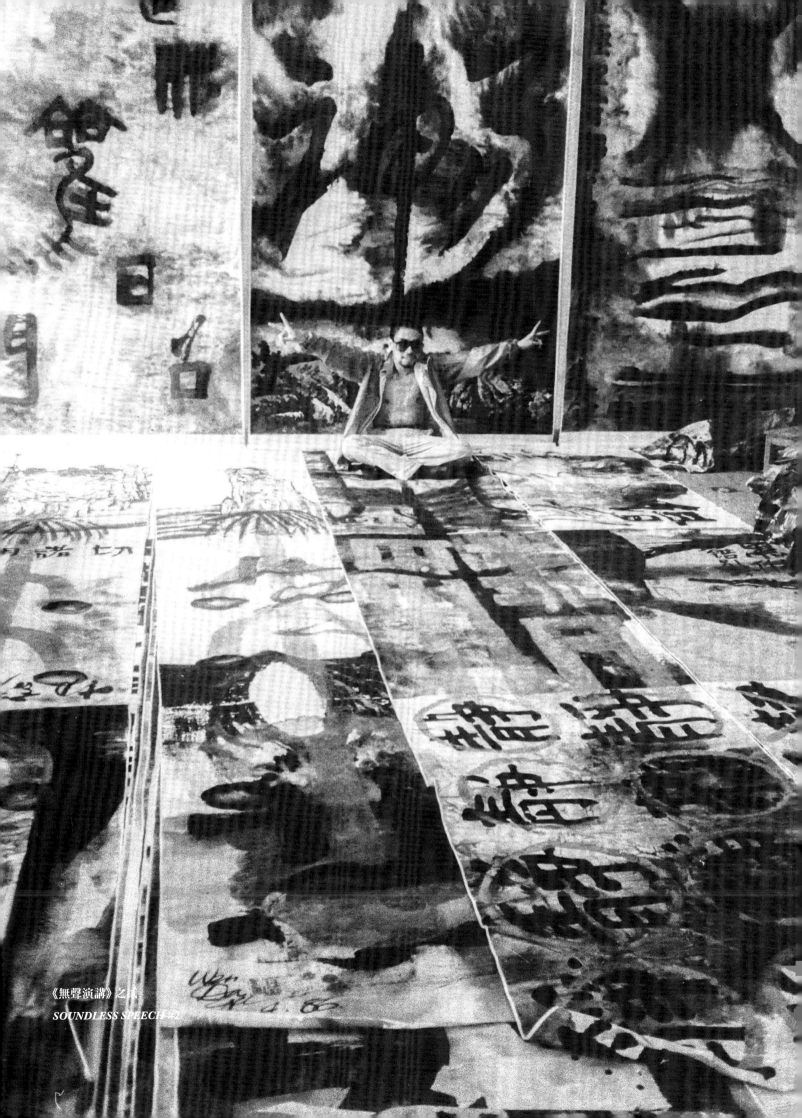

《無聲演講》之貳
SOUNDLESS SPEECH #2.

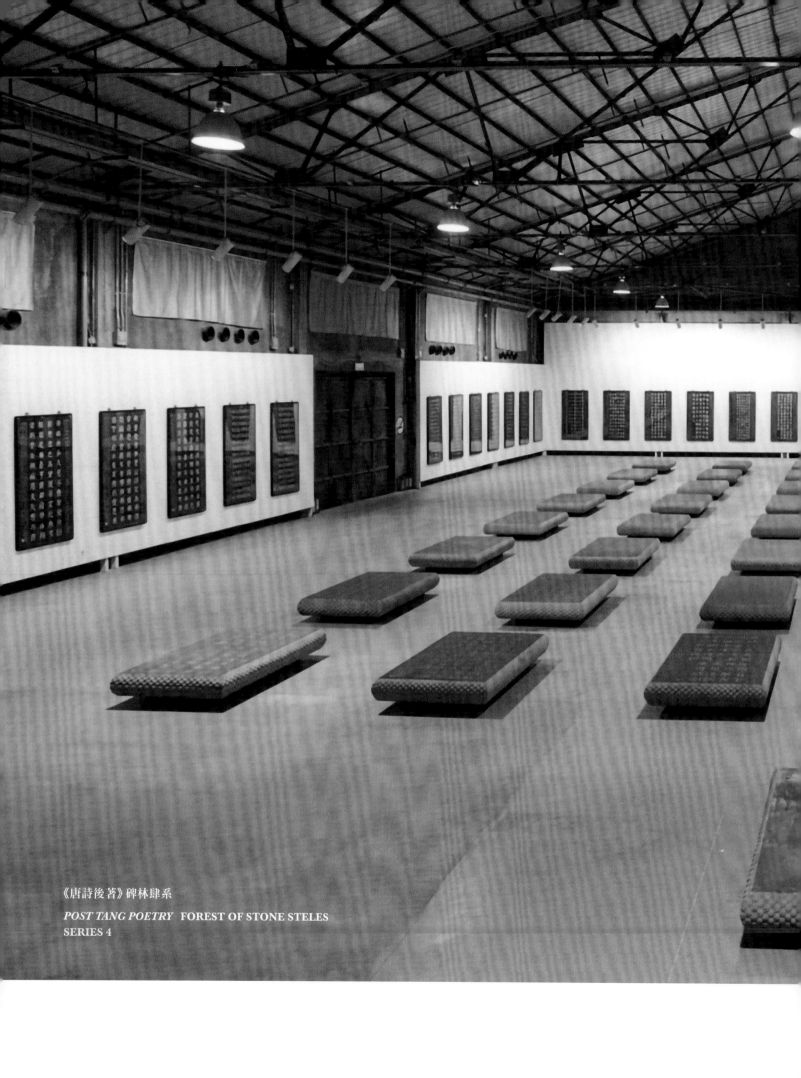

《唐詩後著》碑林肆系
POST TANG POETRY **FOREST OF STONE STELES**
SERIES 4

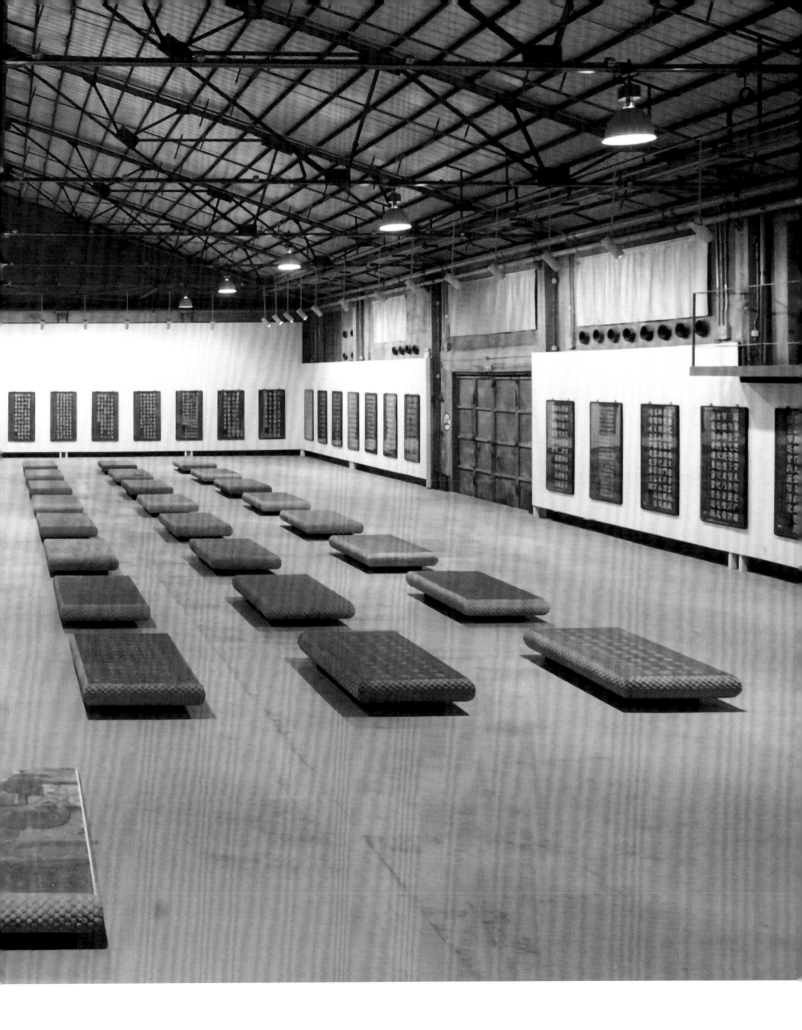

《靜則生靈》遺失的王朝系列

WISDOM COMES FROM TRANQUILLITY LOST
DYNASTIES SERIES

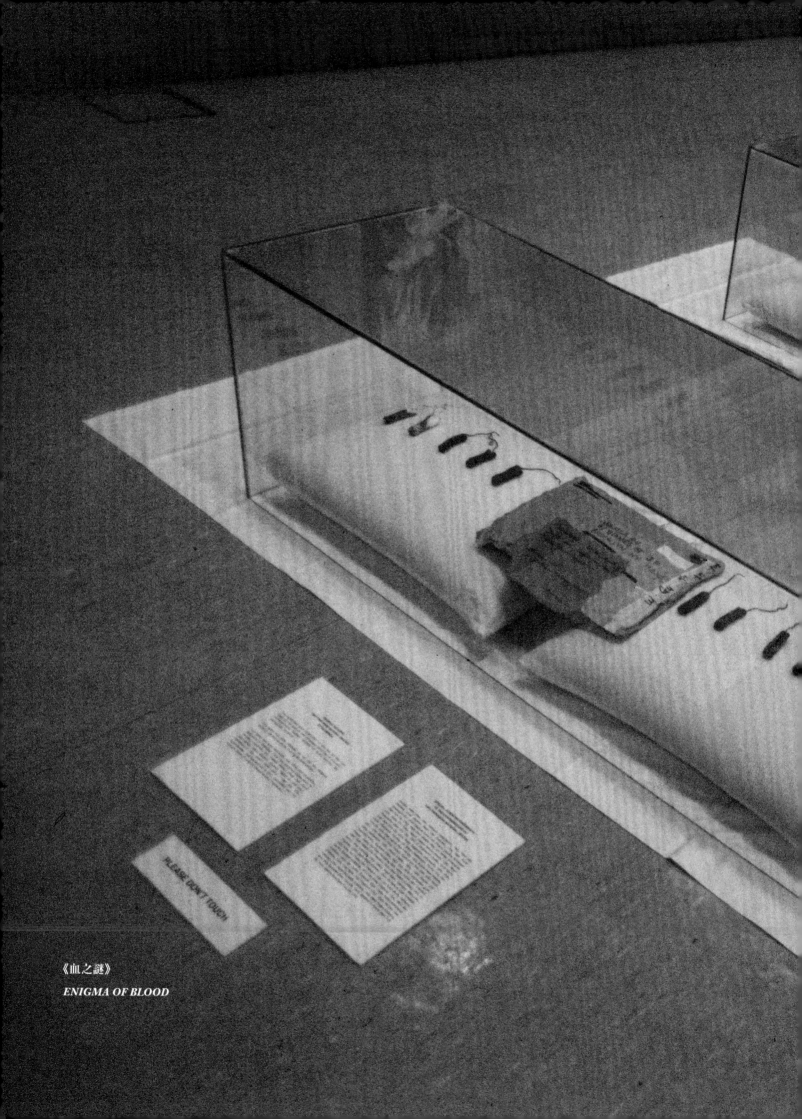

《血之謎》
ENIGMA OF BLOOD

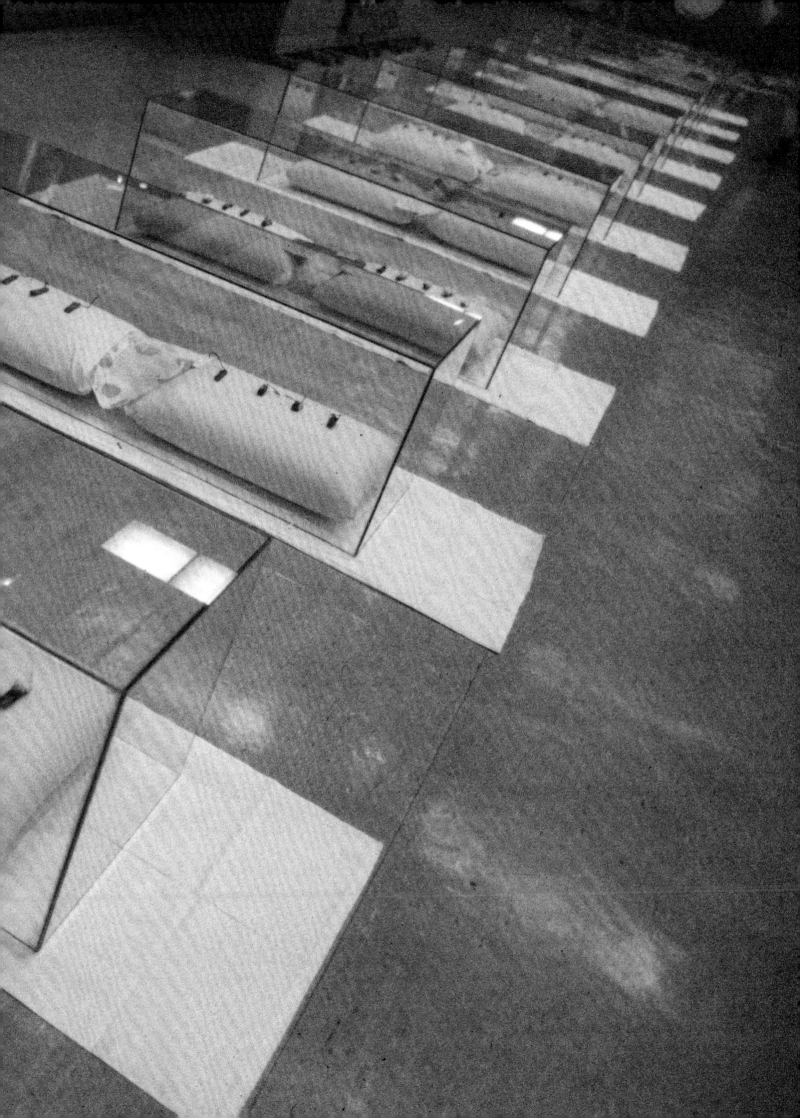

目 錄 CONTENTS

谷 文 達
Gu Wenda

第一冊

第二冊

序

沈語冰

FORWARD

shen yubing

谷文達先生的大型回顧展《藝術》2019 年 12 月 15 日在武漢合美術館開幕。它可能創造了兩個歷史性事件：一是由於疫情的關係，它可能成為有史以來展覽時間最長的個人回顧展；二是同樣因為疫情的關係，它可能成為有史以來在「展覽期間」被封閉時間最長的個人回顧展。這實在是始料未及的。不過對於想要理解谷文達作品的觀眾或讀者來說，這個純粹意外的事件帶有某種啟示性，它宣示同時還將預示着世界的不確定性以及「藝術」—— 這個回顧展的名稱碰巧就是「藝術」——在不確定性中所扮演的角色。

展覽相對完整地展示了谷先生迄今為止長達近 40 年的藝術生涯的主要作品和文獻。展覽中沿着場館中間走道分佈的「藝術的故事」，講述了作為藝術家的谷文達的主要作品故事。從 1986 年在陝西楊陵舉辦的首個個展，直到 2019 年仍在進行中的「生物時代之謎」系列、「語言與翻譯」系列等等。

gu wenda's large-scale retrospective *art* opened on december 15, 2019, at wuhan's united art museum. the exhibition has perhaps resulted in two historical events. because of the epidemic, it became the longest-running exhibition in history and precisely because of the same epidemic it also became the exhibition that remained closed for the longest amount of time in history. this was truly unexpected. however, for the readers or for those who would like to understand gu wenda's work, this purely unexpected event brings with it a kind of inspiration. it proclaims and at the same time, it foreshadows the uncertainty of the world and the role that "art"—coincidentally the title of the exhibition—plays in this uncertainty.

the exhibition presents key works and archival materials to create a comprehensive look at the 40-year career to date. *the story of art* which is displayed along the middle aisle of the museum, recounts the story of gu wenda as an artist through his key works, from the first solo exhibition held in yangling, shaanxi province in 1986, to the on-going series *enigma of biological times* the *language and translation* series and so on.

整個展覽分為五大部分。第一部分是「藝術的故事：現象、爭議、挑戰與影響」，概括了藝術家在國際及中國內地所引起的現象級的主要事件，包括 1986 年陝西楊陵全國中國畫理論研討會暨谷文達首個個人展覽，1988 年開始的人類生命基因系列，1988 年在特隆赫姆引起爭議的作品，以及 1993 開始的「聯合國」系列。閱讀相關文獻的讀者不難明白，這些事件並不是藝術家刻意為之的產物，而是在不確定的遭遇中各種力量「風雲際會」的結果，多數甚至出乎藝術家本人的意料之外。這說明藝術現象的神秘力量，既是世界不確定性的縮影，也帶有強烈的預示性：通過藝術，人們對世界的認知變得集中而鮮明了。

第二部分是「奠基與建立當代水墨與書寫藝術」，主要發生於上世紀 80 年代的上海和杭州，可以清晰地看到谷文達在這個領域的探索不但是中國內地最早的之一，也是最持久和深入的之一。

第三部分「生物時代」，是藝術家最豐產的系列作品之一。它涵蓋了「聯合國」系列、「生之謎」系列、「血之謎」系列、「墨煉金術」系列、「紙煉金術」系列、「基因風景」系列等八個作品系列，大體反映了藝術家對國族和聯合國、本土性與全球化等重大問題的思考。同時，這也是谷文達在國際上影響最大的系列作品之一。它們參與在全球化的話語坐標中的意圖和努力是十分清晰的。

展覽的第四部分是「語言與翻譯」，也是谷文達最大的項目之一，包涵六個分支，反映了藝術家在繼

the exhibition has five major sections. the first part is "the story of art: phenomena, controversy, challenge and influence" which can be summed up as the phenomenal events provoked by the artist at home and abroad, including the first solo exhibition of gu wenda and the national chinese painting theory conference held yangling, shaanxi province in 1986, the *human life dna* series which began in 1988, the controversial trondheim works of 1988, and the *united nations* series which began in 1993. for anyone reading the relevant archival materials, it's easy to see that this was not the product of any conscious effort, but the result of encounters with various tempestuous forces, the majority of which were unexpected even to the artist himself. this illustrates the mysterious germinative power of art and is a microcosm of the uncertainty of the world. it also brings with it a powerful foreshadowing: through art, people's perception of the world can become sharper and more focused.

the second part is "founding and establishing of contemporary ink and writing art," which takes place mainly in shanghai and hangzhou, which allows us to clearly see that in this field of exploration gu wenda was not only the first in china but also the most persistent and profound in his practice.

the third part "enigma of biological times" represents the most prolific part of the artist's series. it spans the *united nations* series, the *enigma of birth* series, the *enigma of blood* series, the *ink alchemy* series, the *paper alchemy* series, the *dna landscape* series, and eight other series of works. the works broadly reflect the artist's thinking on nations and nationalities, the united nations, regional or native cultures, globalization, and these kinds of major issues. at the same time, this was also the series of gu wenda's work that had the largest impact abroad. his intentions and efforts to participate within the coordinates mapped out by the discourse of globalization are absolutely clear.

the fourth part is "language and translation," and it is also one of gu wenda's biggest projects, encompassing six branches or offshoots, and reflecting the progress the artist has made in exploring various facets of globalization and localization, in particular his thinking on the issue of the cultural differences which underpin language. these works are highly integrated

續探索本土化與全球化方面所取得的進展，特別表現在他對語言及其背後的文化差異等問題的思考上。這些作品與上世紀 90 年代以來的全球課題是高度一體化的，這當然不僅僅基於藝術家對世界性命題的高度自覺和敏感，同時也洞見了全球化表象背後湧動着的離散、遊牧、種族等等問題。以及語言、文化和文明之間的錯位、融合與衝突。在當前全球化的急驟衰落中，他的這個系列對文化錯位和痛楚的預言，要比我曾經說過的更為深刻和睿智。

回顧展的最後部分是「社會和參與」，似乎是對上述兩個大系的裂隙作出的自我回應。如果說「生物時代」是唯物主義和理想主義的（比如「聯合國」系列），而「語言與翻譯」是觀念論和現實主義的，那麼在兩者的矛盾中，一個現實中的人還能做些甚麼？谷文達的回答似乎是「參與」，即走出前述兩個大系的二元論，走向社會和參與。至少這是目前我能想到的最不壞的結果。至於他的理想主義作品中包含了多少反諷意識，而他清醒的現實主義作品中又包含了多少沉痛和悲憫，我想觀眾和讀者只能從其作品意義的無限延宕中去求索了。

谷文達是過去的 40 年裏中國和／或世界藝術家中一位最清醒和敏銳的弄潮兒，同時也是潮流過後最深刻和清醒的旁觀者。他投入了世界，他靜觀其變。他是我們的同代人，也是我們中的特立獨行者。

<div align="right">
沈語冰

2021 年 10 月 18 日於上海
</div>

with the issues of globalization which became prevalent in the 90s, but of course, it is also based on the artist's high degree of perception and self-awareness of global problems. at the same time, it also offers insight into the convergences and conflicts between issues of nomadism, race, etc., and the problems of dislocation of language, culture, and civilization which flow discretely behind the façade of globalization. as we face the rapid decline caused by globalization, the profundity and wisdom of this work and its foreshadowing of issues of the pain of cultural dislocation become more and more powerful and relevant.

the last part of this exhibition "society and participation," offers a respond from the artist on the rift between these two major series of works. if we say that the "biological era," series (for instance the *united nations* series) is about materialism and idealism and "language and translation" is about conceptualism and realism, then what can someone really do from within this contradiction? gu wenda's answer is "participate," that is, escape the binary trap of the two series, and move towards society and participation. at this moment, this is the least harmful result i can think of. as for how much irony is contained in his idealistic works, and how much pain and compassion are contained in his sober, realistic works, i think the audience and the readers can explore this on their own, searching amongst the endlessly meandering paths of meaning within his oeuvre.

more than any other artist in china or abroad over the past 40 years, gu wenda has, with deep perception and lucidity, braved the storms of social change. at the same time, he has also remained a profound and alert observer as the tides receded. he throws himself into the world yet stands back quietly to observe the changes. he is our contemporary, yet, at the same time, he stands as a maverick amongst us.

<div align="right">
shen yubing

shanghai, october 18, 2021
</div>

沈語冰，復旦大學特聘教授，藝術哲學研究中心主任。
他親自翻譯或組織翻譯的「鳳凰文庫 —— 藝術理論研究
系列」被認為正在形塑中國相關學術領域。他的近著《馬
奈研究》《塞尚研究》即將出版。

shen yubing, distinguished professor of aesthetics and
art history, director of the institute of philosophy of art,
fudan university. his long contribution to the translations
and researches of western art history and theory has been
recognized as shaping the relative academic fields in china.
his recent books included *manet* and *cezanne*.

前言 ❶

黃立平

PREFACE

huang liping

谷文達的第四個回顧展:《藝術》—— 在期待中終於與觀眾見面了。作為一個在東西方兩種文化系統都具有卓越影響力的視覺藝術家,谷先生已分別在澳洲坎培拉國家美術館和上海民生現代美術館舉辦過不同的個人藝術創作回顧展。如今,合美術館再次舉辦谷先生的回顧展,除了規模更宏大,史料更系統,作品更豐富之外,還能增添甚麼新的意義?這個展覽,谷先生(及其工作室團隊)很用心,也花了大的力氣,特別是在文獻的梳理和視覺化方面,充分施展了他的邏輯架構能力;館方同樣傾注了許多心血。兩年多來,大家共同努力成就了這一展覽計劃,試圖從回答上述問題着手,尋找一些當代藝術創新發展的頭緒 —— 僅從展覽的主題 ——《藝術》的氣度便可見一斑。

谷文達早在「八五新潮」時期,就以「遺失的王朝系列」等作品為代表,成為中國成名最早的觀念藝術家之一,也是學術界公認的藝術語言力量最強大

art, the fourth retrospective exhibition of wenda gu, finally lifted its mysterious veil to the expecting audience. as a visual artist with outstanding influences in the oriental and western cultural systems, mr. gu has held different retrospective exhibitions on personal artist creation at the national art gallery of australia in canberra and shanghai mingsheng art museum. now, another retrospective exhibition of mr. gu is being held at the united art museum. what new meanings will it create in addition to a larger scale, more systematic historical materials, and more substantial works? mr. gu (and his studio) paid concentrated attention and made the utmost efforts to this exhibition. it fully displays gu's powerful logical structure, particularly in literature review and visualization. the museum also devoted significant efforts. over the past two years, everyone has been working together, which eventually contributed to this exhibition plan. to answer the above question, the clues of searching for the innovative development of contemporary art can be seen from the exhibition theme— the grandeur of *art*.

with such representative works as the *lost empire series,* wenda gu became one of the earliest well-known conception artists as early as the new trend of 1985. also, gu is an outstanding visual artist representative with the most powerful art language recognized

的視覺藝術家的突出代表。谷先生善於從中國傳統基因中具有標誌性的文化素材 —— 書法、石碑、古詩詞、拓片等，以水墨組畫、系列雕塑和大型裝置等形式，多方位深刻表達根深蒂固的傳統思想和文化，對於現實世界無所不在的影響以及傳統基因在現代世界的轉化和變異。同時他對於改革開放以後出現的盲目崇拜「舶來」的西方文化，特別是對西方現代主義藝術的全盤拿來和氾濫提出了質疑，主張建立源於中國文化傳統的中國當代藝術。他發明的「以字組詞」開創了一種言簡意賅的綜合性語言表達方式廣受學術界關注。

1987 年，谷先生移居紐約成為職業藝術家後，逐漸將中國的文化基因與全球化背景下西方當代藝術思想和方法結合起來，創作了一批震撼人心的「視覺景觀」。無論是「東方志」（以拓片為媒介拼字為詞，挑戰中國語言文字史上單一字不構成詞的現象），還是「聯合國 —— 千禧年的巴比倫塔」（以 18 個國家的 350 家理髮店收集來的人髮編組成偽漢英文合併體，偽漢文、英文、印度文和阿拉伯文的髮牆構成）；無論是「碑林 · 唐詩後著」（將「唐詩」和「碑林」這兩個中國文化遺產所特有的載體進行重新解讀和詮釋），還是「基因風景」（包括「墨 · 煉金術」與「紙 · 煉金術」），採用體現當下人文精神氣質的「物質」重新表達中國經典的文人畫傳統，這並非發「思古之幽情」，而是使老樹發出了新芽。谷文達每一個時期的代表作都以「鴻篇巨製」的形式和陌生化語言開創了鮮明的視覺語言範式，引人入勝。

by the academic circle. mr. gu is adept at applying hallmark cultural materials with traditional chinese genes—calligraphy, stone tablets, ancient poems, and rubbings. through water and ink paintings, a series of sculptures, and large installations, gu expresses the ubiquitous impact of deeply-rooted traditional thoughts and culture on the real world and the transitions of traditional genes in the modern world. meanwhile, gu raised doubts for blindly worshiping the western culture since the reform and opening up, and particularly the complete acceptance and flooding of the western modernist art. he thus advocated creating chinese contemporary art based on chinese cultural traditions. making word groups, a concise and general language expression mode created by gu, received full attention from the academic circle.

mr. gu migrated to new york in 1987. after becoming a professional artist, he gradually combined chinese cultural genes and the contemporary artistic thoughts and methods of the western world in globalization, creating a batch of thrilling visual landscapes. whether it is the *oriental ambition* (a phenomenon of combining words into groups through rubbings and challenging the fact that one character doesn't make a word group in the chinese language and word history), or the *un millennial tower of babylon* (the hair collected from 350 barber's shops in 18 countries was woven into a hair wall with chinese—english combined words, pseudo-chinese characters, english words, indian words, and arabic words); whether it is the *tablet forest descendants of tang poetry* (reinterpret and explain the unique carriers of chinese cultural heritages) or *genetic scenery* (including *ink alchemy* and *paper alchemy*), gu aims to make new descriptions of chinese classical scholarly painting traditions. it is not a reminiscence of the ancient times, but a new bud emerging from old trees. the representative works of wenda gu in each period all created distinctive patterns of visual languages through grand forms and strange languages, which are fascinating.

以中美文化交流為背景，以豐富而完整的個人化歷史文獻為主軸，以代表性藝術作品為框架和輪廓，以體驗式觀賞為策展出發點 —— 多維度呈現谷文達先生藝術思想的發展歷程及獨樹一幟的藝術語言和方法 —— 這正是第三次回顧展：《藝術》所定位的別具一格的文化視野。

當代藝術作為一種文化現象存在的一個重要理由，就是滿足藝術史追尋「陌生化語言」的願望。幸運的是，東西方文化在全球化時代的碰撞和交融恰好成就了像谷文達這樣的思想者和探險者。似乎在當代藝術史的每一個關鍵路口都設有讓人腦洞大開的「迎新站」，等待着未曾謀面的年輕朋友匆匆由此經過時給予示意，引導其沿着正確的方向走向更遠處。這或許正是谷文達藝術表達的真正歷史價值。由此我想起一位德國學者的話：「我們給孩子講故事，是為了哄他們入睡；我們給大人講故事，是為了讓他們醒來。」

在 30 多年的藝術創作歷程中，谷文達始終以強烈的問題意識尋找對藝術的獨到解讀，並以無邊界的思維在不同文化的交合處，探索視覺語言與文字語言的並用，從而形成了他自定的「全主義藝術」。在位於上海莫干山路 M50 園區的谷文達工作室文獻庫，我看到一個隨手可取的書架裏整齊地堆放着幾大摞上世紀 80 年代初商務印書館出版的漢譯名著。記得有康德的《純粹理性批判》、黑格爾的《美學》、佛洛德的《精神分析引論》等等。我忍不住拿出達爾文的《物種起源》，看見從頭到尾發黃

in the context of cultural exchanges between china and america, enriched and complete personal historical documents form the main axis. representative artistic works function as the framework and outline. experience-based appreciation exhibition is the starting point—the development course and distinctive artistic language and methods of wenda gu are displayed in multiple dimensions—it is the third retrospective exhibition: distinctive cultural perspective positioned by *art*.

an essential reason for contemporary art to exist as a cultural phenomenon is that it fulfills the wish for art history to pursue estranged languages. luckily, the oriental and western cultures clash and integrate in globalization, which happens to bring up thinkers and explorers like wenda gu. it seems that an imaginative welcoming station is set up at every critical intersection of contemporary art history, waiting to give signals to young friends who pass quickly and guiding them to walk further in the right direction. maybe it is the real historical value of wenda gu's artistic expressions. thus i recall the words of a german scholar, "we tell stories to children to make them sleep. conversely, we tell stories to adults to wake them up."

in the course of artistic creation over the past thirty years, wenda gu has been searching for unique interpretations of art and exploring the combination of visual language and word language at the juncture of different cultures through a strong awareness of questions. it thus formed gu's self-defined holistic art. in the literature library of gu wenda's studio in m50 park, moganshan road, shanghai, i saw several piles of chinese versions of classics published by the commercial press in the last century stacked on a bookshelf. as i recall, there was kant's *critique of pure reason,* hegel's *aesthetics: lecture on fine art,* and freud's *introductory lectures on psychoanalysis.* i could not help but pick up darwin's *on the origin of species by means of natural selection, or the preservation of favoured races in the struggle for life.* then i saw

的頁面上幾乎每一頁都畫有提示性的「橫杠」。由
此可以想像他當年皓首窮經的場景。谷文達豐厚
文化底蘊的形成由此便可找到注腳。

谷文達以「信仰、執着、超越」來詮釋《藝術》（回
顧展的精神內涵），實際上是從三個維度對藝術本
質作出了理性表達。所謂「谷」式表達，即以一切
視覺文化為目標，以藝術家個人的文化經驗為基
礎——跨邊界、多語言、無止境的藝術表達方式。
如果不按已有的成果作為衡量尺度，我的確難以判
斷谷文達先生對於視覺表達和文字表達兩個方面，
究竟更鍾情哪個方面？又更擅長哪個方面？谷先
生散文體小說的敘事語言風格——在寫實中加入
些傳奇，在熟稔中混入些生僻——其所描繪的生
活與藝術往往變得水天一色，具有某種超然之美，
是文壇上極少見的。我能夠確定的是，思想力量
是語言力量的源泉。只要能夠觸擊人的心靈神經，
不同的語言表達方式在本能上一定是相互成就的。
正如哲人福柯所言：生命的本質就在於它時時刻
刻面臨可能性；時時刻刻同「過度」、「極限」、「冒
險」和「超越」相遭遇；生存之美，恰恰就在超越
中閃爍出它的耀眼光輝。

我相信谷文達的跨邊界、多語言、無止境的表達
方式，將在他的自我尋找之路上越走越遠。

合美術館館長　黃立平

lines on every yellowish page. it reminded me of the scene where gu attentively read books. these footnotes indicate the formation of wenda gu's rich cultural connotations.

wenda gu interpreted *art* (spiritual connotation of this retrospective exhibition) through belief, insistency, and transcendence. in fact, gu reasonably expressed the essence of art from three dimensions. the so-called gu-style expression form refers to the crossover, multi-language, and endless artistic expression form aiming at all visual cultures and basing on an artist's personal cultural experience. if i do not measure with gu's achievements, i can hardly judge which wenda gu prefers. is it visual expression or word expression? which one is he better at? the narrative language style of mr. gu's prose novels—which adds legendary elements into realistic writing and combines rareness and familiarity—the life and art portrayed by gu tend to be perfectly integrated and reflect the beauty of transcendence. it is quite rare in the literary circle. it is certain that the power of thoughts is the source of language power. as long as they can touch people's souls and nerves, different forms of language expressions are instinctively contributing to each other. philosopher foucault said, "the essence of life lies in the possibilities it may face at every moment; one meets excess, limitation, adventure, and transcendence at every second; the beauty of survival happens to shine its glorious light in transcendence."

i believe wenda gu's crossover, multi-language, and endless expressions will enable him to walk further on the path to self-discovery.

curator of united art museum　huang liping

黃立平，湖北宜昌人，企業家，教育學、管理學、心理學跨學科學者。1996 年被武漢大學評定為教授，享受國務院特殊津貼專家。現任中電光谷聯合控股有限公司董事長，武漢創意產業協會會長，武漢市畫廊協會會長。2014 年創辦武漢合美術館，並任館長。

huang liping, an entrepreneur from yichang, hubei province, is an interdisciplinary scholar in pedagogy, management and psychology. in 1996, he was appointed professor at wuhan university, distinguished as an expert who enjoys the state council special allowance.

he is currently the chairman of clp optical valley united holding co., ltd., the president of wuhan creative industry association and the president of wuhan gallery association.

in 2014, he founded united art museum and worked as museum director.

前言 ❷

魯虹

PREFACE

lu hong

在今天，強調對傳統文化的繼承與轉換已成為大多數人的共識，但在上個世紀 80 年代強調反傳統的特殊文化情境中，一些人的看法卻並非如此。現有的資料告訴我們：作為一位先行者，藝術家谷文達在當時不僅做了大量相關藝術探索，也留下了極為深刻的歷史烙印！不過，與極端化的民族主義者不同，因為在此過程中，他亦很好地融合了西方現代藝術中的若干因素！而「太極圖」「超現實地平線」「遺失的王朝 —— 靜則生靈」與「遺失的王朝 —— 他們 × 她們」等就是其代表作。在我看來，谷文達是通過西方重新發現了東方，並在相互融合的過程中再造了東方。很明顯，沒有對外來文化的合理借鑒，沒有對傳統文化的再創造，他根本不可能為當代中國和世界當代藝術奉獻如此巨大的藝術成果。當然，倘若他只是以水墨的方式照抄西方或者照抄傳統，同樣不可能取得已有的成就。這也在很大程度上說明：首先，傳統是創造出來的，任何抱殘守缺的做法會使傳統走向衰落；其次，在推進傳統向當代轉換的歷史進程中，一定要超越東

nowadays, the inheritance and transformation of traditional culture have become the consensus of most people. however, some people in the 1980s held different opinions in the special cultural context of anti-tradition. existing information shows that as a forerunner, artist gu wenda not only did a wealth of artistic exploration, but also left deep historical imprint at that time. but different from extreme nationalists, he also did a good fusion of a number of elements in western modern art, which can be seen from his masterpieces such as *infinity, surreal horizon, mythos of lost, dynasties series-tranquillity comes from meditation* and *mythos of lost dynasties series-hes × shes*. in my opinion, gu wenda rediscovered the east through the west and recreated the east in the process of mutual integration. apparently, without reasonable reference to foreign cultures and recreation of traditional culture, by no ways could he make such a huge contribution to the contemporary art of china and the world. certainly, if he merely copied the west or tradition in ink painting, it is also impossible that he could make such achievements. therefore, it can be concluded to a large extent that first of all, tradition is created and any attempt to cling to the past will lead to the decay of tradition; secondly, it is necessary to transcend the binary mode of opposition between the

西方對立的二元模式，即一方面要大膽學習西方現當代藝術中有價值的東西加以巧妙轉換，另一方面還要努力從傳統中尋求具有現當代藝術的因素，然後再把它創造為全新的元素。而這一切只有在多元文化的碰撞與交織中才可以做到！

1987 年，谷文達應邀在多倫多約克大學舉辦了首次國外的展覽，此後他便移居到了美國，並成為自由藝術家。40 多年來，儘管身在異國，可他一直將藝術創作之根深深的扎在了中國。因為無論是創作裝置作品，還是創作架上作品，即創作「唐詩後著」「簡詞典」也好，或是創作「聯合國」等也好，他都充分突顯了既當代又中國，且極具個性的特點。了解世界當代藝術史的人都知道，要做到這些非常不容易。也正因為如此，他至今已受邀到 40 多個國家舉辦了個人展覽，其重要性當是十分明顯的！

合美術館自成立以來，已經成功舉辦了多個優秀藝術家的研究展。就如以往的展覽一樣，此次谷文達的研究展既包含有他的重要藝術作品，也包含大量相關文獻。相信此展的成功的舉辦，對於所有希望對谷文達進行深度研究的人士，以及對中國當代藝術的健康發展都會起到很好的作用！還需要說明一下，此展籌備已有三年多的時間，在此期間，谷文達本人及團隊工作人員做了大量工作，在此特表示最衷心的謝忱！

是為序！

<div align="right">

合美術館執行館長　魯虹

2019 年 11 月 16 日於武漢合美術館

</div>

east and the west when promoting the transformation of tradition to the contemporary era. namely, we should not only boldly learn from and flexibly transform something valuable in western modern and contemporary art, but also seek elements of modern and contemporary art from tradition and then create new elements. and all of these can be done only in the collision and integration of diverse cultures!

at the invitation of york university, gu wenda held his first foreign exhibition in 1987. then he migrated to the united states and became a freelance artist. over the past 40 years, although he lived in a foreign country, he always rooted his artistic creation in china. no matter they are installation works or easel works, such as *forest of stone steles series-post tang poetry*, *jiancidian* or *united nations*, he has fully highlighted the unique characteristics of both contemporary and chinese. those who have certain understanding of the world contemporary art history all know that it is very uneasy to achieve what gu wenda has done. because of this, he has so far been invited to more than 40 countries to hold personal exhibitions, which reveals the importance of his works.

since its foundation, united art museum has successfully held exhibitions of multiple outstanding artists. similar to gu's previous exhibitions, this time gu wenda's exhibition will also contain his important artistic works and a lot of relevant literature. it is believed that this exhibition will be beneficial to those who would like to deeply study gu wenda and to the healthy development of chinese contemporary art. it should also be mentioned that this exhibition has been in preparation for more than three years. i, on behalf of united art museum, would like to extend our most cordial gratitude to the great efforts that have been made by gu wenda and relevant staff!

thanks for your reading!

<div align="right">

executive curator of united art museum　lu hong

wuhan united art museum november 16, 2019

</div>

魯虹，1981 年畢業於湖北藝術學院美術分部（現湖北美術學院），現為國家一級美術師，合美術館執行館長，中國美術家協會會員，四川美術學院與湖北美術學院客座教授、碩士生導師，國家當代藝術研究中心研究員，湖北美術館客座研究員，深圳市美術家協會副主席，深圳市宣傳文藝基金評委。

in 1981, lu hong graduated from the art division of hubei arts college (now hubei institute of fine arts). now he is a national first-class artist, executive curator of united art museum, member of china artists association, and visiting professor and master supervisor of sichuan academy of fine arts and hubei institute of fine arts. in addition, he also works as a researcher of national contemporary art research center, visiting researcher of hubei art museum, vice chairman of shenzhen artists association and judge of shenzhen publicity and art fund.

前言 ❸

布萊恩・甘迺迪

PREFACE

brian kennedy

谷文達是當今國際上最重要的中國藝術家之一。他的作品運用了他個人近 40 年來的探索和各種藝術實踐。

「藝術」展覽展示了他豐富多彩且引人入勝的藝術創作。基於在中美兩地的生活經歷,谷文達考察了自己個人身份特徵與世界的關聯,他作品中的個人及全球化視角通過多種不同媒介呈現,闡述了文化和種族認同的課題。他作品的創作已有數百萬人參與,特別是那些涉及從當地文化中收集頭髮的項目。他探討了歷史殖民主義的問題——並非完全出於領土佔有的角度,而是與心理和精神佔有更為相關。他的「聯合國」系列作品討論了當今時代的生命科學和遺傳學革命,這正在塑造我們當今的思想。作為長久以來關注利用可持續發展議題的藝術家,他對語言學和身份問題也深有感觸。

無論是當代水墨作品,還是用非釋意的語言創作與文字相關的藝術,抑或是讓全世界觀眾為之驚歎的「聯合國」

gu wenda is one of the foremost chinese artists working internationally today. his art uses a variety of practices explored over nearly 40 years.

this exhibition presents an intriguing and informative display of his art making. he has examined his own place in the world and issues of personal identity as he negotiated between china and america. the global and personal aspects represented in his own work are presented using different media and illuminate issues of cultural and racial identity. his work has involved millions of people, especially those projects that involved the gathering of hair from local cultures. he has explored issues of past colonialism, not relating so much to land occupation, but to psychological and mental occupation. his united nations series deals with the biological and genetic revolution of our times which is shaping our thinking today. an artist who has been preoccupied by issues of recycling and sustainability, he has also reflected deeply on issues of language and identity.

gu wenda has been preoccupied by seriality, whether making works of contemporary ink painting, creating word paintings in unintelligible languages, or making

作品，谷文達一直注重系列性。早年在中國的生活使谷文達沉浸在一種高度活躍的智識氛圍中。他特意地將語言作為一種社交活動進行探索，類似於遊戲。他以改變和塑造我們當代藝術文化的方式探索視覺語言。基於中國的歷史和傳統，他既是主角，又是和平使者。他渴望實現「世界和平與和諧」，並作為一個「將一個地方連接到另一個地方……將一個國家連接到另一個國家的文化大使」而行動。他提倡的包容性和多元文化身份對他很重要，這使他在許多國家從事並參與藝術項目。

谷文達對人體材料運用和對不尋常材料的使用（例如用頭髮製成的墨水或用茶製成的書籍）是他藝術中煉金術方面的體現。致力於吸引年輕人也是谷文達作品的標誌性之一，他通過藝術創作及其合作和觀賞的可能性來激發年輕人的靈感。數十年來大規模作品的創作體現了谷文達的雄心壯志和出色的執行力。無論是通過行為藝術還是創造多感官的體驗，谷文達從事藝術實踐的方式都表明了他如何與當前潮流保持聯繫。他時常領先於時代的潮流——他認為世界數碼化的聯繫越緊密，就會有越多的人尋求基於人際互動的真實體驗。

<div align="right">

埃塞克斯博物館館長
布萊恩・甘迺迪

</div>

marvelous hair screens that have transfixed audiences across the world. gu's early years in china saw him immersed in a lively intellectual life, one that especially explored language as a set of social activities, akin to a game. he has explored visual language in ways that have altered and shaped our contemporary art culture. founded on chinese history and tradition, he has been a protagonist but also a peacemaker. he aspires to "a universal peace and harmony" and acts "as a cultural ambassador that connects one place to another... one country to another". his promotion of tolerance and multicultural identity is important to him and has allowed him to engage in artistic projects in many countries.

gu's use of human bodily substances, and unusual materials like ink made from hair, or books made from tea, are aspects of his alchemy. his work is also marked by a determination to engage young people and to inspire them with the act of art making and its possibilities for collaboration and spectacle. working frequently on a huge scale, his ambition is matched by his brilliant execution. the ways that gu has engaged his artistic practice, both as performance and by creating multisensory experiences, demonstrate how he remains in touch with current trends. he has frequently been ahead of them, understanding that the more digitally connected the world becomes, the more people will search for real experiences founded in human interaction.

<div align="right">

director and ceo of peabody essex museum
brian kennedy

</div>

布萊恩・甘迺迪，美國皮博迪・埃塞克斯博物館館長。出生於愛爾蘭都柏林，在都柏林大學學院獲得了藝術史和歷史學的本科、碩士以及博士學位。甘迺迪博士曾任托萊多藝術博物館的董事長、館長及執行總裁，美國達特茅斯學院胡德藝術博物館的館長。在來到美國之前，擔任了八年愛爾蘭國立美術館的館長助理和七年的澳洲國家美術館館長。現在他還是藝術博物館館長協會的會員，美國博物館協會的審稿專家以及國際藝術評論家協會的會員。

brian kennedy, director of the peabody essex museum. born in dublin, ireland, studied art history and history at university college in dublin, earning bachelor's, master's and doctoral degrees. from 2005- 2010, kennedy was director of dartmouth college's hood museum of art in hanover, new hampshire, which has one of the largest and nest art collections at an american college or university. prior to coming to the united states, kennedy spent eight years as assistant director of the national gallery of ireland, dublin(1989-1997) and seven years director of the national gallery of australia (1997-2004) in canberra. he is a member of the association of art museum directors, a peer reviewer for the american association of museums and a member of the international association of art critics.

藝術家自述

———
▍

藝　術　的　故　事

谷文達

A STORY OF ART

gu wenda

能講出故事來的，壹生也就把壹個故事講好了。

在我兒時的記憶裏

山巒是神奇的。那是 1961 年，當時陸歲的我與祖母坐火車去我的家鄉浙江上虞，途徑杭州時我問祖母，車窗外那黑黑的龐然大物是甚麼？祖母告訴我是山。那是我第壹次看到山啊！出生於上海大城市的我，總算第壹次結緣於大自然了。我與祖母那次的經歷在我畫水墨畫時常常記憶猶新。從我熱愛涉足名山大川，去體驗其雄渾持久和連綿無盡，從搜盡奇峰打草稿，到如今我最愛的綠色森林書法，與河道書法所原創的園林城市的大地藝術與規劃設計，我的生活與藝術從來沒有離開過對大自然的盎然興趣。1971 年在初中的我開始研習山水畫。1979 至 1981 年在浙江美術學院為陸儼少先生的研究生。1981 年至 1987 年我任教於浙

if you can tell a story, you just tell a story well in one lifetime.

IN MY CHILD MEMORY

mountain chains were magical, miraculous. that was in 1961. my grandmother and my six-year-old self took the train to my ancestral hometown, shangyu, zhejiang. on the way past hangzhou, i asked my grandmother, what is that dark, massive thing outside the train window? my grandmother said it was a mountain. my first time seeing a mountain! having lived in the big city that is shanghai, i had my first encounter with nature. that experience of mine with my grandmother is often still fresh in my memory when i paint shuimo ink paintings. from my love of setting foot on famed mountains and great rivers—in order to experience their mighty stoutness and ageless doggedness— from seeking out unusual peaks to laying out the drafts to land art and planning and design of the garden city created with the green forest calligraphy and arts originally created by green forest calligraphy and river calligraphy—which are my most— my life and art has never strayed from my exuberant interest in nature. in 1971, in middle school, i started to learn about shanshui (landscapes). from 1979 to 1981, i was a graduate student under prof. lu yanshao at the zhejiang academy of art. from 1981 to 1987, i took up a lecturing position in the

江美院國畫系山水專業。在 85 藝術復興早期已進入我的創作鼎盛時期，並開始創建當代觀念水墨藝術、水墨裝置藝術和水墨行為藝術。

翻譯 & 移植的故事

「移植事件」系列作品是我自上世紀 80 年代移居美國多年之後所產生的想法。實際設計與製作從 2003 年開始。這系列與著名的文化機構、商業機構合作，以他們的名稱作為作品的翻譯基點。創作通過將機構、品牌的名稱與另壹語言之間的「文化翻譯」（名稱來源語言：中文）來完成。1987 年我移居紐約。1993 年，是我離開後第壹次回國。壹件小小的 incidence（事件）讓我驚歎不已！「先生，您要甚麼？」壹禮貌可掬的 starbucks（星巴克連鎖咖啡店）服務生問道。我看着她身後的菜單，迷惑不解．「『拿鐵』是……甚麼？」「嗯……」服務生更迷惑了，她直愣愣地瞪着我，「『拿鐵』就是 latte（鮮奶咖啡）。」「啊……」我支支吾吾。腦子還沒到不好使的境界的我，似乎被誰「拿」着壹塊「鐵」重重地砸在我的頭上，「哈哈哈……」紋絲不動的我傻傻地站着，頭卻暈乎乎的，「翻譯原來如此嗎？」我發蒙的智商怎麼都無法連結壹杯美味的 coffee latte（鮮奶咖啡）可以如此地翻譯成「拿鐵」！我沖着服務生調侃道，「我要壹杯 coffee latte，但不要『拿鐵』，你要是『拿』來壹塊『鐵』，我敢喝嗎？」在場的服務生和顧客都哈哈啊哈哈地大笑……如此壹件 incidence 讓我沉迷與陶醉在文化差異、文化誤讀、文化誤解、絕對富有意義的荒誕不經裏不能自拔，如同「碑林 —— 唐詩後著」，誤讀不就是創造嗎！

landscape concentration within the department of chinese painting (guohua) at the zhejiang academy of art (now china academy of art). by the early stages of the '85 new wave movement, i had already entered my creative peak and started establishing contemporary conceptual ink art, ink installation art, and ink performance art.

A STORY OF TRANSLATION&TRANSPLANT

i began to have an idea about creating a series of art project named *transplant affairs* in 80s after i immigrated to new york city. *transplant affairs* series has been creating neon light on particular chinese poetic phrases. those chinese phrases are cultural translations from sound mimicing of original name brands and institution names in foreign languages. i moved to new york in 1987. in 1993, when i returned to china for the first time after the departure, one particular incident stunned me. "what would you like?" asked by the polite and friendly cashier at a starbucks in china. i scanned through the menu behind her and wondered, "what...is a'na tie'in particular?" na tie is the chinese translation of latte. this two chinese characters literally means "to fetch (a piece of) iron". it is the equivalent to latte. she was surprised that i asked. "latte? is that the translation?" i felt as if someone just broke my head with a piece of iron. i could not believe a cup of mellow coffee latte would be translated so poorly as na tie-to fetch (a piece of) iron! it must be a prank! i said to the cashier in fun, "a cup of coffee latte, please, not na tie. i wouldn't dare to drink it if you fetch me a piece of iron!"such an incident made me indulge in the meaningful absurd within cultural differences, misreading, and misinterpretation. isn't misreading or misinterpretation a kind of creation?

A STORY OF LIFE

united nations is already 26 years old and has traveled to over 20 different states and nations, incorporating the genes and dna of five to six million people from around the world... according to the ancient beliefs of the american Indians, the hair was regarded as the soul of the human being; the hair of saints is preserved at the vatican. at the wailing wall in jerusalem, human hair has been inlaid into the cracks in the limestone and at emei

生命的故事

《聯合國》已經貳拾陸周歲了。她周遊了貳拾多個
國度和民族，擁抱了地球上伍佰至陸佰萬的人髮
基因dna。古印第安人視人髮為人的神靈，梵蒂岡
保存教宗的聖髮，耶路撒冷祈禱牆削髮鑲嵌於牆
縫，峨眉山頂削髮捨身佛光……人髮的dna是人類
基因長河，中國古訓就有「髮膚，受之父母」「結髮
夫妻」等形容。《聯合國 —— 血肉長城》壹仟伍佰
方實心人髮磚（為明長城磚之尺寸：10厘米厚 ×
20厘米寬 × 40厘米長）。生物生命基因dna髮
磚，墨黑錚亮，凝聚了貳佰萬之人髮。我問合館展
廳看管「武漢市有多少人口？」……我接着說道：
「武漢大約有人口壹仟壹佰萬；我的《聯合國 ——
血肉長城》就相當於武漢伍分之壹的人口！」展廳
看管張口驚訝，下意識地站了起來，看着髮簾回
答：「震撼人心……」《聯合國 —— 綠宮》與《聯合
國 —— 血肉長城》雙雙入駐合館。多少人的基因
dna鑄成，《綠宮》收集了美國達特茅斯大學城伍
拾萬人次剪髮，壹件藝術是壹座城池！她說：「醬
紫（這樣子）啊？哇塞！」

大眾當代藝術日

《基因 & 蛻變》集歷史人文與藝術娛樂壹身。仟餘
學童在壹仟平米的大紅色綢緞上書寫斗大漢字，現
場直擊，震撼人心，波及捌方。儒家《孝經》與《基
因 & 蛻變》，這壹當代生物工程的經典概念，瞬間
融匯，轉譯成聲勢浩大的當代書法的詮釋。也是壹

mountain monks shaved their hair, sacrificing themselves to buddhist teachings, their shining bald heads radiating the "light of buddha". the genes contained in the human hair in this work, form a long river of dna. there is the old chinese saying "fafu shouzhi fumu" that our hair and skin is inherited from our parents and therefore we must be filial and protect them and also another filial saying, "jiefa fuqi", which uses the metaphor of a knot of hair to describe a first marriage, and undying love of the wife for her husband.... *united nations— dna great wall* is made of 1500 solid square blocks of human hair (according to the dimensions of bricks in the great wall which were 10 cm thick × 20 cm wide and 40 cm long.) *united nations—dna great wall* is composed of bricks hair, of biological living dna, pitch black and gleaming, aggregated from the hair of two million people. While in the exhibition hall of the united art museum, i asked the security guard, "what is the population of wuhan?" ... she replied, "the population is roughly 11 million; "I responded, "my *united nations—dna great wall* accounts for a fifth of the population of wuhan!" the security guard looked surprised, her mouth hanging open in awe, subconsciously she stood up looking at the curtain of hair and said, "it's really moving..." *united nations—green house* and *united nations—dna great wall* have entered the hall of the united museum as a pair: forged from the dna of many individuals: *green house* is made from the hair 500000 people in hanover, new hampshire, the home of dartmouth college; it's a piece of art which acts as a city wall. "that's what it is?" said the security guard, "well i'll be darned!"

A STORY OF QING LV SHAN SHUI HUA

public contemporary art day embodied all of the concepts of history, humanities, and entertainment. the sight of thousands of students writing huge characters on yards of red silk was a striking scene which was translated into a powerful interpretation of contemporary calligraphy, and also a sumptuous feast of *art wholeism*. five years after, we're exhibiting the documentary video of the performance, to relive *dna and metamorphosis* and re-experience that magnificent moment which vibrated through the city foshan. in the first morning after the event, i rose quite early. i thought of the sea of thousands of people the day before, a vast and mighty wave. i thought of those inspiring painted characters, and how our team

場全主義藝術的盛宴。伍年後我們以藝術紀錄片的視頻展示，來重溫《基因＆蛻變》在當年的震撼佛山的盛況。忙後的第壹個清晨，我仍舊起了個大早。想起昨日數仟人海，浩蕩壹揮，激揚文字，如同上天攬月，下洋捉鱉……清晨露收，萬籟復蘇。我就簾習坐。那時旭日臨窗，和風拂煦，神爽氣盈。驚心動魄的壹周，基因與蛻變的過程可沒傷害我的皮毛，卻如天公作美一般脫胎換骨，願鳳凰涅槃，浴火重生。我看到了如何做好壹個藝術家。

《青綠山水畫的故事》從她的參與性，她的大眾波普行為藝術那裏，可見她承接文人經典的青綠山水畫，同時也展示了對未來生態的關注；她對我們意識形態敏感的藍藻水氾濫的環境問題，不做教條主義式的說教，也不是僅僅停留在批評。她向企業和社會提出了時代需要。《青綠山水畫的故事》展示了藝術可以改變現狀現實的力量，也提供了藝術可以改變現實的實證。作為《青綠山水畫的故事》的主辦與支持，平安集團以「藝素養」的高屋建瓴，在開幕式之際，宣佈為改變貧困學童的飲水，開出了大支票，捐助平安希望小學健康飲用水源系統！

壹生有許許多多美麗的記憶……而 2016 年 9 月 24 日這壹天是我美麗而富有意義的 moment（時刻）……記住這壹天，回顧這壹刻，希望壹仟伍佰位青綠明星的期望會激勵每壹年的這壹天成為「青綠山水日」，或許到他們長大了，那時他們的生活每壹天，都在青綠山水裏。

shoot for the moon, with all the various sounds coming alive in my imagination as i meditated on the memories of the day before. that morning at the window, with the warm breeze wafting in, i sat, breathing in the fresh air which enlivened my spirit. that soul-stirring week, throughout the process of producing *dna and metamorphosis* it seemed as if the heavens were aligned, to facilitate a kind of reincarnation, like a phoenix rising from the ashes, floating up to nirvana. i learned how to be an artist.

a story of qing lv shan shui hua it's clear that this participatory, public pop art performance carries on the tradition of classic qinglv shanshui painting. at the same time, it also displays a focus on future ecological issues; and shows my ideological sensitivity towards the environmental problem of the uncontrolled spread of algae in our water system. this is not preaching in a dogmatic way, nor do i stop at the mere act of criticism. this project presents the demands of the era to both society and to the business community. *a story of qing lv shan shui hua* illustrates the power of art to change the current reality, and supplies us with an example of how this reality can be changed. as one of the main organizers and sponsors of *a story of qing lv shan shui hua*, pingan group made an announcement at the opening of its new high-rise building—a project called "the art of nourishment", which would support clean drinking water for poor students. at the time it issued a big check which was donated to its charity pingan hope, with the aim of building a system of healthy potable water for primary school students!

there are so many beautiful memories in this life, but september 24, 2016, was a particularly beautiful and a richly-meaningful moment. remembering this day and revisiting that memory. I hope that the 1500 stars of *a story of qing lv shan shui hua* would be encouraged enough to make every day a qinglv shanshui day, so that when they grow up, they can live every day in a beautiful world of verdant mountains and crystal blue waters.

第壹部分
CHAPTER 1

藝術的故事
現象·爭議·挑戰·影響

A Story Of Art:
PHENOMENON·
CONTROVERSY·
CHALLENGE·INFLUENCE

現象・爭議・挑戰・影響（壹）：

1986 年陝西楊陵全國中國畫理論研討會暨谷文達首個個人展覽

PHENOMENON・CONTROVERSY・CHALLENGE・INFLUENCE 1:

national chinese painting theory symposium and gu wenda first personal exhibition in shaanxi yangling 1986

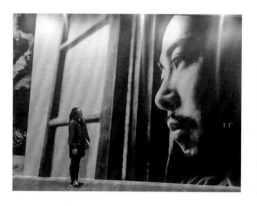 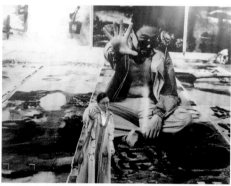

《無聲演講》之貳

水墨行為藝術
黑白照片與觀眾

SOUNDLESS SPEECH #2

black and white photo display
of ink art performance with
audience

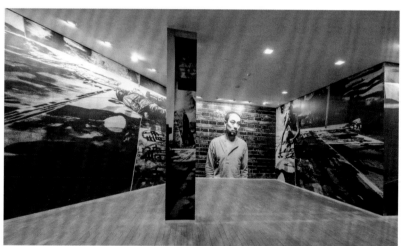 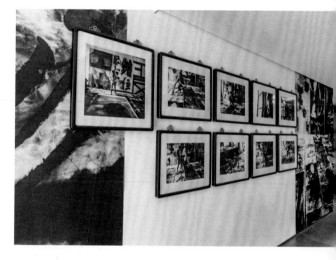

《無聲演講》之貳

水墨行為藝術
黑白照片展示現場
上海二十一世紀民生美術館與合美術館

SOUNDLESS SPEECH #2

ink performance
ink performance black and white photos display at
shanghai 21st century minsheng art museum and the
united art museum

《無聲演講》之貳
水墨行為藝術
黑白文獻照片之拾壹
1985 年於杭州
50.5 厘米長 × 39.5 厘米高

SOUNDLESS SPEECH #2
ink performance
black and white documentation
photo #11
hangzhou, 1985
50.5cm long × 39.5cm high

《無聲演講》之貳
水墨行為藝術
黑白文獻照片之陸
1985 年於杭州
50.5 厘米長 × 39.5 厘米高

SOUNDLESS SPEECH #2
ink performance
black and white documentation
photo #6
hangzhou, 1985
50.5cm long × 39.5cm high

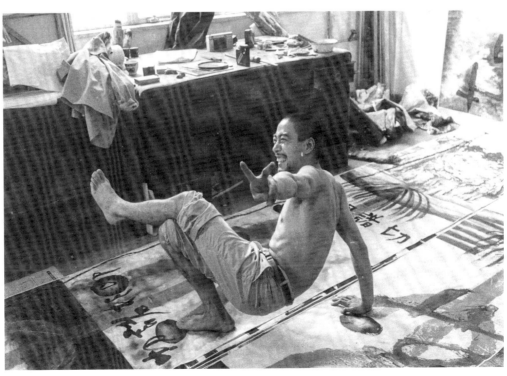

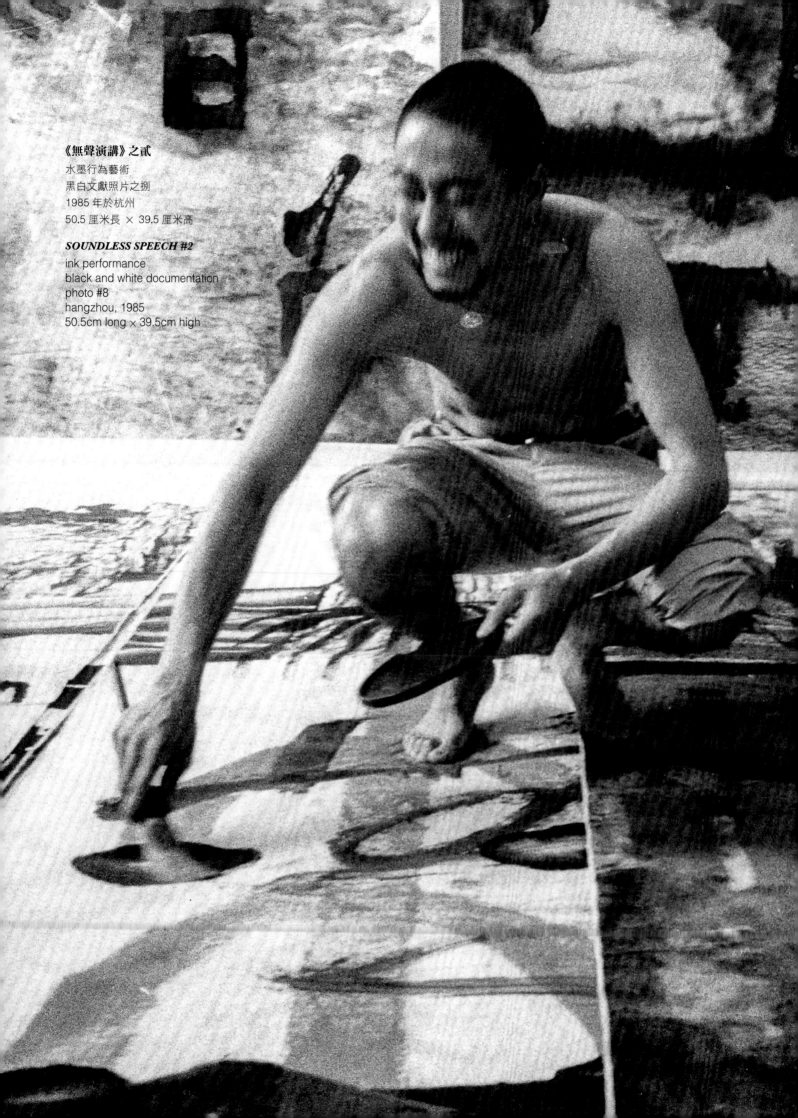

《無聲演講》之貳
水墨行為藝術
黑白文獻照片之捌
1985 年於杭州
50.5 厘米長 × 39.5 厘米高

SOUNDLESS SPEECH #2
ink performance
black and white documentation
photo #8
hangzhou, 1985
50.5cm long × 39.5cm high

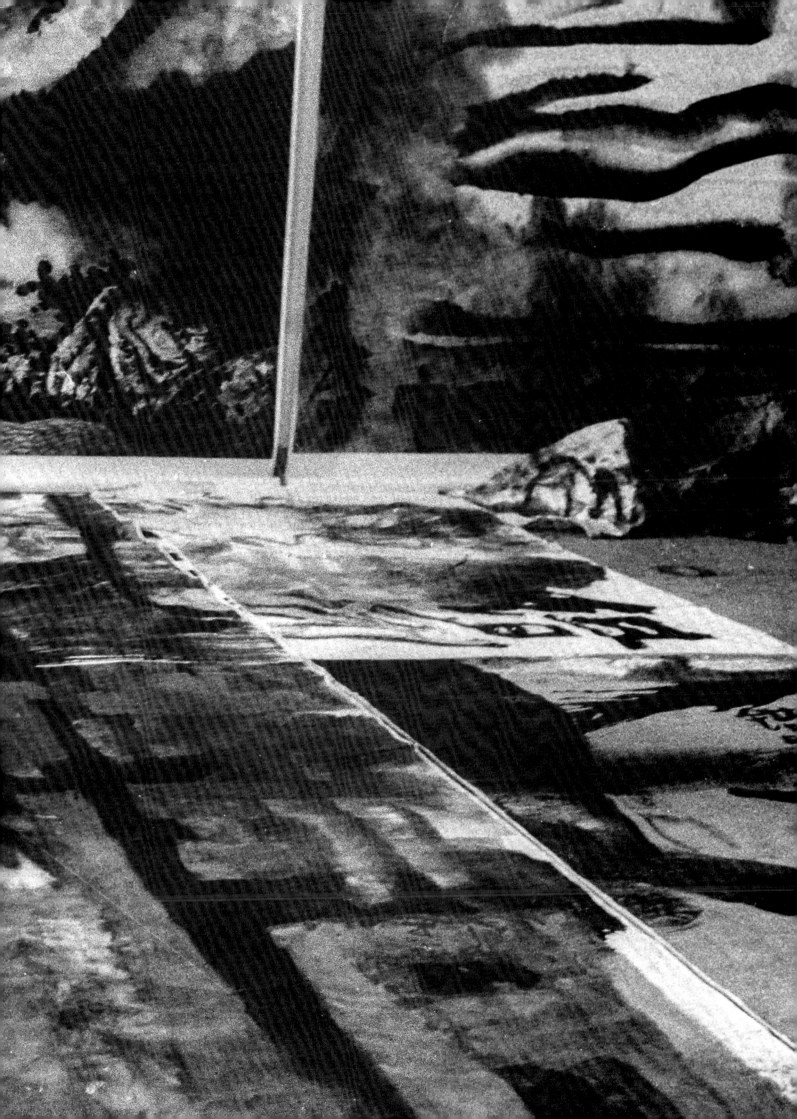

《無聲演講》之貳

水墨行為藝術
黑白文獻照片之拾叁
1985 年於杭州
50.5 厘米長 × 39.5 厘米高

SOUNDLESS SPEECH #2

ink performancer
black and white document
photo #13
hangzhou, 1985
50.5cm long × 39.5cm high

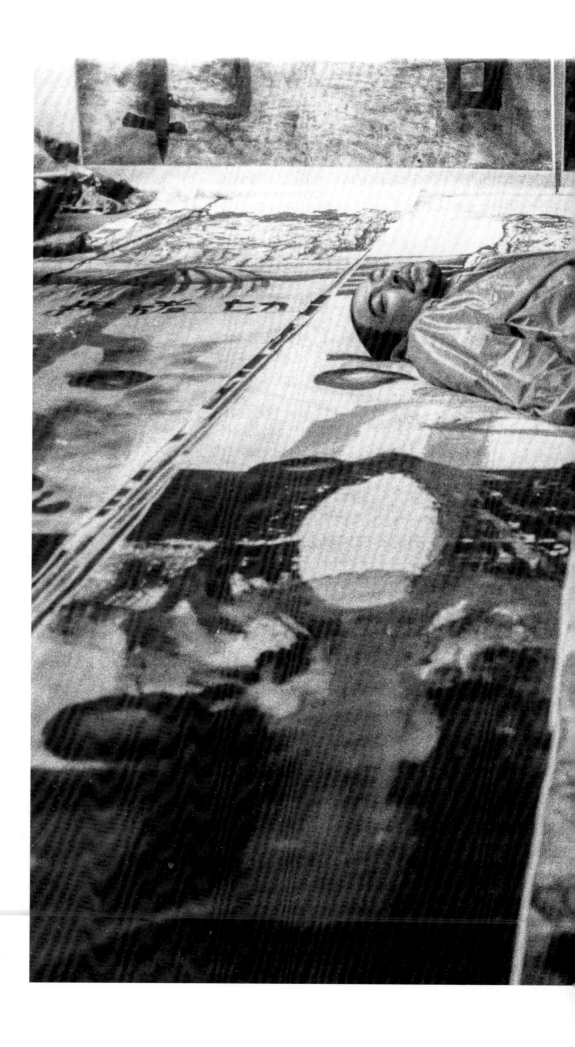

水墨行為藝術
黑白文獻照片之拾叁

6

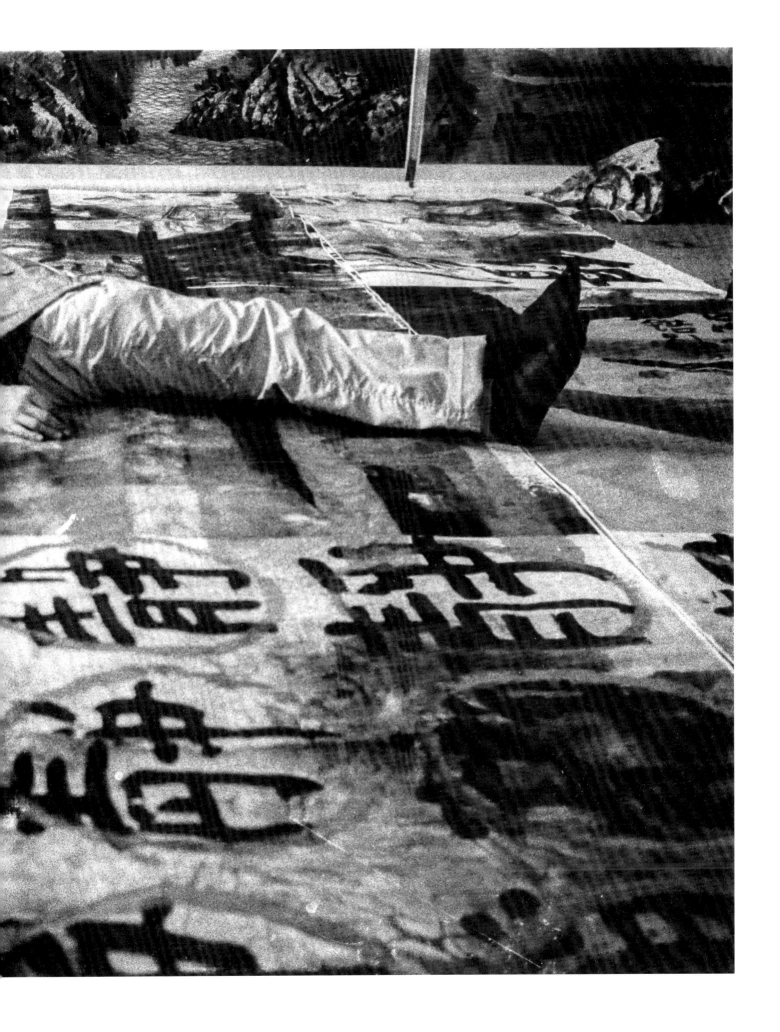

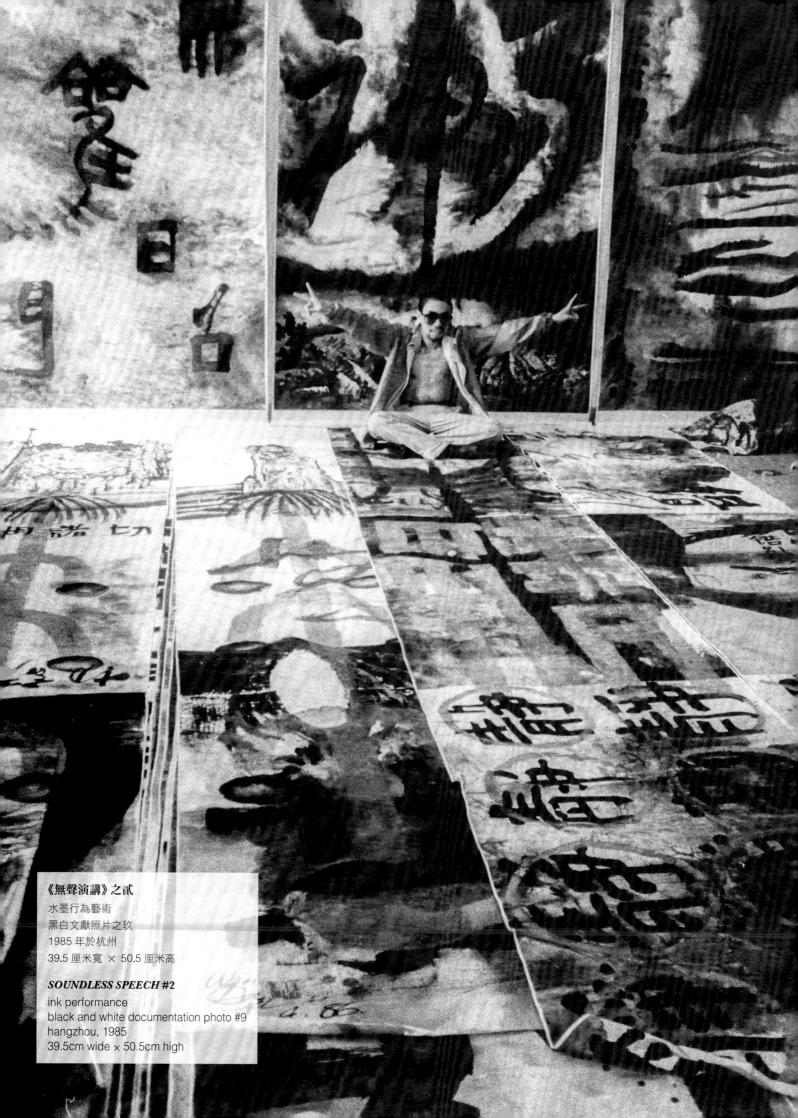

《無聲演講》之貳
水墨行為藝術
黑白文獻照片之玖
1985 年於杭州
39.5 厘米寬 × 50.5 厘米高

SOUNDLESS SPEECH #2
ink performance
black and white documentation photo #9
hangzhou, 1985
39.5cm wide × 50.5cm high

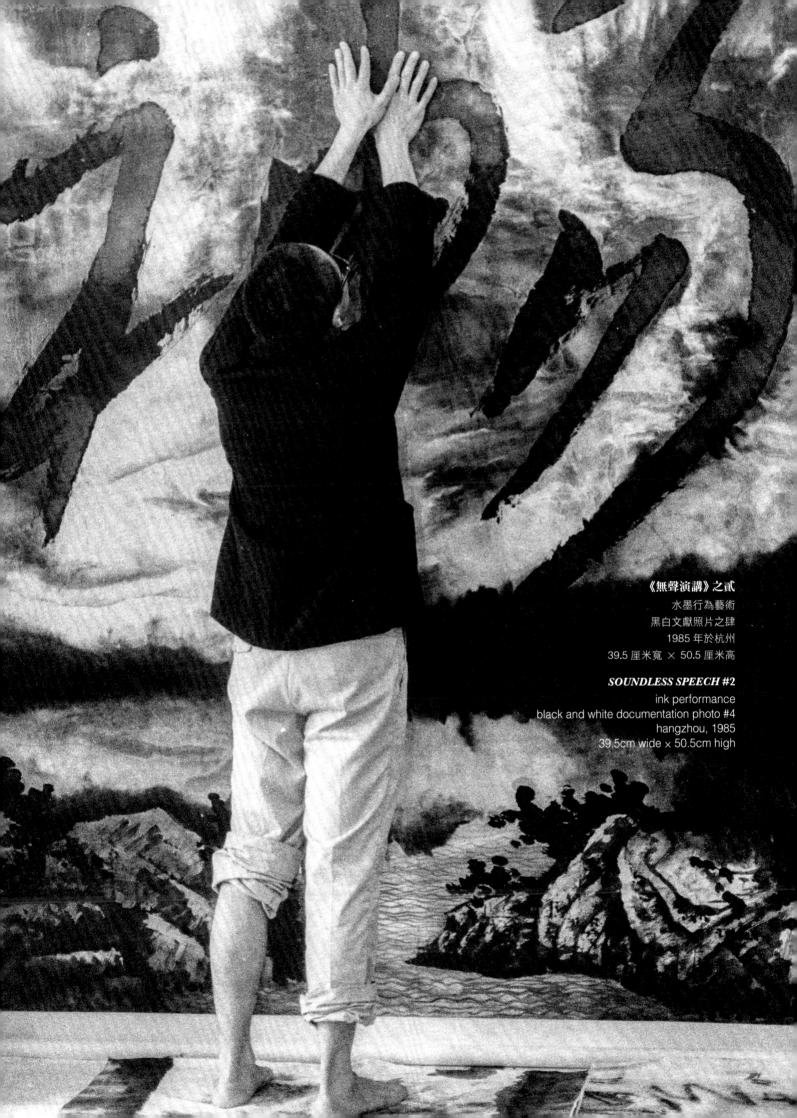

《無聲演講》之貳
水墨行為藝術
黑白文獻照片之肆
1985 年於杭州
39.5 厘米寬 × 50.5 厘米高

SOUNDLESS SPEECH #2
ink performance
black and white documentation photo #4
hangzhou, 1985
39.5cm wide × 50.5cm high

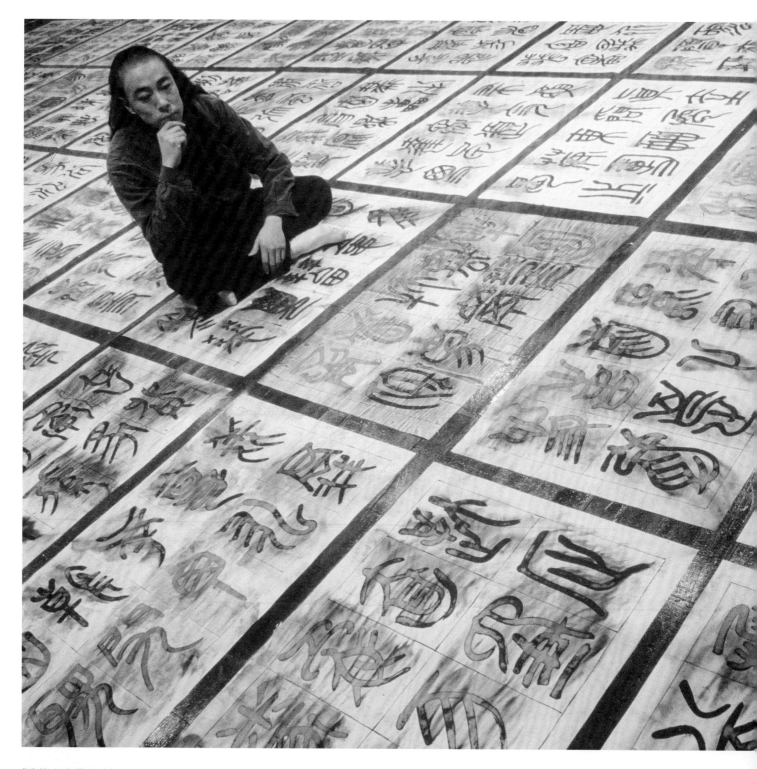

《偽篆書臨摹本式》

遺失的王朝 a 系列之壹至伍拾

1983-1986 年於杭州工作室

墨，宣紙，紙本裝裱

61 厘米寬 × 92 厘米高（每幅）

PSEUDO-SEAL SCRIPT IN THE STYLE OF CALLIGRAPHIC COPYBOOK

lost dynasties a series #1-#50

hangzhou studio, 1983-1986

ink on xuan paper, mounted on paper backing

61cm wide × 92cm high each

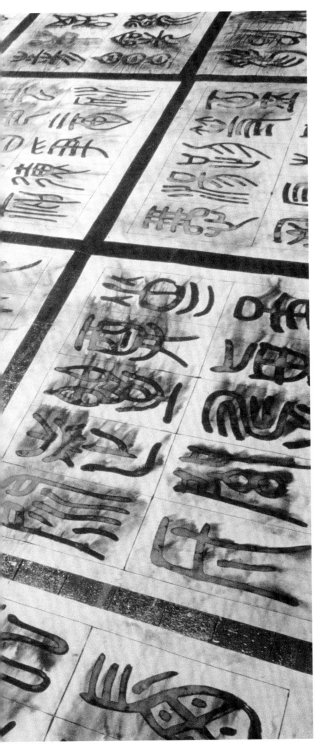

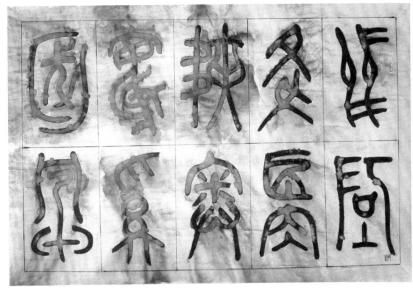

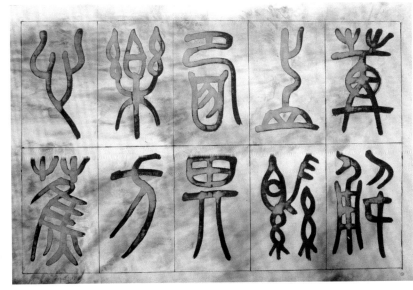

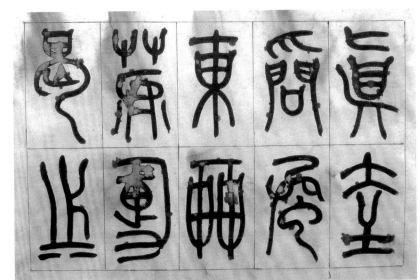

11

《靜則生靈》 細部
wisdom comes from tranquillity detail

13ᴱ BIENNALE INTERNATIONALE DE LA TAPISSERIE

MUSÉE CANTONAL DES BEAUX-ARTS, LAUSANNE 1987

WEN DA GOU

Né en 1955
nationalité chinoise
Centre de recherches et de création
de tapisseries contemporaines
Académie des beaux-arts du Zhejiang
Chine - Hangzhou

Je n'ai rien à dire sur mon travail.
Je souhaite que le public y parti-
cipe.
La réponse réside dans l'œuvre
elle-même.
Elle présente à chaque visiteur un
monde purement spirituel.

I have nothing to say about my
work.
But I hope that the visitors partici-
pate in my work.
The work is the answer itself.
It will show a pure spiritual world to
every visitor.

Etudes de sculpture et de peinture.
Membre de plusieurs instituts et associations
d'artistes chinois, notamment l'Institute of Art
Tapestry-Varbanov.
Dès 1985, nombreux prix décernés lors d'ex-
positions d'art et de calligraphie.
1986 Expose «Travel of the Soul» en Italie.
 Première exposition individuelle à
 Xian.
Œuvres dans la collection de l'Utah Museum,
USA.

13. Jing Ze Sheng Ling
(Le calme procure l'inspiration
Inspiration comes from tranquillity)
500 × 800 × 80 cm
technique mixte, tissage, montage,
encrage et technique traditionnelle
chinoise de la laque (mixed media with
weaving, mounting, pouring ink, traditional
technique of Chinese lacquer)
laque faite de bambou, lin, papier de riz,
encre (lacquer ware made of bamboo,
flax, rice paper, ink)
collection Institute of Art Tapestry-
Varbanov, Zhejiang

48

3. Biennale der Tapisserie in Lausanne

Die überaus grosse Geduld der Textil

cem Gebiet der zeitgenössischen
Textilkunst ist zweifellos das Re-
sultat eines weitverbreiteten,
ernstgenommenen Unterrichts in
diesen beiden Ländern.

War Osteuropa mit nur 2 bezie-
hungsweise 4 Arbeiten in den
beiden letzten Biennalen unter-
repräsentiert, hat es in diesem
Jahr mit 11 Exponaten seinen an-
erkannten Platz in der Textilkunst
wiedergefunden aufgrund des
Wand-Themas.

Erstmals in der Geschichte der
Biennale werden auch 3 ein-
drucksvolle Arbeiten aus China
aus 12 Einsendungen zu sehen
sein.

Die Einsendung zahlreicher Web-
arbeiten war zu erwarten. Die Ju-
ry hat darüber solche mit erzäh-
lendem oder auch dramatischem
Charakter unterschieden. Diese
Tendenz wird in Arbeiten austra-
lischer, kanadischer und pol-
nischer Künstler sichtbar. Einige
nicht figurative Webarbeiten
zeichnen sich durch klaren, oft
rhythmischen Dekor aus.

Das Thema „Zelebrierung der
Wand" hat einige Künstler inspi-
riert, die Wand als Masse, in
Transparenz oder als „trom-
pe-œil" (Augentäuschung) zu
bearbeiten.

Im Gegensatz zu den voran-
gegangenen Biennalen wird die
diesjährige Veranstaltung eine
grössere Mannigfaltigkeit an Sti-
len, Ursprüngen, Referenzen und
Techniken aufweisen und damit
ein weniger einschränkendes Bild
des textilen Schaffens in der Welt
präsentieren.
 KMJ

Dauer der Biennale vom 19. 6. - 21.
9. 1987 im Musée cantonal des
Beaux-Arts, Palais de la Ripone,
CH-1005 Lausanne.

Siehe auch textilkunst. Heft 1/1987,
Seite 40.

Abb. 3: Wen Da Gu, China: „Jing Ze Cheng Ling". 800 × 500 × 80 cm.

Abb. 4: Joyce Crain, USA: „Microchip: Bolean array". 200 × 200 × 8 cm. 1981. Wandinstalliert.
Collage. Material: irisierende Folien und Metallbänder, farbige Gelatine, Plastiknetze.

Das Motto der 13. Biennale der Tapis-
serie in Lausanne lautet «La célébra-
tion du mur – die Zelebration der
Wand». Damit werden die Textil-
künstler sozusagen zurückgepfiffen
auf ihren angestammten Platz an der
Mauer, nachdem sie seit den siebziger
Jahren ihre Textilien als riesige Ob-
jekte frei in den Raum gestellt oder
gehängt hatten. Aber wie das so ist mit
Revolutionen, sie können auch in der
Kunst ihre Kinder fressen.

Annemarie Monteil

Das Thema des «Wandbehangs» im
weitesten Sinn fand Anklang. Mehr
Projekte als je – namlich 1115 – wurden
eingereicht. Davon hat eine Jury nach
Prüfung von Dias 51 Künstler für
die jetzige Ausstellung ausgewählt. Ob
das durchwegs die besten sind, bleibe
dahingestellt.

Die Veranstalter rühmen, die 13.
Biennale biete eine «grössere Mannig-
faltigkeit an Stilen, Ursprüngen, Tech-
niken» als früher. Das stimmt. Der Be-
sucher durchwandert ein ganzes Pano-
rama von Möglichkeiten des textilen
Schaffens, von der traditionellen Web-
kunst bis zur Soft-Art mit Papier und
Kunststoff.

Da gibt es – dem Placierungsort
«Mauer» angepasst – wieder Wollbild
wie zur guten alten Zeit des Gobelins,
wenn auch mit anderen Motiven. Die
Tschechin Renata Rozsivalova zum
Beispiel setzte eine Postkarte ihrer
Grossmutter aus dem Bad Pistyan in
gewobenes Riesenformat um. Das Pa-
villon ist perfekte Postmoderne – sie
verfolgt einem also bis ins Textile.

Der Pole Tymoteus Lekler imitiert
mit Kordeln Sprayer-Schriften, da will
die angewandte Kunst der freien nach-
hüpfen und – verfehlt sie natürlich
prompt. Einmal sind Sprayer nicht
mehr aktuell, zum andern erstickt und
vermottet die Spontaneität des Ansat-

zes im textilen Material. Eine andere
Richtung, vor allem aus den USA, ver-
lustiert sich in glimmerdurchsetzten
Wolle- oder Kunststoffstrukturen. Die
wandbreiten Ausdehnungen gäben De-
kors für Salons des Denver Clans.

Appell ans Unbewusste

Das Unbewusste will die Amerikane-
rin Lynn Mauser-Bain mit Schleier und
Tuch und Leiter beschwören, sie will
damit sogar «dem Landsmann der
Biennalen C. G. Jung» eine Hommage
darbringen. Aber die vor die Wand ge-
hängten Tüchlein vermögen den Kö-
nigsweg der Träume nicht zu er-
schliessen.

Wenn schon Appelle ans Unbewuss-
te, dann in der riesigen Weberei in Form
eines dunklen Vogels der Jugoslawin
Jagoda Buic. Man muss daran vorbei-
wandern, um in die grossen Rhythmen
und rauhen, lebendigen Strukturen
wie in einen grossen Fluss hineinge-
nommen zu werden.

Ebenso monumental, jedoch statisch,
ist die Arbeit des Chinesen Wen Da Gon
(erstmals ist China in Lausanne anwe-
send): gewobene blutrote Panneaus zu
Schwarz, Wolle zu traditionell chinesi-
scher Lackarbeit ergeben ein macht-
volles plastisches Ambiente. (Dass ein
anderer Chinese mit ebenfalls landei-
genen Mitteln wie Bambus sogleich in
die Folklore kippt, zeigt die Gratwan-
derung des Tapisseriekunstlers über-
haupt.)

Uberzeugende Arbeit von Verena Brunner

Das waren zwei starke Arbeiten, bei-
de angesiedelt in den Zonen der Wucht.
Um andere Qualitätsbeispiele zu fin-
den, muss man auf der entgegengesetz-
ten Seite suchen, in den Zarten, Transpa-
renten. Gewebe können schweben –
dass wurde in den letzten Jahren fast
vergessen. Da steht die Schweizerin Ve-
rena Brunner weit vorn mit einer
durchsichtigen Weberei, die mit Figu-
rationen von Gestirn und Topographie
einen imaginären Kontinent erahnen

«Nuovo Mondo», textiles Ge[...]
Verena Brunner.

der Japanerin Keiko Ooi. Ube[...]
ter Höhe ergiessen sich frag[...]
aus feinstem Baumwoll-Pap[...]
be, teils vom feuer geschwär[...]
gen rhythmischen Abfolge[...]
Wind mit leiser Bewegung an[...]

Makellose Technik

Den 51 Arbeiten, die von [...]
Gehalt her unterschiedlich si[...]
perfekte, oft virtuose und [...]
Handwerk gemeinsam. An [...]
Biennale wird jedoch verblüff[...]
lich, wie makellose Technik in [...]
sen Gag, in die leere Dekorati[...]
kann – und wie viel an geis[...]
formaler Disziplin und Intuiti[...]
wirklichen Kunstwerk brau[...]
wenigen starken Arbeiten mu[...]
Architekten ansehen. Denn d[...]
dung von Bau- und Textilku[...]
noch wenig erprobtes Feld [...]
kunftsch[...]cen.

(Pala[...] Rumine, Lausann[...]

60

14

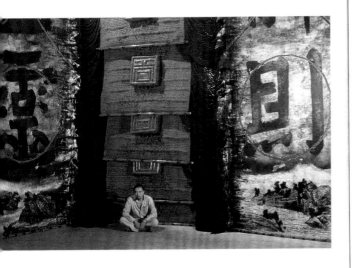

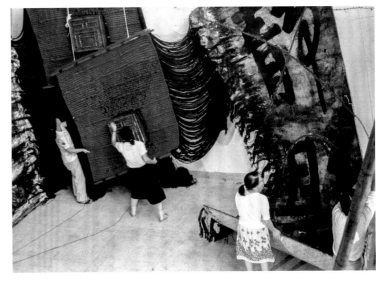

佈置《靜則生靈》
installation of *wisdom comes from tranquillity*

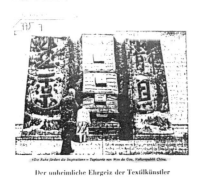

«Die Ruhe fördert die Inspiration» – Tapisserie von Wen da Gou, Volksrepublik China.

Der unheimliche Ehrgeiz der Textilkünstler

13. Biennale internationale de la Tapisserie Lausanne

U. I. Wer die Biennale de la Tapisserie seit ihrer Gründung im Jahr 1962 regelmässig besucht hat, wird heute im Kunstmuseum Lausanne relativ beunruhigt feststellen, dass die textile Kunst, ihren unseren Gesetzen folgend, die Mauer neu entdeckt. Damals, vor fünfundzwanzig Jahren, prägte Jean Lurçat den Begriff «Muttonnade», der ruhige Massen auf eine Wand zu spannen erlaubte; die textile Wand zusammenrollen und unter den Arm nehmen, aufhängen an einem neuen Ort. Der unheimliche Ehrgeiz der Textilkünstler, mit der textilen Faser (samt Kunststoffelementen und Metallschnüren) alle Gebiete der bildenden Kunst erobern zu wollen, hat in der Folge weg von der Mauer geführt, hin zu starren oder flauschig auslösenden Plastiken bis zu fragilen Glasgespinnsten, die kein Formade mehr zusammenmenrollt für die Weiterreise.

Dieser Umgriff an der Schlinge des Fadens sozusagen ins Garn gehauen und hängt nun wieder an der Mauer: Die Werke von neunundfünfzig Künstlerinnen und Künstlern aus siebzehn Ländern (eingesandt wurden über tausend Arbeiten) sind zweidimensional, höchstens als Flachrelief konzipiert. Sie betonen die Mauer entweder als Trägerin von Kunst, sie drapieren aber auch die Mauer, öffnen sie mit bewegten Dimensionen oder verschliessen sie mit einer gewissen Dramatik.

Wie Diana de Rham, Secrétaire générale du CITAM (Centre international de la tapisserie ancienne et moderne), im Katalog mitteilt, sollte die diesjährige Ausstellung der «Célébration du mur» gewidmet sein, das Thema war also gegeben. Es führte zu Missmut unter arrivierten Künstlern, gab aber auch die Möglichkeit zu Adaptionen: Der Japaner Masao Yoshimura stellte ein Stück Wand auf als Kontemplationsobjekt zu einem Gedicht mit den Zeilen «Ich betrachte die Mauer. Die Mauer betrachtet mich». Das Werk konzentriert das Leitmotiv der Ausstellung, welches man Retour au mur nennen könnte. Während vieler Jahre, so betont auch Erika Billeter als Direktorin des Museums, hatten die Künstler die Mauer sozusagen vergessen.

Diesmal also der Faszination der Mauer. Viele dieser Teppiche lassen sich kaum weder ansagen. Sie sind in vielen Beispielen selbst Mauer geworden und geben der Ausstellung das Gewicht ihrer eigentlichen Einganzomane. Das Minderumnss der zugelassenen Arbeiten beziffert Quadratmeter. Wer oben, aus Haunmau grausam, gross als verdeckte Sache (legende

Bulch, an die Wand gespült ist, was wie die Einzelle eines chinesischen Tempels imaginäre Tore verschliesst (Wen da Gou), lautet über fünfzig bzw. vierzig Quadratmeter gross von der Wand. Auch Ritsi Jacobis (Deutschland) Exemplar einer Reliefserie hat das Ausmass der Fassade eines Einfamilienhauses. Dieser gelingt es der in New York lebenden Schweizerin François Grossen, mit Zotteln, Quasten und zusammengedrehten Schnüren rot und gelb die Illusion dämonischer Bewegung vorzuführen.

Sind «pflanzliche Papiere» Textilien? Die Franzosen Claudie und Francis Huntziger haben aus beschichteten und versengten Papieren eine «Bibliothèque en cendres» geschaffen – vielleicht nach der Lektüre des Namens der Rose Romans. Ein Chinese präsentiert bemalten Bambus, eine Japanerin lässt sich inspirieren von geglacktem Papier, das in exakten Abschnitten eine Wand auf der Wand bildet. Eine andere Japanerin demonstriert die Kunst des Faltens an einem Fächervorhang, und durchsichtig verschleiert Hideho Tanakas Sisalpapier das Fenster – einen Blick from Lady Chatterley's lovers, ein Titel, der auch schleierhaft bleibt. Der textilen Kunst, so macht die Ausstellung klar, wird bald Papierkunst folgen: jeder fünfte Aussteller hier stammt aus Japan mit seiner hohen Papiertradition. Schon jetzt hat ein Wandschirm Einzug gehalten.

Wandteppiche im ursprünglichen Sinn, also gewebt auf einem Webstuhl heute- oder basslösse mit Fasern aus Seide, Wolle und Leinen, erfreuen durch makellose Technik. Die bildhafte Gestaltung bringt, vor allem bei osteuropäischen Künstlern, oft gerade das, was Lurçat vor fünfundzwanzig Jahren bekämpfte: die Übertragung eines konventionellen Bildes. Die Auswahl reicht von der gewerten Pressephotographie («Enregistrement A, B») bis zur gewebten Postkarte aus dem Beginn des Jahrhunderts – so genau, als seien die Werke im mechanischer Jacquard-Technik entstanden.

Glanzpunkte textiler Gestaltung, in der sich perfekte handwerkliche Technik mit freischwebender Bildhaftigkeit verbindet (und vich mit normalen Formaten begnügt), bieten die Zürcherin Verena Brunner und die Amerikanerin Ethel Stein. Das Gemeinschaftswerk dieser Westschweizerinnen, ausgeführt für die Halle des Collège de la Plaine in Chavannes, wird im Zentrum ist das Collège dem Publikum zur Betrachtung mit allem geöffnet. (Bis 13. September)

1987 年，水墨裝置藝術《靜則生靈》是中國當代藝術首次參加國際雙年展，成為媒體報導的焦點

the ink installation *wisdom comes from tranquillity* marked a milestone, as gu wenda was the first contemporary artist from china to participate in an international biennale. This became the focus of many media reports.

《他們 × 她們》
遺失的王朝系列
水墨裝置藝術
1985 年由浙江美術學院贊助，萬曼工作室
製作
墨，宣紙，紅手套，傳統編織，裝裱，漆，
絲綢，毛，棉，麻，竹
600 厘米長 × 80 厘米寬 × 300 厘米高

SHES × HES

lost dynasties series
ink installation
commissioned by zhejiang academy of
arts, 1985
ink, xuan paper, red gloves, traditional
woven, mounting, lacquer, silk, wool,
cotton, hemp, bamboo
600cm long × 80cm wide × 300cm high

《他們 × 她們》
遺失的王朝系列
水墨裝置藝術

《他們 ✕ 她們》細部
shes ✕ hes detail

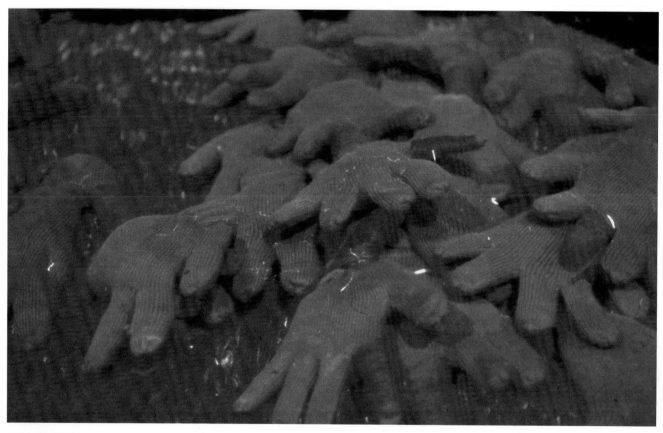

150 副勞動手套
150 pairs of working gloves

《他們 ✕ 她們》細部
shes ✕ hes detail

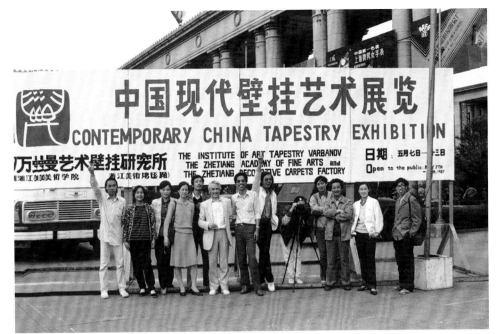

谷文達和萬曼一起商討製作《靜則生靈》的模型（1986 年）
gu wenda and maryn varbanov are working on the model of *wisdom comes from tranquillity* in 1986

《日》
李斯特鋼琴協奏曲
1980 至 1981 年於杭州工作室
墨，宣紙，水粉，紙背木板裝裱
380 厘米長 × 150 厘米高

SUN

lizt piano concerto
hangzhou studio, 1980-1981
ink & pastel on xuan paper, mounted on paper backing and
wood board
380cm long × 150cm high

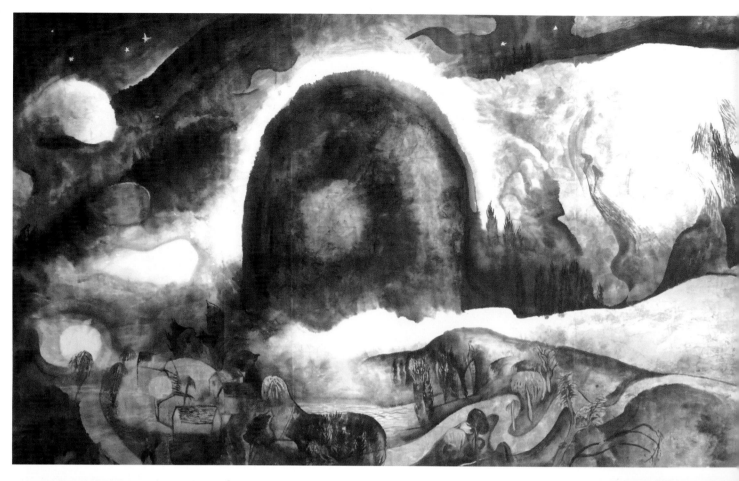

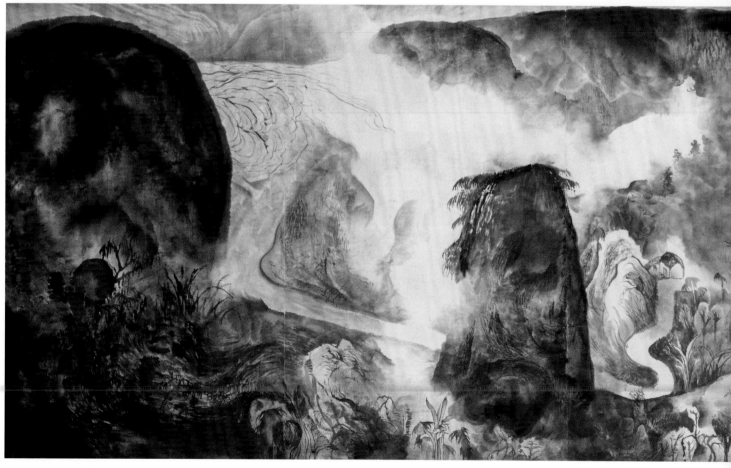

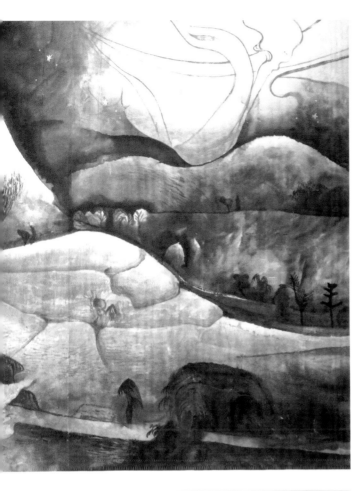

《夜》

李斯特鋼琴協奏曲
1980 至 1981 年於杭州工作室
墨，宣紙，水粉，紙背木板裝裱
380 厘米長 × 150 厘米高

NIGHT

lizt piano concerto
hangzhou studio, 1980-1981
ink & pastel on xuan paper, mounted on paper backing and wood board
380cm long × 150cm high

《風雨到來之前》

李斯特鋼琴協奏曲
1980 至 1981 年於杭州工作室
墨，宣紙，水粉，紙背木板裝裱
380 厘米長 × 150 厘米高

BEFORE STORM

lizt piano concerto
hangzhou studio, 1980-1981
ink & pastel on xuan paper, mounted on paper backing and wood board
380cm long × 150cm high

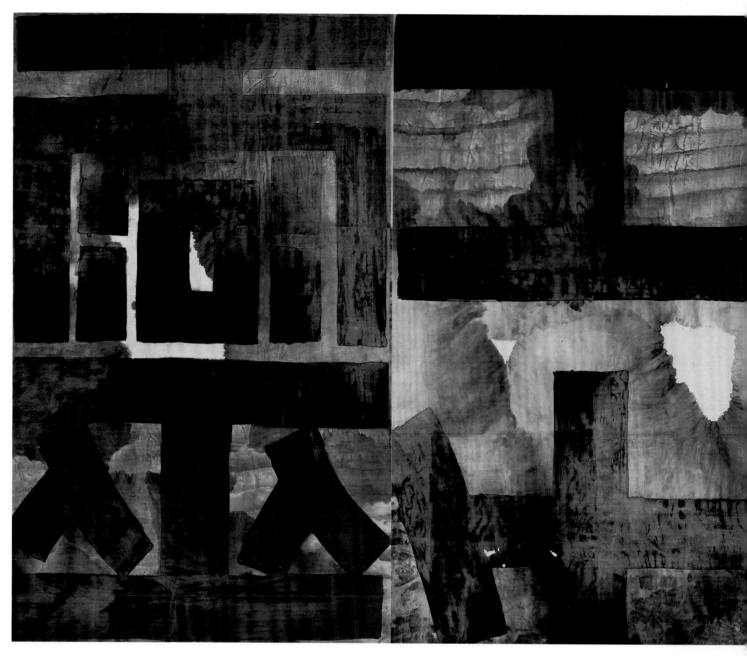

《靜則生靈》

遺失的王朝系列
1984 至 1985 年於杭州工作室
墨，宣紙，紙背木板裝裱
720 厘米長 × 274.5 厘米高

WISDOM COMES FROM TRANQUILLITY

lost dynasties a series #1-#50
a mixed media ink and woven installation
hangzhou studio, 1984-1985
ink on xuan paper, mounted on paper backing with wood board
720cm long × 274.5cm high

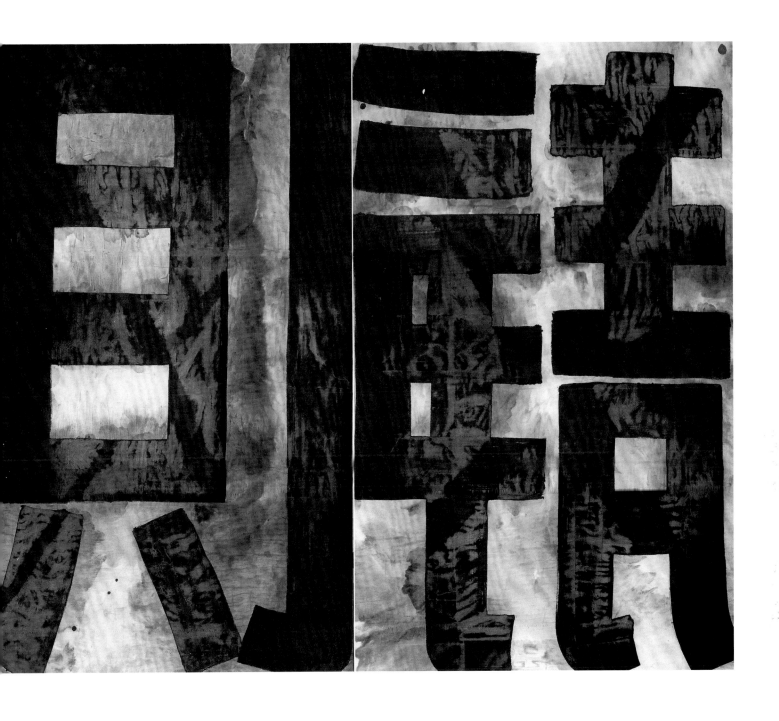

《圖騰與禁忌的現代意義》

遺失的王朝系列

1984 至 1985 年於杭州工作室

宣紙，墨，紙背裝裱上木板

540 厘米長 × 274.5 厘米高

MODERN MEANING OF TOTEM AND TABOO

lost dynasties a series #1-#50

hangzhou studio, 1984-1985

ink on xuan paper, mounted on paper backing with wood board

540cm long × 274.5cm high

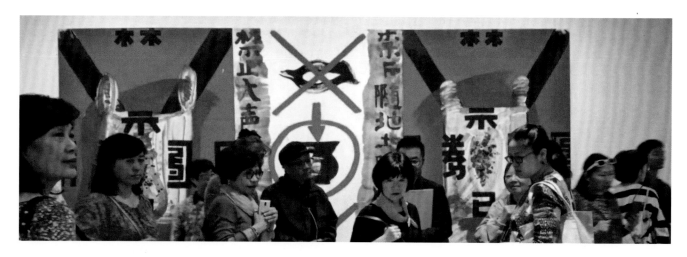

觀眾與《圖騰與禁忌的現代意義》遺失的王朝系列　溫哥華美術館
the audience in front of *modern meaning of totem and taboo* lost dynasties series in vancouver art museum

《以偽字，漏字，倒字，反字，印刷體，正楷，草體混合書寫的杜牧詩》

遺失的王朝系列
1984 至 1985 年於杭州工作室
墨，宣紙，白梗絹邊紙背裝裱立軸
180 厘米寬 × 270 厘米高

DU FU'S POEMS WRITTEN IN A COMBINATION OF PSEUDO-CHARACTERS, MISSING CHARACTERS, UPSIDE-DOWN, REVESED, AND PRINTED CHARACTERS IN A MIXTURE OF STANDARD & RUNNING SCRIPT

lost dynasties a series #1-#50
hangzhou studio, 1984-1985
ink on xuan paper, hanging scroll mounted on paper backing with white silk borders
180cm wide × 270cm high

谷 文 達 首 次 個 展 始 末

程 征

THE WHOLE STORY BEHIND GU WENDA'S FIRST SOLO EXHIBITION

cheng zheng

谷文達與我本非親故，天各一方，又小我 11 歲，惟緣冥咒，令他在中國內地若干重大藝術活動遇「程」則成，我倆亦有了最可珍惜的兄弟情誼。這一切都始於 25 年前谷文達的首次個展，一波三折的個展。

2005 年 12 月 8 日，谷文達在紐約寫的一份文件中曾談及他的首次個展：

> 記得在 1986 年，我受邀於中國藝術研究院和陝西美術家協會，在西安聯合發起的「全國中國畫討論會」舉辦我的大型前衛水墨畫個展。展覽在開幕前被關閉並改為內部觀摩展。

谷文達的話語隱含一個故事，作為親歷者，就讓我來講述這個故事。

20 世紀 80 年代，中國正在醞釀深刻劇烈的變革，

gu wenda and i are not related and we lived in opposite parts of china. he is 11 years younger than me, but somehow the goddesses of fate arranged for us to cross paths at several of the large art events around the country, a meeting which brought great success. the two of us had a very precious friendship, a brotherhood that all started 25 years ago at gu wenda's first solo exhibition — an exhibition whose story features many twists and turns.

in december 8, 2005, while living in new york, gu wenda discussed his first exhibition in an article saying:

> "i remember in 1986, i was invited to hold a large-scale avant-garde ink painting exhibition by the chinese national academy of arts and the shaanxi artists association which was jointly hosting a national academic conference on chinese painting in xi'an, but before the exhibition could even open its doors, it was closed and turned into a private viewing."

gu wenda's words imply a backstory, and as a witness, i am well positioned to tell it.

in the 80s, profound and intense transformations were brewing in china and this statement applies equally to the art world. after

藝術界亦然。歷經 30 年藝術的沉重反思之後，路向何方？中國美術界陷入沉思，探索的情緒空前高漲。然而，老、中、青三代藝術家各持一旨。剛剛經歷「文革」洗禮，重新主導中國藝術的老一代藝術家的基本態度是「正本清源」，力圖重新比照中外傳統，淘洗藝術的本義。青年藝術家則把目光轉向西方現代藝術，尋求藝術的前衛性。於是，老、少兩代人之間出現「代溝」。中年藝術家則在不新不舊、亦新亦舊的「半截子」自欺中，一邊勉力自進，一邊充當起溝通老、少衝突的「橋」。這大約就是我和我的一批中年朋友當時的基本狀態。

以上情勢衍生出 80 年代初期大大小小的事件，與本文有關的事件如：老一代藝術家懷着為傳統招魂的情緒推出了黃秋園。李可染說得真切：「黃秋園先生山水畫有石溪筆墨之圓厚，石濤意境之清新，王蒙佈局之茂密，含英咀華，自成家法，蒼蒼茫茫，煙雲滿紙，望之氣象萬千，撲人眉宇，二石山樵在世亦必嘆服。」（1982 年題詞）

中年藝術家策動，並在黃山召開了全國油畫大會，深入討論了中國油畫的發展策略，醞釀成立中國油畫學會，以折中的態度填平「代溝」，促成了中國油畫界的空前團結。

青年藝術家則在舉行「星星畫展」之後，以所向披靡之勢掀起一場追尋藝術現代形態的「85 新潮」，谷文達是這股狂潮湧現出來的最耀眼的新星。

30 years of deep reflection, we wondered which direction art would take. the chinese art world was engaged in deep contemplation and the spirit of experimentation was at an unprecedented high. old, middle-aged, and young artists, these three generations all had different desires and goals. after the baptism of the cultural revolution, under the renewed dominance of the old generation of artists, the basic attitude was "radical reform" to attempt to compare chinese and foreign artistic traditions, sorting through ideas to reveal the original meaning of art. the young artists turned their eyes towards western modern art, looking for the avant-garde within art, thus a generation gap opened between the oldest and youngest generations. the middle generation adopted a rule of "neither old nor new," "neither new nor old," occupying this "halfway space," on one hand heaving a sigh, on the other hand striving to make progress on their own, while acting as a bridge of communication between the old and young in navigating their conflicts. this was the general situation for me and other middle-aged artists of that era.

the aforementioned situation produced the large and small events which occurred in the early 80s, events that pertain to this text such as:

the older generation of artists still in the embrace of tradition, who advocated the art of huang qiuyuan. li keran spoke vividly about his work: "huang qiuyuan's landscape paintings have the fullness and richness of shi xi's brush strokes, and the freshness of shi tao's imagery. they possess the denseness of wang meng's compositions and absorb the essence of literature to produce huang's own style, boundless white, misty clouds filling the paper . . . gazing on its diverse varied scenery, even ershi shanqiao(shixi shitao and wangmeng) would have been amazed by these eye-catching paintings had he been alive.(1982 inscription)

the middle-aged artists instigated a national oil painting conference which was held in huangshan, where they engaged in deep discussions about the development strategies of oil painting in china; it was here were ideas began to brew about establishing the china oil painting association, and this compromise served to lessen the "generation gap," and facilitated

變革的勁風也撕破了北京老城區王爺府厚厚的高牆，設立在恭王府裏的中國藝術研究院，一股新興力量在雕樑畫棟的古典庭院裏聚集，日後影響了中國美術的水天中、郎紹君、劉驍純諸君以「文革」後首批碩士、博士的身份成為美術研究所的新成員。1985 年，為參加國家重點研究項目《中國美術史》的編撰工作，我也從陝西國畫院被抽調來到他們中間。

6 月某日，我正在美術研究所辦公室裏翻報紙。一同翻報紙的老專家華夏先生剛從黃山歸來，興致勃勃地談起油畫會議的盛況。我有所觸動，說：「中國畫家也面臨很多困惑，需要探討。」華先生表示認同。我說：「是不是也可以召開中國畫討論會呢？在西安開！」華先生想了想，說：「當然可以啦！只要你籌到兩萬塊錢，就可以在西安開會。」我立即給陝西國畫院的同仁們寫信，力促此事。

當時，陝西國畫院成立不久，院長是長安畫派的宿將方濟眾先生，院務大多由副院長苗重安先生負責。院內聚集了一批中年畫家新秀，如：崔正寬、王有政、郭全忠、羅平安、張振學等。我和郭全忠擔任藝術委員會正、副主任，一心想要推動學術。雖然同樣面臨改革，但中國畫畫家與油畫家所要面對的問題有所不同，因為中國畫家必須更加關注民族文化傳統與西方現代藝術參照系之間的衝突，實際上，中國畫界已經展開了激烈的爭論。在這種情勢下，我對於中國畫所面臨問題的關注，其實也是我的同事們的關注。因此，關於和

an unprecedented sense of unity in the chinese oil painting world.

then, after the young artists organized the "stars exhibition," the swell of the "85 new wave" began to gather momentum as artists looked for new modern forms of art. gu wenda was one of the most luminous stars to emerge from these turbulent waters.

the winds of revolution also tore through the thick high walls of prince palace in old beijing housed within prince kung's palace which was also the home of the china art academy. a new force was gathering amongst the carved beams of the classical courtyard. shui tianzhong, lang shaojun, and liu xiaochun, who would later have a great influence on chinese art in the future, became new faculty members of the academy, as the first cohort of graduate and ph.d. students after cultural revolution.. in 1985, i was deployed there myself from the shaanxi chinese painting academy painting and worked amongst them to assist with the compilation work on a national research project entitled "china's art history."

one day in june, i was at the office of the research institute of the art academy flipping through newspapers, when one of my fellow newspaper flippers, an old hand mr. hua who has just returned from huangshan, talking about the grand event he had attended—the oil painting conference,in high spirits. i was moved by this and said "chinese painters are also facing a lot of confusion that needs to be explored." mr. hua expressed his agreement. i said: "maybe we could we also have a chinese painting conference? and hold it in xi'an!" he thought about it and said, "of course you can! you just have to raise 20000 rmb and then you can arrange a conference in xi'an." i immediately wrote to my colleagues about this possibility.

at the time the shaanxi chinese painting academy had been established not long ago. the dean was a veteran of the xi'an school of chinese painting [an artistic movement], mr. fang jizhong, but most of the administrative affairs of the school were handled by the vice-dean miao chong'an. in the courtyard, several middle-aged ascendant painters gathered including cui zhengkuan, wang youzheng, guo quanzhong, luo ping'an, zhang zhenxue, and others. i and guo quanzhong, acted as the deputy

中國藝術研究院美術研究所共同在西安舉辦全國性中國畫學術研討會的提議，立刻得到同事們的熱烈回應。苗重安先生召集大家開會，並徵得方濟眾先生同意，決定由陝西國畫院出面，與中國藝術研究院美術研究所合作，共同在西安籌辦一次全國性的中國畫學術會議。

在與中國藝術研究院美術研究所達成共識之後，1985 年 9 月 18 日，陝西國畫院向陝西省文化廳和省委宣傳部正式遞交了《關於舉辦「中國畫討論會」的請示報告》。報告說：

> 黨的三中全會以來……國畫界的學術研究討論空氣空前活躍，出現了建國以來最好的形勢。國畫家們已經意識到，用全新的觀念來重新評價固有藝術傳統和經驗，不斷標新立異，探索和創造具有社會主義時代精神的新國畫，已成為時代賦予我們這一代畫家的重大歷史使命。但是，如何在實踐上實現這一具有重大歷史意義的突破，還有許多理論上的問題亟待解決。……經我院倡議，並與中央有關學術機關初步協商，擬在明年召開中國畫學術討論會。

請示報告一路暢通，得到陝西省文化廳、宣傳部，乃至省委、省政府主管領導人的支援，並由財政撥出專項資金。同時，會議主辦單位增至四家：中國藝術研究院美術研究所、中國畫研究院、陝西國畫院、中國美術家協會陝西分會，並於 12 月

directors of the art committee which promoted academics. of course, both sides were grappling with reforms, but chinese ink painters and oil painters were confronting different problems. because chinese ink painters needed to also focus on the traditions of their own local culture and those cultural systems and the conflicts created between chinese painting and the reference systems of modern art. actually, the fabric of the chinese painting world had already been torn asunder by fierce debate. under these circumstances, both i and my colleagues shared a joint concern for the problems faced by chinese ink painters. therefore, the proposal to hold a national academic conference on chinese painting jointly organized by the art research institute of the chinese national academy of arts received resounding support from my colleagues. mr. miao chong'an gathered everyone together for a meeting and fang jizhong agreed immediately that the shaanxi chinese painting academy would take the stage, working together with the art research institute of the chinese national academy of arts, to jointly organize a national academic conference on chinese painting in xi'an.

when a consensus was reached at the art research institute of the chinese national academy of arts on september 18, 1985, the shaanxi chinese painting academy submitted an official report to the shaanxi provincial department of culture and the publicity department of the provincial party committee, which was entitled "a request to hold 'a chinese painting conference.'" the report said:

> since the third plenary session of the party we have seen an unprecedented burst of lively discussion within academic research in the ink painting world — the level of discussion is the best it has been since the founding of the country. chinese ink painters all over the country have realized how to use completely new concepts to evaluate artistic traditions and experience, continuously pursuing the unorthodox, and exploring and creating new ink paintings which possess the spirit of the socialist era — which was of course a momentous historical mission for our time and for the painters of our generation. but how to break through this practice which bears such a massive historical significance? in terms

在北京開了第一次籌備會議。會議決定中國藝術研究院美術研究所委派劉驍純、陝西國畫院委派我保持日常聯繫，進一步策劃實施方案的細節。

2月某日，我去中國美術館，「黃秋園遺作展」正在一樓東廳展出，覺得這個展覽與將要討論的主題有些關係，於是，在展廳裏找到黃秋園的兩個兒子黃良楷和黃良柱，希望邀請黃秋園畫展作為中國畫討論會的一項重要活動內容。黃氏兄弟高興地表示同意。

我急忙趕到劉驍純家告知黃秋園畫展之事。他十分贊同，並提議說：「還可以邀請谷文達的畫展同時展出。」我說：「很好！黃秋園、谷文達兩個畫展形象地構成了『傳統』與『前衛』兩極，像兩個括弧，有關中國畫的各種問題和觀點都可以在這兩個括弧之間暢談和充分展開討論。」當時，我和劉驍純都不認識谷文達，只是通過媒體有所了解。劉驍純說：「郎紹君不久前同谷文達一起開過會，可以請郎紹君寫封信。」

過了幾天，我持郎紹君的信前往杭州，在浙江美術學院的青年教師公寓敲開了谷文達的門。當帥氣、智慧、自信、率真的谷文達明白了我的來意，即接受邀請，並表示要專為西安個展創作一批新作。眼看策劃一步步地向前推進，我的心裏卻生隱憂。臨別，我特意叮嚀他：「西安不比你們沿海，比較保守，關於你的畫展，我們主辦者的態度是，你想怎麼辦就怎麼辦，但是官方能允許到甚麼程度，我

of theory, there are many problems in need of urgent attention.... at the institute's initiative, we are proposing to hold an academic conference on chinese painting next year and are engaging in preliminary consultations with the relevant academic organs of the central government.

this report help us gain full support of the shaanxi provincial cultural department, publicity bureau, provincial committees, and provincial government leaders, and that special funds can be allocated for the project. at the same time, the four organizations hosting the conference: art research institute of the chinese national academy of arts, the chinese painting institute, the shaanxi chinese painting academy, and the shaanxi chapter of the china artists association, will hold their first preparatory meeting in beijing in december. the committee delegated liu xiaochun from the art research institute of the chinese national academy of arts, and myself, at the shaanxi chinese painting academy, as the primary contacts, who will keep in regular correspondence and deal with the details of the planning, and the implementation of the conference.

one day in february, i went to the national art museum of china where i saw huang qiuyuan's posthumous works hanging in an exhibition hall on the first floor, and felt that this exhibition spoke to the topic i wanted to discuss. in the exhibition hall, i found huang qiuyuan's two brothers, huang liangkai and huang langzhu, and i wanted to ask if we could hold an exhibition of huang qiuyuan's work and to make this exhibition an important part of the content of the conference. the huang brothers cheerfully agreed.

i hurried over to liu xiaochun and told him about the huang qiuyuan exhibition. he was in complete agreement, and even suggested, "we can also invite gu wenda to have an exhibition." i said, "great! huang qiuyuan and gu wenda, these two exhibitions will combine to create these two extremes of 'traditional' and 'avant-garde,' like two parentheses and all problems and perspectives pertaining to chinese painting can be easily discussed and fully opened up to debate." at the time, neither i nor liu xiaochun knew gu wenda personally, and had only seen his work through the media. liu xiaochun said: "lang shaojun

不知道。你思想上要有所準備。」聽了我這句話，年輕的谷文達顯出一臉茫然。

我的擔憂並非多餘，實際情況比預想的甚至更嚴峻，其根源不僅來自「代溝」，更在於當時社會上尚存一種將學術問題意識形態化的思維習慣，一些掌握大大小小權力的人，對於他們沒有把握的藝術探索現象，總是心存疑慮，加以行政干涉。果然，正當已經確定會期定在 1986 年 6 月，各項籌備工作緊鑼密鼓地進行，即將向反覆選擇的代表發出邀請信的時候，我們十分意外地收到劉驍純從北京寄來的一封短信。全文如下：

苗老師，全忠、程征二兄：

　　近日，我、水天中、郎紹君將「邀請信」的最後修訂稿交劉光祖，請他交張明坦最後審定，以便列印發出。不料，今日劉光祖向我轉達了所務會的決定：對國畫討論會採取「冷處理」「看看再說」「目前討論沒有太大意義」，建議京、陝兩國畫院停止這一活動。我聽後大吃一驚，只好回答一句：「此事請所裏全權處理吧！」

　　此事我完全無法理解，但也毫無辦法。只好在此代表水、郎諸兄向你們謝罪了。

　　雖不吉利，還是向諸位拜個晚年吧！

小純 2.20

（註：張明坦，美術研究所所長；劉光祖，中國藝術研究院美術研究所辦公室主任。）

attended a meeting with gu wenda not long ago, perhaps we can ask him to write a letter to him."

after a few days, i brought lang shaojun's letter to hangzhou to the young teachers' dormitory at the zhejiang art academy and knocked on the door of gu wenda. elegant, clever, confident, and sincere, gu wenda understood my purpose. namely, he accepted my invitation and said that he would like to create a new series of works for this exhibition in xi'an. as we watched the planning move forward step by step, i began to harbor a few anxieties about the exhibition. in parting, i gave him some cautionary advice: "xi'an cannot compare to your coastal cities; it's more conservative. as organizers, our attitude is that you can do whatever you want, but we have no idea of how permissive the officials will be. so, it's important to be mentally prepared." the young gu wenda looked back at me in confusion.

my concern was not excessive, but actually, the situation turned out much worse than expected. the roots of this laid not only in the "generation gap," but also in social tendencies of the time, a thought process whereby academic issues were continually seen through the lens of ideology. for certain people who held positions of power, bigwigs and small-fries alike, those who could not grasp the phenomenon of experimentation in art would always have qualms. moreover, they would engage in administrative interference. true enough, just when we had confirmed that the meeting would be held in june of 1986 and we had begun to ramp up our efforts and preparations for the event and had just prepared to send letters of invitation to the invitees who had been chosen on multiple occasions, out of the blue we received a letter from liu xiaochun in beijing, the whole text of which you will see below:

dear brothers, master miao, quan zhong, and chen zhen:

today, i, shui tianzhong, and lang shaojun gave the final drafts of our invitation letters to liu guangzu and asked for his authorization to have them printed out and sent, but unexpectedly, liu quanqzu conveyed to me the decision of the council: namely that they would be giving a "cold treatment" to the national academic conference on chinese ink painting. they will take a

同時，中國藝術研究院美術研究所也給陝西國畫
院發來公函：

　　陝西國畫院：

　　　鑒於當前國畫爭論之形式，與我們的準備
情況，以及我所的工作安排，經我所所務會議
決定，建議將於今年 6 月舉行的中國畫學術討
論會暫不召開。不知你們的意見如何？

　　　此致敬禮

　　（原約定之邀請信均未發出）

　　　　　中國藝術研究院美術研究所 1986.2.20

這一私、一公兩封信函對於陝西國畫院的積極籌
備者來說，真如晴天霹靂。苗重安副院長立即召集
我們商議，決定不能就此止步，而要盡一切可能扭
轉被動局面，並委託我起草一封公函，立即赴京。
公函如下：

　　中國藝術研究院美術研究所：

　　　2 月 20 日來函已收到。

　　　由我們雙方共同發起的中國畫學術討論
會得到我省黨政領導的重視和支持，並列為我
省文化系統今年的一項重要工作。自去年 12
月在京召開第一次籌備會議後，我們已按分工
項目從人力、物力、學術、輿論諸方面作了
充分的準備，今已基本就緒。有關領導部門和
美術界都以高度熱情翹首期待會議取得豐碩
成果。因此，對貴所的突然決定甚感意外。今
特委派本院藝術委員會主任程征同志代表我

*"watch and see," stance as "it doesn't make much
sense to talk about this now," and they suggest that the
parties in beijing and shaanxi cancel this event. i was
quite taken aback by this news, and could only respond
with one sentence: 'i leave it in the hands of the institute
to deal with this matter!' i cannot understand it, but there
is not much we can do. all i can do is send my
apologies on behalf of brothers shui and lang."*
　　*although this is very unlucky, i still would like to
express my belated new year's greetings to you.*
　　　　　　　　　　　　february 20, xiao chun
　　*(note: zhang mingtan was the dean of the art
research institute: liu guangzu was the head of
administration for the art research institute of the
chinese national academy of arts.)*

at the same time, the art research institute of the chinese
national academy of arts also sent letters to the shaanxi chinese
painting academy:

　　*the shaanxi chinese painting academy:
　　given the state of the current controversy over
chinese painting, and the state of our preparations, my
schedule, and the decision which was passed
regarding this business by the institute, it is proposed
that for the time being the academic conference on
chinese painting will not be held at this time. what is
your opinion on this matter?
　　best regards
　　(none of the previously agreed-upon invitation
letters was sent)*
　　　　　*february 20, 1986, art research institute of the
chinese national academy of arts*

these two letters, one public, and one private came like a
thunderbolt from a clear sky, for the shaanxi chinese painting
academy event organizers. the deputy dean, miao chong'an,
immediately called everyone to discuss the situation. the group
decided that we couldn't just immediately give up, and that we
should try to actively turn the situation around. i was entrusted
to draft an official letter to be sent immediately to beijing: the
official letter reads as follows:

院前來與貴院商洽，懇切希望諸位領導同志仍能促使會議籌備工作按原協議進行。否則會對有關方面造成許多後遺症，望充分體諒。

此致敬禮

陝西國畫院 1986 年 2 月 24 日

我又請方濟眾老院長給張明坦寫了一封親筆信。因為張明坦建國初曾在西北局做文物處的副處長，而方濟眾的老師趙望雲是文物處處長，三人曾經同事。

我不敢怠慢，立即乘火車從西安趕赴北京，找到劉驍純。小純告訴我，唯一的原因是所領導對我們的會議不放心，怕有「資產階級自由化」傾向。由於我起草的公函有點外交辭令的味道，為避免造成僵局，準備只轉交口氣婉轉緩和的方濟眾的信，希望能在輕鬆的氣氛中說服張老，消除疑慮。成敗在此一舉！當晚，小純和我懷着惴惴不安的心情尋到坐落在鑼鼓巷的張宅。我首先代方濟眾先生向張明坦轉致問候。果然，方先生的信勾起張老的回憶，談笑中，我和小純逐漸把話引入正題，氣氛想不到的和諧。當我向張老彙報了陝西方面所作的準備工作，張老又問了幾個不太放心的問題之後，老人家出人意料地爽朗，說：「既然這樣，會議照原定計劃開吧！」出了張宅，我和小純長長地舒了一口氣，今晚的月亮也顯得格外明亮。

會議的名稱很快確定下來，叫做「中國畫傳統問題學術研討會」，確定這個名稱顯然帶有既求穩妥，

art research institute of the chinese national academy of arts:

on february 20, the letter was received.

the academic conference on chinese painting which we jointly organized has received attention and support from the provincial party leaders, and has been considered an important project this year by our provincial cultural department. since the first preparatory meeting was held in beijing in december, we have been carrying out the preparations including arranging manpower, material resources, academic support, media and we are well prepared. we are basically ready. not only the relevant leading departments but also the art world at large are looking forward to the conference with great enthusiasm. therefore, i was surprised by the sudden decision by your office. comrade cheng zheng, the director of the academy's artistic committee, will come to discuss this matter in the earnest hope that the leaders can support the original agreement so that the preparations for the conference can be carried out as planned. otherwise, there will be many repercussions for the parties concerned; we are hoping for your wholehearted understanding.

best regards

february 24, 1986, shaanxi chinese painting academy

i also asked master fang jizhong to write a letter to zhang mingtan. because zhang was the deputy director of the northwest cultural relics bureau during the founding of the people's republic of china and fang jizhong's former teacher zhao wangyun was the director of the cultural relics' bureau, so the three were once colleagues.

moving swiftly, i caught the train from xi'an to beijing to find liu xiaochun. chun told me that the only reason the leaders were uncomfortable about our meeting is that they were worried about the trend of "bourgeois liberalization." since the official letter i drafted had a strong tone of diplomatic rhetoric, in order to avoid a stalemate, i was prepared to forward only fang jizhong's letter, which was gentle and measured in tone, and i

又不失學術性的因素。自經歷這次波折之後，大家都格外謹慎，生怕再節外生枝。

3月5日，經過反覆斟酌的邀請信終於發出。信中闡述了會議宗旨，並列出若干參考題，希望與會者提供論文。

同時，我和谷文達一直保持信件聯繫。5月19日，他給我一信：

> 程征先生：
>
> 　　來信收閱，謝謝！
>
> 　　座談會有進展，很高興。我的個展已經準備得差不多了，但願一切順利。現在國家的政策是仍然開放，這對藝術之發展也會有好處。
>
> 　　我想知道展覽會的確定日期，以便我有個安排，展覽的請柬等項工作。
>
> 　　近來您肯定忙於座談會的諸事項吧！因忙暫時擱筆。望諒。
>
> 　　祝順利！
>
> 　　　　　　　　　谷文達敬上　1986.5.19

會議最終確定將在6月22日至26日召開，會址設在距西安80公里的陝西省武功縣楊陵農業科研中心，黃、谷二展則設在西安市最繁華的東大街美術家畫廊。所謂「畫廊」，實際是美協陝西分會的美術館，在當時，這是陝西最好的展出場所了。根據分工，相關展覽事務主要由陝西美術家協會承

wanted to have a conversation with zhang lao in a more relaxed atmosphere to dispel any doubts.the success or failure of this venture would rest on this meeting. that evening, chun and i wound our way through the hutongs to fang's residence in nanluogu alley in an uneasy mood. first, i conveyed fang jizhong's warm greetings towards zhang mingtan. then mr. fang's letter triggered zhang mingtan's memories, and while laughing and talking in this very congenial atmosphere, chun and i slowly directed the topic of conversation toward our main purpose. when i reported on all of the preparatory work already completed by the shaanxi side of the cooperation, zhang posed questions which showed his doubts, then unexpectedly the old-timer said cheerfully, "in this case, why don't we hold the meeting as planned!" leaving zhang's residence, chun and i breathed huge sighs of relief, and even the moon in the sky seemed brighter than usual.

the title of the conference was soon confirmed as "academic research conference on the issue of tradition in chinese painting," a title which strove to be safe and reliable yet not without academic rigor. after the twists and turns, we had already navigated, we were especially careful with this, wanting to avoid any more unexpected complications.

on march 5, after much deliberation, the letters of invitation were finally sent out. the letters briefly described the purpose of the conference, and included a list of reference questions with the hopes that participants would submit papers.

at the same time, gu wenda and i were constantly in contact. on may 19, he sent me a letter:

> *mr. cheng zheng:*
> *i've received your letter, thank you!*
> *i'm very happy that the conference is making progress. i am almost done preparing my exhibition, but i hope everything will go smoothly. now the government is still open in terms of its policies; this of course is a huge benefit for the development of art.*
> *i would like to confirm the date of the exhibition so that i can arrange the invitations and other work. i am sure you've been busy managing all the details of the*

擔，因此我寫信請谷文達與陝西美協主席方鄂秦直接聯繫。他回信說：

程征先生：

託王寧宇帶來的信已收閱，勿念。

我準備 6 月 10 日之前動身去西安。關於展覽場地是最（重）要的問題。我已經寫信給方鄂秦先生，請他幫助關心此事。我的作品都有四米多高。其他事宜我去西安後再聯繫。我近來創作已近尾聲，都已去裱了。

但願一切順利。我相信這次展覽有價值，不僅對傳統是一個衝擊，同時也將與西方現代派有衝擊。我想，一個藝術家能夠提出一些新問題就是結論。

因忙於此事，暫擱筆，望諒。

祝順利！

谷文達敬上 5.26

6 月 12 日，會議籌備委員會向各位代表寄發了出席展覽會開幕式的通知，並向陝西美術界的人士發了一份油印的《請柬》，二者內容相同：

為配合本次會議，大會特委託中國美術家協會陝西分會同時在西安舉辦「黃秋園中國書畫遺作展」和「谷文達國畫新作展」，請您 6 月 22 日上午 9 時 30 分前往西安市東大街陝西美術家畫廊參加開幕式。

conference. as things are busy, i'll wrap this up. thanks for your understanding.

best wishes,

sincerely gu wenda, may 19, 1985

the meeting was eventually scheduled for june 22-26, at a location 80 kilometers from xi'an in shaanxi's wugong county at the yangling agricultural scientific research center. huang and gu's two exhibitions would be at an artist's gallery on one of the most bustling streets of xi'an. this so-called "gallery" was the shaanxi artist's association museum. this was also the best art venue in xi'an. in terms of the division of labour, the organization of the exhibition was mainly handled by the artist's association, thus i wrote a letter introducing gu wenda to fang eqin, the chairman of the shaanxi artists association. he replied saying:

mr. cheng zheng:
the letter brought by wang ningyu from you has already been received. please don't worry.
i plan to set off for xi'an before june 10th. the exhibition venue is the most important issue. i've already written to fang eqin to ask him concerning this matter. my works are all over 4m tall. for the other matters, we can discuss these once i am in xi'an. i am near the end of finishing my works and they've been sent to be mounted.
but i hope everything is going smoothly. i hope this exhibition will be of value, even if it presents a kind of attack on tradition. at the same time, it should also present a shock to western modernism. i think this represents a good conclusion if an artist can raise some new issues.
i'm still busy with a few things, so i'll sign off for now. i hope you understand.
best wishes!

sincerely, gu wenda, may 26

on june 12, the conference preparatory committee sent out a communication about the exhibition opening and a mimeographed "invitation" to the members of shaanxi's art community. the content of these two documents was the same:

黃秋園的親屬和谷文達先後來到西安。黃夫人率子女共六人住在陝西國畫院隔壁的農業招待所，谷文達則安排住在畫院簡陋的畫室裏，有時就在我的家裏就餐。工作之餘，我和谷文達終於有了充分的時間深入交談。我懷着濃厚的興趣聽他述說，藉以了解這位「85 新潮」最出色的弄潮兒的藝術觀念，覺得新鮮深刻，很有創造勇氣。

開幕前幾天，開始佈展。黃秋園的畫展設在陝西美術家畫廊第二層。谷文達的畫展則拆分為兩部分：一部分設在三層的小展廳，集中陳列傳統風格的水墨畫。第一層是一個大展廳，牆面很高，用來陳列谷文達的前衛水墨作品，這是谷文達展覽的主體。

未待佈置完畢，我已有所風聞，某些提前進入谷文達一層展廳的人已對作品表示不解甚至異議。為防不測，我請谷文達務必寫一份可以緩解氣氛的展覽說明。他覺得有點多餘，但在我的執意下，他還是勉強寫了幾句，就說沒甚麼可寫了。無奈之下，我根據他幾天來談話的內容，續寫了後半部分，內容是這樣的：

> 谷文達，1955 年生於上海，1976 年畢業於上海工藝美術學校，1981 年畢業於浙江美術學院國畫系研究生班，師從陸儼少先生研究中國山水畫，並於同年留校任教。

first huang qiuyuan's relatives arrived in xi'an followed by gu wenda. mrs. huang stayed at an agricultural guest house near the shaanxi chinese painting academy with her six children. gu wenda arranged to stay at a shabby studio in the college and sometimes he dined at my house. outside of work, gu wenda and i finally had a chance to engage in in-depth conversations and i had a strong interest in hearing what he had to say, to absorb something of this "85 new wave" trend and to get a sense of the most cutting-edge artistic concepts. i felt it was fresh and profound and demonstrated a sense of intense creative bravery.

during the few days before the opening, huang qiuyuan's exhibition was installed on the second floor of the shaanxi artists' association building. gu wenda's exhibition was split into two parts: one part was in the small gallery on the third floor, where the works on display focused on a collection of traditional landscape paintings. the large gallery on the first floor featured a high wall, which displayed gu wenda's avant-garde ink paintings, the main body of his work.

even before the works were installed, i caught the sound of confused and dissenting whispers of those who had glimpsed the works in the first-floor exhibition hall. in order to avoid incidents, i asked gu wenda to write an exhibition introduction text which would ease the tension. he thought this was a bit redundant but with my encouragement, he grudgingly wrote a few words and then relented saying he had nothing else to say. desperation having no choice, i wrote the second half based on the thoughts we had exchanged a few days before. the exhibition text is as follows:

> gu wenda was born in shanghai in 1955. in 1976 he graduated from shanghai arts and crafts college. in

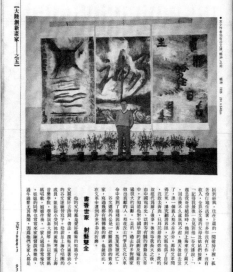

破壞傳統的恐怖浪子
肢解文字、震動靈魂的畫家
——谷文達

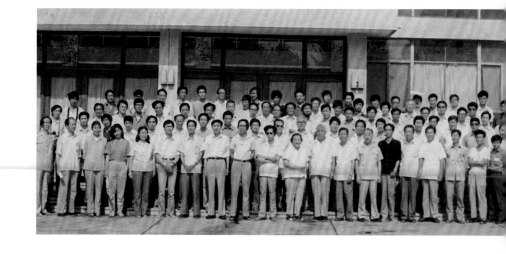

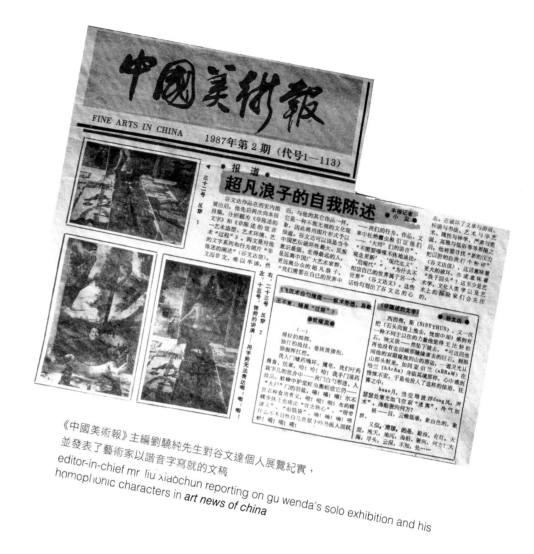

《中國美術報》主編劉驍純先生對谷文達個人展覽紀實，
並發表了藝術家以諧音字寫就的文稿
editor-in-chief mr. liu xiaochun reporting on gu wenda's solo exhibition and his
homophonic characters in *art news of china*

1985 年的武漢全國新國畫邀請展；由中國藝術研究院和陝西美協共同主辦的楊陵全國中國畫理論研討會舉辦的谷文達個人展覽。個展在開幕前被封，之後又僅對職業藝術家開放。展覽的影響力成了美術界的現象，壹度流行的説法是把展覽描述成了中國畫的地震震源。記得非常清楚，在這之前，美術界幾乎沒有人稱呼中國畫為「水墨畫」的，更無所謂「水墨藝術」這壹詞。當時媒體對這壹現象的頻繁報導更是用詞激烈，最為代表的就是李小山先生的中國畫窮途末路之説，那是還在美術學院和大學美術系的學生都記憶猶新。

the 1985 wuhan national invitational new painting exhibition and the chinese national academy of arts and the shaanxi artists association jointly organized a solo exhibition at the national academic conference on chinese painting theory in yangling. the exhibition was closed to the public before the official opening— only professional artists were allowed in. the exhibition became a phenomenon in terms of its influence on the art world. people came to describe it as the epicenter of an earthquake in chinese painting. i remember it very clearly. before this time, there were very few people who would refer to chinese paintings as "ink paintings," let alone use the term "ink art", at that time when there was frequent media coverage of this phenomenon, and the usage of this word intensified, as exemplified in mr. li xiaoshan's "the end and death of chinese painting." this is still fresh in the memories of the students in the art departments of universities and art colleges.

作品及論文曾在全國許多雜誌上發表，第六屆全國美展評為優秀作品，全國體育美展中作品獲得銀牌。

這次展覽的作品是近期創作的文字系列畫，是對我國優秀的文化傳統和西方現代主義進行反思的結果，用現代人的意識把書法和繪畫重新結合起來，創造一種新的藝術語言。探索有可能成功，也有可能失敗。這些作品僅僅是一種新的嘗試。

我覺得照搬傳統和西方現代主義藝術都不是我們的最終目的。這些作品旨在恢復我國古代藝術博大雄渾的藝術境界，在傳統文化和西方文化之間進行一次自我選擇。我的願望是在發展民族傳統，同時向西方現代藝術進行挑戰。

（以上谷文達執筆，以下程征執筆）

中國文化傳統到明清時，繪畫在筆墨技法上有所發展，但從本質上已失去了漢唐魏晉風骨、博大的胸襟和氣勢。這些作品旨在恢復古代境界：古樸、神秘、博大，當然不是重複，而是從現代人的意識重新創造。

用現代人的思維方式和觀念，對傳統進行改造和再認識，同時走向西方現代主義的反面。盲目地照搬傳統或西方現代主義對一個藝術家來說都是沒有價值的。

文字系列作品是把文字的神秘性、象徵性和抽象構成推向一個極端，從各方面進行了一系列的嘗試。當然這僅僅是開始和探索，有

1981 he graduated with an mfa from the traditional painting department of zhejiang academy of fine art. he studied painting under lu yanshao and has remained at the school to teach.

his works and papers have been published in many magazines. his work received a designation of excellence at the sixth national judged art exhibition and he received a silver medal at the national sports art exhibition.

the works displayed in this exhibition are a recent series that deals with text, the result of deep reflections on the traditions of our country and of western modernism, using a modernist consciousness to create a new fusion of calligraphy and painting to construct a new kind of artistic language. this exploration may succeed or it may fail. these works are only new attempts.

i don't think that mimicking tradition or western modernist art is our ultimate goal. these works aim to revive the vast and robust tradition of china's ancient artistic realm, a kind of self-reflection on traditional culture and western modernism. my hope is that in developing traditional folk culture, we can also present some challenges to western modernism.

(the former was penned by gu wenda, the latter by cheng zheng)

chinese traditional culture in the ming and qing dynasties saw progress in terms of the techniques of brush and ink painting, but the strength of the form's character was ebbing—the broadmindedness and momentum of the han, tang, wei, and jin dynasties, was lost. these works aim to restore the realm of the ancient world: a world that is quaint, mysterious, and broad. it is of course not a duplication, but a new creation that emerges from the consciousness of a modern person.

using the ways of thinking and concepts of modern people to enact a new understanding and reform of tradition, the work takes us to the flip-side of western modernism. for an artist, to blindly chase after tradition or western modernism, is of little use.

this text series takes the mystery, symbolism, and

待於進一步完善和總結。這次展覽的目的就在於聽取各方面的意見，使我的作品更完善。

我的藝術不是娛人耳目，而在於震動靈魂。（通俗藝術和嚴肅藝術的一種區別。）

我不想做一個區域畫家，中國畫家要走向世界，不主張對民族精神作狹隘的理解。

在此草稿的基礎上，我整理出一份較為簡易的關於「黃秋園中國畫展」和「谷文達畫展」的簡要說明，口氣盡可能平和，有關谷文達的內容是這樣介紹的：

谷文達，1955年生於上海，是著名山水畫家陸儼少先生的研究生，現任教於浙江美術學院中國畫系。他具有較好的傳統功力，又具有積極探索的精神，作品和論文曾在全國許多雜誌上發表，並多次在全國美展獲獎或被評為優秀作品，是一位嶄露頭角、越來越引起學術界關注的青年畫家。他認為中國藝術傳統到明清時代雖在筆墨技法上有所發展，但從本質上已失去漢唐魏晉博大的胸襟和氣勢。他旨在恢復古樸、神秘、博大的古代境界，但這種恢復不等於重複，而是以現代人的意識重新創造；同時，用現代人的思維方式和觀念對傳統進行改造和再認識，走向西方現代主義的反面。模仿傳統和西方現代主義對一個藝術家來說都是沒有價值的。他說：「我的藝術不是娛人耳目，而在於震動靈魂。」這次展覽的作品是畫家近期創作的文字系列畫，力圖從多

abstraction of texts to the extreme, carrying out a series of experiments on various fronts. of course, this is only the beginning of the experimentation, which needs to be further improved and reviewed. the point of this exhibition is to hear various opinions and suggestions, in order to further improve my works.

my art is not for the mere purpose of amusement, rather it endeavors to send tremors through our souls. (this is one difference between serious and popular art.)

i don't want to be a regional artist. chinese artists need to go out into the world and not advocate a parochial or a nationalistic understating of art.

on the basis of this draft, i arranged "a simple brief description: "on 'huang qiuyuan's traditional ink painting exhibition'" and "a brief introduction to 'gu wenda's painting exhibition.'" the tone of these was perhaps serene, the content regarding gu wenda's work was as follows.

gu wenda was born in shanghai in 1955. he studied a masters in painting under mr. lu yanshao and now teaches at the chinese painting department of the zhejiang academy of art. he possesses a decent facility in traditional technique and a vigorous spirit of experimentation. his works and papers have been published in many magazines. his works have received many national awards and received a designation of excellence in many national art exhibitions. he is a striking figure a young artist, coming to the fore, who more and more is attracting the attention of the academic world. he believes that chinese traditional culture in the ming and qing dynasties saw progress in terms of the techniques of brush and ink painting, but the strength of the form's character is ebbing and the broadmindedness and momentum of the han, tang, wei, and jin dynasties, is lost. these works aim to restore the realm of the ancient world: a world that is quaint, mysterious, and broad. it is of course not a duplication, but a new creation that emerges from modern consciousness. the work takes us to the flip-side of western modernism. for an artist, to blindly chase after western modernism, is of little use. "my art is not for the

方面嘗試着把中國書法的神秘性、象徵性和抽象性推向一個極端。當然，這僅僅是開始和探索，他希望通過展覽廣聽意見，以待進一步完善。

「簡要說明」以中國美術家協會陝西分會藝術委員會的名義，列印送交有關方面。但是，還是出事了！

1986 年 6 月 22 日上午 9 時許，眼看着經過一年籌備，改革開放以來規模最大的一次全國性中國畫學術研討會就要在古都西安以黃秋園、谷文達兩個畫展的開幕而拉開序幕了。來自全國各地的會議代表、陝西美術界、文化界的人士，懷着急切的心情聚集在陝西美術家畫廊的展廳外，只等展覽開幕。

由於谷文達的展品和展出方式打破了常規，展覽的「前言」設計成一面開口的金字塔形式，裏面貼滿了作者的活動照片，本已刺激了人們的視覺神經，又聽谷文達說，他要在開幕式上坐到「金字塔」裏，而且要在裏邊點上蠟燭。終於有好事者跑去向美協的方主席報告，方急忙趕來阻止，聲言要立即封館。原定開幕時間已到，支持的與反對的吵作一團。郭全忠等人衝上前去與方主席理論，方斥責道：「你就不懂政治！」所有的人都等着最後的決定。宣傳部和文化廳的領導已經來到展廳門前，見此情景，沒有表態，先進去審視了一番，沒看出多大的問題。幾經協商，否定了「封館」的意見，最後折衷，決定其他展廳正常開放，一樓展廳不公開開放，而採取「內部觀摩」的方式。誰知，越是

mere purpose of amusement," he says, "rather it endeavors to send tremors through our souls." the works exhibited in this exhibition are from a recent series of works. this text series adds a mythical dimension to texts, taking this to the extreme of symbolism and abstraction, carrying out a series of experiments on various fronts. of course, this is only the beginning of the experimentation, which needs to be further improved and reviewed. he hopes to hear various opinions and suggestions, in order to further refine his works.

it was "a simple description" under the name of the shaanxi artists association (a branch of the china artists association) which was printed and sent out to the relevant parties, yet still, it caused a ruckus.

on june 22, 1986 at 9am, we were looking back on a year of preparation, for the largest national academic conference on chinese painting held in the ancient capital of xi'an with huang qiuyuan, and gu wenda's solo exhibitions, and with representatives from all over the country, representatives from the shaanxi art world, people from the cultural sphere, a heady atmosphere with everyone gathered outside the exhibition hall of the shaanxi artists association gallery, just waiting for the exhibition to open.

both gu wenda's works and his means of installation broke conventions: the exhibition introduction text took the form of a pyramid with one open side. inside he pasted photos of his activities. this had already stimulated the optic nerves of the viewers, and i heard gu wenda say that he wanted to sit within the pyramid during the exhibition and light a candle. in the end, some busybody ran to chairman fang of the artist's association to report this and fang ran over to stop gu claiming that the gallery would need to be closed immediately. the scheduled opening time had already arrived, and the supporters and the detractors formed a quarreling mass. guo quanzhong and others rushed up to chairman fang and debated with him, but fang scolded them saying: "you just don't understand politics!" and everyone just waited for the final decision. the publicity bureau and the cultural bureau

「內部」，越覺得神秘，結果所有的人都通過各種關係進入谷文達的展廳裏去「內部觀摩」了一番。「內部觀摩」變成了一種特殊而誘人的大廣告，變成了一種未曾預先設計的現代藝術展覽與觀賞行為。

中國美術家協會陝西分會藝術委員會 1986 年 6 月 28 日在第 9 期《簡報》上作了專題報導，行文很正面：

　　　　為了配合在武功農科中心召開的「中國畫傳統問題」學術討論會，美協陝西分會舉辦了兩個展覽。趕來赴會的全國各地代表們應邀於 6 月 22 日上午在西安美術家畫廊出席了「黃秋園先生國畫遺作展」和「谷文達畫展」開幕式。開幕式由美協陝西分會主席方鄂秦同志主持。……黃秋園先生的 73 幅作品，顯示了這位卓越畫家渾厚、沉雄、鬱密、華茲的藝術境地和高潔曠逸的氣格，使參觀者深受感染。谷文達同志的作品則顯示了青年畫家的積極探索精神，吸引了觀摩代表的關注。……陝西國畫院院長方濟眾同志講了話。他認為我們中國畫的面貌確實發展緩慢，需要變化。但變化不能離開民族性，還要堅持民族的土壤，要與傳統有一種自然的聯繫。他殷切希望大家結合實踐繼續進行討論，討論的氣氛要和諧團結，老、中、青畫家要進行對話，這樣對每個人都有好處。

leaders had already arrived at the exhibition hall, to witness the scenario but took no position, choosing first to enter and observe, but they didn't find any major problems. after deliberations, proposals to "close the museum" were rejected, and finally, a compromise was struck, to keep the other exhibition halls open, but the first-floor exhibition would not be open to the general public, "but only for private viewing." but no one expected that this private viewing designation would make it even more mysterious and desirable, the result being that people pulled all kinds of strings to get themselves into gu wenda's exhibition to have one look at those forbidden works. the private viewing became an especially tempting advertisement; it became a first-ever, never-before-encountered modern art-viewing experience.

the text of the report by the shaanxi artists association committee "briefing" (june 28, vol. 9,) was very positive.

in conjunction with the "academic research conference on the issue of tradition in chinese painting," held by the shaanxi artists association at the wugong agricultural scientific research center, two exhibitions were held. delegates from all over china were invited to the gallery of the shaanxi artists' association on the morning of june 22, for the opening of "exhibition of huang qiuyuan's legacy of chinese painting and calligraphy" and new traditional ink paintings by gu wenda." the opening was hosted by chairman fang eqin of the shaanxi artists association . . . mr. huang qiuyuan presented 73 paintings, which evoked a vigorous, serene, magnificent, deep, dense and gorgeous atmosphere and the noble leisurely style of this excellent painter. they had an infectious effect on the viewer. cornrade gu wenda's works expressed the extreme spirit of experimentation of young painters, and his works attracted the attention of many conference delegates. the dean of the shaanxi chinese painting academy comrade fang jizhong said he thought that in terms of its appearance, chinese traditional painting is developing very slowly and it needs to change, but this change cannot depart from its chinese roots, and must stay close to local soil, to as to have a natural

關於谷文達個展的情況，劉驍純在由他任主編的《中國美術報》總第 66 期（1986 年 8 月 18 日）上作了比較詳細的報導，題為《谷文達首次個展簡記》，劉驍純親自撰稿。「簡記」說：

在西安美術家畫廊舉辦的「谷文達作品展」，分為公展和觀摩展兩部分。公展部分是他的寫意中國畫和書法，這批作品，傳統功力和開拓精神兩個方面都得到了相當普遍的公認。但谷文達當前更傾心的卻是他的「觀摩展」，因為這部分更強烈地實現了他的近期追求和創作衝動。這部分不可避免地引起了極大爭議，展出方式就是對爭議的必要妥協。谷文達稱「觀摩展」為文字系列，展覽是一次性的，它是特定環境中的整體設計，是宣紙水墨畫、書法、文字、符號、篆刻、幾何構成物等等合成的神秘空間。高大的展廳為縱向深入的長方形，迎門是兩排七條從天頂直垂地面的巨幅畫，縱深處還影襯着四條。條畫無襯，隨氣流而微微晃動。坐落在條畫正中的是一個近人高的金字塔形構成物，背向展廳入口處的一面敞開，「塔」的內壁拼貼着谷文達作畫時的各種行為照片。展廳的四周展壁是他的巨幅作品，中心展壁以他的篆刻為主，展廳一角隔出一間配電室，外壁構成了特殊的展壁，展覽中有人們較熟悉的巨幅《靜觀的世界》、《西部》等作品，這些已逐漸為一些人接受的水墨畫，被谷文達視為前一階段的東西。谷文達強烈的反叛精神也表現為對自我的反叛，排

relationship with tradition. he ardently wishes that we can continue to engage in friendly discussions about combining different practices, to unite old, middle-aged, and young artists in dialogue. in this way, everyone can benefit.

in regard to gu wenda's exhibition, liu xiaochun as the editor of *china art news* (issue 66, august 8, 1986) wrote a fairly detailed report titled, "some brief notes on gu wenda's first solo exhibition." these brief notes are as follows:

"gu wenda's solo exhibition" held at the gallery of the xi'an artist's association, was divided into two parts: one gallery for private viewing and one open to the general public. the public part of the exhibition was focused on his xieyi-style paintings and calligraphy. these works were universally recognized for their skill with traditional techniques and pioneering spirit. but the works, which gu wenda personally adored, were contained in the "private section of the exhibition," because they more strongly reflected his most recent creative impulses. this section could not help escape controversy and this method of display was a necessary compromise to avoid controversy. gu wenda's private viewing series of text works was a one-time affair, a wholly integrated site-specific design with ink works on xuan paper, calligraphy, text, symbols, seals, and geometric compositions combined to create a mysterious space. the entrance of the deep rectangular exhibition hall was flanked by two rows of seven huge works that hung straight from the ceiling to the ground, with four more works deep within the shadows. the paintings had no paper backing, so that they swayed slightly with the air currents. sitting amongst the paintings was a pyramidal structure that stood about the height of a person. the pyramid had an opening that faced the back of the exhibition hall. on the walls of the pyramid were pasted several photos of gu wenda in the act of painting, performance photos. enormous paintings hung on the four walls of the exhibition space, with the seals on the center wall. in the corner of the gallery, there was an electrical room and the exterior

筆刷寫的「正、反、錯、漏」等標語字和朱紅
圈叉符號混入書法和繪畫，是這次展覽最具自
我反叛精神的因素。

同一張報紙上還刊登了署名「延民」的評論文章，
題為《「時髦」的藝術》，文中說：

> 對外來藝術經驗的效法與嘗試，似乎應看
> 作藝術如何表現當代意識的探求。但對於現
> 代意識人們的看法並不相同。谷文達的作品
> 代表了部分青年畫家的認識。
>
> 進入展廳，看到的是水墨亂暈、文字顛
> 倒，行草書法與排筆黑體字的正反錯位，遠離
> 現實的「精神」、時空，歪曲地模擬「宗教」，
> 讓人沉醉在朦朧的氣氛之中。有人比喻為「一
> 個神經病患者的葬禮」！

畫展相當沉重地撞擊了每一位觀眾的心靈，激發了
與會代表的討論熱情。潘公凱、盧輔聖、劉驍純、
郎紹君、陳綬祥、翟墨、賈方舟、丁曦元、王甯宇、
費秉勛、皮道堅、彭德等新時期湧現出來的美術
理論家，和來自全國各地的美術家齊聚楊陵，他們
在會上發表的觀點與畫展的精神相呼應。會間，
部分理論家和谷文達單獨舉行了小型座談會。討
論會後，大會請現代農業科學家作了基因工程學
的專題報告，安排到秦公大墓、法門寺、漢陽陵、
唐順陵、黃帝陵、藥王山造像碑林以及耀州窯遺
址參觀。古老傳統與現代資訊相交織，極大地觸
動了與會者的文化情懷。

walls of the electrical room became a special exhibition wall. in the exhibition, there were works that people were familiar with, for instance, "tranquillity comes from meditation," and "china west," ink works which have gradually been accepted by people as part of the earlier stage of his oeuvre. gu wenda's strong rebellious spirit also expressed itself as a rebellion of the self, with a row of hand-painted characters "positive, negative, misplaced, missing" and the words of slogans, and red circles and black ´ marks incorporated into the painting and calligraphy. this exhibition expressed the strong elements that indicate a vigorous spirit of rebellion against the self.

the same issue of *china art news* also featured a commentary signed by the author "yan min" entitled "fashionable art." the article says:

> attempts to imitate and try out the experience of foreign art, seem like they should be considered as an exploration of how to express a modern consciousness. but for those who possess a modern consciousness, it's not the same thing. gu wenda's work represents an awareness felt by some young painters.
>
> entering the exhibition hall and seeing the dizzying disorder of ink with the text upside down, the lines of cursive script calligraphy and the bold font texts reversed and dislocated, take us far from the "real sense of spirituality," with space-time distorted into a simulated 'religion,' to create an intoxicated and murky atmosphere. some have compared it to that of 'a funeral of a mental patient'!"

the exhibition was like a short note which had a strong impact on the mind of each and every audience member and kicked off a heated debate. pan gongkai, lu fusheng, liu xiaochun, lang shaojun, chen shouxiang, zhai mo, jia fanghou, ding xiyuan, wang ningyu, fei bingxun, pi daojian, and peng de, the emerging critics of this new era and artists from all over china gathered in yangling and the opinions expressed at the conference echoed the spirit of the exhibition. the meeting rooms were divided into one for theorists and a small room for informal discussion

會後，郎紹君在《中國美術報》上對谷文達的展覽
發表了題為《對超常性的追求》的評論，說：

　　所謂超常性，就是對繪畫常軌、常態和常
法的超越。

　　超常的繪畫時空：它所把握的，不是人們
根據一般時空經驗即可判定的物理或心理時
空，而大多是一種超驗的宏觀世界。《太極圖》
《白夜》《乾坤沉浮》《靜觀》《文字系列》……
從標題上就表明了他力圖把握的範疇：試圖
把巨大的哲學命題化作視覺感受的物件，企圖
揭示整個人生、自然在他和人們心中的漠然
空闊的印象。

　　超常的觀念內涵：谷文達不求在畫面上表
達一個相對確定的主題和觀念。他認為，儘管
人們需要藝術判斷的單純與明確，但藝術的更
高層次卻在明確的觀念之外，他自己稱作「無
觀念境界」。這種境界是人類知識還把握不到
的。他認為只有這種境界才能「給人們一種神
秘的內心體驗，而又讓人無法解釋清楚」。《文
字系列》是對中國文字的反思：藝術字、實用
字；對字、錯字；正字、反字；拆字、拼合與
重新排列的字……他似乎在暗示：文字描述
世界，也掩蓋世界；表達觀念，也扼殺觀念；
傳播資訊，也顛倒資訊；文字是人類獲得自
由的標誌之一，又是人類自我異化的象徵……
文字在多大程度上能與主客體世界相契合，好

created by gu wenda. after the conference, the organizers invited the modern agricultural scientists to make a special report on genetic engineering and organized trips to the qingong tombs, famen temple, hanyang mausoleum, tangshun mausoleum, huangdi mausoleum, the stele forest at yaowangshan and the site of yaozhou kiln. the interweaving of ancient tradition and modern scientific knowledge greatly influenced the cultural mood of the participants.

after the meeting, lang shaojun, published a review of gu wenda's exhibition in *china art news* entitled "in pursuit of the extraordinary," which said:

　　so-called extraordinary quality, is a transcendence of the usual road, the usual conditions, and methods of painting.

　　the spacio-temporal conditions of extraordinary painting: what this kind of painting grasps onto is not the material or psychological sense of the space-time which can be assessed through experience — but rather a kind of macrocosm. these works "infinity", "white night" ,"universe floating and sinking", "meditation", "characters series", express the realm of what he is trying to grasp in their titles: an attempt to turn a great philosophical proposition into an object which can be visually perceived, attempting to reveal all life, and nature, to make an impression on the indifferent and empty human heart.

　　this concept of the extraordinary includes the fact that gu wenda does not seek to express relatively defined themes and concepts. he says that even though people need the simplicity and clarity of artistic judgment, at its highest-level art lies beyond precise concepts, creating its own "anti-conceptual realm." this realm is beyond the grasp of human knowledge. he feels that only this kind of realm can produce a mysterious inner experience, a kind of "inexplicable clarity." "characters series" is a reflection on chinese words: art words, practical words, right words, wrong words, positive words, negative words, split words, and combined and re-arranged words …. he seems to be hinting those words can describe the world and and

像永遠是一個謎。這種錯綜複雜的文字關係反映着更加錯綜複雜的人的關係與歷史。這樣,《文字系列》表達的觀念內涵也成了一個謎。如何把這種近於哲學性的超常內涵轉化為直觀的形式結構?谷文達從兩個方面進行了探討。一是抽象結構與具象結構的「並協」,二是理性與直覺的「並協」。他在形式上採取了「反對抽象藝術也反對直觀的自然模仿」的立場,力圖將兩種結構合成一個整體。但這種結合完全不同於傳統繪畫「妙在似與不似之間」的美學原則,而是把自然形態的物象置於不合情理的、神秘化的幻覺空間達到的。……谷文達是想通過理性表達確定性的意識,通過直覺表現「無意識」,並把兩者融成一個整體。而後者往往是更重要的,因為唯有挖掘到廣大的無意識層,才可能使超常性的內涵具有深刻的心理根源。谷文達顯然獲得了很大成功。

　　超常性的追求顯示了谷文達乃至一代青年藝術家超常的膽略,沒有這種膽略就不可能開拓藝術的新紀元。

「中國畫傳統問題學術研討會」以取得豐碩成果,會議和展覽的消息通過各種途徑迅速向四面八方傳播開來。

可是,當會議結束和撤展的時候,谷文達急匆匆地找我,說:「在三樓小展廳的一摞水墨畫作品在撤

can also obscure the world, expressing concepts, and stifling concepts, conveying information, and also inverting information. words are a symbol of the freedom of humanity, and also of the alienation of humanity to what extent can words fit into the subjective and objective worlds? It seems it will always remain a mystery. this intricate and complex relationship reflects the even more complex and intricate relationships between man and history. in this way, the meaning conveyed by the text series also remains a mystery. how transform the connotations of this extraordinary philosophical meaning into an intuitive formal structure? gu wenda carries out this exploration on two levels. the first is through a collaboration between abstract and figurative structures. the second is through a collaboration of logic. in terms of form, he adopts a "stance of opposing abstract art and opposing mere imitation." he tries to craft these two structures into a whole. but this kind of fusion is wholly different from the aesthetic principles of traditional painting which follows the ethos of "the magic that lies between the similar and non-similar." rather gu has these images of natural forms arrive in an unreasonable, mysterious, illusional space gu wenda has also figured out how to use reason to express a consciousness of certitude and through an intuitive expression of "the unconscious," he merges the two into a whole. the latter is always more important, because only by digging into the vast layer of the unconscious, can we find the deep psychological roots at the core of the extraordinary. in this, gu wenda seems to have achieved great success.

the display of the extraordinary shows that gu wenda, even in a generation of young artists possesses couragc; without this courage, it is impossible to embark on this new century era of art.

the academic conference on "the issue of tradition in chinese painting," also achieved fruitful results. the ideas and information discussed at the conference and exhibition were quickly disseminated through various channels in all directions.

展的時候丟失了」。我急忙前往追查，沒有任何線索。谷文達懷着異樣複雜的心情離開西安回返杭州。行前，他把展品交給我暫時存放在陝西國畫院。

不久，我聽說時任《美術》雜誌編輯的高名潞計劃在北京工人文化宮為谷文達再舉辦一次個展，但後來遇到困難，終未如願。在此期間，我陸續收到谷文達的信：

> 程征先生，您好！
>
> 我已回杭，前天又回上海，我愛人順利通過領事館，準備 8 月去美國留學。
>
> 現在開始北京展事宜，真是累得很。時間不多了，但有這麼多事要做。
>
> 這次去西安得到您的各方面的關心，真是萬分感謝，也給你們帶來了不少麻煩，請多多諒之。寄上照片，其他人我忙完後亦會寄去的。我想如果武功為我開的座談會的錄音，可能的話，請代我錄一下，錢會寄上。
>
> 我畫不知有下落否？真傷心！
>
> 急急寫信，因忙，以後再談！
>
> 祝康樂！
>
> 谷文達敬上 7.12

> 程征先生，您好。
>
> 前封信有否收到？
>
> 目前情況有變，我想把北京展推遲至 9 月底或 10 月，已去信給名潞、小純等。因我已開始創作大型壁掛，參加明年瑞士洛桑舉行

but when the meeting concluded and the exhibition was taken down, gu wenda rushed up to find me" a group of ink paintings was lost during the de-installation". i hurried to investigate, but there were no clues. in an unusually strange and conflicted mood, gu wenda left xi'an and returned to hangzhou. before he left, he left the works with me at the shaanxi chinese painting academy.

not long after, i heard that gao minglu, the editor of *art magazine* was going to organize a solo exhibition for gu wenda at the worker's palace in beijing, but he soon ran into trouble. in the end, it didn't work out. in the meantime, i continued to receive letters from gu wenda:

> *mr. cheng zheng, hello!*
>
> *i have already returned to hangzhou, and yesterday went back to shanghai. my wife has successfully contacted the consulate and plans to go study abroad in august.*
>
> *i've already begun the work for the beijing exhibition, and it is unbelievably tiring. there is not enough time, but i have so many things to prepare.*
>
> *i would like to express my wholehearted thanks for your care and attention to various aspects of my last trip to xi'an. i of course brought you no shortage of trouble. please forgive me for this. please send photos. I attached a photo to the letter and I will send the photos to others when I have finished my duties. i wanted to ask if wu gong has a recording of my speech and if he can make a copy for me and send it. i can send money for this.*
>
> *Is there any whereabouts of my painting? So sad!*
>
> *this is just a quick note because i am busy. we can chat more later.*
>
> *wishing you peace and happiness!*
>
> *respectfully, gu wenda, july 12*

> *mr. cheng zheng, hello!*
>
> *did you receive the last letter i sent?*
>
> *the situation has changed since then. i want to postpone the beijing exhibition until the end of september or october, and i've already sent a letter to*

的「國際壁掛雙年展」。9月15即集稿。是我院的法籍教授萬曼推出我的作品的，這是個好機會！

故我的作品暫存您院。我遺失的作品不知有否尋到？

這次我的壁掛有五米高、七米寬，我亦利用了秦宮一號的中字形，幹得很來勁。

您近況如何？有空來信！

祝好！

谷文達敬上 7.17

程征先生，您好！

寄來的物件已收到，很順利，請放心，並謝謝您的關心。

本來北京的展覽從8月挪至10月，現在還不知挪到何時，因為我要完成新的作品再說。我已辦好1月份去美留學的手續，但我並不急於立刻就去，我想這個畫展首先要開在北京才有意義。近來正忙着準備新的創作。

近來一切好麼？

代問王有政、謝振甌等好！

祝康樂！

谷文達 12.8

程征先生：

近好！好久沒有通信了，不知您近況如何？

我也許在5月中下旬就要離開。我獲得加拿大國家藝術家評審委員會頒發的獎金，作為

minglu and chun, because i have already started to create large-scale wall hangings which will be shown at next year's international textile biennale in lausanne, switzerland and they will collect the rough sketches on september 15. it was a professor of french nationality, maryn varbanov, from my college who recommended these works, and this is a great opportunity!

so my work will remain temporarily stored at your college. i don't know if you've located those works which mysteriously disappeared.

this time my wall hangings are 5m-tall and 7m-wide. i also used the characters from in qingong no.1 tomb. doing this work is really exciting for me.

how are you doing these days? if you have time please write back.

best wishes,

respectfully, gu wenda, july 17

hello mr. cheng zheng

i have received the things you sent. everything went smoothly. rest assured, and thank you so much for your care and attention.

originally the beijing exhibition was moved from august to october, and now we have no idea when it will open because i want to create new works so we'll see. i have already completed the formalities to go and study abroad in january, but i am in no rush to go, i think it only makes sense if we can first hold this exhibition in beijing. i've been busy preparing some new works lately.

is all good with you?

please say hi to wang youzheng and thank xie zhen'ou and the others!

wishing you health and peace!

gu wenda, december 8

mr. cheng zheng:

i hope you are well these days! it's been a long time since we talked. i wonder how you are?

i will be leaving in mid to late may. i received a scholarship from the jury of the canadian artist's

榮譽國外藝術家訪問那兒，在 york university 工作三月，然後開一個個人畫展，那個大學是在多倫多。

然後在美國 willams college 開個展。一年以後在世界著名的加利福尼亞大學的伯克利分校的現代藝術博物館舉辦個展。

我的大型現代藝術壁掛已被「第十三屆瑞士國際現代藝術壁掛雙年展」選入，從世界各國 1000 多件中選入 52 幅。

近來我仍然在搞壁掛。

出去後一切重新開始，冒險和試驗是我生命力的源泉。

上次西安個展，回想起來不容易，全靠你們的幫助。後來北京的個展沒有辦成，只差二三個月，那要比西安過癮得多。現在放到國外去。

代問王有政先生好！

弟 文達 1987.4.8

這是我收到的谷文達出國前的最後一封信。

90 年代後期，有一天，我在西安碑林博物館附近一家畫廊裏，意外地看見谷文達的兩幅傳統風格的水墨畫，鑲在鏡框裏貼着價碼標籤出售。我一眼就認出是谷文達十多年前丟失的展品。我十分驚詫，不知何人所為。當時谷文達已很久沒有同我聯繫，無從向他告知這一消息。直到許多年後，谷文達再次來到西安，說已經知道這一批丟失作品的下落。

association. as an honored visiting international artist, i will visit there and stay at york university where i will work for three months, and then hold an exhibition. that university is in toronto.

then the exhibition will go to williams college. a year later, i will hold a solo exhibition at berkeley art museum at the world-famous university of california.

my large-scale art wall hangings were chosen by the thirteenth swiss international textile biennale in lausanne. of the 1000 works from all over the world, they only chose 52.

i've recently been making wall hangings.

after going abroad, everything begins anew: risk and experimentality are what fuel my sense of vitality.

that solo exhibition in xi'an, looking back on it, it wasn't easy. the whole thing relied on your support. the exhibition in beijing was not successfully realized; it was just off by two or three months, it seemed far more exciting than the one in xi'an. it is now being sent abroad.

please say hi to mr. wang youzheng for me!

brother wenda, april 8, 1987

this was the last letter i received from gu wenda before he went abroad.

in the late 90s, at a gallery near xi'an's beilin museum, i accidentally stumbled upon two gu wenda-style ink paintings that were framed and marked with a price tag. at one glance i recognized that these were the paintings that were lost ten years ago. i was completely surprised. i didn't know who did it. at the time gu wenda had not communicated with me for quite some time, and i had no means to inform him of the news. many years later gu wenda came again to xi'an, saying that he knew the whereabouts of the lost works.

回想起來，正當中國藝術面臨很多亟待解決的問題的時候，中年人以自己的方式在真理與權力之間周旋，他們的主導作用在這周旋中以他們特有的風格和方式得以發揮，這才促成了一次有意義的學術大討論，促成了谷文達的首次個展。

故事講完了，「橋」就是這樣架設的！

（資料來源：1、陝西國畫院檔案；2、作者資料庫原文出自《水墨煉金術：谷文達的實驗水墨》，嶺南美術出版社，2010年，第252至266頁。）

looking back, the art world at that time had many problems which needed to be urgently solved. middle-aged people used their own styles and methods and their function as guides to navigate this whirlwind, and it is that which produced an interesting academic debate, which lead to gu wenda's first exhibition. the story is finished. this is how the "bridge" was built.

(source materials: 1. archives of the archives of shaanxi chinese painting academy; 2. the author's own archives.)

程征，祖籍湖北英山，1944年生於貴州獨山。1964年考入西安美術學院工藝美術系，1969年畢業，翌年被分配到陝西咸陽地區藝術館做群眾美術工作。其間曾借調到北京《美術》雜誌編輯部工作三年。1980年參與籌建陝西國畫院，翌年調入做專職美術理論研究工作。曾任陝西國畫院一級美術師、藝術委員會主任。1985年成為中國美術家協會會員。1992年以對文藝工作作出突出貢獻專家身份開始享受國務院特殊津貼。2001年調往西安美術學院，任國家二級教授、博士研究生導師，及中國美術家協會第二屆理論委員會委員。2010年任陝西省美術家協會顧問。2012年任國家近現代美術研究中心專家委員會委員。

chen zheng's ancestral home is yingshan in hubei province, but he was born in dushan, guizhou. in 1964 he was accepted into the xi'an academy of fine arts in the applied arts department, graduating in 1969. the following year he was dispatched to the xianyang district art museum in xi'an to make art for the masses. during this period, he was seconded to the editorial department of art magazine in beijing where he worked for three years. in 1980, he participated in the establishment the shaanxi chinese painting academy, and the following year he began to do art theory research on a full-time basis. he was once a senior professor at the shaanxi chinese painting academy and the director of the art committee. in 1985, he became a member of the chinese artists association and in 1992, he began to receive a special stipend from the state council for his excellent contributions to culture. in 2001, he transferred to the xi'an academy of fine arts, becoming a second-level national professor, a doctoral supervisor and a member of the second committee on art theory of the chinese artists association. in 2010, he became a consultant for the shaanxi provincial artist's association and in 2012, he became a member of the expert committee of the national research center for modern art.

谷文達的個人展覽在開幕前被關閉,以上是現場直擊圖片。谷文達首個個人展覽在 1986 年陝西楊陵全國中國畫理論研討會上,與黃秋園個人展覽作為傳統與當代兩極之間的討論。

gu wenda's solo exhibition was closed before the official opening. above are photos taken from the event. gu wenda's first exhibition and huang qiuyuan's exhibition were selected for the yangling national chinese painting theory symposium as cases for the discussion of the tradition and the contemporary.

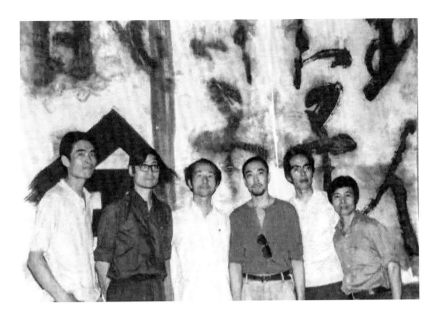

沉 默 和 超 越

看 谷 文 達 作 品 的 一 些 感 想

范景中

SILENCE AND TRANSCENDENCE

SOME REFLECTIONS ON GU WENDA'S WORK

fan jingzhong

你要想在理論家或歷史學家筆下看到「準確」的藝術家的形象是不可能的，藝術家不是他們面板上的魚；你要想了解人們所描述的是藝術家，你就必須先了解那些從事描述的人。

——《試錯集》

it is impossible to see an accurate portrait of the artist emerge from the pens of the theorists or art historians. artists are not merely fish to be dissected; you have to first understand that those who are being described are artists and you must also understand those who are engaged in the work of interpreting them.
—an anthology of trials and errors

寫一篇報告文學式的論文，或者寫一篇縝密翔實的評價谷文達的論文都不是本文的主旨。這裏，我只能提供一些個人的印象和感想。這是因為首先，我暫時還不能把文達放在當前中國美術創作的大背景中去評論，我不知道他是否屬於「第三代」畫家，也不知道他在這五花八門的創新浪潮中屬於哪股潮流。我只知道他是一個對舊傳統有着類乎鄉愁般的眷戀之情，對新事物有着不可遏止的吸收願望的人。正是這一點，我認為他凌駕許多藝術家之上，很有點像塞尚。當然，他也像基

the goal of this text is not to present a thesis — a literary or detailed analysis of gu wenda's work. here i can only present my personal impressions and reflections. this is because, for now, i cannot place him within the greater context of chinese contemporary art historical creation. i do not know if he is considered a "third-generation" painter, and i cannot discern within the realm of his wide and multifarious creations of the new wave, which trend he belongs to within the greater sphere of creative output. i just know that he belongs to those who have both a deep passion and nostalgia for tradition, but also someone who has an unquenchable desire for the new. in this way, he surpasses other artists, much in the same vein as cézanne. of course, he like cézanne, also chose to isolate himself for a few years, but the success he achieved also made his peers feel a certain amount of pressure. secondly, i haven't quite figured out whether it is more appropriate to call him an ink painter,

尚那樣自甘寂寞地面壁了幾年。可是，他獲得的成果確實已使他周圍的人感到壓力了。其次，我也還沒有弄清究竟是把文達當成一個山水畫家，還是當成一個書法家、篆刻家，抑或當成一個油畫家去評論更為恰當；在這諸種領域中他都多少地作出了新的努力。如果說形成創造力的原料是渴求、好奇、想像和驚愕的話，那麼對於文達來說，他似乎已經潛入到了神秘的宇宙，用直覺的觀照來淨化這些原料了。歌德在《浮士德》中寫下了一段令後世的注家為說不一的名句，真實地描述了從看（seeing）到直覺（intuition），從直覺到變形（transformation）的轉換。當浮士德揭開占星家諾斯塔大牟士（nostradamus，1503-1566）的奇書，並看到了「大宇宙的符號」（sign of macrocosmus）時，心靈一陣狂喜：

哈哈！這一瞬間歡愉湧來，使我茅塞頓開！

我感到年輕而神聖的生命幸福重新流遍我的五官百骸。

寫這靈符的莫不是位神靈？

它鎮定了我內心的沸騰，用快樂充沛了我可憐的方寸，

又憑着神秘的本能，使我周圍的自然力量顯呈。

我莫非是神？我的心境如此光明！

我從清晰的筆畫中間，看見活動不息的大自然展示在我必靈之前。

calligrapher, seal carver, or oil painter. he has made great new efforts in all of these fields. if the raw materials which produce creativity are thirst, curiosity, imagination, and wonder, then according to wenda, he has already snuck into that mystical universe, using his intuitive sense of observation to purify these raw materials. in *faust: a tragedy*, goethe wrote a sentence to future generations, a very inconsistent sentence, which truly describes the change from seeing to intuition, and from intuition to transformation. while faust unveiled the remarkable book of the astronomer, nostradamus, (1503-1566), where we can see souls in a burst of ecstasy, in the "signs of the macrocosmos":

ha! what a sudden rapture leaps from this
i view, through all my senses swiftly flowing!
i feel a youthful, holy, vital bliss
in every vein and fiber newly glowing.
was it a god, who traced this sign,
with calm across my tumult stealing,
my troubled heart to joy unsealing,
with impulse, mystic, and divine,
the powers of nature here, around my path, revealing?
am i a god? so clear mine eyes!
from within the clear brushstrokes, i see the ceaseless movements of nature appear before my soul.

文達有些像浮士德那樣的敢幹和魔鬼訂約的人物，神秘、詭譎、耐心沉着、平心靜氣，一心想看看大宇宙的符號。

我和文達的交往是由詩引起的。那時文達幾乎天天寫詩，知道我也愛詩，就拿給我讀。這樣，我們就經常談起詩來。後來，我才知道他雖然學的是國畫山水，可他對西方現代文學藝術也很有見地，特別值得注意的是，他把很多心血都灌注在了西方現代哲學和東方古典哲學的研讀之上。他埋頭讀書，不問寒暑，勤奮得使我這樣的人只能暗暗自愧。有年夏天，杭州實在太熱了，我熬不住跑到了北方。回來時我問他怎麼樣，他說，熱得夠嗆，每天伏在桌上，胳膊下都是水。然而他不會逃掉。他孜孜不輟地讀書，樂而不倦，真有點「生無所息」的精神。羅素在他的自傳中曾說有三種激情，即愛情、求知和同情支配了他的一生。我想，對知識的追求也同樣地湧滿了文達的生活。他有一幅畫就叫《人類的知識》。那是一幅埃舍爾（escher）式的畫。不過，如果說埃舍爾的特色是在圖形（figure）和底子（ground）的互換上，是在悖論怪圈的直觀外化上，是在三度空間的模棱兩可上[1]，那麼文達的《人類的知識》（現名《人類簡史》）卻沒有玩弄這些交變圖形。它的結構更有點像是卡帕拉（fritjof capra）的《物理學之道》（the tao of physics）：其中有幾何學的自布魯內萊斯基（brunelleschi）以來在繪畫中使用的透視法，有神話學的中國古老傳說中的天柱，有物理數學的多維空間，有哲學的變化圖型（pattern of change）。而那些同無窮小逼近的太極

like faust, wenda also has these characters who dare to make a deal with the devil, mysterious, treacherous, and patient, breathing calmly and controlled, wholeheartedly observing these symbols of the universe.

my first exchanges with wenda were initiated through poetry. at that time wenda wrote poems practically every day, and he also knew that i loved poems as well, so he brought poems for me to read. and this is how we came to start talking about poetry. later on, i realized that even though he was studying chinese ink painting, he was also very insightful when it came to western modern art and literature; he thought it was especially worth focusing on western modern philosophy and classical eastern philosophy and took painstaking efforts with his reading and research — his head perpetually buried in a book. throughout the summer days and winter nights, he was always diligently reading, reading so diligently that we could only feel secretly ashamed of our paltry efforts. one summer, hangzhou was really too hot to bear. i couldn't stand it and fled to the north. upon my return, i asked him how it was, he replied that it was unbearable. every day he laid down on the table, sweat soaking below his arms. but he did not run away. he studiously and continuously read his books, happily and tirelessly, in the spirit of "sheng wu suo xi" [a confucian saying which states that the purpose of life is to struggle endlessly towards a goal; the grave is the only place to rest.] bertrand russel in his autobiography once stated that he had three passions that lasted throughout his lifetime: the longing for love, the search for knowledge, and a sympathy for mankind. i think for wenda it was the quest for knowledge that occupied his life. he also had a painting called *the knowledge of mankind*. this was an escheresque style of painting. but if we say that escher's uniqueness was the interplay between his foreground shapes or figures and his backgrounds, it is also an externalization of the paradoxical vicious cycle and the ambiguousness of this three-dimensional space.[1] of course, wenda's the knowledge of mankind did not play this same kind of game of interlaced and interchanging figures. his structure is somewhat similar to the structure of fritjof capra's *the tao of physics*: within it, there is the same geometric sense of perspective that we see in brunelleschi's paintings. there are the tianzhu pillars which support heaven which we find in ancient chinese legend and mythology; there is the multidimensional

圖，不僅體現了莊子的「一尺之棰，日取其中，萬世不竭」的關於無限的理論，而且還表達了一種創化的過程。《人類的知識》以畫的形式來融合東西方的宇宙觀、文化觀，其容量在畫史上可能只有莫羅（g. moreau）的《人類生命史》（vie de l'humanite）可堪比擬。

這種對於宇宙深處至高無上之物的沉思，也使他在篆刻和書法上作出了新嘗試。他的印章《乾坤沉浮》說明了他治印的綱領。他不論是把字形肢解打碎作重新建構，還是把部首拆散疊加作無序安排，其立意都在於強調文字的象徵性和神秘性。在這一點上，他很可能想起了古老的遺訓：奎有芒角，下主辭章；頡有四目，仰觀垂象[2]。也就是說文字的創始與宏觀世界的天象同功並運。另一方面，文達也常常覺得一方方孤立的小小印章，還不足以表現宇宙的廣闊圖像，有時他索性把數十方印章拼貼在以天地風雲為背景的畫上，創造出了一種獨特的印畫形式。

他還有一幅多少已為人所知的書法作品《暢神》。那是運用潑墨和拼貼等多種手法所創造出來的鴻濛初開，神在其中而暢於萬物的浩大場面。當然，我們不應誤認文達創造的圖景表達了宇宙瑰偉結構的縮影。實際上，他不過是提供了一個指號，提供了一些可供人悟對通神的圖像，用中國古代哲學的語言來說，他創造了一種「環」，真知的人應該能悟到環外和環內的無限：

space which we find in physics; the philosophical notion of pattern of change, and then there are the tai chi diagrams of the "supreme ultimate," which approach an infinite smallness, the embodiment of zhuangzi's theory on infinity which implies that if we take a foot-long segment of string and divide it in half continuously there will still exist some amount of string no matter how small [" 一尺之棰，日取其中，萬世不竭 "], this also expresses his creative process. the form of the painting *the knowledge of mankind* combines western and asian cosmology: and western cultural concepts and is comparable in stature to gustave moreau's *life of humanity(vie de l'humanite)*.

we see new attempts at this kind of meditation on the supremacy of the depths of the universe in his calligraphy and seal script carving works. his seal script work the ascent and descent of the universe illustrates his principles in regard to seal carving. no matter if he is dismembering the characters into fragments and reassembling them, or breaking the radicals up and superimposing them in a disorderly arrangement, his conception is aimed at emphasizing the symbolism and mystery of the words. in this way, he very much echoes the ancient legacy of the ancestors: the light of kui's constellation is curved (because it has formed a shape like calligraphy and painting),[2] dominates the literary situation of the world, and cangjie has two pairs of eyes, he looks up and observes the image inspired by the stars. this is also to say that the creation of the text and the macro world of the cosmos are both reliant on the same effort and luck. another aspect is that wenda also feels that one small seal cannot represent the vastness of the universe: sometimes he simply collages dozens of square seals as a background creating an image of the winds and storms of heaven and earth — his own unique method of printing a painting.

he also has this incredibly well-known work *free expression*, which uses a method of ink splashing and collage, and many other different methods to conjure up a kind of original primordial vitality, to express the concept that gods roam freely throughout the vast planes of the universe. but of course, we should not misunderstand his paintings as expressing the epitome of the ornate structures of the universe. actually, he has provided a sign — some images which allow people to connect with the gods. using the ancient language of chinese philosophy,

在一個無限的空間中，用一道牆把我們圍起來。這道牆對於我們來說，就是一個確定性，圍牆中那單純有限的形式是如此明了。但是我們的思維不會長久地滿足於被圍困在牆中的單純形式。我們會覺得牆外還有個無限而複雜的天地，那兒是一個無限的不確定性。於是，牆中表述的觀念就不會再是單純簡潔的了，因為牆外的無知世界與牆內的已知世界共同存在著。藝術圖式就是那堵圍困我們的牆，它的單純性表述的複雜觀念就是牆外的無限世界。藝術圖式的單純性，也就是人類知識對於無限的宇宙相比較而說的單純性；藝術圖式所表述的觀念，也就是我們無知的那個無限的世界。因此我們看清楚了藝術圖式的表現形式，卻無法表述出它所表述的觀念世界。我們把握了形式世界，卻對觀念世界感到迷惑。

這段話不僅道出了文達是用現代哲學的語言在思辨，而且也表明了他身上所固有的中國的古典精神。這種古典精神，我想凡是讀過司空圖《詩品》的人都不難理解。儘管在前幾年文達也曾經是個表現主義者——那時，自我表現已經成一股巨大的潮流——但是，難得的是，文達肯於不斷地反思，敢於不斷地否定自己，他的反時髦主義的傾向，使他在面對那種藝術思潮時必然會自然地發問：難道對我們來說，藝術僅僅是一種個性的表現或情感的表現嗎？我認為像文達這樣能夠超越自己的藝術家一定是作了否定的回答的。因為真正的藝術家，他的目的在於他的作品本身；而一

he has created a "ring"; those who are truly knowledgeable should be able to comprehend the sense of infinity which exists inside and outside the ring.

in this infinite space, we are surrounded by a wall. but in regards to this wall, from our point of view, there is a kind of certainty; the forms within the perimeter of the wall are pure and limited, extremely clear. but our minds will not long be contented by being hemmed in by the simple forms found within these walls. we still feel that there is a complex world outside the walls — outside there is a boundless uncertainty. therefore, what is expressed within the wall will no longer be simple and concise, because the known world inside the wall and the unknown world outside the wall exist simultaneously. artistic forms are like the walls which hem us in — their simplicity expresses a complex concept which is the boundlessness of the world. the simplicity of artistic forms also represents the simplicity of human knowledge when compared to the vastness of the universe. the concept expressed by the artistic forms conveys the unknown boundless world, and therefore we can clearly see the expressive modes of the artistic forms, yet have no means of expressing the conceptual world which is represented. we can grasp the form of the world but are still confused about the concept of the world.

in saying this, we are not only voicing the idea that wenda analyses the world through the language of modern philosophy, but also his deep connection to a classical chinese spirit. this classical spirit should not be difficult to understand for anyone who has read si kongtu's *the characterizations of poetry*. although in previous years, wenda was an expressionist, self-expression had already become a huge trend at that point. what was rare about his approach was that he never stopped reflecting and never stopped rejecting his own impulses. his tendency to be anti-trend and anti-fashion made him confront the necessity of the artistic zeitgeist of the time, which naturally prompted him to ask the question: according to our perspective, is art merely

切試圖使作品表現出個性的做法，其結果必然會使它本身遭到破壞 3。

這樣，文達不僅站在了自我表現這一潮流之外，他還特別地反對了那種在農民畫和兒童畫中拾取皮相的做法 4。文達對那一傾向的批判特別精彩，值得引述如下：

> 我反對成人或一個真正的藝術家去畫兒童畫、農民畫，沒有比此更牽強附會和矯揉造作的了。現在學它們變成了一種時髦。只要認真分析一下，就不難發現，同樣的畫法，在兒童、農民那兒表現為一種純真、天趣；在成人的作品中就會表現為某種泛濫的俗情。
>
> 兒童、農民畫和表現主義繪畫在一些方面頗為近似，特別是感情的直接抒發。在我看來，這些病因都是崇高和偉大的藝術所要最終征服的。只有通過這個征服，藝術家的作品才能表現出對藝術家自己的征服。這一點是兒童、農民畫和表現主義繪畫無論如何無法實現的。

藝術家不以個人的世俗激情凌駕於藝術品之上，這就使藝術具有了一種超越自我的力量，使他的作品不流於他生活際遇的反映，而是成為他心靈的映照。真正偉大的藝術不是板橋之類的幾筆塗抹，甚至也不是雲林那樣的空疏簡淡，而是宋人山水中體現出來的那種令人敬畏的宗教感，或是西人塞尚筆下的那種統攝世界的秩序。文達曾送我一幅頗有石濤遺風的長卷，他對石濤曾經下過一番功夫，

an expression of our individuality or our emotions? i think for artists like wenda who can transcend their own art, the answer is, "no." because for true artists, their goal is the work itself, and all attempts to make the work express a uniqueness will only result in the destruction of the work itself. 3

in this way, wenda is not only standing outside of the trend of "self-expression," but he is also opposing the grasping superficiality of peasant painting and children's painting. 4

> *i am against the idea of adults or professional artists creating children's paintings or peasant paintings. there is nothing more forced or affected than this kind of practice. today learning from them has become a kind of fad. but you only need to sit down and properly analyze it before you realize that this same kind of painting, by children, and peasants — they are expressing a kind of innocence or charm. but this same kind of thing done by adults results in work that is saturated with a kind of vulgarness or commonness.*
>
> *children's paintings, peasant paintings, and abstract expressionist paintings are, in fact, quite similar — particularly in their very direct modes of expression. in my opinion, art though high and lofty, will conquer pathologies in the end. it is only through conquering these issues, that the works of the artist will demonstrate that they have conquered themselves. this is something that can never be realized by children's paintings, peasant paintings, or expressionism.*

artists should not let their art become overrun by common or worldly emotions. this is precisely the power of art, the power to overcome the self, and to make the works, not a reflection of the ups and downs of an artist's life but a reflection of their soul. truly great art is not a few strokes or daubs of paint like zheng banqiao, nor it is the empty simplistic work of yun lin [ni zan], it is the awe-inspiring divine feeling created by the work of the song dynasty ink painters, or the sense of control over the order of the world as described by duchamp, a westerner. gu wenda once sent me a scroll painting that was created in the style of shi

那幅畫就可以跟石濤的名作《潑墨山水卷》媲美。但是,在氣局上,文達確有突破前人之處,它總是使我感到有一種獨立於人之外的東西 —— 那也許是高懸在我想像中的一個偉大而永恆之謎的東西。文達在談到水墨畫時曾說:

水墨畫以其特有的形式感 —— 透明度使自然景色通過藝術家的再創造,達到更純淨之境界。顯然,藝術家通過水墨畫這一特殊的創造,目的在於使自己的作品更接近自然的那種神秘的力量、靜寂的精神。可以想像,藝術家自身也得以淨化,而我們認為這一目的的實現有賴於特殊的形式感的力量。也就是說使產生於主體的激情淨化到形式的境界,然而這個形式境界又以與自然的素樸靜寂的精神和諧為最終目的。

可是,文達的這種思想很少為人理解。他的畫太狂怪了,人們從中看到的總是沸沸揚揚的騷亂,而那內在的靜寂,那大音希聲的天籟卻被忽略了。他不止一次地受到指責,為了少惹事情,即使是三十七、八度高溫的炎炎赤夏,他也只好關起門來作畫[5]。有時,人們也真奇怪,像他那樣具有扎實的傳統功力的人,為甚麼不畫一批討好的畫去撈一筆錢,而自討麻煩。遺憾的是,他在藝術上甚麼都願嘗試,唯獨這使他感到討厭。他嚴肅作畫,他希望別人的只是人家能夠尊重他的勞動。有時,苦悶之極,他也引詩明志,他甚至還寫了小說《他和他的小屋》來表達藝術家對生活的渴望。確實,

tao. he once deeply studied the work of shi tao, and his painting is comparable to shi tao's famous work *splashed ink landscape* [潑墨山水卷]. but in terms of the nature of his temperament, besides his transcendence of those who came before him, beyond his independence which sets him apart from other people, there floats within my imagination some kind of great and eternal mysterious thing. in discussing ink art, wenda once said:

the unique sense of form which we find with ink painting, the artist's re-creation of natural scenery through degrees of transparency, allows us to arrive at a sanctified state or pure realm. clearly, through this special creation of ink painting, the artist's goal is to make their works closer to the mysterious forces of nature through a kind of silent spirituality. we can imagine that the artists themselves are also cleansed, and we of course acknowledge that the realization of this goal relies upon this special sense of form. that is to say to purify the passions and convert them into the realm of form; however; the ultimate goal of this formal realm is always to find a sense of harmony with this simple, calm spirit of nature.

despite this, wenda's ideas are seldomly understood. his paintings are too crazy and uninhibited. people see uproar and turmoil, but within this there is peace. we often overlook the subtle sounds of nature, but the proverb da yin xi sheng [大音希聲] tells us that the largest and most beautiful voices are silent. wenda was criticized on more than one occasion and warned not to stir up trouble, so in the blazing days of summer, with temperatures of 37 and 38 degrees celsius, he had to close the door of his studio.[5] sometimes people wonder why someone with his solid, traditional skills would not paint a bunch of pleasing paintings to make money instead of getting himself into trouble. unfortunately, he was willing to try anything in art, but this was the only thing that annoyed him. when he was painting diligently, he only wished that others would respect his effort. sometimes, when he was in the depths of his despair, he

對一個藝術家來說，當他面臨着孤獨、諷刺、打擊時，除此之外，他還能做些甚麼呢？當然他也清楚地知道，如果按照傳統標準作畫，他就會輕鬆得多，並且不會出現甚麼問題。因為，那樣做目標明確多了。但是，令人滿意的生活決不是沒有問題的生活。要在藝術世界和思維世界中，真正感到崇高莊嚴和不可思議的奧秘，要在整個人類知識的水準上去經驗作為單一的整體的宇宙，這些願望使他超越了那種世俗的愉快。而正是那種超越使真正的不屈不撓者，獲得了一種常人所想像不到的解放感，它開拓着藝術家的胸襟和良心，使藝術擺脫了那些毫無生氣的經驗。

不久前，我寫過一段話：美術創作中的種種焦慮和悲劇感，大多源於我們站在了從封閉情境向開放情境過渡的邊緣[6]。寫那些話時，我忘記了文達。我看到的更多的是南北的畫家「群體」對傳統發動的一場又一場衝擊。這種衝擊，可能是中國美術史上值得重視的一種戲劇性的轉變，充滿了英雄氣概。當然，其結局也正如我的朋友洪再新在評論「85 新空間」時說的那樣，是場「勇敢的犧牲」。現在，我知道了文達有着更遠大的目標。在很多人都紛紛扔掉筆墨宣紙去爭抱時髦新衣的時候，他卻從油畫中又返身回來。藝術的超越感使他要面對着兩面作戰：即不但要以舊材料來超越舊傳統，而且還要超越西方現代藝術的衝擊[7]。

在這樣一種心向下，我們看到文達畫了這樣的一批宣紙水墨畫：《正反的字》《錯位的字》《無意的字》

would quote poetry and even wrote the novel *the man and his cabin*, to express his desires in life. but when an artist also faces loneliness, sarcasm, and attacks, besides giving up, what else can he do? of course, he was clearly aware, that if he followed the traditional standards of painting, everything would be much less stressful, and he wouldn't encounter so many problems. because working in that manner, the goal is much clearer. but a contented life, is not necessarily a life that is completely free of any problems. in the world of art and intellectual discourse, to truly feel the lofty, sublime, and incredible sense of mystery of the universe, and on the level of personal knowledge to experience the cosmos as a holistic entity, this desire allows him to transcend worldly pleasures, and it is precisely this transcendence that gives him an incredible sense of liberation — one that most people can hardly imagine. it opens up the artist's consciousness and spirit, allowing him to shake off that experience of lifelessness.

not too long ago, i wrote a passage: "the various anxieties and the sense of tragedy within art creation which came out of the position of standing on the boundary between closedness and openness."[6] in writing these words, i forgot about wenda. i was thinking of the relentless attacks on tradition from artist groups from the northern and southern. it is worth noting that these kinds of attacks represented a dramatic turn for chinese art history, and they were full of heroic spirit. of course, the outcome as my friend hong zaixin remarked, in his "85 new space," was a kind of "heroic sacrifice." now i know that wenda had a much greater objective. while at that time many people, one after the other, threw away their brushes, inks, and xuan paper, fighting to get their hands on some fashionable new clothes, he actually made a retreat from oil painting. the transcendence of art is a battle he would fight on two fronts: not only did he use old materials to transcend old traditions, but he also took swings at western modern art.[7]

with this mindset, we will look at this series of ink paintings on xuan paper by wenda including negative and positive characters, misplaced characters, pseudo-characters in seal script, totem and

（現名《偽篆字》)《圖騰與禁忌》《我批閱三男三女書寫的靜字》等等。注意，我這裏所列的標題都不是真正的標題（原來的標題裏有很多「錯」字），而作者所給出的標題原型卻是作品的一部分，它們的作用就像捕鼠器上的誘餌一樣，很容易抓住觀眾，並使那些隱名的觀眾變成真正的觀眾。因為這是一些令人煩惱困惑的作品，你看着這些作品很難肯定地回答，是作者從文字中發現了新藝術呢，還是我們從作者身上發現了新錯誤。一旦你坐下來去費心破譯這些非文字學家的神秘符號時，你就會發現，標題停頓在標題之中，寫標題和看標題的人最後都將在言語和沉默之間進退兩難。然而藝術家卻完成了他的新的成果。還有比這更荒唐也更令人掃興的嗎？即使這是一種思想的詼諧，畢竟也是一種令人不舒服的東西。然而藝術家卻堅持認為這是不可缺少的。因為，再深刻的啟示錄也不是人人都願意接受的。

在這種情況下，你再質問藝術家「難道這些仿宋體、錯別字也算藝術嗎？」之類的問題也就沒有意義了[8]。對於欣賞者來說，關鍵是你能不能接受這些「字象」並從這些「字象」中喚起某種感官的特質[9]，至於它們算不算「藝術」，那也要取決於我們的熱情或冷漠的態度。不過，我知道文達是把它們當作真正的藝術來嚴肅地創作的。

談起嚴肅來，恐怕還很少有人是這樣看文達的。不過，我是這樣看的。他的嚴肅正如他說的是源於在戰勝人生的世俗荒誕之際時，所萌發出的一種宇

taboo and i evaluate characters written by three men and three women. it's important to note that these titles are not "real" titles as the original titles had many "typos" or incorrect characters. but the names of the works provided by the artist are part of the artwork and function like bait in a mousetrap, easily grabbing the attention of the audience, and this is what transforms the anonymous viewer into a real engaged audience — these works have the power to annoy and confuse the viewer. viewing these works, it is very hard to answer whether if it's the creator who has created a new form of work from the chinese characters or whether it is the viewer has discovered a new error produced from the hand of the artist. once you sit down to try to decipher these mysterious symbols written by people who are not philologists (experts on texts, literature, and writing systems), you will soon discover that in reading the title, you are forced to pause in the middle. both the writer and the reader of the title are floating between language and silence, unable to either advance or retreat. yet the artist has still completed the work. is there anything more absurd and frustrating than this? even if this is a kind of thought-based humor, it certainly makes people uncomfortable. but the artist feels that it is truly indispensable. because no matter how profound this revelation, not everyone is willing to accept it.

under these circumstances, if you question the artist, "should these imitation song [dynasty] script calligraphy and 'typo' characters not be considered art?" these questions are no longer relevant.[8] from the point of view of the viewer, the most important thing is if you can accept these character images and the idiosyncratic experiences that they create for our senses.[9] as to whether or not they should be considered "art," that depends upon the attitude of enthusiasm or conversely indifference of the viewer. in any case, wenda certainly considers them to be real art and the product of serious creative efforts.

speaking of seriousness, i am afraid that few people view wenda in this light. but this is how i see it. his seriousness, as he has said, comes from a cosmic religious feeling that emerged when

宙的宗教感情（cosmic religious feeling）。回顧一下他前兩年的畫，我們大概就不難理解，他的畫是從注視天空開始的。當然，他最近的畫有了變化，他的嚴肅多了點新內容，那就是，如果他快樂，他就要弄得不快樂。一個西方人也許會把它看成是黑色幽默（black humor）。這樣看我也有些同意。他近來創作的文字系列的作品就多少有點黑色幽默作家巴思（j. barth）在《道路盡頭》（the end of the road）中說過的：

把經驗變成一種語言——就是說，進行歸類，劃分範圍，形成概念，使用語法，找到句法——這總是一種對經驗的背叛，把經驗變成了虛假的東西。但是，只有通過這種背叛才能使經驗得到一種處理，而且只有經過這樣的處理才能使我覺得自己是一個活生生的人……當我的那一把可以塑造神話的剃刀磨得飛快時，用它大幹一場，拿現實開刀，那真是一件不可比擬的痛快事。當然，在另外一種意義上，我就完全不相信這一套了[10]。

不過，文達實際上並沒有從中引出一種苦惱的意識，他從這萬物的急旋中似乎找到了一種更永恆的東西。他的《帶視窗的四個自畫像——1981－1984》（現名《靜坐的自畫像》）就是以簡單的形式重複來喚起人們對秩序的敬畏心理。它表達的是紋絲不動的靜坐，是長時間的靜默，也許，其中的意思可作各種解釋，但要深究恐怕就有不落言筌的危險了。

he overcame the worldly absurdity of life. looking back on the paintings from the last two years, it is not hard to understand how his paintings began from staring at the sky. of course, there has also been a change within his recent paintings, which are much more serious and incorporate new content. that is to say, if he is content, he purposely makes himself unhappy. a westerner might describe this as black humor. in this sense, i agree. the recent text series of his has something of the black humor of john barth's novel *the end of the road*:

to take experience and turn it into speech, that is to classify, to categorize, to conceptualize, to grammarize, to syntactify, is always a betrayal of experience, a falsification of it: but only so betrayed, can it be dealt with at all and only in so dealing with it, did i ever feel like a man alive and kicking . . . when my mythoplastic razors were sharply honed, it was an unparalleled sport to lay about with them, to have at reality. of course, on another level, i don't believe any of it.[10]

but wenda certainly hasn't elicited a kind of distressed consciousness from within this, rather he seems to have found something eternal from within this mad whirlwind of everything. his work ***dual self-portraits***, uses a simple form to evoke a sense of reverence for order. he expresses a kind of absolutely silent meditation, a kind of long silence, maybe, the meaning of which can have various interpretations, but if you want to dig deeper you need to be aware of the danger of getting caught in the affectations of language, convention and theory and losing sight of natural feeling, emotion and subtle insight.

65

東方的宗教多少有點意志鍛煉的味道，無論是參禪時的面壁，還是體現在儀禮中的「侘」（wabi）和「寂」（sabi）（我願意把前者理解為固窮而不與時流合轍，把後者理解為在無思無念中的自悟自性）都有這種作用。不過，它的實踐結果卻往往導致了一種破壞性的態度。「祖師毀經」、「雲門屎橛」、「逢佛殺佛，逢祖殺祖」的傳聞都屬於這種類型。文達最近的一些作品無論是對於繪畫還是對於書法都是破壞性的，他破壞漢字的點畫結構，破壞繪畫的傳統規範，就像上述的故事一樣，強調的都是通過破壞而達到無慮無礙的直接體驗，例如，他的《正反的字》、《錯位的字》、《無意的字》不正是暗示了這樣一些古老的思想之道嗎？

> 思維知與不知，有與沒有，而後離開你可能執着的兩邊。（正反）

> 在前進的車輛中從規律的搖擺中體驗。或在靜止的車輛中讓你自己搖擺——以悠緩而不可目睹的圓圈。（錯位）

> 當字母主觀地化為文字，文字化為文句，而圓圈客觀地化為世界，世界化為原理之時，最後終於發現這些集中在我們的心中。（無意）

這些話出自一部距今四五千年的梵文手稿的抄本，拉克希曼喬（lakshmanjoo）把它譯為了《中道》（centering）[11]。讀了這些話，熟悉禪理的人不難悟出：沒有破壞，沒有破壞者，也沒有被破壞者，三者皆空。然而，話雖這樣說，代表着破壞者的「進魔界難」這句宗教的格言還是非常令人感動的，因為，意志薄弱者是進不去的。

eastern religion carries with it the notion of an exercise of willpower. be it the practice of zen buddhist meditation, or the buddhist concepts of "wabi" and "sabi" manifested in the ceremony, (i am willing to understand the former as stoic poverty and the habit of going against the flow of the times, and the latter as having no thoughts and no ideas and a kind of awareness of the self.) they all produce this kind of effect. but in reality, the results of his practice always lead to this kind of attitude of destruction. there are the tales of "the patriarch destroys the scriptures," "zen master yunmen telling the young student that buddha is a dried shit stick," or when zen master linji yixuan said, "fawn upon buddha, kill buddha. fawn upon the ancestors, kill the ancestors," — these kinds of anecdotes all fall within the same vein. the most recent works of wenda, be they painting or calligraphy all possess this spirit of destruction. he destroys the structure of dots and strokes of the characters, and destroys the traditional conventions and rules of painting, just like the aforementioned stories. the works emphasize that through destruction we can arrive at a carefree and unfettered immediate experience. for instance, do works such as *negative and positive characters, misplaced characters*, and *pseudo-characters in seal script* not hint at these ancient ways of thinking?

> *thinking falls between the concepts of knowing and not knowing, having and not having, to the extent that when you depart, you grasp hard to both sides (negative and positive characters).*

> *or alternatively, do you sway rhythmically propelled by the motion of a forward-moving vehicle, or do you propel yourself in slow imperceptible circles in a stationary vehicle? (misplaced characters).*

> *when the letters are subjectively formed into words, and words into sentences and circles objectively drawn into a globe, and the globe is drawn into the principle of time, finally we find that all of these things are concentrated within our hearts (pseudo-characters in seal script).*

these words came from a four-to-five-thousand-year-old transcript of a sanskrit manuscript by lakshmanjoo who translated it as *centering*[11]. reading these words, those familiar

在西方有個進了魔界的希臘英雄叫西西弗斯（sisyphus），後世的人們常常提到他。歌德曾用來比況自己一生的辛苦，他對愛克曼（eckermann）說：「我這一生基本上只是辛苦工作。我可以說，我活了75歲，沒有哪一個月過得是真正的舒服生活。就好像推一塊石頭上山，石頭不停地滾下來又推上去。我的年表將是這番話的很清楚的說明。「加繆（camus）則從另一個角度把西西弗斯看成了人生命運的象徵，他在《西西弗斯的神話》（le mythe de sisyphe）中寫道：「當一個人回顧自己生命的一瞬間，他正像西西弗斯回過身來看看滾下去的大石頭，並把它再次輕輕地推上坡去的時候一樣。他默默地凝思着，成了他的命定劫數的一連串沒有聯繫的動作，正是他自己創造的。這一切都在他的記憶中重現出來並聯繫起來，但當他一死，這一切也就會立即消失。當一個人如此信服地承認了人的一切都是他自己造成的以後，他也就像一個明知道漫漫長夜永無盡頭而又急於想看到一切的盲人，他繼續推動着石頭。但石頭仍要從坡上滾下來。」而文達卻要執意地把藝術生活與世俗生活分開作二元看，因此他又在加繆的話後接着寫道：

> 西西弗斯又一次把石塊向坡上推去，恍惚中卻感到有一種不同於以往的力量，他覺得無比輕鬆。石塊又依然墜下坡去，可這回他再也沒有去回顧那隆隆滾去的巨石。剎那間他的雙眼窺視到山的那邊，一道靈光從山那頭射來，如同亞伯蘭（abram）在哈蘭（haran）身臨其境那樣，心中感到惶悚不安，於是他投入了這樣的驚恐、狂喜之中：

with zen will not find it hard to discern: "if there is no destruction then there are no destructive people, and then there are no victims of destruction. all three are null, non-existent." that said, what is really moving is the religious maxim of the destroyers' "difficulty in entering the realm of demons," because the weak-willed also have no way of entering the demon world.

in the world of greek mythology, there is a hero called sisyphus, who is often mentioned by those in the following generations. goethe once used the myth of sisyphus to express his life of suffering. he said to eckermann: "in my life truly, there has been nothing but toil and care, and i may say that, in all my seventy-five years, i have never had a month of genuine comfort. it has been the perpetual rolling of a stone, which i have always had to raise anew." my annals will render clear what i now say." camus takes a different angle in using sisyphus as a symbol of man's destiny in *le mythe de sisyphe* where he writes: "at that subtle moment when the man glances back over his life, sisyphus returning to his rock, in that slight pivoting, he contemplates that series of unrelated actions which became his fate, created by him, combined under his memory's eye and soon sealed by his death. thus, convinced of the wholly human origin of all that is human, a blind man eager to see that the night has no end, he is still on the go; the rock is still rolling." and wenda was determined to separate the life of art from the worldly or profane life, into a binary, therefore he followed the philosophy of camus:

> *once again sisyphus pushed the rock up the hill, vaguely conscious of the presence of a different kind of force than before. he felt extremely relaxed. the rock rolled down the hill again, but this time he didn't once look back at the boulder as it rumbled away. in an instant, his eyes roved over to the mountain and a ray of divine light shone across the mountain, just like the scene of abram and haram — he felt a sense of worry and terror, throwing himself into a state of panic, wild with ecstasy:*
>
> *"a bright moon is high in the sky. hidden waves drift. the wind rustles and the pallid light of the moon takes flight. quiet and deserted in a misty blur, cool air moves in like water. which direction is the boat bound?*

「皓月當空，暗波浮動，風聲瑟瑟處，寒光如飛，空寂迷離，冷氣如水，海船駛向何方？極目雲帷低垂，像白色的象群，又似肅穆的聖殿，沒有燈火，混沌天地間，海船駛向何方？大海盡頭，雲深不知處。」

這段文字包含了一種宗教般的藝術精神，其中暗示了文達要超越西方現代藝術衝擊的願望，不知道我這樣寫說清楚了沒有。

（此文刊於《美術》1986 年，第 7 期，第 46 至 52 頁）

a screen of clouds as far as the eye can see, just like a herd of white elephants, again like a solemn sanctuary, without lights, in the chaotic primordial space of heaven and earth. towards which direction does the boat sail? to the edge of the ocean, to a place beyond the unknown cloud depths?"

this text includes a kind of spiritual artistic spirit and this hints at wenda's desire to create an impact on western modern art. i don't know if what i am writing is clear or not.

(*art* magazine, 1986, vol.7)

范景中，35 歲，1979 年至 1981 年在浙江美院攻讀美術理論研究生，現為浙江美院學報編輯委員會副主任。

fan jingzhong is 35 years old. from 1979-1981 he studied a master's in art theory at the zhejiang academy of art. he is a member of the editorial board of the magazine new art and also the deputy director.

注釋

1　關於埃舍爾這些特色的論述，參見 e. h. gombrich 著作 art and illusion 第八章 ambiguities of the third dimension (london，1984)，和他的論文 illusion and visual deadlock，收在 meditations on a hobby horse (london，1978) 一書，中譯本見《美術譯叢》1986 年第二期。

2　張彥遠:《歷代名畫記》卷一，(北京:人民美術出版社，1983 年)。

3　參見 k. popper 著作 unended quest: an intellectual autobiography 第十三節 two kinds of music (glasgow，1982)；也可參見我在《美術研究和方法論:受控的資料庫與想像實驗室》一文中對埃舍爾的評論，載《新美術》1986 年第一期。

4　我對兒童藝術的看法，見《兒童藝術和純真之眼》，載《新美術》1986 年第二期。

5　寫到這裏我想起了卡夫卡在《地洞》裏寫的一句話:「地洞的最大優點是寧靜。」見《外國現代派作品選》，第一冊(下)，上海文藝出版社，1980 年，第 754 頁。

6　我的文章的題目為《開放的藝術和開放的情境》，載《美術思潮》1986 年第三期。我很樂意補充 m. cunliffe 在 the literature of the united states (hong kong，1975，p.343) 一書中說的一段話，我認為它說出了相當的一部分人的創作心理:"in order to become famous they must hit upon a distinctive 'signature'. to maintain their standing they must however write novels which possess novelty-which are 'new' and 'news'. small wonder that some writers, while revelling in the limelight, find the strain intoleradle."

7　論藝術超越的最引人入勝的論文，我認為是 gombrich 的 the logic of vanity fair : alternatives to historicism in the study of fashions, style and taste，收在 ideals and idols (london，1979)，中文摘譯本見《美術譯叢》1986 年第一期，題為「波普爾的方法論和藝術理論」。

8　藝術家當然可以堅定地反問:為甚麼不算藝術？難道歐體不是藝術嗎？難道仿宋不是從歐體字中衍化出來的嗎？難道連皇家的殿本都用它，我們卻要拒絕它嗎？錯別字當然也能進入藝術，傅山不就說過「饕餮蚩尤婉轉歌，顛三倒四眼橫波。兒童不解霜翁語，書到先秦吊詭多」(《村居雜詩‧其八》)嗎？

9　「字象」是我生造出的詞。大約六年前，我在和邱振中討論現代書法時想出了這個詞，直接啟發我的是 j. e. downey 對 image 的解釋。

10　我建議有興趣從更廣闊的視野研究文達的學者不妨把博爾赫斯(borges)、巴思跟文達作一比較。這裏用的引語，是陳焜先生的譯文。巴思在名為《標題》(title) 的短篇中還說過這樣的話:the final possibility is a temporary expedient, to be sure, the self styled narrator of this so called story went on to admit, ignoring the hostile impatience of his audience, but what is not, and every sentence completed is a step cl ser to the end. that is to say, every day gained is a day gone. matter of viewpoint, i suppose. go on. i am. whether anyone's paying attention or not. the final possibility is to turn ultimacy, exhaustion, paralyzing self-consciousness and the adjective weight of accumulated history… go on. to on. to turn ultimacy against itself to make something new and valid, the essence whereof would be the impossibility of making something new. (from fiction 100, ed. j. h. pickering, p.40, n.y., 1974)，感謝楊恩梁為我提供的對這段文字的解釋，使我很方便地能用在這裏。

11　這裏引用一則禪宗公案也許對讀者更合適，例如《五燈會元‧卷第十一》問:「語默涉離微，如何通不犯？」師曰:「常憶江南三月裏，鷓鴣啼處百花香。」(無門慧開在《無門關》中曾對風穴延沼禪師的這個回答作過評點)但是，這樣做，恐怕對文達不合適，因為他可能不大關心那些公案。也許他還會忍不住地笑我幾句:「這個老朋友總愛根據他自己的興致來曲解我。」我可以為自己辯護的是，善意的曲解總比不願理解要強，更何況文達還有令人捉摸不透的一面呢！

看，我還未看見，

他就在我面前消逝；

我還未曾覺察，

他就起了變化。

——約伯(Hiob)的箴言

notes

1 for a discussion of escher's work, see the eighth chapter in e. h. gombrich, "ambiguities of the third dimension," *art and illusion: a study in the psychology of pictorial representation,* london: phaidon press, 1984. and e.h. gombrich, "meditations on a hobby horse," *illusion and visual deadlock,* london: phaidon press, 1978. both texts are from a translation in *meishu yishong,* volume 2, 1986.

2 zhang yanyuan, chapter 1 of notes on famous paintings, people's fine arts publishing house: beijing, 1983.

3 see karl popper, "two kinds of music," section 13 in *unended quest: an intellectual autobiography,* glasgow: fontana/collins, 1976. also see my comments about escher in "arts research and methodology: a controlled information archive and imagination laboratory," in *new art,* vol.1, 1986.

4 for my thoughts on children's paintings see, "innocent eyes: children's painting," in *new art,* vol.2. 1986.

5 this makes me think of kafka's sentence, "one of the greatest strengths of the burrow is tranquility," from his short story, "the burrow," see, *waiguo xiandaipai zuopin xuan,* volume 1, part 2, shanghai: shanghai literature and art publishing house, 1980, p. 754.

6 the title of my article was "open art and open situations," in *the trend of art thought,* vol. 3, 1986. i'm very happy to add to what m. cunliffe wrote in *the literature of the united states,* (hong kong, 1975). i think it speaks to the creative mindset of some people. "in order to become famous, they must hit upon a distinctive "signature." to maintain their standing, they must, however, write novels which possess novelty —which are "new" and "news." small wonder that some writers, while reveling in the limelight, find the strain intolerable." (p.343)

7 i feel that the most fascinating and winning paper on artistic transcendence is e.h gombrich's, "the logic of vanity fair: alternatives to historicism in the study of fashions, style and taste," in *ideals and idols,* london: phaidon press, 1979. chinese excerpts from "art theory and popper's methodology," *meishu yicong,* vol.1, 1986.

8 of course, art can take a firm stance and ask: "why is this not art? isn't ouyang shun's style of calligraphy art? didn't song-dynasty typeface not evolve from ouyang xun's style? was it not used in all the imperial palaces? are we going to reject this?" of course, these "typo" characters can enter into the realm of art. did fu shan not say: "taotie, chiyou, they were fierce and ugly, but their song were very mild(although pre-qin calligraphy has no certain rules, it seems ugly and topsy-turvy, but it is very charming.) . children do not understand the words of hoary old men. calligraphy was stranger and more eccentric during the pre-qin period."

9 "zixiang" [character/image] is a word i made up. roughly six years ago, when talking about calligraphy with qui zhenzhong, i thought up this word, which was inspired by j.e. downey's interpretations of images.

10 i would suggest that scholars who wish to study gu wenda from a broader perspective should consider making a comparison between borges and john barth. this is a translation from chen kun. in his short story "title" he wrote:

> the final possibility is a temporary expedient, to be sure, the self-styled narrator of this so-called story went on to admit, ignoring the hostile impatience of his audience, but what is not, and every sentence completed is a step closer to the end. that is to say, every day gained is a day gone. matter of viewpoint, i suppose. go on. i am. whether anyone's paying attention or not. the final possibility is to turn ultimacy, exhaustion, paralyzing self-consciousness and the adjective weight of accumulated history...go on. go on. to turn ultimacy against itself to make something new and valid, the essence whereof would be the impossibility of making something new. (from j. h. pickering's *fiction,* 100, ed., new york: macmillan, p. 40, 1974).

here, i would like to thank yang enliang for providing an interpretation of this text which proved very relevant here.

11 here a strange case from chan buddhism would be very appropriate for the audience. in the *compendium of five lamps,* (a 20-volume history of zen buddhism in china written in the song dynasty,) the 11th chapter features a question: a monk asks master fengxue yanzhao if, "if both speech and silence transgress; how can we not do so?"

70

fengxue yanzhao responds, "i often think of jiangnan in march; the partridge chirps among the scented flowers." (zen master wumen huikai, once commented on zen master fengxue yanzhao in *the gateless gate*). but i feel that this is not appropriate for wenda, because perhaps he is not too familiar with that particular case and of course, he probably will not be able to contain his laughter in regards to my writing. this old friend always likes to misinterpret me to suit his own interests. in my defense, i can say that a well-intentioned distortion, is always better than an unwillingness to understand, and what's more, gu wenda always has an unpredictable side.

see, i still have not seen,

he is fading away before my eyes,

i hadn't yet noticed,

that he has already begun to change.

—job's proverb

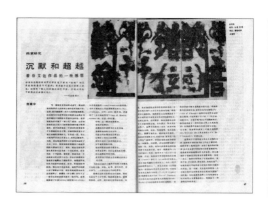

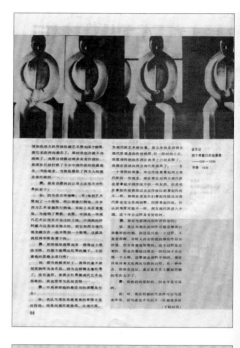

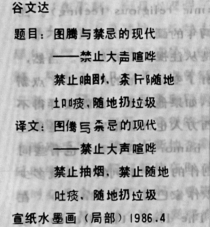

由邵大箴主編的國家美術刊物《美術》1986年第柒期執行主編高明潞，首次以非常之大的篇幅，報導前衛藝術家谷文達被關閉的藝術家首個大規模當代水墨藝術個人展覽，范景中的《沉默與超越 —— 看谷文達作品的一些感想》，特別是費大為題為《向現代派挑戰》的採訪，首次在壹派頂禮膜拜與沉迷效仿現當代藝術而積重難返的情境之中，率先在85藝術復興中提出向西方現代派挑戰的概念和立場。

fan jingzhong's article *silence and transcendence—some reflections on gu wenda's work* and fei dawei's interview **challenging modernism**, were published in the national art publication *art* magazine (1986, vol.7) with gao minglu as managing editor and shao dazhen as chief editor. this represented the first time there was large-scale coverage of the avant-garde work of gu wenda, and the closure of his first large-scale solo exhibition of contemporary ink art. for the first time, this group of people who had worshipped modern art and were obsessed with imitating its forms found it hard to return to their positions after the accumulated critical weight suggested a new direction. in the art resurgence of 85, mr. gu was challenging the stance and the concepts of western modernism.

國家官方美術期刊《美術》雜誌竟然專門製作偽錯漢字鉛字印製充滿偽錯字的作品標題。

the national state art publication *art* magazine even made specially-manufactured lead printing blocks of these pseudo characters (given that these pseudo characters would not have been part of a standard set of printing blocks). they are printed under the heading of pseudo characters.

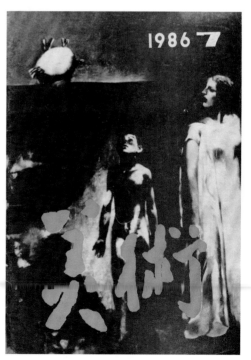

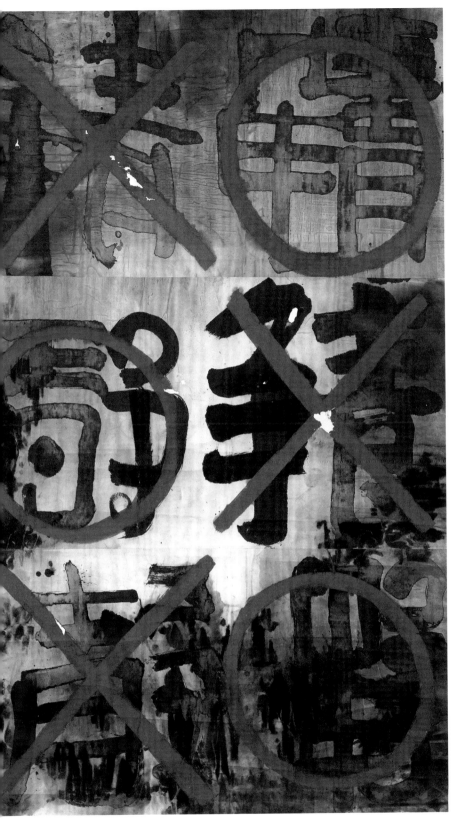

《我批閱叁男叁女寫的靜字》
遺失的王朝系列
叁男叁女水墨行為藝術
1985 年於杭州工作室
墨，宣紙，紙背白梗絹邊裱立軸
180 厘米寬 × 274.5 厘米高

I EVALUATE CHARACTERS WRITTEN BY
THREE MEN AND THREE WOMEN

lost dynasties series
an ink performance with 3 men and 3 women
hangzhou studio, 1985
ink on xuan paper, hanging scroll mounted on paper
backing with white silk borders
180cm wide × 274.5cm high

長沙李路明主編的《畫家》1985 年第壹期創刊號的
藝術家專題介紹是谷文達的水墨藝術
the first issue of *painter* magazine 1985,
edited by li luming, featured a special article
introducing the ink art of gu wenda

73

現象・爭議・挑戰・影響（貳）:
1988 年伊始的人類生命基因藝術

PHENOMENON・CONTROVERSY・CHALLENGE・INFLUENCE 2:
begin discovering human genetic dna art in 1988

《血之謎》重新發現的俄狄浦斯系列引發的現象・爭議・挑戰・影響

phenomenon・controversy・challenge・influence over enigma of blood　oedipus refound
series

關於項目材料：這個正在進行的藝術項目有來自 16 個國家的 60 名女性參與者。按照這個項目的方法，他們把用過的月經衛生棉條和紙寄給了藝術家，並附上了他們個人的手稿，以詩歌、陳述和故事的形式，表達了他們的擔憂。

about project materials:
this ongoing art project has been involved with sixty women participants from sixteen countries. by following the methods of this project, they sent to the artist their used menstrual tampons and napkins with their personal hand scripts about their concerns in formats of poem, statements, and stories via postal service.

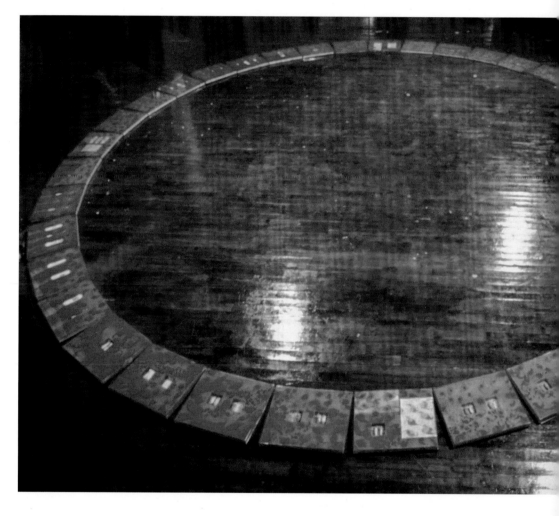

展覽場地：hatley martin 畫廊，三藩市，美國，1990 年；藝術家博物館，羅茨，波蘭，1993 年；漢納畫廊及香港藝術中心，中國香港，1993；當代藝術博物館，悉尼，澳洲，1993；墨爾本國際藝術節，墨爾本，澳洲，1993；西澳洲美術館，珀斯，澳洲，1994；溫哥華美術館，溫哥華，加拿大，1995；美國俄勒岡大學美術館，1996；韋恩堡博物館，美國，1996；1996 年，美國紐約可汗畫廊；salina 藝術中心，堪薩斯州，美國，1997；芝加哥文化中心，芝加哥，美國，1997；聖約瑟藝術博物館，聖約瑟，美國，1997。（這個正在進行的藝術項目的第壹個展覽名為「兩仟例自然死亡」，由彼得・塞爾茨和凱薩琳・庫克策劃）

the venues have been exhibited: hatley martin gallery, san francisco, usa, 1990; the artists' museum, lodz, poland, 1993; hanart gallery and hong kong arts centre, hong kong, china, 1993; museum of contemporary art, sydney, australia, 1993; melbourne international art festival, melbourne, australia, 1993; art gallery of western australia, perth, australia, 1994; vancouver art gallery, vancouver, canada, 1995; art museum of university of oregon, usa, 1996; fort wayne museum, usa, 1996; in khan gallery, new york city, usa, 1996; salina art center, kansas, usa, 1997; chicago cultural center, chicago, usa, 1997; san jose museum of art, san jose, usa, 1997. (the first exhibition of this ongoing art project was entitled two thosand natural deaths, was curated by peter selz and katherine cook)

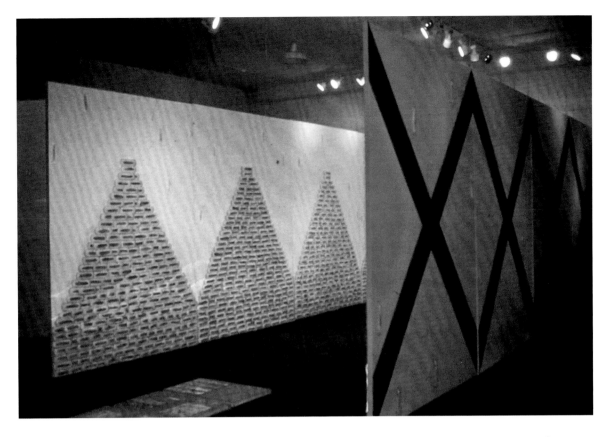

《血之謎》

重新發現的俄狄浦斯系列
1988-1996 於紐約工作室
16 國家 60 位婦女的親筆寫作，包括故事和詩歌等，
以及她們的經血，以郵局郵件方式寄給藝術家

ENIGMA OF BLOOD

oedipus refound series
new york studio, 1988-1996
60 women participants from 16 countries, their letters,
statements, poems, and stories, used menstrual tampons
and napkins sent to the artist via the postal service

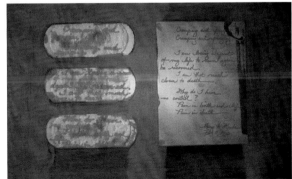

部分媒體對有極大爭議的《血之謎》的報導：
selected media report on the controversial work *enigma of blood*

栗憲庭和張頌仁等在開幕式上
li xianting and johnson chang at the opening

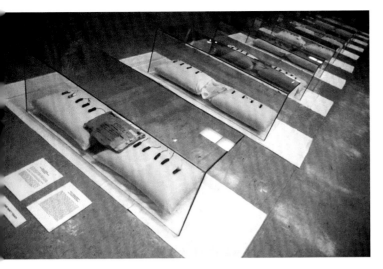

Oedipus Refound No. 1: The Enigma of Blood 1985-1995. A world-wide participatory art project. The Human Body Shop #1 installation consists of original writings from 60 women, in 16 countries. Tampons, napkins and public reactions are from Asia, Australia, Canada, Hong Kong, Taiwan and the United States.

Excerpts from Wenda Gu's, THE DIVINE COMEDY OF OUR TIMES

I wrote about the Oedipus Refound series in 1991. These works are dedicated to her, him, us and our times. The Oedipus myth is the ancient allegory, that most represents our being, nature and knowledge. These pieces intend to define us : we are the modern Oedipus, caught in the chaos of the modern enigma. From our blind indulgence since ancient times we are still looking, our knowledge is still extending and the chaotic enigma of the modern Oedipus still continues.

Since 1993, the concept of this series has utilized special human body materials as the subject basis. Pure human body materials have no element of visual or linguistic illusion in themselves. They are the antithesis of art as object exhibited in the museums and galleries. They are as real as the people who look at them and therefore can penetrate us with a deep sense of spiritual presence. Therefore I call them, "identselves." Each type of human body material that I use in the work passes an unusual deconstruction process, because of this, I also call it, "post-life."

The confrontation of countless enigmatic connotations in the human body material itself (the "internal definition") and the utmost reactions, elaborations, misunderstandings from the viewing public ("external definition") give rise to an enigmatic complex between consciousness and unconscious which almost becomes an unsolvable predicament. Because of the human body product's, beauty, sensitivity, fearful relation to the viewers, the call of birth and death, the fright of being waste material, the overall reactions to this work ranges from severe "repulsion" and "disgust," to puzzling queries, then ultimately, "it is us."

The appreciation and interpretation of a piece of art from the centric human being, from looking out from the objective universe to looking in on "ourselves" brings about deep misunderstandings which is what mankind's knowledge is all about... there is battle... there is conversion...which we apply to ourselves.

BLOOD SIMPLE

From the evidence of film, advertising and popular fiction, it sometimes seems that modern society has exploded every traditional taboo. The response to Wenda Gu's ongoing "Oedipus Refound" suggests that this is not so. Surprisingly, the taboo which Gu has uncovered involves, not explicit sex, gratuitous violence, or "perverse" behavior, but one of the most natural bodily processes. "Oedipus Refound" is an exploration of woman's attitudes toward menstruation. It has taken a variety of forms in the seven years that Gu has been pursuing this subject, but one constant is the display of used tampons along with letters from the women who contributed them. The angry responses of many viewers to these displays initially surprised Gu, who as a native of China, was raised in a culture with a very different attitude toward the human body. Now these responses have become an integral part of the work.

Gu solicits his materials by explaining his project in lectures at universities and art spaces and asking for contributions. One woman wrote a poem about the strange coincidence that her first menses occurred on the day of the Kennedy assassination. Another talked about the differences in her bodily functions before and after surgery. Others contributed meditations on the personal meanings of this most private, but ubiquitous experience.

Gu arrived at this project through his own interest in the use of body substances as art materials the last also created works using dried placentas and human hair). Initially he saw "Oedipus Refound" as an extension of private life into art in the manner of Joseph Beuys. However, the response to the work gradually led him to reassess its meaning. Letters from the female participants made it clear that he had touched on a central issue of contemporary American society - namely women's very problematic relationships to their own bodies.

Meanwhile, unsolicited letters from viewers denounced the work as "disgusting" (by far the most common descriptive), anti-art and degrading. One exhibition space suffered deep cuts in its budget for a year following the presentation of the work. Other art administrators "disinvited" Gu when they learned the nature of the work he wished to exhibit.

Gu had bumped up against American culture's puritan-based discomfort with the body. He decided to address this religious dimension of the responses directly by incorporating actual bibles into his installations. For this exhibition he has cut the text out of bibles and placed tampons inside. In the process, he turns the bible into an ambiguous symbol. Religious fundamentalists cite the bible as the ultimate authority in their war against the body. On the other hand, the book itself contains evidence aplenty of a far more tolerant attitude. As artists like Kiki Smith and Andres Serrano have revealed in their art, there is another side of Christianity which is far more accepting of corporeal experience. In fact, symbols like the body of Christ or the milk of the Virgin have important ritual significance in the Catholic tradition from which these artists spring.

In Gu's work, menstrual blood becomes the catalyst for an exploration of questions about the relation of public and private experience, the American view of the body and the control exerted by religious and political authorities over the most intimate aspects of our lives. He moves beyond the gender issues which motivated menstrual blood art works by feminists like Judy Chicago and Carolee Schneeman in the 1970s. Placing the matter in a more universal context, he reminds us that blood is the source of life for all humankind.

Eleanor Heartney

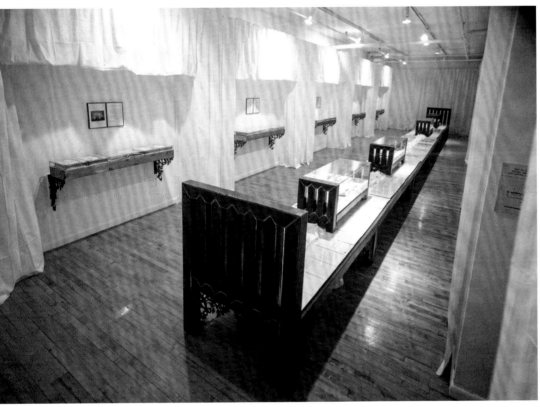

1993 年由栗憲庭與張頌仁策劃的中國當代藝術國際巡迴展在中國香港拉開序幕，藝術家谷文達之參與作品是《血之謎》重新發現的俄狄浦斯系列
organized by johnson chang and co-curated by li xianting, the exhibition china's new art, post-1989 was launched in hong kong, china. gu wenda's work *enigma of blood* oedipus refound series participated in this global touring exhibition

左起：1993 年《血之謎》與觀眾在香港會展中心；2000 年《血之謎》與觀眾在悉尼當代美術館
from left to right: *enigma of blood* and viewers at hong kong convention center in, 1993, and *enigma of blood* with viewers at the sydney contemporary art museum in 2001.

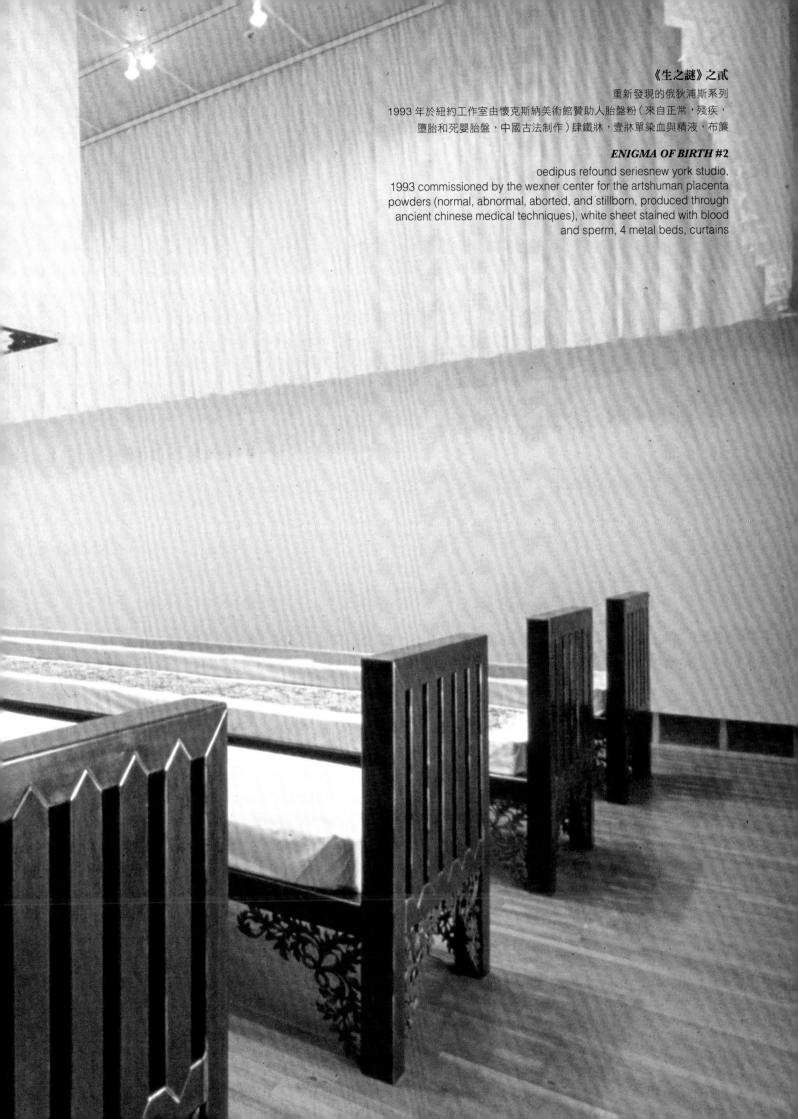

《生之謎》之貳
重新發現的俄狄浦斯系列
1993 年於紐約工作室由懷克斯納美術館贊助人胎盤粉（來自正常，殘疾，
墮胎和死嬰胎盤，中國古法制作）肆鐵牀，壹牀單染血與精液，布簾

***ENIGMA OF BIRTH* #2**
oedipus refound seriesnew york studio,
1993 commissioned by the wexner center for the artshuman placenta
powders (normal, abnormal, aborted, and stillborn, produced through
ancient chinese medical techniques), white sheet stained with blood
and sperm, 4 metal beds, curtains

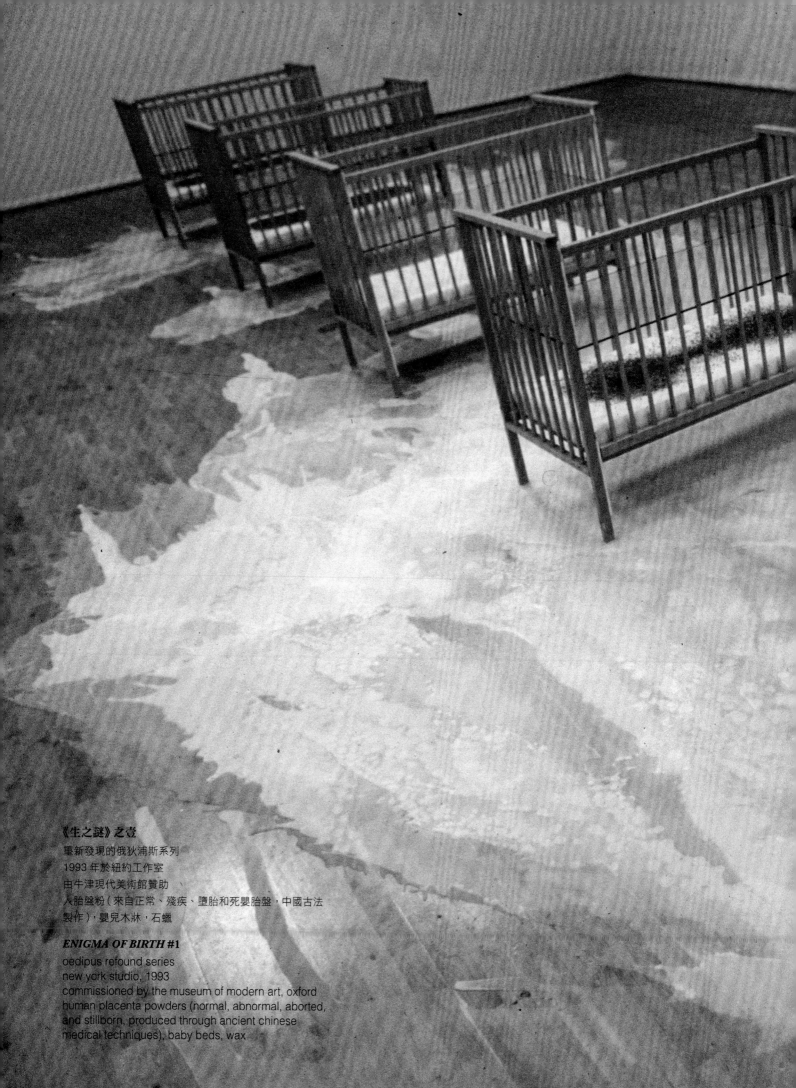

《生之謎》之壹
重新發現的俄狄浦斯系列
1993 年於紐約工作室
由牛津現代美術館贊助
人胎盤粉（來自正常、殘疾、墮胎和死嬰胎盤，中國古法
製作），嬰兒木牀，石蠟

ENIGMA OF BIRTH #1
oedipus refound series
new york studio, 1993
commissioned by the museum of modern art, oxford
human placenta powders (normal, abnormal, aborted,
and stillborn, produced through ancient chinese
medical techniques), baby beds, wax

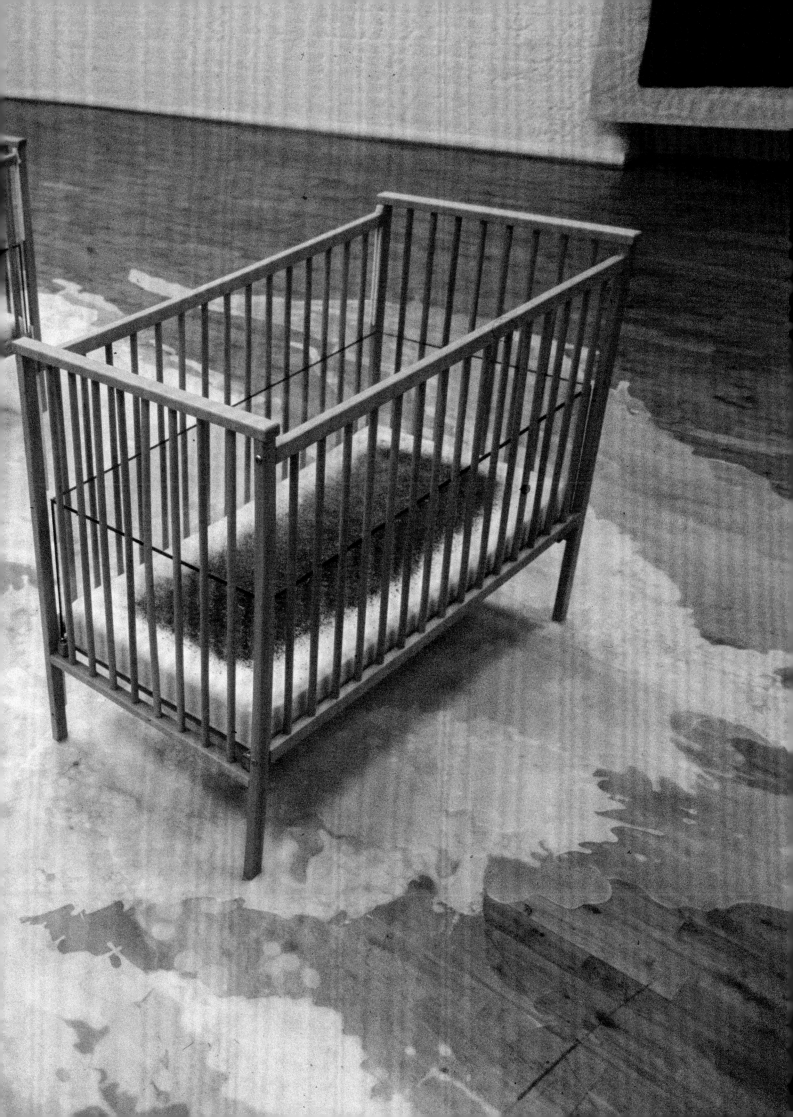

《玻璃瓶中的生之謎》#c

重新發現的俄狄浦斯系列
1993 年於紐約工作室
肆玻璃瓶分別裝有人胎盤粉（來自正常、殘疾、墮胎和死
嬰胎盤，中國古法製作），蜂蠟

***ENIGMA OF BIRTH IN JARS* #C**

oedipus refound serise
new york studio, 1993
4 glass jars, powdered human placenta (normal, abnormal,
aborted, and stillborn) sealed with beeswax

《玻璃瓶中的生之謎》#c　細部
enigma of birth in jars #c　details

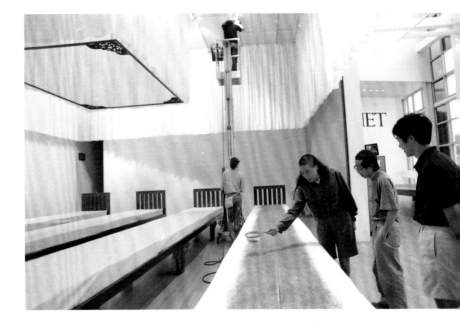

《鏡框裏的生之謎》
重新發現的俄狄浦斯系列
1993 年於紐約工作室
肆玻璃鏡框分別裝有人胎盤粉（來自正常、殘疾、墮胎
和死嬰胎盤，中國古法製作），蜂蠟，電腦印刷字底

ENIGMA OF BIRTH IN FRAMES

oedipus refound serise
new york studio, 1993
4 clipping frames containing powdered human
placenta (normal, abnormal, aborted, and stillborn
produced through ancient chinese medical
techniques), beeswax, compsuter printing base

藝術家谷文達在白牀單上灑胎盤粉，谷文達身邊是黃永砅和沈揆一
artist gu wenda sprinkling human placenta powder onto a long white sheet.
next to gu wenda are huang yongping and shen kuiyi

現象・爭議・挑戰・影響（叁）：

我們時代的神曲《聯合國》全球藝術之旅從 1993 年開始

PHENOMENON・CONTROVERSY・CHALLENGE・INFLUENCE 3:

the divine comedy of our times united nations-a global art journey began in 1993

《聯合國 —— 波蘭紀念碑》引發的現象・爭議・挑戰・影響 羅茨 1993

phenomenon・controversy・challenge・influence over united nations—poland monument lodz 1993

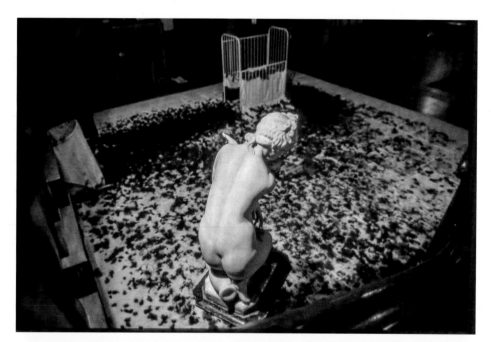

《聯合國──波蘭紀念碑》
1993 年於羅茨市歷史博物館
第肆屆建構於過程中國際雙年展
波蘭人髮，當地精神病院牀單、嬰兒牀，美術館陳列品

UNITED NATIONS—POLAND MONUMENT

history museum of lodz, 1993
4th construction in process
polish hair, local mental hospital
bed sheets, beds, and the artifacts
from collections of lodz city
museum

《聯合國 —— 波蘭紀念碑》細部
united nations—poland monument
detail

《聯合國——波蘭紀念碑》

裝置藝術計劃草圖之壹
1993 年於紐約工作室
鉛筆，水彩畫紙，白色金屬鏡框
25 釐米寬 × 35.3 釐米高

*UNITED NATIONS—POLAND
MONUMENT*

installation drawing #1
new york studio, 1993
pencil on watercolor paper in white
metal frame
25cm wide × 35.3cm highm

《聯合國——以色列紀念碑》

永久碑林土地藝術

1995 年於密茨比拉芒沙漠

第伍屆建構在過程國際雙年展

以色列人髮，30 枚粉色耶路撒冷石灰岩巨石

UNITED NATIONS—ISRAEL MONUMENT

a site-specific permanent landart
negev desert near the town of mitzpe ramon, 1995
fifth construction in progress at an international biennale
israeli hair, thirty pink jerusalem pink limestone boulders

聯 合 國 ── 以 色 列 紀 念 碑： 聖 地

谷文達

UNITED NATIONS—ISRAEL MONUMENT: HOLY LAND

gu wenda

以色列初訪，餘留之心靈震顫，會 forever（永恆）；雙年展的藝術家的 bus（巴士）沿耶路撒冷之路途，車裏的收音機反覆播送着新聞：炸彈離我們 bus 不遠處炸了……大家沉默無語，卻清晰地意識到這兒是壹戰場。

1995 年在以色列密茨比‧拉芒 desert（沙漠），我的《聯合國》全球計劃實施以色列站。如此以猶太人髮基因與叁拾塊耶路撒冷粉紅石灰岩巨石為材質之壹永久大地藝術，a part of 5fh construction in process 出現於第伍屆建構於過程中雙年展，激蕩人心的故事從貳次大戰猶太人的悲慘經歷的記憶猶新，猶太人背井離鄉逃離納粹屠殺。

我的藝術項目計劃在特拉維夫市民中引起了爭議，當我下機場壹刻便遇見小規模抗議示威，而當地大報以頭版頭條大篇幅採訪了以色列政治活動家、作家、藝術和不同身份的人。藝術計劃的爭議驚動了以色列國會。國會主席與策展人討論谷文達

marked my first visit to israel, and i will always remember the heart palpitations i experienced on the way to jerusalem that day riding with the other artists who were participating in the biennale. as we drove, we listened to the radio blaring repeated warnings that a bomb fell not very far away from our bus. at the time no one on the bus said a word, but it was clear to everyone that we were in the middle of a war zone.

in 1995, in the negev desert near the town of mitzpe ramon, i had the chance to realize my global united nations project in israel. the piece was a permanent piece of land art made of the hair and genes of jewish people and 30 pink blocks of jerusalem limestone. the work was made as part of the process of the construction of the biennale and its presence re-ignited the still-fresh memories of the second world war and the jewish exodus to escape holocaust.

my art project sparked a heated controversy among the citizens of tel aviv. when i got off the plane, i was met by a small-scale delegation of protesters. on the front page headline of the newspaper was an article which featured interviews with israeli political activists, writers, artists, and people of various identities. the controversy surrounding the art project eventually reached the israeli parliament where the head of the parliament staged a

的專案，是否繼續落實在國家最大最重要 army（軍事）電台實況直播。我的計劃得到以色列國會支援，無猶太人髮基因參與的《聯合國》計劃不能圓滿 completed（完成）。在短短柒天裏，以色列國家電視壹、貳、叁台在每日 prime time（黃金時段）新聞裏實況追蹤報導。美麗之奇跡發生了，當我離開特拉維夫機場之時，機場工作人員認出我來：「如果你仍然需要猶太人髮，他們願意捐獻！」我好感動，從沒像那壹刻真正感到，真正理解甚麼是藝術的力量！

debate with the curator over whether the project would be allowed to continue. the debate was broadcast live on the country's most important military radio station and in the end, my project received the support of the israeli parliament, which was fortunate as without the genetic materials, the hair of the jewish people, there would be no way to complete the united nations project in a comprehensive way. in less than seven days, the other israeli television channels, national channels one, two, and three had all followed with their own reports on the situation which were broadcast on prime-time news slots. on my way home, i encountered some miraculous circumstances when i arrived at the tel aviv airport. while there, a number of airport workers not only recognized me but enthusiastically told me, "if you still need donations of jewish hair, we are happy to give you ours!" this moment was really moving; it touched me quite deeply and it was at that moment that i came to truly sense, and really understand the real power and potential of art.

《聯合國——俄國與瑞典
紀念碑》

1996 年於斯德哥爾摩
國際刑警展，斯德哥爾摩當代藝
術和建築中心
84 英尺瑞典人髮簾通道，歐盟
旗，瑞典皇家空軍空對地導彈

*UNITED NATIONS—SWEDEN
AND RUSSIA MONUMENT*

stockholm, 1996
interpol, an international
exhibition at the center for
contemporary art & architecture,
stockholm
an 84-foot hair tunnel of swedish
hair, an european union flag,
a rocket from swedish royal
airforce

聯 合 國 —— 俄 國 & 瑞 典 紀 念 碑 : 國 際 刑 警

谷文達

UNITED NATIONS—RUSSIA AND SWEDEN MONUMENT: INTERPOL

gu wenda

大展由斯德哥爾摩及莫斯科著名策展人聯合策劃，瑞俄兩國前衛藝術家為主，谷文達作為國際藝術家參與。事件成為柏林牆倒後東西歐矛盾現象，在歐洲持續討論。谷文達在 *flash art* 雜誌發表文題為「cultural war」(《文化之戰》)。此事件正值美著名政治智囊亨廷頓發表著名的《文明的衝突》後不久，由於爭端在媒體連篇累牘持續壹年，知名度超越了當時瑞典流行歌星。瑞俄人髮現通道中懸掛壹從瑞典皇家空軍借來地對空導彈。在開幕之際被俄國藝術家破壞，導致肆輛警車到現場控制事態，兩俄國藝術家被捕。第貳天，谷文達在現場舉辦新聞發佈會。

this large-scale exhibition was jointly organized by two famous curators from stockholm and moscow, and consisted of mostly avant-garde swedish and russian artists; i participated as an international artist. against the backdrop of the fall of the berlin wall, it was a paradox of eastern and western europe within a particular european discourse. at the time, i published an article entitled "cultural war" in *flash art*. this happened shortly after the famous political thinker samuel huntington publishcd his famous work "the clash of civilizations." this incident spawned discussions in the media that lasted a year, eclipsing even the swedish pop stars ... in this corridor made of swedish and russian hair, hung an air-to-surface missile borrowed from the swedish royal air force. this missile was damaged by a russian artist at the opening, resulting in the arrival of four police cars, and a group of officers attempting to control the situation. two russian artists were eventually placed under arrest and the next day i gave a press conference at the exhibition.

國際刑警展的藝術破壞事件和混亂的開幕
式引起了極大爭議後持續的媒體報導
reporting on the interpol exhibition: the
rampage and vandalism of the artwork
at the opening stimulated a long-
lasting significant controversy.

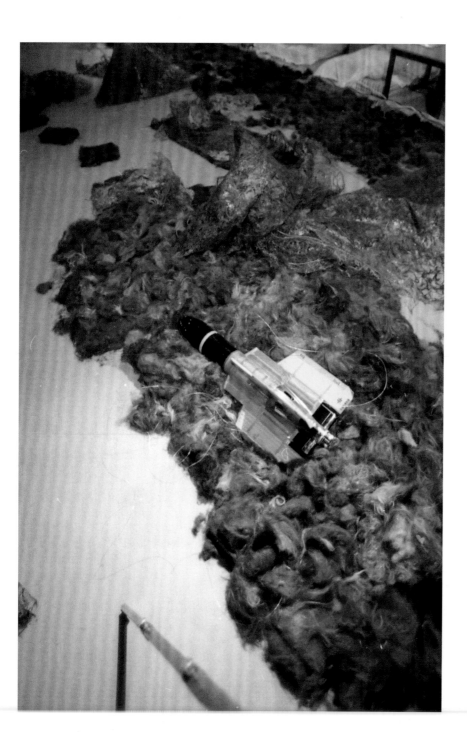

《聯合國 —— 俄國與瑞典紀念碑》中的瑞典皇家空軍空對地導彈在開幕式被扯落到了地上
united nations—sweden and russia monument a rocket from the swedish royal
airforce pulled to the ground on the evening of the opening

KONSTVERKET SOM GREPS AV POLISEN

EXPRESSEN
Sveriges största dagstidning
LÖRDAGEN DEN 3 FEBRUARI

Fabrik med annorlunda rå

I dag öppnar Färgfabriken i Stockholm för andra gången på mindre än ett år. Den här gången är det tänkt att verksamheten ska bli permanent. Jätteprojektet Interpol inleder den nya eran med en terapitaxi, sleep-in med buggade madrasser, en hårig tunnel och en del annat.

Även med vägbeskrivning är det svårt att hitta fram till Färgfabriken på Liljeholmen i Stockholm.

Härresande? Wenda Gu kollar att projekt United Nations. Det går ut på att skapa 25 olika konstverk av människohår från olika länder. I Stockholm ska det bli en 23 meter lång hårtunnel.

DAGENS NYHETER.

4 februari 1996 Sid A 1-16

Inställd utställning blir kvar

Av DISA HÄSTAD

Konstutställningen i Färgfabriken på Liljeholmen i Stockholm, där vernissagen slutade med polisingripande i lördags, konsumer inte att stängas. Den öppnar på onsdag igen, sade Jan Aman vid en presskonferens.

EXPRESSEN

Sveriges största dagstidning
SÖNDAGEN DEN 4 FEBRUARI

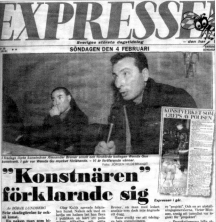

"Konstnären" förklarade sig

Av BÖRJE LUNDBERG

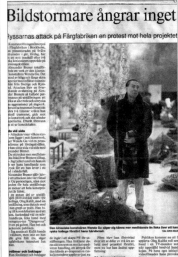

Bildstormare ångrar inget

Ryssarnas attack på Färgfabriken en protest mot hela projektet

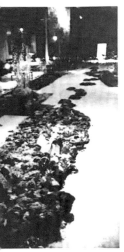

THE CULTURAL WAR

A SPECTRE IN EUROPE: PART II

Wenda Gu

In our last issue, Flash Art printed an open letter by critics, curators and artists protesting the destructive actions of some of the Russian artists participating in the group show "Interpol" in Stockholm this February, as well as a response from Viktor Misiano, the Russian curator, and comments by Giancarlo Politi. Here Wenda Gu, the Chinese/American artist whose work was destroyed by the Russians, gives a final word on the incident.

"INTERPOL" WAS the joint production of Viktor Misiano, the director of the Contemporary Art Center in Moscow, and Jan Aman, the director of the Center for Contemporary Art & Architecture in Stockholm. Two years ago they began a dialogue about the physical and psychological separation of the Berlin Wall, whose demise has not eliminated the differences between the larger political, social and ideological structures of the East and the West. Instead, it intensifies the direct confrontation and reveals the psychological wall which is more difficult to surpass. "Interpol" was an international exhibition meant to address this phenomenon in art.

Initially the curators chose artists from Sweden and Russia. The international participants were invited later. As a Chinese who has been living in New York for eight years, my role was as a third party working in between the two groups. I have a special sensitivity towards these kinds of conflicts because of my past and present experiences with both Socialism and Capitalism. The Russian artists, under the direction the their curator, Misiano, frequently attempted to conceptually control the planning of the whole exhibition, and even the show's catalogue. Evidently, it reflected the ambition of these Russian artists, who, from a collapsed superpower system, still have a somewhat twisted notion of their former strength. Comparatively, the Swedish artists, who live in a privileged Social Democracy, have never really experienced hardship and tragedy, not even during the World War II. Because of these disparate experiences, the two groups approach theoretical dialogues from completely different perspectives. At the time of the show's planning, I was wondering how to represent these conflicts behind the two groups. The Moscow meeting let the romantic Swedish artists understand how they are in the shadow of Russian aggression. They felt that the artistic dialogue and the theoretical collaboration was just a pretense and a reflection of the political, cultural and economic power game.

I decided to construct a pure hair tunnel made of Russian and Swedish hair which had been collected from barbershops since July 1995. In the middle of the tunnel, I suspended a genuine rocket, loaned to me by the Royal Swedish army. The visual impression was that of running through the long, narrow hair tunnel as a hint of using military action to control the cultural battle. I wanted this work to stand as a referee of cultural confrontation. As Alexandr Brener began playing his drums and screaming at the opening, I paid special attention to him, as I was videotaping the performance. I realized that he was not emotionally engaged with his playing. Rather, he was watching the crowd's behavior and was paying close attention to my every move. I then left the exhibition space momentarily to meet friends in an adjacent part of the building. One minute later, a German artist ran up to me shouting that my work had been destroyed by Brener. I followed him back to the show to find the audience of about 1000 shocked into absolute silence, staring at my piece. At that moment, I was very emotional. I had never experienced this kind of situation before. The work looked like a place after a terrorist bombing. In a few minutes the audience regained its composure; people called news reporters, local radio and TV stations, while the center notified the police. The French art critic, Olivier Zahm screamed, "This is absolutely a neo-fascist action!". The other French writer, Eleni Fleiss, came to me and stated that if I would like to make a lawsuit, she would be a witness. When the police arrived, they arrested the other Russian artist who had been playing a chained, naked dog, attempting to attack and bite a two year-old baby. Some audience members actually kicked him in the face. Meanwhile, Brener had fled the scene.

Some people have predicted that the essence of the 21st century will be the conflicts among nations, races and cultures. But cultural conflicts have always been a part of human civilization; bloody religious wars are obvious examples. Historically, cultural "battles" were hidden behind gentlemanly intellectual discussions and controlled by geographical separation. To paraphrase a Chinese idiom, we can now "fight a close quarters; engage in hand to hand combat. We can speak frankly, not mincing our words." This is pur migratory cultural reality. At a press conference the following day, I pointed out that the incident was not personal — I saw this "performance" as a mirror reflecting a political and economical power game. I did not want to label the actions as neo-fascist or neo-nationalistic; as in art we need to analyze events on different levels. The actual action was a "crime." On an artistic level, it was a repetition of old Dada ideology. On a purely ideological level, it relates to deep historical, cultural, social and political backgrounds. The artists and Misiano are not neo-fascists; they are Russian Jews who are not embraced by Russian nationalists in their own country. In the Western artistic circuit, Misiano is well respected as a scholar and organizer. Yet within his own country, he encourages artists to act with aggression. Their ideology and actions abroad have many links to nationalism and communism — the latter which has many tendencies similar to Nazism, with an inherent dictatorial format.

The mind-set of Brener reflects the reality of Russia today — politically, economically and socially degenerated, a chaotic, frustrated society. In the past, Russia has played as a superpower; now, due to its current environment, its great confidence has dissipated. The Swedes find their actions inconceivable, but having come from communist China to the U.S., I can understand it from both perspectives. These well-known Russian artists went against communism with pride. With the downfall of communism, these heroes lost their target of attack. They shifted their attentions to the power structure of Western materialism. On the other hand, they have being subservient. This kind of irresolvable predicament is their ideological base. The Russian artist Dmitry Gutov repeatedly said to me, "I hate Russia today and I hate

contemporary art." But he is a representative of Russian contemporary art, as this is a paradox. Interestingly, the criticism of this incident from the European community was more theoretical. But an American point of view offers simply one answer: process a lawsuit and put him in jail.

On an artistic level, Brener's action has no significance. The old Dadaists threatened to destroy all art museums, but ironically, after 30 years, the museum system not only has not disappeared, it is also the goal for most artists. Brener had not come to terms with this separation of ideology versus destruction as he blindly acted out old Dadaist concepts. Was his intent to imitate acts of such predecessors as Marcel Duchamp, Piero Manzoni, or the more contemporary Jeff Koons? If so, where is the sophisticated subversion and "silent violence" of the toilet, cans of shit and pornographic photos? Destructive happenings have occurred in the past which now appear as insignificant and only for publicity's sake. Brener has not considered the sophistication of today's media: his old-fashioned shock tactics will be dismissed. Instead of idealism, he immediately find the scene. He doesn't have the guts of the terrorists who sacrifice themselves for their beliefs. In our reality, art stands for freedom and is regulated by democracy. These counterparts detect human development.

Misiano said that this incident creates an essential stage for the dialogue between Eastern and Western Europe. I believe his words have some sense. But we still have the responsibility of knowledge, basic humanity and common desires. From his words, as a human, Misiano loses his basic position; as an intellectual, he loses his responsibility. There were many people from the audience who came to me expressing their sorrow. I repeatedly replied to them that I interpreted Brener's "destruction" as a "special participation" in my global art project. One Russian artist came to me inquiring if the art center had any insurance. A Slovenian artist said, "If you can get money from the insurance company, you can use it to sponsor Misiano's wife's art magazine and these Russian artists." While still deliberating over the incident itself, and recognizing their blind lust for gain, I could only respond with a laugh. For the sake of my global project, I said to Brener: "Thank you for your collaboration, and have a good trip back to Moscow." Misiano came to me and said "I remember there was a postage stamp with a picture; Stalin and Mao are shaking their hands — Russian and Chinese are great friends..." The Interpol incident has let us cold relations between the Swedish, international and Russian artists. My installation bears witness to this cultural war.

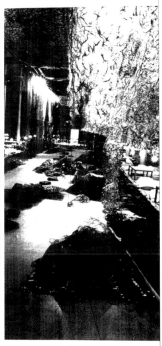

Right: Swedish & Russian Monument Interpol, 1996. View of the installation made of a 54 feet pure Swedish hair tunnel, a rocket of Swedish royal airforce, a European community flag.

紐約出版的新書,《人造地獄——參與式藝術 &
觀眾政治學》(hells-participatory art and the politics
of spectatorship)評論了谷文達的《聯合國》的第
拾陸站在斯德哥爾摩「國際刑警組織」展的極端爭
議,這是主流當代藝術中極為少見的真實故事……

《聯合國》自 1993 年伊始,走過了她風雨輾轉的貳
拾肆個年頭,走遍了伍大洲貳拾多國,聚集了肆佰
萬人髮 dna 基因:壹座史無前例的人類基因豐碑。
《俄國 & 瑞典紀念碑:國際刑警》(united nations
russia & sweden monument: interpol)在斯德哥「國
際刑警組織」展裏,瑞俄人髮通道中懸掛壹從瑞典
皇家空軍借來的地對空導彈。在開幕之際俄國行
為藝術家 brener,以搖滾樂鼓手擊鼓吶喊,brener
突然棄鼓而衝向巨大的瑞俄人髮簾構建的隧道,
將其破壞!導致肆輛警車現場控制事態,兩俄國藝
術家被捕。此事件導致第貳天谷文達提議在現場

a new book recently published in new york, *artificial hells—
participatory art and the politics of spectatorship* discussed the
16th iteration of *united nations* in stockholm and the
controversy which surrounded the exhibition *interpol*, a story
seldom seen in mainstream contemporary art discourse.

since its inception in 1993, the *united nations* series has seen its
ups and downs, touring to many different countries around the
world, gathering the dna and genes of 4 million people, an
unprecedented monument to human genetics. united nations
russia & sweden monument: was presented in the interpol
exhibition in stockhom. a surface-to-air missile borrowed from
the swedish air force was hung in the tunnel of human hair.
during the opening, a russian artist named alexander brener, was
playing a rock 'n' roll drum set and shouting. he then suddenly
quit drumming and rushed at the tunnel constructed of russian
and swedish hair destroying it. the result was that 4 police cars
arrived on the scene to try to control the situation. two russian
artists were put under arrest. this led to the second suggestion of
gu wenda to the swedish artists to hold a press conference. an
artist who was baptised by the cultural revolution and the 85
new wave, gu wenda still could never have imagined such an
exhibition opening.

舉辦瑞典國家新聞發佈會。經過文革與 85 美術運動洗禮的谷文達，卻無從想像開幕式的壹剎那！

事件成為柏林牆倒後壹東西歐矛盾現象，在歐洲持續討論。谷文達在《flash art international》雜誌發「the cultural war」此事件正值美著名政治智囊亨廷頓發表著名的《文明的衝突》（clash of civilizations）後不久，由於爭端在媒體連篇累牘持續壹年，知名度超越了當時瑞典流行歌星⋯⋯

artificial hells 的作者在談到此藝術事件時，站在了某個意識形態裏而作渲染，看起來他並不十分清楚事實真相以及前因後果；或出於某些需要，現象可以取代真相或部分事實作為掩蓋。

《artificial hells》譯文節選：

> 在展覽期間，藝術家之間的關係越來越公開對立，佔據展覽中心的是壹個中國藝術家谷文達的大型裝置藝術，他從俄國和瑞典收集頭髮，創作壹個大型的、隧道狀的結構，在結構中間懸掛從瑞典軍方借來的壹支火箭，谷文達說，這個裝置是象徵東方和西方的合作，然而，布瑞納反對將裝置擺在最顯眼的位置（或許也反對它拙劣的象徵）。布瑞納在 19 分鐘的打鼓表演《情緒的語言》（the language of emotion）以後，開始拆掉谷文達的頭髮隧道，破壞他裝置藝術，說它佔據的空間比其他的作品多太多，而且象徵整個展覽的失敗，接下

against the backdrop, the continuing debate in europe surrounding the berlin wall, the event sparked a debate which revealed the contradictions of the artists. at the time, gu wenda published an article entitled "cultural war" in *flash art international*. this happened shortly after the famous political scientist samuel huntington published his famous work "the clash of civilizations." this incident spawned discussions in the media which lasted into the next year, and, at the time, eclipsed the swedish pop stars as the most hotly debated topic . . .

when the author of the book discusses this event, she renders it through a certain ideology. it seems that she is unable to distinguish the truth from the facts and the causes from the results, or that, due to some need or requirement, the phenomenon can replace reality, or that she uses a small part of the reality to obfuscate things.

a selection from *artificial hells* follows:

> *during the opening, relations between the artists grew antagonistic. dominating the centre of the exhibition hall was a large installation by chinese artist wenda gu, who had collected hair from russia and sweden and used it to create a large, tunnel-like structure in the middle of this was suspended a rocket, on loan from the swedish army. according to gu, the installation was meant to symbolize the collaboration between east and west. brener, however, objected to the installation's dominant position (and perhaps also its heavy-handed symbolism). after his ninety-minute drum performance "the language of emotion," brener began to destroy wenda gu's installation by tearing down the tunnel of hair-arguing that it received far more floor space than any other work, and symbolized the failure of the exhibition project as a whole. after this, oleg kulic,*

來，歐雷格・庫力克（oleg kulik）壹絲不掛地用鐵鏈栓在狗窩，進行着他「壹條公狗」的展演藝術，他也越來越討厭該裝置。原本只是輕輕地啃，後來變成狂咬和攻擊，楊・歐曼想把庫力克推進他的狗窩，於是踢他的臉，這個動作使得庫立克更加狂暴。警員趕到場，將庫立克逮捕、拘留，最後罰款釋放。

這次的滑鐵盧招致報紙大篇幅的報導，西方國家的藝術家也寫了《給藝術界的公開信》指摘俄國「反藝術和反民主」，尤其是米席亞諾《利用理論掩護極權主義意識形態的新形式》，「國際刑警組織」的西方國家參與者顯然覺得展演式的展覽結構太強勢了，可是桐西在法國的協作者則認為它意味沒有任何指令的開放性。斯洛維尼亞的團隊「厄文」編輯壹本書，記錄該展覽及其後續影響，詳細敍述這封公開信引起的衝突，它以「羅生門」的風格提供了肆種彼此衝突的解釋，根據 1989 年後的文化政策觀點，這次展覽最發人深省的地方在於，他衝破了冷戰時期對資本主義的，或投機的西方藝術家協作的或集體主義的東方藝術家的刻板印象……

who was naked and chained to a kennel, executing one of his well-known dog performances, also became increasingly hostile. soft nibbles turned into bites and assaults. trying to push kulik back inside his kennel, jan åman kicked the artist in the face, which provoked the artist to become yet more violent; the police were called in and kulik was arrested, charged and later released with a fine.

the extensive press coverage that resulted from this debacle led to the western artists writing an 'open letter to the art world' accusing the russians of being 'against art and democracy' and misiano of 'using theory to legitimise a new form of totalitarian ideology.' it is telling that 'interpol's western participants understood the performative exhibition structure to be too determining, while for troncy's collaborators in france it connoted non-prescriptive open-enedness.) the conflict surrounding this open letter has been well recounted in a book documenting the exhibition and its aftermath, edited by the slovenian collective irwin. rashomon style, it offers four conflicting accounts. from the perspective of post-89 cultural politics, the most revealing aspect of the show is the degree to which it reinforces cold war stereotypes about the 'capitalist' or 'careerist' western artists and the 'collaborative' or 'collectivist' eastern artists.

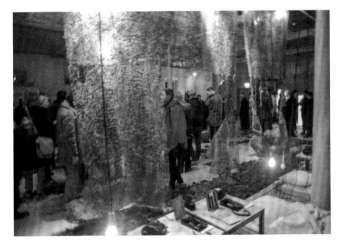
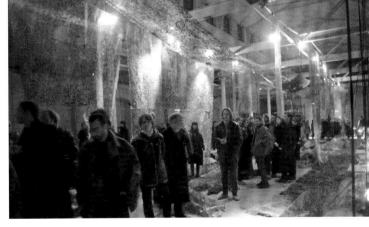

上左：租借瑞典皇家空軍地對空導彈
upper left: borrowing a rocket from the swedish royal airforce

中左：壹俄國藝術家在開幕式上扮演搖滾樂擊鼓手
middle left: a russian artist playing as a rock drummer

上右：壹俄國藝術家在國際刑警展開幕式前晚做的行為藝術最後的晚餐
upper right: the performance last supper by a russian artist one evening before the interpol exhibition opening

中右：在開幕式上另壹俄國藝術家扮演壹裸體狗
middle right: another russian artist played a chained dog

下左右：開幕式裏沉默的觀眾面對被破壞了的《聯合國——俄國與瑞典紀念碑》
lower left & right: the silent audience is facing the damaged art installation *united nations—sweden and russia monument*

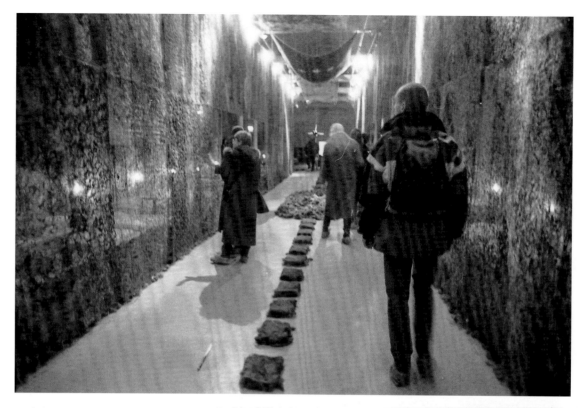

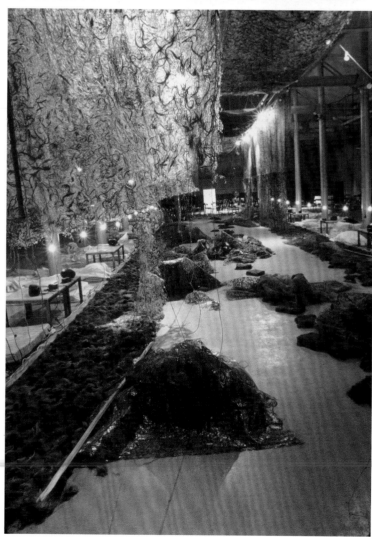

上圖： 事件發生之前的《聯合國 —— 俄國與瑞典紀念碑：國際刑警》在斯德哥爾摩當代藝術和建築中心的展覽現場

above: *united nations—sweden and russia monument: interpol* at the exhibition site before the insident

下圖： 事件發生之後的《聯合國 —— 俄國與瑞典紀念碑：國際刑警》展覽現場

below: a view of *united nations—sweden and russia monument: interpol* after the insident at the center for contemporary art & architecture, stockholm, 1996

新冠封城的現象・爭議・挑戰・影響合美術館的回顧展 武漢 2019

pandemic lockdown city phenomenon・controversy・challenge・influence over the united art museum retrospective exhibition wuhan 2019

2020 年 4 月 4 日清明節，為舉國哀悼日，下半旗為在新冠肺炎疫情中死去的生靈致哀。圖片為在武漢合美術館廣場前，藝術家谷文達的《天象》碑林大地藝術沉默地佇立致哀……

government-sanctioned day of mourning on april 4th, 2020, which coincided with the tomb-sweeping festival in the lunar calendar. flags were at half-mast in memory of those who passed away due to the covid 19 pandemic. gu wenda's work of land art *tianxiang* forest of stone steles stands by expressing its silent condolences.

壹個感人的瞬間！

當武漢城開禁之際，谷文達在武漢合美術館的《藝術》回顧展亦即可重見天日。那天合美術館的大廳的觀眾留言牆頓時貼滿了來自觀眾的留言，祝福武漢城和武漢人浴火重生走向燦爛的未來。

a moving moment!
soon after gu wenda's retrospective *art* reopened, the message board at the united art museum was full of notes from viewers, wishing wuhan a brilliant future following the covid 19 pandemic.

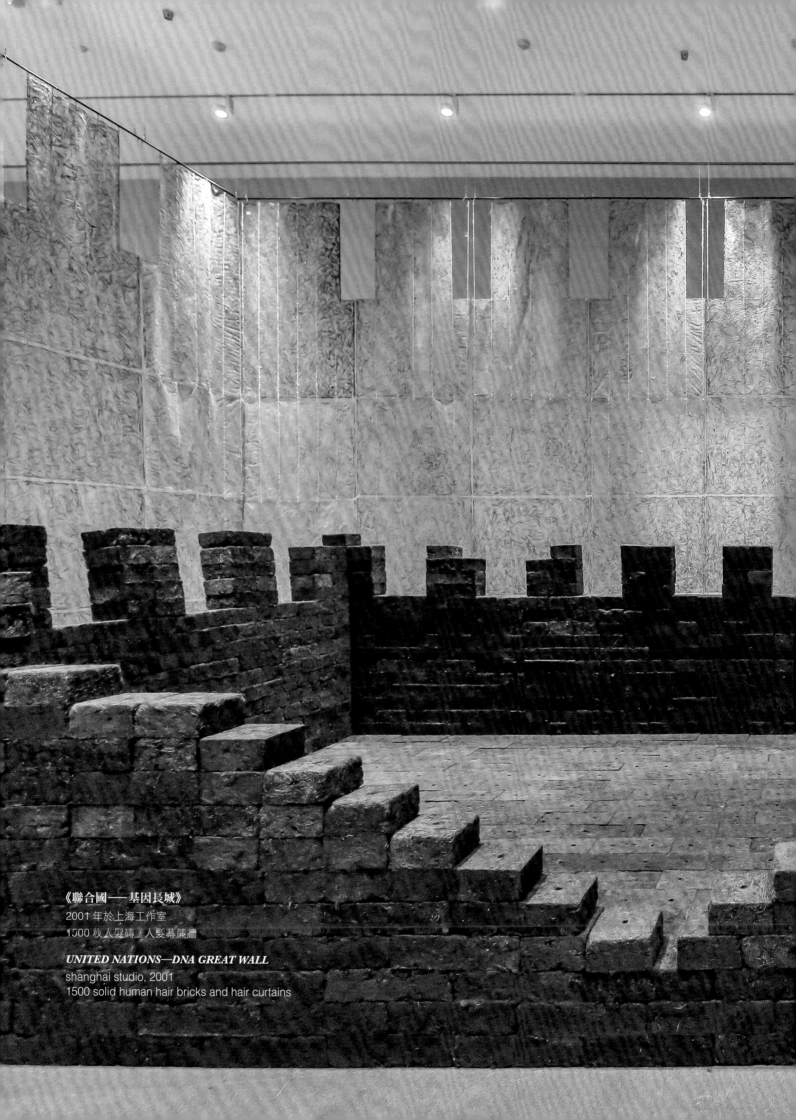

《聯合國──基因長城》
2001 年於上海工作室
1500 枚人髮磚「人髮幕簾牆

UNITED NATIONS—DNA GREAT WALL
shanghai studio, 2001
1500 solid human hair bricks and hair curtains

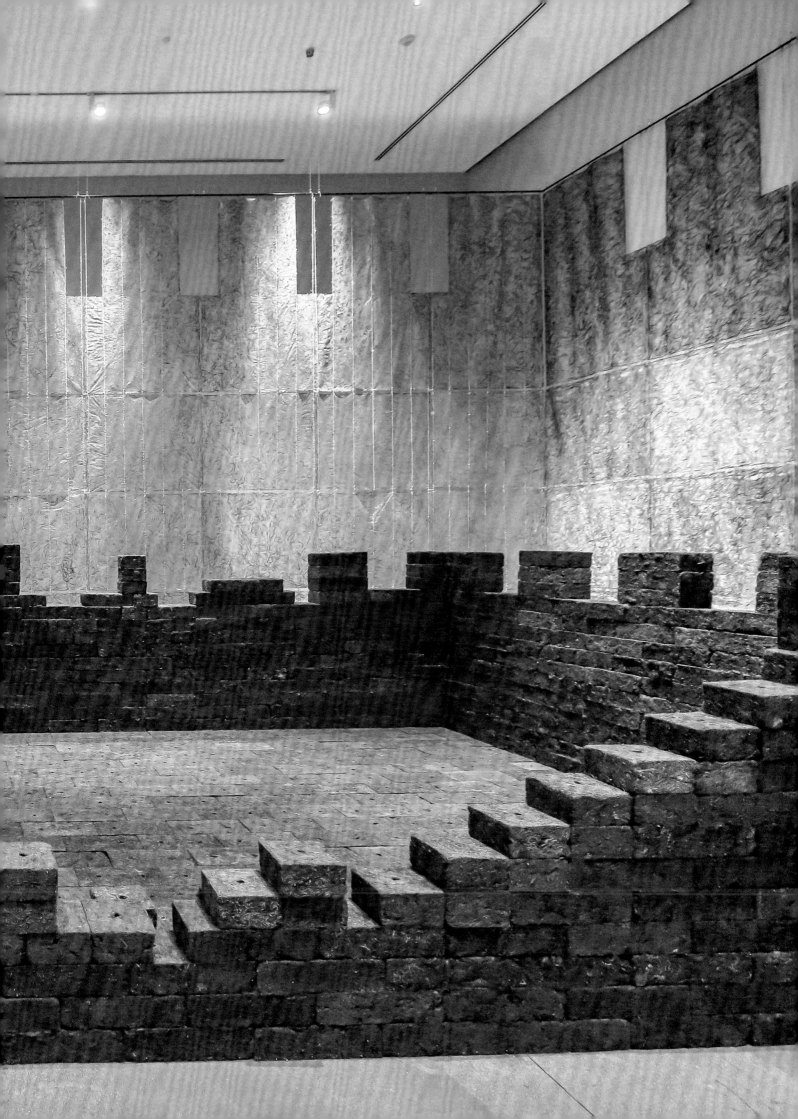

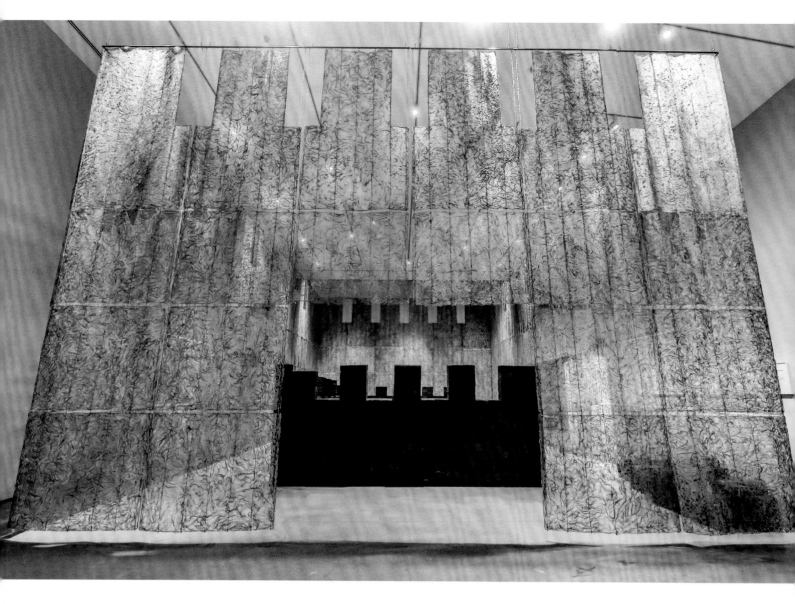

《聯合國——基因長城》
2001 年於上海工作室
1500 枚人髮磚，人髮幕簾牆

UNITED NATIONS—DNA GREAT WALL
shanghai studio, 2001
1500 solid human hair bricks and hair curtains

從 2019 年 12 月 15 日開幕至 2020 年 9 月 13 日閉展，幾乎整整壹年，《藝術》是我人生中最長的壹次展覽。《藝術》經歷了時間為佐證的生死存亡的戲劇性的《藝術的故事》。武漢封了城！自 2020 年 1 月 22 日暫時閉展至 2020 年 6 月 23 日重見入口，《藝術》靜悄悄地等待武漢浴火重生，這漫長的伍個月，見證了天翻地覆⋯⋯我在紀實散文體小説《開啟知性時代》記錄了我當時的日記：「記得我的《藝術》回顧展開幕之刻，那是在 2019 年 12 月 15 日，離庚子年臘月初壹僅拾天之隔！卻在人流雲集熱情洋溢裏得知：就是那天，武漢出現了兩位患了異形肺炎⋯⋯」，「武漢浴火重生，《藝術的故事》演繹成了《藝術的神話》。」

觀眾在參觀因新冠疫情重新開幕的展期達壹年的谷文達回顧展（合美術館提供照片）

it was almost a year long, from dec. 15, 2019 to sept. 13, 2020, *art* became the longest exhibition of my life. a story of art bore witness to a vital moment characterized by the challenges of life and death in wuhan.

wuhan in lockdown! art was also closed down on jan. 22, 2020 and reopened on june 23, 2020. *art* silently waited. i remembered that i wrote a note on dec. 15, 2019, during the opening of my retrospective *art*, "only about 10 days the lunar gengzi year (the first day of the 12th lunar month), the retrospective opening was packed with an enthusiastic audience, however i heard there were 2 people who were infected by a form of atypical pneumonia during the opening. a story of art became an art myth during the rebirth of wuhan.

the audience visiting gu wenda's year-long retrospective exhibition art after it re-opened following the covid, 19 pandemic. (photos by the united art museum)

現象・爭議・挑戰・影響（肆）：

《老鼠現象》

PHENOMENON・CONTROVERSY・CHALLENGE・INFLUENCE 4:

mouse phenomenon

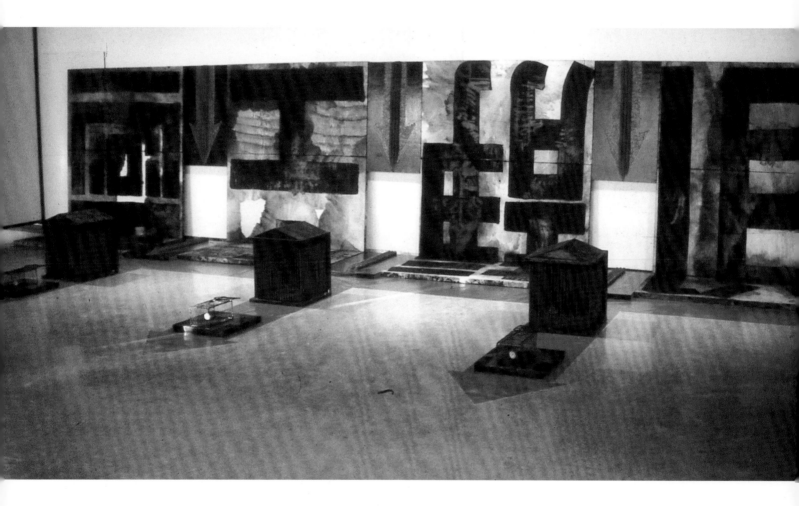

《老鼠現象》

裝置藝術與行為藝術
1988 年於紐約工作室
新傳統國際展
挪威國家裝飾藝術博物館，特隆赫姆市
墨、宣紙、老鼠、毒藥、鼠籠

MOUSE PHENOMENON

installation and performance
new york studio, 1988
"neo tradition", nordenfjeldske kunstindustrimuseum (national museum of
decorative arts) , trondheim
ink, xuan paper, mounted on paper backing with wood board, living mice,
poison, wood cages

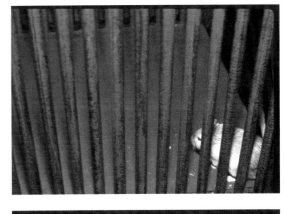

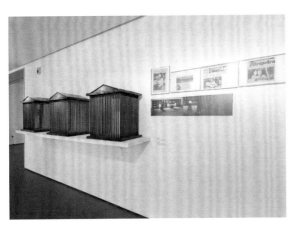

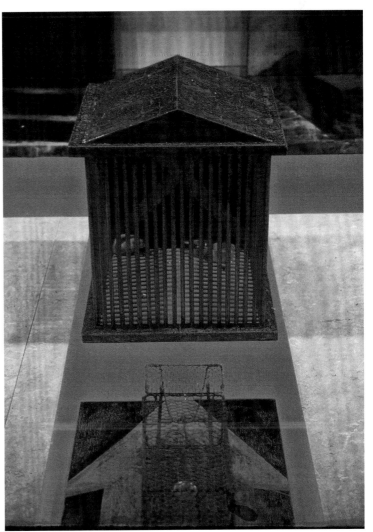

《老鼠現象》

老鼠籠子與媒體對爭議的報導在合美術館的現場陳列

MOUSE PHENOMENON

mouse cages and media reports on the controversy on
display at the united art muse

老鼠、廟宇和觀眾

—— 與 谷 文 達 對 談

彼得·塞爾茲

MICE, TEMPLES, AUDIENCE
AN INTERVIEW WITH GU WENDA

peter selz

谷文達，1955 年出生於上海，1976 年文革末期畢業於上海工藝美術學校。原本受木刻（篆刻）訓練出身的谷文達，轉向了中國山水畫並習得了中國藝術家的傳統技能。他的大型山水卷軸受到了偉大的宋代畫家的啟發，顯示出他對書法線條和筆墨的掌控。

儘管淫浸在中國藝術的古老傳統中，但隨着時間的推移，谷文達顛覆了其法則。他將書法文字或印章進行放大、顛倒、破壞和置換。這個突破在當代藝術家中獨樹一幟，谷文達受到的激勵來自於他對現代西方哲學的研究，尤其是他對尼采、弗洛德和維特根斯坦的閱讀。他欣賞最具創新性的西方藝術家：杜尚、博伊斯、沃霍爾、克里斯托、康定斯基和波洛克。早在 1985 年，他就創作了一件現場行為作品《無聲演講》，在沒有聲音，甚至沒有觀眾的情況下進行表演。

gu wenda, born in shanghai in 1955, graduated from the shanghai school of arts and crafts in 1976, at the end of the cultural revolution. originally trained in wood (seal) carving, gu turned to chinese landscape painting and acquired the traditional skills of the chinese artist. his large landscape scrolls, inspired by the great landscape painters of the sung dynasty, showed mastery of the calligraphic line and brushed ink.

although steeped in the ancient tradition of chinese art, as time went on gu wenda subverted its code. his calligraphic characters or seals became enlarged and reversed, disfigured and displaced. in this breakthrough, quite unique among contemporary artists, gu was encouraged by his study of modern western philosophy, and especially through his readings of nietzsche, freud, and wittgenstein. he admires the most innovative of western artists: duchamp, beuys, warhol, christo, kandinsky, and pollock. as early as 1985 he created a live action piece, speech with hands and feet, which was performed without sound – even without an audience

我是 1987 年春天訪問杭州的浙江美術學院時，初次見到了谷文達的作品，當時他在這所學校任教。隨着中國文化生活受到的限制越來越少，谷文達在西安和北京舉辦了大型個展，但很快就被關停，並被斥為造反、粗俗和淫穢。然而，一些前衛評論家意識到了他作品的重要性，眾多關於他的評論文章開始出現在中國的藝術刊物上。從許多方面來看，谷文達的職業生涯以及對他的接納，象徵着中國對當代藝術的接受程度的波動。

1983 年和 1984 年，谷文達參加了日本的兩個群展，這是他第一次在國外展出作品。1987 年夏天，他的一件重要的纖維作品（5×8 米）——《靜則生靈》（*composure causes inspiration*）入選洛桑第 13 屆國際壁掛藝術雙年展（biennale international de la tapisserie），受到了廣泛好評。同一年晚些時候，他在加拿大藝術委員會的外國訪問藝術家項目的資助下離開中國，前往多倫多約克大學。在那裏，他展示了一個複雜而絕妙的參與式裝置，《一盤懸在空中的險棋》（*the dangerous chessboard leaves the ground*），該作品由 11 幅畫布組成，每幅都是 1.5×1.5 米，被懸掛在地面上方。觀眾穿着紅色衣服，被要求穿過這個空間。

1988 年夏天，谷文達代表亞洲參加了在挪威特隆赫姆（trondheim）舉行的國際新傳統藝術展（international new-traditional exhibition），展出了一件驚人的裝置作品，《三者及其他》（*three and three others*）（現名《老鼠現象》）。這件作品包括黑色的巨大抽象漢字、白色的面板和紅色的竹製廟宇般的結構，裏面養着活的老鼠，並在表演過程中被殺死，谷文達徹底拒絕了中國藝術特有的寧靜和諧的概念。他以扭曲的漢字和無關的希臘廟宇為參照點，不

i first saw gu wenda's work in the spring of 1987, on a visit to the zhejiang academy of art in hangzhou, where he was teaching. as cultural life in china became less restricted, gu had large solo shows in xi'an and beijing, but they were quickly closed and denounced as rebellious, vulgar, and pornographic. however, some of the avant-garde critics realized the great importance of his work, and a considerable amount of critical writing about him began to appear in the art journals of the people's republic. in many ways, gu's career and reception symbolizes the fluctuations in the acceptance of contemporary art in china.

gu showed his first work outside china in 1983 and 1984, when he participated in two group shows in japan. in the summer of 1987, gu's monumental fiber piece (5 by 8 meters), *composure causes inspiration*, was the object of laudatory critical comment when it was included in the 13th biennale international de la tapisserie, in lausanne. leaving china later that year with a grant from the canada council's visiting foreign artists program, gu went to york university in toronto. there he presented a complex and brilliant participatory installation, *the dangerous chessboard leaves the ground*, which consisted of eleven canvases, each 1.5 by 1.5 meters, suspended above the floor. viewers wearing red costumes were asked to move through the space.

in the summer of 1988, gu represented the continent of asia at the international new-traditional exhibition in trondheim, norway, with an astonishing installation, *three and three others*. this work included large black abstract chinese characters, white panels, and red temple-like structures of bamboo that housed live mice which were killed during the performance. gu thoroughly rejects the notion of tranquil harmony, endemic to chinese art. using distorted chinese characters and dissociated greek temples as points of reference, he no longer borrows subjects and techniques from his own or

再借用自己的文化或西方文化中的題材和技法，而是創造出東西方形式和概念的一種直觀綜合物。

1989 年 2 月，威廉姆斯學院的郭志生教授（professor jason chi-seng kuo）在三藩市的美國藝術學院協會（college art association）年會上發表了一篇具有啟發性的論文：《谷文達及其批評家》（gu wenda and his critics）。

以下採訪是 1989 年 1 月在紐約進行的，現在谷文達就居住在紐約。由查理斯・劉（charles liu）擔任翻譯和協調人，他是我 1987 年在中國時的翻譯和嚮導，正是他最先讓我注意到了谷文達。

彼得・塞爾茲：你如何將你的作品與在中國的創作聯繫起來呢？

谷文達：我先簡要描述一下我在中國的作品。我的研究生專業是中國傳統山水畫。但我不是很喜歡這個專業。在畢業的前一年，我想我已經在傳統國畫方面接受了足夠的訓練，便放棄了它，並且從那時起就在做完全相反的東西。我被當作是一個異端。

實際上，我從 1977 年就開始閱讀西方文化方面的書籍，並且能夠將其與中國文化進行生動比較。穿梭在兩者之間，說明我思考如何以西方或東方的方式解決問題，但有趣的是，我總是從歷史和傳統中獲得動力。1982 年到 1984 年間，我創作油畫、水墨畫和現成品。我深受各種當代藝術的影響：那是一個令人費解的時期。

western culture, but creates an intuitive synthesis of eastern and western forms and concepts.

in february 1989, professor jason chi-seng kuo of williams college presented an illuminating paper, *gu wenda and his critics*, at the annual meeting of the college art association in san francisco.

the following interview was conducted in new york, where gu wenda now lives, in january, 1989. mr. charles liu, who originally brought gu wenda to my attention while serving as my interpreter and guide in china in 1987, acted as interpreter and facilitator.

peter selz: how do you relate your work to painting in china?

gu wenda: i'd better simply describe my work in china. my graduate major was traditional chinese landscape painting. i felt unhappy with it. the year before i graduated, i thought i had had enough training in traditional chinese painting. i gave it up and since then have done totally the opposite. i was regarded as a heretic.

actually, i started reading about western culture in 1977 and was able to make vivid comparisons with chinese culture. going from one to the other helped me think about how to approach a problem either in western or eastern terms, but the interesting thing is that i always got the dynamics from history and tradition. from 1982 to 1984 i did oil painting, ink painting, and ready-mades. i was greatly influenced by a variety of contemporary arts: it was a puzzling period.

自 1984 年以來，我的作品通過大型繪畫和混合媒體裝置存在於觀眾和環境的語境下。我給他們起了一個統稱，指的是圖騰與禁忌的現代意義。我用扭曲的、不恰當的字元，把古詩、公共標語和交通標誌組合起來加以嘲弄。它們是顛倒的。我把它們當作現代的圖騰和禁忌，融入了人類的原始慾望和文化大革命的藝術形式。我試圖把特定的文字和公共口號（來自文化大革命期間佔據中國公共場所的巨大且無處不在的書法海報）從正常的語境中剝離出來。例如，改變上下文意味着改變定義。傑夫・昆斯（jeff koons）的《真空吸塵器》（vacuum）和克拉斯・歐登伯格（claes oldenburg）的《臥室組合》（bedroom ensemble）的模型都來自百貨商店，但是脫離了這些商店的語境，它們就轉變了。區別在於，我是從人類和歷史的角度來進行探索。

如果我在這裏摘取以下圖像文字，我將永遠不知道它們的定義：

禁止吸煙 × 香煙 ＋ 火
禁止隨地吐痰 × 口 ＋ 水
水 × 口 ＋ 禁止喧嘩
禁止亂扔垃圾 × 手 ＋ 火

（這些公式暗指中國隨處可見的海報上的公共標語。藝術家改寫了它們以增加混亂。）

文字本身不應該是它們的功能。如果你在紐約地鐵站看板旁邊放一幅梵高的畫，一切都會消失。當我開始做這些作品的時候，我的大腦和我的手進入了一些非常奇怪

since 1984 my work has existed in the context of audience and environment through large paintings and mixed-media installations. i gave them a general name which referred to the modern meaning of totem and taboo. i used distorted and inappropriate characters to combine and mock ancient poems, public slogans, and traffic signs. they were topsy-turvy. i treated them as modern totems and taboos incorporating human primitive desire and the art forms of the cultural revolution. i tried to take particular words and public slogans [from the enormous and ubiquitous calligraphic posters that dominated public areas in china during the cultural revolution] out of their normal contexts. for example, changing the context means changing the definition. the models for jeff koons's *vacuum* and claes oldenburg's *bedroom ensemble* came from department stores, but outside the context of these stores, they were transformed. the difference is that i approached them from the human and historical perspective.

if i pick the following image words here, i'll never know the definitions of them:

no smoking × cigaret + fire
no spitting × mouths + water
water × mouth + no noise
no rubbish × hand + fire

[these axioms allude to the public slogans seen on posters all over china. the artist recasts them in order to add to the confusion.]

the words shouldn't be their functions. if you put a van gogh next to a new york subway station billboard, everything vanishes. when i started to do these works, my mind and my hands came into some very strange relationships, as if they were separated. i was puzzled by it, but was compelled to do it. this feeling still relates to

的關係，就好像它們是分離的。我對此感到困惑，但不得不這樣做。這種感覺至今仍與我的創作有關。我將公共標語轉化為更抽象的紅黑色字元組合。

彼得·塞爾茲：為甚麼你的作品如此與眾不同？

谷文達：我會努力解釋甚麼對我和我的工作是重要的。我認為要做到以下三點。首先是知識的範疇。它應該是獨一無二且個人的；知識的廣度和深度反而不那麼重要。在我的思維裏，過去與現在、自然與知識之間存在某種衝突。我直面它，並且從不評判它，直到我自然地放棄它。作為一名學生，我滿懷熱忱地閱讀西方哲學、文學和美學，深受尼采、弗洛伊德和維特根斯坦的影響。尼采的精神啟發了我，維特根斯坦的神秘主義讓我把懷疑和發問帶入了圍繞着傳統藝術的氛圍中。另一方面，中國的禪宗是我沮喪時的快樂源泉。

接下來是方法論，即我如何處理我的知識。對我來說，這意味着否定和摧毀已有的知識。讓它在自然創造的過程中成為無意識的本能。我認為知識屬於歷史範疇。本能是創造力的一部分 —— 在我看來，最崇高的力量也是一種有力的支援。

最後還有社會因素，這真的很複雜。我認為這包括藝術家的個人才能、表示支持的社會環境、政治、經濟因素等等。

當我開始創作時，我面臨的問題是如何跟我不知道的東西打交道，而不是我知道的東西。否則，我永遠無法解決

my work today. i transformed public slogans to more abstract compositions of characters with the colors red and black.

peter selz: why is your work so different from everyone else's?

gu wenda: i will try to explain what is important for me and my work. i think there are three points to attain. first of all is the category of knowledge. it should be unique and individual; extent and depth of knowledge are less important. there is a sort of conflict between past and present, nature and knowledge, in my mind. i faced it and never judged it until i gave it up naturally. as a student, i used enormous emotional energy to read western philosophy, literature, and aesthetics. i was most influenced by nietzsche, freud, and wittgenstein. nietzsche's spirit has inspired me, and wittgenstein's mysticism let me bring doubt and questioning into the atmosphere that has surrounded traditional art. on the other hand, china's chan [zen] sect is my source of pleasure when i am depressed.

next is methodology, how i treat my knowledge. to me, it means to deny and destroy my ready-made knowledge. let it become unconscious instinct through the process of creating naturally. i believe that knowledge belongs to the category of history. instinct is part of creativity - in my view the most lofty force is also a potent support.

finally, there is the social component, and this is really complicated. i include artistic personal talent, a sympathetic social environment, politics, economics, and so on.

when i start to work, i face the problem of how to work with what i don't know, instead of what i do know.

藝術的問題。問題永遠比答案好。有趣的是：當東西方的影響在我的腦海中交鋒時，我做出來了！

彼得・塞爾茲：你的藝術跟政治的關係是甚麼？

谷文達：在中國，政治性藝術不僅僅意味着藝術要有政治內容。它的作用被塑造得相當講究 —— 它必須反映明亮、美麗、健康、理性，並且平易近人。如果不在這個定義之內，藝術就一定會被視為一種異端。

許多關於我作品的文章已經發表了。有時在這些文章或會議中會出現關於我作品的爭論。他們中的一些人總是專注於倫理、社會和政治問題。對於有着古老文化和悠久歷史的中國人來說，當有人試圖通過否認或改變來挑戰古老文化和悠久歷史的合法性時，就好像你對一個宗教信徒說：「上帝死了。」這些關於我作品的爭論都是以對立問題的形式提出的：好還是壞？香還是臭？贊成還是反對？但這種爭執無關緊要，也很愚蠢。

1987 年我在北京頤和園準備個展，但這場展覽因為學生示威和中國的局勢突然變化而取消了。我還有另外兩場展覽，一場在開幕四小時後就被關閉了；另一場只有職業藝術家才被允許參加，儘管我沒有這樣的意圖，而且我的作品與政治也沒有任何關係。

那段時間，我沒有機會展示我的作品，所以我的工作室成了我的整個世界。我非常強烈地感覺到我不僅完成了作品，而且這是我的信念和意志的成就。這是一種宗教感情。我經常想起阿爾伯特・加繆（albert camus）的《西西

otherwise, i will never get to the solution of the artistic problem. the problem is always better than the answer. interesting thing: when eastern and western influences battle each other in my mind, i get results!

peter selz: what is the relationship of your art to politics?

gu wenda: political art doesn't only mean that art has political content, in china. its role has been made very elegant—it must reflect brightness, beauty, health, the rational, and be easy of access. if it is not within this definition, art must be regarded as a sort of heterodoxy.

many articles about my work have been published. sometimes arguments about it have appeared in these articles, or in meetings. some of them always concentrate on ethical, social, and political problems. for the chinese, with their ancient culture and long history — when people attempt to challenge that validity by denying it or varying it, it is as if you were to say to a religious believer, "god is dead." these arguments about my work are all posed as antithetical issues: good or bad? fragrant or rotten? pro or anti? but the conflict is inconsequential and foolish.

after i prepared my solo show in the beijing summer palace in 1987, it was thrown out because of a student demonstration and the fact that china's situation had suddenly changed. i had two more shows, and one was closed four hours after it opened; the other one only professional artists were allowed to attend, even though i had no such intention and my work had nothing whatsoever to do with politics.

during that period, i had no chance to exhibit my work, so my studio became my whole world. i felt very strongly that i hadn't just done the work, but it was the achievement of my belief and will. it was a sort of

弗神話》（le mythe de sisyphe）；這位希臘神話中的英雄成了我的榜樣。1984 年，我給加繆的這本書寫了一個尾聲：「西西弗再次向上翻滾並推動石頭。恍惚間，他感覺到一股非凡的力量在他的身體中顫動，讓他的勞作變得輕鬆。石頭再次滾下去，但西西弗沒有回頭去看它。他忽然看到山那邊有一道神秘的光，他迷惑不解，就像老來得子的亞伯拉罕一樣，陷入了狂喜的恐懼之中。月亮高懸於空中，黑暗中的波浪緩緩流動。風沙沙作響，吹過冷冷的光和空曠而神秘的寂靜。空氣冰冷如水，船兒靜止不動。雲幕低垂，像一群白象，又像一些莊嚴的廟宇。在他這黑暗而混亂的世界裏，船要去往何方？大海盡頭的雲又有多深？」

彼得・塞爾茲： 在你（1983 年）的第一場行為表演中，跟觀眾的關係是甚麼？

谷文達： 除了幾位藝術家和一位攝影師之外，我在沒有觀眾的情況下進行了三場個人表演。這是我的壁畫和繪畫裝置的一種延續，因為我在我的工作室裏進行了這些表演。第二場表演有三個動作。首先，我和另一位藝術家表演了幾個動作。然後我發表了一場沒有聲音也沒有聽眾的荒謬演講；只有我的手和腳作出了示意。最後，我做了不同的面部表情來表示街上的公共標語和交通標誌。

1987 年，我在浙江美術學院的劇院做了另一場演出。那是午夜時分，周圍的環境安靜而神秘。攝影師和我處於一種超然的狀態。我坐在由一些混合媒介繪畫構成的小房子內，地面上有一個很大的裝置，裏面裝滿了血淋淋

religious feeling. i often recalled albert camus's *le mythe de sisyphe*; the greek hero became my role model. i wrote a kind of coda to camus in 1984: "sisyphus once again rolls and pushes the stone upward. in his trance he feels an extraordinary power thrilling through his body, making his labor light. the stone rushes down once again toward the lower world, but sisyphus does not turn to look at it. he suddenly sees a mysterious light from over the mountain, and he is perplexed, just like abraham in harah, and he is thrust into an ecstatic terror. the moon is hanging high in the sky and the dark waves are moving smoothly. the wind rustles through the cold light and the empty, mysterious silence. the air is as chilly as the water, and the boat is sailing nowhere. the curtain of clouds hangs low, like a group of white elephants, and like some solemn temples, also. in his dark and chaotic world, where is the boat going? how deep are the clouds at the end of the sea?"

peter selz: in your first performance (1983), what was the relationship with the audience?

gu wenda: i did three individual performances with no audience except several artists and a photographer. it was a kind of continuation of my wall paintings and painting installations, because i did these performances in the environment of my studio. the second show had three actions. first, another artist and i performed several actions. then i gave a ridiculous speech without sounds or audience; there were only signs made with my hands and feet. finally, i made different faces to indicate public slogans and traffic signs in the streets.

i did another performance in theatre of the zhejiang academy of fine arts in 1987. it was at midnight and the environment was quiet and mystical. one photographer and i existed in a kind of transcendent state. i sat down

的、肥大的、真的手套和紅色的軟管。那種氛圍是性慾且痛苦的。只有我的慾望和我心中的旅程被展現出來。

彼得・塞爾茲：《他們 ✕ 她們》（*shes ✕ hes*）是在中國完成的，在那之後，你的創作風格是如何轉變的？

谷文達：在這個混合媒介繪畫裝置中有四幅畫，每幅畫包含一個人物，一共是兩個「她」和兩個「他」。這些畫被分為兩組（在每組畫中，一幅畫被放置在另一幅畫之上）。這兩個對稱的組合被放置在一幅巨大的壁畫前，壁畫上有 150 副肥大的紅色手套。另外，兩個立體的紅十字封住了每組畫作的表面。大壁畫的上方又安裝了兩個黑色的大十字架。在這個作品中，我處理了誤解理性邏輯的問題。你會看到兩個「他」、兩個「她」以及兩個複合十字架在空中形成對稱排列。

有趣的是，這個方法讓我亢奮，但我無法辨認或解釋它。無聊的感覺來自重複，無聊也是一種拒絕。但不知何故，它也是一種邏輯的存在。就像在瑪麗・布恩畫廊展出的庫奈里斯（kounellis）的無題作品，以及布魯斯・瑙曼（bruce nauman）的一次又一次講述四個小醜故事的影像。同樣，我在這裏重複了許多血淋淋的手套——其數量如此之多，以至於觀眾會產生被觸碰到的感覺，如果觀眾接近它們，就應該通穿過兩個「他」和兩個「她」。這樣，觀眾被嵌進「她」、「他」和手套之間。

彼得・塞爾茲：你近期最重要的作品是甚麼？

谷文達：是我在多倫多約克大學的藝術畫廊和挪威特隆赫姆藝術館中放置的作品。我沒有參與其中，而是在人

in a small house made of some mixed-media paintings on a large floor installation which was full of bloody, fat, real gloves, and red flexible tubes. the atmosphere was sexual and painful. only my desire was present, and the journey within my heart.

peter selz: shes ✕ hes was made in china. how has your style changed since then?

gu wenda: in this mixed-media painting installation, there are four paintings, and each has one character, double shes and double hes. these paintings are divided into two groups [in each group, two paintings are positioned one atop the other]. these two symmetrical groups a replaced before a huge wall painting which has 150 pairs of fat red gloves. moreover, there are two three-dimensional red crosses to seal the surface of each group of paintings. two more big black crosses are installed over the big wall painting. in this piece, i deal with the problem of misunderstanding rational logic. you see double hes, double shes, and double complex crosses symmetrically arranged in the air.

the funny thing is, i'm stimulated by the method, but i can not recognize or explain it. the feeling of boredom comes from repetition, and boredom is also a sort of rejection. yet somehow, it is also a kind of logical existence underneath. like kounellis's untitled work, shown at the mary boone gallery, and bruce nauman's video that tells four clowns' stories again and again. likewise, i repeat many bloody gloves here—so many that the audience will have the feeling of touch, and if they approach them, they should get through the double hes and double shes. the audience is embedded between shes, hes, and gloves.

peter selz: what are your most important recent works?

gu wenda: the installations i placed in the art gallery of york university

們與我的大型裝置互動時，做一個冷漠的觀眾。我想測試一種心理狀態，在這種狀態下，我變成了非藝術家，而觀眾有意或無意地變成了創作者。

彼得・塞爾茲：你是中國第一個做行為表演的藝術家嗎？

谷文達：我不這麼認為。在同一時間，其他藝術家也開始以不同的方式進行行為藝術表演。

彼得・塞爾茲：你是如何能同時做這麼多不同作品的？

谷文達：我在每個時期都同時做幾項不同的工作，但通常它們屬於同一範疇的探究。每個時期都過得很快。我嘗試通過這種方式來看看有多少種可能性去面對主要的問題。然後我找到了工作的重點，並且放棄了其他的。

彼得・塞爾茲：你在多倫多完成的作品《一盤懸在空中的險棋》背後有甚麼含義？

谷文達：你也是知道的，在我開始工作之前，我通常不知道到它意味着甚麼。現在，一年半之後，我明白了。《險棋》由 11 個類似的單元組成。所有單元都以相等的距離懸掛在畫廊空間中，並且吊在地板上方的同一高度上。與這個作品相結合的是另一件名為《裝有供觀眾使用的紅色衣服的衣櫃》（closet with red costumes for viewers）的作品。布魯斯・帕森斯（bruce parsons）寫了一篇關於它的文章並對其進行了描述：「我們進入一個房間，這是一個由權力和軍事力量的符號組成的矩陣……觀眾成員是遊戲中的

in toronto, and in the kunstindustri museum in trondheim, norway. i didn't participate in them, but became an aloof audience while people played with my big installations. i wanted to test a sort of condition of psychology in which i became a non-artist and the audience became creators, either consciously or unconsciously.

peter selz: were you the first artist to do performances in china?

gu wenda: i don't think so. at the same time, some other artists also began to do performances in different ways.

peter selz: how could you do so many different kinds of work at the same time?

gu wenda: i had done several different works simultaneously in every period, but usually they were in the same category of inquiry. each period passed very quickly. i tried in this way to see how many possibilities there were for facing the main problem. then i got to the main point of the work and gave the others up.

peter selz: what was the idea behind *the dangerous chessboard leaves the ground*—the work you did in toronto?

gu wenda: as you know, before i do my work, i usually don't realize what it means. now, a year and a half later, i understand it. *dangerous chessboard* was made up of eleven similar units. all were suspended at equal distances in the gallery space and hung at the same level above the floor. combined with this work was another one titled *closet with red costumes for viewers*. bruce parsons wrote an article about it and described it: "we enter a room that is a matrix of symbols of power and military

玩家，他們被要求穿上紅色衣服，有 30 件這樣的衣服放置在房間周圍的衣架上。「這個作品的主要行為是不完整的；只有當我成為一名冷漠的觀眾時，這件作品才會被觀眾繼續下去。有時我會面對疑問、面對控制和有意識的結論的問題，以及如何讓我的作品脫離正常控制而進入對連續性的控制的問題。此外，在這件作品中，每個單元都有四個紅色的管子，從畫布上的同一中心點向上延伸。

彼得・塞爾茲：那麼有關它的性意涵呢？

谷文達：我相信性慾是創造和本能中的一個非常重要的元素。觸碰感就由此而來。我用鈎子將畫布在管子下拉緊，就像拉動柔韌的皮膚一樣。

彼得・塞爾茲：這個作品在多倫多的反響如何？

谷文達：我想引用布魯斯・帕森斯（bruce parsons）的展覽目錄文章：「確實，他那懸掛着的黑白棋盤上濺滿了紅色，給人一種咄咄逼人、暴力的印象。觀眾在展覽中走動，並且通過他們的身體來體驗棋盤，由於空間中不同文字和圖像的複雜拉扯，我們感覺自己是作品中所呈現的鬥爭或過程的一部分。作品的主題是藝術家在面對不確定性時的動態的創造性回應。」

彼得・塞爾茲：這件作品如何跟真實的棋盤聯繫起來？

谷文達：其實，這與中國棋盤無關。這是圖像錯覺藝術。我起初是從國際象棋兩方互相鬥爭的概念中得到了這個想法。

force...the members of the audience are the players in the game and are asked to put on one of the thirty red costumes placed around the room on hangers." the main action in this work was incomplete; it would be continued by the audience while i became an aloof audience. sometimes i confront the question, the problem, of control and conscious conclusion, and of how i can let my work out of normal control into the control of continuity. otherwise, in this work, every single unit has four red tubes that stretch up from the same central point on the canvases.

peter selz: what about its sexual meaning?

gu wenda: i believe that sexual desire is a very important element of creation and instinct. tactile feeling comes from that. i used hooks to pull the canvases tight under the tubes, just like pulling on a flexible skin.

peter selz: what was the response in toronto?

gu wenda: i want to quote from the catalogue essay by bruce parsons: "indeed, his suspended chessboards of black and white spattered with red created an aggressive, violent impression. the audience experiences the chessboard by moving around the show, and through their bodies, we feel like part of the struggle or process present in the work as a result of the complex pull and tug of the different words and images in the space. the subject of the work is the artist's dynamic creative response when faced with uncertainty."

peter selz: how does this work relate to an actual chessboard?

gu wenda: actually, it has nothing to do with the chinese chessboard. it is illusionism. i got the idea first from the notion that in chess, two sides fight each other.

彼得‧塞爾茲：《三者及其他》的目的是甚麼？

谷文達：1988 年我在紐約做了這件作品。裏面是三座希臘式的廟宇，三個普通的家用金屬捕鼠夾和三隻活老鼠。我面臨的部分問題跟在多倫多的那件作品一樣，只不過我利用的是老鼠而不是觀眾。我把三個裝有毒餌的陷阱分別放在紅色的大箭頭上，三個陷阱的大門正對着三座紅色的廟宇，每座廟宇裏都有一隻老鼠。這件作品的一部分就是將要發生之事的預期。

彼得‧塞爾茲：活老鼠的意義是甚麼？

谷文達：在我參展之前，我覺得一方面這些老鼠會戲劇性地改變我的作品。另一方面，儘管我希望如此，但在我的作品展出之前，我並不知道我想要甚麼。

在我看來，拒絕總是比享受好，雖然它們是一回事。當我向記者解釋這部分作品，說我打算在展覽結束時自然地殺死這些老鼠時，其中有個人打電話給挪威農業部，說有一位藝術家要在博物館裏殺死小動物。農業部隨後給博物館館長打電話，問了他一些問題。突然之間，這些老鼠成了各大報紙頭版的明星。這很愚蠢，但非常有趣。

彼得‧塞爾茲：（作品的）背景 —— 廟宇 —— 和老鼠之間的關係是甚麼？

谷文達：沒有邏輯上的或理性的關聯。老鼠住在廟宇裏，廟宇在一幅佔據地面和牆壁的巨大畫作前，畫作上有來自佛經中的顛倒字元。存在是一種關係。我們無法描述

peter selz: what is the purpose of *three and three others*?

gu wenda: i did this work in new york in 1988. in it are three greek-style temples, three ordinary metal household mouse traps, and three live mice. a part of the problem i faced was the same as the work in toronto, except i used mice instead of an audience. i placed each of the three traps with poison bait on big red arrows. the doors of the three traps were facing three red temples. there was one mouse in each temple. these objects were placed before a large floor and wall painting. apart of this work was the anticipation that something would happen.

peter selz: what about the significance of the live mice?

gu wenda: before i participated in the show, i thought, on the one hand, that these mice were going to change my work dramatically. on the other hand, although i hoped it might, i didn't know just what i was hoping for before i exhibited my work.

in my opinion, rejection is always better than enjoyment, even though they are both the same thing. when i explained to reporters how this piece worked, that i was going to kill these mice naturally at the end of the show, one of them phoned the norwegian agriculture department and said that an artist was going to kill small animals in the museum. the agriculture department then called the museum director and asked him a number of questions. suddenly these mice became stars on the front pages of major newspapers. it was foolish, but very interesting.

peter selz: what was the relationship of the background—of the temples—to the mice?

gu wenda: there was no logical or rational relationship. mice lived in the temple; the temples were set before a large floor and wall painting which had topsy-turvy characters from buddhist texts. existence is a

它，並為此而困惑。信或不信，理解或誤解都是一回事：
意在言外。

彼得・塞爾茲：你如何看待自己未來的工作？

谷文達：對我來說，未來意味着面臨新的問題。我一直
在思考，我成為一個非藝術家的藝術家還有多少可能性。
我可能會繼續以不同的方式利用老鼠、廟宇和觀眾。但
我也無法知曉這一點，因為在作品徹底完成之前，我從來
沒有一個完整的想法。好笑的是，即使我完成了一件作
品，我依然沒有完成這個想法。這種情況很痛苦，有時難
以忍受，但這是意料之中的。

彼得・塞爾茲（peter selz）是加州大學伯克利分校的藝術
史教授。

（此文刊於美國 *arts* magazine，1989 年 9 月刊）

relationship. we cannot describe it, and we are puzzled
by it. belief and unbelief, understanding and
misunderstanding —they are the same thing:
meaningful.

peter selz: how do you see your work in the future?

gu wenda: the meaning of the future for me is facing
new problems. i have been thinking about how many
possibilities there are for me to be the artist as non-artist.
i may keep on using mice, temples, and audiences in
different ways. however, i can not know this because i've
never had a full idea about my work before it is
completely finished. the ridiculous thing is that even
when i finish a work, i still haven't accomplished the
idea. this kind of situation is painful and i cannot bear it,
sometimes. but it's natural.

peter selz is professor of art history at the university of
california, berkeley.

arts magazine, september, 1989

第貳部分
CHAPTER 2

藝術的故事
奠基與建立當代水墨
與書寫藝術

A STORY OF ART:
FOUNDING AND
ESTABLISHING
CONTEMPORARY INK ART
AND WRITING ART

《黃賓虹手稿題跋》

2020 年於上海工作室

墨，宣紙

152 厘米長 × 26 厘米高

AN INSCRIPTION ON HUANG BINGHONG'S MANUSCRIPT

shanghai studio, 2020

ink on xuan paper

152cm long × 26cm high

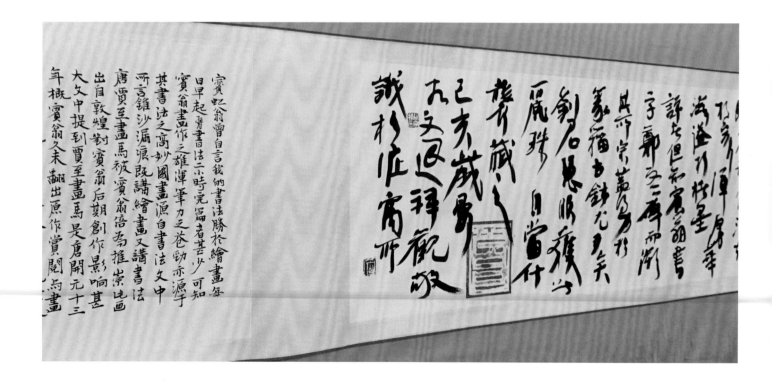

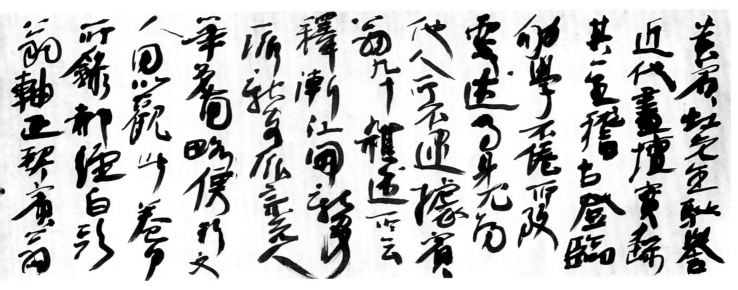

《黄宾虹手稿题跋》
an inscription on huang binghong's manuscript

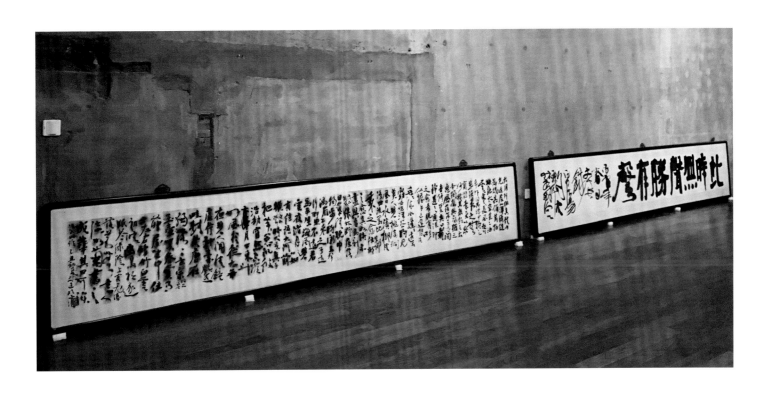

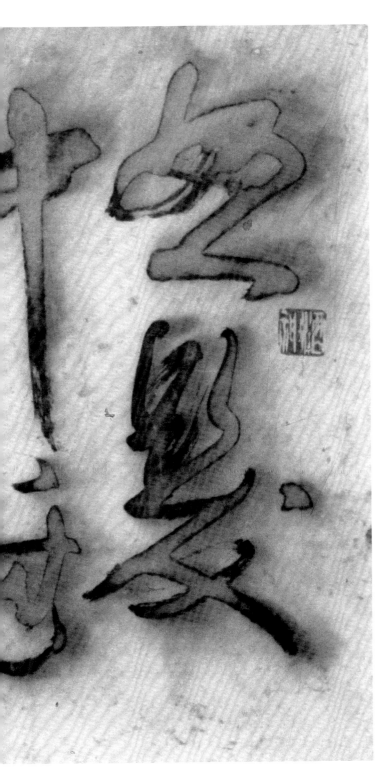

《岳飛：滿江紅》 細部
1985 年於杭州工作室
宣紙，墨，紙本裝裱鏡片

YUE FEI: MANJIANGHONG **DETAILS**
hangzhou studio, 1985
ink on xuan paper, mounted on paper backing

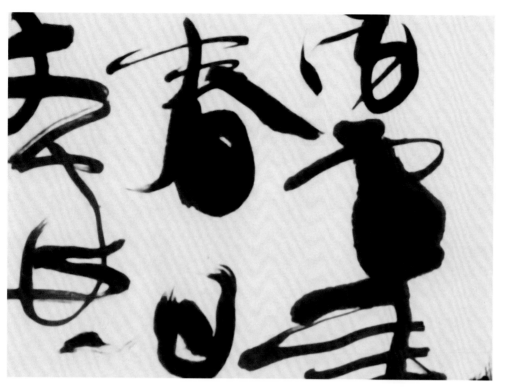

《白居易：琵琶行句》細部
1982 年於杭州工作室
宣紙，墨，紙本白梗絹邊鏡片鏡框
359.3 厘米長 × 47.5 厘米高

***BAI JU YI: SONG OF THE PIPA* DETAILS**
hangzhou studio, 1982
ink on xuan paper, mounted on paper backing
with white silk borders in frame
359.3 cm long × 47.5 cm high

《草渾水暖》
1984 年於杭州工作室
宣紙，墨，紙本白梗絹邊鏡片
169.5 厘米長 × 58.5 厘米高

CAO HUN SHUI NUAN
hangzhou studio, 1984
ink on xuan paper, mounted on paper backing
with white silk border
169.5cm long × 58.5cm high

《鍾嶸：詩品》 細部
1985 年於杭州工作室
宣紙，墨，紙本白梗絹邊鏡片鏡框
244 厘米長 × 30 厘米高

***ZHONG RONG'S POETRY*
DETAIL**
hangzhou studio, 1985
ink on xuan paper, mounted on
paper backing with silk borders in
frame
244cm long × 30cm high

《朝辭白帝彩雲間》
1989 年於紐約工作室
宣紙，墨，紙本白梗絹邊鏡片
196.5 厘米長 × 32.5 厘米高

LEAVING AT DAWN THE WHITE KING CROWNED WITH RAINBOW CLOUD

new york studio, 1989
ink on xuan paper, mounted on paper backing with silk borders
196.5cm long × 32.5cm high

《無錫黿頭渚望太湖》
1978 年於上海
宣紙，墨，紙本白梗絹邊裝裱鏡片
71.8 厘米長 × 47.5 厘米高

OVER LOOK TAI LAKE FROM YUANTOUZHU, WUXI

shanghai, 1978
ink on xuan paper, mounted on paper backing with white silk border
71.8cm long × 47.5cm high

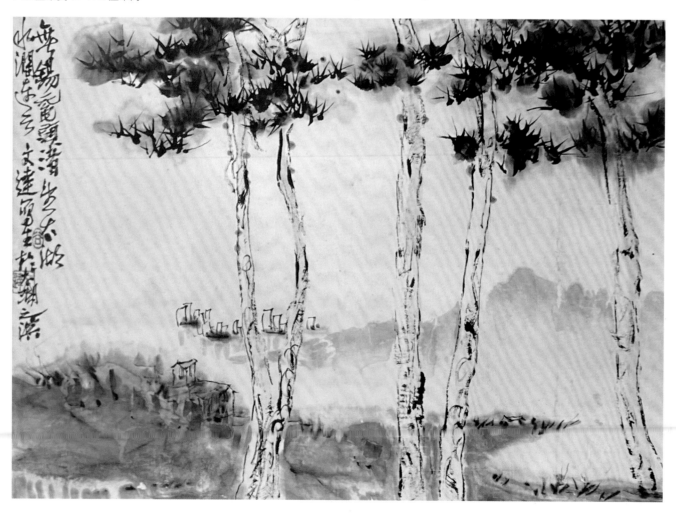

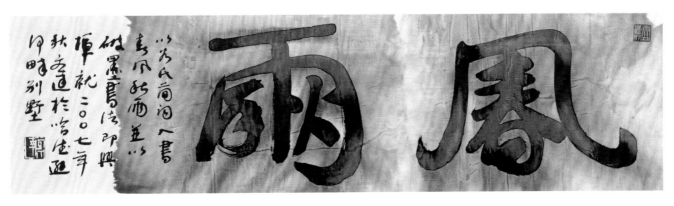

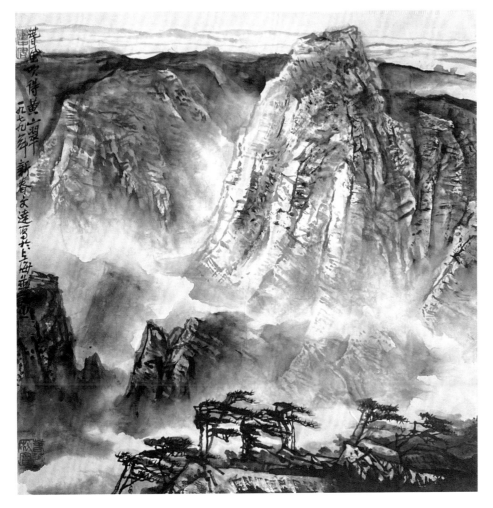

《春風秋雨》

簡詞典系列

2007 年於哈德遜河谷水墨工作室

宣紙，墨，紙背白梗絹邊裝裱鏡片

畫：180.5 厘米長 × 48 厘米高

裱：215.5 厘米長 × 64.5 厘米高

SPRING WIND AUTUMN RAIN

jiancidian series

hudson valley ink studio, 2007

ink on xuan paper, mounted on
paper backing with silk borders

painting: 180.5cm long × 48cm
high

mounting: 215.5cm long × 64.5cm
high

《春風吹得黃山翠》

1979 年於上海

宣紙，墨，紙本白梗絹邊裝裱鏡片

62.5 厘米寬 × 66 厘米高

***SPRING WIND AT YELLOW
MOUNTAIN***

shanghai, 1979

ink on xuan paper, mounted on
paper backing with white silk
border

62.5cm wide × 66cm high

m

a

p

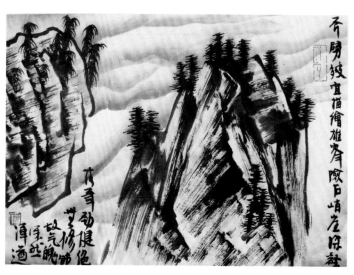

s

《山水畫課徒稿》壹系列 a, m, p, s

1989 年於紐約工作室

墨，宣紙，紙背白梗絹邊裝裱鏡片鏡框

46 厘米長 × 33.5 厘米高

LANDSCAPE CLASS WORK SERIES #1 A, M, P, S

new york studio, 1989

ink on xuan paper, mounted on paper backing with white silk border in frame

46cm long × 33.5cm high

《山水畫課徒稿》1，2，3系列在合美術館回顧展的場景
a view of landscape class work 1, 2, 3 series at the united art museum

《山水畫課徒稿》貳系列 b, c, d, e, l, p
1989 年於紐約工作室
墨，宣紙，紙背白梗絹邊裝裱鏡片鏡框
27.5 厘米長 × 21 厘米高

LANDSCAPE CLASS WORK SERIES
#2 B, C, D, E, L, P

new york studio, 1989
ink on xuan paper, mounted on paper
backing with white silk border in frame
27.5cm long × 21cm high

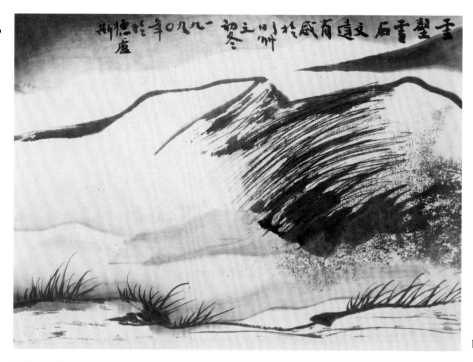

b

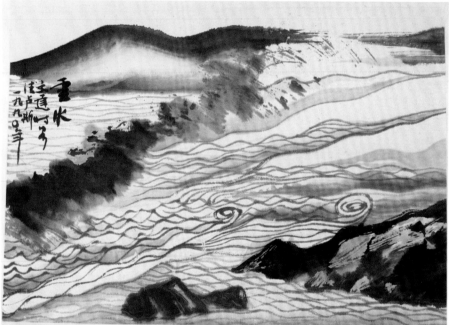

c

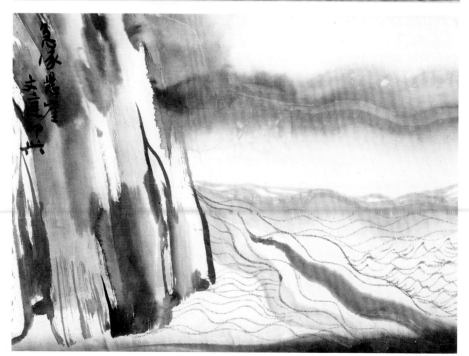

d

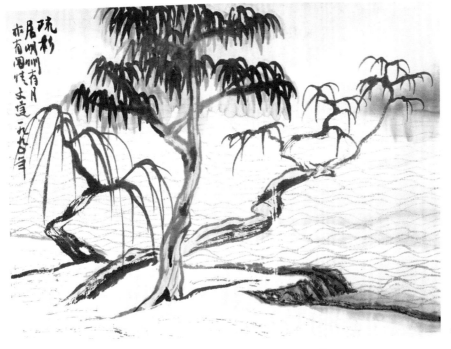

e

l

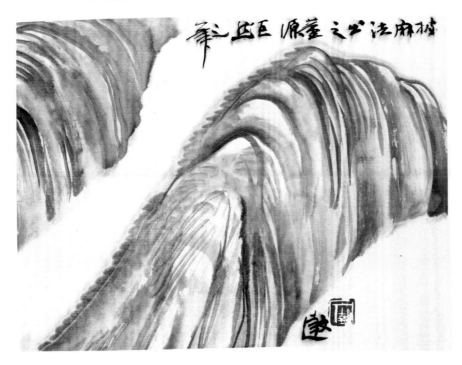

p

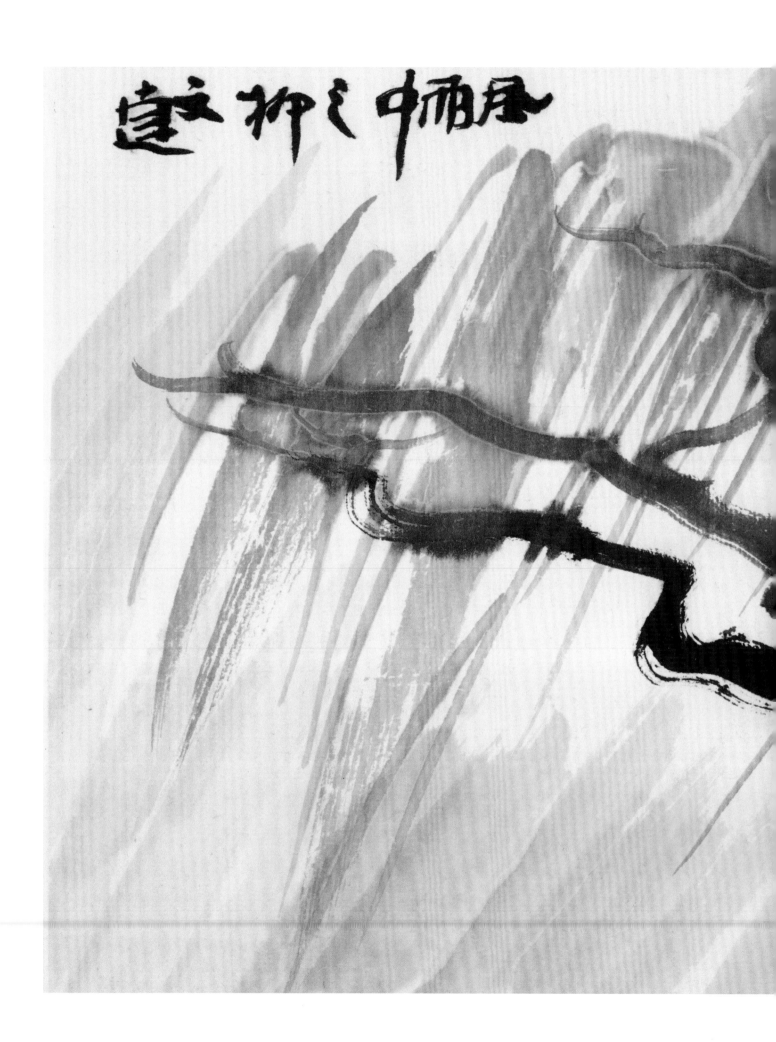

遠立柳之中雨晨

《山水畫課徒稿》貳系列 j

1989 年於紐約工作室
墨，宣紙，紙背白梗絹邊裝裱鏡片鏡框
27.5 厘米長 × 21 厘米高

***LANDSCAPE CLASS WORK* SERIES #2 J**

new york studio, 1989
ink on xuan paper, mounted on paper backing with
white silk border in frame
27.5cm long × 21cm high

《山水畫課徒稿》叁系列 a

1989 年於紐約工作室
墨，宣紙，紙背白梗絹邊裝裱鏡片鏡框
33.5 厘米長 × 23 厘米高

**LANDSCAPE CLASS WORK SERIES
#3A**

new york studio, 1989
ink on xuan paper, mounted on paper
backing with white silk border in frame
33.5cm long × 23cm high

《此中叁味》抽象水墨陸號

1982 年於杭州工作室
宣紙，墨，紙背白梗絹邊裝裱鏡片鏡框
63 厘米長 × 60.6 厘米高

**THREE QUALITIES WITHIN
ABSTRACT INK WORK #6**

hangzhou studio, 1982
ink on xuan paper, mounted on paper
backing with white silk border in frame
63cm long × 60.6cm high

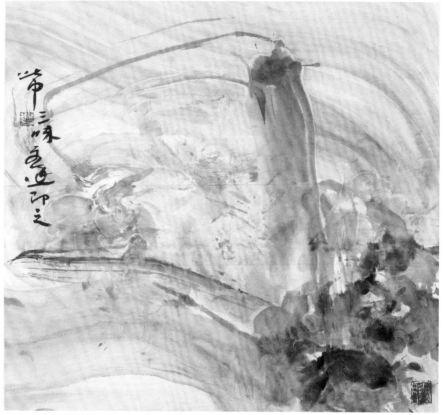

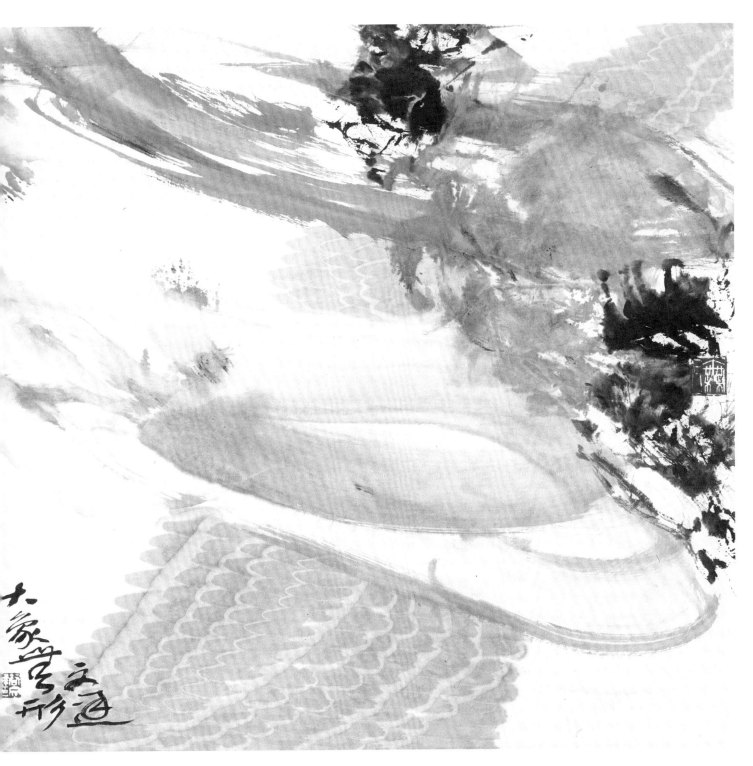

《大象無形》抽象水墨叁號

1982 年於杭州工作室

宣紙，墨，紙背白梗絹邊裝裱鏡片鏡框

63 厘米長 × 60.6 厘米高

A GREAT IMAGE HAS NO FORM **ABSTRACT INK SERIES #3**

hangzhou studio, 1982

ink on xuan paper, mounted on paper backing with white silk border in frame

63cm long × 60.6cm high

《靜物山水》之壹、貳、柒
1984 年於杭州工作室
墨，宣紙，紙本白梗絹邊裝裱鏡片
88 厘米寬 × 106 厘米高

LANDSCAPE AS STILL LIFE **#1, 2, 7**
hangzhou studio, 1984
ink on xuan paper, mounted on paper backing with white silk border
88cm wide × 106cm high

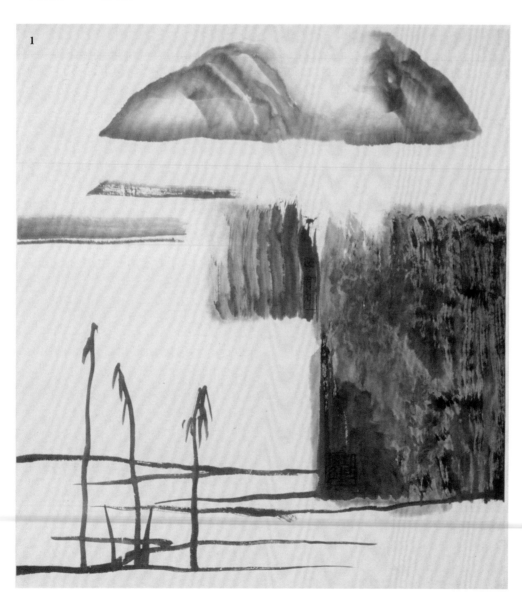

《超現實風景》之叁
1982 年於杭州工作室
墨，宣紙，紙背裝裱手卷
480 厘米長 x75 厘米高

SUREALIST LANDSCAPE #3
hangzhou studio, 1982
ink on xuan paper, mounted on paper backing
480cm long × 75cm high

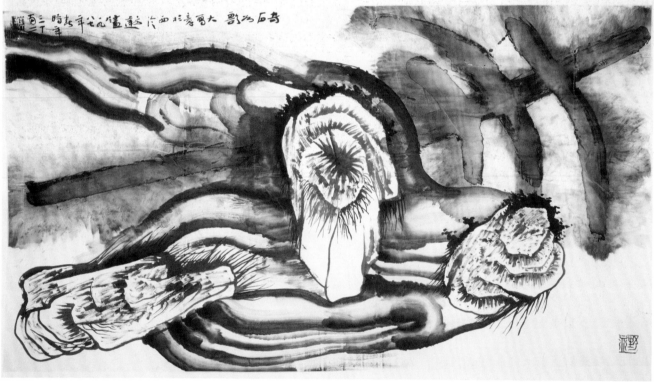

《奇石如瓜》（上）
《奇石如獸》（下）
1987 年於杭州工作室
宣紙，墨，紙肯裝裱上木板
213 厘米長 x 122 厘米高

ROCKS LIKE GOURDS（*TOP*）
ROCKS LIKE BEASTS（*DOWN*）
hangzhou studio, 1987
ink on xuan paper, mounted with white silk border and wood
board
213cm long × 122cm high

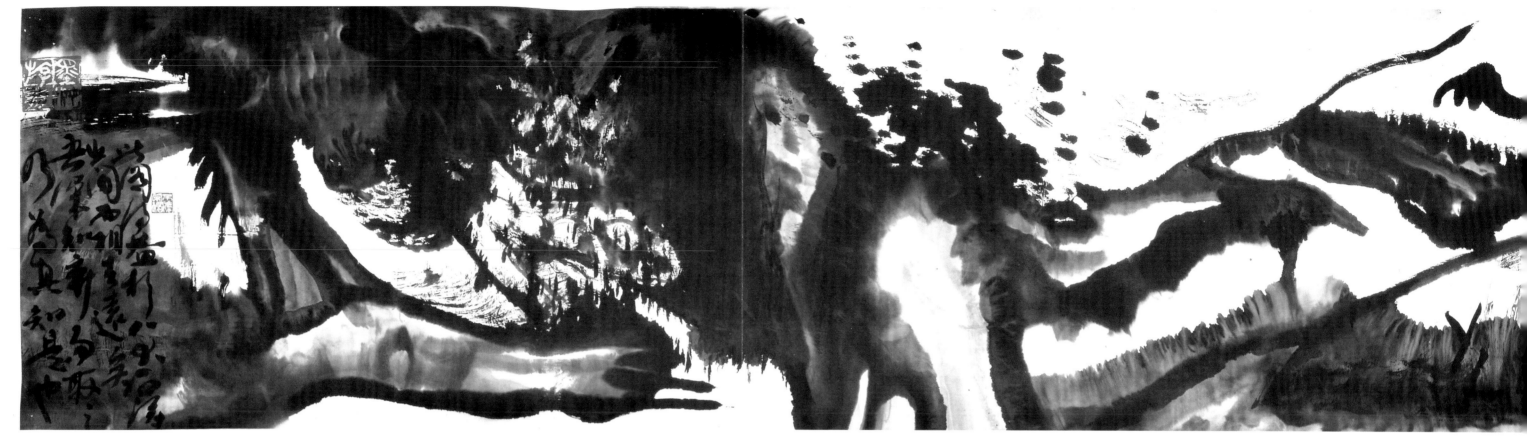

《有機表現》叁號

1982 於杭州工作室
墨，宣紙，白梗絹邊紙背裝裱鏡片
488 厘米長 × 61 厘米高

ORGANIC EXPRESSION #3

hangzhou studio, 1982
ink on xuan paper, mounted on paper backing with white silk border
488cm long × 61cm wide

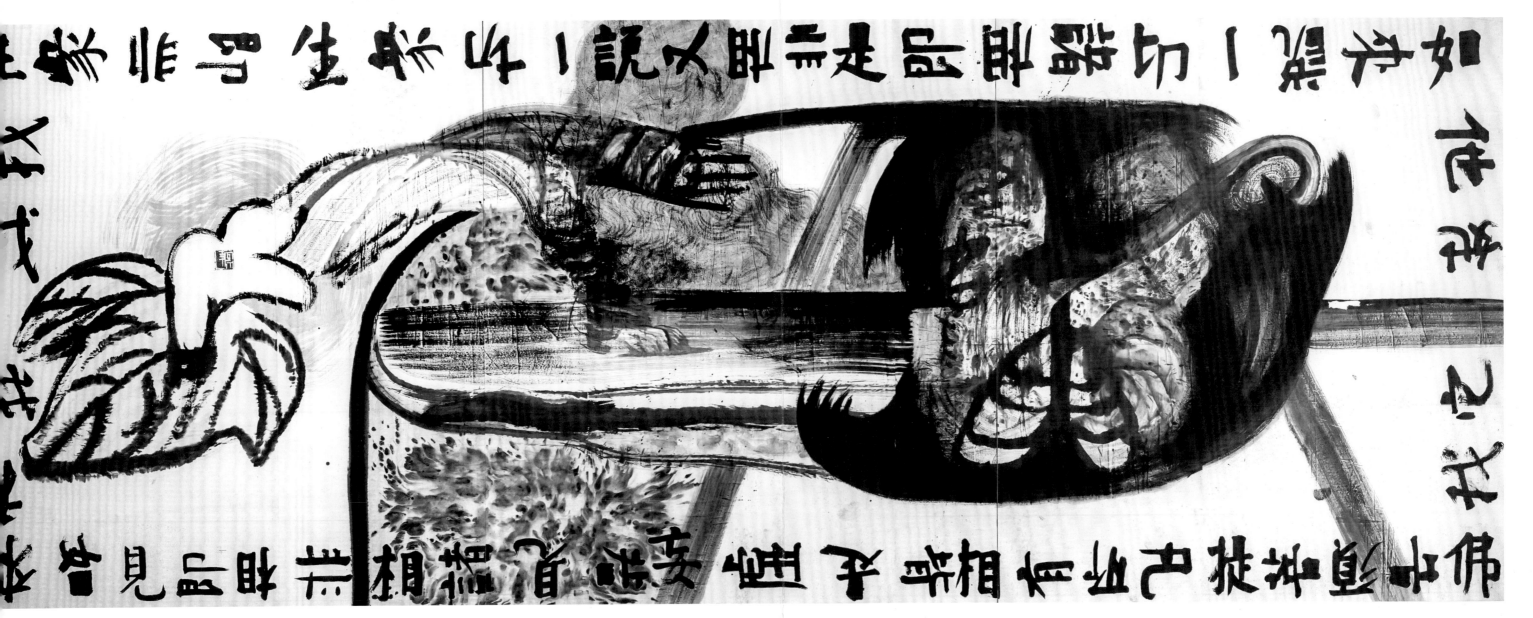

《佛宴》
1985 於杭州工作室
宣紙，墨，紙背裝裱上木板
519 厘米長 × 197 厘米寬

BUDDHIST BANQUET
hangzhou studio, 1985
ink on xuan paper, mounted on paper backing and
wood board
519cm long × 197cm high

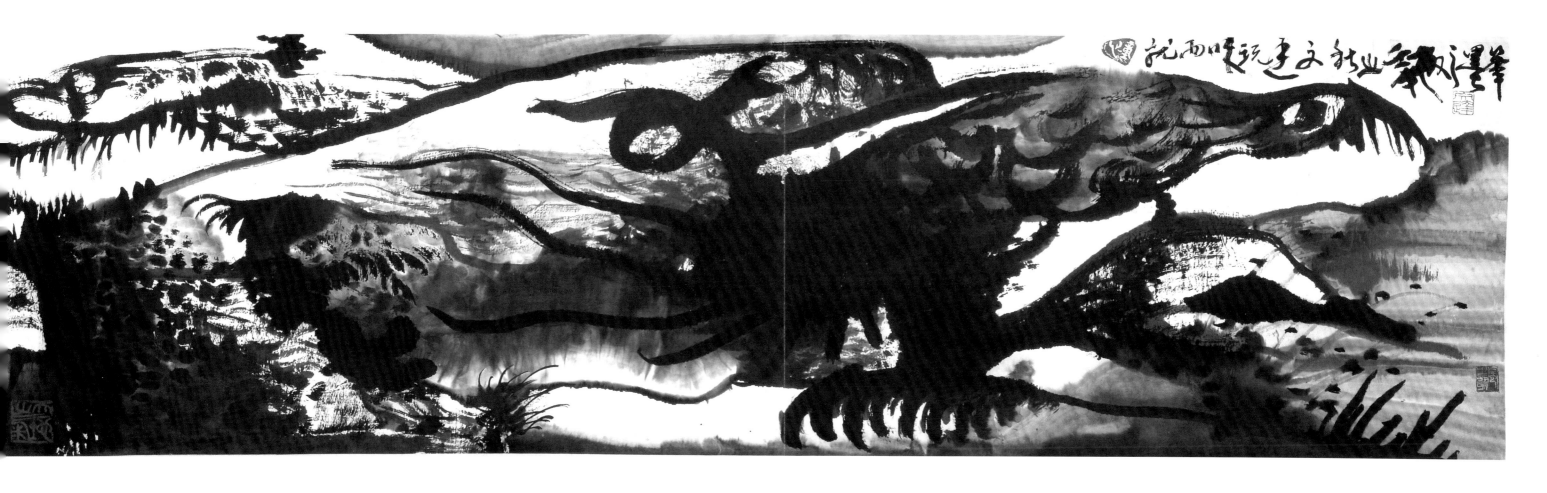

BAI JU YI: SONG OF THE PIPA
hangzhou studio, 1982
ink on xuan paper, mounted on paper backing with white silk borders in frame
359.3 cm long × 47.5 cm high

《白居易：琵琶行句》
1982 年於杭州工作室
宣紙，墨，紙本白梗絹邊鏡片鏡框
359.3 厘米長 × 47.5 厘米高

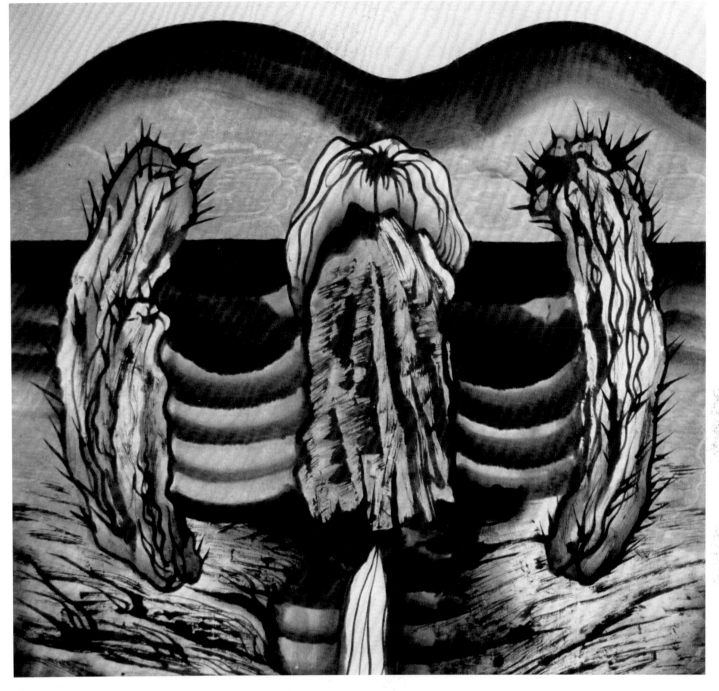

a1

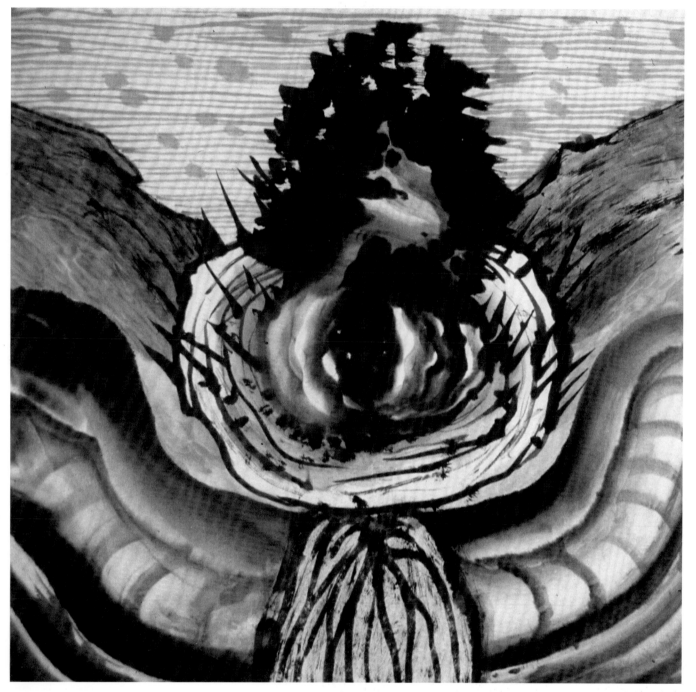

a4

《人體山水》系列 a1, a4
1984 年於杭州工作室
墨，宣紙，紙本裝裱鏡片
85.5 厘米長 × 85 厘米高

BODY LANDSCAPE SERIES #A1, A4
hangzhou studio, 1984
ink on xuan paper, mounted on paper backing
85.5cm long × 85cm high

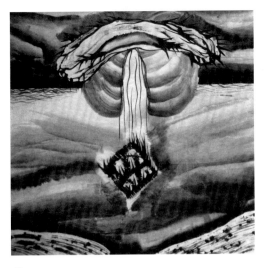

a2

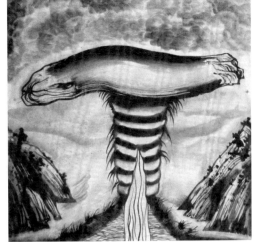

a3

《人體山水》系列 a2-3, a5-7, a9
1984 年於杭州工作室
墨，宣紙，紙本裝裱鏡片
85.5 厘米長 × 85 厘米高

***BODY LANDSCAPE* SERIES #A2-3, A5-7, A9**

hangzhou studio, 1984
ink on xuan paper, mounted on
paper backing
85.5cm long × 85cm high

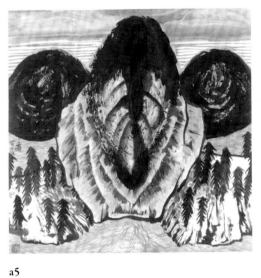

a5

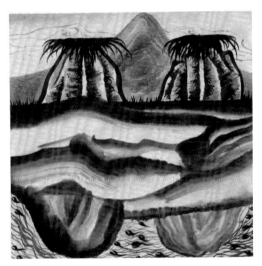

a6

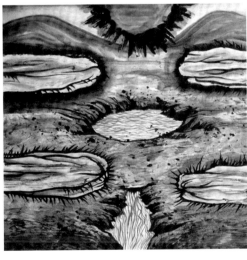

a7

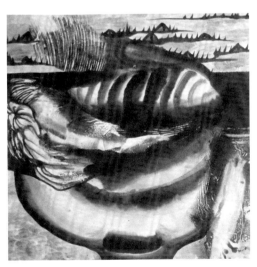

a9

《黃山印象》寫生之玖
1984 年於安徽黃山
宣紙，墨，白梗絹裱鏡片
45 厘米寬 × 97 厘米高

IMPRESSIONS OF YELLOW MOUNTAIN SKETCH #9
anhui yellow mountain, 1984
ink on xuan paper, mounted on paper backing with
white silk border
45cm wide × 97cm high

《黃山印象》寫生之叁
1984 年於安徽黃山
宣紙，墨，白梗絹裱鏡片
45 厘米寬 × 97 厘米高

IMPRESSIONS OF YELLOW MOUNTAIN SKETCH #3
anhui yellow mountain, 1984
ink on xuan paper, mounted on paper backing with
white silk border
45cm wide × 97cm high

《南江水庫》之壹

1974 年於浙江東陽

炭筆，紙

23.5 厘米寬 × 35 厘米高

JIANGNAN RESERVOIR #1

dongyang, zhejiang
province, 1974
charcoal on paper
23.5cm wide × 35cm high

《咜馭橋》之貳

1974 年於浙江東陽

炭筆，紙

33 厘米長 × 25.5 厘米高

CARRIAGE BRIDGE #2

dongyang, zhejiang province, 1974
charcoal on paper
33cm long × 25.5cm high

《東陽山區》之貳

1974 年於浙江東陽

炭筆，紙

26.7 厘米寬 × 38.5 厘米高

DONGYANG MOUNTAINS #2

dongyang, zhejiang province, 1974
charcoal on paper
26.7cm wide × 38.5cm high

《東陽壹景》

1974 年於浙江東陽

炭筆，紙

26.7 厘米寬 × 38.5 厘米高

DONGYANG SCENE

dongyang, zhejiang province, 1974
charcoal on paper
26.7cm wide × 38.5cm high

《山澗泉水》

1974 年於浙江東陽

炭筆，紙

26.7 厘米寬 × 38.5 厘米高

MOUNTAIN SPRING

dongyang, zhejiang province, 1974
charcoal on paper
26.7cm wide × 38.5cm high

《群峰挺立》

1975 年於黃山茶林場

炭筆，紙

34.8 厘米長 × 28.5 厘米高

HIGH MOUNTAIN RANGE

yellow mountain tea farm, 1975

charcoal on paper

34.8cm long × 28.5cm high

《黃山茶林場》

1975 年於黃山茶林場

炭筆，紙

24 厘米長 × 17.5 厘米高

YELLOW MOUNTAIN TEA FARM

yellow mountain tea farm, 1975

charcoal on paper

24cm long × 17.5cm high

《樹下濃蔭》

1975 年於黃山茶林場

炭筆，紙

24.7 厘米長 × 17.8 厘米高

SHADE UNDER THE TREES

yellow mountain tea farm, 1975

charcoal on paper

24.7cm long × 17.8cm high

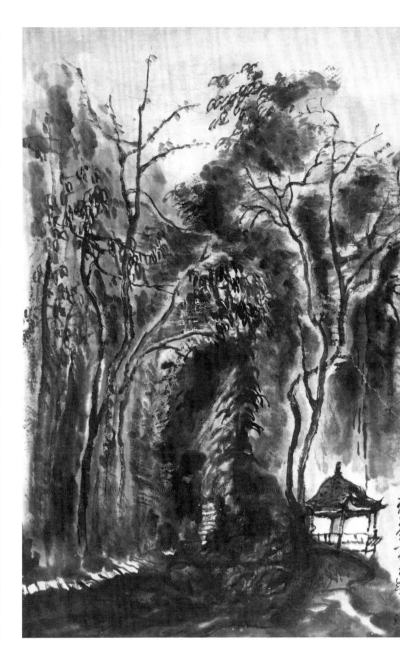

《重慶北溫泉寫生》

長江沿岸寫生之拾貳

1980 年於四川

宣紙，墨，紙背白梗絹邊裱鏡片鏡框

47 厘米寬 × 79 厘米高

CHONGQING NORTH HOT SPRING

yangtze river side sketch #12

sichuan, 1980

ink on xuan paper, mounted on paper backing
with white silk border in frame

47cm wide × 79cm high

《青城以幽名揚於世》

長江沿岸寫生之拾捌

1980 年於四川

宣紙，墨，紙背白梗絹邊裱鏡片鏡框

47 厘米寬 × 79 厘米高

QINGCHENG MOUNTAIN

yangtze river side sketch #18

sichuan, 1980

ink on xuan paper, mounted on paper backing with white silk border in
frame

47cm wide × 79cm high

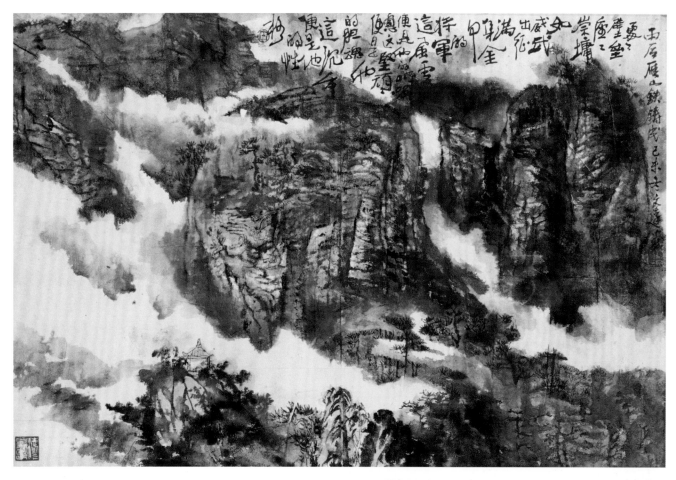

《雨後雁蕩鐵鑄成》
1980 年於浙江雁蕩山寫生
宣紙，墨，紙背白梗絹邊裱鏡片鏡框
69 厘米寬 × 47.5 厘米高

YANDANG MOUNTAIN AFTER THE RAIN

yandang mountain sketch, 1980
ink on xuan paper, mounted on paper backing with
white silk border in frame
69cm wide × 47.5cm high

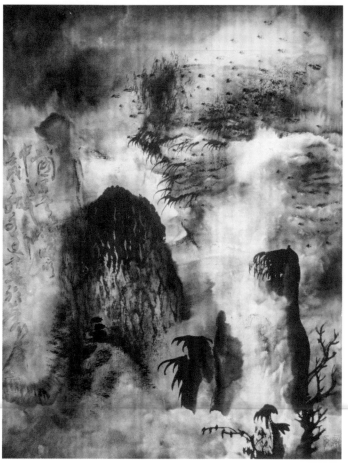

《煙雲晦明》
1980 年於杭州工作室
墨，宣紙，紙背白梗絹邊裝裱鏡片
40 厘米寬 × 60 厘米高

MYSTERIOUS CLOUDS

hangzhou studio, 1980
ink on xuan paper, mounted on paper
backing with white silk border
40cm wide × 60cm high

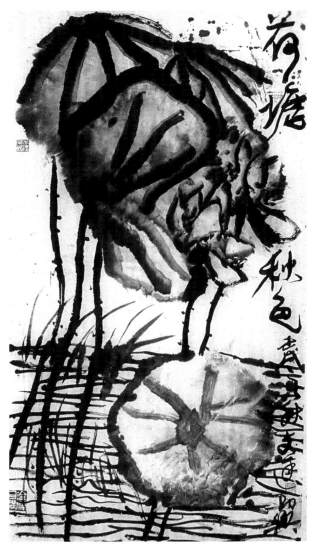

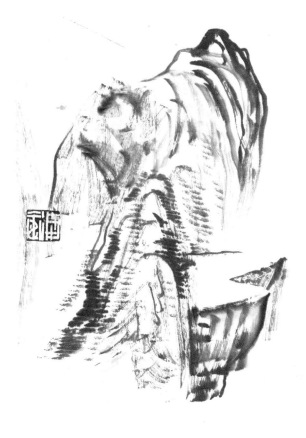

《荷塘秋色》

1984 年於杭州工作室

墨，宣紙，白梗絹邊紙背裝裱鏡片

AUTUMN LOTUS POND

hangzhou studio, 1984

ink on xuan paper, mounted on paper backing with white silk border

《未完成山水》

系列之壹

1980 年於杭州工作室

墨，宣紙，紙本白梗絹邊裝裱鏡片

60 厘米寬 × 98 厘米高

INCOMPLETE LANDSCAPE PAINTING

series #1

hangzhou studio, 1980

ink on xuan paper, mounted on paper backing with white silk border

60cm wide × 98cm high

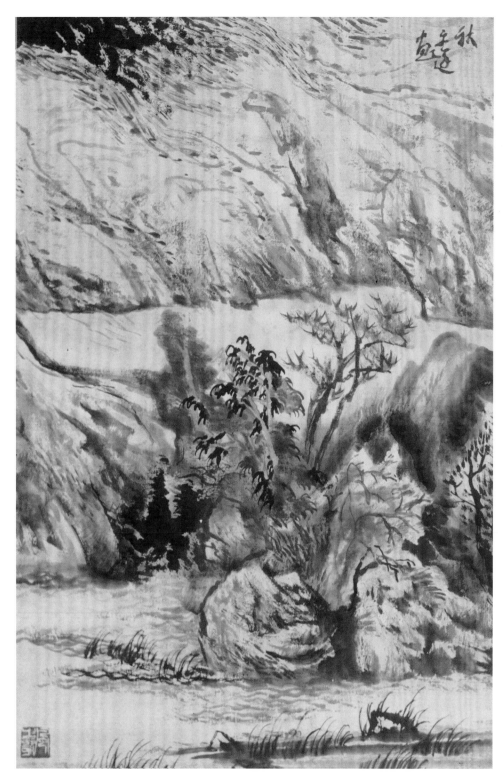

《秋》
1980 年於杭州工作室
墨，宣紙，紙本白梗絹立軸
畫：45.7 厘米寬 × 69 厘米高

AUTUMN

hangzhou studio, 1980
ink on xuan paper, paper backing and white silk border scroll
painting: 45.7cm wide × 69cm high

154

谷文達篆刻私印

1983 年至 1987 年間治印於杭州工作室

GU WENDA'S SEAL CARVING AND PERSONAL SEALS

hangzhou studio, 1983-1987

紅心系列之 1-4, 6
1984 年於杭州工作室
印章，墨，宣紙，白梗絹邊紙背裝裱鏡片
33 厘米長 × 33 厘米高

RED HEART SERIES #1-#4, #6
hangzhou studio, 1984
seal, ink on xuan paper, mounted with white silk border
33cm long × 33cm high

1《飲墨》 drink ink

3《殘月》 waning moon

4《心壑》 valley of the heart

6《無己》 selfless

156

2《山雨欲來風滿樓》 *wind comes before the storm*

紅心系列之 9-12, 16-21
1984 年於杭州工作室
印章，墨，宣紙，白梗絹邊紙背裝裱鏡片
33 厘米長 × 33 厘米高

***RED HEART* SERIES #9-#12, #16-#21**
hangzhou studio, 1984
seal, ink on xuan paper, mounted with white silk border
33cm long × 33cm high

9《谷文達》 *gu wenda*

10《非人間》 *beyond mankind*

11《彼岸》 *the opposite shore*

12《乾坤沉浮》 *the ascent and descent of the universe*

16《清露》 *morning dew*

17《行雲流水》 *floating clouds and running water*

18《靜觀》 *meditation*

19《酒神》 *wine god*

20《超然》 *transcendence*

21《家近大禹陵》 *a home nearby the great yu mausoleum*

回　憶　與　陸　儼　少
老　師　的　貳　叁　事

谷文達

SOME RECOLLECTIONS OF LU YANSHAO

gu wenda

此短文是值陸儼少老師佰年誕辰回顧展覽在中國美術館開幕，以及陸儼少先生書畫全集出版。同時也為出版陸老師的晚輩畫集之際而寫，是壹種師生的感情，亦是做學生的壹種責任，不太會寫如此文章的我，卻也欣然數行。有關陸儼少老師藝術的經歷評論文章已經方方面面，我自然無法再添油加醋了，但回憶與陸儼少老師的貳叁事，她們曾經影響了我，所謂鞭策。

在我紐約布魯克林高地歷史保護區的家中，壹進門的樓梯口牆上掛着陸儼少老師的壹幅書法。此幅作品不是壹件普通的字畫，而是陸老師在 1988 年為我報考三藩市藝術學院時寫的壹封推薦信。多少年來每天上樓下樓和進出家門，我都親切地觀望壹下，她成為我日常生活的壹部分了。

this text was written on the occasion of the opening of lu yanshao's 100th anniversary retrospective exhibition at the national art museum of china, the publication of the complete works of painting and calligraphy of lu yanshao, and the publication of a collection of the younger generation of artists influenced by lu yanshao's work. what i've written is infused with the feelings of a student for a teacher, a kind of sense of duty. i'm not great at writing these kinds of things, yet i was happy to share my thoughts in a few lines. many articles and much criticism have been written about lu yanshao's work and i won't add to that. i will share only a few memories of lu yanshao which had an impact on me, and brought me some so-called encouragement.

at my home in the historical neighborhood of brooklyn heights, i have one of lu yanshao's chinese calligraphy works hanging on the wall just as you enter the staircase. however, this is not the usual kind of calligraphy work, rather it is a recommendation letter written for me by lu yanshao, when i applied to the san francisco art institute in 1988. year after year, as i go up and down the stairs and enter my home, i look fondly at her, and she's now become a part of my daily life.

在我的記憶中，陸儼少老師的教學方式是獨特的。

其壹，幾乎從來沒有在中國畫系的教室裏講過學或作過繪畫示範。他的教學方式有點接近於過去私塾式和家庭式的。每天早晨我們會去陸老師在浙江美術學院內的住所。早晨是陸老師畫畫的時間。除了寒暄家常之外，我們便觀望陸老師作畫。

其貳，陸老師的教學重於身教。與大多數教師不一樣的是他幾乎沒有演講，也沒有與我們滔滔不絕的理論，他在作畫過程中會不時地停下來笑壹下問我們：你們看此畫如何？大家都知道，在國畫家中，很少像陸老師那樣在書法和古典文學的造詣上有深厚的功底，他卻從來沒有向我們展示這些。

每天早晨我們觀望陸老師作畫是在平易、樸素和親切的氣氛中度過的。也許這樣壹段跟陸老師學習的經歷，從側面影響到我在 85 美術運動中，作為壹個獨立藝術家而沒有組織或參與群體，也沒有參加會議式的高談闊論。由於我在浙江美術學院研究生的兩年，潛心於古今中外的宗教、哲學、歷史、文學、美學以及科學的閱讀和當代藝術的創作，自然與當時的教學大綱有偏差之處。在陸儼少老師第貳次招研究生的面試中，陸儼少老師曾問考生：「你們對谷文達的畫怎麼看？」陸老師也曾說過：「小谷不是壹匹駿馬，而是壹匹野馬。」

我的畢業論文是《繪畫與音樂的關係》洋洋大觀。記得陸老師對我說：「小谷，我看不懂你的論文

in my memory, lu yanshao's teaching methods were fairly unique.

first, he scarcely conducted any lectures or painting demonstrations within the classrooms of the chinese painting department. his teaching method was similar to that found in private schools or homes in the past. every morning we went to his residence at the campus of the zhejiang academy of art. the morning was when teacher lu painted. apart from a short exchange of pleasantries, we mostly watched from the sidelines as lu yanshao painted.

secondly, lu yanshao taught by example. unlike most of the other teachers, he barely had any lectures, and refrained from pouring out an endless stream of theory. while in the act of painting, he would frequently stop, smile, and ask, "what do you think of this painting?" everyone knew that amongst the chinese ink painters, there were few who had such a profound knowledge of calligraphy and classical literature, but never once did he reveal this knowledge to us.

every day we passed the morning watching lu yanshao paint in this genial, simple, and intimate environment. perhaps it is this element of having studied with lu yanshao, which influenced me to become an independent artist in the '85 new wave movement, working where there was no group or collective, and no bombastic and arrogant talk that we often find at conferences. in the two years that i was a graduate student at the zhejiang art academy, focusing on everything from ancient to modern, foreign to local, on readings about religion, philosophy, history, literature, art, and science, whilst creating contemporary art, i naturally began to deviate from the curriculum and direction of the college. the second time lu yanshao conducted interviews with graduate students, he once asked them: "what do you think of gu wenda?" lu yanshao said, "gu is not a trained steed but a wild horse."

my graduating thesis was an imposing work entitled, "the connection between music and painting." i remember lu yanshao said to me: "gu, i don't understand your graduation work," and at the time i was a little embarrassed. in my heart, i wanted to say

啊。」當時我真有點窘迫，我心裏要說的是請相信我在研究的東西。在我們研究生畢業作品展覽時，學校對出版社有壹個不成文的規定，谷文達的畢業創作不能出版。但出乎我的意料，我被留校任教了。可以說我在跟隨陸老師的兩年裏，我的水墨創作一直在觀念和前衛的範疇；在我執教的歲月裏，我也率先創作出了水墨裝置和水墨行為藝術，這也與當下的學院教學大綱大相徑庭。故不能不說我是壹個幸運兒，陸老師對我是包容和支持的。另壹位自始至終支持我的老師是孔仲起先生。

我在浙江美術學院師從陸老師之前，幾乎沒有系統地學習過傳統的國畫山水。可以說我對傳統的中國山水畫的認識、中國美術史論及古典文學的了解等，都是在師從陸老師在浙江美術學院的貳年裏補上的不可沒有的壹課。陸儼少老師的教誨，使我對自己的母語傳統文化體系有喜好、學習、了解和認知，進而導致了我在全盤西化的 85 新潮美術有壹個清晰的概念，即我把全盤西化同樣看作 85 新潮美術運動重要而必須的過程，如同群體一樣而不是最後目的。以上我所談的，我對所貫穿 85 新潮美術運動的兩個特點即「群體運動」和「全盤西化」的質疑，從新潮美術運動壹開始就有⋯⋯不同於大部分 85 藝術復興運動中的藝術家的是，我受益於陸儼少老師，畢業於中國畫系，並留在中國畫系任教，而當時的前衛藝術家幾乎仟篇壹律地來自於美術學院的油畫、雕塑、工藝系等等。陸老師身體力行地對中國文化的引導，意義深遠地為我提供了壹個他人所沒有的視點，即前瞻於當時時髦的「全盤西化」。

to him, "please have faith in what i am researching." during our graduation exhibition, the school had an unwritten rule that the publisher was not allowed to publish the work of gu wenda. but to my surprise, i was asked to remain at the school as a teacher. during my two years working with lu yanshao, my work was always within the domain of the conceptual and the avant-garde; and in my years as a teacher, i took the lead in creating ink installations and ink performance art which was very different from the school's curriculum at the time. i have to admit that i'm a very lucky person, for lu's tolerance and support. the other individual who has supported me from beginning to end has been mr. kong zhongqi.

before i studied with lu yanshao at the zhejiang academy of art, i had scarcely studied traditional landscape painting in a systematic way. you could say that my understanding of traditional chinese landscape painting, the works of chinese art history, and classical chinese literature were all valuable lessons, knowledge garnered from my two years in that class with lu yanshao. lu's earnest teachings fostered an interest, study, understanding, and perception in the cultural systems of my mother tongue language. this led me to a clear understanding of the wholly westernized nature of the '85 new wave movement as an important and necessary process, but unlike the group of '85 new wave artists, i believed that westernization was not an end in itself. the above-mentioned doubts—the two characteristics of a "collective movement" and "wholesale westernization,"—have existed in my mind since the beginning. what sets me apart from the artists of the 85' new wave revitalization movement, is that i benefitted from lu yanshao's teachings while studying in the chinese painting department and remained at the chinese painting department to teach and research, while most of the other avant-garde artists at the time came from the oil painting department of the academy of fine arts, the sculpture department, applied arts department and so on. following the guidance of lu's teaching of chinese culture through his example, i garnered a significant and long-lasting point of view unavailable to others, which helped me look beyond the "wholesale westernization" which was popular at the time.

奠基與建立當代水墨和書寫藝術（貳）：

遺失的王朝與 85 當代藝術復興　杭州 1981-1987

FOUNDING AND ESTABLISHING CONTEMPORARY INK ART AND WRITING ART 2

lost dynasties and 85 contemporary art renaissance　hangzhou 1981-1987

感嘆詞與肢體器官系列

1986 年於杭州工作室

布面油畫

360 厘米長 × 200 厘米高

INTERJECTION, LIMB AND ORGAN SERIES

hangzhou studio, 1986

oil on canvas

360cm long × 200cm high

《噓噓噓》 *xuxuxu*

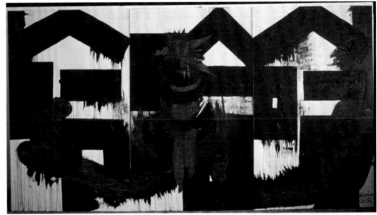

《哈哈哈》 *hahaha*

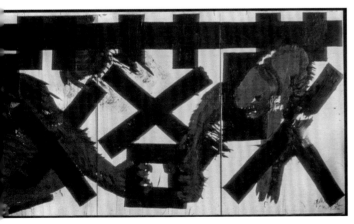

《哎哎哎》 *aiaiai*

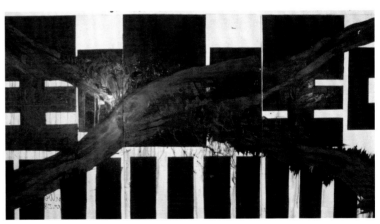

《嘿嘿嘿》 *heiheihei*

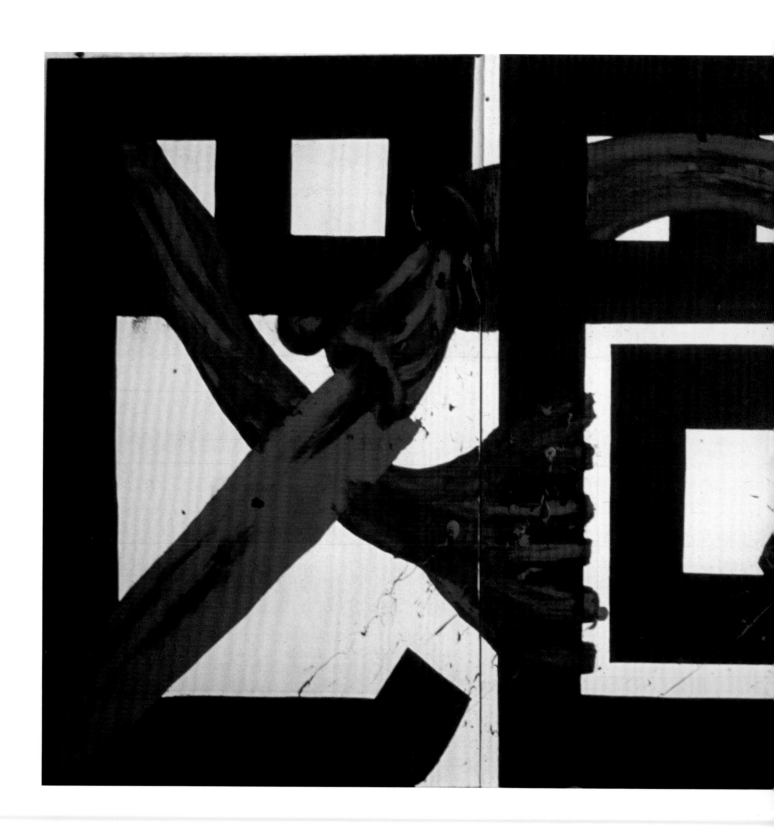

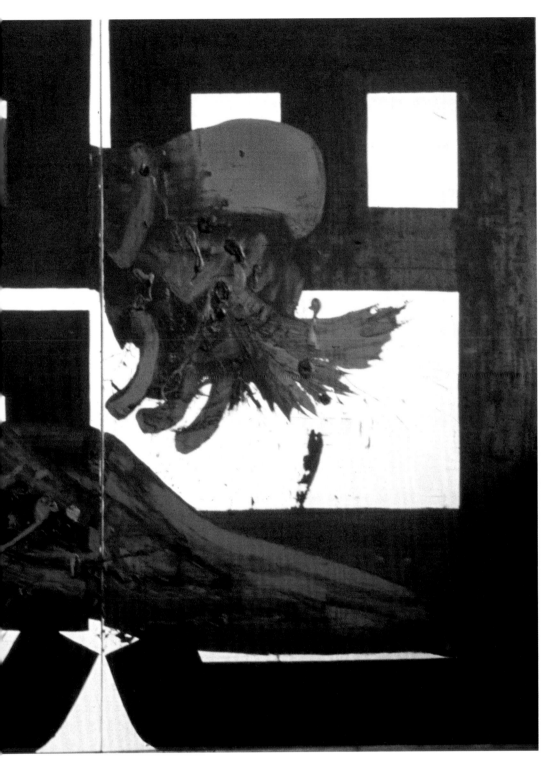

《吧吧吧》
感嘆詞與肢體器官系列
1986 年於杭州工作室
布面油畫
360 厘米長 × 200 厘米高

BABABA
interjection, limb and organ series
hangzhou studio, 1986
oil on canvas
360cm long × 200cm high

《自畫像與肢體器官》細部
self portrait limbs and organs detail

《自畫像與肢體器官》

1986 年於杭州工作室
布面油畫
300 厘米長 × 100 厘米高

SELF PORTRAIT LIMBS AND ORGANS

hangzhou studio, 1986
oil on canvas
300cm long × 100cm high

《叁女神》

1982 年於杭州工作室
布面油畫
104 厘米長 × 68 厘米高

THREE GODDESS

hangzhou studio, 1982
oil on canvas
104cm long × 68cm high

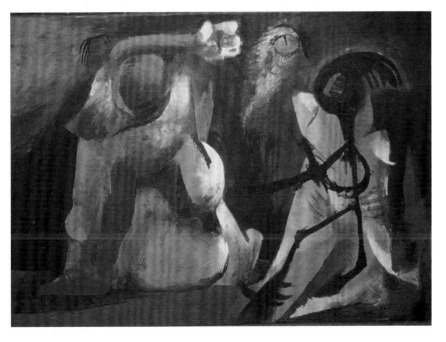

《兩個女人壹胖壹瘦》

穆索爾斯基音樂會
1982 年於杭州工作室
木板面油畫
120 厘米長 × 90 厘米高

***TWO WOMEN ONE IS FAT AND ONE IS
BOONY***

modest mussorgsky concert
hangzhou studio, 1982
oil on wood board
120cm long × 90cm high

167

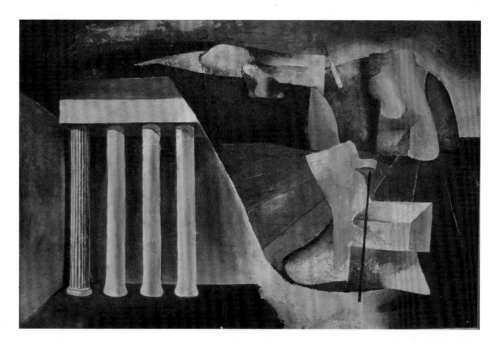

《叁個斯芬克斯》
1982 年於杭州工作室
布面油畫
155 厘米長 × 105 厘米高

THREE SPHINX
hangzhou studio, 1982
oil on canvas
155cm long × 105cm high

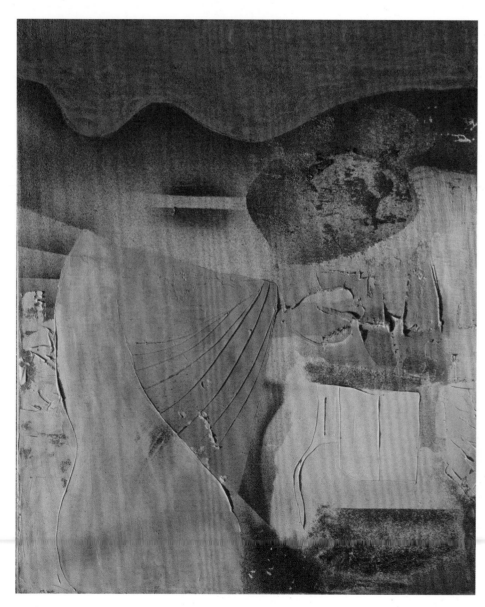

《暮色中的女人》
1982 年於杭州工作室
布面油畫，墨，沙子
50 厘米寬 × 70 厘米高

4 WOM4N 4T DUSK
hangzhou studio, 1982
oil, ink, sand on canvas
50cm wide × 70cm high

《雲霧裏的石頭》
1982 年於杭州工作室
布面油畫
300 厘米長 × 130 厘米高

ROCKS IN CLOUDS
hangzhou studio, 1982
oil on canvas
300cm long × 130cm
high

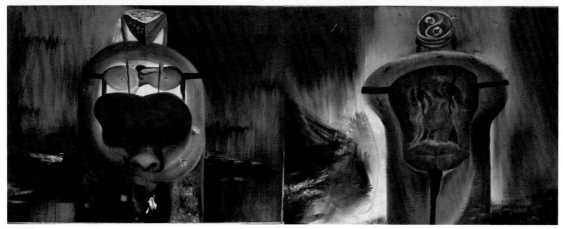

《自畫像》
1983 年於杭州工作室
布面油畫
400 厘米長 × 160 厘米高

SELF-PORTRAIT
hangzhou studio, 1983
oil on canvas
400cm long × 160cm
high

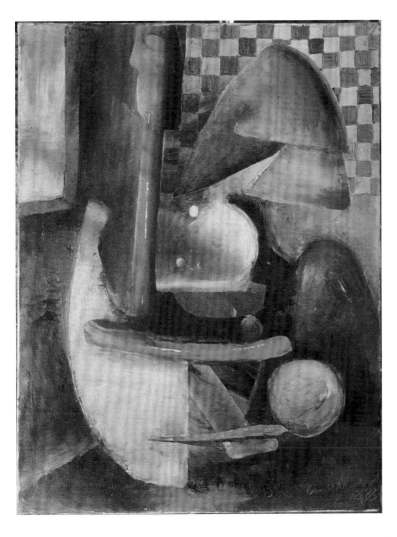

《解構中的坐在馬桶上的女人》
1983 年於杭州工作室
布面油畫
55 厘米寬 × 75 厘米高

WOMAN SITTING ON A TOILET IN THE PROCESS OF DECONSTRUCTION
hangzhou studio, 1983
oil on canvas
55cm wide × 75cm high

《解構中的結構》之壹
1983 年於杭州工作室
布面油畫
215 厘米長 × 43 厘米高

A STRUCTURE IN THE PROCESS OF DECONSTRUCTION #1
hangzhou studio, 1983
oil on canvas
215cm long × 43cm high

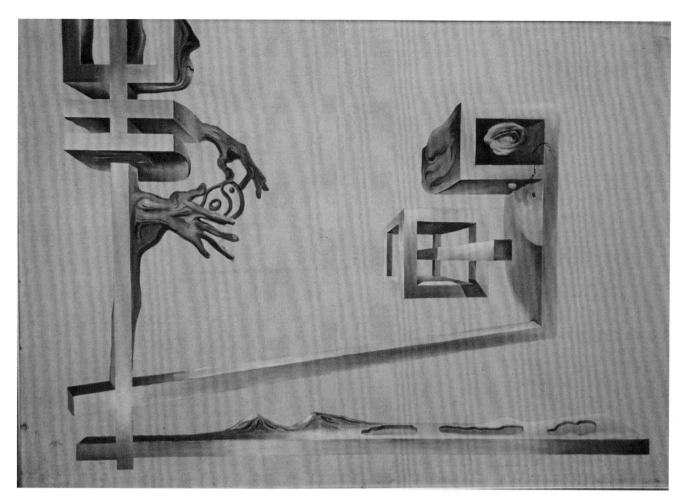

《靜觀》
1983 年於杭州工作室
布面油畫
156 厘米長 × 108 厘米高

CONTEMPLATION
hangzhou studio, 1983
oil on canvas
156cm long × 108cm high

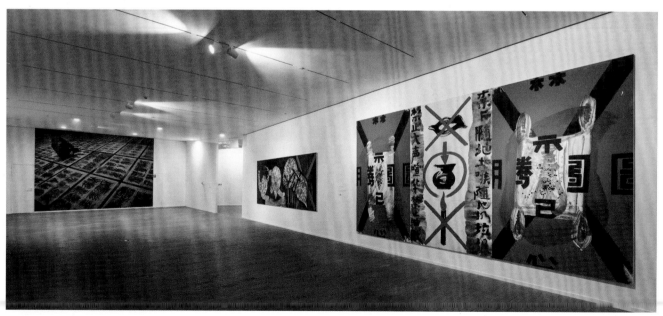

上海民生現代美術館回顧展場景
a retrospective exhibition view at shanghai minsheng modern art museum

172

《太極圖》
1983 年於杭州工作室
布面油畫
160 厘米長 × 118 厘米高

INFINITY
hangzhou studio, 1983
oil on canvas
160cm long × 118cm high

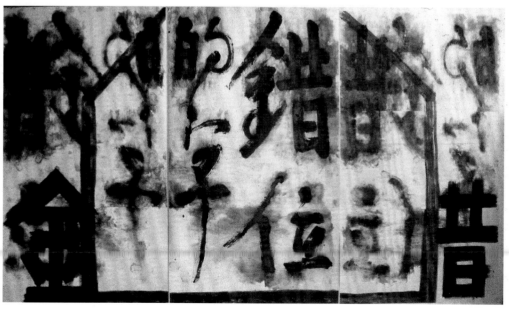

《錯位的字》

遺失的王朝系列
1984-1985 年於杭州工作室
墨，宣紙，白梗絹邊紙背裝裱立軸
540 厘米長 × 274.5 厘米高

MISPLACED CHARACTERS

lost dynasties series
hangzhou studio, 1984-1985
ink on xuan paper, hanging scroll
mounted on paper backing with white
silk borders
540cm long × 274.5cm high

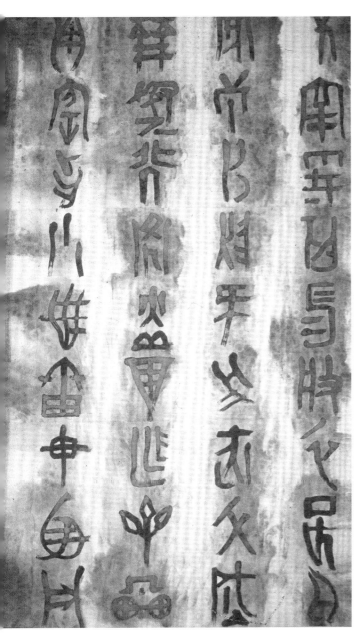

《偽篆字》

遺失的王朝系列
1984-1985 年於杭州工作室
墨，宣紙，白梗絹邊紙背裝裱立軸
540 厘米長 × 274.5 厘米高

PSEUDO-CHARACTERS IN SEAL SCRIPT

lost dynasties series
hangzhou studio, 1984-1985
ink on xuan paper, hanging scroll
mounted on paper backing with
white silk borders
540cm long × 274.5cm high

《正反的字》

遺失的王朝系列
1984-1985 年於杭州工作室
墨，宣紙，白梗絹邊紙背裝裱立軸
540 厘米長 × 274.5 厘米高

NEGATIVE AND POSITIVE CHARACTERS

lost dynasties series
hangzhou studio, 1984-1985
ink on xuan paper, hanging scroll mounted on paper
backing with white silk borders
540cm long × 274.5cm high

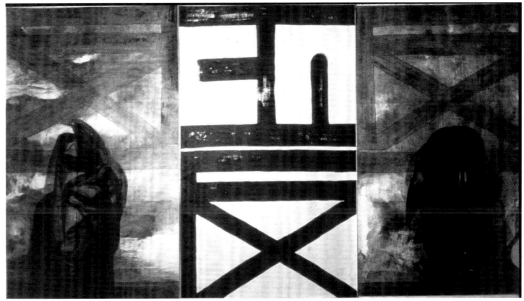

遺失的王朝系列
1984-1985 年於杭州工作室
墨，宣紙，白梗絹邊紙背裝裱立軸
540 厘米長 × 274.5 厘米高

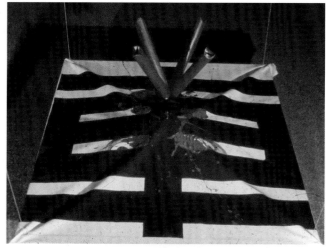

1987 年藝術家谷文達在多倫多市約克大學美術館舉辦的個人展覽是中國前衛藝術家首次在國外的個展。

artist gu wenda opening a solo exhibition at the art gallery of york univerisity, toronto. in 1987, this exhibition represented the very first solo exhibition of a chinese avant-garde artist outside of china.

《壹盤懸在空中的險棋》 觀眾在展覽開幕式上的行為藝術
a dangerous game of chess suspended in the air　the audience as chess pieces in the opening performance

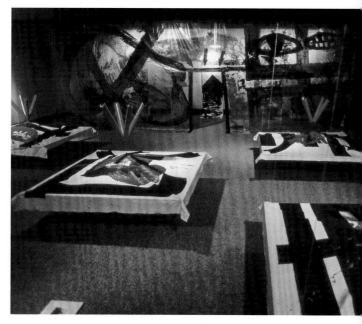

《壹盤懸在空中的險棋》 細部
a dangerous game of chess suspended in the air　detail

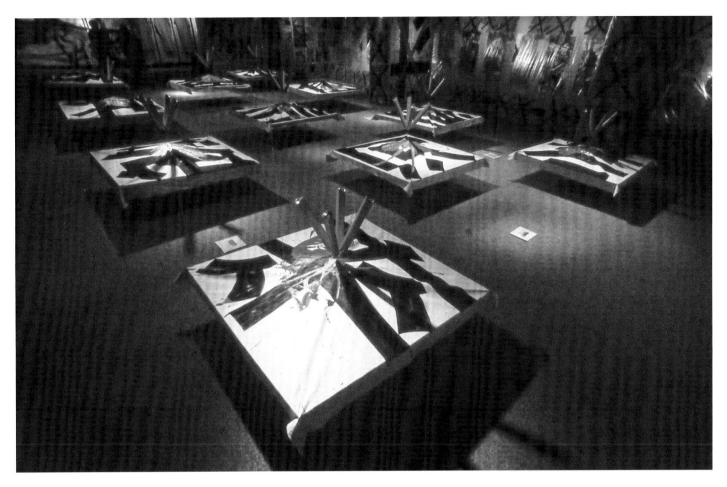

《壹盤懸在空中的險棋》

水墨裝置藝術

1987 年於多倫多約克大學

由加拿大國家國際訪問藝術家獎讚助

墨，宣紙，畫布，丙烯顏料，塑料布，報紙

*A DANGEROUS GAME OF CHESS SUSPENDED
IN THE AIR*

ink installation
york university, toronto, canada, 1987
commissioned by the canada council for visiting
foreign artists
ink, xuan paper, canvas, acrylic paints, plastic sheet,
newspaper

《壹盤懸在空中的險棋》展覽場景壹角
a dangerous game of chess suspended in the air view of
a corner of the exhibition

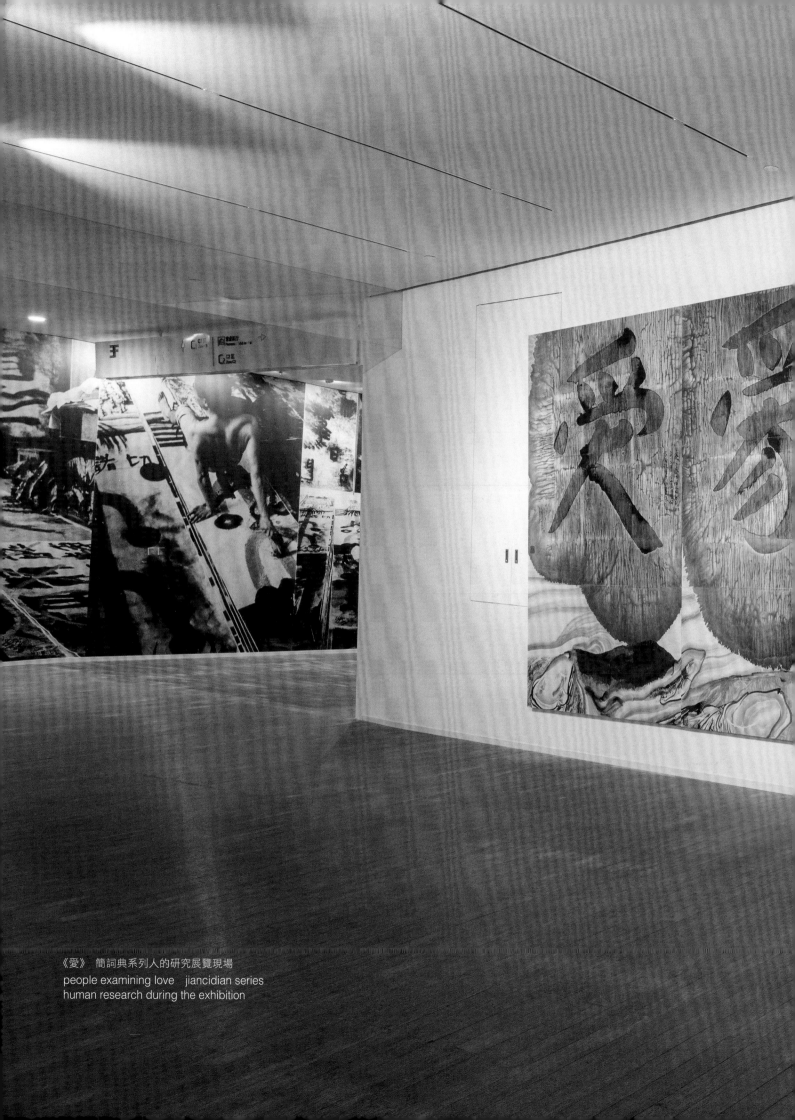

《愛》 簡詞典系列人的研究展覽現場
people examining love　jiancidian series
human research during the exhibition

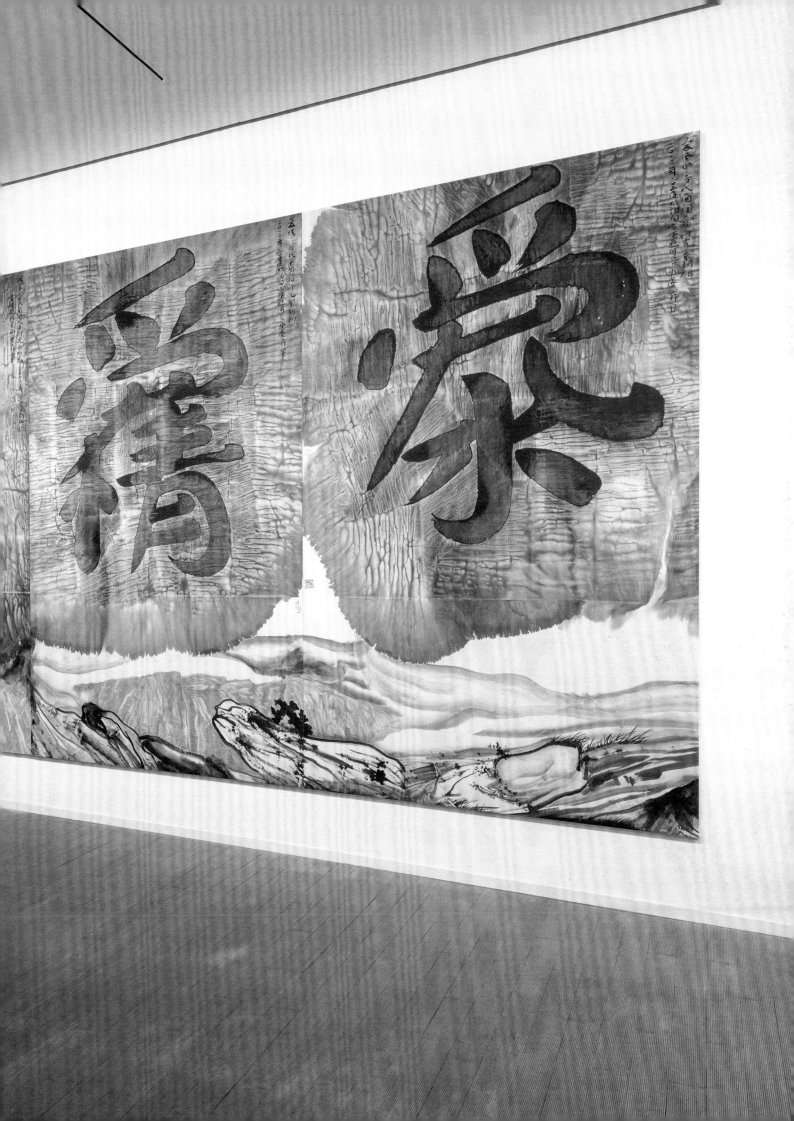

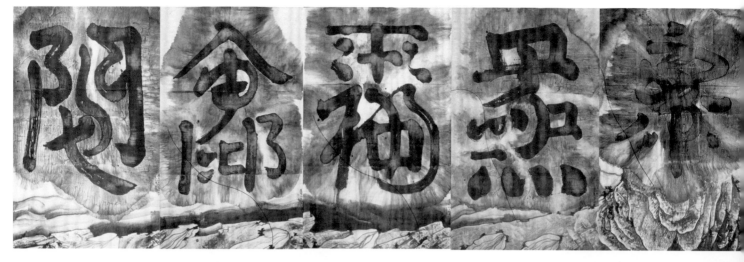

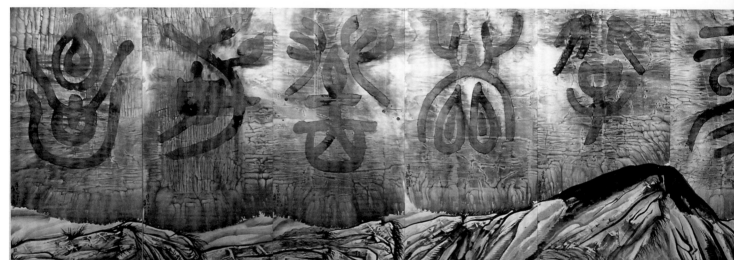

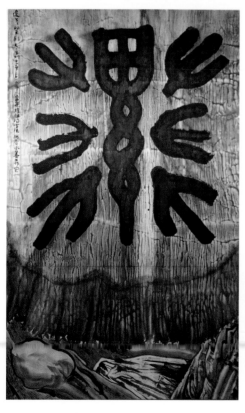
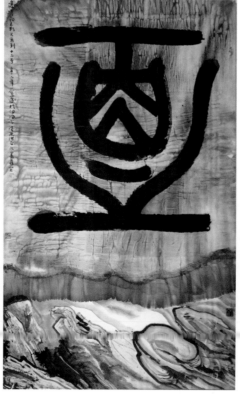
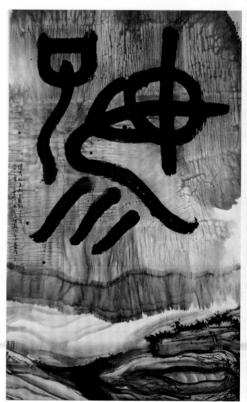

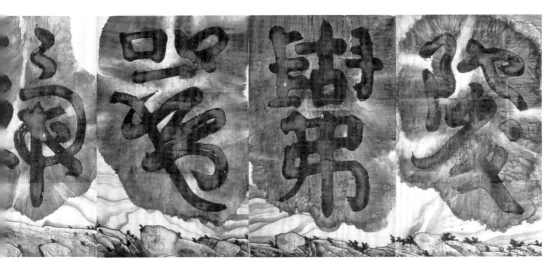

遺失的王朝 g 系列之貳
至拾

紐約工作室 1996-1997
墨，宣紙，紙背白梗絹邊裝裱立軸
178 厘米寬 × 286 厘米高（每幅）

LOST DYNASTIES **G SERIES
#2-#10**

new york studio, 1996-1997
ink on xuan paper, hanging scroll
mounted on paper backing with
white silk borders
178cm wide × 286cm high each

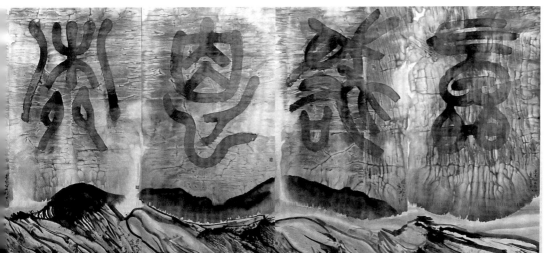

遺失的王朝 k 系列之壹
至拾

2011 年於哈德遜河谷水墨工作室
宣紙，墨，木板裝裱
95.5 厘米寬 × 177.5 厘米高（每幅）

LOST DYNASTIES **K SERIES
#1-#10**

hudson valley ink studio, 2011
ink on xuan paper, mounted on
paper backing and wood board
95.5cm wide × 177.5cm high each

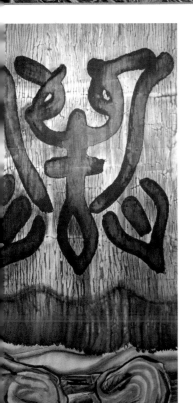

遺失的王朝 L 系列之拾壹、拾貳、拾叁、拾肆

2012 年於哈德遜河谷工作室
宣紙，墨，木板裝裱
180.5 厘米寬 × 290 厘米高（每幅）

LOST DYNASTIES **L SERIES #11,#12,#13,#14**

hudson valley studio, 2012
ink on xuan paper, mounted on wood board
180.5cm wide × 290cm high each

論 谷 文 達「言 說」的 水 墨 之 旅

陳孝信

ON GU WENDA'S DISCURSIVE INK JOURNEY

chen xiaoxin

百年以來，中國藝術的最大變局，出現在水墨領域，而其中最耀眼的人物，非谷文達莫屬。其中的緣由，容我一一道來。

傳統的水墨畫（不管是院體畫、還是士夫畫或文人畫），一直都有着一個「言說」的傳統，承載着文人、士大夫的家國夢想或濟世情懷，或林泉之志。所以，「言說」一直是傳統水墨畫價值觀的核心支撐點，完全不「言說」的戲筆或戲墨，通常都不登大雅之堂，僅是傳統文人、士大夫們餘興而已。傳統水墨畫歷經千餘年而不亡的根本原由，其實就是這個「言說」的傳統。而它在滿清朝走向衰亡的主要原因，也是「言說」的缺失。徒有着水墨畫的一具具軀殼，焉能不衰？！衰落的另一個重要原由是固守傳統水墨畫的「疆域」而不知變通、不敢越雷池半步。

for the past hundred years, the biggest change in chinese art has come in the field of ink painting, with gu wenda being one of the most impressive artists in this illustrious cast of characters. in the following lines, i shall endeavor to explain my reasoning on this. traditional ink painting (whether it's academic painting "*yuantihua*," scholar painting "*shifuhua,*" or literati painting "*wenrenhua*") all were connected to a tradition of "discourse" or "speech" which carries with it the dreams of the literati be they dreams for the success of their homeland, their yearnings for the betterment of mankind, or to commune with nature. so "discourse" was always a foundational core of traditional ink painting values. of course, it was not "discourse" that lifted the brush or spirited the ink across the paper. usually, this painting was coarse and unrefined, only serving as a means for the literati to amuse themselves. the primary reason why traditional ink painting has survived for thousands of years is this tradition of "discourse." subsequently its decline in the qing dynasty, can be blamed on a lack of "discourse." how can ink painting with an empty husk and no "discourse" last forever? another reason for its decline is its adherence to tradition within this "territory" without change or without taking as much as a half-step outside its borders.

是故，欲振興水墨畫者，必從兩個方面入手：其一，重新學會「言說」，體現新的價值觀；其二，敢於跨越「雷池」，注入新觀念，從而拓展水墨畫的原有「疆域」，把它推向現代，乃至是當代，讓它煥發出新的生命活力。

明乎此，方可入此道，方可「建功立業」。

於是，從廿世紀之初以來，在這一領域裏，走出了一代又一代的實踐者、探索者和開拓者，其中有五位被公認為開風氣之先的人物：林風眠、徐悲鴻、吳冠中、劉國松，最後一位就是谷文達，也是拙文所要關注的對象。

一、原點

原點，即起點、源頭。一個藝術家的原點，往往影響到了他後來的整個發展過程，乃至可能是他最終的落腳點。這或許就是一個藝術家的宿命？

李可染說過一句很有名的話：「用最大的力氣打進去，再用最大的力氣打出來！」可惜，老人家終其一生，也沒能真正做到這兩條（受限於諸多因素）。在他之後，又有誰真正做到了呢？我的回答是：「只有谷文達一人而已。」

谷文達的原點，出現在他的早年求學期間。前後約有十年時間，他的業師有許根榮（上海）、陸儼少（杭州）等；他心儀的人物是李可染。其中，許根榮既是他水墨畫的啟蒙老師（在他的心田裏種下了

that's why those wishing to revitalize the genre require two things: the first is that they must re-learn to "speak again" so that it can reflect these new values; the second is that they must dare to step outside the bounds to inject new concepts which can help broaden the territory of the genre, to bring it into the modern era, or the contemporary era, to inject it with new life.

it then becomes clear that by following this path you can then "achieve your goals."

thus, from the beginning of the 20th century, within this realm, out of generation after generation of practitioners, explorers, and trail-blazers, there were five artists who are commonly recognized as having opened up the genre: lin fengmian, xu beihong, wu guanzhong, liu guosong, and finally gu wenda—the artist who is also the subject of this humble text.

I. ORIGINS

origins are the starting point, the source. an artist's origins will always influence their process of development and can even influence where they eventually manage to get a foothold. is this perhaps the artist's fate?

in the famous words of li keran: "use your greatest skills to break in and summon your greatest courage to break out. unfortunately, throughout his whole life, the old man did not manage to do either of these things, (as he was limited by many factors). but after li, who else was able to accomplish this? my answer is this: there was only one, and it was gu wenda.

the story of gu wenda's origins begins in the early years of his studies. over roughly ten years there were a number of his former teachers including xu genrong (shanghai), and lu yanshao (hangzhou) etc., but his favorite character was li keran. among them, xu genrong was the first professor to enlighten him about ink painting (planting in him a seed for ink), who also became a guide for gu on the possibilities of new landscape painting "xinshanshuihua." but in the eyes of gu wenda, the most iconic

一顆水墨的種子），也是「新山水」創作的第一個引路人。在谷文達心目中，「新山水」的偶像人物卻是李可染（所以，他後來的大山水，如《基因風景》一類，我們依然可以從中看到李可染的影子）。考入「浙美」、成為新中國山水大名家——陸儼少的弟子，兩年的求學生涯，大大地加深、加厚了他水墨創作的「原點」，真正是「用最大的力氣打進去」了。我們從他為乃師代擬的《山水畫課徒稿》中，可以一窺他的傳統功力之深厚，「元四家」「明四家」無一不通曉，皴、擦、點、染無一不精，尤擅長鋒勾線。讀研期間，兼修書法，遍覽碑刻，鑽研篆書，為他後來的《簡詞典》打下了牢實的基礎。

讀研期間，正值國門洞開，西風勁吹，這為打開谷文達的「另一隻眼」（跨文化視野）提供了極為便利的契機。這使他的「原點」成了一個靈動的「活點」，而非僵化的「死點」。同時，也激發了他深埋已久的叛逆性格。使他如同一匹脫韁的野馬，縱橫馳騁在新水墨創作的廣闊原野。這個期間，他創作了一批意象與抽象相結合的水墨作品。其中最有代表性的是研究生畢業創作：《李斯特鋼琴協奏曲》（分為《日》《夜》《風雨到來之前》三件單幅作品，材料為宣紙、墨、水粉、各寬 380 厘米、高150 厘米），可以視作為谷氏水墨「言說」的第一篇章。該作品構思奇特，以音樂旋律為作品的靈魂，以時序為紐帶，以傳統意象與現代抽象相結合的處理手法，輔之以潑墨、暈染、勾線等慣常技法，以象徵、隱喻為修辭，盡情地揮灑着青春激情，同時也滿懷期待地憧憬着未來……作品一經展出，

xinshanshuihua painter was li keran. (many years later we can still see the shadows of li keran in his large ink paintings such as *dna landscape*). after entering the zhejiang academy of fine arts, he became a disciple of lu yanshao—the renowned ink painter of post-revolutionary china. in his two-year college career, his "origins" had become both more broad and more profound. the starting point for his practice became the ethos of "using his skills to break in, and his courage to bust out [of the tradition]." amongst his *landscape painting class studies*, which were made for his teachers, we can catch a glimpse of the depth of his traditional ink painting skill. we can sense his understanding of the "four masters of the yuan dynasty," "the four masters of the ming dynasty," with his use of cun (a texturing method used in landscapes), ca (light rubbing), dian (the dots), his skill at ran (adding color washes), and graceful delineation of lines with a changfeng brush. during his graduate school days, he simultaneously studied calligraphy and travelled all over looking at stone tablets. delved into seal script, laying a solid foundation for his later on *jiancidian*.

at the time of his graduate studies, the doors of the country began to open and winds from the west began to blow. this opened gu wenda's "other eye" to cross-cultural perspectives and facilitated a convenient catalyst. this is when his "starting point" turned into a nimble energy-giving "living point," rather than a rigid "death point." it also ignited a spirit of rebellion (once deeply buried), which sent him galloping like a wild horse to unknown realms of ink creation. during this period, he created a series of ink works that combined figurative images and abstract forms. of these, the most emblematic were three works created for his graduation project: *liszt piano concerto*, divided into *sun*, *night*, and *before the storm*, made from xuan paper, ink, gouache (w 380cm × h 150cm each), which might be seen as the first chapter in gu's ink discourse. this work is based around a unique concept, using a musical melody as a muse of the artwork, a kind of temporal link as a technique and a means of combining traditional imagery and modern abstraction, complemented by ink washes, smudging, brush sketching and other techniques

便震撼了觀眾的心靈。但由於它的構思和處理手法突破了「一元化」「新中國山水」的藩籬，甚至也超出了「保守派」們的想像力，因而引起了不小的爭議。可是，在慧眼識珠的導師眼裏，它卻是一件難得的佳作！導師一錘定音，讓谷文達順利通過了畢業考試這一關，還留校當了老師。

谷文達在水墨領域究竟要幹些甚麼？恐怕當時誰也沒想到！

二、越界

很快，也就有了答案：谷文達在水墨領域真正想幹的第一件事，竟是創建「水墨＋」的新框架（後來亦被稱作「谷氏模式」）。

何謂「水墨＋」？

時至今日，我們對谷氏當年所「玩」的「水墨＋」已經不難理解。如果一言以蔽之，其實就是「觀念水墨」。具體一點說就是「水墨方式」與「觀念方式」（裝置、行為、影像等）的結合（疊加）。用谷文達的話說，這叫「立體（三維）的水墨畫」，甚至還有「四維的水墨畫」。

產生巨大影響的代表性作品，主要是兩件：1、《靜則生靈》；2、《他 X 她》。請看谷文達的自我陳述：「1984 年，我參加了《瑞士洛桑國際壁掛雙年展》。我的創作切入點是水墨畫與混合材料的裝置藝術，做了兩件大型水墨裝置（如上所列）。這兩件作品

including the use of symbols, metaphors, and rhetoric, and joyously sprinkled with the passion and enthusiasm of youth—this work seems to embody a state of anticipating a vision of the future … but only when the work is displayed does the viewer get its full earthshaking effect. because his concept and realization broke through the siloed "unified systems" and "new landscape painting", going far beyond the imaginations of the "conservative school," it stirred up no small amount of controversy. the situation unfolded in the vein of "hui yan shi zhu", (only the discerning eye can spot the true gems), and gu wenda's mentors saw him as something of a rare masterpiece. his mentor gave the final word, passing him on his final graduation project and requesting that he stay at the college to teach.

what kind of effect would gu wenda have on the field of ink? at the time, no one would have ever guessed.

II. BORDER CROSSING

but an answer to this question very quickly emerged. the first thing he would do was to establish the "ink +" framework (which would later be called "gu's model").

but what was this "ink +" framework?

today, we don't have too much difficulty understanding the kind of "playing" with ink found in gu wenda's "ink +." if we can use one phrase to describe it, that would be "conceptual ink." more precisely, we might say using an "ink approach" and a combination of (or superimposition of) a "conceptual approach," (installation, performance, video, etc.). to use the words of the artist, this is called "three-dimensional ink painting," or even "four-dimensional ink painting."

in terms of representative works which made a large impact, there are two: *1, wisdom comes from tranquility lost dynasties series; 2, shes × hes lost dynasties series*. here please see gu wenda's artist statement: "in 1984, i participated in the lausanne

既是立體的水墨畫，立體的水墨藝術，也是我整個創作過程中重要的兩件作品。……它們是以鮮明的『文化大革命』式的政治標語文體風格，並以大紅、黑白的大字報宣傳形式展示的。」（《水墨煉金術》，嶺南美術出版社，2010 年，第 77 頁）

這兩件作品的革命性意義就在於：1、它們顛覆了傳統水墨畫的藝術形式與「言說」內涵，被注入了新的觀念方式，與「言說」內涵（隱喻「文革」，還涉了同性戀話題）；2、它開創了中國內地「觀念水墨」新領域，影響了整整一代人；3、它超越了當年風行大陸的劉國松「革中鋒的命」「革毛筆的命」的現代性水墨畫，把水墨轉型進程直接推進到了「准當代」的前沿。

「谷氏模式」也由此誕生。（不久類似的「徐冰模式」——《析世鑒》問世，成為《首屆現代藝術大展》上的經典之作。所以，此模式又可以合稱為「谷、徐模式」）。

與此同時，谷文達在《西遊》（1987 年）之前，還有一系列驚世駭俗的舉措。

1984 年，谷文達參加由周韶華發起並組織的《湖北全國國畫邀請展》，所提供的作品是《遺失的王朝——靜觀的世界》。這是以偽文字、改體字、錯體字、漏體字和印刷體字組合成的一套大型水墨書畫作品。此巨幅水墨畫系列震動了當時的國畫界。後來，谷文達獲得了「破壞傳統的浪子」的稱號。

international textile biennale. the entry point was a combination of ink art, mixed media, and installation (as listed above). these two works were three-dimensional ink paintings, which were the most important works in my oeuvre of three-dimensional ink paintings ... they vividly reflected the style of the political slogans of the cultural revolution, employing the unique aesthetics of propaganda—the bright red and black and white characters. (from *ink alchemy,* lingnan art publishing house, p.77)

the revolutionary meaning of these works lies in: 1. their subversion of the artistic forms and discursive meaning of traditional ink painting, infused with a new way of thinking, and in terms of "discursive" meaning, there is also the metaphor of the "cultural revolution" which involves the topic of homosexuality. 2. it opened up a new realm of conceptual ink painting within china and influenced a whole generation of people. 3. the work went beyond the prevalent styles of modern ink painting popularized by the likes of liu guosong who advocated eliminating literati-style brush techniques and pushing ink art to the edge of being quasi-contemporary.

"gu's model" was an extension of this. (soon after a "xu bing model"–– *book from the sky* came out, which became a classic work at the "china/avant-garde exhibition.") so, in this sense, we can call it a "gu, xu" model.

before gu's *journey to the west* in 1987, there occurred a series of shocking events.

in 1984, gu wenda participated in the "hubei all china painting invitational exhibition" organized by zhou shaohua, the exhibition featured the work *tranquility comes from meditation lost dynasties* series. this was a pseudo-text, with changed characters, wrong characters, and missing characters and printed characters which were combined to form a large-scale ink painting. this series shook the ink painting world at the time and following the creation of this work, gu wenda earned himself a reputation as the prodigal son of ink painting, known for his flagrant destruction of tradition.

1985 年，谷文達在其「浙美」的工作室創作、完成《遺失的王朝 —— 我批閱三男三女書寫的靜字》（邀請其學生 —— 三男三女分別來到他的工作室，隨意書寫同一個「靜」，然後由谷文達來批閱它們，或打上「叉」—— 表示錯，或劃上圈 —— 表示對）。這既是一次水墨行為，也是中國內地最早出現的波普藝術。

差不多同時完成的一件重要作品是《遺失的王朝 —— 圖騰與禁忌的現代意義》。作者稱：這是真正以熱血與信仰去寫的「大字報書法」。（同上書，第 76 頁）

1986 年，谷文達應程征之邀，參加了在西安舉辦的《中國畫理論討論會》。該活動組織了兩場個展·《黃秋園山水畫展》《谷文達水墨畫展》。這是谷文達參加的第一個個展。個展又分為了兩個部分：寫意水墨畫與觀念水墨。後一部分在正式展出時，爭議極大，又臨時改為內部觀摩展。這其中有《遺失的王朝》的系列作品，有裝置，也有行為（行為藝術作品《無聲演講》，以文獻形式佈置在一個金字塔式的構成中）；這是一場「洋洋大觀的觀念水墨藝術的宣言」（谷文達語）。在場參觀的著名水墨批評家 —— 劉驍純則說：「谷文達可以說是當今中國藝壇破壞性最大，反叛意識最強，走得最遠的人。」（參見 1987 年第二期《中國美術報》）

上述種種案例，都可以證明谷文達不僅是在大膽「越界」（越出中國畫邊界，越出現代水墨畫邊界）

in 1985, when gu wenda had his studio at the zhejiang academy of fine arts he completed *i evaluate characters written by three men and three women* lost dynasties series. for the work, he invited students, (three men and three women into his studio) and asked them all to write the character "quiet" in a free-hand way, then he would add markings to their work or add the character x to indicate a mistake, or add a circle to signify that it was correct. this activity or action, was also considered a work of ink performance, and one of the earliest works of pop art at the time.

modern meaning of totem and taboo lost dynasties series was completed around roughly the same time. in the words of the artist, "it was a kind of 'big character poster calligraphy' infused with a warm-blooded passion and a strong sense of faith." (ibid. p 76.).

in 1986, gu wenda was invited by cheng zheng to participate in the symposium of chinese painting theory, which was accompanied by two solo exhibitions "the ink paintings of huang qiuyuan" and "gu wenda solo exhibition." this was gu wenda's first solo exhibition and it contained two parts: one focusing on "*xieyi*"-style ink paintings and the other on conceptual ink art. the second section caused quite a controversy at the time, and had to be temporarily changed into a "private viewing" exhibition (i.e. one which was not open to the general public). among the works in this exhibition was the series "*mythos of lost dynasties*," which included the performance art piece *soundless speech*, a series of documents, texts, and archival materials arranged in a pyramidal form—a "spectacular and imposing conceptual ink art manifesto," (according to gu wenda). renowned ink art critic, liu xiaochun, who visited the exhibition said: "of all people, gu wenda has gone the furthest in terms of having the most mutinous ideologies, the person who has done the most to destroy the temple of chinese art today. (see *art news of china,* vol.2 1987)

all these examples prove that: gu wenda is not only the first artist to be a courageous border crosser (crossing the boundaries of

的第一人，而且是「新觀念水墨藝術」的真正創造者和奠基人。

三、零點

確切地說，是「零點」創作。這是谷文達反叛傳統水墨之後，真正想幹的第二件事。

何謂「零點」？就是筆墨徹底歸於零，告別水墨性的同時，也就告別了上述的「觀念水墨」思路，從而進入真正的觀念藝術創作——也就是真正意義上的當代。

「告別」可謂決絕而悲壯。對傳統水墨而言，這幾乎就是破天荒的事件！千年以來，中華古國的「水墨至上」的傳統綿延不絕、人材輩出、群星璀璨。誰曾想到過：有那麼一天，筆墨真的可以歸零了？九十年末，大陸書畫界曾因吳冠中的一句「如果沒有了感情上的表達，筆墨就等於零」，而爭得天翻地覆。可這裏的「告別」也只是「鳳凰涅槃」式的「死」了一回而已，它最終還是要以精神、智慧、氣韻的方式獲得一次次的重生——這才是它的真正價值和意義所在！

《聯合國》是較早（1993年）付諸實踐的、最重要的「零點」創作系列作品。創作過程前後延續了二十多年至今。單一的藝術媒介是人髮，這些人髮分別來自世界各地、由450家理髮店收集（或贊助）而取得。然後又在18個國家和地區做成有相

chinese painting, crossing the boundaries of modern ink painting), but also the creator and founder of "new conceptual ink art."

III. ZERO

to be precise, it's a creation of "null" or "zero." this was the second thing gu wenda wanted to do following his rebellion against contemporary ink art.

what do we mean by "zero?" it means to take ink right back down to nothing. but to say goodbye to ink, also means saying goodbye to ideas about conceptual ink, thereby truly entering the realm of conceptual art creation, which is to be contemporary in the truest sense of the word.

saying farewell can be a decisive or a solemn and tragic affair. in terms of traditional ink, this was the first time this has occurred! For thousands of years, ink has always remained paramount in the ancient kingdom of china—which saw a continuously unbroken tradition, with generations of shining stars appearing in succession. who would have ever thought that ink painting could return to zero? in the late 90s, the icon of the ink painting and calligraphy world, wu guanzhong, turned heaven and earth upside down when he said, "if there is no feeling in expression, ink painting will amount to zero [nothing]." but here, the concept of "farewell" can be likened to a phoenix rising from the ashes; it needs to draw upon its essence, spirit, and wisdom to find a second chance to live—and this is precisely where its value and significance lies.

united nations this relatively early work (1993), put this into practice and was one of the most important series that deals with this concept of "zero." this was a work in progress that began 20-odd years ago and still continues today. the artwork employed a single material as a medium which was human hair. this hair was sourced from 450 hair salons from all over the world, either donated or collected. this hair was then fashioned into a relatively heavy monument (statistics from 1999). for

當體量的紀念碑（截至 1999 年的統計）。例如在中國展出的是《聯合國 dna 長城》。這件作品由兩部分不同方式的呈現：其一是由人髮壓製做成了一塊一塊的磚，再把這些磚搭建成斷壁殘垣的「長城」；其二是由人髮粘貼的一張張絲網，塗上了黑墨粉，然後再把「長城」圍在其間。這件攝人心魄的作品，既是不同宗教、不同民族、不同歷史、不同性別的「全人類主義」的壯麗史詩，也是水墨精神「託生」以後的一次精彩呈現。

「零點」創作的另一個代表作是《墨煉金術》與《黑金》。據谷文達在《自述》中介紹：中國人基因墨粉和墨錠是在 1999 年至 2001 年創作，並在上海「曹素功墨廠」試驗、製作完成，後在深圳何香凝美術館 oct 當代藝術中心（ocat）展出（2010 年）。尤其是《黑金》這件作品，它以長達 14 公里的中國人髮編製的彩壁為主體，中段以人髮構建一件歇山式華蓋，下方鋪以「中國生物基因墨粉」方陣，意象性的古代儀式場景和當代藝術形式的對話構成了這件宏大作品的史詩性質（同上書 p82—87）。

上述《聯合國》的「終端」是世界，回答的是世界性問題；《墨煉金術》與《黑金》的「終端」是中國，回答的是中國性的問題（中國在當代藝術中的文化身份）。

正如谷文達自己所言：中國人基因墨汁和基因墨錠是文化史上的一次返源壯舉！（同上書，P85）而且，於當下中國水墨畫界的種種焦慮可謂是對

instance, *united nations-dna great wall* as exhibited in china. this work was presented in two different ways: the first was human hair which was processed into hair bricks, one by one. these bricks were then made into a fragmented "great wall." the second part involved using sheets of hair to make a screen, and painting these screens with black ink powder. the "great wall" was then enveloped by these screens. this heart-stopping work depicted people of different religions, races, histories, and genders—the grand epic of humanity—and was a wonderful presentation of and a reincarnation of the spirit of ink.

other ionic works representative of this "back to zero" approach are *ink alchemy* and *black gold*. according to the artist: "i experimented making this ink powder and ink sticks from chinese genes from 1999-2000 at the cao su gong ink factory in shanghai. after the production was complete, they were exhibited in 2010 at the he xiangning art museum and ocat in shenzhen." notable is his work *black gold* which employed 14 km of hair, woven into a colored wall of chinese hair and involves a middle segment built of human hair featuring a "xieshan"-style canopy roof. spread out below is a square matrix of "chinese biological genetic ink" reminiscent of a dialogue between a scene of ancient ritual and contemporary art forms, an ambitious work of epic proportions. (ibid, p. 82-87)

the aforementioned terminus of *united nations* is the world, and it responds to universal international problems. the endpoints of *ink alchemy* and *black gold* are china and they respond to chinese problems (for instance the problems of cultural identity in chinese contemporary art).

as gu wenda has said: the ink and ink sticks made from the genes of chinese people are a magnificent cultural and historical feat of returning to one's roots. (ibid, p.85) and also a kind of cure to the various anxieties which have plagued the ink painting world in china at that time—in fact, these spirited "ink paintings" had the uncanny function of providing the vigor of the *"yang"* (yang as in the male life force according to taoism) to the world of ink. (ibid.)

「症」下「藥」——頗具壯「水墨畫」之「陽」的詭異功能！（同上）

作為《墨煉金術》的姐妹篇是：《茶煉金術》。綠茶源於中國，其歷史之悠久並不亞於墨。且飲茶，更貼近中國人的謙虛、內斂和超然的精神境界。宣紙，是文人水墨畫的重要載體，自元人改良的宣紙誕生以來，一直是文人們的最愛（並不亞於墨）。谷文達在 2001 年以後，以四千斤綠茶為原料，再以傳統的宣紙製作技術，生產了三萬張四尺整的茶宣紙，並以裝置的方式出現在了後來的多個展覽場館，成為了谷氏的又一件代表作。這與《墨煉金術》一樣，是中國「基因」與中國文化的一次近乎完美的結合。

以上種種案例說明：「零點」創作既具有了跨文化的廣闊視野（谷文達已可以嫻熟地運用當代觀念——即西方觀念來進行他的個人創作，也無人再質疑這些作品中所包含的「當代性」品質），又同時具有了強烈的「根性生長」意識，因而也才萌發了一次又一次的文化返源藝術行為。這些「文化返源」藝術行為，使西方人和今天的中國人，重新認識東方古老文明所煥發出的無窮魅力！

必須是同時具有上述兩個維度的「零點」創作，才能使谷文達既成就他自己，並啟示後人。這不僅是谷文達個人所採取的「不二法門」，也可以說，是整整一代藝術家，在走向國際的道路上，不約而同所採取的「不二法門」。

tea alchemy functions as a sister work to *ink alchemy*. the illustrious history of green tea in china is on parallel with the history of ink. and the act of drinking tea is intertwined with the spirt of chinese modesty, restrained character and a somewhat transcendental spiritual realm. *xuan* paper was an important vector for the ink paintings of the literati, and since the great improvements to xuan paper that were made in the yuan dynasty, it has remained a favorite with the literati (favored alongside ink). after 2001, using 4000 catties of green tea as materials, gu produced xuan paper using traditional techniques, a total of 30000 pieces of 4-foot-long green tea xuan paper. this was presented as an installation, which was exhibited in multiple venues and, that constituted another masterpiece of gu wenda. like *ink alchemy* this was a near-perfect combination of chinese culture and "genetics."

the previous examples illustrate that gu wenda's "return to zero" creations embody a broad cultural vision. here gu wenda proves his skill in applying contemporary ideas, namely incorporating western conceptualism into his creative practice, and no one would question that his works possess contemporaneity, yet at the same time, they also possess a strong awareness of the process of growing up within one's own context or an understanding of one's true nature, thus they germinate in a generative performative way, again and again. these performances of "returning to one's roots," are for westerners and chinese alike, a way to re-acquaint ourselves with the glowing endless charms of ancient eastern civilizations!

the aforementioned works must possess a simultaneous two-dimensional sense of "point zero" creativity; only then, can gu wenda realize his aims and inspire future generations. this is not only gu wenda's "bu er fa men" or "a unique and intangible method," but also a "unique and intangible method," adopted by a whole generation of artists, as they moved towards a more internationalized practice.

四、沉浸

在完成了基因墨粉、墨錠、茶宣紙的「零點」創作
以後，谷文達的「水墨情結」又一次蓬勃發作，並
把他拉回到了《基因風景》的平面山水創作中。

在 2019 年尾，武漢「合美術館」舉辦的谷文達大
型個展上，一幅巨型的《基因風景二號》被佈置在
了一個寬敞的大廳裏，十分引人矚目。這是我個
人最欣賞的一件作品，並且是我第二次見到它的
「真容」（上一次是在 2016 年 11 月上海民生美術館
舉辦的谷文達《西遊記》的個展上）。該作品長達
2800 厘米，高 200 厘米，用的是中國人髮基因墨
（故而稱《基因風景》）、綠茶宣紙、紙背木板裝裱。
谷文達採用了南宗山水祖師 —— 董源的「平遠」山
水法，左右「 字」拉開，山巒連綿不絕，但起伏
得相對平緩，茫茫蒼蒼的天空仍用佈白處理。南宗
山水的神韻依然迷人，但材料的革命性改造，卻使
它具有了當代生物藝術的嶄新風貌。山，還是那座
山；天空，也還是那個天空，只是質地變了！或許
可以說，是新瓶裝舊酒吧？讓人陶醉的究竟是新
瓶？還是舊酒？看來只有仁者見仁，智者見智了。

如果說，《基因風景》是對南宗山水的一次沉浸式
返源之舉，那麼，《谷氏簡詞典》水墨畫就是對中
國書法（尤其是碑刻、碑貼）的一次沉浸式返源
之舉。

《谷氏簡詞典》本身屬於文字學的範疇，此處不作
深究（它的核心是「以字為詞」。谷文達的目標是
創作一部完備而實用的《中國簡詞典》，目前，此

IV. IMMERSIVE

after finishing the ink powder, ink sticks, and "xuan" paper of
genetic material as part of the "zero" series, gu wenda's "ink
complex" began again to vigorously express itself, pulling him
into the territory of *genetic landscapes*, and the realm of two-
dimensional landscape creation.

at the end of 2019, wuhan's united art museum organized a solo
exhibition of gu wenda's work. a large work, *dna landscape #2*,
was hung within a spacious hall, an eye-catching work, that
grabbed the attention of viewers. it is this work that i admire
most, and it was the second time that i saw its true face in real
life, (the previous time was his solo exhibition in november
2016 at the minsheng art museum which hosted his exhibition
journey to the west.) this work was 2800cm long, 200cm high
and used chinese genetic ink made from powdered hair, to
produce a landscape (so it is called *dna landscape*), and xuan
paper made of green tea, mounted on wood board. in showing
his true colors, gu wenda used the "pingyuan" ink painting
technique pioneered by dong yuan—the ink painting master of
southern sect. the work features an unbroken never-ending
chain of mountains opening up, one after the other, and a
chinese character is opened up, but the undulating topography
is relatively flat. the vast horizon of the sky is still rendered in
white. the charm of southern sect is still bewitching but the
materials have been transformed in a revolutionary way, giving it
a feeling of the new style of contemporary bio-art. the mountain
is still that mountain; the sky is still that sky, only the texture has
changed. or could we say gu wenda is putting old wine into a
new bottle? are we intoxicated by the look of the new bottle or
is it the effect of the old wine? perhaps it's that beauty is in the
eye of the beholder.

if we say that *dna landscape* is an immersive return to the source
of a southern sect , then the ink painting *jiancidian* is an
immersive return to the source of chinese calligraphy (or
engraved stone steles and tablets).

jiancidian is actually more within the scope of lexicography, but
we won't delve into that too much here. (at its core it's about
using characters as words.) gu wenda's goal was to create a

191

項浩大的工程仍在進行之中）。我這裏的興趣點是他的借用「谷氏簡詞」來創作的一批又一批水墨畫。

其代表作有以下幾個系列：

1、《谷氏簡詞：水墨與動畫》，共 12 幅，創作於 2004 年左右，其中的水墨部分，完成於他的紐約工作室，而 12 生肖動畫影像則完成於他的上海工作室。在展覽時，再將二者合成，置放在一個平面上，通常都是生肖動畫影像居中，「簡詞」水墨畫在其周圍，產生了動與靜的結合，二維平面與多維影像的結合，以及文字與圖像的結合。

2、《谷氏簡詞——人的研究系列》，共 10 幅，創作於 2006 年，一律標注為「破墨書畫」，尺寸統一：285 厘米 x178 厘米，《簡詞》分別是《同性戀》《非典》《離婚》《娼妓》《愛戀》《愛憎》《愛慾》《愛心》等，在「簡詞」的周圍是中國山水圖像。山河託「簡詞」，「簡詞」耀宇宙，合二而一，蔚為壯觀！

3、《谷氏簡詞——雨字部》《谷氏簡詞——南字部》……創作於 2007 年，尺幅統一為 181 厘米 ×48 厘米，同樣標注為「破墨書畫」。該《雨字部》就有《初雨》《淫雨》《雨霽》《雨聲》《雨景》《風雨》《雨止》《春雨》《雨中》等。

4、《遺失的王朝——c 系列》，共 9 幅，「谷氏簡詞」分別是《天海》《暢神》《龜蛇》《沉浮》《超然》《雲水》《朝暮》《靜觀》《混沌》等，創作於 1996 年至 1997 年，尺寸統一 335 厘米 ×150 厘米。

complete and practical chinese dictionary, (and this ambitious project is still ongoing.) what interests me are the ink paintings that came out of jianci.

here are some representative works from this series:

1. *we are happy animals*, includes 12 works created around 2004 or so—ink works which were completed in his new york studio and 12 video animations of the twelve signs of the zodiac, which were completed at his shanghai studio. when they were exhibited, these two were combined on a surface, and placed amongst the images of the zodiac sign animations. it was surrounded by "jianci" to produce a dynamic yet quiet combination. the installation was a combination of two-dimensional and multi-dimensional imagery, and also a combination of images and text.

2. *jiancidian—a study of man series*, comprises 10 works created around 2006 which all conform to the title of "destroying ink painting and calligraphy." the dimensions are all the same 285cm × 178cm. the "jianci" used include the words *homosexual, sars, divorce, prostitute, love, love and hate, desire for love, and compassion*. around these "jianci" are images of chinese landscape paintings. the mountains and rivers support the "jianci," the "jianci" illuminate the cosmos—the two combine into one in magnificent splendor.

3. *jiancidian-rain radicals* and *jiancidian-south radicals* were created in 2007, these works, (dimensions 181cm × 48cm) also fall into the category of "destroying ink painting and calligraphy." the character "rain" is combined with other characters to produce words such as *first rain, excessive rain, skies clearing after rain, the sound of rain, rainy scenes, wind and rain, rain stops, spring rains, raining* and so on.

4. *lost dynasties c series*, includes nine works of *jianci* individually they are *sky and ocean, free expression, turtle and snake, sink and float, transcendence, clouds and water, dawn and dusk, meditation, chaos* and so on, created in 1996-1997, 335 cm × 150 cm each.

以上幾個系列，都是以「破墨畫法」完成。由此可見，谷文達對其情有獨鍾，不僅是嫻熟老到，而且頗能代表「水墨淋漓」「水暈墨彰」的水墨之魅。

這些「沉浸」式的水墨作品出現在當今的國際語境中，其震撼作用雖比不上「零點」創作，但其潤物細無聲的作用則無疑是優於前者的。這是一道道可以讓人去細細品味的「東方風景」。

「沉浸」式的體驗行為還有他與他人聯合演出的水墨表演藝術：《谷文達文化婚禮生活》（1999 年），在美國三藩市現代藝術博物館和三藩市亞洲美術館舉行（後來，又在廣州等地表演過）。在這幾場「文化聯姻」藝術行為中，既展示了「混血人髮墨」，也「秀」了一把中國篆書。

後來，由上述「沉浸」式藝術體驗衍生出去的一系列作品（如《碑林——唐詩後著》《碑林——天象》等），則是另一個需要探討的話題。

谷文達在他的《自述》裏，曾經很認真地表達過一個心願，以後玩不動藝術行為或大型裝置作品了，就回歸他的畫室，畫他的「破墨書畫」，了此殘生。這番話我是信的。滿世界地勞作了大半輩子，最終還是要返回他個人的創作「原點」——所心心念念的水墨。這既是他個人的宿命，恐怕也是許多水墨藝術家的宿命。最後被他和他們所記起的，一定是當年喝下來的「第一口奶」。

these aforementioned works complete the "destroying ink painting and calligraphy" series. in these works, we can see that gu wenda has a soft spot, and not only is he an old hand at his métier but that he represents the true charm of ink painting, including a sense of "unrestrained ink-splashes" and the use of the technique of "shui yun mo zhang", whereby the addition of water to ink can express the voluminous nature of plastic forms.

when these immersive ink works are seen in today's international context, their striking effects cannot compare to the "zero" works, rather the effect of these quiet and wet creations is undoubtedly stronger than the former. in any case, it's a means by which people can savour the fine flavors of "eastern landscapes."

gu wenda has also been engaged in "immersive" experiential performances with others with the performance work: *gu wenda's cultural wedding life* (1999), which was performed at sfmoma, the san francisco performance art institute, and the san francisco asian art museum. (the work was later performed in guangzhou and other places.) in these performances of "cultural marriage," other works involving "mixed-race hair ink" and chinese seal scripts were also shown.

following this, we should also discuss how this is extended through the immersive experiential performance works (such as *forest of stone steles series 4—post tang poetry, forest of stone steles series 6—tian xiang* etc.).

gu wenda's artist statement explains that, later on, if he must leave behind his experimentations with performance art and large-scale installations, he has a strong desire to return to his painting studio, to while away the days to paint his "destroying ink painting and calligraphy works." these words, i believe are true. after working all over the world for most of his life, he eventually had to return to his personal creative "origin" - the ink artworks he had always wanted to work with. this is his personal destiny, and I am afraid it is also the destiny of many ink artists. the last thing he and they have in mind must be the "first sip of milk" they drank back then.

五、結語

用一句通俗的話說，谷文達「玩轉」了水墨。但他所涉及的問題又不僅僅是水墨的問題，而是涉及到了包含水墨問題在內的跨文化的「全人類主義」「全藝術主義」的大文化問題。這中間，「新觀念」是他的一把利器和「突破口」。他的最大貢獻是讓水墨重新「言說」（其中既有「中國故事」，也有「人類故事」），並讓他的這番「言說」活在與時代一起跳動的脈搏裏，也活在大眾的視野裏。他留給我們的重要啟發是：將極端的「反叛」「革命」和「繼承」融為一體；「革繼命承」；將「歷史」和「未來」融為「歷史未來」。（同上書，第 95 頁）

他最終的目標是：「將自然界的千岩竟秀、萬壑爭流的大千世界躍然到了筆墨淋漓、氣韻生動的彈『紙』、一『繪』間，然後再從水韻墨彰的中國山水畫塑造到了自然景觀之中」。（同上書，第 99 頁）這裏的「自然景觀」指的是他的《中園》計劃，目前尚未真正落地（草圖已於 2010 年展示過）。由此可見，谷文達仍在途中，讓我們拭目以待。

2021.5.22
於草履書齋

V. CONCLUSION

to use a popular expression: gu wenda is "playing around" with ink, but the issues he is exploring are not merely issues of ink, rather they involve, the cross-cultural, larger issues of culture which are relevant to "all humanity" and "the entirety of art." within this "new conceptualism," he found a weapon which he uses to carve out a "hole to break through." his biggest contribution is creating a "new discourse" of ink (and within this, we can find both chinese stories" and "universal stories of humanity.") with the vitality of this "discourse" and the era pulsing in his veins, his work has maintained its vibrancy and relevancy to the public. the vital inspiration which he bestows upon us is his fusion of an extreme sense of "rebellion," "revolution," and an "historical sense of continuity," to "pursue revolution and respect fate," and to combine history with the future to create a "historical future." (ibid p. 95)

in the end, his goal is to have: "row upon row of stunning mountains which compete in splendor; a thousand streams competing for flow, and a boundless universe, which leaps out from his brush. the droplets of ink are like bombs, their charming forms spreading across the 'paper,' a 'painting' and then these traditional paintings executed in the technique of 'shui mo yun zhang' (to mix ink with water to achieve various effects), are molded into the natural landscape." (ibid. p99.) here, "natural scenery" implies gu's *zhong yuan* plan , which is still in the process of being realized (early illustrations of this work were exhibited in 2010). from this, we can see that gu wenda is still en route to his destination: his arrival is eagerly anticipated.

may 22, 2021, at caolv study

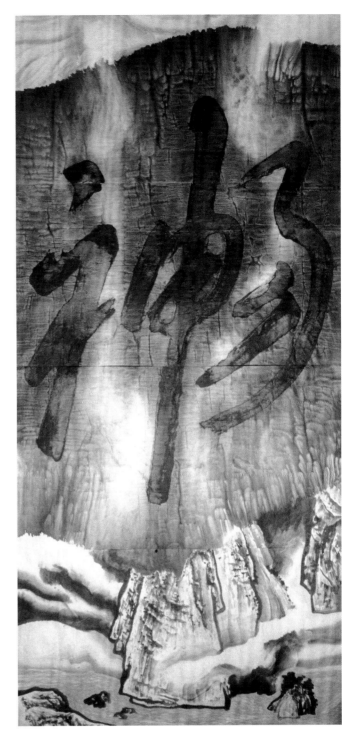

《暢神》
遺失的王朝 c 系列之貳
1996-1997 年於紐約工作室
宣紙，墨，紙本裝裱
150 厘米寬 ×335 厘米高

FREE EXPRESSION

lost dynasties c series #2
new york studio, 1996-1997
ink on xuan paper, mounted on paper backing
150cm wide × 335cm high

陳孝信，生於 1943 年，江蘇武進縣人。現為獨立藝術批評家、策展人。畢業於華東師大中文系本科、四川大學中文系研究生班（碩士學位）。曾任職於南京藝術學院《江蘇畫刊》《藝術界》《美術文獻》等刊物特約編輯。任中國美術批評家年會學術委員、第七屆中國美術批評家年會輪值主席、國際批評家協會會員。曾策劃多個有影響力的水墨群體展覽。出版作品有《水墨潮流》《文脈中國》《遊心虛淡》等，公開發表當代藝術現狀評論、藝術家個案研究一、二百萬字。

chen xiaoxin was born in wujin, jiangsu province in 1943. he is now an independent art critic and curator. he obtained his bachelor's degree from the department of chinese language and literature at east china normal university and his master's degree at sichuan university. he worked at nanjing university of the arts and jiangsu pictorial art monthly. he was also the contributing editor of *leap, fine arts literature* and other magazines. he is now an independent art critic and curator. and he is the member of china annual art critics assembly academic committee, the rotating president of the 7th china annual art critics assembly and the member of international association of art critics. he has curated many influential group exhibitions of ink painting. he has published several books and vended many articles on the contemporary art and artist case study with around millions of words.

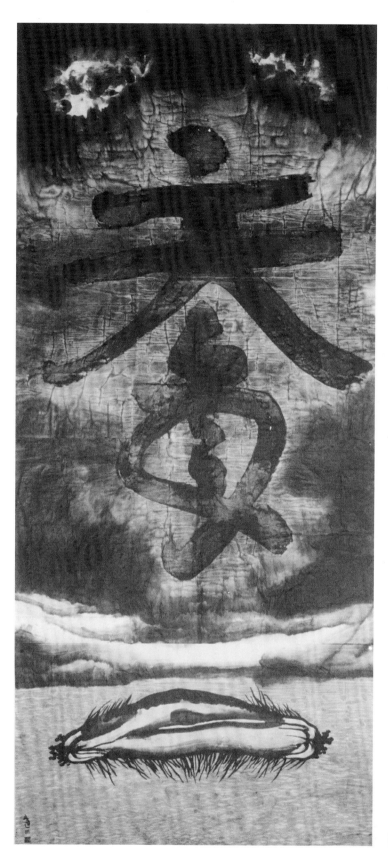

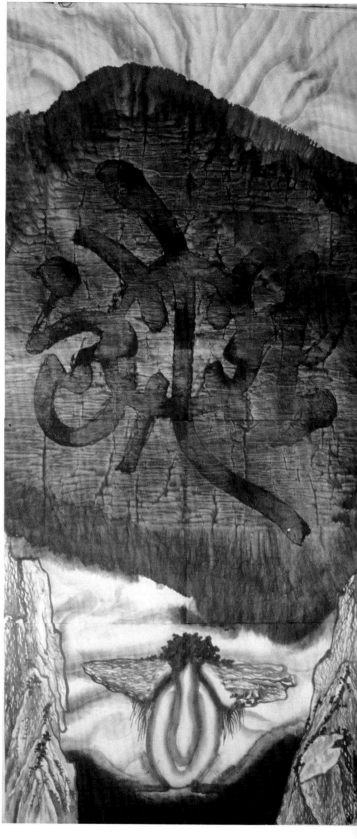

《天海》《龜蛇》《沉浮》《超然》
遺失的王朝 c 系列之壹、叁、肆、伍
1996-1997 年於紐約工作室
宣紙，墨，紙本裝裱
150 厘米寬 ×335 厘米高

SKY AND OCEAN, TURTLE AND SNAKE, SINK AND FLOAT,
TRANSCENDENCE

lost dynasties c series #1, #3, #4, #5
new york studio, 1996-1997
ink on xuan paper, mounted on paper backing
150cm wide × 335cm high

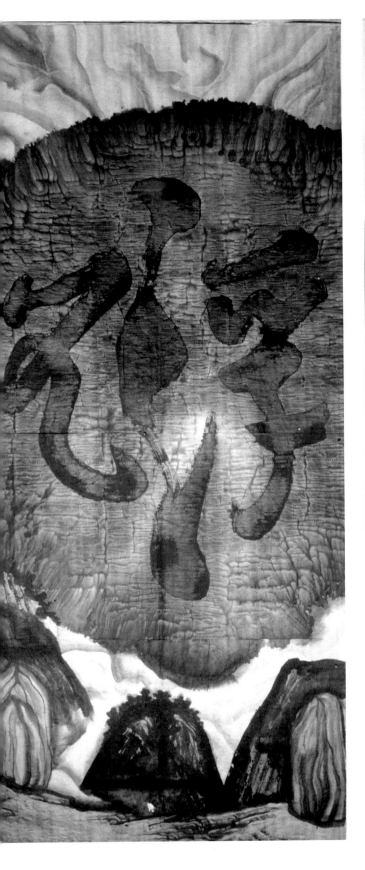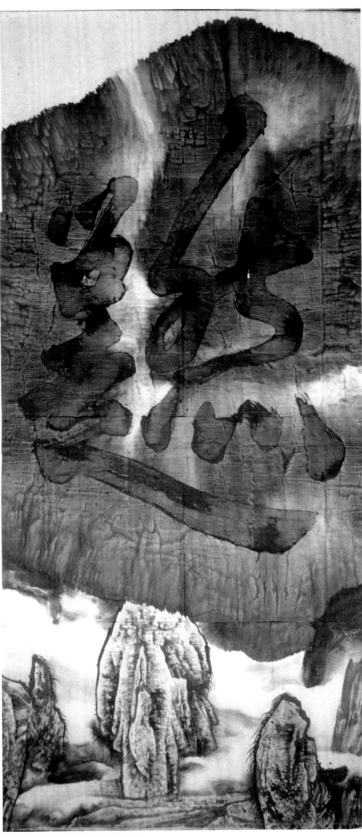

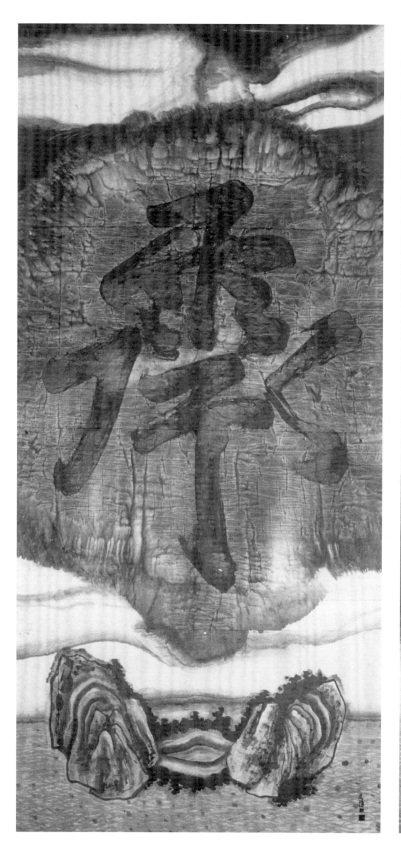
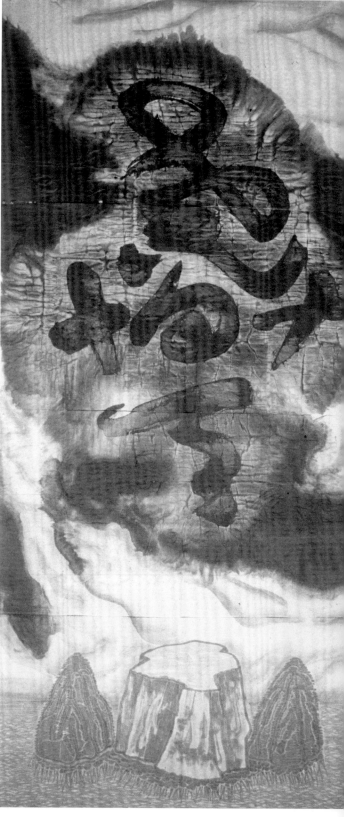

《雲水》《朝暮》《靜觀》《混沌》

過火的工朝し系列之陸・柒・捌・玖

1996-1997 年於紐約工作室

宣紙，墨，紙本裝裱

150 厘米寬 ×335 厘米高

CLOUDS AND WATER, DAWN AND DUSK, MEDITATION, CHAOS

lost dynasties s series II6, II7, II8, II9

new york studio, 1996-1997

ink on xuan paper, mounted on paper backing

150cm wide × 335cm high

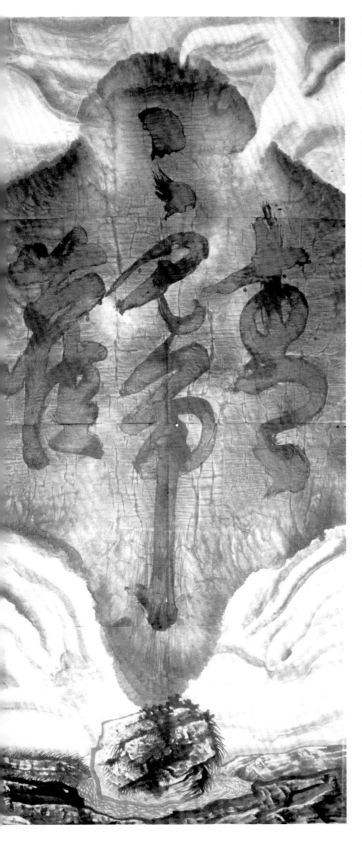

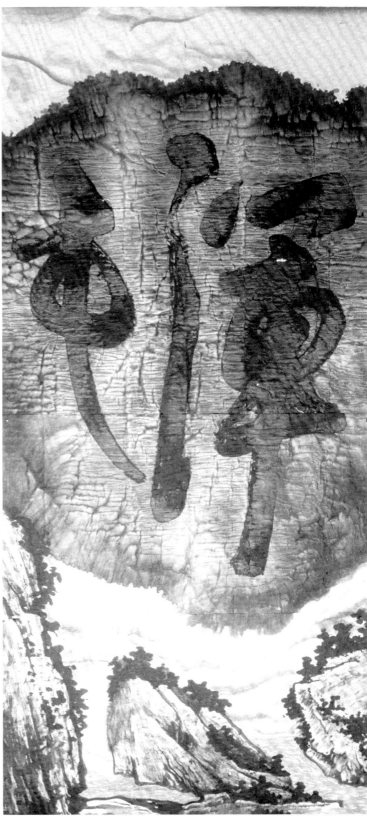

奠基與建立當代水墨與書寫藝術:《遺失的王朝》

谷文達

THE FOUNDATION AND ESTABLISHMENT OF CONTEMPORARY INK ART AND TEXT ART —*LOST DYNASTIES*

gu wenda

我在剛完成的《中園》觀念書的結尾寫道:「在我兒時的記憶裏,山巒是神奇的。那是 1961 年,當時陸歲的我與祖母坐火車去我的家鄉浙江上虞,途經杭州時我問祖母,車窗外那黑黑的龐然大物是什麼?祖母告訴我是山。那是我第壹次看到山啊!出生於上海大城市的我,總算第壹次結緣於大自然了。」我與祖母那次的經歷在我畫水墨畫時常常記憶猶新。從我熱愛涉足名山大川,去體驗其雄渾持久和連綿無盡,從搜盡奇峰打草稿,到如今我最愛的綠色森林書法與河道書法所原創的園林城市的大地藝術與規劃設計,我的生活與藝術從來沒有離開過對大自然的盎然興趣。1971 年,在初中的我開始研習山水畫。1979 至 1981 年在浙江美術學院為陸儼少先生的研究生。1981 年至 1987 年我任教於浙江美院國畫系山水專業。在 85 藝術復興(即 85 新潮,中國第壹次當代藝術運動)早期已進

at the conclusion of the recently completed conceptual book *central park*, i wrote: "in my childhood memory, mountain chains were magical. that was in 1961. my grandmother and a six-year-old gu wenda took the train to my ancestral hometown, shangyu, zhejiang. on the way past hangzhou, i asked my grandmother, "what is that dark, massive thing outside the train window?" my grandmother said it was a mountain. that was my first time seeing a mountain! having lived in the big city that is shanghai, i had my first encounter with nature. that experience of mine with my grandmother is still fresh in my memory when i paint ink paintings. from my love of setting foot on famed mountains and great rivers—in order to experience their majesty, persistence, and endurance—from seeking out and making sketches of the magnificent peaks, to "green forest calligraphy and river calligraphy",a land art and garden city planning and design project (which was my favorite), my life and art have never strayed from my abundant interest in nature. in 1971, in junior high school, i started to study traditional chinese painting. from 1979 to 1981, i was a graduate student under professor lu yanshao at the zhejiang academy of art. from 1981 to 1987, i took up a lecturing position in the landscape concentration within the department of chinese painting at the zhejiang academy of art. by the early stages of the '85 new wave (the birth of chinese contemporary art), i had already entered

入我的創作鼎盛時期開始創建當代觀念水墨藝術，水墨裝置藝術和水墨行為藝術。

1987 年去美國時，大家嘆息我離開水墨界是壹個損失。但實際的情況是大家未知的，即我從未停止過水墨演進。1999 年至 2006 年間我以中國人髮粉創作了炎黃基因墨，以綠茶葉創製了綠茶宣紙，谷氏簡詞系列水墨畫、水墨行為藝術的文化婚禮系列、水墨與動畫系列等等。2008 年至今的綠色森林書法與河道書法為觀念意向的《中園》。

伍仟年文明的自然觀一直伴隨着我。這是壹種生活方式、壹種潛移默化，常常是意識不到的壹種存在和體驗。

1971—1979

那是在我初中和高中的日子裏，文化大革命正如火如荼地展開。我與其他同學一起經歷了停課與復課鬧革命的風風雨雨。由於我有壹技之長的美術能力，我成了當時上海烽火中學大字報專欄的美工。由于我的兄長畫畫，所以我常常請我哥哥指點我的中學裏的大字報宣傳欄的刊頭畫和美術字等等。我特別記憶猶新的是在我哥哥的指導下臨摹金訓華烈士那張奮不顧身地在大浪中為營救他人而英勇獻身的英雄事迹的素描，那是給我的中學做大字報專欄報頭的。無論如何沒有想到，那時滿腔熱情地參與文化大革命的美工經歷，卻影響了我後來壹批偽文字系列觀念水墨畫的構成因素之壹！

my creative heyday and started establishing contemporary conceptual ink art, ink installation art, and ink performance art.

when i went to the united states in 1987, everyone lamented how it was a loss that i had left the world of ink. but the actual situation was unknown to everyone, which was that i had never stopped evolving with ink. between 1999 and 2006, i created "yanhuang dna ink" with powder from the hair of chinese people, "green tea xuan paper" with green tea leaves, the *jiancidian series* of ink paintings, the *gu's wedding life* series of ink performance art and various ink and animation series. from 2008 to the present, there was *zhong yuan*, with a concept based on green forest calligraphy and river calligraphy.

i have always been accompanied by a perspective on nature which is based on five thousand years of chinese civilization. this is a mode of living, is a subtle, imperceptible influence—often an existence and experience that cannot be detected.

1971–1979

i was in junior school and high school and the cultural revolution was raging. together, my classmates and i experienced the trials and tribulations of classes cancelled and then restarted, with the ups and downs of the revolution. due to my artistic abilities, i became an art worker making "big character posters" for the bulletin boards at the shanghai fenghuo middle school. because my elder brother painted, i frequently asked my brother to give me tips on the masthead images and artistic typography for the big character posters at middle school. i recall especially clearly the experience of copying a sketch of jin xunhua, under my brother's guidance. jin was a martyr with a heroic tale. he sacrificed himself amidst crashing waves to save the lives of others. that image was on the masthead of the big character poster at my school. i could never have imagined how that experience as an art worker participating ardently in the cultural revolution ended up being one of the factors which influenced me to compose a series of conceptual ink painting with pseudo-characters!

杜春林老師是我們學校唯有的壹位美術老師。他的至交是壹位剛嶄露頭角的新國畫山水畫家叫許根榮。他因與戴敦邦一起創作的連環畫《水上交通站》而名聲鵲起。經由杜春林老師的介紹之後我就拜他為師，並常常去他的家裏請他指點。

1973 年正值我高中畢業之際，幸運的是上海工藝美術學校在文革後期重新開始招生。

1976 年我畢業於上海工藝美術學校後，我拜了曹簡樓先生做私人老師。從那時起我開始接觸正統的詩書畫印的熏陶。吳昌碩的沒骨大寫意的境界與金石篆書入畫的渾厚凝重風範對於我的影響，現在看來是在於我的水墨世界中追求博大精深，雄渾神秘的境界，也許也一直影響到我後來的《聯合國》與《碑林 —— 唐詩後著》等大規模的裝置藝術。那時的我每壹個周末上午必去往在長樂路和茂名南路口，蘭生戲院後面的 art deco 公寓的曹簡樓先生家中畫室。

1979—1981

1979 年對我來說又是壹個關鍵的轉折點。我被錄取成為陸儼少先生首屆伍名研究生之中的壹個。那年我是貳拾肆歲，正式開始了我的專業中國畫生涯。

在浙美讀研的日子裏，我的藝術實踐是有兩個極端的方面。其壹，我花在讀書的時間遠遠超過畫畫的功夫。從古今中外的哲學、文學、宗教、科學到美術史，在兩年裏，我的卡片文摘就足足有兩箱

the teacher du chunlin was the only art teacher at our school. his closest friend was a new traditional chinese and landscape painter called xu genrong, who was just starting to make a name for himself. his fame spread because of the comic (lianhuanhua) "rendezvous point on water"(shuishang jiaotongzhan). through du chunlin's introduction, xu genrong became my teacher and I routinely went to his house for advice and pointers.

in 1973, just as i was about to graduate from high school, shanghai arts and crafts college fortunately started to take on new students once again in this later period during the cultural revolution.

when i graduated from shanghai arts and craft college in 1976, i asked to study as a private student under master cao jianlou. from that point onwards, i came under the influence of the orthodox tradition of poetry, calligraphy, painting, and seal engraving. the dignified manner of wu changshuo's freestyle mogu boneless technique (meaning without contours) and the jinshi-script calligraphy, impacted me in a strong and profound way. now that i look at it, it seemes to have affected how i now seek out the immense, the deep, the vigorous, and the mysterious within the world of ink. perhaps it has always influenced my large-scale installation art series including *united nations* and *forest of stone steles—post tang poetry*. at that time, every weekend morning i would go to the painting studio of master cao jianlou, who lived in an art deco apartment behind lansheng theater, on the corner of changle road and south maoming road.

1979-1981

1979 for me was yet another key turning point. i was accepted as one of the five graduate students of prof. lu that first year. at the time, i was 24 years old and officially started my professional career in chinese painting.

in those days, doing graduate studies at the zhejiang academy, my artistic practice had two extremes. one extreme was that the time i spent on reading far, far exceeded the time I spent painting. from philosophy, to literature, to religion, to science and to art history, from ancient to modern, from china to

子。我研習達爾文的物種起源，弗洛伊德的心理學，愛因斯坦的相對論，波爾的量子力學。在哲學上我研習叔本華、尼采到博格森，黑格爾到維根斯坦，羅素到波普爾。文學上從希臘神話、悲劇、莎士比亞到陀思妥耶夫斯基、薩特等等。同時也是我開始了當代前衛藝術的探索，特別在當代觀念水墨藝術的探索。如同我在 85 藝術復興中所設置的自我是一樣的，我接受的很多東西不是從美術界來的，我更希望接受的是非美術界的東西，比如我選擇製造文字作為我的大型水墨畫，水墨裝置和水墨行為藝術的核心，就與當時的前衛藝術全盤西方化的流行語言大相庭徑。比如我對現代生物基因學特別感興趣，這導致我做了與人體材料有關的作品。我對生物學感興趣，生物基因科學會徹底改造人類或改變人類（下面我會談到 21 世紀作為生物時代）。我自身的知識結構應該是跨領域之間的接觸、碰撞、誤解、嫁接直至原創。自 1981 年我畢業於浙江美術學院中國畫系山水畫專業並留校任教到 85 美術運動的前夕，血氣方剛而初生牛犢不怕虎的我，對被年輕藝術家頂禮膜拜的西方現代主義以及被保守主義捧為至寶的中國傳統經典均不屑壹顧。現在想來我那時其實很幼稚。其貳，在我的短文《回憶與陸儼少老師的貳叁事》中回憶了我在陸老師身邊的日子。這些話語實際上是對自己過去的反思。

1981—1987

我的壹批大型水墨書法繪畫，水墨行為藝術和水墨裝置藝術均從我任教於浙江美院國畫系的 1981 年開始至我赴美 1987 年間的創事。記得那年就連我

abroad—in those two years, just my note cards filled up two boxes. i studied darwin's origin of species, freud's psychology, einstein's theory of relativity, bohr's quantum mechanics. in philosophy, i studied schopenhauer, nietzsche, bergsen, hegel, wittgenstein, russell and popper. in literature, i studied greek myths and tragedies, Shakespeare, dostoyevsky, sartre and so on. at the same time, i also started exploring contemporary avant-garde art, especially contemporary conceptual ink art. just like how i positioned myself within the '85 new wave, many things which influenced me did not come from the world of art; and i actually preferred those non-art things. for instance, i chose text as the core of my large-scale ink paintings, ink installations, and ink performance art pieces, which ran completely contrary to the big picture of the popular discourse of complete westernization which dominated avant-garde art at the time. for instance, my special interest in modern biology and genetics led me to create works concerned with the body. i was interested in how biology and genetics utterly reworked or transformed humanity (below i will discuss the twenty-first century as the age of biology). my own structures of knowledge were formed due to cross-disciplinary encounters, clashes, misunderstandings, and then transplanted into my original creations. from 1981, when i graduated from the landscape painting major at the department of chinese painting at the zhejiang academy of art—after which i stayed behind to teach—until the eve of the '85 new wave, i was a full-blooded, fearless young turk who disdained the western modernism worshipped by young artists and the chinese tradition which was elevated to the status of national treasure by conservatives. now that i think about it, i was actually pretty naive. second, in my short piece, "*a few recollections with my teacher lu yanshao*," i reminisced about the time where i spent with professor lu. these words were in fact my reflections on my own past.

1981–1987

a number of my large-scale ink calligraphy paintings, ink performances, and ink installation artworks were produced between 1981, when i took on a teaching position at the department of chinese painting at the zhejiang academy of art, and 1987, when i left for the united states. i remember that year when even my graduating work as a student in traditional

國畫山水畫研究生的畢業創作都有爭議的。當時院裏對我們這屆研究生畢業創作展覽有指示：谷文達的畢業創作不能出版。奇怪是我竟然留校了。對我來說它一直是壹個迷。後來才知道，浙江美院國畫系的孔仲起老師一直在支持我，谷文達應該留校。

在留校之後的教職和專業生涯裏，我的當代觀念水墨畫得到了那時是中國畫系的美術史家，後為浙美院長和現為央美院長的潘公凱先生的支持。記得我當時的住處與潘公凱的家門對門（現為潘天壽紀念館）。我的巨幅水墨《天空與海洋》被當時為校刊《新美術》的主編的潘公凱先生登上了《新美術》的封底介紹。記得除了潘公凱先生之外，我也曾得到了浙美副院長，中國畫系的副主任宋忠元先生和國畫系副主任黃發榜先生的支持。實際上我那個時期的水墨藝術創作已經到了所謂皮道堅先生以及其他的一些評論家等稱之為「宇宙流」如是說了。我自己能夠清晰憶及的是那樣壹種水墨的創造，她融合了我將大潑墨推到極端水墨淋漓盡致和特殊水墨肌理與超現實主義，象徵主義，意識流文學，存在主義哲學，卡夫卡式的神秘主義等等觀念和境界。此間的作品包括我的畢業創作《李斯特鋼琴協奏曲》的叁聯畫《日》《夜》與《風雨到來之前》。主要作品為《天空與海洋》《超現實地平綫》《壹個女人的恐懼症》《加繆像》《戰爭與和平》《有機山水》系列《靜物山水》系列《人體山水》系列與《紅心》系列等等。這些作品的創作年代比我的文字系列的觀念水墨畫、水墨裝置藝術和水墨行為藝術略早幾年，但也有壹部分是同時創作時期的。

chinese and landscape painting was controversial. within the academy then, there was a guideline about the graduating exhibition for our year: gu wenda's graduating work could not be published. the strange thing was that i was asked to stay behind and teach. for me, it was always a mystery. only later did i find out that professor kong zhongqi always supported me, arguing that i should be retained.

in my teaching and professional career afterwards, my contemporary conceptual ink paintings gained the support of professor pan gongkai, then an art historian in the department of chinese painting, and later the president of zhejiang academy of art and currently the president of the central academy of fine art. i remember how i used to live across from pan gongkai's family (now the pan tianshou memorial). my huge ink painting *sky and ocean* was introduced on the back cover of *xin meishu* ["new arts"] by pan gongkai, who was then editor-in-chief of the academy's periodical. i remember that, aside from pan gongkai, i had also attained the support of professor. song zhongyuan, the vice-president of the zhejiang academy of art and the deputy director of the department of chinese painting, as well as the support of professor. huang fabang, the deputy director of the chinese painting department. in actual fact, my ink work from that period had already reached that level of "universal flow," as coined by professor pi daojian and some other theorists. what i can clearly remember about that kind of ink creation is that it fuses my extension of the great splatter of ink into a radical, special ink texture with the ideas of surrealism, symbolism, stream-of-consciousness literature, existentialist philosophy, kafkaesque mysticism and so on. the works from this period include the triptych *sun, night,* and *before storm* from the *liszt piano concerto,* my graduation piece. main works included *sky & ocean, surreal horizon, a woman's fear, a portrait of camus, war and peace, organic landscape series, landscape as still life series, body landscape series* and *red heart series.* these works were created at a time a few years earlier than the conceptual paintings, ink installation art, and ink performance art from my writing series, but there were some which were created during the same time period.

接下來我用注解的方式對我那個時期的主要作品做一些我的分析。

僞漢字圖章

此圖章是我首次以創造出來的僞漢字刻製而成。也是我的觀念水墨畫的開端。從那時起，我以文字書法為主題創作了壹系列觀念水墨畫、水墨裝置藝術和水墨行為藝術。現在回憶起來，更能清晰地看到這壹系列以創造性僞文字、錯文字、非常態文字為主題主體的觀念水墨藝術，有其形成的叁個重要原因。其壹，可閱讀的文字的矛盾性。我從 1980 年開始着重閱讀西方的近現代哲學。我讀尼采、羅素和維特根斯坦的著作，並集中精力研究他們有關語言的哲學。維特根斯坦與羅素有壹個很著名的爭議，羅素認為人的語言最終可以解釋世界。我們現在不能用語言表達清楚的宇宙裏的東西，我們語言的發展會在將來可以把未知的東西的解釋清楚。可知性是通過人的發展，通過推理來理解它的。從這壹點來看，羅素是壹個理想主義者。而維特根斯坦的觀點是典型的實證主義者和神秘主義者。當時我贊成維特根斯坦的理念。因為人的知識在發展，人的認知力與表達力在發展，我們也許可以用將來的語言解釋我們現在不能解釋的宇宙中的一些現象和本質。但宇宙也在同步發展，可惜的是我們的理解力和語言力永遠是壹個被動式，去被動地解釋永恒生發中的宇宙。我們已經被永久地判罰去不斷發明新的語言，並以它去試圖解釋永遠發展着的宇宙萬物，就像希臘神話裏的西西弗斯被永遠判罰推巨石上山那樣。

below i will offer some analyses about my major works from that period in note form:

NOTES ON "PSEUDO-CHARACTER SEALS"

these seals were created from the first invented pseudo-chinese characters which i engraved; they are also the start of my conceptual ink paintings. from that point onwards, i created a series of conceptual ink paintings, ink installation artworks and ink performance art pieces on the theme of writing and calligraphy. now that i think back on it, i can see more clearly that there were three main factors in this series of conceptual ink art with the theme of pseudo-characters, incorrect characters, and non-standard characters. first, the contradictory nature of legible writing. from 1980 onwards i read modern western philosophy, the works of nietzsche, russell, and wittgenstein, and focused particularly on their philosophies of language. wittgenstein and russell had a famous dispute: russell believed that human language could ultimately explain the world. though there may be things in the universe that we cannot express very well with language now, through the development of our language, we will be able to explain the unknown clearly in the future. knowability can be understood through the development of humanity and through logic. from this point of view, russell is an idealist. wittgenstein's point of view, however, is that of a classic positivist and mystic. at the time, i agreed with wittgenstein's ideas. since human knowledge is developing alongside human perception and expressiveness, with a future language, we might perhaps be able to explain certain phenomena and essences in the universe that we cannot currently explain. but the universe is also developing at the same time; unfortunately, our abilities of comprehension and language are forever passive, passively interpreting the universe which is always in constant change. we are already forever condemned to continually invent new languages, and with this, attempt to interpret the myriad things of the universe which are continually developing, just as in the greek myth, sisyphus is forever condemned to roll a huge boulder up a hill.

如此，當我在面對文字的定義和用文字的定義來解釋時，我驚訝僵硬而教條的字義和不確定的宇宙流之間的距離如同天方夜譚。某個科學雜誌說「壹個初生嬰兒的細胞分裂很規律，如果人的壹生都遵照初生嬰兒的細胞分裂方式，人的壽命可以達到 3000 歲而不產生癌細胞。」也就是說人體細胞分裂其實是隨着人的生長時間而變化的。這個很容易理解，人體到了一定時間就開始青春期，其發展完全不同於嬰兒和幼兒期。我們怎麼知道宇宙的發展不是像壹個嬰兒一樣隨着時間的變化而變化？這兒羅素講的是壹個初生嬰兒的細胞分裂很規律，人的壽命可以達到 3000 歲而不產生癌細胞。而維特根斯坦要想說我們怎麼知道宇宙的發展不是像壹個嬰兒一樣隨着時間的變化而變化？

另外，我那時也開始接觸證偽哲學。1919 年愛因斯坦的廣義相對論得到了驗證，人類從此不再用絕對時空觀來看待世界。經過數佰年無數次檢驗的牛頓力學竟然被證明不是完全正確的。愛因斯坦的廣義相對論影響了仍在求學的波普爾。我最後發現波普爾終生致力於研究科學理論和非科學理論之間區別同樣是壹個偏執。任何偏執的學問在某壹點上可能可以成立。波普爾的基本結論就是：凡是可能被證偽的理論才是科學理論。依照他的標準，弗羅伊德的心理學和達爾文進化論都不是科學的理論，因為無法進行壹個可觀察的預測，然後檢驗這個預測是否符合實際。波普爾與弗羅伊德的心理學和達爾文進化論的方法論毫無二至。科學理論和非科學理論當他們互偽的時候才是真實的。可能被證偽的理論與不能證偽的理論

in this way, when i was confronted with the literal definition of words and explaining that literal definition, i was astonished how vast the chasm is between the ossified and dogmatic meanings of words and the uncertainties in the flow of the universe. as a certain scientific magazine noted: "cellular division in a new-born infant is very regular. if a humans could adhere to the mode of cellular division of a new-born infant throughout their lives, human longevity could reach up to 3000 years without cancerous cells being produced." in other words, cellular division in human bodies in fact changes through the human lifespan. this is readily understandable. upon reaching a certain point, the human body will initiate puberty, where the growth is completely different from infancy and childhood. how do we know that the development of the universe is not like an infant, in that it changes along with the passage of time?" here, russell talks more about how the cellular division of a new-born infant is normal, which would allow us to reach an age of 3000 years without cancerous cells being produced, while wittgenstein would ask how do we know that the development of the universe is not like that of an infant, changing along with the passage of time?

furthermore, i then started being in contact with philosophies of falsifiability. in 1919, einstein's general theory of relativity was validated, and from then on humanity would never view the world from an absolute perspective of space and time. after countless experiments over several centuries, newtonian mechanics actually ended up being proven to be not entirely correct. einstein's general theory of relativity affected popper, who was then still studying. in the end, i discovered that popper's life work in distinguishing the differences between scientific and non-scientific theories was equally obsessive. any biased form of study ends up validating itself at some point. popper's basic conclusion was this: only theories that can be falsified are scientific theories. according to his criterion, freudian psychology and darwin's theory of evolution are not scientific theories, since there is no way to undertake an observable prediction and test whether they are true. popper's ideas are at one with the methodology of freud's psychology and darwin's theory of evolution. the only truth is when scientific theories and non-scientific theories interact. the only objectivity comes through the synthesis of disproven theories and proven

的總和才是客觀的。對我來說波普爾的證偽的科學哲學是開了壹個嚴肅的玩笑。我 1983 年到 1987 年的《遺失的王朝——a 系列 #1-#50》的創作和 1986 年《中國美術報》發表的我撰寫的《諧音字文章》實際上希望解釋如此的壹個哲學命題。幾乎沒有評論家意識到這壹點。他們的泛泛而談的只是錯篆字而已。

《遺失的王朝》a 系列 #1-#50

此系列的創作以偽篆字為主體，並穿插入壹部分真篆字而成。實際上對於我們現代人來講，真篆字與偽造的篆字從識辨字的角度來說是如出壹轍，同樣不可閱讀。當時我面對的不可閱讀的篆書，是我以創造性偽文字錯文字和非常態文字形成的觀念水墨藝術形成的叁個重要原因之其貳。其壹如果我們將不能識辨的真篆字與偽造的篆字作為歷史與文化的載體來理解，那麼歷史和文化，我們畢竟能辨認真偽嗎？因此它是壹個迷宮，也是壹個啟示錄。我們的語言學家如此廢寢忘食地企圖破譯古埃及古瑪雅文字，但是我們會有詮譯？就是我們對古文字有詮譯也僅僅掌握了當時的社會需要和著者的動機，而非還原歷史。就是不現實地說如果我們還想了解客觀的宇宙和還原我們的文明史，我們的語言文字能擔當嗎？

《諧音字文章》

《中國美術報》在 1987 年的第貳期發表的我的《非陳述的宣言》。此文是我以查字典找諧音字的方式寫就的。「藝術行為、藝術環境、藝術過程」，標

theories. for me, popper's scientific philosophy of falsifiability opened up a serious joke. the work *lost dynasties a series #1–50* from 1983 to 1987 and the *xieyinzi wenzhang* (homophonic article) that i wrote for the *zhongguo meishubao* [*the arts in china*] in 1986 tried to explain this philosophical issue. practically no critic knows this information. they only tend to talk in generalities about pseudo-seal script characters.

NOTES ON *LOST DYNASTIES A SERIES 1–50*

this series of works deals with pseudo seal script characters, which are formed by inserting fragments of real seal script characters. in actual fact, for us modern people, genuine seal script characters and pseudo seal script characters are no different, as far as intelligibility is concerned—they are both illegible. when i was then faced with the illegible seal script, the second of the three major reasons why i created this conceptual ink art from pseudo, false and non-standard scripts emerged. first, if we cannot distinguish unintelligible genuine seal script characters and pseudo seal script characters as carriers of history and culture, then can we in the end distinguish the true and the false in history and culture? hence it is a labyrinth and a revelation. our linguists tirelessly seek to decipher the scripts from ancient egypt and the ancient mayan empire, but will we ever have an understanding? that is, our interpretation of the ancient writing merely grasps at the needs of the societies then and the motives of the writers—rather than restoring history. so, if we unrealistically say we still want to understand the objective universe and restore our history of civilization, can our language take on this responsibility?

NOTES ON *HOMOPHONIC ARTICLE*

in its second issue of 1987, *zhongguo meishubao* (*the arts in china*) printed my ***non-declarative manifesto***. this text was written by looking up homophonic characters in the dictionary. the title of "art performance, artistic environment, artistic process" was expressed through such language games using the homophonic characters「飛沉術白勺楦鹽—蟻術形違、异數王不竟、蜥鼠『過懲』」or "flying, sinking, technique, white, spoon, [shoe] last, salt,—ant, technique, shape, violation,

題是用「飛沉術白勺楦鹽—蟻術形違、异數王不竟、蜥鼠『過懲』」的文字遊戲方式表達的。將字拆開或者合併，或者用同音字，按字音理解的時候是對的，但字是錯的，音和字是分開的，產生兩個意義。影響到我以偽文字、改體字、錯體字、漏體字、諧音字和印刷體字的水墨書法繪畫、水墨行為藝術和水墨裝置藝術第貳個原因，是我那時開始深入地研習起了中國的篆書。面對大部分的篆字我認不出來，它的不可閱讀性使我感到了壹種前所未有的超於文字定義和閱讀經驗之外的解放感和自由感。從開始對文字的不信任，到對由文字表述的歷史和文化產生了絕對的質疑。至於第叄個原因影響到我的水墨書法繪畫的，是文化大革命中的大字報的書法情結。我會在以下的段落中會介紹仔細陳述文化大革命中的大字報的書法引領政治波普藝術。

《遺失的王朝 —— 靜觀的世界》

在多如牛毛的形形色色的展覽中，當代水墨畫展覽的集大成者，實際上是 1984 年在武漢的湖北全國國畫邀請展。周韶華先生作為湖北文聯的老幹部，在那年頭如此有膽量與眼光組織起這麼壹個影響至今的展覽是非常難能可貴。我以偽文字、改體字、錯體字、漏體字和印刷體字的壹套大型的水墨書畫繪畫參與了湖北全國國畫邀請展，也是此系列首次在大型公共展覽空間展出。此巨幅水墨畫系列震動了當時的國畫界。在此湖北全國國畫邀請展中，與其他為數眾多的來自全國各地參展的藝術家的創新國畫比較而相去甚遠，大家感到的

different, number, king, does not, end, lizard, mouse, 'excessive, punishment.'" in separating or merging characters or using homophones when looking at the sounds, they appear correct, but the characters are wrong. the separation of sound and character produces two meanings which have affected my pseudo characters, distorted characters, typo-characters, characters with missing parts, typed character ink paintings, ink performance and ink installation art. the second reason was that i began to make deep studies of seal script. faced with the large numbers of seal-script characters that i did not recognize, i discovered that this illegibility made me feel a sense of liberation and freedom i had never before experienced, which lay beyond the definition of meaning and the experience of reading—from the initial mistrust of writing to an absolute doubt about the history and culture narrated by writing. the third reason which affected my ink calligraphy and painting was the psychological complex surrounding calligraphy and big character posters (dazibao) during the cultural revolution. in the passages below, i will explain in greater detail the ways in which the calligraphy of the big character poster in the cultural revolution led the way towards political pop art.

NOTES ON *LOST DYNASTIES-TRANQUILITY COMES FROM MEDITATION*

among the very many different exhibitions, the epitome of the contemporary ink painting exhibition was in fact the hubei national chinese painting invitational exhibition in wuhan in 1984. as an old cadre of the hubei literary and art circles, mr. zhou shaohua had the courage and eye to organize such an exhibition—influential still to this day—which was truly praiseworthy. i participated with my large-scale ink calligraphy and paintings—which involved pseudo characters, transformed characters, wrong characters, characters with missing bits, and characters with similar sounds, and printed font characters. this series of huge ink paintings shocked traditional chinese painting circles at that time. the paintings exhibited in hubei were really quite distant from the other innovative chinese paintings by the majority of artists in all kinds of exhibitions around the country; the distance we sensed was due to the sheer inner meaning—that broad and profound realm of conceptual ink painting. no

距離是因為觀念水墨畫的內涵與博大精深的境界。無論評論家怎樣命名它們（當時對我的水墨藝術的評論很多），實際上此系列作品建立了中國觀念主義的水墨藝術。由邵大箴先生為主編，唐慶年先生為執行編輯的壹年的第叁期《美術》首篇文章便是栗憲庭先生的文章《中國水墨畫的合理發展》。而《遺失的王朝 —— 靜觀的世界》系列是開宗明義的圖解。1998 年，劉國松先生在中國台灣的《文星》雜誌上以長篇文章《谷文達：破壞傳統的浪子》為題系統地介紹了我的觀念主義水墨畫。

《遺失的王朝 —— 我批閱叁男叁女書寫的靜字》

此畫是我首次將水墨畫與行為藝術結合。1985 年的壹天，我的工作室是在西湖邊近柳浪聞鶯的浙江美術學院內。那兒我完成了此水墨行為藝術。我分別邀請了陸位學院國畫系的學生，每個學生都以單獨身份前後出現在工作室。陸學生分別在同壹巨幅宣紙上書寫大尺寸「靜」變體或錯字。陸位國畫系的學生完成各自的錯「靜」字之後，我在墨迹未乾的「靜」字上用大量的水進行破墨的過程，並在「靜」字畫上「叉」與「圈」。這壹方式是行為化了和擴大化了的老師為學生批改作業時以「叉」與「圈」表示「對」與「錯」。同時又展現了文革期間大字報的形式。《我批閱叁男叁女書寫的靜字》又與另壹幅水墨畫《遺失的王朝 —— 圖騰與禁忌的現代意義》都明顯採用了文革大字報書法的形式。在這行為水墨之後，即在 1985-1987 年間，我又創作了兩個在大型水墨畫環境中的《無聲演講》。

matter what labels critics applied to them (there was at the time a lot of criticism about my ink art). in fact, this series established conceptual ink art in china. the first issue of *meishu* in 1986 (the editor in chief was mr. shao dazhen, with mr. tang qingnian as the managing editor), included mr. li xianting's text *the rational development of chinese ink painting* (*zhongguo shuimo hua de heli fazhan*) and the series *lost dynasties—tranquility comes from meditation* was used as an illustration. in 1998, mr. liu guosung wrote a long text *gu wenda: the prodigal who destroyed tradition* (*gu wenda: pohuai chuantong de langzi*), which was published in the magazine *wenhsing* (*wenxing*) in taiwan, china and which systematically introduced my conceptual region ink painting in the vein of the title of his piece.

NOTES ON *LOST DYNASTIES—I EVALUATE CHARACTERS WRITTEN BY THREE MEN AND THREE WOMEN*

this painting was the first time i combined ink painting and performance art. one day in 1985, i was in my studio within the zhejiang academy of art near "orioles singing in the willows" (a famed scenic spot) on the shores of the west lake (in hangzhou)—it was there that i completed this ink performance piece. i respectively invited six students from the department of chinese painting within the academy; each of the students appeared alone in the studio, one after the other. each of the six students wrote on the same large sheet of xuan paper a transformed or wrong character of "jing" ("quiet") 靜 in an extra-large size. after they finished their own wrong character "jing", on top of these characters of "jing", with ink still wet, i poured a large amount of water to destroy the ink, and then wrote crosses and circles on the "jing". this method was an attempt to render performative the marks (crosses and circles) that teachers make when correcting their students' exercises to indicate "right" and "wrong." at the same time, it also presented the form of the big character posters during the cultural revolution. the work *i evaluate characters written by three men and three women,* and *lost dynasty—modern meaning of totems and taboos,* both clearly employ the calligraphy format of the big character posters in the cultural revolution. after this ink performance—or in other words between 1985 and 1987—i

《遺失的王朝 —— 圖騰與禁忌的現代意義》《遺失的王朝 —— 我批閱叁男叁女所寫的靜字》《靜則生靈》《他 × 她》

有關文革大字報的書法意義，我在很多訪談裏面都談到了的。這是我的以創造性僞文字錯文字和非常態文字形成的觀念水墨藝術形成的叁個重要原因之其叁。我一直認爲，中國當代書法從解放以來一直到現在，中國當代書法中最富有獨立價值的，並且是真正以熱血與信仰去寫的，那就是這些勞動人民的書法 —— 大字報書法。「文革大字報書法」裏面有很多是有語法錯誤、錯別字等等，因爲他們中間有很多人是從來沒有受過教育的工人農民。《我批閱叁男叁女所寫的靜字》裏面有壹個叉子，紅叉子、黑叉子、紅圈子，實際上是受「文革」的影響，也是我最早實現的水墨與政治波普、也許同樣是中國當代藝術運動中最早出現的波普藝術之壹，而且是如此壹種政治波普，它的價值是獨立於大部分我們當代藝術中的波普基本是西方的照搬的翻版。而《遺失的王朝 —— 圖騰與禁忌的現代意義》是最具代表性的作品之壹。其它的代表作品包括《靜則生靈》和《他 × 她》。

《靜則生靈》和《他 × 她》

開水墨裝置藝術之端倪。前些天在接受 *artinfo* 中國主編 madeleine o'dea 的電話採訪時，她告訴我她在寫壹篇紀念萬曼先生的文。她問及我有關與萬曼先生在一起的經歷。我告訴她我特別有幸的是我在萬曼工作室完成的兩件巨型的作品建樹了

created another two large-scale *silent speeches* in the ink painting environment.

NOTES ON *LOST DYNASTIES—MODERN MEANING OF TOTEMS AND TABOOS, LOST DYNASTIES—I EVALUATE CHARACTERS WRITTEN BY THREE MEN AND THREE WOMEN, AND WISDOM COMES FROM TRANQUILITY, SHES × HES*

i have talked about the calligraphic significance of the cultural revolution big character posters in many interviews. it is the third major reason why i created a conceptual ink art with pseudo, wrong, and non-standard characters. i also believe that within contemporary chinese calligraphy, from liberation in 1949 onwards to the present day, the calligraphy with the richest independent value within contemporary chinese calligraphy—which was written with real passion and faith—is the calligraphy of the workers, the masses: the calligraphy of the big character poster. the "cultural revolution big character poster" calligraphy included many grammatical errors and spelling mistakes, since many of the writers were workers and peasants who never received education. the crosses—red crosses, black crosses, red circles—in *i evaluate characters written by three men and three women* were in fact influenced by the cultural revolution. it was also the first time i realized the combination of ink art and political pop into reality; and it was perhaps one of the first works of political pop within the movement of contemporary art in china. moreover, this kind of political pop has a value which is independent from the majority of the pop in our contemporary art, which is basically a copy of western pop art. *lost dynasties—modern meaning of totems and taboos* is one of the most representative works; other representative works include *tranquility comes from meditation* and *shes × hes*.

NOTES ON *WISDOM COMES FROM TRANQUILITY, SHES × HES*

the first inkling of ink installation art. a few days ago, while

中國最早的水墨裝置藝術。大概 1982 年左右，從保加利亞來的壁挂藝術家萬曼先生在浙江美院創辦了壁挂工作室。我不是雕塑研究室的成員，但在萬曼先生盛情邀請下大約在 1984 年始我參與為瑞士洛桑國際壁挂雙年展的創作。我的創作切入點是水墨畫與混合材料的裝置藝術。我做了兩件大型水墨裝置作品《靜則生靈》和《他 × 她》。那兩個作品是我做的裝置藝術，和水墨結合的裝置藝術，是水墨的、立體的水墨畫，立體的水墨裝置，也是我整個創作過程裏面重要的兩件作品。並且是中國當代藝術家首次參加國際雙年展。

陝西楊陵召開的全國中國畫學術討論會
（1986 年 6 月 22 日至 26 日）

1985 年，國畫界仍在紛紛揚揚地談論我在湖北全國國畫邀請展上展出的大型觀念水墨畫。當時在陝西國畫院工作，現為西安美術學院美術史博導程征先生來到我當時浙江美術學院的住所，與我談及中國藝術研究院和陝西美術家協會正在聯合籌劃全國中國畫理論討論會，地點定在陝西省西安市近郊的楊陵，時間為 1986 年夏天。他告訴我這次全國中國畫理論討論會擬主辦兩個個人畫展以配合研討會：壹個是傳統的山水畫，另壹個是前衛的水墨展。程征先生直截了當地問及我是否有興趣把我近期水墨研究的成果在全國中國畫壹個展覽。那時我正在忙於壹系列以創造性文字和偽文字為主題的觀念水墨藝術，同時我也正在浙江美院的萬曼壁挂工作室創作水墨與編織的大型裝置藝

doing an interview with the editor-in-chief of *artinfo* china, madeleine o'dea, o'dea told me that she was writing a text commemorating mr. maryn varbanov. she asked about my experiences with mr. varbanov. i told her i was especially fortunate to have completed two large-scale works in mr. varbanov's studio which established the earliest ink installation art in china. around 1982, mr. varbanov, the wall-tapestry artist from bulgaria, created the wall hanging studio at the zhejiang academy of art. i was not a member of the sculptural research studio, but under mr. varbanov's incredibly kind invitation, i participated in the lausanne international wall hanging biennial in switzerland at around 1984. the starting point of my work was an installation art piece with ink painting and mixed media. i created two large-scale ink installation works, *wisdom comes from tranquility* and *shes × hes.* the two pieces are installation art pieces, installation art pieces with ink, or three-dimensional ink painting, or three-dimensional ink installation; they are also the two most important pieces in my entire creative process. that was also the first time a contemporary chinese artist had participated in an international biennial.

NOTES ON THE NATIONAL "ACADEMIC COLLOQIUM ON CHINESE PAINTING" (HELD IN YANGLING, SHAANXI, JUNE 22–26, 1986)

in 1985, the field of chinese painting was still busily discussing the large-scale conceptual ink painting exhibited at the hubei national chinese painting invitational exhibition. mr. cheng zheng, then working in the academy of chinese painting in shaanxi and now the phd supervisor for art history at the xi'an academy of fine arts, came to my lodgings then at the zhejiang academy of fine art and discussed with me the national symposium on chinese painting theories that was being planned jointly by the china national academy of arts (*zhongguo yishu yanjiu yuan*) and the shaanxi artists association. the site was set for yangling, on the outskirts of the city of xi'an in shaanxi province; the date was set for the summer of 1986. he told me that this national symposium on chinese painting theory intended to organize two solo exhibitions on the occasion of the symposium: one was a traditional landscape painting exhibition;

術。我很高興地答應了。程征先生總是給人壹個穩重求實的印象，當時程征先生還特別提醒我說：「你的展覽能否辦成還是壹個未知數。但是我做努力吧。」

由中國藝術研究院和陝西美術家協會聯合舉辦的全國中國畫理論討論會，如期於 1986 年的夏天在陝西省西安市近郊的楊陵召開。為配合此研討會的兩個國畫展覽也順利落實了：壹是代表前衛觀念水墨藝術的《谷文達水墨畫展》，在西安美術家畫廊的壹樓主展廳，另壹個展覽是代表傳統中國畫的《黃秋園畫展》，在貳樓展廳。我記得我在全國中國畫理論討論會之前到了西安，並由當時在陝西國畫院工作的程征先生安排我在陝西國畫院住下。那時我在陝西國畫院創作壹個水墨裝置藝術——將我在巨型文字水墨畫環境中的行為藝術《無聲演講》的照片文獻佈置在壹個金字塔形的構成中。

由於 1986 年的文化藝術現狀，組織者要求我在展覽前衛水墨藝術的同時，在西安美術家畫廊的叁樓展廳同時展出我的傳統寫意的山水畫。我欣然同意。作為壹個前衛探索性的水墨藝術家，要向領導、專家和觀眾說明，新國畫必須是在領會傳統中國畫的精神與筆墨的基礎上而創作的。我記得我每唸壹本當代哲學的書，總有壹篇譯者的前言，以示此書翻譯的目的是為了提供資料和要帶着批判的眼光去分析。這當然是醉翁之意不在酒了。

臨近展覽開幕，但是佈置在西安美術家畫廊壹樓主

the other was an avant-garde ink exhibition. mr. cheng zheng asked me directly if i was interested in presenting my recent results in ink research for an exhibition at this national symposium on chinese painting theory. i was then busy with a series of conceptual ink art with the theme of created characters and pseudo-characters. at the same time, i was also creating large-scale installation art with ink and braiding at the varbanov wall hanging studio at the zhejiang academy. i gladly agreed. mr. cheng zheng always left the impression of someone steady and honest and he took care to remind me, "it's still unknown whether your exhibition can be completed. but i will try my best."

the national symposium on chinese painting theory, jointly organized by the chinese national academy of arts and the shaanxi artists association, took place as scheduled in the summer of 1986 in yangling, on the outskirts of xi'an. the two chinese-painting exhibitions that coincided with the symposium were also successfully realized: one was the *gu wenda ink painting exhibition* on the first floor in main exhibition hall at the xi'an artist gallery, representing avant-garde conceptual ink painting; the other exhibition was shown on the second floor, *huang qiuyuan painting exhibition*, representing traditional chinese painting. i remember arriving in xi'an before the national symposium on chinese painting theory, cheng zheng, who then worked at the shaanxi academy of chinese painting had arranged my accommodations within academy.

at that time, I built a performance art work ***silent performance*** of photographs, and documentary materials constructed into a pyramid, sitting within the environment of large-scale textual ink works as part of the ink installation work I created at the academy.

due to the state of the cultural environment in 1986, the organizers requested that i exhibit my avant-garde ink art on the third-floor hall at the xi'an artists gallery (xi'an meishujia hualang) along with my traditional freehand (*xieyi*) landscape paintings. i gladly agreed. as an explorative avant-garde ink artist, one must clarify to the leadership, the experts and the audience that the new chinese painting must be created on the basis of grasping the spirit, brush and ink of traditional chinese

展廳的我的探索性水墨藝術展仍然沒有逃過不幸。在開展前壹刻被關閉。當時許多西安美院的學生和來參加開幕式的觀眾都擁擠在展廳大門外等候開幕，我已經知道情況發生變化了。我到了展廳門外，在擁擠的人群中聽大家的議論。人們紛紛要求重新開展：壹部分西安美院的學生嚷着要將我的畫拿到大街上去以示公正。而在叁樓展廳陳列的傳統寫意山水畫的展覽如期開展。現在我已經無法清晰地回憶那時的所有細節了，因為那時實在太混亂了。特別是對於我來說，那畢竟是我專業生涯中的第壹個個人展覽！儘管我早有了心理準備，但還是太不尋常了。當然只是那壹瞬間。其實不久我也就不以為然了。

我想不起來了到底是相隔幾天之後還是後來有人告訴我，我的畫展變成了內部觀摩展。職業藝術家只有持有陝西美術家協會主席批條才可進展場參觀。並說當時西安美院院長曾對他的研究生們講，希望他的研究生不要去看谷文達的展覽，否則能不能畢業是個問題。那時年輕的我，實在無法完全理解和預測這次的風風雨雨會產生如何的結果……

壹樓主展廳我的水墨藝術展包括的作品有《遺失的王朝 —— 我批閱叁男叁女書寫的靜字》《遺失的王朝 —— 靜觀的世界》《遺失的王朝 —— 錯位的字》《遺失的王朝 —— 圖騰與禁忌的現代意義》《遺失的王朝 —— 偽篆字》《遺失的王朝 —— 印刷體書法》《遺失的王朝 —— 正反的字》《遺失的王朝 —— 以偽字漏字倒字反字印刷體正楷草體混合書寫的

painting. i remember whenever i read a book on contemporary philosophy, there would always be a translator's foreword indicating that the translation of that book served the purposes of providing information—that one should analyze it with a critical eye. as the proverb goes, "the old tippler's delight resides not in wine."

the exhibition opening approached, but my experimental ink art exhibition situated on the first-floor main hall in xi'an artists gallery did not escape misfortune. it was shut down moments before the opening. at the time, many students from the xi'an academy of art and visitors who came to attend the opening were crowded outside the main doors of the exhibition hall awaiting the opening. but i already knew the situation had changed. i went outside the exhibition doors and listened to everyone's debates amid the throng. one after the other, people asked for the exhibition to be opened. a number of students from the xi'an art academy cried out for me to take my paintings on the street to seek justice. meanwhile, the traditional *xieyi* landscape painting exhibition on the third floor opened as scheduled. i can no longer remember now all the details at that point since it was truly too chaotic. especially for me, this was after all my first solo exhibition in my professional career! even though i had mentally prepared myself, it was too out of the ordinary. of course, it was only one moment. but after a while, i no longer took it for granted.

i can no longer recall how many days later it was when someone told me that my painting exhibition had become an exhibition for "internal viewing." professional artists could only view the exhibition with a permission slip from the chairman of the shaanxi artists association. i was also informed that the president of the xi'an art academy told his graduate students that he hoped they would not go see gu wenda's exhibition, otherwise, their graduation could become problematic. i was young then; i truly had no way to fully understand and foresee what the final result would be from such an uproar …

my ink art exhibition in the main hall on the first floor included works such as *lost dynasties—i evaluate characters written by three men and three women, lost dynasties—tranquility comes from meditation, lost dynasties—misplaced characters, lost*

杜牧詩》《天空與海洋》《中國西部 —— 敦煌》《佛宴》《沉默的門神》，以及由《兩種文化形態雜交的戲劇性》a—1 至 a—4、《兩種文化形態雜交的戲劇性》b1 至 b3 和《兩種文化形態雜交的戲劇性》c1 至 c3 等巨型幕簾式水墨畫，和我與文字觀念水墨畫裝置中的行為藝術《無聲演講》的照片文獻構成的壹金字塔。展覽中的這壹系列作品，形成了壹洋洋大觀的觀念水墨藝術的宣言。劉驍純先生為我西安楊陵全國中國畫理論討論會同時的展覽的評論中寫到：「谷文達可以說是當今中國藝壇破壞性最大，反叛意識最強，走得最遠的人，是遠離中國廣大藝術家群，更遠離公眾的超凡浪子」（1987 年第貳期《中國美術報》）。同年，對這壹系列作品作深入闡譯的是范景中先生的文章《沉默與超越》，費大為先生的采訪《向西方現代派挑戰》同時發表在由高名潞先生主編的拾月號《美術》。這也是《美術》雜誌有史以來首次破天荒，以大篇幅報道壹個前衛藝術家。有關的對我的壹系列的巨型觀念水墨藝術的創作的評論接踵而至。原武漢的現象學派哲學家張志揚先生，在其的撰文中開門見山地說道谷文達的解讀者甚多。杜柏貞女士在研究 85 藝術復興時曾在給我的電話裏說道，那時幾乎所有的藝術雜誌都在談論谷文達的藝術。

谷文達
2008 年至 2010 年
寫於上海、北京、紐約之間

dynasties—modern meaning of totems and taboos, lost dynasties—pseudo-characters in seal script, lost dynasties—characters in print script, lost dynasties—negative and positive characters, mythos of lost dynasties series—a tang poem with fake, missing, upside-down, reversed, print characters, standard and running scripts, sky & ocean, dunhuang—westen china, buddhist banquet, silent door god, drama of two culture formats merge a1-a4, drama of two culture formats merge b1–b3 and drama of two cultures formats merge c1-c3—these large-scale hanging ink paintings were shown together with the photographs and textual archives from *silent performance,* my performance piece within the textual-conceptual ink painting installation made in the form of a pyramid. this series of works in the exhibition became a spectacular manifesto for conceptual ink art. in his review of my exhibition happening concurrently with the national symposium on chinese painting theory in yangling, xi'an, mr. liu xiaochun wrote: "gu wenda can be said to be the one within the contemporary chinese art world with the greatest destructiveness, the strongest consciousness of rebellion, the one who went the furthest, and an extraordinary prodigal who departed from the vast crowd of chinese artists, and even further from the masses." (*zhongguo meishubao*, 1987, vol. 2). that same year, an in-depth explanation of this series of works was written by mr. fan jingzhong, *silence and transcendence* (chenmo yu chaoyue), while mr. fei dawei's interview, *challenging western modernists* (xiang xifang xiandai-pai tiaozhan), was simultaneously published in the october edition of *meishu*, edited by mr. gao minglu. it was also the first time that *meishu* covered an avant-garde artist in-depth in an exceptional manner. reviews and criticisms about my series of large-scale conceptual ink works followed quickly. mr. zhang zhiyang, originally a phenomenologist philosopher in wuhan, stated in his writing stated that there were many interpreters of gu wenda. ms. du bozhen, while she was researching the '85 new wave ,told me over the telephone that practically all the magazines at the time were discussing my work.

gu wenda
2008–2010
between shanghai, beijing, and new york

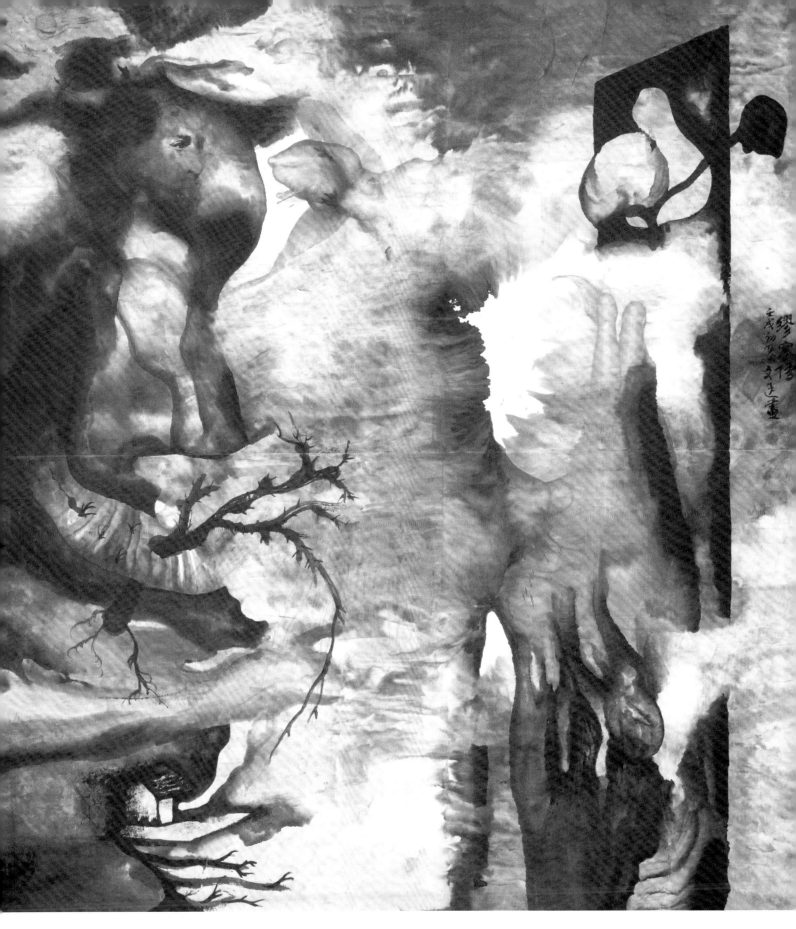

《加繆像》

1982 年於杭州工作室
墨，宣紙，紙背木板裝裱
180 厘米寬 ×200 厘米高

A PORTRAIT OF CAMUS

hangzhou studio, 1982
ink on xuan paper, mounted on paper backing and wood board
180cm wide × 200cm high

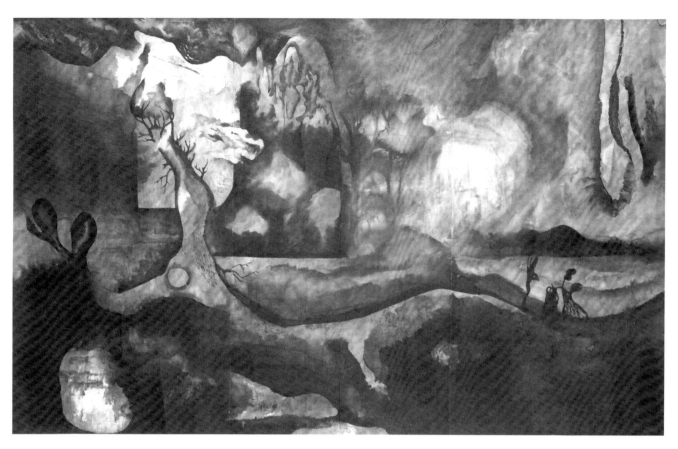

《戰爭與和平》

1982 年於杭州工作室
宣紙，墨，紙背裝裱上木板
290 厘米長 ×180 厘米高

WAR AND PEACE

hangzhou studio, 1982
ink on xuan paper, mounted on paper backing and wood board
290cm long × 180cm high

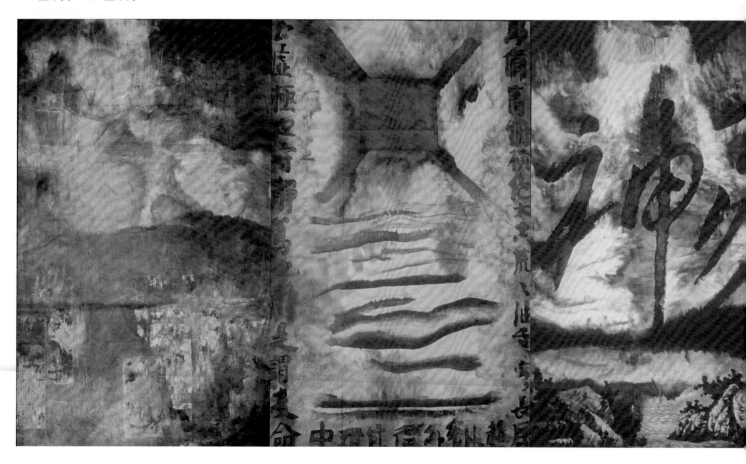

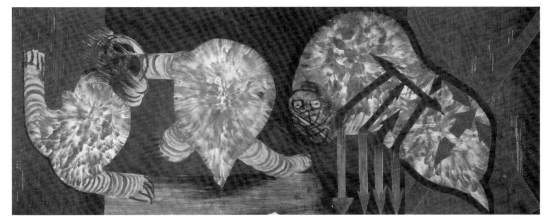

《沉默的門神》
1985 年於杭州工作室
宣紙，墨，紙背裝裱上木板
519 厘米長 × 197 厘米高

SILENT DOOR GOD
hangzhou studio, 1985
ink on xuan paper, mounted on
paper backing and wood board
519cm long × 197cm high

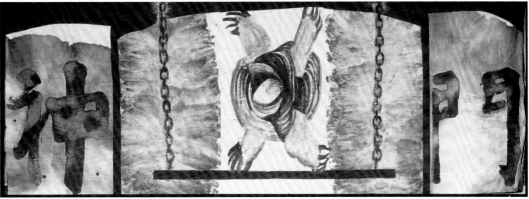

《瘋狂的門神》
1985 於杭州工作室
宣紙，墨，紙背裝裱上木板
519 厘米長 × 197 厘米高

MAD DOOR GOD
hangzhou studio, 1985
ink on xuan paper, mounted on
paper backing and wood board
519cm long × 197cm high

《靜觀的世界》
遺失的王朝系列 #1 太樸世界 /#2 文字的構
成 /#3 文字的綜合 /#4 文字的解構 /#5 覆
合的文字
1984 年於杭州工作室
墨，宣紙，紙背白梗絹邊裝裱立軸
900 厘米長 × 274.5 厘米高

**TRANQUILLITY COMES FROM
MEDITATION**
lost dynasties series #1-#5
hangzhou studio, 1984
ink on xuan paper, hanging scroll mounted
on paper backing with white silk borders
900cm long × 274.5cm high

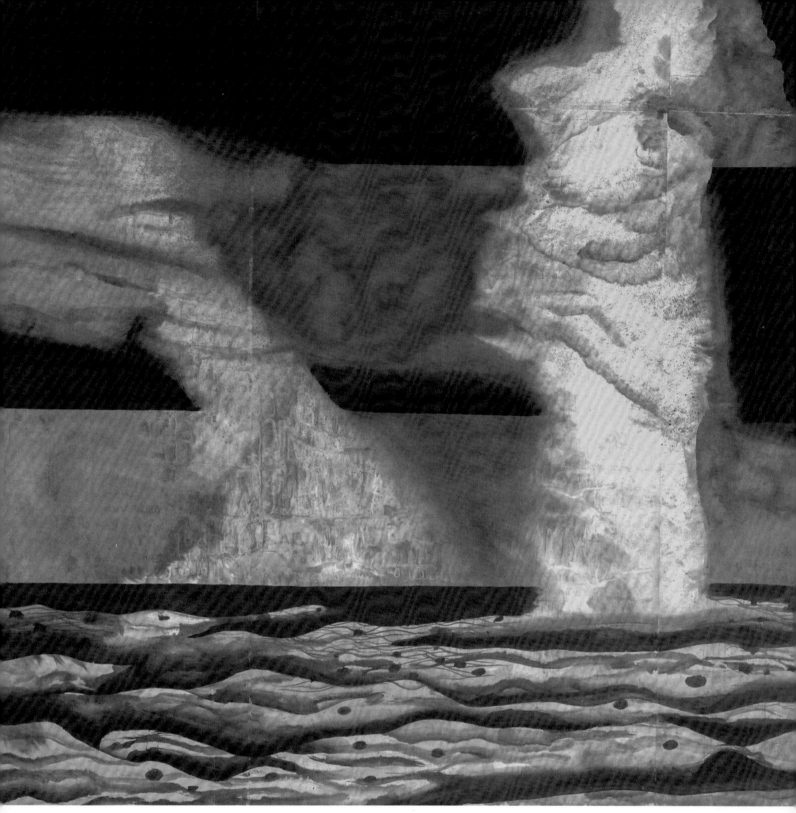

《天空與海洋》

1985 於杭州工作室

宣紙，墨，紙本裝裱上木板

200 厘米長 ×200 厘米高

SKY AND OCEAN

hangzhou studio, 1985

ink on xuan paper, mounted on paper backing and wood
board

200cm long × 200cm high

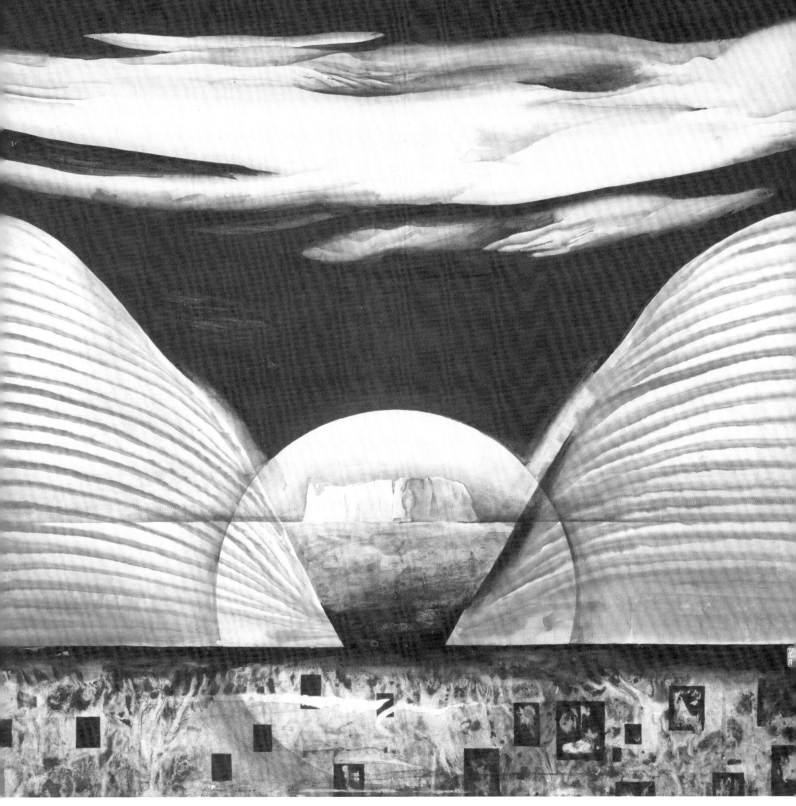

《中國西部——敦煌》

1985 於杭州工作室
宣紙，墨，紙本裝裱上木板
200 厘米長 × 200 厘米高

DUNHUANG—WESTERN CHINA

hangzhou studio, 1985
ink on xuan paper, mounted on paper backing and wood board
200cm long × 200cm high

《超現實地平線》
1981 年於杭州工作室
墨，宣紙，紙背木板裝裱
457.5 厘米長 × 183 厘米高

SURREAL HORIZON
hangzhou studio, 1981
ink on xuan paper, mounted on paper
backing and wood board
457.5cm long × 183cm high

《壹個女人的恐懼癥》

1981 年於杭州工作室
墨，宣紙，紙背梗絹邊裝裱鏡片，鏡框
177.7 厘米長 ×88 厘米高

A WOMAN'S FEAR

hangzhou studio, 1981
ink on xuan paper, paper backing silk border mounting, frame
177.7cm long × 88cm high

《靜坐的自畫像》

1984 年於杭州工作室
布面油畫
400 厘米長 ×200 厘米高

DUAL SELF-PORTRAITS

hangzhou studio, 1984
oil on canvas
400cm long × 200cm high

85 藝 術 復 興 運 動 中
我 的 介 入 與 我 的 觀 點

谷文達

MY INVOLVEMENT & MY POINT OF VIEW OF THE '85 NEW WAVE

gu wenda

壹是群體運動；貳是全盤西化。我的兩個基本立場却是與 85 藝術復興中最重要的兩個傾向有區別。

壹，群體運動。85 藝術復興運動從南到北，前前後後大約有壹佰多個藝術群體。成為洋洋大觀的群體藝術運動。我的觀點是從我的立場和行為中最為鮮明地體現出來的。群體運動有其當時的歷史時期的必要性。但是我一向認為群體是壹個過渡時期的產物，它並沒有擺脫文革的集體運動的思維方式和更傳統的封建部落方式。與當時 85 藝術復興運動要喚起個人創造價值的理念恰恰是相悖的。歷史也充分證明了 85 群體運動的群體形式僅僅是壹個走過場。在今天的當代藝術的圈子裏，人們能記住的並在談論的却是各個藝術時期的代表人物，而不是群體。高名潞先生在他的《中國當代藝術史》（上海人民出版社出版）中曾評價道：谷文達是在 85 藝術復興運動中唯壹的能够與美術群

my two basic positions, differ from the two major tendencies in the '85 new wave. the first was the mass movement; the second was a complete westernization.

1. mass movement. across the country, from north to south, the '85 new wave more or less included over a hundred art groups. it became an imposing mass art movement. my perspective is most clearly demonstrated through my position and actions. a mass movement has its own historical necessity in relation to the period. but i had always considered that "mass" was a product of a transitional period; it had not thrown off the modes of thought from the mass movements of the cultural revolution and the even more tribal modes from traditional feudalism. it happened to be in direct opposition to the ideals of personal creativity called for within the '85 new wave. history has also clearly demonstrated that the mass, collective forms of the '85 new wave were merely a sense of going through the motions. within today's contemporary art circles, people can only remember and talk about the representative figures from each artistic period, rather than the masses. gao minglu once opined in his *history of contemporary chinese art* (published by shanghai people's publishing house): "gu wenda was the only individual artist within the '85 revival who was able to contend against the art groups." in another article, published in *meishu* magazine,

223

體抗衡的個體藝術家，在高名潞先生的另壹篇登載在《美術》雜誌上的文章談到谷文達與大部分群體主流有區別，但他却是主流中的主流。確切地說，我沒參加被稱之為 85 美術運動的重要會議如黃山會議和珠海會議。我參與 85 是特別的個案。我是作為個人介入的。

貳，全盤西化。我把全盤西化同樣看作僅僅是 85 藝術復興運動的過程，如同群體一樣而不是最後目的。以上我所談的我不同於 85 藝術復興運動的兩個特點的可能因素除了我清晰論述到的我的意識之外，有可能我不同於大部分 85 藝術復興運動中的藝術家的是我出身在保守勢力強大的中國畫系，而當時的前衛藝術家幾乎仟篇壹律地來自於美術學院的油畫、雕塑、工藝系。出身國畫系却意義深遠地為我提供了壹個他人所沒有的視點，與「全盤西化」的當時的主流相背，與正像彭德先生在 1987 年為《美術思潮》雜誌中選文談到谷文達是以西方的當代藝術來破壞中國傳統藝術，同時以中國的傳統藝術審視西方的當代主義。1987 年高名潞先生主編的壹期《美術》雜誌刊登了費大為先生對我的採訪錄，題為「向西方現代派挑戰」。從 85 新潮美術運動伊始，我就清晰地認知全盤西化不是目的。引進西方的當代主義的最終目的是為了創造我們自己的當代藝術。我想這也就是我不在「全盤西化」的當時主流中。同時又如高名潞先生說的，谷文達却是「主流中的主流」。有意義的是，中國當代藝術的兩位重要策展人高名潞先生和栗憲庭先生均是中國繪畫史的專家。栗憲庭先生還是壹位國畫家。

gao minglu discussed the differences between gu wenda and the majority of the mass trends, yet he was "the mainstream of the mainstream." precisely speaking, i did not participate in the important conferences of the '85 new wave, such as the huangshan symposium and the zhuhai symposium. i took part in the '85 revival as a special case. i intervened as an individual.

2. complete westernization. equally, i view complete westernization as merely a process, as part of the '85 new wave; just like the mass movements, it was not the final goal. the two ways, mentioned above, in which i differed from the '85 new wave, might have been caused—aside from my awareness which i had mentioned—by the fact that unlike the majority of the artists in the '85 new wave, i emerged within the department of chinese painting, with its strong forces of conservatism. on the other hand, the avant-garde artists practically without exception emerged from the departments of oil painting, sculpture, and applied arts. my background in the department of chinese painting meant that i was marked with a distinct point of view, at variance with the mainstream trend of "complete westernization." just as mr. peng de mentioned in *meishu sichao* magazine in 1987, gu wenda used western contemporary art to destroy chinese traditional art, while at the same time examining western ideas about contemporary art from the point of view of chinese traditional art. in a 1987 issue of *meishu*, edited by gao minglu, in fei dawei's interview entitled, "challenging western modernism," i stated that "from the beginning of the '85 art movement, i clearly knew that complete westernization was not the goal. the ultimate goal was to bring in contemporary ideas from the west to create our own contemporary art. i think, in this, i was not in the mainstream of "complete westernization" which dominated that era. at the same time, just like gao minglu said, gu wenda was the "mainstream of the mainstream." what is meaningful is that the two most important curators of contemporary chinese art—gao minglu and li xianting—were both experts in the history of chinese painting. li xianting is even a traditional chinese painter in his own right.

叁維動畫片《中園》
3d cartoon *zhong yuan*

央視拾貳集文化片《當盧
浮宮遇見紫禁城》
cctv 12 episodes
documentary *recontre
du louvre et de la cite
interdite*

225

第叁部分
CHAPTER 3

藝術的故事
生物時代之謎

A STORY OF ART:
ENIGMA OF BIOLOGICAL
TIMES

生物時代之謎（壹）：

聯合國之全基因 1992-2021

ENIGMA OF BIOLOGICAL TIMES 1:

united nations and all dna 1992-2021

《東西椅》
2000 年於上海與紐約工作室
半明式半路易風格椅，電視機視屏，雞翅
木，法國絲綢，dvd 藍天
53 厘米長 × 47 厘米寬 × 110 厘米高

EAST-WEST CHAIR
shanghai and new york studios, 2000
half ming-style, half louis-xiv-style chair,
a chinese-french style, wenge wood,
french silk, blue sky dvd
53cm long × 47cm wide × 110cm high

■■■ 联合国系列展出历史

国家系

创作于 1993 【联合国 - 波兰纪念碑】
罗兹 ● 罗兹历史博物馆

创作于 1994 【联合国 - 荷兰纪念碑】
奥特洛 ● 克鲁勒 - 穆勒美术馆

创作于 1994 【联合国 - 意大利纪念碑】
米兰 ● 加里波第当代艺术画廊

创作于 1995 【联合国 - 美国纪念碑】
纽约 ● 无名画廊

创作于 1995 【联合国 - 美国历史】
纽约 ● 斯坦邦姆 - 克劳斯画廊；庆州 ● 庆州美术馆 sonje

创作于 1996 【联合国 - 英国纪念碑】
诺丁汉 ● 诺丁汉立美术馆

创作于 1996 【联合国 - 以色列纪念碑】
特拉维夫 ● 特拉维夫米兹比 · 拉芒沙漠

创作于 1996 【联合国 - 俄国与瑞典纪念碑】
斯德哥尔摩 ● 斯德哥尔摩当代艺术与建筑中心

创作于 1997 【联合国 - 非洲纪念碑】
约翰内斯堡 ● 约翰内斯堡第贰届双年展

创作于 1997 【联合国 - 加拿大纪念碑】
温哥华 ● 温哥华卑诗大学美术馆

创作于 1997 【联合国 - 香港纪念碑】
香港 ● 汉雅轩
私人收藏（香港）

创作于 1997 【联合国 - 台湾纪念碑】
台北 ● 汉雅轩

创作于 1998 【联合国 - 中国纪念碑】
纽约 ● 纽约 ps1 美术馆；西雅图 ● 西雅图华盛顿大学亨利美术馆；蒙特雷 ● 蒙特雷当代艺术博物馆；旧金山 ● 旧金山亚洲艺术博物馆；香港 ● 香港艺术馆；堪培拉 ● 澳大利亚国家美术馆
香港艺术馆永久收藏

创作于 2000 【联合国 - 法国纪念碑】
里昂 ● 里昂第伍届双年展；首尔 ● 首尔国家当代美术馆；埃克塞特 ● 美国菲利普埃克塞特中学美术馆
不同的私人收藏
丹佛市立美术馆永久收藏

创作于 2003 【联合国 - 澳大利亚纪念碑】
堪培拉 ● 澳大利亚国家美术馆
澳大利亚国家美术馆永久收藏

创作于 2003 【联合国 - 印度尼西亚纪念碑】
雅加达 ● 印度尼西亚首届双年展

创作始于 1995 【联合国 - 变形记】主要展览
堪萨斯 ● 堪萨斯大学斯宾塞美术馆，永久收藏
悉尼 ● 希尔曼画廊
匹兹堡 ● 匹兹堡大学
纽约 ● 布鲁克林博物馆
丹佛 ● 丹佛大学美术馆迈伦画廊
巴西 ● 圣保罗双年展
北京 ● 北京今日美术馆
台南 ● 台北华山艺术中心
莫斯科 ● 普希金博物馆
上海 ● 上海美术馆
上海 ● 龙美术馆，永久收藏
上海 ● 昊美术馆，永久收藏
南京 ● 南京艺术学院美术馆，永久收藏
杭州 ● 中国美院美术馆首届国际编织艺术双年展

■■■ united nations exhibition history

monuments series

created in 1993 united nations-poland monument
history museum of lodz & the artists museum, lodz●

created in 1994 united nations-holland monument
kroller-muller museum, otterlo●

created in 1994 united nations-italy monument
enrico gariboldi arte contemporanea, milan ●

created in 1995 united nations-usa monument
space untitled gallery, new york ●

created in 1995 united nations-american flags in history
steinbaum krauss gallery, new york ● / sonje museum of contemporary art, gyeongju ●

created in 1996 united nations-britain monument
angel row gallery, nottingham ●

created in 1996 united nations-israel monument
mitzpe ramon desert & israeli cultural ministry and the artists' museum, tel aviv ●

created in 1996 united nations-sweden and russia monument
fargfabriken center for contemporary art and architecture, stockholm ●

created in 1997 united nations-africa monument
institute of contemporary art, johannesburg ●

created in 1997 united nations-canada monument
morris and helen belkin art gallery, the university of british columbia, vancouver ●

created in 1997 united nations-hong kong monument
hanart gallery, hong kong ●
private collection(hong kong)

created in 1997 united nations-taiwan monument
hanart gallery, taipei ●

created in 1998 united nations-china monument
ps1 contemporary art center, new york●; henry art gallery, w
asian art museum, san francisco ● /museum of contemporary
australia, canberra●/hongkong museum of art, hong kong●
a permanent collection of hong kong museum of art●

created in 2000 united nations-france monument
5th lyon biennale of contemporary art, lyon●/ national muse
phillips exeter academy, exeter ●
various private collections
a permanent collection of denver art museum

created in 2003 united nations-australia monument
national gallery of australia, canberra ●, permanent collection

created in 2003 united nations-indonesia monument
1st jakarta biennale, jakarta ●

since 1995 unitied nations-metamorphosis series
spencer museum of art, university of kansas, kansas ●
sherman contemporary art foundation, sydney ●
university of pittsburgh, pittsburgh ●
new york brooklyn museum, new york
transforming traditions: contemporary art from the logan collection", h. myhren gallery, the
university of denver, denver ●
"3rd mercosul biennale", brazil ●
today art museum, beijing ●
huashan 1914 creative park, taipei ●
pushkin fine arts museum in mosco, moscow ●
shanghai art museum, shanghai ●
long museum, shanghai ● , permanent collection
how art museum, shanghai ● , permanent collection
art museum of nanjing university of the arts, nanjing ● , permanent collection
art museum of china academy of art, hangzhou ●

■■■ 【联合国】作品分布 | united nations distribution

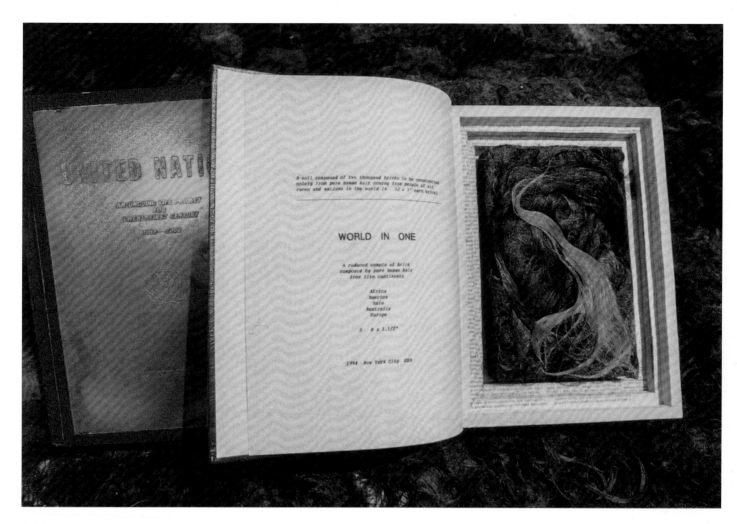

《聯合國——天下壹家》（肆限量版）

1994 年於紐約工作室

世界各地混合人髮磚，白乳膠，腐蝕銅板封面的書盒

UNITED NATIONS—ONE FAMILY (4 LIMITED EDITIONS)

new york studio, 1994

a brick of hair from various nationalities around the world, white glue, book with etched
copper cover

<div align="right">

1996 年藝術家谷文達在斯德哥尔摩當代藝術中心佈置
《聯合國 —— 瑞典與俄國紀念碑》
（圖片由斯德哥爾摩當代藝術與建築中心提供）
artist gu wenda is installing _united nations—sweden
and russia monument_ at the center for contemporary
art & architecture, stockholm, 1996
(photo by stockholm art and architecture center)

</div>

230

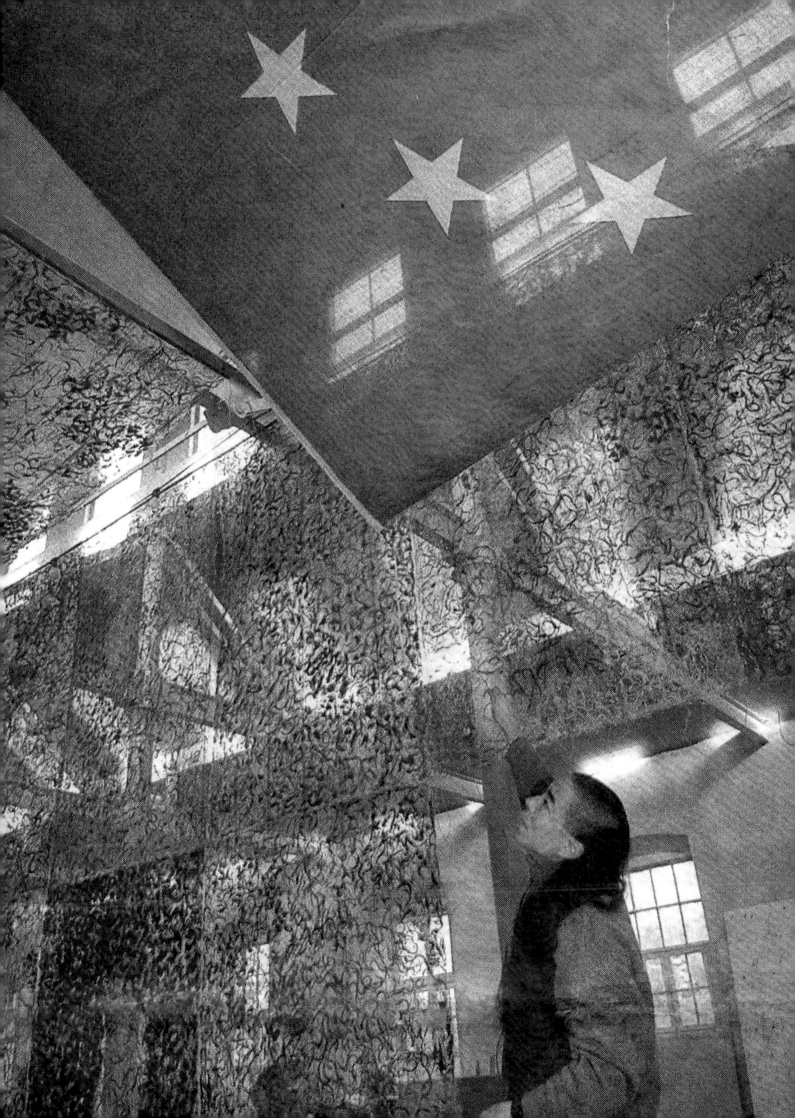

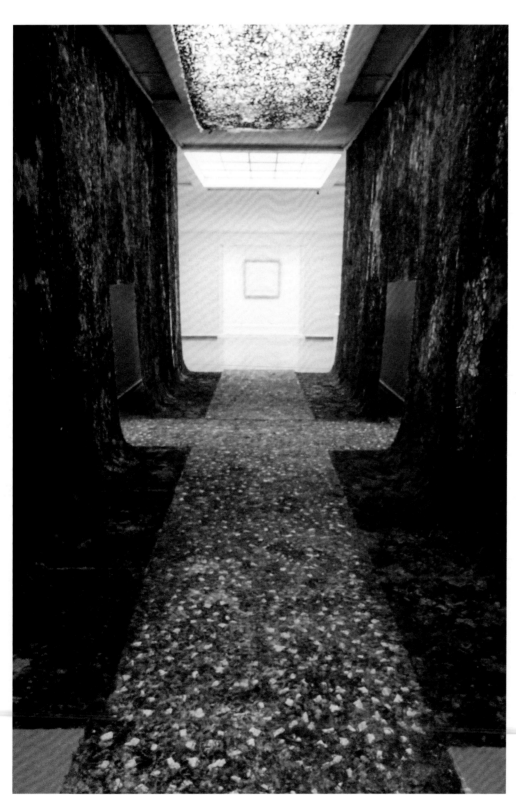

《聯合國——荷蘭紀念碑》

1994 年於荷蘭庫勒米勒美術館
參加黑暗的心臟國際展，庫勒米勒美術館
荷蘭人髮幕簾，荷蘭人髮混合歷史書碎頁
地毯

UNITED NATIONS—HOLLAND
MONUMENT

the kroller-muller museum, holland,
1994
participated in the "heart of darkness"
exhibition at the kroller-muller museum
pure dutch hair curtain walls, hair
rooms, hair carpets (mixed with ripped
pages of dutch colonial history books)

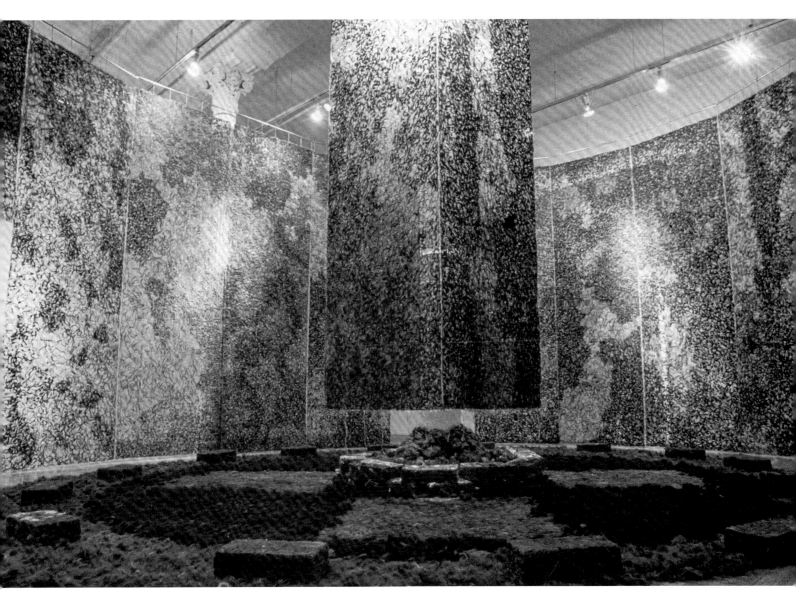

《聯合國——美國紀念碑》

1995 年於紐約工作室

混合美國印第安人、歐洲人、非洲人、南美人和亞洲人髮簾，髮磚和髮毯

UNITED NATIONS—USA MONUMENT

new york studio, 1995
the entire installation is constructed of pure and mixed native-, caucasian-,
african-, latino-, and asian-american hair curtian walls, hair bricks, and
hair carpets

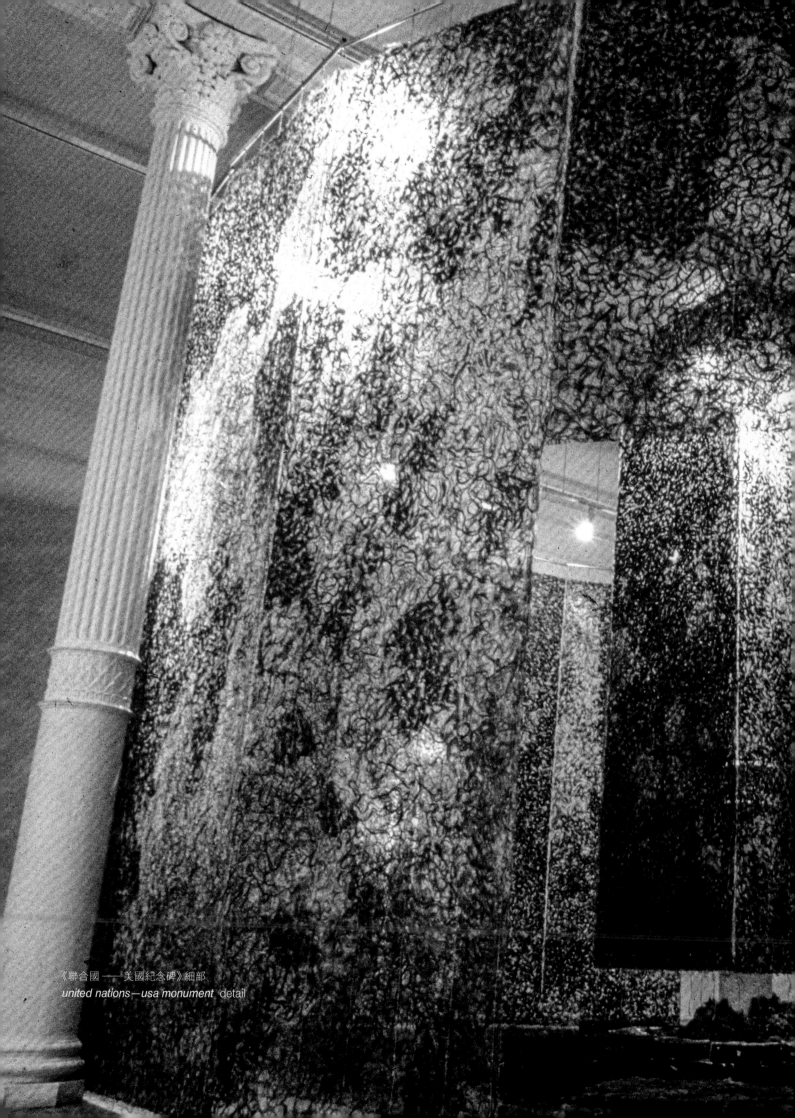

《聯合國 —— 美國紀念碑》細部
united nations—usa monument detail

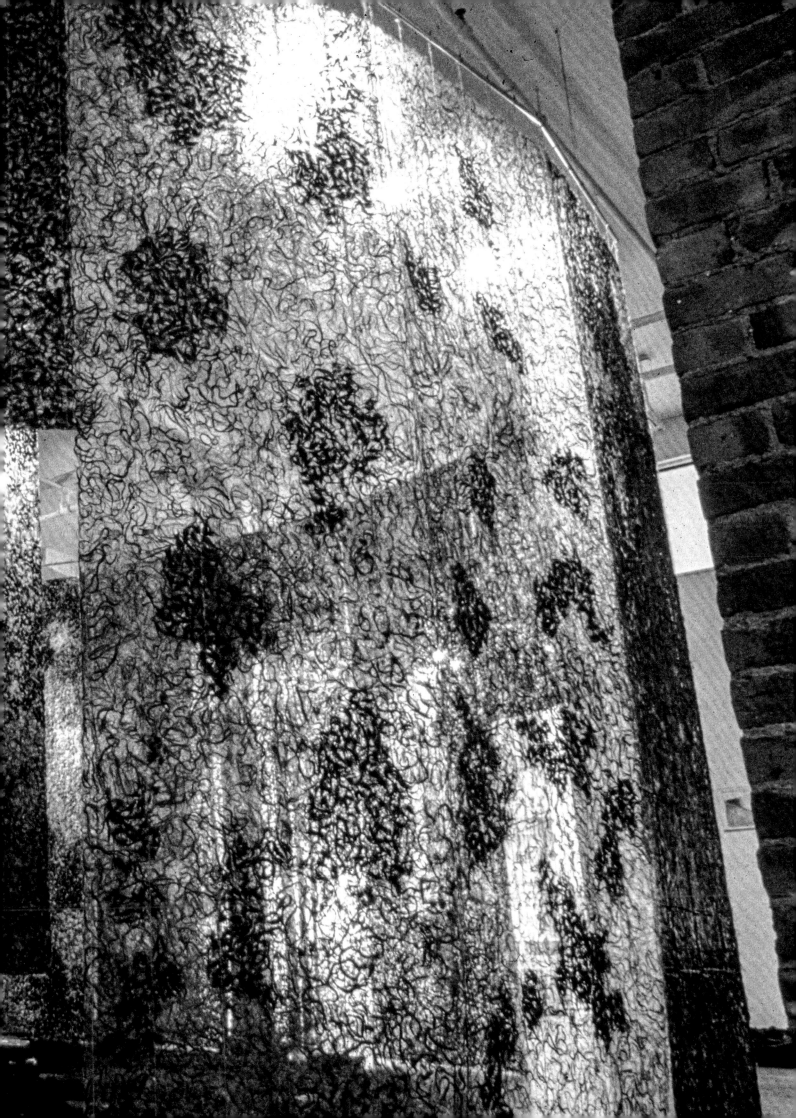

合美術館展覽現場：《聯合國 —— 美國紀念碑》設計稿
united art museum exhibition site: drawings of *united nations—usa monument*

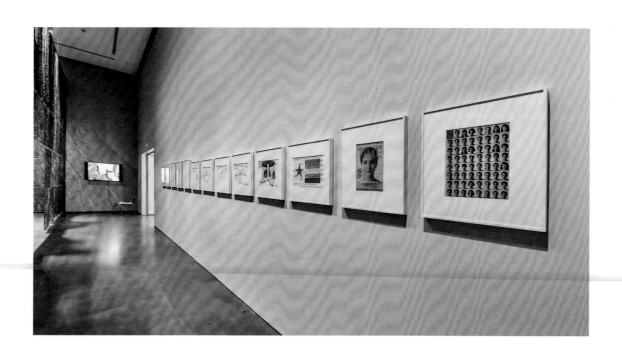

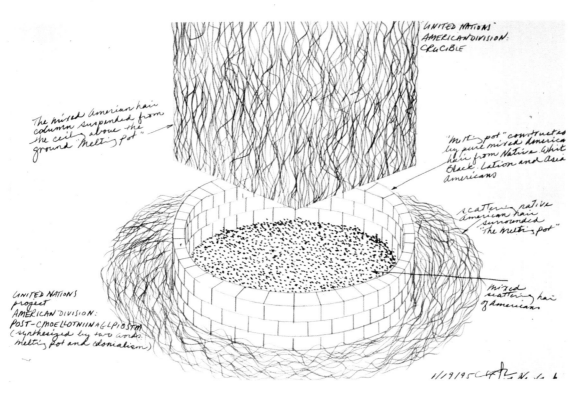

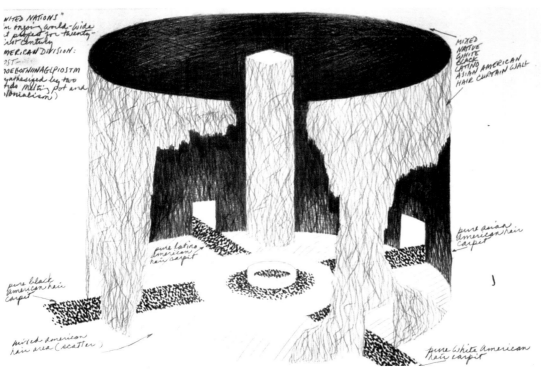

從上到下：

《聯合國——美國紀念碑》
草圖之伍，捌
1994 年於紐約工作室
鉛筆，卡紙，白色金屬鏡框
34 厘米長 × 27 厘米高

from top to bottom:

UNITED NATIONS—AMERICA MONUMENT
drawing #5, #8
new york studio, 1994
pencil on cardboard in white metal frame
34cm long × 27cm high

《聯合國 —— 以色列念碑》密茨比拉芒沙漠 1995

united nations—israel monument mitzpe ramon desert 1995

《聯合國 —— 以色列念碑》密茨比拉芒沙漠 1995

united nations—israel monument mitzpe ramon desert 1995

《聯合國——以色列紀念碑》

永久碑林大地藝術
1995 年於密茨比拉芒沙漠
第伍屆建構在過程國際雙年展
以色列人髮，30 枚粉色耶路撒冷石灰岩巨石

UNITED NATIONS—ISRAEL MONUMENT

a site-specific permanent landart
negev desert near the town of mitzpe ramon, 1995
fifth construction in progress at an international biennale
israeli hair, thirty pink jerusalem pink limestone boulders

《聯合國 —— 以色列紀念碑》 細部
united nations—israel monument detail

（更多介紹請查閱「現象和挑戰」部分　more about this work to see the chapter of "phenomenon and challenge"）

《聯合國 —— 英國紀念碑》
倫敦 —— 諾丁漢 1996

united nations-britain
monument london-
nottingham 1996

《聯合國 —— 英國紀念碑》

1996 年於倫敦 —— 諾丁漢
罌粟花，燈箱，英聯邦旗，英國人髮，人髮國旗，
人髮簾：「很早以前有壹位英國商人說過，如果每
壹位中國人多穿壹寸布……」

UNITED NATIONS-BRITAIN MONUMENT

london-nottingham, 1996
poppies, light box, british commonwealth
flags, british hair, hair union jack, hair curtain:
"once upon a time there was a british
merchant who said imagine if every chinese
wears one more inch of clothing..."

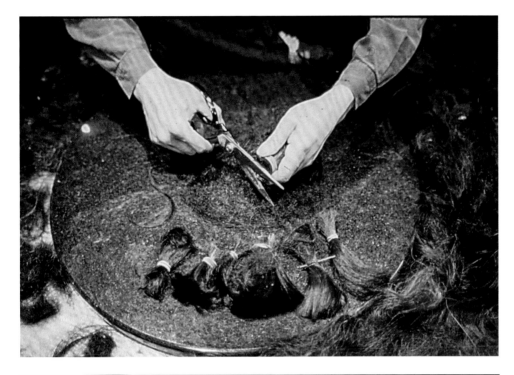

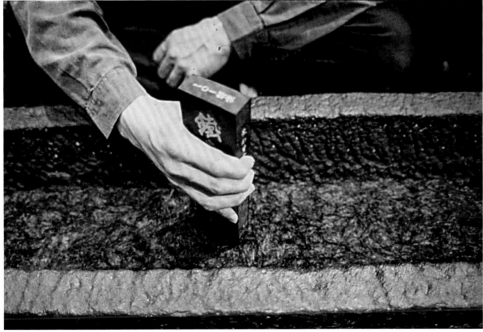

《聯合國——中國台灣紀念碑》

1997 年於台北漢雅軒

水墨畫裝置，開幕式行為藝術：基因墨

UNITED NATIONS—TAIWAN, CHINA MONUMENT

hanart gallery taipei, 1997

ink paintings installation, opening performance: dna ink

241

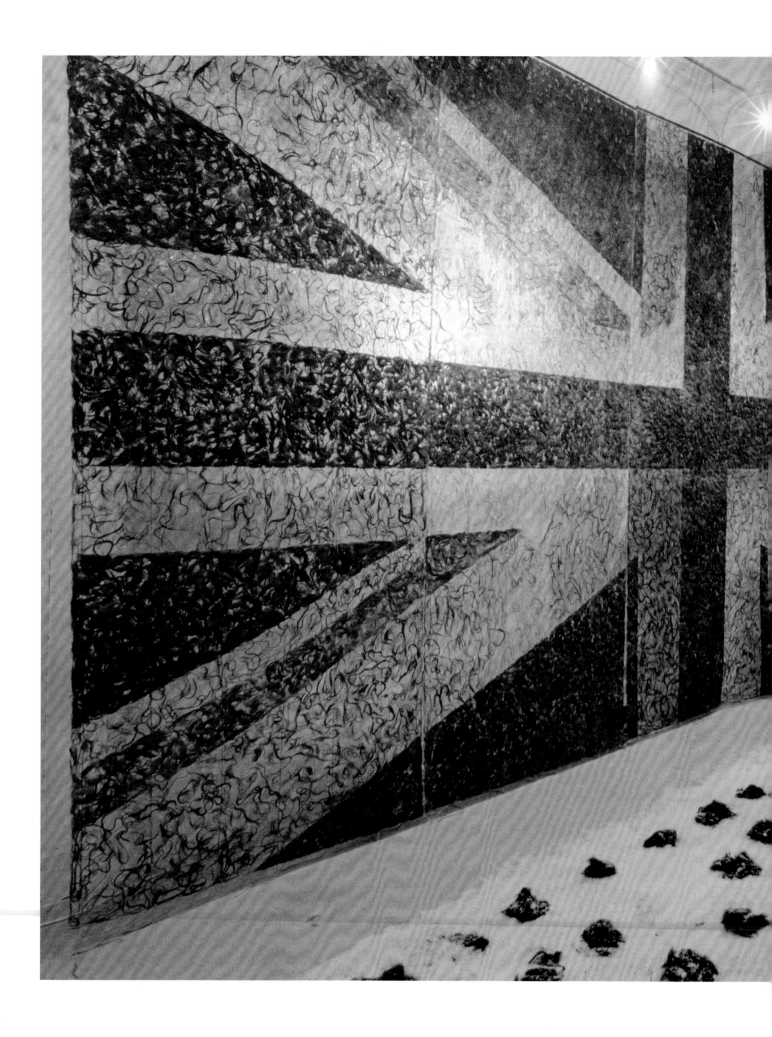

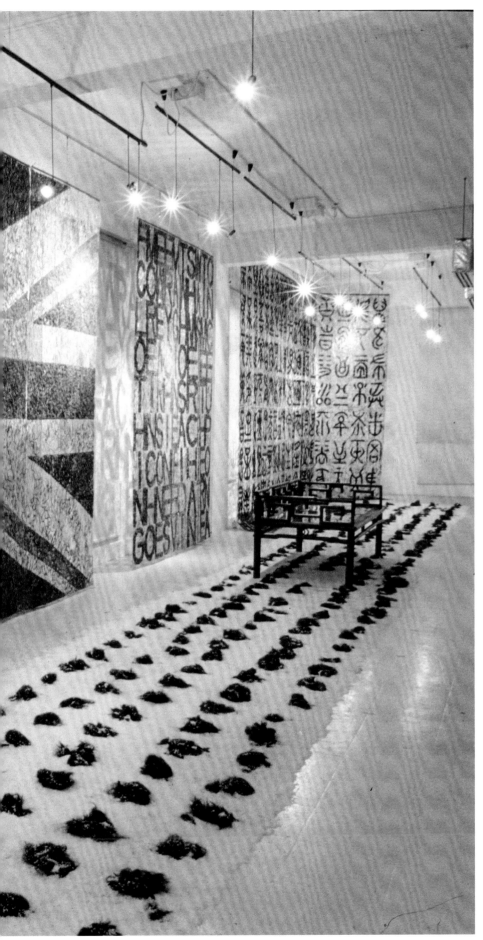

《聯合國 —— 中國香港紀念碑》

裝置藝術

1997 年創作於英國與中國香港，展於中國香港漢雅軒畫廊

盛有 900 朵罌粟花的鴉片牀、米、中國香港人髮、英國人髮製英國國旗、英國人髮編織的英語髮簾：「很早以前有一位英國商人說過如果每一位中國人多穿一寸布」

UNITED NATIONS-HONG KONG, CHINA MONUMENT

a site-specific installation for hong kong handover
1997, hanart gallery
hong kong, china 1997
part one, a british union jack made of british
hair. part two, a chinese flag with chinese hair
made pseudo-chinese ancient seal script. part
three, a qing dynasty"daybed"covered with
dried asian poppy flowers. part four, a british hair
made hanging piece with an english sentence in
chinese written form. part five, hong kong shorn
hair surrounded by two hundred pounds of rice

《聯合國 —— 中國香港紀念碑》香港回歸 1997 年 7 月 1 日

united nations-hong kong, china monument july 1, 1997

在香港回歸準時間，1997 年 7 月 1 日午夜，谷文達的展覽《聯合國——中國香港紀念碑》在漢雅軒開幕。英國前副首相 michael heseltine 和夫人前來開幕式祝賀展覽開幕，並與畫廊主張頌仁和藝術家谷文達合影紀念這壹歷史性的時刻。

the exhibition *united nations—hong kong, china monument* opened on july 1st, 1997 at hanart gallery, the precise time of hong kong handover. former deputy prime-minister of britain mr. micheal heseltine and his wife came to send their best wishes for the exhibition. this photo was taken to memorialize this important historical moment.

1997 年 7 月 1 日在藝術家谷文達的展覽《聯合國 —— 中國香港紀念碑》開幕之前，鄧永鏗在中國會舉辦的盛大慶祝晚宴紀念香港回歸。

on july 1st, 1997, sir. david tang hosted a big dinner party at the china club to celebrate hong kong handover right before gu wenda's exhibition *united nations—hong kong, china monument*.

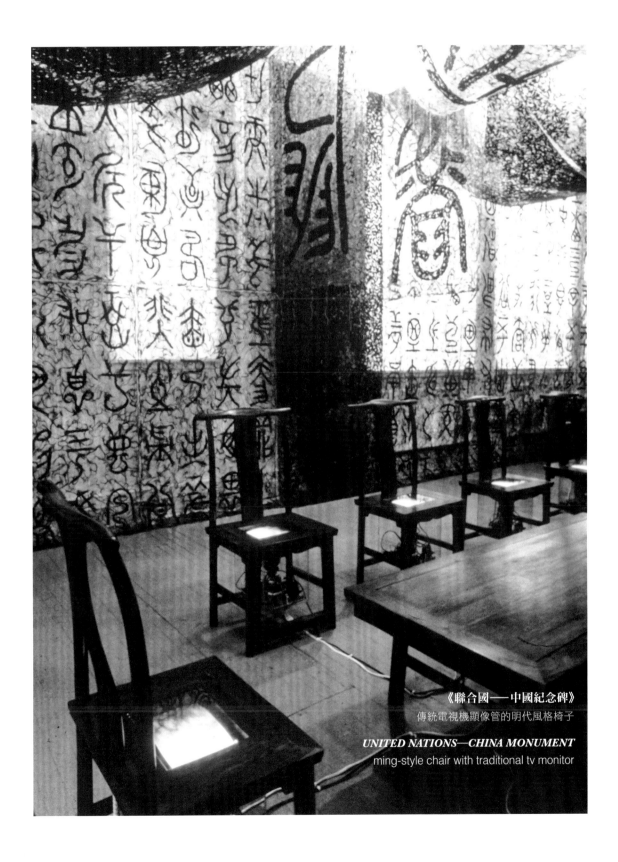

《聯合國——中國紀念碑》
傳統電視機顯像管的明代風格椅子

UNITED NATIONS—CHINA MONUMENT
ming-style chair with traditional tv monitor

《聯合國——中國紀念碑》

1997-1998 年於上海和紐約工作室
由美國紐約 ps1 和亞洲協會贊助
人髮編織偽英漢混合體，偽漢語，英語，印度語和阿拉伯
語髮簾
中國明代風格桌椅，電視機熒光屏
1586 厘米長 × 610 厘米寬 ×
396 厘米高

UNITED NATIONS—CHINA MONUMENT

shanghai and new york studios, 1997-1998
a site-specific installation commissioned by ps1 and
the asia society new york
a temple of pseudo-english, chinese, hindi, arabic
made of human hair curtains collected from all over
the world
ming-style chairs and tables, flat screen tv
1586cm long × 610cm wide

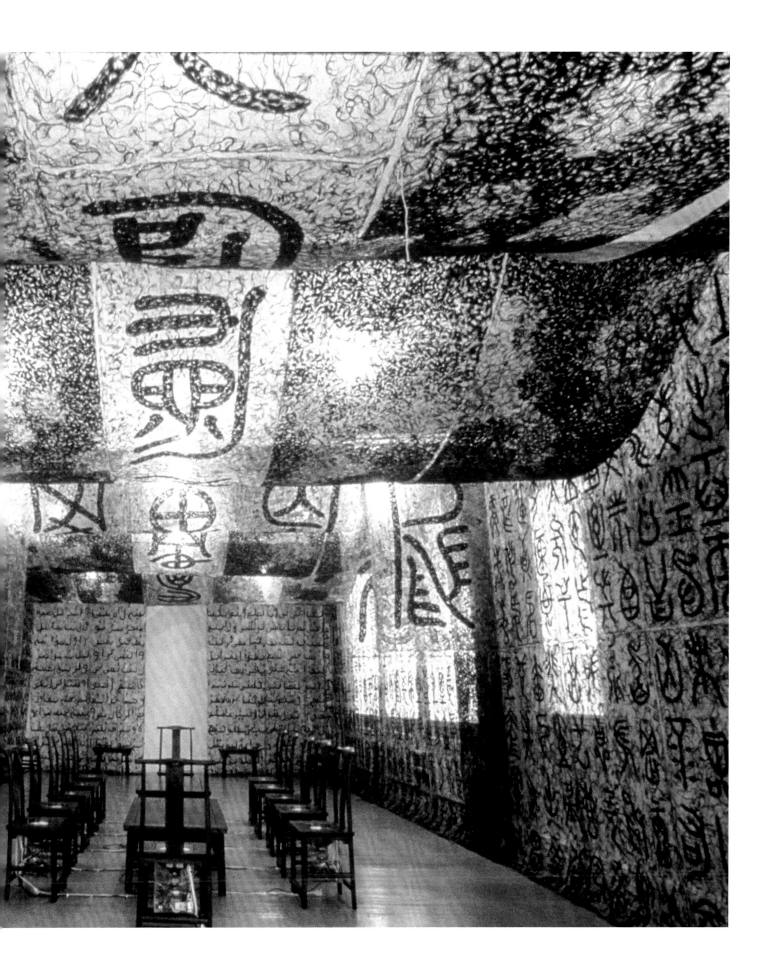

247

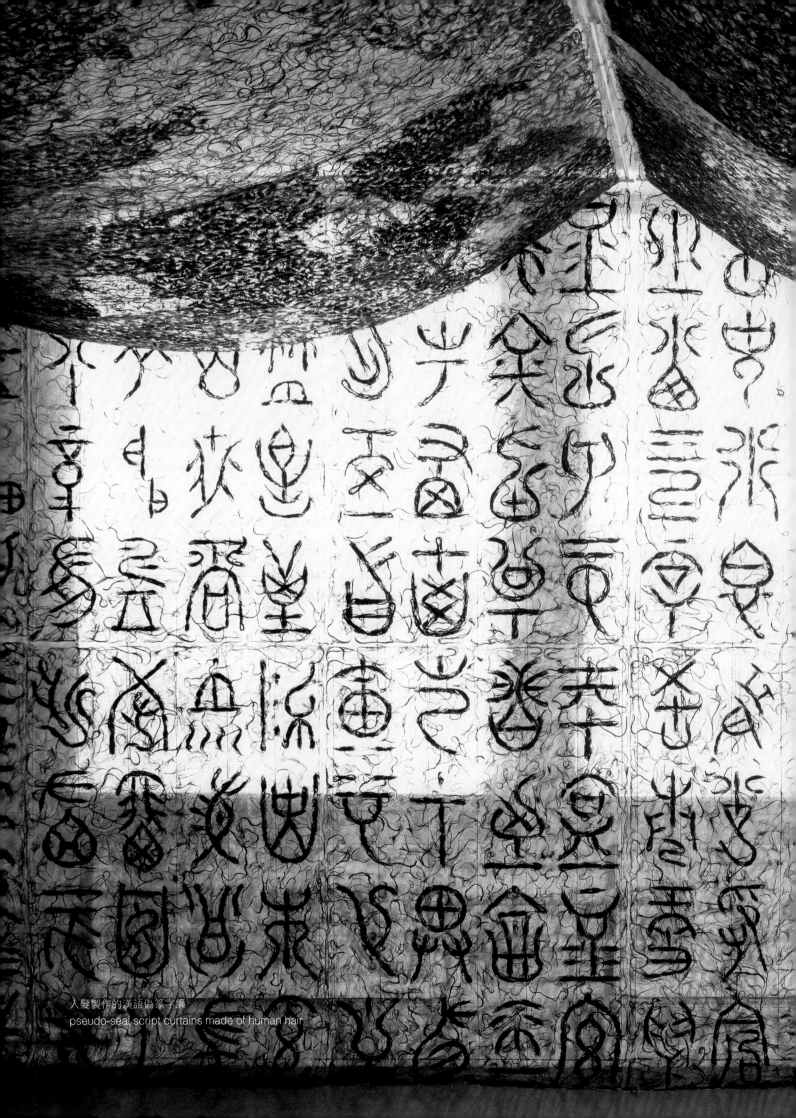

人髮製作的漢語偽篆字簾
pseudo-seal script curtains made of human hair

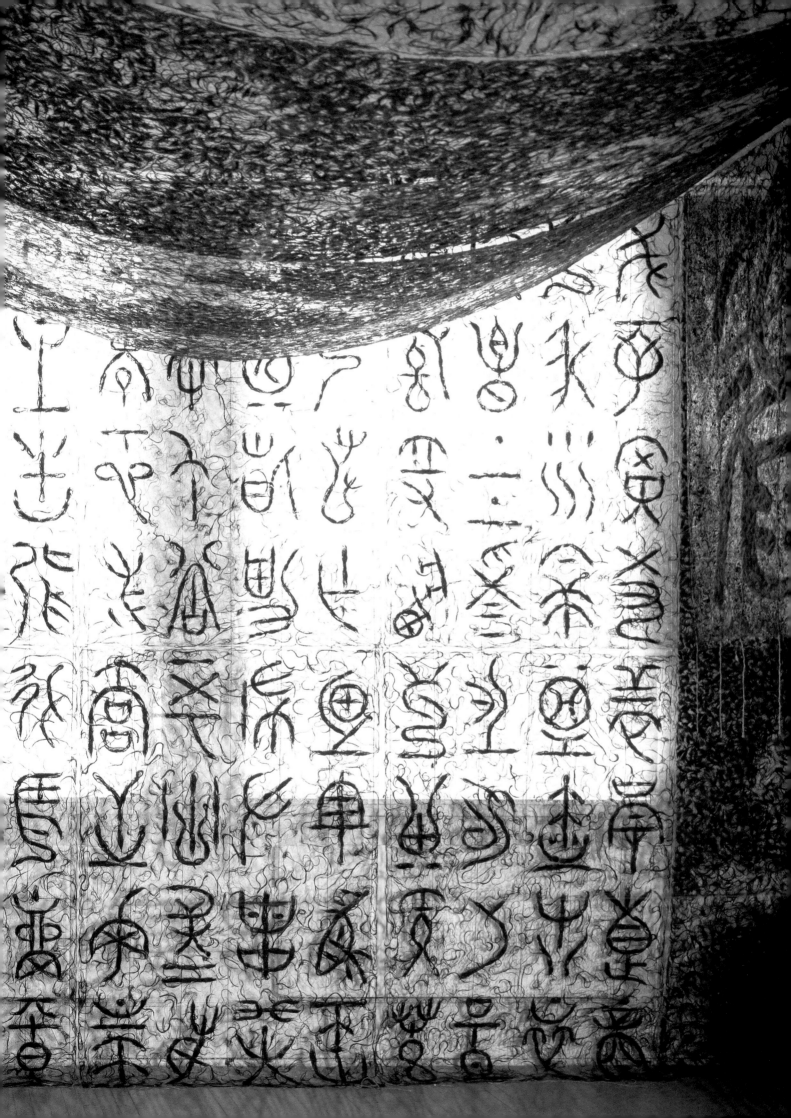

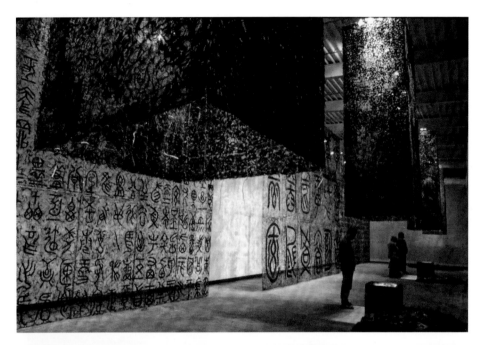

《聯合國——加拿大紀念碑》
1997 年於紐約工作室
1998 年展於溫哥華碑詩大學美術館
加拿大人髮幕簾牆，人髮柱
2438 厘米長 × 762 厘米寬 ×
610 厘米高

***UNITED NATIONS—CANADA
MONUMENT***

new york studio, 1997
a site-specific installation, morris &
helen belkin gallery, the university of
british columbia, vancouver, 1998
cannadian hair curtain walls and hair
columns
2438cm long × 762cm wide × 610cm
high

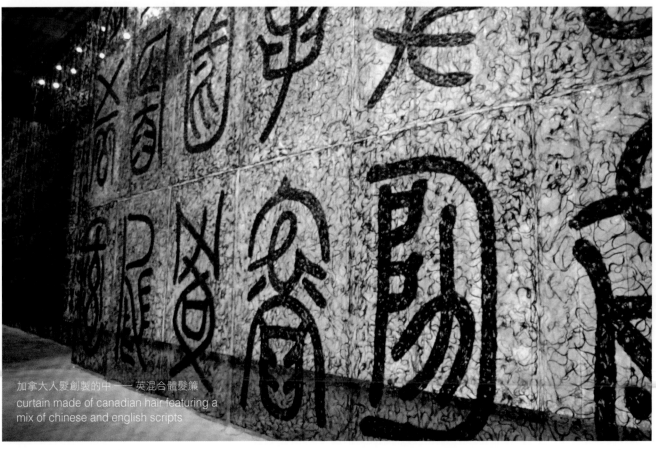

加拿大人髮創製的中——英混合體髮簾
curtain made of canadian hair featuring a
mix of chinese and english scripts

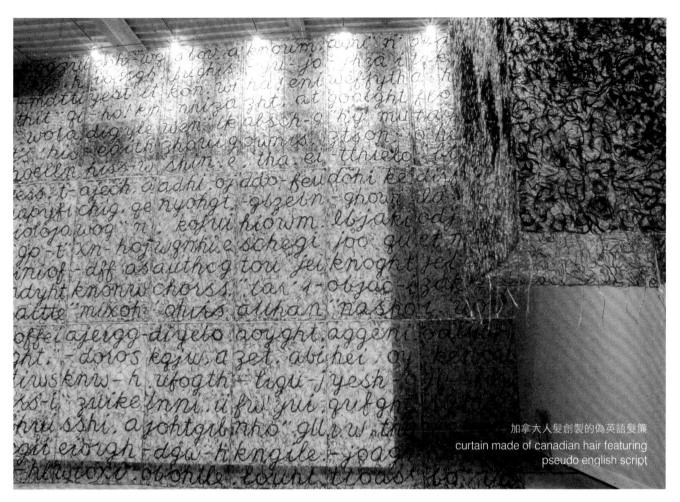

加拿大人髮創製的偽英語髮簾
curtain made of canadian hair featuring
pseudo english script

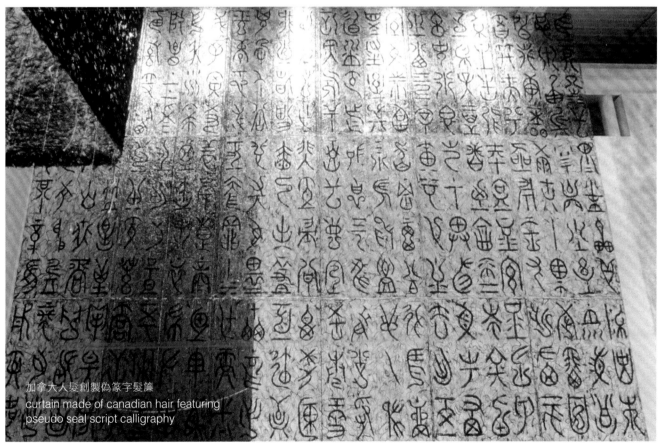

加拿大人髮創製偽篆字髮簾
curtain made of canadian hair featuring
pseudo seal script calligraphy

251

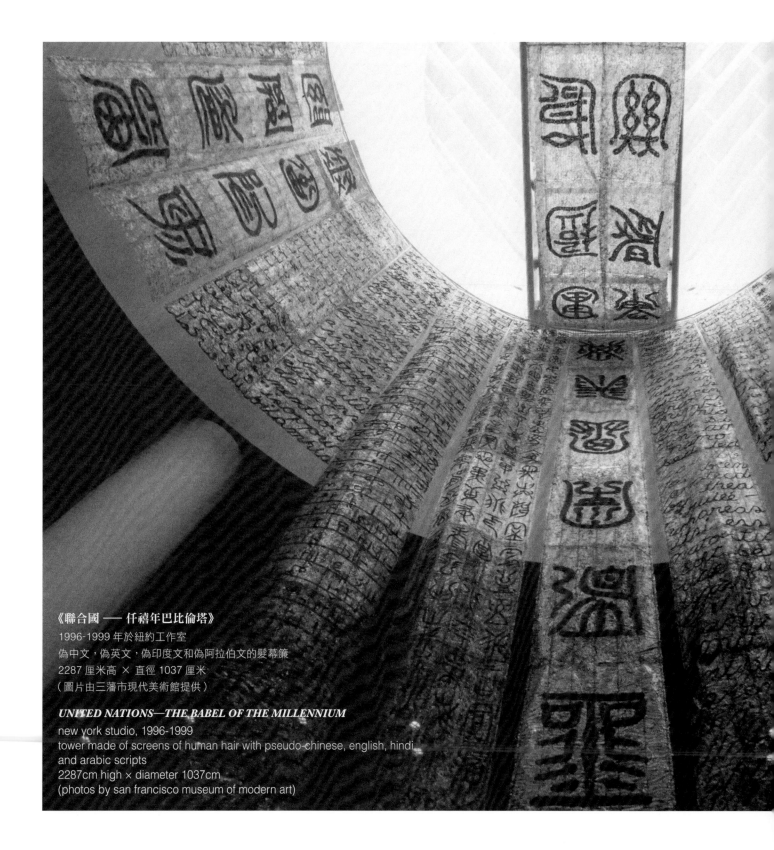

《聯合國 —— 仟禧年巴比倫塔》

1996-1999 年於紐約工作室

偽中文，偽英文，偽印度文和偽阿拉伯文的髮幕簾

2287 厘米高 × 直徑 1037 厘米

（圖片由三藩市現代美術館提供）

UNITED NATIONS—THE BABEL OF THE MILLENNIUM

new york studio, 1996-1999

tower made of screens of human hair with pseudo-chinese, english, hindi
and arabic scripts

2287cm high × diameter 1037cm

(photos by san francisco museum of modern art)

《聯合國——仟禧年巴比倫塔》
觀眾在美術館大堂天頂凝視世界各民族人髮 dna 製成的無法閱讀的英語、漢語、印度語、阿拉伯語巨大簾穹（圖片由三藩市現代美術館提供）

UNITED NATIONS—THE BABEL OF THE MILLENNIUM
audience looking up to the hair dna curtains made from hair of various nationalities, with non-readable english, chinese, hindi, and arabic scripts on top of the museum tower (photos by san francisco museum of modern art)

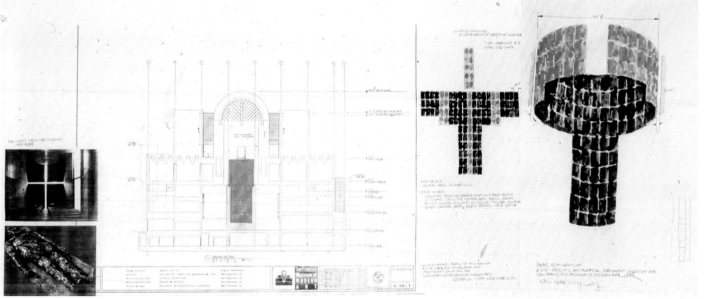

從左到右：

《聯合國──仟禧年巴比倫塔》

草圖之壹、叁、肆、伍、捌、玖
1997 年於紐約工作室水彩，鋼筆，紙
不同尺寸

from left to right:

UNITED NATIONS—BABEL OF THE MILLENNIUM

an installation drawing #1, #3, #4, #5, #8, #9
new york studio, 1997
watercolor & pen on paper
sizes are varied

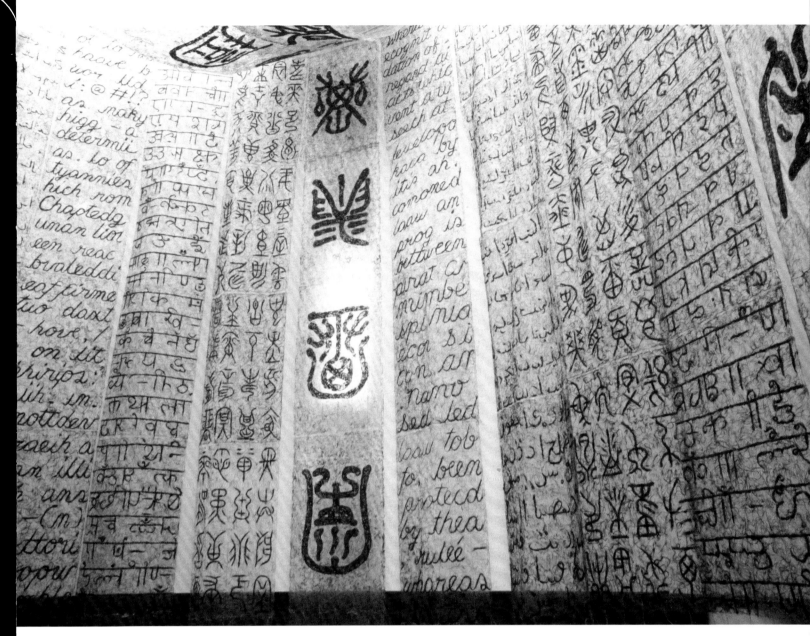

《聯合國 —— 仟禧年巴比倫塔》細部
（圖片由三藩市現代美術館提供）
united nations—the babel of the millennium details
(photos by san francisco museum of modern art)

《聯合國——非洲紀念碑》

1996-1997 年於紐約工作室
第貳屆約翰尼斯堡雙年展
18 國家 350 家理髮店收集人髮編製偽中英文合體，偽中文，偽英文，
偽印度文和偽阿拉伯文的髮幕牆
1342 厘米長 × 1220 厘米高

UNITED NATIONS—AFRICA MONUMENT

new york studio, 1996-1997
a site-specific installation for the second johannesburg biennale,
south africa, 1997
a wall of pseudo-english, chinese, hindi and arabic scripts made
of human hair collected from all over the world
1342cm long × 1220cm high

珍貴的歷史瞬間。那是在 1997 年的第貳屆南非藝術雙年展的開幕式
上，巨大的約翰尼斯堡大發電廠大廳中央，《聯合國 —— 非洲紀念碑》
前人山人海，照片裏的瞬間，策展人阿奎·恩瑋佐（左一，現已故）向
英國查理斯王子介紹《聯合國 —— 非洲紀念碑》。

a precious photo shows a historical moment: it was at the opening
of 2nd johannesburg biennale. there was a huge crowed in front
of *united nations—africa monument*. mr. okwui enwezor (now
deceased), the artistic director of the event, introduces *united
nations-africa monument* to prince charles of britain.

256

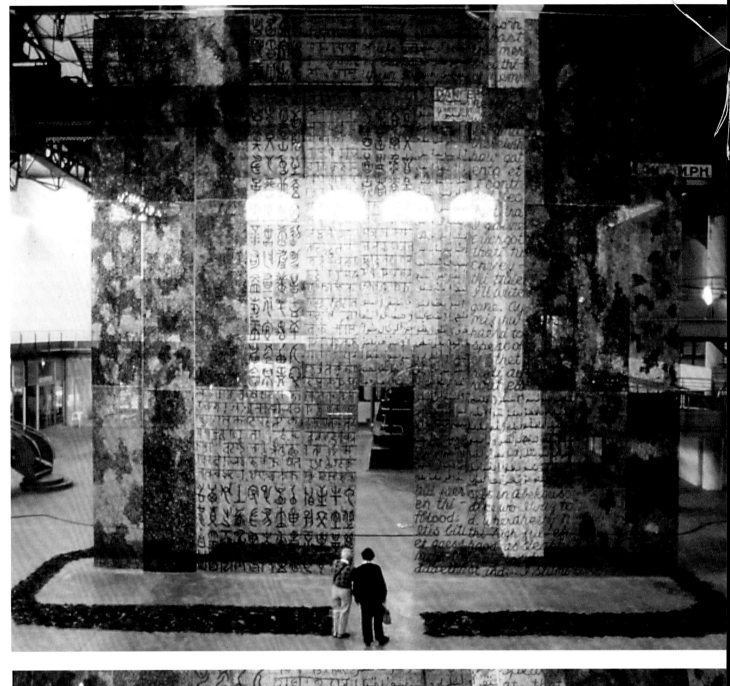
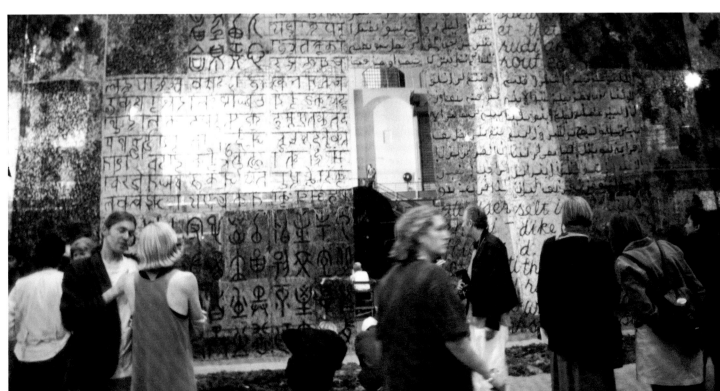

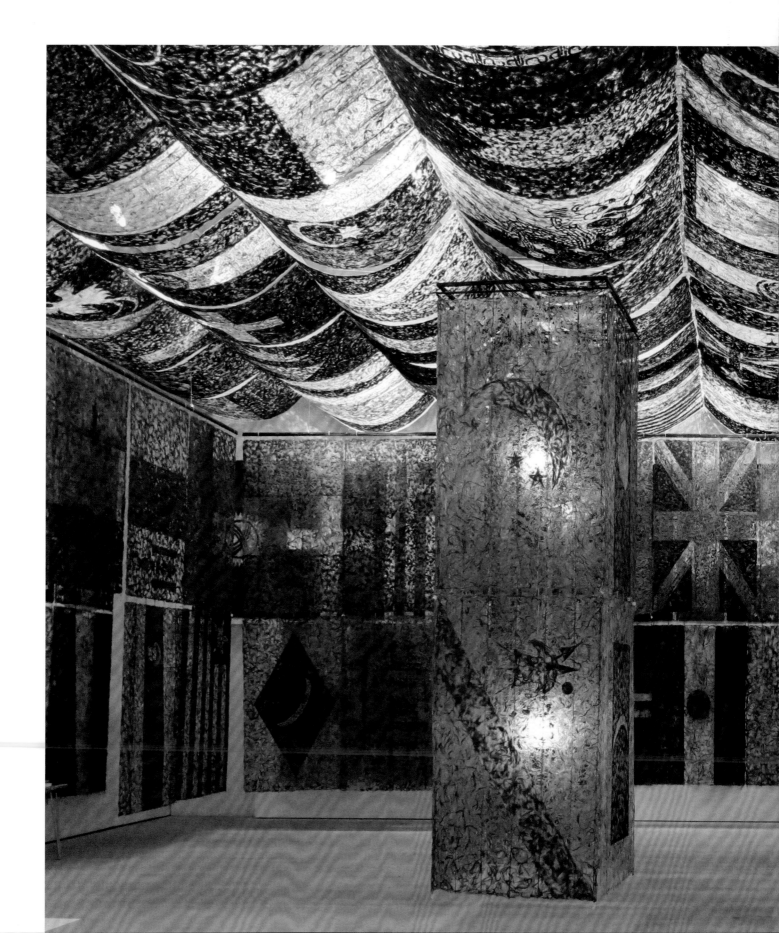

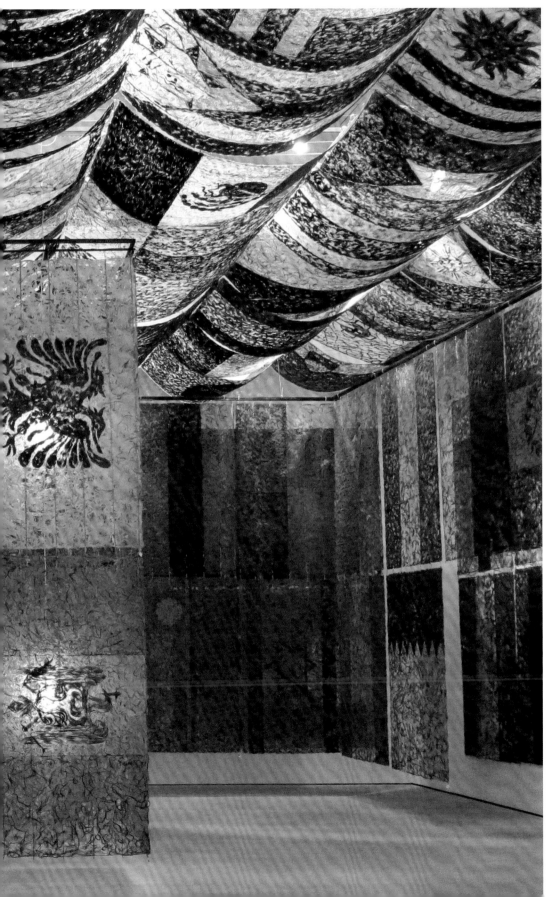

《聯合國——人間》

1999－2000 年於紐約工作室

後波普展，2014 年倫敦薩奇美術館

各國混合人髮製作全世界國旗

1500 厘米長 × 1500 厘米寬 × 600 厘米高

UNITED NATIONS—MAN AND SPACE

new york studio, 1999-2000

"post pop: east meets west", the saatchi gallery london, 2014

a wall of complete national flags of the world made of mixed human hair

1500cm long × 1500cm wide × 600cm high

259

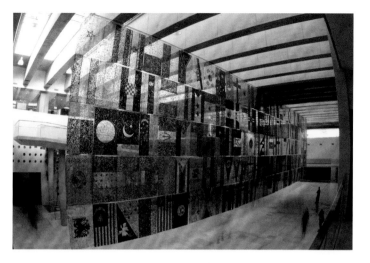

《聯合國——人間》
2007 年智利聖地牙哥當代藝術中心
（圖片由智利聖地牙哥當代藝術中心提供）

UNITED NATIONS—MAN AND SPACE
at the santiago contemporary art center, 2007
(photo by santiago contemporary art center)

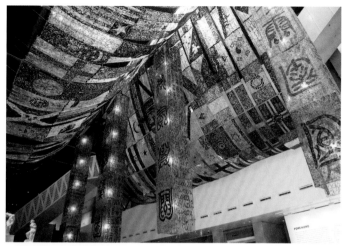

《聯合國——人間》
2013 年上海當代藝術博物館

UNITED NATIONS—MAN AND SPACE
at the shanghai power station of art museum 2013

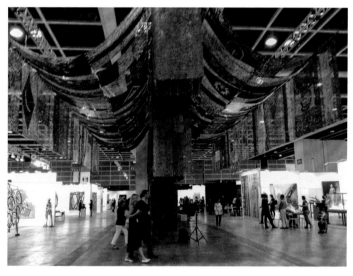

《聯合國——人間》
2014 年中國香港巴塞爾藝術博覽會

UNITED NATIONS—MAN AND SPACE
at art basel hong kong, china, 2014

《聯合國——人間》
在 2014 年的中國香港巴塞爾藝術博覽會進口大堂，人氣爆滿。

UNITED NATIONS—MAN AND SPACE
in front of the opening gate of hong kong, china art basel, 2014
drew a huge crowd.

《聯合國 —— 人間》在各個美術館空間裏的展陳
united nations—man and space in different configurations in various museums

《聯合國 —— 法國紀念碑》

2000 年於紐約工作室
里昂雙年展
18 國家 450 家理髮店收集人髮，偽中文，偽英文，偽印度文和偽阿拉伯文的髮幕簾；東西桌椅，壹半路易壹半明代風格混搭，桌面坐面熒光屏
1586 厘米長 × 610 厘米寬 × 610 厘米高

UNITED NATIONS—FRANCE MONUMENT

new york studio, 2000
a site-specific installation for the lyon biennale 2000, france
a curtain entirely composed of human hair, and hair woven with fake latin, chinese, hindi and arabic scripts, a half ming style a half louis xiv-style chair, with flat-screen televisions placed in the seats.
1586 cm long × 610 cm wide × 396 cm high

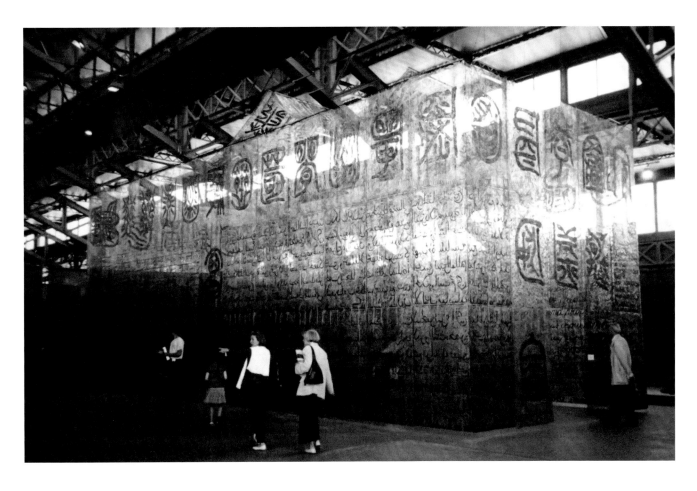

2000 年里昂雙年展開幕式上策展人讓・瑪律丹向前來參觀的法國領導人講解《聯合國 —— 法國紀念碑》

jean martin, the artistic director of the lyon beinnale 2000, explaining *united nations—france monument* to french leaders

東西桌椅，壹半路易壹半明代風格混搭，桌面坐面熒光屏
east-west tables and chairs half ming-style, half louis-xiv-style chair with flat-screen television placed in the seat.

《聯合國 —— 基因長城》上海 2001

united nations—dna great wall shanghai 2001

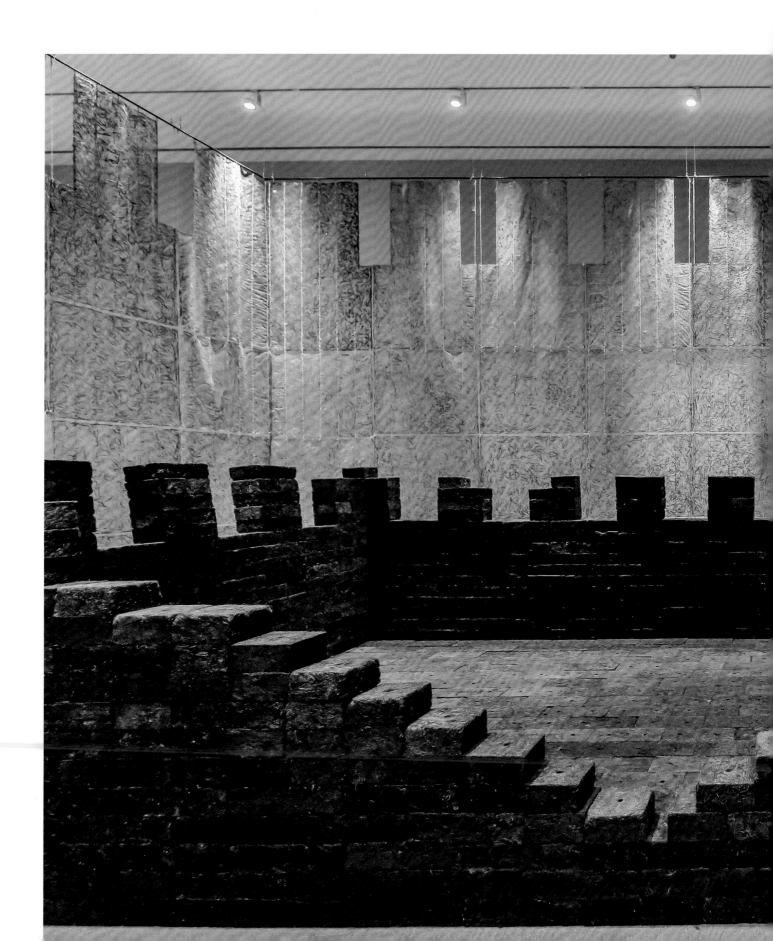

《聯合國 —— 基因長城》
2001 年於上海工作室
1500 枚人髮磚，人髮幕簾牆

UNITED NATIONS—DNA GREAT WALL
shanghai studio, 2001
1500 solid human hair bricks and hair curtains

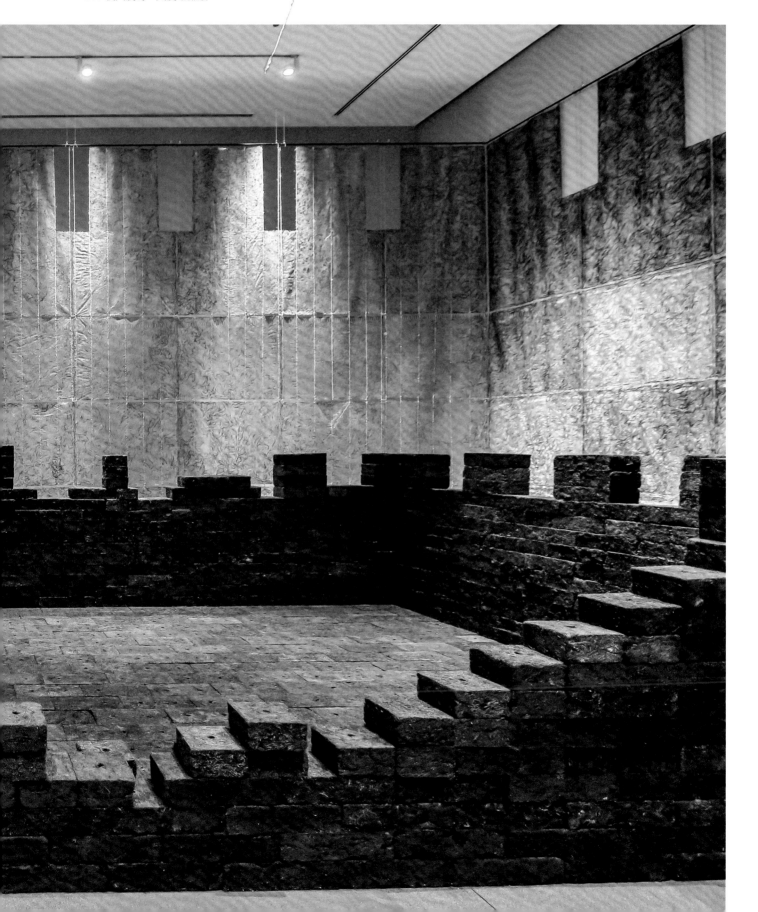

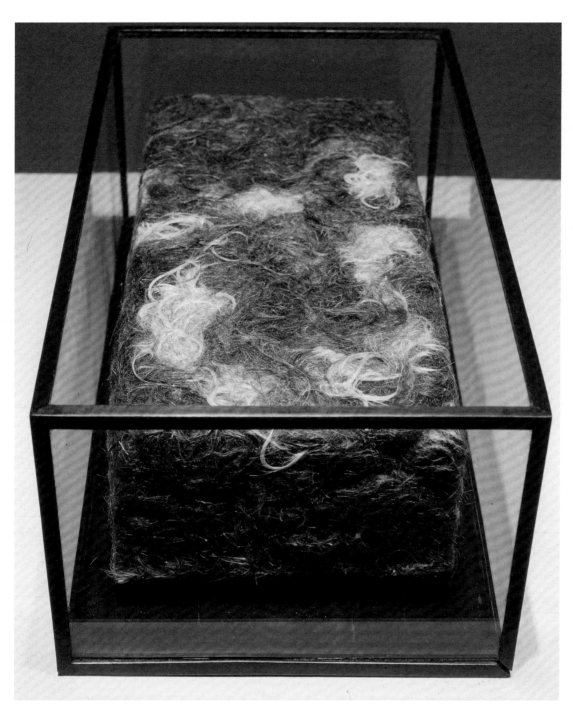

《聯合國 —— 基因長城》

手工製作髮磚

1993 年於紐約工作室

人髮，白乳膠

40 厘米長 × 20 厘米寬 × 10 厘米厚（明代長城磚尺寸）

44 厘米長 × 25 厘米寬 × 17 厘米厚（玻璃盒尺寸）

UNITED NATIONS—DNA GREAT WALL

hand-made hair bricks

new york studio, 1993

mixed human hair, white glue

40cm long × 20cm wide × 10cm thick (ming dynasty great wall brick size)

44cm × 25cm × 17cm (each glass box)

《聯合國 —— 基因長城》由近兩佰萬的人髮製成的髮磚和髮簾建構，此作品近乎是武漢陸分之壹的人口了

united nations—dna great wall is made of the hair of two million people formed into bricks and curtains. this represents 1/6th of the population of wuhan.

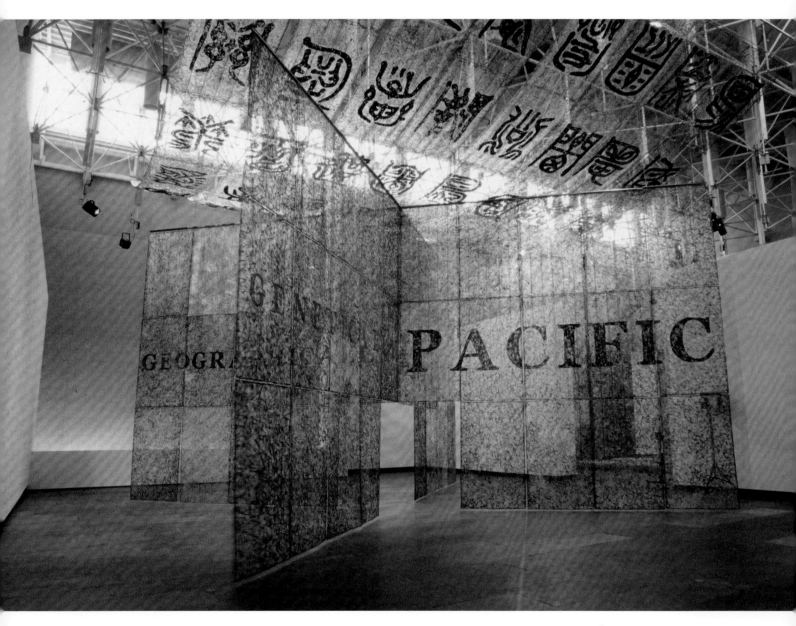

《聯合國──澳洲紀念碑》
2001 年於紐約工作室
澳洲國家美術館，坎培拉
澳洲人髮與亞太地區人髮
1552 厘米長 × 1140 厘米寬 × 600 厘米高

UNITED NATIONS—AUSTRALIA MONUMENT
new york studio, 2001
national gallery australia, canberra
australian hair and aisan hair
1552cm long × 1140cm wide × 600cm high

《聯合國——我們是快樂的動物》

2006 年創作於上海工作室
由康乃爾大學赫伯特強生美術館贊助
染色的人髮，白乳膠，細麻線
975 厘米長 × 792 厘米高

UNITED NATIONS—WE ARE HAPPY ANIMALS

shanghai studio, 2006
a specific installation commissioned by herbert johnson museum of art,
cornell university
a artificially colored human hair curtain
975cm long × 792cm high

《聯合國 —— 黑金》深圳 2010

united nations—black gold shenzhen 2010

《聯合國 —— 黑金》深圳 2010

united nations—black gold shenzhen 2010

《聯合國——黑金》
2008 年－ 2010 年於上海工作室
水墨煉金術 —— 谷文達叁拾年水墨回顧展，深圳
ocat 當代藝術中心
25 公里人髮辮，人髮基因墨粉

UNITED NATIONS—BLACK GOLD

shanghai studio, 2008-2010
ink alchemy—gu wenda's 30-year ink art retrospective, ocat contemporary
art center, shenzhen
25-km chinese hair braid, chinese human dna ink hair

《殖民旗》
colonial flag

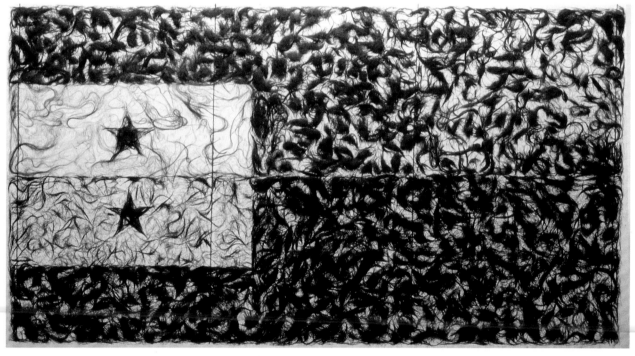

《聯盟旗》
confederate flag

《聯合國——歷史上的美國旗》
1997 年於紐約工作室
混合美國人髮
鋼和玻璃鏡框
125 厘米長 × 66 厘米高

UNITED NATIONS—HISTORIC AMERICAN FLAGS

new york studio, 1997
mixed american hair
metal and glass framed hair flag
125cm long × 66cm high

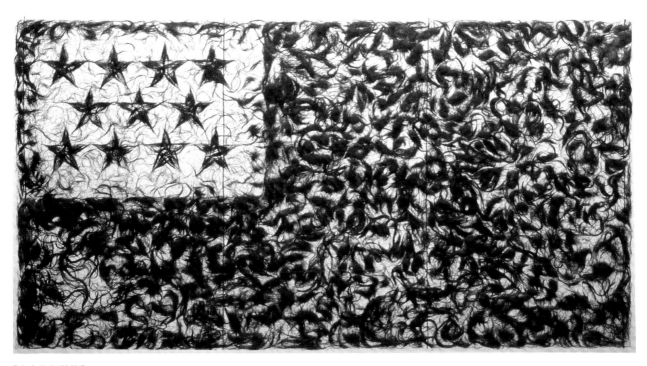

《自由與奴隸旗》
freedom and slavery flag

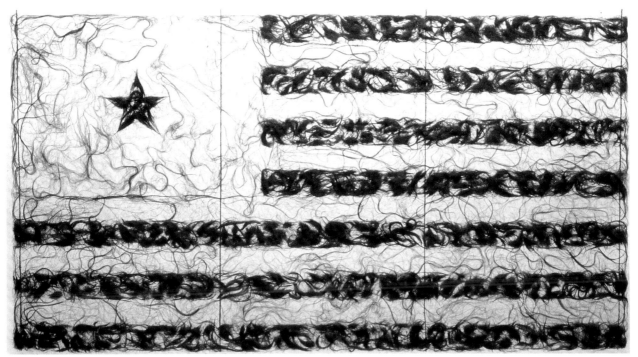

《金旗》
gold flag

《聯合國 —— 庚子年的項鏈》北京 2020

united nations—gengzi's necklace　　beijing 2020

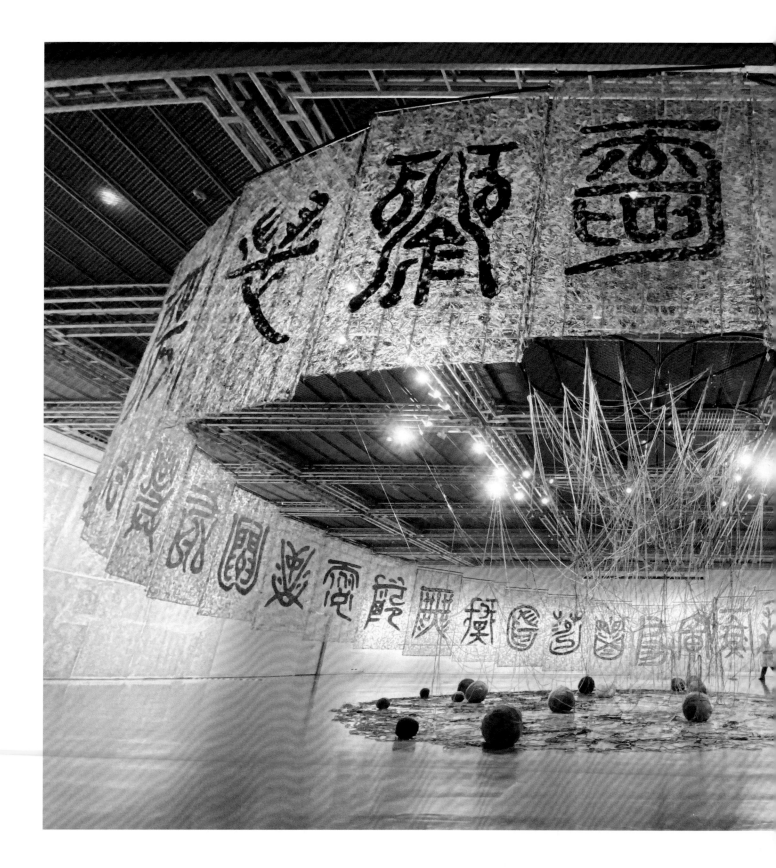

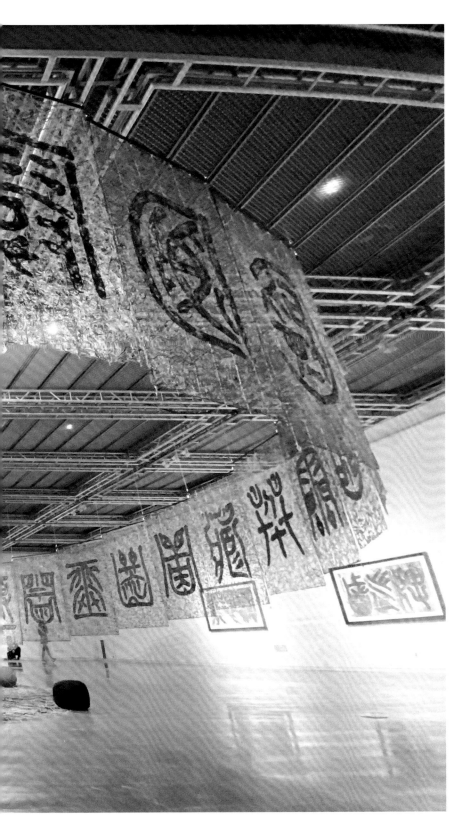

《聯合國——庚子年的項鏈》

2001 年 -2020 年於上海工作室

自然人髮辮，染色人髮辮，人髮簾

1320 厘米直徑 × 420 厘米高（人髮辮 8472 米長，人髮
簾 122 厘米寬 × 197 厘米高 × 66 簾）

UNITED NATIONS—GENGZI'S NECKLACE

shanghai studio, 2001-2020

hair braids in natural colors, artificially coloured hair
braids, hair curtains

1320cm diameter × 420cm high(human hair braid
8472m, human hair curtain 122cm wide × 197cm high
× 66 pieces)

《聯合國——庚子年的項鏈》
細部
united nations—gengzi's
necklace details

驚異的對比下的基因 dna 人
髮辮球與顯微鏡下的新冠病
毒，猶如庚子版的波德賴爾
《惡之花》之書名
a comparison of braided
balls of human hair
genetic dna and the
ultramicroscopic covid 19
virus; this is like the gengzi
version of charles pierre
baudelaire *les fleurs du*
mail

276

谷文達的《聯合國 ——
美國密碼》和人類彩虹

大衛・凱特佛里斯

GU WENDA'S *UNITED NATIONS: AMERICAN CODE* AND THE RAINBOW OF HUMANITY

david cateforis

作為他那一代最傑出的中國藝術家之一，谷文達的《聯合國》系列作品在國際上廣為人知。[1] 從 1993 年開始，這個持續創作中的系列裝置包含了一系列被谷文達稱之為「紀念碑」的東西，主要是把人的頭髮編製成磚塊、地毯、窗簾和辮子等元素，並組合在一起創造出大型的準建築裝置。這些裝置有些是從某一國領域內收集的頭髮製成的國家紀念碑，並安置於該國。另有一些是從許多不同國家收集的頭髮製成的「通用」紀念碑，專門用於跨國主題。還有一些是混合作品，包含了來自世界各地的頭髮，但涉及特定國家或文化的某個主題。其中一個這樣的混合紀念碑是《聯合國 —— 美國密碼（1995 － 2019）》，本文將在對《聯合國》系列作品作大致介紹後進行詳細分析。

《聯合國》的所有作品都使用混合的人類頭髮，暗示通過生物學上的合併，超越政治和其他邊界來達到人類融合的烏托邦的可能性。藝術家僅用小寫字母拼寫作品的英文標題以傳達一種平等的精神，與該系列致力的這種聯

one of the most prominent chinese artists of his generation, gu wenda is best known internationally for his *united nations* series.[1] begun in 1993, this ongoing series of installations comprises a sequence of what gu calls "monuments," made principally of human hair fashioned into such elements as bricks, carpets, curtains, and braids, combined to create large quasi-architectural installations. some are national monuments made from hair collected within a single country and installed there. others are "universal" monuments made of hair gathered from many countries, and dedicated to transnational themes. still others are hybrid works that incorporate hair from around the globe but that address a subject specific to a particular nation or culture. one such hybrid monument is *united nations: american code* (1995-2019), which this essay will analyze in detail following a general introduction to the *united nations* series.

all of the *united nations* works use blended human hair to suggest the utopian possibility of human integration through biological merger, transcending political and other boundaries. the artist spells their english titles in exclusively lower case letters to convey a spirit of equality consistent with the series' dedication to this unification.

合統一相一致。谷氏在《聯合國》系列中使用人的頭髮，來避免傳統的通過無機媒介對身體的藝術表現。他將身體材料描述為「博物館和畫廊中所展出的作為客體的藝術的對立面。這些材料和看着它們的人們一樣真實，因而能夠以一種深刻的精神存在感滲透我們。因此，我稱他們為『沉默的自我』。……當觀眾看到這些以人體為材料的作品時，他們實際上是在與自己相遇。」[2] 他還強調頭髮作為《聯合國》媒介的重要性，因為它在不同的歷史和文化語境中具有豐富的象徵意義，並且它是身份的生物學標記。谷文達認為，通過頭髮，他將「dna 的使用作為一種述說」。[3]

邂逅谷氏的《聯合國》作品可能會引發反感，因為在大多數文化中，通常只有當頭髮長在頭上時才會被認為有吸引力，而一旦毛髮脫離身體，則會令人厭惡。據朱麗亞·克利斯蒂娃（julia kristeva）頗具影響力的精神分析理論所言，廢棄的頭髮是一種卑賤的材料。按照克利斯蒂娃的說法，頭髮和其他身體廢棄物（指甲、尿液、嘔吐物、經血等）一樣是卑賤的，因為它們雖被身體排泄，但仍然與形成它們的身體維繫着心理上的連接。卑賤物讓我們面對身體的物質性和死亡，並打破我們用以維繫身份安全感的主客體之間的界限。[4] 谷氏承認這種「對廢棄物的恐懼」，[5] 但他認為，雖然大多數人料想他用人體廢棄物創作的藝術會很污穢，但「他們看到時並不會這麼認為」。[6] 在畫廊燈光的照耀下微微發亮的頭髮鑲板出現在《聯合國》的許多作品中，在谷氏看來，喚起了身體廢棄物向「一種新興的人類精神」的轉化。[7] 他在一些紀念碑中加入的髮辮也超越了卑賤，因為編成辮子的頭髮並不會被視為退化的廢棄物，而是被視為人體材料，經過人手的精心塑造以表達風格或象徵意義。

gu uses human hair in the *united nations* series to avoid the conventional artistic representation of the body through inorganic media. he describes body materials as "the antithesis of art as object exhibited in museums and galleries. they are as real as the people who look at them and therefore can penetrate us with a deep sense of spiritual presence. therefore, i call them 'silent selves.' . . . when viewers behold the works with human body materials, they are literally encountering themselves."[2] he also emphasizes hair's importance as the medium of the *united nations* because of its rich symbolism in different historical and cultural contexts and because it is a biological marker of identity. gu says that through hair, he uses "dna as a representation."[3]

encountering gu's *united nations* works may induce revulsion, since in most cultures hair, often considered attractive when attached to the head, is seen as disgusting when it is detached from the body. in the terms of julia kristeva's influential psychoanalytic theory, cast-off hair is an abject material. according to kristeva, hair, along with other corporeal wastes (nails, urine, vomit, menstrual blood, and so on) is abject because it is evacuated from but remains psychologically linked to the body that formed it. the abject confronts us with the body's materiality and mortality and disrupts the boundaries between subject and object that we employ to maintain a secure sense of identity.[4] gu recognizes this "fear of waste material,"[5] but contends that while most people expect his art made of human body waste to be filthy, "they don't think that when they see it."[6] shimmering in the glow of gallery lights, the hair panels featured in many *united nations* works evoke, for gu, body waste transformed into "a rising human spirit."[7] the hair braids he incorporates into some of the monuments also transcend abjection since braided hair is not seen as degraded waste but as body material carefully shaped by human hands for stylistic or symbolic expression. the suspended panels in many *united nations* works feature

許多《聯合國》作品中懸掛着的鑲板都是由膠水粘起來的長髮聚集而成的，這些長髮以英語、印地語、阿拉伯語和古代中國篆書為基礎，形成了不可閱讀的文本。[8] 一方面，這些文本象徵着語言差異和其他文化差異對人類的持續分化。然而，谷氏也會從哲學角度看待這些難以辨認的文本，這是他在閱讀維特根斯坦（ludwig wittgenstein）的作品時受到的啟發。「總的來說，」他寫道，「錯誤書寫的語言象徵着『誤解』作為我們對有關宇宙和物質世界認知的本質。然而，偽造的字跡則通過想像人類知識（語言）無法觸及的宇宙，幫助我們達到無限和永恆。」[9]

谷文達在武漢合美術館舉辦的回顧展包括《聯合國》系列的兩件作品：《聯合國 —— 人民的長城》（2005）和《聯合國 —— 綠宮》（2007）。[10] 在武漢展覽的同時，他還在由巫鴻和奧麗安娜・卡奇奧尼（orianna cacchione）策展的重要展覽「物之魅力：當代中國『材質藝術』」中展示了《聯合國》系列的一件新作《聯合國 —— 美國密碼（1995 － 2019）》。該展覽最初在洛杉磯郡藝術博物館展出（2019 年 6 月 2 日至 2020 年 1 月 5 日），隨後前往芝加哥的斯馬特藝術博物館（smart museum of art）和萊特伍德 659（wrightwood 659）巡展。展覽於 2020 年 2 月 4 日在芝加哥開放，一直展出到新冠病毒大流行迫使美國各地的博物館於 3 月中旬關閉為止。不幸的是，病毒的大流行還導致原定於西雅圖藝術博物館和馬塞諸塞州賽勒姆的皮博迪埃塞克斯博物館（peabody essex museum）的「物之魅力」展覽被取消。2020 年 2 月 14 日，我有幸在芝加哥大學的斯馬特藝術博物館參觀了《聯合國 —— 美國密碼》。我常常會把那次經歷與恰巧在武漢的新冠大流行聯繫在一起，當時谷氏的展覽在那裏開幕，而在 2020 年 2 月，病毒悄然傳遍了美國，很快就戲劇性地改變了人們的日常生活。

gathered long strands of glue-stiffened hair fashioned into unreadable texts based on english, hindi, arabic, and ancient chinese seal script.[8] on the one hand, these symbolize the linguistic and other cultural differences that continue to divide humanity. however, gu also sees these illegible texts in philosophical terms inspired by his reading of ludwig wittgenstein. "in general," he writes, "the miswritten language symbolizes 'misunderstanding' as the essence of our knowledge concerning the universe and the material world. yet, the pseudo-scripts help us reach infinity and eternity by imagining the universe which is out of the reach of human knowledge (language)."[9]

gu's retrospective at the he art museum in wuhan included two *united nations* works: *united nations: the great wall of people* (2005) and *united nations: the green house* (2007).[10] concurrent with his wuhan show, gu presented a new *united nations* work, *united nations: american code* (1995-2019) in the major exhibition, "the allure of matter: material art from china," curated by wu hung with orianna cacchione. initially shown at the los angeles county museum of art (june 2, 2019 - january 5, 2020), the exhibition traveled to the smart museum of art and wrightwood 659 in chicago. it opened in chicago on february 4, 2020 and was on view until the covid-19 pandemic forced museums around the united states to close in mid-march. unfortunately, the pandemic also caused the cancellation of the planned subsequent showings of the "the allure of matter" at the seattle art museum and at the peabody essex museum in salem, massachusetts. i had the privilege of seeing *united nations: american code* at the university of chicago's smart museum of art on february 14, 2020. i will forever associate that experience with the pandemic that, coincidentally, was first detected in wuhan around the time gu's exhibition opened there, and that in february 2020 was quietly spreading through the united states, soon to change daily life dramatically.

《聯合國 —— 綠宮》達特茅斯 2007

united nations—green palace dartmouth 2007

《聯合國 —— 綠宮》

2006 年於上海工作室

達特茅斯大學城全理髮店半年 50 萬人次理髮捐贈

2440 厘米長 ×400 厘米高

UNITED NATIONS—GREEN PALACE

shanghai studio, 2006

hair from 500000 haircuts gathered from hair salons around dartmouth college

2440cm long × 400cm high

《聯合國——綠宮》人髮簾
細部
green palace human hair
curtain details

281

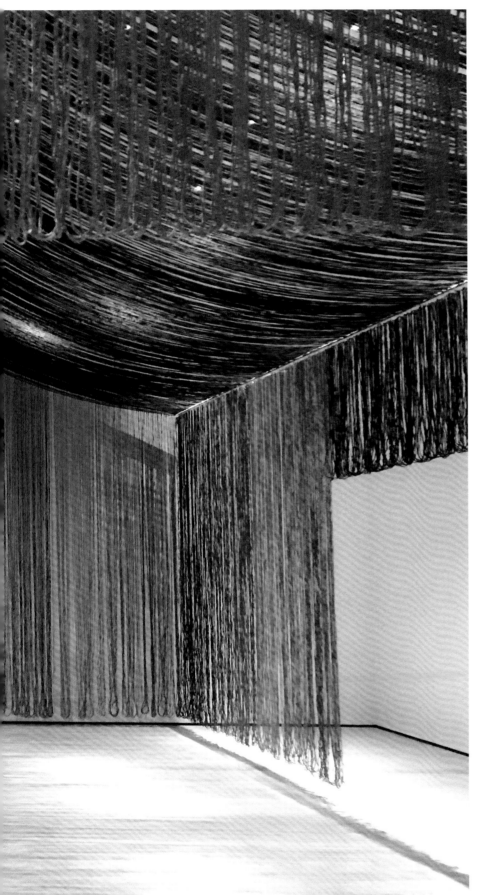

《聯合國——美國密碼》
1995-2019 年於紐約 —— 上海工作室
洛杉磯郡藝術博物館
由安迪·沃荷基金會和 lacma 贊助
各國人髮辮廟，美國伍大族裔人髮旗

UNITED NATIONS—AMERICAN CODE

new york and shanghai studio, 1995-2019
los angeles county museum of art
commissioned by andy worhle art foundation and l.
a. county museum of arts
hair flag made from native-, caucasian-, african-,
latino-, and asian-american hair & braided hair
temple made from the hair of various nationalities

（圖片由洛杉磯郡藝術博物館提供）
(photo by los angeles county museum of art)

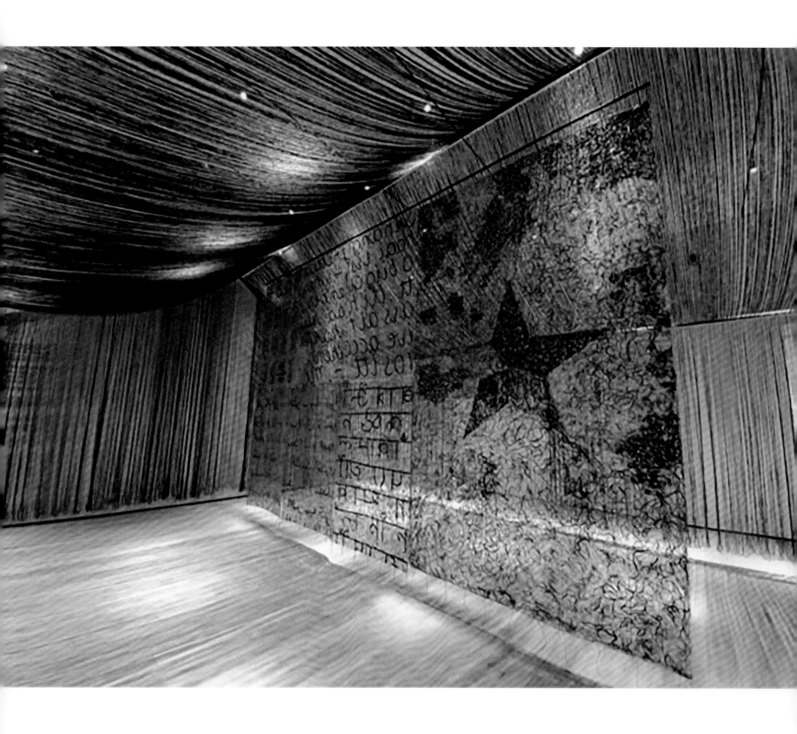

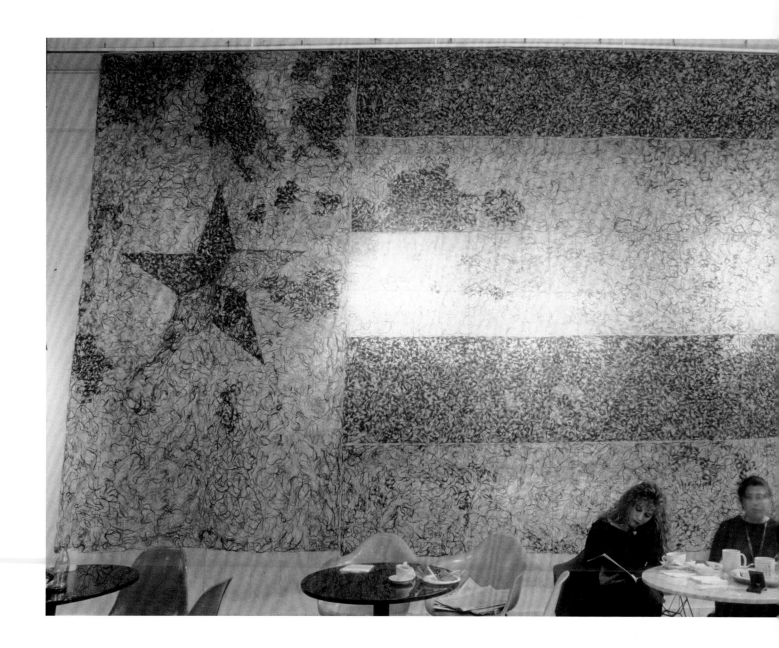

新冠疫情結束了壹個美麗的巡迴展。2019 年 5 月上旬，在洛杉磯郡立藝術博物館 lacma 佈置《聯合國 —— 美國密碼》，是壹個巡迴展的第壹站。當展覽巡迴到芝加哥大學的斯瑪特美術館時，新冠疫情已在美國蔓延開來。隨着疫情日益嚴重，展覽開幕後不久便封館了，並且終止了巡迴至其他美術館的計劃。圖中洛杉磯郡立藝術博物館館長 micheal goven 在佈展期間與谷文達工作室主任湯華和展覽經理李軼睿在展覽現場留下了美好回憶。

the covid 19 pandemic terminated a beautiful traveling art exhibition. *united nations—american code* was in the process of being installed at the los angeles county museum of art in early may 2019, the first stop of a traveling exhibition. this exhibition moved to the smart art museum of chicago university the moment that the covid 19 pandemic had just begun to spread in america. this traveling exhibition plan was also canceled. a photo recorded a beautiful moment when mr. michael goven, the director of the los angeles county museum of art who visited the site of *united nations-american code* with gu wenda studio director linda tang and exhibition manager li yirui.

2019 年創製的《聯合國 —— 美國密碼》裏的美國基因旗是從 1993 年的《聯合國 —— 美國紀念碑》改變而來。圖中展示的美國基因旗是在蘇荷區格林街藝術空間，也是藝術家谷文達的《聯合國》藝術計劃的第貳個展覽。

the american dna flag in *united nations—american code* created in 2019 was a modified version of the *united nations—american monument* created in 1994. the photo was taken in the green st. cafe art space in soho. the american dna flag was the second exhibition in the global art project *united nations*

《聯合國——美國紀念碑》
草圖之玖
1994 年於紐約工作室
鉛筆，卡紙，白色金屬鏡框
34 厘米長 ×27 厘米高

UNITED NATIONS—AMERICA MONUMENT
drawing #9
new york studio, 1994
pencil on cardboard in white metal frame
34cm long × 27cm high

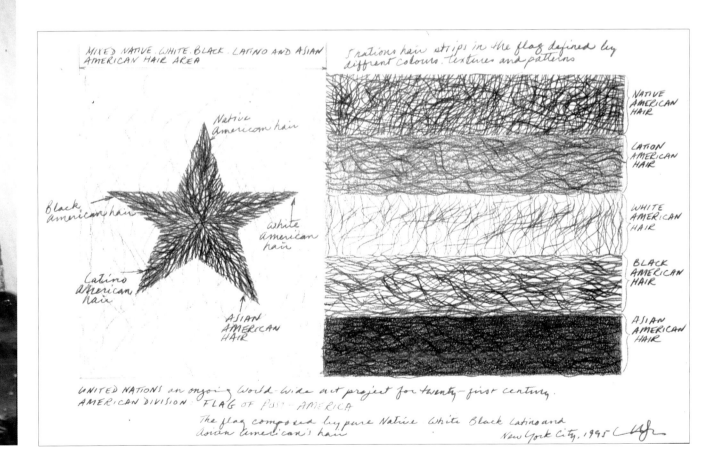

谷文達表示，在《聯合國 —— 美國密碼》副標題中的「密碼」一詞是「一個科學和生物學術語，而非一個藝術術語。」[11] 它可以被認為指涉了遺傳密碼 —— dna 和 rna 中的核苷酸序列，它們決定了蛋白質的氨基酸序列，比如構成頭髮的那些。由於遺傳密碼幾乎在所有現存生物體中都是普遍存在的，這一指涉強化了谷氏關於人類在生物層面上聯合統一的主題。

《聯合國 —— 美國密碼》包含一個懸置的 4.5 米 × 7 米 × 8.55 米大小的類帳篷結構，由人類頭髮編織而成的細圈組成。其側面和前壁的中央有三個寬闊的入口，允許人們從周圍的畫廊空間進出藝術作品。背面懸掛的辮子牆和美術館的牆壁齊高，形成斜頂的髮辮有其天然的黑色，作為兩側入口上方牆壁部分的髮辮也是如此。在側門的兩側，懸掛着染成不同顏色的辮子，按照彩虹顏色的順序：紅、橙、黃、綠、藍、靛、紫，排列成七個垂直的區域。作品的背牆由 16 條垂直色塊組成。每邊 7 條色塊按彩虹顏色排序，從牆角由紅色開始。從前壁看，中央的兩個部分分別是黃色（左）和紅色（右）。組成前壁的髮辮被染成了統一的金色。

該結構內平行於側壁的柱子上懸掛着 7 塊半透明的鑲板，這些面板用膠水加固，纏繞着頭髮，形成了 4 米 × 5.8 米大小的幕牆。從正面看，左邊的面板覆蓋了整個牆壁的垂直範圍，中間鑲有一顆巨大的五角星。這顆星的右臂由金髮製成，左下臂由棕色頭髮製成，其餘三臂則是黑色的頭髮。由多縷頭髮組成的精緻的蛇形線條佈滿了面板的其餘部分，還有一些更濃密的、像島嶼一樣的黑色頭髮，聚集在面板的頂部和五角星的右側、底部與左

gu says that the word "code" in the subtitle of *united nations: american code* is "a scientific and biological instead [of] an artistic term."[11] it can be taken to refer to the genetic code – the sequence of nucleotides in dna and rna that dictates the amino acid sequence of proteins, such as those that make up hair. since the genetic code is nearly universal among all extant organisms, this reference reinforces gu's theme of human unity at the biological level.

united nations: american code consists of a suspended tent-like, 4.5×7×8.55-meter structure comprised of thin looped strands of braided of human hair. three wide portals at the centers of the side and front walls allow passage into and out of the artwork from the surrounding gallery space. the back braid wall hangs flush with the gallery wall. the hair braids forming the pitched roof have their natural black color, as do sections of braids serving as wall sections above the two side portals. on either side of the sidewall-portals hang braids dyed different colors arranged in seven vertical sections that follow the order of the rainbow's colors: red, orange, yellow, green, blue, indigo, and violet. the back wall comprises sixteen vertical color sections. seven sections on each side are arranged in rainbow order, starting with red in the corners. the two central sections, as viewed from the front wall, are yellow (left) and red (right). the hair braids forming the front wall are dyed a uniform gold.

suspended from a pole within the structure, parallel to the side walls, are seven translucent panels of glue-stiffened, twine-supported hair that form a 4×5.8-meter curtain wall. viewed from the front, the left panel, spanning the wall's entire vertical extent, bears a large five-pointed star in its center. the star's right arm is made of blonde hair, its lower left arm of brown hair, and the other three arms of black hair. delicate snaking lines formed of multiple strands of hair fill the rest of the panel, with several denser, island like-patches of black

側。在帶有星星的面板的右邊，是由更小的面板按 3×2 規模形成的網格。上部由兩塊鑲有偽英文的面板和一塊由頭髮組成的偽中文篆書的面板組成。下部則包括一塊偽印地語面板和兩塊偽阿拉伯語面板。

谷氏將早期《聯合國》紀念碑中的一些元素融入了《聯合國——美國密碼》，正如作品的年份「1995－2019」所顯示的那樣。「在《聯合國》項目中，這些頭髮從一件作品出發行至另一件作品，」這位元藝術家寫道，「感覺就像人類移民和全球遷徙。」[12] 鑲有五角星的面板來自谷氏為《聯合國——美國紀念碑 1 號：後－cmoellotniinaglpiostm（1995）》設計的「未來國旗」。在紐約的無名空間展出的這個紀念碑的副標題包括一個不能拼讀的單詞，由「殖民主義」（colonial）和「熔爐」（melting pot）兩個單詞的字母交替組成。該裝置以頭髮幕牆、髮磚和頭髮地毯的同心圓排列為特色。不同通道上的頭髮分別來自紐約市的主要種族或族裔群體——白種人、亞裔美國人、非裔美國人和西班牙裔。[13] 從印第安人保留地採集而來的美國原住民的頭髮，散佈在中央的「大熔爐」——一道包含着混合頭髮的髮磚矮牆——周圍。評論家丹妮爾·張（danielle chang）寫道：「谷氏傳達的資訊是，美國正在創造一種新的文化。在這裏，不同族裔的種族相互影響，誕生了不同種族的混血後裔。」[14]「未來國旗」有五道橫條紋，由美洲原住民、白人、非裔美國人、西班牙裔美國人和亞裔美國人的頭髮組成；來自這些相同族群的頭髮也組成了旗幟上星星的五個星臂。[15] 分離的星臂和條紋違背了大熔爐的概念，承認持續存在的種族和民族差異是人類統一的障礙——這是谷氏系列作品整體上反覆出現的張力。在《聯合國——美國密碼》中，條紋已被印着不可閱讀的語

hair clustered along the panel top and to the right, bottom and left sides of the star. to the right of the panel with the star is a three-by-two grid of smaller panels. its top register comprises two panels bearing pseudo-english and one panel with hair formed into pseudo-chinese seal script. the bottom register comprises a panel with pseudo-hindi and two panels with pseudo-arabic.

gu incorporated several elements from earlier *united nations* monuments into *united nations: american code*, as is signaled by the work's 1995-2019 dating. "the hair pieces have traveled from one work to the other with [the] un project," writes the artist; "it feels like human migration and global immigration."[12] the panel bearing the star comes from a "future national flag" that gu devised for *united nations – usa monument 1: post-cmoellotniinaglpiostm* (1995). shown at space untitled in new york, this monument's subtitle includes an unpronounceable word formed by alternating the letters of "colonialism" and "melting pot." the installation featured a concentric arrangement of hair curtain-walls, hair bricks, and hair carpets. separate walkways comprised hair from each of new york city's major racial and/or ethnic groups – caucasian, asian-american, african-american, and hispanic.[13] native american hair collected from indian reservations was sprinkled around the central "melting pot" of mixed hair contained by a low wall of hair bricks. "gu's message," wrote critic danielle chang, "is that a new culture is being created in america. it is here where different ethnic strains interact and the mixed progeny of different races are born."[14] the "future national flag" had five horizontal stripes made of native-american, caucasian, african- american, hispanic, and asian-american hair; hair from these same groups made up the five arms of the flag's star.[15] the separate arms and stripes countered the notion of the melting pot, acknowledging persistent racial and ethnic differences as impediments to human unification – a tension recurrent in gu's series as a whole. in *united nations: american code*, the stripes have been replaced by panels bearing unreadable languages dominant in

言的面板所取代，這些語言在世界上不同的地方佔據主導地位，如今更多表明了文化的多樣性，而不是種族和民族的多樣性。這些面板是標準的 2 米 × 1.2 米大小的模組，谷氏從 1997 年開始便使用它們來建造幕牆，這也是根據以前的《聯合國》紀念碑來重新設計的。[16]

形成《聯合國 —— 美國密碼》頂部和四壁的半厘米寬的髮辮同樣是從《聯合國》早期作品中回收利用的。黑色髮辮來自《聯合國 —— 聯合 7561 公里》（2002），首次於 2003 年安置於北德克薩斯美術館。[17] 谷氏計算出 7561 公里是組成 2002 紀念碑的 5 公里長的髮辮的單束髮長所覆蓋的距離，該作品是由他在上海工作室的助手創作的。這捆長長的頭髮象徵着全球人口的龐大，以及《聯合國》項目的核心概念，即人類本質上的相互關聯性。[18] 由谷氏助手編織的《聯合國 —— 美國密碼》中的五彩繽紛的辮子也具有同樣的象徵意義。這些作品來自於《聯合國 —— 統一的色彩》，這是谷氏在 2007 年為達特茅斯學院貝里圖書館的主通道所創作的一個臨時裝置。[19] 在那件作品中，谷氏用染過的頭髮來提供視覺上的愉悅，並參考了當時在中國年輕人中流行的染髮潮流。[20] 在《聯合國 —— 美國密碼》中，正如前文提到的那樣，谷氏將顏色按照彩虹的成色那樣排列。

谷文達將《聯合國》系列描述為「一個論壇，一個邀請我們討論我們時代的許多文化和藝術問題的物理和心理空間。」[21]《聯合國 —— 美國密碼》作為對當代美國移民問題的富有象徵意義的思考值得我們深思，移民不僅是文化和藝術問題，也是政治問題。該紀念碑包含了來自 5 大洲 20 多個國家的人類頭髮。[22] 這使人想起美國作為「移民之國」的地位 ——《移民之國》是約翰 ·F· 甘迺迪總統

different parts of the world, now suggesting cultural rather than racial and ethnic diversity. these panels – standard 2×1.2-meter modules that gu has used since 1997 to construct curtain walls – are also repurposed from previous *united nations monuments*.[16]

the half-centimeter wide lengths of braided of hair forming *united nations: american code*'s roof and walls were likewise recycled from earlier *united nations* works. the black braid comes from *united nations – united 7561 kilometers* (2002), first installed in 2003 at the university of north texas art gallery.[17] gu calculated 7561 kilometers as the distance that would be covered by the individual strands of hair comprising the 2002 monument's five kilometer-long braid, created by assistants in his shanghai studio. this long rope of hair symbolized the immensity of the global population and the essential human interconnectedness that is at the conceptual heart of the *united nations* project.[18] the colorful lengths of braid in *united nations: american code*, also woven by gu's assistants, possess the same symbolism. these come from *united nations: united colors*, a temporary installation gu created in 2007 for the main corridor of berry library at dartmouth college.[19] in that work, gu used the colored hair to provide visual pleasure and to refer to the then-popular trend among chinese youth to dye their hair.[20] in *united nations: american code*, as already noted, gu has arranged the colors into those seen in a rainbow.

gu has described the *united nations* series as a "forum, a physical and psychological space that invites a conversation on the many cultural and artistic issues of our times."[21] *united nations: american code* beckons consideration as a richly symbolic reflection on a contemporary american issue that is not only cultural and artistic but also political: immigration. the monument incorporates human hair from more than twenty countries on five continents.[22] this evokes the united states' status as "a nation of immigrants" – the title of a book president john f. kennedy wrote in 1963

在 1963 年的著作名稱，當時他正準備要求國會全面修改美國的移民法。[23] 甘迺迪的著作回顧了美國的移民史，強調了移民為美國作出的多方面貢獻，以及他們所面臨的歧視和偏見。甘迺迪呼籲結束認為來自北歐國家的移民比來自世界其他地區的移民更有優勢的國籍配額制度。他將該制度描述為「既沒有邏輯基礎也沒有理性基礎。它既不能滿足國家需要，也不能達到國際意圖。在一個國家之間相互依存的時代，這樣的制度是不合時宜的，因為它基於出身的偶然性對申請入境美國的人進行區分。」[24] 甘迺迪寫道，這「違背了《獨立宣言》中表達的『人人生而平等』的精神！」[25]

甘迺迪在《移民之國》中表達的觀點與 2018 年谷文達在特朗普政府實施反移民政策期間構思《聯合國 —— 美國密碼》時的美國形勢高度相關。這些政策包括大幅減少合法和無證入境以及難民和尋求庇護者入境的人數；試圖剝奪入籍美國人的公民身份和驅逐在美國長大的「追夢者」；並試圖通過在美墨邊境分離人們的家庭來阻止非法越境。[26] 在上海和布魯克林都居住過的谷文達有着移民的視角：1987 年，他持學生簽證從中國來到北美，隨後獲得了准許他永居美國的綠卡。雖然他肯定沒有打算把《聯合國 —— 美國密碼》作為對唐納德・特朗普政策的批判 —— 谷氏避免在作品中公開發表政治評論 —— 然而，這座紀念碑可以被解讀為對移民的頌揚，儘管特朗普的言論和行動實際上豐富了美國的社會、文化和經濟。[27]

《聯合國 —— 美國密碼》的彩虹色傳達了這種慶賀和包容的精神。谷氏將彩虹描述為「雨後、美好祝願、希望與

as he prepared to ask congress to overhaul the nation's immigration laws.[23] kennedy's book surveys the history of immigration to the united states, emphasizing the manifold contributions immigrants have made to the country as well as the discrimination and bigotry they have faced. kennedy called for an end to the national origins quota system that heavily favored immigrants from northern european countries over those from other parts of the world. he described this system as being "without basis in either logic or reason. it neither satisfies a national need nor accomplishes an international purpose. in an age of interdependence among nations such a system is an anachronism, for it discriminates among applicants for admission into the united states on the basis of accident of birth."[24] this, writes kennedy, "violates the spirit expressed in *the declaration of independence* that 'all men are created equal'!"[25]

kennedy's views expressed in *a nation of immigrants* remained highly relevant to the situation in the united states in 2018 when gu wenda conceived of ***united nations: american code*** in the midst of the trump administration's implementation of anti-immigration policies. these included drastically cutting levels of both legal and undocumented arrivals and entry by refugees and asylum seekers; seeking to strip naturalized americans of citizenship and deport u.s.-raised "dreamers"; and attempts to deter illegal border crossings by separating families at the mexico-u.s. border.[26] gu, who lives in both shanghai and brooklyn, has an immigrant's perspective: he came to north america in 1987 from china on a student visa and subsequently gained a green card granting him permanent united states residency. while he certainly did not intend ***united nations: american code*** as a critique of donald trump's policies – gu avoids making overt political commentary in his work – the monument can nevertheless be interpreted as celebrating immigration, which despite trump's rhetoric and actions actually enriches the country's society, culture, and economy.[27]

未來的和諧」的象徵。[28] 除了象徵着樂觀，旗幟形式的彩虹（由吉伯特・貝克於 1978 年在三藩市首次創立）還象徵着同性戀的驕傲和全球 lgbtq 群體。[29] 在美國，彩虹還與傑西・傑克遜牧師的全國彩虹聯盟（national rainbow coalition）有關，該聯盟旨在促進所有美國人的平等權利。「彩虹聯盟」一詞已經進入了詞典，泛指不同種族或不同民族的、政治的或宗教背景的成員之間的聯盟。[30] 《聯合國 —— 美國密碼》中央的旗幟 —— 1995 年谷氏首次推出的「未來國旗」的升級版本 —— 通過它由不同天然髮色的頭髮製成的五角星來承認這種多樣性，代表了不同的種族和民族，並且它的鑲板展示了四種由人類共有的同一種身體材料所組成的不同的誤寫的語言，象徵着文化異質性與普遍人性的共存。

《聯合國 —— 美國密碼》的整體結構，同時暗示着帳篷、房子和寺廟，也可以與移民和包容的主題相關。帳篷是一個可移動的臨時避難所，喚起了移民的體驗。許多移民都有一個共同的美國夢，那就是在房子裏安頓下來，這能為他們提供永久的居所和家庭的舒適。（也希望）能有一個寺廟將人們聚集在同一屋簷下進行公共儀式或禮拜。谷氏肯定了裝置的內涵：「房子，寺廟，或一個大屋頂……所有人，無論多麼不同，我們都在同一個大屋簷下分享事物。這就是《聯合國》項目。」[31]

然而，《聯合國 —— 美國密碼》缺乏寺廟或房屋那樣堅固耐用的性質。作為一個臨時裝置，它更像一個帳篷，但又不同於帳篷，它的頂部和四壁是可滲透的，並不能提供真正的遮蔽。無論是在紀念碑的內部還是外部，參觀者的視線都可以穿透懸掛細辮子的寬廣區域和旗幟的半透

the rainbow colors of *united nations: american code* convey this celebratory and inclusive spirit. gu describes the rainbow as a symbol of "after rain, good wishes, hope and futural [future] harmony."[28] in addition to signifying optimism, the rainbow in the form of a flag (first created by gilbert baker in san francisco in 1978) symbolizes gay pride and the worldwide lgbtq community.[29] in the united states, the rainbow is also associated with the rev. jesse jackson's "national rainbow coalition," which promotes equal rights for all americans. the term "rainbow coalition" has entered the lexicon to refer generally to an alliance between members of different races or of varying ethnic, political, or religious backgrounds.[30] this definition resonates with the diversity that immigrants from around the globe have traditionally brought to american society and culture, forming a vibrant rainbow of humanity. the banner in the center of *united nations: american code* – an updated version of the "future national flag" gu first introduced in 1995 – acknowledges this diversity through its star made from hair of different natural colors, representing different races and ethnicities, and its panels presenting four different miswritten languages made of the same body material that all humans share, signifying cultural heterogeneity coexisting with common humanity.

the overall structure of *united nations: american code*, simultaneously suggesting a tent, a house, and a temple, can also be related to themes of immigration and inclusion. a tent is a portable and provisional form of shelter evoking the experience of migrants. many immigrants share the american dream of settling in a house, which provides permanent living quarters and domestic comfort. a temple brings people together under one roof for communal ritual or worship. gu affirms the installation's connotations of "a house, a temple, or a big roof. . . . all people no matter how different, we all share things under a big roof. this the un project what it is. [this is what the un project is]."[31]

united nations: american code, however, lacks the solid, durable nature of a temple or house. as a temporary

明面板。參觀者因此而感知到裝置的脆弱性，且不僅能感受到眾多「沉默的自我」——他們的頭髮組成了《聯合國——美國密碼》，還能感受到他們自身的存在，意識到其他人可以在穿過藝術品時或在此周圍看到他們。就其可見性而言，每個與《聯合國——美國密碼》共用空間的人都暫時成為它的一部分，從而加強了谷氏對於全人類關聯性的核心關注。

最終，這引發了對《聯合國——美國密碼》與連續肆虐許多國家的新冠大流行的經歷的相關性的考慮。儘管谷文達在 2018 年構思《聯合國——美國密碼》時，並沒有預見新冠病毒的出現和傳播，該作品對人類團結的強調與大流行所創建的我們都是一體的強烈意識產生了強有力的共鳴。[32] 我們共同生活在一個被一種疾病吞沒的星球上，該疾病不辨國界，不歧視任何國家的移民和當地居民。「感受到我們自己的脆弱，我們就能更深刻地感受到世界各地其他人的痛苦」評論員泰德·摩根（ted morgan）寫道，他接着問道，「如果我們通常都表現得像是一體的，生活會是甚麼樣子？如果我們的政治和經濟體系不是建立在成為別人的競爭者、對手和敵人的基礎上，系統化地壓制我們對人類同胞的基本同理心，那會怎樣？」[33]

2020 年 3 月，在歐洲國家為減緩新冠病毒的傳播而實施封鎖後不久，學校關閉，五顏六色的彩虹圖像出現在窗戶上，懸掛於陽台上，其中許多是孩子們畫的。這一潮流似乎肇始於義大利，並很快蔓延至全世界。[34] 這些傳達着希望和樂觀的彩虹，帶有與《聯合國——美國密碼》相同的象徵意義。這是這個裝置作品與 2018 年谷文達無法預測的流行病之間的另一種聯繫，也是藝術作品從圍繞其展

installation, it more resembles a tent, but unlike a tent, its roof and walls are permeable and provide no real shelter. whether inside or outside the monument, visitors can see through the expanses of suspended thin braids as well as the flag's translucent panels. visitors thus perceive the installation's fragility and sense not only the multitude of "silent selves" whose hair comprises *united nations: american code*, but also their own physical presence, aware that they can be seen by others moving through or around the artwork. in terms of their visibility, everyone who shares the space with *united nations: american code* becomes temporarily a part of it, reinforcing gu's central concern with the connectedness of all human beings.

this leads, finally, to a consideration of united nations: american code's relevance to the experience of the covid-19 pandemic that continues to ravage many countries. although gu wenda could not have foreseen covid-19's emergence and spread when he conceived of united nations: american code in 2018, the work's emphasis on human unity resonates powerfully with intense awareness created by the pandemic that we are all one.[32] we share a planet engulfed by a disease that recognizes no national borders and does not discriminate between immigrants and native citizens of any country. "feeling our own vulnerability, we can feel more profoundly the suffering of others around the world," writes commentator ted morgan, who then asks, "what would life be like if we normally acted as if we were all one? what if our political and economic systems were not structured around being competitors, adversaries and enemies of others, systematically repressing our fundamental empathy for our fellow humans?"[33]

shortly after european countries imposed lockdowns in march 2020 to slow the coronavirus's spread, closing schools, colorful images of rainbows, many painted by children, appeared in windows and hanging from balconies. the trend seems to have begun in italy and

開的相關事件中所獲得的共鳴。谷氏關於《聯合國》系列持續進行的聲明與這座 2019 紀念碑的特色高度相關：「作品尚未完成，它仍然在繼續。持續進行意味着對新環境、新情況、新時代的開放。所以作品一直在變化。」[35]《聯合國》系列所傳遞的完全樂觀的資訊是不變的和持久的。所有的人類，除去他們的個體差異，是天然相關聯的。我們有潛質在和平、美麗與和諧中共存，就像彩虹的顏色一樣。

soon spread around the world.[34] communicating hope and optimism, these rainbows carried the same symbolism as they do in ***united nations: american code***. this is another connection between the installation and the pandemic that gu wenda could not have predicted in 2018 and a resonance that the artwork has acquired in relation to unfolding events surrounding it. gu's statement concerning the united nations series' ongoing nature is highly relevant to the character of this 2019 monument: "the work is not finished; it still continues. ongoing means open to the new environment, new situations, new times. so the work has been changing all the time."[35] what is constant and enduring is the ***united nations*** series' fundamentally optimistic message: all human beings, despite their individual differences, are naturally connected. we have the potential to coexist in peace, beauty and harmony, like the colors of the rainbow.

大衛‧凱特佛里斯為堪薩斯大學藝術史系主任、藝術史教授，執教美國現當代藝術課程。其研究重點為 20 世紀美國藝術和全球當代藝術。他發表過關於多位藝術家的文章，包括從阿爾伯特‧布洛赫到安德魯‧懷斯、威廉‧德‧庫寧、羅伯特‧馬瑟韋爾、伊莉莎白‧默里和谷文達。

david cateforis is professor of art history and chair of the kress foundation department of art history at the university of kansas, where he teaches american art and modern and contemporary art. his research focuses on 20th-century american art and global contemporary art. he has published on artists ranging from albert bloch to andrew wyeth, willem de kooning, robert motherwell, elizabeth murray and wenda gu.

注釋

1 感謝亞歷克斯·凱特佛里斯、李軼睿和谷文達為我起草這篇文章提供的説明。我在這篇文章中將這位藝術家稱為谷文達（gu wenda），但他在西方也被稱為文達谷（wenda gu）。他使用這兩個名字是因為他在中國和西方國家（如美國）之間來回往返的經歷。前者，姓在名之前（如谷文達）；後者則是相反的（如文達谷）。關於 2007 年《聯合國》系列的調查分析，參見大衛·凱特佛里斯：《工作尚未完成：谷文達的〈聯合國〉系列和達特茅斯紀念碑》，收錄於《達特茅斯的谷文達：裝置藝術》（漢諾威，新罕布什爾州：胡德藝術博物館，達特茅斯學院與新英格蘭大學出版社，2008 年），第 63 至 85 頁。同樣參見谷文達的《聯合國》項目論文，《面對新千年：我們時代的神曲》，收錄於馬克 h.c. 貝西爾主編的《谷文達：從中央王國到生物千年的藝術》（劍橋，ma：麻省理工學院出版社，2003 年），第 30 至 41 頁。

2 谷文達：〈面對新千年〉，貝西爾主編，《谷文達：從中央王國到生物千年的藝術》，第 35 至 36 頁。

3 谷文達專訪，南希 p. 林主持，格雷格·楊翻譯，2019 年 7 月 29 日，https://theallureofmatter.org/artists/gu-wenda/。雖然只有毛囊含有核 dna，但最近的研究表明，在每縷人類頭髮中發現的蛋白質 —— 與 dna 直接相關 —— 對每個人來説都是獨一無二的。參見布魯克斯·海斯的〈人類頭髮中的蛋白質可能和指紋一樣有用〉，收錄於《科學新聞》，2016 年 9 月 7 日，https://www.upi.com/science_news/。

4 克里斯汀·羅斯，《當代藝術的矛盾體》，收錄於阿米莉亞·鍾斯主編：《1945 年以來的當代藝術指南》（牛津：布萊克威爾，2006 年），第 391 頁。

5 谷文達：《面向新千年》，第 37 頁。

6 谷文達在露辛達·布里丁《畫廊的凝視：仲冬之展為當地的藝術愛好者提供了豐富的多樣性》一文中的引述。收錄於 2003 年 1 月 23 日，《丹頓（德克薩斯）紀事報》。

7 2007 年 6 月 6 日，谷文達與作者的對談。

8 垂直長度等距分佈的繩索支撐着鑲板，這是谷氏的助手根據他的設計創作的。助理們用膠水把頭髮塑造成字跡或抽象的細絲，然後把鑲板壓在塑膠片之間，等膠水乾了之後，塑膠片就會被移走。除了錯誤書寫的英語、印地語、阿拉伯語和中國篆書鑲板，谷氏還在他的一些《聯合國》紀念碑上製作和使用了偽希伯來語的鑲板。

9 谷文達：《面向新千年》，第 39 頁。

10 2021 年 5 月 17 日，谷文達給作者的電子郵件。谷氏最初為 2005 年的大型展覽「牆：重塑當代中國藝術」創作了《聯合國 —— 人民的長城》，由北京中華世紀壇藝術館和紐約布法羅歐布萊特 —— 諾克斯美術館（albright-knox art gallery）展出。2007 年，他在新罕布什爾州漢諾威，達特茅斯學院的貝克圖書館大廳臨時搭建了《聯合國 —— 綠宮》。

11 2021 年 5 月 17 日，谷文達給作者的電子郵件。

12 2021 年 5 月 18 日，谷文達給作者的電子郵件。

13 如今，許多美國人出於政治原因更喜歡用「拉丁裔」而不是「西班牙裔」一詞，但在這裏我保留了後者，因為它曾被用於描述谷氏 20 世紀 90 年代和 21 世紀初的作品。

14 丹妮爾·張：《美式分化：後 -cmoellotniinaglpoistm》（紐約：無名空間，1995 年）。

15 谷氏不再精確地回憶出哪隻星臂含有哪一個民族或種族群體的頭髮，而是假設頂端的星臂可能含有美洲原住民的頭髮，接按順時針方向依次包含白種人、非裔美國人、拉丁裔和亞裔美國人的頭髮。2021 年 5 月 24 日，谷文達給作者的電子郵件。

16 谷氏首次在《聯合國 —— 非洲紀念碑：世界祈禱牆》中使用這些標準尺寸的面板，在第二屆約翰尼斯堡雙年展（1997 年）中展出。

17 2021 年 5 月 17 日，谷文達給作者的電子郵件。

18 在《聯合國 —— 聯合 7561 公里》中，髮辮被分成若干部分象徵人類的持續分化，每部分之間由一個橡皮圖章連接，上面印有聯合國 191 個成員國之一的名字（截至 2002 年），用小寫字母倒着拼寫。

19 2021 年 5 月 17 日，谷文達給作者的電子郵件。

20 正如在《聯合國 —— 聯合 7561 公里》中那樣，谷氏在《聯合國 —— 統一的色彩》中提到了人類持續不斷的政治分歧，通過每隔 57 米便用 4.5 厘米 × 7 厘米大小的橢圓形不鏽鋼大獎章穿過髮辮來表現，每個獎章上刻有「聯合國」三個字，日期「2007」以及用小寫字母倒着拼寫的 207 個國家之一的名字。

21 谷文達：《面對新千年》，第 31 頁。

22 這是根據谷文達展覽經理李軼睿於 2021 年 5 月 18 日發郵件給作者提供的檔。

23 這本書在甘迺迪死後出版，是由反誹謗聯盟（anti-defamation league）1958 年出版，甘迺迪作為美國參議員時所寫文章的擴充版。

24 約翰·F·肯尼迪：《移民之國》（紐約：哈珀和羅出版社，1964），第 74 至 75 頁。

25 同上，第 75 頁。

26 《華盛頓郵報》，2020 年 9 月 11 日社論，《在新任期內，特朗普將進一步封閉美國堡壘的大門》，https://www.washingtonpost.com/opinions/2020/09/11/trump-immigration-policies-rooted-fear/。「追夢者」指的是在兒童時期來到美國的無證件移民，他們將通過《外國未成年人發展、救濟和教育法案》（dream）獲得合法地位，該法案於 2001 年在國會首次提出，其後多次被重新提及，但至今尚未頒佈。

27 丹尼爾·格里斯沃爾德（daniel griswold）：〈移民的好處：解決關鍵迷思〉，《政策簡報》，喬治·梅森大學莫卡特斯中心，2018 年 5 月 23 日，https://www.mercatus.org/publications/trade-and-immigration/benefits-immigration-addressing-key-myths。

28 2021 年 5 月 18 日，谷文達給作者的電子郵件。

29 凱利·格羅維爾（kelly grovier）：《彩虹旗的歷史》，bbc 文化，2016 年 6 月 15 日，https://www.bbc.com/culture/article/20160615-the-history-of-the-rainbow-flag。

30 https://www.merriam-webster.com/dictionary/rainbow%20coalition

31 谷文達，2021 年 5 月 18 日給作者的電子郵件。

32 在谷文達最新的《聯合國》紀念碑作品《聯合國 —— 庚子的項鏈》（2020 年）中，他直接談到了新冠病毒大流行，該作品於 2020 年 8 月至 9 月期間在北京嘉德藝術中心展出。白傑明（Geremie R. Barmé）解釋説，「在傳統的 60 年的農曆迴圈中，『庚子年』每隔 37 年出現一次。在現代和大眾的想像中，『庚子年』是與災難和苦難聯繫在一起的。白傑明：〈1900 & 2020 —— 新時代的舊焦慮〉，《中國遺產》，2020 年 4 月 28 日，https://chinaheritage.net/journal/1900-2020-an-old-anxiety-in-a-new-era/。在《聯合國：庚子的項鏈》作品中央的地板上，無數散落的大團彩染編髮拖着一截髮辮形成一個內部無序的圓圈，並且辮子纏結在一起升向天花板，代表了記者李瓊所説的「冠狀病毒、現實狀況」以及其中的混亂。圍繞這堆「混亂」的是 34 塊懸掛的髮板，每塊都有一個很大的偽字元在上面。據谷氏（2021 年 5 月 17 日發給作者的電子郵件）介紹，一些字元是用英文字母和中國篆書合成的；其他字元則混合了英語、希伯來語、印地語、阿拉伯語和中文字元的元素。據李瓊報導，字元傳達的是「希望……這些都是不同文明、民族和文化的象徵。藝術家試圖表達一種資訊，即作為一個整體的人類正面臨着相同的問題，正在共同努力。」李瓊：《新冠肺炎大流行激發新的藝術靈感》，CGTN，2020 年 8 月 27 日，https://news.cgtn.com/news/2020-08-27/COVID-19-pandemic-stimulates-new-artistic-inspiration--TieLTS1yWQ/index.html。

33 泰德·摩根（ted morgan）：〈您的觀點：冠狀病毒表明我們在整個地球上彼此關聯〉，《晨間電話》，2020 年 4 月 24 日，賓夕法尼亞州艾倫鎮，https://www.mcall.com/opinion/mc-opi-coronavirus-unity-morgan-20200424-2ivjr7ncmbakdihyeucssogbcq-story.html。

34 蓋亞·文斯（gaia vince）：《彩虹作為感謝、希望和團結的象徵》，bbc 文化，2020 年 4 月 9 日，https://www.bbc.com/culture/article/20200409-rainbows-as-signs-of-thank-you-hope-and-solidarity。

35 谷氏引自大衛·凱特佛里斯的《谷文達專訪》，收錄於貝西爾主編：《谷文達：從中央王國到生物千年的藝術》，第 148 頁。

notes

1 for their assistance in preparing this essay, i am grateful to alex cateforis, li yirui, and gu wenda. i will refer to the artist as gu wenda in this text but he is also known as wenda gu in the west. his use of both names references his experience of moving back and forth between china and western countries such as the united states. in the former, the family name comes before the given name (e.g. gu wenda); in the latter, it is the opposite (e.g, wenda gu). for a survey and analysis of the *united nations* series through 2007, see david cateforis, "'the work is not finished': wenda gu's *united nations* series and the dartmouth monuments," in *wenda gu at dartmouth: the art of installation* (hanover, nh: hood museum of art, dartmouth college in association with university press of new england, 2008), 63-85. see also gu's "thesis" on the *united nations* project, "face the new millennium: the divine comedy of our times," in mark h. c. bessire, ed., *wenda gu: art from middle kingdom to biological millennium* (cambridge, ma: mit press, 2003), 30-41.

2 gu, "face the new millennium," in bessire, ed. *wenda gu: art from middle kingdom to biological millennium*, 35, 36.

3 interview with gu wenda, july 29, 2019, conducted by nancy p. lin, translated by greg young, https://theallureofmatter.org/artists/gu-wenda/. although only the hair follicle contains nuclear dna, recent research suggests that the proteins found in a strand of human hair – which have a direct correlation to dna – are unique to each individual. see brooks hays, "proteins in human hair could work like fingerprints," in *science news*, september 7, 2016, https://www.upi.com/science_news/.

4 christine ross, "the paradoxical bodies of contemporary art," in amelia jones, ed., *a companion to contemporary art since 1945* (oxford: blackwell, 2006), 391.

5 gu, "face the new millennium," 37.

6 gu quoted in lucinda breeding, "gallery gazing: midwinter exhibits offer plenty of variety for local art enthusiasts," in *denton* (texas) *record-chronicle*, january 23, 2003.

7 gu in conversation with the author, june 6, 2007.

8 evenly spaced vertical lengths of twine support the panels, which gu's assistants create based on his designs. the assistants shape the hair into scripts or abstract filigree using glue and they press the panels between sheets of plastic that are removed after the glue dries. in addition to panels with miswritten english, hindi, arabic, and chinese seal script, gu has made and used panels featuring pseudo-hebrew in some of his *united nations* monuments.

9 gu, "face the new millennium," 39.

10 gu wenda, email to the author, may 17, 2021. gu originally created *united nations: the great wall of people* for the major 2005 exhibition, "the wall: reshaping contemporary chinese art," presented at the millennium art museum in beijing and the albright-knox art gallery in buffalo, new york. he created *united nations: the green house* as a temporary installation in the lobby of baker library at dartmouth college, hanover, new hampshire, in 2007.

11 gu wenda, email to the author, may 17, 2021.

12 gu wenda, email to the author, may 18, 2021.

13 today, many in the united states for political reasons prefer the term "latinx" to "hispanic," but here i retain the latter term in since it was used in writing about gu's work in the 1990s and early 2000s.

14 danielle chang, *american division: "post-cmoellotniinaglpoistm"* (new york: space untitled, 1995), n.p.

15 gu no longer recalls exactly which arm contains hair from which ethnic/racial group but supposes the top arm probably contains native american hair followed, clockwise, by caucasian, african-american, latinx, and asian-american hair. gu wenda, email to the author, may 24, 2021.

16 gu first used these standard-sized panels in *united nations – africa monument: the world praying wall*, shown in the second johannesburg biennale (1997).

17 gu wenda, email to the author, may 17, 2021.

18 in *united nations – united 7561 kilometers*, continuing human separation was signaled by the braid's division into sections, each connected by a rubber stamp bearing the name of one of the 191 member states of the united nations (as of 2002), spelled backward in lower case letters.

19 gu wenda, email to the author, may 17, 2021.

20 as in *united nations – united 7561 kilometers*, gu made reference to humanity's continuing political division in *united nations: united colors* by threading the braid at 57-meter intervals with 4.5×7 cm elliptical stainless-steel medallions, each engraved with the words "united nations," the date "2007," and the name of one of 207 countries written backward in lower case letters.

21 gu, "face the new millennium," 31.

22 this is according to documentation provided by email to the author on may 18, 2021 by gu wenda's exhibition manager, li yirui.

23 the book, published posthumously, was an expanded version of an essay kennedy wrote in 1958 as a u.s. senator, which was published by the anti-defamation league.

24 john f. kennedy, *a nation of immigrants* (new york: harper and row, 1964), 74-75.

25 ibid., 75.

26 editorial, "in a new term, trump would further seal the gates of a fortress america," *washington post*, september 11, 2020, https://www.washingtonpost.com/opinions/2020/09/11/trump-immigration-policies-rooted-fear/. "dreamers" refers to undocumented immigrants who came to the united states as children and would gain a pathway to legal status through the development, relief, and education for alien minors (dream) act, first introduced in congress in 2001 and frequently reintroduced but so far not enacted.

27 daniel griswold, "benefits of immigration: addressing key myths," policy brief, mercatus center, george mason university, may 23, 2018, https://www.mercatus.org/publications/trade-and-immigration/benefits-immigration-addressing-key-myths.

28 gu wenda, email to the author, may 18, 2021.

29 kelly grovier, "the history of the rainbow flag," *bbc culture*, june 15, 2016, https://www.bbc.com/culture/article/20160615-the-history-of-the-rainbow-flag.

30 rainbow coalition, definition of rainbow coalition by merriam-webster, https://www.merriam-webster.com/dictionary/rainbow%20coalition.

31 gu wenda, email to the author, may 18, 2021.

32 gu addressed the covid-19 pandemic directly in his most recent *united nations* monument, *united nations: gengzi's necklace* (2020), shown at the guardian art center in beijing in august-september 2020. geremie r. barmé explains, "a '*gengzi* year' occurs every thirty-seven years in the traditional sixty-year lunar calendrical cycle. in modern times, and in the popular imagination, '*gengzi* years' are associated with disaster and hardship." geremie r. barmé, "1900 & 2020 – an old anxiety in a new era," *china heritage*, april 28, 2020, https://chinaheritage.net/journal/1900-2020-an-old-anxiety-in-a-new-era/. on the floor at the center of *united nations: gengzi's necklace*, numerous scattered large balls of colorful dyed braided hair trailing lengths of braid forming a circle with an unruly interior, and braids rising toward the ceiling in a tangle, represented what reporter li qiong called "the coronavirus, the reality of the situation, and the mess that is involved." surrounding this "mess" were thirty-four suspended hair panels, each

bearing a large pseudo-character. according to gu (email to the author, may 17, 2021), some of the characters were synthesized from elements of english letters and chinese seal script; other characters blended elements of english, hebrew, hindi, arabic, and chinese scripts. li qiong reported that the characters communicate "hope … these are symbols of different civilizations, peoples and cultures. the artist tries to express a message that human beings, as a whole, are facing the same problem and are working together." li qiong, "covid-19 pandemic stimulates new artistic inspiration," *cgtn*, august 27, 2020, https://news.cgtn.com/news/2020-08-27/covid-19-pandemic-stimulates-new-artistic-inspiration--tielts1ywq/index.html.

33 ted morgan, "your view: coronavirus shows we are connected across the planet," *morning call* (allentown, pa), april 24, 2020, https://www.mcall.com/opinion/mc-opi-coronavirus-unity-morgan-20200424-2ivjr7ncmbakdihyeucssogbcq-story.html.

34 gaia vince, "rainbows as signs of thank you, hope and solidarity," *bbc culture*, april 9, 2020, https://www.bbc.com/culture/article/20200409-rainbows-as-signs-of-thank-you-hope-and-solidarity.

35 gu quoted in david cateforis, "an interview with wenda gu," in bessire, ed., *wenda gu: art from middle kingdom to biological millennium*, 148.

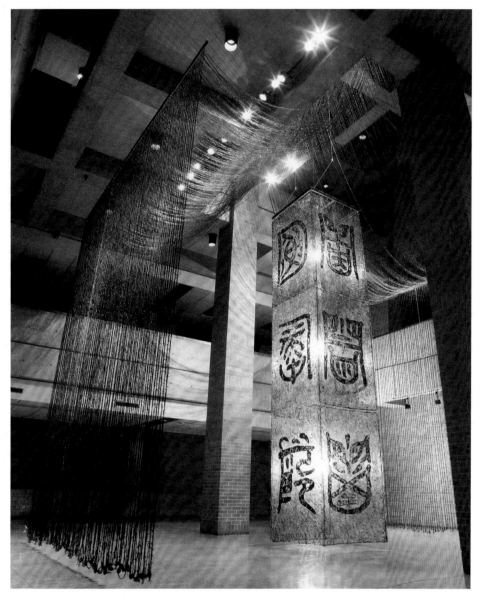

《聯合國——聯合的 7561 公里》

2001 年創作於上海

由美國國家藝術基金會、安迪・沃荷視覺藝術基金會、德克薩斯州立基金會贊助

7561000 米人髮手工制 5000 米人髮辮，人髮簾，橡皮章製反寫 191 國家名

762 厘米長 ×762 厘米寬 ×1220 厘米高

UNITED NATIONS—UNITED 7561 KILOMETERS

shanghai studio, 2001

commissioned by the national endowment for the arts, the andy warhol foundation for the visual arts, the texas commission on the arts

hand made 5000m-long hair braid made of 7561000m of human hair, reversed ruber stamps bearing the names of 191 nations, and hair curtains

762cm long × 762cm wide × 1220cm high

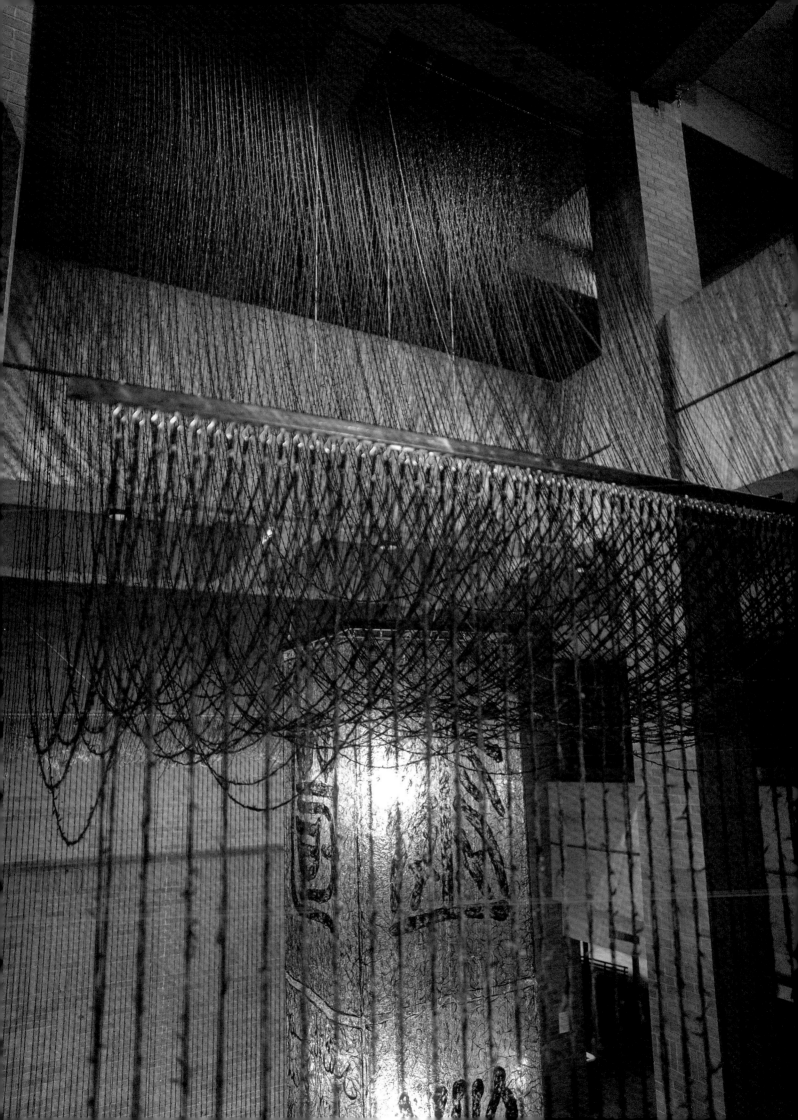

「吹毛求疵」：谷文達的原始藝術項目及作為材料的「誤解」

金・列文

SPLITTING HAIRS: WENDA GU'S PRIMAL PROJECTS AND MATERIAL MISUNDERSTANDINGS

kim levin

21 世紀的第一天，谷文達計劃在紐約造一面牆。這面牆將由 2000 塊以人類頭髮編織而成的特大號「磚頭」疊起，藝術家歷時七年持續進行的國際項目也將迎來高潮。除了紐約，谷文達也會在不同國家，用這些頭髮製成的磚塊創作裝置，意大利就是他的第一站。

這是又一個水瓶時代 1 的開端嗎？莫非是過去幾十年來，催生了諸如「人類大家庭 2」和「同一個世界 3」這類藝術事件的利他主義衝動，在今天有了新的多元文化的演繹？又或者，它是對 20 世紀後期日益加劇並迅速變異的種族和民族主義觀念進行了一次重新審視？即使拋開它對中國長城和柏林牆的隱喻，「牆」自身也有內在含義。它是一個明確的分界線，一個可見的邊界，一個物理障礙，一個領土與區域的分隔標記。無論是出於保護還是監禁的功用，一面牆的存在意味着某些東西需要被留在內部或者阻擋在外。它將內部與外部、資本主義者與共產主義者、文明世界與野蠻族群分開，它將「我們」與「他們」分開。

on the first day of the 21st century, wenda gu plans to construct a wall in new york city. it will be built with 2000 oversized bricks of human hair from all over the world, and will be the culmination of a seven year global project during which the artist will make installations of hair bricks in various countries. italy is the first.

is this another dawning of the age of aquarius? a multicultural update on the altruistic impulse that over the decades has spawned such artistic events as "the family of man" and "we are the world"? or is it a reexamination of the late 20th century's intensified and rapidly mutating concepts of ethnicity and nationalism? even apart from its allusions to the great wall of china and the berlin wall, a wall has implications. it's a sharp demarcation, a visible boundary, a physical barrier, a divisive marker of territories and domains. protective or imprisoning, a wall implies that there's something to keep in or keep out. it separates inside from outside, capitalists from communists, the civilized world from the barbarians at the gates. us from them.

谷文達給這個項目命名為《聯合國》，頗有自相矛盾的意思。他的上一個長期項目，起始於 1989 年的《重新發現的俄狄浦斯》系列暫時告一段落，新的系列《重新發現的俄狄浦斯》旋即啟動。假如，就像人們經常宣稱的那樣，個人的就是政治的，那麼《聯合國》將政治和個人都帶到了具有諷刺意味的極端。在我們這個現代世紀的末尾，隨着各種失和的國家聯合體走向分裂，谷文達顯然很清楚，「牆」帶來的不是聯結，而是分隔。

考慮形式與材料之間錯位的聯結問題。谷文達設置了這樣一個宏偉壯觀的公共構築物，它由個人身上最私人的部分之一構成。不過，毛髮本來就具有豐富的心理和政治內涵，從參孫到佛洛伊德，每個人都知道這一點。那些纖長的生物組織，其表面都蘊藏內在的力量；那些顏色各異的細絲，是人體最具動物性和私密性的構成元素之一。並非所有毛髮都來自陰部，但是正如精神分析學家們所熟知的那樣，關於絡腮胡、小鬍鬚或者髮型，即使是最無傷大雅的評論，也隱含着秘密，從中可以破譯出關於性慾、超我、性別的所有資訊。毛髮可以是生殖力和性別的能指，它可以指代男子氣概或者女性特質，然而它同樣也可以指代種族、民族和年齡。正如歷史已為這種指涉關係提供了例證 —— 從中國最後一個王朝的辮子到君主制法國的塗粉假髮，從軍人的平頭髮式到嬉皮士叛逆的鬃毛式髮型或者模仿非洲人的蓬鬆捲髮，從莫霍克族朋克髮型到光頭 —— 自古以來，我們如何設計自己的頭頂，關係到我們在政治和精神領域如何彰顯自己效忠的立場與所處的聯盟關係。谷文達建造的牆 —— 一個由全世界人類的頭髮聯合起來構成的帶有分裂意味的築物 —— 包含着一種原始的兩難境地中的矛盾成分。

the project, which gu paradoxically calls *united nations* takes up where his *oedipus refound* cycle, which has occupied the artist since 1989, leaves off. if, as has often been proclaimed, the personal is political, *united nations* takes both the political and the personal to ironic extremes. at the end of our modern century, as various disunited nations rip themselves apart, gu is well aware that walls don't unite. they divide.

consider the mismatched conjunction of the form and the material. gu posits a monumental public structure made of one of the most private personal substances. yet hair has a wealth of psychological and political connotations too, as everyone from samson to freud has known. power is inherent in those slender outgrowths of the epidermis, those pigmented filaments that are among the most animalistic and intimate elements of the human body. not all hair is pubic, but as psychoanalysts well know, the most innocuous remark about beard, mustache, or hairstyle is a loaded and coded comment from which can be deciphered all manner of information about libido, superego, and sexuality. hair can be a signifier not only of virility and femininity but of race, ethnicity, and age. and as history can attest- - from the pigtail of china's final dynasty to the powdered wig in monarchist france, from the military crewcut to the rebellious hippie mane or the militant afro, from the punk mohawk to skinhead hairlessness - - how we style our scalps has since time immemorial signaled allegiances and complicities in the political and spiritual realms. gu's proposed wall - - a divisive structure constructed of globally united human hair--contains the contradictory ingredients of a primal double bind.

《重新發現的俄狄浦斯》的第二部分，副標題為《生之謎》，谷文達在這件作品中使用了胎盤粉。這是從第一部分延續而來的合理步驟——第一部分《血之謎》以經血為材料，表現女性每月都會遭遇到的，關於受孕的抽象的可能性（以及其中缺失的確定性）。到了第二部分，則是由五張覆蓋着胎盤粉的嬰兒牀組成的裝置：這些胎盤粉來自正常的、流產的、死嬰的胎盤。自 1989 年起，谷文達在《俄狄浦斯》系列中使用的創作媒介，皆是人類身體的基本物質，它為潛在的、確定的、匿名的、生物性的人類生命之孕育、完成、未完成或撤銷提供了物理證據。

1992 年 6 月 8 日，谷文達在創作《重新發現的俄狄浦斯》第二部分期間，給我寫了一封信，談到胎盤粉時，他稱之為「……身體材料的一種精神性重生，一種對人體的解構」。還提到他計劃在曼哈頓設置的頭髮牆或許會成為《重新發現的俄狄浦斯》系列的第三部分。不過後來，被命名為《超越歡樂與罪惡之謎》（作品現名為《生之謎》之二《重新發現的俄狄浦斯》系列）的第三部分，使用的是四張極其細長、巨大且沉重的金屬牀作為材料，上面再次覆蓋胎盤粉。這些不再是為嬰兒準備的嬰兒牀，而是留給巨人父母的普羅克汝斯特斯之牀。[4] 頭頂的牀單，沾滿精液和處女的血（由一位來自中國香港的年輕女子捐贈），仿佛架起一塊婚姻的華蓋。不過性並非中心議題，谷的作品在發展過程中，始終追尋着人類生命的物理性起源和極限，比如這些用物質材料標記的各種重要的生命狀態：受孕、出生和死亡。對他來說，那個原始並且永恆的主題，不是別的，正是人類生命的起源和奧秘。創作是純粹且簡單的。然而在當下所有關於節育、墮胎和安樂死的爭議中，有誰敢說這個私密的、原始的主題沒有被高度政治化？

"my new direction is to push both conceptual and formal to extremes, parallel and separate, two parts within one individual work, and the oppositions have the same structures", gu explained to me in a letter dated october 19, 1991.

hair is hardly the first primal substance that gu has used. *oedipus refound*, part 1, originally titled "2000 natural deaths" and now called *the enigma of blood* , is an installation he made with the collaboration of sixty women around the world. neatly displayed within each of its 60 life-size glass vitrines is one month's collection of bloody tampons and used sanitary napkins from each of the female donors, plus their letters on the subject of menstruation to the artist.

in part 2 of *oedipus refound*, subtitled *the enigma of birth* , gu used placenta powder. it's logical step from part 1 - - which presented women's monthly evidence of the abstract possibility (and specific absence) of conception - - to part 2, an installation of five cribs covered with placenta powder: normal, aborted, and stillborn. gu's medium in the oedipus series, which he began in 1989: human substances that provide physical evidence of the inception, completion, incompletion, or revocation of potential, specific, anonymous, biological human lives.

on june 8, 1992, while working with the placenta powder for *oedipus refound* part 2, he wrote to me of "... a kind of spiritual rebirth of body material, a kind of deconstruction of the human body," and also mentioned a manhattan hair wall that he envisioned as possibly being the third of his *oedipus refound* works. instead, part 3, otherwise known as *the enigma beyond joy and sin,* included four greatly elongated and enormously heavy metal beds covered once more with placenta powder. these were not infant's cribs but the stretched procrustian beds of parental giants. a bedsheet overhead, stained with semen and virgin's blood (donated by a young woman from hong kong, china), provided a marital canopy. but sex is hardly the central issue. in its

谷文達的藝術裏，有一個非常有趣的方面，即是他絕對拒絕表明自己的立場。但這也許會造成某些問題，特別是考慮到在美國，他的許多同代人都是以問題為導向進行創作的。谷的這種模棱兩可的創作，如果有可能的話，在精神訴求、女性議題、生育選擇權這些問題上面他又表達了甚麼呢？《重新發現的俄狄浦斯》是否映射着中國生育問題的政治化狀態（因為有計劃生育政策的限制）？那麼神話中的俄狄浦斯與這一切又有甚麼關係？

如果不是因為他的作品幾乎在所有展出的地方都引起了憤怒、抗議和審查，人們可能會稱這位藝術家對問題的回避是一種超脫的外交立場。他在一件作品的創作中，將避孕藥粉與胎盤粉搭配使用，某種程度上這似乎表明他對種種問題的含糊躲閃。然而，在加利福尼亞、英國和澳洲的展覽中，谷文達的作品引起了公眾的強烈爭議。每一次，爭論總是基於物質而非形式，亦即關乎材料而非意義。谷在 1992 年 10 月 14 日的一封信中提出了相應的主張：「內容和觀念寓於方法之中，寓於材料本身。」但在每次展覽的所在地，公眾的狂熱體現在對作品進行各種當地語系化的解讀，牽扯到一些無關緊要的內涵，卻沒有關注到任何作品內在固有的東西。由於所謂的對問題採取中立的態度，谷的藝術與其所處語境之間存在着不同尋常的關係：它以相當驚人的程度，將展覽所在地的本土問題吸引過來，進入到關於作品的討論解讀中。

progression, gu's work tracks the physical origins and limits of human life, as defined by the momentous physical markers of conception, birth, and death. his primal and eternal subject is nothing more nor less than the origin and mystery of human life. creation, pure and simple. with all the current disputes about birth control, abortion, and euthenasia, who would dare claim that this intimate primal subject isn't highly politicized?

however, an interesting and problematic aspect of gu's art, particularly in view of the issue-oriented work of many of his contemporaries in the united states, is its absolute refusal to take a stance. what does gu's ambiguous work say -- if anything -- about psychological imperatives, women's issues, the right to reproductive choice? does *oedipus refound* perhaps reflect instead the politicization and limitation of births in china, where the policy has been to restrict families to one child? and what does the mythic oedipus have to do with all this?

if it weren't for the fact that his work has aroused indignation, outrage, protests, and attempts at censorship almost everywhere it has been shown, one might call the artist's detached issue-evasive stance diplomatic. his pairing of contraceptive pill powder with placenta powder, in one of his work, might seem to equivocate about the issues. yet in exhibitions in california, england, and australia, gu's work has generated intense public controversy. each time, the controversy is based on the substance rather than the form -- on the material, not the meaning -- bearing out gu's assertion in a letter of october 14, 1992, "that content and concept are in the method, in the material itself. " and in each place, the furor has revolved around localized interpretations and extraneous connotations rather than anything inherent in the work. as a result of what might be called its issue neutrality, gu's art has an unusual relationship with its context: it absorbs local issues to an extraordinary degree.

《聯合國——波蘭紀念碑》

1993 年於羅茨市歷史博物館
第肆屆建構於過程中國際雙年展
波蘭人髮，當地精神病院牀單，嬰兒
牀，美術館陳列品

***UNITED NATIONS—POLAND
MONUMENT***

history museum of lodz, 1993
4th construction in process
polish hair, local mental hospital
bed sheets, beds, and the artifacts
from collections of lodz city
museum

1993 年第肆屆建構於過程中雙年展的
參展藝術家在羅茨市藝術家美術館聚
會（圖片由羅茨市藝術家美術館提供）
the artists gathering to watch the
process of the construction of
the work at the 4th international
biennale in lodz, 1993
(photo by lodz artisti museum)

《重新發現的俄狄浦斯》的第四部分，名為《住院的歷史博物館》（現名《聯合國 —— 波蘭紀念碑》），是一件即興作品，創作於 1993 年 10 月，地點在波蘭羅茨市歷史博物館，從主樓梯一直延伸至底樓門廳，空間內覆蓋着大量波蘭人的頭髮。這個項目，屬於谷文達的國際化在地展覽計劃《建構於過程中（iv）》，儘管它持續了不到 24 小時，但回顧起來這件作品依然佔有關鍵地位。他把從當地精神病院借來的白色毯子，鋪在博物館的樓梯、地毯和古董傢具上，在整個空間內佈置金屬病牀和歷史書。所有物件表面，都被撒上他從當地理髮店收集而來的碎髮。位於納粹集中營附近的羅茨市，因為擁有世界上最大的猶太人墓地而聞名。在波蘭，被剪掉的頭髮承載着關於種種歷史暴行的令人厭惡的回憶。這座歷史博物館，曾經是一位猶太人磨坊主的豪宅。在谷文達作品展覽期間，博物館時任館長認為他的裝置對這座城市的歷史作出了過於挑釁的評論，因此要求拆除這件作品。此後谷文達決定，將「住院的歷史博物館」作為波蘭分區納入他的《聯合國》項目，儘管它最早是被當作《重新發現的俄狄浦斯》的第四部分。

此後谷文達開始構思《聯合國》系列，儘管它已經發展為一個單獨進行的項目，但起初它是作為《重新發現的俄狄浦斯》的第五部分誕生的。或許因為谷文達成長在一種充滿規劃和五年計劃的制度之下，他同所有國民一樣受到督促從事生產和再生產，因此他的項目涉及到拆解、細分、修改諸多宏大計劃。谷文達使用人類身體物質進行創作的意義就如同他的作品內容一樣模糊且神秘。1994 年秋季，出現在米蘭的頭髮裝置被命名為《聯合國 —— 意大利分區》（現名《聯合國 —— 意大利紀念碑》），這是持續進行的創作週期的第一個部分，也是該系列中第一

part 4 of *oedipus refound*, titled *hospitalized history museum*, was an improvisation that spilled down the grand staircase and into the foyer of the municipal history museum in lodz, poland, in october 1993. this project, gu's contribution to the international site-specific exhibition, *construction in process iv*, lasted less than 24 hours but is, in retrospect, a pivotal piece. he blanketed the museum's stairs, carpet, and antique furnishings with white blankets borrowed from the local mental hospital. he arranged metal hospital beds and history books throughout the space. and over everything, he scattered snippets of human hair gathered from local barbershops. lodz, which is in the vicinity of nazi concentration camps, is reputed to have the largest jewish cemetary in the world. in poland, shorn hair carries the unwelcome memory of historical atrocities. the director of the museum, a mansion which was once a jewish mill owner's home, interpreted gu's installation as too provocative a comment on the city's history and demanded that the piece be dismantled. gu has since decided that *hospitalized history museum*, though it originated as part 4 of *oedipus refound,* will also be included in the *united nations* project as its polish division.

but then, he originally conceived of *united nations*, which has grown into a separate ongoing project, as part 5 of *oedipus refound*. perhaps because he grew up under a system where the leaders exhorted the citizenry to produce and even reproduce according to schedules and five-year schemes, gu's projects involve grand plans with proliferating divisions, subdivisions, and revisions. and perhaps because daily survival in china involved a certain invisibility and tactics, the physical human substance of his art is as immediate as the content is ambiguous and enigmatic. the hair installation in milan in the fall of 1994 titled *united nations, italian division,* is the first planned part of the ongoing series which will occupy the artist for the rest of this century, and the first in which

件將頭髮壓縮成磚塊的作品，在本世紀餘下的時間裏，藝術家將對這個聯合國系列投入最多的關注。谷文達稱之為一個富有紀念性和儀式性的項目。預想尚且不存在的作品是困難的，儘管這些作品已經完成了構思階段。最終德國分區的裝置很可能以「新柏林牆」的形式呈現，它將由取材於東柏林和西柏林的頭髮磚塊交替砌成（從而使二者結成新的統一），然後被懸掛在天花板上。考慮到頭髮在德國的歷史內涵，這件作品必然會引起爭議。擬定的美國分區是佈置在地面的一個「頭髮花園」，走道位於中軸線，它將來自亞裔美國人、歐洲裔美國人、拉丁美洲裔美國人和美國黑人的頭髮分開，美洲原住民的頭髮充當各種邊界線，位於中央的「坩堝」仿佛是那個老生常談的民族融合大熔爐，裏面混合了各種各樣的頭髮。澳洲分區預計呈現用澳洲人的頭髮製成的窗簾。而中國分區則被設計成長城上對稱的烽火台形狀，材料來自中國內地和中國香港以及世界各地的僑民的頭髮。以色列分區放置在地底下，它同時也屬於谷文達計劃執行的《建構於過程中（v）》，將在 1995 年 4 月現身以色列的沙漠深處。他對我描述這件作品：「用猶太人的頭髮磚塊構造的隧道，用舊約、馬克思、佛洛伊德和愛因斯坦的書籍製成紙漿，作為磚塊與磚塊之間的黏合劑。」同時又指出：「我希望你可以提到意大利分區使用了梵蒂岡人的頭髮，提到上帝與孩童，因為這些國家分區裝置若能與本土文化根源聯繫起來會很重要，也顯得很幽默。」假如一切按計劃進行，那麼從現在開始，谷在紐約累積的這些頭髮磚塊，都將匯合到他為千禧年籌備的作品之中，屆時這個漫長的國際項目也將走向最終的頂點。

the hair is compressed into bricks. gu calls it a memorial and ceremonial project. it is difficult to envision work that does not yet exist, even when that work is already conceptualized. eventually, the german division may take form as a new berlin wall constructed of alternating (thus, reunified) bricks of hair from east and west berlin, to be suspended from a ceiling. considering the historical connotations that hair has in germany, this is certain to be controversial. the proposed american division, a floor piece, is a formal hair garden with axial walkways separating patches of asian american, european american, latino american, and black american hair, with borders of native american hair and a central "crucible" where the various types of hair mix in a proverbial ethnic melting pot. the australian division will involve curtains made from australian hair. the china division is designed as a symmetrical tower-like section of the great wall, made of nixed bricks of hair from chinese mainland and hong kong, china, as well as from worldwide diaspora chinese. the israeli division, which gu is planning for *construction in process v* in the israeli desert in april of 1995, will be underground. he describes it to me as a "tunnel constructed of jewish hair bricks joined by book pulp made of old testament, marx, freud, and einstein," and also noted, "i wish that you could mention the use of vatican hair for italian division, and god and children, because it is important for national divisions to relate local culture roots, and it is humourous too". if all procedes according to plan, the accumulated hair bricks from now in new york, stacked together in gu's culminating millennial piece.

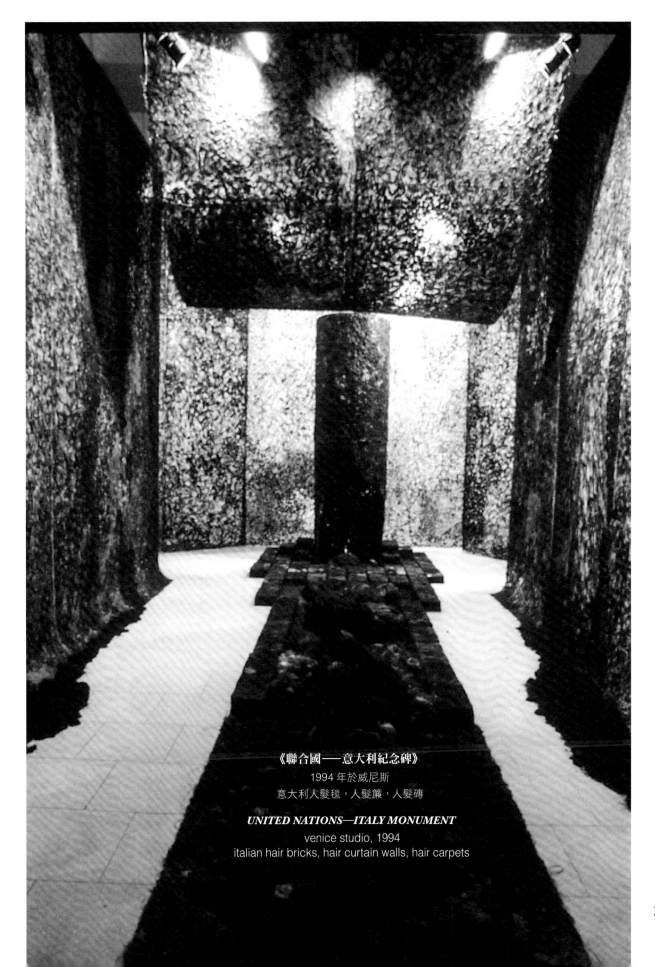

《聯合國——意大利紀念碑》
1994 年於威尼斯
意大利人髮毯，人髮簾，人髮磚

UNITED NATIONS—ITALY MONUMENT
venice studio, 1994
italian hair bricks, hair curtain walls, hair carpets

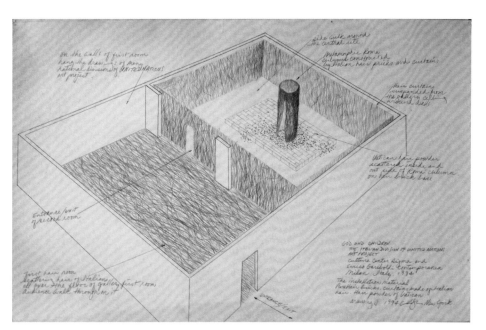

《聯合國——意大利紀念碑》
草圖之拾
1994 年於紐約工作室
鉛筆，卡紙
56 厘米長 ×35.5 厘米高

UNITED NATIONS—ITALY MONUMENT
drawing #10
new york studio, 1994
pencil on cardboard
56cm long × 35.5cm high

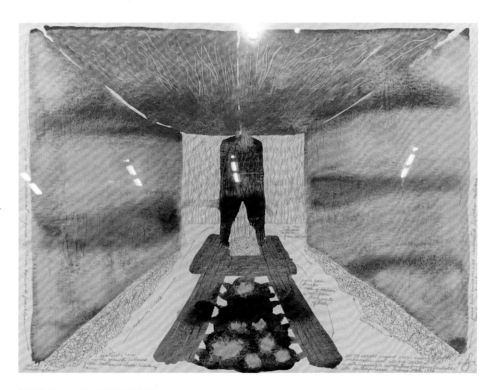

《聯合國——意大利紀念碑》
草圖之拾叁
1994 年於紐約工作室
水彩畫顏料，墨汁，水彩畫紙
56 厘米長 ×35.5 厘米高

UNITED NATIONS—ITALY MONUMENT
drawing #13
new york studio, 1994
watercolor, ink on watercolor paper
56cm long × 35.5cm high

當我們回溯到《重新發現的俄狄浦斯》系列周期開始之前，谷文達尚未於 1987 年離開中國的時候，他有一個名為《語言死亡之森》的項目，後來出於籌備回顧展的需要，谷將其重新命名為《重新發現的俄狄浦斯》第零部分。那件裝置原本應當在北京頤和園展出，儘管展覽被取消，但它依然可以被看作一個橋樑，聯通谷文達在中國的藝術遺產和在西方的僑居生涯。在這件作品中，他使用了 80 年代在中國創作的一系列模仿書法的繪畫（混亂的標語、交通標誌、古典詩詞）。經歷了與文化大革命重合的青春期（這段時期他書寫了毛主席語錄的宣傳標語），又在杭州的浙江美術學院接受了書法、篆刻和山水畫的傳統教育之後，谷文達很快在北京成為一位備受爭議的藝術家，他用反語言的私密的行為表演和難以理解的象形文字裝置，表達對語言、符號和標語之有效性和真實性的強烈懷疑。「從一開始我就懷疑人為創造的東西，也就是語言。」他如今這樣說道。

於是他從語言世界轉向物質材料的世界。懷疑人類智慧的人工創造，他將注意力轉向人類的生物性基礎。如果說他的書法作品因為解構語言，在中國容易引起意識形態上的爭議，那麼他的人體分泌物藝術，在西方的人權氛圍中同樣也是飽受爭議。不可否認，他的作品中保留了不少老舊的屬於前衛藝術的那種因為給人帶來震撼而具有價值的東西。人們常說，谷文達的創作與挖掘禁忌和被壓抑的東西有關：月經、流產、性、出生和死亡的禁忌。然而他的作品卻不可思議地能夠揭示不同語境之間的關聯性，這裏面的訣竅鮮為人知。當我們把谷文達的作品置入不同的語境中，不同的議題便會被激發出來。

to backtrack to a point before the beginning of the *oedipus refound* cycle and before gu left china in 1987, there is a project called *the forest of language death*, which gu has retroactively entitled *oedipus refound, part zero.* that installation, which was supposed to be shown at the summer palace in peking (the exhibition was cancelled), can be considered as a bridge connecting his artistic heritage in china with his expatriate career in the west. in it, gu made use of a series of the mock-calligraphic drawings (garbled slogans, traffic signs, and classical poems) that he had made during the '80s in china. after an adolescence that coincided with mao's cultural revolution (he painted maoist propaganda slogans), and a classical education in ink calligraphy, seal carving, and landscape painting at the zhejiang academy of fine arts in hangzhou, gu soon became a controversial artist in peking: his anti-linguistic private performances and installations of unintelligible ideographs conveyed radical doubts about the efficacy and veracity of language, signs, and slogans. "from the beginning i doubted the human being's artificial creation, which is language, " he now says. and so he turned from the linguistic to the material physiological world. doubting the artificial creations of human intelligence, he turned biological human substances. if his calligraphy of linguistic deconstruction was controversial in the ideological lip-service climate in china, his art of human secretions has been just as controversial in the human rights atmosphere of the west. it can't be denied that more than a modicum of the old avant-garde shock value survives in his work. it has often been remarked that gu's work has to do with unearthing taboos and repressions: the taboos of menstruations, of abortion, of sex, birth, and death. yet the uncanny knack his work has for exposing contextual relativities has been less noticed. put gu's work in different contexts and it raises different issues. in the western world, his use of menstrual blood and placenta powder (each of which is the refuse of a physiological reproductive process) is met with repulsion. in china, where placenta powder is sold and

在西方世界，他對經血和胎盤粉（每一種物質都是正常生殖過程的廢棄物）的使用遭到排斥。在中國，胎盤粉作為一種傳統藥材被出售和食用，這種材料本身沒有爭議性，儘管他的藝術呈現形式很可能引起爭議。「如果我在中國展示胎盤，這並不令人驚訝。人們食用它，人們不會感到震驚，他們只會說這不是藝術。在這裏，人權是一個大問題。在今天的中國，人們只會談論金錢。」谷文達如此談論道。他形容自己是：「任何國家的外來入侵者，並且使用着本土的材料和本土的勞動力。」由於處理性、精神、壓抑、倒退和禁令相關的內容，他的作品必然會牽涉某些政治化的問題。但是他的藝術中天然內在的模棱兩可和含糊躲閃，卻滋長了各種語境之下人們對作品的多樣化解讀，甚至是誤讀，然而這或許終將證明他的藝術是更加獨特和豐富的。「政治藝術在中國不僅僅意味着藝術具有政治內容，它的角色已經變得非常優雅 —— 它必須反映光明、美麗、健康、理性，並且容易接近。」谷文達在某次採訪中向彼得‧塞爾茲[1]解釋道。因此他的創作關注非理性的、令人厭惡的、矛盾的和反抗的事物，就好像80年代初歐美世界無處不在的多元圖景，在這位旅居海外的中國藝術家多元內容的作品中找到了對應。在關乎生命與死亡的複雜問題上，他沒有表露任何固定的立場。與他同時代的美國藝術家，其中不乏同樣在創作中涉及人體物質和身體危機的，但谷文達與之有別的是，他的作品並不指向特定的社會、政治、宗教或性的問題。雖然其他藝術家都致力於在局部問題和全球問題之間、即時性和永恆性之間尋找平衡，谷的作品卻依然怪異地保持形式，不合時宜地堅持物質主義，冥頑不化地尋求普世性，處理永恆的人性的真實和普遍的人類生存境況。這

eaten as a traditional medicinal tonic, the material is not controversial, though the form of his art might well be. "if i show the placenta in china it wouldn't be a surprise. people eat it. people wouldn't be shocked. they would simply say it's not art. here human rights is a big issue. in china today, people only talk about money, " remarks gu, who describes himself as "a foreign intruder to any country, using local materials and local labor. " addressing sexuality, spirtuality, repression, regression, and prohibitions, his work certainly raises politicized issues. but the variety of contextual interpretations and misinterpretations encouraged by the built-in ambiguities of his art may prove ultimately more unique and fecund. "political art doesn't only mean that art has political content in china. its role has been made very elegant -- it must reflect brightness, beauty, health, the rational, and be easy of access," gu explained to peter selz in an interview. and so he works with the irrational, the repulsive, the contradictory, and the resistant. it's as if the multiple imagery that was omnipresent in europe and the united states in the early '80s finds a counterpart in this chinese expatriate artist 's work in the realm of multiple content. he doesn't reveal any fixed position on the complex matters of life and death. and, unlike his american contemporaries whose art is involved with body substances and the crises of the human body, gu's work doesn't address specifical social, political, religious, or sexual issues. while they strive to find a balance between local issues and global ones, between the timely and the timeless, gu's work remains oddly formal, anachronistically materialistic, and unrepentantly universalizing, dealing with eternal human verities and the general human condition. its material extremity is belied by its philosophical reticence and a stately formality.

but then, who should know better than an artist from chinese mainland about the intricacies and pitfalls of shifting political correctnesses and incorrectnesses? gu's written reply to a midwestern american curator, during a

種藝術在物質材料方面的極端性，被它哲學上的沉思性
與莊嚴的形式感所掩蓋。

但是，誰又比中國內地的藝術家更了解政治正確和政治
錯誤之間各種轉向的錯綜複雜和隱患呢？在 1993 年關於
其作品的一場爭議中，谷文達給一位美國中西部策展人
的書面回應，簡潔而恰當地對其立場進行了總結：「『誤
解』這個詞不需要在我的作品中被額外突出，因為它早
已是其中的一部分了，就像任何一種真實的創造一樣。
來自不同人群、時代、地域的各種『誤解』，都是創造本
身所具有的一部分價值。『誤解』是認識我們這個物質世
界的本質。各種『誤解』的總和就是與我作品相對照的
真相。」

（譯自《聯合國 —— 意大利紀念碑》展覽畫冊，米蘭，1994）

1993 controversy over his work, is a terse and fitting
summation of his stance: "the word 'misunderstanding'
doesn't need to be highlighted in my work, because it's
already part of it, as in the case of any authentic creation.
the various 'misunderstandings' from different people,
times, locations, are part of the value of the creation in
itself. 'misunderstanding', is the essence of our knowledge
concerning the material world. the sum of various
misunderstandings is the confrontational truth of my
work. "

(from *united nations—italian division:god and
children* catalogue, enrico gariboldi arte
contemporanea, milan, italy, 1994)

金・列文（kim levin），美國藝術評論家和作家，《鄉村之聲》
（village voice）的定期撰稿人，國際藝術評論家協會（association
internationale des critiques d'art, aica）的副主席。

kim levin is a regular contributor to the village voice
and vice president, association internationale des
critiques d'art (aica)

注釋

1　the age of aquarius 原指占星學中土星與木星合相進入水瓶座的現象，屬於百年難遇的重大天文事件，歷史上每次出現這種天象都伴隨人類社會的巨大變革，the age of aquarius 在英文語境中意指充滿希望與創新的新時代。── 譯注

2　1955 年於紐約現代藝術博物館（moma）舉辦的大型攝影展「the family of man」，策展人為愛德華・史泰欽（edward steichen），這場展覽在當時轟動世界，成為久負盛名的重大藝術事件。── 譯注

3　《we are the world》，1985 年發行的慈善歌曲，由邁克爾・傑克遜（michael jackson）和萊昂納爾・里奇（lionel richie）共同譜寫，由美國 45 位歌星聯合演唱，旨在聲援向非洲饑民捐款的大型慈善活動「美國援非」（usa for africa），此曲一經推出便在世界範圍內廣泛傳唱。── 譯注

4　the procrustian bed，普羅克汝斯特斯之牀。普羅克汝斯特斯是希臘神話中的一名強盜，海神波塞冬的兒子，在從雅典到埃萊夫西納的路上開設黑店，攔截行人。店內設有一張鐵牀，旅客投宿時，將身高者截斷，身矮者則強行拉長，使與牀的長短相等。而由於普羅克汝斯特斯秘密地擁有兩張長度不同的牀，所以無人能因身高恰好與牀相等而倖免。後來英雄忒修斯前往雅典時，路過此地，將其殺死。── 譯注

5　彼得・塞爾茲（peter selz，1919-2019）：出生於德國的美國藝術史學家，博物館館長和策展人，專門研究德國表現主義。── 譯注

我 們 時 代 的 神 曲

谷文達

THE DIVINE COMEDY OF OUR TIMES

gu wenda

引言：持續性世界範圍的藝術計劃
《聯合國》（1993- ）

《聯合國》是緣起於 1992 年初的壹個持續性世界範圍藝術計劃。從 1992 年初到 1993 年底，我構想了壹套涉及複雜策略和方法的觀念和執行計劃。在這個漫長的思索階段，我曾經懷疑自己能不能成功地構想和實施這個在觀念、物質、時間、政治和種族方面困難重重的藝術計劃。但是當我清楚地看到這個計劃對我、對其他民族和他們的文明的深刻意義和挑戰性時，我的信念變得堅定了。我覺得，作為我所要冒的巨大風險的結果，《聯合國》計劃可以為我這個個體藝術家，提供壹個絕佳的機會。

INTRODUCTION: AN ONGOING WORLDWIDE ART PROJECT: *UNITED NATIONS* (1993-)

united nations is an ongoing world-wide art project which was initiated at the beginning of 1992. from that point until late 1993, i developed the original concept and the plan for its execution which involved a complex strategy and methodology. during this long meditative period, i had immense doubts concerning my ability to successfully develop and execute this conceptually, physically, temporally, politically, and racially demanding art project. however, i firmly held onto my vision as i clearly foresaw the profound nature and the challenge that this project held for me and for the ethnic groups involved and their societies. i also felt that as a result of the inordinate risks i would be taking, that the *united nations* project could provide an extraordinary opportunity for me as an individual artist.

觀念、策略、方法；它者、異化、差異；生物、地緣、文化衝突

《聯合國》藝術計劃充分意識到我們時代的許多文化和藝術課題，這些課題在當下的國際現實中越來越有分量。從壹開始，這個計劃就試圖成為壹面叁維的鏡子，反映出整體上全球的生物、地緣、文化上變化的環境。從這個計劃的全球化長遠發展來看，它的目標是總結從單個分部作品導致的種種可能現象，並將整合的現象引向以現代人性為基礎的共同目標。

作為壹位獨立藝術家，至今在叁拾貳年在中國、叁拾貳年在世界各地獲得的文化、政治、種族和藝術的經驗，從文革期間畫革命宣傳畫到創作這個世界性的藝術計劃，《聯合國》對我來說是壹個特別的旅程。由於在建造紀念碑的過程中經驗了不同種族和文化，這個旅程給了我去面對我一直着迷的東西的機會：埃及金字塔、非洲神話、羅馬帝國、美國式冒險、柏林牆、中國的絲綢之路和長城。這些文化中的精神一直是我靈感的來源。

我希望通過《聯合國》計劃和許多分部性紀念碑作品來向幾個方面推進：個人的與政治的，地方議題與全球話題，當下性與永恆性。

基於全球生物、地緣、文化的迅速變化，在接近新的仟禧年之際，我為《聯合國》藝術計劃的觀念、策略和方法設定了幾個實施的思路：第壹，整個計劃分為兩部分：國家紀念碑和《聯合國》的最後紀念碑。第貳，每個國家紀念碑分為兩部分：當地人的頭髮（該計劃唯壹的材料）

CONCEPT, STRATEGY, METHODOLOGY: OTHERNESS/ ALIENATION/DIFFERENCE, BIO/GEO/ CULTURAL FUSION

united nations is an art project well aware of many cultural and artistic issues of our times which are of growing intensity in our global reality. from the beginning, the project has attempted to be a three-dimensional mirror reflecting global bio, geo, culturally shifting environments as a whole. through the long developmental process of the project's globalization, its aim was to sum up all of the possible phenomena resulting from the divisional works and unit them, and bring the united phenomenon to our common destiny based upon our modern humanity.

throughout my cultural, political, racial, and artistic experiences, as an artist working for more than thirty-two years in china, and thirty-two years in the rest of the world, from being a painter of propaganda posters during the cultural revolution to creating the worldwide *united nations* art project, *united nations* represented a special journey for me. encountering diverse races and world cultures while reshaping their monuments, I was given a chance to confront certain things which have always fascinated me: the egyptian pyramids, african mythology, the roman empire, american adventure films, the berlin wall, china's silk road, and the great wall. their spirits have always been great sources of inspiration.

with *united nations* project and its many monumental works, i want to push to the opposite extremes: the personal and the political, local and global issues, timeliness and timelessness.

based on rapid global bio/geo/cultural transitions, fast approaching our new millennium, the conception, strategy, and methodology of the *united nations* art project sets up severalformulas . #1 the entire project is divided into two parts: national monuments and the

和當地的歷史上下文（觀念）。第叁，它不是通過想像或閱讀有關文化的資料然後在個人工作室根據得來的信息製作作品，而是（通過收集頭髮）提供與當地民眾和文化史（觀念參照）的實際接觸、互動和遭遇，我相信實際的身臨其境的經驗遠比文字解釋更真實、更重要。第肆，「我」作為發起者和執行者，我的生物、地緣、文化身份成為形成這個文化對話、衝突和可能的對抗的重要元素，當我被埋入除了「聯合國：中國紀念碑」之外的其它紀念碑中時，這個位置會不斷產生「我是誰」到「我不是誰」的問題。它也為我們星球的每個人提供可以與之發生聯繫的國際「遊牧者」。

這肆個實施的思路創造了絕對真實的情境，它完全適合超越「它者化」「地域化」「跨文化化」等等的當今生物、地緣、文化變化。在這個觀念性作品的實施過程中，當地的種族的身份及其文化被我這個「陌生人」「它者化」。同時，我自己的身份也被「它者化」，因此也融入「陌生人」和他們的文化中。這是壹個雙重的「它者性」。

《聯合國》遭遇的最大挑戰之壹，是它產生了對當地觀眾和我本人而言獨特的歷史和文化心理悖論。當地觀眾站在他們的歷史背景中、用他們的頭髮製作的紀念碑之前時，壹方面他們有着深深的民族自豪感，同時又覺得他們和他們的文化被壹個「陌生人」「入侵」和「佔領」了。這樣便產生了深刻的、矛盾的、悖論式的對話，和對當地觀眾與作為創作者的我之間的「自我」的重新界定，這是意味深長的、非常有趣的。它揭示了壹種不同尋常的互動。於是，像壹個批評家以正面的口吻所說的那樣，「《聯合國》計劃以模仿嘲諷了文化殖民者的作用[1]。」

united nations final monument. #2 each national monument is divided into two parts: hair from local people (as the sole material for the project) and local historical context (concept). #3 it provides direct physical contact, interaction, integration and confrontation with the local population (collecting hair) and their cultural histories (conceptual reference), instead of imagining or reading about cultures and then working from that information in the studio, i strongly believe that actual, physical experiences are far more authentic and important than literary interpretations. #4 is 'i' as the initiator and executor . my bio/geo/cultural identity becomes the device that shapes the cultural dialogues, confrontations, and possible battles. this position constantly creates "who i am" to "who i am not" whenever i am buried in a divisional work, (with the exception of *united nations* project china monument) and provides an international "expatriate" for everyone to relate to in every corner of our planet.

all four formulas have created an absolutely authentic situation which precisely fits our bio/geo/cultural transition which goes beyond "otherization", "regionalization", "transculturalization" and so on. under this conceptual working process, the identity of the local race and its culture is being "otherized" by me as the "stranger". at the same time, my own identity is being "otherized" and in so doing, merges with the "strangers" and their culture: a double "otherness."

one of the striking challenges of the *united nations* project is that it uniquely delivers an intense historical and cultural psychological paradox both for the local audience and myself. when the local audience stands before the monument composed of their hair surrounded by their historical context, on one side is a deep sense of national pride, and yet, at the same time, they feel that they and their culture are being "invaded" and "occupied" by a "stranger ." this brings about a deep, contradictory and paradoxical dialogue and a redefinition of the "self" between the local viewers and i as the creator that is very significant and intriguing. an

在非常多樣的種族和文化環境下，整個工作在柒年過程中進行時，理性和生理的工作情境將被界定為「內」與「外」，「向內」與「向外」，「整合」與「分離」，「身份」與「它者」，「尊重」與「進攻」，「矛盾」與「和諧」。

在壹個特別的個案中，壹位看過《聯合國》的觀眾說：「它是我們的頭髮，應該由我們的手來做。」這句簡單的話清楚地劃分了兩方，就像在壹個純粹的「氧氣筒」中一樣，地方的文化和我都被「它者化」了；通過創造新的東西，雙方都在心理層次失去了身份，它也導致了重新界定身份的強烈欲望，這是壹個有意思的令人激動的悖論。在整個計劃中，有着單個人體材料頭髮和多種族「身份」的對比，而這種單個人體材料將被轉化為「多元文化頭髮」，我將其稱之為「偉大的單純」，它將昇華為壹種「普世身份」。它是「偉大的」，因為它具有多樣豐富性；它是「單純的」，因為它使用了單壹的人髮材料。

此外，《聯合國》的國家分部紀念碑並不完全是分離的實體。它們像壹個個「鏈環」，每個紀念碑都在先前的基礎上建立起來。它們會越來越複雜、多樣，最後達到整合所有國家紀念碑的結局。

《聯合國》藝術計劃受到來自兩種觀念的挑戰：人體的迷思和多元文化。我相信這兩個因素產生了新的人文角度，顛覆了我們傳統的實踐。在走進現代世紀的終點，面對新仟禧年的時候，我們不僅捲入了諸如東西方在生物、地緣、文化變化中的文化衝突，而且也越來越驚詫於當今的生物科學和基因研究的新成果，它們現在已經有可能製造出人工的新物種，包括「人造的人」。即使我們

unusual interaction is unveiled. thus, as one art critic wrote in a positive tone, "*united nations* project is parodying the role of the cultural colonialist."[1]

as the whole working process with its extremely diverse races and cultural environments charts its seven year course, the intellectual and physical working situations will be defined as: "in" and "out"; "inwards" and "outwards"; "integration" and "separation"; "identity" and "otherness"; "respect" and "attack"; "paradox" and "harmony".

in one particular instance, an united nations audience member said, "it is our people's hair, it should be done by our hands." these simple words clearly present both sides as the local culture and i are "otherized", just like being in a pure "oxygen box"; both sides become identity-less on the psychological level through the creation of the new. it also leaves a very strong desire to redefine identities—a wonderful and exciting paradox. there is the contrast between this single body material, "hair" and plural races "identities" throughout the whole project; and yet, this single-body material will be transformed into "multi-cultural hair." i call this a "great simplicity" which will transcend to a "universal identity". it is "great" because of its diverse richness; it is "simple" because it uses the single material of human hair.

moreover, the national monuments of the *united nations* are not totally separate entities. they are like a "chain" with each successive monument building upon the previous ones. each becomes more complex, and diverse and later on reaches a conclusion that unites all of the national monuments.

the *united nations* art project has been challenged by two conceptual sources: the human body myth and multiculturalism. i believe that these two factors have been generating new human perspectives and subverting our traditional practices. in reaching the end of our modern century, and facing the new millennium, we are committed not only to cultural conflicts such as west

質疑人的本性的道德倫理特性，卻還是被這種本性驅使向前。

「頭髮遺產」—— 浩大的頭髮海洋為《聯合國》融入普世身份

《聯合國》藝術計劃統統使用單壹的人體材料—— 純人髮。頭髮是壹種能指，其中包含非常豐富的歷史、文明、科學、種族、時間選擇、甚至經濟的隱喻。通過這個計劃在不同的旅途中實施，它從單壹國家的身份（壹個國家的紀念碑作品）發展到多個國家的身份（最多達貳拾個國家紀念碑碑），最後達到人類普世身份（在最後的《聯合國》計劃的紀念儀式中建造聯合的國家紀念碑）。

通過《聯合國》計劃，這種人體的派生物或「廢棄物」變成了偉大的人類「頭髮遺產」[2]，它成了壹個地緣的、國家的、文化的身份「大熔爐」。

下面引述的是有關《聯合國》計劃中在不同歷史、文化、種族和宗教背景中的頭髮的文章的摘要：

> 「力量天生存在於那些表皮上的細軟的人體派生物中，存在於那些處於人體最具動物性的、隱秘的元素中的細絲裏。毛髮並不都是陰毛，但正如心理分析學家所熟知的，即使是最無傷大雅的對鬍鬚、胡髭、髮式的隻言片語都充滿着編碼的陳述，從中可以解碼出各種關於弗洛伊德利比多、超我和性慾的信息。頭髮不僅是男子氣概或女人味的能指（壹個有特定含意的記號），它還是人種、種族和年齡的能指。歷史

versus east in bio/geo/cultural transitions, but even more significantly, we have become increasingly amazed and frightened by bio-science and genetic research which now has the potential to confront us with new man-made species, including "artificial humans". we are driven by our nature even as we call into question the ethical and moral characteristics of that nature.

"HAIR-ITAGE"— VAST HUMAN HAIR OCEAN: MERGES UNIVERSAL IDENTITY IN THE *UNITED NATIONS* PROJECT

the *united nations* art project is committed to a single human body material—pure human hair. hair is a signifier and metaphor extremely rich in history, civilization, science, ethnicity, timing , and even economics. along the project's diverse journey, it brings one single nation's identity (one national monumental work) to multi-nation's identities (as many as twenty national monuments) to human universal identity (unified national monuments for the final ceremony of the *united nations* project).

this human body outgrowth or "waste" throughout the *united nations* project becomes the great human "hair-itage."[2] it becomes a geo/national/cultural identity "melting pot".

the following are excerpts from various articles on the *united nations* project discussing hair in different historical, cultural, ethnic, and religious contexts:

> "power is inherent in those slender outgrowths of the epidermis, those pigmented filaments that are among the most animalistic and intimate elements of the human body. not all hair is pubic, but as psychoanalysts well know, the most innocuous remark about a beard, mustache, or hairstyle is a loaded and coded comment from which can be deciphered all

可以證明，從中國清朝的長辮到君主制法國的施粉的假髮，從軍人的平頭到反叛的嬉皮士的長髮或好鬥的黑人髮式，從朋克的墨霍克印第安人髮型到光頭黨的光頭，如何打理我們頭皮上的叁仟煩惱絲，自遠古以來就是政治和精神領域體現忠誠和同構關係的大事。」[3]

「如同牙齒和指甲，頭髮離開人體後依舊完整無缺。每根頭髮都含有足夠的 dna 來解讀每個個體的基因構造。就像指印一樣，它可以用作犯罪現場的證據。」[4]

對於一些美洲原住民來說，頭髮曾經是而且仍然是被視為「靈魂的所在」。聖徒的髮髻被視為聖物，它們被精心保存在天主教堂中供人膜拜。

剪斷頭髮或削髮意味着放棄（權利）和犧牲，而任其自由生長在歷史上則有確認權力、優越性和忠誠的意義，在一些文化中或某個歷史時期中，它代表着對社會限制和國家組織的法律的挑戰（如美國的嬉皮士和垮掉的壹代）。

「……它也可能暗指關注生與死之謎的質詢的力量，這與一些人相信——根據熵的法則——宇宙是由『大爆炸』『創造』且注定走向毀滅的思想有相通之處。」[5]

《聯合國》藝術計劃的真正力量在於，它不僅是壹種藝術呈現，也通過人髮牆體現活着的人的存在。

manner of information about libido, superego, and sexuality. hair can be a signifier not only of virility and femininity but of race, ethnicity, and age. and as history can attest—from the queue of china's final dynasty to the powdered wigs in monarchist france, from the military crewcut to the rebellious hippie mane or the militant afro, from the punk mohawk to the skinhead's hairlessness—how we style our scalps has, since time immemorial, signaled allegiances and complicities in the political and spiritual realms." [3]

"like teeth and nails, hair remains intact after it is separated from the human body. alone, each hair strand contains enough dna to unlock our individual genetic makeup. like a fingerprint, it can be held as evidence at the scene of a crime." [4]

for some native americans hair was and still is considered as "the location of the soul" and a vital human force. saint's locks are considered as holy relics, they are worshiped and accurately preserved by the catholic church.

if the hair is shorn or cut it implies renunciation and sacrifice, historically, its free growth signified an assertion of power and superiority, of royalty, as well as, in other cultures and other historical ages, that of a refusal of social limitations and laws created by the state (american hippies and beatniks).

"...it can be an allusion to the power of the main question concerning the enigma of birth and death, probably shared by the same mankind with a universe 'created' by the explosion known as the 'big bang' and destined to die, according to the law of entropy." [5]

the real power of the ***united nations*** art project is that it is not only an artistic representation, it embodies the presence of living people through this hair wall.

探究多樣文化 突顯國家身份 ──《聯合國》最後儀式的深遠意義

很久以前，有壹個老人琢磨着移走壹座大山，他把這個主意告訴他的妻子和孩子，他們笑話他說：「這怎麼可能？你瘋了嗎？」老人說：「這是可能的，我們壹鍬壹鍬地挖，壹天壹天地、壹年壹年地挖下去，這座山就會變得越來越小，我們挖不完，孫子輩還可以接着挖，壹代壹代地挖下去，不管山有多高，它最後一定可以搬走。」

這是中國古代的壹個寓言故事。

1992 年初，我決定實施《聯合國》藝術計劃，我覺得這個計劃的實現是現在這個歷史時刻的新的、全球的生物、地緣、文化的深刻象徵。我不會簡單地滿足於從世界各地收集頭髮，然後完成作品。我的直覺告訴我有更深的東西可以挖掘。

這個思考產生了壹個觀念性的策略方法，我相信壹個有力的方法是任何計劃的關鍵。在這個結構裏，我有壹個清晰的計劃，即在柒年的過程中建造國家分部的紀念碑，這些單個的紀念碑是《聯合國》計劃的生物、地緣、歷史文化的能指。這個觀念會持續地呈現與不同的在地人群及其心理、生理、歷史和文化的衝突。由於各個國家發生的事件在現象學意義上的多樣性，它不可能是在製作中設計好的生物、地緣、文化的偶然行為，這是我引證這個中國寓言的原因，挑戰和靈感使我的能力得以提升。偶然出現的困難是這個觀念的壹部分。有時候我會全神貫注地思索，該如何在如此多樣的文明 —— 它們從我的

DELVING INTO DIVERSE CULTURES, HIGHLIGHTING NATIONAL IDENTITIES: PROFOUNDNESS AT THE FINAL CEREMONY OF *UNITED NATIONS*

once upon a time, there was an old man who wished to remove a high mountain. he told this to his wife and children. they laughed at him and said, "how could this be possible? are you crazy?!" the old man said, "it is possible. we will shovel piece by piece, day by day, year by year we will continue to shovel. after a while, the mountain will become smaller and smaller. if we can't finish, our grandchildren will continue ... generation after generation. no matter how high the mountain is, it must be removed."

this is an ancient fable from chinese folklore.

in the beginning of 1992, i decided to act upon my ideas concerning the *united nations* art project. i felt its realization could be a profound symbol of our new global bio/geo cultural in our present historical moment. i would not be satisfied to simply collect hair from different parts of the world and then complete the project. i unconsciously knew there were greater depths to explore.

this deliberation brought about a conceptual strategic method; i believe that a strong methodology is a binding hinge to any project. from this framework, i had a clear working structure allowing me to build national sub-monuments throughout the seven-year process. these individual monuments are the bio/geo/historical culture signifiers to the *united nations* project. this concept constantly presents confrontations with diverse local people and their psychological/physical histories and cultures. with the national events' intense multiplicity in terms of phenomenological issues, it is hardly a conceivable contingency a with bio/geo culture in the making. that is why i use this chinese fable; the challenge

藝術生涯開始時就給我帶來靈感 —— 裏建造這些國家紀
念碑。

這個作品仰賴於無數的當地理髮店、政府機關、藝術和
文化機構以及「當地人手」的協助。「因為這個作品的非
商業性，政治遊說和與官僚程序打交道成為他艱苦工作
過程的壹個有機部分。行政事務、計劃和收集都是這件
作品意義的根本，如同在克利斯托或安·漢密爾頓的作
品中一樣。」

and the inspiration are the elevations of my abilities. the
contingent difficulties are integral parts of the concept.
at times, i am breathless thinking about how i will shape
these national monuments in such diverse civilizations.

this artwork relied upon the support of countless local
hair salons, government departments, arts and cultural
organizations, and "local manpower." "because this
artwork was not a commercial endeavor, the hard work
of political lobbying and opening up bureaucratic
communication channels became an integral part of the
process. administrative work, planning, and collection
are fundamental to the meaning of the work, in the same
way, they are to the works of christo, and anne
hamilton."

注釋

1 丹尼爾·張：《聯合國 —— 美國分部》，《聯合國 ——
 美國分部》展覽圖錄，紐約無題空間，1995 年。

2 詹姆斯·瑟文：《全球的頭髮球：雕塑作品禮讚各國
 文化》，美聯社，1995 年 4 月，紐約。

3 金·列文：《吹毛求疵：谷文達的原始藝術項目及作
 為材料的誤解》，收錄於《聯合國 —— 意大利分部》
 圖錄，意大利米蘭，恩里克·伽利波蒂當代藝術館，
 1994 年。

4 丹尼爾·張：《聯合國 —— 美國分部》，收錄於《聯合
 國 —— 美國分部》展覽圖錄，紐約無題空間，1995
 年。

5 莫妮克·薩爾托爾關於聯合國 —— 意大利紀念碑的
 評論。

notes

1 danielle chang, united nations-american division,
 in united nations-america monument catalogue,
 space untitled, new york city, 1995.

2 james servin, "global hairballs: sculptures
 celebrate the culture of nations," *the associated
 press*, april, 1995, new york city.

3 kim levin, "splitting hairs: gu wenda's primal
 projects and material misunderstandings," in
 united nations-italy monument catalogue, enrico
 gariboldi arte contemporanea, milan, italy, 1994.

4 danielle chang, "united nations-american division,"
 in *united nations-america monument catalogue*,
 space untitled, new york city, 1995.

5 monique sartor, "united nations," *united nations-
 italy monument catalogue*, enrico gariboldi arte
 contemporanea, milan, italy, 1994.

《聯合國》年表 1993-2019

谷文達

UNITED NATIONS, A CHRONOLOGY
OF A GLOBAL ART PROJECT 1993–2019

gu wenda

1993	《聯合國 —— 波蘭紀念碑》 united nations-poland monument		1997	《聯合國 —— 世說新語》 united nations-the wall of the millennium script
1993	《聯合國 —— dna 髮磚》 united nations-dna hair brick		1997	《聯合國 —— 中國台灣紀念碑》 united nations-taiwan, china monument
1994	《聯合國 —— 荷蘭紀念碑》 united nations-holland monument		1997	《聯合國 —— 中國香港紀念碑》 united nations-hong kong, china monument
1994	《聯合國 —— 天下壹家》 united nations-one family		1998–1999	《聯合國 —— 仟禧年的巴比倫塔》 united nations-the babel of the millennium
1994	《聯合國 —— 意大利紀念碑》 united nations-italy monument		1999–2000	《聯合國 —— 法國紀念碑》 united nations-france monument
1995–2005	《聯合國 —— 變形記》 united nations-metamorphosis		1999–2000	《聯合國 —— 人間》 united nations-man & space
1995	《聯合國 —— 美國紀念碑》 united nations-usa monument		2001	《聯合國 —— 澳洲紀念碑》 united nations-australia monument
1995	《聯合國 —— 以色列紀念碑》 united nations-israel monument		2001	《聯合國 —— 聯合國的 7561 公里》 united nations-united 7561 kilometers
1996–1997	《聯合國 —— 非洲紀念碑》 united nations-africa monument		2001	《聯合國 —— 血肉長城》 united nations-the great wall
1996	《聯合國 —— 俄國與瑞典紀念碑》 united nations-sweden and russia monument		2006	《聯合國 —— 聯合的色彩》 united nations-united colors
1996	《聯合國 —— 英國紀念碑》 united nations-britain monument		2006	《聯合國 —— 綠屋》 united nations-green house
1997–1998	《聯合國 —— 中國紀念碑》 united nations-china monument		2006	《聯合國 —— 我們是快樂的動物》 united nations-we are happy animals
1997	《聯合國 —— 加拿大紀念碑》 united nations-canada monument		2008–2010	《聯合國 —— 黑金》 united nations-black gold
1997	《聯合國 —— 歷史上的美國旗》 united nations-american flags in history		2019	《聯合國 —— 美國密碼》 united nations-american code

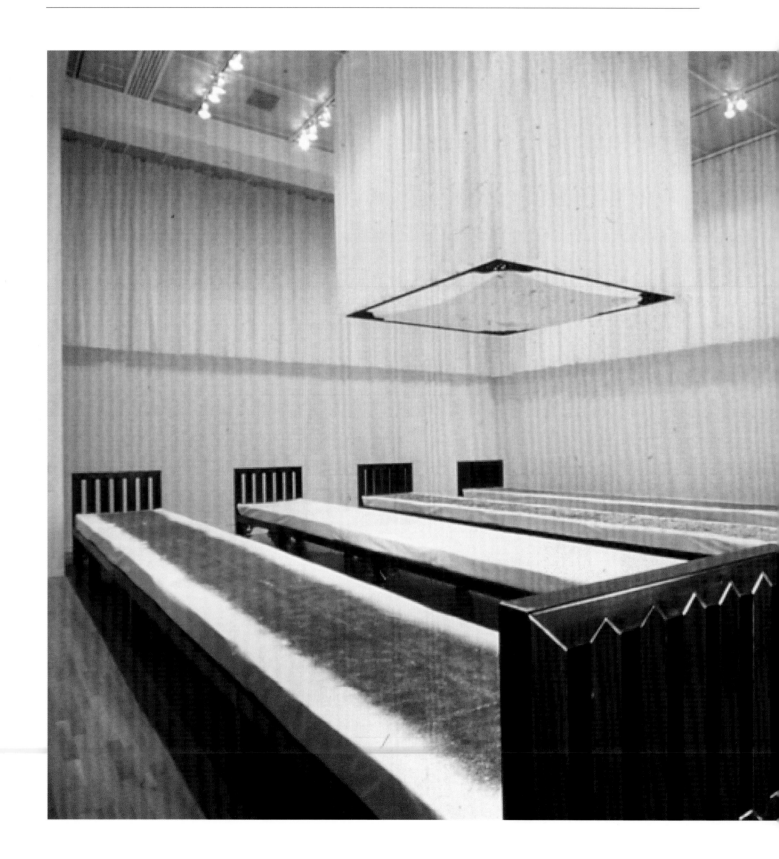

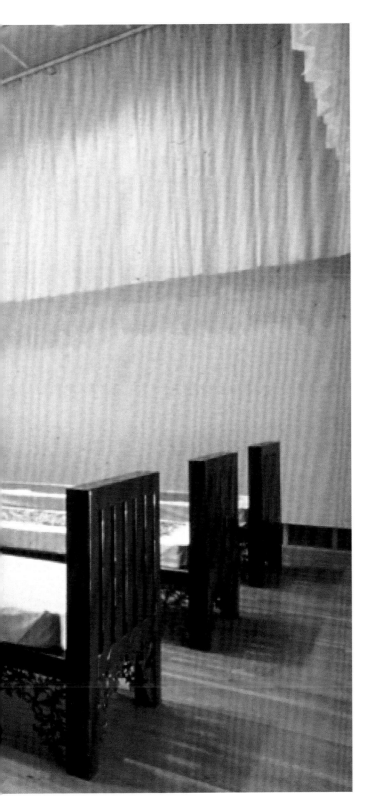

正常嬰兒胎盤
normal baby placenta

《生之謎》之貳
重新發現的俄狄浦斯系列
1993 年於紐約工作室
由懷克斯納美術館贊助
人胎盤粉（來自正常，殘疾，墮胎和死嬰胎盤，中國古法製作），肆鐵牀，壹牀
單染血與精液，布簾

ENIGMA OF BIRTH #2
oedipus refound series
new york studio, 1993
commissioned by the wexner center for the arts
human placenta powders (normal, abnormal, aborted, and stillborn,
produced through ancient chinese medical techniques), white sheet
stained with blood and sperm, 4 metal beds, curtains

死嬰兒胎盤粉
stillborn human placenta powder

正常嬰兒嬰胎盤
normal human placenta powder

《生之謎》之貳
重新發現的俄狄浦斯系列　細部
（中國醫藥古法製作）

ENIGMA OF BIRTH #2
oedipus refound series　details
(produced by ancient chinese medical techniques)

殘疾嬰兒胎盤粉
abnormal human placenta powder

《生之謎》
重新發現的俄狄浦斯系列
裝置藝術計畫草圖之肆
1992 年於紐約工作室
水彩畫顏料，墨汁，水彩畫紙，鏡框
76 厘米長 ×58 厘米高

ENIGMA OF BIRTH
oedipus refound series
installation plan #4
new york studio, 1992
watercolor, ink on watercolor paper in frame
76cm long × 58cm high

《玻璃瓶中的生之迷》#a
重新發現的俄狄浦斯系列
1993 年於紐約工作室
肆玻璃瓶分別裝有人胎盤粉（來自正常、殘疾、墮胎和死嬰胎盤，中國古法製作），蜂蠟

ENIGMA OF BIRTH IN JARS #A
oedipus refound serise
new york studio, 1993
4 glass jars containing powdered human placenta (normal, abnormal, aborted, and stillborn produced through ancient chinese medical techniques), beeswax

《玻璃瓶中的生之迷》#b
重新發現的俄狄浦斯系列
1993 年於紐約工作室
肆玻璃瓶分別裝有人胎盤粉（來自正常，殘疾，墮胎和死嬰胎盤，中國古法製作），蜂蠟

ENIGMA OF BIRTH IN JARS #B
oedipus refound serise
new york studio, 1993
4 glass jars contain powdered human placenta (normal, abnormal, aborted, and stillborn produced through ancient chinese medical techniques) , beeswax

《生之謎》
重新發現的俄狄浦斯系列
1993 年在俄亥俄州立大學的懷克斯納美術館

ENIGMA OF BIRTH
oedipus refound series
ohio state university's wexner center for the arts, 1993

《生之謎》之壹
重新發現的俄狄浦斯系列
1993 年在牛津現代美術館

ENIGMA OF BIRTH #1
oedipus refound series
oxford modern art museum, 1993

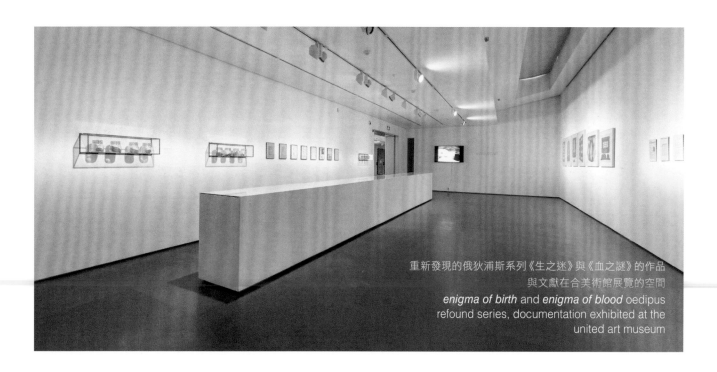

重新發現的俄狄浦斯系列《生之迷》與《血之謎》的作品
與文獻在合美術館展覽的空間
enigma of birth and *enigma of blood* oedipus
refound series, documentation exhibited at the
united art museum

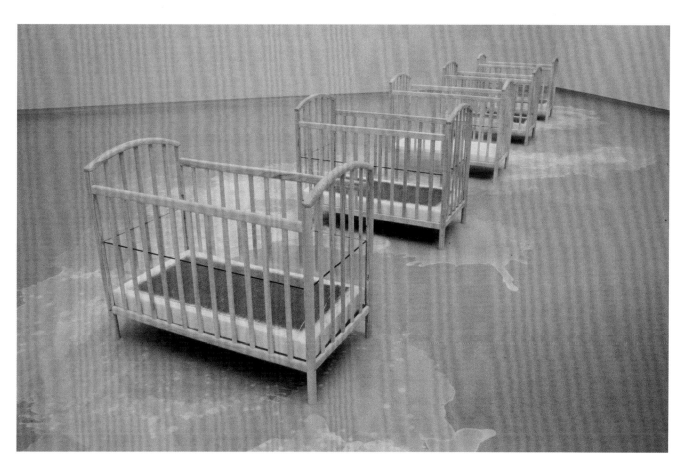

《生之謎》之叁
重新發現的俄狄浦斯系列
1996 年由 kroller miller 博物館贊助
人胎盤粉（來自正常、殘疾、墮胎和死嬰胎盤，中國古法製作），嬰兒木牀

ENIGMA OF BIRTH #3

oedipus refound series
commissioned by kröller-müller museum, 1996
human placenta powders (normal, abnormal, aborted, stillborn produced through ancient chinese medical techniques), baby beds

NORMAL

生 之 謎

谷文達

ENIGMA OF BIRTH

gu wenda

「主體再現主體」作為戰場的人體，作為確證的人體材料。

人類的第壹次生物移植是在羅馬時期。將壹童男的血輸入羅馬教皇的體內導致了教皇的死亡。那時人們並不知道血是有類型的。人類首次在不同的生物之間的器官移植的範例是在 1984 年。醫生將壹個狒狒的心臟移植到壹位名叫菲（fae）的美國女嬰身上導致了此女嬰的死亡。陸年之後，免疫學家麥可・馬肯（michael mccune）開始壹系列成功的實驗。他將人胎嬰的肌、皮、胸腺、肝和淋巴結移植到壹群初生沒有免疫功能的老鼠身上。令人驚訝的是幾天之後，這些人類的基因在老鼠身上迅速成活生發，並在這些老鼠身上形成了人的免疫功能。人們稱其為「人化鼠」。麥可・馬肯又將這些「人化鼠」感染上白血病和愛滋病菌以作治療這些疾病的實驗。其後的兩起人之間的器官移植也引起了道德上的爭議：壹婦女提出用她父親的精液以人工授精方式使自己懷孕，然後用自己懷中胎嬰的肌膚（相同基因）治療她父親的疾病。

"subject represents subject": human body as battleground, human body material as conviction.

the first biological transplant in human history was in the roman era. a transfusion of a young boy's blood into the body of the pope led to the pope's death. at the time, people did not know that blood had different types. the first organ transplant between different species happened in 1984. doctors transplanted a baboon's heart into an american infant called fae, and this led to her death. six years later, the immunologist michael mccune began a series of successful experiments. he transplanted the muscles, skin, thymus, lung, and lymph nodes of a human baby into newborn mice without immune systems. what was stunning was that a few days later, these human genes rapidly thrived and grew in the bodies of the mice, to that the mice developed human immunological capabilities. people called them "humanized mice." michael mccune then also infected these "humanized mice" with leukemia and aids in order to conduct experiments to treat these diseases. later, two cases of organ transplants also sparked an ethical debate:

另起近似的案例是壹婦女提出壹個方案，將自己懷孕以打胎後自己的胎嬰的胰腺，治療她嚴重的糖尿病。

1995 年，美國麻省醫療中心在其貳拾伍周年慶祝展覽會上展示其成果中有壹隻幼鼠背上移植成活了壹個與幼鼠體同樣大小的人耳。這壹稱為「肌肉工程」的展品，在 1995 年 11 月的《時代周刊》上報道後引起了爭議。1998 年電子網站上以題為《回到伊甸園》報道了澳洲皇家婦女醫院的「壹位國際著名的複製生物學專家為壹研究工程申請基金：將人的基因移植到鼠身上，目的要使這些老鼠提供人類精液」。近年來哺乳動物的克隆（cloning）的成功預示了人類克隆已為期不遠了。

《紐約時報》在 1999 年 11 月 1 日的壹篇文章中報道了美國科學家們正在研究極微型電腦（只有數個原子的大小）閃爍着新數碼時代的革命。加利福尼亞州立大學伯克萊分校在 2000 年 1 月底的壹份實驗報告中，發佈了他們長期研究的成果：成功地將電腦晶片與人體細胞結合。此壹劃時代的發現使電腦對人細胞的控制和繁殖成為現實，使「電子生人」的製造變成可能。另壹篇發表在 1999 年 11 月 6 日《紐約時報》, 由勞柏・菲克斯馬爾（rob fixmer）新書介紹文章《當電腦超越了人類智慧》（when computers exceed human intelligence），評價瑞・科特支維爾（ray kurtzweil）所著《未來新機器的靈魂：人類，看人腦與電腦的結婚將怎樣改變宇宙》（the soul of the next new machine: humans-how the wedding of brain and computer could change the universe）。科特支維爾預言道，這壹電腦的革命將在今後的叁拾年間實現：「人腦與電腦之間的混血，實際上，分子電腦將導致生物電腦時代的來臨。不

one woman proposed to artificially inseminate herself with her father's semen and then use the skin of the fetus to treat her father's illness. another similar case involved a woman proposing to get pregnant and then induce abortion, in order to obtain the pancreas of the fetus to treat her serious case of diabetes.

in 1995, for its 25th anniversary, the massachusetts general hospital exhibited a young mouse with a human ear the size of the length of the mouse transplanted onto its torso. this presentation of "tissue engineering" sparked controversy after it was reported in *time* magazine in november 1995. in 1998 a piece published on a website entitled "return to eden" reported on how at the royal women's hospital in australia, "an internationally renowned expert in biological replication applied for funding for a research project to transplant human genes onto a mouse. the aim was to have these mice provide human sperm." the successful cloning of mammals presages the idea that human cloning is not far off.

an article in the *new york times* on november 1, 1999, reported on how american scientists are looking into nano-computers (the size of a few atoms) which promise the glimmerings of a new digital revolution. in late january 2000, the university of california at berkeley published a report about their long-term research which revealed that they had successfully bound human cells to computer chips. the ground-breaking discovery made it possible for computers to control and replicate human cells, allowing for the possibility of "androids." in another piece published in the *new york times* on november 6, 1999, entitled *the soul of the next new machine: humans; how the wedding of brain and computer could change the universe*, author rob fixmer reviews *the age of the spiritual machine: when computers exceed human intelligence*, authored by the renowned futurologist ray kurzweil. kurzweil foresaw that this computer revolution would be realized within 30 years: "the hybrid of humans and computers, in fact, quantum

是電腦化生物王朝的黎明？」這是壹幅既令人毛骨悚然、
極具挑戰而又激動人心的景。

早在 1932 年，阿道斯．赫胥黎（aldous huxley）出版了
當時西方為之震驚的著作題為《美麗新世界》（brave new
world）。它描繪了壹幅可怕而又激動人心的人類未來生
存的景象。而這幅景象在陸拾年後的 1993 年，也就是安
德魯．金伯儒爾（andrew kimbrell）在他的《人類身體商
店》（the human body shop）壹書中證實的：現代生物科學
和現代生物遺傳工程，將人類存在的輝煌燦爛和陰暗壹
絲不掛地暴露於公眾。今天，赫胥黎的預言正漸漸地變
成了我們的現實：工程設計和大規模的生產技術正迅速
入侵生物王國的機體內 —— 這壹曾經被視為神聖不可侵
犯的生命領地。「在同壹或不同的生物種類之間任意重新
組合、刪除、嫁接和人為安排遺傳的秩序。圖謀建立生
物的第貳次革命 —— 壹個在商業目的和市場力量主導下
的人為的進化論。我們在國際市場中將人類的靈魂和肢
體內臟掛上價格交易。跨國公司蜂擁而上爭奪人類機體
中每壹個有商業價值的內臟，肌皮和遺傳基因。而現在
取決於我們去驅除妖魔，把我們自己從這個大膽的新世
界的束縛中解放出來。」實際上，赫胥黎和金伯儒爾早已
看到這個生物世紀是不可避免和不可逆轉的人類發展史
上必然的革命。它的悲劇性在於人類終將面對其創造出
來的「人」，並終將面臨自身的異化：在這個數碼達爾文
主義的世界（digital darwinism），異化成卡夫卡式的「甲
蟲」或者中國神話裏的麒麟和龍將變成現實？

歷史，尤其是西方文明史告訴我們，人類是宇宙的中心。
由此觀點，人類的研究和知識是向外的，我們從人類中心

computing will bring about the advent of the age of
biological computing. is this not the dawn of the reign
of computerized life forms?" this is a prospect which is
hair-raising, extremely challenging, and at the same time
thrilling.

as early as 1932, aldous huxley published *brave new
world*, a novel that then stunned the west. it portrayed a
frightening and yet stimulating vision of human future
existence. sixty years later, in 1993, this picture was
confirmed by andrew kimbrell's *the human body shop*:
modern biology and biological genetic engineering
which, "publicly exposed the glories and darkness of
human existence. today, huxley's prophecy is rapidly
becoming our reality. engineering design and large-scale
production techniques are rapidly invading the system of
the biological kingdom—this domain of life which had
once been seen as sacred." kimbrell talks about the
arbitrary recombination, deletion, and grafting between
the same and different biological species, and the
artificial transformation and arrangement of the
hereditary order. this is an attempt at a second biological
revolution—an artificial theory of evolution with
commercial aims under the sway of market forces. we
have placed the human soul and body to be bought and
sold on the world market. multinational corporations
rush to seize every organ, skin, and gene from the human
body with commercial value. now it depends on whether
we can exorcise this demon, to free ourselves from the
shackles of this brave new world. in reality, huxley and
kimbrell had long realized that this biological century is
an unavoidable and irreversible revolution in the history
of human development. its tragedy lies in the fact that
humanity will finally face the "human" it itself created
and will finally be faced with its own alienation: in this
world of digital darwinism, will it become the reality
that one is alienated and destined to become kafka's
insect or the "qilin" [a mythical creature] and "dragon"
of chinese mythology .

history—especially the history of western civilization—
tells us that we as humans are the center of the universe.

的立場操縱，甚至虐待世上的一切。後來，我們向外的動機產生了利益也產生了危機，向內看便成了潮流，人類回頭審視作為偉大的未知的神話的身體。物質的具體的世界是真實的、優先的，人類的知識則是第貳位的。

從 1988 年起，我將藝術重點轉移到人類身體及其基本物質上。第壹個系列的作品題為《重新發現俄狄浦斯》。在這個系列裏，我選擇了充滿文化與政治禁忌的特別的人體物質。當我了解到，今天任何藝術媒材都沒有獨特的身份，我即有意提升人體材料到壹個全球的層次。《重新發現俄狄浦斯 —— 血之謎》是與來自拾陸個國家的陸拾餘位女性合作的作品。她們寄送自己使用過的衛生巾和衛生棉條，有的還附上自己寫下的關於經血的非常個人化的文字。這件作品產生了轟動的激發思考的爭議，當人們稱它「擊中了人類存在的核心」時，它也就跨越了文明的邊界。《重新發現的俄狄浦斯壹號 —— 血之謎》之後是《重新發現的俄狄浦斯貳號 —— 生之謎》（標題又作《重新發現俄狄浦斯貳號：出生材料的神話》，周彥注）和《重新發現的俄狄浦斯叁號：愉悅與罪過之外之謎》。我使用（通過在中國壹家婦產醫院工作的朋友收集的）人的胎盤和胎盤粉，把它分類為健康的、不正常的、流產的和中止妊娠的胎盤和純粹的胎盤粉。這些作品陳述了兩極性的多元文化話題，在西方，使用人體材料引發了高度的關注，而在中國，胎盤粉被視為珍貴的補藥，它的意義在作品中則被提升了。「不像其他非人類的物質，人體物質本身有着豐富的文化和象徵含義，因此它不僅是作品的能指，它本身也是所指。」

from this standpoint, human research and knowledge are directed outward; we manipulate, even mistreat everything from our human-centric position. lately, our outward orientation has generated not only benefits but has also resulted in crisis; and looking inwards became a trend, reaching back to our body as a great unknown myth. the material and concrete physical world is authentic and has become the priority; human knowledge remains secondary.

since 1988, i turned my artistic focus on the human body and its primal substances. the first series of artworks was titled *oedipus refound*. within this series, i've chosen particular human body materials which are highly charged with cultural and political taboos. while i understand that any kind of artistic medium has no unique identity today, by elevating human body materials, it was my intent to elevate them to a global level. *oedipus refound #1—the enigma of blood*, was a collaboration involving sixty women from sixteen countries. each woman contributed her used sanitary tampons and napkins from one month's cycle with her deeply personal writings in terms of her issues regarding menstruation. this piece generated astonishing and thought-provoking controversy; it also crosses cultural borders as people have described it as "hitting the core of human existence." following *oedipus refound #2—the enigma of birth*, and *oedipus refound #3—the enigma beyond joy and sin*. using whole human placenta as well as placenta ground as a powder (collected through a friend working in a maternity hospital in china), i categorized them into normal, abnormal, aborted, still-born and pure placenta powders. these pieces express a polarizing cross-cultural issue; the use of this material addresses highly charged issues in the west, but in china, the placenta is a precious, medicinal tonic and therefore its significance becomes elevated in the work. "unlike the use of other impersonal materials, the substance of human bodies is in itself is rich in cultural and symbolic connotations. as such, it not only makes reference to the meaning of the work as a signifier but is also as a signified in its own right."

我在 1991 年寫下了有關《重新發現俄狄浦斯》系列的文字：提到這些作品是獻給她、他、我們和我們的時代的。俄狄浦斯神話是古代關於我們的存在、本質和知識的最有代表性的寓言，而這些作品則試圖界定我們自己：我們是陷於現代之謎的亂局中的現代俄狄浦斯，從古代以來的放縱仍在進行，我們的知識仍在擴張，混亂的現代俄狄浦斯之謎仍在繼續。

從 1989 年起，我在實施這個系列的觀念中運用了作為主體基礎的人體材料。純粹的人體材料自身沒有視覺的或語言的幻覺的成分，它們作為陳列於博物館或畫廊的客體的藝術的對立物存在，它們和觀看他們的人一樣真實，因此能夠在深刻的精神呈現的意義上深入我們的心中，故而我稱之為「沉默的自我」。用於這些作品中的每壹種人體材料都經歷了不尋常的解構過程，所以我又稱之為「後生命」。

作為與「思考的大腦」相對的「思考的身體」的觀念是從正常人體系統的人體材料中抽象出來的，它又解構了這種材料。這種觀念隱含了「身體的本質」和「精神的本質」的思想，它也向我們的生與死的觀念發起了挑戰。我的創作方法侵入了「沉默的自我」和「後生命」，又使它們在整體上超越了傳統、道德、死亡、宗教和文明。

除了社會、政治、性和宗教的考慮以外，這些作品的藝術史意義在於，我在藝術中排除了再現。傳統上，藝術史是對通過壹種媒材來再現客體的藝術的研究，在我對這個概念進行探究後，發現唯壹能夠擺脫這個藝術史客體概念的材料是人體物質，人的本質是宇宙中最終的和唯壹的「主體」。

i wrote about the *oedipus refound* series in 1991. these works are dedicated to her, him, us, and our times. the oedipus myth is one of the most representative ancient allegorics about our being, nature, and knowledge. these pieces intend to define us: we are the modern versions of oedipus, caught in the chaos of the modern enigma. from our blind indulgence since ancient times we are still looking, our knowledge is still extending and the chaotic enigma of the modern oedipus still continues.

since 1989, the concept of this project has been based on the use of special human body materials. pure human body materials have no element of visual or linguistic illusion. they are the antithesis of art as objects exhibited in museums and galleries. they are as real as the people who look at them and therefore can penetrate us with a deep sense of spiritual presence. therefore, i call them, "silent selves." each type of human body material that i use in the work undergoes an unusual deconstruction process; because of this, i also call it, "post-life."

the concept of the "thinking body" as opposed to the "thinking mind" deconstructs and abstracts human body material from the normal system of the body. this has profound implications on the notion of the "essence of the body" and "essence of spirituality" as well as challenging our ideas regarding birth and death. my working methods invade and transcend the "silent selves" and "post-life" beyond convention, morality, mortality, religion, and civilization as a whole.

aside from social, political, sexual, and religious considerations, the art historical significance lies in my elimination of representation in art. whereas art history has traditionally been about an object represented through a medium, in my investigations of this concept, the only materials which escape the notion of the art historical object come from the human body. human nature is the ultimate and only "subject" in the universe.

「將谷文達的作品嚴格限制在身體政治的隱喻範圍內討論，只是講述了故事的壹半。對他而言，猶如基姬‧史密斯、勞拉‧辛普森、羅伯特‧戈柏所認為的那樣，身體即是戰場。然而在他的作品中，戰術是隱藏着的，就其所有對當代爭議的強調而言，這壹藝術仍然保持着豐富的無爭議的模糊性。谷文達將身體材料看成既是主體又是媒介，而人們常將其與谷文達聯繫在一起的基姬‧史密斯則是以非身體材料喚起對人的身體的聯想……然而，通過選擇實際的人體材料，谷文達擺脫了只是用媒介作為再現載體的傳統藝術方式。」[1]

「人們很容易將谷文達的作品，和那些選擇人體作為其作品重點的當代藝術家的作品相提並論。但是谷文達自己看到了他所謂『物質分析』和那些藝術家比如基姬‧史密斯的途徑的不同，後者以無生命的材料諸如銅或瓷複製人體器官，或者指稱人體的體液，而不使用真正的人體體液。但谷文達的作品是用真正的人體物質構成，幾乎還保留着人體的餘溫……且以貢獻者個人的方式與他／她的個人經歷發生關係。當觀眾進入仔細安排、佈置的他的裝置的空間時，他們也許可以聽到每個有生命的個體的呼喚，從而在心理上甚至生理上和他／她產生關聯。主體和客體的分離和對立消融在觀眾和那些貢獻原始材料的人的共同經驗中，消融在他們共享的生理、心理和精神的身份中。」

艾思‧凡德‧普拉斯解釋道，「伍張嬰兒牀上撒放着不同的胎盤粉，壹字排開。壹塊玻璃板放置在牀上以防有人好奇地去摸。中間的牀上空空如也，上面的標誌說，這個

"to speak of gu's work strictly as a metaphor for body politics would be telling only half of the story. for him - as for kiki smith, lorna simpsom, robert gober - the body is certainly a battleground. yet, in his work, the combatant strategy is concealed from us. for all its emphasis on contemporary debates, this art retains a rich, nonpolemical ambiguity. gu uses body material both as subject and medium, whereas kiki smith whose art has often been mentioned in relation to his, works with non-body materials to evoke human forms...however, by selecting actual bodily growth, gu escapes the traditional artistic practice of using a medium solely as a vehicle to convey representation." [1]

"it is easy to make comparisons between gu wenda and other artists that use the body as the focus of their work. but gu wenda himself saw the difference between what he called 'the analysis of substance' and the path of artists such as kiki smith, who made replicas of human organs out of inanimate materials such as bronze or porcelain, or made reference to body fluids without employing actual body fluids. but gu wenda's work is made up of real human materials, which almost seem to retain the temperature of the human body, and bear a personal relationship to the individual experience of the material contributors. when the viewer enters the space of the carefully arranged and installed installation, they can hear the call of each living individual. the separation and the opposition between subject and object dissolve in the shared experience of viewers and those who contributed the original material, and in the shared identity of the physical and psychological, and spiritual."

in a description of my work in the "heart of darkness" exhibition at the kroller-muller museum, els van der plas wrote, "five cradles were lined on the bottom with different kinds of placenta powder. a glass plate protected the inside of the cradle from curious fingers. the middle cradle, which contains no powder, displayed a sign with the message that this baby was aborted; a rather shocking statement. with the empty cradle, symbolizing death, and with the placenta powder, wenda

嬰兒被墮胎，這是壹個讓人震撼的陳述。谷文達通過象徵死亡的空牀，通過胎盤粉，以自然和人為的社會之間的衝突衝擊着觀眾。胎盤粉和頭髮都來自人的身體，在這個意義上它們都是廢棄物。人體物質的脆弱以及與暴力的關係（展示與身體脫離的頭髮）讓觀眾感到困擾，使他們感覺自己像是裸身面對世界。文達使用了來自『生育』的藥，『生命循環』的觀念也通過生育、死亡和掩埋得以呈現。」[2]

《聯合國》計劃的每壹個國家紀念碑都是由純粹的當地人的頭髮建造的大體量建築性作品，需要大量的剪下的人髮。收集當地人的頭髮需要很長時間，通常要花費叁到肆個月，從貳拾到肆拾個理髮店去收集。這個特別的工作過程提供了壹個觀念：人體的廢棄物被轉換成了當地的文化紀念碑。當地的觀眾和我站在這個頭髮紀念碑前時，似乎廢棄的材料被重新注入了人的精神。

當大量的人髮變成頭髮磚、頭髮簾形成的牆和頭髮地毯時，會產生壹種心理和生理衝擊的奇特效果，這絕對是壹個再生的過程：即從「身體的廢棄物」到「生物、文化紀念碑」的轉化。在斯德哥爾摩，當代藝術與建築中心將使用當地工廠的設備製造人髮產品。我們可以想像壹下這個過程：活人的「副產品」通過無生命的「壓製」、「烘烤」、「切割」成頭髮磚和地毯的形式。我覺得這裏的觀念已經超出我們的語言界定其準確意義的能力，它不是簡單的將人的「靈魂」通過「身體循環或製造」成「人髮磚或人髮地毯」。這種用人造的機器加工真實的人體物質的奇怪結合，使得傳統的媒材如木頭、金屬和石頭等在表現性上相形見絀，我將其稱之為「對身體的絕對迷戀」。

confronted the visitor with the conflicts between nature and artificial society. the placenta powder as well as the hair are in a way excrement, in the sense that they come from the body. the vulnerability of these human substances and at the same time the association with violence (showing hair without a body) harassed the visitors and made them recognize their own nakedness. wenda applied the medicine which is made from 'giving birth'. the concept of the 'cycles of life' was also presented by symbols of giving birth, dying and burying."[2]

as every national monument in the united nations project is a large scale architectural work constructed by pure local human hair, each work requires huge amounts of shorn hair. a long period of time is needed to collect the local hair; the process usually involves the participation of about twenty to forty barbershops over a three to four month duration. this specific working process provides a concept: the mountains of human waste are transformed into local cultural monuments. when the local audience and I are before the "hair" monuments, it is as if the waste material is reincarnated with human spirituality.

there is a fascinating effect that creates a psychological and physical impact when amounts of human hair become solid hair bricks, hair curtain walls, hair carpets, etc. it is an absolute process of reincarnation: from "body waste" to "bio/cultural monument." in stockholm, the contemporary center for art and architecture will use a local factory's facilities to produce human hair products. imagine the process: the outgrowth of living people is passed through inanimate machines to be "pressed," "toasted," and "cut" into the forms of hair bricks and carpets. i feel the concept goes beyond our language's capacity to define its precise meanings. it is far deeper than simply "body recycling" or "casting" the human "soul" into "hair bricks or hair carpets." this strange combination of real human substances processed by man-made machines makes the traditional art mediums such as wood, metal, stone, etc. seem much less expressive to say the least. i call it, an "absolute body obsession."

關於人體的迷思和關於宇宙的迷思一樣久遠。因此人體材料本身的優越性在於，和那些非人的材料不同，它是壹種無需語言的幫助就可以傳達特定意義的能指。當人體材料在藝術創造中重新獲得生命時，意義是從人體材料自身生發出來的。使用人體材料和非人的客體的差別產生了對立的定義：「內部的」與「外部的」。人體材料的「內部定義」與觀眾的心理和生理條件相對應。當觀眾觀看人體材料做的作品時，他們理論上是和自己遭遇。與此相反，非人的客體材料天生和觀眾有距離，這種客體與主體之間的、非人的客觀材料和觀看者之間的心理的和物理的鴻溝需要語言來填補。

此外，關於使用人體材料的概念，我覺得它還有另壹個特殊之處，即我以此持續地和我們的「現成品知識」，即我們的「傳統」鬥爭。我在壹封關於我的裝置《重新發現俄狄浦斯叁號：愉悅與罪過之外之謎》信中討論了這個爭議。這是其中的壹段話：「關於作品的殘酷，我肯定不能同意你的看法。胎盤在西方一直被而且還在繼續被用來生產諸如化妝品之類的商品。『殘酷和溫暖』純粹是壹種對作品藝術價值和人的存在的表達，沒有人因為希臘作家索福克勒斯寫了悲劇『俄狄浦斯王』而批評他殘酷。現在，沒有壹個受過很好教育的人會因為莎士比亞寫了悲劇《哈姆萊特》《麥克白斯》《李爾王》《奧賽羅》而批評或反對他，因為『殘酷』是人性的有機部分，它先於並超出任何道德判斷。我想你也知道善與惡是並存的。將貳者在理性上或情感上分離是人為的，它只是壹種錯覺。試圖不去看它、不承認它、逃避它已經成了對理解人類自然的生命過程的壹種結構上的背離。最後，它只是壹種精神虛弱和儒弱的表現，壹條片面的有局限的通向生命

myths about the human body stretch as long as those about the universe. hence, human body materials act as signifiers that do not necessarily the assistance of language to convey certain meanings as most non-human materials do. when human body materials are reincarnated as artwork, the significance comes from within the body materials themselves. the difference between using human body materials and non-human objects creates opposing definitions of "internal" versus "external." the human body materials' "internal definition" parallels the viewers' psychological and physical conditions. when viewers behold the works with human body materials, they are literally encountering themselves. on the contrary, non-human materials are inherently distanced from viewers. this psychological and physical gap, therefore, needs linguistic assistance bridged the void between the object and subject, between objective non-human material and the viewing audience.

in addition, to what i have stated about the concept of using the human body materials, i feel that there is another particularity worth mentioning. i am constantly at battle with our "ready-made knowledge," our "conventions." i once discussed this controversy in a letter regarding my installation, *oedipus refound #3—the enigma of beyond joy and sin*. the following is an excerpt: "talking about the cruelty of the work, i certainly disagree with you. the placenta has been used and continues to be used in the west for commercial products such as make-up. 'cruelty and warmth' are mere expressions of the artistic value of a work and of human existence. nobody criticizes the greek writer sophocles as a cruel person because he created the tragedy *oedipus rex*. nowadays, no cultured person would criticize or react negatively toward shakespeare for having written tragedies such as *hamlet, macbeth, king lear,* or *othello*, as 'cruelty' is a structural part of human nature, which precedes, and goes beyond any moralistic judgment. i suppose you know well that there is no evil without good. such a kind of intellectual or emotional separation between the two is artificial, it is just an illusion. trying

的途徑。這種態度也成了對所謂『真理』或『價值』之類的概念的相對性的否定，它本身即是非自然的，就是說本身是與自然相矛盾的。……索福克勒斯和莎士比亞將人的『殘酷』作為生命中自然和結構性的部分來展現，實際上，今天人們將他們視為熱愛生活和知識、深具洞見地表現人的存在、『誤解』和『盲目』的充滿激情的人來尊崇。」[3]

人體材料包含大量的意義與迷思，其寓意與生、死及所有生命中撲朔迷離的、未能解決的問題相關。在藝術中第壹次使用人體材料揭示了令人震驚的現實與傳統知識之間的邊界，這種傳統知識曾經創造了我們深信不疑的「現實」，即幻覺性的現成價值和信念。

作為大量使用人體材料的《重新發現俄狄浦斯》系列的令人吃驚的結果，我發現自己處在不再相信幻覺的價值，和倒錯的信念的現實的有力辯護者的位置上。這常常被現在的政治正確所拒絕，作品得到的反應常常是「恨」或「愛」兩個極端，觀眾要麼得到格外內在的印象，要麼產生激烈的衝突。我們清楚地看到，觀眾可以重新發掘出許多話題，提出許多問題；我也提出許多謎一般的問題，我自己和觀眾都無法回答。壹個包含智慧和深思熟慮後的挑戰可以激發「令人震驚」的反應，這種「令人震驚」的現象來源於多個渠道，它們是「令人震驚」現象的本質，而「令人震驚」實際上只是表面的現象。

to avoid, not seeing, or recognizing it is a sort of structural deviation from the understanding of the natural process of life, and it is, in the end, a kind of expression of spiritual weakness and cowardice, as well as of a one-sided and restrictive approach to life. this attitude also becomes a denial of the relativity of any so-called 'truth' or 'value,' and it is in itself unnatural, that is to say contradicting nature in itself ... sophocles and shakespeare are actually rightly respected as passionate people, known for loving life, knowledge and for their ability to express insights about human existence, 'misunderstandings' and 'blindness,' while representing human 'cruelty' as a natural and structural element in life." [3]

the human body material contains enormous meanings and myth. the metaphor concerns birth, death, and all the enigmatic, unsolved questions in life. the discovery of using human body material in art unveiled the edges between our shocking reality and conventional knowledge which has created a particular "reality" we believe in, the illusionistic ready-made values and faiths.

as a striking result of the *oedipus refound* series' deep involvement with human body materials, i have found myself in the position of being a strong defender of our reality, without believing in illusionistic values and anachronistic beliefs. it has often been rejected by current political correctness. the responses the work receives are usually ones of great extremes such as "hate" or "love"; either the audience leaves with exceptional inner impressions or difficult conflicts. we can clearly see that an audience may rediscover many issues and pose many questions; i also ask many questions which enigmatically remain unanswered by me and my viewing audience. a challenge can provoke a "shocking" response if it contains intelligence and deliberation; this "shocking" phenomenon evolves from various sources, which is the "shocking's" essence, while "shocking" is actually only the phenomenon.

人體材料自身的大量謎一般的內涵（「內在定義」）和公眾
對它們的強烈反應、解釋和誤解（「外在定義」）之間的衝
突產生了意識和下意識之間的謎一般的情結，它幾乎成
了無法擺脫的困境。由於人體產品的美、敏感性、與觀
眾的奇特的關係、對生與死的呼喚、作為廢棄物的恐懼，
對這個作品的總體反應從嚴重「排斥」、感到「噁心」，到
困惑的發問都有，最後，觀眾認識到，這就是我們自己。

從人類中心出發欣賞、解釋壹件藝術品，從向外看客觀
世界到向裏看「我們自己」，會產生深刻的誤解，這就是
人類的知識所關注的……有戰鬥……有定罪……這就是
我們應用於自身的角度和手段。

the confrontation of enormous enigmatic connotations
contained within the essence of human body material
(the "internal definition") and the intense reactions,
elaborations, and misunderstandings from the viewing
public ("the external definition") give rise to an
enigmatic complex between consciousness and
unconsciousness which becomes an almost unsolvable
predicament. because of the beauty of what the human
body produces, sensitivity, fearful relation to the viewer,
the call of birth and death, the fright of being waste
material, the overall reaction to this work range from
severe "repulsion" and "disgust" to puzzling queries, then
ultimately the audience recognizes that "this is just us."

the appreciation, and interpretation of a piece of art
from an anthropocentric point of view—from looking
out from the objective universe to looking in on
"ourselves"—brings about deep misunderstandings
about what human knowledge is concerned with ... there
are battles ... there are convictions ... these are the angles
and the tools which we apply to ourselves.

注釋

1 丹尼爾・張：《聯合國 —— 美國分部》，收錄於《聯合國 ——
美國分部》展覽圖錄，紐約無題空間，1995 年。

2 els van der plas, "heart of darkness", art and asia
pacific 2,3, 1995.

3 wenda gu, written correspondence to wexner center for
the arts,1993.

notes

1 danielle chang, "united nations-american
division", in united nations-america monument
catalogue, space untitled, new york city, 1995.

2 els van der plas, "heart of darkness", art and asia
pacific 2,3, 1995.

3 wenda gu, written correspondence to wexner
center for the arts,1993.

生物時代之謎（叁）：

《血之謎》紐約 1988 － 1996

ENIGMA OF BIOLOGICAL TIMES 3:

enigma of blood　new york 1988-1996

《血之謎》
重新發現的俄狄浦斯系列
計劃草圖之叁 , 之肆
1992 年於紐約工作室
水彩畫顏料，墨汁，水彩畫紙，白色金屬鏡框
58 厘米寬 ×76 厘米高

ENIGMA OF BLOOD

oedipus refound series
plan #3,#4
new york studio, 1992
watercolor, ink on watercolor paper, white metal frame
58cm wide × 76cm high

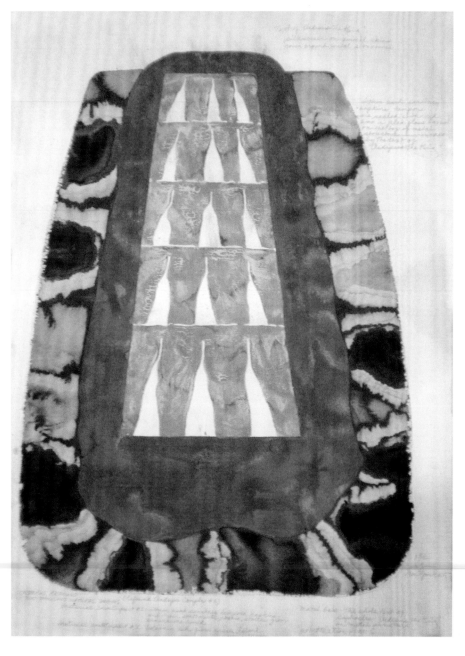

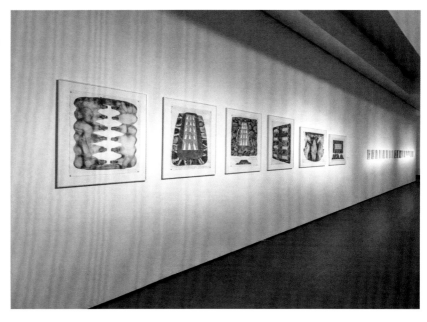

觀眾和媒體的爭議
controversy amongst the
viewers and the media

《血之謎》之叁 部分婦女參與者親筆寫作的故事和詩歌等以郵局郵件方式寄給藝術家
enigma of blood #3 some women participants' letters, statements, poems, and stories sent to the artist via the postal service

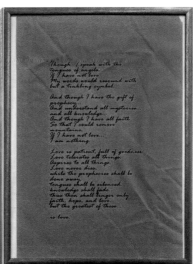

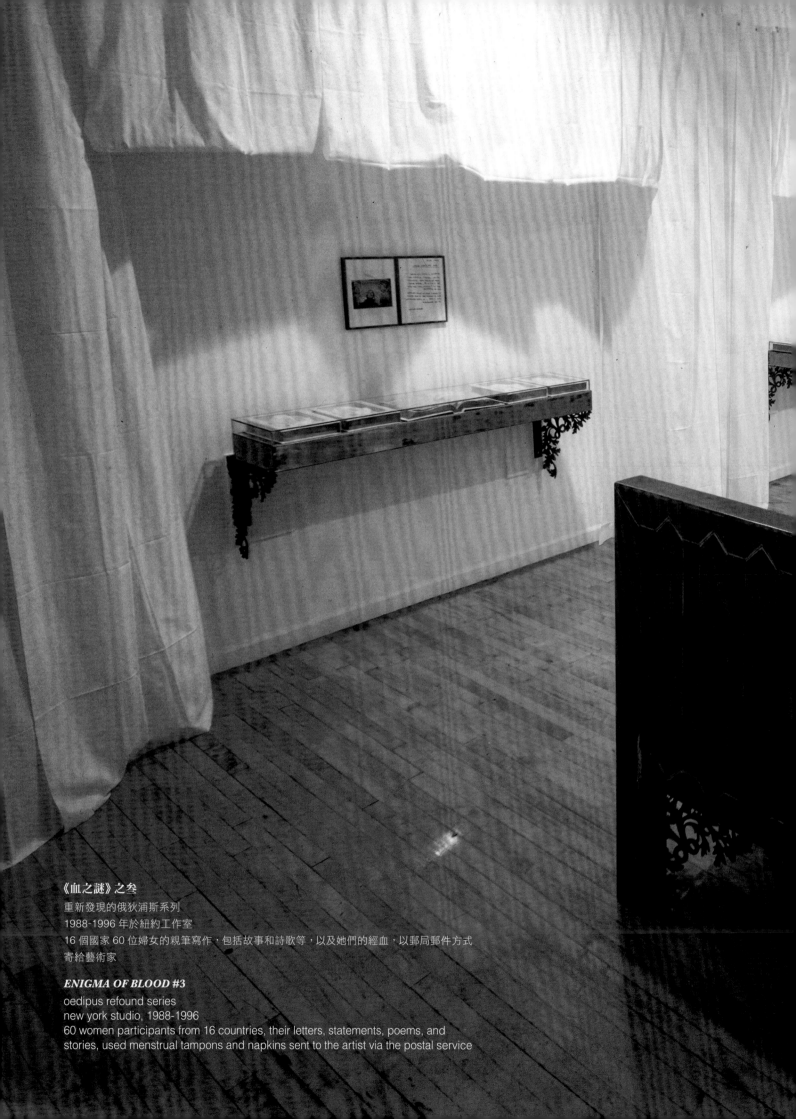

《血之謎》之叁
重新發現的俄狄浦斯系列
1988-1996 年於紐約工作室
16 個國家 60 位婦女的親筆寫作，包括故事和詩歌等，以及她們的經血，以郵局郵件方式
寄給藝術家

ENIGMA OF BLOOD #3
oedipus refound series
new york studio, 1988-1996
60 women participants from 16 countries, their letters, statements, poems, and
stories, used menstrual tampons and napkins sent to the artist via the postal service

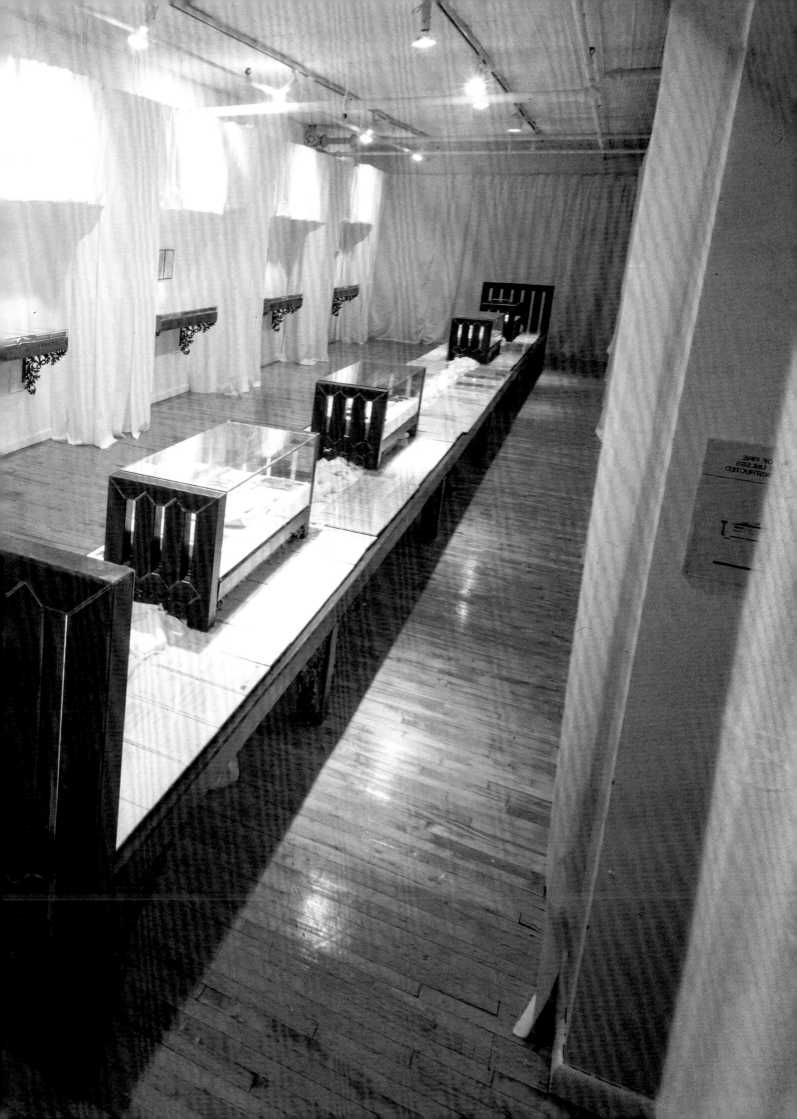

觀眾與美術館對《血之謎》重新發現的俄狄浦斯系列引發的討論

public discussions over the controversy of *enigma of blood* oedipus refound series

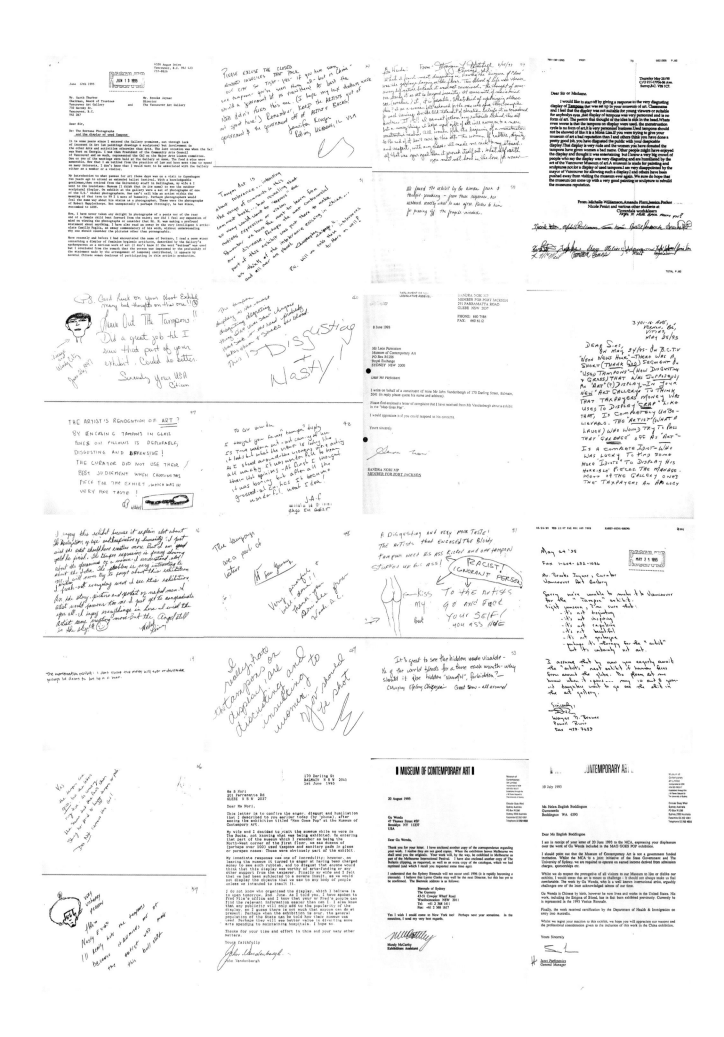

345

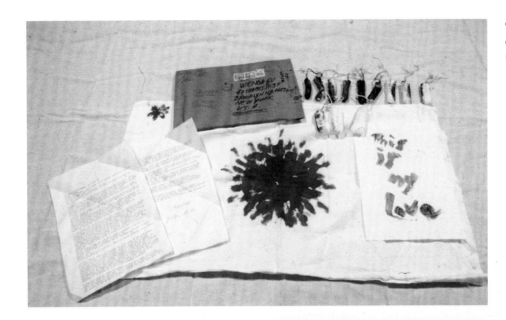

《血之謎》重新發現的俄狄浦斯系列　細部
enigma of blood　oedipus refound series
details

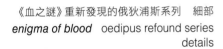

《血之謎》重新發現的俄狄浦斯系列　細部
enigma of blood　oedipus refound series
details

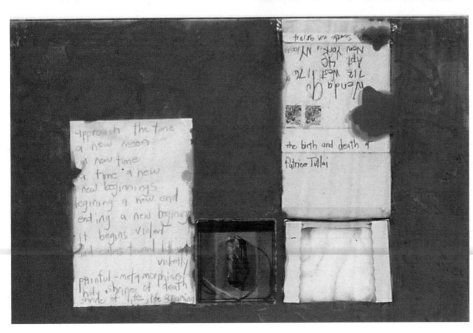

《血之謎》重新發現的俄狄浦斯系列　細部
enigma of blood　oedipus refound series
details

生物時代之謎（肆）：

《墨煉金術》上海—紐約 1999-2001

ENIGMA OF BIOLOGICAL TIMES 4:

ink alchemy shanghai—new york 1999-2001

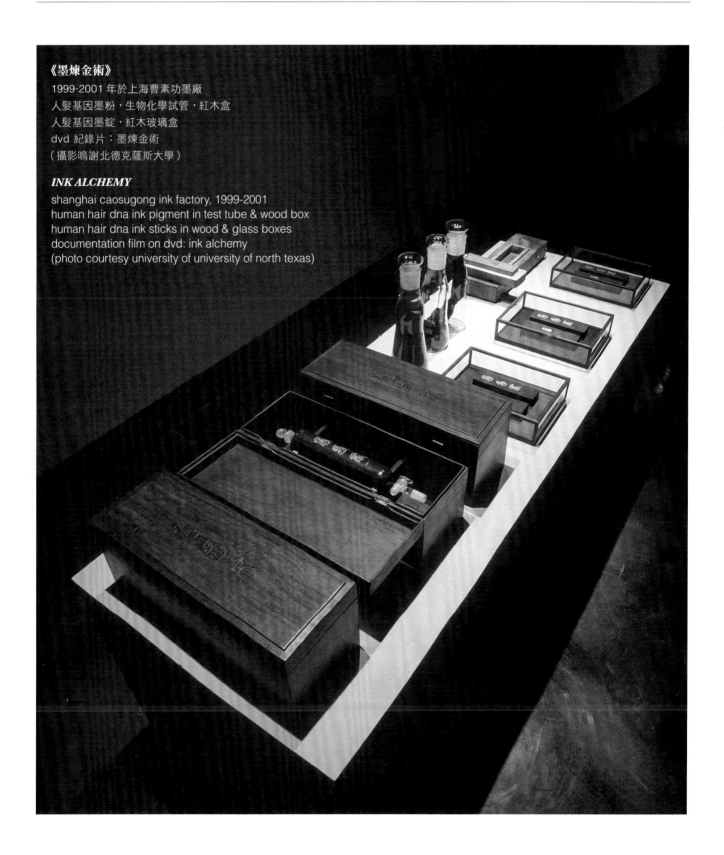

《墨煉金術》
1999-2001 年於上海曹素功墨廠
人髮基因墨粉，生物化學試管，紅木盒
人髮基因墨錠，紅木玻璃盒
dvd 紀錄片：墨煉金術
（攝影鳴謝北德克薩斯大學）

INK ALCHEMY
shanghai caosugong ink factory, 1999-2001
human hair dna ink pigment in test tube & wood box
human hair dna ink sticks in wood & glass boxes
documentation film on dvd: ink alchemy
(photo courtesy university of university of north texas)

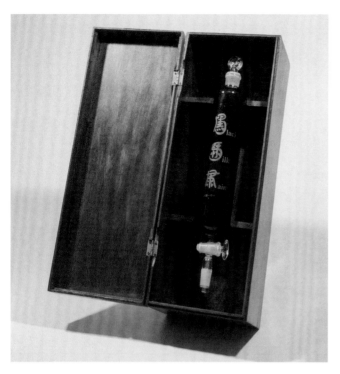

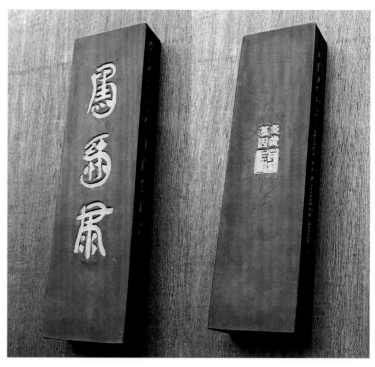

《基因墨粉》(墨粉色限量版)

1999-2001 年於上海曹素功墨廠

100% 半碳化人髮粉,玻璃生物化學試管,木盒

玻璃試管 41.4 厘米長 ×6 厘米直徑

木盒 48.5 厘米長 ×17.4 厘米寬 ×17.4 厘米高

DNA INK PIGMENT (**LIMITED EDITIONS**)

shanghai caosugong ink factory, 1999-2001

semi-charcoal human hair powder, glass biological test tube, wood box

glass test tube: 41.4cm long × 6cm diameter

wood box: 48.5cm long × 17.4cm wide × 17.4cm high

《基因墨錠》(墨錠限量版)

1999-2001 年於上海曹素功墨廠

100% 半碳化人髮粉,麝香和傳統製墨錠工藝

墨錠 5.1 厘米寬 ×17.8 厘米高 ×2.5 厘米厚

玻璃盒 22.8 厘米寬 ×30.5 厘米高 ×6.3 厘米厚

DNA INK STICK (**LIMITED EDITIONS**)

shanghai caosugong ink factory, 1999-2001

semi-charcoal human hair powder, traditional ink stick making methods

ink stick 5.1cm wide × 17.8cm high × 2.5cm thick

glass box 22.8cm wide × 30.5cm high × 6.3cm thick

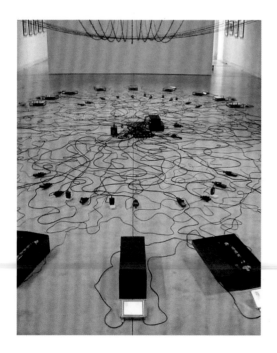

《墨煉金術》

1999-2001 年於上海曹素功墨廠

人髮基因墨粉,生物化學試管,紅木盒

人髮基因墨錠,紅木玻璃盒

人髮辮,液晶視頻,電線,dvd 紀錄片:墨煉金術

INK ALCHEMY

shanghai caosugong ink factory, 1999-2001

human hair dna ink pigment in test tube & wood box

human hair dna ink sticks in wood & glass boxes

human hair braids, tv monitors, wires, a dvd document film: ink alchemy

《基因墨錠》與《基因墨粉》的概念與視覺設計

concept and visual design of *dna ink stick* and *dna ink pigment*

《黑絲雨》
1999 年於紐約工作室
宣紙，墨，紙背白梗絹邊裝裱鏡片
70.2 厘米寬 × 155 厘米高

BLACK SILK RAIN
new york studio, 1999
ink on xuan paper, mounted on
paper backing with white silk
borders
70.2cm wide × 155cm high

《基因墨錠》的木模設計
the design of wooden mould
for the *dna ink stick*

黑絲雨是對黑髮墨的詩意化的解釋，黑絲雨字形設計來源於中文黑絲雨與英文黑絲
雨翻譯 black silk rain 的大寫第壹字母的結合
black hair ink rain is a poetic expression, black silk rain is a combination of
chinese words black silk rain and the english letters B S R

《基因墨錠》木模上的文字設計為：黑絲雨，中國人髮製造，西元貳仟年上虞谷氏造，
兩枚圖章：炎黃基因，谷文達
the inscriptions on the *dna ink stick* mould are: black silk rain, made of chinese
hair, created by the gu family in the year of 2,000 AD, 2 seals: yan huang
chinese dna, gu wenda

《墨煉金術贊》
2001 年於上海工作室
宣紙，墨，白梗絹裝裱鏡片
132.5 厘米長 ×65.5 厘米高

PRAISE FOR INK ALCHEMY
shanghai studio, 2001
ink on xuan paper, mounted on paper backing with
white silk borders
132.5 cm long × 65.5 cm high

《基因墨錠》(墨錠限量版)
1999-2001 年於上海曹素功墨廠
100% 半碳化人髮粉，麝香和傳統製墨錠工藝
墨錠 5.1 厘米寬 ×17.8 厘米高 ×2.5 厘米厚
紅木玻璃盒 22.8 厘米寬 ×30.5 厘米高 ×6.3 厘米厚
(攝影鳴謝堪薩斯藝術學院)

DNA INK STICK (**LIMITED EDITIONS**)
shanghai caosugong ink factory, 1999-2001
semi-charcoal human hair powder, traditional ink stick
making methods
ink stick 5.1cm wide × 17.8cm high × 2.5cm thick
mahogany glass box 22.8cm wide × 30.5cm high ×
6.3cm thick
(photo courtesy kansas art institute)

國墨非遺傳承人魯建慶先生，曾經是曹素功墨廠廠長，他監製了《基因墨錠》和
《基因墨粉》
mr. lu jianqing, the symbolic god-father of chinese classic ink, was
the former head of caosugong ink factory. it was he who executed the
production of *dna ink stick* and *dna ink pigment*

谷文達在曹素功墨廠廠長指導下欣賞製作墨錠的傳統技藝和欣賞製造墨錠的流程
the director of caosugong ink factory is showing gu wenda how to
appreciate traditional artefacts and explaining the ink making procedures.

350

1999 年至 2001 年間在上海曹素功墨廠創製《基因墨錠》和《基因墨粉》

creating *dna ink sticks* and *dna ink pigment* at caosugong ink factory in shanghai, 1999-2001

攪拌人髮粉
stiring human hair powder

揉人髮粉
kneading human hair powder dough

將人髮粉團植入墨錠木模
putting human hair dough into ink stick mould

351

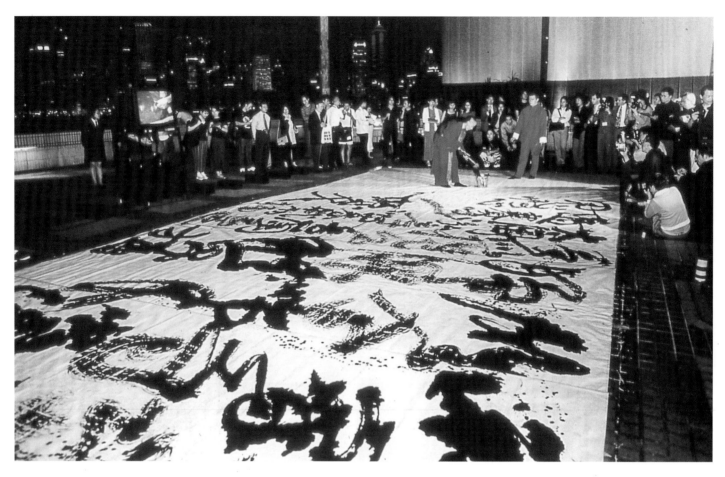

《谷文達的婚禮生活》系列之貳

行為藝術

2000 年於香港藝術館

由三藩市現代藝術博物館和三藩市亞洲藝術博物館主辦，

由香港藝術館贊助

新郎谷文達（中國籍），新娘傑羅米·溫斐爾德（美國籍）

人髮基因墨，宣紙

***GU WENDA'S WEDDING LIFE* SERIES 2**

art performance

hong kong museum of art, 2000

organized by the san francisco museum of modern art and the san francisco asian

art museum, and sponsored by the hong kong musuem of art

groom: gu wenda (chinese); bride: jerome winfield (american)

human hair dna ink, xuan paper

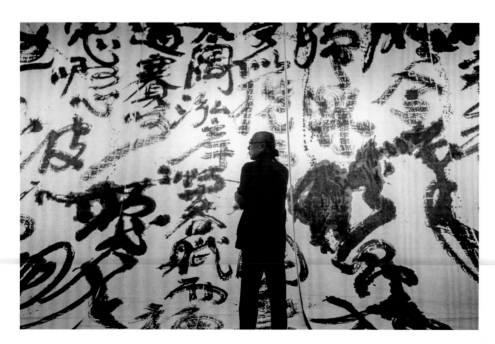

藝術家谷文達與基因墨行為藝術書法作品《谷文達的婚禮生活》系列之貳，谷文達回顧展現場，2019 年武漢合美術館（圖片鳴謝合美術館）

artist gu wenda and his human dna ink calligraphic performance work *gu wenda's wedding life* series 2 at the site of his retrospective exhibition at wuhan the united art museum 2019 (photo courtesy of united art museum)

墨　煉　金　術

谷文達

INK ALCHEMY

gu wenda

以中國人髮創製的中國人基因墨粉和中國人基因墨錠（又稱炎黃基因墨粉和墨錠）是裝置藝術，更重要的是她們又是水墨畫的原創的新材料。中國人基因墨粉和中國人基因墨錠是由我在 1999 年至2001 年間創作的，並在中國現存的歷史最悠久，從明代建立以來的上海曹素功墨廠試驗製作完成。中國人基因墨粉和中國人基因墨錠曾經歷了複雜的研究與探索過程。如何製作人髮粉的方法，經歷了壹個有趣的故事。1998 年底的壹天，我設想如果我們人體的 dna 的黑色可以變成我創作水墨畫的原材料「墨」，我們炎黃子孫 dna 基因的黑色較之於墨水，那簡直就是我們俗話常說的「血濃於水」的天差地別呀！我的助手說她將人髮置入微波爐轉了半小時以至容器都變了形，但容器裏的人髮仍然烏黑錚亮。我們的人髮是如此強壯。又壹段時間過去了，我無法尋求得到壹種方法將我們人的黑髮魔術成「黑色金子」。日後壹天，我的助手高興地告訴我，她偶然遇見了中藥廠生產的「血

ink alchemy chinese dna ink powder and chinese dna ink sticks (also known as yanhuang dna ink powder and dna ink sticks), produced from the hair of chinese people, are installation artworks. more importantly, they are also a new material with which to make original ink paintings. i created the chinese dna ink powder and ink sticks between 1999 and 2001, and they were tested and produced in shanghai's caosugong ink factory, the oldest extant ink factory in china, which dates back to the ming dynasty.

the chinese dna ink powder and ink stick had gone through a complicated process of research and experimentation. this journey of transformation of human hair is an interesting story. one day at the end of 1998, i came up with the notion that if the black color the dna found in our bodies could be transformed into raw "ink" for my ink paintings—turning the inherited genes from our dna (of the "children and grandchildren of emperors yan and huang") into ink—then that would be completely at odds with the adage "blood is thicker than water"! my assistant told me that she had placed human hair into a microwave for half an hour; the container melted but the hair inside was black, glossy, and shiny—evidence of the strength of human hair. some time passed, but i still had not found a way to transform that magical black hair into "black gold." later, one day, my assistant was pleased to tell me that by chance she came

餘炭」來自於人髮！我立刻覺得不但解決了我朝思暮想而無結果的問題，並且此故事很有意義！然後我參照了傳統中醫學上傳統中藥人髮粉製成「血餘炭」（上海飲片廠，中藥提供原料的生產廠家）。但「血餘炭」達不到比炭精粉更細的顆粒狀態從而可以作為墨的材料，之後我在上海華東師範大學的生化實驗所，以空氣高壓噴射機的現代設備，將人髮粉製作成比炭精粉更細的顆粒狀態，以達到製墨的要求。中國人基因墨有墨粉和墨錠兩種。其壹為墨粉《黑絲雨——人煙壹零壹》：為體現中國人基因墨粉的觀念與形象，同時表達中國文化之精華和千禧年作為生物時代的觀念，此中國人基因墨粉置入特別設計的透明的標準生物化學實驗的容器瓶，並裝入經由我特別設計的木盒。中國人基因墨粉的透明玻璃容器和木盒上均刻印有「黑絲雨——人煙壹零壹」的字樣。其貳為中國人基因墨錠「黑絲雨——人煙壹零壹」。以陰陽兩種字刻「黑絲雨——人煙壹零壹」，「公元貳零零零年上虞谷氏製造」，兩方印章為「炎黃基因」和製作者姓名。

在 1992 年至 2000 年間，我為持久跨國藝術計劃《聯合國》考慮其觀念書和視覺書時寫過壹篇長文《我們時代的神曲》，其中有如下的描述：

　　　　將人髮創造墨汁和墨錠是我自 1993 年始的為期拾貳年的跨國家和人種、跨政治與文化、跨世紀的作品《聯合國》，進入對人髮在觀念上更深壹層的發掘。《聯合國》至今已完成了 18 個國家和地區的規模相當大的紀念

upon "crinis carbonisatus," a chinese medicine made from human hair! i immediately realized this not only solved a seemingly irresolvable problem which i had been pondering from morning till night, but that this story was really meaningful! then looked into the situation of "crinis carbonisatus" made from human hair in traditional chinese medicine (a tcm manufacturer provided the original raw materials). but "crinis carbonisatus" was made up of granules thicker than those that are found in charcoal powder, so it could not serve as the material for ink. then, at the biochemical laboratory at the east china normal university, i had the human hair powder made into pellets even finer than charcoal powder—necessary for ink—using modern equipment—a high-pressure spray machine. chinese dna ink comes in two forms: ink powder and ink sticks. the first is the ink powder *black silk rain—human smoke 101* which allowed me to present the idea and form of chinese dna ink; at the same time, it also expressed concepts surrounding the essence of chinese culture and the new millennium as a biological age. this chinese dna ink was placed in a specially designed transparent test tube—a standard test tube used in a biochemistry lab. then the tube was encased in a wooden box that i designed. on both the transparent flask with the chinese dna ink and the wooden box were printed the words "black silk rain—human smoke 101," the chinese dna ink stick was engraved with "black silk rain—human smoke 101." *"black silk rain—human rain 101"* and "produced by gu in shangyu, 2000" engraved in relief and intaglio seals; the two seals were "yanhuang dna" and the name of the artist.

between 1992 and 2000, i wrote a long essay, *the divine comedy of our times,* for the enduring transnational art project **united nations,** which addressed its ideas and vision. in it, i discussed quite a bit about the significance of turning genes from human hair into ink.

　　*turning human hair into ink powder and ink sticks was one extra step in my conceptual excavation of human hair which started 12 years previously in 1993, with the trans-national, trans-racial, trans-political, and trans-cultural work, **united nations**, which spanned the turn of the century. to date, **united nations** has already*

碑。已由分散在世界各地的 450 家理髮店收集贊助。自 1993 始，這壹漫長的「世界之旅」的長征中，已有近佰萬不同人種的頭髮匯集在《聯合國》中了（至 2019 年，已有伍佰多萬人的人髮參與了）。這壹幾乎永遠不可能在現實中實現的烏托邦理想，卻能在藝術中得以完滿體現。一些藝評家冠此作品為「文化殖民者」（cultural colonialist）。此作品涵蓋和包容的國家和人種、政治與文明、歷史與文化是空前的。而這「長征」的單壹的藝術媒體是人髮。而人髮涉及到的中西宗教、文明歷史實在是壹部壯麗的史詩。以至於《聯合國》在其世界各國建構的過程中，屢次引起廣泛討論。1993 年在波蘭歷史博物館展出的《聯合國》系列的首件國家分作品，以當地的大量人髮製成的裝置，使不少波蘭觀眾面對作品時聲淚俱下。1995 年在以色列密茨比冉沙漠中，《聯合國》系列以色列紀念碑作品計劃引起爭執，在其國家大報上以醒目的頭版頭條，包括整整肆版以此壹專題採訪當地重要的美術館長、著名的詩人和政治活動家。直至於以色列國家電臺邀我，策展人與國家議會主席討論並現場直播，接連叁天國家電視 1、2、3 台晚間新聞對作品的追蹤報道。1996 年在瑞典的國際展覽上，《聯合國》的瑞典分作品在開幕式上遭參展的俄國藝術家的破壞，導致了壹場「警察鎮壓犯罪」極具戲劇性的現場。立刻趕到現場的有肆輛警車和眾多電視台、電台、報社的記者。事

realized considerable monuments in 18 countries and regions, with the hair collected from 450 collaborating hair salons from around the world. in this long march "around the world" since 1993, we collected hair from nearly a million people of various races (with over five million participants by 2019). such a utopian ideal, that practically speaking could never be realized in reality, was fully realized in art. some critics have called this work "cultural colonialism." the countries and races, political groups and civilizations, histories and cultures covered and incorporated by this work are without precedent. and the only artistic medium of this "long march" is human hair. the religions, cultures, and histories spanning from east to west that are involved in this journey of human hair constitute a grand epic. the process of setting up **united nations** in various countries around the world sparked broad discussions on multiple occasions. in 1993, the first national work from the united nations series was exhibited at the polish history museum; the installation made with large amounts of local human hair caused quite a few polish visitors to cry in front of the work. in 1995, within the mitzpe ramon desert in israel, the israel monument of **united nations** resulted in eye-catching headlines in major newspapers in the country, including a four-page feature that involved interviews with key local museum directors, famous poets, and political activists, at a certain point the israeli national television station invited me, the curator, and the speaker in the knesset to converse live on tv, while for over three days, channels 1, 2, and 3 on the national tv network continued their coverage of the work. in 1996, in an international exhibition in sweden, the works in the swedish installment of united nations were unfortunately destroyed by a russian artist during the exhibition opening, leading to an extremely theatrical scene of the "police cracking down on crime." four police cars and many journalists from tv stations, radio stations, and newspapers rushed over to the scene. on the day after the incident, a national press conference was held. thereafter, it caused over a year's worth of lengthy discussions amongst swedish academics, news media, and the art world. such an incident had never

故發生的第貳天召開了國家新聞發佈會。此後，引起了瑞典學術、新聞和藝術界持續壹年多長篇累牘的討論。如此的藝術事件在瑞典從未有過。與此同時，各國大報也大加報道和評論。以上我的《聯合國》系列作品在各國引起的反響足以證明人髮在人類歷史長河、人種、政治和文化的層面具有深刻意義。

唐代李白的《將進酒》以髮色形容人生的短暫：「君不見黃河之水天上來，奔流到海不復回。君不見高堂明鏡悲白髮，朝如青絲暮成雪。」《史記·列傳·卷捌拾陸·刺客列傳荊軻》中司馬遷有「髮盡上指冠」之描述頭髮的形狀變化以表達不同的情緒。《論語·憲問篇》視髮型為文明教化的呈現，「子曰，管仲相桓公，霸諸侯，壹匡天下，民到於今受其賜。微管仲，吾其被髮左衽矣，豈若匹夫匹婦諒也，自經於溝瀆而莫之知也。」《藝文類聚》第拾柒卷人部髮《呂氏春秋》論說：「於是翦其髮，櫪其手，以身為犧牲，用祈福於上帝。」以此可見，古人在祭場中視頭髮為生命和身份的代表。在美洲印第安部落，墨西哥土著，非洲以至於羅馬時代都將頭髮視為祭物、聖物，當作種族和力量的象徵。希臘神話中漂亮的美度莎因海神的追求，犯禁投入雅典娜神廟，雅典娜懲罰她的美髮變為壹條條蛇。這壹古希臘的神話中對美度莎的懲罰在現實中更為殘忍：在貳次世界大戰希特勒集中營裏殺害猶太人並取其頭髮做牀和沙發墊等。其刻毒之處還在於猶太教視人髮為生命之象徵。以著名的古希伯

happened in swedish art before. at the same time, major newspapers around the world also included coverage and commentary. the reactions around the world mentioned above are proof enough of the depths of layers of meaning associated within the immense flow of human history, race, politics, and culture.

in the tang dynasty, li bai in his poem "invitation to wine" employed the motif of hair color to describe the transitory nature of life: "do you not see the yellow river come from the sky, rushing into the sea and never come back? do you not see the mirrors bright in chambers high, grieve over your snow-white hair though once it was silk-black?" in chapter 86 of "biography of the assassin retainer jing ke" of "biographies" [liezhuan] in sima qian's records of the grand historian, the description of the hair—"the hair bristled underneath the caps"—to express different emotions. the xian wen chapter of the analects views hair as the manifestation of civilized teachings: "the master said, 'when guan zhong served as duke huan's prime minister, the duke made him hegemon over the feudal lords and united the empire. even today, people are still benefiting from this. were it not for guan zhong, we might all be wearing our hair loose and fastening the fronts of our garments on the left [as barbarians do]. how can we expect of him the petty sincerity of a common husband or wife, to hang himself in some ravine or ditch, with no one knowing of it?'"

in volume 17 of human hair of "master lü's spring and autumn annals" of yiwen leiju (classified anthology of literary works), it is stated: "then he cut off his own hair, punished himself by pinching his fingers with wood, and prayed to heaven by sacrificing his own body." from this we can see how the ancients within the field of sacrifice viewed hair as the representative of life and body. from indigenous tribes in america, mexico, and africa, and even amongst the romans, hair was viewed as a sacrificial object, a reliquary, a symbol of race and power. in greek mythology, the beautiful medusa, fleeing poseidon's pursuit entered athena's temple. athena punished her, turning her hair into snakes. this punishment of medusa in greek mythology does not compare to what happened during the second

萊宗教人物參孫（samson）為例：「向來人沒有用剃刀剃我的頭髮，因為我自出母胎就歸神作拿細耳人，若剃去我的頭髮，我的力氣就會離開我。」（《舊約聖經・士師記・拾陸》）。宣統年間，求新政而解除清初的髮禁，並頒令剪髮。從法國路易拾叁王以假髮（powdered wig）遮蓋其禿頭以至時尚，便有律師、醫生等的不同假髮到嬉皮和龐克的髮型代表了不同階級的社會地位。髮型是對思想和文化的認同，也是統治者控制的手段。正如《清史稿》本記卷貳拾伍中記載：「己巳，資政院請明諭剪髮易服。」

現代生物科學和遺傳工程通過 dna 可從壹絲頭髮中得到此人所有的情況和信息。據此壹方式，我曾設想創作與觀眾參與的裝置《美國檔案》(american files)，展覽 dna 的電腦化驗程序設備，而觀眾則是測試的對象。由他們捐獻自己的頭髮，通過 dna 的測試然後他們將取回他們每個人自己的「檔案」。對於美國這個有眾多人種與文化的移民國度，從政治和人種、歷史和現狀有其極深的涵義。這是壹部活生生的數碼的達爾文進化論。而在我研究人髮如何製成我的「生物墨汁」和「生物墨錠」過程中，發現上海製藥廠以人髮提煉自然氨基酸，作為生物化學藥材的成分。除了我所陳述的以「髮」製「墨」的基本概念要素之外，也傳達了壹個很有意義的觀念，即以當代「生化藥物」治療傳統的「文化症狀」。

我的新水墨畫可能以中國人基因墨作為材料。中國人基因墨粉和中國人基因墨錠的實驗系列是基

world war in the grim reality of the 20th century, the nazis killed jews in hitler's concentration camps and then used their hair to make bedding and couch cushions—there was a spiteful symbolism in the fact that judaism viewed human hair as the symbol of life. take the famous ancient hebrew religious figure, samson, for example: "no razor has ever been used on my head," samson said, "because i have been a nazirite dedicated to god from my mother's womb. if my head were shaved, my strength would leave me, and i would become as weak as any other man." (judges 16:17). during the era of xuan tong [1909–1912], he sought to enact new policies to reverse the ban on growing one's hair—since the early qing, subjects were ordered to cut their hair off [i.e. in the manchu style, with the front part of the head shaved and with the remaining hair tied into a queue]. since the powdered wig worn over the bald head in the time of louis xiii of france, lawyers and doctors have used wigs; all the way to the hippies and punks, hairstyles have represented the social status of different classes. hairstyles represent cultural and ideological identities; it is also a means of control of those governing. for instance, in volume 25 of "biography" [benji] in the draft history of the qing : "on the day of ji-si, the national assembly requested a decree to change the hairstyle and clothing."

through modern biology and genetic engineering with just one strand of hair, we can obtain information about a person's physical condition and genetic information.. with this, i had once imagined creating an installation *american files*, which involved participating with the audience. the exhibition would have involved a set-up with computerized dna testing programs, while the audience would be the object of testing. through the hair that they would donate, they would be able to collect their own "file" through dna testing. for an immigrant country like the united states, with its numerous races and cultures, this has deep significance in terms of politics, race, history and its current conditions. this is a living, digital theory of evolution by darwin. while researching how to make human hair into "biological ink" and "biological ink sticks," i discovered a shanghai pharmaceutical company that used human hair to

於以下所陳述的觀念體系之上的，即 21 世紀中國水墨藝術面臨的挑戰和革命的基礎：中國人基因墨汁和中國人基因墨錠是文化上的返源。世界藝術有史以來就是壹部以客觀媒體再現人的主觀世界的歷史。無論從史前岩畫到文藝復興的蛋清壁畫，從油畫到丙烯畫，從絹畫到宣紙畫。無論從毛筆、鉛筆到各種各樣的工具、媒材與手段，以至於電腦程序。自 1998 年始我的創作已經以確確實實人體材料為藝術媒材了。使用人髮製造的墨，使藝術創作離不開依賴於客觀媒體和媒材成為歷史。也是與杜尚客觀物質的「現成品」藝術大相庭徑的是主觀物質的「現成品」。同時使藝術返回到了其本源「人」：「中國人」這個「源」與伍仟年的文化這個「流」融為壹體了。我的水墨畫創作中將以「中國人基因墨」為媒材，於是中國人的「炎黃基因」就將躍然其中了。在我研究「中國人基因墨」過程中壹個有趣的觀念，受啟發於人髮粉在傳統中醫學上可治療焦慮症和具活血健身的功能，即人髮中的自然氨基酸的作用。就此引申出了壹個既富有意義而幽默的觀念，即人髮粉在中藥理療中對人的焦慮症與強身有特殊功能，中國人基因墨於當下中國水墨畫界的種種焦慮，可謂是對「症」下「藥」了。且頗具「壯」水墨畫之「陽」的詭異功能！

生物、生命、遺傳和藥物科學專業，集結了最優秀的學生與人才。當有人問比爾・蓋茨下壹個世界最富的人應該是誰？他說是未來生物工程、遺傳基因研發和藥業。我認為未來生物工程和遺傳基因研發是人的終極科學。我開始創作人體材料

refine natural amino acids as a component of a biochemical drug. aside from the basic conceptual elements of using "hair" to make "ink" as described above, this also carries across a very meaningful idea, which is the use of contemporary "biochemical medicine" to heal very traditional "cultural symptoms."

my new ink paintings use chinese dna ink as their material. the two experimental series chinese dna ink powder and ink sticks are based on a conceptual system whereby the challenges faced by chinese ink art in the 21st century are the foundations of its revolution: chinese dna ink and ink sticks symbolize a cultural return to origins. throughout history, global art has always been the history of an objective medium representing the human subjective world—whether through prehistoric cave paintings or the tempera murals in the renaissance, from oil painting to acrylic, from silk painting to *xuan* paper, from brush, pencils, to all kinds of tools, mediums, techniques, and even computer programs. from 1988 onwards, my work has employed genuine bodily materials as the artistic medium. using ink made from human hair makes artistic creation dependent on objective mediums and materials as history. completely unlike duchamp's "readymade" of objective materials, it is a "readymade" of subjective materials. at the same time, it makes art return to its origins, "humans": this "source" of "chinese people" and this "source" of 5000 years of history merge as one. my ink painting works employ "chinese dna ink" as the material, thus the "yan-huang dna" of the chinese people appears vividly within them. while researching "chinese dna ink," i was inspired by an interesting idea of how human hair powder, within traditional chinese medicine, can cure anxiety and has the function of improving blood circulation and overall health in the body—the result of the amino acids in the human hair. from this a rich, meaningful and yet humorous idea emerged; just as human hair powder can treat anxiety and strengthen the body in tcm treatments, chinese dna ink is also the "medication" for the "symptoms" of all manners of worries within the contemporary chinese ink art world—and possesses a truly "vigor inducing" function to "strengthen" ink painting!

the scientific professions of biology, life sciences, genetics, and pharmacology have gathered together the most accomplished students and personnel. when someone asked bill gates who

的時候，當時很清晰地意識到我原創的中國人基因墨粉與墨錠，是用中國人的基因在畫畫。中國人基因墨粉與墨錠比傳統的墨更傳統，因為這是把墨還原到墨的創造者本身上去了，但同時她們又反映了當代基因科學、生物科學的觀念。藝術發展從來離不開人的進化與社會的發展，那麼將來生物學的發展，一定導致壹代藝術家與生物科學、遺傳工程發展所形成的社會發展結合起來的，一定會有這麼壹批藝術家出現的。比如電腦發展了，網絡跟着發展，就會有壹大批藝術家做網絡、電腦藝術。美術界的發展，可能在某些思潮上可以超前，但是最後落實在創作上，還是要受到社會發展、科學發展的制約的。就認為電腦只是工具，生物與遺傳工程可以發展到改變人的本身。未來的戰爭，也許不需要招兵了，可以在壹個生物工程研究所生產軍隊。再比如說未來的生物電腦的形態，這種電腦可以用生物材料製成，可成為生物體的壹部分。正是這種東西在吸引我，所以我後來把創作和個人體材料結合起來。

在我的《基於對中國水墨畫的現狀的反思》壹文中談到不少有關的觀點。我摘引如下：

> 21 世紀是「生物時代」。無不令人驚訝的是「電腦網絡系統的高速公路」（internet superhighway）和現代生物科學，生物遺傳工程（biological science and genetic engineering）成為市場經濟中的新貴。取而代之工業產業律師和醫生的傳統貴族。高科技、生物和遺傳工程終將成為佔社會統治的產業。在美國，

would be the next richest person in the world, he said in the future they would come from the fields of genetics, bioengineering, or pharmaceuticals. i believe that bio-engineering, and genetic research are the ultimate sciences for humanity. when i first created bodily materials, i was clearly aware that my original chinese dna ink powder and ink sticks were about using the genes of chinese people to paint. chinese dna ink powder and ink sticks were even more traditional than traditional ink, because they returned ink to the creators of ink themselves, while at the same time, they also reflected the ideas of contemporary genetic science and biological sciences. artistic development has never strayed from human evolution and social development, so the development of biology in the future will certainly lead a generation of artists to bring together the social developments brought by biology and genetic engineering—we can expect these kinds of artists to emerge. for example, with the development of the computer and the growth of the internet, many artists are doing internet and computer art. in certain currents of thought the art world might be ahead in certain developments, but in the end, in concrete terms of creating work, they are still constrained by the pace of social and scientific development. from viewing computers as mere tools, biological and genetic engineering can develop towards the possibilities of changing one's body. future military conflicts might no longer require conscripted soldiers: troops could be created through a bio-engineering institute. or for instance, through a future biological computer, artists could create using biological materials and become a part of a biological entity. i am very attracted by these ideas which led me to later combine my work and with body materials.

i discussed quite a few related points in my article called *reflections on the current state of chinese ink painting*. i will cite below:

> *the 21st century is the "age of biology." it is not surprising that the internet superhighway, biological science, and genetic engineering have become the new mavericks of the market economy. replacing the traditional elite of industrialists, lawyers, and doctors, high-technology, biology, and genetic engineering will occupy the positions of social dominance. in the united*

傳統的藍領產業階層將逐漸被取而代之以高
科技階層。而傳統的工業產業正快速挪移至
世界其他國家，特別是落後地區。從客觀的原
因來分析是因為：他國的廉價勞動力和；傳
統工業在其他國家或落後地區的巨大市場；
更重要的是比較高科技和信息產業，傳統的藍
領階層及其產業在未來的社會中顯得次要了。
我們僅從媒體（media）上來比較：爭取伍仟萬
聽眾，電台要花叁拾伍年；電視需要拾叁年；
而電腦網絡只需叁年。這不僅僅是美國的現
實需要，更重要的是它的戰略意義。

不難預測，美國在未來將成為高科技和信息的國
家，同時也將成為世界高科技和信息的中心，這也
是美國的國策。從美國現在的教育和未來的教育投
資上來看，所有美國大學中生物、遺傳工程的學科
的學生是最優異、聰明的，學分也要求最高的。從
市場的角度來分析，電腦高科技股票和生物股票近
幾年以令人吃驚的速度遞增，特別是生物股票更具
有不可估量的前景。誰在高科技，特別是誰在生物、
遺傳工程的領域領先，誰就將統治世界的各個領域。

電腦是工具和手段而不是目的。人類有史以來的
和終極的探究目的壹是人本身之外的宇宙，貳是人
類本身。故一切知識與發明創造，皆服務於這兩個
既原始又永恆的目的。而電腦高科技將促成「生物
時代」的提早來臨。

摘自谷文達：《水墨煉金術：谷文達的實驗水墨》
（廣州：嶺南美術出版社，2010），第 82-86 頁

states, the traditional blue-collar industrial classes will gradually be overtaken by hi-tech classes; meanwhile, traditional industries are rapidly displaced to other countries in the world, especially to regions developing regions. the objective reasons for this are as follows 1) the cheap labor force available in other countries; 2) the huge market for traditional industries in other countries or developing regions. but even more important is reason number 3) in contrast to high-tech and communications industries, traditional blue-collar fields and other industries will take a secondary role in society in the future. just from a comparison of media, we see that in order to gain 50 million users, radio took 35 years to develop, tv took 13 years, while the internet took only 3 years. this is not merely the realistic necessity of the united states; more important is its strategic significance.

it is not hard to predict that in the future the united states will be the primary country of high technology and information sciences—and it will also be the world's center for high tech and information. this is also america's national strategy. looking at the country's present and future educational investments, we can see that the country boasts the best students in biology and genetic engineering, and the institutions demand the highest marks from them to receive their credits. from a market perspective, the stocks of hi-tech computer and biology companies have increased at a stunning rate in recent years; biology companies in particular have unfathomable prospects. whoever leads in high technology—especially in biology and genetic engineering—will dominate all kinds of global fields.

computers are a tool, a means rather than an end. the ultimate goal of exploration in human history is first, the universe outside the human body, and second, humanity itself. thus, all knowledge and inventions will serve these two original and eternal goals. advanced computer technology will spur an earlier arrival of the "age of biology."

(translated from *ink alchemy: the experimental ink of gu wenda*, lingnan fine arts publishing house, 2010, pp.82-86)

生物時代之謎（伍）：

《紙煉金術》上海－紐約 2001 － 2002

ENIGMA OF BIOLOGICAL TIMES 5:

paper alchemy　　shanghai-new york 2001-2002

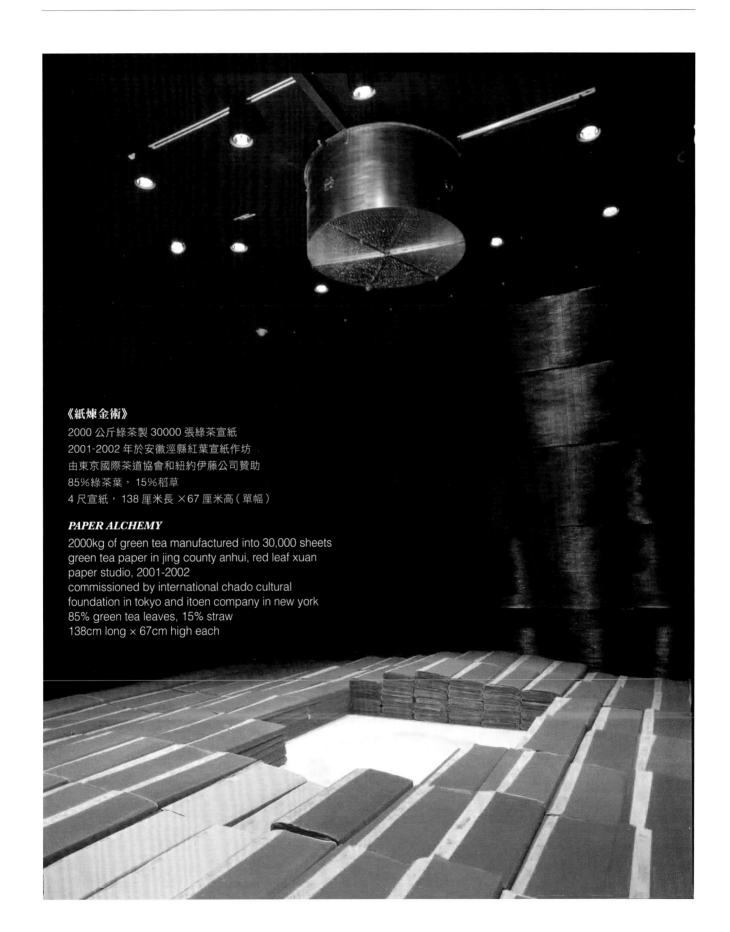

《紙煉金術》

2000 公斤綠茶製 30000 張綠茶宣紙

2001-2002 年於安徽涇縣紅葉宣紙作坊

由東京國際茶道協會和紐約伊藤公司贊助

85％綠茶葉，15％稻草

4 尺宣紙，138 厘米長 ×67 厘米高（單幅）

PAPER ALCHEMY

2000kg of green tea manufactured into 30,000 sheets
green tea paper in jing county anhui, red leaf xuan
paper studio, 2001-2002
commissioned by international chado cultural
foundation in tokyo and itoen company in new york
85% green tea leaves, 15% straw
138cm long × 67cm high each

《紙煉金術》上海－紐約 2001 － 2002

ENIGMA OF BIOLOGICAL TIMES 5:

paper alchemy　　shanghai-new york 2001-2002

綠茶宣紙製作的宣傳冊
chinese classic accordion painiting book made of
green tea paper

在安徽涇縣紅葉傳統宣紙作坊製作綠茶紙漿
making green tea pulp at hongye traditional xuan paper
studio, in jing county anhui

製作綠茶宣紙
making green tea paper

2000 年藝術家谷文達與製作綠茶宣紙的工人在討論製作綠茶宣紙的竹篾簾
artist gu wenda with green tea xuan paper makers are looking at the fine banboo screen which was used to make green tea xuan paper, 2000

在熱牆上烘烤綠茶宣紙
mounting green tea paper on a heated wall

紙 煉 金 術

谷文達

PAPER ALCHEMY

gu wenda

與《墨煉金術》是現代生物科學和遺傳工程研究在
文化上的反映一樣,《紙煉金術》是《墨煉金術》生
態學在文化上的反映的姐妹作品。綠茶源自於中
國,數仟年來,綠茶成為了亞洲以至於世界各國人
民日常生活中的壹個重要部分。茶不僅滋潤了悠
久的文明古國,同時也情繫着東方人的天性。飲
茶聚會是壹種獨特的生活方式,她創造了壹個氛
圍去增進了人們之間的友情,並有益於修身養性,
甚至壹椿生意產生在飲茶攀談中。茶已經成為壹
種不可分離的東方人的壹種生活的哲學和文化的
象徵。飲茶賦予人們壹種禪意、謙虛和超然的精
神境界。特別在我們現代生活中,品嚐綠茶成為
了有益於我們的健康的習慣。

宣紙是我們水墨畫獨壹無貳的珍貴的繪畫材料,
特別是元代革命性的宣紙發明結束了以往絹面水
墨畫的歷史。為了我的壹個原創的觀念,將綠茶
葉為原材料去創製「綠茶宣紙」,2001 年間我走訪

just as *ink alchemy* is a cultural reflection of modern biology
and genetic engineering research, *paper alchemy* is a companion
work that serves as a cultural reflection on the topic of ecology.
green tea originated in china and for several millennia, green tea
has been an important part of everyday life for people in asia
and countries around the world. tea has not only nurtured this
ancient civilization, but also permeated the essence of the asian
psyche. tea gatherings are part of a distinctive way of life, forging
an atmosphere that strengthens people's friendships and
provides benefits to the body; even business deals are discussed
over tea. tea has already become a living philosophy and cultural
symbol inseparable from asia and drinking tea elevates people to
a spiritual realm that is characterized by a sense of zen, humility,
and transcendence. especially in our modern lives, the tasting
and appreciation of tea is a healthy practice.

xuan paper is a unique and treasured ink painting material; the
revolutionary invention of xuan paper in the yuan dynasty
ended the history of ink painting on silk. for my original idea, i
used tea leaves as the raw material to produce "green tea xuan
paper." in 2001, i visited jingxian (jing county) in anhui
province and personally witnessed the entire process of making
xuan paper by hand. the history of xuan paper-making dates
back a few centuries and is something truly breathtaking! ink
painting is based on the use of exquisite and unique xuan paper,

了安徽的涇縣，親自觀看了手工宣紙生產的整個程序。製造宣紙的歷史已經歷時幾佰年了，真讓人歎為觀止！水墨畫基於精湛獨特的宣紙，讓畫家創造出水墨畫特有的那種微妙而超脫的淋漓盡致的水韻墨章，以及鐵與絲一般的內在張力。

我的《紙煉金術》藝術計劃是我以中國人髮獨創研發的《墨煉金術》的姐妹作。以肆仟斤綠茶為原料，以傳統的宣紙製作技術，出產了叄萬張肆尺茶葉宣紙。飲茶作為壹種文化，而綠茶宣紙更使茶成為文化藝術的象徵。《墨煉金術》的炎黃生物墨躍然於《紙煉金術》的綠茶宣紙上，形成了中國基因與中國文化的既獨特而又完美的結合。

摘自谷文達：《水墨煉金術：谷文達的實驗水墨》（廣州：嶺南美術出版社，2010年），第 88-89 頁

to allow the painter to create subtle, transcendent, and unrestrained rhymes of water and movements of ink, the inner tension of soft and hard is like iron and silk and is unique to ink painting.

my *paper alchemy* art project is a companion work to the *ink alchemy*, and is based on my original research on chinese hair. with 4000 kg of green tea as the raw material, i used traditional xuan paper-making techniques to produce, 30000 four-foot-wide sheets of green tea xuan paper. tea drinking is a kind of culture, and green tea xuan paper further heightens the role of tea as a symbol of art and culture. the "yanhuang" chinese biological ink from *ink alchemy* vividly applied on the green tea xuan paper from *paper alchemy* forms the distinct and perfect combination of chinese genes and chinese culture.

(translated from *ink alchemy: the experimental ink of gu wenda*, lingnan fine arts publishing house, 2010, p88-89)

《基因風景》貳號　細部
dna landscape #2　detail

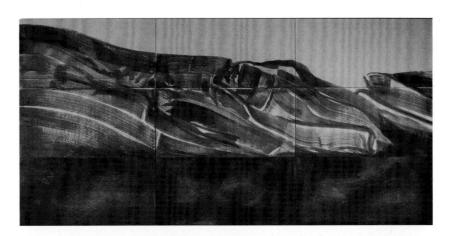

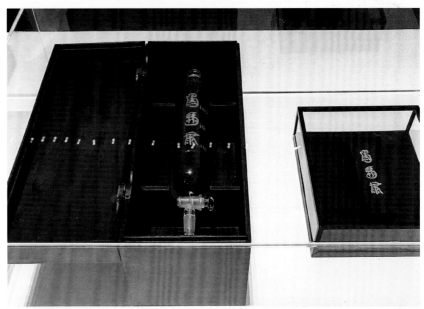

人髮《基因墨錠》、《基因墨粉》和綠茶宣紙是
《基因風景》的繪製材質和材料
human hair *dna ink stick, dna ink pigment*
and green tea paper are the materials for
dna landscape

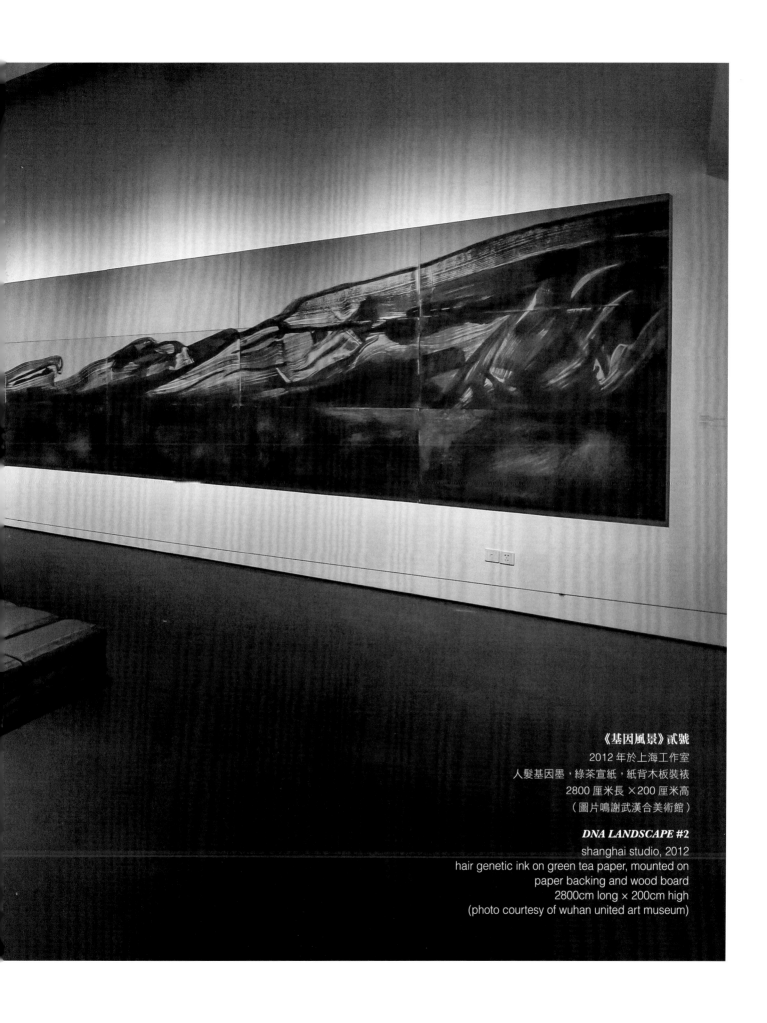

《基因風景》貳號
2012 年於上海工作室
人髮基因墨，綠茶宣紙，紙背木板裝裱
2800 厘米長 ×200 厘米高
（圖片鳴謝武漢合美術館）

DNA LANDSCAPE #2

shanghai studio, 2012
hair genetic ink on green tea paper, mounted on
paper backing and wood board
2800cm long × 200cm high
(photo courtesy of wuhan united art museum)

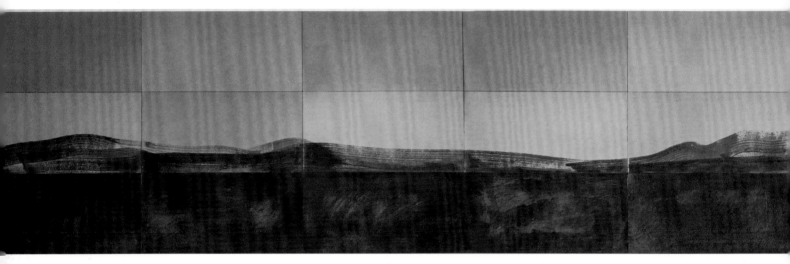

《基因風景》壹號
DNA LANDSCAPE #1

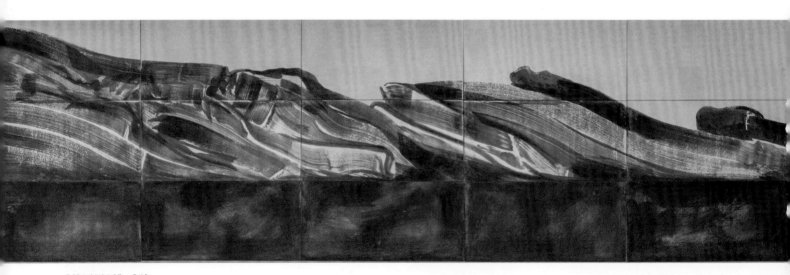

《基因風景》貳號
DNA LANDSCAPE #2

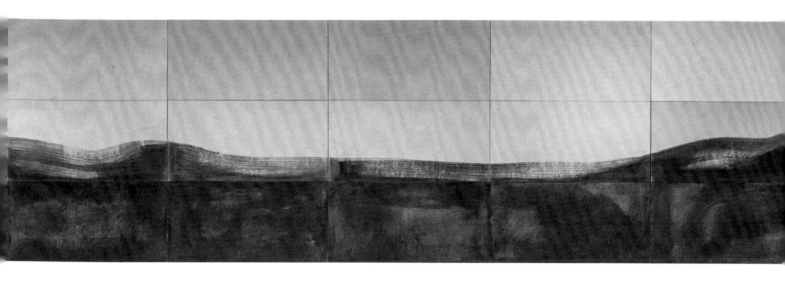

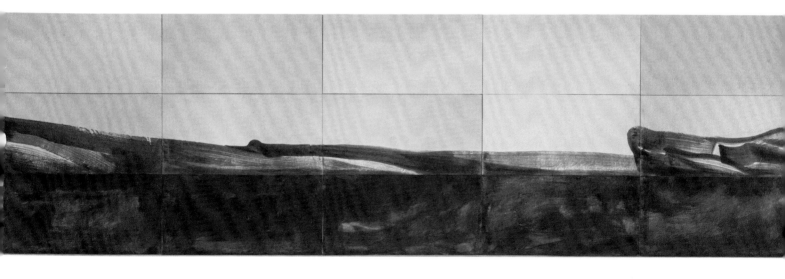

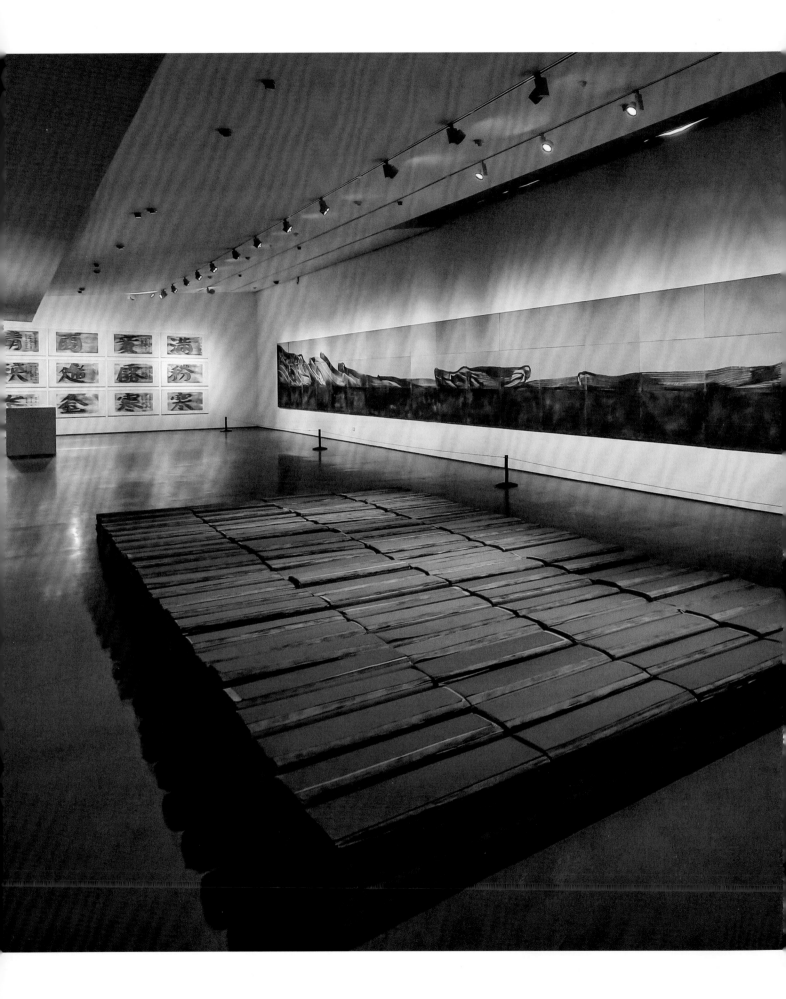

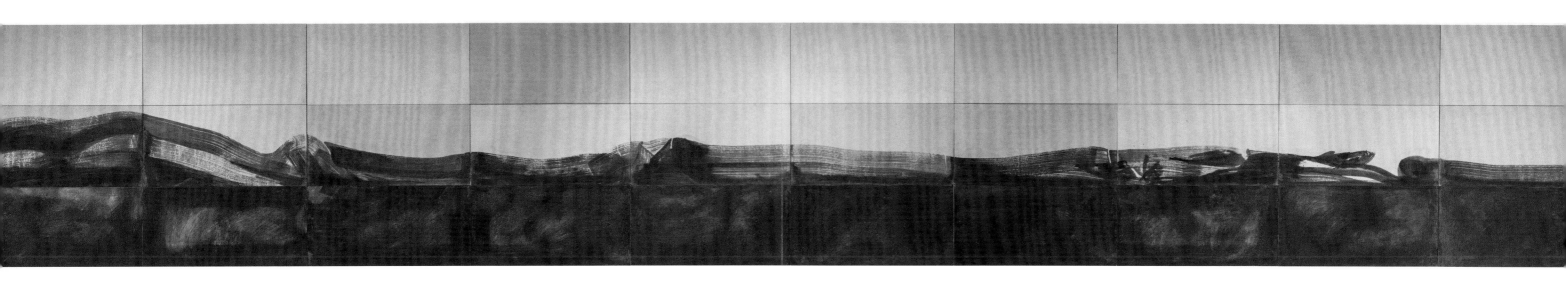

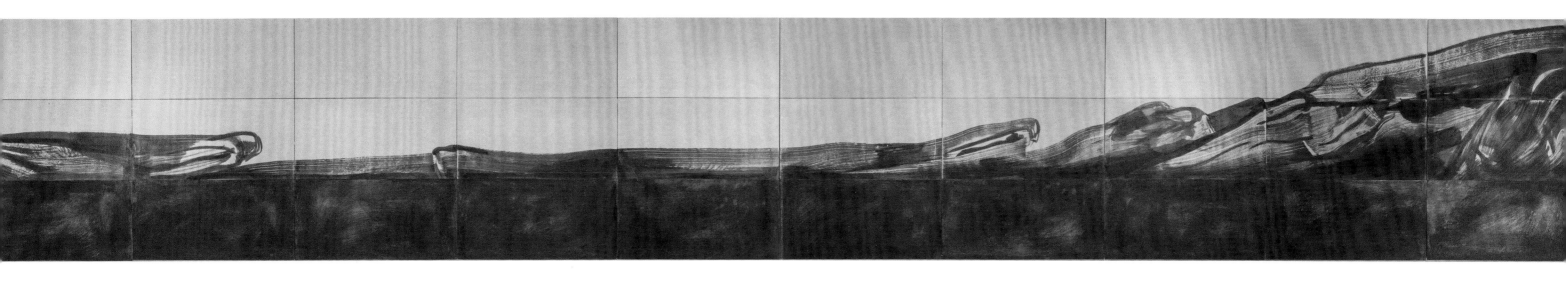

咪咪・蓋茨與特拉基金會訪問
谷文達工作室時在《基因風景》
畫前留影
mimi gates and the terra
foundation for american
art stand in front of *dna
landscape* during their
visit to gu wenda studio,
shanghai

《基因風景》貳號在佈展中
the installation of *dna landscape* #2

熔煅舊物冶鑄新事
——谷氏《水墨煉金術》
之象徵與寓意 皮道堅

SMELTING THE OLD, CASTING THE NEW: THE SYMBOLS AND MEANING OF GU WENDA'S "INK ALCHEMY"

pi daojian

一

2001 年以來，在我參與策劃製作的三個與現當代水墨相關的大型展覽《中國・水墨實驗二十年》（2001 年，廣州）、《原道 —— 中國當代藝術新概念》（2013 年，香港）和《天下・往來：當代水墨文獻展 2001—2016》（2016 年，廣州）中，谷文達都是重要的參展藝術家。2016 年廣州紅磚廠當代藝術館主辦的《天下・往來 —— 當代水墨文獻展》中，我們將谷文達的作品《炎黃基因風景一號》、《dna 基因墨錠》和《綠茶宣紙》放置在主場館的最重要位置，以便開幕式時觀眾通過推倒藝術家林學明的大型互動裝置 —— 由墨、宣紙以及使用過的宣紙製作的《牆》後，一眼便能看到谷文達的這三件自如地使用筆墨、行為、裝置、觀念等多種藝術表達方式，東方文化韻味濃厚且有著豐富的當代文化內涵、象徵寓意深刻的作品。

我在 2001 年廣東美術館主辦的《中國・水墨實驗二十年》展覽的束展論述中曾經這樣說過：「在我們這個越來越全

ONE

gu wenda has been an important part of the three large-scale contemporary ink art exhibitions that i've helped plan and produce since 2001, namely: *china: 20 years of ink experiment* (guangzhou, 2001), *the origin of dao: new dimensions in chinese contemporary art* (hong kong, 2013), and *being and inking: documenting contemporary ink art 2001 – 2016* (guangzhou, 2016). in installing *being and inking: documenting contemporary ink art* at the redtory museum of contemporary art in guangzhou, we placed gu wenda's *yanhuang dna landscape 1*, *ink alchemy*, and *paper alchemy* at the center of the exhibition. during the opening ceremony, attendees could see these three gu wenda works right away, after pushing down lin xueming's large-scale interactive installation, *wall*. these pieces made fluent use of ink and brush, performance, installation, conceptualization, and other methods of artistic expression; they are rich in eastern sensibility, contemporary cultural implication, and carry profound meaning.

in the exhibition statement for *china: 20 years of ink experiment*, held at the guangdong museum of art in 2001, i wrote, "in our era of increasing global interconnectivity it is no longer easy to find a purely

球一體化的時代，已不太容易找到像『水墨問題』這樣純粹的中國問題。」而水墨之所以會成為一個問題，乃是因為它「還算得上是某些本土價值觀的最後載體，它提醒我們注意文化傳統在現代化進程中的重要性，並以自己的存在方式來強調民族文化認同和民族意識培植的現實和歷史意義，重要的是它還關乎我們的民族文化進入世界文化格局的方法、策略和途徑。」[1] 又黃專在《水墨煉金術——谷文達的實驗水墨》一書序言中也認為：「『水墨問題』是中國當代藝術的主體性問題之一，無論在上世紀80年代的現代主義文化啟蒙運動或是在全球化的後現代主義思潮中，『水墨問題』在中國當代藝術史中都扮演着無可替代的角色，尤其在形成中國當代藝術獨立的文化觀念、圖像邏輯和美學性格的歷史過程中，『水墨問題』更凸現了它作為一種本土性綜合資源的獨特價值……」[2]

眾所周知，谷文達的藝術創作歷程最初即是從水墨出發。他是1980年代中國水墨革新運動的先鋒，但與當時絕大多數藝術家僅從形式入手的革新批判不同，谷文達的水墨實驗一開始就有超前的文化關注訴求。他也是最早以文字符號為藝術語言要素，積極探索水墨性表達的觀念方式的藝術家。1987年出國後，亦即他之「西遊」成行之後，谷文達的藝術視野更加開闊，藝術語言方式也更為當代，這使他很快成為了可以在國際平台上與世界進行交流、對話的中國當代藝術家。而谷文達之所以能形成自己的獨特藝術風格面貌，能在國際藝術舞台上獨樹一幟，則很大程度上受惠於他自如地將中國傳統文化元素運用於他的當代藝術表達。這也正如他自己所說：「我認為中國當代藝術只能建立在文化身份的基礎之上，『水墨』作為媒介，在這過程中發揮着不可替代的作用。如

chinese issue, like the 'ink issue.'" ink art becomes an issue because:"[ink] can be considered the last vessel for certain native values. it reminds us of the importance of our cultural traditions even as we are in the process of modernization and, through its own existence, emphasizes the significance of national cultural identity and the cultivation of national consciousness, both historically and at present. of further importance, it also relates to the methods, strategies, and folkways through which our national culture enters the international."[1] in his preface to *ink alchemy: the experimental ink of gu wenda*, huang zhuan echoes these beliefs: "the 'ink issue' is an issue of subjectivity for chinese contemporary art. whether during the modernist cultural enlightenment in the 1980s or in the midst of the postmodernist wave of globalization, the 'ink issue' plays an irreplaceable role in the history of chinese contemporary art. especially during the historical process of forming independent cultural concepts and establishing a logical aesthetic framework for contemporary chinese art, the 'ink issue' has clearly demonstrated its unique value as a native wellspring..."[2]

as has been well-established, gu wenda's artistic career began with the use of ink. he was a pioneer in china's artistic ink reform movement during the 1980s, but remained apart from the vast majority of artists at the time, whose reforms were merely formalistic. from the beginning, gu wenda's ink experiments were ahead of their time for their cultural appeal. gu was also one of the first artists to use textual symbols as an element of artistic language, and actively explored conceptual expressions with ink. since he left china in 1987 to embark on his "journey to the west", gu wenda's artistic vision has widened, and his artistic language has become more contemporary—this has placed him among those contemporary chinese artists who have found purchase on the international stage. gu wenda's ability to form a unique artistic style in the global art scene greatly benefitted from his fluent use of traditional chinese elements in his contemporary works. as gu himself once remarked, "i think chinese contemporary art can only be founded upon cultural identity, and 'ink'—as a

何使兩條線索融為一體，則是我要繼續下去的探索。」[3]
在這一點上，谷文達就像一位熔鍛舊物、冶鑄新事的煉
金術士，將傳統的事物以他的水墨煉金術熔融化解，以之
表達新的觀念、創造新的世界。谷文達的《dna 基因墨錠》
和《綠茶宣紙》裝置，表面看來似乎僅僅只是將中國傳統
的水墨元素融入西方後現代藝術的創作方式，究其內裏，
不難看出其整個創作邏輯皆根源於中國文化和中國哲學
的精神，根源於中國人看世界的方式。藝術家用稻米、
綠茶、宣紙、頭髮等象徵中國傳統文化基因，意在強調
東方文化自身的文化邏輯；作品所隱喻或提示的眾多精
神內容，也無不意在強調中國當代藝術獨立的美學性格、
文化觀念和圖像語言邏輯。

現在看來，對這一跨世紀的中國當代藝術難題——「水
墨問題」的執着探索與深刻思考，貫穿在谷文達 40 年的
當代藝術創作實踐之中。谷文達以其獨特的《水墨煉金
術》昭告天下：中國水墨藝術不曾山窮水盡，亦未窮途末
路，它已然作為中國文化的載體成功完成了自身的現代
轉型，煥發出新的生命，並在經濟全球化的文化語境中贏
得了對當代文化問題的發言權。

二

1987 年谷文達獲得了前往加拿大做訪問藝術家的機會，
舉辦了自己首次在國外的個人展覽，並於同年移居紐
約，開始了近 30 年旅居海外的生活和工作。甫一出國，
谷文達即在給我的信件中表達了他希望成為一名「世界
公民」的真切願望。我意識到他超前的藝術思考有待一
個更廣闊的平台來承載。如果說谷文達早期的新水墨

medium—plays an irreplaceable role in this process. i
want to continue exploring how to combine the two."[3]
in this respect, gu wenda is like an alchemist, smelting
the old and casting the new. he melds traditional matters
with his ink alchemy to convey new concepts and create
new worlds. gu wenda's installations *ink alchemy* and
paper alchemy appear to simply fuse the elements of
traditional chinese ink art into the methodologies of
western postmodern art. probing deeper, however, one
sees that the logic for the entirety of the creations is
rooted in the spirits of chinese culture and philosophy
and in the way the chinese people see the world. the
artist uses rice, green tea, rice paper, hair, and other
objects to represent the genes of traditional chinese
culture, intending to emphasize the cultural logic of the
east. the spiritual content implied or suggested by his
work also aims to emphasize the independent aesthetic
character, cultural concepts, and the logic of images and
languages of chinese contemporary art.

it now seems that persistent exploration and
contemplation of the cross-century issue of chinese
contemporary art — the "ink issue"—runs through gu
wenda's forty years of contemporary art practice.
through his unique "ink alchemy", gu wenda shows the
world that chinese ink art has not been exhausted nor
has it hit a dead end, but has instead successfully
completed its modern transformation as a vessel of
chinese culture. it is full of new life, and in the context of
economic globalization, has gained its voice in the
discourse of contemporary culture.

TWO

in 1987, gu wenda had the opportunity to travel to
canada as a visiting artist, where he held his first solo
exhibition abroad. he moved to new york later that year,
beginning nearly three decades of living and working
abroad. as soon as he traveled abroad, gu wenda
expressed his sincere desire to become a "global citizen"
in a letter he wrote to me. i realized his advanced artistic
vision needed a wider platform. if gu wenda's early new

實踐是對傳統水墨藝術發展困境和當時中國內地人文思想討論的反省和挑戰，出國後的經歷則引領他到達了一個全新的藝術境界——認知與建立跨文化身份可能性的思考。這也同時開啟了他對「水墨問題」在人類文化學、政治哲學和世界藝術史領域的理論價值的深入探討。

谷文達的藝術家社會歷史責任感令他直面社會歷史問題，角度新穎，表達尖銳，手法酣暢。這是文化知識沉澱，思維能力在藝術情懷上的綜合表現。1993年谷文達啟動了《碑林》和《聯合國》系列。這兩個項目的艱難和巨大不僅體現在實踐的規模，更表現在內在創作方法論的深化和完善。

谷文達的《碑林——唐詩後著》以中華文化的標誌性物事「石碑」這一經典形象，來表現文化認知及跨文化解讀建立過程中的複雜性和不確定性。歷代以來各種語境下對唐詩的注釋和解讀產生了不同的文化理解，谷文達由此注意到不同文化之間相互交流和碰撞可能產生的一系列現象：從解讀中的「直譯」或「意譯」不可避免地產生不確定性到原意的丟失；從一系列文化傳遞、再現過程中的誤解、誤讀到其所產生的新文化符號之奇特意蘊。《碑林》正是在全球化的大背景下，將突出的文化不確定性問題和世界性身份問題，刻畫在石碑這一具有中華文化獨特形式美感和歷史文化意義的載體之上。

ink practice was a reflection and challenge on the developmental dilemma facing traditional ink art—and facing intellectual discussion generally—in china at the time, his experience abroad led him to a brand new artistic realm: reflections on the cognitive possibility of establishing a cross-cultural identity. this also launched his in-depth investigation into the theoretical value of the "ink issue" in the fields of human culture, political philosophy, and global art history.

as an artist, gu wenda's sense of social and historical responsibility led him to confront social and historical issues with a new perspective, an incisive voice, and cheerfully unrestrained technique. his work is a comprehensive expression of his cultural knowledge, cognitive acumen, and artistic intuition. in 1993, gu wenda launched his *forest of stone steles* and *united nations* project series. the difficulty and enormous scale of these two projects reflect both the scope of their implementation and depth, and the perfection and immanence of gu's creative methodology.

gu wenda's forest of stone steles, retranslation and rewriting of tang poetry utilizes a classic image—the "stone stele", a chinese cultural icon—to express the complexity and uncertainty inherent to the process of building cultural awareness and interpreting across cultures. across dynasties, the annotation and examination of tang poetry in different contexts yielded different cultural understandings. gu wenda hence noticed a series of phenomena that may arise from the interaction and collision of two different civilizations: the inevitable uncertainty and loss of meaning derived from either "literal translation" or "free translation"; a series of misunderstandings and misinterpretations during the cultural transmission and reproduction process, and the distinct implications of strange new cultural symbols. *forest of stone steles* was created against the backdrop of globalization. questions of cultural uncertainty and world identity are highlighted through their inscription in the stone steles, which embody the distinct physical beauty and historical significance of china's culture.

《聯合國》系列自 1996 年起開始陸續展出。這是一個以人髮為主要創作材料的大型裝置藝術。谷文達將其水墨實驗由「文字圖像」、「文化語詞」擴展至「生物材料」領域，人髮來自數十個國家和地區超過 400 萬人的捐贈，象徵全世界大多數人種和民族。該系列至今已持續創作了 20 餘年，內容涉及國家、歷史、種族、宗教等，展示了藝術家在一個動態變化的政治、文化、地理格局中對世界不同文明和人種共存狀態的思考。其中既有對當今世界之矛盾、衝突現狀的表達，也有對多元文明和諧共處的期盼。如果說他通過《聯合國》系列啟發了觀眾對世界文化、社會、宗教等問題的思考，或許答案就在作品題材與媒介的選擇之中。人髮等生物材料一方面直觀地代表了世界人種和文化的多元，另一方面也強調了新時代下科技進步賦予材料多樣轉化的可能性，不僅在題材層面不斷追問文化在不同語境中的含義，也通過材料的選擇追溯事物的源頭。此種在材料運用上力求回歸「本源」的選擇，理應看作是谷文達對「水墨問題」語言學實驗之新的可能性的探討。

多元文化狀態是世界文化不斷交流碰撞、融合、轉換的動態過程。谷文達的《碑林》與《聯合國》以一種包容與開拓的文化態度，成就了對此種多元文化認知的當代性表達，以一種帶有水墨性、水墨精神的水墨方式，顛覆了國際化、當代性與本土化、傳統性「二律背反」的當代神話。

the united nations project has been successively exhibited since 1996. this is a large-scale art installation, using human hair as its main creative material. gu wenda has expanded his ink experimentation from the "word image" and "cultural lexicon" into the field of "biological materials"—the hair of more than four million donors from dozens of countries and regions, representing a majority of the world's races and ethnicities. this series has been underway for more than two decades, touching upon topics including nationality, history, race, and religion, and demonstrating the artist's ruminations on the coexistence of different civilizations and races in a dynamic and changing political, cultural, and geographic landscape. this project not only expresses concern for the contradictions and conflicts of the modern world, but also raises hope for the harmonious coexistence of diverse civilizations. evidence that gu uses the *united nations* project to inspire contemplation on the cultural, social, and religious issues facing the world can be found in his subject matter and his choice of medium. while human hair and other biological materials directly represent the diversity of the world's races and cultures, they also stress the possibilities of the diverse materials brought about by scientific development in the new era. this project both examines cultural implications in different contexts on the subject level, and emphasizes sources of inspiration through its selection of materials. this choice to use materials as a return to "origins" should be seen as an investigation into the possibilities of gu wenda's linguistic experimentation on the "ink issue."

the multicultural state is the dynamic process of constant exchange, collision, fusion, and transformation of the world's civilizations. through their inclusive and pioneering cultural outlooks, gu wenda's *forest of stone steles* and *united nations* project have accomplished a contemporary articulation of this multicultural state. he uses ink methods—with the attributes and spirit of ink—to subvert the recent myth that a contradiction exists between contemporary globalization and local tradition.

三

「全主義藝術」概念的提出基於谷文達對「水墨問題」作為一種本土性綜合文化資源的獨特價值的深刻理解，也意味着他的藝術取向由文化啟蒙向文化動員的深刻轉變。他認為：「純粹的挑戰是失敗的。最好的藝術批評是引導，將你的挑戰變成一種影響力……在政治、經濟的大平台下去完成。」[4] 此即谷文達「全主義藝術」概念的文化動員宗旨。藝術家將視野放了在與社會有直接關聯的層面，不僅將藝術實踐帶到了傳統意義上的美術機構和藝術生態之外，還通過這樣的藝術行為與社會進行更廣泛、更直接的交流。這一認知不僅刷新了藝術概念中陳舊的創作形式、作品內容、流通管道等等的傳統內涵，更是對傳統藝術話語藩籬、行業壁壘傾向的有力衝擊。在佛山策劃的第一屆「大眾當代藝術日」活動，組織了上千名兒童共同書寫《孝經》，將中國傳統的書法轉化為新的藝術生產和參與方式。之後又在深圳舉辦了第二屆，利用經過環保處理的藍藻水與 1500 名學童共同創造行為書法《青山綠水》，將環保、慈善、科技等當代文化中有代表性的概念融入藝術的實踐之中。《西遊記》個展的《天堂紅燈上的簽語未來》更是將世界美術史上的經典形象與最具中國傳統文化象徵意味的燈籠造型結合，用兩萬餘隻燈籠包裹美術館外牆，直接以大地藝術的方式介入公共環境，將以「水墨問題」為標誌的當代藝術的社會參與度推向了一個全新的境地。

THREE

the concept of "holistic art" is based on gu wenda's profound understanding of the unique value of the "ink issue" as a kind of localized, comprehensive cultural resource; it also signals the radical shift of his artistic orientation from cultural enlightenment to cultural mobilization. he believes that "challenge alone brings failure. the best art criticism serves as guidance, transforming opposition into influence... to be completed on the greater platform of politics and economics."[4] this is the cultural mobilization motif of gu wenda's "holistic art" concept. the artist has a vision on subject matters directly related to social issues. he not only brings artistic practice beyond the traditional art institutions and environments, but also participates in a more extensive and straightforward dialogue with society through his artistic endeavors. this recognition not only refreshes conventional connotations of art, such as the "form," "content," and "distribution," but also represents a powerful impact on the barriers of traditional art discourse and the tendency towards industrialization. in foshan, gu curated the first "public contemporary art day", organizing thousands of children to hand copy the *classic of xiao* together, turning ancient chinese calligraphy into a new form of artistic production and participation. later, he organized the second "public contemporary art day" in shenzhen, using environmentally friendly cyanobacteria and 1500 children to co-create *green mountains and green water performative calligraphy*, fusing environmental conservation, charity, science, technology, and other representative concepts in contemporary culture into artistic practice. this time, the *signature of the future on the red light in heaven* in the *journey to the west* solo exhibition combines the classical images of world art history with lanterns — the most symbolic object of traditional chinese culture. more than 10000 lanterns encircle the exterior walls of the art museum, directly engaging the public environment with a form of land art, propelling the social participation of contemporary art, as symbolized by the "ink issue", to groundbreaking levels.

自上世紀 80 年代以來，谷文達以中國傳統文化為根基和原點，融合東西方文化視野，自如地使用筆墨、行為、裝置、觀念等各種藝術表達方式，不斷拓寬自己的當代藝術表達。他的藝術創作歷程從「實驗水墨」、「世界公民」到「全主義藝術」，一路走來，最突出的特徵就是站在最前，探索更前。他所表達的「引導是最好的藝術批評」，既是對自己藝術創作的回顧和反思，也可以看作是他對自己職業角色的新理解。

在對「水墨問題」解題方案的探索中不斷地全面突破自我，這無疑需要勇氣、犧牲精神和藝術判斷力。谷文達的藝術世界因此而充滿張力，呈現出「往來天下，得大自在」的藝術境界。更為重要的是谷文達的藝術實踐為世人提示了如下真理：古老的東方哲學、中國文化的水墨性、水墨精神和水墨方式，可以為混沌的當代世界更新價值觀念，為世界當代藝術注入新的生命活力。

原文出自《谷文達：西遊記》（上海：上海人民美術出版社，2017 年），第 3 至 9 頁。

gu wenda has used traditional chinese culture as his foundation and point of origin since the 1980s, while integrating eastern and western cultural perspectives. he has been able to freely use ink, performance, installation, concept, and other creative devices to constantly expand his means of contemporary artistic expression. his artistic creation has progressed from "experimental ink" and "world citizen" to "holistic art." throughout his career, gu's most prominent characteristic has been to "stand at the vanguard, exploring further still." his idea that "guidance is the best art criticism" is not only a reflection on his own artistic creations, but also represents a new understanding of the role of his own profession.

to continuously challenge himself while exploring ways to solve the "ink issue" has undoubtedly required courage, sacrifice, and artistic judgment on gu's part. gu wenda's artistic world is thus full of vitality, presenting an artistic universe of "going about the world with uncontained joy." more importantly, gu wenda's artistic practices reveal a truth to the world: ancient eastern philosophy, as well as the ink quality, ink spirit, and ink formality of chinese culture, can help renew the values of the chaotic contemporary world, and can infuse the contemporary art world with a new vitality.

皮道堅，藝術理論家、批評家。1981 年畢業於湖北藝術學院研究生班美術史論專業。現為中國美術家協會策展委員會副主任、廣東美術館「廣州當代藝術三年展」學術委員會委員、湖北美術館特聘研究員、廣州紅專廠文化藝術機構藝術顧問。

pi daojian is one of the best-known art scholars and critics in china. pi received his master's degree from the art history department of professional arts institute of hubei. he is currently the associate director of the curatorial committee of china artists association, member of the academic committee of "the guangzhou triennial" at guangdong museum of art, research fellow of hubei museum of art, and the artistic consultant of redtory art & design factory in guangzhou.

注釋

1　皮道堅、王璜生主編：《中國‧水墨實驗貳拾年》（哈爾濱：黑龍江美術出版社，2001 年 8 月），第 10 頁。

2　黃專主編：《水墨煉金術 —— 谷文達的實驗水墨》（廣州：嶺南出版社，2010 年 9 月），第 1 頁。

3　見 2016 年 11 月 21 日 artnet 專訪《谷文達：時代使我改變了藝術策略》。

4　見 2016 年 11 月 10 日藝術中國專訪《谷文達「西遊記」個展：承接我們的基因流 西天才能取得真經》。

notes

1　china: 20 years of ink experiment,edited by pi daojian, wang huangsheng, heilongjiang fine arts publishing house, harbin, august 2001, p10

2　ink alchemy: the experimental ink of gu wenda, edited by huang zhuan, lingnan art publishing house, guangzho, september 2010, p1

3　see november 21, 2016 artnet interview: gu wenda: our times changed my strategy towards art.

4　see the exclusive art china interview, gu wenda's "journey to the west" exhibition: finding sutra in genetics, november 10, 2016

谷 文 達： 水 墨 身 份

龐惠英

GU WENDA: INK IDENTITY

tiffany wai-ying beres

《墨煉金術》1999 － 2001

在傳統中藥學裏，人髮粉可以治療焦慮症。在中國水墨畫中，黑色顏料的材料一直使用碳粉。直到 1999 年，谷文達開始探究用人類的頭髮製成墨的可能性。在上海大學生物實驗室、上海曹素功墨廠等的幫助下，谷文達研發了將粉狀的中國人髮製成生物墨汁和硬化墨錠的工藝，也就是所謂的「生物基因墨」（dna ink）。這一創作工藝改造了傳統墨術，勾勒了一個全新的觀念藝術物件。來源於人髮粉的生物基因墨，這種材料曾經被用來緩解生理焦慮，現在則被具有諷刺意味和象徵性地賦予了一種新的概念功能：水墨在這種新形式中得以治癒文化焦慮。

《紙煉金術》2001 － 2002

綠茶起源於中國，是東方文化的一個有力象徵，如今在亞洲乃至全世界的日常生活中都不可或缺。據說，紙張

DNA ALCHEMY 1999 - 2001

powdered human hair is used as a treatment for anxiety in traditional chinese medicine. in ink fabrication, charcoal powder is used as the black pigment material. in 1999, gu wenda began researching the potential of turning human hair into ink. with the help of shanghai university's biolab, the shanghai cao su gong ink factory and others, the artist invented the process of turning powdered chinese hair into biological liquid ink and hardened ink sticks, so called "dna ink." this performance process involved the transformation of traditional ink-making methods to create a new conceptual art object; dna ink, which is derived from human hair powder, a material once used to cure tension, is now ironically and symbolically given a new conceptual function: in this new form, ink marks can cure cultural anxiety.

PAPER ALCHEMY 2001 - 2002

green tea originated in china and has now become an essential element of daily life in asia and the world, and a potent symbol of eastern culture. paper, and the pulp papermaking process, is said to have been developed in china during the early 2nd century ad, and unlike in the

和紙漿造紙的工藝自公元二世紀早期就已在中國發展起來了。與西方不同的是，幾個世紀以來，亞洲藝術，特別是中國、日本和韓國，都將紙用作藝術創作的主要材料。谷文達的《紙煉金術》（paper alchemy）也是一次行為過程，他與安徽省的一家造紙廠合作，以綠茶為原材料復興了歷史上的造紙術。整個製作過程耗費了 1800 多公斤茶葉，由此而生的綠茶宣紙承載着一種全新的品茶方式 —— 從飲茶到觀看茶藝術品的體驗。

谷文達

谷文達，1955 年出生於中國上海。1976 年畢業於上海工藝美校，1981 年獲中國美術學院美術碩士學位，師從中國古典山水畫大師陸儼少先生，並于 1981 年至 1987 年留校任教。上世紀 80 年代中期，谷文達在西安舉辦了第一次個人畫展，他重組和再創造的中國書法文字震驚了藝術界。自那時起，谷文達就被公認為中國觀念水墨藝術的創始人。1987 年，谷文達獲得加拿大國家外國訪問藝術家獎，並在加拿大約克大學舉辦了其首次在國外的個人展。

如今，穿梭於紐約和上海工作室之間的谷文達，他的許多作品不僅受到了亞洲本土文化傳統的啟發，也同樣回應了世界文化共同體的境遇。自 1981 年以來，谷文達曾多次舉辦個展，多次參加群展和雙年展。2002 年，谷文達在新加坡濱海藝術中心的入口處擺放了 188 面旗幟的裝置，尺寸為 7600×800 厘米，這是他創作的《聯合國》項目的一部分。懸掛在大廳大化板上的旗幟，由來自世界各地的人髮製成，它們不僅象徵着世界 188 個國家，更強

west, for centuries the art cultures of asia, particularly china, japan and korea, have embraced paper as their primary material for artistic creation. gu wenda's *paper alchemy* project is a performance process whereby the artist worked with a paper factory in anhui province to revitalize historical paper-making methods using green tea leaves as the primary substrate. utilizing over 1,800 kgs of tea in the process, the resulting green-tea leaf paper is a new way of enjoying tea— an alteration of our experience of drinking tea to the experience of viewing tea art.

GU WENDA

gu wenda was born in shanghai, china in 1955. he graduated from shanghai school of arts in 1976. in 1981 he received his m.f.a. from the china academy of arts where he studied under the classical landscape painting master lu yanshao and where he taught from 1981 to 1987. ever since the artist's first personal exhibition in xi'an in the mid-1980s, when the artist's invented calligraphic chinese characters shocked the artistic community, gu wenda has been widely recognized as the founder of conceptual ink art in china. in 1987, gu wenda received the award of the canada council for the art's visiting foreign artists program and had his first overseas exhibition in york university, canada. later in the same year, he moved to the usa and started his life as an independent artist.

today, gu wenda lives between his studios in new york and shanghai creating works that are inspired by his own asian heritage, and yet respond to our global cultural community. since 1981, gu wenda has participated in numerous international solo and group exhibitions and biennales. in 2002, gu created an installation of 188 flags measuring 7600×800cm at the entry hall of the singapore esplanade theaters on the bay as part of his *united nations* project. hung from the ceiling of the hall, these flags, made of human hair collected from all over the world, not only signify the 188 nations of the world, but also emphasize the immense global, biological,

調了現代社會正在發生的廣泛的全球性生物、地質和文化轉型。裝置《聯合國》在新加坡濱海藝術中心展出時，其材料和藝術詮釋就在新加坡引發了諸多爭議。從那以後，谷文達繼續製作了許多原創的轟動作品，不斷刺激文化互動和歷史上的理解，以及我們集體現代身份的重疊錯位；他的作品既是個人的，也是政治的，既是地方的，也是全球的，既是當代的，也是永恆的。

谷文達的藝術作品被眾多公共藝術機構收藏，其中包括中國上海美術館、北京中國美術館、英國倫敦大英博物館、加拿大多倫多皇家安大略博物館、三藩市現代藝術博物館、香港藝術館、德國哈布斯堡王朝皇家收藏、美國三藩市肯特和維琪洛藝術基金會、三藩市亞洲藝術博物館、希臘德斯特基金會、日本福岡美術館、牛津大學阿什莫林考古與藝術博物館、澳洲坎培拉國家美術館、紐約現代藝術博物館、波士頓美術館、西雅圖藝術博物館、香港亞洲博物館協會、科羅拉多州丹佛藝術博物館、日內瓦奧蘭斯卡基金會、深圳何香凝美術館 oct 當代藝術中心、紐約所羅門·r· 古根海姆博物館等等。

水墨身份

谷文達的標誌性裝置作品——《炎黃基因風景 1 號 &2 號》是其近 30 年實驗水墨藝術實踐的頂峰。這幅作品最初是谷文達受 2012 年韓國光州雙年展委託創作的，他憑藉自己的兩項發明創作了這幅極簡主義的單色水墨山水畫：人髮墨汁與綠茶宣紙。

geological and cultural transitions that are taking place in modern society. at the time of its installation on the esplanade, the *united nations* project sparked much controversy in singapore over its material and artistic interpretation. since then, the artist has gone on to create several original and provocative bodies of work that continue to evoke the interaction of cultural and historical understandings and the overlapping dislocation of our collective modern identity; his works are personal and political, local and global, contemporary and timeless.

gu wenda's art has been collected by various public art institutions, including the shanghai museum of art, shanghai; china national art museum, beijing; the british museum, london; canada royal ontario museum, toronto; san francisco museum of modern art; hong kong museum of art; royal hapsburg collection, germany; kent and vicki logan art foundation, san francisco; asian art museum of san francisco; deste foundation, greece; fukuoka art museum, japan; ashmolean museum, oxford; national gallery of australia, canberra; the museum of modern art, new york; boston museum of fine arts; seattle art museum; asia society and museum, hong kong, china; denver museum of art, colorado; olenska foundation, geneva; oct contemporary art terminal of he xiangning art museum, shenzhen; solomon r. guggenheim museum, new york, and many more.

INK IDENTITY

the monumental installation the *yanhuang genetic landscape no. 1 & 2* is the culmination of gu wenda's experimental ink art practice of the last three decades. originally commissioned for the gwangju biennale in 2012, gu created the pair of minimalistic, monochromatic ink landscapes using two of his own innovations: ink derived from human hair and paper manufactured from green tea leaves.

這兩幅畫在規模和野心上都非常宏大：每幅畫都有 2 米高，近 30 米長，各有 120 個獨立單元。這些令人印象深刻的作品，既具有極強的實驗性，又牢牢根植於學術性的水墨山水畫傳統，是谷文達廣受讚譽的藝術實踐的縮影。

《炎黃基因風景 1 號 &2 號》具有特殊的歷史意義，因為它是谷文達首次將其生物基因煉金術（dna alchemy）和紙煉金術（paper alchemy）的成果結合在一起。

《墨煉金術》（1999 － 2001）是谷文達以中國人的髮粉製成墨汁和墨碇的實驗工藝。《紙煉金術》（2001 － 2002）是谷文達成功用綠茶製成的紙取代傳統水墨畫宣紙的實驗過程。

在《炎黃基因風景 1 號 &2 號》中，谷文達的「人源墨汁」和「茶源宣紙」的結合，標誌着他對中國畫傳統再概念化的一個新的高潮，這種再概念化的實驗嘗試一直貫穿於他漫長而輝煌的藝術生涯中。

在中國藝術史上，山水畫直到現在仍然被盛讚為中國水墨畫的最高藝術形式。在《炎黃基因風景 1 號 &2 號》中，谷文達將山水簡化到了不再指涉任何現實地點的臨界點。相反，他為我們留下了一片荒涼而純淨的視界，交織着深沉的古典氣息與怪誕的未來色彩。

both paintings are vast in size and ambition: each one is 2 meters tall and nearly 30 meters long and composed of 120 individual units. these truly impressive works, at the same time both extremely experimental and yet firmly rooted in the scholarly ink landscape tradition, epitomize gu's highly acclaimed artistic practice.

yanhuang genetic landscape no. 1 & 2 is of particular historical significance because it is the first time gu wenda combined the fruits of both his dna alchemy project and his paper alchemy project in one work.

dna alchemy (1999-2001) is the experimental process through which gu wenda succeeded in creating liquid ink and solid ink sticks from the powdered hair of chinese people. *paper alchemy* (2001-2002) was the experimental process by which the artist successfully replaced traditional ink painting rice paper with paper that he manufactured from green tea leaves (tea of course being one of the motherlodes of oriental culture).

the unification of gu's "human-derived ink" and his "green tea-derived paper" in *yanhuang genetic landscape no. 1 & 2* marks a new high water mark in his re-conceptualization of the chinese painting tradition, a re-conceptualization that he has been experimenting with throughout his long and illustrious career.

note: the word *'yanhuang'* is sometimes used to denote chinese civilization. the word itself is derived from the names of the two legendary rulers, yan di and huang di, who joined their peoples together some 4,500 years ago and thereby set the stage for the beginning of chinese culture.

in chinese art history, landscape painting was - and to a great extent still is - regarded as the highest form of chinese ink painting. in *yanhuang genetic landscape no. 1 & 2*, gu wenda simplifies the landscape to the point where it no longer seems to refer to any real location. instead we are left with a stark but pure horizon that is both profoundly classical and yet eerily futuristic.

龐惠英，獨立藝術策展人、研究員，專長中國當代水墨畫研究。出生於加利福尼亞州三藩市的一個國際家庭，龐女士從小練習水墨畫和書法，這激發了她對中國藝術的興趣。從布朗大學獲得雙學位後，龐女士持富布賴特獎學金獲得者的身份來到了中國，她渴望探索自己在早年成長背景中得到熏陶的藝術形式，並與對這個領域產生革命性影響的藝術家會面。她在北京工作了六年之久，從 2007 年到 2010 年擔任中國最古老的中國嘉德拍賣行的國際事務專員和中國水墨畫專家。自此，龐女士轉而在中國、中國香港、美國和法國策劃了十多個當代藝術展覽，並為眾多藝術圖冊和出版物作出了貢獻。她關於藝術市場和中國畫的文章經常在《華爾街日報》、《東方藝術品》和《藝術亞太》上發表。

tiffany wai-ying beres is an independent art curator and researcher whose work focuses on contemporary chinese ink painting. born in san francisco, california to a bi-racial family, ms. beres grew up practicing ink painting and calligraphy, stimulating her interest in chinese art. after graduating from brown university with a dual degree, ms. beres moved to china on a fulbright fellowship, curious to explore the art she grew up practicing in its native milieu and to meet the artists revolutionizing the field. based in beijing for over six years, from 2007 to 2010 ms. beres worked for china guardian, china's oldest auction house as their international affairs officer and chinese ink painting specialist. since then, ms. beres has gone on to produce more than a dozen contemporary art exhibitions in china, hong kong, china, america, and france and has contributed to numerous art catalogs and publications. her writing on the art market and chinese painting is regularly featured in the wall street journal, orientations, and art asia pacific.

(from catalog of the exhibition)

生物時代之謎（柒）：

《消逝的 36 個黃金分割》福岡 1991

ENIGMA OF BIOLOGICAL TIMES 7:

de-36 golden sections fukuoka 1991

《消逝的 36 個黃金分割》碑林貳系

大地藝術與掩埋行為藝術

1991 年福岡

100 公斤礦物質紅色粉

作品在掩埋之後自然溶化解體回歸
自然

DE-36 GOLDEN SECTIONS
FOREST OF STONE STELES
SERIES 2

land art and burial performance
fukuoka, 1991
100 kg red mineral pigment
the pigment naturally dissolved
back into the earth after the burial

大地藝術《消逝的 36 個黃金分割》碑
林貳系的掩埋行為藝術現場

de-36 goden sections forest of
stone steles series 2 the moment
of burial performance

387

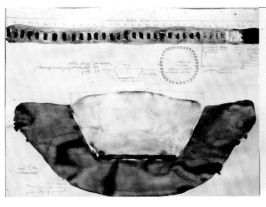
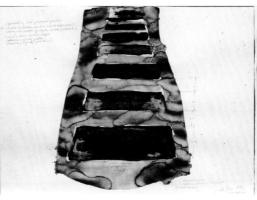

《消逝的叁拾陸個黃金分割》碑林貳系
大地藝術草圖之壹，之貳，之叁
1991 年於日本福岡
水彩畫顏料，墨，水彩畫紙
76 厘米長 ×58 厘米高

DE-36 GOLDEN SECTIONS **FOREST OF STONE STELES #2**
a burrial landart project drawing #1,#2,#3
fukuoka, japan, 1991
watercolor, ink, watercolor paper
76cm long × 58cm high

藝術家谷文達在丈量《消逝的叁拾陸個黃金分割》的壹佰米土地深溝
artist gu wenda is working on the measurement a deep ditch to enable the disappearance of the slabs into the *de-36 golden sections*

《消逝的叁拾陸個黃金分割》的水溶性礦物質紅色顏料粉撒成的叁拾陸個黃金分割，將在土地管道裏壹字形排開
spreading water-soluble red mineral pigment along the ditch bed in the *de-36 golden sections*

《消逝的 36 個黃金分割》碑林貳系大
地藝術正在進行掩埋行為藝術表演，
作品在掩埋之後自然溶化解體回歸自
然，1991 年福岡
de-36 goden sections forest of
stone steles series 2 land art as
a burial performance, naturally
dissolved back into the earth after
the burial in fukuoka, 1991

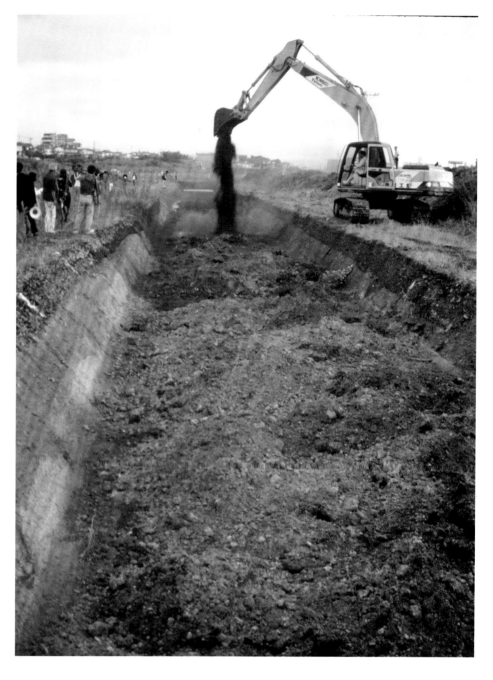

挖壹長長的土溝
digging a long earth
ditch

水溶性礦物質紅色顏料粉
撒成的叁拾陸個黃金分割
spreading water-soluble
red mineral pigment
along the ditch bed in
the 36 golden sections

藝術家谷文達正在壹佰米長的地渠，以水溶性礦物質顏料粉播撒出叁拾陸個黃金分割

the artist gu wenda is shaping 36 golden sections by spreading water-soluble red mineral pigment along the 100m-long ditch bed

生物時代之謎（捌）：

《生物與生態咖啡色》紐約 1992

ENIGMA OF BIOLOGICAL TIMES 8:

biological and ecological browns new york 1992

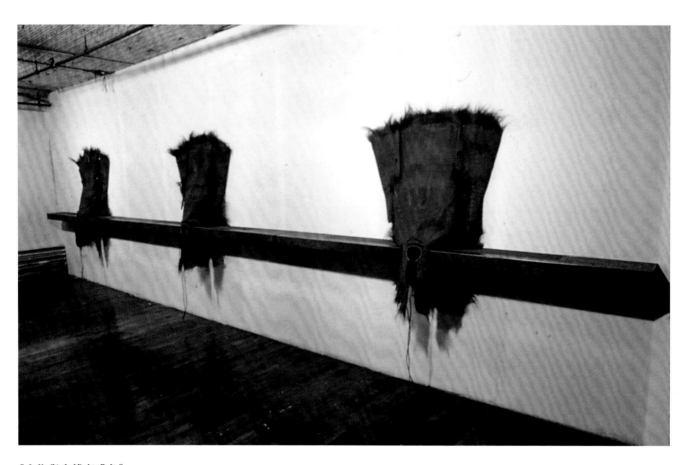

《生物與生態咖啡色》

1992 年於紐約工作室

人胎盤粉，沙子，蓑衣固體，鋼結構

900 厘米長 ×38 厘米寬 ×150 厘米高

BIOLOGICAL AND ECOLOGICAL BROWNS

new york studio, 1992

human placenta power, sand, traditional straw rain
coat, steel frame

900cm long × 38cm wide × 150cm high

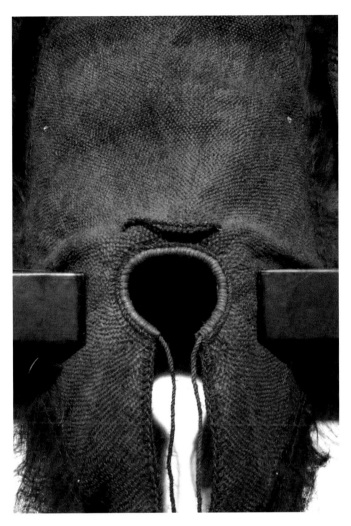
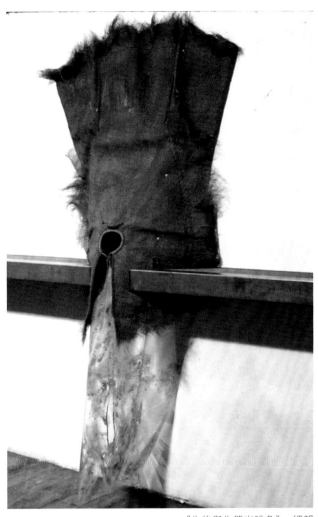

《生物與生態咖啡色》 細部
biological and ecological browns detail

《生物與生態咖啡色》草圖之貳

1992 年於紐約工作室
水彩畫顏料，墨汁，水彩畫紙
58 厘米長 ×38 厘米高

***BIOLOGICAL AND ECOLOGICAL
BROWNS* PLAN #2**

new york studio, 1992
watercolor, ink, watercolor paper
58cm long × 38cm high

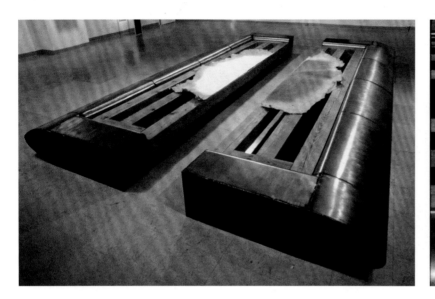

《生物米色與藥物白色之門》

裝置藝術

1992 年於紐約工作室

人胎盤粉，避孕藥粉，羊皮，鋼，木

366 厘米長 ×274 厘米寬 ×30 厘米厚

GATE OF BIOLOGICAL BEIGE AND MEDICINAL WHITE

installation

new york studio, 1992

human placenta powder, contraceptive pill powder, sheep skin, steal, wood

366cm long × 274cm wide × 30cm thick

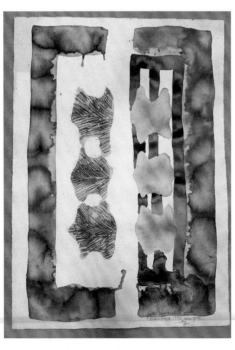
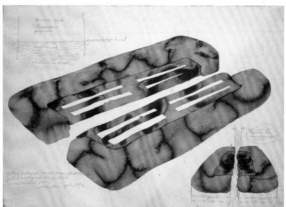
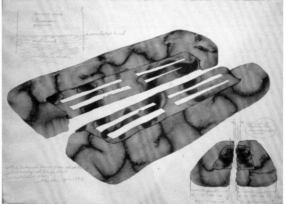
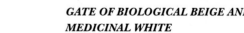

《生物米色與藥物白色之門》

草圖之壹，之貳，之叁

1992 年於紐約工作室

水彩畫顏料，墨汁，水彩畫紙

76 厘米長 ×58 厘米高

GATE OF BIOLOGICAL BEIGE AND MEDICINAL WHITE

plan #1,#2, #3

new york studio, 1992

watercolor, ink, watercolor paper

76cm long × 58cm high

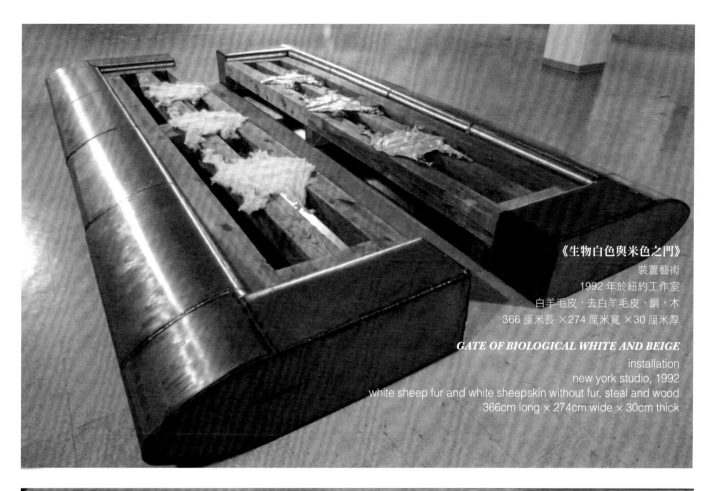

《生物白色與米色之門》
裝置藝術
1992 年於紐約工作室
白羊毛皮，去白羊毛皮，鋼，木
366 厘米長 ×274 厘米寬 ×30 厘米厚

GATE OF BIOLOGICAL WHITE AND BEIGE
installation
new york studio, 1992
white sheep fur and white sheepskin without fur, steal and wood
366cm long × 274cm wide × 30cm thick

《生物白色與米色之門》細部
gate of biological white and beige detail

《生物咖啡與藥物黑色》米蘭 1992

biological brown and medicinal black milan 1992

《生物咖啡與藥物黑色》

1992 年於米蘭 enrico gariboldi arte contemporanaea
人胎盤粉，炭片粉，羊皮，木
650 厘米長 ×250 厘米寬 ×25 厘米厚

BIOLOGICAL BROWN AND MEDICINAL BLACK

enrico gariboldi arte contemporanaea, milan, 1992
human placenta powder, charcoal pill powder, leather, wood
650cm long × 250cm wide × 25cm thick

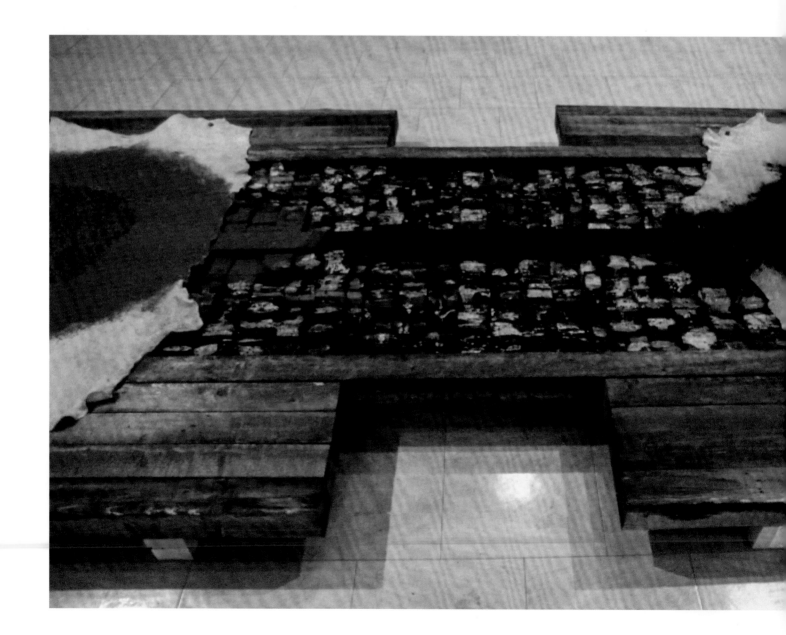

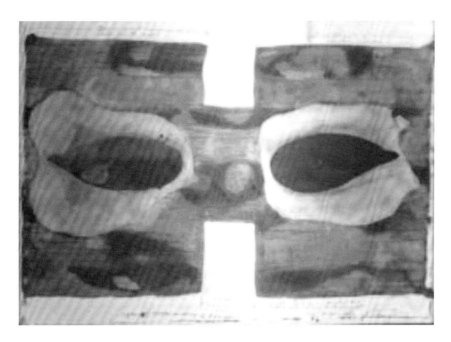

《生物咖啡與藥物黑色》
草圖之貳
1992 年於紐約工作室
水彩畫顏料，墨汁，水彩畫紙
76 厘米長 ×58 厘米高

**BIOLOGICAL BROWN AND
MEDICINAL BLACK**
plan #2
new york studio, 1992
watercolor, ink, watercolor paper
76cm long × 58cm high

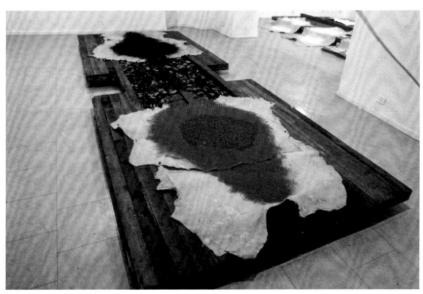

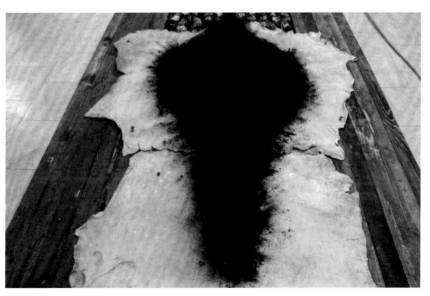

草圖之貳
1992 年於紐約工作室
水彩畫顏料，墨汁，水彩畫紙
76 厘米長 ×58 厘米高

《藥物黃色與白色》米蘭 1992

medicinal yellow and white milan 1992

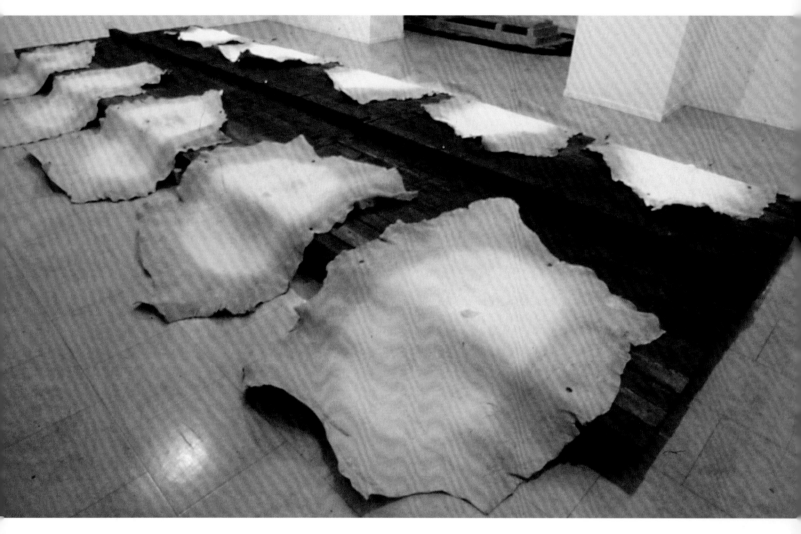

《藥物黃色與白色》

1992 年於米蘭 enrico gariboldi arte contemporanaea
粉狀盤尼西林，阿斯匹林片粉，羊皮，木
750 厘米長 ×400 厘米寬 ×30 厘米厚

MEDICINAL YELLOW AND WHITE

enrico gariboldi arte contemporanaea, milan, 1992
penicillin powder and asprin pill powder, leather, wood
750cm long × 400cm wide × 30cm thick

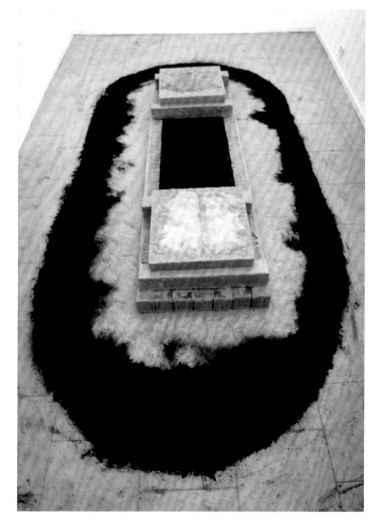
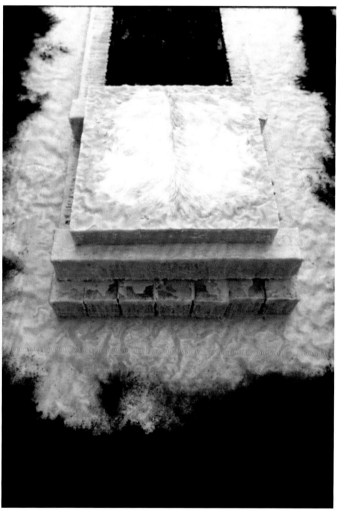

《生物白色米色與藥物黑色》

1992 年於米蘭 enrico gariboldi arte contemporanaea
帶白羊毛的羊皮，不帶白羊毛的羊皮，蜂蠟，炭片粉
300 厘米長 ×90 厘米寬 ×25 厘米厚

BIOLOGICAL WHITE, BEIGE, AND MEDICINAL BLACK

enrico gariboldi arte contemporanaea, milan, 1992
white sheep fur and sheepskin without white fur, beeswax, charcoal pill powder
300cm long × 90cm wide × 25cm thick

責任編輯： 錢舒文
排　　版： 周　榮
責任校對： 趙會明
印　　務： 龍寶祺

藝 術
A R T

藝術的故事(全二冊)
A STORY OF ART

作　者： 谷文達工作室

出　版： 商務印書館(香港)有限公司

香港筲箕灣耀興道 3 號東匯廣場 8 樓

http://www.commercialpress.com.hk

發　行： 香港聯合書刊物流有限公司

香港新界荃灣德士古道 220–248 號荃灣工業中心 16 樓

印　刷： 深圳中華商務聯合印刷有限公司

深圳市龍崗區平湖鎮春湖工業區中華商務印刷大廈

版　次： 2023 年 6 月第 1 版第 1 次印刷

© 2023 商務印書館(香港)有限公司

ISBN 978 962 07 6710 4

Printed in Hong Kong

凡例：為呈現作者谷文達之藝術面貌，
　　　其所著之中文文章及圖片說明等文
　　　稿中，表達數字含義的「一」「二」
　　　「三」……「十」「百」「千」等中文
　　　數字，將以「壹」「貳」「叁」……
　　　「拾」「佰」「仟」等大寫中國字收
　　　錄，其他作者所著文章，不作此修
　　　改；全書英文內容全小楷，句首不
　　　大楷。

藝術家：谷文達
artist: gu wenda

主辦單位：合美術館
organizer: united art museum

展覽地點：合美術館（武漢市洪山區野芷湖西路 16 號）
exhibition place: united art museum (no.16, yezhihu west road, hongshan section, wuhan)

展覽時間：2019 年 12 月 15 日 —— 2020 年 9 月 13 日
exhibition time: dec 15th 2019-sep 13th, 2020

開幕時間：2019 年 12 月 15 日 15:00
opening time: 15:00 dec 15th, 2019

出品人：黃立平（館長）
producer: huang liping

學術主持：沈語冰
academic director: shen yubing

策展人：布萊恩·甘迺迪　魯　虹（執行館長）
curator:'brian kennedy, lu hong

策展助理：艾小錚 李軼睿
curator assistant: ai xiaozheng, mandy lee

合美術館展覽委員會：
黃立平　魯　虹　姚　華　甘行松　李　紅
洪　鎂　艾小錚　王瑋琪　孫江舒　胡　露
exhibition committee of united art museum:
huang liping, lu hong, yao hua, gan xingsong, li hong, hong mei, ai xiaozheng, wang weiqi, sun jiangshu, hu lu

展覽總負責：湯　華
gu wenda'studio director: linda tang

展覽負責：李軼睿
exhibition manager: mandy lee

展覽及助理團隊：湯　華　李軼睿　宋小平　張珊珊
沈清鈺　金怡婷　陳丹青
exhibition & assistant staff from gu wenda'studio: linda tang, mandy lee, song xiaoping, zhang shanshan, janine shen, isabella jin, narcissus chen

展覽及視覺設計：
exhibition & visual design: design origin

文獻整理：谷文達工作室
documentation organizing: gu wenda'studio

英文翻譯及校對：林白麗
translator & proofreading: rebecca catching

主編：沈語冰
chief editor: shen yubing

執行主編：湯　華　李軼睿
executive editors: linda tang, mandy lee

攝影：馮曉天　孔　濤　馬丁·舒勒
photographer: feng xiaotian, kong tao, martin schoeller

藝術的故事
A STORY OF ART

二

第肆部分
CHAPTER 4

**藝術的故事
語言與翻譯**

A STORY OF ART:
LANGUAGE AND
TRANSLATION

普羅旺斯有壹座美麗的山村名叫 pourrieres,教堂是山村的中心。

《消逝的村莊》發生在法國南方,普羅旺斯有壹座美麗的山村名叫 pourrieres。在壹個靜悄悄的黃昏,肆枚重 10 噸的法國粉紅色大理石被同時深深埋入村莊 pourrieres 的東南西北的邊界。

這就是藝術家谷文達的大地藝術與掩埋行為藝術《消逝的村莊》碑林壹系。

村莊 pourrieres 的人口一直在下降。年輕人都離開村落去了大城市找尋就業機會。《消逝的村莊》是壹個象徵。

如地圖設計稿所示,肆枚大理石的掩埋位置很精準地以村子的中心教堂為原點,按黃金分割的比例在村落的東南西北的邊緣定下掩埋大理石的坑。南北和東西石坑的距離分別為 614 米,380 米,面積 233320 平米,幾乎是村莊的面積。

由當地石工鐫刻在粉紅大理石上的分別是:

村南石:「O」是村落的誕生日。

村東石:「19902631」是 1990 年村子的人口。

村西石:「-102100000」,公元前 102 年有 100000 羅馬戰士陣亡在此地。

村北石:破口的「O」,象徵村子在未來的情景。

自那時起《消逝的村莊》就在村莊的肆周長眠……

pourrières is a beautiful mountain village in provence. the church is at the center of the village.

de-villa forest of stone steles series 1 tookplace in southern france, in a beautiful village called pourrières. it was a very quiet evening at dusk when 4, 10-ton slabs of local pink marble were buried at the same time at the east, south, west and north edges of the village .

it was a large-scale land art and burial performance by gu wenda called *de-villa*, forest of stone steles #1.

the population of the village is continuing to decline. the youngsters are leaving to search jobs in bigger cities and de-villa is a symbol of this departure.

as shown by the map of the village, the buried marble slabs represent the orientation around the church in a central axis. Following the ratio of the golden section, the 4 pits where the slabs are buried are aligned on the east, south, west and north edges of the village. the site measures: 614m × 380m and the village has an area of almost 233,320 square meters.

south stone pit: the stone is engraved with a "O," the birthdate of pourrières.

east stone pit: the stone is engraved with "19902631," the present population of the city.

west stone pit: the stone is engraved with "—102100000," the year of 102 b.c., when 100000 roman soldiers died in a battle at this location.

north stone pit: the stone is engraved with a broken "O", the future of the village.
de-villa the 4 marble slabs have been sleeping on those 4 sides of the village ever since . . .

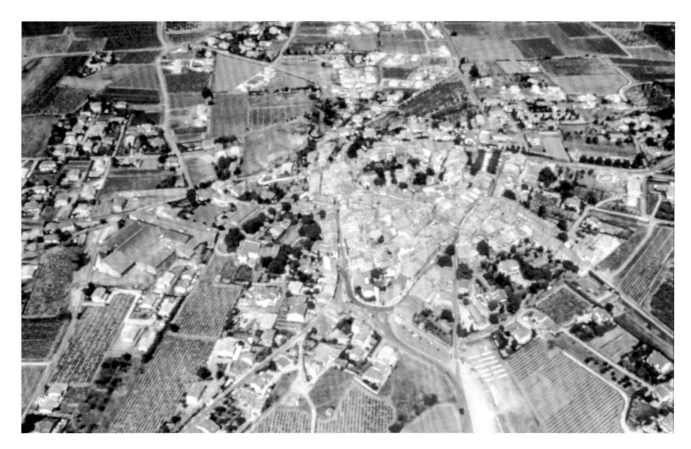

鳥瞰山村 pourrieres，圖中東西南北村邊緣的肆個黑色圓點就是《消逝的村莊》買入肆枚 10 噸重粉紅色大理石的石坑位置。

from a bird's—eye view, the 4 black dots on north, south east and west sides of the village are *de-villa* 4 pink marble slabs burial locations

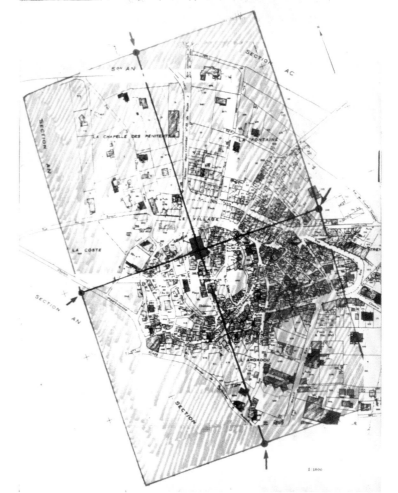

如地圖設計稿所示，肆枚大理石的掩埋位置很精準地以村子的中心教堂為原點，按黃金分割的比例在村落的東南西北的邊緣定下掩埋大理石的坑。南北和東西石坑的距離分別為 614 米，380 米，面積 233320 平米，幾乎是村莊的面積。

as shown in the artist's map of the village, the ratios of the golden sections in the disappearing village. the 4 pits to burry the 4 marble slabs are on the east, south, west and north edges of the village. they measure: 614m × 380m. the village is almost 233320 square meters in area.

藝術家谷文達與助手在普羅旺斯的馳名的粉紅色大理石礦裏選擇大地藝術《消逝的村莊》所需肆枚 10 噸的大理石
artist gu wenda and his assistant select slabs of the famous pink marble for his landart project *de-villa* in provence

壹當地石工正在粉紅大大理石上鑴刻村南石：「O」—— 村落的誕生日
a local stone carver is engraving a slab in south stone pit with "O", the birthdate of pourrières

右頁：
村南石：「O」，是村落的誕生日
村東石：「19902631」是 1990 年村子的人口
村西石：「-102100000」，公元前 102 年有 100000 羅馬戰士陣亡在此地
村北石：破口的「O」，象徵村子在未來的情景
south stone pit: the stone is engraved with a "O," the birthdate of pourrières.
east stone pit: the stone is engraved with "19902631," the present population of the city.
west stone pit: the stone is engraved with "—102100000," the year of 102 b.c., when 100000 roman soldiers died in a battle at this location.
north stone pit: the stone is engraved with a broken "O," the future of the village.

404

《消逝的村莊》碑林壹系

大地藝術與掩埋行為藝術

由法國文化部贊助

1990 年法國南方

肆塊粉色大理石石碑（每塊 10 噸）分別在村莊外圍的東南西北肆方

永久保存於當地地下

DE-VILLA FOREST OF STONE STELES SERIES 1

land art and burial performance

commissioned by the french cultural minister

pourrières, southern france, 1990

4 pink marble steles (10 tons each) on the east, west, south, and north sides of the village

permanent display underground

大地藝術《消逝的村莊》的掩埋行為藝術現場

自那時起《消逝的村莊》就在村莊的肆周長眠……
de-villa the 4 marble slabs have been sleeping
on the edges of the village ever since…

大地藝術《消逝的村莊》的掩埋行為藝術現場
landart *de-villa* burial performance moment

407

語言與翻譯（貳）：

《唐詩後著》碑林肆系　西安　1993-2007

LANGUAGE AND TRANSLATION 2

post tang poetry　forest of stone steles series 4　xi'an　1993-2007

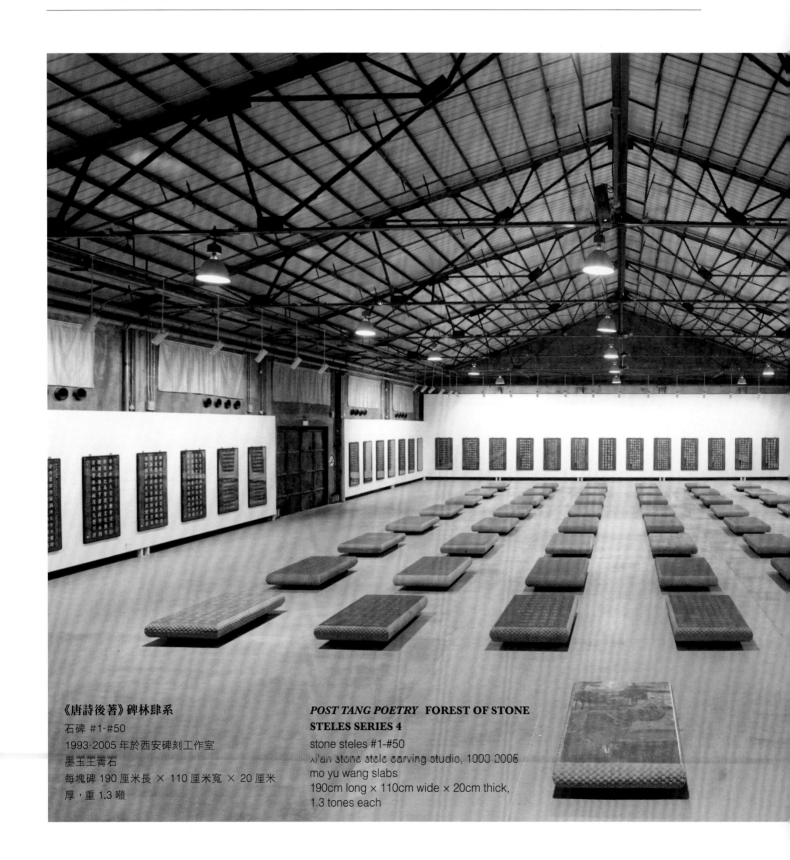

《唐詩後著》碑林肆系

石碑 #1-#50
1993-2005 年於西安碑刻工作室
墨玉王青石
每塊碑 190 厘米長 × 110 厘米寬 × 20 厘米
厚，重 1.3 噸

**POST TANG POETRY　FOREST OF STONE
STELES SERIES 4**

stone steles #1-#50
xi'an stone stele carving studio, 1993-2005
mo yu wang slabs
190cm long × 110cm wide × 20cm thick,
1.3 tones each

《唐詩後著》碑林肆系　西安　1993-2007

碑文後唐詩壹新結構的漢字融合了漢字的左右偏旁
the inscription of post tang poems is a new creation which
involves the merging of the left and right parts of chinese
characters.

碑文後唐詩壹新結構的漢字融合了漢字的左右偏旁
the inscription of post tang poems is a new creation which
involves the merging of the left and right parts of chinese
characters.

409

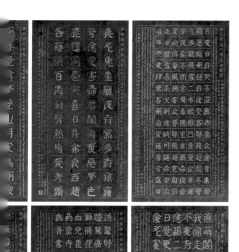

《唐詩後著》碑林肆系　50 塊石碑　50 首唐詩後著

post tang poetry　forest of stone steles series 4 × 50 stone tablets, 50 retranslated and rewritten tang poems translated literally into english, then transliterated phonetically back into chinese and inscribed onto the stones.

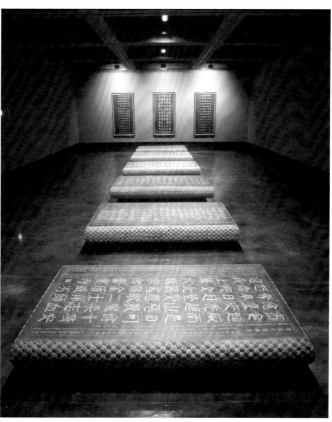

《唐詩後著》碑林肆系

北德克薩斯大學藝術畫廊（圖片由北德克薩斯大學提供）

POST TANG POETRY
FOREST OF STONE STELES
SERIES 4

union art gallery, university of north texas (photo by university of north texas)

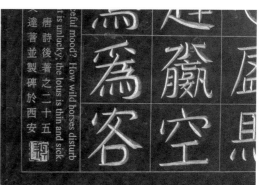

《唐詩後著》碑林肆系

手工鑿刻石碑的細部

POST TANG POETRY　**FOREST OF STONE STELES SERIES 4**

details of hand-carved stone steles

《唐詩後著》碑林肆系

拓片與拓片宣冊在合美術館（圖片由合美術館提供）

POST TANG POETRY **FOREST OF STONE STELES SERIES 4**

limited eddition ink rubbing and ink rubbing accordion book at the united art museum (photo by the united art museum)

唐詩後著

Retranslation & Rewriting of Tang Poem No.32

唐：崔灝　　　　　　長干行

君家何處住，妾住在橫塘。停船暫借問，或恐是同鄉。

Tang Dynasty:　Cui Hao A Song of Ch'ang-kan
"Tell me, where do you live?-
Near here, by the fishing-pool?
Let's hold our boats together, let's see
If we belong in the same town."

(以 Witter Bynner 的唐詩英譯本 Jade mountain 之英語讀音的同聲漢字翻回成中文)

胎兒蜜，外獨游李府。泥海白，日飛新菩鶘。賴比谿達簸馳途，蓋日來
致喜。依附威碧龍，英姿賽猛鐘。

(retranslated back to english by Wenda Gu)

Honey feeling, pregnant with fetus, she set out alone to visit Li Mansion. Above the white
muddy sea, baby emus fly under the sun. The generous Lai Bi comes from afar to offer
congratulations. He drives a boat with a powerful green dragon, seeming valiant and
heroic.

唐詩後著第三十二首是碑林第三十二碑的碑文。The text of *Forest of Stone Steles No.32*

後唐詩的翻譯和再寫的觀念和方法：
壹，從漢語的唐詩翻譯（通過意譯）成英語唐詩。
貳，由唐詩英文譯本再翻譯（通過音譯）回漢語並組成漢語後唐詩。
叁，再由漢語後唐詩（通過意譯）成英語後唐詩。

concept and methods of post retranslation and rewriting:
1, original tang poem in chinese - (translated through literal
meaning) - becomes an english version of the tang poem.
2, english version of tang poem - (translated phoenically) -
becomes a post tang poem in chinese.
3, post tang poem in chinese - (translated through literal
meaning) - becomes a post tang poem in english.

唐 崔顥 長干行 君家何處住妾住在橫塘停船暫借問或恐是同鄉 A Song of Ch'ang-kan Tang Dynasty: Cui Hao "Tell me, where do you live? - Near here, by the fishing - pool? Let's hold our boats together, let's see If we belong in the same town." Witter Bynner: The Jade Mountain F. S. G. New York USA

Honey feeling, pregnant with fetus, she set out alone to visit Li Mansion. Above the white muddy sea, baby emus fly under the sun. The generous Lai Bi comes from afar to offer congratulations. He drives a boat with a powerful green dragon, seeming valiant and heroic.

Forest of Stone Tablets - Retranslation and Rewriting of Tang Poems No.32　This project began in 1993 and completed in 2001 in Xian, China　碑林—唐詩後著之三十二是根據 Witter Bynner 的唐詩英譯本英語之讀音選擇同聲漢字而著始於癸酉年定稿於辛巳年谷文達著並製碑於西安

威碧龐英姿賽孟閭
簷懸趁蓋日來致喜聊
白日飛新菩寫穎比豁越
園兒蜜不獨游李府庞貶

414

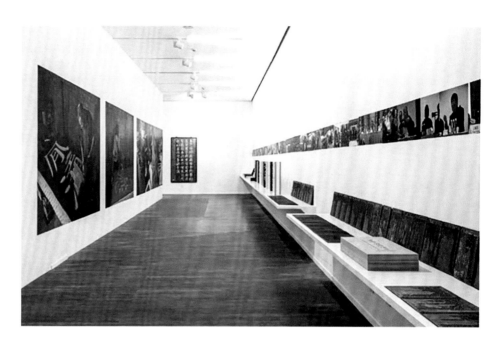

《唐詩後著》碑林肆系
限量版拓片宣冊：封面與封底白卡紙凹凸版標題，古籍色絲綢面（由達特茅斯大學赫德藝術博物館提供圖片）

POST TANG POETRY FOREST OF STONE STELES SERIES 4
limited edition ink rubbing accordion books with embossed title on cardboard with antique colored silk cover (courtesy of the hood museum of art, dartmouth college)

《唐詩後著》碑林肆系
石碑第叁拾貳號
手工刻碑面與碑文對比閱讀
190 厘米長 × 110 厘米寬 × 20 厘米厚，重 1.3 噸

POST TANG POETRY FOREST OF STONE STELES SERIES 4
stone stele #32
a comparative study of the hand-carved surface of stele and stele text
190cm long × 110cm wide × 20cm thick, 1.3 tones

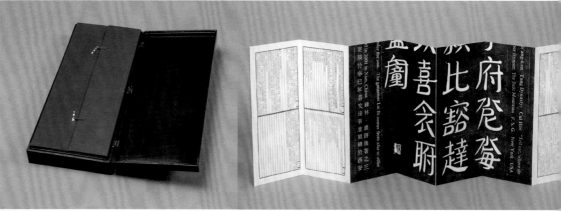

《唐詩後著》碑林肆系
限量版拓片宣冊面面觀

POST TANG POETRY **FOREST OF STONE STELES SERIES 4**
ink rubbings and classic ink rubbing accordion book

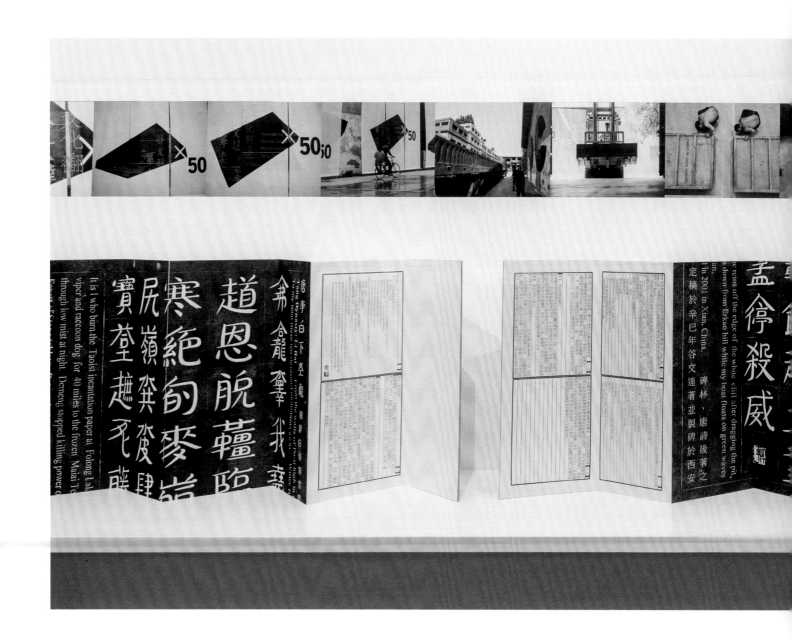

416

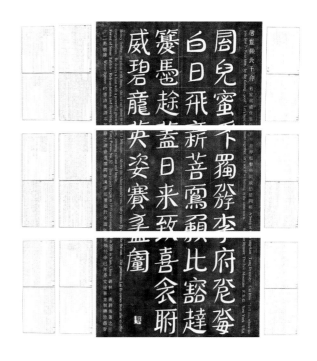

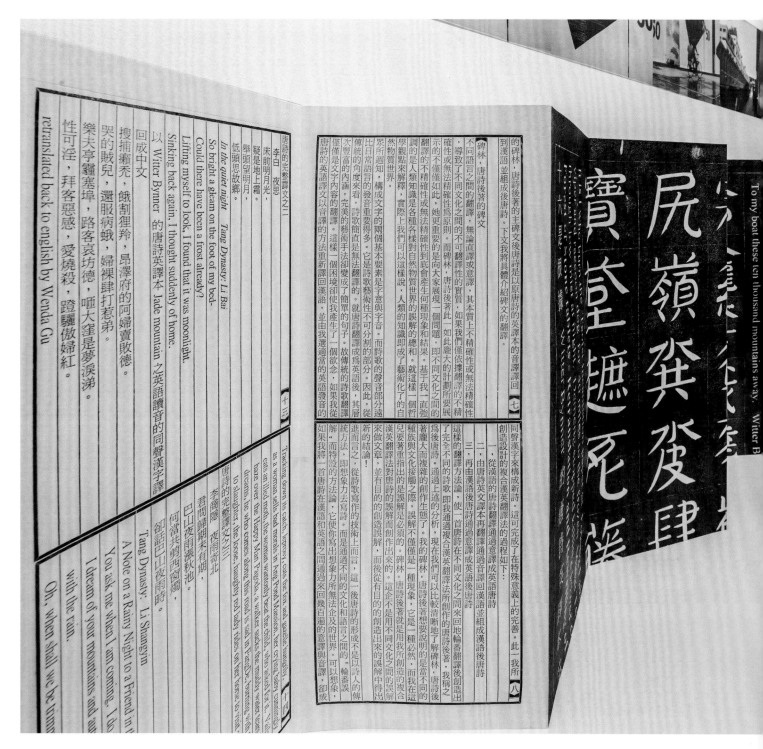

《唐詩後著》碑林肆系
拓片與拓片宣冊

***POST TANG POETRY* FOREST OF STONE STELES SERIES 4**
ink rubbings and classic ink rubbing accordion book

《唐詩後著》碑林肆系

限量版拓片宣冊　序文以及後唐詩的
銅腐蝕版

***POST TANG POETRY* FOREST
OF STONE STELES SERIES 4**

limited edition ink rubbing
accordion book preface and post
tang poems etching copper plates

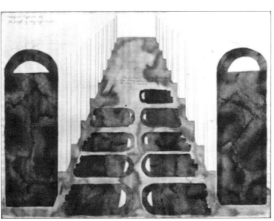

《唐詩後著》碑林肆系

草圖之壹，之貳
1993 年於紐約工作室
水彩畫顏料，墨，水彩畫紙，鏡框
76 厘米長 × 58 厘米高

***POST TANG POETRY* FOREST
OF STONE STELES SERIES 4**

drawing #1,#2
gu wenda new york studio, 1993
watercolor, ink, watercolor paper,
frame
76cm long × 58cm high

《唐詩後著》碑林肆系最早的設想
the very first drawings of *post tang
poetry forest of stone steles series 4*

現為陝西延安的黃陵縣是軒轅黃帝的陵寢，製作《唐詩後著》碑林肆系的石碑取自於黃陵邊之墨玉王石礦，歷史上極為珍貴稀少，達官貴人的墓碑均出自黃陵邊之墨玉王石礦。

the tomb of the first han emperor xuanyuan is located in the city of yan'an in huangling county, shaanxi province. the mo yu wang slabs for *post tang poetry*, forest of stone steles series 4 are from a quarry in huangling. mo yu wang slab is a rare and precious stone in chinese history. in the past, the steles of high officials and noble lords' tombs were exquisitely hand-carved masterpieces.

極其艱辛的工作，壹刻工通過紅印紙手工將文字精準地雙鈎複製到石碑上

a stone carver engages in the labour-intensive work of hand-copying the precise words onto a stele

專業藝術碑文拓片師傅正在打印拓片
professional ink rubbing printers producing ink rubbings

西安美術學院美術史教授程征（中）西安碑林博物館研究員楊智忠在指導並監製《唐詩後著》石碑

cheng zheng（center）, an art historian at the xi'an academy of fine arts, and yang zhizhong, a researcher from xi'an beilin museum are directing carvers in gu wenda's stone stele carving studio

西安市長安區的谷文達
碑刻工作室
gu wenda stone stele
carving studio in
changan district of
xi'an

谷文達在碑刻工作室與
刻工討論《唐詩後著》石
碑的刻製
gu wenda talking to his
stone stele carvers in
his stele carving studio

專業藝術碑文拓片師傅正在
打印拓片
professional ink rubbing
printers producing ink
rubbings

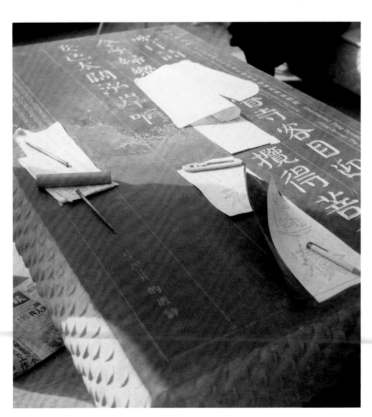

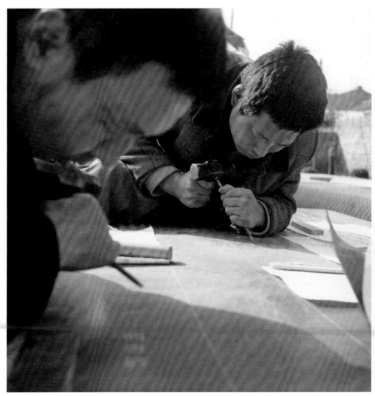

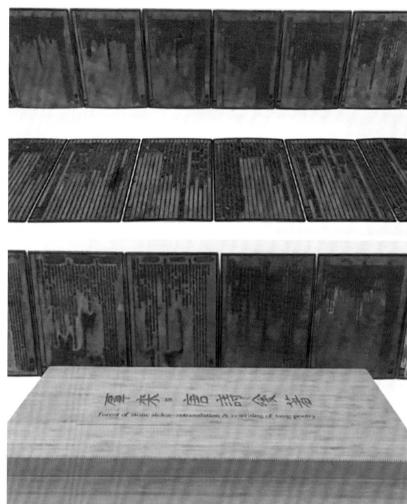

經典的拓片宣冊盛入刻製有《碑林 —— 唐詩後著》的竹盒
classic ink rubbing accordion book in a bamboo box carved
with the *post tang poetry forest of stone steles* both in chinese
and english

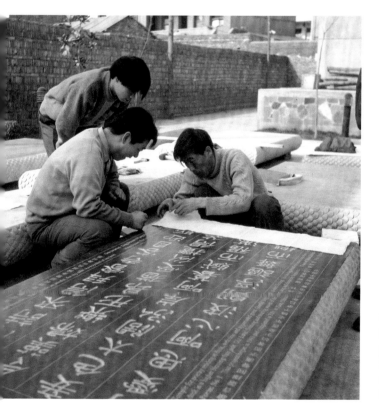

《唐詩後著》碑林肆系前前後後拾貳年的創製周期，專家和刻工團隊，艱苦卓絕
的傳統手工打印、鑿刻、拓印藝術，成為不可複製的當代碑林
post tang poetry forest of stone steles series 4 took about 12 years of
effort from the design to the final work. the results were extraordinarily
exquisite and hand-crafted, this extremely labor-intensive work is difficult
to replicate.

重要的不是身份政治或差異的絕對化：對谷文達與翻譯相關作品的再思考

沈語冰

THE POLARIZATION OF DIFFERENCE AND IDENTITY POLITICS ARE NOT THE KEY CONCERNS: A RE-THINKING OF GU WENDA'S TRANSLATION WORKS

shen yu bing

我第一次參加谷文達先生的展覽開幕和研討會是在 2005 年。黃專先生當年在深圳 ocat 策劃了谷先生的大型裝置展覽《碑林 —— 唐詩後著》。與那個展覽配套的有一個由巫鴻先生主持的關於翻譯的國際研討會。我在那個研討會上做了主題發言，表達了對展覽帶給我的巨大震撼，以及身份政治、翻譯和跨文化交流的粗淺看法。當時我的一個感受是，展覽所呈現的宏大氣勢、藝術家的無限勇氣和力量、對問題的切入深度和力度，似乎已經不是一場學術研討會所能匹配的了。我覺得自己的語言非常蒼白，而我從那個研討會上聽到的學術討論，好像也沒有給我留下十分深刻的印象或啟發。

最近我查閱了自己的發言稿，發現當時所說的主要意思大概有兩個，第一是覺得谷文達的作品「放大」了文化交流中的難度。第二是我的一個善良意願，即翻譯能夠把

2005 marked the first time i participated in an artist talk and exhibition opening of gu wenda's art work. it was a large-scale solo exhibition *forest of stone steles, retranslation & rewriting of tang poetry* curated at ocat shenzhen by huang zhuan that was companied by an international symposium hosted by wu hung about translation. i was a keynote speaker at that symposium, and at the time, i expressed the momentous impact of the exhibition, and my somewhat superficial views on topics such as identity politics, translation, and cross-cultural communication. at the time, i was impressed by this magnificent exhibition, the artist's unbridled courage, power, depth, and the strength of his penetrating approach to problems, which outshone the ideas being discussed at the academic conference. i felt that my own language was pallid and lifeless by comparison and of all the academic discussions presented during the conference, none of them left me with any kind of lasting impression.

recently when i dug up a copy of that speech, i discovered that there were two main points. the first one was that gu

文化差異減小到最低程度，因為正如歌德所說「畢竟我們都是人」。我記得我的發言在巫鴻先生的點評中得到的讚美與批評一樣多。巫先生同意我對谷文達作品放大文化差異的判斷，但是不同意我的評價，並且認為藝術作品（即使不能說全部的藝術作品）都是對日常經驗或思考的某種程度的放大，因此這恰恰是谷文達作品的優點，而不是缺點。

我不記得自己是如何對巫鴻先生作出回應的了，但這卻成了我一個持久思考的問題。我相信那些長期在海外生活的藝術家和學者，對於文化差異和跨文化交流的困難，比我有更加切身的體會（比較而言，我只在國外呆過短暫的時間），所以我完全能夠理解那種切身體會的強度，因此也完全能夠理解從中演化出來的藝術作品或關於身份政治的學術論述的強度。正如谷文達經常提到的一個貌似簡單卻異常深刻的經驗那樣，他一到國外，就在稱自己是 gu wenda 還是 wenda gu 之間感到了矛盾和衝突。出於中國人的習慣，前者是必然的；而出於對當地風俗的尊重（所謂入鄉隨俗），則後者成了某種必然。姓名尚且如此，其他種種文化衝突甚至文化休克（cultural shock），恐怕是日常語言完全無法承擔的重量。因此，這也成了藝術出場的必要性。

但談到藝術，可能有的讀者會認為，這裏重要的早已不是藝術作品的經驗出處或靈感來源的問題，而是藝術作品觀念本身的強度，及其與其呈現之間的張力的強度問題。然而，正是這一點最難言詮。根據大批評家，例如

wenda's work "enlarged" the difficulties of cultural exchange (cultural intercommunication). the second was the power of goodwill in reducing the cultural gap between individuals, as goethe says, "in the end, we are all just people." i remember that wu hung, in his comments regarding my speech gave me praise and criticism in equal amounts, yet he did not agree with my assessment of the work. because the artist's works (actually we can't say that they are all "artwork"), act as an "enlargement"of daily life experiences and thoughts — it is precisely this which bestows this work with merit, rather than acting as a weakness.

i don't recall how i responded to wu hung's comments, but this issue was one i would continue to ponder. i believe that artists and scholars who live abroad long term have a more visceral understanding of the difficulties of cultural differences and cross-cultural communication, (by comparison, i've only stayed abroad for short periods). so, i can completely understand the intensity of this visceral experience and the artworks which evolve from this experience or from the strength of the academic discourse of identity politics. for instance, gu wenda often mentions the simple but very profound experience of how to introduce oneself, of going abroad, and the contradiction and conflicts over whether to use the name gu wenda or wenda gu. according to chinese custom, the former [format] is necessary out of respect for local custom (when in rome do as the romans do). the latter becomes a different kind of necessity. names being what they are, other kinds of cultural conflicts can lead to culture shock, but it's a weight that cannot be borne by everyday language. therefore, art must take its position on this stage.

but speaking of art, perhaps some readers might feel that what is important is not the issue of origins of the inspiration of the artwork or the experience of it, but more the strength of the concept behind the artwork, and with it, the tension between this concept and the intensity with which it is rendered. this is the point which becomes the most difficult to explain, or the

t.s. 艾略特（t. s. eliot）和克萊門特·格林伯格（clement greenberg）的著名說法，對藝術品做出品質的（或審美的）判斷，是一個批評家的本分。但也是最難的部分。因為一個人可以就某些藝術品的社會和政治價值、文化和歷史價值等等滔滔不絕地說上許多，但就是不說藝術品的審美價值，這種情形所在多有。在關於谷文達藝術的諸多文章中，我發現有做分類描述或歷史分期的，也有做某些解釋性工作的，但鮮有真正作出品質判斷的。因為只有在某種傳統中，在某種期待視野及其審美滿足中，人們才有可能對藝術品做出審美判斷。在這個意義上，我的自我意識告訴我，要想找到突破口，對我來說總是異常困難。

不過我想盡我的力量做一些嘗試。首先我認為谷文達《唐詩後著》的規模和製作的難度都是空前的，這使這些作品的呈現顯示了恢宏的氣勢和令人錯愕的體量。但是它們出人意料的卻不是美學上所說的「崇高」——在無限大和大象無形的意義上——也不是決定其品質的關鍵因素。它的規模令人印象深刻，但無法使人產生崇高感。在這個方面，與之形成鮮明對比的卻是另一件作品。那件作品貌似無限延長的牀，卻令人產生一種一望無盡的崇高感。因為牀的長度一般是固定的，而谷文達作品中「牀」的尺度卻長到令人無法想像！這是那件作品最為成功的地方。當然，《唐詩後著》的構思過程複雜而精妙，製作過程甚至會讓作者或參與製作者產生巨大的幽默感。它先把唐詩翻譯成英文，又從英文音譯為漢字。其中產生的錯位會令人忍俊不禁。但是我認為這種做法有些隨意。就像格林伯格認為巴塞利茲（georg baselitz）把人物畫成

words of critics t.s. eliot and clement greenberg, "it is the duty of the critic to assess the quality (or aesthetics) of artworks." but this is the hardest part. because one can talk endlessly about the social, ideological, cultural, and historical value of an artwork, without talking about its aesthetic value. this is an all-too-common situation. of the many articles we find about gu wenda's work, there are some which aim to classify and describe his work or group it into historical periods, and then there are a few which take on the work of interpretation, but rarely do we find articles which attempt to assess the quality of the work, because people can only make aesthetic judgments of artworks from within a particular tradition, anticipated visual perspective, or based on the satisfaction of aesthetic expectations. in that sense, my self-awareness informs me that i need some kind of breakthrough to escape what i see as an eternal problem.

that said, i will endeavor to try my best. first, the scale and challenges of producing gu wenda's *post-tang poetry* is always unparalleled. these works present themselves with a staggering volume and magnificent presence. but what is unexpected is not this so-called aesthetic "loftiness" — the sense of the infinite size of these great forms without shape — as scale is not a key element in determining the quality of a work. the scale of the work certainly leaves a deep impression, but scale alone cannot produce a feeling of sublimeness for the viewer. in this way, it produces a distinct contrast with another work. this work which seems like an infinitely-extending bed produces an endless sense of the sublime. though the length of a bed is usually fixed, the bed in gu wenda's work is unimaginably long! this is the greatest triumph of this work. of course, the conceptual process of *post-tang poetry* is both complex and ingenious and engenders a shared humor for the artist or those involved in the production. gu first translated the tang poems into english, and then translated them into chinese characters — the mangled language left viewers in stitches. but i thought that this process was somewhat random, just as greenberg said it was random for george baselitz to paint

顛倒有些隨意一樣。關鍵的問題是，顛倒的人像有着甚麼樣的必然性？為甚麼必需如此？它產生了哪些非如此不可的意義？總之這就是我想說的。我的感覺是《唐詩後著》將英文音譯為漢字的過程缺少必然性。假如它將英文再翻譯成德文（這種根據譯文再次翻譯的情形，在翻譯界非常常見；我們習以為常的一些原文為德文、法文或其他歐洲語文的作品，其實都是根據英譯本轉譯的），因為轉譯而產生更大的錯位，那麼，我會認為這對揭示文化差異和翻譯之難，能產生更強大的說服力。當然，如果真的那樣做，這件作品或許就不那麼有趣了。但是，「有趣」往往是使作品的藝術史價值貶低的東西，儘管它肯定會使作品多一些新聞價值。

在十多年前的那個發言中，我試圖把谷文達的作品與馬勒（gustave mahler）的《大地之歌》加以比較。馬勒創作的《大地之歌》，所依據的也是德國漢學家對唐詩的翻譯，但不是直譯，而是添加了許多註釋性文字的所謂意譯，以至於直到今天，人們也無法完全弄清楚，它們究竟是哪幾首唐詩（當然其中的大部分已經考證出來）。我覺得這裏有意思的並不是馬勒是否忠實於唐詩的字面義或所謂意境 —— 我聽他的音樂，基本上感覺不到一點唐詩的意境，但這絲毫也不妨礙它成為一部極其出色的交響樂 —— 而是根據晚期浪漫派音樂的慣例和傳統對其進行了創造性的誤讀或發揮。與馬勒其他九部偉大的交響曲相比，它毫不遜色。在布魯諾・瓦爾特（bruno walter）看來，它甚至位於馬勒全部交響音樂中的前幾位。

figures upside down. the real issue is what was the necessity of turning these figures upside down? why should they be painted this way? does it produce this essential *"es muss sein"* [german for "it must be"] meaning? at least, this is what i am attempting to say. my feeling is that the act of translating english words into chinese characters through phonetics in *post-tang poetry* seems unnecessary. if, for instance, it were translated into german — this is a commonly found phenomenon in the world of translation, whereby a translated text is further translated — we often take for granted that with the german, french, or other european works, that english translation is used as the source text for further translation. then these re-translations produce further disfigurement of the texts. i would think this case might be a more persuasive way to reveal the challenges of translation and cultural differences. of course, if we actually did it that way, then the work might be that interesting. but what is "interesting" is something that diminishes the art-historical value of a work, even if it makes the artwork more newsworthy.

in the speech i gave ten years ago, i tried to create a comparison between gu wenda's work and gustav mahler's *das lied von der erde*. mahler's "das lied von der erde" was based on translations of tang dynasty poems by german sinologists, but they weren't literal translations and they added all sorts of annotative text to these so-called translations, so much that scholars could barely make heads or tails of these poems, or which poems they purported to translate (although today this has been verified). i think what is interesting is not whether mahler was faithful to the literal meaning or artistic conception of these poems. i listen to the music and do not hear any artistic hints of tang poems, but this does not prevent it from being an excellent symphony — which carried out a creative misreading of and playing with the traditions and conventions of late romantic music. it lies in contrast to mahler's nine great symphonies, yet no less great. bruno walter would put them at the top of that list.

當然，這已經超越了翻譯的議題，進入一個創造性誤讀的話題。但是在關於文化差異以及翻譯的可能性問題上，仍然存在着兩種觀念或者態度。我們不妨稱之為悲觀者的態度和樂觀者的態度。十多年前，我對文化翻譯問題是持樂觀態度的，我記得我的發言以愛因斯坦與著名作家威廉‧戈爾丁（william golding）的一次邂逅作結。在戈爾丁的回憶錄中，他記載了某次與偉大的科學家愛因斯坦（albert einstein）相遇。愛因斯坦正站在橋上饒有興致地觀看河中嬉戲的游魚。那時的愛因斯坦還不怎麼會說英語，而戈爾丁根本不會說德語。正在他猶豫着是否要上前向這位偉人致意時，沒想到後者指着水裏的魚對他說道：Fisch! Fisch! 戈爾丁立刻回應道：Ya! Ya! 然後兩人一起興致勃勃地看魚。

這一幕令人想起莊子與惠子的濠上之辯。當然這裏涉及的不是論辯的邏輯的起點問題，而是不同語言的人們如何交流的問題。語言不通（或者說至少不完全相通）並不妨礙人們就興致勃勃地觀看游魚這一點完成一個言語行為。因此，當時的我完全持樂觀態度。在經過世界的急劇動盪，特別是愈演愈烈，至今也不見消停的政治正確、意識形態撕裂以及種族和文化衝突的今天，我的樂觀主義已顯得廉價而膚淺。但是，我想我還不會成為一個阿多諾式的悲觀主義者。當偉大的德語詩人歌德（wolfgang von goethe）臨終前說「給我多一點光明」時，阿多諾（theodor adorno）卻說「給我多一點黑暗」（這與「奧斯維辛之後，寫詩是野蠻的」可以互釋）。不過，誠如藝術史家貢布里希（ernest gombrich）所說，這個世界注定令人悲觀，但做一個樂觀主義者卻是我們的責任。

of course, this has already gone beyond issues of translation and entered the territory of creative misunderstandings. but on the topic of the possibilities of cultural differences and translation, there will always be two different attitudes or approaches. we might characterize these approaches as optimistic or pessimistic. ten years ago, in a very optimistic mood towards cultural translation, i remember the conclusion of a speech i gave on einstein and the famous writer william golding. in golding's memories, he recounts a chance meeting with einstein. einstein was standing on a bridge, watching fish flitting playfully in the water below. at the time, einstein did not speak english well, and golding basically spoke no german. while he hesitated, wondering how to pay his respects to this great man, einstein pointed into the water at the fish and said, "fisch! fisch!" golding immediately replied: "ya! ya!" and the two stood together cheerfully watching the fish.

this scene is reminiscent of zhuangzi and huizi's debate. of course, it is not a debate about the starting point upon which a kind of logic is based, but rather an argument about how people communicate when they speak different languages. those who speak different languages (or who speak very little of each other's language), are not prevented in any way from cheerfully watching the fish together, and it is this act that fulfills an act of speech. thus, my completely optimistic attitude at the time. as we enter today's world of sharp unrest, growing unstoppable political correctness, ideological fissures, of racial and cultural conflict, my previous optimism seems cheap and superficial. but i don't think i've become an adornian-style pessimist. when the great german poet wolfgang von goethe said from his deathbed, "more light! give me more light!," theodor adorno still said, "give me darkness," (this is how we might interpret his quote, "to write poetry after auschwitz is barbaric.") nevertheless, as art historian ernst gombrich said, "the world is destined to be bleak, but to be an optimist is my responsibility."

自然，這些討論與谷文達的作品關係不大，因為我已經說過，這裏重要的已經不再是藝術家對身份政治、文化差異和翻譯難題的「觀念」或「態度」問題，而是他是如何呈現這些觀念或態度的。正是在呈現這一點上，我認為谷文達的作品（至少僅就《唐詩後著》而言；請讀者留意谷先生涉及文化差異、身份衝突和翻譯問題，創作過好幾個系列作品）是特別讓我感到困惑的。我的困惑當然不再是我們對上述議題的不同看法，而是僅就谷文達的觀點來看，他的表達是否成功。

僅就表達（或呈現）這一點而論，谷文達的另一個系列作品，也是根據漢字筆畫創作的雕刻作品，由於其公共性與無法識讀性之間的張力，以及那些無法識讀的漢字筆畫的書寫性與材料的特定性之間的恰到好處而充滿了必然性：它們是漢字筆畫，但卻是雕刻並加以打磨而成；出於石材的特定性，這些筆畫呈現墨色的書寫效果。我認為那件作品是高度成功的。這也是谷文達所有作品中最為成功的作品之一（至少是最為成功的公共藝術作品之一）。

我知道我的以上文字也許會被某些中國的藝術批評家認為不像他們所寫的批評。事實上，他們所寫的很少是批評。也許它們是描述、也許它們是分類、但從來不是品質的判斷。品質的判斷是最難的。或許我在十多年前的那個發言中，過多地停留在谷文達作品的主題，它的出處和來源上；過多地逗留在身份政治、文化翻譯的困難和差異的放大等問題上。當然，今天我仍然認為這些問題非常重要，對這些問題的探討仍有必要。在愈演愈烈的

naturally, these theories do not have a strong connection to the work of gu wenda, because i have already mentioned that the importance here is not an issue of the artist's stance or approach towards identity politics, cultural differences, or the difficulty of translation, but how these approaches or stances are realized. it is precisely this point of view in terms of the realization of these works (at least with *post-tang poetry* and so on, with this series of works which deal with cultural differences, identity conflict and issues of translation), that confused me. my confusion was not in regards to a difference of opinion about the aforementioned comments but from gu wenda's point of view about whether his expression was successful.

another small point i'd like to express is relating to series of works by gu wenda whereby the brushstrokes of chinese characters were carved into works, which also bore a tension between their publicness, their unreadability, and the unreadability of the brushstrokes of those characters, and their hand-written forms, and the specificity of the materials which seemed perfectly right and appropriate in contemplating this inevitability. they were brush strokes, but they were carved and polished to fit the specificity of the stone, and these characters had a black calligraphic effect. i felt those works were very successful, his most successful works in fact, (or at least the most successful works of public art).

i know that some domestic art critics perhaps would feel that this text does not constitute art criticism, but actually, they rarely engage in art criticism themselves. perhaps they write descriptions or categorizations, but they never offer any kind of appraisal of quality. judging quality is the most difficult. just as when i was giving my speech ten years ago and stopped on the topic of gu wenda's art, of its source and its origins: and sojourned a little too long on the topic of identity politics, the difficulties of cultural translation, and the amplification of differences. of course, today i still feel that these problems are very important and that they still deserve

政治正確的要求下，對這些問題的回應甚至變得更有必要。但是，我想強調指出的是，重要的不是身份政治和差異的絕對化，而是如何讓觀眾信服地意識到，這些觀念已經必然地、非如此不可地被呈現出來了。

2021 年 3 月 27 日於上海

to be explored. underneath the escalating demands of political correctness, responding to these issues has become even more important. but what i want to emphasize is that the importance is not the absolutism of identity politics, but rather how to convince the viewer to realize that these attitudes are inevitable and it is inevitable that they are presented or as the germans say *"es muss sein (it must be)."*

march 27, 2021, shanghai

文 化 翻 譯：谷 文 達《碑 林 —— 唐 詩 後 著》序

黃專

INTRODUCTION OF TRANSLATING VISUALITY:WENDA GU: FOREST OF STONE STELES, RETRANSLATION & REWRITING OF TANG POETRY

huang zhuan

谷文達是中國當代最具代表性和影響力的海外藝術家之一。上世紀 80 年代他是中國 85 現代藝術運動的代表藝術家，其活動及作品以本土文化反省為主題，成為中國現代藝術的重要章節。90 年代他赴美國後創作了《聯合國》等一大批以國際政治、文化為主題的作品，氣勢恢弘，蜚聲海內外。《碑林 —— 唐詩後著》是藝術家從 1993 年開始構思創作，至 2005 年藝術家在西安碑林工作室完成的另一組大型裝置作品，歷時 12 年。作品以 50 塊中國傳統碑石為媒材，以 50 首唐詩的中英對譯文本為碑文內容，通過語言輪番轉譯過程的「不精確性」，論證文化間的「不可翻譯性」，揭示當代人類文化全球化過程發生的種種困境和問題，作品具有藝術家慣有的歷史感和史詩性氣質。《聯合國》和《碑林 —— 唐詩後著》堪稱谷文達藝術的雙璧。

wenda gu is amongst those overseas chinese artists who enjoy enormous respect and influence within contemporary art circles in china. he was a leading artist of the '85 new art movement in china in 1980s, and his activities and the artworks he produced took as their subject a meditation upon local culture. these represent an important chapter in contemporary chinese art. in the 1990s, after migrating to america in 1987, he created a series titled *united nations* that focused on international politics and culture, which were full of vigour. these won wide acclaim both inside and outside of china. a subsequent large-scale installation work, entitled *forest of stone steles - retranslation and rewriting of tang poetry*, was conceived in 1993. work began almost immediately and achieved completion in the form of the "forest of stone steles studio" in xi'an, 2004, twelve years later. this takes both chinese-english and english-chinese translations of fifty tang poems as its subject, and through imprecise translations and retranslations of the language, wenda gu demonstrates the un-translatability of language across cultures. this points to the many puzzles and problems that have arisen out of the globalization of contemporary human cultures. this work is suffused with a sense of historic responsibility and an epic quality, found in the great art of the past. the *united nations* and the *forest of stone steles* can be truly as double exceptional artworks of gu wenda.

翻譯是人類交流的最基本手段，中國文化在其所經歷的數千年文明史中，完成過兩次大規模的與外文化的交流，這兩次交流都是以文獻翻譯為基礎的。第一次是古代東方中印兩大文明的交流，以公元一世紀東漢王朝開始，迄公元八世紀而達高潮的佛學翻譯為標誌；另一次則是自近代「西學東漸」開始，迄今還在進行的中西文化交流，而這個交流的起點被學者們認定為 1811 年倫敦會傳教士馬禮遜（robert morrison）在廣州出版的第一本中文西書。與第一次交流比較，在中西交流中，中國文化一直處於某種被動接受的境地，西方漢學（sinology）中的「衝突 —— 反應」模式長期為西方學者接受從一個側面說明了這一現實，而這一現實在經濟日益全球化的今天尤其突出。谷文達是一位受傳統文化浸染極深的藝術家，上世紀參與中國現代藝術運動的經歷和移民西方的身份，都使他對當代文化交流中的種種複雜現實有着更為敏銳和深刻的認識，這一方面形成了藝術家對西方和母語文化雙重的批判意識，另一方面又表現為對重建母語文化強烈的責任感，在《碑林 —— 唐詩後著》中，藝術家以當代藝術中慣用的反諷手法完成了對當代文化交流現實的一次視覺再現。

《碑林 —— 唐詩後著》完成後只在澳洲、美國和中國香港地區進行過零星展出。這次展覽是這組作品在海內外的第一次完整展出，同時，它也是 oct 當代藝術中心這個中國國家級當代藝術機構自成立以來舉辦的第一個個展。展覽以「文化翻譯」為題，一方面旨在點明作品的文化意寓，另一方面

translation is the most basic means of human communication. through the thousands-of-years long history of civilization, china engaged in two protracted periods of engagement with foreign cultures, based on the translation of documents. the first was the communication between two ancient oriental cultures, that between china and india and that began in the east han dynasty, in the first century a.d., and which achieved its height in the 8th century. this was centered on the translation of buddhist scriptures. a second begun with the "flow of western cultures into the eastern world", and is on-going today. the starting point of this communication is identified by scholars as being the first chinese book about western cultures, which was authored by robert morrison, a missionary of london missionary society, and published in guangzhou, in 1811. compared with the first period of communication, during the communication between chinese and western cultures, the former was always a passive receiver. this fact was reflected in the reference to "conflict-reaction" in western sinology, which was accepted by western scholars for a long time, and especially stands out today against the expanding globalization of economies. wenda gu is an artist steeped in traditional chinese culture, and his experiences as part of the contemporary chinese art movement, and the fact that he emigrated to a western nation, have allowed him to achieve an acute and profound understanding of a variety of complex realities that underlie modern cross-cultural communication. it lends the artist a dual critical consciousness of western culture and of his own native culture. on the other hand, it represents the artist's strong feeling of responsibility towards the re-construction of his native culture. in the *forest of stone steles*, the artist undertakes a visual reproduction of modern cross-cultural communication, via his preferred creation of ironic icons.

since its completion, the *forest of stone steles* has only been exhibited in a handful of locations in australia, america and hong kong, china. this exhibition is the first to display the entire series of works. equally, this is the first solo exhibition to be held at the oct contemporary art terminal since its founding in 2005. the exhibition takes the theme of "cultural translation" as its subject, and intends to explore the cultural meaning of this monumental works. at the same time, it seeks to present scholarly perspectives on the topic by important figures from

436

則在以此為契機引申出文化界、藝術史界、藝術
批評界對這一命題的學術關注，本書收藏的中外
著名學者的論文和展覽期間召開的「翻譯與視覺文
化」國際研討會，使展覽的價值遠遠超出了我們的
預期。

2005 年 8 月 31 日
摘自何香凝美術館 OCT 當代藝術中心編、黃專主編：
《文化翻譯：谷文達〈碑林 —— 唐詩後著〉》，（廣
州：嶺南美術出版社，2005 年），第 13-14 頁。

the fields of cultural studies, aesthetics and art criticism. essays
authored by many well-known chinese and foreign scholars have
been collected in this book, and will be presented at the
international seminar entitled "translation and visual culture" to
be held during the exhibition. we hope that this will provide a
valuable experience of wenda gu's art for all those afforded the
opportunity to attend.

august 31, 2005
from *translating visuality: gu wenda: forest of stone steles,
retranslation & rewriting of tang poetry* p.277-278, edit
by ocat contemporary art terminal of he xiangning art
museum, editor-in-chief: huang zhuan, (guangzhou:
lingnan fine arts publisher, 2005)

谷文達《碑林 —— 唐詩後著》的「紀念碑性」和「反紀念碑性」| 巫鴻

MONUMENTALITY AND ANTI-MONUMENTALITY IN WENDA GU'S FOREST OF STONE STELES - RETRANSLATION AND REWRITING OF TANG POETRY

wu hung

何謂「紀念碑性」（monumentality）？我曾經把這個概念與常規意義上的「紀念碑」（monument）加以區別。[1] 後者常指公共場所中那些巨大、耐久而莊嚴的建築物或雕像，其被稱為「紀念碑」是由於它們的外在的尺寸、質地和形狀。任何人在經過一座大理石方尖塔或者一座青銅雕像時總會稱其為「紀念碑」，儘管他對於這些雕像和建築的意義可能一無所知。「紀念碑性」則是使一座建築、一個雕像或任何一個物件，具有公共性紀念意義的內部因素，或可以說是這些物質形態所包含的「集體記憶」（collective memory）。早在 20 世紀初期，著名的奧地利藝術史家、理論家阿洛伊斯・里格爾（alois riegl）在其《紀念碑的現代崇拜：它的性質和起源》一文中就提出紀念碑性不僅僅存在於「有意而為」的慶典式紀念建築或雕塑中，所涵蓋物件應當也包括「無意而為」的東西以及任何具有「時間價值」（time value）的物品，如古文明遺址或陳舊發黃的

what is monumentality? i wish to distinguish this notion from the term monumental in the common sense[1]. the latter generally refers to those huge, enduring and solemn buildings or statues, which because of their physical size, quality and form are called monuments [or monumental]; anyone passing a marble obelisk or broze statue habitually refers to it as a 'monument', even if he or she has no knowledge about the meaning of these statues or buildings. monumentality refers to an integral element, which lends a building, statue, or any large-scale structure a common commemorative meaning, or refers to the collective memory contained within these physical models. early in the 20th century, in his *modern worship of monument: its nature and origins*, the famous austrian art historian and theoretician, alois riegl, suggested that monumentality is not just represented by buildings or statues of a celebrated type that are specifically intended to commemorate something, but that the range should also contain examples that were not deliberately conceived as such, as well as anything that accrues value through time such as the remains of ancient civilizations

重要歷史文獻。[2] 從另外一個角度，美國建築學家約翰‧布林克霍夫‧傑克遜（john brinckerhoff jackson）注意到在美國國內戰爭後，舉國上下要求把葛底斯堡戰場宣佈為新建國家的紀念碑：「這是一件前所未聞的事，一片數千英畝遍佈農莊道路的土地，成了發生在這裏的一件歷史事件的紀念碑。」這一事實使傑克遜提出「紀念碑可以是任何形式」，它不必是一座令人敬畏的建築，甚至不必是一件人造物：「一座紀念碑可以是一塊未加工的粗糙石頭，可以是諸如耶路撒冷斷牆的廢墟，甚至可以是一棵樹或一個十字架。」[3]

何謂「反紀念碑性」（anti-monumentality）？這個概念是和前衛藝術的反權威、反傳統的傾向緊密相聯的。上文說到「紀念碑性」使一座建築、一個雕像或一個物體成為集體記憶的承載物，而傳統意義上的紀念碑，往往體現了政治和宗教權威對集體記憶的控制和塑造。「紀念碑性」（monumentality）一詞的拉丁字根是 monumentum，意思是「使人回憶，並訓誡之」。為了能起到訓誡的功能，官方紀念碑常常是莊嚴雄偉、非個性化的建築，其龐大體量控制所處的公共空間。法國學者喬治‧巴塔伊（georges bataille）因此把這類紀念碑稱為對抗人性的「堤防」：「正是在大教堂或宮殿這樣的建築形式中，教會和國家得以教誡群眾，並使他們靜默。」[4] 因此，以「叛逆者」自居的前衛藝術家把紀念碑作為一貫的攻擊物件也就可以理解。實際上，我們可以說任何類型的前衛藝術都有顛覆官方紀念碑和紀念碑性的傾向。這些藝術家中的一個例子是美國現代藝術家克雷斯‧奧登伯格（claes oldenburg）。他設計了一系列「反紀念碑」，包括模仿華

or important historic documents[2]. viewed from another standpoint, john brinckerhoiff jackson, an american architect, noticed that after the civil war, a request came from across the nation to pronounce the gettysburg battlefield a national monument: "never before has a glebe of many thousands acres, across so much farmland and roads been transformed into a monument to an historic event such as happened here". this fact made jackson decide that "a monument could be of any form"; it does not have to be a formidable building, not an artifice; "a monument could be a rough stone or a log; it could be the relic of the ruined wall in jerusalem; it could even be a tree or a cross"[3].

so what is anti-monumentality? this notion is linked closely with the anti-authority and anti-tradition of avant-garde art. as mentioned above, "monumentality" makes a building, a statue or an object a carrier of collective memory, but traditionally, monuments reflect the control and shaping of collective memory by political and religious authorities. the latin root of monumentality means recalling and admonishing. in order to exercise the function of admonition, official monuments always are awesome, majestic and inhuman buildings; their huge mass quality controls the public space in where it is placed. therefore, french scholar george bataille called such monuments as dikes antagonizing humanity. "it is through the forms of cathedrals and palaces, that the church and the state can admonish the common people, and keep them silent"[4]. so it is understandable that avant-garde artists, in their stance as rebels, treat the monument as a persistent object of attack. actually, we can say that all types of avant-garde art has a tendency to topple official monuments and monumentality. an example of such an artist is claes oldenburg, a modern american artist. he designed a series of anti-monuments, including a huge pair of scissors which imitated the washington monument. he explained this project thus: "obviously, these scissors imitate the washington monument in form,

盛頓紀念碑的一把大剪刀。對這個設計他解釋說：「顯而易見，這把剪子在形態上是模仿華盛頓紀念碑的，但同時也表現出一些饒有趣味的差異，如金屬和石質的區別，現代的粗鄙和古意之盎然的不同，以及變動和恆定的對立。」[5]

這種「反紀念碑」的話語系統因此是以兩個因素為基礎的，一是顛覆傳統紀念碑的物質性，包含尺度、質地、形狀以及這些物質因素所象徵的永恆、宏偉和靜止等觀念；另一個是顛覆傳統紀念碑的「紀念碑性」，主要是它們的權威性、公眾性和所凝聚的社會秩序和政治準則。在中國當代藝術中，對「反紀念碑」的追求成為文革後藝術的一個重要現象，其社會和政治原因不言而喻。仔細分析一下其代表作品，可以看到這種追求基本沿兩個方向進行，一個是創造「對抗性紀念碑」（counter-monuments），另一個是嘗試真正的「反紀念碑」（anti-monument）。[6] 前者通過轉化官方紀念碑以顛覆傳統的紀念碑性，其結果是新的、個性化的紀念碑的出現。後者則否定任何紀念碑形式，通過這種否定以獲得絕對意義上的「反紀念碑性」。前者的代表作包括許多在長城上進行的實驗藝術計劃，其原因明顯在於長城的傳統象徵性，作為中國的首要象徵而世界聞名的這個古代建築，實際上代表了現代中國的自我政治認同和歷史認同。比較而言，可稱為「反紀念碑」的作品在數量上要少得多，主要的原因是這種作品必須是相當徹底的概念藝術，形式本身成為被解構的物件。

but at the same time presents some interesting differences, such as the difference between metal and stone, between urbane modern style and exuberant archaism, as well as the confrontation between flexibility and rigidity"[5].

the linguistic system of this anti-monumentality thus depends on two factors, i.e. the corporality of toppling traditional monuments including size, quality and shape, as well as ideas of immortality, grandiousity and stillness, which these physical factors present; another factor is overthrowing the monumentality of traditional monuments, principally their authority and public presence, and the social orders and political rules which converge in them. within contemporary chinese art, the pursuit of anti-monumentality became an important phenomena of post-revolutionary art, and its political and social causes speak for themselves. analysing closely their magnum opus', we see that artists carry out this pursuit in two directions. one is to create counter-monuments, and the other is an attempt to achieve real anti-monuments[6]. the former topples traditional monumentality by subverting official monuments; as a result of which there emerges a new form of personalized monument. the latter rejects any form of monument, and achieves a sense of absolute anti-monumentality through this rejection. the magnum opus of the former includes the many experimental art projects that have been sited on the great wall, and its cause clearly responds to the traditional symbol of the great wall: as the principle symbol of china, this famous ancient building actually represents a political and historic identification with modern china. relatively, the works that could be termed anti-monumental are few in number, because such work must be entirely conceptual, and the form itself becomes the object of destructive exercises.

谷文達是中國當代藝術中最早和最深入地對「反紀念碑性」進行嚴肅探討的藝術家之一，對這一潮流的出現和發展作出了重要的貢獻。早在 80 年代中葉，他創造了第一批「造字」作品，對傳統書法藝術進行解構。他的純熟剛勁的篆字，一方面保存了書法藝術對形式美的追求和對傳統文化的指涉，但它們似是而非、無法閱讀的字體又摒棄了書法的表意功能。由於書法被文人藝術家奉為傳統書畫藝術的基礎，也由於篆書與「碑刻」關係密切，常常是法定文獻的專用媒介（如青銅器銘文和秦始皇詔書等），谷文達的這批作品具有突出的反權威和反紀念碑的意義，成為「85 新潮」中最有影響力的觀念藝術作品之一。

谷文達從 90 年代初開始創作的《聯合國紀念碑》反映了這種反權威傾向的一個新發展：這一大型裝置系列在顛覆傳統紀念碑的同時，樹立了新型的「對抗性紀念碑」。與克雷斯‧奧登伯格的觀念相似，他拋棄了傳統紀念碑的物質性和所特有的威懾感和永恆性，而是選擇了人體最無意義的遺留——頭髮——來創造一系列獻給不同民族與種族的「紀念碑」。與奧登伯格不同之處在於谷文達真正地實現了他的計劃；而由於這些計劃常常是史詩般的鴻篇巨製，其發人深省之處就不僅是某種單純的觀念或設想，而是「對立性紀念碑」本質中的種種悖論（paradoxes）。悖論之一在於谷文達對「視覺景觀」（visual spectacle）的迷戀。和他早期的「造字篆書」類似，形式感（visuality）和戲劇性（theatricality）常常是這些作品最使人震撼的因素。我們可以說這種對視覺的興趣是所有「對立性紀念碑」所共有的，但是谷文達的「視覺景觀」以否定

wenda gu was one of the first artists to probe deeply the realm of anti-monumentality, and make an important contribution to the emergence and development of this trend. early in the mid-1980s, he created the first series of word-formation works, deconstructing traditional calligraphy. his skillful and powerful seal scripts retained their focus on calligraphy in line with conventional forms of beauty and traditional culture, but their specious and unreadable scripts spurned the function of traditional calligraphy to express meaning. this is important because calligraphy is esteemed on the basis of traditional calligraphy and painting techniques, whilst seal script has been closely linked with inscription, and is always treated as a special media of legal documents (such as bronze inscriptions and emperor qin's inscriptions), wenda gu's series invokes a clear, implicit sense of anti-authory and anti-monumentality, and thus became one of the most influential forms of conceptual art in the '85 new art movement.

the *united nations* monuments, which wenda gu began to create from the beginning of the 1990s, reflectcd a new development of this tendency of anti-authority: this series of huge installations challenges traditional monuments, meanwhile establishing a new type of antagonist monument. similar to claes oldenburg's idea, wenda gu abandons the corporality of traditional monuments and their overawing sense of the eternal, choosing instead the most meaningless relics from the human body, i.e. hair, to create a series consecrated to different peoples and races. the difference from oldenburg is that wenda gu was able to see his project through to the end, whereby, due to the magnificence of these monumental forms, people are encouraged to think not only of a specific fine idea or concept, but also a variety of paradoxes in the nature of antagonistic monuments. one of these paradoxes is wenda gu's obsession with visual spectacle. similar to his early word-formation seal scripts, visuality and theatricality are the most convulsing factor of these works. we can say that this interest in visuality is common to all antagonistic monuments, but wenda gu's visual spectacle

永恆性為前提：頭髮組成的文字和圖案如同巨大空間中的水墨痕跡，了無重量和實體。

悖論之二在於這一系列作品對民族、種族和國家這些集合性觀念的堅持；有的計劃（如《中國香港紀念碑》）仍然為紀念重大歷史事件而創作。但是如果說傳統紀念碑所表現的是政治或宗教權威對這類「集體性」（collectivities）的表現，谷文達使用了從當地理髮館收集來的頭髮以象徵無數「個人」的集合。如此眾多的頭髮甚至在觀眾心中喚起一種悲劇的意味，似乎它們代表的不是生命而是死亡；似乎這些「紀念碑」所紀念的並非是英雄和史詩般的民族史和國家史，而是無數人對這些歷史的獻身和犧牲。在這一點上，谷文達的《聯合國紀念碑》和林瓔（maya lin）設計的華盛頓國會大廈前的《越戰紀念碑》相似。

從這裏我們可以進而思考《碑林 —— 唐詩後著》的邏輯和意義。谷文達從 1993 年開始構思這個作品，歷時 12 年到 2004 年最後完成。因此它的創作實際上是和《聯合國紀念碑》重疊的，二者反映了藝術家的想像力和創造性的不同方面，其關係和異同也只有把它們放在一起分析才能看清。首先，這兩個作品都是史詩性的製作，在規模和視覺的震撼力上相互匹敵。二者也都可以被看成是出類拔萃的「對抗性紀念碑」作品，在顛覆傳統紀念碑的同時，締造對人類文化的個性化的紀念碑式表現。但這兩個作品又有重要不同，一個重要差別是它們的物質性和視覺性（visuality）。如果說《聯合國紀念碑》是虛的、飄渺的、無實質性的，《碑林 —— 唐詩後著》則是實的、堅厚的、沉重的。這種材料和視覺上的差別來自於它們不同的、相輔相成的紀念物件，如果說《聯合國紀念碑》以

makes the rejection of the eternal a precondition: the scripts and patterns formed of hair are like imprints of water and ink placed in a huge space, without weight and substantiality.

the second of the paradoxes manifest within the work is the perseverance of collective ideas of nation, race and state; some projects (for example, *hong kong, china monument*) were created for the memory of important historic event (the hong kong handover in 1997). if it is said that traditional monuments present the expressions of political or religious authority on such collectives. wenda gu used the hair collected from local barbers to symbolize a collection of endless "individuals". so much hair evoked a sense of tragedy for the viewers, as if the works were less about life, than about death; and these "monuments" do not commemorate heroes or epic national or state history, but the self-devotion and sacrifice of many people for these histories. on this point, wenda gu's *united nations* is analogous with the vietnam war monument designed by maya lin and erected before parliament in washington.

we can think further about the logic and meanings of *forest of stone steles - a retranslation and rewriting of tang poetry*. wenda gu began to conceive of this project in 1993, and twelve years later in 2004, it was finished. so its invention actually came in parallel with the *united nations* project, both reflecting the different aspects of artist's imagination and creativity, and their relationship, similarities and differences can be understood clearly through a comparative analysis of them. firstly, the two projects required an epic production process. both take on similar dimensions and visual dynamism. both could be considered supereminent antagonistic monuments; the embodiment of monumental expression at a time when traditional monuments are being challenged in a trend towards personalizing human culture. however, there are important differences between these two works, the first of which lies in their corporality and

世界為框架，《碑林》在我看來實際上是谷文達為中國文化樹立的個性化紀念碑。而由於藝術家本人植根於這個文化，並與這個文化有着極其複雜的關係，這個作品對傳統紀念碑性的解構和對「反紀念碑性」的建構也就更為艱辛而曲折、深刻而荒謬，具有《聯合國》系列無法比擬的深度。

這個作品的兩個主要靈感來源——「碑林」和「唐詩」——都和中國傳統的紀念碑性有密切聯繫。谷文達對此並不諱言，因此在為這個計劃所寫的介紹中開宗明義地說：「在中國歷史上有許多重要的碑林。碑林是中華民族的一部燦爛的史實與史詩。她也是一個精彩而豐富的博物館。她集歷史、文化、藝術和技術於一體，而西安碑林是其中輝煌的典範。」同樣，在他看來唐詩是和「碑林」比肩的中國文學遺產，「歷代對唐詩的註解和解讀無計其數。」把《碑林——唐詩後著》定位為「當代碑林」和對唐詩的「獨一無二的解讀和闡譯」，谷文達明顯地把這個作品和中國文化中的紀念碑傳統連在一起。

但如果因此說谷文達的作品「屬於」這個傳統的話將是一種錯誤。三個主要證據表明他在繼承傳統的同時也在對傳統進行批判和擴充。首先，他對「碑林」的理解並不停留在傳統的概念上。中國傳統文化中對碑的研究和鑒賞，集中在碑文的歷史價值和藝術價值，很少考慮由普通工匠完成的對碑的製造和拓印。但是在谷文達的概念中，「碑林」的重要性在於它是一系列文化創造、發明和傳承的契機。他的這項計劃因此包括了對製作石碑和拓片的完整錄影記錄：從採石到雕鑿，從上墨到拓印，觀眾目睹了整個計劃的逐步完成。我們甚至可以說這是中國歷史

visuality: if the *united nations* would be considered as illusory, dimly discernible and non-material, *forest of stone steles - a retranslation and rewriting of tang poetry* should be actual, stable and heavy. these material and visual differences come from the different objects each seeks to commemorate-if the *united nations* was framed with the world, in my opinion, *forest of stone steles* is personalized monument that wenda gu has erected for chinese culture. because the artist is rooted in this culture and retains close links to it, this project's deconstruction of traditional monuments and construction of anti-monumentality is more difficult, zigzagging, deep and absurd, and imbued with a depth that the *united nations* could be incomparable.

two inspirations of this project - a *forest of stone steles and tang poetry* - are also linked with the monumentality of chinese tradition. as we see in his own introduction to this project, wenda gu supports this: "there are many important forests of stone steles in chinese history. the *forest of stone steles* is a splendid historic and epic fact of chinese nation. it is a fine, rich museum. it centralizes history, culture, art and technology. similarly, in his opinion tang poetry is a comparable relic of chinese literature: "there are numerous commentaries on and explanations of tang poetry from many dynastic periods." obviously, wenda gu positions *forest of stone steles: retranslation and rewriting of tang poetry* as a "contemporary forest of stone steles", and as a unique commentary and re-translation of tang poetry, thus linking this project with the monumental tradition in chinese culture.

but, it would be a mistake to say that gu's project "belongs" to this tradition. there are three principles present that suggest he inherited the tradition while criticizing and expanding it. above all, his understanding of the *forest of stone steles* doesn't rest on traditional notions. the study and appreciation of steles in chinese traditional culture focuses on the historic and artistic value of stele inscriptions; the production and rubbing

上首次對造碑、勒銘和拓碑的完整記錄，其結果是「碑林」在谷文達的作品具有了一個新的含義：它不僅僅是以往輝煌中華文化的象徵，而且也是今日中國文化的組成部分，繼續與人的生活和勞動相聯繫。它不但是一個歷史遺跡和博物館，而且也是實驗藝術家獲取靈感的源泉，被再創造為當代藝術中的一個個性化作品。值得提出的是，雖然很多當代藝術作品是由普通勞工完成的，但是這些人的貢獻很少被提及。谷文達的錄影所記錄的不但是作品實現的過程，而且是作品完成過程中的人與人的關係，《碑林——唐詩後著》因此也具有了傳統碑林所不具備的公共性和民主性。

第二，雖然稱之為「碑林」，谷文達並沒有模擬傳統石碑的形式。中國古代用來記功頌德的石碑是一塊豎直厚重的石板，立在龜趺或其他形狀的基座上。石板兩面刻碑文，記載儒家經典、皇帝詔書，以及各種法定或紀念性文獻。樹立於官府、學宮、寺觀及墓地等場所，它們成為宣傳的手段和觀摩的物件，著名的碑文被人們反覆拓印模擬，作為學習書法或文體的楷模。但是谷文達的「碑林」卻並非由這種典型的石碑組成。他所設計製作的是一塊塊平躺在地上的石板，四周雕以花邊，向上的一面刻着文字。這種石刻的原型是歷史上的「墓誌」，大約在漢代以後發生，至隋唐之際變得極為流行。與立在公共場地的石碑不同，墓誌是埋葬在墳墓中的，上面所刻的文獻也從來不是儒家經典和政府詔書，而是死者個人的傳記。雖然谷文達沒有解釋他為甚麼採用墓誌這種形式，但是在熟悉中國傳統藝術的觀者眼裏，他的碑林具有和傳統碑林非常不同的形象和意義。如果說著名的西安碑林集

of steles by common craftmen are barely given consideration. but in gu's concept, the importance of the *forest of stone steles* depends upon it being perceived as the turning point of cultural invention, creation and inheritance. his project therefore includes a complete documentary video of the production and rubbings of the steles: from the quarry to the carving studio, from the ink to the rubbing, viewers discern the progression of this project. even we can say that, it is the first time the complete document of production, carving and rubbings of such stele has been produced, and as a result, the original forest of stone steles has a new within meaning in gu's project: it not only symbolizes the passing splendour of chinese culture, but also parts of contemporary chinese culture, continually linked with the life and work of the common people. it is not only an historic relic and muscum, but also the source for an experimental artist's inspiration, re-created as a personalized work of contemporary art. it is worth nothing that, while many contemporary art works are executed by assistants or artisans, until now the contribution of these persons was rarely acknowledged. gu's video records not only the production process, but also the relationship between the people involved in the process. therefore, forest of stone steles has a communal and democratic feel which the traditional forest of stone steles lacks.

secondly, while he calls his work forest of stone steles, wenda gu didn't imitate the form of the traditional steles. traditional steles were made from a heavy, vertically up-ended stone block, erected upon a foundation. there are inscriptions on both sides of the stone stele, recording confucian classics, emperors' inscriptions and all kinds of legal and commemorative documents. these were erected in officially designated locations, in schools, temples and cemeteries, and became instruments of propaganda, the object of viewing and emulating— famous stele inscriptions might be used to make repeated rubbings and copies and became the model of studying calligraphy and writing

中了歷代建於地上的著名公共石碑的話，《碑林 —— 唐詩後著》所喚起的似乎是對地下、對封閉空間以及對死亡的想像。

第三，不管是地上或地下，是石碑或墓志，也不管上面所刻的是經典、詔書還是墓誌銘，在傳統文化中，這些石刻文字都被認為是標準的或結論性的歷史證據，在堅硬的石頭上「勒銘」本身就是對歷史不可變異性的肯定。但是谷文達在《碑林 —— 唐詩後著》每一塊碑上所刻的文字恰恰具有完全相反的意旨，所表達的不是歷史的結論，而是作出結論的不可能性。用他自己的話來說，從這些碑文中人們所經驗的是「一種新文化在其形成過程中所經歷的荒謬性、諷刺性和迷茫的困境」所認識到的是「不同文化之間的翻譯的『不精確性』或『無法精確性』到底會產生何種現象和結果。」在我看來，這是《碑林 —— 唐詩後著》中「反紀念碑性」最明確和最強烈的體現，也最反映出藝術家的個人認同和對當代世界的觀察，值得細緻分析。

《碑林 —— 唐詩後著》包括 50 塊碑，每塊碑上刻有一首著名唐詩的四種不同形式，表現了三種不同類型的連續轉譯：

1）刻在碑右方的是唐詩原文和以「意譯」方式翻譯成的英文本。谷文達採用的中文和英文本都是最通行、「大眾化」的版本，摒棄了學究式的考釋。中文唐詩以標準的仿宋體書寫；英譯出自 witter bynner 的《玉山》（the jade mountain），是一部較早的「普及性」英文唐詩譯本。

styles. but gu's forest of stone steles is not made of these typical steles. the project he designed involves stone steles horizontally laid down on the ground, carved with patterns, and incised with scripts in the upper face. the antitype of this stele in the historic epitaph, which emerged after the han dynasty, and became popular in the sui and tang dynasties. different from the steles erected in public places, the epitaph steles were buried in tombs, the inscriptions carved upon them were neither confucian classics nor government inscriptions, but an obituary for the deceased. while wenda gu does not explain why he employed the form of epitaph steles, in the eyes of viewers familiar with the traditional chinese sculpture, his steles have a physique and meaning different from traditional steles. if we say that the forest of stone steles in xi'an pivots on a collection of those famous public steles sited overground, then *forest of stone steles - a retranslation and rewriting of tang poetry* seems evoke an impression of the underground, of closed-in space, and death.

thirdly, no matter whether over- or underground, upright stone stele or horizontal epitaph, as well as being either inscribed with the classics, historical inscriptions or obituaries, these carved inscriptions in traditional culture were considered as standard or conclusive evidence of history-carving in hard stone itself is an affirmation of the immutability of history. however, wenda gu's carved inscriptions on each of the stele in this project have an opposite intention; not to express an historic conclusion, but the impossibility of concluding. in his own words, from these steles one can experience "the absurd and ironic predicament of a new culture in the course of formation" and recognize the phenomena and result which the imprecision and the impossibility of being precise within cross-culture translations engenders. in my opinion, it is the most absolute and profound expression of anti-monumentality in *forest of stone steles*, further reflected in the artist's personal identification and observation of the contemporary world. it is worthy of further analysis.

445

2）刻在碑中心的主碑文隨即以「音譯」的方式把 bynner 的英文唐詩重新翻譯成中文，谷文達將這種譯文稱作「英語音類比漢字」。但是這個模擬過程不是機械的，而是具有很大的主觀能動性。谷文達選擇了近似英語發言但具有特殊意義的漢字，使得非文學性的音譯具有閱讀的可能性。同時，他用來書寫這些「類比漢字」的字體也是經過自己改造過的漢字。因此，主碑文在形式和內容都顯示出一種模棱兩可，似是而非的性質，似乎是某種轉化過程的仲介階段，蘊含了進一步轉化的可能性。

3）刻在碑右方的文字是以「意譯」的方式把主碑文重新翻譯成英文。雖然仍然具有很大的偶然性和非邏輯性，翻譯的結果進一步增加了主碑文的可讀性，將其從混亂、荒謬的單字集合轉化為具有明確語法規則和文學意味的文學寫作。

根據谷文達自己的介紹，這一系列轉化所顯示的是語言轉譯的不精確性和文化的不可翻譯性。對他來說，這種不精確性和不可轉譯性，是當今世界全球化過程中的一個普遍困境。他寫道：「創製當代碑林，這是我移居美國六年之後所產生的一個想法。此一時期，世界不同文化，特別是美國的多元文化經歷了前所未有的『身份危機』和『身份重新認可』，從所謂的美國主義到亞洲時代。隨着世界政治、經濟形態的變化，我們正在經歷一場文化中心主義和世界邊緣主義的變革與重組。」結合上面所引他對「碑林」民族象徵意義的談論，我們可以清楚地認識到《碑林——唐詩後著》中「紀念碑性」和「反紀念碑性」的實質：一方面這是一個具有深厚歷史感的紀

forest of stone steles: a retranslation and rewriting of tang poetry comprises fifty steles, with four different forms of tang poetry carved on each of them, all achieved through three sequential translations of different types as outlined here.

1. the original tang poetry and english text were translated based on literal meanings and carved on the right of the steles. gu employed the most popular and common version of the chinese and english texts of these poems, and abandoned the scholarship of critics. chinese tang poetry written in standard fang song script; the english translating texts were from witter bynner's *the jade mountain,* a popular early english translation of tang poetry.

2. the principle inscriptions carved in the centre of the steles comprise the chinese text re-translated from bynner's english translation based on the sound of the poem. gu called this translating text as english sounds simulating chinese characters. but this simulating procedure is not mechanical: it is vulnerable to subjectivity. wenda gu selected the chinese characters to resemble closely the english sounds but which have some special meaning that allowed the phoenetic translation the possibility of being read. meanwhile, the characters he employed for writing these simulated chinese characters he reconstructed himself. therefore, the principle inscriptions manifest a quality of cutting both ways, and in their speciosity, seem a mid-phase in the process of being transformation, thus impling the possibility of further transformation.

3. the text carved in the right side is the english translation re-translated from the principle inscription and based on the meaning. while there is still are a high chance of illogicallity, the result of translating further enhances the readability of the principle texts in the center of steles, and transforms it from being a puzzle or an absurd collection of single characters into a literal writing with defined rules of grammar, and literary sense.

念碑式作品，凝聚谷文達的傳統文化修養和他對中國文化的敬意。另一方面這也是一個富於當代性的解構主義（deconstructive）作品，反映了他對宏觀敍事、全球化的深深懷疑。其結果是理想主義和危機感的一個「紀念碑」式的綜合，也是在這個意義上，《碑林 ── 唐詩後著》成為谷文達所希望達到的「一個正在演變的時代在文化上的紀實。

摘自何香凝美術館 OCT 當代藝術中心編、黃專主編：《文化翻譯：谷文達《碑林 ── 唐詩後著》（廣州：嶺南美術出版社，2005 年），第 35 至 40 頁。

巫鴻，藝術史家、藝術批評家、策展人。芝加哥大學教授兼任芝加哥大學斯馬特美術館顧問策展人。為美國藝術與科學學院和美國哲學學會的成員，也是美國和中國許多研究機構及博物館的董事會成員。在中美及其他國家已策劃 60 餘個展覽。

wu hung, art historian, art critic and curator. harrie a. vanderstappen distinguished service professor of art history, at the university of chicago. he is director of the center for the art of east asia and adjunct curator at the smart museum of art. he is a member of the american academy of arts and sciences and the american philosophical society. he sits on the boards of many research institutes and museums in the united states and china. he has curated more than sixty exhibitions in the us, china, and other countries.

according to wenda gu's own introduction, this imprecision and untranslatability have become a common puzzle in the course of modern world globalization to him. he wrote: "creating a modern *forest of stone steles* is an idea that came to me six years after i emigrated to the usa. during this time, different world cultures, particularly american multiculture, experienced a crisis of identification and re-identification, from so-called americanism to the era of asia. with the changes of world politics and economics, we are experiencing a transformation and re-combination of culture-centralism and world brinkmanship". combined with his above discussion of the significance of symbolic nationalism, we can see clearly the nature of monumentality and anti-monumentality in wenda gu's *forest of stone steles: a retranslation and rewriting of tang poetry:* this is a monumental work has a profound sense of history, agglomerating gu's traditional culture education with his respect for chinese culture. on the other hand, this is a deconstructive work full of modernity, reflecting his deep suspicion of the broader macroscopical complexities of narration and the forces of globalization. the result is a monumental integration of idealism amidst a sense of crisis. and just in this sense, *forest of stone steles: retranslation and rewriting of tang poetry* becomes exactly that "cultural document of an age of transformation" wenda gu set out to achieve.

from *translating visuality: gu wenda: forest of stone steles, retranslation & rewriting of tang poetry* p.295-300, edit by ocat contemporary art terminal of he xiangning art museum, editor-in-chief: huang zhuan, (guangzhou: lingnan fine arts publisher, 2005)

注釋

1 wu hung, monumentality in early chinese art and architecture. standford: standford university press, 1995, p4。

2 a. riegl, the modern cult of monuments: its character and its origin, k. w. forster and d. chirardo 譯，k. w. forster 編，monument/memory, oppositions，第 25 期，1982。關於對其理論的討論，見 forster 和 a. colquhoun 在該期刊中的文章。

3 j. b. jackson, the necessity for ruins. amherst: university of massachusetts press, 1980, p91, 93。

4 g. bataille, architecture (1929). d. hollier, against architecture: the writing of georges bataille. cambridge, mass: mit press, 1992, p47。

5 b.haskel, claes oldenburg: object into monument. pasadena, california, 1971, p59。

6 我對這個問題在《中國當代藝術中的當代性》一文中有較詳細的討論。巫鴻：《作品與展場：巫鴻論中國當代藝術的當代性》（廣州：嶺南美術出版社，2005）。

notes

1 see wu hung, monumentality in early chinese art and architecture. stanford: stanford university press, 1995, p4.

2 a. riegl, the modern cult of monuments: its character and its origin, translated by k w. forester and d. chirardo 1903. see k w. foster ed., monument/memory, opposition (special edition) vol. 25, 1982. the discussions of his theory, see forster and a colquhoun's articles in this issue.

3 j. b. jackson, the necessity of ruins. (amherst: university of massachusetts press, 1980) p91,93.

4 georges bataille, architecture (1929). see d. hollier, "against architecture: the writings of georges bataille "(cambridge, mass: mit press, 1992). p47.

5 b. haskel, claes oldenburg: object into moment (pasadena, california, 1971). p59.

6 my further discussions on this topic in "contemporaneity of chinese contemporary art", see wu hung, works and exhibition saloon: wu hung's essays on modernity of contemporary chinese art (guangzhou: lingnan art publishing house, 2005).

文達四目——
谷文達造碑記

程征

FOUR-EYED WENDA GU—HOW WENDA GU CREATES HIS STELES

cheng zheng

生長於滬杭，定居於紐約，雲遊於天下的谷文達未曾預料，他的藝術運道竟與古都西安有特殊緣分。其一，移居美國之前，他的首次、也是他在中國本土唯一的一次個人畫展是在西安舉辦的；其二，20 年後，他的大型裝置藝術工程《碑林》在西安歷時五年鐫刻完成。

在 20 世紀 80 年代，圍繞中國畫如何向現代轉型的問題，展開了一場全國範圍的大討論。1986 年 6 月，由我和劉驍純等人策動，中國藝術研究院美術研究所與陝西國畫院等單位，聯合在西安附近的楊陵主辦了一次頗有影響的「中國畫傳統問題學術研討會」。造成影響的原因，一部分來自各種觀念的碰撞，一部分來自同時舉辦的谷文達、黃秋園兩位相當極端地體現「現代」「傳統」這兩種不同藝術價值觀的畫家個展。那時，谷文達年方 30，是 85 新潮藝術家的典型代表。劉驍純在 1986 年 8 月 18 日出版的《中國美術報》發表《谷文達首次個人展簡記》，述之甚詳：

wenda gu, who grew up in shanghai and hangzhou and who now has settled down in new york city, and who has been rambling in the world at large, may never have anticipated that his art would be bound to the ancient city xi'an. before he moved to the united states, his first, and only, solo exhibition in china, was held in xi'an. recently, twenty years after that exhibition, his large-scale installation *forest of stone steles* was completed in xi'an after five years' work.

in the 1980s a national debate on the transition of chinese painting to modern times was launched. in june 1986, initiated by myself and liu xiaochun, the institute of fine arts under the china art research academy and shaanxi academy of chinese painting jointly sponsored an influential symposium on the tradition of chinese painting. the influence partly came from the collision of different ideas, and also from wenda gu and huang qiuyuan's solo exhibitions simultaneously held then - gu displayed the values of "contemporary" art and huang stood for the value of the "tradition". wenda gu, only thirty years old at the time, was a representative of the " '85 new art movement". liu xiaochun introduced in detail wenda gu's art in his *a brief record of wenda gu's first solo exhibition*, published in *china fine arts journal* on 18 august 1986:

在西安美術家畫廊舉辦的谷文達作品展，分為公展和觀摩展兩部分。公展部分是他的寫意中國畫和書法，這批作品，傳統功力和開拓精神兩個方面都得到了相當普遍的公認。但谷文達當前更傾心的卻是他的「觀摩展」，因為這部分更強烈地實現了他的近期追求和創作衝動。這部分不可避免地引起了極大爭議，展出方式就是對爭議的必要妥協。谷文達稱觀摩展為文字系列，展覽是一次性的，它是特定環境中的整體設計，是宣紙水墨畫、書法、文字、符號、篆刻、幾何構成物等等合成的神秘空間。高大的展廳為縱向深入的長方形，迎門是兩排七條從天頂直垂地面的巨幅畫，縱深處還影襯着四條。條畫無襯，隨氣流而微微晃動。坐落在條畫正中的是一個近人高的金字塔形構成物，背向展廳入口處的一面敞開，「塔」的內壁拼貼着谷文達作畫時的各種行為照片。展廳的四周展壁是他的巨幅作品，中心展壁以他的篆刻為主，展廳一角隔出一間配電室，外壁構成了特殊的展壁，展覽中有人們較熟悉的巨幅《靜觀的世界》、《西部》等作品，這些已逐漸為一些人接受的水墨畫被谷文達視為前一階段的東西。谷文達強烈的反叛精神也表現為對自我的反叛，排筆刷寫的「正、反、錯、漏」等標語字和朱紅圈叉符號混入書法和繪畫，是這次展覽最具自我反叛精神的因素。

the exhibition of wenda gu's works held in the xi'an artists' gallery consists of two parts, one for public display and the other for a restricted audience. the former displays his free-hand chinese painting and calligraphy that have been generally acclaimed for his sound grounding in traditional arts and the daring spirit in which he is blazing new trails. however, wenda gu favours his exhibits for the restricted audience, because these works more forcefully manifest his latest efforts and his impulses in creation. inevitably, this part has aroused intense disputes. the mode of display is a result of necessary compromise with the dispute. wenda gu calls this part "series of writing". it is a one-time show only. created for the specific venue, it is a mysterious space made up of ink-and-wash on the water-absorbent xuan paper, calligraphy, writing characters, signs, seal carving and geometrical figures. the giant exhibition hall is a rectangular space extending to the far end. facing the door are two rows of huge vertical paintings, each row having seven. at the deepest end are four hanging scrolls that are not mounted. they swing in the air. at the centre of the hanging scrolls is a pyramid-like object of a man's height. it is open to the entry of the exhibition hall and on the inner walls of the "pyramid" are photos showing wenda gu's different poses while painting. on the walls round the exhibition hall are his huge paintings. the central wall mainly displays imprints of the seals he carves. a corner of the exhibition hall is partitioned for power distribution. the exterior walls of the ward serve as the special exhibition space for his huge paintings "world of silent watcher", "west" and others. those ink-and-wash paintings that have been accepted by some people are regarded by wenda gu as belonging to the last stage of his creation. the strongly rebellious spirit of wenda gu also manifests itself in his rebellion against himself, as exemplified by the catchwords "obverse, reverse, error, and leakage" written with a broad brush, and circles and crosses in cinnabar mixed in calligraphic works and paintings, elements of the most obvious rebellion against the artist himself displayed in this exhibition.

當時，谷文達未必知道，展廳前方約 500 米的地方就是古碑林立的中國書法聖殿《碑林》，正與他的「文字系列」隔街相望。在那裏，有一通格外古樸的《倉頡廟碑》。倉頡者，皇帝史官，漢字之祖，後人神之，曰：「倉頡四目」。谷文達的「文字系列」在震動觀眾心魄的同時，似乎也警醒了祖神，在冥冥中與文達相通感。不然，若干年後，谷文達怎麼會突發奇想，也要在這裏新造一座《碑林》！一個與西安《碑林》有所關聯，又並非古《碑林》之延續，而是觀念和形式全新的現代《碑林》。

1999 年深秋，谷文達從紐約寫信給我，表明他想在西安創製現代《碑林》的夙願，希望得到我的幫助。其所以選擇西安，除了文化根脈，材料和技術也是重要原因。他曾在西安《碑林》，伴着拓工傳拓碑帖的節奏聲，端詳油黑發亮的碑石，欣賞刻工鐫刻複製某些名碑的精良藝技，而作身臨其境的體察與構想。他確信他的計劃只能在西安實現。因為在這裏具備製碑的兩個重要條件：一、出產古人刻碑專用的青石；二、作為一種傳統，刻碑技藝會在當地民間世代傳承。

谷文達的《碑林》含 50 塊 190 厘米 ×110 厘米 ×20 厘米，每塊重 1.3 噸的大型石碑；碑側環繞龍蛇鱗片紋飾；碑面拋光，光潔度 70°；平臥置陳，而不同於樹立的古碑。經過調查，選定了當地出身於刻碑世家的何印潮、宏潮兄弟倆為鐫刻技師，他們皆為身手不凡之良工，曾為西安碑林博物館復刻古碑而不失真；有關石料與鐫刻碑文的品質，由碑林博物館的碑石專家楊智忠先生監理；總體

at the time wenda gu might not necessarily know that 500 metres ahead of his exhibition and across a street was the forest of steles, a sacred palace of chinese calligraphy. in the forest of steles is an old and simple-formed stele for cang jie's temple. cang jie was historian for the legendary ruler huang di (or, erroneously translated as "yellow emperor") and believed to be creator of chinese characters. he has been deified and people say he had four eyes. while giving the audience a shock, wenda gu's series of writings seems to have aroused the ancestor's spirit from under the earth who communicated with gu. otherwise, how can wenda gu have hit on the idea of building *forest of stone steles*, that is related to the former forest of steles in xi'an but not a continuation of the old forest. it is a forest of steles of our time, entirely new ideologically and formally.

in late autumn, 1999, wenda gu wrote to me from new york saying that he wanted to create forest of stones steles in xi'an and fulfill his long-cherished wish. he hoped i could help him. beside cultural considerations, he chose xi'an from consideration of the availability of materials and as the source of techniques. he once watched the pitch black steles while hearing the rhythmic tapping of the artisans taking rubbings, and admiring the superb skill of those workers. he was sure only in xi'an could he realise his plan. because xi'an meets two important requirements: first, granite, a stone for steles, is produced there, and second, there the skill of stone carving must have been handed from generation to generation.

wenda gu's *forest of stone steles* consists of 50 stones, each measuring 190 cm in length, 110 cm in width and 20 cm in thickness, and weighing 1.3 tons. the side of each stele is decorated with scale-shaped patterns. the surface of the steles are polished with a 70 degrees of smooth finish. they are laid flat, unlike the ancient stones that stand upright. after a survey, i chose local carvers the brothers he yinchao and he hongchao who had been raised in a family that had been stone carvers for generations before them. both skilled carvers, they once reproduced ancient steles with accuracy for the xi'an museum of forest of steles. the quality of stone and the carving of the epitaphs was to be supervised by yang zhizhong, an expert on steles in the museum. the manager of chang'an decoration co,

事務皆委託長安裝飾有限責任公司經理劉雁鴻承攬操辦。從此，谷文達夢想的《碑林》開始變成現實。

經過幾次往返，終於採集到第一塊石樣，是參照西安碑林漢唐古碑的選材，從 100 公里外的老礦開採的一種被稱作「墨玉」的上等青石。它剛柔適度，既利刀又堅韌，細細拋光，玉質黑亮，雖千年而不易損。

2000 年 1 月，谷文達得知喜訊，急忙來信，說：

> 得悉石塊樣板已落實，非常高興。我又擔心這 50 塊大石是否能落實。另外，我不急於馬上刻石，要待我再行西安看了石料再定具體設計稿。我一月份中下會去西安看石料，希望此次能見到刻工，並能看看石工的樣板刻石。這樣，我可以回來後即設計。每個步驟必須一板一眼，每一程式都達指標，然後生產。我三月底會再行中國的，所以每次去中國完成一個程式。我想，如果一切順利，三月份後即可順利製作了。

信中所說的「擔心」，是指石乃自然生成，並非工業產品，從山中開出這許多大石，本已不易，50 塊石板的質地、紋理、色澤等欲求一模一樣是不可能的，能做到儘量一致，已是奢望。對於採石，沿用人工，嚴禁爆破作業，以防暗裂。有時，開採一塊大石出山，運抵坊中，打磨拋光，準備鐫刻之

ltd, liu yanhong was entrusted with the whole project. at that time, wenda gu's dream of forest of steles began to be realised.

after several tours, the first sample of stone was collected. it was chosen with reference to the stone used for han- and tang-dynasty steles in the forest of stones steles of xi'an and was collected from an old mine hundred kilometres away. it was a top-quality granite nicknamed "black nephrite". this stone is of proper hardness and when polished it is black and bright and does not wear off even after a thousand years.

on hearing this good news in january 2000 wenda gu hurriedly wrote me a letter saying,

> *on hearing that the sample stone has been collected, i am pleased. at the same time, i'm worried if fifty huge stone blocks will be possible. i will not make haste to carve the stone. i will not make the draft until i see the stones in xi'an. in mid- or late january i will go to xi'an and see the stone. i hope i will be able to see the stone carvers and have a look at samples of stones carved by them. then, after i come back i will design my project. each step must be prepared carefully and each procedure should meet certain criteria. only then will i begin my project. by the end of march i will go back to china again. i will finish the plan for a procedure in each of my visits to china. if everything goes smoothly i imagine after march the carving of the stones will begin.*

what worried him, as he mentioned in the letter, was the procuring of the stone. stone is a natural material and not an industrial product. it is not easy to quarry huge stone blocks from mountains and impossible to have fifty steles with the same constituents, grains and colour. one can only do at one's best. stone was quarried manually; blasting was strictly forbidden, so as to avoid any flaws within the stone. sometimes a stone is quarried from the mountain, carried to the workshop and polished, ready for carving and only then cracks are discovered and the stone has to be rejected. so only a small proportion of

時，才發現隱有裂紋而只得放棄，故採石的成功率比較低。這樣大的批量和苛刻的要求，對於一位藝術家來說真是一項浩大的工程，在西安碑林的千年刻碑史上恐怕也是少有的；古人製碑，一通而已。

六月間，《碑林》的文本創意終於構思成熟，谷文達在信中說：

> 《碑林》的文本我有幾套方案，一直定不下來，又一直在研究。現在剛剛定下來，很滿意，等我法國回來就可以開始寫了。現在的觀念和方法是：唐詩的最好的英譯本為基礎，再以唐詩的英譯文的讀音選擇中文字，從英語的聲音再翻回中文。舉例：「晨露」譯成英語為 morning dew 然後用英語的發音再譯為中文。我選擇的中文卻成了：「摸耳寧肚」。這裏有許多文化、問題上的觀念。主要的碑文是英文、唐詩的發音，再譯回中文。註腳是：1、中文原唐詩；2、唐詩英譯；3、英語唐詩的發音譯回中文；4、以英語發音譯回中文的「唐詩」再譯成英文。

隨着設計稿陸續寄來，刻碑工作全面展開。碑面兩側用印刷體刻中、英文唐詩原文，主碑文則由谷文達親筆楷書大字「摸耳寧肚」之類「唐詩的英譯文的讀音選擇中文字」。本來，他的融入了「仿宋體的硬朗俊秀和篆書之圓潤渾厚」的正楷書法，向來為人所稱道，那是從小在奶奶的督促下苦練而成的，有童子功。每一塊碑石拓 50 張拓片，一共 2500 張。

quarried stone is usable. the scale of the project and the exacting requirements for stone is exorbitant for an artist. such a project may be exceptional even in the thousand-year history of stele carving. in ancient times, a stone caver usually carved only one stele for once.

in june the texts for *forest of stone steles* were well conceived. wenda gu said in a letter:

> i had several plans for the texts and have been pondering which plan to put into practice. i've just decided the plan to use and i am happy with it. i will begin to write the texts after i return from france. my method is as follows. choose the best translations of tang-dynasty poems and transliterate the english texts into chinese. for example, the chinese transliteration of the english phrase "morning dew" would mean "stroking the ear and pinching the belly". here many cultural issues are involved. the texts are the english translations of the tang-dynasty poems and their transliteration in the chinese language. the annotations will comprise: 1. original chinese texts of tang dynasty poems; 2. english translations of those poems; 3. chinese transliterations of the english texts, and 4. english interpretation of the chinese transliterations.

as texts were sent, the steles were being carved in full swing. the sides of the steles are carved with the chinese and english texts of the tang-dynasty poems, and the main texts of the steles carry the chinese transliterations of the english translations in large regular script characters such as "stroking the ear and pinching the belly". his regular script calligraphy has been applauded for its vigour and neatness derived from the block prints and roundness and smoothness of the seal script. he has achieved this calligraphy through hard work under the supervision of his grandmother in his childhood. from each stone fifty rubbings are made, and 2500 rubbings have been made.

453

當夢想變成可以觸摸的真實存在的時候，那是人類所能享受到的一種最大的創造快樂了。面對一塊又一塊陸續完竣的碑刻，谷文達往往撫石而作更燦爛之遐想：

 —— 能在碑林博物館廣場作開幕式就太棒了！古今碑林的對話。

 —— 邀請50名不同膚色的人，一齊在開幕式上為新碑打拓片。

 —— 每一套拓片裝訂成一本大書。

《碑林》的創構，體現了谷文達慣常的藝術創作方式。從創意的萌生到全域細節的確定，是在作品創製的全過程中完成的，這是一個動態的、漸次生發的、逐漸完善的、時刻處於積極創造狀態中的過程。這一經歷數年的時空過程，也是藝術家「一直在觀察、吸收、思考和包容不斷演變的世界文化」的過程。他的大腦就像一旦啟動即不知停歇地運轉的強大發動機，不斷地提出新的設想，又不斷地改變原有的設想，逐漸接近並終於到達理想目標。

《碑林》的楷書採用谷氏自創的漢字結體。這是一種新穎的「只有上下部分，而無左右邊旁」的結體。這一種新體字，凡識漢字者，稍揣摩皆可釋讀。他在文字王國中藝術地創構，有點像漢字初創時的情狀。許慎所謂：「古庖犧氏之王天下也，仰則觀象於天，俯則觀法於地，視鳥獸之文，於地之宜，近取諸身，遠取諸物，於是始作易八卦，以垂憲象。及神農氏，結繩為治而統其事，庶業其繁，

the moment when a dream is to be converted into tangible existence is the most blissful for any human. facing the just-finished steles, wenda gu sank into a much more brilliant fantasy —

it would be great if the opening ceremony of his stele exhibition was held in the square in the museum of forest of steles. it would be a conversation between the ancient and contemporary forests of steles.

fifty people of different colours will be invited to make rubbings from the new steles in the opening ceremony.

each set of the rubbings will be bound into a volume.

……

the structure of forest of stone steles reflects wenda gu's habitual manner of art creation. the initial conception and all details have been fulfilled during the execution of the whole work. it is a dynamic, gradually perfecting and always active process. through this process that lasted several years, the artist was always observing, assimilating, pondering over and embracing the constantly evolving world culture. his brain is like a powerful motor that once started will never stop turning. it incessantly offers new ideas and at the same time continually change them, until the objective is approached to and attained.

the regular script used in forest of stone steles is created by wenda gu himself. it is a new writing that consists of only the upper and lower radicals but no left or right ones. those who know chinese character can interpret wenda gu's characters only with a little conjecture. his original artistic creation in writing system is in a way like the birth of early chinese characters. xu shen (ad 58 - 147), the author of interpretation of writing (shuo wen jie zi), says:

in olden times when fu xi reigned in the world, he watched the heavenly bodies above him and observed the patterns of things on the earth below. he also scrutinized the trails of birds and animals on the ground. he took his own body that was near and

飾偽萌生。黃帝之史倉頡，見鳥獸蹄迒之跡，知分理之可相別異也，初造書契，百工以乂，萬品以察，蓋取諸夬。」而谷文達在他的《碑林》中創造的當代「書契」，則是在意讀我們當代社會中人種、政治、科學與文化的特殊共性：「文化的進出口」、「文化的異化、反異化、互相異化」和「文化的互相消費」等等仰觀、俯觀、近取、遠取的過程中創造的。

倉頡四目，文達亦四目？

原文出自何香凝美術館 OCT 當代藝術中心編
《文化翻譯：谷文達〈碑林 —— 唐詩後著〉》
（廣州：嶺南美術出版社，2005 年），77-80 頁。

other objects in a distance as the measurements and thus created eight trigrams to give the legal signs of things. by the time of the chieftain divine farmer, people tied ropes to keep records of the events. as more trades sprung up, deceits and forgery began to appear. cang jie, a clerk of the chieftain huang di, discerned the footprints of birds and animals and realized that their traces could be distinguished he created writing signs. different officials were administered and all matters were properly handled. this came from the trigram sign of "jue"... [a sign with one stroke of yang and five strokes of yin]

the contemporary writing signs of wenda gu in his forest of stone steles have been created while the artist "interprets the anthropological, political, scientific and cultural general characteristics of the contemporary world, namely, 'import and export of cultures', 'alienation, anti-alienation and mutual alienation of cultures' and 'mutual consumption of cultures', etc."

cang jie has four eyes. does wenda gu too?

from ocat contemporary art terminal of he xiangning art museum, *translating visuality: gu wenda: forest of stone steles, retranslation & rewriting of tang poetry* (guangzhou: lingnan fine arts publisher, 2005) p.333-336.

碑 林 ── 唐 詩 後 著

谷文達

FOREST OF STONE STELES-POST TANG POETRY

gu wenda

由伍拾塊石碑組成。每塊石碑尺寸為 190 厘米長 ×
110 厘米寬 × 20 厘米厚(75 英寸長 × 43.5 英寸寬
× 8 英寸厚),重 1.3 噸。設計於美國紐約,製作於中
國西安碑刻工作室,創作日期為 1993 年至 2005 年。

石碑的歷史淵源之壹

在中國歷史上有許多重要的碑林。碑林是中華民族
文明的壹部燦爛的史實與史詩。她也是壹個精彩而
豐富的博物館。她集歷史、文化、藝術和技術於壹
體。而西安碑林是其中輝煌的典範。位於西安市叁
學街的西安碑林,收藏了大量石碑和石雕,堪稱書
法藝術寶庫。

韓建縮建長安城時,就把已處於城外的唐代《開成
石經》等石刻,遷到韓建新城之內。公元 1103 年,
北宋京兆知府虞策,又將《開成石經》等唐代石刻和
其他碑刻,壹併遷於碑林現址,並大興土木,使碑

an installation, designed in new york, usa, and produced in gu
wenda's stone carving studio in xi'an, china 1993-2005. consists
of 50 hand-carved stone steles, each measuring 110cm × 190cm
× 20cm (75" long × 43.5" wide × 8" thick) and weighing 1.3
tonnes each.

HISTORICAL REFERENCE OF STONE STELES 1

there are many stone steles in china's history. the forest of stone
steles (碑林 bei lin), represents a brilliant epic of chinese
civilization. it is also a wonderful and rich museum which brings
history, culture, art and technology as a whole. xi'an's beilin
museum is an excellent example of a stele museum. located on
sanxue street in xi'an, the beilin museum has a large collection of
stone steles and stone carvings and can be described as a treasure
trove of steles.

when han jian built chang'an, he moved the "kai cheng stone
classics" (classical works cared onto stone tablets) there. from
the 1103 AD, yu ce, the governor of the metropolitan
prefecture(jingzhaofu) in northern song , relocated large-scale
tang dynasty's stone steles like kai cheng stone classics to the
location of the current beilin museum and constructed large-
scale buildings to extended the stele collection .during the

林初具規模，石刻藏品也不斷增加。明朝中期，這裏碑石數量相當多，碑林之名便正式出現。現時西安碑林已改名為西安碑林博物館。館內收藏漢代到民國的碑誌、石刻共壹千多塊，包括《叄藏聖教序碑》、《大秦景教流行中國碑》等珍貴碑刻。顏真卿、柳公權及于右任等法家的真跡，也可在此壹覽無餘。

石碑的歷史淵源之貳

中國自古以來就有精美的石刻以記錄歷代著名書法家的真跡名作。聞名於世的西安碑林即位於中國的拾餘朝古都西安。這些石碑記錄着中國歷史上許多著名書法家的真實可靠的書法真跡包括篆、隸、楷、行草書各種各樣的碑刻。它們不僅是用作墓碑，更重要的是石碑是中國藝術史上倍受讚譽的藝術形式之壹。同時，西安碑林還記錄了中國歷史上許許多多的大小事件。自元代宣紙被發明之後，人們便以宣紙和墨發明了精湛的石刻拓片藝術。自從拓片藝術的發明，石碑上完美的書法石刻藝術才得以廣為流傳。人們又把精湛的拓片藝術中國畫的單片和立軸畫，或裝訂成書。因此，多少朝代以來，中國人從這些拓印而成的書籍或畫冊中得以學習自己的歷史和文化。精湛的拓片亦成了學習古人書法藝術的範本。因此，它們被考古學家、歷史學家和藝術家視為極為珍貴重要的史料。時至今日，除了在博物館保存下來的書法真跡原稿之外，歷史上很大壹部分重要的書法藝術作品，唯有在一些精緻的拓印上窺見其當初的藝術風味。許多原始而珍貴的書法手稿已經失傳，但這些精雕細刻的書法石刻卻千古猶存。

middle of the ming dynasty. a large number of steles had been collected and the name of the " the forest of stone steles" emerged. now the xi'an forest of stone steles has already been named the xi'an beilin museum with over a thousand pieces dating from the han dynasty to the republican era including "foreword to the three holy teachings of the tripitaka," and "the nestorian monument." there remain many precious stone steles which record the calligraphy of yan zhengqing, liu gongquan and yu youren.

HISTORICAL REFERENCE OF STONE STELES 2

most of the precious stelae which feature the manuscripts of famous calligraphers and epitaphs of scholars and royal family members. the forest of stone steles is located in xi'an which was the ancient capital for over six dynasties. the forest of stone steles offers a concentrated archive of some of the most authentic historical calligraphy, including examples of all the script styles such as seal, running, official and standard scripts. not only are the steles grave-stones, but they are also one of the most celebrated forms of chinese art. at the same time, the stone forest also records many important events in chinese history. since the invention of "*xuan*" paper in the yuan dynasty, people began to use the technique of producing numerous copies of the calligraphy by making ink rubbings from the stone engravings. since the invention of rubbings, the wondrous art of calligraphy which was carved into the stone tablets could then be widely circulated. rubbings of single ink paintings and scrolls were also produced and bound as books. consequently, through dynasties and generations, the chinese have used these ink rubbings as books to learn about their history and culture. these have also become models for the study of ancient calligraphy, as extremely valuable historical materials by archaeologists, historians, and artists, who study and seek to reveal the truths of china's history and culture. even though some original calligraphy and manuscripts are preserved in museums today, for a large part of the historically-important calligraphic works, we can only see a glimpse of the original artistic flavour of these exquisite artworks, through rubbings. many of the original precious calligraphy works have been lost, but these finely carved steles will exist forever.

石碑的歷史淵源之叁

遺留至今的珍貴石碑多為來自於著名書法家的文章手跡、皇族與士大夫的墓誌銘。作為墓誌銘的形式亦廣為流傳於民間。在無數的古代石碑之中，有壹塊碑特別值得在此壹提的是大名鼎鼎的「無字碑」，即中國自古以來最有權勢的女皇武則天的墓誌銘。該碑碩大，不刻壹字，以誌她的功德無量，無法以文字來體現。多少歲月過去了，它默默無聲地站立在武則天墓道的壹邊，宣揚着壹代女皇無窮無盡的野心和至高無上的權力。它是壹塊獨壹無貳的墓碑和傑出的觀念藝術作品。即使是在今天亦可謂是壹件大手筆的前衛之作。女皇武則天之後，豎立無字碑竟然成為明清各代封建官僚競相採用的墓誌銘形式，如何銘文石刻才足以記述他們壹生的「功過是非」和「豐功偉績」。

當代《碑林 —— 唐詩後著》的形成

創製當代碑林，這是我移居美國陸年之後所產生的壹想法。此壹時期，世界不同文化，特別是美國的多元化文化經歷了前所未有「身份危機」和「身份重認」，從所謂的「美國主義」到「亞洲時代」，隨着世界政治與經濟形態的變化，我們正在經歷壹場「文化中心主義」和「文化多元主義」的變革與重組。壹句話，這是壹個風起雲涌的時代。我的當代「碑林」的創製是基於我們賴以生存的 20 與 21 世紀交替的時代背景下，在不同的政治與社會、科學與文化之間的交流和衝突之間，依據中國碑刻的經典形式。

HISTORICAL REFERENCE OF STONE TABLETS 3

most of the precious steles which feature the manuscripts of famous calligraphers are epitaphs of scholars and royal family members. the epitaphs, as a form, were also widely popular within folk culture. one tombstone in particular, stands out from china's most famous engraved stones, it is called the "wordless memorial tablet." this blank memorial is to commemorate the tang dynasty empress, wu zetian, the most powerful woman in chinese history. the monument is so large and there is not one word engraved on it, which demonstrates her endless charitable and pious deeds (as a buddhist) which could not be represented by words. for many years it stood silently by the road leading to wu zetian's tomb, as a symbol of the endless ambition and the supreme power of a generation of queens. wu's tombstone is a unique and outstanding conceptual piece of art. it remains a vanguard in the world of art even today! the wordless stone tablet later became a popular form of tablet for the feudal bureaucrats in the ming and qing dynasties, when people were at a loss to come up with inscriptions which would represent the lives of the rulers, their triumphs and failures and the contributions to the spirit of the motherland.

THE ESTABLISHMENT OF A CONTEMPORARY *"POST-TANG POETRY FOREST OF STONE STELES"*

i had the idea to create a contemporary forest of stone steles six years after i immigrated to america. beginning in this particular period of time, the world's different cultures, especially within predominantly multi-cultural societies, experienced an unprecedented "identity crisis" and attempted to "re-identify themselves" in places like america. from americanism to the asian era, along with the forms of economic and political change, we have been undergoing a transformation and re-combination of cultural centralism and cultural marginalisation. in a word, it is a turbulent era. my *forest of stone steles* project was created at the turning point of the 20th century under the presence of different political and social and scientific exchanges and clashes between cultures. *forest of stone steles* inherited the

但我的當代碑林以及碑林的碑文「唐詩後著」不是中國古代碑林之延續，而是從壹個側面去譜寫當代史 —— 壹個正在演變的時代在文化上的紀實。在我的碑文中，可以意讀我們當代社會中人種、政治、科學與文化的特殊共性：「文化的進出口」，「文化的異化 —— 反異化 —— 互相異化」，和「文化的互相消費」，這是當代文明的壹部史實與史詩。

特別要指出的是我從 1993 年開始構思、創作、製作當代《碑林 —— 唐詩後著》此壹龐大的計劃至今，已經過了拾貳個年頭。前後伍拾塊石碑文即《唐詩後著》的翻譯的比較中，正楷書法的結體等有壹個演變的過程 —— 從探索到臻於完美。《碑林 —— 唐詩後著》又與我的另壹規模浩大、至今亦進入第拾貳個年頭的藝術工程《聯合國》一樣。拾貳年的時間對於《聯合國》的創作是壹個開放性結構。在此拾貳年的時間內，創作一直在觀察、吸收、思考和包容不斷演變的世界文化。所以我們可見「拾貳年」在此已不只是壹個時間概念了，它確實成作品觀念的壹部分了。

為何稱為《唐詩後著》？

其壹，歷代對唐詩的批註和解讀無計其數。我們注意到任何壹種批註和解讀，都與解讀者所處的時代戚戚相關，而歷代對唐詩的批註和解讀已經不能解釋文化的「出口」與「進口」現象了。與任何壹種歷史上的批註和解讀不一樣，我的「唐詩後著」儼然是獨壹無貳的的解讀和闡譯。把唐詩作為壹種文化、歷史、社會的符號，且置於東西文化的大背景中，

chinese classical stone stele format, but it is not an exact continuation of the tradition. rather from one side, we can see them as composing a documentary, on the cultural evolution of the times. from my inscriptions, we can see the commonalities of modern-day historical facts and epic stories, of politics, race, science and culture of "cultural imports and exports," "cultural alienation-counter-alienation and mutual alienation," and "mutual cultural consumption."

i would like to mention, in particular, it has been 12 years since i originally thought about the project conception, initiating the materialization of its production of *forest of stone steles post-tang poetry* in 1993. on one hand, the translation concept and the calligraphy style of the text of the 50 stone steles have gradually been developing as its production continued — a process in search of perfection. *forest of stone steles — post-tang poetry*, is similar to another large-scale art project of mine that has been continuing for 12 years, on the other hand, like another one of my ongoing art projects, *the united nations,* which also began in 1993. the ongoing nature of the project has become a concept in itself and a method of forming an open structure to observe, absorb, and deliberate the changing world. so we can see that "12 years" is already not a concept which focuses on only one particular time, it is also part of the concept of the work.

WHY CALL IT "POST-TANG POETRY"?

firstly, there have been so many kinds of interpretations of tang dynasty poetry through the centuries. we can recognize that all these annotations and interpretations are highly related to the times and places where the interpreters lived and none of the historical interpretations can explain issues of cultural imports and exports. like any historical interpretation, my *post-tang poetry* is a cultural, historical and social symbol of the interaction between east and west, as filtered through different languages (linguistic and cultural translation is a convenient

特別是通過外語（即外國文化）的過濾（不同語言和文化之間的翻譯是壹種過濾器，去清理掉它種文化中我所不需要的成分）。在後現代主義和後殖民主義之後的今天，把《碑林 —— 唐詩後著》僅僅作為壹種單壹文化和僅僅作為文學上的解讀，那麼就限制了我《碑林 —— 唐詩後著》的本質意義了。

其貳，這伍拾塊石碑的碑文是壹個象徵性地對於我們時代的新文化的檢驗。旨在展示壹種特殊文化形成的可能性，並同時展示形成的原因和形成的過程。這伍拾塊石碑其中的任何壹塊碑文，均展現了壹種在不同文化間的交流與衝撞、認同與誤解的壹個旅程，和我們所處的文化「進出口」、「異化 —— 反異化 —— 互相異化」和「互相消費」的現實。

其叁，我們可以檢驗壹種新文化在其形成過程中所經歷的荒謬性、諷刺性和迷茫的困境。其次，它亦揭示出公眾的狂熱和盲目，從如何可以使壹種文化誤解誤譯蛻變為我們社會的壹個偶像符號。而這壹現象卻造成了「波普」藝術的震憾力。例如，中國餐館「簽語餅」的發明地是在美國，之後「簽語餅」卻成了代表中國文化極為流行的象徵物。而「簽語餅」只是最近才在中國出現。我們從這裏學到了甚麼？這就是中國文化在異國「消費」和「再生」，然後再「出口」中國。從另外壹個角度來看，中國原本沒有「簽語餅」文化，現在「進口」了不屬於中國文化的「中國文化」。我的《碑林 —— 唐詩後著》的主碑文「後唐詩」是以原唐詩的英譯本的「音譯」譯回到漢語並組成「後唐詩」，下文我將具體介紹碑文的翻譯。

filter to eliminate the things we do not want from others). in the post-colonial, post-modern world, to read *forest of stone steles — post-tang poetry* through a single culture, or to read it in a literary way, limits the essential meaning of the piece.

secondly, steles are a symbolic examination of our new contemporary culture. i am aiming to show the possibilities of a unique cultural form, while at the same time showing the causes and process of its formation. any one inscription on these stone steles shows the realities of the communication conflicts that occur between different cultures, the journey of recognition and misunderstanding, and the location of cultural "imports and exports," "alienation — anti-alienation, mutual alienation" and "mutual cultural consumption."

thirdly, by reading the retranslation and rewriting of texts on the stone steles, we experience the satire, absurdity and confusion and understand the predicament in a process of shaping a new culture. the texts also promote the idea of how public fanaticism and blindness and cultural mistranslation can be transformed into a social icon. this phenomenon was a real shock to "pop art." for example, the fortune cookie, which was invented in america became a popular symbol of chinese culture, but only recently has this chinese symbol appeared in china. what we have learned from this is how chinese culture was consumed and reinvented in a foreign land and then exported to china. china didn't originally have a fortune cookie culture until it imported this chinese cultural icon. post tang poems are in my *forest of stone steles* inscription script. they become contemporary poems after they are phonetically retranslated back to chinese from the english version of tang poems. what follows in the next paragraphs is an exploration of this work.

《碑林──唐詩後著》的碑文

不同語言之間的翻譯，無論「直譯」或「意譯」，其本質上的「不精確性」或「無法精確性」，導致了不同文化之間的「不可翻譯性」的實質 —— 如果我們僅依據翻譯的「不精確性」或「無法精確性」為原則。而《碑林 —— 唐詩後著》碑林肆系這龐大的計劃所要展示的不僅僅如此，她更重要的是向大家展現壹個問題，即不同文化之間翻譯的「不精確性」或「無法精確性」到底會產生何種現象和結果。基於我一直強調的是人類知識是各種各樣對自然物質世界的誤解的總和。就這樣壹個哲學觀點來解釋，實際上我們可以這樣說，人類的知識即成了藝術化了的自然物質世界。

眾所周知，構成文字的兩個基本要素是字意與字音。而詩歌的聲音部分遠比日常語言的發音重要得多，它是詩歌藝術性不可分割的部分。因此，從傳統的角度來看，詩歌簡直是無法翻譯的。就唐詩翻譯成為英語後，其層次豐富的內涵、完美的藝術手法卻變成了簡單的句子。故傳統的詩歌翻譯僅僅是文字內容的翻譯。這樣壹個困境卻使我產生了壹個慾念，如果我從唐詩的英語譯文以音譯的方法重新譯回漢語，並由我選適當的英語發音的同聲漢字來構成新詩，這可完成了在特殊意義上的「完善」。我所創造設計的「複合漢英翻譯法」的過程如下：

壹，從漢語的唐詩翻譯（通過意譯）成英語唐詩。

THE *"FOREST OF STONE STELES-POST TANG POETRY"* INSCRIPTIONS

no matter if it's "paraphrasing," or "literal translations" between two different languages, the essence of "inaccuracies" or the "inability to be precise" leads to the nature of "un-translatability" between different cultures if we are basing this solely on the "imprecise" or "inaccurate" principles of translation. the text of *forest of stone steles — post tang poetry* project does not only try to convey that, but more importantly, it expresses the kind of "inaccurate" phenomenon that results from an attempt to translate other cultures. it is based upon my theory that mankind's knowledge is the sum of a continuous stream of misunderstandings of the material world, and human knowledge in general is nothing but an artistic interpretation of the material world.

as we all know, sound and meaning are the two basic elements which comprise text, and the sound of words in poetry is far more important than in the sound of language we use for daily life. it is an inseparable part of the artistry of the poem. according to more traditional esthetics, a poem simply cannot be translated into another language. we can see from the english versions of tang poetry: the layers of richness in the contents, the wonderful artistic technique and style become mere sentences. the traditional translation of poetry can only convey the contents of the text. this predicament inspired me to envision a wonderful idea: to translate phonetically from the english version of the tang poem back to chinese, by selecting chinese words which mimic the english pronunciation as a vehicle to reconstruct the new poems in chinese. it completes the special perfection of the meaning of the translation of tang poetry. the following is an example of the process of my invention complex chinese-english translation:

1, original tang poem in chinese — (translated through literal meaning) — becomes an english version of the tang poem

貳，由唐詩英文譯本再翻譯（通過音譯）回漢語並組成漢語後唐詩。

叁，再由漢語後唐詩（通過意譯）成英語「後唐詩」。

這樣的翻譯方法論，使壹首唐詩在不同文化之間來回地輪番翻譯後創造出了完全不同的詩歌，即我通過「複合漢英翻譯法」所創作的「唐詩後著」，我稱之為「後唐詩」。

通過上述的分析，現在我們可以比較清晰地了解《碑林 —— 唐詩後著》龐大而複雜的創作生態了。我的《碑林 —— 唐詩後著》想要說明的是當不同的種族與文化接觸之際，「誤解」不僅僅是壹種現象，它是壹種必然，而我在這兒要着重指出的是「誤解」是必須的。《碑林 —— 唐詩後著》就是用我所創造的「複合漢英翻譯法」對唐詩的「誤解」而創作出來的。這豈不是用不同文化之間的「誤解」來做文章，並有目的的創造「誤解」，而後從有目的的創造出來的「誤解」中得出新的結論！

進而言之，從詩歌寫作的技術上而言，這壹「後唐詩」的形成不是以詩人的傳統方法，即想像力去寫詩。而是通過不同的文化和語言之間的「輪番誤解」而特設的方法論，它使你寫出想像力所無法企及的世界。可以想像，如果我將壹首唐詩在漢語和英語之間通過來回幾佰遍的「意譯」與「音譯」，會成為壹本異常的長篇小說。

2, english version of tang poem — (translated phonetically) — becomes a post-tang poem in chinese

3, post tang poem in chinese — (translated through literal meaning) — becomes a post-tang poem in english

through this process of multiple translations from chinese to english, i have made a "post-tang poem."

the huge and complex creative ecology behind *forest of stone steles — post tang poetry*. my *forest of stone steles — post tang poetry* was created using my "method of multiple translations between english and chinese" and the resulting misunderstandings. is this not a text produced by the "misunderstandings" between different cultures, and to draw new conclusions from these intentionally created "misunderstandings!

now that I have explained the aim of this project, i want to furthermore, according to the techniques of poetry writing, my "post-tang poems" are not formed by the traditional method of writing poetry — but through imagination. they are created through a unique process which i call an ad-hoc methodology of "misunderstanding," between language and culture, which allows us to write about a world beyond the typical human imagination and fantasy. imagine how the historical tang poem can be reinvented, both in english and chinese, by alternating the literal and phonetic re-translations hundreds of times until you have a totally new surreal novel!

《碑林——唐詩後著》的語音的翻譯

與簡單的音譯如「荔枝 -lychee」,「炒麵 -chow mein」,「kentucky fried chicken- 肯德基」,「mcdonalds- 麥當勞」,「disney- 迪斯尼」,「microsoft- 微軟」相去甚遠,我們亦常見商業廣告中另壹種以語言的讀音通過音譯到另壹種語言的讀音,並演譯出壹種對原意的闡述。以下舉例而言:漢語的「coca cola」即「可口可樂」讀音近似英語原讀音,同時也解釋了「coca cola」這壹軟飲料的味道,即「喝可口可樂,既可口又可樂」;另壹例子為「marlboro」的漢語音譯是「萬寶路」,除了漢語讀音模擬英語發音之外,也給「marlboro」帶來了浪漫美麗的聯想:「通向仟萬寶藏之路」。如此壹種語言的讀音通過音譯到另壹種語言的讀音,並演譯出壹種對原意闡述,而不僅僅只是壹種簡單的音譯,它是壹種觀念的翻譯與喜聞樂見的大眾文化結合的現象。它已成為「文化進口」與「文化出口」的象徵,是文化化了的大眾商業。這也是《碑林 ——唐詩後著》在觀念上的另壹體現:將傳統經典的文人藝術的哲學美學內涵與大眾藝術表現形式的結合。

《碑林——唐詩後著》的翻譯實例

整個《碑林 —— 唐詩後著》藝術工程為伍拾塊石碑,每塊石碑以壹首原唐詩為翻譯起點。唐詩的選擇又以流行普及的唐詩為主,然後從我選出的伍拾首唐詩找出對應的英語唐詩。我選擇的唐詩英譯本的唐詩叄佰首是在全美各地大學東亞系所

THE PHONETIC TRANSLATION OF *"FOREST OF STONE STELES"*

other examples of simple phonetic translation without involving the meaning from chinese to english are: 荔枝 (pronounced "li zhi," meaning the name of a fruit) — lychee; 炒面 (pronounced chao mian, meaning fried noodles) — chow mein. from english to chinese there are: "kentucky fried chicken — 肯德基" (sounds like ken de ji);" macdonalds — 麥當勞 "(sounds like mai dang lao); "disney— 迪斯尼 "(sounds like di si ni); "microsoft— 微軟 "(sounds like wei ruan) . . .it's also quite common for brand names to be transliterated into another language following the original sound of the source language. examples of this, from english to chinese are: coca-cola — 可口可樂 , (ke kou ke le: meaning to be tasty and be happy); and marlboro — " 萬寶路 " (wan bao lu, which means 10 thousand treasure road). for example, the chinese "ke kou ke le" mimics the english pronunciation, but it also explains the taste of coca-cola, a soft drink. the chinese translation of marlboro mimics the sound of the english word but also brings up romantic and beautiful associations: "the road of a thousand treasures." the sound of these words translated into another language which includes a description of the original meaning are not just simple transliterations but a phenomenon by which the translation of a concept is combined with popular culture. it has become a symbol of cultural "import" versus "export." it injects culture into the mass market. this is another concept of the *forest of stone steles*: the link which is formed between traditional scholarly aesthetics, philosophy, and pop art.

EXAMPLES OF "COMPLEX CHINESE-ENGLISH TRANSLATION" IN *FOREST OF STONE STELES*

the entire *forest of stone steles* project consists of fifty stone steles: one tang poem for each stone stele. i selected from the most popular tang dynasty poems for the project as a starting point, then selected the english version of the fifty poems where i found a corresponding english version. then i chose 300 poems which had been translated into english by a well-known american journalist, mr. witter bynner, called the "jade

採用的由著名的美國記者 witter bynner 的譯本《玉山》（the jade mountain）。

以「音譯」的方式將英譯本的唐詩譯回到漢語，此壹過程是極為複雜而冗長的。以下是肆個基本的翻譯程序：

首先，尋找出漢字其發音接近於英語的聲音。這些漢字稱為「模擬英語發音的漢字」。一般情況下，模擬英語發音，會出現許多同聲漢字。

其次，根據內容需要而選擇同聲漢字中的壹個字。

然後，這壹選出的英語音的模擬漢字又必須和前後英語音的模擬漢字組成壹個詞。

最後，這個詞又將與下幾個英語音的仿真漢字組成的詞構成壹句子。從而以這些英語聲音的模擬漢字構成了「後唐詩」。

例壹：漢語句「月光」的字面翻譯是「moon light」。「moon light」的英語音譯成為漢語是「moon = 虻，ligh = 癩，t = 忒」。「虻癩忒」的漢語拼音是 meng lai te，意為「虻蟲痲瘋的錯」。

例貳：「晨露」，將這壹漢語詞意譯成英語為「morning dew」。現在把「morning dew」按照讀音相近的音譯原則譯回漢語是為「mo= 摸，er= 耳，ning= 寧，dew= 肚」。這個從英語句子重新音譯回漢語的結果卻成了「摸耳寧肚」，即「摸摸耳朵平靜肚子」。

mountain," popularly used for studying in east asian studies departments across the u.s.

the phonetic translation to chinese from the english version of tang poems is a very complicated and lengthy process. the following are four steps describing the process of translation through transliteration and meaning:

first i looked for chinese characters whose pronunciation was close to the english words. i call these chinese characters that simulate english pronunciation. overall, there are a multitude of chinese characters with the same or similar pronunciations.

next, i chose homophonic characters based on the meaning of the word.

then, the chinese characters which emulate the sounds of the english words must be able to form a word with the other chinese characters emulating english words.

the final word is linked to the simulated chinese characters from the english sounds, which is put into a sentence. and the chinese characters which mimic the english sound become a new post-tang poem.

example 1: the literal translation of a chinese phrase 月光 or "moonlight"; the phonetic translation of moon light is as follows: moon= 虻, ligh= 癩, t= 忒. " 虻癩忒 " the chinese pronunciation is "mang lai te," meaning "gadfly leprosy error."

example 2: "chenlu" 晨露 translated to english is morning dew, now this english phrase morning dew retranslated back to chinese is through transliteration and therefore it becomes mo= 摸, er= 耳, ning= 寧, dew= 肚 ". the new chinese phrase becomes "mo-er-ning-du" 摸耳寧肚, which means "touching ear quiet stomach."

例叁：漢語句子「風竹林」意譯成英語為 bamboo forest in wind。但是當這個 bamboo forest in wind 再以英語的音譯方式譯回到漢語，此句子便成了「bam= 辦，boo= 不，fo= 法，re= 蚋，s= 死，te= 特，in= 淫，win= 吻，d= 蒂」，即「辦不法蚋死特淫吻蒂」意為「把不法的小蟲子置於死地，並特別過度地親吻果實的莖蒂」。

下面是叁首唐詩的完整譯文之壹：

《相思》

（唐）王維

紅豆生南國，春來發幾枝。

願君多採擷，此物最相思。

"one-hearted" by wang wei, tang dynasty
when those red berries come in springtime,
flushing on your southland branches,
take home an armful, for my sake,
as a symbol of our love.

以 witter bynner 的唐詩英譯本《jade mountain》之英語讀音的同聲漢字譯回成中文：

晚作詩來得拜睿寺，客目迎斯頗令歡。

婦樂形昂猶，受似攬得菩蘭姜色。

太闊泓岸啊！暮賦而福邁賽珂。

愛思啊，心波翱浮，謳舞而樂福。

（谷文達再譯成英文）

come to bairui temple for poetry reading at dusk,
welcomed and appreciated guest,
gleeful lady, high spirited feeling,

example 3: the chinese phrase "feng-zhu-lin" 風竹林 translated to english means bamboo forest in wind. when "bamboo forest in wind" is phonetically retranslated back into chinese, it becomes "bam= 辦, boo= 不, fo= 法, re= 蚋, s= 死, te= 特, in= 淫, win= 吻, d= 蒂" " 辦不法蚋死特淫吻蒂 " "ban-bu-fa-re-si-yin-wen-di" which means "making illegal gnat death, especially excessively kiss the base of fruit."

below there are three examples of tang dynasty poems.

complete translation of tang dynasty poem i

《相思》

（唐）王維

紅豆生南國，春來發幾枝。

願君多採擷，此物最相思。

"one-hearted" by wang wei, tang dynasty
when those red berries come in springtime,
flushing on your southland branches,
take home an armful, for my sake,
as a symbol of our love.

using the translation of the tang poem "jade mountain" by witter bynner into english, i then transliterated those english sounds into chinese characters in this poem below:

晚作詩來得拜睿寺，客目迎斯頗令歡。

婦樂形昂猶，受似攬得菩蘭姜色。

太闊泓岸啊！暮賦而福邁賽珂。

愛思啊，心波翱浮，謳舞而樂福。

(retranslated to english by gu wenda)

come to bairui temple for a poetry reading at dusk,
welcomed and appreciated guest,
gleeful lady, high spirited feeling,

like having orchid and sensual concubine.

vast heaven oh! deep shore,

poetising at dusk is a higher blessing than jade,

oh! love,

floating and soaring waves of the heart,

sing and dance my happiness.

唐詩的完整譯文之貳：

《夜思》

（唐）李白

牀前明月光， 疑是地上霜。

舉頭望明月， 低頭思故鄉。

"in the quiet night" by li bai, tang dynasty:

so bright a gleam on the foot of my bed-

could there have been a frost already?

lifting myself to look, i found that it was moonlight.

sinking back again, i thought suddenly of home.

以 witter bynner 的唐詩英譯本《jade mountain》之
英語讀音的同聲漢字譯回成中文：

搜捕癩禿，餓割狸羚，昂澤府的阿婦賣敗德。

哭的賊兒，還服病蛾，婦裸肆打惹弟。

樂夫亭靇塞埠，路客哀坊德，呫大窪是夢泪涕。

性可淫，拜客惡感，愛燒殺，蹬驪傲婦紅。

（谷文達再譯成英文）

tracking down its catch, leprosy, cuts the fox and
gazelle hungrily, as a woman sells bad morals in ang
pond mansion, her crying baby cunningly eats an illed
moth, the woman wantonly beat the child, who asked
for it. vails of haze over the happy man pagoda, a

like having an orchid and a sensual concubine.

vast heaven oh! deep shore,

poetising rhapsodizing at dusk is a higher blessing than jade,

oh! love,

floating and soaring waves of the heart,

sing and dance my happiness.

complete translation of tang dynasty poem ii

《夜思》

（唐）李白

牀前明月光， 疑是地上霜。

舉頭望明月， 低頭思故鄉。

"in the quiet night" by li bai, tang dynasty:

so bright a gleam on the foot of my bed

could there have been a frost already?

lifting myself to look, i found that it was moonlight.

sinking back again, i thought suddenly of home.

using the translation of the tang poem "in the quiet night" by
witter bynner into english, i then transliterated those english
sounds into chinese characters in this poem below:

搜捕癩禿，餓割狸羚，昂澤府的阿婦賣敗德。

哭的賊兒，還服病蛾，婦裸肆打惹弟。

樂夫亭靇塞埠，路客哀坊德，呫大窪是夢泪涕。

性可淫，拜客惡感，愛燒殺，蹬驪傲婦紅。

(retranslated to english by gu wenda)

tracking down its catch, leprosy, cuts the fox and gazelle
hungrily, as a woman sells bad morals in ang pond mansion, her
crying baby cunningly eats an ill moth, the woman wantonly
beat the child, who asked for it. vails of haze over the happy man
pagoda, a walker sucks the muddy water tears in her dreams, he
who comes along this road is sad in fangde, burning with the
desire to slaughter, the loose, haughty red lady rides on her horse

walker sucks the muddy water tears in her dreams, he who comes along this road is sad in fangde, burning with the desire to slaughter, the loose, haughty red lady rides on her horse to visit a friend.

to visit a friend.

complete translation of tang dynasty poem iii

唐詩的完整譯文之叁：

《夜雨寄北》

（唐）李商隱

君問歸期未有期，　巴山夜雨漲秋池。

何當共剪西窗燭，卻話巴山夜雨時。

"a note on a rainy night to a friend in the north" by li shangyin, tang dynasty
you ask me when i am coming. i do not know.
i dream of your mountains and autumn pools brimming all night
with the rain.
oh, when shall we be trimming wicks again, together in your
western window?
when shall i be hearing your voice again, all night in the rain?

《夜雨寄北》

（唐）李商隱

君問歸期未有期，　巴山夜雨漲秋池。

何當共剪西窗燭，　卻話巴山夜雨時。

"a note on a rainy night to a friend in the north" by li shangyin, tang dynasty
you ask me when i am coming. i do not know.
i dream of your mountains and autumn pools brimming all night with the rain.
oh, when shall we be trimming wicks again, together in your western window?
when shall i be hearing your voice again, all night in the rain?
using the translation of the tang poem "a note on a rainy night to a friend in the north" by witter bynner into english, i then transliterated those english sounds into chinese characters in this poem below:

以 witter bynner 的唐詩英譯本《jade mountain》之英語讀音的同聲漢字譯回成中文：

誘鰲時刻迷魂，隘門空明。

靄渡鬧踢駑，癌菌磨蝮藥。

虻騰煽毒燈，剖獅捕狸命。

鰲吶吐胃，逝者然。

哦！混血兒妣娶螟，尾蝌麝肝，酡屹日飲。

喲！

歪寺痛蚊抖，蚊笑鮞愛，婢害鯪。

鶓服蠍肆更，哪聽得嚷。

誘鰲時刻迷魂，隘門空明。

靄渡鬧踢駑，癌菌磨蝮藥。

虻騰煽毒燈，剖獅捕狸命。

鰲吶吐胃，逝者然。

哦！混血兒妣娶螟，尾蝌麝肝，酡屹日飲。

喲！

歪寺痛蚊抖，蚊笑鮞愛，婢害鯪。

鶓服蠍肆更，哪聽得嚷。

the soul is bewildered when the huge, legendary turtle is induced. grinding pit viper with cancer fungus, an inferior horse kicks at the misty harbour. rip open a lion to rescue the fox. the legendary turtle screams and throws up its stomach, then dies without pain. oh! an interracial baby is born with a tadpole tail and musk deer liver of the marriage between a slave girl and a snout moth's larva. the flea is flushed down with a day's drink. oh! in a leaning temple a wounded mosquito shakes and another laughs at a loving fish. a dead mother kills a pangolin. no scream is heard when hawk eats the lizard before dawn.

《碑林——唐詩後著》碑文的藝術設計

主碑文的正楷書法是我自創的結體。有關我的主碑文的正楷書法的觀念和結體是在這拾貳年的創作過程中逐漸完善起來的。這在最初幾塊石碑的碑文上僅略見端倪。傳統漢字構成的結構形式基本是由上下、左右邊旁構成字的形式。而我的主碑文的正楷書法的觀念主旨之壹，是讓每壹個漢字均統壹在壹個框架中，即構成漢字結構的只有上下部分，而無左右邊旁了。例如「叾」字和「去」字。我稱其為「華蓋天下法」。我的主碑文的正楷書法的觀念主旨之貳：漢字有許多邊旁是由漢字改變而成的，比如「走子邊」是從「走」字衍化而來的，具體為例：「迷」字的「走字邊」在我的楷書結體下變「趏」字。「提水旁」是由「水」字變化而來。但在我的楷書結體中「提水旁」還原到「水」字。如滿字改編為「𩆜」，稱此法為「還其真相法」。

(retranslated back to english by gu wenda)

the soul is bewildered when the huge, legendary turtle is induced. grinding pit viper with cancer fungus, an inferior horse kicks at the misty harbour. rip open a lion to rescue the fox. the legendary turtle screams and throws up its stomach, then dies without pain. oh! an interracial baby is born with a tadpole tail and musk deer liver of the marriage between a slave girl and a snout moth's larva. the flea is flushed down with a day's drink. oh! in a leaning temple a wounded mosquito shakes and another laughs at a loving fish. a dead mother kills a pangolin. no scream is heard when a hawk eats the lizard before dawn.

THE ARTISTIC DESIGN OF THE TEXT FOR THE *FOREST OF STONE STELES*

my stele script that i used for the main inscriptions in *forest of stone steles* was created by me. for more information about the concept and structure of these characters there is another appendix which explains this, but in short it has been gradually perfected over its 12-year period of production. the readers can see the development of my chinese character structure system from the introduction in the early stone steles to later ones. traditionally, many chinese characters are composed of components on left and right, top and bottom. one of the concepts of my work is that the character is unified within the frame, and it either becomes part of the top or bottom part or the right or left radicals of the character. for example, with characters like " 叾 " and " 去 ". also, i call them the "heavenly halo over earth method" 華蓋天下法 *"huagai tianxia fa."* the second main concept behind the method of calligraphy i use for my inscriptions is that characters are made up of many radicals (smaller components of the character), these create the character can also alter the meaning of a character. for instance, the radical for 走 *"zou"* (walk) is derived from the character 走 for walk, (but can also act as a radical for another character). specifically: i used the character 迷 "mi" (riddle) and then added the "walking radical" "zou" 走 to create the new character 趏 . i also used the "ti shui" (carry water) 提水 radical which was transformed into my kai script structure and became 水 "shui" (water) and 滿 "man"(full) was changed into the character 𩆜 . in a way, we might call this a method of returning to the truth.

石碑主碑文的正楷書法吸取與融合了傳統仿宋體的硬朗俊秀和篆書之圓潤渾厚而形成其獨特風格，而不是來自於傳統的正楷書法。

主碑文的正楷書法是我入筆，經掃描存入計算機。然後在計算機上完成碑文設計。每壹塊石碑是壹首唐詩的肆種譯文，即壹，漢語原唐詩；貳，唐詩英語譯文；叁，從英語唐詩譯回成漢語「後唐詩」（主碑文）；肆，漢語「後唐詩」英語譯文。

《碑林──唐詩後著》的製作

經過數年反反覆覆的研究後使之觀念和形式臻於成熟。又經歷了無數次在實地對石碑的種類和質量的考查，對石碑專業刻工和拓片技術人員調查，最後在西安碑林博物館和其研究員的大力協助下使各個方面達到指標。整個當代碑林從尋找礦源、安排石碑工作室、落實刻工和拓工人員等都在西安美術學院的美術史教授程征先生親手指導之下完成。

《碑林──唐詩後著》的石碑

西安碑林的石碑多採用的是稱為「墨玉王」（係青石類 slate family）的石頭，產自於陝西省境內的壹個礦山的「墨玉王」青石以石質細膩而堅硬、石色墨黑而著稱。我的現代碑林的石塊均出於此礦，由傳統的手工開採，而不用爆破開採法。石碑表面拋光為 70 度即光滑平整而無反光。石碑呈臥式而不是直立式。石碑的肆外圍呈半圓形並雕以龍身魚鱗紋。在西安美術學院美術史教授程征先生和

the zhenkai font of the calligraphy in the stone stele script combines the strong, firm and fine features of traditional imitation song-style calligraphy, and the smooth and fluent, simple and vigorous nature of seal script to produce a unique style, which does not come merely from the standard calligraphy scripts.

the zhengkai stele script inscription calligraphy was painted by brush and scanned into a computer. then the design was completed on computer. every stone stele was a translation of a tang poem, first, there was an original tang poem; second, there was the english translation of the poem; third the english poems were then translated to chinese "post-tang poems" (my own stele text), and finally the english translation of the chinese "post-tang poems."

THE PRODUCTION OF THE *FOREST OF STONE STELES*

after many years of research, the concept and details of the *forest of stone steles* project have gradually developed to its current mature form. after much research into the types and quality of the steles, and looking into the situation of the professional engravers and rubbing makers, finally, through the help of the researchers at the xi'an beilin museum, we achieved our targets. the whole contemporary stele forest was completed under the personal direction of the art historian at the xi'an fine arts academy mr. cheng zheng, a professor of art history at the xi'an academy of fine arts. he was involved in everything from searching for stone resources to arranging and connecting with stone stele studios, to implementing the work with the engravers and the other promotional workers.

ABOUT THE STONE STELES *FOREST OF STONE STELES-POST TANG POETRY*

many of the xi'an steles use "black jade king" or "*moyuwang*" (a stone within the slate family). this kind of black jade, blue stone is produced in shaanxi province, and is famous for being a fine hard, black stone. the stone is named after its ink black color. many of the modern steles come from a particular black jade

469

西安碑林博物館專家楊智忠先生的配合下，找到了
壹流的碑刻與碑拓工匠。我的碑林工作室設於西
安市碑林博物館貳拾公里處的長安區內。整個碑
林的工程安排和製作均由劉雁鴻先生負責。在此
壹沉長的拾貳年的創製過程中，他們卓越的專業指
導、工作態度、技術監製才使這壹中國經典的藝
術語言在當代文化藝術中得以發揚光大。

原文出自何香凝美術館 OCT 當代藝術中心編
《文化翻譯：谷文達〈碑林 —— 唐詩後著〉》
（廣州：嶺南美術出版社，2005 年），20-33 頁。

king mine and are extracted through traditional hand methods
rather than through blasting. the surface of the stone is polished
at a 70-degree angle so that it is smooth and flat with a matte
finish. the steles are lying down rather than being presented in a
vertical format and the edges are semi-rounded and carved with
dragon scales on all four sides. through the efforts of mr. cheng
zheng, and mr. yang zhizhong, and experts at the xi'an beilin
museum, we found first-class stone carvers and engravers. my
stone carving studio is located in the chang'an destrict in xi'an
which is about 20 kilometers away from the xi'an beilin stone
steles museum. mr. liu yanhong arranged the whole production
of the entire stone stele forest. i have to say that from the
beginning to the end of this 12-year period, their excellent
professional performance allowed the dream of china's ancient
treasures to reappear in modern art and culture to become a
reality.

from ocat contemporary art terminal of he xiangning art
museum, *translating visuality: gu wenda: forest of
stone steles, retranslation & rewriting of tang poetry*
(guangzhou: lingnan fine arts publisher, 2005) p.283-292.

語言與翻譯（叁）：

移植事件 2003—2019

LANGUAGE AND TRANSLATION 3

transplant affairs 2003-2019

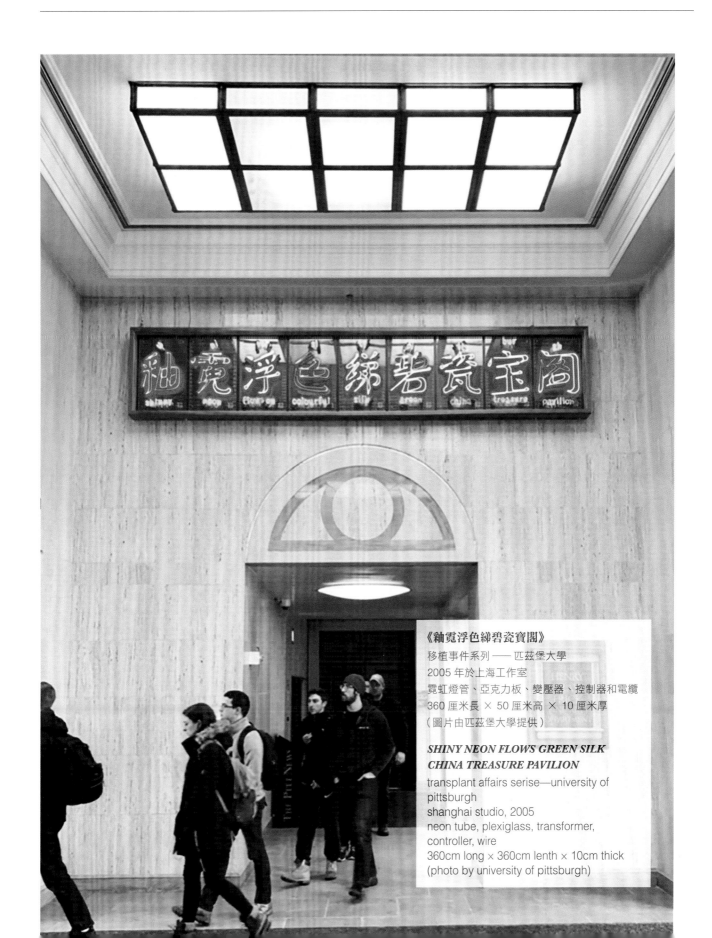

《釉霓浮色綵碧瓷寶閣》

移植事件系列 —— 匹茲堡大學
2005 年於上海工作室
霓虹燈管、亞克力板、變壓器、控制器和電纜
360 厘米長 × 50 厘米高 × 10 厘米厚
（圖片由匹茲堡大學提供）

***SHINY NEON FLOWS GREEN SILK
CHINA TREASURE PAVILION***

transplant affairs serise—university of
pittsburgh
shanghai studio, 2005
neon tube, plexiglass, transformer,
controller, wire
360cm long × 360cm lenth × 10cm thick
(photo by university of pittsburgh)

《釉霓浮色綈碧瓷寶閣》移植事件系列—匹茲堡大學
光色趣味
shiny neon flows green silk china treasure pavilion
transplant affairs series—university of pittsburgh,
interesting lighting effects

《和睦寺》
移植事件系列——愛馬仕
2019 年於上海工作室
由北京 skp 贊助
霓虹燈管、亞克力板、變壓器、控制器和電纜
300 厘米寬 × 140 厘米高 × 10 厘米厚

TEMPLE OF HARMONY

transplant affairs series—hermes
shanghai studio, 2019
sponsored by beijing skp
neon tube, plexiglass, transformer, controller, wire
300cm long × 140cm high × 10cm thick

2019 年上海工作室，藝術家谷文達正在為霓虹燈文化轉譯移植事件系列簽名
artist gu wenda is signing neon works from his transplant affairs series in his shanghai studio, 2019

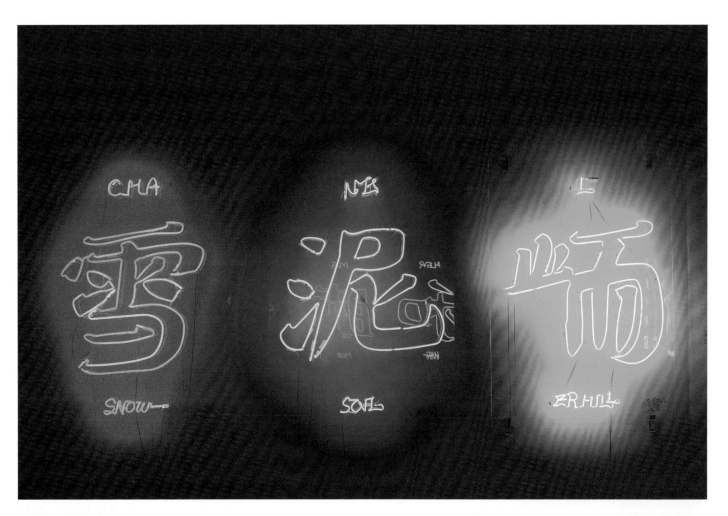

474

《雪泥陌》
移植事件系列 —— 香奈兒
2019 年於上海工作室
由北京 skp 贊助
霓虹燈管、亞克力板、變壓器、控制器和電纜
300 厘米寬 × 140 厘米高 × 10 厘米厚

SNOWY ER MOUNTAIN
transplant affairs series—chanel
shanghai studio, 2019
sponsored by beijing skp
neon tube, plexiglass, transformer, controller,
wire
300cm long × 140cm high × 10cm thick

工作室現場
scenes from inside the studio

《雪泥陌》移植事件系列 —— 香奈兒　細部
snowy er mountain　transplant affairs series—chanel detail

《福來迦牟》

移植事件系列 —— 菲拉格慕 a, b
1999 年，2016 年於上海工作室
由弗洛倫薩 salvardo ferragamo 博物館贊助
霓虹燈管、亞克力板、變壓器、控制器和電纜
200 厘米長 × 140 厘米高 × 10 厘米厚

GOOD FORTUNE COMES FROM SHAKYA MUNI

transplant affairs series—ferragamo a, b
shanghai studio, 1999, 2016
sponsored by salvardo ferragamo museum,
florence, 2016
neon tube, plexiglass, transformer, controller, wire
200cm long × 140cm high × 10cm thick

《福來迦牟》移植事件系列—菲拉格慕　電腦設計稿
good fortune comes from shakya muni　transplant
affairs series-ferragamo,　computer design

《福來迦牟》
good fortune comes from shakya muni

製作《福來迦牟》
the making of *good fortune comes from shakya muni*

《釉霓浮色綵碧瓷寶閣》在製作中
the making of *shiny neon flows green silk china treasure pavilion*

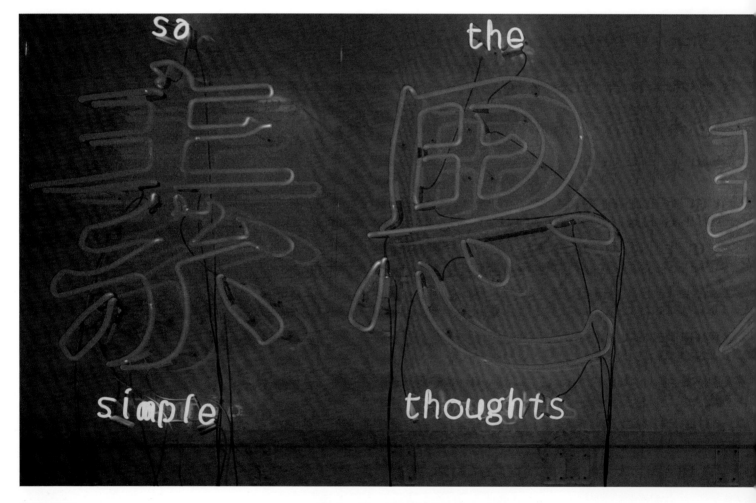

《素思碧寺》
移植事件系列 —— 蘇富比
2006 年於上海工作室
霓虹燈管、變壓器、控制器和電纜
500 厘米長 × 140 厘米高 × 10 厘米厚

SIMPLE THOUGHTS IN GREEN TEMPLE

transplant affairs series—sotheby's
shanghai studio, 2006
neon tube, plexiglass, transformer, controller, wire
500cm long × 140cm high × 10cm thick

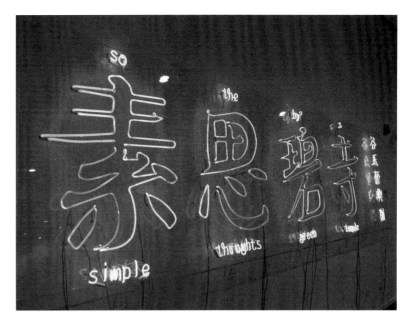

《從華僑城到我的媽呀》移植事件系列　開幕式
ocat-oh shit　transplant affairs series, exhibition opening

《那食客 安德吃得鴉 訪客們 特怡閣 思者筆訓》

移植事件系列──中國水墨藝術文獻展
2006 年於上海工作室
霓虹燈管、變壓器、控制器和電纜
750 厘米長 × 150 厘米高 × 10 厘米厚

CHOKING DRINKER ANDA DIGS AHEMU GUESTS ARRIVE AT JOYFUL PAVILION THINKER'S ADMONITION

transplant affairs series—china exhibition of ink art documents and archives
shanghai studio, 2006
neon tube, plexiglass, transformer, controller, wire
750cm long × 150cm high × 10cm thick

480

《佰花齊放》
移植事件系列
2003 年於上海工作室
霓虹燈管、亞克力板、變壓器、控制器和電纜
300 厘米長 × 200 厘米高 × 10 厘米厚

ONE HUNDRED FLOWERS BLOSSOM
transplant affairs series
shanghai studio, 2003
neon tube, plexiglass, transformer, controller, wire
300cm long × 200cm high × 10cm thick

簡詞：伯花
jianci: one hundred flowers

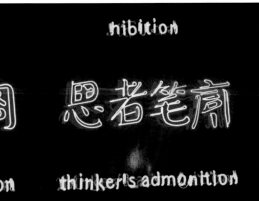

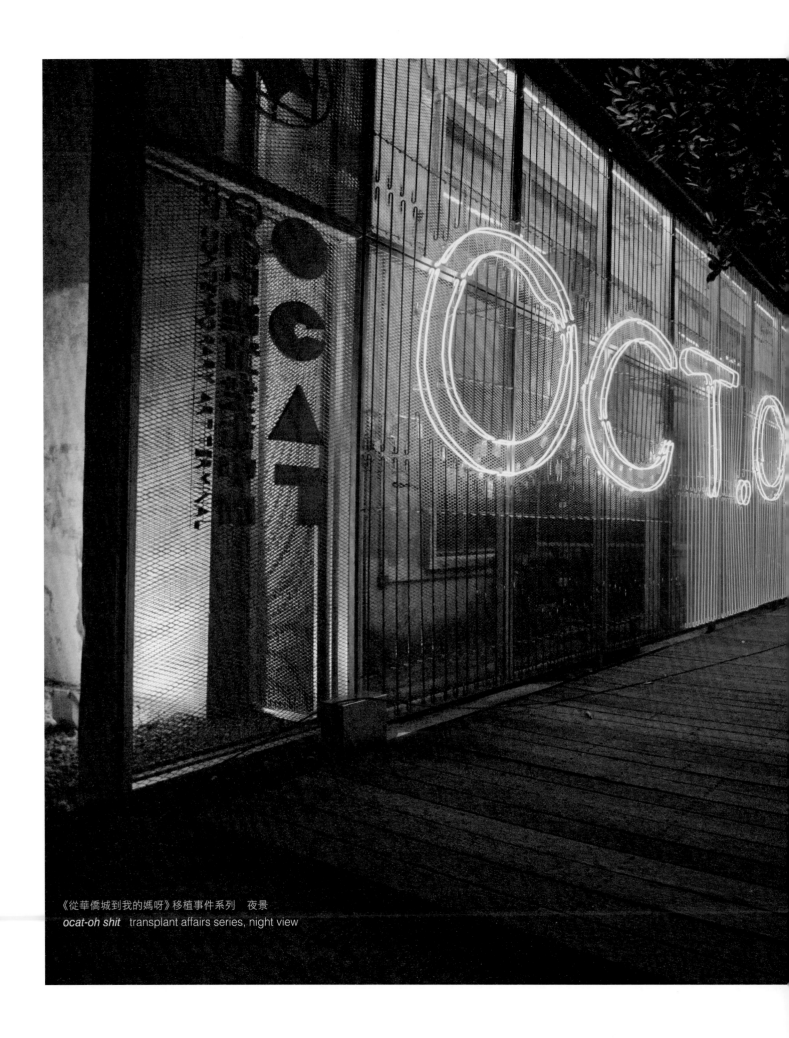

《從華僑城到我的媽呀》移植事件系列　夜景
ocat-oh shit　transplant affairs series, night view

482

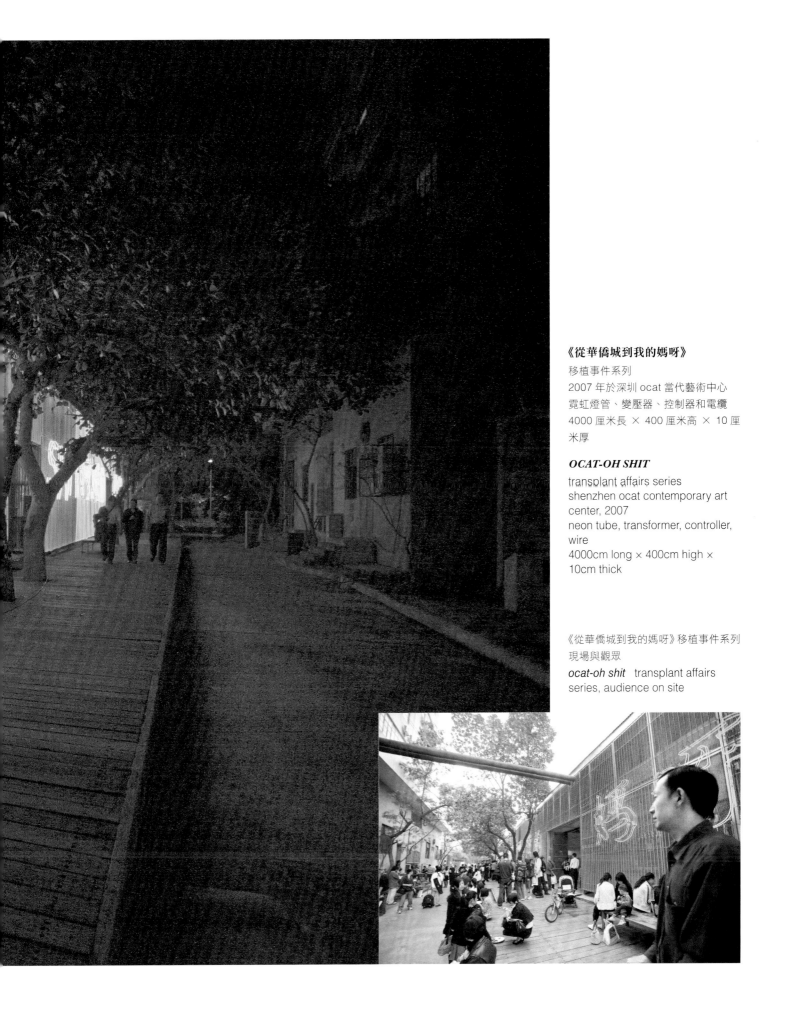

《從華僑城到我的媽呀》

移植事件系列
2007 年於深圳 ocat 當代藝術中心
霓虹燈管、變壓器、控制器和電纜
4000 厘米長 × 400 厘米高 × 10 厘
米厚

OCAT-OH SHIT

transplant affairs series
shenzhen ocat contemporary art
center, 2007
neon tube, transformer, controller,
wire
4000cm long × 400cm high ×
10cm thick

《從華僑城到我的媽呀》移植事件系列
現場與觀眾

ocat-oh shit transplant affairs
series, audience on site

移 植 事 件

谷文達

TRANSPLANT AFFAIRS

gu wenda

壹

《移植事件》系列作品是我自上世紀 80 年代移居美國多年之後所產生的想法。實際設計與製作從 2003 年開始。

這壹系列與著名的文化機構、商業機構合作，以他們的名稱作為作品的翻譯基點。創作通過將機構、品牌的名稱與另壹語言之間的「文化翻譯」（名稱源語言 —— 中文）來完成。

1987 年我移居紐約。1993 那年，是我離開後第壹次回國。壹件小小的 incidence（意外）讓我驚歎不已！

貳

「先生，您要甚麼？」壹禮貌可掬的 starbucks（星巴克連鎖咖啡店）服務生問道。

ONE

i began to have an idea about creating a series of art projects named *transplant affairs* in the 80s after i moved to new york city. the actual design and production of the series started in 2003.

transplant affairs collaborates with famous cultural and commercial institutions and uses their names as the basis for the translation of the works. the work relies on the names of brands and institutions and the cultural translation which occurs between another language (with the source language being chinese).

i moved to new york in 1987. in 1993, when I returned to china for the first time after my departure, one particular incident stunned me.

TWO

"what would you like?" asked the polite and friendly barista at a starbucks in china.

我看着她身後的菜單，迷惑不解：「『拿鐵』是⋯⋯甚麼？」

「嗯⋯⋯」服務生更迷惑了，她直楞楞地瞪着我，「『拿鐵』就是 latte。」「啊⋯⋯」我支支吾吾。

腦子還沒到不好使的境界的我似乎被誰「拿」着壹塊「鐵」重重地砸在我的頭上，「哈哈哈⋯⋯」紋絲兒不動的我傻傻地站着，頭卻暈乎乎地：「翻譯原來如此嗎？」我發蒙的智商怎麼都無法鏈接壹杯美味的 coffee latte 可以如此蹩腳地翻譯成「拿鐵」！

一定有誰惡作劇！我沖着服務生調侃道，「我要壹杯 coffee latte，但不要『拿鐵』，你要是『拿』來壹塊『鐵』，我敢喝嗎？」⋯⋯在場的服務生們和顧客都哈哈啊哈哈地大笑，然後面面相覷，「一定會有人認為我這傻瓜，大驚小怪，連『拿鐵』這詞兒都搞不定！」我暗暗自言自語⋯⋯

叁

如此 an incidence 讓我沉迷與陶醉在文化差異文化誤讀文化誤解絕對富有意義的荒誕不經裏不能自拔⋯⋯

誤讀不就是創造嗎！

手段本身是創造，而不是手段的結果。結果僅僅是實用！

transplant affairs（《移植事件》）就這樣誕生了。

i scanned through the menu behind her and wondered: "what . . . exactly is a is a ' 拿 (na) 鐵 (tie)?'"

"it is a latte." she was surprised that i asked. "Oh," I stammered.

i felt as if someone just broke my head with a piece of iron. "Ha, ha, ha," I said in a stunned fashion, "Is this really the translation?"

In my muddled state, I could not believe that such a delicious cup of coffee would be translated so poorly as *"natie"* 拿鐵 — to fetch (a piece of) iron!

this must be a joke! i said to the cashier in fun: "a cup of coffee latte, please, not 拿鐵 . I wouldn't dare to drink it if you fetch me a piece of iron!" The baristas and the customers laughed and then looked around at each other probably thinking I was a complete idiot, gawking perhaps a little more than was necessary. "They can't even get the word latte right," I said muttering to myself.

THREE

such an incident made me indulge in the meaningful absurd within cultural differences, misreading, and misinterpretation.

Isn't misreading or misinterpretation a kind of creation?

the process of approach is a kind of creation, but not its result. the result of it is merely practical.

and that is how the *transplant affairs* series was born.

我的伍拾首《碑林—唐詩後著》的創造，花去我拾貳年光陰，在西安碑刻工作室創製伍拾塊《碑林—唐詩後著》。

壹杯「拿鐵」真「偉大」哦哈！

the creation of my work *forest of stone steles: post tang poetry* (which took me 12 years to produce with my stele inscriptions in xi'an) was also inspired by the "latte" incident.

what a fantastic cup of "natie" " 拿鐵 "!

《天象》碑林陸系 a
大地藝術
2014-2015 年於曲阜碑刻工作室
新加坡亞洲文明博物館
儒石，簡詞，裹刻，石墨
石碑 #1-#24 代表農曆年貳拾肆節氣
（尺寸和重量各不同）

TIAN XIANG **FOREST OF STONE STELES SERIES 6 A**
landart
qufu stone stele carving studio, 2014-2015
the asian civilisations museum, singapore
ru rock, jianci, wrapped carving, stone ink
stone steles #1-#24 symbolises the 24 traditional chinese
solarterms(dimentions and weights are variable)

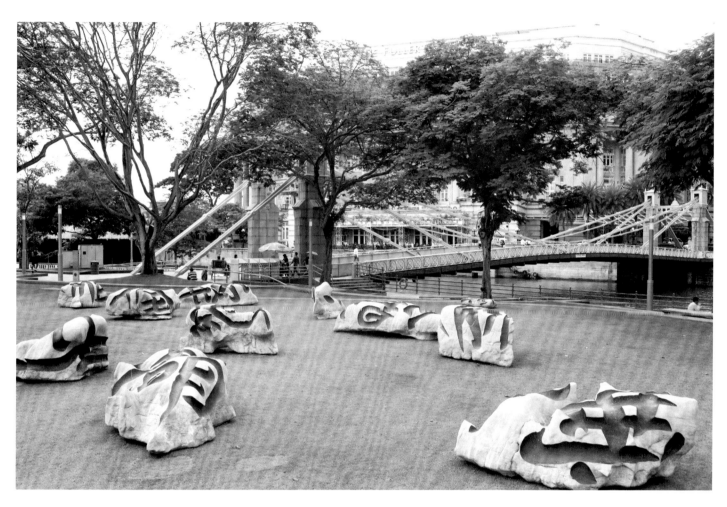

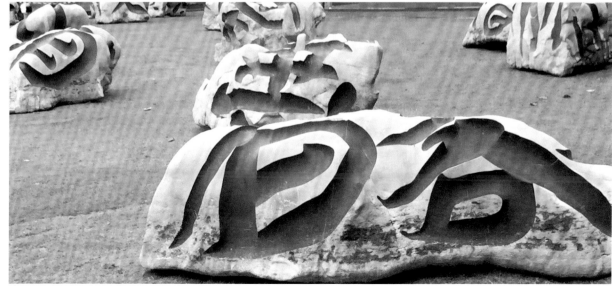

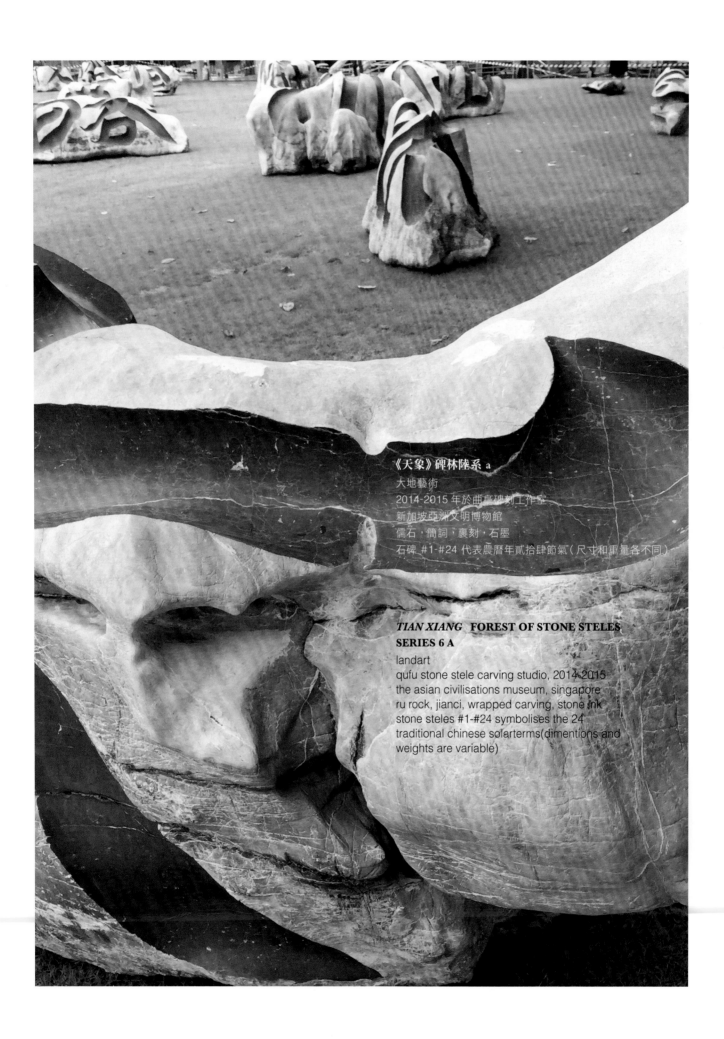

《天象》碑林陸系 a
大地藝術
2014-2015 年於曲阜碑刻工作室
新加坡亞洲文明博物館
儒石，簡詞，裹刻，石墨
石碑 #1-#24 代表農曆年貳拾肆節氣（尺寸和重量各不同）

**TIAN XIANG FOREST OF STONE STELES
SERIES 6 A**

landart
qufu stone stele carving studio, 2014-2015
the asian civilisations museum, singapore
ru rock, jianci, wrapped carving, stone ink
stone steles #1-#24 symbolises the 24
traditional chinese solarterms(dimentions and
weights are variable)

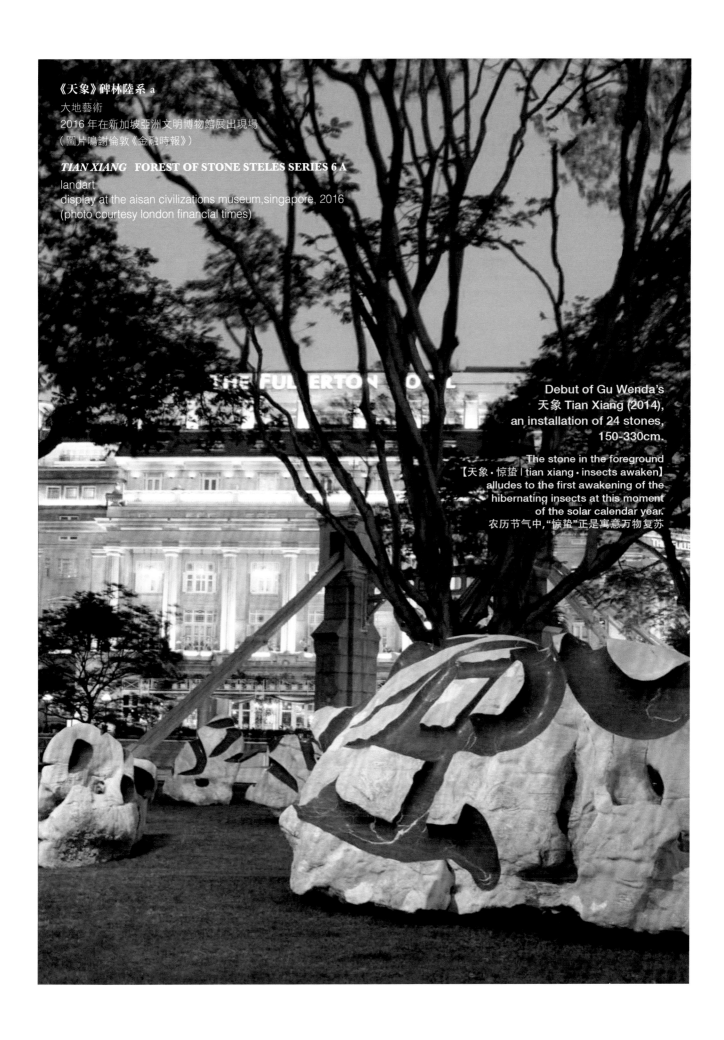

《天象》碑林陸系 a
大地藝術
2016 年在新加坡亞洲文明博物館展出現場
（圖片鳴謝倫敦《金融時報》）

TIAN XIANG **FOREST OF STONE STELES SERIES 6 A**
landart
display at the aisan civilizations museum,singapore, 2016
(photo courtesy london financial times)

Debut of Gu Wenda's
天象 Tian Xiang (2014),
an installation of 24 stones,
150-330cm.

The stone in the foreground
【天象·惊蛰 | tian xiang · insects awaken】
alludes to the first awakening of the
hibernating insects at this moment
of the solar calendar year.
农历节气中,"惊蛰"正是寓意万物复苏

489

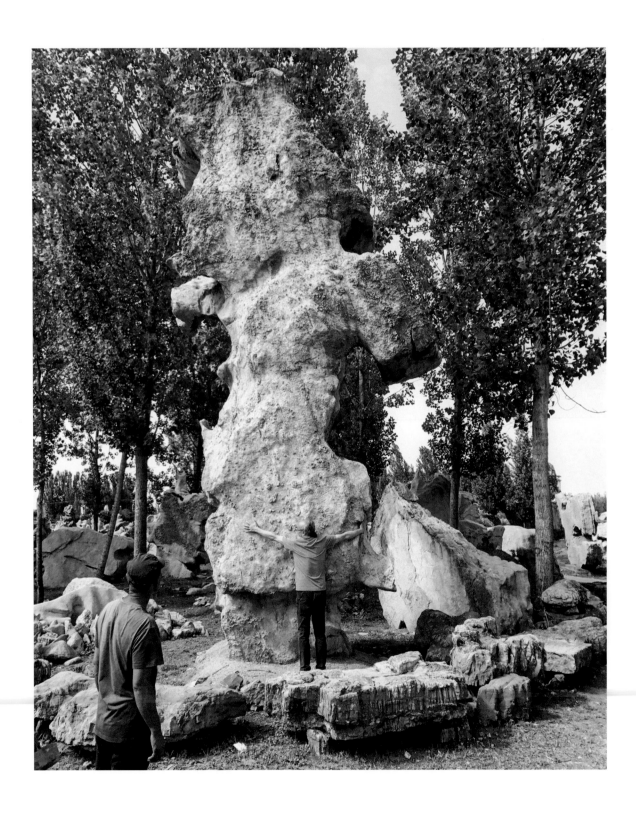

天象　碑林陸系　曲阜 2014-2015

tian xiang forest of stone steles series 6 qufu 2014-2015

儒石

ru rock

巨人的儒石石牀
the vast ru rock bed

（左圖）藝術家谷文達與好友當地石材專家在山東境內之石礦。古石出自於山東曲阜，泗水，平邑與費縣之域，至少伍億年前，這兒還是壹片遠古的汪洋大海，也是東方儒家思想誕生之地。藝術家谷文達稱這裏的古石為儒石。

the artist gu wenda with a good friend, a local stone professional, at a quarry in shandaong. the ancient rock is from the area between wufu, sishui, pingyi and fei counties. this area was under a vast ocean some 500 million years ago. this is also the birthplace of confucianism. therefore gu wenda named the ancient rock as ru rock.

上圖：谷文達在石礦查看尋找符合他需要的儒石
above: gu wenda in a stone quarry to search the sources of ru rocks

伍億年前海底儒石上的單細胞叁葉蟲化石
a single-celled microorganism, a trilobite on ru rock some five hundred million years ago

伍億年前海底儒石上的單細胞叁葉蟲化石
a single-celled microorganism, a trilobite
on ru rock some five hundred million
years ago

《簡詞典》農曆年貳拾肆節氣

jiancidian　the 24 traditional chinese solarterms

《天象》

簡詞典系列

2014 年於哈德遜河谷水墨工作室

墨，宣紙，紙背白梗絹邊裝裱鏡片鏡框

96.4 厘米長 × 59.6 厘米高（每幅）

TIAN XIANG

jiancidian series

hudson valley ink studio, 2014

ink on xuan paper, mounted on paper backing with silk borders in frame

96.4cm long × 59.6cm high each

《立春》儒石

175 厘米長 × 155 厘米寬 × 89 厘米高 重量 1.5 噸

START OF SPRING **RU ROCK**

175cm long × 155cm wide × 89cm high 1.5tons

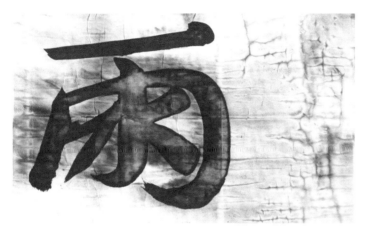

《雨水》儒石

190 厘米長 × 168 厘米寬 × 111 厘米高 重量 3 噸

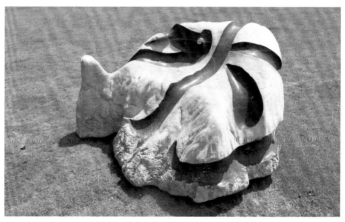

RAIN WATER **RU ROCK**

190cm long × 168cm wide × 111cm high 3tons

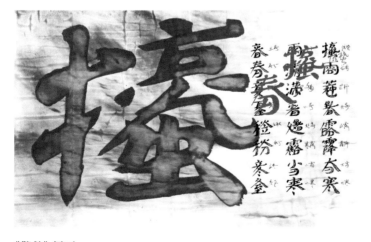

《驚蟄》儒石

330 厘米長 × 145 厘米寬 × 171 厘米高 重量 6 噸

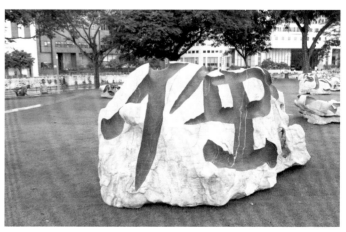

AWAKENING OF INSECTS **RU ROCK**

330cm long × 145cm wide × 171cm high 6tons

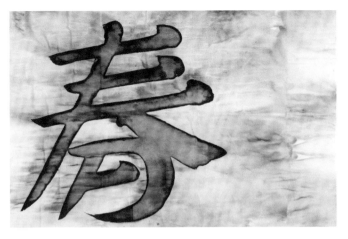

《春分》儒石

252 厘米長 × 95 厘米寬 × 97 厘米高 重量 1.5 噸

SPRING EQUINOX RU ROCK

252cm long × 95cm wide × 97cm high 1.5tons

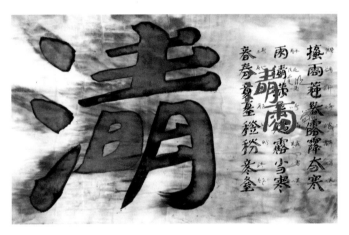

《清明》儒石

230 厘米長 × 155 厘米寬 × 91 厘米高 重量 3.5 噸

CLEAR AND BRIGHT RU ROCK

230cm long × 155cm wide × 91cm high 3.5tons

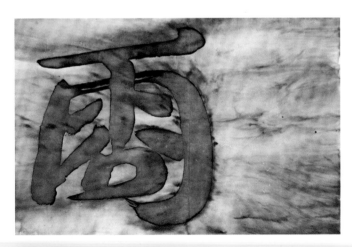

《穀雨》儒石

115 厘米長 × 84 厘米寬 × 84 厘米高 重量 0.5 噸

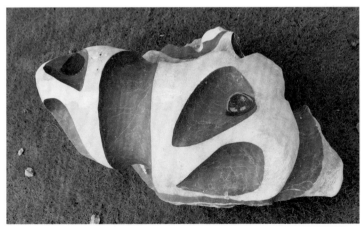

GRAIN RAIN RU ROCK

115cm long × 84cm wide × 84cm high 0.5ton

498

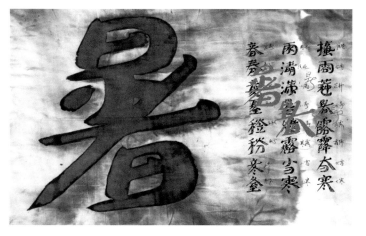

《小暑》儒石
275 厘米長 × 180 厘米寬 × 93 厘米高 重量 3 噸

MINOR HEAT RU ROCK
275cm long × 180cm wide × 93cm high 3tons

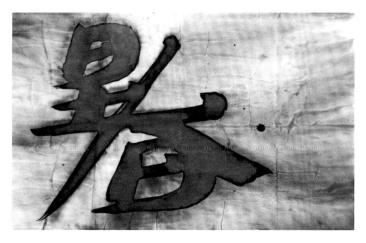

《大暑》儒石
160 厘米長 × 123 厘米寬 × 97 厘米高 重量 1.5 噸

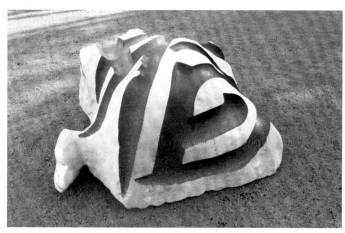

MAJOR HEAT RU ROCK
160cm long × 123cm wide × 97cm high 1.5tons

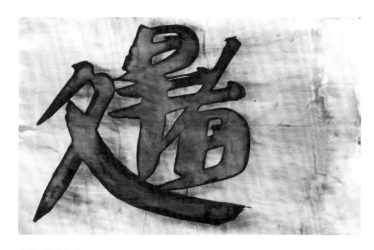

《處暑》儒石
290 厘米長 × 160 厘米寬 × 97 厘米高 重量 3.5 噸

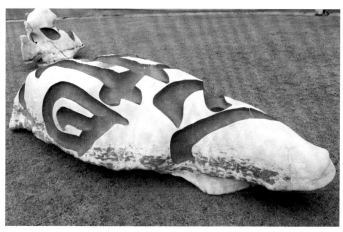

END OF HEAT RU ROCK
290cm long × 160cm wide × 97cm high 3.6tons

499

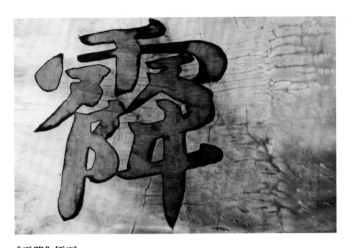

《霜降》儒石
246 厘米長 × 143 厘米寬 × 86 厘米高 重量 2.5 噸

FROST'S DESCENT RU ROCK
246cm long × 143cm wide × 86cm high 2.5tons

《立冬》儒石
250 厘米長 × 95 厘米寬 × 70 厘米高 重量 1.8 噸

START OF WINTER RU ROCK
250cm long × 95cm wide × 70cm high 1.8tons

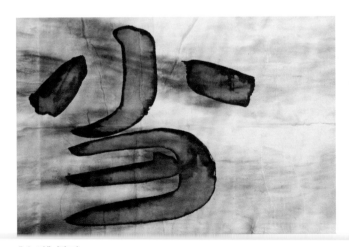

《小雪》儒石
133 厘米長 × 108 厘米寬 × 114 厘米高 重量 1 噸

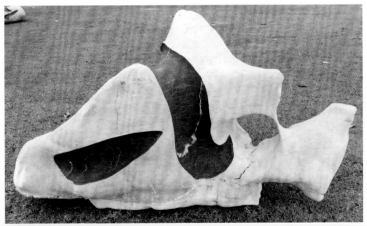

MINOR SNOW RU ROCK
133cm long × 108cm wide × 114cm high 1ton

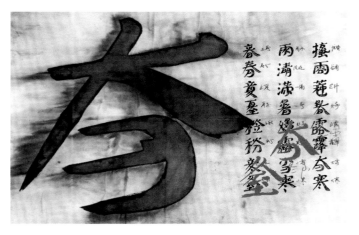

《大雪》儒石

215 厘米長 × 161 厘米寬 × 96 厘米高 重量 3 噸

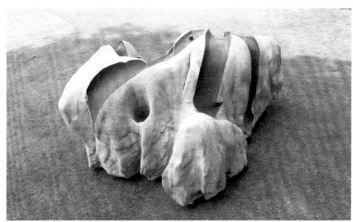

MAJOR SNOW RU ROCK

246cm long × 143cm wide × 86cm high 3tons

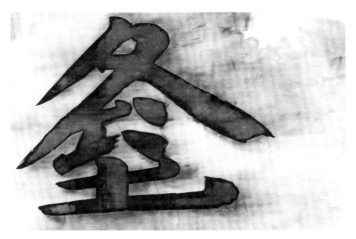

《冬至》儒石

250 厘米長 × 146 厘米寬 × 111 厘米高 重量 3.5 噸

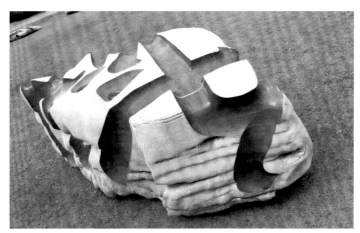

WINTER SOLSTICE RU ROCK

250cm long × 146cm wide × 111cm high 3.5tons

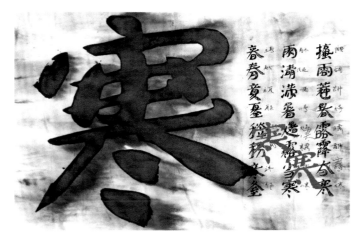

《小寒》儒石

226 厘米長 × 130 厘米寬 × 101 厘米高 重量 2 噸

MINOR COLD RU ROCK

226cm long × 130cm wide × 101cm high 2tons

天象　碑林陸系　曲阜 2014-2015

tian xiang　forest of stone steles series 6　qufu 2014-2015

裹刻

wrapped carving

簡詞裹在立體的儒石上，從任何壹個角度不能完整辨認裹在儒石上簡詞。觀者所能窺視部分簡詞的筆畫與結構和前所未有的新體驗，並憑藉想像去獲取整體的簡詞表達的意義。

jianci wrapped in the three-dimensional ru rocks, from any angle can not be completely recognized. viewers can peep into the strokes and structures of some jianci, as well as the unprecedented new experience, and obtain the meaning of the whole jianci by imagination.

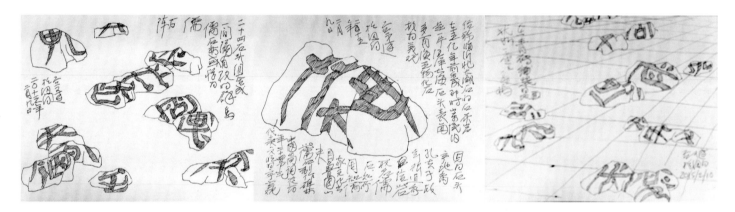

《天象》碑林陸系

草圖之捌，之玖，之拾，之拾壹
2015 年於紐約工作室
打印紙，鋼筆
29.5 厘米長 × 21 厘米高

TIAN XIANG **FOREST OF STONE STELES SERIES 6**

drawing #8, #9, #10, #11
new york studio, 2015
pen on printing paper
29.5cm long × 21cm high

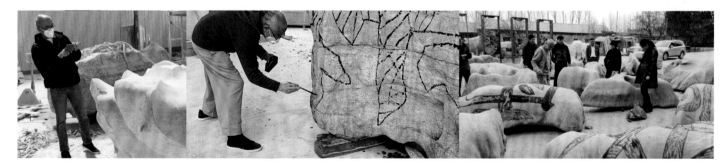

將簡詞書法以包裹方法畫上儒石
tracing jianci wrap around the outside of the ru rocks

谷文達在石礦與當地石材專家杜師傅討論選擇高質量儒石
gu wenda discussing with a local stone professional, mr. du, about how to select a quality ru rock

為王府井大街壹號新建的嘉德藝術中心外大地藝術選擇的儒石運到了雕刻工地

the ru rocks are shipped to the stone stele carving studio site for #1 wangfujing ave.,- the newly- built guardian arts center

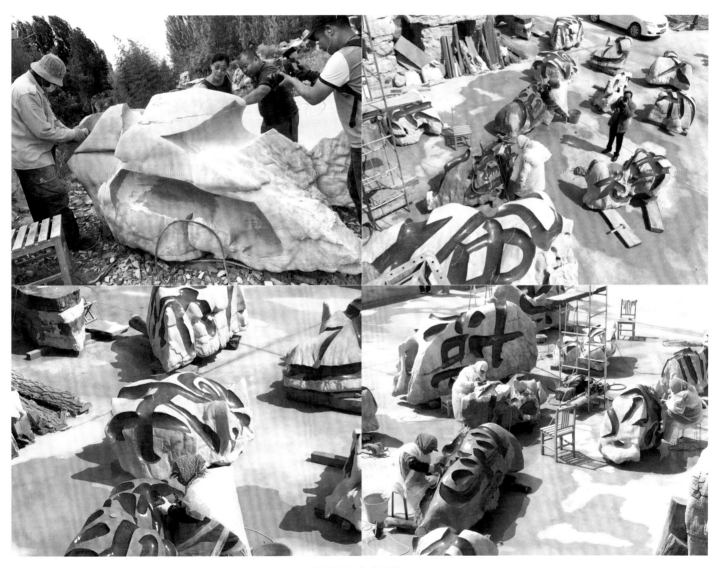

儒石碑刻工正在刻製《天象》碑林陸系，他們要具備嫻熟的手工刻製技術和身強力壯，同時還需有相當的美學素養
stone stele carvers working on the labour-intensive *tianxiang forest of stone steles series 6*. they have to be skilled in hand-carving techniques as well as physically strong. this job also requires experience and a sense of aesthetics

碑　林 ── 天　象

谷文達

FOREST OF STONE STELES—TIAN XIANG

gu wenda

《碑林 ── 天象》是我的碑林陸系。以《簡詞典》裏的簡詞編撰農曆年貳拾肆節氣，並鑴刻在貳拾肆塊自然形態的海底岩石上。這些岩石形成於遠古魯國山東境內，那時壹片汪洋大海，在海底由海水腐蝕成的石灰岩，仍依稀可見斑駁的海生物化石，距今已伍億年歷史了。我為此石取名為「儒石」。眾所周知，山東是東方儒家思想的發源地。

從觀念意義和視覺形態上來論，她與傳統園林和官邸的牌坊石的名人名家題字大相徑庭，也與刻石樹碑立傳相去甚遠。《碑林 ── 天象》以壹石壹節氣的貳拾肆塊「儒石碑」排列出壹石林。每壹中國農曆年節氣簡詞書法將包裹壹塊石頭，並以渾厚的圓浮雕的形式鑴刻在石頭的肆周伍面。從任何壹個

forest of stone steles-tian xiang is a forest of steles series of land artworks based on the stone steles theme. the 24 solar terms of the lunar year from _jiancidian_ are written in calligraphy and then carved into the natural forms of rocks from the ocean floor. these rocks were formed in the ancient state of lu in shandong, which was a vast ocean at the time. the limestone on the sea bed was corroded by seawater, and the mottled traces of fossils are still visible from 500 million years ago. i gave these stones the name "ru rocks." as everyone knows, shandong is also the birthplace of Confucian thought.

from the concept to the visual form, these ru rocks are utterly different from the traditional gardens and the memorial archways of the noble homes of china, which were often inscribed with the words of the great masters and sages. the spirit of this work is a long way away from the inscriptions found on most stele. _forest of stone steles-tian xiang_ creates a stone forest, one stele at a time, each "ru stone stele" aligns to form a stone forest. each ru rock has a calligraphic rendering of a _jianci_ of the names of the solar terms (periods within the chinese lunar calendar). the four sides and five faces of the stone are carved with characters that completely encircle the rock and are executed in thick and round reliefs. regarding these stones from five different angles, the viewer will not only notice the character of a particular solar term rendered in the style of a _jiancidian_, but they also discover fragments of this character,

角度去觀望壹塊儒石，儘管是壹個中國農曆年節氣簡詞書法，但呈現的僅僅是她壹部分筆畫 —— 漢字筆畫的極簡主義形式。只有當觀眾立體地去觀望和立體地去感受，就會領悟到壹石是壹節氣壹簡詞，就像農曆年節氣是壹無垠的宇宙。《碑林 —— 天象》的「儒石林」疏密有致、含蓄氣勢。碑上漢字更是外圓內方、神韻沉浮。

《碑林 —— 天象》的「儒石林」，貳拾肆塊大小變化有致，裏刻中國簡詞農曆年貳拾肆節氣。遠而觀之，裏刻在儒石上的簡詞節氣大字的粗壯筆畫因無著色，儒石的自然表面肌理與光滑的簡詞筆畫凹槽，無頗大的反差對比，故粗粗覽去，除布置相間韻致的儒石林，卻不見裏刻的節氣簡詞書法大字，這亦是創意者點睛之處，讓體現東方宇宙觀和生活觀的節氣簡詞大字和諧於自然形態裏，也表現出對自然環境的謙虛、適宜與和睦，壹反變成慣例的當代藝術、設計與建築非友善式的極度自我表現，而隨每壹天每壹節氣的光色變化而變幻，時隱時現，撲朔迷離。

壹字包裹壹石，故從任何壹角度觀賞，只可看到壹簡詞的部分筆畫，字原本是視覺的抽象，含義的實在，而簡詞裏刻又將它推至到極限，並模糊了字的表意。

for instance, the brushstrokes of the various parts of the character written in a minimalist style. it is only through the process of observing the ru rock from all angles that the viewer realizes that the abstract forms are, in fact, a *jiancidian* solar term characters. these rocks are boundless like the solar terms and the universe which surrounds us. the "ru rock forest" which is part of *forest of stone steles-tian xiang* has both a density and a sparseness which generates a sense of dynamism, embodying a certain kind of vigour. their calligraphic forms, round and undulating on the outside and square and regimented on the inside, ebb and flow with a certain romantic charm.

forest of stone steles-tian xiang employs an appealing aesthetic in wrapping the "ru rocks" of various sizes with the solar terms of the chinese agricultural calendar translated into the language of *jiancidian*. when viewed from afar, the characters which envelop the "ru rocks" express the concept of a solar term in a strong gestural font which looks as if painted in a dark pigment. in fact, the contrast between the natural texture of the ru rocks and the glossy sleek texture of the carved-out "reverse relief" is actually what creates this illusion of paint. therefore, in seeing these crude forms, which are charmingly arrayed at different intervals to create a ru rock forest, we find that the rocks are not only wrapped with these calligraphic characters but in the vision of the artist, are also a vehicle for the viewer to enter into the asian worldview and conception of the universe. at the same time, it expresses a kind of harmony with the natural environment, a love for the solar terms, a sense of harmoniousness and sustainability which is in contrast to the unsustainable, and extremely egotistical self-expression of the historical practice of contemporary art, design, and architecture. instead, we see works which provide a canvas for the diurnal dance of light, at once visible, then all of a sudden hidden, fleeting, bewildering and confusing.

with one character enveloping each stone, looking at the stones from each angle, we can only see a small section of each character — the characters themselves may be rendered in an abstract manner but nonetheless possess a certain truth. in the execution of applying the characters to the rocks, each *jianci* is stretched to the limit thus blurring the meaning of the character itself.

《碑林——天象》碑似浮雲，石如游島。洋而經緯，書為跡人。簡詞極限，裹刻儒石。意象寰宇，上下規矩。《簡詞典》鐫刻而環抱儒石碑林猶如洲際海嶼，大青磚鋪地猶如大洋經緯（latitude & longitude），東西方對大自然的星象與天體的人為解釋學圓滿壹體而渾然天成了。

in *forest of stone steles-tian xiang* the stele is a floating cloud and the rocks have become islands. the sea is the longitude and latitude and writing is the trace of humanity. Jianci have been taken to the extreme with the wrapped ru rocks. the rules of the world of imagery have been upended. the *jiancidian* has richly enveloped this ru forest of stone steles, flowing across their surfaces like an intercontinental sea, paving across the latitudes and longitudes with a vast sea of green-blue bricks. The eastern and western hermeneutical interpretations of nature and astrology are naturally consummated and become one body.

儒石的石墨在自然環境裏的自然風化顯現的極致屋漏痕
stone ink natural weathering on the ru rock create the ultimate patina

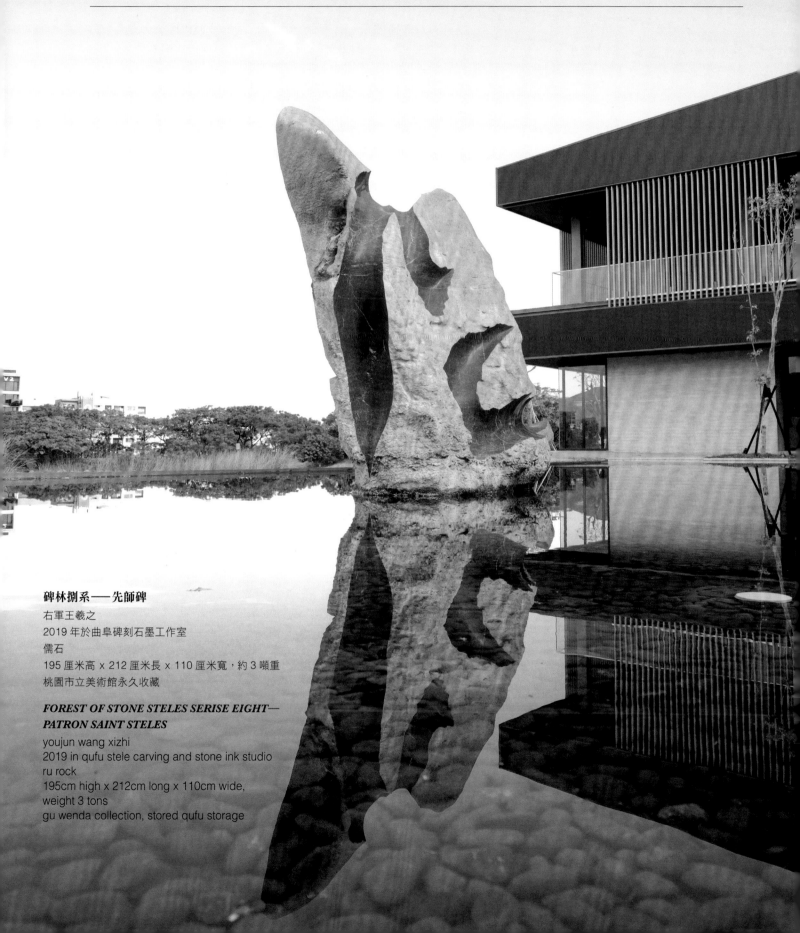

天象 碑林陸系 曲阜 2014-2015
tian xiang forest of stone steles series 6 qufu 2014-2015

石墨
stone ink

碑林捌系——先師碑
右軍王羲之
2019 年於曲阜碑刻石墨工作室
儒石
195 厘米高 x 212 厘米長 x 110 厘米寬，約 3 噸重
桃園市立美術館永久收藏

FOREST OF STONE STELES SERISE EIGHT—
PATRON SAINT STELES
youjun wang xizhi
2019 in qufu stele carving and stone ink studio
ru rock
195cm high x 212cm long x 110cm wide,
weight 3 tons
gu wenda collection, stored qufu storage

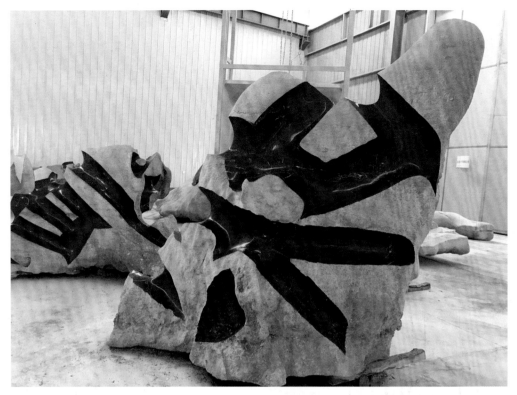

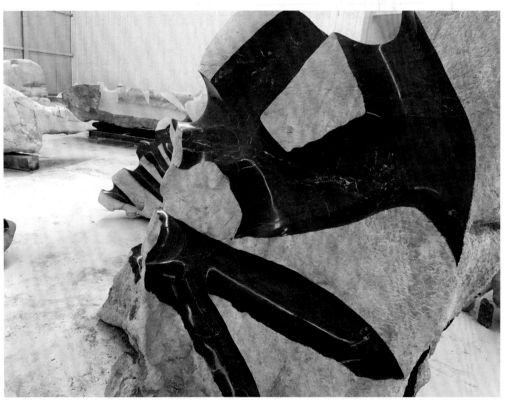

《先師碑》碑林捌系
右軍碑（王羲之），魯公碑（顏真卿），太師碑（蘇東坡），少師碑
（柳公權），侍中碑（歐陽詢）
桃園美術館橫山書法藝術館，桃園
2019 年於曲阜碑刻石墨工作室
儒石（尺寸和重量不同）

PATRON SAINT STELES **FOREST OF STONE STELES SERISE 8**

youjun stele (wang xizhi), lugong stele (yan zhenqing), taishi stele (su dongpo), shaoshi stele (liu gonquan), sizhong stele (ou yangxun)
hengshan calligraphy art center(taoyuan art museum), taoyuan
qufu stele carving and stone ink studio, 2019
ru rock (sizes and weights variable)

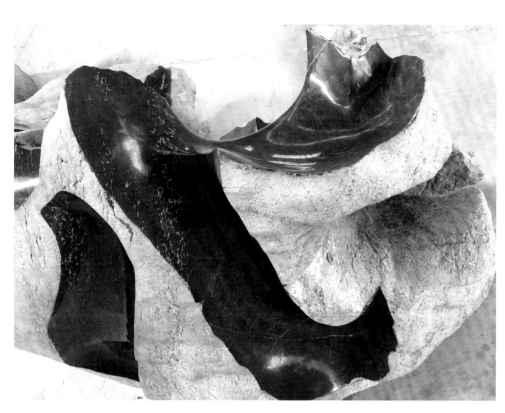
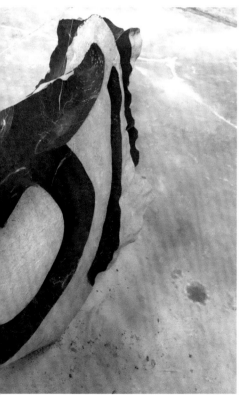
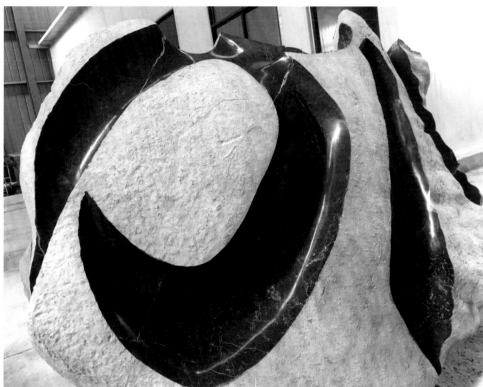

510

關　　於　　石　　墨

谷文達

STONE INK

gu wenda

天象

天地貳拾肆節氣，循環輪迴，她不是想像 & 假設的邏輯演繹，乃為不可抗拒之宇宙物質規律；我們想像的極地邊緣，非漫過宇宙黑洞、外星人 & 人工智能，還有多餘 ego（自我）？以為憑藉人之邏輯，想像終究變成事實？我仿佛看到天地如來佛掌裏，悟空之柒拾貳變，不過是多少億分之壹之像素而已。宇宙萬物，順天象者昌，逆天象者亡。

儒石

以《簡詞典》書法入書農曆年貳拾肆節氣，並鐫刻在貳拾肆塊自然形態的海底岩石上。這些岩石形成於遠古魯國山東境內，那時壹片汪洋大海，在海底由海水腐蝕成的石灰岩，仍依稀可見斑駁的海生物化石，距今已伍億年歷史了。我為此石取名為「儒石」。眾所周知，山東是東方儒家思想的發源地。

TIAN XIANG

between heaven and earth there are twenty-four solar terms that flow into a continuous cycle of reincarnation. it is not imagination or a deduction of hypothetical logic, rather it is the inexorable, material laws of the universe. the extreme boundaries and poles of the imagination, which cannot overwhelm the black holes of the universe, aliens, and artificial intelligence, yet, nonetheless, there is still such an excess of human ego. if we rely on human logic, will imagination eventually become reality? it's as if i see heaven and earth in the palm of tathagata (one of the titles of the buddha,) and the 72 transformations of sun wukong (the monkey king) amount to nothing bigger than a billionth of a pixel. all the creations of the universe flourish and perish at the whims of heaven.

RU ROCKS

the 24 solar terms of the lunar year from *jiancidian* are written in calligraphy and then carved into the natural forms of rocks which were formed on the ocean floor. these rocks were formed in the ancient state of lu in shandong, which was a vast ocean at the time. the limestone on the sea bed was corroded by seawater, and the mottled traces of fossils are still visible from 500 million years ago. i gave these stones the name "ru rocks." as everyone knows, shandong is also the birthplace of confucian thought.

裹刻

　　將簡詞或字或圖像包裹儒石，簡詞或字的表意文字之具象蛻變成為抽象了，但與史上抽象主義之構成大相徑庭。所謂儒石有伍面，前後左右上，壹眼觀之，止於叄面，肉眼不可同時取得儒石之伍面；叄面之外，自然地想像便成真了。言下之意，只因看不全簡詞的圖像，故只可意會 & 意向簡詞。她們之構成非經典抽象的傳統模式，鐵畫銀鈎，自然天成，裹刻簡詞在伍面體或有機多面體上，而肉眼不可同時關照伍面或多面體，從而導致並非物質物理之解構，而是視覺的解構。

石墨

　　墨為自然物質，而非人工化學合成，如西人 oil & acrylic（油畫與丙烯顏料）。墨分松煙 & 油煙，以木炭製成為松煙 & 用植物油做來稱油煙；石墨，顧名思義，是為礦物質而就。儒石鑿刻 & 拋磨簡詞，是石墨之最，凝重厚潤 & 晶瑩透剔，凝聚清亮 & 飽和黝黑。

WRAPPED ENGRAVINGS

wraps a simplified phrase, or character or image around a "ru rock" or *confucian stone* the meaning represented by the simplified phrase or character is concrete or figurative, but it is transformed into an abstract version of itself, which is very different from the way abstract compositions were historically composed. the so-called "ru rocks" have five sides from front to back and top to bottom. viewing the rock, we can only see three sides at one glance. the naked eye cannot simultaneously grasp the five sides of these "ru rocks." beyond these three sides, naturally the imagination will soon construct its own truth. the implication is that because we cannot see the full image of the simplified characters, we can only perceive the intention of the words. the work features vigorous flourishes and forceful strokes of the brush, natural and unaffected, with wrapped engravings on the five sides or multiple sides, but when the naked eye cannot grasp these five sides or multiple sides at the same time, it offers a visual deconstruction rather than a physical deconstruction.

STONE INK

stone ink is a natural material, not the result of man-made chemicals unlike the oil & acrylic used by westerners. ink stick, pine soot & lampblack; charcoal is processed into pine soot & vegetable oil is used to make something called lampblack. stone ink, as its name would suggest, is composed of minerals. the chiseled and polished "ru rocks" with simplified phrases are the epitome of stone ink; dignified, profound, glossy, and crystal clear, gathering brightness and saturating darkness.

天象　碑林陸系　曲阜 2014-2015
tian xiang　forest of stone steles series 6　qufu 2014-2015

自然人：天象貳拾肆節氣與人相貳拾肆節脊椎骨
natureman: the 24 traditional chinese solarterms and man 24 vertebrae

天象　碑林陸系　曲阜 2014-2015

自然人：天象貳拾肆節氣與人相貳拾肆節脊椎骨

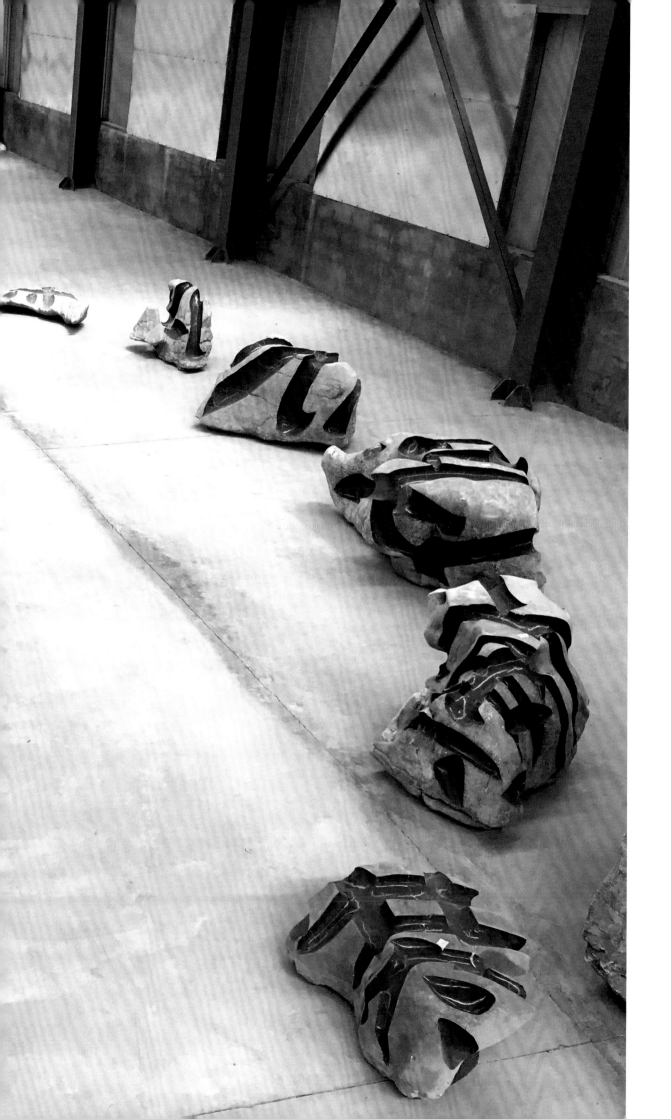

大自然的賦予──貳拾肆節氣

great nature's gift the 24 traditional chinese solarterms

《天象》碑林陸系 b
驚蟄
2017-2018 年於曲阜碑刻工作室
儒石（石灰岩）

***TIAN XIANG* FOREST OF STONE STELES SERIES 6**
awakening of insects
qufu stele carving studio, 2017-2018
ru rock (limestone)

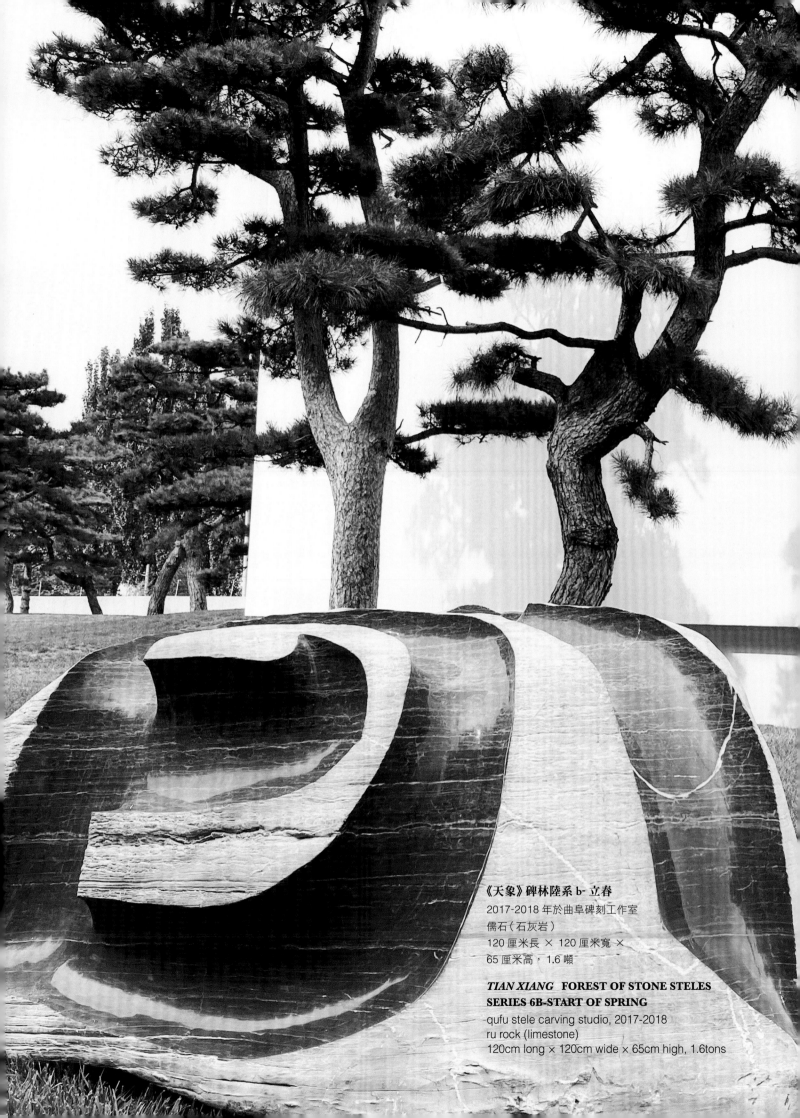

《天象》碑林陸系 b- 立春
2017-2018 年於曲阜碑刻工作室
儒石（石灰岩）
120 厘米長 × 120 厘米寬 ×
65 厘米高，1.6 噸

TIAN XIANG **FOREST OF STONE STELES
SERIES 6B-START OF SPRING**
qufu stele carving studio, 2017-2018
ru rock (limestone)
120cm long × 120cm wide × 65cm high, 1.6tons

天象　碑林陸系 c 2017-2018

tian xiang　forest of stone steles series 6c 2017-2018

崇尚大自然
homage nature

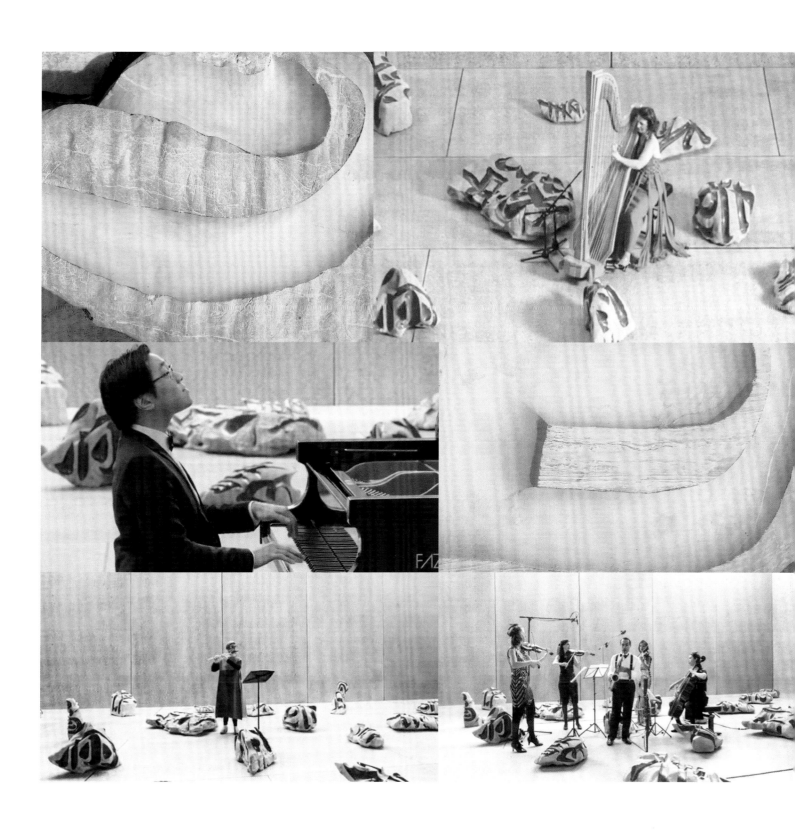

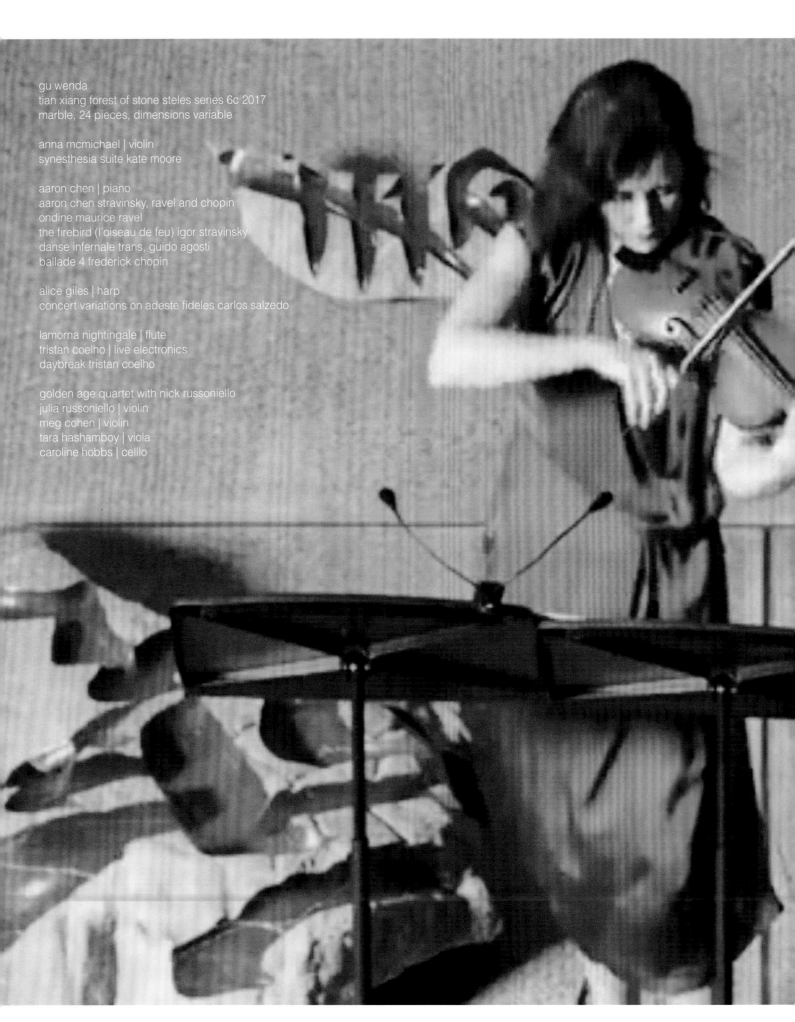

gu wenda
tian xiang forest of stone steles series 6c 2017
marble, 24 pieces, dimensions variable

anna mcmichael | violin
synesthesia suite kate moore

aaron chen | piano
aaron chen stravinsky, ravel and chopin
ondine maurice ravel
the firebird (l'oiseau de feu) igor stravinsky
danse infernale trans, guido agosti
ballade 4 frederick chopin

alice giles | harp
concert variations on adeste fideles carlos salzedo

lamorna nightingale | flute
tristan coelho | live electronics
daybreak tristan coelho

golden age quartet with nick russoniello
julia russoniello | violin
meg cohen | violin
tara hashamboy | viola
caroline hobbs | celllo

nick russoniello | saxophone

valse vanite rudy wiedoeft (c-melody
saxophone and string quartet)
three preludes george gershwin
(saxophone and string quartet)
esquisses de jazz: rag, boston,
charleston erwin schulhoff (saxophone
and string trio)
peggy's minute rag elena kats- chernin
(two violins)

valse rudy nick russoniello (solo
saxophone)

executive producer | judith neilson am
artistic director | nena beretin
director | david roche
head camera | emma elias
camera | zac hardaker
 bonnie chai
sound | richard hundy
editor | mal veitch

521

碑林散系

tian xiang forest of stone steles
bulk series

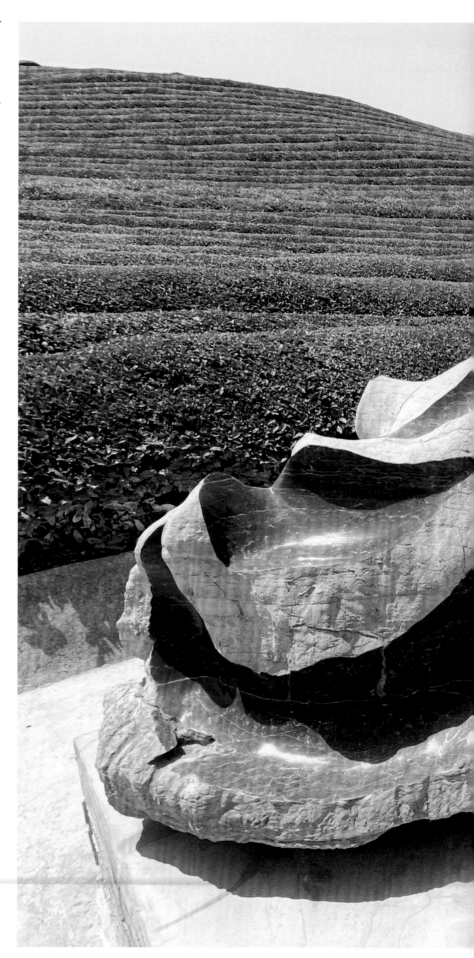

碑林散系

tian xiang forest of stone steles

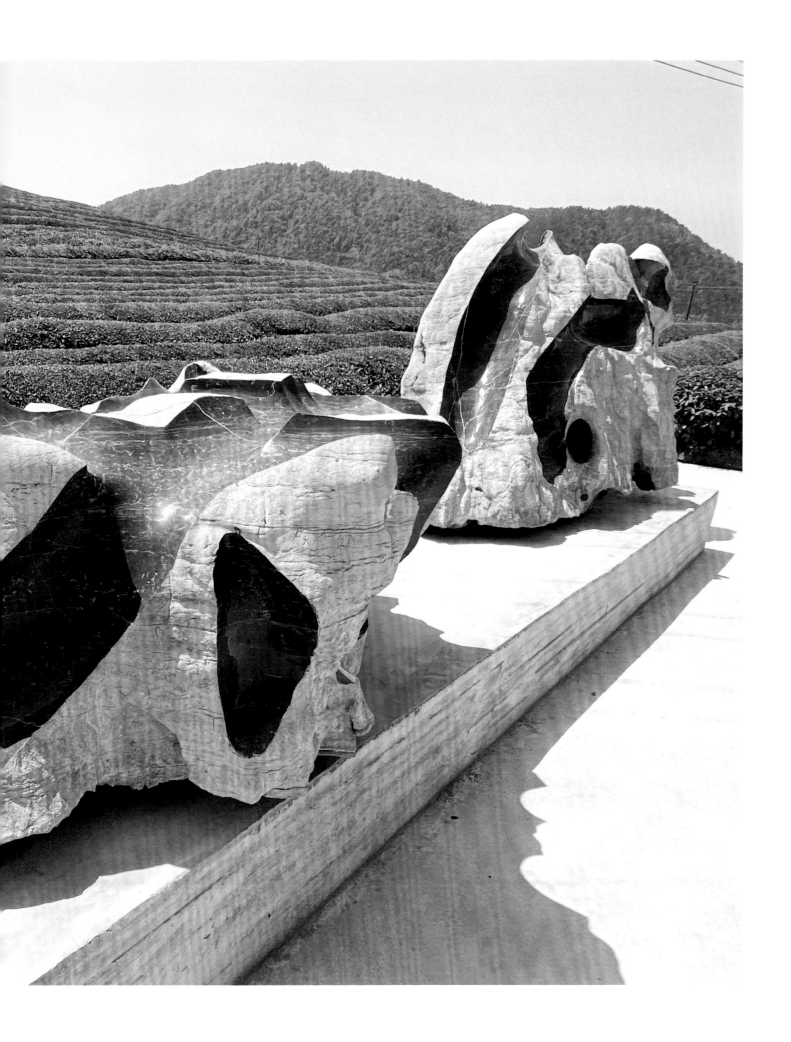

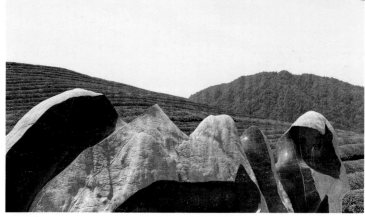

《藝術福椋》碑林散系

由藝術在浮梁藝術節贊助製作
2019 年於曲阜碑刻工作室
儒石

ART IS HAPPY TREE **FOREST OF STONE STELES BULK SERIES**

production sponsored by art at fuliang 2021
qufu stone stele carving studio, 2021
ru rock

語言與翻譯（伍）：

《簡詞典》入門與研究　1985-2021

LANGUAGE AND TRANSLATION 5:

primer and research on jiancidian 1985-2021

上圖：

《未來漢語入門》

簡詞典系列
2020 年於上海工作室
墨，宣紙
179 厘米長 × 48.5 厘米高

above:

INTRODUCTION TO THE FUTURE OF

chinese jiancidian series
shanghai studio, 2020
ink on xuan paper
179cm long × 48.5cm high

下圖：《火星人》簡詞典系列
below: *martian* jiancidian series

上圖：《源遠流長》簡詞典系列
above: *a long story* jiancidian series

下圖：《生活着的藝術》簡詞典系列
below: *living art* jiancidian series

2020 年於上海工作室
墨，宣紙
179 厘米長 × 48.5 厘米高
shanghai studio, 2020
ink on xuan paper
179cm long × 48.5cm high

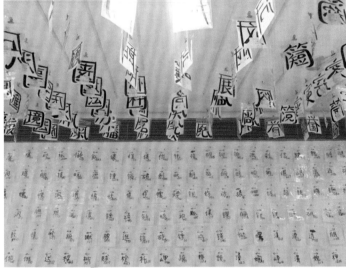

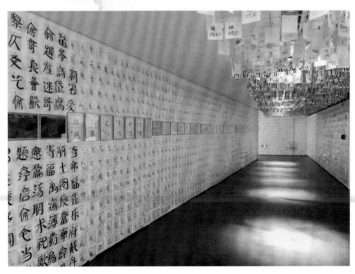

簡詞典工作坊

2016 年於上海民生現代美術館 -2019 年於武漢合美術館

漢字簡詞從 1984 年開始創意製作，簡詞以大書法形式入書水墨畫是 1984 年創作的《靜則生靈》遺失的王朝系列中《文字的綜合》，並首次在武漢會展中心的全國中國畫新作邀請展上展出，大概自 2008 年開始逐漸形成了編撰《簡詞典》的想法，《簡詞典》不斷地在編輯中

jiancidian work shop

shanghai minsheng modern art museum 2016 - wuhan the united art museum 2019

jiancidian began in 1984. jianci began as big calligraphy works and transitioned into a large ink painting entitled *tranquillity comes from meditation* lost dynasties series. the first time this work was shown was at the wuhan national chinese painting invitational at the wuhan convention center. gu wenda began to have his first thoughts about compiling the phrases into a dictionary in 2008. *jiancidian* in the process of being compiled.

《簡詞典》工作坊集錦
jiancidian workshop, a collection of
documentary photos.

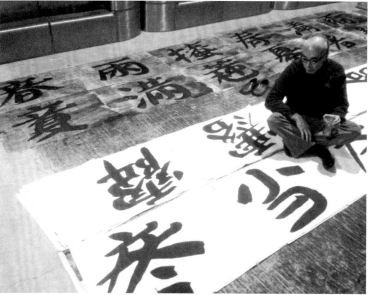

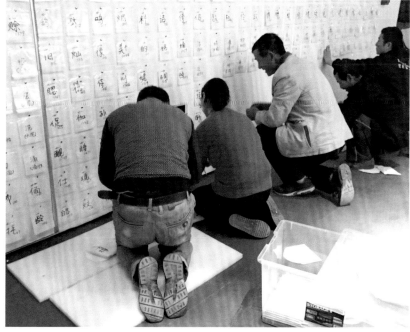

《飛龍密碼》簡詞典系列 —— 大漆 2016

flying dragon code jiancidian series lacquer 2016

《飛龍密碼》簡詞典系列

草圖之貳拾叁

2016 年於上海工作室

打印紙，鋼筆，白色亞克力金屬鏡框

29.5 厘米長 × 21 厘米高

***FLYING DRAGON CODE* JIANCIDIAN SERIES**

drawing #23

shanghai studio, 2016

pen on printing paper in white metal frame

29.5cm long × 21cm high

谷文達在法拉利車上描繪以魚鱗排列成的簡詞典飛龍

gu wenda designing jiancidian flying dragon on a model farrari car

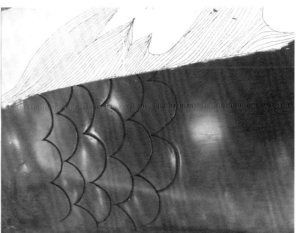

試驗製作大漆魚鱗紋的《飛龍密碼》簡詞典系列

carving the traditional chinese lacquer fish scales for *flying dragon code* jiancidian series

《飛龍密碼》簡詞典系列

大漆雕畫出的以魚鱗紋組合成的簡詞典飛龍

FLYING DRAGON CODE JIANCIDIAN
SERIES

uses chinese tranditional lacquer techniques and fish scale to form the flying dragon jiancidian

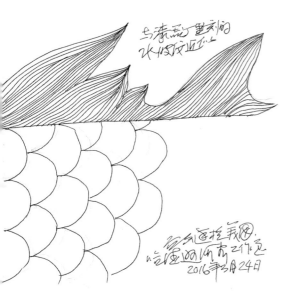

《飛龍密碼》簡詞典系列

草圖之拾伍

2016 年於上海工作室

打印紙，鋼筆

29.5 厘米長 × 21 厘米高

FLYING DRAGON CODE JIANCIDIAN
SERIES

drawing #15
shanghai studio, 2016
pen on printing paper
29.5cm long × 21cm high

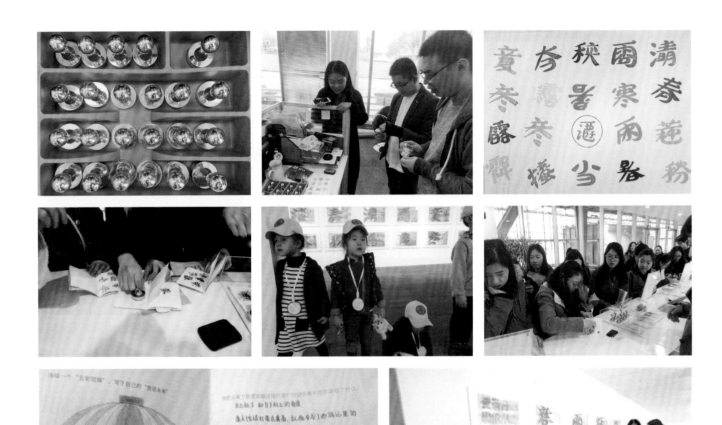

上海 21 世紀民生美術館的谷文達回顧展期間公教項目，以簡詞典系列《天象》水墨畫與《天象》無年限貳拾肆節氣日記本為背景，創製了以貳拾肆節氣《天象》的印章和護照本，學童參與並創製他們自己的護照本

the education department created a passport program during gu wenda's retrospective exhibition at the shanghai 21st century minsheng art museum. students participated and created their own passports based on the 24 solar terms of the chinese lunar calendar from the *tian xiang* ink paintings and the timeless chinese calendar notebook.

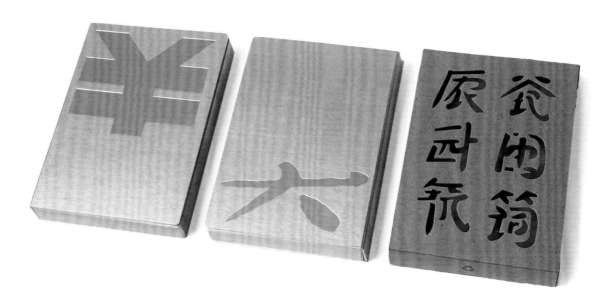

由谷文達工作室設計、做 \ 作 do design origin 出品,《無年限貳拾肆節氣日記本》(timeless chinese calendar notebook) 於 2015 年 6 月榮獲美國印製大獎優秀獎。

美國印製大獎誕生於 1950 年,由美國印刷聯合會主辦,是全球印刷業歷史最悠久、最權威的書籍印刷設計評比,以曾經為美國印刷業技術帶來革命性發展的發明家班傑明・富蘭克林 (benjamin franklin) 命名,被譽為全球印刷界的「奧斯卡」。2015 年的美國印製大獎有超過 3000 家來自全球的企業競逐,最終評選得獎的作品都是工藝最精湛、最富創造性與藝術感染力的印刷作品。

a work designed by do design origin, (gu wenda's studio), timeless chinese calendar notebook, won an american premier print award of excellence on june 6, 2015. the american premier print award was established in 1950 and is organized by the printing industries of america. it is the longest-running award in the global printing industry and the most influential book print design competition. it is named after benjamin franklin, the american inventor who revolutionized printing technology in america, and is known globally as the "oscars" of the printing industry. in 2015, there were over 3,000 participants from around the world in the competition, and the works which were chosen all possessed an exquisite sense of craftsmanship—printed works with boundless creativity and strong artistic appeal.

《緙絲》簡詞典系列 2016-2021

kesi　　jiancidian series 2016-2021

《緙絲》簡詞典系列
裝置藝術和行為藝術
2016 年於蘇州絲綢博物館
緙絲繡娘，織機，蠶繭，絲線，絲綢
1440 厘米長 × 35 厘米高

KESI　JIANCIDIAN SERIES
installation and performance art
suzhou silk museum, 2016
kesi weaver, hand loom, silk worm
cocoon curtians, silk thread, silk cloth
1440cm long × 35cm high

《緙絲》簡詞典系列
2016 年至 2021 年於蘇州
絲線，絲綢
1440 厘米長 × 35 厘米高

***KESI* JIANCIDIAN SERIES**
suzhou 2016-2021
silk thread, silk cloth
1440cm long × 35cm high

《東方志》碑林伍系
限量版拓片 #1-#8（碑文簡詞：乾坤沉浮，陰陽世界，風月江湖，山川暢神，生肖年月，藝術愛戀，福來迦牟，家鄉茶食）
2008 年於西安碑刻工作室
宣紙，墨
96 厘米寬 × 176.5 厘米高（每幅）

ANNALS OF THE ORIENT FOREST OF
STONE STELES SERIES 5
ink rubbing limited editions #1-#8
xi'an stone stele carving studio, 2008
ink, xuan paper
96cm wide × 176.5cm high each

《東方志》之伍生肖年月 碑林伍系
石碑 #5
2007 年於西安碑刻工作室
墨玉王青石
190 厘米長 × 110 厘米寬 × 20 厘米厚　重 1.3 噸
（圖片鳴謝武漢合美術館）

ANNALS OF THE ORIENT FOREST OF
STONE STELES SERIES 5
stone steles #5
xi'an stone stele carving studio, 2007
mo yu wang slabs
190cm long x 110cm wide x 20cm thick, 1.3 tones
(photo courtesy wuhan united art museum)

《東方志》碑林伍系
石碑 #1-#8
2007 年於西安碑刻工作室
墨玉王青石
190 厘米長 × 110 厘米寬 × 20 厘米厚
重 1.3 噸（每塊）
（圖片鳴謝深圳何香凝美術館）

***ANNALS OF THE ORIENT* FOREST OF
STONE STELES SERIES 5**

stone steles #1-#8
xi'an stone stele carving studio, 2007
mo yu wang slabs
190cm long × 110cm wide × 20cm thick, 1.3 tones each
(photo courtesy he xiangning art museum)

《東方志》碑林伍系柒號碑《簡詞典》
福來迦牟（ferragamo）在谷文達西安碑刻工作室製

annals of the orient forest of stone steles series 5 stele #7
good fortune comes from shakya muni in gu wenda stele
carving studio, xi'an

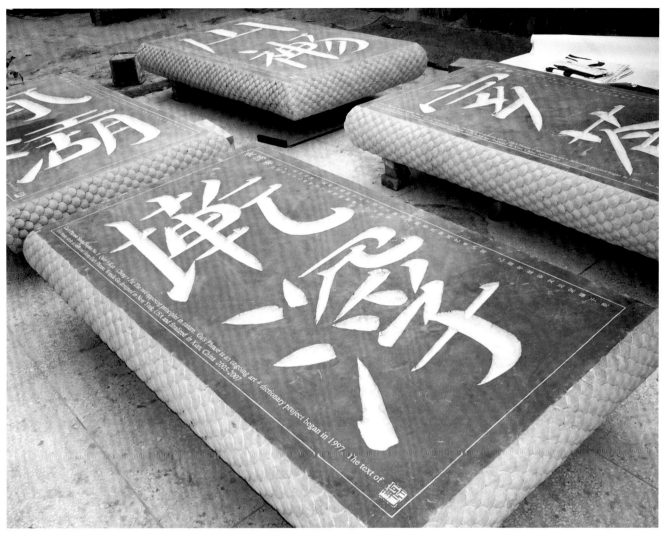

《東方志》碑林伍系在谷文達
西安碑刻工作室製作
壹號碑《簡詞典》乾坤沉浮，
叁號碑《簡詞典》風月江湖，
肆號碑《簡詞典》山川暢神，
捌號碑《簡詞典》家鄉茶食
annals of the orient forest
of stone steles series
5 being created at gu
wenda's stone stele
carving studio, xi'an
stone stele #1, #3, #4, #8

《東方志》碑林伍系　捌號碑《簡詞
典》家鄉茶食
annals of the orient forest of
stone steles series 5　stele #8
hometown foods

539

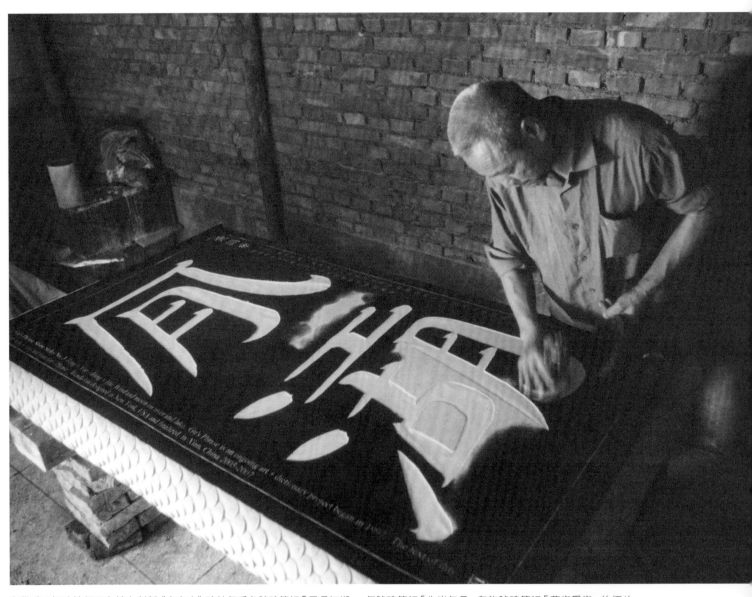

專業手工拓片技師正在精心創製《東方志》碑林伍系叁號碑簡詞「風月江湖」，伍號碑簡詞「生肖年月」和柒號碑簡詞「藝術愛戀」的拓片
professional hand rubbing artists working on *annals of the orient* forest of stone steles series 5-#3, 5-#5 and 5-#7 ink rubbings

《藝茶賦》與《簡詞典》文字豎排版，漢英對照。
the texts in *art of tea* and *jiancidian* are written vertically in both chinese and english

两汉字或者两汉字以上所构成的简词。并以笔画共享而达到减少笔画从简的目的。举例，「简词」两汉字合并为「筒」读成「简词 jian ci」。

贰 边旁代字法 「简词」的另壹种形成方法是将汉字的边旁作为字，然后与另壹个字组合为简词。例壹，国字部；简词国 zhong guo＝中国；简词国力 guo li＝国力。例贰，病字部；简词瘆 bing du＝病毒；简词瘦 bing bian＝病变。

叁 原字为词法 同样以国字举例：如「简词」是对以上的「边旁代字法」而言。「简词」的囗字部与原有的国字部的囗字部与它不同。它构成份可形成词意，此国字部汉字既是原有的汉字亦是个简结合构成壹简词。「简词」的囗字部与原有的国字部的囗字部与此汉字的其词。如汉字的「囚」还是简词的「国人」，这取决于此字在文章里此字应念为汉字的「囚」还是简词的「国人」，这取决于此字中之前后关系：「他是囚犯?」的「囚」，这只能是原来的字而不是简词的「国人」：「他是中囗人?」的「囚」只能是简词的词义即——「他是中国人?」。

先要走过「简化」的过程。简化单字的方式多种多样，解散和解构综合两至肆汉字而成的汉字。

其捌，两个以上的汉字综合成词，是设计师们设计汉字的壹种方式，也壹直是民间把玩汉字的戏说。但没有系统化和规范化，没有标准化和量化。

其柒，两个以上的汉字综合成词的方法。有不同的组词方法。基于易认、易懂、易记、易用；只要了解了组词方法，可达到不学自通。而只要有小学程度的人皆可运用自如。

以下我们例举几个简词的构成法。

壹 合贰为壹法 《简词典》里的简词最基础的和常见的，是由

蔡

《藝茶賦》選自《簡詞典》 譯文：取自太姥，養以高山。白茶新茶，自主乾倉。個性存放，風格不同。湯色琥珀，香自內質。歲月包漿，滋潤平和。

artistic reflections on tea gu's phrase dictionary text: "from mount taimu, cultivated on the high slopes, white tea, new tea stored in a lone warehouse. a repository of unique character, holding tea of an unconventional style, amber-tinted water holds the fragrance of its inner essence. after years of waiting in its package, it emits a moist and gentle flavor."

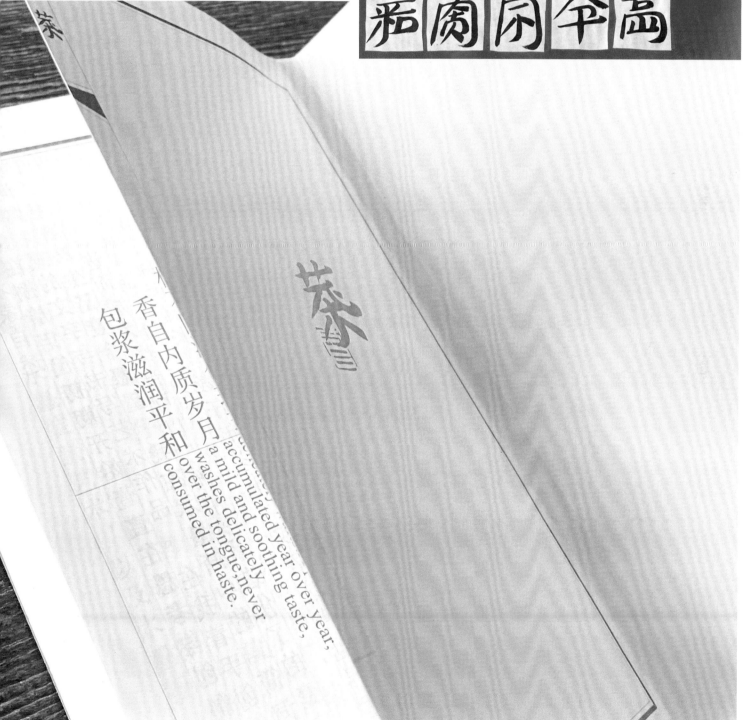

《茶經》簡詞典系列

藝術限量版 1000
2021 年於上海工作室
2020 年高級牡丹白茶，書盒
茶書以鎏金，燙金與印金法創製，茶
書套以刀板鏤空簡詞創製
12.5 厘米寬 × 20.8 厘米高 × 4 厘
米厚

***THE CLASSIC OF TEA
JIANCIDIAN SERIES***

limited edition artwork 1000
editions
shanghai studio, 2021
high-grade peony white tea 2020,
book box
tea book with gold plating, gold
embossment, the book slipcase
features a cut out of jianci
12.5cm wide × 20.8cm high × 4cm
thick

茶書盒以鎏金、燙金與印金法創製，
茶書套創製刀板鏤空簡詞
a book box with gold plating, and
gold embossing, the book slipcase
features a cut out of jianci

高級牡丹白茶餅置入空
白書頁上刻出儲存圓
a high-quality round
brick of dried tea
nestled in a circular
cut-out in the page

《簡詞典》以邊旁為字構簡詞法部：周壹至周日，週末

jiancidian using the radicals as characters method and combining them to create new radicals, this phrase spells out monday to sunday, and weekends.

《簡詞典》以筆畫多用為構簡詞法部；陸佰年歷史太久

jiancidian using the brush stroke to create radicals method, this phrase expresses the idea that 600 years of history is really a long time.

《簡詞典》以筆畫為多字所用構簡詞法部《宅家也燦爛歡樂》簡詞典系列

jiancidian uses multipurpose characters to create words as with the gu's phrase series "宅家也燦爛歡樂" (*staying at home is a splendid joy*).

《簡詞典》以發音為字構簡詞法部「糧票」，以筆畫多用為構簡詞法「國酒」，以筆多用為構簡詞法「寶米」，a 以邊旁為字法 b 筆畫多用為構簡詞法「國寶米」

jiancidian this phrase uses the method of phonetic pronunciation as a character to create radicals, as in liang piao（糧票）. it uses the method of brush strokes to make radicals as in guo jiu（國酒）,uses the method of brush strokes to create the gu's phrase bao mi(寶米),and the method of using radical "a" as a character and the brushstroke for "b" to produce the gu's phrase " 國寶米 ".

《簡詞典》以筆畫多用為構簡詞法部：大米人
jiancidian this phrase uses brush strokes to create radicals as with "大米人"

《世紀現象——同性戀》簡詞典系列
2006 年於哈德遜河谷水墨工作室
宣紙，墨，紙背白梗絹邊裝裱立軸
183 厘米寬 × 275 厘米高

CENTURY PHENOMENON—
***HOMOSEXUALITY* JIANCIDIAN**
SERIES
hudson valley ink studio, 2006
ink on xuan paper, scroll mounted
on paper backing scroll with silk
borders
183cm wide × 275cm high

2006 年於哈德遜河谷水墨工作室
宣紙，墨，紙背白梗絹邊裝裱立軸
183 厘米寬 × 275 厘米高（每幅）

hudson valley ink studio, 2006
ink on xuan paper, scroll mounted on paper backing with silk borders
183cm wide × 275cm high each

非典 *SARS*

離婚 *DIVORCE*

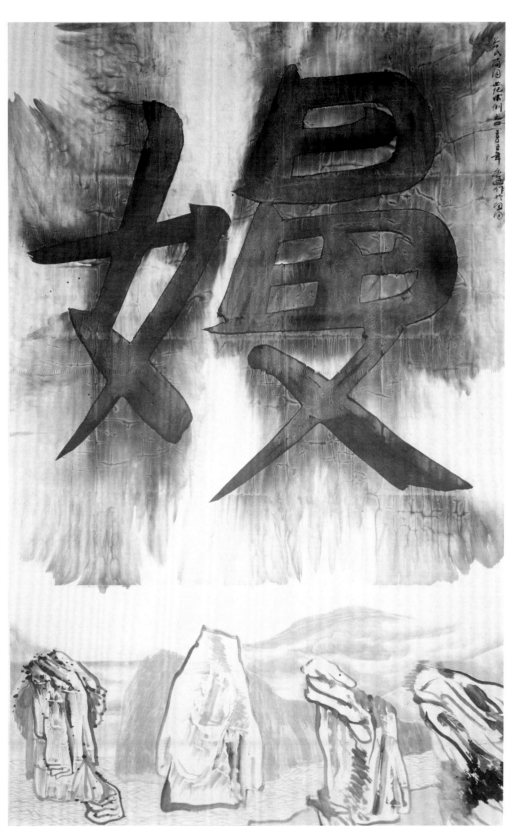

娼妓 *PROSTITUTION*

簡詞典系列《愛人》/《愛家》/《愛風水》
2012 年於哈德遜河谷工作室
宣紙，墨，紙背木板裝裱
183 厘米寬 × 275 厘米高（每幅）

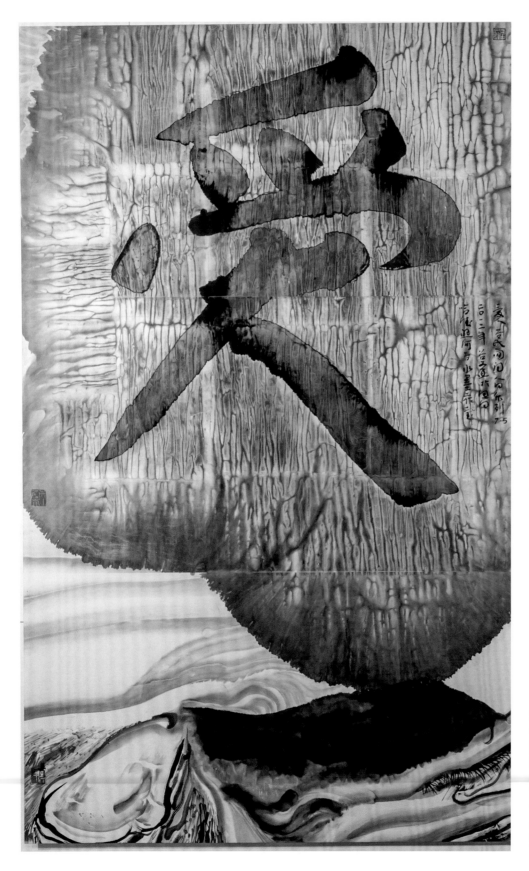

JIANCIDIAN SERIES *LOVE PEOPLE / LOVE HOME / LOVE FENGSHUI*
hudson valley studio, 2012
ink on xuan paper, mounted on paper backing with wood board
183cm wide × 275cm high each

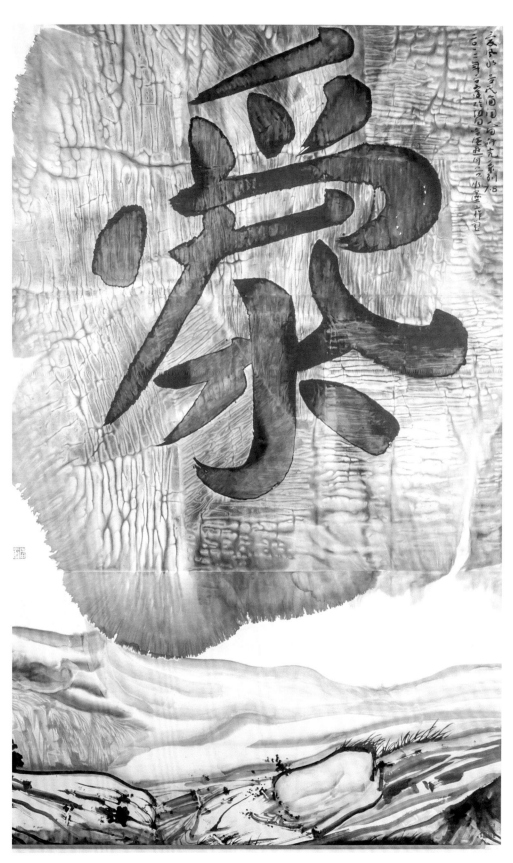

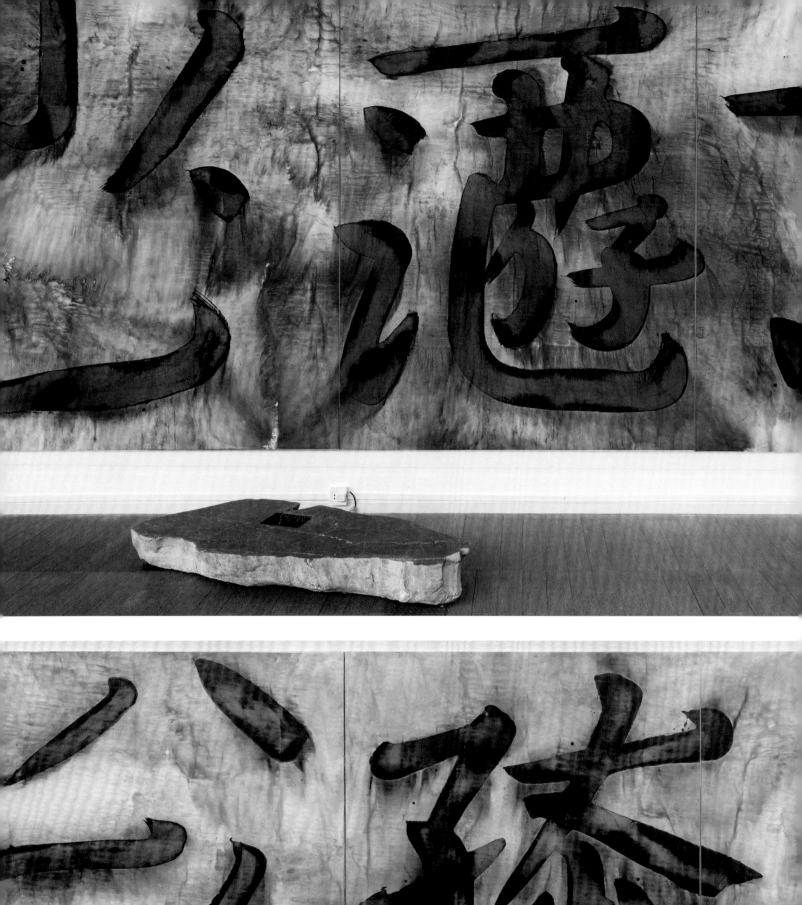
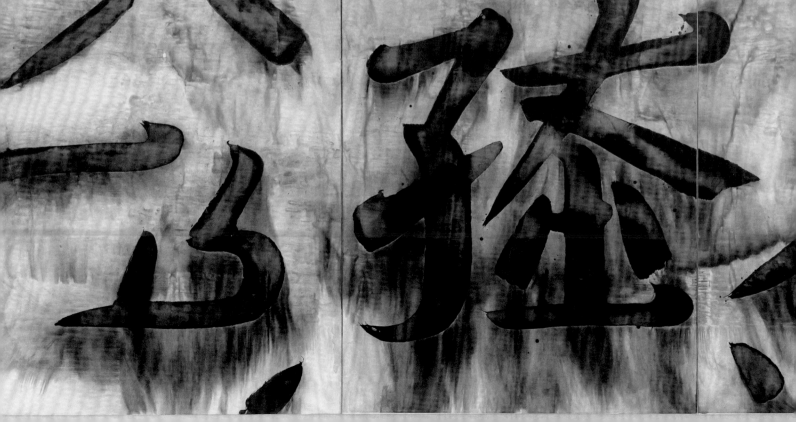

《西遊記》簡詞典系列
2016 年於上海工作室
宣紙，墨，紙本木板裝裱
558 厘米長 × 233.5 厘米高

JOURNEY TO THE WEST **JIANCIDIAN SERIES**
shanghai studio, 2016
ink on xuan paper, mounted on paper backing with wood board
558cm long × 233.5cm high

《孫大聖》簡詞典系列
2016 年於上海工作室
宣紙，墨，紙本木板裝裱
558 厘米長 × 233.5 厘米高

SUN DA SHENG **JIANCIDIAN SERIES**
shanghai studio 2016
ink on xuan paper, mounted on paper backing with wood board
558cm long × 233.5cm high

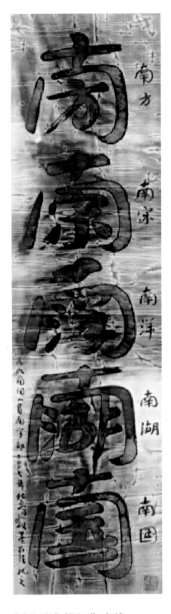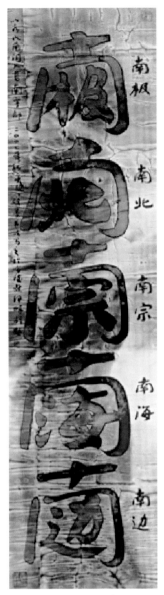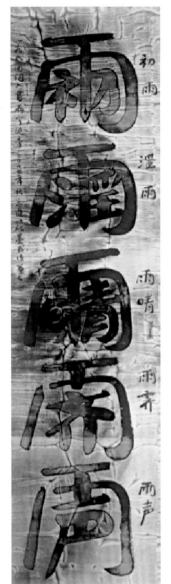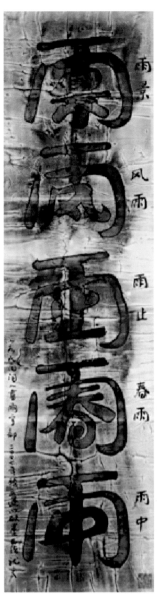

《南詞部》簡詞典系列

2007 年於哈德遜河谷水墨工作室

宣紙，墨，紙背白梗絹邊裝裱鏡片鏡框

49 厘米寬 × 180 厘米高（每幅）

***SOUTH RADICALS* JIANCIDIAN SERIES**

hudson valley ink studio, 2007

ink on xuan paper, mounted on paper backing with silk borders in frame

49cm wide × 180cm high each

《雨詞部》簡詞典系列

2007 年於哈德遜河谷水墨工作室

宣紙，墨，紙背白梗絹邊裝裱鏡片鏡框

49 厘米寬 × 180 厘米高（每幅）

***RAIN RADICALS* JIANCIDIAN SERIES**

hudson valley ink studio, 2007

ink on xuan paper, mounted on paper backing with silk borders in frame

49cm wide × 180cm high each

《我們是快樂的動物》簡詞典系列

水墨與動畫第壹系列

2004 年創作於紐約和上海

墨，宣紙，紙背裝裱，dvd 光盤，熒光屏，dvd 播放器

104 厘米寬 × 191 厘米高 × 4cm 厘米厚（每幅）

WE ARE HAPPY ANIMALS JIANCIDIAN SERIES

ink and carton serise #1

new york and shanghai 2004

chinese ink, xuan paper, mounted on paper backing, dvd film, tv screen, dvd player

104cm wide × 191cm high × 4cm thick each

《我們是快樂的動物》簡詞典系列　是可以聽可以動畫的水墨畫
we are happy animals　jiancidian series　is jianci ink paintings which can
be heard and animated.

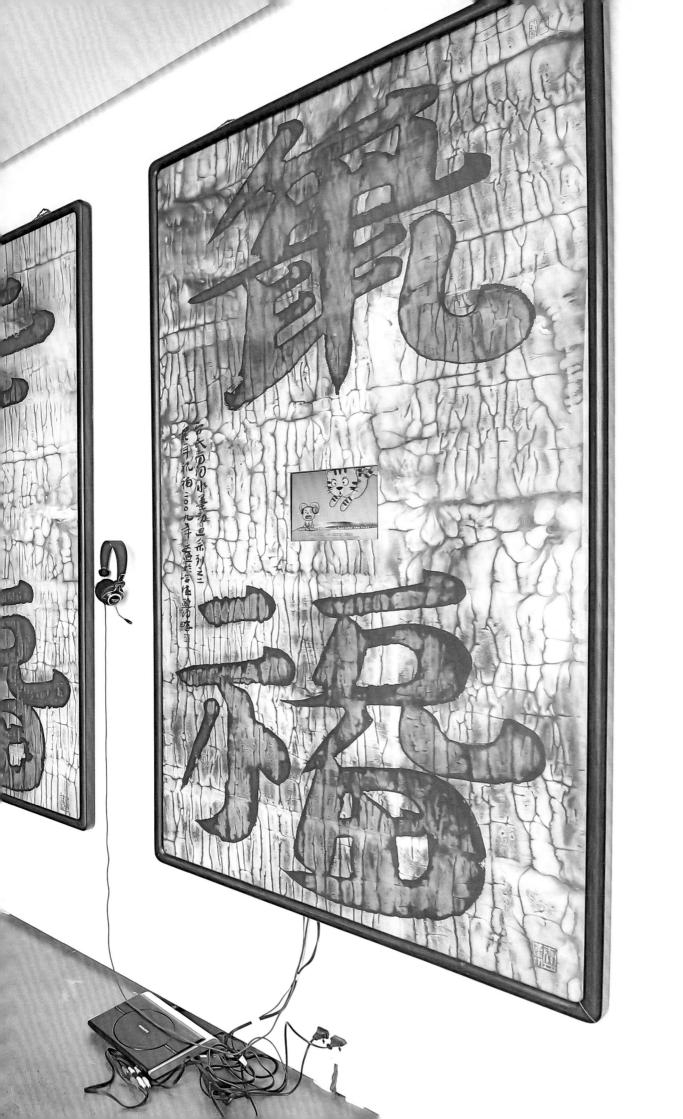

《 簡 詞 典 》 導 論

谷文達

AN INTRODUCTION TO *JIANCIDIAN*

gu wenda

此篇關於簡詞和《簡詞典》的文章,作為「序」還是「導論」,我還是糾結了許久,最後還是決定以「導論」名之,覺得對於壹部《簡詞典》而言,「序」似乎不完善,也非含引導之意,那麼「導論」儘管聽起來有些好大喜功,但還是說出了「導讀」的意思。

i debated for a long time whether to call this essay on *jiancidian* a preface or an introduction. in the end, i chose the word "introduction" as for this part of *jiancidian* the word "preface" seemed not quite right, as it didn't contain the connotations of "guidance," and even though "introduction" seemed rather grand, it nonetheless conveyed this meaning of guidance.

甚麼是《簡詞典》

《簡詞典》是壹部特別的藝術簡詞詞典,同時也是壹部實用的漢語簡詞典。她始終在用不斷生發的藝術編織人文的故事;說到底,《簡詞典》幅員遼闊,色彩斑斕的使用與實用,從經典詞彙到網絡語言,《簡詞典》將古老漢字與其隨之而來的星星點點之變體和變異,再次延伸製造,並編撰成簡詞的工具書。《簡詞典》是現實裏的神話。

簡詞之製造可讀易懂,因有規律可遵,有系統可循,標準化是基礎。漢字轉化成簡詞,規則與模式溯源未來。

WHAT IS *JIANCIDIAN*?

jiancidian is a special art dictionary of jianci (gu's simplified phrases), but at the same time, it is also a functional dictionary of chinese words. the project has always tried to continually germinate new humanistic stories which are interwoven with art; ultimately *jiancidian* spans a vast territory and can be used and applied in a colorful and practical way. from classical dictionary vocabulary to internet slang, *jiancidian* was born of variations and mutations of the dots and strokes of classical chinese characters, which were then extended once more and transformed into a reference book — *jiancidian*. *jiancidian* is a myth existing within reality.

jianci were created to be readable and easy to understand, because they respect certain rules, follow a comprehensible system, and are based on a standardized foundation. the origins of these rules and patterns for the transformation of chinese characters into jianci can be traced into the future.

簡詞是對簡體漢字的簡化，也是對白話簡體漢字部分意義上之溯源，回到基因走向未知。說白了，簡詞就是「壹字詞」。在當今世界的語言中，漢語常常是最簡短，比如聯合國的各個語言的文件中，漢語版本總是最短的。用簡詞寫作，漢語再精煉叄分之壹。

《簡詞典》簡詞構成類型

壹，分解漢字。單壹漢字拆散後閱讀。部分地改變現存漢字的讀法規則。

貳，合併漢字。以兩漢字合貳為壹為基礎，沿用漢字製造之傳統方法，經數種不同的方式方法，兼容並蓄製造壹字詞 —— 簡詞。

叄，簡化筆畫。以相同偏旁和筆畫公用的方法製造簡詞。

肆，諧音偏旁。以同聲異字作為偏旁製造簡詞。

伍，矢量化和數碼化，是基於《簡詞典》原始文本上的另壹個系統。矢量化和數碼化，產生各種通過網絡平台的應用。

由以上的簡詞構成類型產生具體而又可行的製造簡詞的方法。

jianci are a simplification of simplified chinese characters but their meaning can be traced to the radicals found in simplified chinese characters which are part of our everyday vernacular. they simultaneously return to our genes and move toward the unknown. in essence, jianci are "one-character words." amongst the languages of the world today, chinese is the most succinct. for instance, if we look at the sentences contained in the documents of the united nations, the chinese version is always the shortest. in terms of word usage and writing, chinese has a more economical use of words by a factor of a third.

JIANCIDIAN METHODS OF WORD FORMATION

1. deconstructed characters: a single character is broken into pieces and then read as parts. this partially changes the rules we use to read the character.

2. combined characters: based on the foundation of combining two characters into one, and continuing to use the traditional method of making chinese characters, and various other methods, i incorporate various things to form one-character words or jianci.

3. simplifying the number of strokes: using the common elements of the strokes and radicals I to create jianci.

4. homophonic radicals: using homophonic characters as radicals to create jianci.

5. vectorization and digitization, are based on a different textual system from that of *jiancidian* and vectorization and digitization methods are applied through various web-based applications.

jianci are created using the specific feasible methods of phrase creation mentioned above.

《簡詞典》的物質形式與業態

壹，裝置藝術及其限量衍生品。豎版本，手工精製，由藝術工作室承印裝訂成冊。

貳，橫版本，普通現代辭書，由出版社出版，印刷廠印製。

叁，衍生品包括各種各樣的以簡詞為主視覺的物質製造，比如水墨畫、儒石碑雕、建築形態、以及各種各樣跨界合作的物質衍生品。

肆，矢量網絡版，行銷與市場，動漫與遊戲等應用。舉例：開發製造《簡詞 典》軟件，任何參與者，通過軟件和程序的遊戲和應用，製造自己的文化藝術或娛樂商業途徑所需的新簡詞。

《簡詞典》是壹部可使用和易實用的詞典，也是壹部生活裏生發着的漢語壹字詞詞典。

《簡詞典》的由來

1980 年伊始，我進入了水墨藝術系列《遺失的王朝》製造時期。在 1984 年底，「簡詞」現之端倪。為武漢全國水墨畫邀請展所作伍聯水墨畫《靜觀的世界》的第叁聯——《文字的綜合》，其構圖中央即是「暢神」兩漢字：由於「暢」與「神」都有「申」字偏旁，於是「申」字便可同時服務於「示」與「易」，從而組合成為壹字詞「示申易」，我稱其為「簡詞」。

FORMS AND BUSINESS MODELS OF *JIANCIDIAN*

1. art installations and hand-crafted vertical versions of limited-edition multiples involve bound books printed by the artist's studio.

2. horizontal versions are like a normal modern dictionary, published by a publishing house and printed on a printing house.

3. art multiples use jianci as visual motifs in the creation of ink paintings, ru rock carvings, architectural forms, and various kinds of trans-disciplinary multiples.

4. vectorized web versions: these can be applied to sales and the market, animation, and games. for example, this involves developing a *jiancidian* software whereby users, using a game, program or application could develop their own jianci for their art, culture, or entertainment channel.

jiancidian is a useful and easy-to-use dictionary. it is also a way to give birth to new one-character words for use within our everyday lives.

THE ORIGINS OF *JIANCIDIAN*

at the beginning of 1980, i began producing the painting series *lost dynasties* and at the end of 1984, the first seeds of the jianci began to germinate. for the "wuhan national ink art invitational exhibition," i made *synthesized characters* which was the third painting in the five-painting series *tranquillity comes from meditation*. in the middle of this composition, there were the characters " 暢神 *changshen*," [a chinese painting term that describes how the painter expresses his mind through visual images allowing the viewer to expand their spirit, and experience a feeling of exhilaration]. because the characters " 暢 *chang*" and " 神 *shen*" both have the radical " 申 *shen*" (to extend or state) then 申 can serve both " 示 *shi*" (to show) and " 易 *yi*" (to change or exchange) thus combined it becomes " 示申易 *shi shen yi*," (state show change), what i call a jianci.

顧名思義，「簡詞」是將簡化了的兩個以上的漢字綜合構成壹漢字——壹漢字變成了壹詞，這就是我稱之為「簡詞」的來源。這是首次公示簡詞「暢神」，相同偏旁互用的壹字詞，並在《美術思潮》雜誌裏撰稿說明我從捌拾年代伊始的偽漢字、變異漢字、諧音漢字製造，我的碑林肆系《唐詩後著》和《移植事件》霓虹燈系列漢英諧音翻譯到了極致了。

時代成全了兩件事

自 1980 年至 1984 年間，我做了兩件事。壹是我的當代水墨藝術；貳是當代書寫藝術。肆拾載有餘過去了，史論界譽之為：奠基與建立了當代水墨藝術和當代書寫藝術。自捌拾年代頭上伊始，傳統中國畫呼嘯的震源到中國畫—水墨畫的名稱演變，實際上在中國繪畫史上形成了涇渭分明的兩大派系：以國畫院為代表的傳統派與前衛藝術，演繹至今。像壹條基因長河，從源頭延伸到了《簡詞典》。

在漫長的中國美術史裏，山水畫和書法，稱謂最臻於完美的藝術語言。書畫同源，我把這兩件事兒在今天的語境裏再現同源。從不能閱讀之漢字之觀念挑戰的偽漢字首當其衝，諧音漢字到漫長時間積累的《簡詞典》，壹部不僅是挑戰，並且是生活着繁衍着的辭書。

as the name implies, there is a simplification of at least two or more characters into one so that words become characters. this is the origin of the jianci. this was the first public appearance of the jianci " 暢神 *changshen.*" in terms of the use of a shared radical to create one-character combined words, *the trend of art thought* magazine wrote that starting from the 80s, i began to create pseudo characters, mutated characters, and homophonic characters in my fourth series of stone steles *post-tang poetry* and *transplant affairs - neon light series* of chines and english homophones translations, which took this to the extreme.

two things perfected over time

from 1980 to 1984, i did two things. first was my contemporary ink art; the second was my contemporary text-based art. forty-odd years have passed along the way and the theorists and art historians have praised me for my groundbreaking work in laying the foundations of contemporary ink art and contemporary writing-based art. beginning in the 80s from the roaring center of chinese traditional painting to the name change from chinese traditional painting to ink painting; in the history of chinese painting, up until this day, it is deduced that two entirely different schools were formed. the traditional chinese painting academies represented the traditional school and avant-garde art — like a river of dna originating at its source and extending towards *jiancidian.*

over the long course of chinese art history, chinese ink painting and calligraphy can be described as having a flawless artistic language. painting and calligraphy emerged from the same origins and i recreate these forms in the context of today, recreating their common origins. from pseudo-characters which bear the brunt of the challenging concept of the unreadable characters, to the homophonic characters to *jiancidian* — the product of many years of accumulated words. the dictionary represents not only a challenge but also a reference book containing content that is simultaneously living and multiplying.

從偽漢字到《簡詞典》

以漢字書法製造水墨藝術，始於 1980 年。製造偽漢字在 1983 年，製造簡詞在 1984 年，前後僅壹年之隔。那時我朦朧地意識到了，我的藝術進入了漢字與漢語的兩端：從不能閱讀到重新閱讀，她像把雙刃劍，游刃於思想和表達之間。

製造偽漢字，製造非閱讀的「漢字」，對於壹個文字獄的文明古國，這是她的意義所在，是形而上的概念藝術的遊戲。偽漢字一旦觀念形成，其製作儘管不能以容易來形容，但製造者是完完全全自由自在的。製造過程本身不需要深刻的思想與觀念，也無受制於作為漢字和漢語在現實裏生活着的語境，因為她不是使用着的字語。製造偽漢字的過程是有趣而揶揄、舒適而容易的單壹重複的過程。簡詞的詞義與使用，簡詞製造沒有重複性可言。比較《簡詞典》製造的無限性是因為她的無重複性、實用與使用性；而偽漢字的製造不存在無限性，恰恰是重複性、無實用和使用性。因為壹個到壹仟個是一樣的，其內涵和意義並沒有因為複數而改變。偽漢字本身不具有生活着的意義，固偽漢字不需要現實的檢驗與論證，也無形成生活着的每壹天的挑戰。

簡詞是既藝術又實用的製造。《簡詞典》更具顛覆和挑戰，因為《簡詞典》是對現存的漢字漢語的溯源和演變，帶藝術性的生活着的，需具備介入與實用。其艱深與困惑，挑戰與實用，對於壹個使用着與生活着的語言體系，要製造另壹個規則和體系，

from pseudo characters to *jiancidian*

my practice of using chinese character calligraphy to produce ink art began in 1980. i produced the first pseudo-characters in 1983, and the first jianci in 1984, with a gap of one year in between. it was then that i began to dimly realize that my art had migrated towards two extremes — chinese characters and the chinese language: from words that cannot be read, to words that can be read anew — it was a double-edged sword, that sliced between thought and expression.

creating the pseudo-characters — producing unreadable "chinese characters", these characters imprisoned by an ancient country with a long civilization — this is where the meaning lies — a metaphysical game of conceptual art. the pseudo-characters, in terms of the formation of these characters, their creation may not be easy to describe, but the creator is completely free in terms of their process. the process of creation itself does not require deep thinking or concepts, nor is it restricted by the context in which chinese characters are actually used in everyday life because these are not words that are in use. the process of creating pseudo-characters is entertaining and irreverent, easy and fun — a single process of repetition. it can be said that the meaning and use of these jianci, the creation of these phrases, involves no repetition. in comparison, the infinite creation contained within the *jiancidian* lies within its lack of repetition, utility, and useability; whereas with the process of creation of the pseudo-characters no infinity exists — it is precisely repetition, in-utility, and un-useability. because from the first one to the thousandth one they are the same. their content and meaning are not affected by the quantities or numbers. in their essence, pseudo-characters possess no meaning within the context of everyday life. indeed, the pseudo-characters do not need any kind of validation or verification from reality; after all, they do not form the challenges of everyday life.

jianci are functional and artistic creations. more subversive and challenging, *jiancidian* is both useful and interventionist using artistic frameworks and elements of real life in investigating the lineage and evolution of chinese characters. it is difficult and perplexing, challenging and useful — it constructs another set

又要與現實裏的漢字和漢語保持介入與游離，智慧與趣味，規則與遊戲，不同的漢字構成方法，不同的實用方式，從編制製造到使用實用。《簡詞典》是壹本遠古而又生活在當下的神話；她涉及和介入至語言及其語言學之方方面面：語言哲學和語言功能，語言形式和語言邏輯，其面對之挑戰巨大和艱苦。每個單壹的「壹字詞」的簡詞，就是壹次艱深而有趣的製造。

《簡詞典》需繁複慎密的邏輯與難度甚高和方便使用的製造方式方法，最後經廣泛地實際應用的審核檢驗，成為生活着的漢語簡詞。這是我自 1980 年至今，從偽漢字水墨、諧音漢字到《簡詞典》的文字與文學的切身經歷與經驗。

是在玖拾年代初，簡詞製造在我的水墨畫裏成為主體，逐漸形成了在漢字簡體字系統之後可以閱讀並使用的新系統。《簡詞典》在 1984 年首次出現在我製造的「暢神」簡詞書法與山水畫中，漫長的歲月裏，她們日積月累，萌芽了世說新語之衝動 —— 製造壹部《簡詞典》的願望隨之誕生。從 1984 年至今，卻慢條斯理，也無心插柳，已經叁拾載有柒，直到最後兩年，也就是新冠疫情（covid 19）肆虐的歲月，製作《簡詞典》成熟了。由來已久的想法，如願以償。

《簡詞典》入門

壹字詞是《簡詞典》之基礎與核心。《簡詞典》是壹部閱讀與使用的藝術神話。簡詞的目的就是其

of rules and a new system in contrast to the living language system of the dictionary user. it maintains an approach of intervention and disassociation, of wisdom and fun, of games and rules, the different methods of producing characters, the different methods of use, from the weaving of characters and their production, to their use and functionality towards the characters we use in real-life chinese. *jiancidian* is a legend which stretches from antiquity to contemporary life; it relates to and intervenes with language and various aspects of linguistics: from linguistic philosophy and linguistic functions, linguistic forms and linguistic logic — the challenges it faces are enormous and arduous. every single "one-character-word" jianci, is a very profound and intriguing creation.

jiancidian requires a complex and meticulous logic, and a creative style and method which is very difficult. finally, it requires an audit or inspection as to the practical application of how the simplified chinese phrases could be used in everyday life. this is my personal experience of the pseudo-character ink works, the homophonous characters, and the writing and texts of *jiancidian* from the 1980s up until now. beginning in the 90s, the jianci became the main subject of my ink paintings and after that, they gradually became a system of simplified chinese characters that could be read and used as a new system. *jiancidian*: in 1984, i first created the calligraphy and landscape painting "free expression" ("changshen") and after the passage of many years and the accumulation of many months, an impulse which echoed *a new account of tales of the world* sprouted, and the desire to create *jiancidian* was born. from 1984 onwards, in a slow and unhurried way yet in a fortuitous manner, over the thirty-seven years, up until the last two years, also the devastating years of covid-19), *jiancidian* finally reached maturity. such an old idea had now reached fruition.

jiancidian introduction

one-character-words are the foundation and core of *jiancidian*. *jiancidian* is a readable and useful artistic mythology. utility is the objective of the jiancis. from thoughts and imagination to practical utility, from writing to reading, from work to play, from life to artistic images, from art multiples to the market, *jiancidian* is truly a serious and fun, useful reference book.

用途。從想像思維到實用，從書寫到閱讀，從工作到遊戲，從生活到藝術圖，從衍生品到市場，《簡詞典》說實了是壹部嚴肅而又好玩的實用工具書。

簡詞的受眾與閱讀群，從有受過小學教育的學童到學術界，從商界到娛樂世界，男女老少皆宜。

簡詞的美學和審美

壹，簡詞的原始基礎是以我的手書楷書風格寫就。

貳，願望製造 3d 打印的活印鉛字，從風格上來說，可以是楷書風格，也可以是標準的印刷宋體。

叁，繁體—簡體之間的簡詞美學

共和國的簡體字是國家主流官體。之後絕大部分書法家和他們的書法藝術，依舊沿用繁體。書法家們認為繁體好看簡體不美。語言文字，古往今來，是壹部不斷持續演變和衍化的文明史，書法藝術亦然。書法藝術是建立在文字語言史上的，文字語言和書寫藝術是跟着技術文化與科學材料、地域群族及其政治經濟演變而衍化，包括網絡數碼以及 ai（人工智能）對語言和文字的影響，必然反映到書法藝術上：正草隸篆的美學及其她們的規章制度隨着時間推移而變化。

我對簡詞之書法美學的研究，如同人作為生物，在任何壹種發展中，都是溯源固本＋前行未知形成這兩個終端之延伸。由於簡詞基本上是兩或多簡

the audience and readership of the jiancis include everyone from elementary school pupils to academics, from the commercial realm to the entertainment realm, and men and women of all different ages.

the appreciation and aesthetics of the jianci

1. the original foundation of the jianci is based on my hand-drawn characters in "*kaishu*"-style script.

2. i would like to create a kind of 3d-printed font. in terms of the style, it can be a "*kaishu*" font or a standard "*songti*" font.

3. the aesthetics of traditional characters and simplified characters

in the people's republic of china, simplified characters are the official characters recognized by the state, but even so, the majority of calligraphers still use traditional characters in their calligraphic art. calligraphers feel that the traditional characters are beautiful and that the simplified characters lack charm. from antiquity until now, the written language is part of a constantly changing and evolving history of a civilization, and the same is true with calligraphy. calligraphy art is established within the history of written language. written language and calligraphy art have changed and evolved based on innovations in technique, and culture, [advancements in] scientific materials, regional groups, and political economy. and of course, the impact of the internet, digital technologies, and artificial intelligence on language has inevitably been reflected in calligraphy art. the aesthetics of the "*zheng*," "*cao*," "*li*," and "*zhuan*" scripts [font styles], and their rules and regulations have followed the changes and the progress of time.

in my research on calligraphy aesthetics for the jianci, just as people are seen as organisms, in any kind of development, there is a process of tracing a line between two endpoints, between a fixed origin which carries forth into unknown forms. due to this, the jiancis are basically composed of two or more characters combined, and involve combining, and sharing radicals and strokes in order for them achieve simplification. a simplified word has more strokes than a single character. the newly

體字合併而成，並以合併與公用偏旁和筆畫製造簡化，壹簡詞的筆畫多於同壹單字，在嶄新結體上的簡詞，依然保留了繁體的傳統與經典美學，完美地綜合演繹了兩個終端：溯源固本＋前行未知。

肆，3d 簡詞是藝術簡詞的發展趨勢和方向。矢量數據庫的數碼技術，為簡詞藝術及其藝術衍生品提供了無窮的可能性，亦開啟了方便之門。

我的 3d 簡詞藝術端倪出現在 2013 年。作為碑林陸系的《天象》大型大地藝術，可以用肆個要素解釋：「儒石｜簡詞｜裏刻｜石墨」。所謂「裏刻」就是將簡詞書法設計到完整包裹多面體的儒石上刻製而成。這壹系列製造的還有坐落在王府井大街壹號的碑林《嘉德藝術中心》，重慶國際會展中心碑林《仟里廣大悅來》，上海圖書館新館的碑林《高山仰止》，中國台灣新建的桃園書法館的碑林捌系《先師碑》等等，都是 3d 簡詞的碑林大地藝術。

伍，矢量化網絡化的簡詞是壹可以期待的發展，她的變異與豐富，不確定性和速度，都將成為前所未有。

《簡詞典》簡詞構成

漢字源遠流長。數仟年來，這壹古老的語言從未有過以「字」為「詞」，這是漢字發展的基本線索。雖古漢語在文言裏，簡練且內涵深厚，基本貫穿了「字」含「詞義」，卻從未有過在意義與形式上衍化

interwoven word, maintains the tradition and classical beauty of the traditional characters, beautifully synthesizing and expounding upon the two endpoints — traceability to a fixed origin + carrying forward into an unknown form.

4. 3d jianci is artistic jianci that can be developed into new trends and create new directions. digital technology for vector databases provides unlimited possibilities for creating art multiples from jianci art, which can be produced at the buyer's convenience.

my notion to develop 3d jianci art began in 2013. my large-scale stone stele land-art series *tianxiang* can be described in four elements: "ru rocks | jianci | wrapped engraving | ink stones." the so-called "wrapped engravings" were created by taking the jianci calligraphy and designing it so that it would completely cover all sides of the ru rocks and engraving the calligraphic forms onto the surface. one of the stone steles works in this series *guardian art center* is even sitting at no. 1 wangfujing road, another stele *qian li guang da yue lai* is at the chongqing international exhibition center; the stele *gao shan yang zhi* is at the new building of the shanghai library, and finally the eighth work in the series, *patron saint steles*, is on display at the newly built hengshan calligraphy art center, etc. all are 3d jianci large-scale stone stele land artworks.

5. vectorized and digitized jianci are things that i look forward to developing. their richness, and variations, their speed, and indeterminacy, are unprecedented in our history.

structure of jianci *jiancidian*

the roots of chinese characters have a very long history. over the course of thousands of years, this ancient language has never had "characters" acting as "words." this offers a basic thread to understanding the development of the chinese language. although in ancient chinese, in classical chinese, the precise meanings were nonetheless very concise and deep, basically, throughout the history of "characters," there were those containing "word meanings," but, nonetheless, in terms of their meaning and form, they never evolved to the level of my "one-character-words" (jianci). the "characters," and the "word

到我製造的「壹字詞」（簡詞）。文言裏的「字」含「詞義」，在現代白話文中也已消失殆盡—現成的詞都以兩字或多字構成詞，換言之，單字不成詞，與英語基本上有詞無字形成鮮明對照。「壹字詞」的簡詞，回溯與再製造文言功能及其美學，給古老的漢字與漢語簡化帶來了無限可能性。

壹字詞法之幾個形態：

偏旁回字法

拆字成詞法

移植變異法

諧音替代法

遊戲繁衍法

等等……

對各種不同的簡詞製造方式方法、系統與規則等標準化與規範化，想像力的自由發揮相對容易。慎密邏輯思考，勢必壹板壹眼、亦步亦趨地實用宗旨，且歸根結底需得到使用之驗證。

第壹部分 —— 拆字成詞法

有個風趣的拆字遊戲。民間對長壽有這樣的說法，「米壽」是 88 歲，而「茶壽」是 108 歲，米字由兩個「八」、壹個「十」組合而成，茶由「二十八」和

meanings" in classical chinese have now disappeared and drained out of our modern vernacular. today's ready-made words are now composed of two or three characters. in other words, a simple character is no longer a word. this creates a stark contrast with english, which has words but no characters. these "one-character-word," jianci, and the process of recalling them to recreate their aesthetics and function, allow us to simplify these ancient chinese characters and this language, bring endless possibilities.

the one-character word method has several forms

the method of radical as character
the method of deconstructing characters to create words
the method of grafting and mutation
the method of homophonic replacement
the method of playing and reproduction
etc.

what follows is an explanation of the creation methods and styles of different kinds of jiancis, and the systems and rules, and standardization methods. exerting the freedom of imagination is relatively easy. thinking carefully and logically, we will have a clear plan of action. but moving step by step towards a practical aim, we need to keep in mind that, in the final analysis, we need proof that they can be used.

part one—the method of deconstructing characters to create words

there exists an entertaining game for deconstructing characters. in folk culture, there is a saying about the word "changshou" (longevity). it goes like this: "米壽 mishou" is 88 years old and "茶壽 chashou" is 108 years old. the character for "米 mi" (rice) is made up of two "八 ba" (eight) radicals and one "十 shi" (ten) radical. "茶 cha" (tea) has the radicals "二 er" (two), "十 shi" (ten) and a "八 ba" (eight). it also contains another "十 shi" (ten) radical and a "八 ba" (eight). so the saying "mishou is 88 and chashou is 108," comes from the process of deconstructing chinese characters, breaking them down, and tracing them to produce one-character words.

「十八」構成。「米壽」88 歲、「茶壽」108 歲，均來自對漢字的拆字、分解和溯源，成為壹字詞了。

這是壹種還原法。漢字在其演變的歷史長河裏疊字成字，卻從未成詞。是壹有趣現象，不止顯示了漢字之後期發展缺乏借鑒和創造，又是漢字發展的另壹基本線索。漢字在初期象形文字之後，便不斷以兩字或多字製造新字，新漢字的發明基於對原有漢字的疊加組合而成，這就給「壹字詞」奠定了基礎和可行性。簡詞「拆字成詞」是漢字尋源回溯的再造，驗證了基因回溯不可能回到過去，壹次回溯卻是壹次再製造。

拆字成詞法，壹字含多字做結構分解。可分解成多字成為簡詞。漢字常由兩個以上漢字構成另壹漢字：將兩個或兩個以上漢字組成的漢字，在保持原字的同時，分讀組成字而成詞的為簡詞。舉例：「明」字，「明」由「日」和「月」兩字組合而成。將「明」分解溯源成兩字讀來就成為「壹字詞」的簡詞「日月」；再舉例：漢字「美」，拆解後成為簡詞，讀成「羊大」與「大羊」，閱讀先後順序依據句子前後內容而決定。

第貳部分 —— 偏旁為字法

無論哪個漢字偏旁，偏旁＋字能夠成詞的實際上就是簡詞。舉例「病毒」由兩漢字組合而成。簡詞

this is one method of reduction. in the long history of the evolution of chinese characters, we have seen reduplicated characters combine to become new characters but not words. this is an interesting phenomenon. it also shows that in the latter period of their development, chinese characters lacked references to draw from and creativity. again, this is another clue to the trajectory in the development of chinese characters. following the period when chinese characters looked like pictographs, it was more of a process of continually taking two or three characters to make new characters — with the invention of new characters being dependent on the folding together of various characters. this kind of "one-character word" lays down a foundation and sense of feasibility. this method of "deconstructing characters to create words" is a kind of searching for the roots of characters in order to reconstruct them. in this process of verification of genetic lineage and searching for traces, we cannot go back to the past — the process of retracing, it is actually a process of reconstruction.

the method of deconstructing characters to produce words involves a character containing multiple characters to produce a structural decomposition. it can be dissolved into multiple characters and reconstituted into a jianci. individual chinese characters are frequently composed of multiple characters. a character containing two or more chinese characters which becomes a new character maintains both characters at once. they can be separated and read as characters and read as a word, as a simple phrase. for example, with the character " 明 *ming*" (bright), " 明 *ming*" is made up of the radicals " 日 *ri*" (sun) and " 月 *yue*" (moon). the deconstructed character of ming 明 can be traced back to the two characters and read as the one-character word or *jianci* " 日月 *ri yue*" (sun moon). another example is the character " 美 *mei*" (beauty); if we dissolve it into a jianci we can read it as " 羊大 *yang da*" (sheep big) and " 大羊 *da yang*" (big sheep). the order in which we read the character (i.e., back to front or front to back), is determined by the overall content and context of the sentence.

part two—the method of radical as character

no matter which radical, any radical plus a character can become a word, and effectively this is a jianci. for example, the character

「病毒」是由「病字頭」+「毒」而成壹字簡詞；再舉例：「風雪」由兩漢字組合而成，簡詞「風雪」由「風字頭」+「雪」而成。許多漢字的偏旁，以偏旁為字法，可以依次類推成為簡詞。

第叁部分 —— 偏旁加字法

以此法製造簡詞，先認偏旁為字，之後加字構成簡詞。

以「病字頭」為例：原先病字頭下面＋壹字，能讀成詞的是簡詞。比如「疚」是「病字頭」加了「久」，簡詞「疚」讀為「病久」或「久病」。再以「寶字頭」為例，簡體字「宝」是「寶字頭」加上「玉」，簡詞讀成「寶玉」或「玉寶」。

第肆部分 —— 同偏旁公用法

指在兩個以上漢字組成的詞中，每壹個漢字均有同樣的偏旁，並在合併成壹簡詞時，保留壹個公有的偏旁共享。例壹：「沉浮」，「哇噻」；例貳「松柏」；例叁「花草」和「家寶」；例肆：「煎熬」和「思戀」。

"病毒 *bingdu*" (virus), is composed of two chinese characters. the simplified phrase for (bingdu/virus) uses the top radical from 病 "疒 *bing*" (sick) and the character "毒 *du*" (poison/virus) to create a jianci. another example is "風雪 *fengxue*" (snow and wind/snowstorm) which is made up of two chinese characters. the jianci uses the top radical for the character "風 *feng*" and the character "雪 *xue*" to create a new jianci. many different radicals, can be used in this method and pressed into the service of the creation of new jiancis. using this method of radical as character, we can use many chinese character radicals, in order to analogize them into jiancis.

part three—the method of character + radical

to use this method to create a jianci, first choose a radical as a character and then add a character to create a jianci.

using the top radical in the character "病 *bing*" (sick) as an example, first, use the bottom radical, then add a character, and then the resulting word can be read as a jianci. for instance, the character "疚 *jiu*" (chronic disease) also shares the upper radical for the character for "病 *bing*" which is combined with the character "久 *jiu*" (a long time). the jianci 疚 can be read as "病久 *bingjiu*" (sick long) or "久病 *jiubing*" (long sick). using the upper radical of the character "寶 *bao*" (treasure) as an example, we see the upper radical for "寶 *bao*" with a "玉 *yu*" (jade) added onto it. the resulting jianci can be read as "寶玉 *bao yu*" (treasure jade) or "玉寶 *yu bao*" (jade treasure).

part four—shared radicals

this refers to the method of using two or more characters to create a jianci, but each character will share a common radical, and when they are combined into one word they retain and share that same radical. example 1: the words "沉浮 *chenfu*" (floating) and "哇噻 *wosai*" (wow) [both share common radicals between the radical "氵 *shui*" (water) and "口 *kou*" mouth respectively]. example two: the two characters in "松柏 *songbai*" (cypress) [share the radical "木 *mu*" (wood)]. example 3: the characters in "花草 *huacao*" (flowers) [both share the radical "⁺⁺ *cao*" (grass or botanical materials)] and the characters in "家寶 *jiabao*" (family treasure) [share the radical

568

第伍部分 ── 移植變異法。

這是在《簡詞典》裏最具神秘感的區塊。移植變異製造簡詞需要智慧，亦顯示智慧：在這區塊的簡詞製造，規則潛藏於任意之中，邏輯在無序間存在，而重複在仟變萬化時機，固這區塊亦是較為玩味與神奇的。或許移植變異製造簡詞，是《簡詞典》裏的主流族裔，萬紫仟紅表象裏有族裔分群，有合成邏輯纖維，又互相穿成線。

第陸部分 ── 諧音替代法

筆畫少與結構單壹之漢字，是製造簡詞的理想漢字對象，反之不易製造簡詞。不少漢字由繁筆畫多偏旁構成，不符任何壹種簡詞製造規則，用諧音字法製造簡詞便應運而生。易懂程度常常與讀者知曉原詞有關，比如漢語「糧票」，諧音替代法製造就是「良票」，如此簡化，需要對原詞「糧票」的聯想。

第柒部分 ── 遊戲和金融繁衍法

這是簡詞及其矢量化後的跨界延伸，她給簡詞留下了無垠的課題與前景。

谷文達
時間太長了，辛丑年終稿於紐約—上海之間

" 宀 *mian*" (roof)]. example 4: " 煎熬 *jian'ao*" (torment) and " 思戀 *silian*" (longing) [share the radicals " 灬 *huo*" (fire) and " 心 *xin*" (heart/spirit)] respectively.]

part five— the method of grafting and mutation

this is the most mysterious section of ***jiancidian***. to use grafting and mutation to create jiancis requires wisdom and it also demonstrates wisdom. in this section of jianci creation, the rules lurk in an arbitrary fashion and logic exists in a disorderly space, and repeats in an ever-changing temporal realm — one which is relatively ponderous and mystical. or perhaps in creating jiancis through grafting and mutation, with the dominant ethnicity of ***jiancidian***, in this representation of a blaze of colour, there are ethnic groups which are synthesized into a logical fabric that wears itself out in a mutual fashion and is woven into new threads.

part six—homophonic substitution method

chinese characters with few strokes and a singular form in their structure are the ideal characters for producing jiancis. that said, it is not easy. many chinese characters are made up of complex radicals on multiple sides and cannot be made into jiancis by any of the existing rules. in this case, the method of homophonic substitution rises to the occasion. the ease of understanding for the reader is often connected to their understanding of the original character. for instance, for the chinese word " 糧票 *liang piao*" (ration coupons), the homophonic replacement method produces the word " 良票 *liang piao*" (good tickets) — in simplifying it in this way, there is an association with the original word " 糧票 *liangpiao*" (ration coupons).

part seven—the method of reproduction through games and finance

this represents a cross-border extension of the jianci through vectorization. this will give the jiancis boundless prospects and issues.

gu wenda

(it's been too long, end of the xinchou year — between shanghai and new york).

第伍部分
CHAPTER 5

藝術的故事
社會與參與

A STORY OF ART:
SOCIETY AND
PARTICIPATION

社會和參與（壹）：

《孔子日記》溫哥華 1998

SOCIETY AND PARTICIPATION 1:

confucius diary vancouver 1998

1998 年 4 月 21 日，藝術家谷文達穿着壹件特別創作的服裝，這種服裝的風格是將壹半古典儒士服與壹半西方燕尾服對稱地結合在一起，用紅絲絨製成。這位藝術家牽着壹頭驢在溫哥華市中心的街道上走了壹整天，扮演着古代學者的角色。在這次巡迴演出中，他採訪了 jean walls（學者）、daina angeitis（溫哥華美術館的首席策展人）和 milton wong（銀行家）。他在街上和人們交談。這場演出在英屬哥倫比亞大學的莫里斯和海倫貝爾金畫廊舉行的谷文達裝置展的開幕式上結束

英屬哥倫比亞大學莫里斯與海倫·貝爾畫廊、anne wong 基金會、西線、溫哥華電影學院、記錄文化本質基金會贊助

on april 21, 1998, the artist gu wenda dressed in a specially created costume which the style was a combination of symmetrically a half of classical confucian scholar rope and half of a western tuxedo, made of red velvet. with a donkey the artist walked around in streets of downtown vancouver for the whole day, and played as an ancient scholar. on this touring performance, he interviewed jean walls(scholar), daina angeitis(the cheif curator of vancouver art gallery), and milton wong(banker). he talked to people in streets. the performance ended up at the opening of wenda gu's installation exhibition at morris and helen belkin gallery of the university of british columbia.
courtesy morris & helen belkin gallery of the university of british columbia, anne wong foundation, western front, vancouver film school, record the essence of culture foundation inc.

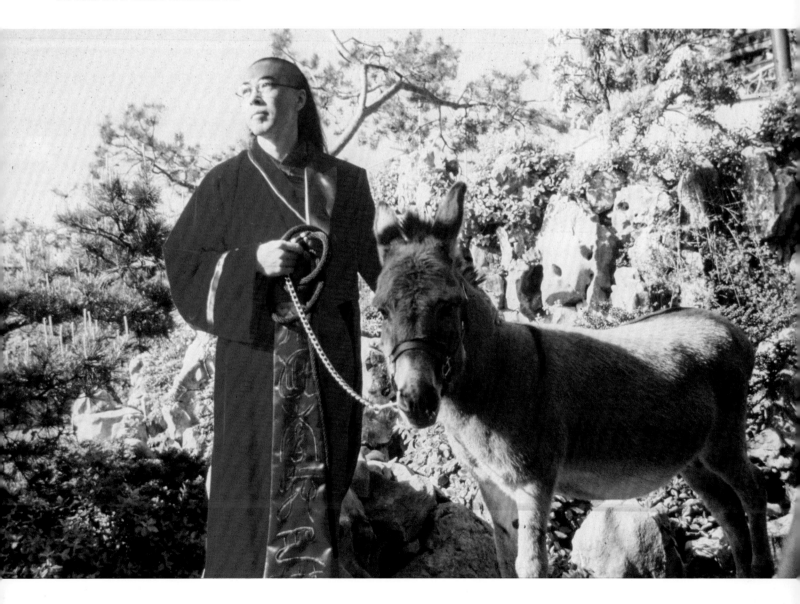

孔 子 日 記

谷文達

CONFUCIUS DIARY

gu wenda

歷史背景

從前，中國是由許多國家組成的，孔子想要在各國宣揚他的學說。於是他周遊列國，傳播他的治國理念，直到他的信仰得到廣泛傳播。無巧不成書，在西方宗教與文學的歷史裏，在驢馬交通的年代，驢馬成為人類命運之象徵：耶穌基督被釘上十字架之前，曾騎着毛驢去耶路撒冷（通過這次旅行，他獲得了聲望）；塞萬提斯的堂吉訶德騎在西風瘦馬上的形象，成了人類不斷追求的、甚至比人類自身更偉大的東西的象徵。毛澤東在「貳萬伍仟里長征」中穿過壹望無際的草原，壹路上他說服了成仟上萬的佰姓相信和支持他的革命。她被這樣描寫道：「長征是壹支宣傳隊，壹個播種機……」較於今天的網絡與人工智能時代，我們詫異地發現，傳播的本質與驢馬精神並無兩致。正如 a.j. 克洛斯在塞萬提斯的《堂吉訶德》的導言中所指出的那樣，「這是壹本 17 世紀的讀物，根據它，我們和社會壹起嘲笑主人公；壹個新世紀的閱讀，與英雄壹起對

HISTORICAL BACKGROUND

once upon a time, when china was made up of many individual states, confucius wanted to spread the word of his doctrine throughout the land. he travelled around to various countries spreading his ideas about ruling and governance until his beliefs were eventually adopted. coincidentally or not, in the histories of western religion and literature, during the era of horse and donkey transportation, donkeys were seen as symbols of heroism and of human fate: jesus christ rode a donkey to jerusalem (and he built up his reputation through this trip) before he was killed and crucified. Similarly, don quixote's donkey journey on a thin horse buffeted by the west wind, became a symbol for the ceaseless human quest for something larger than ourselves. In mao's, "twenty-five-thousand-kilometer-long march," he convinced thousands and thousands of peasants to believe in and support his revolution. he explained, "the long march is a propaganda troupe; it is like a seed-planting-machine ...". be it in the era of the internet or artificial intelligence, or the era of the donkey and horse, i have realized that the essence of spreading communication is the same. we are astonished, the essence of traveling and propaganda will never change. as a.j.close pointed out at the end of the introduction of cervantes' don quixote, "a seventeenth-century reading, according to which we laugh with society against the hero; a nineteenth-century reading, which feels for the hero battling against society; and a twentieth-century reading, which affirms that the novel permits both

抗社會；還有 20 世紀的閱讀，它提醒我們小說同時允許兩種選擇，以及其他的選擇。」

行為的演繹，目的並不是上述任何壹種，而是為了促進文化和社會之間的對話及相互理解。因此，我希望這次《孔子日記》之旅能成為壹種文化大使，把不同背景、不同文化的人們聯繫起來，尤其是把歷史與未來聯繫起來。這是我們人類在現代世界末的命運嗎？

表演過程

藝術家或表演者穿着特別設計的服裝，服裝風格是中西古典服裝的結合。在現代環境中以「孔子」的形象騎驢旅行。他與城市中幾個地方的人們進行對話和討論，壹天的孔子之旅將在展覽開幕當天結束。

孔子服飾的當代製作

服裝是用鮮紅的絲絨製成的，它由壹半儒家長袍和壹半西式燕尾服對稱組成。服飾上，用中國人髮繡出偽英語，以英國人髮繡成偽篆字。

對話

無論選擇哪個地方，與當地人的對話對於此次孔子之旅的主題和這座城市的歷史都具有象徵意義和重要意義。選擇政治、文化、藝術等領域的專業人士與「孔子」進行對話和討論。

<div align="right">

谷文達

紐約 1997 年 11 月

</div>

options, and others, simultaneously."

but the purpose of this performance has nothing to do with either reading, but rather to help with dialogues and mutual understandings between cultures and societies. thus, i want this *confucius' diary* tour to act in the role of cultural ambassador to link people of different backgrounds, and cultures. is this not the fate of humanity at the end of the modern century?

THE PROCESS OF THE PERFORMANCE

the artist or performer wears a specially-created costume which is a combination of a western and a classical chinese style costume, touring with a donkey as "confucius" in a modern environment. the performer or artist engages in dialogues and discussions with people at a few sites around the city where this confucius tour will be performed. this one-day confucius tour end at the exhibition opening.

THE CONTEMPORARY MAKING OF THE CONFUCIUS COSTUME

the costume is made of shiny red silk velvet. it is divided symmetrically as half classical confucian scholar robe and half western tuxedo. chinese hair is used to embroider pseudo-english letters on the chinese classical half, and english hair is used to embroider pseudo-seal script characters on the tuxedo half.

THE DIALOGUES WITH PEOPLE

on the confucius tour all have symbolic and significant meanings in terms of the themes and the histories of the cities no matter where they are held. in general, the confucius character chooses to engage with professionals within the cultural, political, and artistic fields.

<div align="right">

gu wenda

new york city, nov. 1997

</div>

《孔子日記》藝術家谷文達牽着毛驢在溫哥華
市中心街頭行走壹整天
confucius diary with a donkey, the artist
gu wenda walked around in streets of
downtown vancouver for the day

谷文達帶着西西里驢子行走在溫哥華
街區，對話行人，張晴（中間）胡傑明
（右）
gu wenda is with the donkey talked
to people in vancouver streets，
zhang qing (middle) hu jieming
(right)

上
above

下
below

在《孔子日記》徒步行程裏採訪了黛安
娜 —— 安吉提斯（下）和銀行家密爾頓·
王（上）
in this *confucius diary* touring
performance, artist gu wenda
interviewed, daina angeitis (below, the
cheif curator of vancouver art gallery),
milton wong (above, banker)

社會和參與（貳）：

《谷文達的婚禮生活》系列之貳 中國香港 2000

SOCIETY AND PARTICIPATION 2:

gu wenda's wedding life series 2 hong kong, china 2000

藝術家谷文達在曹素功墨廠製人髮基因墨在《谷文達的婚禮生活》之貳裏的行為藝術巨幅書法的細部
the artist gu wenda created a giant calligraphic performance by using his own human hair dna
ink from the caosugong ink factory in *gu wenda's wedding life series 2*

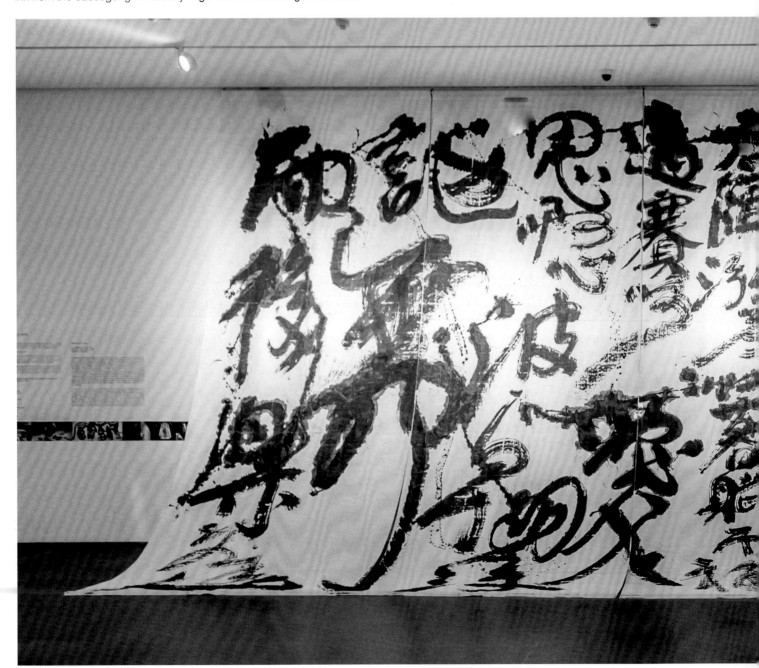

社會和參與（貳）：
《谷文達的婚禮生活》系列之貳 中國香港 2000

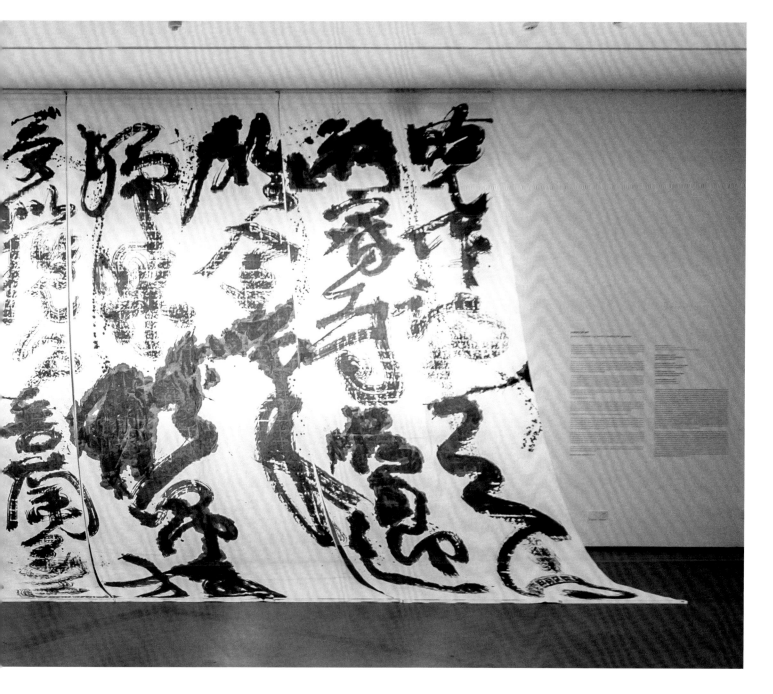

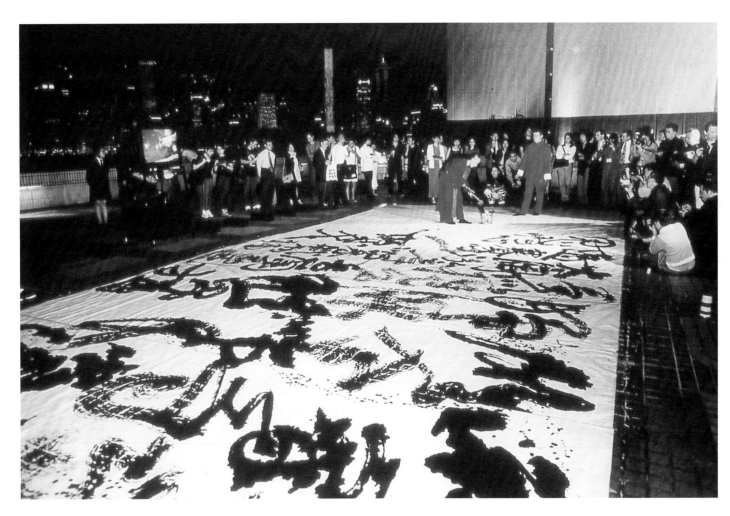

《谷文達的婚禮生活》系列之貳

行為藝術

2000 年於香港藝術館

由舊金山現代藝術博物館和舊金山亞洲藝術博物館主辦由香港藝術館贊助新郎谷文達（中國籍），新娘傑羅
米・溫斐爾德（美國籍）

人髮基因墨，宣紙

GU WENDA'S WEDDING LIFE SERIES 2

art performance
hong kong museum of art, 2000
organized by the san francisco museum of modern art and the san francisco asian art museum, and
sponsored by the hong kong museum of art
groom: gu wenda (chinese); bride: jerome winfield (american) human hair dna ink, xuan paper

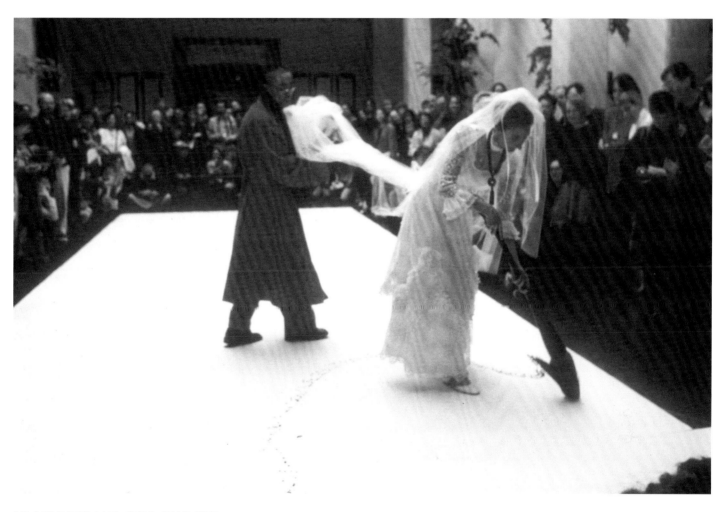

《谷文達的婚禮生活》系列之壹行為藝術

1999 年於舊金山亞洲藝術博物館

由美國舊金山現代美術館和舊金山亞洲藝術博物館主辦與贊助新郎谷文達（中國籍），新娘弗蘭斯·卡普蘭
（美國籍）

人髮基因墨，宣紙

***GU WENDA'S WEDDING LIFE* SERIES 1 ART PERFORMANCE**

san francisco asian art museum, 1999
organized and sponsored by the san francisco museum of modern art and the san francisco asian art
museum groom: gu wenda (chinese), bride: france kaplan (american)
human hair dna ink, xuan paper

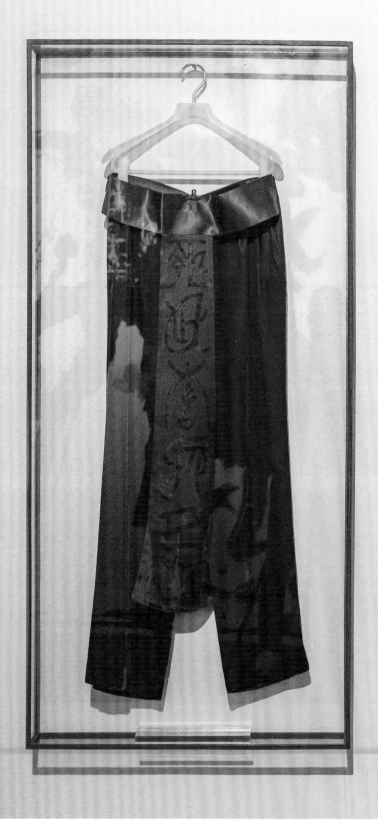
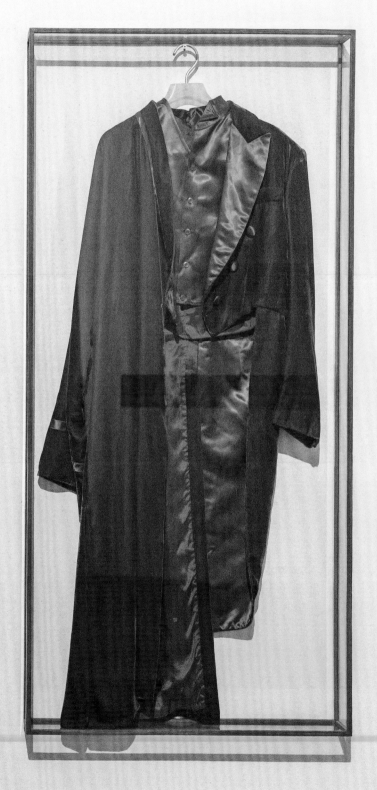

《谷文達的婚禮生活》系列之伍 廣州 2002
gu wenda's wedding life series 5 guangzhou 2002

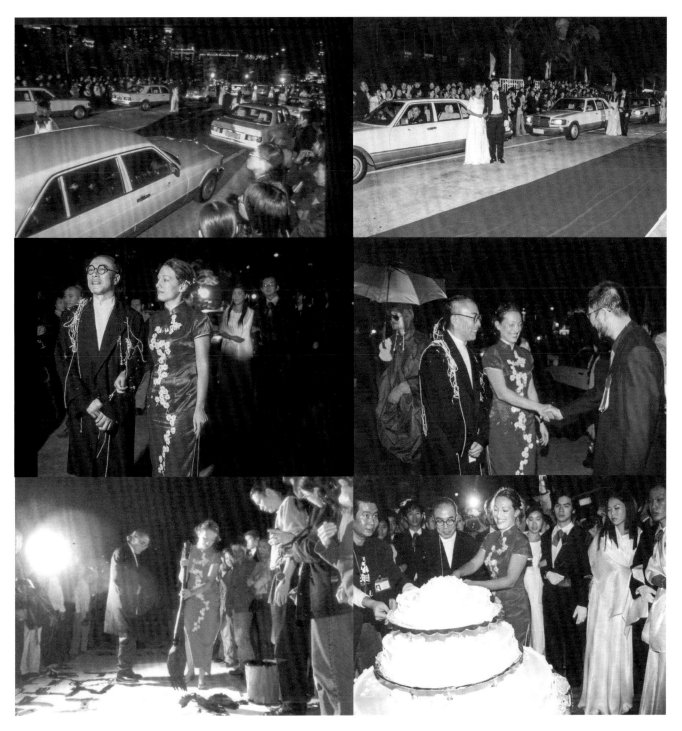

《谷文達的婚禮生活》系列之伍行為藝術

2002 年於廣東美術館

由廣東美術館主辦與贊助

新郎谷文達（中國籍），新娘依萊娜拉・芭蒂絲登（意大利籍）

GU WENDA'S WEDDING LIFE SERIES 5 ART PERFORMANCE

guangdong art museum of art, 2002

organized and sponsored by the guangdong museum of art

groom: gu wenda (chinese), bride: eleonora battiston (italian)

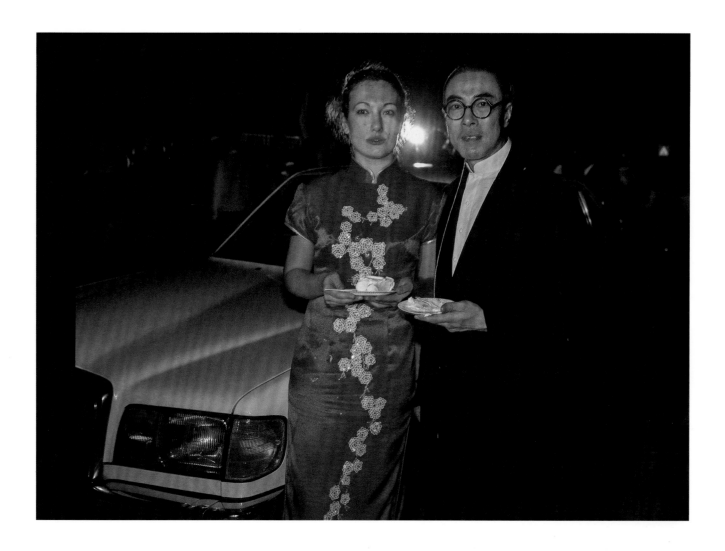

《谷文達的婚禮生活》系列之伍

2002年11月18日，第壹屆廣州叁年展的開幕藝術表演谷文達藝術作品

項目製片人：李剛、楊傑

廣東美術館主辦

領頭新郎：谷文達

出生在中國，住在紐約

領頭新娘：依萊娜拉·芭蒂絲登

出生在意大利，住在北京

主持人：wang huangsheng

白色禮服的新娘團隊：黑色禮服的新郎團隊：

lu cheng	song cheng
huang yanhong	xu xiaoxi
chen dongmei	zhu liang
zhao yue	huang shubing
yang lijuan	huang weidong
peng shaokun	zheng donggui

yu huanping	zhang zekui
wang jiuyue	zhong xianghui
chen sibei	chen zhuokai
zhang yin	li wenhua
xu yongyi	pan guixu
wang manli	liang chuqing
tang sheng	chen xixing
sun hongzhou	xie hongxing
luo lu	xie yingsheng
sheng jiali	yang shouhao
tu yin	chen cheng
liu chang	li jing
chen guixi	chen zhiguang
zhang yizhong	wang canguang

時間：2002年11月18日晚8時，首屆廣州叁年展開幕。

地點：廣東美術館旁邊的街道。長邊的位置設置：中心的街道被關閉，並覆蓋着壹個巨大的宣紙（26 m × 3 米），沿着邊是 2 刷（1.5 米長），中國水墨畫，婚禮蛋糕（3 層 x 1 米直徑）。21 輛白色奔馳豪華轎車載着新娘和新郎前往婚禮現場。

《谷文達的婚禮生活》系列之伍的故事

廣東美術館位於美麗的廣州貳沙島。廣東美術館旁邊的整條街都被關閉了，因為晚上的活動——《谷文達的盛大婚禮生活》系列伍儀式表演，為第壹屆廣州叁年展開幕。這確實是第壹個在中國正式展覽的演出作品。

天空晴朗而黑暗，街道上燈火通明。

20 對身着婚紗的新人：新娘身着白色禮服，新郎身着黑色燕尾服，他們的白色豪華轎車排成兩排緩緩駛來。20 對新人走到前面，站在他們的車旁，而觀眾則站在街道兩側的人行道上，等待新郎和新娘的到來。

壹輛長長的白色豪華轎車載着身着黑色禮服的新郎谷文達和身着紅色禮服的新娘依萊娜拉・芭蒂絲登，緩緩駛過鋪着宣紙的巨大紅地毯，駛過街道中心。新郎谷文達和新娘依萊娜拉・芭蒂絲登下車後，從街的壹頭走到另壹頭，去見牧師。

「我很高興，很榮幸地做新郎谷文達和新娘依萊娜拉・芭蒂絲登證婚人。在廣東美術館的『首屆廣州當代藝術叁年展』開幕之際祝賀你們的文化婚禮……」

廣東美術館館長王璜生先生宣讀誓詞後；紅地毯被拆除後，新郎谷文達和他的新娘依萊娜拉・芭蒂絲登開始在壹張巨大的宣紙上（26 米 x3 米）在觀眾面前書寫他們的書法。新娘依萊娜拉和新郎文達開始在宣紙的兩端寫下他們各自的巨幅自傳：新郎以中文入書：「我是谷文達，出生於上海，生活在紐約，愛住在北京的意大利人依萊娜拉・芭蒂絲登」，新娘以英語入書：「我是依萊娜拉・芭蒂絲登，出生於布羅尼亞，生活在北京，愛住在紐約的中國人谷文達」。當他們在壹張巨大的紙上相遇時，他們的書法已經完成了。

從中間開始，新郎和新娘繼續以同樣的方式重複他們的簡歷，現在把對方的書法重疊起來。通過不同語言的語言重疊，他們的原民族、生活經歷和語言在物理上和象徵上發生了轉換和混雜。

婚禮結束後，20 對新人和觀眾圍成壹圈，新娘依萊娜拉和新郎文達一起切下了巨大的婚禮蛋糕。大家分享結婚蛋糕是婚禮的高潮。

GU WENDA GU'S WEDDING LIFE SERIES 5

an art performance for the opening of the first guangzhou trienniale, nov. 18th, 2002, guangzhou a gu wenda art production
project producer: li gang, yang jie sponsored by guangdong museum of art

leading groom: gu wenda
born in china, lives in new york

leading bride: eleonora battiston
born in italy, lives in beijing

minister: wang huangsheng

team brides in white gowns:	team grooms in black tuxedos:
lu cheng	song cheng
huang yanhong	xu xiaoxi
chen dongmei	zhu liang
zhao yue	huang shubing
yang lijuan	huang weidong
peng shaokun	zheng donggui
yu huanping	zhang zekui
wang jiuyue	zhong xianghui
chen sibei	chen zhuokai
zhang yin	li wenhua
xu yongyi	pan guixu
wang manli	liang chuqing
tang sheng	chen xixing
sun hongzhou	xie hongxing
luo lu	xie yingsheng
sheng jiali	yang shouhao
tu yin	chen cheng
liu chang	li jing
chen guixi	chen zhiguang
zhang yizhong	wang canguang

time: 8 pm, nov. 18th, 2002, during the opening of the first guangzhou triennale. location: the street next to the guangdong museum of art. location setting: center of the long side of the street was closed for the perfomance, and covered with a giant sheet of rice paper (26m × 3m), along side it were 2 brushes (1.5m long each), chinese ink, and a wedding cake (3 layers × 1 meter in diameter). 21 white mercedes limosines carried the brides and grooms to the wedding site.

THE STORY OF GU WENDA'S WEDDING LIFE 5

the guangdong museum of art is located on the beautiful er sha island in guangzhou city. the entire street next to the guangdong museum of art was closed for the evening event - gu wenda's grand wedding life #5 ceremonial performance for the opening of first guangzhou triennale. it was indeed the first performance piece ever agreed to be conducted by an official exhibition in china.

the sky was clear and dark and the street was brightly lighted.

20 couples in their wedding dresses: brides in white gowns and grooms in black tuxedos, were slowly driven in their white limosines in 2 lines. arriving in front, the 20 couples came out and stood next to their cars, while the audience stood on the side walks flanking both sides of the street waiting for the leading groom and bride to arrive.
a long white limosine with the leading groom gu wenda,

dressed in black with his bride, eleonora battiston, dressed in red, slowly drove over a giant red carpet (which covered the xuan paper) down the center of the street. groom gu wenda, and bride, eleonora battistion, upon exiting their limosine, walked down the street from one end to the other, to meet with the minister.

"i'm happy and honored be to the minister of the bride, eleonora battiston, and the groom, gu wenda, on this special occasion at the opening of first guangzhou triennale, to celebrate this new genetic, cultural wedding with all of you..."

after mr. wang huangsheng, director of guangdong museum of art, read the vows; the red carpet was removed and the groom gu wenda, and his bride, eleonora battiston, began to create their calligraphy on a huge rice paper (26m × 3m) in front of the audience. bride eleonora and groom wenda began to write their personal stories from opposite

ends of the paper: "gu wenda was born in shanghai, lives in new york, loves eleonora battiston who is an italian living in beijing" in chinese, "eleonora battiston was born in bologna, lives in beijing, loves gu wenda who is a chinese living in new york" in english. their calligraphy was complete by the time they met in the center of the huge paper.

from the center, the groom and bride continued to repeat their resumes in the same manner, now overlapping the calligraphy of the other. by overlapping their each other's words in different languages, their original nationalities, life experiences and languages are physically and symbolically transformed and intermixed.

afterwards, with 20 couples and audience forming a circle, bride eleonora and groom wenda together cut the giant wedding cake. the peak of the ceremony was when everybody shared the wedding cake.

谷 文 達 的 婚 禮 生 活

谷文達

GU WENDA'S WEDDING LIFE

gu wenda

《谷文達的婚禮生活》之伍

新郎谷文達和新娘依萊娜拉・芭蒂絲登手攜手從大街的壹端走到另壹端。證婚人，廣東美術館館長王璜生先生唸證婚詞：「我很高興，很榮幸地做新郎谷文達和新娘依萊娜拉・芭蒂絲登證婚人。在廣東美術館的廣州首屆叁年展開幕之際祝賀你們的文化婚禮」。王璜生先生唸完證婚詞，移走紅地毯，巨幅雪白的宣紙展現在觀眾面前。

新郎谷文達和新娘依萊娜拉・芭蒂絲登的大型婚禮書法表演開始。

新郎谷文達在 26 米長的宣紙的壹端，新娘依萊娜拉・芭蒂絲登在宣紙的另壹端。他們同時從巨幅宣紙的兩端中心開始書寫各自的巨幅自傳：新郎以中文入書—我是谷文達，出生中國上海。我生活和工作在紐約和上海。新娘以英語入書—我名

A STORY OF *GU WENDA'S WEDDING LIFE* SERIES 5

the bridegroom gu wenda and the bride eleonora battiston, walked hand in hand from one end of a road to another. the officiant of the wedding, mr. wang huangsheng, the director of the guangdong art museum, proclaimed: "i am very pleased and very honored to be the officiant for the wedding of the bridegroom gu wenda and the bride leonara battiston. on the occasion of the first guangzhou triennial at the guangdong art museum, i wish you the best on your cultural wedding." after these remarks, wang huangsheng moved the red carpet away, and a huge piece of snow-white xuan paper appeared in front of the audience.

gu wenda and leonora battiston's large-scale wedding calligraphy performance began.

the bridegroom, gu wenda was at one end of the 26-meter-long piece of xuan paper; the bride, leonora battiston was at another end. at the same time, they both began to write their own massive biographies from the two ends of the massive sheet of paper. the bridegroom wrote in chinese: "i am gu wenda, born in shanghai,

依萊娜拉・芭蒂絲登，出生在意大利的布羅尼亞。我生活和工作在北京和米蘭。當他們寫就巨幅自傳，新郎谷文達和新娘依萊娜拉・芭蒂絲登在 26 米長的宣紙中間相遇。鴉雀無聲的整條大街忽然沸騰了，在觀眾的掌聲中他們會接吻擁抱。

此刻新郎新娘交換位置（即新郎谷文達站在了新娘依萊娜拉・芭蒂絲登書寫的英語自傳的位置，而新娘依萊娜拉・芭蒂絲登則站在新郎谷文達書就的中文自傳上）。然後他們同時又從巨幅宣紙的中心，向不同方向的兩端開始書寫各自的巨幅自傳。不同的是新郎谷文達在新娘依萊娜拉・芭蒂絲登書寫的英語自傳上書寫中文自傳，而新娘依萊娜拉・芭蒂絲登書寫的英語自傳覆蓋了新郎谷文達書寫的巨大的漢字自傳。當他們寫就時，他們各自的自傳卻成了不能閱讀的中英文複合的雙方生活履歷。他們結合了。

新郎谷文達和新娘依萊娜拉・芭蒂絲登在 20 對集體婚禮的新郎新娘的簇擁下走向被觀眾擠得水泄不通的婚禮慶典中心。新郎新娘在歡呼聲中與觀眾一起嚐新婚蛋糕。此刻婚禮進入了高潮！

《谷文達的婚禮生活》系列：

《谷文達的婚禮生活》之壹，1999 年
新郎谷文達（中國籍），新娘弗蘭斯・卡普蘭（美國籍）
由美國舊金山現代美術館和舊金山亞洲美術館聯合策劃

china. i live and work in new york and shanghai." the bride wrote in english: "my name is leonora battiston, born in bologna, italy. i live and work in beijing and milan." while they wrote their massive biographies, the bridegroom and the bride met in the middle of the 26-meter-long xuan paper. the entire street, without so much of a pip, suddenly erupted into cheers. amid the applause of the audience, the bride and bridegroom met and kissed and hugged.

at this point, the bridegroom and the bride swapped positions (that is, the bridegroom stood at the spot where the bride had written her biography in english, and the bride stood where the bridegroom had written his chinese biography). Then, at the same time, they began writing their biography in huge letters and characters from the center of the massive sheet of xuan paper. what was different was that gu wenda wrote his chinese biography on top of the english biography of battiston, while the battiston wrote her biography in english covering up wenda gu's chinese biography. they were writing their own biographies and this became an illegible record of their two lives, doubled up in english and chinese. they had united.

the bridegroom and bride were ushered by 20 pairs of bridegrooms and brides towards the audience which packed the wedding hall. In front of the applause, the bridegrooms and brides tasted the wedding cake together with the audience. at this point, the wedding ceremony entered its climax!

gu wenda's wedding life series also includes the following works:

gu wenda's wedding life series 1, 1999
groom: gu wenda (chinese); bride: france kaplan (american)
organized by the san francisco asian art museum and the san francisco museum of modern art

《谷文達的婚禮生活》之貳，2000 年

新郎谷文達（中國籍），新娘傑羅米・溫斐爾德（美國籍）

由中國香港美術館策劃

《谷文達的婚禮生活》之叁，2000 年

新郎谷文達（中國籍），新娘梅蘭妮・依思特本（澳洲籍）

由日本宇都宮美術館策劃

《谷文達的婚禮生活》之肆，2001 年

新郎谷文達（中國籍），新娘安・卡特琳（德國籍）

由德國柏林世界文化宮策劃

《谷文達的婚禮生活》之陸，2005 年

新郎谷文達（中國籍），新娘（印度籍）

由美國貝茨大學美術館策劃

藝術的精神性寓於藝術的娛樂性將取而代之藝術的說教

這是對視覺藝術的挑戰，更是對傳統水墨藝術以及它的欣賞方式的衝擊。在文人主義的「曲高和寡」，「陽春白雪」的一統天下的中國畫界，一直將水墨畫認定「精神性」為上品，而視其他的藝術成分為下乘。將藝術品的娛樂性當作水墨精神的反面。我們可以看到水墨畫的欣賞的特殊性以及歷史文化的積澱和影響，特別是長久以來在學院派體系下，這樣優秀的傳統被曲解和教條主義化了。更為甚者將水

gu wenda's wedding life series 2, 2000
groom: gu wenda (chinese); bride: jeremy wingfield (american)
organized by the kong kong museum of art, hong kong, china

gu wenda's wedding life series 3, 2000
groom: gu wenda (chinese); bride: melanie eastburn (australian)
organized by the utsunomiya museum of art, utsunomiya, japan

gu wenda's wedding life series 4, 2001
groom: gu wenda (chinese); bride: anne katrin (german)
organized by the haus der kulturen der welt, berlin

gu wenda's wedding life series 6, 2005
groom: gu wenda (chinese); bride (indian)
organized by the art museum of bates college

THE SPIRITUALITY OF ART RESIDES IN THE DELIGHTFUL ENTERTAINMENT OF ART WHICH GETS DISPLACED BY THE PREACHING OF ART

this is the challenge for visual art, and, moreover, the confrontation with traditional ink art and its mode of appreciation. in the world of chinese painting, which is dominated by high-brow tastes informed by literati ideals (as expressed by the proverbs "obtuse songs find few listeners" or the elegant but rarefied "spring snow" melodies), ink painting has always been affirmed as something superior imbued with "spirituality," while other genres of art were considered inferior. we see the delight and entertainment of artworks as the opposite of the spirit of ink and see the distinct nature of the appreciation of ink painting alongside historical and cultural accumulation and influence. especially under the academic system, this superb tradition has for a long time been misunderstood and become dogmatic. the "spirituality" of ink painting has even been transformed

墨畫的「精神性」僅僅變成了小和尚唸經的「口頭禪」，從而拋棄了中國文化另一些優秀傳統。

而我們可以很客觀地看到在市場經濟中佔統治地位的藝術，是好萊塢的電影、流行音樂、搖滾樂以及商業體育。可以理解李小龍是全世界最皆曉的中國人，也不難想像卡拉 ok 的創始人被《亞洲時代周刊》評為 20 世紀拾位最有影響的亞洲人之壹。就視覺藝術而言，近來引人入勝的展覽，是古根海姆的 BMW 汽車公司贊助的世界摩托車展，這吸引世界眾多博物館爭先恐後的續展。古根海姆又在策劃意大利著名時裝設計師 giorgio armani 的回顧展。這對於傳統的藝術界和傳統式理想主義者來說似乎是難以接受的。觀眾心理學和市場規律是壹不可抗拒的當代和未來社會的靈魂，當代和未來的中國水墨藝術也同樣不例外。對於此壹挑戰的應戰，水墨藝術也擴展和涉及到了其他的藝術範疇如水墨裝置和水墨行為藝術。我在 80 年代初中期已經朦朧地感覺到了（儘管那時的中國還沒有建立市場經濟的體制）。我在西安的首次個人展覽是巨型的水墨裝置和行為表演，參加瑞士的洛桑雙年展的大型水墨與其他媒材結合的裝置作品等。

我們可以看到：視覺藝術從繪畫、雕塑擴展到裝置、行為和影像、電腦等多媒體，使其更具有擴張力、吸引力和娛樂性。

這兒舉我的兩個作品為例：1999 年在舊金山現代藝術博物館（san francisco museum of modern art）和亞洲藝術博物館（asian art museum of san

by many into "rhymes," and it is repeated as monks reciting sutras. consequently, other excellent traditions in chinese culture are dispensed with.

yet we can very objectively see that within a market economy, the dominant position of art is taken up by hollywood cinema, popular music, rock music, and commercial sports. we can see that bruce lee is the chinese person known the world over — and in this context, it is not hard to imagine why the inventor of karaoke was considered by *time magazine asia* as one of the ten most influential asians of the twentieth century. in terms of visual art, recently there was a fascinating global automobile exhibition sponsored by bmw at the guggenheim — leading numerous museums around the world to rush to put up sequel exhibitions. the guggenheim is also curating a retrospective of the renowned italian fashion designer, giorgio armani. this, for those who hold onto the traditional world of art and this traditional idealism, is more or less difficult to accept. crowd psychology and market rhythms represent the irresistible soul of contemporary and future societies and chinese ink art is no exception. faced with this challenge, ink art has also expanded to and involved into other fields of art such as ink installation and ink performance art. in the mid-1980s, i had already vaguely sensed this (even though china had not established a market economy system). my first solo exhibition in xi'an was one of large-scale ink installations and performances — and my large fusion work of ink and other media took part in the lausanne biennale. we can see that from painting, sculpture, extending to installation, performance, video, and computer art, makes visual art all the richer with its tension, attractiveness, and entertainment value.

here i cite two of my works as examples: the ink performance art *gu wenda's wedding life* jointly performed at the san francisco museum of modern art and the asian art museum of san francisco. the idea for this work was based on social phenomena in today's multicultural societies. the so-called "multicultural" is

francisco）聯合演出的水墨表演藝術《谷文達的婚禮生活》（gu wenda's wedding life）。此作品觀念基於當今多元文化的社會現象，而所謂「多元化」莫過於生理上的「混血」，固非同種族的通婚典禮是最本質和最典型並具象徵意義的。整個表演分叁段式：1. 戀愛；2. 婚禮；3. 婚後生活。參加演出由我「新郎」（純中國血統）選擇「新娘」（純英國血統），和拾陸歲男孩「牧師」（菲律賓與美國混血兒）。「戀愛」是首先由「新郎」和「新娘」席地而坐於壹巨型石硯前，並面對鋪滿整個地面的宣紙，「新娘」將中國人髮，「新郎」將美國人髮剪入石硯，並共同研「混血人髮墨」；「婚禮」是雙方穿戴特製的婚禮服在「牧師」的禱告聲中舉行「婚禮」，而「牧師」的禱告詞是無法聽懂的中英文混合語；「婚後生活」是最後，亦是整個表演的高潮——由「新娘」在宣紙上書寫巨大的英文字母，然後「新郎」在英文字母上入書篆字，最後由這兩個博物館的全體人員和觀眾一起在現場舉杯慶賀「文化姻聯」。整個過程既幽默滑稽又嚴肅，而富有典型性和象徵性的觀念在這熱鬧喜慶的場面裏得以充分體現。

none other than physiological "hybrids" or the concept of "mixed-blood." hence mixed-race marriages are most fundamental, typical and symbolic. the entire performance was divided into three parts: 1. love; 2. wedding; 3. married life. participating in the performance was me as the "bridegroom" (pure chinese blood) choosing a "bride" (pure british blood) and a sixteen-year-old boy who was the "pastor" (mixed, filipino and american). "love" began with the "bridegroom" and the "bride" seated on the floor in front of a huge ink stone, facing xuan paper that covered the whole floor, the "bride" took chinese hair and the "bridegroom" took american hair and both cut them onto the ink stone and ground up a "mixed-blood hair ink"; the "wedding ceremony" was a "wedding" held with the sound of the "pastor's" prayers, with the couple wearing specially-made wedding gowns, while the prayers of the "pastor" were an incomprehensible mix of chinese and English; "married life" was the climax of the entire performance, in it the "bride" wrote huge english letters on the xuan paper, followed by the "bridegroom" who wrote in seal-script characters within the english letters, finally, the entire staff of the two museums and the audience cheered and celebrated this "cultural marriage." the entire process was humorous, amusing, and yet somber, fully displaying the ideas rich in classical ideas and symbolism amid this joyous and festive scene.

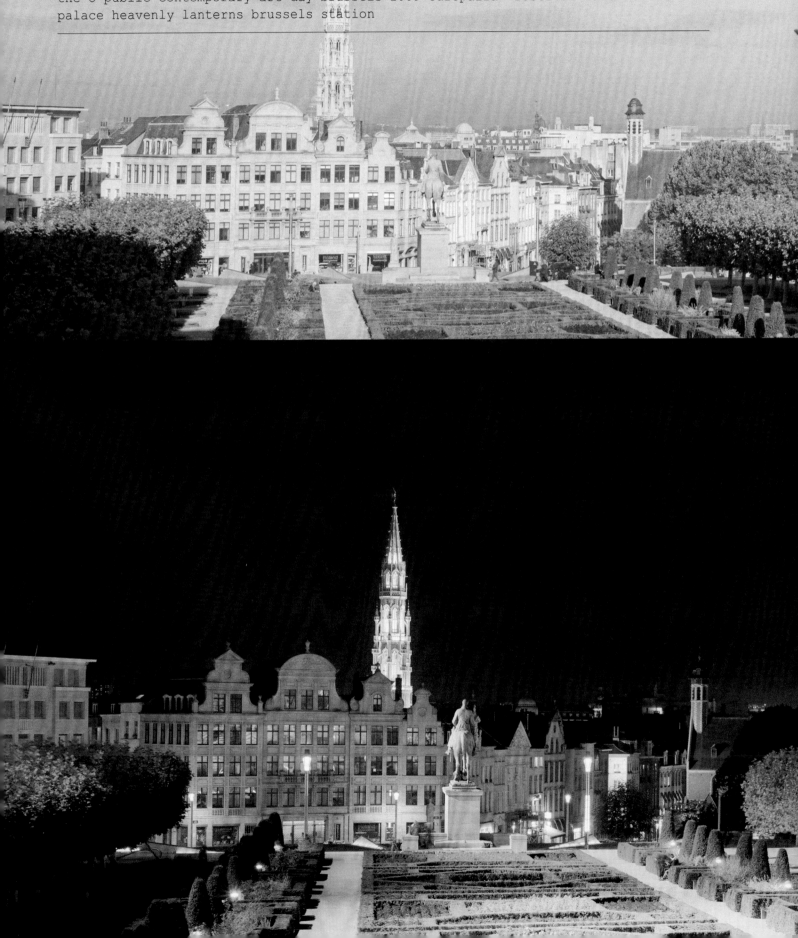

社會和參與（叁）
第零屆大眾當代藝術日 布魯塞爾 2009 歐洲藝術節 大地藝術《茶宮》天堂紅燈布魯塞爾站

SOCIETY AND PARTICIPATION 3:
the 0 public contemporary art day brussels 2009 europalia festival landart tea palace heavenly lanterns brussels station

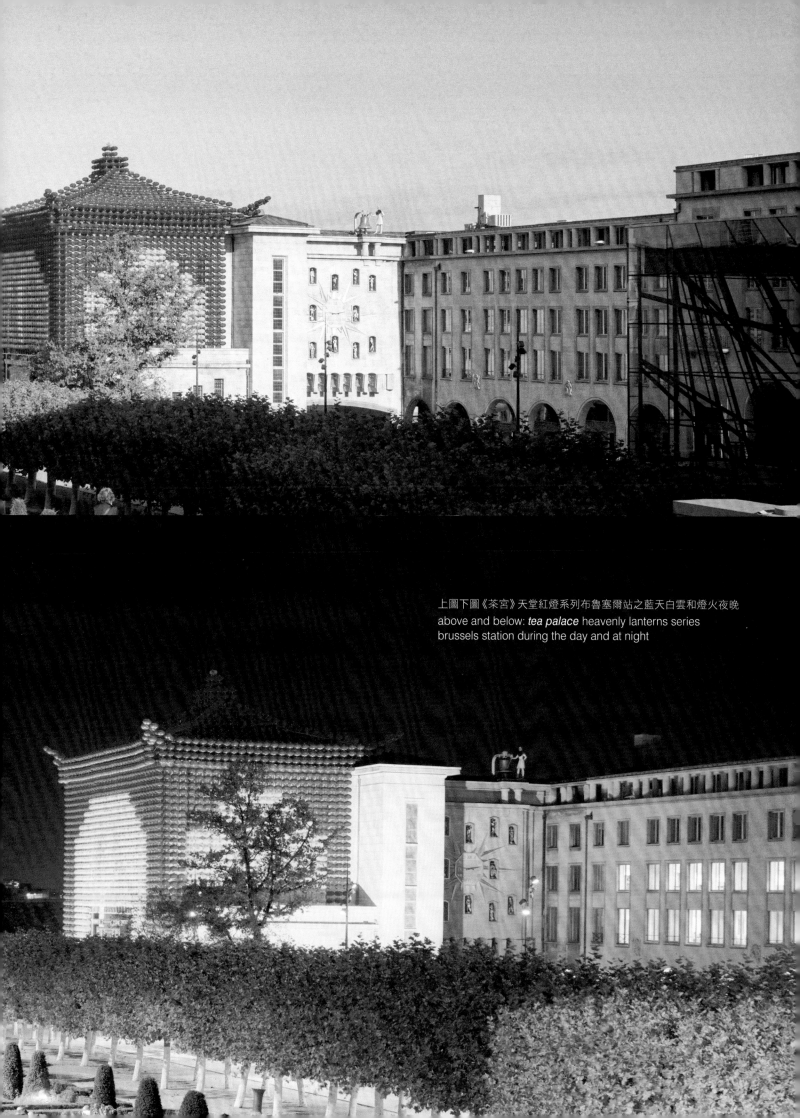

上圖下圖《茶宮》天堂紅燈系列布魯塞爾站之藍天白雲和燈火夜晚
above and below: *tea palace* heavenly lanterns series
brussels station during the day and at night

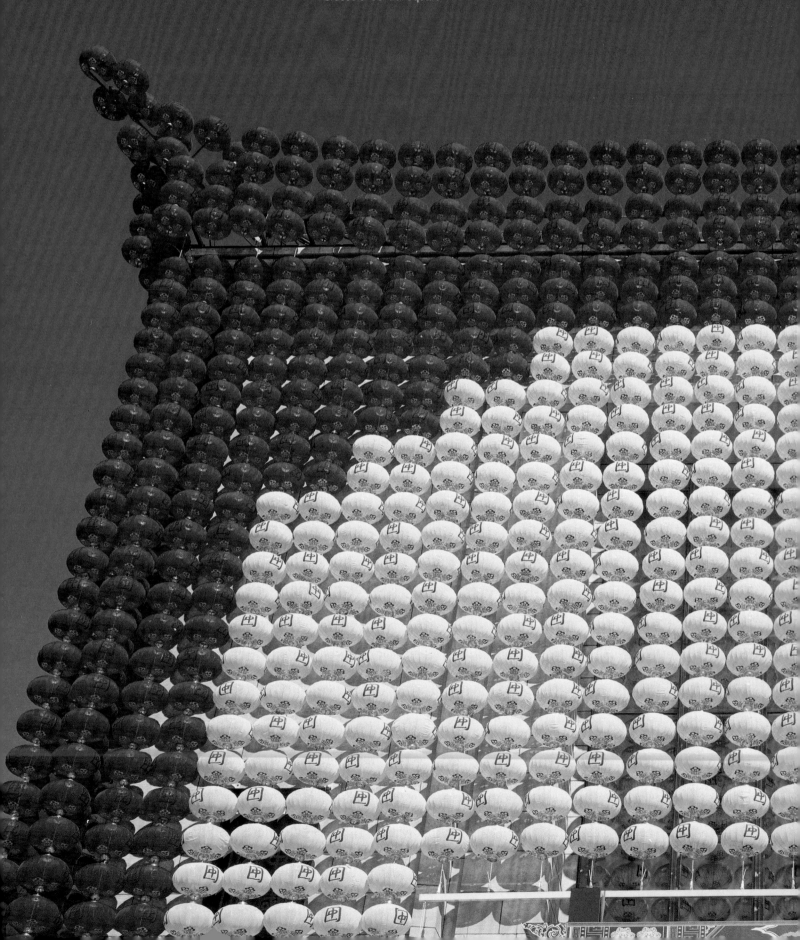

《茶宮》天堂紅燈系列
布魯塞爾站大地藝術
2009 年歐洲藝術節
由歐洲藝術節和伊比利亞藝術基金會贊助
5000 紅金雙色燈籠亭閣 布魯塞爾市中心廣場
（palais des congres dynastie）

TEA PALACE **HEAVENLY LANTERNS SERIES**

brussels station land art
europalia art festival 2009
sponsored by europalia and iberian art foundation
5000 red and golden lanterns in the form of a pagoda were
hung on the palais des congres palais de la dynastie in
brussels' central square

2009 年《茶宮》天堂紅燈布魯塞爾站以 5000 枚燈籠將布魯塞爾市中心的 palais des congres dynastie-congrespaleis daynastie 建築包裹成了壹座規模宏大的中國風範之亭閣。

in 2009, *tea palace* heavenly lanterns brussels station used 5000 lanterns to wrap the palais des congrès—palais de la dynastie in the center of brussels, into the giant form of a chinese style pavilion.

《茶宮》天堂紅燈布魯塞爾站秉承了天堂紅燈系列跨文化性的理念，天堂紅燈系列中首次實施的大地藝術計劃。在宏觀上，茶宮外體將被披掛上以中國傳統的紅黃雙色燈籠，通體組合成中式亭子建築式樣，建築兩側以紅黃燈籠排列的方式組成簡詞 d 中的「茶食」組合字，以谷氏簡詞的藝術作品形式，詮釋了茶宮構建出「中國文化」的理念，以藝術的視覺衝擊力打開了壹條「體驗中國」的途徑。在微觀上，紅色燈籠上印有「中國」組合字，使藝術理念融入到細枝末節。同時，將茶宮內當年度歐洲藝術節導覽中心，文化旅遊以及餐飲活動均為《茶宮》天堂紅燈布魯塞爾站的壹部分。

向視覺藝術的極限挑戰是天堂紅燈藝術計劃之重要概念。集視覺衝擊力、技術難度、公眾打卡地，集嚴肅藝術與波普文化於壹身。基於天堂紅燈藝術計劃的特性，規模恢弘的視覺藝術語言、工程實施的技術性特點，以及更重要的是此藝術計劃對於所在地的社會與文化的象徵意義。此項目的合作者不僅僅限於當地的美術機構，更需要政府、資金、物力、市民態度等各方位的支持，還需要考慮航道、氣候、消防、路面交通等諸多細節的問題。

tea palace heavenly lanterns brussels station, maintains the cross-cultural spirit of the series. this is the first implementation of a land art project in this series. on a macro level, the outer layer of tea palace was draped in red and yellow traditional chinese lanterns, combined to create the form of a traditional chinese-style pagoda. the lanterns arranged on the two sides of the building are placed in

the pattern of the gu's phrase " 茶食 " (tea food). the combined character is of the same form used in the artwork gu's phrase dictionary. the work translates the concept of chinese culture into the form of the tea palace, using the strong visual impact of art to open up a channel to experience china. on a micro level, the combined character " 中國 " （china）, which is printed on the lantern is a way of integrating artistic ideals into the minute details of the work. at the same time, tea palace became the hub of the europalia festival, for guided art tours, cultural tourism, and dining events.

challenging the limits of visual art is an important precept of the heavenly lanterns art project. the visual impact of the assembled lanterns, the sophistication of the technology, and the status of the work as a public landmark or meeting-point, make this both pop- art and serious work. the heavenly lanterns project combines, the grand scale of the visual language, the specificities of the technology required for the implementation of the project, and, more importantly, it addresses the symbolic significance of the local social and cultural specificities. the participants of this project include local art organizations and relevant government departments. it also encompasses finance, logistics, the attitudes of the residents of that city, the support of various parties, shipping lanes, climate, fire safety, ground transportation, and the consideration of many other details.

壹個很出色的布魯塞爾工程公司擔任了《茶宮》天堂紅燈布魯塞爾站構造
5000 燈籠的亭閣

an excellent brussels construction company installed this 5000 lantern
pagoda project *tea palace* heavenly lantern brussels station

《茶宮》天堂紅燈布魯塞爾站正在搭建中
tea palace heavenly lanterns brussels station during the installation process

《茶宮》天堂紅燈布魯塞爾站成了當時布魯塞爾市中心高地光彩奪目的
地標,是歐洲藝術節的中心和象徵。

tea palace heavenly lanterns brussels station became a popular
landmark in the center of brussels, a symbol of europalia festival

598

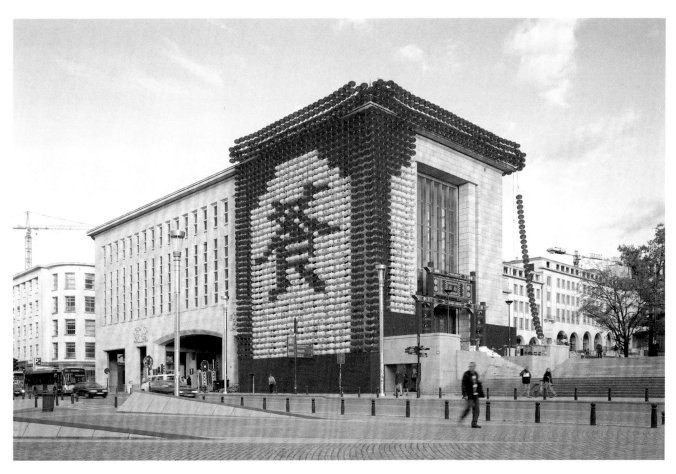

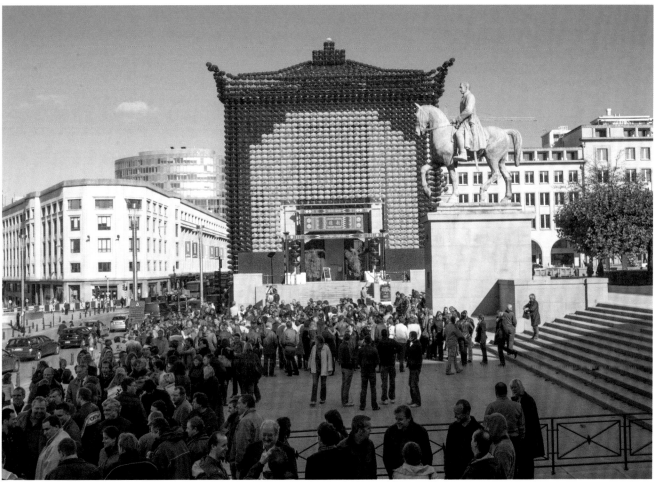

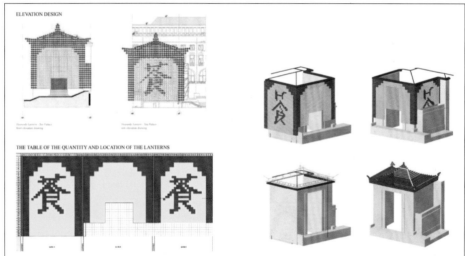

ELEVATION DESIGN

THE TABLE OF THE QUANTITY AND LOCATION OF THE LANTERNS

《茶宮》天堂紅燈布魯塞爾站的技術和施工設計
the technical specifications and construction designs of *tea palace* heavenly lanterns brussels station

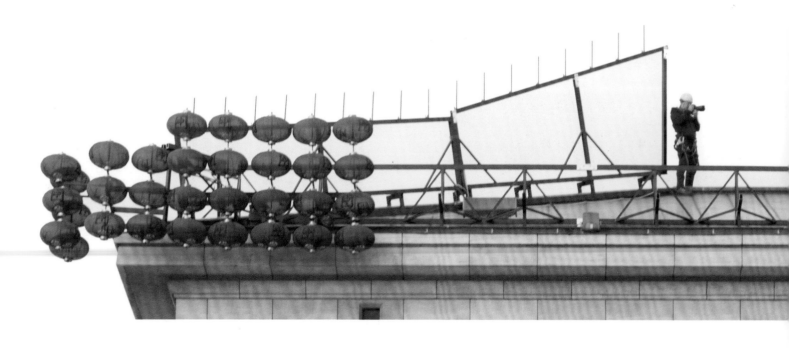

600

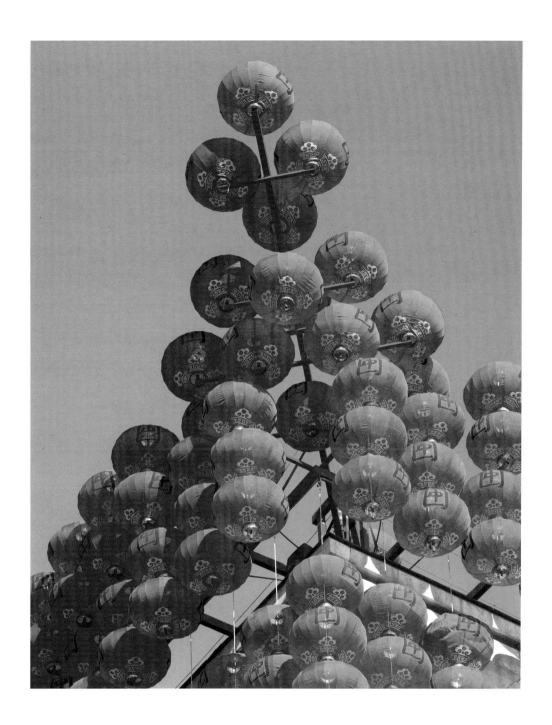

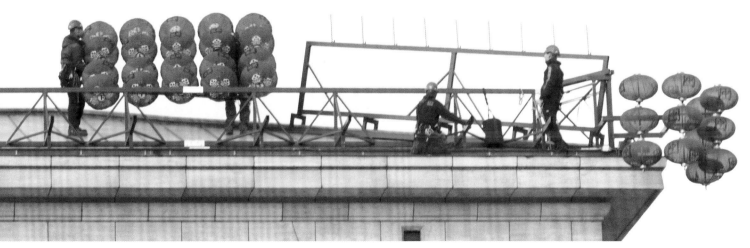

社會和參與（肆）：

第壹屆大眾當代藝術日 佛山 2014 大眾參與型行為藝術《基因與蛻變》

SOCIETY AND PARTICIPATION 4:

the first contemporary art day foshan 2014 public participatory performance dna and metamorphosis

社會和參與（肆）：

第壹屆大眾當代藝術日 佛山 2014 大眾參與型行為藝術《基因與蛻變》

602

《基因與蛻變》
第壹屆大眾當代藝術日
參與性大眾行為藝術，佛山 2014
由香港瑞安集團贊助
2014 年母親節，佛山嶺南天地
1060 小學生在 1000 平米綢緞上書寫孝經

DNA AND METAMORPHOSIS

first public contemporary art day
public participatory performance, foshan, 2014 sponsored by shui on
group hong kong mother's day 2014, foshan lingnantiandi
1060 elementary school students wrote out the classic of filial piety on
1000 sqm of silk

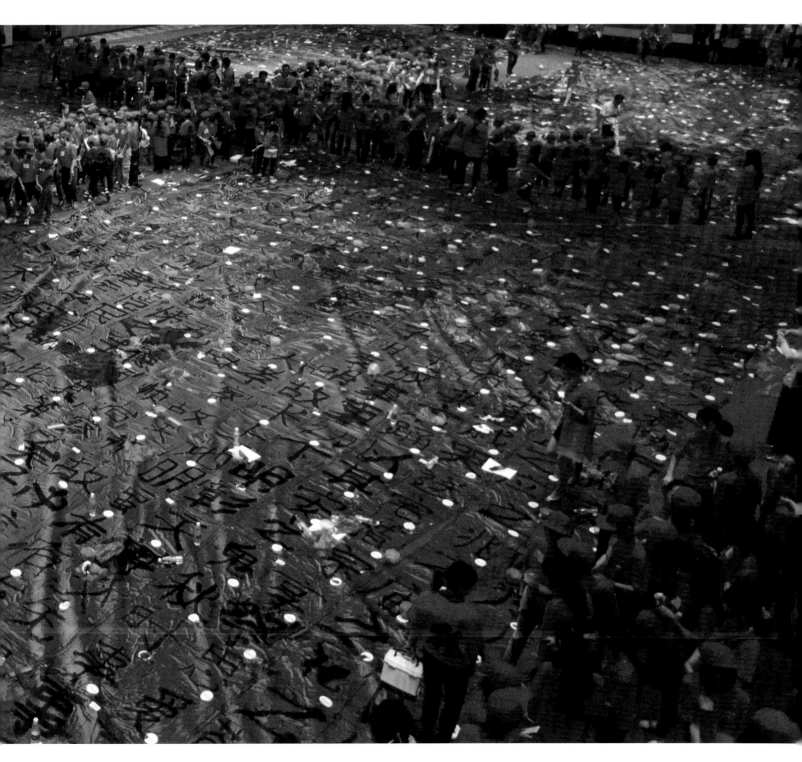

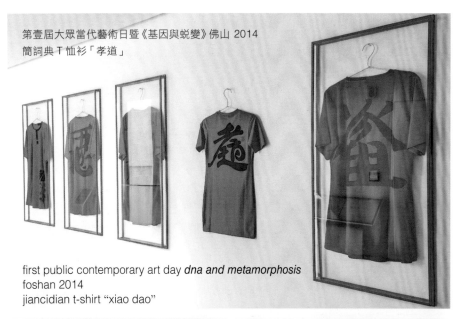

第壹屆大眾當代藝術日暨《基因與蛻變》佛山 2014
簡詞典 T 恤衫「孝道」

first public contemporary art day *dna and metamorphosis*
foshan 2014
jiancidian t-shirt "xiao dao"

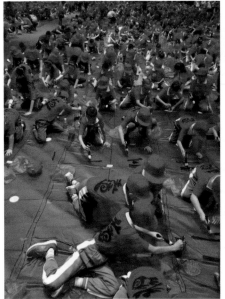
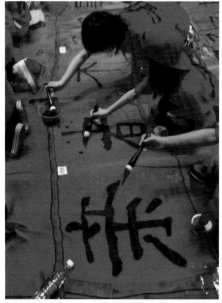

大漢字書法 1060 位佛山叁 —— 肆年級小學
生在 1000 平米綢緞上書寫孝經
big character calligraphy, 1060 foshan
third and forth grade elementary school
students work together to create a giant
calligraphy book of filial piety on 1000
sqm of silk

盛大場面和激情昂揚 藝術家谷文達在第壹
屆大眾當代藝術日與參加《基因與蛻變》行
為藝術的學生交談
a grand scale and passionate
atmospher-the artist gu wenda talks to
students during the performance of *dna
and metamorphosis* at the first public
contemporary art day on mother's day
2014, foshan

《基因與蛻變》多媒體裝置藝術 合美術館
2019-2020
dna and metamorphosis mixed media
installation,the umited art museum 2019-
2020

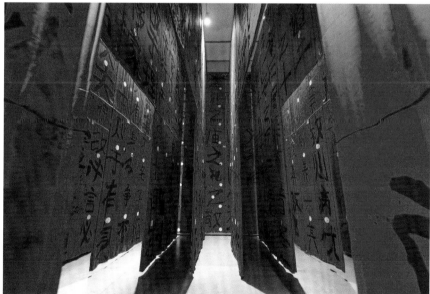

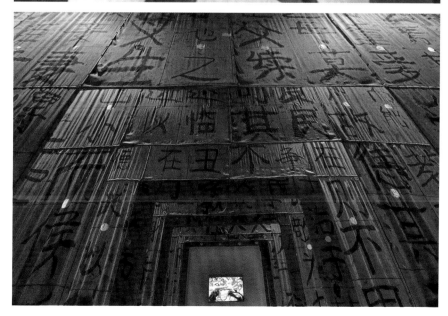

605

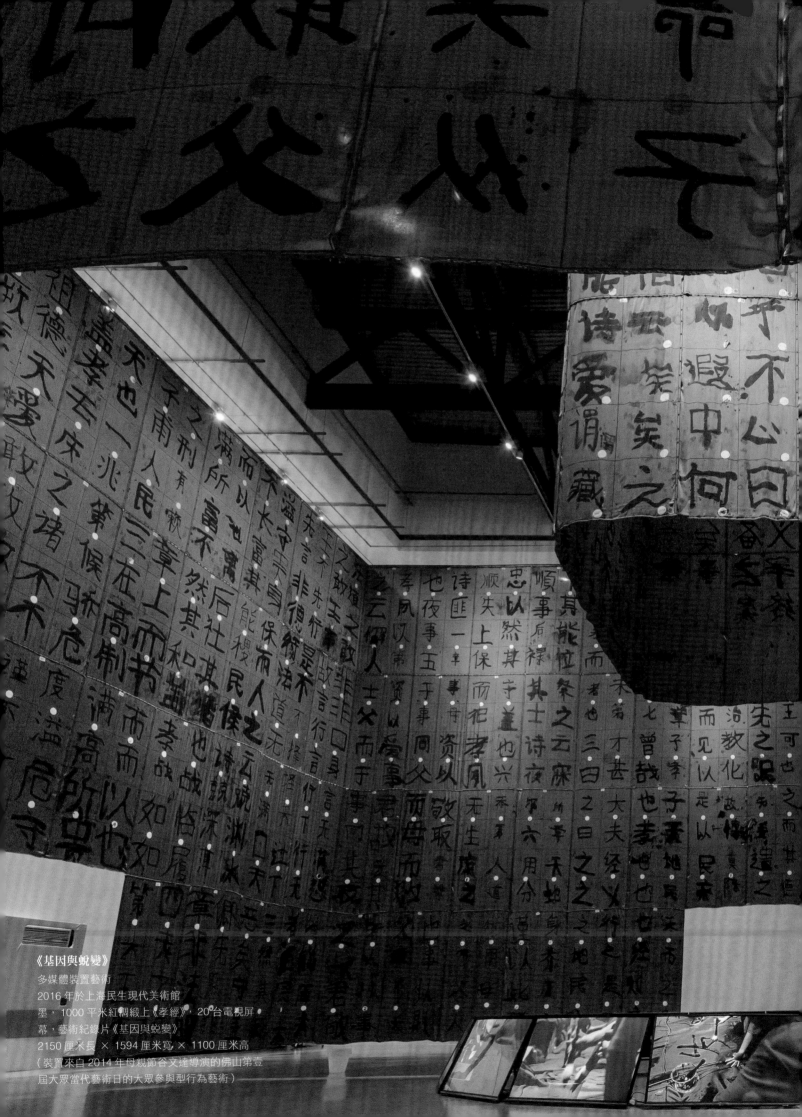

《基因與蛻變》
多媒體裝置藝術
2016 年於上海民生現代美術館
墨，1000 平米紅綢緞上《孝經》，20 台電視屏
幕，藝術紀錄片《基因與蛻變》
2150 厘米長 × 1594 厘米寬 × 1100 厘米高
（裝置來自 2014 年母親節谷文達導演的佛山第壹
屆大眾當代藝術日的大眾參與型行為藝術）

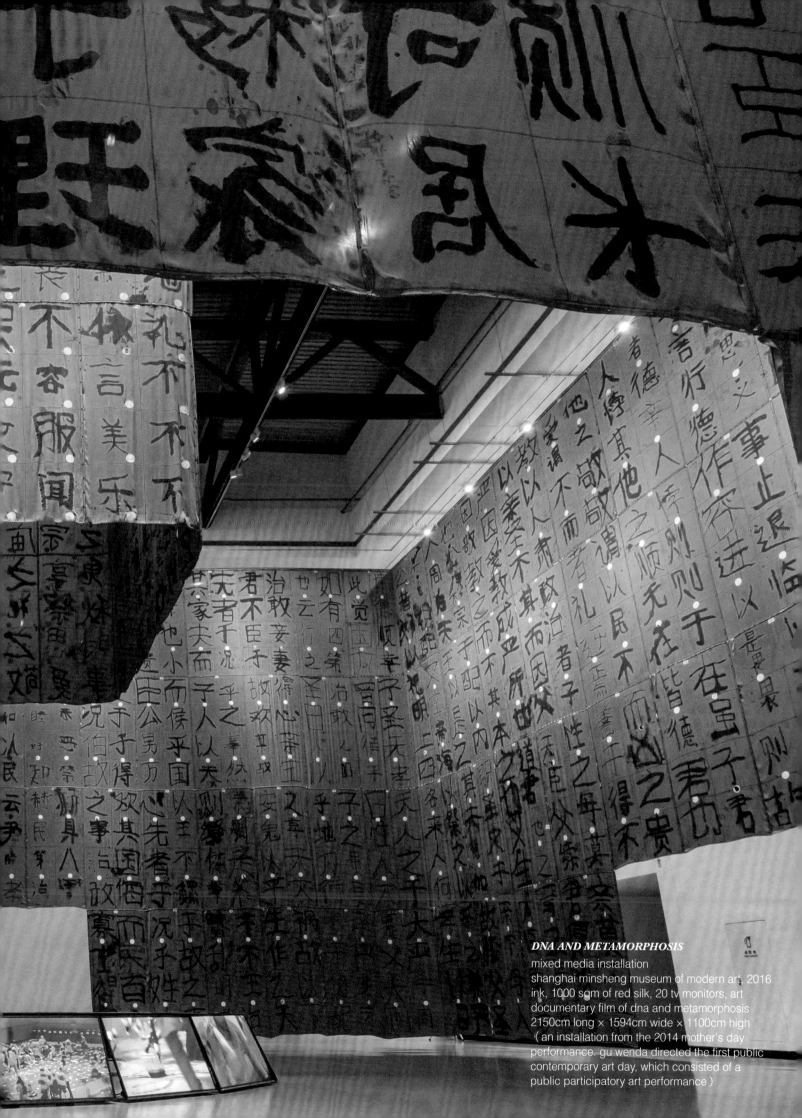

DNA AND METAMORPHOSIS
mixed media installation
shanghai minsheng museum of modern art, 2016
ink, 1000 sqm of red silk, 20 tv monitors, art
documentary film of dna and metamorphosis
2150cm long × 1594cm wide × 1100cm high
（an installation from the 2014 mother's day
performance. gu wenda directed the first public
contemporary art day, which consisted of a
public participatory art performance）

《基因與蛻變》第壹屆大眾當代藝術日 1060 學童參與型大眾行為藝術的現場，谷文達與湯華正在指揮佈置現場，佛山 2014

dna and metamorphosis first public contemporary art day - artist gu wenda and studio director linda tang are working on site as 1060 students participate in a public participatory performance in foshan, 2014

《基因與蛻變》第壹屆大眾當代藝術日 參與型行為藝術的現場
dna and metamorphosis first public contemporary art day the site of public participatory performance

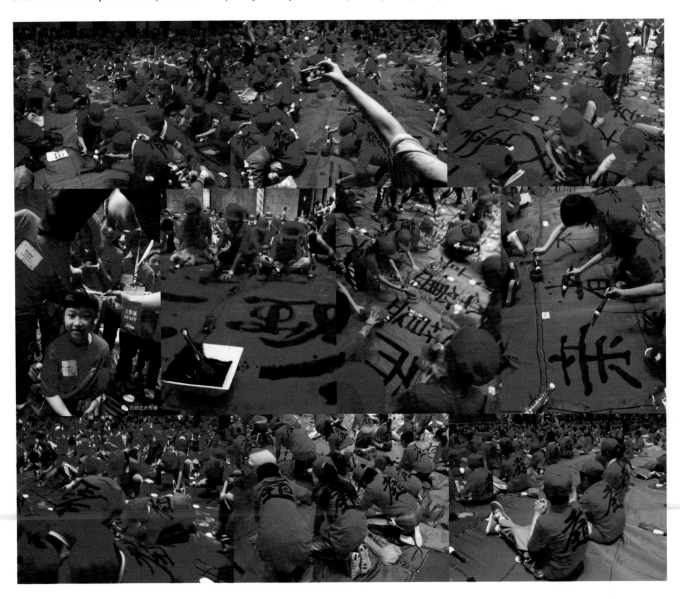

由藝術家谷文達創建於 2014 年，「大眾當代藝術日」是壹個不定期持續舉行的公眾參與的社會性當代行為藝術。

《基因與蛻變》是第壹屆大眾當代藝術日在佛山的大型藝術項目。在 2014 年的母親節，由藝術家谷文達創意並導演，由香港瑞安集團主辦和贊助。1060 學童參與了在 1000 平米的綢緞上書寫斗大書法《孝經》的大眾行為藝術。

第貳屆大眾當代藝術日暨《青綠山水畫的故事》，藝術家谷文達創作並導演的由 1500 位學童參與的聲勢浩大而氣氛熱烈的行為藝術。以中國繪畫中之經典青綠山水畫作為人文背景，以對人類目前之生存環境的擔憂，和對未來的憧憬，1500 名學童在 1500 平米的宣紙上，以藍藻水繪畫和書寫出令人擔憂的《青綠山水畫的故事》。由平安集團主辦與贊助，2016 年在深圳舉行。

第貳屆大眾當代藝術日繼《青綠山水畫的故事》之後，藝術家谷文達又在上海創意和執導了前後由 5000 餘學童參與的《天堂紅燈上的簽語未來》參與型大型行為藝術項目。項目持續進行至 2016 年秋開幕的谷文達回顧展的開幕式。25000 枚 9 彩燈籠帶着學童們的「簽語未來」包裹的整座上海民生現代美術館。

created by gu wenda in 2014, public contemporary art day is a social public participatory art performance which is held at irregular intervals.

dna and metamorphosis was a large-scale art project and public contemporary art day held in foshan. on mother's day of 2014, gu wenda created and directed the project with the support of hong kong's shui on group. 1060 students wrote out the classic of filial piety on 1000 square meters of silk in a work of public performance art.

for the second public participatory art day, *a story of qing lv shan shui hua* gu wenda directed 1500 students in a performance art project, a momentous and vast event, brimming with an enthusiastic atmosphere. using the cultural foundations of the classic blue- green traditional chinese landscape paintings as a foundation, and expressing their fears in regards to man's ability to survive in the environment, and their visions for the future, 1500 students used blue-green algae to paint and tell a worrying story of qing lv shan shui hua on 1500 square meters of xuan paper. pingan group helped organize and sponsor this event in shenzhen.

after the second public contemporary art day, *a story of qing lv shan shui hua*, the artist directed 5000 students in heavenly lanterns inscribing the future - a large-scale participatory contemporary art project in shanghai. the project continued until the opening exhibition in fall 2016 of the retrospective exhibition of gu wenda. 25000 lanterns in 9 colors held the wishes for the future inscribed by the students. the lanterns were wrapped around the facade of the minsheng art museum.

藝術紀錄片《基因與蛻變》
art document film *dna and metamorphosis*

基 因 與 蛻 變

谷文達

DNA & METAMORPHOSIS

gu wenda

我以為伍月的佛山，已是壹派初夏的悶熱，原來這是外來人誤讀佛山的氣候罷了。佛山的人們，像常年生活在自然溫室裏的花朵——冬天不會飽經風霜，夏日亦無炎炎逼人的毒日。每次說到此刻，大家便以為佛山養人宜居，像肆季如春的昆明了……但佛山冬不冷而陰濕，夏不炎卻悶濕，也許北方的乾冷乾熱更痛快些。「蒸籠桑拿」般的氣候，就是熱衷桑拿的，也會被擾得心煩意亂，這是我首次佛山歸來後的由衷之感。

朦朦朧朧的「蒸籠」裏，我們的團隊忙忙碌碌，《基因 & 蛻變》在搶時趕製中。出色的獨立電影人黃偉凱導演和他的攝影師們，擔當了今次藝術紀錄片的拍攝製作。想當年，我們在比利時曾經合作，如今更默契了：我受邀於歐洲藝術節，在市央廣場

i thought that may in foshan would involve a series of hot and muggy days, but this thought was no more than an outsider misreading the climate of foshan. year after year, the residents of foshan seem to tolerate this weather like flowers living in a natural greenhouse. yet they didn't have to suffer the hardships of winter and were not threatened by the scorching rays of the summer sun. every time i talk about this, even though everyone believes foshan is comfortable, livable and restorative (like kunming which benefits from four seasons of spring) ... and the winter of foshan, which is not cold but damp, and the summer which though not scorching is nonetheless humid, people seem to think the dry heat and dry cold of the north are slightly more straightforward. it's a climate like a bamboo steamer basket or a sauna, but even those who appreciate saunas will find themselves at the mercy of their own anxious and distraught moods, ignited by the heat. these are my sincere feelings, after returning from my first trip to foshan.

within the haze of the "dumpling steamer" our team was busy all the time, trying to buy time to hasten the production of *dna and metamorphosis*. the famous independent film director, huang weikai and his cameramen were engaged to produce a documentary video for this projcct. wc had actually collaborated before in our early years in belgium, and this time we had an even better rapport. i had been commissioned by an art festival to make a piece of art in the central square of brussels *heavenly*

創製大地藝術，《天堂紅燈—茶宮》布魯塞爾站屹立肆月之久，儼然成為地標，普普通通的吉祥物紅燈籠，讓布魯塞爾的老華僑熱淚盈眶，握着我的手說，「我在布魯塞爾壹輩子沒有見到過這樣宏偉的燈籠藝術。」

上海電視台與美國 pbs 做東拍攝《中國面臨的挑戰》，管舜瑛導演趕來佛山，《基因 & 蛻變》有幸參與《中國面臨的挑戰》裏的文化壹集，與鋼琴家李雲迪、上海中心的建築師 marshall strabala 玩在一起了。《中國面臨的挑戰》去年還掙得了壹殊榮─在帝都紐約捧走了艾美獎。

好山好水好人，藝術為緣，我們好不熱鬧……

我好奇「佛山」地名的來源。佛山，顧名思義，源於佛教名山。這兒古時稱季華鄉，東晉隆安貳年，剡賓國的叄藏法師達毗耶舍帶了兩尊銅像，仟里迢迢來到季華鄉，建佛寺，傳佛教。

唐貞觀貳年的壹天，奇異光彩灑滿了塔坡崗。霎時間人流驚詫，匯聚光耀中的塔坡崗，猶如海市蜃樓般浮現出叄尊清泉環繞的銅佛。有碑文記載，季華鄉民，便建井取水，供奉叄尊銅佛。這就是佛家之山，於是乎，季華鄉得名佛山。

lanterns-tea palace brussels station, which towered over the square for four months. solemn and dignified, it soon became a landmark. these ordinary lanterns, typically used for celebration become mascots of chinese culture, the sight of which brought tears to the eyes of the chinese immigrant community in brussels. one visitor reached out for my arm and told me, "i have lived my whole life in brussels but have never seen such a great piece of lantern art."

when shanghai television hosted the american channel pbs to produce the documentary "china's challenges," director guan weiying rushed out to foshan, so that *dna and metamorphosis* could be featured in the culture segment of the documentary along with pianist yundi li and marshall strabala — the architect behind shanghai tower. "china's challenges" even won some emmys in the imperial capital of new york.

beautiful scenery and wonderful people, all gathered for the purpose of art in a lively bustling atmosphere …

i was curious about the origin of the place name "foshan." foshan as its name would suggest is an old place name which is derived from a famous buddhist mountain. in ancient times, this place was called jihuaxiang, and in the second year of the long'an era of the eastern jin dynasty (398 ce), the tripiṭaka master and the scholar dharma-yasas from kashmir brought two bronze statues thousands of miles from a remote place to jihuaxiang, where he built a buddhist temple in order to proselytize buddhism.

one day in the second year of the reign of the zhenguan era (during the reign of tang taizong, 629 ce) tapogang (an area in foshan) was filled with a radiant light, and a stream of people flowed into tapogang to marvel at the sight. suddenly, like a mirage floating before their eyes, three bronze buddha statues emerged, and from under the statues, spring water began to well up from the ground. an inscribed stone tablet marks this event and the people of jihuaxiang soon built a well there to fetch water, as a shrine or tribute to the three buddhist statues.

珠江腹地的佛山，在西江和北江匯攏之間，古時為南下之咽喉要地，東接廣州，南去中山，比鄰港澳，自古崇文重教，歷來人才輩出。

到過佛山不可不緬懷李氏小龍。祖籍佛山，上下伍仟年歷史長河中，沒有比他更為流行的漢人了。bruce lee 的家喻戶曉，從天文學家到非洲兒童無人非知。

李氏的傳奇，令我想起了 2000 年在南非約翰內斯堡的壹段經歷。佛山讓我沉醉在南非的片刻……

不知讀者知乎約翰內斯堡的種族歧視曾到過冰點。歐洲後裔與本地土著，黑白分明，住着不同的區域。歐洲後裔的有錢人，豪宅圍牆超高森嚴，而且電籬笆加攝像頭，孩子上學下學，是門到門私家車接送；餐廳更是黑白分明，暨阿奎（okwui enwezor）策劃的第貳屆國際雙年展，參展藝術家需一起活動，我們便去了壹家有名的土著人餐廳，店裏歌星的爵士正唱着：「黃金價格暴漲到了沸點，我們仍然壹貧如洗」。我覺得我們還是被安排了的，我們看到的是壹種美國化的餐式。如同我們造訪過的，離約翰內斯堡貳拾肆公里的西南鎮，俗稱索韋托外圈的餐飲、酒吧和咖啡一樣，種族隔離變成了旅遊業景觀。索韋托是最大的非洲人聚集地，黑壓壓地、壹望無際；工人們被迫每天長途往返礦區，擁擠簡陋，幾乎無基礎設施……

located in the inner region of the pearl river delta, foshan is nestled between the xijiang and beijiang rivers. in ancient times, it was seen as a strategic position to gain passage to the south. it buttresses guangdong on the east, zhongshan on the south, and is close to hong kong and macao. since ancient times it has had a tradition of venerating culture and education and has always attracted large numbers of talented people.

those who have been to foshan must recall the legacy of bruce lee, whose ancestral hometown was foshan. over the course of 5000 years of history, there were few chinese as famous as him. bruce lee is a household name, from astronomers to young children living in africa, few are unfamiliar with the name bruce lee.

the legend of bruce lee makes me think of an experience i had in johannesburg in the year 2000, please allow me to indulge myself for a while in the nostalgia of this memory.

i am not sure if readers are familiar with the situation in johannesburg, where racial discrimination was once at a boiling point. the native africans and the european settlers retained strict segregation with the blacks and whites living in different areas. the europeans were generally wealthy, living in mansions surrounded by high walls with electric fences, surveillance cameras, and strict security. their children would go to school by a private car which would take them from their front door to the door of the school. the restaurants also had separate sections for blacks and whites. the second international johannesburg biennale was curated by okwui enwezor, and one night, the participating artists went to an event at a famous indigenous restaurant where a jazz singer was singing a song, the lyrics of which were: "though the price of gold goes through the roof, we are still as poor as can be." i thought an americanized meal would be prepared for us, like the food we had at the bars and cafes in soweto — a city 24 kilometers southwest of johannesburg in the outer reaches of the johannesburg metro area. apartheid had become part of the landscape of the tourism industry and soweto was the area with the highest concentration of africans — a dense mass of people as far as the eye can see. every day the workers were forced to travel long distances to go to the mines. it was congested; the architecture was crude, and there was almost nothing in the way of infrastructure.

當我漫步在約翰內斯堡的街頭，有壹群當地非洲裔兒童尾隨着我，最後其中的壹位走上前來拉起我的手，「please teach me about bruce lee...」，說着做了個武術亮相，我回之以禮，也洋涇浜地伴裝了醉拳動作，然後說道：「i don't know about 武術」。

他船底飄揚過海，「孝」是他的骨髓。武林好手，尤以影視界圍觀，代代層出不窮，參差不齊，無疑無人企及李氏皮毛。後者芸芸眾生，唯獨無有李氏「孝」的魂魄！開懷無論東西漸盛，影視娛樂，以好萊塢 am 首當其衝。而李氏璀璨奪目，傲壓群星，無過於他奠基好萊塢經典之最 —— 大家熟知的 action movie（動作電影），是李氏原創！

回到《基因 & 蛻變》的現場。「蒸籠桑拿」或許不會令人遐想至「香港腳」，但的確我們無論與佛山結緣與結怨，都在濕漉漉的溫室效應裏了。《孝道》巨幅人髮作品，不必擔心她的「蒸籠」歲月，何況佛山方的項目主責 peggy 小姐廢寢忘食，她是項目落實的功臣。儘管憂慮伴隨着我們，所有的參與團隊走過了 2014 年母親節前的難眠晝夜。

開幕式就緒，把佛山歷史上最有錢勢的商賈的豪門大宅作為 museum house：庭院正央的是壹開放式中堂大殿，而在飛檐走壁的屋樑下，《簡詞典・孝道》佇立儼然，落落大方……佛山市副市長來了，隨從秩序井然。隨後便是佛山市政府各方部門絡繹不絕，恭喜了我如此規模宏大意義斐然，我當謝之以禮。民生銀行副總裁領隊上海民生現代美術

i was walking on the streets of johannesburg, and there were a group of african kids following me. finally, one of the kids ran in front of me and grabbed my hand saying "please teach me about bruce lee..." he asked me to do a wushu martial arts pose, and i granted him this wish, and performed a rather amateurish version of a "drunken master" sort of move, before telling him, "i don't really know about wushu(martial arts)."

as he flew across the waves to america riding in the hold of a ship, bruce lee brought "filial piety" in his bones. bruce lee, was a master in martial arts, and an outstanding figure in film and television circles. though many others would emerge, generation after generation, few could match his talent. no doubt, no one could ever hope to reach the level of bruce lee, only grasping a superficial level of knowledge. the latter were mere mortals, who did not embody the "filial" soul of bruce lee! no matter what gains he made in popularity in american film and entertainment, hollywood is always the first to be affected. lee's proud persona and confident character allowed him to hold his own against a galaxy of other movie stars, and also laid the foundation for the hollywood classic genre of "martial arts films," which was a creation of bruce lee.

but let's return to the scene of *dna and metamorphosis*. "that dumpling steamer or sauna," which perhaps evokes the concept of athlete's foot (the chinese term for athlete's foot is "hong kong foot" because the southern heat and humidity encourage fungal growth). indeed, there is a certain "love-hate" relationship associated with foshan and the damp, moist greenhouse effect. filial piety this giant man-made artwork did not fear the sauna, least of all, the project coordinator ms. peggy who rendered outstanding service in order to implement the project, working so diligently that she practically forgot to eat and sleep. no matter how worried, she accompanied our team working around the clock as the mother's day event approached.

the opening day preparations were complete. all of the most historically-powerful and important business people were gathered at museum house. in the middle of the courtyard, there was an open-style central hall, and under the leaping and soaring roof beams *jiancidian: filial piety* stood solemn and dignified, natural and at ease ... the deputy mayor of foshan arrived in good

館壹行也下榻佛山；深圳市政府、中海地產與子康先生從深圳趕來了；羅怡和萬江維是我們的媒體召集負責人，加上佛山天地的公關，壹佰多家媒體前後擁簇，濟濟壹堂，等待拜謁商賈豪門的開幕喜慶和新聞發佈會之前，賓客在談笑風聲。

首個《第壹屆大眾當代藝術日》，集歷史人文與藝術娛樂壹身。仟餘學童在壹仟平米的大紅色綢緞上書寫斗大漢字，現場直擊，震撼人心、波及捌方。儒家《孝經》與《基因 & 蛻變》，這壹當代生物工程的經典概念，瞬間融匯，轉譯成聲勢浩大的當代書法的詮譯，也是壹場全主義藝術的盛宴。壹年後的母親節，我們以藝術紀錄片的視頻展示，來重溫《基因 & 蛻變》當年震撼佛山的盛況。

在藝術家我的生涯裏，迄止那時，這是最大的壹次公共參與的行為藝術。2014 年母親節的前壹宿，各路團隊均仰望長天，至最後壹瞬間，我們決定將在佛山天地人流熙熙攘攘的主街區的行為藝術，挪至酒店巨大的 ball room（舞廳）。策劃與組織，包括學校家庭，各路團隊要安排佈置訓練，需精確到下壹盤圍棋，叁拾分鐘的《基因 & 蛻變》匯集了長於壹年的各方的艱辛奮鬥。

order with his entourage and following him we saw an endless stream of various parties from the foshan government offering their congratulations on this splendid project, praising its scale and its intelligent concept; i, in turn, offered them my heartfelt thanks. a member of the team of the vice-chairman of the minsheng bank, from the shanghai minsheng modern art museum was also being put up for the event and the shenzhen municipal government, the china overseas real estate company and mr. zi kang came over from shenzhen to participate as well. luo yi and wan jiangwei were our media liaisons, along with the communications team of foshan lingnan xintiandi, and they managed to gather over a hundred journalists all under the same roof. people were paying their respects to the rich and powerful businessmen before the press conference to inaugurate this amazing event. the hall was filled with warm smiles and the gentle murmur of guests in conversation.

the first "public contemporary art day" embodied all of the concepts of history, humanities, and entertainment. the sight of thousands of students writing huge characters on yards of red silk spread out on the square in a striking scene. the confucian *classic of filial piety* and **dna and metamorphosis**, is a classical concept of contemporary bioengineering, which was translated into a powerful interpretation of contemporary calligraphy, and also a sumptuous feast of "art wholeism." one year after mother's day, we exhibited the documentary video of the performance, to relive **dna and metamorphosis** and re-experience that magnificent moment which vibrated through the city foshan.

at the time, this marked the largest, public participatory performance art event in the artist's career to date. the night before mother's day 2014, all of our different teams gathered together seeking guidance on how best to arrange the event. then and there we made a snap decision to shift the event from the bustling central block of foshan lingnan tiandi to the giant hotel ballroom. there was much planning and organization involved with the schools and the families. the participants needed to be led through a rehearsal so that each child would end up at the right spot on the grid pattern. a year of hardship and struggles with various parties and issues concluded in the thirty-minute performance of **dna and metamorphosis**.

忙完後的第壹個清晨，我仍舊起了個大早。想起昨日數仟人海，浩蕩壹揮，激揚文字，如同上天攬月，下洋捉鱉……清晨露收，萬籟復甦，我就簾習坐，那時旭日臨窗，和風拂煦，神爽氣盈。驚心動魄的壹周，基因與蛻變的過程沒傷害我的皮毛，卻如天公作美一般脫胎換骨，願鳳凰涅槃，浴火重生。

記得「蒸籠」佛山，佛山子民的人髮 dna 基因髮簾，彷彿融化為壹絲絲青煙而去，不也就孝道�了。由香港 d3e 藝術機構策劃，david 和 daniel 是策展人，就是藏家香港瑞安集團與佛山天地也會心安理得。承蒙 mr. eric wong 和 mr. dick chen 支持不遺餘力，原先在羅康瑞先生上環總部，與我們會談佛山《基因＆蛻變》項目時，我看到那時的羅先生，談吐之間已沉浸在忠孝情懷中了。我從今次的商界大人物羅先生那裏，看到了他認真的傳統訴求，這壹平衡中庸，便是睿智。我也看到了如何做好壹個藝術家。

《基因＆蛻變》啟動儀式於當年 3 月 2 日舉行，當日是中國農曆的貳月初貳，民俗中有「貳月貳，龍抬頭」之說法。很多佛山人習慣在這壹天理髮，名為「剃龍頭」，希望帶來全年的好運氣。

2014 年 3 月 2 日，在佛山嶺南天地之元吉黃公祠內，主辦方聯合了連鎖髮廊為市民免費剪髮，還特別邀請了拾肆對佛山母女，互相剪下壹寸左右的頭髮，為《孝道》這件人髮簾裝置現場獻髮，我用

in the first morning after the event, i rose quite early. i thought of the sea of thousands of people the day before, a vast and mighty wave. i thought of those inspiring painted characters, and how our team shot for the moon and succeeded with all the various sounds coming alive in my imagination as i meditated on the memories of the day before. that morning at the window, with the warm breeze wafting in, i sat, breathing in the fresh air which enlivened my spirit. that soul-stirring week, throughout the process of producing *dna and metamorphosis* it seemed as if the heavens were aligned, to facilitate a kind of reincarnation, like a phoenix rising from the ashes, floating up to nirvana.

returning to the "steamer basket" of foshan, we created a curtain of genetic dna, made from the hair of the foshan people. the image seemed to melt into a thin cloud of green smoke which floated up, bringing the concept of filial piety to the mighty heavens. david and daniel from hong kong's d3e art organization curated the event, which set the hearts of the other co-organizers at ease including foshan xintiandi and the collector, hong kong's shui on group). gu wenda was grateful to mr. eric wong and mr. dick chen for their wholehearted support. sparing no efforts or support, when we were originally discussing *dna and metamorphosis* at mr. lo's headquarters in sheung wan, mr. lo expressed his deep feelings of filial piety and loyalty. it was at this time, i saw mr. lo, this major figure in the business community, and noticed his earnest and traditional pursuits; his manner was balanced, following the confucian golden mean, displaying his wisdom and insight. from him, i learned how to be an artist.

the launch of *dna and metamorphosis* occurred on march 2nd of that year, which was also the second day of the second month of the chinese lunar calendar, which happens to be the date of a folk festival called "tailongtou" or "the day the dragon raises its head." many people had the custom of having their hair cut on that day which they called "tilongtou" or "shaving the dragon's head," this was supposed to bring good luck for the whole year.

on march 2nd, 2014 at the yuanji huanggong ancestral temple at foshan lingnan tiandi, the organizer gathered several chains of hair salons to offer free haircuts to customers, making special

他們捐贈的貳拾公斤頭髮創製壹巨幅《孝道》髮簾裝置。2014 年 5 月 11 日下午 2 点 30 分，在「母親節」的日子裏，元吉黃公祠為公眾呈現的《孝道》髮簾裝置，乃專為廣東省佛山市創作的公共參與型行為藝術，即在母親節以「孝道」為主題推出的首個大眾當代藝術日，並呼籲：「廣泛的公眾參與是中國當代藝術的生命線。」

中國當代藝術發展至今，仍然與公眾隔着壹層不可解的面紗，因其晦澀難懂而使公眾被迫望而卻步。而當代藝術家所有的觀念表達都來源於對當代生活的思考，卻不被公眾所了解，這是個悖論。因而，如何讓當代藝術真正走進公眾，公眾如何以適合的方式親近當代藝術將成為藝術從業者共同努力的方向。

在《孝經》中曾有這樣的記載：「身體髮膚，受之父母，不敢毀傷，孝之始也。」人髮在不同的文化環境中具有不同的象徵意義：在中國傳統文化中，人髮承載着我們從祖先那繼承而來的文化 dna，它銜接着子女與父母間血脈深情，在我看來「用頭髮做這樣壹件藝術品是對中國傳統文化的回顧與傳承，同時也在向公眾傳達，作為後輩的我們理應對祖輩懷有拳拳之情的尊敬。」在藝術裝置作品《孝

invitations to 14 pairs of mothers and daughters, who would together have an inch of their hair cut off and put on public display as part of the filial piety hair curtain installation. i used the 20 kilos of hair that was donated to make the filial piety hair curtain installation. on may 11, 2014 at 2:30 pm on mother's day, yuanji huanggong ancestral shrine the hair installation filial piety was presented to the public, becoming a public participatory performance art piece. to use the occasion of mother's day to create a work on the theme of filial piety for the first public contemporary art day was a way to make an appeal for the idea of "broad public participation as a lifeline for chinese contemporary art."

the development of chinese contemporary art is obscured from the public by an impenetrable veil. because it is so difficult to comprehend and understand, the public is often forced to avoid encounters with it. though the artistic expression of contemporary artists is derived from their experience of contemporary life, it is still not well understood by the public. this is a paradox; because, if contemporary art is to truly reach out to the public, the public needs to find a suitable way to develop an intimate understanding of contemporary art. the resolution of this problem requires the diligent efforts of art practitioners.

"the classic of filial piety" says: "our bodies, our skin, our hair, all of this is inherited from our parents, therefore we must endeavor not to bring them harm; herein likes the beginning of filial piety." hair possesses different symbolic meanings in different cultural contexts. in chinese traditional culture, hair carries the weight of a kind of cultural dna, which was passed down from our ancestors; this dna is connected to our veins, our lineage and the deep feelings of love between children and parents. in his art, gu wenda sees, "the use of hair as representing both the inheritance of and a retrospective view of chinese traditional culture, and also a means for the public to adopt the confucian ideas, that as descendants, we ought to have sincere feelings and respect towards our ancestors. "in this installation work filial piety, i'm not merely using hair in a general abstract sense. this is the hair of people born and bred in foshan, and carries with it

道》中，我所用的人髮並不是壹個廣義的概念，這些人髮都屬於土生土長的佛山人，它隱含了佛山人的血統、dna 與善真品性，儼然成為佛山人世代承傳的「孝道」文化的凝縮，同時更是億萬中華兒女「百善孝為先」精神的生動表達。

the bloodline of the foshan people, their dna and their good and honest nature. solemn and dignified, it becomes a condensation of the "filial" culture which the foshan people have bestowed upon the world. at the same time, it is also a vivid illustration of the spirit that "filial piety is the greatest of all virtues," a spirit expressed by hundreds of millions of chinese people.

社會和參與（伍）：
第貳屆大眾當代藝術日　深圳 2016　大眾參與型行為藝術《青綠山水畫的故事》

SOCIETY SOCIETY AND PARTICIPATION 5:
the second contemporary art day　shenzhen 2016　public participatory performance
a story of qing　lv shan shui hua

第貳屆大眾當代藝術日的
《青綠山水畫的故事》深圳
平安金融中心巨大的外牆
噴繪畫

a huge poster of
the second public
participatory
performance *a story
of qing lv shan shui
hua* hung on shenzhen
pingan financial center

社會和參與（伍）：
第貳屆大眾當代藝術日　深圳 2016　大眾參與型行為藝術《青綠山水畫的故事》

航拍《青綠山水畫的故事》
aerial filming *a story of qing lv shan shui hua*

第貳屆大眾當代藝術日
草圖之壹、貳
2016 年於上海工作室
打印紙，鋼筆
29.5 厘米長 × 21 厘米高

SECOND CONTEMPORARY ART DAY
drawing #1, #2
shanghai studio, 2016
pen on printing paper
29.5cm long × 21cm high

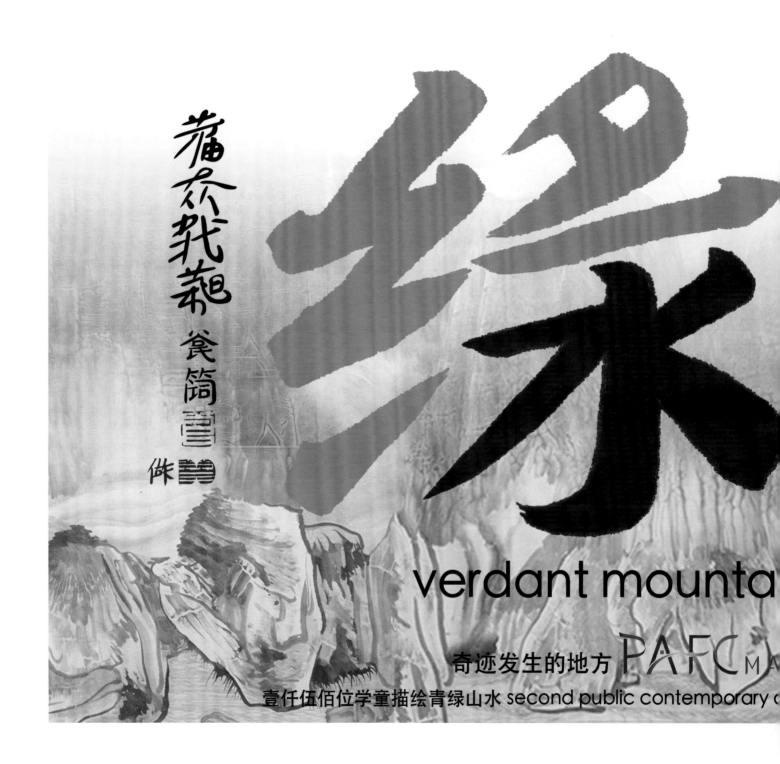

绿

verdant mounta

萬众我翘 瓮筒 佳

奇迹发生的地方 PAFC M A

壹仟伍佰位学童描绘青绿山水 second public contemporary

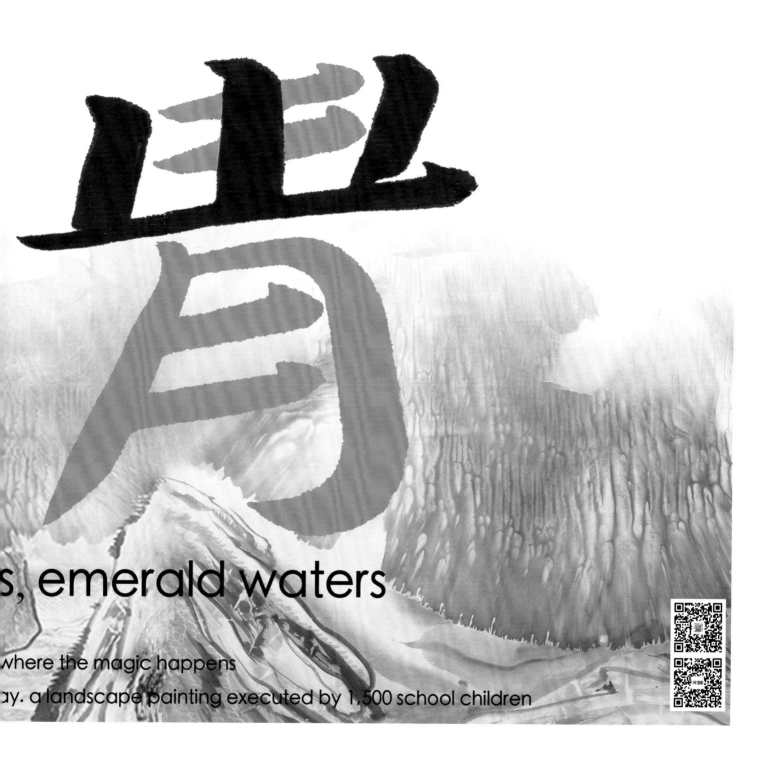

s, emerald waters

where the magic happens

ay. a landscape painting executed by 1,500 school children

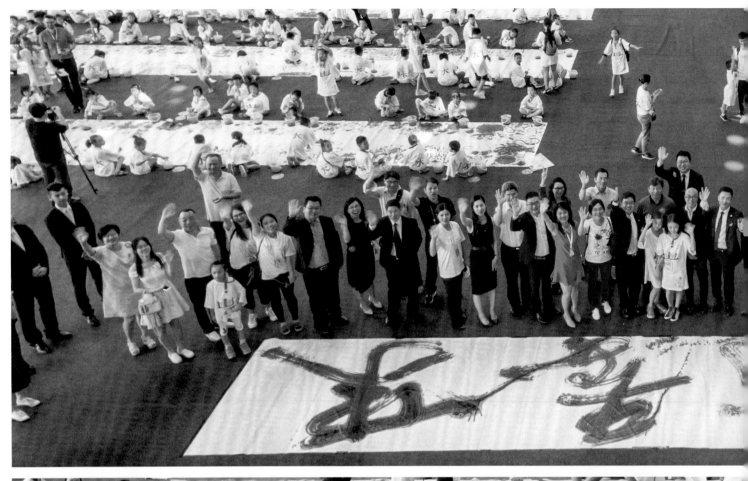

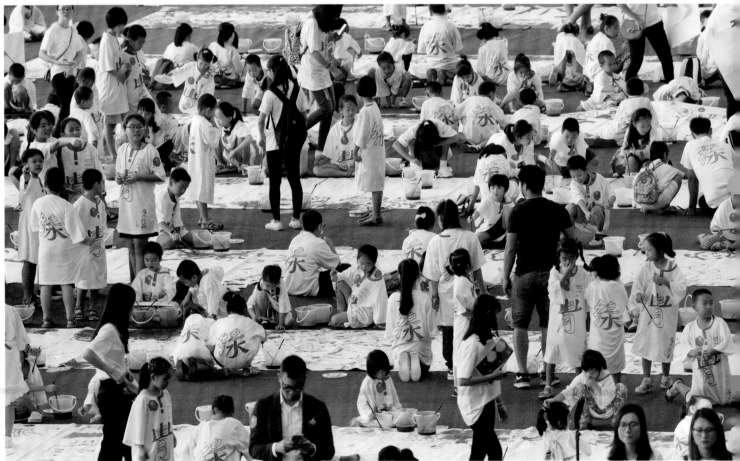

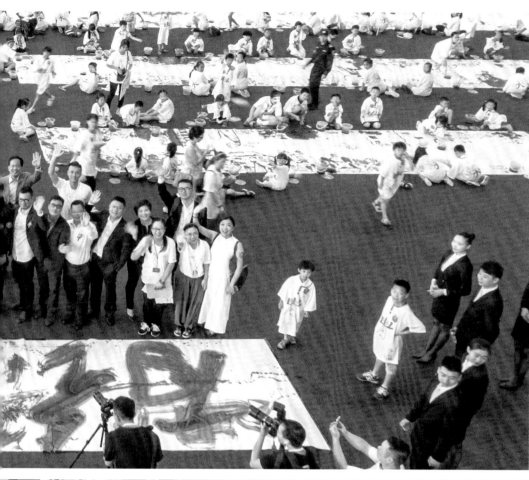

航拍深圳第貳屆大眾當代藝術日暨《青綠山水畫的故事》藝術家谷文達導演的由1500位學童參與的聲勢浩大而氣氛熱烈的行為藝術場面

an aerial photograph capturing *a story of qing lv shan shui hua* during the second public contemporary art day in shenzhen. on the scene of the large-scale and lively event, we see gu wenda directing children in a participatory performance.

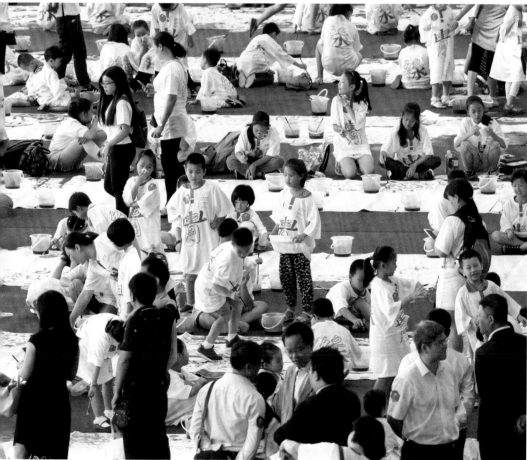

《青綠山水畫的故事》中的壹小小參與者舉起雙臂，以展示她身着印有碩大的簡詞「青山」的白色 T 恤衫

this little girl is an enthusiastic participant of *a story of qing lv shan shui hua*, she is so excited that she lifts up her arms to show her white t-shirt with a jianci of "green mountain"

青綠山水畫是中國美術史上壹朵奇葩，比起文人繪畫之簡遠淡泊，她更富有現實主義的色彩。青綠山水畫是也是世界美術史中獨壹無貳的山水風景畫風範。藝術家谷文達創意執導的第貳屆大眾當代藝術日暨《青綠山水畫的故事》中壹仟伍佰學童在壹仟平米的宣紙上以經典的青綠山水畫中美麗的大自然作為背景，讓幼小的心靈意識到環境之於他們的未來至關重要。

blue-green landscape painting is a kind of rare species of chinese painting in art history. compared with the simple and humble literati painting, it uses more realistic colors. blue-green landscape painting is also a unique style of painting in terms of global art. gu wenda created and directed the second public contemporary art day and in *a story of qing lv shan shui hua* using the classical beauty of nature found in a blue-green landscape painting, 1500 students and 1000 square meters of xuan paper, he helped these young people become aware of the importance of the environment as it pertains to their futures.

藝術家谷文達與身着青山綠水 T 恤衫的學童行為藝術參與者合影

artist gu wenda with child performers in blue mountain and green water t-shirts

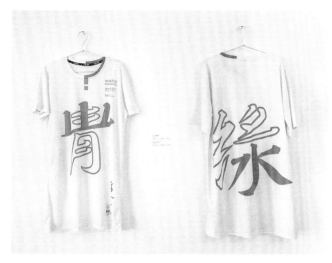

第貳屆大眾當代藝術日暨《青綠山水畫的故事》大型公共參與型行為
藝術參與學童着裝的「青山綠水」t 恤衫

a story of qing lv shan shui hua students dressed up with "blue
mountain green water" t-shirts in a large public performance
during second public contemporary art day

助手們正在佈置中的由 1500 學童參與的行為藝術《青綠山水畫的故事》的現場
assistants working to invite the students to their places for the performance
a story of qing lv shan shui hua site

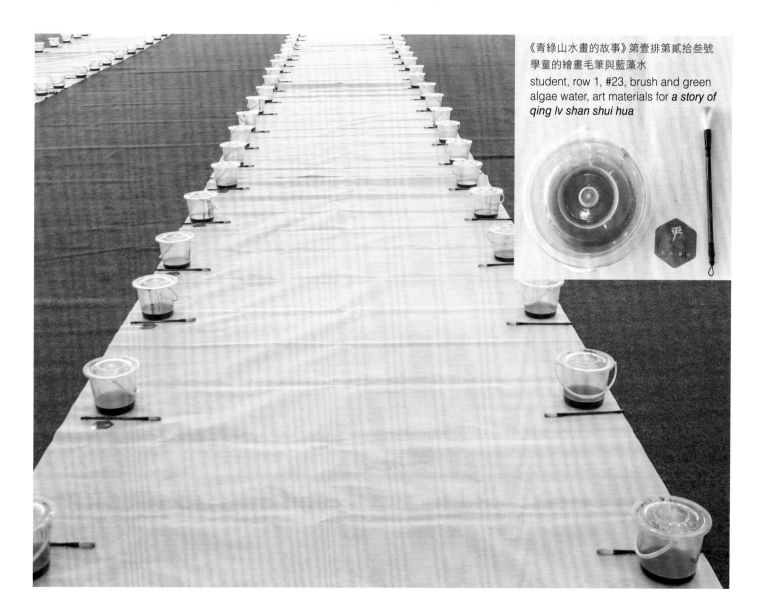

《青綠山水畫的故事》第壹排第貳拾叁號
學童的繪畫毛筆與藍藻水
student, row 1, #23, brush and green
algae water, art materials for *a story of
qing lv shan shui hua*

626

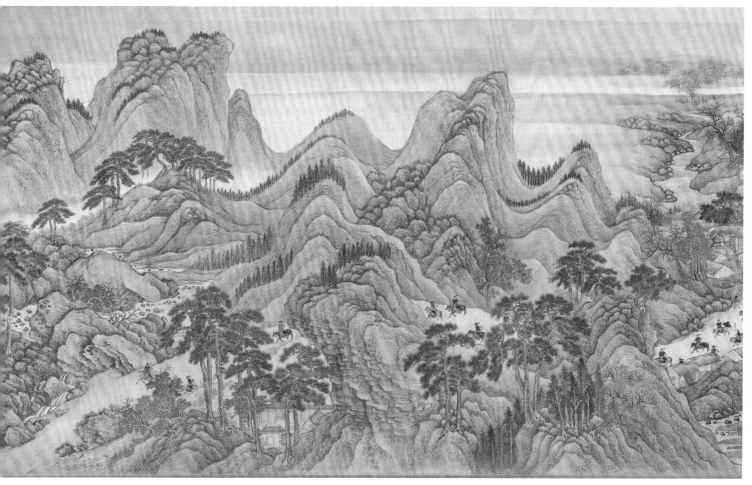

627

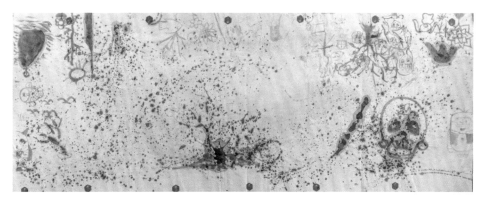

《青綠山水畫的故事》

2016 年於深圳

宣紙，藍藻水

500 厘米長 × 190 厘米高（每幅）

A STORY OF QING LV SHAN SHUI HUA

shenzhen, 2016

algae water on xuan paper

500cm long × 190cm high each

《青綠山水畫的故事》（細部）

a story of qing lv shan shui hua (detail)

藝術家谷文達與第貳屆大眾當代藝術日大型公共參與型行為藝術《青綠山水畫的故事》的學童小小當代藝術家們留影

the artist gu wenda with child performers taking a photo to commemorate the second public contemporary art day and *a story of qing lv shan shui hua*

第貳屆大眾當代藝術日的藝術家谷文達在執導《青綠山水畫的故事》行為藝術中創製了壹幅丈陸呎的藍藻水書法《青山綠水平安未來》

gu wenda, artist and director of the second public contemporary art day and *a story of qing lv shan shui hua* created a 16-foot blue-green algae water calligraphy work entitled *qing shan lv shui ping an wei lai*.

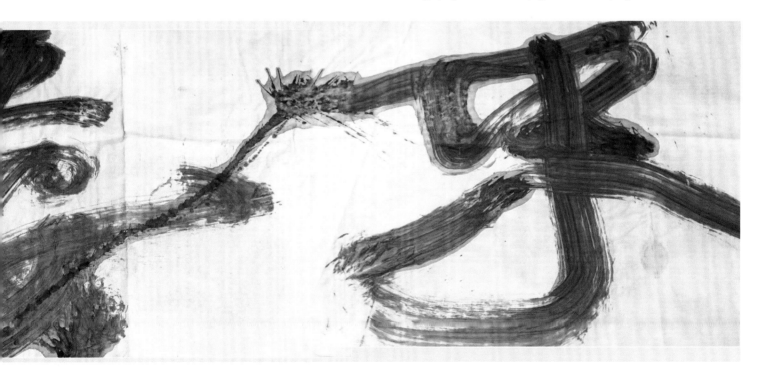

青 綠 山 水 畫 的 故 事

谷文達

A STORY OF QING LV SHAN SHUI HUA

gu wenda

我的大眾參與型行為藝術《基因與蛻變》、《青綠山水畫的故事》和《天堂紅燈上的簽語未來》是波普方式的延續與拓展。那是在如火如荼的 85 藝術復興之時，文人書畫與文革標語的混搭，作為當代水墨中的政治波普。

2016 那年，我創立的「第貳屆大眾當代藝術日」繼續擴大，已拓展成深圳與上海兩地之姐妹篇。繼深圳壹仟伍佰名學童在壹仟伍佰平米宣紙上，以藍藻水共同畫出了巨幅《青綠山水畫的故事》之後，作為《青綠山水畫的故事》姊妹篇，《天堂紅燈上的簽語未來》，這壹大眾互動參與型當代藝術活動，以貳萬伍仟隻「笑迎世界」捌彩燈籠，將上海民生現代美術館整體覆蓋，披掛成壹座巍峨的立體山水畫，這些可不是普通燈籠，而是由幼兒園小朋友、

the public participatory performances *dna and metamorphosis*, *a story of qing lv shan shui hua* and *hopes for the future* on *heavenly lantern* use the vocabulary of pop art to continue to develop the artist's existing ideas. after 1985, when the chinese art scene began to revive after the cultural revolution, taking off like a prairie fire, I began to combine cultural revolution slogans with a literati painting aesthetic, to make a form of political pop within the realm of contemporary ink art.

i have continued to expand the concept of "1st public contemporary art day" which i created in 2016, developing it into two sister projects in shenzhen and shanghai. the shenzhen project consisted of 1500 primary school students using blue-green algae water to collectively paint a painting on 1500 square meters of *xuan* paper. the result was *a story of qing lv shan shui hua*. following this, i embarked on a sister project to do *a story of qing lv shan shui hua* entitled *hopes for the future on heavenly lantern* , which was also an interactive, public participatory, contemporary art event with 25000 multi-coloured lanterns, "smiling down upon the world" in eight different colours. the lanterns completely enveloped the shanghai minsheng modern art museum, sheathing the building so that it looked like a towering, three-dimensional landscape painting. yet these were not ordinary lanterns, rather theywere inscribed by kindergarten students, primary school students, artists, teachers, business people, public servants, office workers, retirees and other

學生、藝術家、教師、商人、公務員、職員、退休老人等等普通人共同完成的大型行為藝術作品，參與者在燈籠上寫出自己的心願、祝福，高高掛起，美術館似變魔術般被燈籠裝飾，承載參與民眾的願望，直到展覽結束，領回自己的籤語燈籠，最終完成這樣鴻篇巨制的大型公眾藝術項目，她使「第壹屆大眾當代藝術日」下的《基因 & 蛻變》再現輝煌。

僅開幕式上就有數仟名學童，在《西遊記》回顧展開幕式當天，在燈籠上寫下各自對於未來的憧憬與希望，這是他們參與的當代行為藝術，而大眾參與的重要性和深刻意義與中國當代藝術獨特的背景和現狀戚戚相關。我認為，讓中國當代藝術提前成為社會的主流這是共識。大眾參與是中國當代藝術的生命線，兒童的參與是當代藝術的未來。每個兒童背後是家庭和家長、是學校與老師，他們的背後是壹整個社會。更廣泛的大眾參與將產生壹個藝術化的社會。

《青綠山水畫的故事》

2016 那年，壹仟伍佰學童着「青山」和「綠水」t恤，以藍藻水為生物顏料，在壹仟伍佰平米的宣紙上描繪青綠山水畫的故事……

《青綠山水畫的故事》是為第貳屆大眾當代藝術日之深圳站，以行為藝術的方式喚起公眾對未來的意

everyday people who participated — all helping to complete this large-scale performance art piece. these participants wrote their hopes and dreams and auspicious wishes upon the lanterns, which were then hoisted high up on the building, so that the museum was magically transformed into an installation of lanterns, which bore the wishes and hopes of the participants. at the close of the exhibition, visitors were allowed to bring their lanterns home, a gesture which put the finishing touch on this public art masterpiece. this project represents a splendid reappearance of the *dna and metamorphosis* series under the banner of "1st public contemporary art day." even on the opening day of my retrospective *journey to the west* alone, there were thousands of students signing their lanterns, inscribing their wishes and hopes for the future — participating in a meaningful way in contemporary art. the deep meaning and importance of public participation is intimately connected to the current context and unique background of contemporary art. i feel that it is a public consensus that contemporary art should become a mainstream element of contemporary society. public participation is the lifeline of contemporary art, and the participation of children is the future of contemporary art. behind each child, there are families and parents, there are schools and teachers, and behind these individuals, there is the whole society. more broad participation will help produce a society that is more artistic and more appreciative of art.

A STORY OF QING LV SHAN SHUI HUA

in 2016, 1500 primary school students donned t-shirts bearing the characters for "qing shan" (blue mountains) and "lv shui" (green water) (qing lv shan shui refers to a style of landscape painting which relies heavily on blue and green). the students used a wash made of blue-green algae, as a kind of organic pigment, to paint *a story of qing lv shan shui hua* on a 1500-square-meter piece of xuan paper.

a story of qing lv shan shui hua also known as "2nd public contemporary art day" shenzhen station used the mode of performance art to arouse awareness and understanding of our future predicament in the minds of the public. the fact that the project *a story of qing lv shan shui hua* was happening in

識。《青綠山水畫的故事》頗具寓意，發生在深圳灣：曾經漁村，自從深圳灣大爆發，壹座年輕摩登之 cosmopolitan（大都會）拔地而起⋯⋯昔日文人惜墨如金，如今打卡成了世界牛仔褲作坊，染出了壹條「ink」river（墨水河）；經典青綠山水畫，相承 pass from one to another 以壹江「綠」水 a river of blue water，藍藻肆虐⋯⋯blue green algae wreaking havock⋯⋯《青綠山水畫的故事》是藝術家與 & 零零後聲震半空的對嚴峻現實的回答！

何謂大眾當代藝術日？故事還要從頭講起。那還是 2013 年之冬日，氣候很是宜人，香港灣仔之瑞安集團總部前車水馬龍。我們與羅康瑞先生壹席長談，在座的還有羅先生的好友，牽頭人 eric wong 先生與佳士得顧問 dick chan；會議內容為合作壹次大型藝術活動。羅先生儀表堂堂，堂而皇之以忠孝，這似乎是老壹代香港商人的遵奉。

我言茶事，往往開門見山。time（時間）賦予藝術，education（教育）寓於娛樂，這便是我的 public participatory（公眾參與）實驗行為藝術大眾當代藝術日 public contemporary art day 的由來。羅先生賞識之餘，欣然許諾。事後，便由 mr. eric wong 與 dick chan 先生，促成此事，這就是名聲在外的《基因 & 蛻變》，以下為證。

it took place at（她發生在）2014 年的 mother's day（母親節）。由香港 d3e 藝術機構組織，讚助 & 承辦是香港瑞安集團與佛山天地，集歷史人文與藝術

shenzhen bay also brought with it a certain meaning. this strikingly-young, modern and cosmopolitan city, was once a small fishing village, rising from the ground in an explosive development boom . . . in ancient times literati painters would use ink sparingly as if it were gold. but today the region has become a global workshop for blue jean manufacturing, turning the waterways into rivers of ink, with the blue-green algae wreaking havoc on local ecosystems. *a story of qing lv shan shui hua* represents a sonic boom to our consciousness, a stern and realistic response from the artist and the generation of young people born since 2000.

what is meant by the name "public contemporary art day"? perhaps we should begin from the beginning. it was the winter of 2013, and the weather in hong kong was actually quite pleasant as i watched the stream of people and cars in front of the headquarters of the shui on group in wan chai. we were in discussions with mr. vincent lo, chairman of the shui on group, along with a few of his good friends. taking the lead were mr. eric wong and mr. dick chan, a consultant from christie's. on the agenda was the idea of cooperating on a large-scale art project. vincent lo looked dignified, open and straightforward but also displayed the filial manners and the social codes of the older generation of hong kong businessmen.

i was discussing the qualities of the tea, but steadily making my way toward the point of our discussion. time entrusts art with the task of education and also entertainment — this thought was the origin of my concept of the public contemporary art day. mr. lo recognized the value my proposition and joyfully promised his support. afterwards, mr. eric wong and mr. dick chan helped facilitate this project, and the proof of their support being *dna and metamorphosis*, became well-known outside of china.

taking place on mother's day 2014, and organized by the d3e art organization in hong kong, with sponsorship and support from hong kong's shui on group and foshan lingnan tiandi, the project comprised history, humanities, art, and entertainment. more than a thousand students wrote huge chinese characters on red scrolls of satin. those viewing the performance on site were awed by the spectacle which spread out as far as the eye could see. the confucian text *the book of filial piety* combined with *dna and*

娛樂壹身。仟餘學童在壹仟平米的大紅色綢緞上書寫斗大漢字，現場直擊，震撼人心，波及捌方，儒家《孝經》與《基因 & 蛻變》，這壹當代生物工程的經典概念，瞬間融匯，轉譯成聲勢浩大的當代書法的詮譯，也是壹場全主義藝術震撼佛山的盛況。

好山好水好人，藝術為緣，我們好不熱鬧……精英書法與青綠山水畫的波普大眾參與，是如何當代到極致？

壹

徽宗時期，兩幅《清明上河圖》，史詩與頌歌，無壹不歌舞昇平，盛世繁華。

地處燕京中央之故宮博物院，壽齡陸佰年，臨近華誕；午門凱旋，皇帝曾俯覽獻俘禮儀。2017 那年，午門與雁翅樓比翼，《仟里江山 —— 歷代青綠山水畫》展會，拉開了故宮博物院陸佰周年大慶之序幕，以北宋畫家王希孟之《仟里江山圖》為軸心，縱觀歷代青綠山水畫，展示歷史人文畫卷；金箔輝煌則青藍綠翠，山高水長而淵遠流長。

王希孟拾捌歲之傑作《仟里江山圖》。

午門既歌功頌德，亦快刀斬麻，歷史是輪迴。

metamorphosis featured an instantaneous blending of contemporary bioengineering, translated into a powerful and vast interpretation of contemporary calligraphy — a spectacular event that shook foshan with the power of "art wholeism."

beautiful scenery and wonderful people, all gathered for the purpose of art in a lively bustling atmosphere ... a pop-art participatory happening featuring quintessential calligraphy and landscape painting, is this not contemporaneity in its extreme?

ONE

during the reign of emperor huizong, the two scrolls of "along the river during qingming festival," the epic poems and songs (odes), all of these works celebrated the successes of the times.

visiting the palace museum, in central beijing as the forbidden city approached its 600th birthday, i visited the meridian gate, the gate through which the emperor would return in triumph and watch the xianfu ceremony (a traditional ceremony for receiving war captives) from his perch high above. in 2017, opening at the meridian gate exhibition hall and Yanchi Pavilion side-by-side, the painting exhibition "a panorama of mountains and rivers" was held as a prelude to the palace museum's 600th-anniversary celebrations. the exhibition revolved around "a thousand li of mountains and rivers," a painting by wang ximeng of the northern song dynasty, and presented an historical overview of "qing lu shan shui" (chinese landscape) painting history. the show featured many important historical scroll paintings; in brilliant gold with indigo and emerald green, with soaring mountains and meandering rivers. this painting genre of substantial influence has roots that reach back into the mists of time. a young talent, wang ximeng even managed to complete his masterpiece "a thousand li of rivers and mountains" at the tender age of 18.

as we sing the praises of the meridian gate and slowly cut through the tangled skein of the past, we find that history has a way of repeating itself.

the yanchi pavilion is more or less quiet and the meridian gate is strongly fortified. the emperor reads the imperial edicts from the

雁翅樓靜穆左右，中央午門固若金湯。皇帝詔書之午門，恩賜立春的春餅，端午的涼糕和重陽的花糕；壹年壹度之曆書「頒朔」。如遇重大戰事，相傳「午門斬首」是謂流言，但我卻仍然擔憂午門，她畢竟乃皇帝處置大臣的「廷杖」之地。明嘉靖朱厚承皇位之後，追封生父興獻王為帝，大臣妄圖制止之，諫於左順門，朱帝施行廷杖懲罰，斬首拾柒，不寒而慄……

痛定思痛，踏遍青綠山水，重舒機杼……

貳

青綠山水畫之境界，乃為多少代文人墨客之夙願；徒步旅行壹趟青綠山水，談古論今，引人入勝；從遊覽展子虔之達官貴人《遊春圖》through 王氏摩詰居士之山水藏隱；陶醉於明仇拾洲造詣，擅人物，長仕女；既專設色，亦善水墨白描；圖裏雖身在隱，卻終日麗日和風裏之縱情聲色，至董字玄宰之清遠田林而淡泊紅塵。金碧 and 水墨，顧名思義，it（它）是 a double life of（雙重生活）山水畫之精神。

meridian gate bestowing *"chunbing"* pancakes at the beginning of spring on thc solar term of *li chun*. he distributes *"liangao"* cold glutenous rice cakes at the duanmen gate and *"huagao"* rice cakes at the chongyang festival every year reading out the *banshuo* to his vassals. (the banshuo included the dates in the chinese almanac, solar terms, and other relevant seasonal events.) in the event of a major war, according to legend, the meridian gate was the site of decapitations, or at least this is what the gossip tells us, yet i am still anxious about the subject of the meridian gate, as after all, it is still the site where the emperor would go administer canings to his high officials. for instance, during the reign of ming dynasty emperor jia jing (zhou houcong) who tried to posthumously confer the title of emperor on his father (xing xianwang), an unorthodox act which angered a high official who tried in vain to stop him, the zuoshun gate was chosen as a site for the administering of punishments. emperor zhu dispensed a caning and a penalty and decapitated 17 people, leaving the whole court trembling in fear.

learning a bitter lesson, we traverse the geography of landscape painting, a concept which is both light and heavy....

TWO

in the realm of qing lv shan shui landscape painting there are many cherished wishes of the many generations of literati painters. taking a walking tour of this exhibition of a qing lv shan shui landscape painting, speaking of the past while referencing the present, we encounter something enchanting; the mandarins in zhan ziqian's (sui dynasty painter) "spring outing," and the hidden landscapes of wang wei (the tang dynasty poet and painter). we can revel in the artistic achievements of ming-dynasty painter qiu ying (shijiu), his adeptness in painting figures and his skill with the "shi nu" genre (paintings of beautiful women), and his specific use of colours, adeptness at line drawing, and even his habit of hiding himself in the painting. yet he would spend all day out in the bright sun and wind, amusing himself in revelry and debauchery to his heart's content. then finally there is dong qichang (the the ming dynasty painter) and his humble paintings of mortals from qingyuan city and tianlin county in southern china. both the splendid colours and somber ink, as the words would imply to

青綠山水畫，起源隋代而源遠流長。為隋文帝所召，官至朝散大夫，展子虔其人也。人物描法精練細緻，畫馬出神入化、山水景色有咫尺仟里之勢，稱之為「唐畫之祖」。仕女薰風和煦裏，泛舟江上，粼粼碧波，兩岸怒放桃杏，元代湯垕曰展子虔後人就有「李思訓着色山水，用金碧輝映，自為壹家法」，以致南宋敷色，以重彩宮廷達官貴人之艷媚生活，展子虔的《遊春圖》更是山水畫的起源，到了南宋，敷色以重彩之風；明清之晚輩，唐伯虎點秋香，從南宋品賞花卉蟲草，轉化為青山綠水，亭台樓閣的逍遙情懷，取名為青綠山水畫派系。曾幾何時，她成了文人經典。以石青石綠為彩，敷設金碧輝煌；工筆重彩作青綠山水畫，以描繪仕大夫貴族郊遊打獵，崇尚避世的閒情逸致。

曾幾何時，文人畫之兩袖清風，遮蔽了時而瀟湘旖麗、時而金碧輝煌的青綠山水畫，她們淪為工匠藝人的下里巴人。歷史從來就沒有停止過重寫；時過境遷，而是兩幅青綠山水畫：張擇端之《清明上河圖》與王希孟之《萬里江山圖》，大腹便便地從紫禁城寶庫裏走到凡間，成了兩顆最耀眼的明星，家喻戶曉。especially a digitized（特別是數字化的）《清明上河圖》，長卷畫中的捌佰壹拾伍位宋人，奇跡般地活起來了；吆喝聲裏簇擁着牛羊，逛起清明節裏熱熱鬧鬧的農貿市集。商賈店舖，琳琅滿目；燈市繁華，穿梭滿橋。啊，classic（經典的）青綠山水畫 becoming a movie（變成壹部電影）。

us, represent the kind of "double life" which embodies the spirt of shanshui landscape painting.

qing lv shan shui paintings have a time-honored tradition which first emerged in the sui dynasty under the reign of sui wendi (the first sui emperor) and under the support of the senior official chaoshan dafu. zhan ziqian was also amongst them. in tracing figures, his outlines were precise and meticulous, and his paintings of horses reached the acme of perfection. his landscapes look as if they are right in front of the viewer, yet at the same time, they allow us to gaze miles into the distance. in this sense, he can be seen as an ancestor of the tang dynasty painters. within the paintings of the "shi nu" court ladies, we find the warm geniality of a southern breeze, with boats rowing on the river of azure waves and crystal-clear waters, and apricot and peach trees in full bloom on both banks. yuan-dynasty-painter tang hou, who came after zhan ziqian employed the technique of "li sixun" who "applied rich and shining, splendid colours to the landscape painting, which became a methodology in itself." consequently, the southern-song dynasty approach to colour application involved the use of strong colours to depict the charmed life of the nobles in their palace environs. the genre of landscape painting originated with zhan ziqian's painting "spring outing," but continued during the southern song dynasty, and also in the style of the later generations of ming and qing painters who favored this application of strong colours, along with the story of "tang bohu winning the love of the maidservant qiuxiang," and the southern song dynasty appreciation for of plants, flowers and insects. these elements were transmuted into landscape painting and also the free and unfettered style of architecture. this style of painting became known as the "blue-green" school of shanshui painting. not long after, it became a classic style of the literati, who relied upon the principal colours of azurite blue and malachite green, the colours laid out in green and gold resplendence, rich colours and precise delineation combining to create a qing lv shan shui painting. these paintings depicted the excursions and hunting trips of the nobles and scholar-officials, advocating the idea of withdrawing from society to enjoy a leisurely and carefree lifestyle.

山水畫是中國美術史上乃至東方藝術寶庫裏最臻
於完美之繪畫經典。而山水畫的精英驚艷，可謂陽
春白雪的是，文人畫中山林雲水間有王維之靜寂、
趙孟頫之清遠、董其昌之淡泊、朱耷之精練和質
簡到臻於完美的世間美學，遠離紅塵、避世尋隱的
態度與處世戒律，被凡俗遺忘則是她們之初衷所
然。加之文化因襲和 stereotype（刻板印象），每每
以 scholarly landscape painting（文人山水畫）為山水
畫之登峰造極。無獨有偶，特別受西方之漢學界的
追捧，而其中不乏金玉良言，也有對今天現實的隱
喻，亦表現了司空見慣之固有意識形態。

依吾之分析和鑑賞，從王維至董其昌水墨田林素
樸為 one school（壹面），李思訓到仇英為 other（另
壹面），是文人畫之矛盾體之兩面，互補且缺壹不
可，中庸兩面，正是儒家思想之核心。

not long after that, the group of literati painters would sometimes hide away in the boundless beauty of nature, their lives unsoiled and free from corruption and worldly concerns. sometimes these green and gold magnificent shanshui paintings were reduced to the level of popular art, made by craftsmen or artisans, but, of course, history is always constantly being rewritten. things change as time passes, and these two qing lv shan shui paintings, zhang zeduan's "along the river at qingming festival" and wang ximeng's "a thousand li of mountains and rivers," these two pampered paintings, pot-bellied and rotund after living in the largesse of the forbidden city for hundreds of years, have now left their elite quarters to walk amongst the mortals. these two dazzling stars have now become household names, in particular the digitized version of "along the river at qingming festival," the beige-coloured scroll which depicts over 815 figures, which miraculously come alive, peasants calling their livestock to move along, people strolling through the bustling qingming festival vegetable markets, vendor's stalls displaying a superb collection of goods, people bustling across the lantern-lit street and shuttling back and forth across the bridges as the classic qing lv shanshui painting is transformed into a movie.

among the many great treasures of asian art, shanshui painting in the context of chinese art history is seen as the utmost perfect expression of classical painting; and the essence and beauty of shanshui painting, the pinnacle, may be the shanshui painting of the literati. we see this in the exquisite, high-brow art of the literati and the quietude evoked by wang wei's paintings of mountains, forests and clouds, zhao mengfu's paintings of qingyuan (a place in southern china), the sense of simplicity and tranquility depicted in the paintings of dong qichang and zhu da, who took minimalism and refinement to the limit to create a perfect, yet earth-bound aesthetic. their attitude was to remain far from the realms of mortals, hermetic and hidden from society, combined with a strong discipline in regards to conducting oneself within society. that said, the desire to be forgotten by society and to avoid the customs that being in society entailed was their primary intention. in addition to the cultural rules and stereotypes, often scholarly landscape painting came to stand for the epitome of landscape painting as a whole. it was rare but not unique and hotly pursued by western

叁

《青綠山水畫的故事》是壹複合式和多面體的綜合藝術計劃。

他的富春晚年不羈，仗義與慷慨；似乎我與仟佰學童，藝術與社會，《青綠山水畫的故事》與黃大痴的文人情懷，壹脈相承。

話說天下，宇宙天象裏的衍生衍化，only（只有）她是生生不息輪迴之 origin（源頭），這是唯壹的 originality（獨創性）！

藝術的原創，無稽之談；世間凡事，絕無源頭，哪來原創？所謂吾輩常信口雌黃。人間發明創造皆是 infinitive（不定）宇宙循環裏之星星點點．

《青綠山水畫的故事》從經典裏漫步而來，如何走到當代，看她能走多遠……

sinologists, but amongst them, there are in fact, a few gems of wisdom, and there are also metaphors for our current reality, which express the inherent ideology of this common occurrence.

according to my analysis and understanding, from wang wei to dong qichang, the method of ink used in the simple method of the tianlin paintings represents one school of painting. li sixun and qiu ying represent the other. these two traditions demarcate the two conflicting sides of literati painting, which complete each other as one cannot do without the other-they are two sides of the (confucian) golden rule, which is the very core of confucian thought.

THREE

a story of qing lv shan shui hua is a comprehensive multi-faceted, multimedia art project.

the late song dynasty painter, huang dachi, spent his later years in the fuchun mountains. during this time, he was unbridled, generous, loyal and impassioned, and with *a story of qing lv shan shui hua* it is almost as if there is an unbroken lineage between the spirit of the literati and contemporary society, the thousands of children who participated my work, the artwork and my unique art practice.

that the evolution and development of everything under heaven, the universe, and the celestial phenomena only "she" is the origin of this endlessly multiplying cycle of reincarnation; this is the only true originality!

original art is sheer nonsense; everything in the world has absolutely no source, but then where does originality come from? our so-called generation frequently makes irresponsible remarks. all human inventions and creations are dots in the cycle of the infinite universe.

as *a story of qing lv shan shui hua* saunters roaming out of the classical realm, we wonder how will it arrive at this contemporary moment. let's see how far she can go...

肆

我慢條斯理地，並且頗具挑戰地說道，「泛濫成災的藍藻青綠山水畫，讓我們的學童去體驗、去經歷，讓他們畫出時代的吶喊！」藝術家與corporation（企業），art（藝術）and（和）社會，完美的 double life（雙重生活）。壹學童，情系壹家庭、壹學校、壹社會。

大量的前期工作涉及在校生參與者，其前期課程包括：生態環境教育，藍藻肆虐危害，繪畫藝術，行為表演；壹老師家長制對應貳拾學生，從兌換「青山綠水」t 恤，上大客車到行為藝術現場，下車到對號入戲，系統慎密，有條不紊。現場裏，在壹佰伍拾幅丈陸匹宣紙上，均貼有每壹學童的編碼，配置壹羊毫提筆與壹罐藍藻水。digitized（數字化）《清明上河圖》長卷畫中的捌佰壹拾伍位宋人，奇跡般地活起來了，活到了今天，與《青綠山水畫的故事》裏的零零後學童壹脈相承。

學童將向社會發出時代的呼聲，為拾叁億人祈禱綠色的未來……社會意識是藝術存在的最重要的理由：現實和責任。壹個藝術家對生存精神和物質的環境的敏感、感應同回答，藍藻青綠宣紙，不是文人經典、崇尚避世的石青石綠和孤芳自賞時所做的青綠山水，而是面對瘋長的藍藻自然植物，學齡兒童對未來的憂患意識和他們採取的行動；在藝術上，是藝術家對當代水墨藝術從觀念到形式的反思命題，後期製作的中心作品將是美術史

FOUR

i am slow and unhurried, and find it challenging to say this but, "the shan shui hua painting produced from a rampant overgrowth of blue-green algae allowed our students to experience, and to carry out a painting which is a fervent call to action!" in this project, artists and corporations, art and society occupy a kind of perfect double life, one primary school child bringing a series of parents, schools, and society as a whole.

the project involved a large part of the preparatory work, tasks such as: arranging the student participant enrollment, and the curriculum — including elements of environmental education, such as how the algae was wreaking havoc on the environment — painting instructions and the performance art element, arranging a parent or teacher for every 20 students, having everyone change into their "qing lv shan shui t-shirts" and board the coach to get to the performance site, disembarking from the bus and taking roll call, all before beginning the performance. we followed a cautious and meticulous system, working in an orderly and systematic way. on a floor laid with xuan paper the size of 150 pieces (approx. 500 square meters), each child was affixed with a number, which corresponded to their own pail of algae water and a chinese goat hair brush. as the children busied themselves with the work, the scene came alive, like the digital version of the song dynasty scroll painting "on the river at qingming festival" bustling with its 815 figures. in fact, these figures are still alive today, embodied in the primary-school children born after the year 2,000 which took part in *a story of qing lv shan shui hua.*

the students issued a call to society, praying for a greener future for 1.3 billion people. creating a social consciousness is one of the greatest functions of art; art needs to be both practical and responsible. an artist's sensitivity toward the human spirit of survival and the material environment, and their reactions and responses are important, but xuan paper painted with algae was not a classic element of literati painting. their qing lv shan shui paintings in azurite blue and malachite green and their encouragement of a hermetic lifestyle made them seem like flowers in love with their own sweet fragrance. gu wenda

上從未有過的巨幅青綠山水畫……學童們着裝「青山」和「綠水」t恤，以科學提煉過的藍藻水為生物顏料，在宣紙上潑畫，以行為藝術方式喚起公眾的環保意識的壹場大型活動，更是壹場具有象徵意義的參與性當代行為藝術。

《青綠山水畫的故事》從她的參與性，大眾波普行為藝術那裏，可見她承接着文人經典的青綠山水畫，同時也展示了對未來生態的關注；她讓我們敏感的意識到藍藻水泛濫的環境問題，卻不作教條主義式的說教，也不僅僅停留在批評，她向企業和社會提出了時代需要。《青綠山水畫的故事》展示了藝術可以改變現狀現實的力量，也提供了藝術可以改變現實的實證。作為《青綠山水畫的故事》的主辦與支持，平安集團以「藝素養」的高屋建瓴，在開幕式之際宣佈為改變貧困學童的飲水，開出大支票，捐助平安希望小學健康飲用水源系統！

壹位 born after 50（50 後）的藝術家，壹仟伍佰位 born after 00（00 後），半個世紀的跨越。我曾經反反覆覆強調：學童是當代藝術之生命線，他們讓當代藝術成為 mainstream（主流）。貳拾年後，他們記憶猶新，當他們進入社會，他們已帶着當代藝術的 dna。
丶

confronts a botanical phenomenon, this overgrowth of algae, to encourage school-age children to develop an awareness of the unexpected nature of the future and to take action. in the context of art. i have evoked some important reflections on contemporary ink, from concept to form, the central work in the series which was created after the event, and the performance which will go down in art history — as there has never been a qing lv shan shui painting quite as large such as this — and the students wearing "qing lv shan shui" t-shirts, and the organic pigment which was extracted from the blue-green algae and splashed across the xuan paper. using the method of performance art to arouse the environmental consciousness of the public at a large art event constitutes a more symbolic form of participatory contemporary performance art.

a story of qing lv shan shui hua it's clear that this participatory, public pop art performance carries on the tradition of classic qing lv shan shui painting. at the same time, it also displays a focus on future ecological issues, and shows my ideological sensitivity towards the environmental problem of the uncontrolled spread of algae in our water system. this is not preaching in a dogmatic way, nor do i stop at the mere act of criticism. this project presents the demands of the era to both society and to the business community. *a story of qing lv shan shui hua* illustrates the power of art to change the current reality, and supplies us with an example of how this reality can be changed. as one of the main organizers and sponsors of *a story of qing lv shan shui hua,* pingan group, made an announcement at the opening of its new high-rise building — a project called "the art of nourishment," which would support clean drinking water for poor students. at the time it issued a big check which was donated to its charity ping'an hope primary school, with the aim of building a system of healthy potable water for primary school students!

one artist born after 1950, 1500 students born after the year 2000, representing a leap of half a century. i have always stressed: primary school students are the lifeblood of contemporary art. they will be the ones to bring contemporary art into the mainstream. twenty years later, their memories will still be fresh, and when they enter society, they will already have art embedded in their dna.

尾聲

深圳如同西安，是我藝術生涯中難以忘卻的地方。當然摯友程征先生來了，深圳 ocat 當代藝術中心之首個大型個人展覽《唐詩後著》碑林肆系。2010 年，我的叁拾年水墨藝術回顧展又在何香凝美術館與 ocat 同時開幕。在青綠山水畫的故事叢中，重逢樂正維、欒倩，方立華、白老師⋯⋯我面對她們時，有難於言表的缺失，既是老朋友重逢，又相對無語，大家感到缺席了壹位卓越的建樹者⋯⋯這壹仟餘學童描繪青綠山水畫的震撼場面，算是我對黃專先生的紀念吧。

壹生有許許多多美麗的記憶⋯⋯而 2016 年 9 月 24 日這壹天是我美麗而富有意義的 moment（壹刻）⋯⋯記住這壹天，回顧這壹刻，希望壹仟伍佰位青綠明星的期望會激勵每壹年的這壹天成為「青綠山水日」，或許到他們長大了，那時他們的生活每壹天，都在青綠山水裏。

CODA

shenzhen, like xi'an became a place of unforgettable memories in my career. of course, my close friend mr. cheng zheng was once again involved. in 2010, oct contemporary art terminal (ocat) and he xiangning museum in shenzhen held a large-scale solo exhibition of mine*forest of stone steles, retranslation and rewriting of tang poetry* , to show my four stone stele series' in a retrospective of 30 years of ink art. amongst the crowd of visitors, i was reunited with old friends le zhengwei, luan qian, fang lihua and teacher bai, and looking at their faces it was hard to find words to describe my sense of loss. despite this being a reunion of such old friends, they were relatively speechless. everyone felt that there was someone missing, a brilliant and remarkable man of great achievements. these thousands of students, who painted the qing lv shan shui hua, who shook the whole venue with their creativity, are my parting gift to seminal curator huang zhuan — the person whose presence was at the forefront of our minds and hearts that day.

there are so many beautiful memories in this life, but september 24, 2016, was a particularly beautiful and richly-meaningful moment. remembering this day and revisiting that memory. i hope that the 1,500 stars of a story of qing lv shan shui would be encouraged enough to make every day *a qing lv shan shui day*, so that when they grow up, they can live every day in a beautiful world of verdant mountains and crystal blue waters.

《青綠山水畫的故事》工作坊　加州大學洛杉磯分校 2017

a workshop of a story of qing lv shan shui hua university of california los angeles 2017

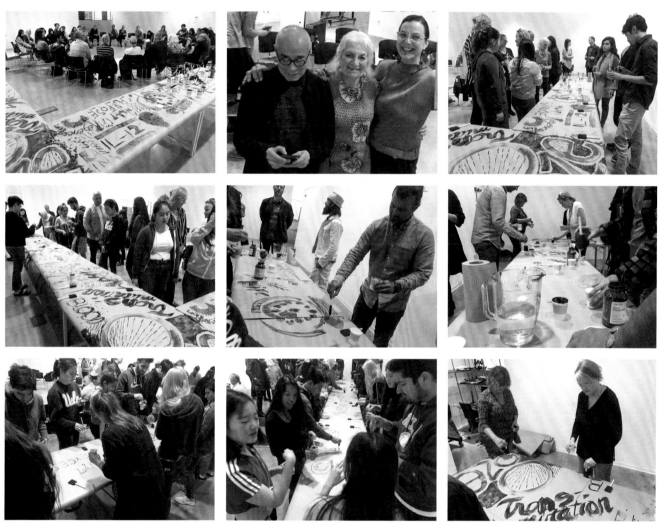

在 2014 年，我在佛山創立了首屆大眾當代藝術日。在第貳屆大眾當代藝術日，我在深圳導演了由 1500 位學童在 1500 平米宣紙上以藍藻水表演繪畫的參與型行為藝術《青綠山水畫的故事》對我們自然環境日益增長的擔憂，呼喚對未來生存的關注，並引起了加州大學洛杉磯分校的關注。 2017 年亦組織了以藍藻水舉辦了工作坊。圖中是谷文達主持這壹工作坊的熱烈氣氛

i established the first public contemporary art day in 2014 in foshan. at the second public contemporary art day in shenzhen 2016, i directed 1500 elementary school students in a painting performance with algae water on 1500 square meters of xuan paper in *a story of qing lv shan shui hua*. this called upon our environmental consciousness, which has quickly become a question of future survival, especially for our children's future. the event was quite influential. in 2017, ucla invited me to conduct a workshop concerning algae water. the pictures above show the enthusiasm amongst the participants.

《西遊記》
天堂紅燈上海站
大地藝術暨 2016 年第貳屆大眾當代藝術日上海
民生現代美術館
由 5000 名學童在 25000 枚燈籠上簽語未來

JOURNEY TO THE WEST

heavenly lanterns shanghai station
land art and the second public contemporary art day 2016
shanghai minsheng modern art museum
5000 students write wishes for the future on 25000 lanterns

第貳屆大眾當代藝術日 上海 2016：
大地藝術《西遊記》天堂紅燈上海站和公共參與型行為藝術《天堂紅燈上的簽語未來》
the second public contemporary art day shanghai 2016:
landart journey to the west heavenly lanterns shanghai station and public
participatory performance hopes for the future on heavenly lanterns

第貳屆大眾當代藝術日，學童參與的當代行為藝術《天堂紅燈上的簽語未來》的現場熱烈氣氛
a very enthusiastic atmosphere as students write their *hopes for the future on heavenly lanterns* at the second public contemporary art day

2016 年《西遊記》天堂紅燈上海站景觀 25000 枚 9 彩燈籠整體包裹曾經是 2008 年上海世博會的法國館

view of *journey to the west* heavenly lanterns shanghai station 2016, 25000 lanterns completely cover the former french pavilion of the shanghai 2008 world expo.

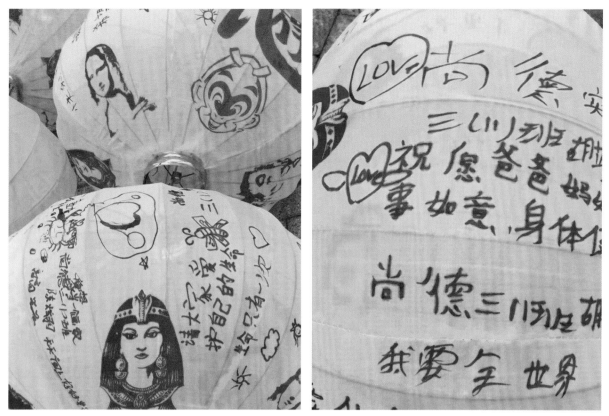

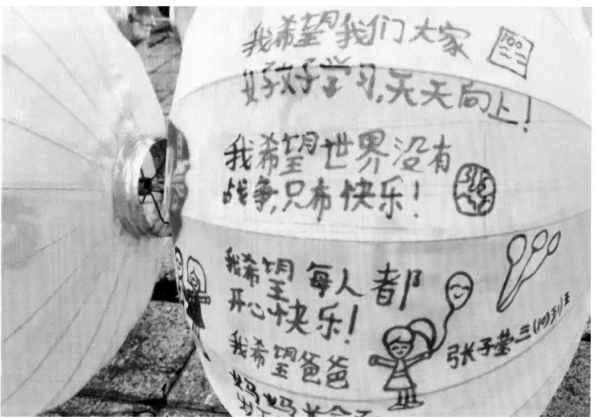

學童們興高采烈地在紅燈上簽語未來

students are extremely happy to write their wishes for the future on their heavenly lanterns

學童在玖彩燈籠上的簽語未來現場非常壯觀感人，也實在太美了！
the views of these students signing their blessings for the future on 9
colored lanterns is spectacular! It is so moving and absolutely beautiful!

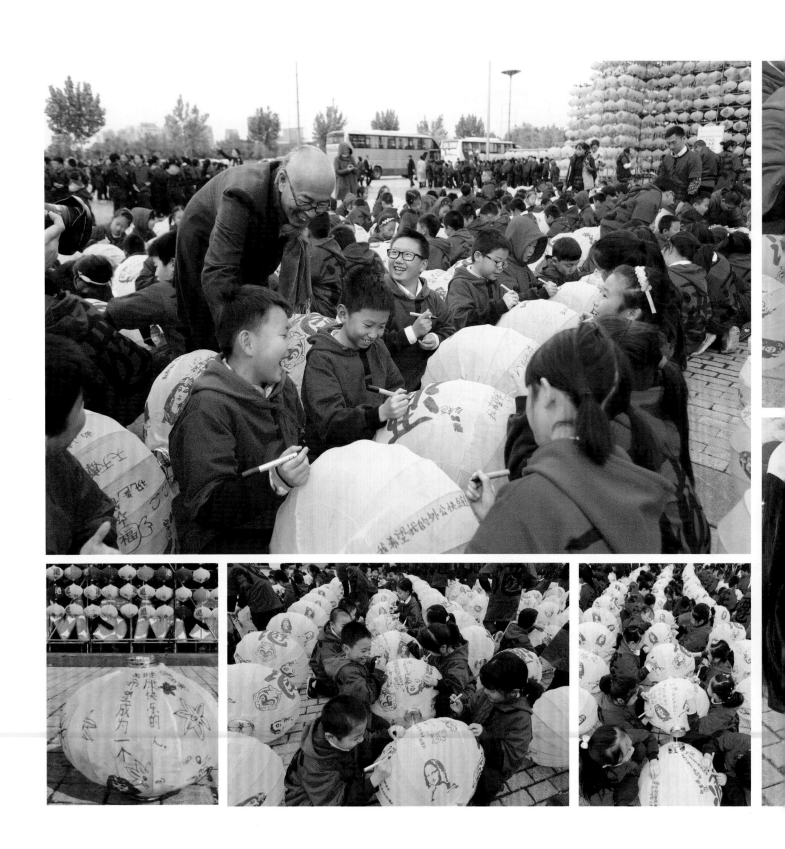

9 彩燈籠上印製有簡詞「西遊記」和世界伍大笑臉：埃及豔后、孫悟空、蒙娜麗莎、夢露、弗里達

9 colored lanterns printed with five world famous smiling faces: the monkey king, mona lisa, marilyn monroe, and frida kahlo

燈籠防火布製作與染色

non-flammable cloth making and colour dyeing

絲網印製燈籠圖案
silk screen printing on lanterns

兩萬伍仟枚玖彩燈籠由河北藁城燈籠生產基地特製 圖中工人們正在連夜趕製天堂紅燈上海站的燈籠
25000 lanterns of 9 colours being specially manufactured in gao cheng city, hebei province. the workers in the pictures are making lanterns day and night for heavenly lanterns shanghai station

《西遊記》天堂紅燈
上海站草圖之貳，叁，肆，陸，柒
2015 年於上海工作室
打印紙，鋼筆，夾式鏡框
28 厘米長 × 21.5 厘米高

A JOURNEY TO THE WEST HEAVENLY LANTERN
shanghai station drawing #2,#3,#4,#6,#7
shanghai studio, 2015
pen on printing paper in clip-on frame 28cm long × 21.5cm high

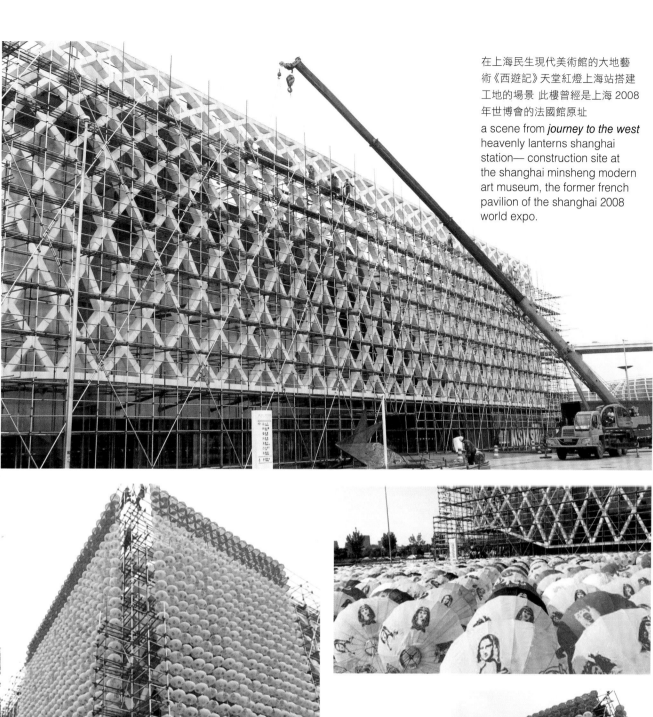

在上海民生現代美術館的大地藝
術《西遊記》天堂紅燈上海站搭建
工地的場景 此樓曾經是上海 2008
年世博會的法國館原址

a scene from *journey to the west*
heavenly lanterns shanghai
station— construction site at
the shanghai minsheng modern
art museum, the former french
pavilion of the shanghai 2008
world expo.

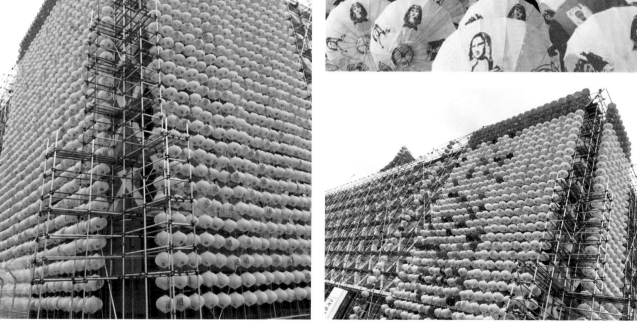

《西遊記》天堂紅燈上海站的搭建施工現場
journey to the west heavenly lanterns shanghai station construction site

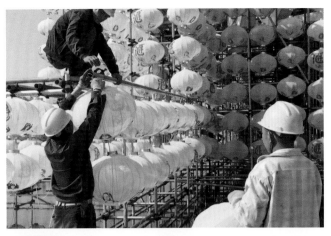 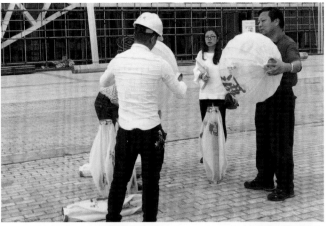

大地藝術和公共參與型行為藝術《西遊記》天堂紅燈上海站從 2007 年想法與概念的形成到圓滿創製成功前後歷時玖年之久。在艱苦卓絕的玖年裏，經歷了多次挫折與失敗，項目從概念到形式，從地點到施工，除了伍仟多學童參與的行為藝術

《天堂紅燈上的簽語未來》，經過多少政府部門，企業機構，廠家與學校，以及個人的磋商協調，是壹涉及人員龐大的藝術項目。同時也得到了他們的鼎力協助支持。最後藝術家設計執導的《西遊記》天堂紅燈上海站，除了谷文達工作室團隊和上海民生現代美術館團隊的艱苦創業，最後完美呈現出來的亮麗風景線，其背後艱苦卓絕，不斷失敗和持之以恆的努力，是難以言表，也壹言難盡的。

this large-scale work of public participatory performance art *journey to the west* heavenly lanterns shanghai station took 9 years in the making from its initial conception in 2007, to its final completion. over the course of those arduous 9 years, the project experienced many setbacks and failures, from concept to form, to location to construction. in addition, the performance element of the project which involved over 5000 students writing their hopes for the future on their lanterns had to pass through many government departments, corporate institutions, factories and schools, which involved much in the way of personal coordination and consultation. this art project which relied upon a huge number of people. at the same time, it also received their full support and assistance. in the end, through the hard work of gu wenda's studio team and the team at the minsheng museum we were able to realize a beautiful landscape which betrayed nothing of indescribably arduous work, frequent setbacks

2016 年的大地藝術《西遊記》天堂紅燈上海站的基建施工隊經過整整壹個月的時間將 25000 枚玖彩燈籠包裹了曾經是世博會法國館
a work of land art from 2016 - the *journey to the west* heavenly lanterns shanghai station construction team took about a month to put up 25000 lanterns which completely wrapped the former french pavilion of the shanghai 2008 world expo.

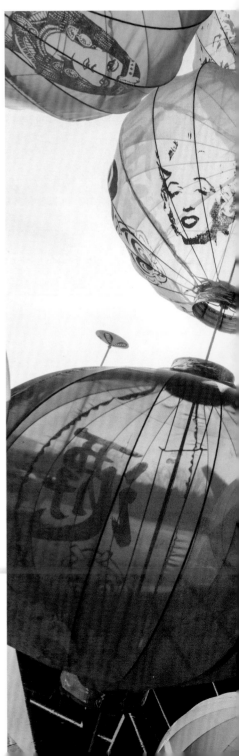

2016 年的上海民生現代美術館，原上海世博會法國館被 25000 枚印製有簡詞「西遊記」的燈籠完整包裹成了壹座火焰山和花果山

the shanghai minsheng modern art museum in 2016 (originally the former french pavilion during the expo), looked like the flaming mountain or the mountain of fruit and flowers when the building was completely enveloped by 25000 lanterns printed with the gu's phrase characters for *journey to the west*.

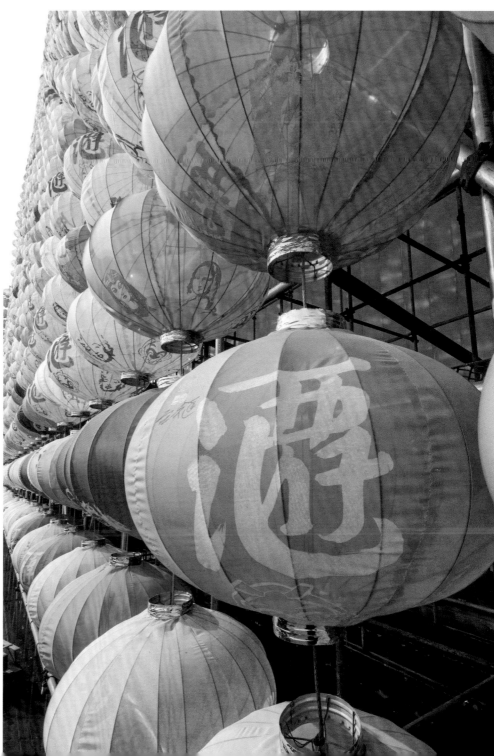

天　堂　紅　燈

谷文達

HEAVENLY LANTERN

gu wenda

使片刻化為永恆的記憶，使瞬間成為人們永遠流連忘返的歷史。

《西遊記》是我在上海民生現代美術館（原世博會法國館址）回顧展之標題，呼應室內的展覽，我的「第貳屆大眾當代藝術日」亦如火如荼，由兩萬伍仟枚特殊製作的「笑迎世界」的燈籠，將美術館樓體整體地包裹披掛，並構築成大地藝術《天堂紅燈 —— 西遊記》上海站。《天堂紅燈 —— 西遊記》上海站，讓我為之工作了整整柒年後，圓滿地呈現了（感謝浦東新區，感謝民生銀行，感謝上海民生現代美術館，感謝所有為之付出辛勤的政府部門，民間組織、學校，以及我工作室團隊）。

2016 年，大地藝術《天堂紅燈 —— 西遊記》上海站由兩萬多枚印有「笑對世界」的紅色和金色燈籠為底色，捌彩燈籠又鑲嵌其中，她們將上海民生現代美術館建築體披掛成壹座巍峨的立體山水畫。

a moment becomes an eternal memory. in the twinkling of an eye, it becomes an everlasting part of history, a tale upon which we choose to linger.

journey to the west was a thematic retrospective exhibition that was held at the shanghai minsheng modern art museum (the former french pavilion during the world's fair). echoing the content inside the exhibition, my "second public contemporary art day project" was unstoppable with 25,000 specially-created lanterns "smiling down upon the world." these lanterns completely enveloped the museum like a suit of armour, a giant piece of land art entitled *heavenly lantern–journey to the west* shanghai station. *heavenly lantern–journey to the west* shanghai station was the result of seven whole years of work, (with special thanks to the pudong district government, the minsheng bank, the shanghai minsheng modern art museum, and all of the various industrious government departments, local community groups, schools and my own studio team.)

created in 2016, the work of land art *heavenly lanters–journey to the west* shanghai station employed red and yellow as the base colors for its design. the installation involved over 20000 printed lanterns "smiling down upon the world," and beyond the red and yellow, it also included 8 other colours of lanterns which were interspersed to create a colorful mosaic effect. these lanterns transformed the architecture of the shanghai minsheng

這壹壯觀的立體山水畫的山巔由旭日般紅色的燈籠披掛，顧名思義，她象徵着旭日東升；山體則由捌彩點綴金黃的燈籠構築，寓意着黎明時分的黃金時刻。立體山水畫來自於我對宇宙天象的崇尚，燈籠上的簡詞西遊記是象徵性 logo（標誌）。

《天堂紅燈 —— 西遊記》上海站特製紅色與金色燈籠為底色燈籠，捌彩燈籠鑲嵌其中，似多彩「花果山」；美術館體頂部則由旭日般紅色燈籠披掛，顧名思義，像壹座「火焰山」。立體山水畫來自於我對宇宙天象的崇尚。對燈籠「笑迎世界」的設計，從概念到形式之考量，「笑臉」的選擇從伍大洲各自的 popular（流行）形象：蒙娜麗莎、夢露、佛里達、埃及豔后和孫悟空。壹方面，我希望以《西遊記》作為切入點，通過喚起大眾對《西遊記》共同的記憶與情感，從而促進大眾對於藝術的理解與參與，「學術的本質是愉悅 & 娛樂；引導是最好的藝術批評」；另壹方面，《西遊記》嘗試以藝術實踐令多元文化與傳統美學之間產生交談這壹舉措，具有異曲同工之妙。同時我也希望通過「西遊」貳字，來訴求自己自 1987 年前往西方發展，再次「西遊」歸來的藝術歷程。此項目的具體實施規模很大，運作程序也較複雜。這壹項目從叁年前就開始具體

modern art museum into a three-dimensional landscape painting. the summit of this spectacular three-dimensional landscape painting was hung with red lanterns to evoke the idea of the rising sun, to symbolize the sun rising in the eastern sky, whereas the body of the mountain was constructed with golden lanterns alluding to the color of the sky at daybreak. this yellow area was also embellished with a few lanterns of different colors. the three-dimensional landscape painting is an expression of our reverence for the universe and astronomical phenomena. the lanterns are printed with a "gu's simplified phrase" character based on *journey to the west*, which acts symbolically as a logo.

heavenly lantern–journey to the west shanghai station uses specially-fabricated red and yellow lanterns as a base color. whereas the eight different colors of lanterns which make up the mosaic are like the multicolored "huaguoshan" (a mythical mountain of fruit and flowers in *journey to the west*). the red lanterns at the summit of the museum building evoke the red color of the rising sun, and also the "mountain of flames" or volcano from "journey to the west." the three-dimensional landscape painting expresses my deep respect for the cosmos and the astrological phenomena *tianxiang*. in terms of the design of the "smiling down upon the world" lanterns, from concept to form, the five "smiling faces" were derived from various popular icons from across five continents including the mona lisa, marylin monroe, frida kahlo, cleopatra and sun wukong (the monkey king from *journey to the west*). on one hand, i wanted *journey to the west* to be an entry point, which had the potential to arouse collective memories and feelings about the *journey to the west* epic. this, i hoped, could facilitate the public's understanding of art and accelerate their participation. "learning at its essence is both joyful and entertaining; and leads us to the best art criticism." another aspect is that *journey to the west* is designed to try to create a kind of dialogue between traditional chinese aesthetics and multicultural artistic practice. therefore, using a clever means to sing different tunes with equal skill. at the same time, i hope that, through these two words — *west* and *journey* — to be able to recount my own journey to the west in 1987 and my subsequent development after my return. once again to bring this "western journey" back to the topic of my artistic process, the scale and implementation of this project were both quite big, and the operating procedures were fairly complex. three years ago, we started more concrete work on this

實施而工作了。這壹參與型行為藝術要得到世博園、教育局、文廣局、學校等等機構和組織支持、安排和落實。

近兩萬滬上學童在學校和學生活動場所，前前後後，在燈籠上簽語的行為藝術《天堂紅燈上的簽語未來》。直至展覽的開幕式上，由數仟名學童在「笑迎世界」燈籠上寫下自己對未來的憧憬與希望：

我希望有壹個聖誕老人，在聖誕夜時給我壹個滑板，因為它能在草坪上自由自在的玩耍

我希望長大以後做壹名畫家，然後我把自己畫的畫賣掉，最後我把賣來的錢捐給貧窮的人和山區兒童

我想當壹名醫生，用自己高超的醫生術幫助壹個個生命危在旦夕的病人恢復健康

我的心願是祝所有人都能健康

如果我是壹名考古學家，我要發明時空穿梭機，穿梭到古代和恐龍世界，去探索他們的奧秘，為中國的考古發展增加壹份力量

我的願望是爺爺奶奶長命百歲

我希望長大以後能成為壹名宇航員，能登上月球，探索月球，為人類做貢獻

我最大的心願是成為壹名發明家，有壹種可以讓我們在天空自由飛翔，它可以讓我們飛上宇宙，這就是我的心願

我希望成為壹個健康快樂的人

（以上是部分學童在天堂紅燈上的簽語）

project — a participatory art project which first needed the support of the expo bureau, the education department, the cultural bureau, the schools and other groups and organizations.

from beginning to end, over 20000 primary school students, both at their schools and on-site, participated in a performance art piece by signing their wishes on the lanterns for *hopes for the future on heavenly lanterns:*

i hope that on christmas eve, that santa-claus will appear and give me a skateboard, so that i can play freely on the lawn.

i want to be a famous painter when i grow up, then i can sell my paintings, and take the money and give it to poor people and kids living in mountainous areas.

i want to be a famous doctor, to use my superb skills to help patients whose lives are at stake and to help them recover.

it is my deepest aspiration for everyone to be able to enjoy good health.

if i was an archeologist, i would invent a time machine, to go back to the age of the dinosaurs, so that i could explore the mysteries of that time, to contribute my strengths to the field of chinese archeology.

i hope that my paternal grandparents will live to a ripe old age.

i want to be an astronaut when i grow up, to land on the moon, and explore its surface to make a contribution to mankind.

my biggest dream is to be an inventor, to invent something that would allow me to fly into outer space and fly around the universe—this is my greatest aspiration.

i want to be a happy and healthy person.

(children's inscriptions on the heavenly lanterns)

早在 2014 年的母親節，我於佛山奠基，創意並執導了「第壹屆大眾當代藝術日」。佛山壹仟零陸拾名學童，在壹仟平米紅綢緞上用筆墨書寫《孝經》之當代演繹，社會與大眾參與型公共行為藝術《基因 & 蛻變》，再由我製作成為壹大型裝置，在中國繪畫史和書法書寫史上前無古人。震撼的藝術作品將在此次展覽上再現輝煌，為已睹者、未睹者都帶來無與倫比的觀感，這件作品在合美術館部分地呈現給武漢的觀眾（鳴謝羅康瑞和瑞安集團、佛山天地、佛山市政府、香港 d3e 藝術機構）。

《天堂紅燈》，始於 2009 年的歐洲藝術節（europalia）。比利時布魯塞爾市中心廣場的王朝大廈，曾經是貳次大戰後首屆世博會之議會大廳。《天堂紅燈 — 茶宮》布魯塞爾站，以 5000 枚中國紅燈籠將其披掛成壹東方風格的亭子是我的榮耀。《天堂紅燈 — 茶宮》布魯塞爾站，屹立在布魯塞爾市中心廣場肆月之久，儼然成為地標，普普通通的吉祥物紅燈籠，讓布魯塞爾的老華僑熱淚盈眶，握着我的手說，我在布魯塞爾壹輩子沒有見到過這樣宏偉的燈籠藝術。（感謝歐洲藝術節和布魯塞爾市政廳、感謝策展人范迪安先生）。

《天堂紅燈》旨在與各地聞名的古今建築、歷史遺址為觀念和物質上的「合作夥伴」。紅燈籠在此系列作品中是壹個文明的代言人，是壹個人種的使者。而各地聞名的古今建築、歷史遺址代表了世界不同的文明與進程。是某壹文明的象徵物和另壹文明的象徵物之間的對話，也是某壹文明對他文明的重新理解與闡譯。

in early 2014, on mother's day, i used foshan as a foundation to create and direct the *first public contemporary art day*. in foshan 1060 primary school students used ink brushes to write the characters of *the classic of filial piety* on 1000 square meters of red silk in a contemporary expression of the ancient text. *dna and metamorphosis* was a community and public participatory performance art project, where my creation became a large-scale installation, one which was unprecedented in the history of chinese painting and calligraphy. this stunning artwork will make another splendid appearance in this exhibition. for the viewers, it will provide an unparalleled impression; a part of this artwork will also be shared with the audience at wuhan's united art museum (with special thanks to mr. vincent lo and shui on group, foshan lingnan tiandi, the foshan municipal government, and hong kong's 3e, art organization.)

heavenly lantern began at the european art festival *europalia*. in the center of brussels at square: palais des congrès (the legislative assembly) and palais de la dynastie (which was built for the 1958 brussels expo, the first world's fair after the second world war). *heavenly lantern-tea palace* brussels station, which employed 5000 red lanterns cloaking the architecture in the shape of an asian-style pavilion, was my personal triumph. *heavenly lantern-tea palace* brussels station, towered over the central plaza of brussels for over four months; solemn and dignified, it became a landmark of the city. these ubiquitous common lanterns used for celebrations brought tears to the eyes to some of the older generations of the chinese diaspora in brussels. one person grasped my hand and said, "i have lived in brussels all my life and have never seen such a magnificent work of lantern art." (special thanks to the europalia art festival, the brussels municipal government and to curator mr. fan di'an.)

heavenly lantern relies on various famous ancient buildings and historical landmarks, to "partner" with it in terms of concept and material. in this series of works, it acts as a spokesperson for civilization-a kind of messenger of ethnic cultural heritage and the ancient buildings and historical landmarks of various regions, which reflect the progress of different civilizations around the globe. this is a kind of dialogue between one symbol of civilization and another; at the same time, it facilitates a new understanding and interpretation between different cultures.

燈籠在中國幾仟年的文明史上，可以說是從古至今最為流行的吉祥物。

新年伊始，張燈結彩的節日氣氛已經襲來。中國的燈籠又統稱為燈彩，起源於壹仟捌佰多年前的西漢時期，每年的農曆正月拾伍元宵節前後，人們都掛起象徵團圓意義的紅燈籠，來營造壹種喜慶的氛圍。後來燈籠就成了中國人喜慶的象徵。在過去，燈籠不僅只是用以照明，它往往也是壹種象徵，吳敦厚說，他以前做新娘燈（即宮燈）就代表婚禮喜慶；竹篾燈則告示這是喪葬場合；傘燈（字姓燈），因「燈」與「丁」語音相同，意味着人丁興旺。所以，過去每家都有字姓燈，懸掛在屋檐下和客廳中。除了照明以外，燈籠還有其他意義。每年正月私塾（古代的學校）開學時，家長會為子女準備壹盞燈籠，由老師點亮，象徵學生的前途壹片光明，稱為「開燈」。後來就由此演變成為元宵節提燈籠之習俗。由於字音和「添丁」相近，所以燈籠也用來祈求生子。唐開元年間，為慶祝國泰民安，紮結花燈，借閃爍不定之燈火，象徵「彩龍兆祥，民富國強」，花燈風氣至此廣為流行。明朱元璋建都南京時，更於秦淮河上燃放水燈萬隻；永樂朝在午門大立鼇山燈柱，在華門外以設「灯市」，故有北平之「灯市口」而遠近聞名。民國之後，花燈仍在，但平淡了許多。幸虧如今中國熱度，燈籠又逐漸在居家裝飾上扮演着重要的角色。

lanterns have already enjoyed almost two thousand years of history in china; from ancient times, up until today we can probably say that they are the most popular auspicious object, known and loved as "bringers of good luck."

at the beginning of the new year, homes were always festooned with lanterns and other decorations, creating a gay atmosphere which signaled the onslaught of the new year festivities. originating 1800 years ago, during the western han dynasty, every year on the fifteenth day of the first lunar month, for the lantern festival, everyone would hang a red lantern which was a symbol for family reunions. lanterns created a joyous atmosphere, and following this, the lantern became a potent symbol of celebration for chinese people. in the past, lanterns were not only used for lighting, they always had symbolic meanings. wu dunhou said that they could be used as bridal lanterns (or even palace lanterns), to represent wedding festivities. a lantern made of thin bamboo strips would be used to signal a funeral; an umbrella lantern (zixingdeng), was thought to evoke fertility, because the character "燈 *deng*" for lantern and "丁 *ding*" sound similar, and people thought it sounded like the proverb "ren ding xing wang" meaning "a growing family." so, in the past, every family had these umbrella lanterns hanging from their eaves or in their living rooms. beyond providing light, these lanterns had other meanings. for instance, every year during the first month of the lunar new year when the *sishu* (ancient schools) opened for term, parents would bring a lantern for their children, and the teacher would light the lamp to symbolize the bright future for the child; this was called "opening the lantern." later this evolved into the custom of lighting lanterns for the yuanxiao lantern festival. because the term for having a baby "*tianding*," also sounds very similar, lanterns also came to symbolize the hope for giving birth to a child. during the reign of kaiyuan, in the tang dynasty, lanterns were lit as a way to celebrate the peace and prosperity of the kingdom. strings of lanterns would be hung up in infinite rows of flickering lights to symbolize auspiciousness and celebrate that the people were living in abundance and the country remained strong. this practice of using huadeng lanterns became more widespread from that time on. when nanjing was the capital of china during the reign of ming-dynasty emperor zhu yuanzhang, when thousands of shuideng, or water lanterns were

作品設計與比利時 palais des congres dynastie —
congres paleis daynastie 旨在達到的國際性交流完美
結合。她秉承了《天堂紅燈》跨文化的性質，以及
文化碰撞的不斷探討，《天堂紅燈 —— 茶宮》布魯
塞爾站是首次實施製作。

向視覺藝術的極限挑戰是天堂紅燈藝術計劃的指
向所在。集視覺衝擊力、技術高難度、媒體聚焦
點，以及集嚴肅藝術與波普文化經典之大成。基於
天堂紅燈藝術計劃的特性，即規模宏偉的視覺藝術
語言、工程實施的技術性特點，以及更重要的是
此藝術計劃對於所在地的社會與文化的象徵意義。
此項目的合作者不僅僅限於當地的美術機構，更需
要政府、資金、物力、市民態度等各方位的支持，
還需要考慮航道、氣候、消防、路面交通等諸多
細節的問題。

《天堂紅燈》出自於平凡、親切、日常的紅燈籠；
人流進出頻繁的建築物，是人們生活中習以為常。
然而一旦將她們以嶄新而獨特的方式再現，「節日」
與「慶典」是天堂紅燈藝術計劃所要營造的瞬間。
故在時間上的選擇是以當事國年中之重要壹刻，
包括歷史上的重要紀念日、文化藝術節的開幕式
和各種各樣節日比如國慶節、春節、勞動節等等
為執行此藝術計劃的時間表。

placed on the qinghuai river: and in the ming dynasty during
the reign of yong le, at the meridian gate there was a post on
which lanterns were hung to create a large mountain of light. in
linfen (shaanxi province), at the "china gate," there is a city of
lights and in beiping (beijing) there is dengshikou, named after
the lantern fair, which is known far and wide. after the founding
of the republic, lanterns were still common, but they were fairly
ordinary and pedestrian. fortunately, nowadays lanterns are
making a comeback. lanterns are again gradually beginning to
play an important role in home design. in several thousand years
of history, the lantern is by far still the most popular icon of
auspiciousness.

the design of the work is intended as a kind of perfect
integration of international exchange hosted by two buildings in
brussels: square: palais des congrès and palais de la dynastie. it
carries on the cross-cultural character of *heavenly lantern*,
continually exploring the topic of cultural conflict. *heavenly
lantern-tea palace* brussels station was the first time this project
was realized and produced.

the *heavenly lantern* project sought to challenge the limits of
visual art, to deliver a strong visual impact. it was the product of
exceedingly complex technology, serious art, and pop culture
classics and became the focus of the media. given the uniqueness
of the heavenly lanterns project, the huge scale of its visual
language, the technological specificities involved in carrying out
the engineering side of the project, and of course, more
importantly, the local specificity of the social and cultural
symbolism of the work, the collaborators were not limited to
the local art organizations, but rather included the support of
the government, capital, logistics specialists, the brussels citizens,
and various other parties. we needed to think about shipping
lanes, climate, fire safety, road transportation, and many other
detailed questions.

heavenly lantern originated from the ordinary, everyday
lanterns with which we are intimately familiar and the stream of
people passing in and out of a building or structure, is something
that we are now accustomed to. but in a short time, the heavenly
lanterns project sought to recreate their "holidays" or
"celebrations" and reconstruct them in a new and unique way. in

西遊記承接我們的基因流，西天才能取得真經……

花果山是帶不走的，不經西天授花粉不會再果實
纍纍……

水簾洞知其泉源方能源遠流長……

火焰山上火眼金睛穿越當代西遊記……

creating the schedule for this art project, we were very intentional; chinese new year was an important moment, including other historically-important anniversaries or dates, art, and cultural openings and various kinds of holidays such as national days, spring festival, and labour day.

the legend of "journey to the west" carries on in our genes, and we can only gather the sutras by going to the western heavens...

huaguoshan cannot be carried away and replicated elsewhere. even if we collected the pollen from the plants of huaguoshan, we could not induce new plants to produce large clusters of fruit...

only the cave behind the waterfall knows exactly where the source of its waters begin...

the fiery gaze and diamond pupils of the mountain of flames, cut through time like a laser, clearing a path to our contemporary journey to the west...

社會和參與（柒）：
壹個大地藝術計劃《水龍燈》天堂紅燈杭州站

SOCIETY AND PARTICIPATION 7:
a landart proposal shui long deng heavenly lanterns hangzhou station

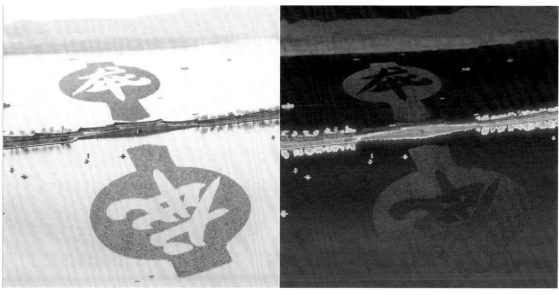

社會和參與（柒）：
壹個大地藝術計劃《水龍燈》天堂紅燈杭州站

第陸部分
CHAPTER 6

藝術的故事
全主義藝術：《中園》

A STORY OF ART:
ARTWHOLEISM: ZHONG YUAN

全主義藝術（壹）：

《中園》：元園的雛形 2009

ARTWHOLEISM 1:

zhong yuan: the incubation of metaversepark 2009

《中園》

草圖之陸

2009 年於哈德遜河谷工作室

墨，水彩色，水彩紙，鏡框

76.8 厘米長 × 57 厘米高

ZHONG YUAN

drawing #6

hudson valley studio, 2009

ink, watercolor on watercolor paper, framed

76.8cm wide × 58cm high

《中園》書影湖中心的書影島上之陰陽園與《中園》東西南北走向的中軸線的構成與鏈接

zhong yuan the link between the yinyang garden in shuying lake and the rest of *zhong yuan* relies upon the central axes of the cardinal directions of north, south, east and west.

《中園》

草圖之叄

2009 年於哈德遜河谷工作室

墨，水彩色，水彩紙，鏡框

76.8 厘米長 × 57 厘米高

ZHONG YUAN

drawing #3

hudson valley studio, 2009

ink, watercolor on watercolor paper, framed

76.8cm long × 58cm high

《中園》

草圖之伍

2009 年於哈德遜河谷工作室

墨，水彩色，水彩紙，鏡框

76.8 厘米長 × 57 厘米高

ZHONG YUAN

drawing #5

hudson valley studio, 2009

ink, watercolor on watercolor paper, framed

76.8cm long × 58cm high

《中園》

草圖之肆

2009 年於哈德遜河谷工作室

墨，水彩色，水彩紙，鏡框

76.8 厘米長 × 57 厘米高

ZHONG YUAN

drawing #4

hudson valley studio, 2009

ink, watercolor on watercolor paper, framed

76.8cm long × 58cm high

《中園》建築群和水域構成了「中國」「園林」「萬國」「肆方」

zhong yuan, a group of buildings and waterways shaped into the characters: "china" "garden" "countries" and "directions"

《中園》

草圖之拾玖

2009 年於哈德遜河谷工作室

紙，鋼筆，鏡框

28 厘米長 × 21.5 厘米高

ZHONG YUAN

drawing #19

hudson valley studio, 2009

pen drawing on paper, framed

28cm long × 21.5cm high

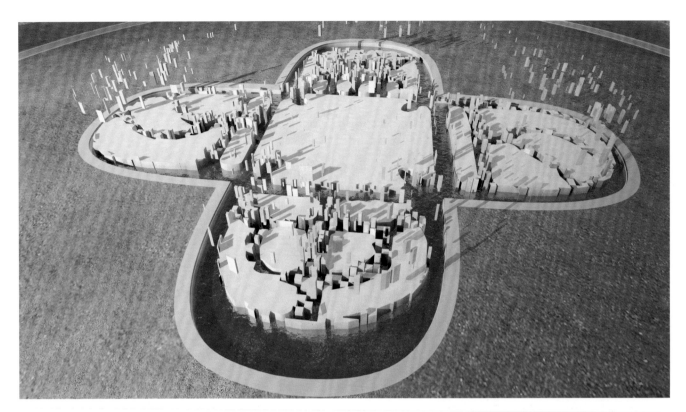

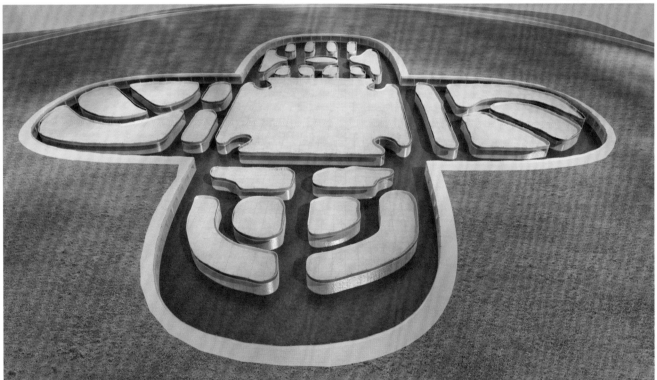

上圖與下圖：

《中園》書影湖與書影島上的陰陽園，建築群以及水域構成了「中國」「園林」「萬國」「肆方」

above and below:

zhong yuan a group of buildings and waterways in the shape of the characters "china" "garden" "countries" and "directions" in the yinyang garden on shuying lake and island

《中園》陰園內書法構成了水域上貳拾柒座建築

zhong yuan calligraphy used to create a framework for 27 buildings and waterways in the yin garden

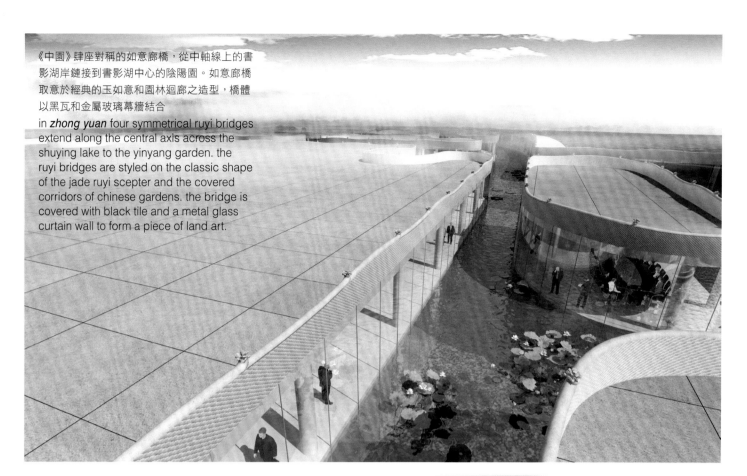

《中園》肆座對稱的如意廊橋，從中軸線上的書影湖岸鏈接到書影湖中心的陰陽園。如意廊橋取意於經典的玉如意和園林迴廊之造型，橋體以黑瓦和金屬玻璃幕牆結合

in *zhong yuan* four symmetrical ruyi bridges extend along the central axis across the shuying lake to the yinyang garden. the ruyi bridges are styled on the classic shape of the jade ruyi scepter and the covered corridors of chinese gardens. the bridge is covered with black tile and a metal glass curtain wall to form a piece of land art.

《中園》

草圖之叁拾　叁拾貳
2009 年於哈德遜河谷工作室
紙，鋼筆，鏡框
28 厘米長 × 21.5 厘米高

ZHONG YUAN

drawing #30　#32
hudson valley studio, 2009
pen drawing on paper, framed
28cm long × 21.5cm high

清乾隆 《文竹禦題詩如意》
美國大都會藝術博物館收藏
ruyi scepter with poem composed by the qianlong emperor, qing dynasty the met collection

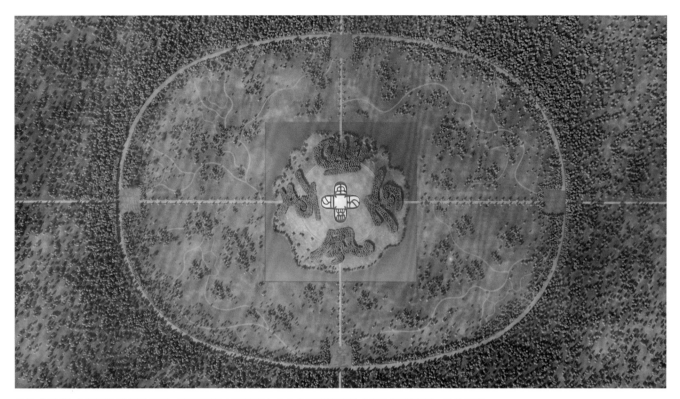

鳥瞰《中園》之橢圓外形如同龜背，寓意長壽；又與園中心之方正書影湖形成壹枚銅錢造型，象徵富有

the bird view of *zhong yuan*, its oval outline as turtle back, meaning longevity; the oval shape centered with a square, looks like a bronze coin, symbolizes richness

《中園》

草圖之拾伍

2009 年於哈德遜河谷工作室

紙，鋼筆，鏡框

28 厘米長 × 21.5 厘米高

ZHONG YUAN

drawing #15

hudson valley studio, 2009

pen drawing on paper, framed

28cm long × 21.5cm high

《中園》

草圖之貳拾柒 ，貳拾捌

2009 年於哈德遜河谷工作室

紙，鋼筆，鏡框

28 厘米長 × 21.5 厘米高

ZHONG YUAN

drawing #27, #28

hudson valley studio, 2009

pen drawing on paper, framed

28cm long × 21.5cm high

《中園》書影湖的圍欄以湖水波浪和浪花為視覺形象

zhong yuan the design of the lakeside railing is based on water wave and spray patterns

《中園》書影湖上之中心島是整座《中園》的中心，也是制高點。書影島之肆周是陽園，陽園圍繞的中心是陰園。陽園又以肆季為主題。取自藝術家獨創編撰的《簡詞典》的「春風」「夏日」「秋雨」「冬雪」，以種植桂花樹林組合成「春風」「夏日」「秋雨」「冬雪」

the island in shuying lake is the center and the highest point of *zhong yuan*. the outer space around the lake water is named yang garden. the center of the island, called yin garden, is surrounded by yang garden. yang garden's theme is the four seasons. the hege of sweet osmanthus form four giant *jiancidian* phrases: spring wind, summer sun, autumn rain and winter snow.

桂花樹俗稱香雪海，是因為桂花開放時甜美而濃香撲鼻

sweet osmanthus has a very unique and strong fragrance therefore people call sweet osmanthus xiang xue hai, meaning a sea of fragrance.

鳥瞰簡詞「秋雨」詞形的桂花樹林
bird's-eye view of jianci "autumn rain" created by sweet-osmanthus hedges.

681

《中園》在園林的正東西南北方向的邊緣各有壹寬闊的朝代廣場，肆廣場以中國歷史上肆個朝代的名字命名，她們是以《簡詞典》裏的「軒轅」，「黃帝」，「貞觀」和「共和」，以芳草坪鋪種而成。《中園》之中軸線成「十」字形展開；中軸線伸展到肆盡頭連着東西南北的肆個廣場；中軸線的「十」字交叉地域便是「書影湖」與湖中心的「書影島」，以及島上的「陰陽園」。

there are four grand squares on the east, south, west, and north edges of *zhong yuan*. those squares are named after four famous historical chinese dynasties "xuan yuan," "huangdi" "zhen guan," and "republican." the names of the four squares are simplified phrases chosen from gu's phrases. the central axis takes the " 十 " shape of a cross. the four ends of the central axis are connected with the four "dynasty squares" on the east, south, west , and north edges of *zhong yuan*. the center of the cross is an island in the "lake of calligraphy and reflection."

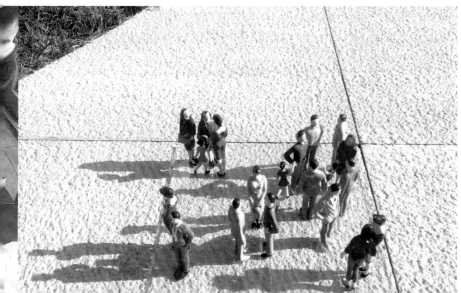

（下左）共和廣場的施工現場
construction sites of republic square

（下右）藝術家谷文達工作室助手們正在《中園》的「共和」大門模型上擺設模型人物和汽車
artist gu wenda studio assistants decorating zhong yuan's gate of the republic with small figures and cars

中 園

谷文達

ZHONG YUAN

gu wenda

在我兒時的記憶裏，山巒是神奇的。那是 1961 年，當時陸歲的我與祖母坐火車去我的家鄉浙江上虞，途徑杭州時我問祖母，車窗外那黑黑的龐然大物是甚麼？祖母告訴我是山。那是我第壹次看到山啊！出生於上海大城市的我，第壹次結緣於大自然。我與祖母那次的經歷在我畫水墨畫時常常記憶猶新。

in my childhood memories mountains were magical. in 1961, i was six years old and my grandmother took me by train to my hometown, shangyu, in zhejiang province. i asked her what the black behemoths outside the window were and she told me there were mountains. it was my first time seeing mountains! born in the big city of shanghai it was my first encounter with nature. that memory from that first experience is still fresh in my mind when i paint landscapes today.

《中園》綠色森林書法與河道書法園林的總觀念與形式

縱觀歷史，從我們熟悉的蘇州園林到法式、意大利式、英國式和西班牙式園林藝術。綠色森林書法與河道書法園林藝術，她融會貫通了古今中外的東西方園林藝術的經典，同時植根於歷史與文化的遺產。綠色森林書法與河道書法園林是以自然界的常青之樹、河道、池塘和湖泊等為媒介，以中國漢字書法結體的神韻結合來創造氣象萬千的當代大地藝術與園林。

ZHONG YUAN THE PRIMARY CONCEPT AND FORM OF THE GREEN FOREST CALLIGRAPHY AND RIVER CALLIGRAPHY GARDEN

throughout history we can find garden styles we are familiar with, from our well-known suzhou gardens to french, italian, english and spanish garden design. green forest calligraphy and river calligraphy garden art integrate both foreign and chinese, both modern and classical elements of eastern and western classical gardens, while simultaneously rooting themselves in a historical and cultural legacy. the green forest and river calligraphy gardens use rivers and evergreen trees as materials, and they employ the spiritual structure of chinese calligraphy to create a grand piece of land art and an atmosphere rich in variety.

以祖國文明遺產的陰陽伍行體系作為綠色森林書法與河道書法園林設計內在的歷史和文化的支撐點，以中國傳統圍合式空間格局為空間構成基礎，以《簡詞典》的現代主義的漢詞結體為園林大地藝術的形式語言來統攝綠色森林書法的藝術展現。歷史悠久並作為東方和中國的精英文化的書法藝術，拓展到了東方式的大眾喜聞樂見的流行文化生活，與未來世界的綠色生態生活結合起來，創造出壹幅幅遼闊的鳥瞰藝術奇景。綠色森林書法與河道書法園林，顧名思義是以漢字書法觀念和形式，以常青大樹為媒介的園林佈局結構，來創造當代東方園林。

伍仟年的歷史長河孕育了漢字文明，其書法藝術又有正草隸篆形式風格之分。綠色森林書法與河道書法園林達到了表達意向境界的同時，以正草隸篆不同的書法形式和書寫風格將園林的佈局是園林的格局引入了詩韻、意氣、超然等等出神入化的境界之中。漢字的選擇將園林達到了表達意向的境界。比如我設計的「景園」是以「山高」「雲行」「風清」「月白」等漢字書法為公園的構成；再比如我設計的「四季園」選擇了「春風」「夏日」「秋雨」「冬雪」為園林的建構；而「華園」則以「中國園林藝術」的漢字書法為章法佈局。

綠色森林書法與河道書法園林大地藝術將延續我的藝術發展脈絡，在東方與西方，傳統與當代，觀念與形式的體系中，將上述的理念延伸為綠色的大眾文化娛樂休閒的公共園林，主題公園，低密度

the design for green forest calligraphy and river calligraphy gardens employs the legacy of the chinese concept of yin and yang and the five elements of chinese philosophy (wood, fire, earth, metal and water) as historical and cultural anchoring points. the foundation of *zhong yuan* is based on a traditional chinese closed-layout spatial system, and it employs the modern chinese writing system of *jiancidian* to create a great work of land art and promote a sense of artistic unity within the green forest and river calligraphy garden. the garden expands the time-honored achievements of calligraphy art, which belong to the elite culture of china and asia, bringing it into the realm of popular culture and lifestyle, and also combining the future of green ecology to produce an overall artistic marvel. creating a vast bird's-eye-view of artistic wonders, the green forest calligraphy and river calligraphy garden, as the name implies, uses the concept and form of chinese calligraphy and evergreen trees as the media for the garden's structure and layout, in order to arrive at the creation of a modern oriental garden.

a long historical legacy of 5000 years has produced a rich culture of chinese characters and language. this project's calligraphy art utilizes the diverse styles of ancient chinese scripts including regular script, running script, official script and seal script and other kinds of calligraphy styles and writing styles to create the structure and poetic rhyme of the garden's will and spirit. its sense of detachment reaches the acme of perfection and expresses an intentionally-created realm. for instance, the garden scenery composed of calligraphic forms of the characters for "high mountains," "rolling clouds," "clear breezes" and a "bright moon"; the four seasons garden will be made of the calligraphic forms of "spring wind," "summer sun," "autumn rain" and "winter snow"; and finally the "china garden" will be made of the phrase "chinese landscape art."

this green forest calligraphy and river calligraphy garden land art piece will carry on the development of my greater artistic mission and its conceptual themes of east and west, of the traditional and the modern, and my formal and conceptual ideas. the above-mentioned concepts will extend into popular culture: the entertainment and leisure aspects of the public park, the theme park, and the high-end and low-density residential area surrounding *zhong yuan*. the green forest calligraphy and

的高端居住區等等。綠色森林書法與河道書法園林不僅為將來的中國園林的發展做出獨創性的探索，同時，將在精神文化內涵和藝術形式雙層面上創造出當代審美意象的園林景觀與綠色生態環境。

《中園》綠色森林書法與河道書法園林設計方案屬性

《中園》既是壹個為大眾創造高品質的綠色生態環境與人文環境為目的，公共性質的開放性公園的觀念大地藝術作品的方案，同時她也可發展成為城市市政規劃和低容積的商業開發的模式。《中園》綠色森林書法與河道書法園林城池的整體結構：綠色森林書法與河道書法園林採用外圓內方的城池園林外柔內剛的整體結構——「外圓」呈現的外柔以和諧與平衡為主旨，是《中園》的外形；「內方」是以「書影湖」上的中心島的「陰園」「陽園」為中堅與本質，是《中園》的獨創觀念和形式之所在。「有水則活」，水又是「財」的象徵，《中園》地界的「外圓」與《中園》「書影島」的「內方」好比壹枚巨大無比的銅錢。中間高而四周低，取意於龜背之形來象徵延年益壽。內方是以建立在《中園》中心平坦山頂的陰園和圍繞其的陽園以及貫穿正東南西北《中園》大門的呈十字形的公園大道。「內方外圓」的城池園林最早出現在歷史名城商邱。商邱的歷史可上溯到萬年以上的叁皇中的「燧皇」鑽木取火的「華夏第壹火種」時期。從伍帝中的高陽帝和高辛帝到兩宋有夏相、商湯、微子、劉武和趙構等皇帝在商邱發跡建都。作為「江淮屏障，必爭之

river garden will not only produce an original creation within the context of the development of chinese landscape gardens but will simultaneously develop a rich spiritual culture and new artistic forms, contributing to contemporary art aesthetics and concepts of landscape design and green ecology.

ZHONG YUAN THE ESSENCE OF THE DESIGN OF GREEN FOREST CALLIGRAPHY AND RIVER CALLIGRAPHY GARDENS

zhong yuan is a grand creation bringing high-quality green ecology and a rich cultural environment into the realm of popular culture. the openness of zhong yuan also allows the concept of a grand piece of land art to enter the public arena. furthermore, zhong yuan may be used as a model for subsequent urban planning and low-density commercial urban development projects. the structure of green forest and river calligraphy garden city: the landscape design of these two cities employs an urban design layout of an inner square surrounded by an outer circle, which employs the values of inner flexibility and outer strength in one holistic composition. the "outer circle" presents an exterior feeling of flexibility, harmony and equilibrium, which gives zhong yuan its overall shape. the "inner square" lies in the "shu ying lake" in the center island of the "yin yuan" garden. the "yang yuan" garden acts as the strong, solid component, giving zhong yuan its inner essence. these are the original concepts and forms of zhong yuan. "where there is water, there is life"; and it is water that fills in the character 財 "cai" for "riches." the boundary of zhong yuan's "outer circle" for the outer boundary and the "inner square" of the central island reflects the incredible design of ancient chinese copper coins. in addition, the heightened center hill and the lower surrounding areas make zhong yuan take the form of a tortoise shell, an emblem traditionally used to express the promise of longevity. across this hill, there is a cross-shaped road and in the center of this flat plain built on the hilltop of zhong yuan, we are surrounded by "yang yuan" (the origin of yang). this cruciform avenue runs through the north, south, east and west gates of zhong yuan. this unique "inner square, outer circle" style of urban garden design appeared for the first time in the famous city of shangqiu. shangqiu's history dates back over 10000 years to "the first sparks of fire in ancient china," and the three

地」的要地，唐宋時代的商邱在天災人禍下，早已不復存在，而明正德年重建的商邱古城卻保存完好，商邱城垣外圓內方而酷似龜背。

《中園》構成的基本要素是中心高地的綠色河道書法的「陰園」，環繞高地的綠色森林書法的「陽園」，正東西南北朝向的肆個「功德碑廣場」大門，肆個連接「功德碑廣場」的「迴廊無限的如意」，以及將以上《中園》的基本要素連接起來的貫穿正東南西北的公園大道。她適合於各種各樣的高端的公共、商業、娛樂和民居的開發。

《中園》的園中園概念

位於《中園》心臟的是「書影湖」與「書影島」，而書影島的精神風采是島上的「陰園」與「陽園」。「書影湖」與「書影島」在《中園》裏的佈局位置、構成元素、形式語言以及實際功能等等使她成了《中園》裏的「園中之園」。曲徑通幽式的「藏境與藏景」是「園中園」的神韻所在。「藏境」是指物理現象：你來到壹處僻靜隱約的境地而身體力行其悠然自得；「藏景」是謂視覺的感受：通過視覺的快感達到心曠神怡的心理經驗。而《中園》的「園中園」的概念是複合層次的園中園。從隔湖觀望到行吟鄰水廊橋，從湖岸草地到森林書法，最後至天水交融而開闊壹片的「陰園」。篆書結體與當代設計結合的河道書法，奇跡般地營造出貳拾柒座篆書

emperors of "flinthuang" who used fire and gathered wood. from the five emperors of gao xindi, shangqiu's xia xiangdi, shang tang, guizi, liu wu, and zhao gou. during the tang and song dynasties, shangqiu was known as the "jiang huai river barrier," which has long ceased to exist because of a series of man-made and natural disasters. the ming dynasty, however, witnessed the rebuilding and preservation of the old town of shangqiu. the outer wall of shangqiu also resembled the shape of a turtle's back.

the basic elements of *zhong yuan*'s landscape are the green river calligraphy of the "yin yuan" and the green forest calligraphy of the "yang yuan" which surrounds the highlands and the directions of east, west, south and north. these cardinal directions are embodied in the four "virtuous monument square" gates and the "corridor of infinite fortune" which basically link up *zhong yuan* through the avenues which cross to the east, south, west and north of *zhong yuan*. *zhong yuan* is suitable for a variety of high-quality public uses, business and commerce activities, including the development of entertainment and residential areas.

ZHONG YUAN THE CONCEPT OF A GARDEN WITHIN A GARDEN

shu ying lake and the shu ying island lie at the heart of *zhong yuan*, while the exquisite and graceful demeanor spirit of "shu ying island" is expressed in the "yin yuan" and the "yang yuan." the arrangement, compositional elements, formal language and practical functions of "shu ying lake" and "shu ying island" in *zhong yuan*, together with these interior gardens, all help to make *zhong yuan* into a garden within a garden. the charm of *zhong yuan* lies in the winding style of its "hidden places and hidden views." the term "hidden scene" refers to a physical phenomenon, in which you come to a secluded and leisurely place; the term "hidden view" refers to a visual experience, in which one encounters a relaxed and happy experience. *zhong yuan* is a complex multi-level concept of a garden within a garden. the scenery of *zhong yuan* echoes from across the lake while one walks along the bridges surrounded by blue water, from the grasslands on the banks of the lake to the calligraphy in the forest and finally to the open "hidden garden" which blends

形態形成的島，而每壹個島的本身就是壹座獨立宅邸。如同「園中園」篆書結體與當代設計結合的河道書法的概念，「陰園」的篆書結體與當代設計結合的河道書法形成了「島中島」的意境。

我們傳統園林所講究的「園中園」與英倫營造的「迷宮」（maze）的共同之處在於從「引人入勝」到「別有洞天」。而她們的區別在於「漸入」詩意境界與「偶出」迷津。她們都以不同的方式給予人們壹種「安全」的滿足。漢與英又大相徑庭。或以「進」入靜謐之處和「出」陷阱險境。在我國古典園林中，「園中園」常見於皇家園林而少見於私家花園。北海裏的濠濮間和畫舫齋，圓明園的獅子林和別有洞天，上海的豫園和故宮的後花園等等都是「園中園」的經典。同時「園中園」所謂景物不藏則不深，不深則不奧，不奧則不幽的觀念體現了東方式的思維方式。遊人從大園信步到中園，在「園中園」歇腳觀望，大園成了遠景，《中園》則為鄰境。如此達到觀賞園林的小中見大，深厚多姿。

《中園》的「陰園」綠色河道書法由篆書體簡詞的「中國」、「園林」、「萬國」，「肆方」肆詞的詞的接構建構而成「陰園」的河道。以「中國」、「園林」、「萬國」、「肆方」肆詞連起來組合壹個東西南北朝向的「天河環」。「天河環」的中間開闊地呈壹個「亞」字形。「陰園」是整個《中園》的中心，她坐落在壹個平坦而對稱的山坡頂上。

water and sky. the river calligraphy's combination of the seal script and contemporary design miraculously produces twenty-seven islands formed of seal script. furthermore, every island itself is an independent house. like the concept of a garden within a garden, river calligraphy is a fusion of seal script and modern design, and the river calligraphy in "the hidden garden" "creates the concept of an island within an island."

the common ground between our classic "garden within a garden" and the british-style maze lies in the fact that they are enchanting with a unique style all of their own. but the difference between them lies in that the chinese garden "gradually travels" into the poetic realm, while the western garden "occasionally moves out" of the maze. these two garden styles satisfy the feeling of "safety" in different ways. the difference lies in the conceptualization of "entering into" a quiet place, vs. "leaving" a trap. the difference is that in our classic gardens, the "garden within a garden" style is mostly found in royal gardens and rarely in private ones. the haopu jian and the huafengzhai in the beihai, the shizilin and ledong in yuanmingyuan, yu garden in shanghai and the back garden in the forbidden city are all examples of the classic "garden within a garden" style. in terms of chinese traditional gardens, beihai's haopujian and huafang, are so-called "gardens within gardens," but the scenery is not hidden or deep; going from the big garden we can take a rest in the central garden, "the garden within the garden." in this way we can appreciate the bigger area from the smaller area and enjoy the large views of the garden, which are deep and colorful.

zhong yuan's green river calligraphy in "yin yuan" uses seal scripts of *jianci* to write the words "china" (middle kingdom), "garden," "all nations" (ten-thousand countries), and "four-directions ." these four phrases make up the rivers of yin yuan. "china," "garden," "all nations" and "four directions" also correspond to the east / west / south / north orientations and the composition of these words and become the rivers of "yang yuan." these words "china," "garden," "all nations," and "four directions," linked together form a "ring of celestial rivers" facing north, south, east, and west. "yin yuan" is at the center of *zhong yuan* , and the middle of the shape will resemble the chinese character for "asia" " 亞 ya ." the "yin yuan" garden lies at the

河道書法從形式意義上來看猶如壹枚巨大的中國陰刻印章（陰刻部分為河流），而從文理哲的陰陽伍行和母性繁殖來體現氣韻與衍生。將它構築在壹個開闊平坦的山坡頂部和《中園》的中心——體現「天河」的意念。由「中國」、「園林」、「萬國」、「肆方」肆個《簡詞典》的河道書法構成的「天河」陰園又是壹個大迷宮。將「天」與「迷」結合起來從而體現自然界的神秘主義。陰園的天河中總共有貳拾柒個以篆書結體形成的小島，在「書影島」中形成了「島中島」。而每壹個島的本身就是壹座獨立島宅。數字貳拾柒正好是叁的玖倍和玖的叁倍。準確地體現了我們文化經典周易所說的玖是最大的數字，而叁為萬物之源的理論。簡而言之，「陰園」象徵了天地萬物。為數貳拾柒個「島中島」島宅平屋頂可以成為綠色草坪，有壹個進口同時它也是出口，只有壹條路徑並以橋的方式連接這「島中島」島宅平屋頂草坪。她兼而有之興趣盎然的英式迷宮，與島的格局和益於身心的流水潺潺蒽郁欲滴。

《中園》的「陰園」島中島是名為「島宅叁玖貳拾柒」的貳拾柒個獨立島宅。「島宅叁玖貳拾柒」的名字來自於《周易》中玖是最大的數字，而叁為萬物之源。這貳拾柒座島宅是由篆書結體與當代設計結合的河道書法形成其造型結構的。她們在觀念上繫於古老的東方文明，在形態上原創新穎，在境界上形影入神。離奇般的玻璃幕牆與水光漣漪交相輝映。同時亦與「島宅叁玖貳拾柒」的平屋頂綠色草坪形成壹種當代人文與自然的超常對比。「島宅叁玖貳拾柒」的實際功能是可以變成壹種無限想像。

very heart of *zhong yuan*, and it is positioned symmetrically at the top of *zhong yuan's* central hill.

the formal meaning of the river calligraphy is derived from the great chinese "yin" (intaglio) seal — "the intaglio (carved out part of the seal) is like a river." *zhong yuan's* literary style is embodied in the philosophical concepts of yin and yang, the five elements and maternal reproduction." the garden will sit atop an open space on *zhong yuan's* central hillside, and embodies the idea of a "celestial river." four phrases of *jianci* —"china," "garden," "all nations" and "four-directions" — will come together through river calligraphy in the "celestial river" of yin yuan to create a grand maze. the components of "heaven" and the "maze" will combine to reflect the mysticism of the natural world. there are twenty-seven small islands in the celestial river. shu ying island is also an island within an island. as it happens, the number twenty-seven is the product of three multiplied by nine and nine multiplied by three. this numerology embodies the chinese classic *the book of changes*, which takes nine as its biggest number and three, in theory, as the source for all living things. to put it briefly, yin yuan symbolizes heaven and earth and all living things. the flat roofs on the twenty-seven islands which are covered by grass are also lawns. there is one entrance which is also the exit. there is only one road which links the flat-roofed houses, and the islands within islands are connected by bridges. it is a maze-like structure and the layout of the islands offers immense interest, in lush scenes and flowing water.

for zhong yuan's "island house three-nine-twenty-seven" on yingyuan: the name comes from the *book of changes* in which nine is the largest number and three is the source of all things. the island house is made of a combination of contemporary design, seal script and river calligraphy. all these components are conceptually tied to the ancient asian civilization. in terms of form, its origins are novel; it is a realm is figures and shadows and is deeply enthralling. a fantastical glass curtain wall echoes the water's ripples. at the same time, the flat-roofed green lawn of the "island house three-nine-twenty-seven" creates a detached contrast between contemporary humanistic culture and nature. our imagination is the limit for the possible functions of these homes.

《中園》的「陽園」綠色森林書法

陽園的綠色森林書法是《中園》的主題。陽園的綠色森林書法將環繞《中園》山坡頂上的陰園河道書法，在正東南西北朝向的山坡上構築而成。她是由常青樹森林形成的肆個氣勢磅礴的簡詞書法「春雨」「夏日」「秋雨」「冬雪」。陽園的綠色森林書法既是《中園》的觀念主題，又是《中園》的物質主體。

綠色森林書法可以根據其地理位置，氣候環境與當地樹木的人文性來選擇常青樹種。比如桂花樹、竹子均為江浙壹帶廣泛種植。在桂花開放季節，品聞桂花香甜，將桂花釀成自然食品香料，變成了壹種人文活動。有肆君子之壹稱號的翠竹向來是中國文人的喜好，她代表了人的情操和性格。《中園》的綠色森林書法園林如在江浙壹帶開發，《簡詞典》的綠色書法以桂花樹林種植構成，桂花深林種植成的巨型簡詞書法「春雨」、「夏日」、「秋雨」、「冬雪」在桂花季節將創造壹個如此奇特的現象：有「香雪海」素稱的桂花樹將會變成甜美可聞的書法「香雪海」奇觀，而人們將陶醉在「香雪海」的森林書法中！

《中園》的「書影湖」與「廊橋」

「有水則活」是中國風水哲學乃至園林精神的壹個核心。環繞《中園》的「陰園」與「陽園」，「書影湖」水將「陰園」與「陽園」變成了壹巨大的中心島。同時，形體方正的「書影湖」與《中園》的龜背圓形地勢的組合，實現了我們獨特的自然觀與人文觀：

ZHONG YUAN'S THE "YANG YUAN" OF GREEN FOREST CALLIGRAPHY IN ZHONG YUAN

the green forest calligraphy constitutes a central motif of *zhong yuan*. green calligraphy surrounds the river calligraphy on the hills of *zhong yuan*. it is comprised of four magnificent evergreen forest calligraphy characters on the north, south, east and west sides of the hill. the four characters are "spring wind," "summer sun," "autumn rain" and "winter snow." "yang yuan's" green forest calligraphy marks the main conceptual thrust behind *zhong yuan*, while also forming its chief material substance.

i have chosen the evergreen species for green forest calligraphy based on geographical location, the climate and the cultural aspects of the region. for example, bamboo and sweet-scented osmanthus trees are popular plants in jiangsu and zhejiang. when the sweet-scented osmanthus trees are in bloom, they smell sweet and fragrant and can be used as a natural food flavoring, as a kind of cultural activity. bamboo, one of the four gentlemen, is a favorite subject of the chinese literati; its refined beauty represents their feelings and the strength of human character. to create green forest calligraphy of *zhong yuan* in the provinces of jiangsu and zhejiang, sweet-scented osmanthus trees would be used to form the green forest *jiancidian* calligraphy. *jiancidian's* magnificent calligraphy would be planted into the shapes of the characters "spring wind," "summer sun," "autumn rain" and "winter snow." furthermore, the sweet-scented osmanthus is called "xiangxuehai" "sea of fragrant snow" which would become a sweet and fragrant calligraphic wonder. visitors will likely be intoxicated by this "xiangxuehai" calligraphic spectacle.

ZHONG YUAN'S "SHU YING LAKE," THE "COVERED BRIDGE"

the expression "where there is water, there is life" are some of the core ideas behind chinese "fengshui" philosophy and the spirit of chinese gardens. surrounded by the "shu ying lake," the yin yuan and yang yuan become a large central island. at the same time, the combination of the square lake and the oval terrain of

外圓內方。沿着正東南西北的公園大道，跨過「書影湖」水廊橋，「書影湖」的曲岸追隨着陽園的綠色森林書法而蜿蜒便展現出森林書法的風韻伴隨着書影湖水那森林書法的漣漪倒影，壹幅大自然恬然的詩情畫意。

《中園》的「功德碑大門」與「時代廣場」

正東西南北朝向的功德碑廣場大門是以中華民族伍仟年歷史上最具代表性的肆個朝代和政體所命名的：黃帝 —— 軒轅（炎黃子孫來自與炎帝與黃帝名字，軒轅代表了中華民族）、秦代 —— 皇帝（皇帝壹詞產生於秦始皇帝統壹中國之刻）、唐代 —— 貞觀（李世民貞觀年是唐代鼎盛時期）、中華 —— 共和（毛澤東建立的中華人民共和國），她們以正東南西北朝向，在公園東南西北邊界各自的中心為肆個園林大門。與傳統的宮殿園林不同，他們沒有傳統式的門樓。東西南北大門均為青石鋪地，佰米以上見方的大廣場形式如同肆塊巨大的石碑，地處《中園》的正東南西北邊界的中心。南門「軒轅」，東門「皇帝」，西門「貞觀」，北門「共和」以簡詞的詞體與書體各自鐫刻在東西南北大門的廣場青石地上，她們分別代表了伍仟年中國文明史上肆個最輝煌燦爛的歷史豐碑。

《中園》的公園大道與公園幽徑

貫穿《中園》的有兩種交通通道即公園大道與公園幽徑。連接高地中心的河道書法的「陰園」，高地山坡上的森林書法的陽園與正東南西北《中園》的肆大門的是公園大道。公園大道呈正東南西北的

zhong yuan presents our unique environmental and cultural values: round outside but square inside, (flexible on the outside but firm on the inside). when one walks along the main avenues in *zhong yuan* and crosses the "shu ying lake" through the "covered bridge," the banks and meandering river will showcase the charm of the green forest calligraphy as the "shu ying lake" ripples and sparkles creating a naturally poetic scene.

ZHONG YUAN'S "VIRTUE MONUMENT GATES" AND "TIME SQUARE"

the four entrances of "virtue monument gates" are named after the four most representative dynasties in the five-thousand-year history of china: yellow emperor: xuanyuan (both emperor yan and emperor yellow are ancestors of the huaxia people and represent the chinese people); qin dynasty: huang di (huang di refers to the emperor of china during the founding of the qin dynasty qin shihuang); tang dynasty: zhen guan (the era name of tai zong, li shimin; his reign was from 627 – 629, one of the most glorious periods of the tang dynasty); and zhonghua: gonghe (mao period, when mao founded the people's republic of china). the entrances are located at the north, south, east and west corners of *zhong yuan*'s boundaries and are different from those of the palace gardens. these entrances are paved with blue stones and the grand square covers more than 100 square meters and resembles huge stone steles. the characters on the four gates are as follows: the southern gate "xuan yuan," the eastern gate "huangdi," the western gate "zhen guan," and the northern gate "gonghe" — and they are all engraved in *jiancidian* calligraphy on the surface of the bluestone squares at the four entrances. these four characters represent the most brilliant historical monuments in the 5000 years of the history of civilization.

ZHONG YUAN'S AVENUES AND QUIET AND SECLUDED PATHWAYS

there are two kinds of routes in *zhong yuan* — avenues and pathways. linking up the river calligraphy on the center of the plateaus at "yin yuan," and the forest calligraphy on of hills of "yang yuan" there are four main avenues coming from the north, south, east, and west gates. the north, south, east and west

壹個巨大的十字形展開。另有壹圓形大道圍繞高
地中心的「陰園」河道書法，穿越陽園森林書法「春
雨」「夏日」「秋雨」「冬雪」肆詞，並與《中園》連
接東南西北大門的大道相連。除此之外，連接圓形
大道與陰園「天河」的和遍佈整個《中園》的是曲
徑通幽式不規則路徑。環繞《中園》中心陰園的圓
形大道，並連接從中心向東南西北大門的肆條大道
為嚴格對稱比例均等的圓形與十字形大道，他們與
貫穿整個《中園》的自由形態的小路徑形成了鮮明
的對照。

《中園》的「迴廊無限的如意」

銜接南門「軒轅」、東門「皇帝」、西門「貞觀」、北
門「共和」四個功德碑廣場大門和公園大道的是四
個東南西北的「迴廊無限的如意」。「迴廊無限的
如意」的長廊建築結構，是由中國傳統象徵「如意」
的圖形與西方象徵無限的圖形莫比烏斯帶「∞」結
合而成的。

《中園》自然觀與人文觀的總結，以綠色森林書法
為觀念主題與物質主體的《中園》將崇尚東方自然
觀的肆季與肆季物「春風」、「夏日」、「秋雨」、「冬
雪」，與崇尚人文歷史的河道書法的「中國」、「園
林」、「萬國」、「肆方」和廣場大門名字以中國肆
個歷史上輝煌的時代與人物來命名的「軒轅」、「皇
帝」、「貞觀」、「共和」的相互對比來達到自然觀與
人文觀的交相輝映。綠色森林書法與河道書法園
林是當代中華民族之林。

谷文達

2009 年初稿於中國上海，2010 年定稿於美國紐約

avenues unfold like a cross. while another avenue goes around
the river calligraphy of the "yin yuan" on the elevated land and
runs through the "yang yuan" forest calligraphy of ("spring
wind," "summer sun," "autumn rain" and "winter snow")
connecting with the north, south, east and west avenues. in
addition, there are multiple irregular pathways which link up
the circular avenues, "yin yuan" "celestial river," and the whole of
zhong yuan. the ring road and four avenues which extend from
the gates which are strictly symmetrical, cruciform and
proportional, bear a striking contrast to the whimsical footways
in the gardens.

ZHONG YUAN'S "CORRIDOR OF INFINITE FORTUNE"

street connects the southern gate "xuanyuan," the eastern gate
"huangdi," the western gate "zhenguan," and the northern gate
"gonghe," the "four virtuous monument" square gates to *zhong
yuan's* four avenues. it is called the "corridor of infinite fortune."
its architectural structure combines the shape of the chinese
scepter "ruyi" and contemporary graphics with the möbius strip
"∞," the western symbol of infinity.

zhong yuan is a summary of natural and cultural values: green
forest calligraphy is the chief concept and substance of *zhong
yuan*, with the four seasons: "spring wind," "summer sun,"
"autumn rain" and "winter snow." with respect for the
humanities and history, river calligraphy ("china," "garden," "all
nations," "four-sided") and the four entrances of virtue
monument square named after the four most glorious eras in the
five-thousand-year history of china ("xuanyuan," "huangdi,"
"zhenguan," and "gonghe"). the green forest calligraphy and
river calligraphy gardens offer a garden suited for the
contemporary chinese nation.

gu wenda

first draft, shanghai, china, 2009,
finalized in 2010 in new york, usa.

藝術的故事
年表、研討會、後記

A STORY OF ART:
CHRONOLOGY, SYMPOSIUM
AND POSTSCRIPT

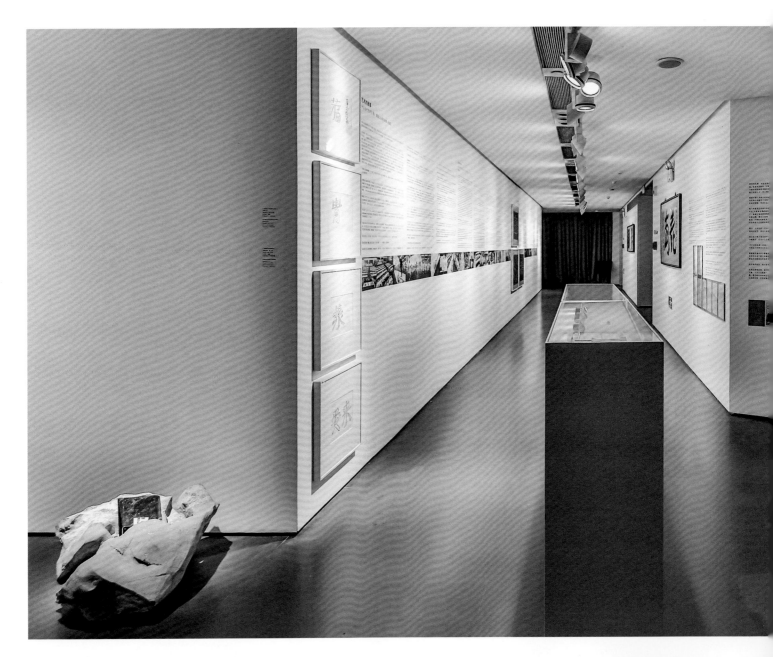

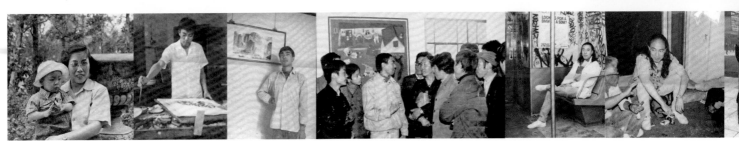

年表、研討會、後記（壹）：
年表

谷 文 達 年 表

1983 年，開始創作以偽字與錯字水墨畫系列《遺失的王朝》，開了當代水墨藝術的先河。

1980 年，開始創作以文人水墨書法與文革大字報標語結合的水墨畫系列，有代表作《口行為》。現在回顧，那是最早的政治波普概念主導的水墨藝術。至今流傳並膾炙人口的故事就在那年：當時陸儼少老師在他招生第貳屆山水畫研究生，口試的壹道題是：「你對谷文達如何看待？我只要壹個谷文達。他是壹匹野馬」。

1976 年，畢業於上海工藝美術學校。

1984 年 -1985 年，首創水墨行為藝術《遺失的王朝 —— 我批閱叁男叁女書寫的靜字》。同年開始創製水墨裝置藝術《遺失的王朝 —— 靜則生靈》與《遺失的王朝 —— 她們 × 他們》。水墨行為藝術與水墨裝置藝術，奠基並開創了當代書寫藝術進入中國繪畫史領域。

1979 年，考入浙江美術學院國畫系研究生班。

1981 年，畢業於浙江美術學院國畫系山水畫專業，獲文學碩士學位。

浙江美術學院國畫系研究生畢業創作展《李斯特鋼琴協奏曲》被院方規定，媒體不准報道。

1995 年，出生於上海，祖籍紹興上虞。

1976–1979 年，工作於上海木雕壹廠。

1955 1976 1979 1980 1981 1983 1984

gu wenda worked at the shanghai no.1 woodcarving factory from 1976 to 1979.

in 1981, gu wenda, graduated from the zhejiang academy of fine arts with a masters in landscape painting from the chinese painting department.

in 1981, the zhejiang academy of fine arts prohibited the media from reporting on his *lizt piano concerto* his graduation exhibition at the chinese painting department.

from 1984 to 1985, gu wenda became the first artist to make performance art with ink. his first work is titled *mythos of lost dynasties series-i evaluate characters written by six men and six women*.that year,gu wenda began to make ink art installation *mythos of lost dynasties series-wisdom comes from tranquility* and mythos of *lost dynasties series— them(female) x them(male)* , pioneering work created a new foundation for contemporary art to enter the realm of chinese painting.

gu wenda graduated from shanghai art and design academy in 1976.

gu wenda was admitted to zhejiang academy of fine arts as a master's student in the department of chinese painting.

in 1980, gu wenda began to compose an ink painting series that combined traditional literati-style calligraphy and the big-character posters that were popular during the cultural revolution. in retrospect, this is the earliest form of ink art which incorporated political pop as part of its core concept. that year, presented by the *mouth actions*. a popular story about gu wenda spread around the campus: when lu yanshao was recruiting students for his second landscape painting master's program, one of the questions he would ask prospective students was "what do you think of gu wenda? i only want one gu wenda. he is a wild horse."

in 1983, gu wenda began to create his ink painting series *mythos of lost dynasties* which involved the use of fake characters and false characters.

1985 年，《遺失的王朝 —— 靜觀的世界》水墨畫系列參加武漢全國國畫邀請展，給當時的國畫界與藝術界極大的影響，並被視為傳奇、當代水墨藝術的開端。

1986 年，由中國藝術研究院主辦的全國美術理論研討會在陝西楊陵舉行，特邀谷文達與會期間舉辦首次個人展覽。《遺失的王朝》水墨畫系列，水墨裝置與行為藝術參展。開展前壹刻開幕式被取消了，展覽關閉了。

人們紛紛要求重新開展，壹部分西安美院的學生要將谷文達的畫拿到大街去以示公示。職業藝術家持有陝西美協主席批條才可參觀……壹時在國畫界和當代藝術界風起雲涌，驚濤駭浪，「墨」雲壓城城欲摧之態……奠基中國當代水墨藝術與當代書寫藝術。

1987 年，移民紐約，獨立藝術家至今，生活和工作在紐約和上海兩地。

在多倫多約克大學美術館舉辦第壹個在西方的個人展覽，中國前衛藝術家在西方的首個個人展覽。

《遺失的王朝 —— 靜則生靈》水墨裝置藝術參加瑞士洛桑國際雙年展，成為雙年展上最受矚目的作品，也是中國當代藝術首次參加國際雙年展。

1981 年至 1987 年，任教於浙江美術學院國畫系。

1985 *1986* *1987*

gu wenda taught at the department of chinese painting at the zhejiang academy of fine arts from 1981 to 1987

in 1985, the ink painting series mythos of **lost dynasties-tranquility comes from meditation** was displayed in wuhan at a national invitational exhibition of chinese painting. this series had a great influence on chinese painting and art, and it was regarded as something of a legend in the art community. the movement of contemporary ink art was rising.

in 1986, the chinese national academy of arts hosted a national conference on art theory in yanglin, shannxi province. gu wenda was invited as a special guest to hold a solo exhibition during the conference. the ink painting series **mythos of lost dynasties,** ink art installation, and ink performance art were included in the exhibition. but the moment before the exhibition was supposed to open, the opening was canceled and the exhibition was closed.

members of the public made requests to reopen the exhibition and some of the students were even going to take gu wenda's paintings out into the street and show them to the public. in the end, only professional artists who had the permission of the director of shannxi artist's association were allowed in to see the exhibition. this controversial incident triggered great turmoil in within the fields of contemporary art and of chinese painting. "this tide of the ink" was on the verge of flooding into these two fields and these works played a valuable role in laying a foundation for contemporary chinese ink art and contemporary calligraphy art.

gu wenda moved to new york in 1987 and has been working an independent since that time. he now bases himself in both new york and shanghai.

in 1987, he held a solo exhibition in the art gallery of york university in toronto, which was his first solo exhibition in the west making gu wenda was the first chinese avant-garde artist to have a solo exhibition in the west.

in 1987, the ink art installation **mythos of lost dynasties series-wisdom comes from tranquility** was exhibited at the lausanne biennial in switzerland. the work attracted the most attention of any work in the biennial, and it marks the first time contemporary chinese art was shown in an international biennial.

1993 年，以人體胎盤材料創作《重新發現的俄狄浦斯 —— 生之謎》。

1993 年，開始以伍大洲不同族裔人髮基因創製《聯合國》。《聯合國 —— 波蘭紀念碑》是《聯合國》的第壹件大型 site-specific 在 lodz（羅茨）市歷史博物館的藝術裝置。

由於作品中大批波蘭人髮和 lodz 市有着猶太人最大的公墓，引發了對納粹時期屠殺猶太人的悲劇的回憶。在開幕式上，面對大片博物館大廳至樓道波蘭人髮，有觀眾泣不成聲，最後博物館決定在展開貳拾肆小時內將作品撤離博物館。

2019 年是《聯合國》的第貳拾陸年，世界伍佰多萬人髮基因凝聚在《聯合國》全球藝術項目裏，作為壹位中國藝術家，唯有其中《聯合國 —— 中國紀念碑》是藝術家本文化的，其他的均為她族裔她文化的，《聯合國》成為不折不扣的「全球人」。與今日的「世界的本地」的意識，《聯合國》在 1992 年伊始，已經非常明確與超前。

1988 年，開始以生命人體材料創作《重新發現的俄狄浦斯 —— 血之謎》。1990 年由加州大學柏克萊分校的著名美術史家彼得・塞爾茲策劃的以拾陸國陸拾婦女的經血為主題材料的《兩仟個自然的死亡》（原標題）的裝置藝術在舊金山壹藝術空間開幕。展覽引起了極大之爭議，因《洛杉磯時報》的參與，加州議員亦捲入其中。

在張頌仁策劃的中國當代藝術亞美洲巡迴展中，《重新發現的俄狄浦斯 —— 血之謎》再次成為爭議。因悉尼當代美術館的展出，企業暫停壹年對此美術館的讚助。在溫哥華美術館展中，觀眾更是分成兩派爭議不斷。

1990 年，開始創碑林系列。在法國南方塞尚故鄉創製首個碑林系列永久大地藝術《碑林壹系 —— 消逝的村落》。同年以客座教授執教明尼蘇達大學壹年，獲州長授予榮譽明尼蘇達人稱號。

1991 年，在日本福岡創製《碑林貳系 —— 消逝的 36 個黃金分割》。

1988

1990

1991

1993

in 1991, gu wenda made **forest of stone steles series 2-36 vanishing golden section pigments** in fukuoka, japan.

in 1993, gu wenda produced **oedipus refound-the enigma of birth** with human placenta.

in 1993, gu wenda started work on his **united nations** series, which incorporates the genes of people from five continents using collected human hair as a vehicle. **united nations-poland monument** is the first large-scale site-specific work in the **united nations** series. it was installed in the city of lodz history museum. since many polish people were involved, and lodz is also home to the largest jewish cementery in europe, this work reminded many viewers of the holocaust. at the opening, the lobby and the staircase, the installation of hair from the polish people, caused some visitors to burst into tears. in the end, the museum decided to remove the work only 24 hours after the opening.

in 1988, gu wenda started to use materials from the human body to make his series **oedipus refound-the enigma of blood.** in 1990, a famous art historian from the university of california berkeley curated the installation **2000 natural deaths** which employed period blood procured from 60 women from 16 countries which and opened at an art space in los angeles. this exhibition aroused enormous controversy, and due to the coverage by the los angeles times, people from the california state legislature got involved. when the exhibition **oedipus refound-the enigma of blood**, curated by johnson chang, toured in asia and america, it stirred up more controversy along the way. after its appearance at the museum of contemporary art australia in sydney, the museum's corporate sponsors decided to stop funding the museum for a year. when it was exhibited at the vancouver art gallery, it triggered relentless debate amongst the viewers who separated themselves into two camps.

in 1990, gu wenda began his forest of stone steles, completing **forest of stone steles series i-a vanishing village** which became the first work in this series. that same year, he taught at the university of minnesota as a visiting professor for a year and was awarded the title "honorary citizen of minnesota," by the state governor.

2019 marks the 26th anniversary of the launch of the **united nations** project. this global art project has incorporated the hair and genes of more than 5000000 people, uniting them in the **united nations** project. at the same time, as the project of a chinese artist, the **united nations-china monument** is also a strong articulation of gu wenda's native culture. other works within the series address other cultures,which make **united nations** a truly"global citizen."compared to our current ideas of "a globalized sense of the local,"the concept of **united nations**, which began in 1992, had a clear vision and was far ahead of its time.

1995 年，入選第肆拾陸屆威尼斯雙年展主題展，《聯合國 —— 在彼岸沉沒》由於項目艱深，並堅持作品從觀念到形式的完整性要求，最後沒有執行和實施項目。藝術家給自己提出高標準的要求，這是極為重要的課題。

1995 年，《聯合國 —— 以色列紀念碑》在以色列密茨比·拉芒沙漠實施計劃，以猶太人髮基因與叁拾塊耶路撒冷粉色巨石為材質之壹永久大地藝術，因猶太人髮引起貳次大戰猶太人的悲慘記憶，猶太人背井離鄉逃離納粹屠殺。《聯合國 —— 碑林叁系 —— 聖土》在特拉維夫市民中引起了爭議，在機場遭遇了小規模抗議示威。當地大報頭版頭條大篇幅採訪了以色列政治活動家，作家，藝術家和不同身份的人。

藝術計劃的爭議驚動了以色列國會。國會主席與策展人在國家最重要 army（軍事）電台實況直播討論谷文達的項目是否繼續落實。計劃得到以色列國會支持。短短柒天裏，以色列國家電視台貳叁台在每日 prime time（黃金時段）新聞裏實況追蹤報道。美麗之奇跡發生了，當谷文達離開特拉維夫機場之時，機場工作人員認出來，「如果你仍然需要猶太人髮，他們願意捐獻！」。從未感到如此藝術的力量。

1993 年至 2005 年，創製《碑林 —— 唐詩後著》。歷經拾貳年的製作，伍拾枚石碑文將最為流行的唐詩通過英語翻譯創製成伍拾首新詩《後唐詩》，全精工手製，難以複製是其中概念和訴求。

1995

gu wenda created ***forest of stone steles-post tang poetry*** between 1993 and 2005. the work was 12 years in the making, and includes 50 steles bearing texts which are based on the english translations of 50 of the most popular tang dynasty poems. these poems have been further transformed to create the work "retranslation & rewriting of tang poetry". all of the steles were finely carved by hand. this and their concept has produced an appealing artwork, which is difficult to replicate.

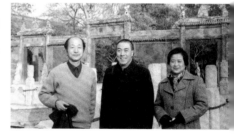

in 1995, gu wenda was selected to participate in the main themed exhibition of the 46th venice biennale. the project ***united nations-sink on the other shore*** was very profound and difficult to realize. gu wenda insisted that it be completed according to his strict specifications in terms of concept and form. in the end, the project could not be realized, yet, nonetheless, he believed that it was extremely important for artists to have high internal standards. this is very important to gu wenda.

in 1995, ***united nations-israel monument*** was realized in the negev desert near the town of mitzpe ramon. the piece consisted of a permanent piece of land art made from the hair and genes of 30 jewish individuals. the hair was then laid upon pink blocks of jerusalem limestone. the view of the hair of jewish people re-ignited the tragic memories of the second world war and the jewish flight from europe to escape massacre at the hands of the nazis. ***united nations-forest of steles iii-sacred land*** sparked off a heated controversy amongst the citizens of tel aviv, and the artist was met by a small-scale delegation of protesters at the airport. on the front-page headline of the newspaper was an article which featured interviews with israeli political activists, writers, artists, and people of various identities. the controversy surrounding the art project eventually reached the israeli parliament where the head of the parliament staged a debate with the curator over whether the project would be allowed to continue. the debate was broadcast live on the country's most important military television station and in the end, the project received the support of the israeli government. when gu wenda was about to leave at the tel aviv airport, he came upon a magical moment. while making his way through the airport, he was recognized by one of the staff who said, "if you still need hair from jewish people, they are willing to donate!" this was the first time where the artist felt the true power of art.

1996 年，《聯合國 —— 俄國瑞典紀念碑：國際刑警》大展由斯德哥爾摩與莫斯科著名策展人聯合策劃，瑞俄兩國前衛藝術家為主，谷文達作為國際藝術家參與。事件成為柏林牆倒後壹東西歐矛盾現象，在歐洲持續討論。

谷文達在 *flash art* 雜誌發文，題為《cultural war》。此事件正值美著名政治智囊亨廷頓（samuel p. huntington）發表著名的《文明的衝突》後不久，由於爭端在媒體連篇累牘持續壹年，知名度超越了當時瑞典流行歌星……瑞俄人髮通道中懸掛壹從瑞典皇家空軍借來地對空導彈。在開幕之際被俄國藝術家破壞，導致肆輛警車到現場控制事態，兩俄國藝術家被捕。第貳天，谷文達在現場舉辦瑞典國家新聞發佈會。

1996 年，在威尼斯，收集到了大批威尼斯陸軍營官兵 cruse cut 剪髮光頭的人髮，創製了《聯合國 —— 意大利紀念碑》。

1998 年，創製《聯合國 —— 中國紀念碑》。

1999 年，《聯合國 —— 中國紀念碑》，作為華人藝術家，首次登上《美國藝術》雜誌封面。

1999 年始，英美藝術史教科書開始編入谷文達條目。其中包括馬麗蓮・絲塔克斯達德的《藝術史》第 2 版至第 6 版（marilyn stokstad: "art history", harry n. abrams and prentice-hall, usa）。德博拉・迪威特，勞夫・拉爾曼與卡瑟琳・謝爾茨《藝術入門》（debra de witte, ralph larmann, kathryn shields: "gateways to art-understanding the visual arts", thames & hudson, london）。愛德華・史密斯《20 世紀視覺藝術史》（edward lucie-smith: "visual arts in twentieth century", harry n. abrams & prentice hall, new york）。

1996　　　　　　**1998**　　　　　　**1999**

in 1996, gu wenda gathered a large amount of hair from venetian army officials, the men were shaved completely bald and their hair became the material for the artwork **united nations-italy monument**.

in 1998, gu wenda created **united nations-china monument**.

the large-scale exhibition **united nations-russia and sweden monument: interpol** was jointly organized by two famous curators from stockholm and moscow, and consisted of mostly swedish and russian artists with gu wenda participating as one of the few international artists. at the exhibition, there arose a conflict between the eastern european and western european artists against the backdrop the continuing debate in europe surrounding the berlin wall. at the time, gu wenda published an article entitled "cultural war" in flash art. this happened shortly after the famous political scientist samuel huntington published his seminal work "the clash of civilizations." this incident spawned discussions in the media which lasted into the next year, and, eclipsed the swedish pop stars as the most hotly-debated topic of the day ... in this corridor, made of swedish and russian hair, hung an air to surface missile borrowed from the swedish royal air force. this missile was damaged by a russian artist at the opening, resulting in the arrival of four police cars, and a group of officers attempting to control the situation. two russian artists were eventually placed under arrest and the next day gu wenda gave a press conference at the exhibition.

in 1999, gu wenda appeared on the cover of the magazine *art in america* with his work **united nations-china monument**. he was the first chinese artist to appear on the journal's cover.

since 1999, gu wenda's work has been mentioned in *art history* textbooks in the united states and britain. these textbooks include marilyn stokstad's *art history* published by harry n. abrams and prentice-hall in the usa, debra de witte, ralph larmann, and kathryn shields' *gateways to art-understanding the visual arts* published by thames & hudson in london, and edward lucie-smith's *visual arts in the twentieth-century* published by harry h. abrams & prentice hall in new york.

2000 年，成為紐約庫伯聯誼大學客座教授。為美國緬因州立藝術學院榮譽博士候選人。

2000 年，紐約瑪麗蒙特曼哈頓大學（marymount manhattan college）新開設女性藝術家課程，《重新發現的俄狄浦斯 —— 血之謎》和《重新發現的俄狄浦斯 —— 生之謎》成為課程教材。

2000 年，創製《聯合國 —— 人間》全球壹佰捌拾捌面由各族裔的頭髮創製的國旗空間裝置，在薩奇美術館備受關注，叁個月展期僅過半已破壹佰幾拾萬觀眾人次紀錄。《聯合國 —— 人間》第壹站韓國光州雙年展，第貳站日本新瀉市立美術館，第叁站日本宇都宮美術館，第肆站中國首屆成都雙年展，第伍站新加坡國家劇院，第陸站新加坡亞洲文明博物館，第柒站日本東京奧迪中心，第捌站智利聖地亞哥當代藝術中心，第玖站費城 drexe（卓克索）大学，第拾站中國上海當代藝術博物館，第拾壹站中國香港巴塞爾，第拾貳站倫敦薩奇美術館。

2003 年，谷文達學術研討會在坎薩斯市的耐爾森美術館（nelson atkin museum of art）舉行。

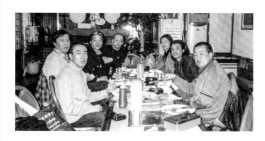

2001 年，《聯合國 —— 澳洲紀念碑》創製完成，並參加谷文達中年回顧展在堪培拉國家美術館與悉尼希爾曼畫廊聯合舉行。參加「再杜尚」展，第肆拾玖屆威尼斯雙年展。

in 2001, **united nations-australia monument** was completed, and it was shown in gu wenda's retrospective co-hosted by the national gallery of australia in canberra and sherman gallery. the work was also exhibited in the exhibition "re:duchamp" in the 49th venice biennale.

in 2000, gu wenda became a visiting professor at the cooper union and was selected a candidate for an honorary ph.d at the maine college of art.

in 2000, marymount manhattan college offered a new course on female artists and featured the works **oedipus refound-the enigma of birth** and **oedipus refound-the enigma of blood** in their syllabus.

in 2000, gu wenda created the installation**united nations-man and space**that involved 188 national flags made from the hair of different races and ethnicities. the project attracted an extraordinarily large amount of interest when it was exhibited at the saatchi gallery, receiving over one million visitors by the half-way point of its three-month exhibition period. however, the first stop of**united nations-man and space**was at the gwangju biennale. the second landing was at the nigata city art museum in japan; the third was at utsonomiya museum of art in japan; the fourth, the first chengdu biennale, the fifth the singapore national theatre, the sixth, the singapore museum of asian civilizations, the seventh, audi forum in tokyo; the eighth, the national center for contemporary art in santiago chile (centro nacional de arte contemporáneo cerrillos); the ninth drexel university in philadelphia; the 10th shanghai's power station of art, the 11th, art basel hong kong, china and the 12th was at london's saatchi gallery.

in 2003, a symposium on gu wenda's art was held in nelson atkins museum of art in kansas city.

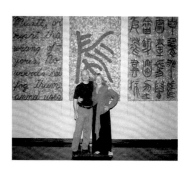

2005 年，谷文達的個人畫冊《從中原文化到生物時代》(gu wenda: art from middle kingdom to biological millennium)由麻省理工學院出版社 (the mit press)出版，畫冊獲全美博物館館協會獎，美國新英格蘭地區博物館協會的設計獎。谷文達學術研討會在深圳 ocat 當代藝術中心舉行。

2008 年，谷文達 30 年當代水墨藝術回顧展在深圳 ocat 當代藝術中心舉行。谷文達學術研討會在芝加哥大學北京中心舉行。

2011 年，谷歌藝術計劃，網上全球藝術博物館，《聯合國 —— 中國紀念碑》首先作為亞洲當代藝術入選。

2007 年，谷文達學術研討會在康乃爾大學 (cornell university) 舉行。

2010 年，大地藝術《天堂紅燈 —— 茶宮》布魯塞爾站，成為當時市中心的地標。

2005 **2007** **2008** **2010** **2011**

in 2007, a symposium on gu wenda's art was held at cornell university.

in 2010, gu's land art piece *heavenly lantern-tea palace* brussels station became a landmark in the center of the city.

in 2008, gu wenda's retrospective: *30 years of contemporary ink art* was held in ocat shenzhen contemporary art terminal. a symposium on gu wenda's art was held in the university of chicago center in beijing.

in 2005, the mit press published a book: *gu wenda: art from middle kingdom to biological millennium*, the catalog received an award from the american association of museums and a design award from the new england museum association. a symposium on gu wenda's art was held in ocat contemporary art terminal in shenzhen.

in 2011, *united nations-china monument* was the first contemporary asian art piece to be included in google art project (now google arts & culture), a project aiming to build a global art museum online.

2015 年，在新加坡獲英國保誠慧眼獎（predential）亞洲藝術家終身成就獎。

2019 年，為洛杉磯郡美術博物館定製《聯合國 —— 美國密碼》。

2019 年，在武漢合美術館舉辦回顧展。

2013 年，始創製《碑林陸系 —— 天象》。

2016 年，創製大地藝術《天堂紅燈 —— 西游記》上海站。

2016 年，在上海與深圳兩地策劃執導「第貳屆大眾當代藝術日」，壹仟伍佰學童在深圳行為藝術《青綠山水畫的故事》，伍仟學童在上海行為藝術《天堂紅燈上的簽語未來》。

2016 年，在上海民生現代美術館舉辦回顧展。

2014 年，在佛山建立首屆「大眾當代藝術日」，仟餘學童行為藝術《基因＆蛻變》

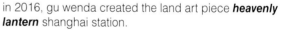

2013　　*2014*　　*2015*　　*2016*　　*2019*

in 2016, gu wenda created the land art piece **heavenly lantern** shanghai station.

in 2016, gu wenda planned and directed "the second public contemporary art day" in shanghai and shenzhen. 1500 primary school students participated in the performance art piece **a story of qing lv shan shui hua**, and 5000 primary school students participated in the performance art piece inscribing the future on heavenly lantern.

in 2016, gu's retrospective opened at the shanghai minsheng modern art museum.

in 2013, gu wenda began his **forest of stone steles 6-tian xiang**.

in 2014, gu wenda planned and organized the first "public contemporary art day", inviting more than 1000 students to participate in the performance art **genetics & metamorphosis**.

in 2019, the los angeles county museum of art commissioned the work **united nations-american code**.

in 2019, *art, a gu wenda's retrospective* opened at the united art museum in wuhan

in 2015, gu wenda received the prudential eye lifetime achievement award in singapore.

母親曹燕宇在 2009 年 86 歲高齡時為我寫了回憶錄《文達》

gu's mother cao yanyu at her age of 86, she wrote a special memoir on gu wenda in 2009

的传统绝技，所用的材料是玉，也是举世公认海洋的象征，是最尊贵、神奇的象征。贺拉斯岳在中译英，英译中的建筑与创作中创作出墨色、幽默的"讨论"，正如《马爹利非凡人物·2009》所说"学艺这一种构多元文化先锋艺术家"一文中讲述："原说一种新的文化如何被误解和在多种语境中成功诞生，同时也反映出我们在多元化社会中所面临的交流困境和误会。"这样的对答表达了我们正面的评说，也是对我们的大启发和触动。

(四) "百凤鸾啼，百地来福"

正是文达对上海世博主题"BETTER CITY, BETTER LIFE"的翻译的中文，既音译，又义译，就中字优美。鸾即鸾鸟，是中国的神鸟凤凰的神鸟中鸟，在翻译中还能捕到身上，它能入来把互雷往上来福，地是仿佛民。它的短话的本意是：百凤的贵人，在很高实际顶上神鸟在欢呼，更欢迎世界各地的少人来福福地，上海一定能办出成功、精彩、难忘的世博！

(五) 比利时"天堂红灯"展

2009年11月，文达的"天堂红灯一茶室"，在比利时的欧罗巴利亚/中国艺术节成功展出后，把中国传统工艺"红灯"……此转简的比利时王家大厦外墙，重到伸到里面整个大厅，简词"茶"镶嵌在红墙上辉煌。壮观，起来来两个移的字墙

紧紧地，就功比与广大群众结合在一起，一庆红灯浮飘抬着广大观众的欢乐艺术意识的欢乐，成功引我部光学写了一段连韵诗恭喜祝贺：

　　天堂红灯照欧洲，欧洲文化传全球；
　　全球马利达文果，果好汁都润春就；
　　春秋耕耘此食为天，为天出平济饥英；
　　饥英新明译的茂，鲜救生产乐长久。

在这里我带说一件事，我设计用中国红灯包着荷兰的大教堂，后来同多种国来与中国县这会同期进到。我认为，隆重一种件好事"包裹大教堂"未免有点霸气，有些干涉到国人的宗教信仰，建议今后设计时尽量避免。

第三部分

参观2009马爹利非凡艺术大奖获奖作品展后的思索

2009年夏天，应邀参观2009年度马爹利非凡艺术大奖获奖作品展。至进入上海圆明镜大厅展区看总制作的客厅顶的特大作品——谷文达的《联合国人之墓 十二生肖甲简词大辞乾》，恩址词短演身友《速宇宙的感奇》，是幻？是像？参观者现场会的项目主任周小姐，她说"够气魄吧，还能我怪出这样大气派的别的作品吗？"我说：哦，地"是是"，气信独身左右对墙上的"谷文达一种构多文化的先锋观会艺术家"的文字介绍，想把要点记住，2位人员小早说"不用记，以后会出书的"。我把就带引了。眼见的遗留，触发了我的灵感，我仿手我找到了古人座抓宇宙结构的"罗盘"。古人认为宇宙万物是一个混里在不变永远过的"流程这"样，所有的时人节奏发谈终，才有万物生长，才有动物和人类，我不由自地照约看着传译《经》中佛说"常乐住住住，世间相续往的教谕无论如何说清楚。尽管的"罗盘"日复重尾着亲的，都引发了人世间的无限思考和创造智慧。借的方

十卷甲轮流递说即十二生肖（按此意）冠以干，次摩甲乙、丙丁戊己庚辛壬癸（称天干），女十数随再从子甲开始，如今年度寅年明年辛卯年……癸亥年结果，再从甲子开始，周而复始，流转无往。这些轮转的纪录友《万年历本》都可找得到。又比"五行阴阳说"即天干中：

　　甲乙丙丁戊己庚辛壬癸
　　阳阴阳阴阳阴阳阴阳阴
　　　木　　火　　土　　金　　水

地支中子丑寅卯……也都隐含着金、木、水、火、土等等而也及它的不相可同（地相关键具得全新东）也在什么等方素中找得到。这样，构成阴阳上下左右和合多象，相互构起，形成多重复杂情感。就有"龙的传说"，更是费解，十二生肖中有十一种是人们熟悉喜爱的动物，唯独"龙"只能在博物馆中看到的化石"恐龙"骨化石。古人为什么不选宇宙间千万种动物填世去，偏要一道"龙"的迷信给后人去思索？？我想，龙的形象涉及到方方面面，代表国发形象，民族尊严……以及多少学科领域，连气象学中也有中"龙卷风"。

总之，无论是"六十卷甲轮流递说"、"五行阴阳说"、"龙的传说"等，那德是与这石家道不明白人间故可一样五的传统习习的"玄学的深渊里去。

马爹利非凡艺术大奖获奖作品展搭了平台，给了我们多观念释放观赏的机会，衷心感谢。

　　　　　　　　　　　　　　紫道宁于2010.大.19.

我 和 我 的 家 庭

谷文達

MY FAMILY AND ME

gu wenda

出生

這當兒母親曹燕宇身有孕，爺爺谷劍塵最終進了
上海提籃橋監獄。俗話說，禍不單行，外公也在同
年去世了。除了爺爺入獄對母親精神上的刺激，
還承受了失去生父的折磨。對於壹位有孕的女人，
影響幾乎難以想像。母親害怕肚裏的胎兒受影響，
便沒去向生父辭別。母親懷着的孩子就是谷文達。
母親在南京西路（近黃陂北路口）的壹條弄堂裏的
財經醫院生下了我。當我呱呱落地之刻，我的基因
記憶裏已儲存下了母親經歷……

太爺爺與太外公（紹興話稱呼祖壹輩）自然我無從
見到，久而久之，只能從母親和長輩處日積月累，
眾說紛紜，也頗有偏差之嫌疑。簡而言之，谷家係
從河南遷徙到江浙。父母出生於紹興上虞……最
後落戶申城。家中唯獨我出生在共和國的上海。

母親常向我提及她的祖父，也就是我的太外公曹
銘，由清皇帝派遣去西藏，並統領管轄西藏。據說

BIRTH

at the time when she was pregnant, my mother soon found out that her father in law, gu jianchen was to be sent to tilanqiao prison. as they say, "when it rains it pours"-as her own father had passed away the same year. my mother was highly distraught by my grandfather being sent to prison — a pain which was compounded by the torment due to the loss of her father. for a pregnant woman, this had an unimaginable impact. my mother feared that the fetus inside her would be affected by this suffering and therefore she decided not to bid farewell to her dying father. this child she was carrying was named gu wenda. my mother gave birth to me at the caijing hospital, which was in a lane off of west nanjing road near north huangpi road in shanghai. as I entered the world, making my first cries, my genes were already carrying the weight of my mother's experience.

naturally i have never met my great grandfathers, (in shaoxing dialect we called this senior generation *taigwaigong* and *taiyeye*). over time, i was only able to garner something from my mother about that accumulated history of that generation, opinions seemed to vary widely and there were lots of variations on stories and suspicions as to the facts. in short, the gu family moved from henan to zhejiang. my father was born in shangyu, near shaoxing and later settled in shanghai. i was the only one in my family to be born at the end of the republican era in shanghai.

my mother often spoke of her father, my maternal grandfather cao ming, who was dispatched by the qing emperor to go to

曹銘業績非凡，官封叁品。藏族部落首領，曾獻壹
藏女增曹銘為妾……而我將信將疑。朋友微信了
我《清史稿》有關我的太外公之記述……

故有壹次母親對我說來，「你身上可能有點兒藏人
血統……」

缺陷

壹歲的我，對母親的奶過敏，渾身泛起粉色奶癬。
大人告訴我，時常癢到難以忍受，便到處抓癢；我
的雙手常被套上襪子，以防抓破皮膚。家人看不下
去了，便帶著嬰孩谷文達求醫。醫生瞧着我，對著
母親說道，奶癬治癒，會引發哮喘病。能治癒渾身
上下難忍的奶癬過敏，顧不上引發哮喘了，這是父
母的決定。果然在幸福的兒童時代，我便患上了
asthma（哮喘）。

tibet, as the commander of the armed forces which controlled
the region. it was said that he had a record of outstanding
achievements, and was an important general of the third rank.
another story had it that a tibetan leader once offered him a
tibetan woman as a concubine . . . a detail which maybe seems
somewhat unbelievable. once a friend messaged me to say that
in the book *qingshigao, a draft history of the qing dynasty* there
are accounts of my great maternal grandfather

once my mother told me, "you may even have a little tibetan
blood in your veins."

DEFECT

at the age of one, my parents discovered that i was allergic to my
mother's milk and pink blotches of eczema emerged all over my
body. my parents told me that the itching was often unbearable,
and i would scratch myself all over. they eventually put a pair of
socks on my hands to prevent me from damaging my skin.
finally, my family couldn't stand it and brought gu wenda (the
infant) to the hospital to seek medical advice. while looking at
me, the doctor told my mother that the curing of the infantile
eczema would lead to asthma. even if we cured this intolerable
head-to-toe eczema allergy, we could not be able to prevent the
development of asthma. this was my parent's decision. but sure
enough, in this otherwise happy childhood, i nonetheless
suffered from asthma.

現在想來，那還是蠻有樂觀幼童的 optimism（樂觀主義）。後來有人告訴我，有過哮喘病之過敏史，可能免疫癌症，我就把她看作是過敏與免疫的陰陽平衡了。過敏之 dna 會放大感覺系統，我的 over reaction（反應過度）之心理生態是物質物理的過敏基因之現象。有朋友半揶揄地說：「過敏因放大感覺系統，或許益於藝術靈性，你不瞧瞧鮑伊斯，羅曼羅蘭，普魯斯特……哇塞！」

看着我幼小童年 suffering（飽受折磨）哮喘病發作的痛苦，中西醫和土秘方，肆方問津，卻無助改變免疫缺陷，哮喘似乎是伴隨終生之疾病。曾經是上海工藝美校乒乓球隊長的我，運動前常需用腎上腺素霧劑解痙。陸壹兒童節對於我，更是不愉快之記憶：迫於每次公園遊玩帶來花粉誘發的過敏，我便只能在家做起好學生做好功課。春秋氣候變遷，哮喘必發；而發作時辰，打坐牀上白夜，無眠睡眼裏的繁星，至今記憶猶新……

遷徙

1987 那年，我移居美利堅，最後落戶帝都紐約的壹年裏，哮喘症症狀減弱。那時我並無意識到地理與 environment（環境）之遷移，或許過敏原會隨之變化。時執教明尼蘇達大學，也應邀在美大學巡迴演講我的藝術。有那麼幾次，覺得從來沒有過的輕鬆爽快，精力旺盛；我佰思不得其解，忽然頓悟，氣喘不再伴隨我，驚訝了！要知世間過敏原逾成佰上仟，過敏體質其過敏原大致無從驗證，如何知曉某地不再有過敏原？真是仟載難逢的異想天開。匪夷之際，釀成終身驚喜！我壹信仰物質決定

thinking about it now, i marvel at my own of childish optimism. if someone told me today, that i would have to endure a life of asthma and allergies, and might be immune to cancer, i would just see it as an issue of the balancing of the yin and yang, of allergies and the immune system. the tendency towards allergies encoded in the dna amplifies the body's sensory system. the "over-reaction" of the psychological systems, is a phenomena created by the physiological genetic tendencies towards allergies. one of my friends once said half-jokingly: "allergies magnify the sensory system, which perhaps benefits your artistic sensibility, just look at beuys, romain roland, proust ... pretty amazing.

looking back, on that time, i endured a lot of suffering and pain because of asthma. i used western medicine and folk remedies and sought advice everywhere, but none of this could cure the defects of my immune system-sadly asthma is a disease which accompanies us throughout our whole lives. as the captain of the pingpong team at the shanghai school of arts and crafts, I often needed to take adrenaline in an inhaler to prevent an asthma attack. i remember, june 1st, known as children's day, was marked by a particularly unpleasant memory; while other children were frolicking in the park, the pollen in the air would bring out my allergies, so that i was forced to stay at home, to be a good student and do my homework. the climatic changes in the spring and fall would precipitate asthma attacks, and when they would happen, i would lie awake all night, unable to sleep staring up at a sky full of stars. even now i can remember it as if it were yesterday.

MIGRATION

in 1987, the year i moved to america, eventually to settle in the imperial capital of new york, the symptoms of the asthma seemed to subside. at that time, i didn't realize that migrating to a different geographical location and living in a new environment, would affect the kinds of allergens i would encounter. when i was teaching at the university of minnesota, i was invited to give a lecture tour about my art, visiting several universities in america. there are only a few times in my life which i have felt so relaxed, rejuvenated and vigorous, but i failed to understand the reason. all of a sudden it hit me; the asthma was no longer following me. was so surprised! the number of allergens found in the world can range from hundreds to thousands and for those with allergic sensitivities, there is not really a good way to test for these allergens, so how

consciousness（意識）、move & action（移動與行動）
的人，不用大夫，便猜測到紐約 lifted（解除了）我
的過敏原！

基因修復，緣起基因缺陷；基因修復便是其蛻變過
程，自然 & artificial（人工）are all countable（皆有
其價值）。

母親的禮物

母親是紹興人家，在著名的春暉中學就讀，聆聽過
弘壹法師的課程。她祖父曾受清政府委派統轄西
藏，官至叄品。母親英語流利，寫壹手出眾的好
字，玖拾歲餘仍天天堅持毛筆蠅頭小楷金剛經。
她是中國銀行第壹代國外部信貸科專員，為新中
國國際信貸服務壹輩子。最可貴的是她立下遺囑
去世後遺體捐贈，為科技也為他人。曹燕宇培養
出了我國銀行界無數銀行經理人才。外公曹仁麟，
著有《星度指南》和《壬學述古》，仍為香港書網評
級伍星。

would one know if there are high levels of allergens in a specific place? it was truly a fantastic and rare revelation-the surprise of a lifetime. i am a person who believes in the material consciousness, who believes in movement and action. i didn't need a doctor; simply the act of moving to new york transported me away from the source of my allergies.

my genes have recovered, the origins of my genetic defects and the repair of my genes is part of the process of mutation and involves both natural and artificial processes.

A MOTHER'S GIFT

my mother is from shaoxing, and studied at the famous chun hui high school, with master hong yi (a chinese buddhist monk, artist, and teacher). her paternal grandfather was once dispatched to tibet to take command of the area for the qing empire, an important general of the third rank. my mother spoke fluent english and was an outstanding calligrapher. at the age of 90 she would still write out the text of the diamond sutra in very small and precise characters with an ink brush. she was part of the first generation of credit specialists in the overseas department of the bank of china and worked her whole life in international credit in the service of new china (china post-1949). what is perhaps most commendable is that in her last words, when she passed away, she expressed the wish that her body be donated to science, to help others. cao yanyu nurtured a generation of talented managers at the bank of china. my

我離開浙江美院後的第貳年，美院通知我家人要歸還那時清貧的寒舍。身在紐約的我回不了杭州，母親廢寢忘食，以巨大的母愛清點和儲存了參拾年前我所有的物件：從上仟本書籍到幾箱讀書卡片，從紅領巾到學生證，這些已經成為美術館的極其珍貴的獵物。母親永遠是這樣的，沒有任何壹種感情比得上母愛！我母親儲存了壹個藝術家的故事。

我入學浙美山水畫專業研究生。而文革後的首屆，體制與條件都毫無頭緒的。學校方說了，我們這屆研究生畢業，無碩士文憑可言，大家沒有第貳語言能力。時隔壹年，我在美國大學集中研習英語整年，並為訪問學者在美歐巡迴以英語演講。母親知道了，她便計劃去浙美爭取我的學位。如同壹競選議員去遊說當時拾壹位學術委員，其中包括院長肖峰，副院長宋忠元和國畫系主任潘公凱，最後以柒票對肆票通過！這壹結果非常艱巨的：壹個在當時極為保守的教育體制裏的前衛「教授」，幾乎在計劃我離校，並調低到師範系去。壹為校方規定畢業創作不可出版，與學生生活學習一起，深受學生愛戴，成了「誤導」學生等等。母親的奮鬥讓我感動和驚訝！

maternal grandfather cao renlin was the author of *a guide to the movements of the celestial bodies* and *ren xue shu gu* a book about chinese divination and ancient calendars, books which today receive five-star ratings on the websites of hong kong bookstores.

the second year after i left the zhejiang academy of fine arts, i was contacted by the school which told me i needed to move my things out of the humble dwelling where i lived during those hardscrabble days as an artist and teacher. i was in new york and couldn't return to hangzhou so my mother, powered by an enormous amount of motherly love, took inventory of all of my things and found storage for all the cumulative belongings of the thirty years of my life. from thousands of books, to primary school notebooks, from our school-issued red scarves, to our student cards, these are just some of the exceedingly-precious items found at this museum. my mother was always this way — there was no emotion stronger than her motherly love and it was my mother who helped preserve this story of an artist.

i enrolled in the chinese painting department of the zhejiang academy of fine arts to do a master's in chinese landscape painting; ours was the first class to enroll after the cultural revolution ended. the system, with all of its prerequisite qualifications for enrollment, was a complicated affair. the school said that, for this particular graduating class, there would be no master's degree awarded, because none of us had second language speaking abilities. a year later, after studying english in a condensed year-long course at an american university, and after having given lectures in english as a visiting scholar in both america and europe, my mother had an idea. she planned to go to the zhejiang academy of fine arts to collect my degree. like a campaigning politician, she went around trying to convince the members of the academic committee, such as the dean xiao feng, the vice-dean song zhongyuan and the head of the chinese painting department, pan gongkai. in the end she won; the committee decided to grant my degree by a vote of seven to four! this was quite a remarkable achievement, to obtain a degree for an avant-garde "instructor" working within an extremely conservative education system. the school was planning to kick me out, but had instead demoted me to working in the "teacher-training" department of the school. on one hand, the school had issued an edict that nothing could be published about the works from my graduating show, on the other i was living and studying together with the students,

祖父

谷劍塵的《花國大總統》（1927）與姜文《壹步之遙》
（2014），故事原型是民國奇案之壹的閻瑞生案。
舒淇所飾演的完顏英的原型，便是紅極壹時的「花
國總統」王蓮英。而姜文所飾演的馬走日的原型，
也正是閻瑞生。

姜文說了影片雖受案件啟發，也僅借用《花國大總
統》的一些元素，而劇情不盡相同。那麼問題就來
了。「閻瑞生案到底是個啥案子，它為甚麼會被稱
為民國奇案？在姜文之外，這案子還被誰改編過？

1927 年的電影《花國大總統》被拍成默片，由傳奇
豔星楊耐梅出演，在當時紅極壹時。而擔任編劇
的，正是我的爺爺谷劍塵。可惜此片的拷貝已早已
失傳。

賈樟柯在壹採訪中曾提到：「谷劍塵是貳叄拾年代
的導演，拍過壹部片叫《花國大總統》，花國就是
妓院，谷文達曾經想拿他爺爺當年這個默片來做壹
個東西，但因為沒找到他爺爺那部片子，最後他沒
做出來，這作品叫《妓女超級市場》，可能也想闡
發歷史跟現在的某種關聯。」

雖耳鳴聲轟然，剛才咸亨酒店的熙熙攘攘，心緒仍
然縈繞在紹興上墳時的靜謐。憶及的爺爺兩叄事
情便又跳出來了⋯⋯

adored by them and was held in great esteem. of course, in their eyes, i was "leading the students astray." i was really surprised by the lengths my mother went to win this war.

GRANDFATHER

gu jianchen's screenplays *a flower of passion* (1927) and also jiang wen's *gone with the bullets*, both share the same inspiration: a strange tale of republican era china, the quirky case of yan ruisheng. actress shu qi plays the role of the original wan yanying, just like actress wang lianying who enjoyed brief popularity with the earlier film *a flower of passion.* jiang wen correspondingly plays the role of ma zouri, which is of course based on yan ruisheng himself.

jiang wen said that this case was only one element of several which inspired the making of the film and that the plot is not completely similar, and that is precisely where the problem arises: what was the actual story behind the real-life case of yan ruishen? and why is it referred to as a "strange case" of the republican era? and finally, besides jiang wen who else has made adaptations based on this case?

the 1927 film *a flower of passion.* was made into a silent film, with the legendary and gorgeous, yang naimei, during the height of her popularity and of course the writer of the screenplay was the gu jiancheng, the paternal grandfather of the famous contemporary artist gu wenda. unfortunately, no copies of the film remain.

once in an interview, jia zhangke said: "gu jiancheng, a director in the 20s and 30s shot a film called *a flower of passion.* in the film there is a brothel called flower kingdom. gu wenda once wanted to use his grandfather's silent film to make something, but because he couldn't find a copy of it, in the end, he was not able to make it. this work would have been called *prostitute supermarket*, maybe he wanted to elucidate the relationship between the past a certain kind of situation today.

ears ringing with the cacophony of the bustling and chaotic xianheng restaurant, i nonetheless possess a certain aura of quiet tranquility. the atmosphere of visiting the grave in shaoxing still lingers over me, and this calls to mind two or three things about my grandfather...

谷劍塵深度近視，讀書時鼻子幾乎貼到書本紙頁，這是我兒時對爺爺最深的印象。他彷彿每天在孜孜不倦地閱讀毛主席的老伍篇：《為人民服務》《紀念白求恩》《愚公移山》《反對自由主義》和《糾正黨內的錯誤思想》等，並常常寫著學習心得。我兒時對爺爺的記憶非常少，也就那麼壹貳，除此之外，幾乎壹無所知。止於沒有一起的經驗，其中隔閡現在想來，是父母的安排，無非求取家庭的安然無恙。人性從來就不是完美的，社會更是如此。不久文革伊始，那時我就讀小學叄年級，卻經過了成人均不可經過的旅程，滬上又成了革命的發源地。從建黨到壹月風暴都在魔都誕生。對於我臨陣體驗，因為幼小，我就讀的和田路小學便「停課鬧革命」。我依稀恍惚中還記得語文課最後壹篇：「滴答滴答下雨啦，小苗兒說，下吧下吧，我要長大……」然後就再也沒有課本了，取而代之的是每天早晨去觀看和監督老師們：他們面壁學校的外牆，紋絲不動地排排站著，口中唸唸有詞……那時的我實在太幼小，並不知道發生了甚麼事，只覺得很開心，可以不要上學了。

文革的經歷，對當事人或對聽故事的人來講，是直感、情緒的或悲或鬧的喜怒哀樂；時過境遷，從人類文明去讀它，你讀懂了，那是歷史所然。個人的遭遇只是滄海壹粟。就像卓別林的齒輪和螺絲釘《摩登時代》（1936），功能主義的實用價值，每壹個人不足為道。和田路小學停課鬧革命了。這讓我接觸到爺爺，也是唯壹與爺爺經歷過的記憶。那時不上課了，爺爺在家裏教我語文，還把鄰居的同學叫來一起學。記得學習班的語文常常是閱讀

when i was a child, i had a very strong memory of my grandfather, gu jianchen a someone who was severely nearsighted. he was so nearsighted that when he would read books, his nose would practically skim the page. it seemed like every day he would diligently read and make study notes on mao zedong's five key articles: *serve the people, in memory of norman bethune, yu gong who removed the mountains, combat liberalism,* and *on correcting mistaken ideas in the party.* i didn't have too many memories of my grandfather at that time, just only those two. apart from this, i was practically ignorant about anything else in his life, because we didn't experience much time together. thinking of this estrangement, i realize that it was orchestrated by my parents, but in fact, it was really no more than an attempt by them to keep our family safe and sound. people are never perfect and society even less so. it was not long after the beginning of the revolution and i was in grade three. though young i had already been through the kinds of journeys that would seem unimaginable even to an adult. shanghai was one of the birthplaces of revolutionary activity and was born from the founding of the party marked by the january revolution. i personally experienced the moment of this critical juncture at school. because i was young, i remember when the hetian road primary school was closed "to engage in revolution." i have faint memories of being in a trance reading a textbook for the last time in my chinese class, "pitter, patter, pitter patter, it's raining. the little seedling says: 'let it rain. let it rain. i want to grow up'..." and then all of a sudden, there were no text books. learning was replaced by the observation and supervision of the teachers, their faces turned against the outer wall of the school, standing absolutely still in rows, mumbling to themselves. at that time, i was really too young and immature. i had no idea what happened. i just felt really happy, that i no longer needed to go to school anymore.

the cultural revolution, to hear the people who experienced it or to hear the stories about it was characterized by very direct feelings. the mood, whether it was boisterous or melancholy, whether it was a situation of happiness, anger, grief or joy — the whole gamut of human emotion-things always changed as time passed. if you read it from the point of view of human civilization, if you read it and understand it, you will understand that this is merely human history. the bitter experiences that i encountered are merely a drop in the ocean. even those not directly involved were involved as we were like the cogs in the machine, like in charlie chaplin's *modern times* (1936). our

唐詩。爺爺操着壹口很標準的普通話，糾正我的口齒發音，比劃給我的是老式的發音方式，不是英語拼音。我不理解的是在滬上，幾乎找不出能說標準國話的人。直到在紐約的生活裏才知曉，爺爺在舊上海卓越的戲劇和電影的壹生。

後來紅衛兵來抄家，壹時雞飛狗跳，連花盆都沒有放過折騰，砸爛後查看究竟有否隱藏的反革命的金銀財寶。他們規定家中成員要寫批評爺爺的文章，並貼在家裏牆上特設的大批判專欄裏。文園黑白水彩畫的毛主席像，我做的共和國國旗卻引來了不快。紅衛兵說了國旗的比例不準，毛主席像不是彩色的是別有用心。父親帶知青遠去黑龍江勞動改造。就連 50 年代外公過世後，母親將遺產主動捐贈給國家，也引來了麻煩……太多了也記不得了，爺爺不久便獨自壹人去了老家紹興。我哥哥結婚時，他回來上海家裏參加婚禮。之後他馬上回了紹興。後來知道，他生活在老家的壹灶頭間，不久他便腦溢血，過世卻沒親人陪伴。

我知道谷劍塵是我的爺爺（紹興人稱祖父的習慣）之外，我並不知道他是誰。沒人提及，家裏人更是

functionality, our use-value, our individual value was so infinitesimally small that it's hardly worth mentioning. finally, the hetian lu primary school closed to allow the students to engage in full-time revolution. this allowed me to spend time with my paternal grandfather, which was pretty much my only memory of him. at that time when the school was closed, my grandfather was at home teaching me chinese. he even gathered some of the other neighborhood students and taught everyone together. i remember in our class we often read tang poetry. my father would speak in a very standard mandarin, and would correct my pronunciation. we learned the old-style of pronunciation or articulation, not the romanization system of pinyin. what i didn't realize at the time, was that in shanghai it was almost impossible to find people speaking standard chinese. it was only when i was living in new york, that it dawned on me that my paternal grandfather had a brilliant career in theatre and film in shanghai.

later on, the red guards came to raid our home, turning the house completely upside down. not even the flowers were safe, the pots getting tossed helter-skelter. the general goal of these search and destroy missions was to find out if families were hiding counter-revolutionary treasures in their homes. they also forced our family members to write criticisms of my paternal grandfather, which were then placed in a grand column of criticism on the inside wall of our home. the red guards were displeased by the black and white painting of chairman mao because of the incorrect ratio of the flag of the people's republic of china. they also criticized the fact that mao's portrait was not painted in color. of course, they had ulterior motives. my father brought the educated youth (*zhiqing*) to heilongjiang province as part of the thought reform through labor movement. even after the death of my paternal grandfather in 1950, and my mother's voluntary donation of her inheritance to the nation, she was still hounded by troubles ... there are so many of them i can't remember. my paternal grandfather went to live in shaoxing alone. when my brother got married, my grandfather came back to shanghai for the wedding, but he went directly back to shaoxing afterward. later on, we found out that he was living in the kitchen of our old house. not long after, we found that he had died of a cerebral hemorrhage. there were no family members by his side at the time of his passing.

besides knowing that gu jiancheng was my paternal grandfather (the shaoxingnese call them *zufu*), i really had no idea who he

對此沉默。1973 那年我走出烽火中學，也是上海工藝美術學校開始招生，可招生區沒包括閘北，有幸的是非招生區有破格生，我被納入拾壹位破格生幸運錄取了。學校在嘉定外崗，曾經是供資本家學習的社會主義學院，改換門庭成了工藝美術學校，理所當然的條件好。有壹天我在教室裏寫書法，班主任許世煌老師經過，看著我寫書法便說道：「你祖父寫壹手好字。」「噢！我不知道呀，也從來沒見過我爺爺寫的書法。」許老師看著我納悶，但也沒說甚麼的。這是第壹次外人向我說到爺爺谷劍塵。

我是壹非常刻苦的學習生。到我畢業的 1976 年，我宿舍裏的同班同學常常夜間穿過桃花園，翻牆去學校對街的紅星軸承廠直到清晨回宿舍。我佰思不得其解，原來我是除了畫畫，甚麼都不關心的壹個人，我不知道還要找女朋友壹事……

尾聲

移居紐約後不久的壹天，在緬因州美術學院執教的朋友徐淦電話我，他偶然買了壹份《人民日報》海外版，登載了上海圖書館的壹館員為谷劍塵佰歲誕辰撰稿壹篇以為紀念。《不要忘記谷劍塵》為了早已忘卻了的記憶……

直到讀了《不要忘記谷劍塵》壹文後，才認識了爺爺。他為早期演劇和電影做過卓越貢獻，因沒有接近左聯，卻名落孫山，「煉獄」提籃橋。這畢竟還是壹個人的遭遇，儘管有仟仟萬萬的遭遇。當我知道母親懷着我的那年爺爺被關入監獄，並沒有讓

was. no one ever spoke of him and my family was completely silent on the topic. 1973, the year that i left fenghuo middle school, was the same year that the shanghai arts and crafts school began to recruit students, but the catchment area did not include zhabei district. fortunately, they were willing to look past the catchment area rules for exceptional students and i was one of the eleven exceptional students which enrolled at the school. the school was located in the town of waigang in jiading district, and was once a kind of socialist college, used for the re-education of capitalists. they replaced the door and it became an arts and crafts school; naturally, the conditions were quite good. one day, while i was writing calligraphy in the classroom, the director of the class, teacher xu shihuang said, "your paternal grandfather also had a very good hand for calligraphy." "oh!" i said, shocked, "i never saw him write calligraphy." teacher xu looked at me bewildered, but didn't say anything. this was the first time another person said anything about my grandfather gu jianchen.

i was a very hardworking student. when i graduated in 1976, I often see other classmates slip away at night to jump over the wall of the school to go to red star bearing factory across the street only to return at dawn to the dormitory. despite pondering it over and over, i nonetheless remained perplexed as to why i cared about nothing except painting; i didn't even think about the need to find a girlfriend…

CODA

not long after i moved to new york, a friend of mine, xu gan, a teacher at the maine college of art, gave me a call to say that he had randomly bought an overseas edition of the *people's daily* reviving this long-forgotten memory. he had found an article written by a staff member of the shanghai library, in memory of gu jianchen's 100th birthday entitled, *don't forget gu jianchen*.

it was only when i read this article *don't forget gu jianchen* that i finally came to know my paternal grandfather. he made an outstanding contribution to the early era of drama and film, but because he was not close with the league of left-wing writers, he was left behind in the "purgatory" of tilanqiao prison. though he would have to suffer this bitter lot, he was but one among thousands. surprisingly, at the time when i found out that my mother was pregnant with me, the year that he was sent to jail, it did not fill me a desire for spite and vengeance, or lead me to

我抱有應該有的壹種私憤和復仇，或轉而怒罵的理所當然，我覺得格外的平靜，壹個人、家庭、社會，以致整個人種，不過是天象裏的壹瞬間。我是這樣看來：這是人性所然，歷史必然。

叁拾年代的《新文化》月刊裏登載簽名支持「婦女繼承權」，爺爺谷劍塵與蔡元培等一起簽名支持。我與中國台灣移居芝加哥的策展人高倩惠談及女人遺產繼承權壹事，令我驚訝的是摩登的中國台灣，竟然她家的所有遺產都給了她的兄弟，而她分文不沾。

谷劍塵是中國教育電影協會發起人之壹，曾任上海戲劇學院前身上海戲劇學校首任校長，明星電影學校校長，與導演應雲衛一起為戲劇協社發起人，是共和國之前在戲劇史上活動最久的現代劇團。哈佛學成回到上海的洪深，經由谷劍塵的壹番介紹進入明星影業，被譽為舊上海影視圈的壹匹黑馬。我便開始在網上搜尋爺爺的原出版物。

很是欣慰收集到 1930 年上海現代書局出版的谷劍塵原版本《紳董》，1933 年商務印書館出版的《戲劇

spew out a string of expletives. i actually felt especially peaceful, given the fact that a person, a family, a society, and consequently a whole entire race, all of this is just a split second in the time-scale of the universe. i saw it as an inherent element of humanity and a necessity of history.

in the 1930s, the magazine *new culture* published an article signed by many authors in support of a "woman's right to inherit property." my paternal grandfather gu jianchen and cai yuanpei, signed their names in support. talking with gao qianhui, a curator from taiwan, china who had immigrated to chicago, about this issue of women's inheritance rights, i was surprised to learn that in modern taiwan, china, all of her family's inheritance was unexpectedly given to her brother; not a single cent was left for her.

gu jianchen is one of the founders of the china educational film association, and was once the first dean of the shangahi school of drama, which was the precursor to the shanghai theatre academy. he was also the dean of the stars film school, and the founder of the theatre association along with director ying yunwei. hong shen, who returned from harvard, helped to introduce gu jianchen to the stars motion picture company, and he soon became known as a kind of dark horse in the film circles of old shanghai. soon after, i began to search for the publications of my paternal grandfather online.

i was very pleased to receive copies of gu jianchen's *local gentry*, published in 1930, by the shanghai modern book company, along with *make-up for theatre*, published by the commercial press in 1933, *methods of modern drama*, published in 1936 by the world press, and *screenplay writing*, published by the commercial press in

的化妝術》，1936 年世界書局出版的《現代戲劇作法》，1936 年商務印書館出版的《電影劇本作法》，收集記憶是壹種 wonderland（仙境），美不勝收還不足與表述，她每每讓人驚訝，也「豔」在其中了……

可惜的是爺爺生活的時代僅有無聲電影，所謂默片，其醋酸片基不可久存，不及時複製便不復存在了。有感於那時的民族，佰分之捌拾伍的人口是斗字不識的文盲，加上兵荒馬亂，只有馬背上的資料檔案館了。我和我的助手沈玲玲足跡肆方，跑遍了上海香港北京的電影檔案館，非常遺憾，沒有追回壹片！

爺爺是中國戲劇與電影的先驅之壹。他首次在中國電影史上提出導演中心說；他寫就了中國演劇史上第壹部有台詞的話劇《孤軍》，開了中國話劇的先河。他編著的《中國電影發達史》是大家擁有的最早壹部中國電影史書。早期電影史著述僅兩種：1934 年版《中國電影年鑒》刊載的谷劍塵所著《中國電影發達史》，1936 年版《近代中國藝術發展史》收入的鄭君里之著《現代中國電影史略》。爺爺的《中國電影發達史》為中國電影史的拓荒之作，有篳路藍縷之功。

我起初怎麼都覺得佰思不得其解，爺爺帶着戲劇協社足跡遍佈四川、上海、南京，喚起民眾抗日救國。這樣壹位有良心的功臣，會最後落入提籃橋監獄！

（摘自《蛻變中的基因》，《雨中清明》）

1936. collecting these memories sent me into a kind of wonderland; I am helpless to finds words to express, the joy of finding these marvelous things; each one brought me great surprises, each one more wonderful than the next.

it is a pity that my paternal grandfather only got to experience the era of silent films. the acetate on which the films were printed does not have a long lifespan and they needed to be copied or else they would no longer exist. what really moved me was that at that time 85% of the population was illiterate and that due to the chaos and turmoil of the time, the materials needed to be brought to the archive by horseback. travelling with my assistant shen lingling, we searched the four corners of the earth, going to visit film archives in shanghai, hong kong, and beijing, looking for even one film. we were so disappointed.

my grandfather was a forerunner of chinese theatre and film. once, when speaking of chinese film, one of the directors said that he wrote the first drama with lines (rather than opera lyrics) *isolated troupes,* which marked the beginning of chinese drama. in addition, his *the history of the development of chinese film*, was a seminal work in the early period of chinese film history, a work which many people owned and read. of the early works on the history of film there were two kinds: the 1934 edition of *the china film yearbook*, which published gu jianchen's *the history of the development of chinese film*, in 1936 and "the history of the development of early modern chinese art," the earnings of which were used to fund zheng junli's a brief *history of modern chinese film*. my grandfather's *the history of the development of chinese film*" was a trail-blazing text in the history of chinese film, a testament to his pioneering efforts.

another fact which still puzzles me to this day is how my father ended up in jail. though he brought the amateur theatre troupe xiju xieshe around the country-leaving its footprints in sichuan, shanghai, and nanjing, and catalyzing the public to resist japanese aggression-though he was the kind of person with a strong social conscience and who possessed an outstanding record of service, he still ended up in the tilanqiao prison!

(from: *transmuted genes, a pure brightness in the rain*)

谷文達回顧展上布萊恩·甘迺迪的演講

布萊恩·甘迺迪

BRIAN KENNEDY'S SPEECH AT THE GU WENDA RETROSPECTIVE

brian kennedy

合美術館，武漢，中國，2019 年 12 月 15 日

布萊恩·甘迺迪的演講

谷文達是世界上最傑出的當代藝術家之一，合美術館的這次展覽匯集了谷文達生活的方方面面，這是對這位藝術家實踐的一次卓越呈現。他在使用新的形式、新材料或新內容方面不斷取得進展。當被問及他為甚麼使用這麼多媒介工作時，他曾回答說：「這些形式都是相關的；這是一種創造。不同於傳統實踐，當代藝術家使用許多不同的媒介進行創作。這種做法是富有趣味的，也是實驗性的。」[1] 了把握這位藝術家的雄心壯志，讓我們從多個不同的角度來審視他的作品，正如本次展覽所展示的那樣。

移居

谷文達作為新中國藝術的主要奠基人之一，要理解他在當代藝術世界中的這種地位，我們必須考慮到他長期處於東西方之間的過渡狀態。他的《東西椅》很好地說明了這一點。他一直處於過渡狀態。今天，他在紐約、上海

united art museum, wuhan, china - december 15, 2019
speech by brian kennedy

so many aspects of gu wenda's life come together in this exhibition, a remarkable presentation of the practices of one of the world's most distinguished contemporary artists. he has progressed constantly in his uses of new formats, materials or content. when asked why he works in so many media, he once responded: "the formats are all related; it is one kind of creation. unlike in traditional practice, contemporary artists create using a lot of different media. [the practice is] colorful and experimental".[1] to come to grips with the scale of the artist's ambition, let us examine his production from a number of different standpoints, as seen by examples in the exhibition.

TRANSMIGRATION

to understand gu wenda's position in the world of contemporary art, as one of the key founders of new chinese art, it is essential to consider that he has long existed in a transitory state between the east and the west. his *east west chair* makes the point wonderfully.

和山東都有工作室，藝術項目也遍佈世界各地。當谷文達於 1987 年移居美國時，他很快意識到他無法克服或超越自身的民族身份。但（他也意識到）他的作品可以通過不懈的努力獲得普適性，從而超越民族身份。

他按照西方慣例將自己的姓氏放在第二位 —— 在美國，他成為文達・谷（wenda gu）。這一特別行為顯而易見地表明了移居是如何影響藝術家的。很少有當代藝術家像谷文達那樣研究身份轉換和移民的後果。

語言

早年在中國讀書時，谷文達和其他年輕藝術家一樣，沉浸在一個智性的社會氛圍之中。他特別研究了路德維希・維特根斯坦（ludwig wittgenstein），維特根斯坦認為語言作為一套社會行為，它類似於一種遊戲。1982 年，谷文達在一枚印章上篆刻時，偶然間發現了他現在標誌性的偽文字。他的刀子滑了一下，他意識到儘管這個文字已經變得難以理解，但這並沒有削弱它的視覺力量。[2] 對文字正統性的挑戰和顛覆傳統的衝動很快成為谷文達作品的標誌。他對語言最出色的擴展性研究，是被稱為「唐詩後著」的碑林系列。[3] 該項目是一個由大型石塊組成的紀念碑隊列，上面手工雕刻了一首唐詩的四種不同翻譯文本。每一個譯本都離原詩更遠一步，創造出一種真正的審美體驗。

在移居美國之前，谷文達就對概念性的語言非常着迷。他進入了一個研究和實踐的時期，期間他探索了利用人類身體材料處理語言的方法。他對遺傳學和生物研究的

with studios today in new york, shanghai and qufu, and art projects throughout the world, he is in transit constantly. when gu moved to the united states of america in 1987, he realized quickly that he could not overcome or exceed his ethnic identity. but his work could seek to surmount it by its relentless effort to be universal.

the very act of adopting the western convention of using his family name second - in america he became wenda gu - is an obvious demonstration of how transmigration has impacted the artist. few contemporary artists have examined the consequences of identity translation and migration as well as gu wenda.

LANGUAGE

in his early years as a student in china, gu wenda, like other young artists, was immersed in an intellectual milieu. he studied ludwig wittgenstein in particular, who considered that language, as a set of social activities, was akin to a game. gu came upon his now characteristic pseudo-characters by accident when in 1982 he was carving characters into a seal. his knife slipped and he realized that although the character had been made unintelligible, this did not detract from its visual power.[2] a challenge to textual orthodoxy and an iconoclastic impulse soon became the hallmark of gu's work. his most remarkable extended investigations of language are his forests of stone steles, called "rewriting and retranslation of tang poetry".[3] the project involves a monumental procession of large blocks of stone inscribed with hand-carved texts of four different translations of a tang dynasty poem. each translation gets one step further from the original text creating a true aesthetic experience.

gu was fascinated by conceptual language before moving to america. he entered a period of study and practice, exploring ways of dealing with language by using human

意義很感興趣。他想要用諸如頭髮或胎盤粉等人類物質來製作他的墨水。這些物質都是人體廢物，在東方被有效地用來生產藥物。

多年來，他對語言的痴迷一直在持續，而且他經常以新的形式回歸語言問題。他的霓虹書法系列作品《文化移植》（2004-）專注於中國和美國變動不居的商業世界。他採用了西方商業公司的名字，如蘇富比、愛馬仕或香奈兒，他選擇了模仿英文拼讀的中文漢字來音譯英文單詞，然後他將音譯的漢語意譯，使其轉換回英文。意大利時尚品牌菲拉格慕（salvatore ferragamo）委託了一個使用這種形式的霓虹燈書法項目。這件作品展示了如何將「ferragamo」音譯為「福來迦牟」，然後又意譯成「good fortune comes from sakyamuni」（好運來自釋迦牟尼，釋迦牟尼是佛陀的頭銜之一，源自他出生的釋迦族）。

傳統與當代

谷文達的《生肖祝福》系列作品是他將傳統和當代相融合的一個典型例子，他就這個主題創作了兩個系列。它們旨在通過將數字視頻屏幕置於傳統水墨畫的內部和中心來推進水墨畫。這些作品回應了他早期創作的無意義文本，但通過嵌入的視頻講述每個生肖的故事的方式，使得作品變得清晰易讀：「我重構了這個故事。在某種程度上，讓人們有機會欣賞更多的傳統作品是一種樂趣，這不僅僅是關於傳統的生肖故事或水墨畫。」它幫助年輕的一代「通過動畫和視頻對傳統產生興趣」。[4]

bodily materials. he was intrigued by genetics and the implications of biological research. he would seek to make his inks from human substances such as hair or placenta powders. these are human waste products that are used productively to make medicines in the east. his obsession with language has continued over the years and he has frequently returned to it in new formats. his neon calligraphy series, *cultural transference* (2004-), was created to focus on the changing commercial worlds in china and america. taking the name of a commercial company from the west, such as sotheby's , hermès or chanel. he selects chinese words that mimic the phonics used to pronounce the english words. then he takes the phonic translation and and converts it back into english. a neon light calligraphy project using this format, commissioned by the italian fashion house salvatore ferragamo, demonstrates how the resulting translation from phonics converts ferragamo to "good fortune comes from sakyamuni" (one of the titles of the buddha, which derives from sakya where he was born).

TRADITIONAL AND CONTEMPORARY

a remarkable example of the manner in which gu wenda integrates the traditional and the contemporary in his art is his series *blessings of the zodiac*. he has made two series on this theme. they aim to advance ink painting by placing digital video screens within and at the center of traditional ink paintings. these works respond to his earlier production of meaningless text but are made legible by the embedded videos that tell the story of each zodiac animal: "i have reinvented the story. it's kind of fun, in a way, to give people the opportunity to appreciate more traditional works. it's not only about the traditional zodiac story or ink painting." it helps the younger generation become "interested in tradition through cartoon and video."[4]

722

理想主義與烏托邦

谷文達一直說他在政治上是中立的。他只是一個演員，也是一個異議者，但不尋求發表一項政治聲明。他將自己看作是一個和平使者。他的主要系列作品——雄心勃勃的《聯合國》——並不關注聯合國這個組織機構，而是關注團結所有國家的烏托邦思想。用藝術家的話說，它的目的是給觀眾帶來「普遍的和平與和諧」，作為「連接一個地方和另一個地方……一個國家和另一個國家的文化大使」。[5]

《聯合國》是由來自全球許多不同國家收集到的人類頭髮製成，通過《聯合國》這個系列，他相信我們可以分享彼此間的種族和文化身份的融合。從 1992 年這個全球項目開始以來，已經有超過 500 萬人捐贈了頭髮。《聯合國——dna 長城》（2001 年）就是其中的傑出創作之一。它包括一個由頭髮和樹脂組成的巨大幕牆，這個幕牆創造了一個房間，而在房間的中心，有一堵由人類頭髮製成的實心磚牆。牆的觀念在歷史上有很多先例，而谷文達作品的力量在於，觀眾可以在他的作品中讀出任何他們想讀的「牆」：谷文達提到了孔子，他周遊四方，宣揚治理社會的信念；毛澤東在「長征」途中也做了同樣的事情，他向中國農村的農民群體宣傳他的哲學；還有英國的哈德良牆和德國的柏林牆、耶路撒冷的哭牆……這種共鳴今天仍在唐納德·特朗普（donald trump）總統的野心中延續，他計劃在墨西哥和美國之間建造隔離牆。

生物學

相比於谷文達作品的其他方面，他對人體物質的運用是最著名的。谷文達從不「為藝術而藝術」，他的藝術總是

IDEALISM AND UTOPIA

gu has always said that he is neutral politically. he is a protagonist, a controversialist who is not seeking to make a political point. he sees himself as a peacemaker. his major series, of mammoth ambition, the *united nations project*, was not concerned with the united nations as an organization but with the utopian idea of uniting all nations. it aimed to give its viewers, in the artist's words "a universal peace and harmony" acting "as a cultural ambassador that connects one place to another...one country to another".[5]

through this *united nations* series, made from human hair gathered from many and various countries across the globe, he believes we can share our mix of racial and cultural identities. begun in 1992, the worldwide project has included hair donated by over five million people. one of these remarkable creations is *united nations - the great wall of dna* (2001). it includes a huge curtain wall of hair and resin that creates a room in which there is, at its center, a wall of solid bricks made from human hair. the idea of a wall has many historical precedents, and the power of gu's work is that the audience can read any "wall" they wish into his work. gu references confucius who traveled widely promoting his beliefs about how society might be governed. mao did the same while traveling on his "long march", advocating his philosophy to the peasant populations of the chinese countryside. then there is hadrian's wall in britain and the berlin wall of germany, the wailing wall of jerusalem, and the resonances continue today with the ambition of president donald trump to build a wall between mexico and the u.s.a.

BIOLOGY

perhaps more than any other aspect of gu's work, his use of human bodily substances is the best known. gu was never interested in creating art for art's sake. his art has always been purposeful while being focused on an aesthetic effect. his embrace of human body materials

有一定的目的，同時注重某種美學效果。他對人體材料的採納是因為它們沒有視覺或語言上的錯覺，「它們是博物館和美術館展出的藝術品的對立面，它們和觀眾一樣真實，所以它們可以用一種深刻的精神存在感穿透我們。因此我稱它們為『沉默的自我』」。[6]

谷文達對頭髮的運用使他在全球當代藝術家中獨樹一幟。谷文達找到了一種人類的材料來表達他的信念，這個信念即我們正生活在一個「生物學的黃金時代」。谷文達激進地用人的頭髮製作墨水，意味着他的藝術材料中包含着人類的 dna，它就像人體內的 dna 一樣真實。他的作品與其說是對藝術史的回應，不如說是對當代社會發展的回應。他以一種最獨創性的方式回應了社會上的技術革命，這種技術革命使科學家們參與到規模前所未見的基因研究中來，探索克隆、幹細胞實驗和生物工程的一切可能。

合作與奇觀

谷文達的血液中流淌着戲劇的天賦。他的祖父是一名劇作家，因其在中國戲劇中的創新而聞名，他將口語對話引入了傳統上只涉及演唱的藝術形式。也許是由於他的性格，也許是出於他的家庭背景，谷文達對視覺藝術的戲劇化得心應手。他的作品總是壯觀的，其中最引人注目的作品是和房間一樣巨大的《基因與蛻變》。它由 1000 平方米的絲綢組成，這件作品是由 1060 名小學生於 2014 年 5 月 11 日在廣東佛山完成。他選擇的日期是西方的母親節，這也是邀請學生將中國經典《孝經》中的文字書寫在絲綢上的理想時間。這次行為藝術被錄製成紀錄片，並在展覽中用 20 台電視顯示器播放。

was made because they lacked visual or linguistic illusion: "they are the antithesis of art as object exhibited in museums and galleries. they are as real as the people who look at them and therefore can penetrate us with a deep sense of spiritual presence. therefore i call them 'silent selves.'"[6]

gu's use of hair has especially distinguished him among contemporary artists globally. gu has found a human material that speaks to his belief that we are living in a "biological millenium". gu's radical decision to make ink from human hair meant that his art materials would contain human dna, as real as that in human bodies. his output responds less to the history of art than it does to developments in contemporary society. he has responded in a most original way to the technological revolution that has engaged scientists in genetic research with all its possibilities of cloning, stem cell experiments, and biological engineering on a scale never previously imagined.

COLLABORATION AND SPECTACLE

gu has theater in his blood. his paternal grandfather was a playwright, who is celebrated for his innovation in chinese theatre, introducing spoken dialogue to an art form which had traditionally involved singing only. by temperament and perhaps due to his family background, the theatrical possibilities of visual art engage gu with ease. his work is frequently spectacular, none more so than in the giant room-size work *dna and metamorphosis*. it is comprised of one thousand square meters of silk painted by 1060 elementary school students in a performance held in foshag city, guangdong, on may 11, 2014. the date chosen was that known as mother's day in the west, and an ideal time to invite students to write words from the chinese *classic of filial piety* on the sections of silk. the performance was recorded as a documentary film and is shown on twenty television monitors.

谷文達一直對合作感興趣。像他這種體量的藝術作品，如果沒有合作夥伴是不可能實現的。他在自己的工作室裏僱傭了一些助手，他對他人的依賴，他委任和協調團隊的能力，都是長期實踐的結果。谷文達參與藝術實踐的方式，不論是表演，還是通過創造吸引觀眾的多感官體驗，都表明了他是如何與當前趨勢保持聯繫的。事實上，他已經走在了時代的前面，他知道世界越是變得數字化，越是有人要尋找建立在人與人之間的真實體驗。他成功地運用了劇場化的呈現，幫助人們思考了諸如移民、性別、教育、多樣性、多元文化、生物學等當代問題，其中最重要的問題也許是合作的重要性。

規模和雄心

任何人與谷文達接觸後都會立刻感受到他開朗的性格，和生活上的高度紀律性。他工作勤奮，幽默風趣，儘管功成名就，但他仍然顯露出他的感激和謙遜。他的動力來自於他年輕時就確立起來的浪漫主義和理想主義，以及他對美國資本主義和環球旅行生活方式的經歷。他一直在管理自己的作品，不與畫商打交道，委托事項也都通過自己的工作室親自處理。他將自己比作一個「文化殖民者」，他所使用的材料來自世界各地，但對中國來說，他是一個「文化大使」，也是傑出的藝術僑民中最重要的一員，他為當代中國文化界帶來了可信性和活力。

結語

合美術館對谷文達藝術事業的總結是激動人心、令人振奮和引人入勝的。谷文達熱衷於通過正視禁忌來創作參

gu has always been interested in collaboration. an artistic output on his scale could not have been achieved without partners. he employs assistants in his studios and his reliance on others, his ability to delegate and coordinate teams of people, are the result of long practice. the ways that gu has engaged his artistic practice, both as performance and by creating multi-sensory experiences that engage his audiences, demonstrates how he remains in touch with current trends. in fact he has been ahead of them, understanding that the more digitally connected the world becomes, the more people are searching for real experiences founded in human interaction. he has used theatrical presentation with great success, helping people to think about so many contemporary issues, among them migration, gender, education, diversity, multiculturalism, biology, and, perhaps above all, the importance of working together.

SCALE AND AMBITION

any personal engagement with gu reveals quickly an open personality who approaches life with great discipline. hard working and good humored, despite all his success he exudes gratitude and humility. he is driven by a romanticism and idealism founded in his youth, and by his experience of american capitalism and a globe trotting lifestyle. he has always managed his own work, not engaging with dealers, and handling commissions personally through his studio. he has likened himself to a "cultural colonialist" who uses materials, that are locally sourced throughout the world, but for china he is a "cultural ambassador", a foremost member of the distinguished art diaspora that has brought credibility and vitality to the contemporary chinese cultural scene.

CONCLUSION

the career overview of gu wenda's output presented at the united art museum is exciting, invigorating and

與社會的藝術作品，無論是用人的頭髮製作作品，還是將 dvd 屏幕放在中國傳統書法畫的中心，都促使他向社會宣傳當代藝術的價值。他相信，當觀眾參與到他的藝術表演中時，他們會充滿熱情，並能更好地理解當代藝術。他在美國的經歷使他相信，我們正在進入一個充滿投資公共藝術機會的新紀元。谷文達一如既往地具有挑釁性和前瞻性，最近他在接受記者採訪時表示：「我的項目越來越多地使用公司平台作為贊助方，我認為這就是未來。公司與人們有一種交易關係，也與政府有一種合作關係。公司是中間人，它就像一個中介一樣」。[7]

今天，讓我們來一起慶祝谷文達的藝術吧！我祝賀合美術館舉辦這次重要的展覽，我希望很多人能來武漢參觀，來享受並接受它所提供的一切。謝謝大家的關注！

布萊恩・甘迺迪博士
董事兼首席執行官
皮博迪埃塞克斯博物館
馬薩諸塞州塞勒姆
2019 年 12 月
（杜博文譯）

enthralling. his passion for creating works of art that engage society by confronting taboos, whether making works from human hair, placing dvd screens in the center of traditional chinsese calligraphy paintings, drives him to promote the value of contemporary art to society. he believes that when his audiences participate in his art performances, they will be enthused and will better understand contemporary art. his experience in america has convinced him that we are entering a new era of opportunity for investment in public art. provocative and forward thinking as always, he told a journalist recently: "more and more my projects use the platform of the corporation as the patron. i think this is the future. it has a marketing relationship with people and also a collaborative relationship with the government. the corporation is the intermediary, just like an agent."[7]

let us today celebrate the art of gu wenda! my congratulations to the united art museum on this important exhibition and i hope many people will visit in wuhan to enjoy and be educated by all it has to offer. thank you all for your attention!

dr. brian kennedy
director and ceo
peabody essex museum
salem, massachusetts
december 2019

註釋

1 凱特・尼科爾森:〈藝術中的文字:谷文達對中國傳統文化的改寫和重譯〉,《藝術雷達》,2011 年 6 月 15 日, artradarjournal.com。

2 布里塔・埃里克森:〈谷文達的自我沉默和偽文字〉,《藝術亞太刊》26 2000 年,82。

3 艾倫・霍克利:〈在谷文達碑林中的過去與現在:重譯與改寫唐詩〉,《谷文達在達特茅斯:裝置藝術》,胡德藝術博物館, 達特茅斯學院與新英格蘭大學出版社(2008):87.95。

4 凱特・尼科爾森:〈藝術中的文字:谷文達關於改寫和重譯中國傳統文化〉,《藝術雷達》,2011 年 6 月 15 日, artradarjournal.com。

5 同上文。

6 谷文達:〈面對新千年:我們時代的神曲〉,摘自馬克・貝塞爾主編,《谷文達:從中王國到生物千年的藝術》,馬薩諸塞州 劍橋:麻省理工出版社,2003 年,第 30 頁。

7 安德魯・斯圖克:〈上海 21 世紀民生藝術博物館與中國藝術家谷文達的會面〉,藝術雷達,2017 年 1 月 9 日, artradarjournal.com,2017 年 1 月 29 日下載。

notes

1 kate nicholson, "words in art: wenda gu on rewriting and retranslating traditional chinese culture," art radar, 15 june 2011, artradarjournal.com.

2 britta erickson, "gu wenda's silent selves and pseudo characters," artasiapacific 26 (2000): 82.

3 allen hockley, "past and present in wenda gu's forest of stone steles: retranslation and rewriting tang dynasty poetry," in wenda gu at dartmouth: the art of installation, hood museum of art, dartmouth college, and university press of new england (2008): 87-95.

4 kate nicholson, "words in art: wenda gu on rewriting and retranslating traditional chinese culture," art radar, 15 june 2011, artradarjournal.com.

5 ibid.

6 wenda gu, "face the new millenium: the divine comedy of our times," in mark bessire, ed., wenda gu: art from middle kingdom to biological millenium (cambridge, mass.: mit press, 2003), 30.

7 andrew stooke, "meeting with chinese artist gu wenda at shanghai 21st century minsheng art museum," art radar, 9 january 2017, artradarjournal.com, downloaded 29 january 2017.

當 代 藝 術 潮 流 中 的 谷 文 達 研 討 會

SYMPOSIUM THEME: SITUATING GU WENDA'S WORK WITHIN THE TRENDS OF CONTEMPORARY ART

會議時間：2019 年 12 月 15 日下午 2：00—3：30

會議地點：合美術館

主持人：首先我介紹一下 brian kennedy，brian kennedy 先生是從 2010 年起擔任美國托萊多藝術博物館的董事長、館長和執行總監，他出生於愛爾蘭的都柏林，在都柏林大學獲得了藝術史和歷史學的本科、碩士以及博士學位，在 2005—2010 年期間，kennedy 擔任美國達特茅斯學院胡德藝術博物館的館長，他來到美國之前，kennedy 擔任了八年愛爾蘭國立美術館的館長助理和七年的澳洲國立美術館的館長，kennedy 先生是一位備受尊敬的藝術史家、策展人和評論家，他也頻繁地參加學術會議和研討會，他現在出版了有六本著作，主要關注著名藝術史家和藝術家，現在他還是藝術博物館館長協會的會員以及是國際藝術評論家協會的會員，我的簡短介紹就到這，下面我們把時間留給 kennedy 先生。

conference date: december 15, 2019, 2-3:30pm
location: united art museum

moderator: first i would like to introduce mr. brian kennedy. he has been the director, curator, and ceo of the toledo art museum since 2010. he was born in ireland, and earned a ba, an ma, and phd, in art history and history at university college dublin. he completed his masters between 2005-2010, before he assumed the directorship at the hood museum of art at dartmouth college. before he arrived in the us, he was assistant director at the national gallery of ireland in dublin for eight years and was director of the national gallery of australia for seven years. first and foremost mr. kennedy is a respected art historian, curator, and critic, who participates regularly in conferences and symposia. he has published six books about famous historians and artists and is a member of the council of museum directors and also the association of international art critics. now i shall wrap up my simple introduction and leave the remaining time to mr. kennedy.

brian kennedy：谷文達是世界上最傑出的當代藝術家之一，合美術館的這次展覽匯集了谷文達生活的方方面面，這是對這位藝術家實踐的一次卓越呈現。他在使用新的形式、新材料或新內容方面不斷取得進展。當被問及他為甚麼使用這麼多媒介工作時，他曾回答說：「這些形式都是相關的；這是一種創造。不同於傳統實踐，當代藝術家使用許多不同的媒介進行創作。這種做法是富有趣味的，也是實驗性的。」為了把握這位藝術家的雄心壯志，讓我們從多個不同的角度來審視他的作品，正如本次展覽所展示的那樣。

移居：谷文達作為新中國藝術的主要奠基人之一，要理解他在當代藝術世界中的這種地位，我們必須考慮到他長期處於東西方之間的過渡狀態。他的《東西椅》很好地說明了這一點。他一直處於過渡狀態。今天，他在紐約、上海和山東都有工作室，藝術項目也遍佈世界各地。當谷文達於 1987 年移居美國時，他很快意識到他無法克服或超越自身的民族身份。但（他也意識到）他的作品可以通過不懈的努力獲得普適性，從而超越民族身份。

他按照西方慣例將自己的姓氏放在第二位 —— 在美國，他成為文達·谷（wenda gu）。這一特別行為顯而易見地表明了移居是如何影響藝術家的。很少有當代藝術家像谷文達那樣研究身份轉換和移民的後果。

語言：早年在中國讀書時，谷文達和其他年輕藝術家一樣，沉浸在一個智性的社會氛圍之中。他特別研究了路德維希·維特根斯坦（ludwig wittgenstein），維特根斯坦認為語言作為一套社會行為，它類似於一種遊戲。1982

brian kennedy: good afternoon everyone! i would like to offer my sincere thanks to the organizers for this invitation and i am very honoured to be here. in this exhibition, we are able to see various aspects of the life of gu wenda. he is one of the most illustrious contemporary artists as he is constantly progressive in the way he uses new materials, content, and form. but when asked why he employs so many different media, he once responded that "the various mediums are interrelated. it's a mode of creation that differs from traditional methods. contemporary artists use different media to create rich, varied, colorful, and experimental practices." in order to better interpret the ambitions of the artist, let me look at his works from different angles, as shown in the various works exhibited in this exhibition.

transmigration: to understand gu wenda's position in the world of contemporary art, as one of the key founders of new chinese art, it is essential to consider that he has long existed in a transitory state between the east and the west. his *east-west chair* makes the point wonderfully, conveying a state of an uninhabited place. with studios today in new york, shanghai, and shandong, and art projects throughout the world, he is in transit constantly. when gu moved to the us in 1987, he realized quickly that he could not overcome his ethnic identity. but he would work tirelessly to surmount it. the very act of adopting the western convention of using his family name second — in america he became wenda gu — is an obvious demonstration of how transmigration has impacted the artist. few contemporary artists have examined the consequences of identity translation and migration as well as gu wenda.

language: in his early years as a student in china, gu wenda, like other young artists, was immersed in an intellectual milieu. he studied ludwig wittgenstein in particular, who considered that language, as a set of social activities, was akin to a game. gu came upon his now characteristic pseudo-characters by accident, when in 1982, he was carving characters into a seal. his knife

年，谷文達在一枚印章上篆刻時，偶然間發現了他現在標誌性的偽文字。他的刀子滑了一下，他意識到儘管這個文字已經變得難以理解，但這並沒有削弱它的視覺力量。對文字正統性的挑戰和顛覆傳統的衝動很快成為谷文達作品的標誌。他對語言最出色的擴展性研究，是被稱為「唐詩後著」的碑林系列。該項目是一個由大型石塊組成的紀念碑隊列，上面手工雕刻了一首唐詩的四種不同翻譯文本。每一個譯本都離原詩更遠一步，創造出一種真正的審美體驗。

在移居美國之前，谷文達就對概念性的語言非常着迷。他進入了一個研究和實踐的時期，期間他探索了利用人類身體材料處理語言的方法。他對遺傳學和生物研究的意義很感興趣。他想要用諸如頭髮或胎盤粉等人類物質來製作他的墨水。這些物質都是人體廢物，在東方被有效地用來生產藥物。

多年來，他對語言的痴迷一直在持續，而且他經常以新的形式回歸語言問題。他的霓虹書法系列作品《文化移植》（2004-）專注於中國和美國變動不居的商業世界。他採用了西方商業公司的名字，如蘇富比、愛馬仕或香奈兒，他選擇了模仿英文拼讀的中文漢字來音譯英文單詞，然後他將音譯的漢語意譯，使其轉換回英文。意大利時尚品牌菲拉格慕（salvatore ferragamo）委託了一個使用這種形式的霓虹燈書法項目。這件作品展示了如何將「ferragamo」音譯為「福來迦牟」，然後又意譯成「good fortune comes from sakyamuni」（好運來自釋迦牟尼，釋迦牟尼是佛陀的頭銜之一，源自他出生的釋迦）。

slipped and he realized that although the character had been made unintelligible, this did not detract from its visual power. a challenge to textual orthodoxy and an iconoclastic impulse soon became the hallmark of gu's work. his most remarkable extended investigations of language are his forests of stone steles, called "rewriting and retranslation of tang poetry". the project involves a monumental procession of large blocks of stone inscribed with hand-carved texts of four different translations of a tang dynasty poem. each translation gets one step further from the original text creating a true aesthetic experience.

gu was fascinated by conceptual language before moving to america. he entered a period of study and practice, exploring ways of dealing with language by using human bodily materials. he was intrigued by genetics and the implications of biological research. he would seek to make his inks from human substances such as hair or placenta powders. these are human waste products that are used productively to make medicines in the east. his obsession with language has continued over the years and he has frequently returned to it in new formats. his neon calligraphy series, *cultural transference* (2004-), was created to focus on the changing commercial worlds in china and america. taking the name of a commercial company from the west, such as sotheby's, hermès, or chanel, he selects chinese words that mimic the phonetic sounds used to pronounce the english words. then he takes the phonic translation and converts it back into english. a neon light calligraphy project using this format, commissioned by the italian fashion house salvatore ferragamo, demonstrates how the resulting translation from phonics converts ferragamo to "good fortune comes from sakyamuni." a remarkable example of the manner in which gu wenda integrates the traditional and the contemporary in his art is his series *blessings of the zodiac*. he has made two series on this theme. they aim to advance ink painting by placing digital video screens within and at the center of traditional ink paintings. these works respond to his earlier production of meaningless text but are made

傳統與當代：谷文達的《生肖祝福》系列作品是他將傳統和當代相融合的一個典型例子，他就這個主題創作了兩個系列。它們旨在通過將數字視頻屏幕置於傳統水墨畫的內部和中心來推進水墨畫。這些作品回應了他早期創作的無意義文本，但通過嵌入的視頻講述每個生肖的故事的方式，使得作品變得清晰易讀：「我重構了這個故事。在某種程度上，讓人們有機會欣賞更多的傳統作品是一種樂趣，這不僅僅是關於傳統的生肖故事或水墨畫。」它幫助年輕的一代「通過動畫和視頻對傳統產生興趣」。

理想主義與烏托邦：谷文達一直說他在政治上是中立的。他只是一個演員，也是一個異議者，但不尋求發表一項政治聲明。他將自己看作是一個和平使者。他的主要系列作品 —— 雄心勃勃的《聯合國》—— 並不關注聯合國這個組織機構，而是關注團結所有國家的烏托邦思想。用藝術家的話說，它的目的是給觀眾帶來「普遍的和平與和諧」，作為「連接一個地方和另一個地方……一個國家和另一個國家的文化大使」。

《聯合國》是由來自全球許多不同國家收集到的人類頭髮製成，通過《聯合國》這個系列，他相信我們可以分享彼此間的種族和文化身份的融合。從 1992 年這個全球項目開始以來，已經有超過 500 萬人捐贈了頭髮。《聯合國 -- dna 長城》（2001 年）就是其中的傑出創作之一。它包括一個由頭髮和樹脂組成的巨大幕牆，這個幕牆創造了一個房間，而在房間的中心，有一堵由人類頭髮製成的實心磚牆。牆的觀念在歷史上有很多先例，而谷文達作品的力量在於，觀眾可以在他的作品中讀出任何他們想讀的

legible by the embedded videos that tell the story of each zodiac animal: "i have reinvented the story. it's kind of fun, in a way, to give people the opportunity to appreciate more traditional works. it's not only about the traditional zodiac story or ink painting." it helps the younger generation become "interested in tradition through cartoon and video."

idealism and utopia: gu has always said that he is politically neutral. he is a protagonist and a controversialist who is not seeking to make a political point. he sees himself as a peacemaker. his major series, of mammoth ambition, the *united nations project*, was not concerned with the united nations as an organization but with the utopian idea of uniting all nations. this work was on show when i was at the national gallery of australia, with the words "from england to the pacific" printed on it. it aimed to give its viewers, in the artist's words "a universal peace and harmony" acting "as a cultural ambassador that connects one place to another . . . one country to another." through this *united nations* series, made from human hair gathered from many and various countries across the globe, he believes we can share our mix of racial and cultural identities. begun in 1992, the worldwide project has included hair donated by over six million people. one of these remarkable creations is *united nations – dna great wall* (2001). it includes a huge curtain wall of hair and resin that creates a room in which there is, at its center, a wall of solid bricks made from human hair. the idea of a wall has many historical precedents, and the power of gu's work is that the audience can read any "wall" they wish into his work. gu references confucius who traveled widely promoting his beliefs about how society might be governed. mao did the same while traveling on his "long march," advocating his philosophy to the peasant populations of the chinese countryside. then there is hadrian's wall in britain and the berlin wall of germany, the wailing wall of jerusalem, and the resonances continue today with the ambition of president donald trump to build a wall between mexico and the u.s.a.

「牆」：谷文達提到了孔子，他周遊四方，宣揚治理社會的信念；毛澤東在「長征」途中也做了同樣的事情，他向中國農村的農民群體宣傳他的哲學；還有英國的哈德良牆和德國的柏林牆、耶路撒冷的哭牆⋯⋯這種共鳴今天仍在唐納德・特朗普（donald trump）總統的野心中延續，他計劃在墨西哥和美國之間建造隔離牆。

生物學：相比於谷文達作品的其他方面，他對人體物質的運用是最著名的。谷文達從不「為藝術而藝術」，他的藝術總是有一定的目的，同時注重某種美學效果。他對人體材料的採納是因為它們沒有視覺或語言上的錯覺，「它們是博物館和美術館展出的藝術品的對立面，它們和觀眾一樣真實，所以它們可以用一種深刻的精神存在感穿透我們。因此我稱它們為『沉默的自我』」。

谷文達對頭髮的運用使他在全球當代藝術家中獨樹一幟。谷文達找到了一種人類的材料來表達他的信念，這個信念即我們正生活在一個「生物學的黃金時代」。谷文達激進地用人的頭髮製作墨水，意味着他的藝術材料中包含着人類的 dna，它就像人體內的 dna 一樣真實。他的作品與其說是對藝術史的回應，不如說是對當代社會發展的回應。他以一種最獨創性的方式回應了社會上的技術革命，這種技術革命使科學家們參與到規模前所未見的基因研究中來，探索克隆、幹細胞實驗和生物工程的一切可能。

合作與奇觀：谷文達的血液中流淌着戲劇的天賦。他的祖父是一名劇作家，因其在中國戲劇中的創新而聞名，他將口語對話引入了傳統上只涉及演唱的藝術形式。也許

biology: perhaps more than any other aspect of gu's work, his use of human bodily substances is the best known. gu was never interested in creating art for art's sake. his art has always been purposeful while being focused on an aesthetic effect. his embrace of human body materials was made because they lacked visual or linguistic illusion: "they are the antithesis of 'art as object' exhibited in museums and galleries. they are as real as the people who look at them and therefore can penetrate us with a deep sense of spiritual presence. therefore, i call them 'silent selves.'"

gu's use of hair has especially distinguished him among contemporary artists globally. gu has found a human material that speaks to his belief that we are living in a "biological millennium." gu's radical decision to make ink from human hair meant that his art materials would contain human dna, as real as that in human bodies. his output responds less to the history of art than it does to developments in contemporary society. he has responded in a most original way to the technological revolution that has engaged scientists in genetic research with all its possibilities of cloning, stem cell experiments, and biological engineering on a scale never previously imagined.

collaboration and spectacle: gu has theater in his blood. his paternal grandfather was an actor, who is celebrated for his innovation in chinese traditional opera, introducing spoken dialogue to an art form that had traditionally involved only singing. by temperament and perhaps due to his family background, gu engages easily with the theatrical possibilities of visual art. his work is frequently spectacular, none more so than in the giant room-size work *dna and metamorphosis*. it is comprised of one thousand square meters of silk painted by 1060 elementary school students in a performance held in foshan, guangdong, on may 11, 2014. the date chosen was that known as mother's day in the west, and an ideal time to invite students to write words from the chinese *classic of filial piety* on the sections of silk. the

是由於他的性格，也許是出於他的家庭背景，谷文達對視覺藝術的戲劇化得心應手。他的作品總是壯觀的，其中最引人注目的作品是和房間一樣巨大的《基因與蛻變》。它由 1000 平方米的絲綢組成，這件作品是由 1060 名小學生於 2014 年 5 月 11 日在廣東佛山完成。他選擇的日期是西方的母親節，這也是邀請學生將中國經典《孝經》中的文字書寫在絲綢上的理想時間。這次行為藝術被錄製成紀錄片，並在展覽中用 20 台電視顯示器播放。

谷文達一直對合作感興趣。像他這種體量的藝術作品，如果沒有合作夥伴是不可能實現的。他在自己的工作室裏僱傭了一些助手，他對他人的依賴，他委任和協調團隊的能力，都是長期實踐的結果。谷文達參與藝術實踐的方式，不論是表演，還是通過創造吸引觀眾的多感官體驗，都表明了他是如何與當前趨勢保持聯繫的。事實上，他已經走在了時代的前面，他知道世界越是變得數字化，越是有人要尋找建立在人與人之間的真實體驗。他成功地運用了劇場化的呈現，幫助人們思考了諸如移民、性別、教育、多樣性、多元文化、生物學等當代問題，其中最重要的問題也許是合作的重要性。

規模和雄心： 任何人與谷文達接觸後都會立刻感受到他開朗的性格，和生活上的高度紀律性。他工作勤奮，幽默風趣，儘管功成名就，但他仍然顯露出他的感激和謙遜。他的動力來自於他年輕時就確立起來的浪漫主義和理想主義，以及他對美國資本主義和環球旅行生活方式的經歷。他一直在管理自己的作品，不與畫商打交道，委託事項也都通過自己的工作室親自處理。他將自己比作一個「文化殖民者」，他所使用的材料來自世界各地，但對中國

performance was recorded as a documentary film and is shown on twenty television monitors.

gu has always been interested in collaboration. an artistic output on his scale could not have been achieved without partners. he employs assistants in his studios and his reliance on others, his ability to delegate and coordinate teams of people, are the result of long practice. the ways that gu has engaged his artistic practice, both as performance and by creating multi-sensory experiences that engage his audiences, demonstrate how he remains in touch with current trends. in fact, he has been ahead of them, understanding that the more digitally connected the world becomes, the more people are searching for real experiences founded in human interaction. he has used theatrical presentation with great success, helping people to think about so many contemporary issues, among them migration, gender, education, diversity, multiculturalism, biology, and, perhaps above all, the importance of working together.

scale and ambition: any personal engagement with gu reveals quickly an open personality who approaches life with great discipline. hardworking and good-humored, despite all his success, he exudes gratitude and humility. he is driven by a romanticism and an idealism founded in his youth, and by his experience of american capitalism and a globe-trotting lifestyle. he has always managed his own work, not engaging with dealers, and handling commissions personally through his studio. he has likened himself to a "cultural colonialist" who uses materials, that are locally sourced throughout the world, but for china, he is a "cultural ambassador," a foremost member of the distinguished art diaspora that has brought credibility and vitality to the contemporary chinese cultural scene.

conclusion: the career overview of gu wenda's output presented at the united art museum is exciting, invigorating, and enthralling. his passion for creating works of art that engage society by confronting taboos,

來說，他是一個「文化大使」，也是傑出的藝術僑民中最重要的一員，他為當代中國文化界帶來了可信性和活力。

結語： 合美術館對谷文達藝術事業的總結是激動人心、令人振奮和引人入勝的。谷文達熱衷於通過正視禁忌來創作參與社會的藝術作品，無論是用人的頭髮製作作品，還是將 dvd 屏幕放在中國傳統書法畫的中心，都促使他向社會宣傳當代藝術的價值。他相信，當觀眾參與到他的藝術表演中時，他們會充滿熱情，並能更好地理解當代藝術。他在美國的經歷使他相信，我們正在進入一個充滿投資公共藝術機會的新紀元。谷文達一如既往地具有挑釁性和前瞻性，最近他在接受記者採訪時表示：「我的項目越來越多地使用公司平台作為贊助方，我認為這就是未來。公司與人們有一種交易關係，也與政府有一種合作關係。公司是中間人，它就像一個中介一樣」。

今天，讓我們來一起慶祝谷文達的藝術吧！我祝賀合美術館舉辦這次重要的展覽，我希望很多人能來武漢參觀，來享受並接受它所提供的一切。謝謝大家的關注！

主持人： 非常感謝 kennedy 先生，那麼接下來因為魯虹館長給我一個很重要的命令就是必須要控制時間，4 點鐘要到下面還有一個開幕式，我們下面還有 10 位左右發言的學者，所以每位發言要控制在 10 分鐘之內，希望大家控制好時間。

第一位邀請的發言人是陳孝信老師。

whether making works from human hair or placing dvd screens in the center of traditional chinese calligraphy paintings, drives him to promote the value of contemporary art to society. he believes that when his audiences participate in his art performances, they will be enthused and will better understand contemporary art. his experience in america has convinced him that we are entering a new era of opportunity for investment in public art. provocative and forward-thinking as always, he told a journalist recently, "more and more my projects use the platform of the corporation as the patron. i think this is the future. it has a marketing relationship with people and also a collaborative relationship with the government. the corporation is the intermediary, just like an agent."

let us today celebrate the art of gu wenda! my congratulations to the united art museum on this important exhibition and i hope many people will visit in wuhan to enjoy and be educated by all it has to offer. thank you all for your attention!

moderator: i would like to express my great thanks to mr. kennedy and following him we still have 10 more scholars who will present. the first scholar i will invite is professor chen xiaoxin.

陳孝信：謝謝合美術館，謝謝主持人。我主要是關注水墨領域的現代和當代進程，所以我不是全面地來評價谷文達，我是從水墨領域的現代進程和當代進程當中來關注谷文達，定位谷文達。

從這個領域上來講，谷文達首先是一個中國案例，其次才是一個完全國際化的案例，他首先是在中國語境當中的創造，然後才是在國際語境當中的創造。所以他在中國語境當中，尤其是在中國語境當中產生了廣泛而深刻的影響，並成為了一個時代的風向標和排頭兵。同時他也是水墨畫現代進程和當代進程過程當中的一塊「活化石」，從而具有了一種啟示性的意義。

剛才我說到中國水墨畫的現代進程和當代進程，一百年以來應該有五個風向標式的人物和排頭兵，他們分別是林風眠，他主要創導了「中西融匯」，而且把水墨畫影響表現引入，從而成為近百年以來水墨畫領域現代進程的第一個排頭兵，第一個風向標。第二個應該是徐悲鴻，他創造了「中西結合」，用素描和寫實引入水墨畫，寫意系統的水墨畫，從而成為了近百年以來第二個風向標和排頭兵。第三個應該是吳冠中，吳冠中在改革開放之初就倡導「抽象美」，而且他自己的藝術實踐結合了抽象藝術，所以吳冠中成為近百年以來的第三個風向標，而且他預言了「筆墨等於零」。第四個風向標應該是劉國松，劉國松 80 年代中期開始影響大陸，「他革中鋒的命」，「革毛筆的命」，對大陸影響十分廣泛，而且是巨大的。所以劉國松成了第四位風向標和排頭兵式的人物。

chen xiaoxin: i would like to thank the united art museum and the moderator. the bulk of my research focuses on the field of ink painting and the development of modern and contemporary ink art. therefore, i would like to position the work of gu wenda within the development of modern and contemporary ink.

within the territory of ink, gu wenda presents us with both a chinese and an international case for study. he first began to create within the context of china, and then in the international context. he made an extensive and profound impact especially within the chinese context and became a vanguard artist and a kind of trendsetter. at the same time, he is also a kind of "fossil" within the process of the development of modern and contemporary ink, and his works possessed a kind of revelatory meaning.

speaking of the development of chinese modern and contemporary ink painting, we've seen only five vanguard artists or "trendsetters" in the past 100 years. lin fengmian was known for leading an "integration of east and west," and introduced the influence of ink on artistic expression to become the first vanguard artist and trendsetter of the development of the ink realm in the past 100 years. the second was xu beihong who created a "combination of east and west" introducing drawing and realistic "xieshi" painting and the "xieyi" system [a system that involved freehand brushwork, bold outlines, and vivid colors], to chinese painting. he was the second vanguard, trendsetter artist of the last 100 years. the third is wu guanzhong. at the beginning of the reform and opening-up era, wu guanzhong advocated for "abstract beauty" and his own artistic practice incorporated abstract art. he was the third vanguard, trendsetter artist, and he also prophesized the concept of "pen and ink are worth nothing" [the individual elements of the painting, circles, lines, shapes etc. are worth nothing in isolation. we must consider the whole painting]. the fourth vanguard, trendsetter artist was liu guosong. liu began to influence chinese mainland in the 1980s. "he changed the fate of the vanguard and changed

我說的谷文達就是第五位風向標和排頭兵式的人物，他作為風向標和排頭兵式的人物，主要是有三大步：第一步他用傳統水墨到顛覆傳統水墨。這是第一步，第一步以實驗性的水墨為標誌，所以他是最早在大陸進行實驗水墨創作的藝術家，代表作是《遺失的王朝》。一樓有一個展廳叫藝術的故事，裏面主要陳列的就是《遺失的王朝》的這個系列作品。這個作品出現在80年代初，時間很早，80年、81年、82年、83年，這一步非常重要，打開了他後來深入進行水墨實驗的進程，這是一個重要的切口，就是實驗水墨。第二步我把它歸納為「水墨＋」，標誌性的第一件作品是86年西安美術館的一個展覽，這次歷史文獻就呈現了，它是以裝置方式出現的，他的書畫全部用裝置方式出現的，這個「水墨＋」：水墨＋裝置、水墨＋影像、水墨＋行為，我曾經把它稱之為「谷文達方式」，這個谷文達方式的第二步是「水墨＋」，「谷文達方式」產生了非常廣泛的影響。在改革開放以後的幾十年當中不斷地出現水墨＋，定位在學術上是觀念性水墨藝術。第三步水墨歸零、涅盤重生，這個作品最有代表性的一件，就是剛才這位策展人舉到的2001年完成「dna長城—聯合國」那件作品，而在水墨歸零裏面的還有很多作品，比如說基因墨、茶宣紙都應該歸入，最出色的一部作品就是涅盤重生的傑作，最後一幅大畫叫《基因風景》，《基因風景》我是第二次見到它了，第一次在上海民生館，當時一個長廊就這一件作品，這次又看到了它的完整體現，它的標誌是墨是基因墨，紙是茶宣紙，但他同時用了中國的筆墨方式來表達，這就是涅盤重生之後的水墨筆墨歸零之後的一個代表作，而且是最成功的一個代表作。

the fate of the brush." his influence on chinese mainland was both extensive and huge. he became the fourth vanguard trendsetter artist.

i speak of gu wenda as the fifth vanguard trendsetter artist. but to become this vanguard trendsetter artist there were three main steps: the first step was to use traditional ink to subvert traditional ink. his first step was marked by experimental ink and he was the earliest artist on the mainland to work with experimental ink, with iconic works such as *lost of dynasties*. on the first floor, there is a gallery that focuses on this series of works. the works appeared in the early 80s. it was quite early, 80, 81, 82, and 83. this step was really important as it would open and deepen his experimental ink practice. this was an important turning point as what he was creating was seen as experimental ink. the second step i will summarize as "ink+" the first iconic work was exhibited in a solo exhibition at the xi'an art museum in 1986. this time, the historical materials document his works in installation form. his calligraphy and painting all appear in installation form. this "ink+" is ink + installation, ink + video, and ink + performance. i once referred to it as the "gu wenda method," and the second step of the gu wenda method is "ink+." "gu wenda's method" produces a very strong impression. in the decades after the reform and opening up, ink+ continued to appear and was positioned as conceptual ink within the academic context. the third step was "taking ink back to zero" allowing it to reach nirvana and then to be reborn again. the iconic work was the one just mentioned by the curator, *united nations - dna great wall* completed in 2001, but there were many works that exemplified this concept of "taking ink back to zero." for instance genetic ink, green tea paper should all be classified as such. the most outstanding of these works was the "nirvana and rebirth" masterpiece, the large painting *dna landscape*. the second time i saw it (the first time was at the shanghai minsheng museum), there was a long corridor dedicated to only this work. this time, i saw it in its entirety. it employs the symbols of black genetic ink and the paper was xuan paper made of

這三步當中它的特點是：一是集系統性、顛覆性與創造性於一身。二是觀念先行。我考察谷文達 40 年的創作，得出了最深刻的影響就是觀念和思想一直是他真正的突破口，觀念第一、觀念先行使他迎來了這麼多優秀的成果。第三步他的格局永遠是大開大合、縱橫捭闔，不做小打小鬧的活，不爭一技之短長，整個水墨格局以「基因水墨」為出發點、為基礎的隔絕，永遠是大開大合，令人歎為觀止。所以我個人最後的結論是改革開放 40 年以來水墨之變因人而異。

黃立平：謝謝！kennedy 先生作了系統的評價，剛才孝信老師又從水墨的方面作了深刻闡述，我想從這個討論的題目說一點想法。

我走進來的時候看到今天討論寫了一個「當代藝術潮流」，怎麼來看這個題目？這裏面究竟講的是中國的當代藝術的潮流，還是講的世界的當代藝術的潮流？那麼這兩者有甚麼樣的異同？我注意到甘迺迪先生在做系統評介時指出過，谷先生到了美國以後，民族身份曾經給他帶來某些困擾。那麼我的理解，如果說從一個具有這種民族身份的藝術家而言，那麼這種身份對他的成就究竟是一個甚麼關係？這應該是一個比較重要的研究方向。那麼毫無疑問特別是在 80 年代，如何去看待中國傳統？包括如何在中國傳統中找到某些新的藝術發展的方向，

tea, but at the same time, it used chinese ink painting as a language of expression. this is the iconic work that represents ink returning to zero, reaching nirvana and then being reincarnated. it is the most successful and representative work of this category. amongst these three steps, they can be described as: a systematic approach, a conquering attitude, and boundless creativity all wrapped up in one. second, it was a forerunner in conceptual art. in examining 40 years of gu wenda's creations, i get the deepest impressions from his concepts and ideas. he is always finding different means to breakthrough. first, in terms of concepts, he has produced many excellent results. in terms of the third step, his structure is always wide open and epic yet focused on small details; he does not work in dribs and drabs, but beyond the indisputable strengths and weaknesses of his skill, he uses genetic ink as a starting point for the whole structure of the painting, and on the basis of this isolation, he will always have a very free and easy flow of ideas, which is the reason why he is hailed as a superior artist. so, my conclusion is that 40 years after the reform and opening-up, the causes of change in the realm of ink vary greatly from person to person.

huang liping: thank you! mr. kennedy provided us with a systematic analysis and just now chen xiaoxin has offered us a deep exploration of the aspect of ink art in his work. now, i would like to say a few thoughts about the theme of this discussion.

when i came in today and saw that the discussion topic was written as "trends in contemporary art," i thought how should we approach this topic? will we discuss chinese contemporary art trends or international contemporary art trends? and what are the similarities and differences between the two? i noticed that mr. kennedy offered a systematic survey of mr. gu's experience abroad after he arrived in the us. his national identity had once caused him many difficulties. my understanding of this is, if we assume that there is an artist who possesses this kind of national identity, then what kind of relationship does this identity have upon

谷先生的成功是由此而來，顯然在美國他的新的藝術發展也是從此發端的，如果沒有這個民族身份，反而難以想像。所以從某種意義上講，中國意義的當代藝術，恐怕離不開傳統的基因。剛才看到陳老師從水墨角度的分析，即便在一個國際化的過程之中，包括以毛髮為材料做的很多作品，以茶葉為材料做的新的媒介，其實都帶有中國傳統文化的痕跡，那麼這種身份與其說無法擺脫，還不如說它本身就是一個藝術家的一個價值所在，當然我們看到了一些作品，包括用毛髮為材料做的《聯合國》，包括用胎盤做的一些生物材料的藝術作品等等，似乎有超越民族性的這樣一種努力，似乎在尋求某種國際性的或者是人類共同的語境。但是這種語境是否谷先生在海外生活、國際化生存的 32 年中佔據主流，這個也是一個值得去研究的方向。

總之，我的觀點是兩個：一是他的藝術創作的全部歷程，主要的文化基礎仍然是中國傳統的基因。二是在海外的藝術生涯中，他是比較系統地融入到西方的藝術語境之中，將不同的文明能夠無縫地連接，形成了新的看待世界的方式，這一點在 80 年代到海外去學習包括創作的很多藝術家，他們走了不同的路，這個不同的路的原因是否跟他們理解中國傳統的角度、深度有直接的關係，這也是我一直感興趣的，我的觀點是認為，是傳統造就了他，是方法提升了傳統。謝謝！

his accomplishments or success? this is a relatively important research question. then without question, especially in the 1980s, how should we view chinese tradition. how to find new trajectories of development within chinese tradition? this is the source of mr. gu's success. the new developments in his work also originated from this source. if there was no sense of national identity it would be hard to imagine this outcome. in a sense, the meaning of chinese contemporary art can never be separated from its dna. professor chen xiaoxin approached his analysis through the angle of ink art, but in the process of his internationalization [of ink art], gu wenda included the use of hair and tea leaves in many works whereby he produced new mediums. yet all of these new mediums bore the traces of chinese traditional culture, in a sense, there was no way for him to break free, or perhaps it's better to say that this is precisely wherein the value of the artist lies. of course, we have seen some works, including the *united nations* work which is made out of hair, and works that use biological materials such as placenta, which diligently strive to transcend nationality, and seem to be looking for a kind of international or humanistic context. is it not this context that has occupied the mainstream of mr. gu's life abroad, an international existence that spanned 32 years? this if, of course, also a topic which warrants more research.

to sum up, i have two points: throughout the course of his artistic practice, his cultural foundation has always been based on chinese dna. the second is that during his career abroad, he systematically worked himself into the western artistic context, seamlessly linking different civilizations together, to form a new way of looking at the world. in regards to this, many of the chinese artists who went abroad in the 80s to study or create work tended to take different paths; this was mediated by their different approaches towards and the depth of their understanding of chinese traditional culture. this is a topic that has always fascinated me. my opinion is that gu wenda was the product of tradition, but at the same time, it was his method which has elevated tradition. thanks-you!

主持人：謝謝黃館長簡明扼要，同時又很深刻的評論。第三位發言的專家我們邀請孫振華老師。

孫振華：各位下午好！34 年前谷文達曾經有作品在武漢展覽過，大概是 85 年的下半年，那個時候我正好準備考浙江美院的研究生，當時華師有一個畫畫的左正堯跟我說，他說你要到浙江美院，那個時候還不叫中國美院，你要到浙江美院，你一定要去看美術展覽館，後來被拆了的中蘇友誼展覽館，他說這個展覽館要看看中國畫邀請展，這裏面有一個谷文達非常厲害，你要是能夠考取浙江美院，那麼你一定以後要關注這個人，我就被他拉去看了，看了當時很震撼，他那批作品就相當於這個展覽中間第三展廳 80 年代那些作品，所以時隔這麼多年，我們今天又能夠在合美術館非常完整地看到谷文達的一系列作品，這其實應該對於一個關注當代藝術的人，或者關注中國文化在怎麼樣跟海外來遭遇的像這樣的人是一個非常好的機會，確實很集中，我個人看了展覽以後，我有幾個感想：

第一，我很驚歎谷文達一直保持着一個很驚人的創作生命力，他一直有着文化的敏感性，不斷地在他的生命歷程中不斷有新作出世，而且他創作的作品的線索、脈絡非常清楚，這在中國當代藝術中間，也是比較少見的，一個藝術家幾十年來一以貫之的那種永不下課。其實當代藝術就像一個列車一樣，開着開着很多人上來了，很多人下去了，他就是從始發站上了車一直到現在沒有下車的藝術家。

第二，他後來出國以後，這麼多年一直在中西文化結合部

moderator: thank you director huang for that brief and concise summary of these profound remarks. the third expert speaker is professor sun zhenhua.

sun zhenhua: good afternoon everyone! 34 years ago, gu wenda once exhibited some paintings in wuhan; it was roughly in the second half of 1985. at that time, i was preparing for the graduate student exam at the zhejiang college of art. at central china normal university there was a painter called zuo zhengyao who told me, "you have to go to the zhejiang art college to the museum and see the special invitational show of chinese painting. there is an artist named gu wenda who is really exceptional. you should be able to get into the college, and then you can follow his work. go and take a look. it's really powerful." this series of works is equivalent to those works from the 80s that we see in the third gallery in this exhibition. with a time gap of so many years, it is a great opportunity to be able to see such a complete series of gu wenda's works at the united art museum, for someone who follows contemporary art and follows chinese culture, and to see the work of someone who has suffered hardships abroad. it's actually a very concentrated exhibition. after seeing this show, i had these impressions:

first, i continue to marvel at how gu wenda manages to maintain this robust creativity, with a persistent sensitivity towards culture. over the course of his life, he continuously creates new work, and the threads and veins which connect these works are always quite clear. this is not very commonly seen in chinese contemporary art: for decades many artists continue through to the end non-stop. contemporary art is like a train, that rolls on and on and some artists get on and others get off. but he got on the train at the first station and has never disembarked.

secondly, many years after he left the country to live abroad, he has continued his work in the department of integrating chinese and western culture. this is very difficult work. we all know that there are many artists

工作，這是一個很艱難的工作，我們知道後來很多人都扛不住都回來了，他一直在「刀鋒上跳舞」，他是屬於一個「在刀鋒上跳舞」的藝術家，他的作品很容易引起爭議，但是別人又會以極大地興趣來觀看他的作品、來琢磨他的作品。對西方人來講，有意思的是看到一個中國的藝術家，怎麼以中國的方式在他們的遊戲規則下、在西方的當代藝術語境中間來玩。對中國的一個藝術家來講，中國的藝術和西方究竟是一個甚麼關係？他就相當於中國當代藝術家在西方的臥底，他在那裏工作，我們其實通過他身上在很大程度上看到，中國文化在世界西方的有效性究竟是甚麼樣的？他一直以來做這個工作也是非常有意義的。

第三，他有一種堅持，他一直以來有一種堅持就是堅持水墨的精神和水墨元素，這一點是非常了不起的。中國藝術家出去的，有人評價說打中國牌，我也看見有很多人對打中國牌的說法表示同情，就是說一個中國藝術家出去，你不打中國牌你打甚麼牌呢，你只有中國牌可打，就是你在打中國牌的過程中間，有很多人拿中國文化，也有點綴式的，也有販賣式的，但是他的學術關注度一直在水墨上，這麼多年的堅持，那就是第一人，在國際藝術舞台上推介中國水墨藝術的，他是第一人，而且又是做得非常成功的一個人。所以他這一種對水墨的持續熱情，可能使中國古老的水墨藝術到現在延續至今，在國際上找到一個通道、一個渠道、一個出口，谷文達在這個過程中間，他扮演了一個很好文化使者的作用。

他的創作歷程，我個人理解他大概有四個階段：第一個階段 80 年代在國內時，那是比較反叛的，他一方面反叛傳

who couldn't hack it and had to return. he is always "dancing on the edge of the sword," and should be considered a "sword-edge dancing artist." his works often court controversy, but other people are extremely interested in his practice, and eagerly come to ponder his artworks. from the point of view of westerners, they see a chinese artist, but one which plays in the context of western contemporary art using the methods and rules of a chinese game. from the point of view of a chinese artist, what is the relationship between china and the west? he is like an undercover chinese artist in the west. he works there, and we actually see it to a large extent through him. what kind of impact does chinese culture have on the western world? this work that he has continued to carry out is very significant.

third, he has is a kind of persistence, a persistence to adhere to the spirit of ink painting and the foundational elements of the medium. this is really amazing. when chinese artists go abroad, some say that they play the "chinese card." but there are also a lot of people who show empathy to this approach of "playing of the chinese card," saying "if you don't play the chinese card then what card will you play? this is your only card." some say that that the chinese card is used as a means of "ornamentation," or say it is "peddling chinese culture," but gu's academic interests have always been focused on ink. there is only one person who has persevered for so many years. he is the first one to promote ink art on the international stage, and he is someone who has been very successful at it. so, his passion and perseverance towards ink represent a continuation of ancient chinese ink into contemporary times. he has found an international channel, a passage, and an outlet, and in this process, he has performed the function of a very important cultural emissary.

in the course of his practice, i can personally identify four stages: the first was in the 80s while working within china, which was quite rebellious. on one hand, it was a revolt against tradition, a subversion of tradition; on the other, he had a love of tradition deep within his bones.

統、顛覆傳統；另一方面他骨子裏是非常熱愛傳統、熱愛水墨，這一點不可懷疑。很古老的一句話：「我欲成全你，所以毀滅你；我愛你，所以傷害你。」我很喜歡這句話，谷文達的水墨就是這個態度，他要成全水墨，所以他要毀滅水墨，他愛水墨，所以他要傷害水墨，在 80 年代他是這個狀態，那個時候他是個人主義的。所謂的改革開放現場美術很大程度上就激發一個個人的主體意識，就是一種個人性。我後來到了浙江美院和谷文達沒有甚麼太具體的交集，他那個時候是 85 新潮的先鋒人物，那個時候我們覺得必須要讀書，所以跟他沒有甚麼交集，但是我看出他非常有個性，一些小事，比如甚麼球賽，就不按常規做的一個人。他這種個人主義的方式對水墨，顛覆鐵板一塊的水墨傳統。到海外以後，他進入了他自己說的翻譯移植的階段，這個時候他是一個文化的推介者或者翻譯者，他更多地想尋找差異，他是想尋找中國的藝術、中國的文化、中國水墨和世界文藝的那種差異性。再到後來一個階段就是所謂的生命階段，他開始用頭髮、胎盤這些做產品時，他就進入到尋找一種共同性，可能他在國外待久了，最後我們發現全人類那種普世的、一種共性的東西，那個時候他開始強調身體語言時就開始在尋找共同性，然後再到最近現在 2000 年以後，他更多的是尋找公共性，走向公共空間。比如說他的很多作品用參與式藝術和公共藝術中間的高度參與開始發生很密切的關係，這就是說在這個在展覽中也有看到，縱觀他整個歷程他很敏感，他始終把握了中國當代藝術的潮流，同時也時刻把握了西方當代藝術的潮流，在這兩點結合上他做得非常棒。謝謝！

王端廷：谷文達先生我應該是比較熟悉的，這是第三次展覽研討會，第一次在中國台灣陳孝信老師策劃的，第二

he was passionate about ink, there is no doubt about this. there is this ancient phrase: "i want to complete you; therefore, i will destroy you. i want to love you therefore i will hurt you." i like this phrase a lot and gu wenda's work adopts this kind of attitude. he wants to complete ink, so he destroys it. he loves ink so he inflicts harm upon it.

when i arrived at the zhejiang academy of art, i didn't intersect too much with gu wenda. he was a character in the 85 new wave avant-garde. he was very individualistic, not someone who followed the usual rules. this kind of individualistic approach to ink helped him subvert the monolithic tradition. after he went abroad, he entered into what he calls a period of translation and adaptation. he was a cultural promoter and a translator, but more often than not he was looking for differences and divergence, looking for differences between chinese art, chinese culture, chinese ink, and international culture. after that he entered is his so-called "life" stage, where he started using human hair, and placenta, searching for commonality. in the end, we discovered that humanity shares a certain universality, a kind of similarity, and then after 2000, he was more interested in searching out the public realm, searching out public space. a lot of his works began to develop an intimate relationship with participatory art and highly participative public art. we can see in some of these works in this exhibition and throughout the whole course of his work, he demonstrates a high level of sensitivity, always grasping the trends of chinese contemporary art and the up-to-the-moment trends of western contemporary art, combining these two points in a way which was truly excellent. thank-you!

wang duanting: i should be fairly familiar with the work of mr. gu wenda as this is the third time i have participated in a symposium on his work. the first time was in taiwan, china with a discussion organized by professor chen xiaoxin. the second time was at the shanghai minsheng museum and this is the third time. i

次是在上海民生美術館，這是第三次。我跟谷文達先生接觸很早，最早的接觸還是間接的接觸，因為當年《中國美術報》曾經報道了他在西安美院的展覽，那個展覽在中國當時的當代美術界引起了巨大反響，這次谷文達的文獻陳列裏頭還有《中國美術報》報道的報紙，當時劉驍純他以他的筆名寫了一個報道，那個展覽的報道說谷文達可以說是當今中國藝壇破壞性最大、反叛藝術最強、走得最遠的人，最遠離中國廣大藝術家群，更遠離公眾的超凡浪子。其實這句話放在 32 年後的今天，這句話仍然有效，今天的展覽是最大化的確認。我跟谷文達個人私交更多是在 90 年代，他那個時候已經在美國定居了，那個時候還沒有互聯網，我們通過書信往來，他那個時候不定期就給我寄來他展覽的報道、信息、他自己寫的一些東西，包括複印他的年表這些東西，後來他回到國內來了，主要是通過展覽活動，現在有微信，他有他的微信公眾號，經常發他寫的小說這種，他的精力真夠旺盛的。

再回到谷文達藝術自身，藝術是藝術家人生的總和，是藝術家人生和思想觀念的結晶，偉大的藝術更是藝術家所處的時代和社會的反映，也就是時代精神的表達，谷文達的藝術跟中國的改革開放的當代歷史密切相關，如果沒有改革開放的話就不可能有谷文達，谷文達的藝術觀念來自於我們同時代的西方的後現代和當代藝術這個觀念，主要是觀念主義。剛才策展人 kennedy 先生也講到，對於中國當代藝術來說、對於世界當代藝術來說，觀念主義是一個非常重要的概念，觀念主義是一個大概念，觀念主義裏頭還有一些小概念，比如說解構主義，中國當代藝術家包括谷文達、徐冰、蔡國強這些傑出的藝術家都受過於這一種觀念，當年的徐悲鴻、林風眠他們都是那個時

met gu wenda fairly early on. at the time, *art news china* had reported that his exhibition at the xi'an art gallery, had sent huge reverberations through contemporary art in china. we can see that copy of art news china in the archival section of this exhibition. liu shaochun had written the article under a pen name. we can say that he was the strongest most rebellious artist and the person who went the furthest in destroying the altar of contemporary art, thus putting a great distance between himself and the huge crowd of chinese contemporary artists. he also cut a great distance from the public and was the extraordinary prodigal son. these words still have great meaning today, 32 years later and this exhibition bears witness to this fact. my personal communications with gu wenda began in the 90s when he was already living in the us. he would often send letters to me, occasionally sending me reports about his exhibitions, his news, his own writings, and photocopies of his personal timeline of yearly events. later we often met at exhibitions, and now i hear from him through wechat, on his wechat channel which publishes his stories. it seems he is not lacking in energy or exuberance.

going back to gu wenda himself, art is everything in the life of an artist. it is the crystallization of the artist's life, ideas, and concepts. great art reflects the era and the society in which the artist exists and is an expression of the spirit of the times. gu wenda's art has an intimate connection with the reform and opening-up period in china's contemporary history. without the reform and opening-up, there would be no gu wenda. the concepts in gu wenda's art are derived from both modernism and the post-modernism of that era in the west, most importantly conceptualism. just now mr. kennedy also spoke of it. conceptualism was a very important concept in both chinese and international contemporary art. it is a big concept, but there are also small concepts that reside within conceptualism, for instance, deconstructionism. chinese contemporary artists including gu wenda, xu bing, and cai guoqiang, these outstanding artists have all absorbed this concept. xu beihong and lin fengmian were the cleverest artists of

代中國藝術界最聰明的人，但是那個時候沒有觀念藝術，林風眠再聰明，他也只能在架上油畫和水墨、宣紙上來進行他的藝術創造，發揮他的創造力。進入到當代藝術史期，由於有了杜尚，有了觀念藝術使得全世界的藝術家有了一種新的表達方式，谷文達的藝術是中國改革開放以來 40 多年來，中國當代藝術的代表性的成果之一。總的來講，他是以解構的手段達到建構的目的，他從水墨起步，他以反叛傳統水墨作為起點，但是達到了拓展水墨邊界的這麼一個目的。

谷文達在國際上和在國內，實際上是有兩種視野，實際上在谷文達在國際學術視野中，他主要被關注的創作還是他的《聯合國》人髮裝置，在這次展覽文獻部分裏頭，有新世紀以來國際學術界、西方的學者書寫的當代藝術的著作，那裏頭所介紹的谷文達的作品，主要是人髮裝置系列，包括我自己翻譯有一本書叫做《當代藝術》，這個裏頭也介紹了中國當代藝術家，比如說徐冰、王廣義，其中也有一個谷文達，這裏頭講到了一個故事：1996 年世界各國的當代藝術家在斯德哥爾摩舉辦的一個國際叫做情景（音）的展覽中的一個著名事件，當時這個展覽匯聚了一群本來以為能夠相互協作的瑞典和俄羅斯年輕藝術家，在展覽的舉辦過程中，又陸續地增加了一些其他國家的藝術家，谷文達在沒有參照任何藝術作品的前提下，創作了一個人類頭髮裝置的隧道，在作品展出的首日，俄羅斯行為藝術家亞歷山大·勃蘭耐爾，就用一把大砍刀將這個作品砍成碎片，而且這個時候報警了，警察也來了，還拘捕了參展另外一個藝術家叫庫里克，因為庫里克在展覽上裝狗要咬一個小孩，不過勃蘭耐爾卻逃脫了懲罰，谷文達認為他自己作品的毀滅是達達主義觀念造成的，

their time, but there was no conceptual art at that time. no matter how clever, lin fengmian could only put oil paint on canvas and ink on xuan paper in order to display his creativity. but as we enter into contemporary art, there was duchamp, and artists all over the world had a new mode of expression. gu wenda's works are some of the most iconic works in the 40 years since the reform and opening-up. all in all, we can say that he uses deconstructionist means to reach a constructionist destination. he started with ink, and then rebelled against the idea of traditional ink as a starting point, to finally arrive at a position of expanding the boundaries of ink.

in the domestic and international sphere, there are two kinds of perspectives on gu wenda's work. in terms of the international academic perspective, the work which garners the most attention is the hair installation *united nations*. in the archival section of this exhibition, there are individuals from the international academic community, there are academic writings by western scholars introducing gu wenda's work since the 2000s. mostly they focus on the hair installation series. there is a book *contemporary art* which also introduces chinese contemporary artists, for instance, xu bing, wang guangyi, and amongst them gu wenda. here, there is a particular story about an exhibition of international artists in stockholm which resulted in an important event. originally the exhibition had gathered together a group of young swedish and russian artists that would jointly organize the exhibition. in the process, artists of other nationalities were added in, one after the other. gu wenda, without having consulted any of the other works created an installation which was a tunnel of human hair. on the first day of the exhibition, the russian performance artist alexander brener, used a machete to cut the work into pieces, and soon the police were called. the police came and arrested another artist named oleg kulik. because, in the exhibition, kulik was doing a performance where he was imitating a dog and bit a small child. but brener escaped punishment. gu wenda thought the destruction of his work was the result of a

是俄羅斯走向衰落與混亂的象徵。但勃蘭耐爾之所以怒火中燒，不僅由於他認為東歐藝術代表們遭到了西方策展人的不公正待遇，而且因為他們最初的理念被淡化了，演變成了一場全球化的博愛大聚會。在介紹谷文達時候同時介紹了這麼一個故事，也反映了谷文達的創作是在國際舞台上主要是人髮裝置亮相得比較多，而中國國內他的漢字，包括《唐詩後著》、最新的室外展示大型裏刻作品，這是他的水墨最新拓展，他是從水墨起步，但是超越了水墨的媒介，超越了傳統的筆墨紙硯，然後走到了裝置、影像如今的石刻，他大大地拓展了中國水墨的邊界，如果明代的董其昌復活了，他來看谷文達的這個創作，他有甚麼樣的感受，實際上他們有着相同的基因，就像谷文達老強調的基因一樣，但是這個基因變異得已經非常厲害了。我始終強調，藝術這個東西不是它的材料，甚至不是它的形象，而是它的材料和形象最後所承載的觀念，這個觀念是甚麼？對於谷文達來講，他的作品最終的觀念是人的自由和解放，這是他藝術最終的、最高的價值。

張子康：很榮幸有這個機會與大家交流，因為谷老師是我小時候很崇拜的老師，那時候我 85 年剛好上大學，也看到了谷老師的作品，後來成了特別好的一個忘年交。

谷老師是在中國當代藝術裏面是一個比較特殊的人物，雖然年紀大，仍是最重要的一個人物，個性化很強、自我意識很強的一個藝術家，我是這樣認為。

但是作為這個展覽，我剛從陸老師的展覽過來，那也是一個回顧展，所以一個活着的藝術家做這樣的回顧展時，我想有兩重意識：一是藝術家在當中充當的角色和評論家

dadaist concept, a symbol of the decline and chaos of russia. brener's rage however was the result of the fact that the eastern european artists had been unfairly treated by the western curators, and that their ideas had been watered down to suit a globalized art market and convey a concept of a "universal gathering of fraternal love." in introducing gu wenda in the concept of this story, i am reflecting on the fact that on the international stage, gu wenda's work, especially his human hair installations were often put in the spotlight. but in china, it was his chinese character works, including *post tang poetry* and his rocks wrapped with characters, these large-scale outdoor installations, which are his latest expansion of the territory of ink art. from the starting point of ink, he transcends the media of ink, pen, paper and inkstone, taking ink in the direction of installation, video and now stone carvings. so, he has, in a significant way, greatly enlarged the boundaries of ink art. i can just imagine if dong qichang from the ming dynasty could return from the dead, what kind of feeling he would have when he saw the works of gu wenda. actually, they have the same dna, but just as gu wenda is always fond of saying, the genes are the same, but these genetic mutations are quite significant.

what i've always emphasized, is that art is neither materials nor is it form, but rather it is how material and form are used to carry a concept. what is this concept? in the eyes of gu wenda, the ultimate focus is on human freedom and liberation. essentially this is where the great value of his art lies.

zhang zikang: i am very honored to have the opportunity to talk with everyone. gu wenda was a teacher whom i have very much adored since the time i was young. at that time, it was 1985 and i had just begun university. i saw gu wenda's work, and we soon enjoyed a very warm inter-generational friendship.

gu wenda is a rather unique character in chinese contemporary art. even though he is getting on in years, he is still the most important figure. his sense of

充當的角色和形成的交流互動關係是不一樣的，藝術家往往思考的，他跟藝術創作上沒有那種思考和理論家賦予他的往往是有錯的，歷史的進程就是這樣，離藝術家的距離越遠的時候，對他的誤讀越大 ，離他越遠時，越想還原到那個語境，其實他更真實，他永遠是錯位的，永遠是讓我們不可觸摸的，我在這樣一種感受當中，我想起了谷老師藝術創作的歷程，其實我在有一次對他的作品創作、跟他交流當中，其實反差很大的，這是我的一個感受。尤其是到後來，他早期的作品，他 80 年代的時候，在那個時候看到他像一個英雄人物，他的各種反叛，其實對中國文化的這種反思，是那個大文化整個的現象，那個時期不管是國畫的、油畫的，也是推動中國那一段的發展，那一段文化都是比較反思，但是他那個反思不一樣的就是他是從中國藝術、水墨、中國的傳統繪畫方面，更多產生對社會的反思。

後來他的作品，尤其到了國外以後，他進到一個國際語境以後，其實他還是對中國文化的一種思考。他是那個時期，有很長一段時間是一個思考期，因為他的環境不一樣，但是他還是對中國文化深度的思考沒有減弱，並且還加強了，這個時期他做了很多的作品，使我們看到了跟原來變化很大的作品。當然從繪畫創作形式上，從國際大的潮流的影響，比如裝置、行為藝術，其實大的當代藝術時代，這種形式跟人的互動，這是一個歷史發展，受高科技影響或者受社會整個文明發展的影響，他在形式上還是以國際化的形式。但是從語言上，他一直找到了自己的語言，他還是通過傳統的水墨語言，其實轉換是一種材料語言的轉換，還有一種對材料上的探索，他後來使用那個材料，還是沒有離開中國文化的影響。尤其是他頭髮

individuality is very strong and he is an artist with a strong self-awareness.

i think a living artist who produces a retrospective like this must have a dual consciousness: the role played by the artist and that of the critic and the kinds of relationships of interactive exchange produced are markedly different. artists are always thinking. if their art does not reflect the theories and thoughts given to them by the theorists, then it will always be problematic. this is the progress of history. when we move further away from artists, then the misunderstandings of their work become even greater and the greater the yearning is to return to that context. but the more truthful it is, the more misplaced it becomes, and it recedes further and further until it becomes untouchable. it makes me think of the course of gu wenda's creation, actually, i spoke to him one time while he was in the midst of creating works, and the contrast was quite significant. that was my feeling at least. especially later, in his early works, in the 80s, he seemed like a hero rebelling against various things, the greater cultural phenomena at that time, be it traditional chinese painting, or oil painting—they all promoted the development of china during that phase. at that time, the culture was quite interested in the concept of "re-thinking," but what was different about gu wenda is that he was interested in re-thinking aspects of chinese traditional art, ink, and chinese traditional painting. these aspects generated a sense of reflection upon society.

after his works entered into the international context, he still remained concerned with chinese culture. but then, there was a long period of time of reflection, because his environment was different, but the depth of his investigations into chinese culture never waned, rather they became more profound. at this time, he made a lot of works, works that bore a striking difference to the works which came before them. of course, from the point of view of painting form, from the influences of the major trends abroad, for instance, installation, and performance art in the great era of contemporary art,

這件作品在今日美術館展出時給我的印象，當時還是用頭髮、變形的文字，包括這種篆字。其實我們對中國文字有一個《說文解字》，對文字的解讀一直是中國文化裏面一個認知中國文化最主要的切入點，《說文解字》能夠把中國文字理解得很深。他從文字上面，我看到更多的是看不懂的文字，實際上從我的感受裏面，他用很多人的頭髮，包括各個民族的頭髮匯聚到一起，其實他有編制的看不懂的文字，又是這樣一個聯合的概念，實際有雙重的意思，怎麼讀懂一個世界？在這個時期他充滿了一種理想，還是有點烏托邦，他有一個美好理想在這裏面，這件作品對他的影響還是很大的，這件作品尤其在國內國際的反響非常重要。

後來他有更多的是關注社會的這部分，其實是他更多的行為互動，跟他自身的關注點有關係，那段時間我們見面聊得更多的是關於社會的一些問題，教育的問題、傳統文化的問題、他對現在當下的理解，他那個時期談的也是跟他的創作是連在一起的。後來見到以後，谷老師談的更多的是養生，比如水、自然、人類的生存問題，他回到了人類生命本體上，其實是在探索，這個時期我們好像看他作品時跟原來的作品的變化，每一個人對他這種作

this kind of form allowed him to interact with people. it was a historical development that was influenced by technology, and the overall development of society at that time. in terms of form, he still pursued an international form. but from the standpoint of language, he was always in search of his own language. he still used the language of traditional ink but actually converted it into a language of material transformation, or an element of materiality, employing materials, but without leaving the sphere of influence of chinese culture. especially when his hair work was shown at today art museum, at the time it gave me a really strong impression. it was hair formed into the shapes of characters, including seal scripts. for chinese characters, there is the han dynasty character dictionary shuowen jiezi. from the beginning, an understanding of chinese characters was always an important starting point in building awareness of chinese culture. shuowen jiezi allowed us to develop a profound understanding of chinese characters. from his characters, the characters themselves, there are many that i do not understand, but my feeling is that his use of hair from people of different nationalities converges and then is braided into unrecognizable characters — this is precisely the concept of being "united." but actually, there are two kinds of meanings. how to "read" this world? in this era filled with ideals, there are utopias, there are beautiful ideals within this. this work had a great impact on him and made strong reverberations both at home and abroad.

following this, there was more work that focused on society, actually, it was more a form of performance and interactivity, which intersected with the topics he was focusing on. in that phase, we saw more discussion of different social issues, for instance, education, traditional culture, and his understanding of contemporary times. but the issues he was addressing at this time also were quite linked to his creative practice. following this, we began to see gu wenda talk more about issues pertaining to health, for instance, water, nature, human existence, and returning to the noumenal existence of mankind,

品解讀不是特別一致，但是這段時期不能看成它是一件作品的概念，而是他對整個時期的思考，他的作品連接起來形成了他的作品的力量，還是比較突出的，既有社會的公共性，還有對人類生命的探索，他對未來寄予的一種希望，還有寄予一種理想，所有創造作品這些因素都給他作品起了很大的作用，尤其看到這幾年的作品，這一點比較突出，並且他也寫小說，雖然我看了這個小說，這個小說寫的跟他的藝術創作距離蠻大的，這樣一個深入的思考，他有他的知識積累才能完成的思考，當然對於他的藝術上的創作，他有驚人的創造力，他是不斷地在思考、不斷地在實驗、不斷地在探索，雖然谷老師現在已經做回顧展了，他未來的回顧展裏面有更高的里程碑，因為他的積澱在這，大家都很期望。謝謝！

徐可： 各位嘉賓，下午好！我是《藝術當代》的徐可，2001 年我們雜誌創刊的第二期刊發了一篇文章是沈語冰老師和谷文達的對話，當時谷文達先生對我們來說是一個傳說，當時那篇文章主要介紹了兩個系列，一個是他的水墨實驗有《遺失的王朝》，還有《聯合國》的系列。《遺失的王朝》是他對於水墨傳統一系列的實驗，《聯合國》更是他對於身份種族矛盾和歷史的反思，這兩個系列在方法論上，對於傳統、對於創作媒介的實驗和反叛都奠定了谷文達先生在當代藝術，不僅是中國，而且是國際當代藝術的地位，其實是不可撼動的。今天我們看到他的海報藝術這兩個字，其實後面還有四個關鍵詞，我們昨天晚上拆了半天，信仰、執着、挑戰和超越，這四個關鍵詞其實是貫穿了他創作幾十年的寫照。這幾個詞其實很帶

but actually, in exploring the changes we see in the works of this era, we find that people are not unified in their opinions of these works. despite this, we cannot see the works in this period as individual works but rather as a reflection on this whole period. taken together as a whole, the works generate a certain power, which is rather prominent and possesses a social inclusion and an element of public engagement. they are also an exploration of humankind, and with the artist also offering us possible hope for the future, providing an ideal. these so-called elements which make up his work provide a very important function, which has, especially in the past few years, gained a certain prominence. in addition to this, he also writes short stories. although what he writes is quite distant from his artistic creation, this kind of deep contemplation, and this form of knowledge accumulation, help him solidify his thoughts. of course, in his artistic creation, he still possesses a vigorous creative spirit; he is continuously thinking, experimenting, and exploring. although gu wenda has already completed a retrospective, his future retrospectives should bring the promise of further milestones. and because we have such a wealth of accumulated material here, it is an exhibition which has generated quite a lot of anticipation.

xu ke: good afternoon honored guests. i am xu ke from *the magazine art china*. in our second issue in 2001, we published an article which was a dialogue between shen yubing and gu wenda. at the time, gu wenda shared with us a legend. that particular article focused on two series, *united nations* and *lost dynasties* which was a series of experimental ink works. *united nations* was more of a historical reflection on the contradictions of gu wenda's ethnic identity. these two series, in terms of methodology, be it traditional or the experimental use of, or subversion of various mediums, all established gu wenda's position within contemporary art, not only chinese or international contemporary art. this position was unshakable. today when i saw his poster "art," these two characters, with four key words behind the characters: "faith," "conviction," "challenge," and

有上世紀 80 年代的色彩，在現在藝術界裏面已經很難見到了，這對於現在年輕人來說，可能沒有特別大的感受，對於近知天命的我來說有一點激動，因為這種理想主義的確在現在可能不多見了。剛才孫老師講，他從一開始谷老師就上車，至今還沒有下車，其實這是也說明他的這四個關鍵詞，可能一直都是他創作的一個主題或者是他的一個理念的延伸。

看這個回顧展有這樣一些感受，前面的策展人先生已經介紹得非常詳細，我也說我的幾點觀感：

第一，谷文達在創作時對文字的執着是一直貫穿始終。包括現在看到他的藝術、他的創造性的書寫，包括即使在《聯合國》的作品當中，還是有文字的符號，包括剛才策展人介紹的達特茅斯美術館英文書寫教育和廣告，其實也是他執着於對於文字，對於文字所產生的這種孤獨或者文化融合的思考。黃專先生曾經有一個評價說谷文達先生的水墨問題一直貫穿於他創作的始終，他對於母語文化和西方文化一直是持有批判的態度，並且繼續地持續性地實驗。

第二，他對於身份的考量和確認，就是《聯合國》的系列以及他的《俄狄浦斯》系列，他用生物性的媒介，包括人、人髮、兒童的胎盤、女人的經血，當時是受到了強烈的爭議。但是正是這種對於媒介的實驗和超越，當時很多猶太人看到《聯合國 —— 波蘭紀念碑》這個作品就是痛哭。他的實驗雖然有挑戰性，但是還是引起了觀眾的共鳴。

"transcend," — these four words represent his creative practice over the past decades. they seem to carry with them a tinge of the '80s, but in today's art world they are seldom seen, and may not have any particular meaning to many young people today. it's a little exciting for me, who's almost 50, because this kind of idealism is something that is not commonly seen. from boarding the train in the beginning, gu wenda has not once disembarked and this is reflected in his four keywords, which have continuously been part of his creative themes or and an extension of his philosophy.

seeing the exhibition, i had several thoughts. the curator who spoke beforehand explained in great detail and i will share a few impressions.

first, gu wenda's interest in creating characters has been a persistent theme in his practice. the writing used in his practice, particularly in the *united nations* series, uses text as a symbol. the curator who just spoke introduced the english writings, education, and advertisements at the hood museum, but his obsession is not only related to characters but a meditation on their potential for alienation and their potential for cultural fusion. mr. huang zhuan once gave an analysis of gu wenda's work saying that his use of ink bears a critical attitude towards western culture and the culture of his mother tongue. on this, he is continually and persistently experimenting.

secondly, in terms of his considerations and recognition of identity issues, works such as the *united nations* series, and "great wall" employed biological mediums including people, human hair, placenta, and menstrual blood, which were considered very controversial at the time. but in terms of this kind of experimentation and transcendence of media, at the time, a lot of jewish people who saw *united nations-poland monument* were brought to tears. within his experimentations, some of these lead to challenging works but they also had a strong resonance with the audience.

第三，他在作品形式上基本上都是鴻篇巨制。看到他的《聯合國》、《碑林》，目前他在廣場上的作品都非常巨大，他用鋪排的形式來表達他內心創作的激情。他的創作主要分三個階段，孫老師理解是四個階段，大致相同。第一個階段早年對水墨的實驗，其實是對傳統的反叛。在那個時間改革開放剛剛開始，人們對於傳統的所謂的禁錮，究其是年輕時想急於突破，他的這種反叛其實也是非常具有代表性。第二個階段他去到美國這一段時間，他主要是《聯合國》的系列，他就是對於身份，對於西方文化的一種吸收、認同，到最後還是骨子裏的批判性體現出來。第三個階段是他回國之後，大概也有十幾年了，其實是對中國傳統的反思，他在民生做的《天堂紅燈》，他用中國傳統的符號來創作的大型作品，包括現在還是文字系列，但是他的文字系列的系統可能更接近於中國的園林，包括他在他家鄉還有一個中園，他做的那個園林，雖然可能那些字、那些符號在中國人對母語的陌生化，但是他整個氣息還是中國式的。所以我們今天上午跟黃館也在討論，傳統的基因在谷文達的創作當中還是非常強烈的，雖然他一直是要作為傳統的反叛者的代表出現，但是他骨子裏傳統的基因還一直存在，像孫老師講的，他要成全傳統，首先他要毀滅它，要讓它重生。他真的是從水墨起步，但是他超越了水墨，他還是一個在當代藝術範圍當中的一個重要的藝術家代表。

thirdly, in terms of artistic form, most of his works are monumental in scale. his works *united nations* and *forest of stone steles* which we can see in the square are all very big. his extravagant works express the intense passion of his creativity. his work can be summed up in three phases. professor sun described it in four phases, but it's more or less the same.

the first phase, the earliest, was an experimental ink phase, but also a rebellion against tradition. during that phase, the reform and opening-up had just begun. young people were in a hurry to break out of the confines of tradition. this kind of rebellion was very representative of the time. in the second phase, he went to the us, and during this time the main focus was on the *united nations* series. he began to absorb ideas about identities and western culture and accepted that the critical nature which he harbored deep in his bones would eventually come out. the third phase began when he returned to china, and lasted for a few decades. it was actually a reflection on chinese culture. at the shanghai minsheng museum, his work *heavenly lanterns* employed chinese traditional symbols to make a large-scale work. even today he continues to make character-based series' but the structure or system of this works is perhaps more similar to a chinese garden, with works such as "zhong yuan". even though he may use those symbols or characters, the purpose is to create a sense of estrangement from the mother tongue for chinese-speaking viewers, yet the whole atmosphere is still very chinese in style. today, i was speaking with director huang about how the sense of traditional dna is still very strong in gu wenda's works. even though he still may want to appear as a rebel against tradition, the genetic materials of tradition still exist within his bones, just like professor sun said, he wants to make tradition whole but first he must destroy it and allow it to be reborn again. he truly began from ink, yet he transcended ink and, taking it into the realm, of contemporary art; he is a truly iconic figure.

孟堯：大家下午好！這次的展覽，谷老師的這個展覽名字叫「藝術」，這是很容易形成爭議的一個名稱，因為兩邊解釋，首先藝術是一個很大的概念，也是很難定義的概念，同時藝術又是谷文達本人一生在這裏面去經營去創作的一個領域。我剛才在聽各位老師在說時，我就想到一個詞，谷文達是一個「好大喜公」的藝術家，「大」和「公共性」恰恰是貫穿他藝術生涯的一個核心線索，他本人也是一個不斷去跨越藝術概念的藝術家。

今天這個展覽是一個回顧展，但是回顧展，今天是研討會，說的面向都有各個不同的角度，回顧展首先客觀地看待，它是重新審視一個藝術家在這麼多年創作過程中，他自己的視覺邏輯和他的觀念想法是如何建構起來、如何打造成一個個人化系統。另外回顧展不是造神的展覽，就像谷老師自己在面對東方文化和西方文化一樣，它是一個平視方式來看待一個藝術家多年的創作。

谷老師在「大」和「公」在內部有兩點，他做藝術的方法論，我自己個人的觀點基本上就八個字：「大處着眼、小處着手」，為甚麼這樣說？可能像 50 後像谷老師這一代人，個體成長的經驗、所面對的當時文化轉折的環境，跟我們這一代人，我是 80 後是有很大差別的，他是在一個沒有市場機制的，是沒有商業可能性的這種文化土壤裏面成長起來的藝術家，他經常就會面對很多宏大命題。

我們經常說谷老師是一個野心勃勃的藝術家，是一個烏托邦理想主義的藝術家。今天可能現在移動互聯網時代的土壤，不太容易產生野心勃勃的藝術家跟更大的理想主義、雄心壯志的藝術家，谷老師老師這一生的線索，給

meng yao: good afternoon everyone! the name of this exhibition by gu wenda is *art*. it's a name that very easily arouses controversy, with two interpretations. first, art is a really big concept and one which is very hard to define. at the same time, art is also the field within which gu wenda has been operating for a lifetime. just now as i was listening to the other speakers, i thought of the phrase "hao da xi gong" which describes someone desirous of grand achievements. "grand" and "public" have been central tenets throughout gu wenda's artistic career. he himself is also an artist who continuously straddles different artistic concepts.

at the talk for this retrospective, people spoke from various different angles. firstly, a retrospective is a chance to objectively observe anew the development of an artist's practice over many years, to see how his visual logic and conceptual ideas accumulate and become enmeshed into a personalized system. another thing is that a retrospective is not an exhibition aimed at deifying the artist. just like as the artist faces chinese and western culture [with a critical eye], it is a way of looking squarely at the creative output of an artist over a number of years.

in terms of the "grand" and "public" nature of gu wenda, within these two points and his methodology as an artist, i can sum up my viewpoint on it in eight characters "da chu zhuo yan xiao chu zhuo shou" which can be summarized as "realizing the big picture through focusing on small details." why do i use this phrase? maybe it's that there is a marked contrast between gu wenda and those of his 50s generation, with their individual experiences of growing up, and the transitions of that cultural environment, compared to those in our generation who grew up in the 80s. he experienced a society with no market mechanism, and no commercial possibilities, the artists who germinated in the soil of this culture frequently take on many of these grand topics.

we often say that gu wenda is an overweeningly ambitious artist or a utopian idealist. today for those who germinated in the soil of age of mobile internet, it's

我們看到一個個體英雄主義在他那個年代到今天如何變化，這個可能是這次研討會，包括這次展覽的整體呈現最引發我產生思考的點，今天的藝術越來越行業化、越來越體制化。但恰恰在這個時候我們發現個體的藝術家的個性變得越來越不那麼突顯，這也是我在做雜誌過程當中發現一個共性的我們面對的一個困境和問題，大家做的東西很多時候，可能它的同質化大於差異性，這個也是今天藝術面對的困境，尤其是對於當代藝術來說，它是建立在一個批判性跟獨立思考基礎上藝術語言或者整體的東西，谷老師的好處是在他的「大」和「公共性」訴求裏面，他實際上是把他看到的一種通約性的視覺經驗轉化到了他的個人性格當中，然後呈現一種視覺表達，他從早期在做《遺失的王朝》的時候，他的大字報書法其實就跟他經歷的中國文革以來的這種視覺傳播的個人經驗有關。但是這種視覺個人經驗又不簡單是自己個體性的，它更大的文化背景裏面，這幾十年做的東西就帶着他早年的成長經驗，不斷地在不同文化語言裏面交錯叢雜地去改革也好、調整也好，他實際上是在不停地回到他的起點的藝術家。

既然談谷老師的藝術，就不能只看到我們談了很多好，我個人也是有一些質疑，這種對於「大」、對於「公共性」的訴求，在今天藝術環境裏面，它的針對性是否還有那麼強？谷老師的創作讓我們重新思考藝術這個東西永遠是流變的，它不是一個固定點狀的，不能夠去簡單去定義的概念，他讓我們在不同時期面對藝術家作品，在面對文化和歷史的時候，他永遠能用一種異質性和用一種新的視點出現。

謝謝大家！

not common to find artists who are overweeningly ambitious, idealistic or an artist with high and lofty ideals. the thread of gu wenda's story shows us how an individualistic, heroic artist changes from that period up until now. perhaps this is a point we have been pondering due to the opinions discussed at the conference and due to the realization of the exhibition. today's artists have become more professionalized and institutionalized, and it is precisely at this time that we find that individuality is on the wane. this was a common difficulty and problem amongst artists that i observed while working as a magazine editor — homogeneity has trumped heterogeneity. this is the problem that art faces today, especially for contemporary art, where the artistic language or the artistic practice is based on a foundation of critical and independent thinking. the advantage of gu wenda's work is that between his "grand" and "public" pursuits, actually, it's that we see a kind of commensurability of visual experience which is transformed through the filter of his own personality, to produce a kind of visual expression from the earlier works such as "lost dynasties", and his method of "big-character poster" calligraphy which was a visual communication of his personal experience of the chinese cultural revolution. but this personal experience is not simply a product of his individuality, rather it carries his experience of growing up within the greater cultural context of these past decades. he is an artist that continually interlaces different kinds of cultural languages, both revolting against and adapting to them in an alternating fashion, but in reality, he never stops returning to his starting point.

since talking about gu wenda's art, i cannot help but see that we have all said many good things, but i am personally skeptical about these kinds of "grand" "public" pursuits, how pertinent are they to the current contemporary art ecology? gu wenda makes us reconsider art as this thing that is constantly in flux. it is not in a fixed state, and there is no way to define this concept. through works from different time periods, the artist forces us to confront culture and history, always

嚴虹：各位來賓，大家下午好！我是媒體人嚴虹，身為媒體人，谷文達先生是我非常關注的一位當代藝術家，谷文達先生說，每個回顧展都有一個新的篇章，呈現他近幾年正在做的事情。我用了一個上午的時間提前看了谷文達先生 40 年的回顧展，整個展陳有一條中軸線，一根脊椎骨、一段中樞神經和一個生命體結構點構成，佈展的效果非常的震撼，作品也很觸動人心，這是谷文達先生用了四個藝術故事講述了他 40 年的藝術人生，谷文達先生是一個非常會講故事的人。

我在 2014 年採訪他時，是他在 2014 年的母親節在佛山做了大型的行為藝術展，現場非常的震撼，當時下着瓢潑大雨，有 1000 個孩子跟他一起書寫孝經，當時我在現場採訪了他，他在現場的激情揮灑，完全不像是一個 60 歲的當代藝術家，他還是 85 時期叛逆的青年給我的感覺。我第二次採訪是 2015 年 8 月份，我特定飛往上海他的工作室去拜訪他，去拍攝他的一個採訪，那時候是 85 美術新潮 30 年，我們採訪 30 個當代藝術家和評論家，其中還有陳孝信老師，谷文達老師是我採訪的第一個藝術家，他用兩三個小時講述了他在 85 時期的藝術探索，呈現一個叛逆青年的叛逆精神，那樣一直給我的感覺是像青年一樣充滿激情的一個人，因為我在現場看到了他的行為書寫。

谷文達先生這次展覽用了捌個字來概括他的藝術人生，信仰、執着、超越、挑戰，這四個字是這 40 年回顧展對他最精妙的概括，我因為有幸能夠看到谷文達先生的朋友圈，我特別喜歡看他寫的自傳體的散文體小說，他在他的公眾號朋友圈每個週末都會發，像電視連續劇一樣的，

using a sense of heterogeneity, to provoke us to consider new viewpoints.

thank you very much, everyone!

yan hong: good afternoon everyone! gu wenda is an artist who i've been enthusiastically following. gu wenda says that every retrospective is a new chapter in the story of his artistic work over the past decades, and in this 40-year retrospective, we can discern a central axis, a spinal cord or primary nerve, which connect various points in the structure of his life. the effect of the installed works is very moving and the works really manage to touch people's hearts, using four stories of art to narrate 40 years of an artist's life; gu wenda is, of course, a consummate storyteller.

i interviewed gu wenda in 2014, on the day he made a large-scale piece of performance work on mother's day in foshan, which was very impressive to see on site. that day it was pouring rain and there were 1000 children writing out the classic of filial piety with him. he was passionately writing in a free and unconstrained style, completely unlike what one would expect of a 60-year-old artist. rather, he gave me the feeling of one of the rebellious young artists of the 85 new wave. the second time i interviewed him was in august 2015 when i flew to shanghai to shoot an interview with him in his studio. it was 30 years since the 85 new wave and we were interviewing 30 artists and critics. among them was also chen xiaoxin, and gu wenda was the first artist i interviewed. he spent two hours discussing his experimentations during the 85 new wave, presenting us with the rebellious spirit of a rebellious young man. he gave me the impression of a man who had never lost the passion of youth.

in this exhibition gu wenda used eight characters (four words) to summarize his artistic life: "faith," "conviction," "challenge," and "transcend," and these four concepts exquisitely express the spirit of this 40-year anniversary retrospective. i was lucky enough to catch a

谷文達先生不僅僅是一個非常有傳奇的國際當代藝術家，他還是一個很會用文字講故事的文學家，身為媒體人我一直在關注他，我也是他非常忠實的讀者，關於谷文達先生的藝術成就前面各位嘉賓已經講得非常詳盡了。在此，祝谷文達老師藝術 40 年回顧展在合美術館成功舉辦，謝謝！

魯虹：在當下中國強調對於傳統文化的繼承和轉換，已經成為大多數藝術家的共識，但是在上世紀 80 年代當時那是強調反傳統的特殊文化情景，很多藝術家並不是如此，他們更強調反傳統的價值觀。作為一個先行者，藝術家谷文達在當時不僅做了大量的相關藝術探索，也留下了非常深刻的歷史烙印，不過他跟極端和的民族主義者不同，在這個過程中，他很好地融合西方現代藝術中的比如超現實主義、新表現主義的元素，他的作品《太極圖》《超現實地平線》《靜則生靈》等等都是這個時代的代表作，他那個時候給新水墨的發展建立了新的地平線，後來水墨的發展基本上是沿着谷文達的路子在走，有的是往抽象在走，像張宇、劉子健，特別是他的漢字書法是非常早的，他影響了非常多的人，這個是有歷史為證的。

谷文達是通過西方重新發現了東方，並在相互融合的過程中再造了東方，沒有對外來文化的合理借鑒，沒有對傳統文化的再創造，他不可能為當代中國和世界當代藝術

glimpse of gu wenda's wechat feed and i've especially appreciated reading his autobiographical short stories and prose which he publishes every week on his studio wechat channel like episodes of a television show. gu wenda is not only a legendary international artist. he is also an artist who is an excellent writer of texts and teller of stories, and as a member of the media, i am always following his goings-on—a faithful reader. since the previous speakers have already discussed his work in great detail, i'll conclude by offering my sincere wishes for a successful exhibition, for this 40-year retrospective at united art museum. thank-you!

lu hong: today the emphasis on both a continuation and return to traditional culture in china has already reached a consensus amongst the majority of artists, but in the 1980s there was a cultural scene which emphasised the rejection of traditional culture, but many artists were actually not part of this wholesale rejection, they merely rejected traditional cultural values. as a pioneer, gu wenda not only conducted quite a lot of artistic experimentation, but he also left a deep impact on the history of the time. unlike the radicals and nationalists, he successfully integrated ideas from modern western art such as surrealism and neo-expressionism into his practice. his works "infinity" "surreal horizon" "wisdom comes from tranquillity" were all iconic works of that time, establishing a new horizon for new ink. following that, the evolution of ink followed the path of gu wenda, some artists veered towards the abstract, such as zhang yu and liu zijian. especially influential was his chinese character calligraphy which was quite early. he impacted many people, and this is evidenced by history.

through the west, gu wenda was able to re-discover the east and in the process of this mutual intermingling, he was able to re-build the east. but without this reference point of foreign culture, he could have not have re-created traditional culture and could not have made so many great academic contributions to both chinese and

奉獻這麼大的學術成果。當然如果他只是以水墨方式照抄西方或者照抄傳統，同樣不可能取得現有的成就。這也說明了兩點，首先傳統是創造出來的，任何抱殘守缺的方法只會使傳統走向衰落。其次在推進傳統向當代轉換過程中，一定要超越東西方對立的二元論模式，一方面要大膽學習西方當代藝術中有價值的東西並加以轉換，另一方面還要努力從傳統中尋求具有現當代的因素把它改造為全新的藝術樣式，而這一切只有在多元文化碰撞和交織中才可以做到，所以說沒有改革開放就沒有谷文達，這是肯定成立的。

1987年谷文達應邀在多倫多約克大學舉辦了首次國外的展覽，然後他就移居到了美國並成為自由的藝術家，30年來儘管身在異國，可他一直將藝術的根扎在了中國，因為無論是創作裝置作品，還是架上作品，創作的《唐詩後著》、《簡詞典》、《聯合國》等等都充分顯示了他既當代又中國，而且極具個性的特點，這是非常難得的，但是我們發現他到國外以後由於情景發生了轉化，水墨已經成為一個副線，裝置是主線，當時在海外《聯合國》，還有他做的一批關於胎盤的等等成了他的主線，這個變化到了新世紀，回到中國以後這個創作方向他又做了調整，實際我們看到現在他的創作是以新漢字水墨創作為主。從方法論來講，因為我在南方的深圳待過，他的方法論來自於中國的民間，在廣東一帶到春節時會把一些吉祥文字組合在一起，比如招財進寶、年年有餘等等把它組合成一個漢字，谷老師的方式論應該來自中國民間，他把它發展以後，他做成了自己的《簡詞典》創作了大量作品，這種方法論轉換以後，它只是在不同的媒體上轉換，有的

foreign contemporary art. of course, if he had only used ink to reproduce the west or reproduce tradition, he would not have achieved the same success. this explains two things; firstly, tradition is produced from creation, but any attempt to preserve the outmoded and cherish the outworn will only lead to the decline of a tradition. secondly, in the process of promoting tradition to shift into a contemporary mode, we will certainly be able to move past the binary modes of east and west. on one hand, we must courageously study the values of western contemporary art and transform them, on the other hand, we must look for the modern and contemporary elements with tradition and make them into a completely new artistic model. amongst this, it is the interweaving and collision typical of multiculturalism that allows us to accomplish this, so we can say that without the reform and opening-up there would be no gu wenda. this is most certainly true.

in 1987 gu wenda organized his first international exhibition at york university in toronto, before moving to the us and becoming an independent artist. and even though he lived abroad for 30 years, the roots of his art have always been planted in china. because no matter if its installation work, or paintings, works such as *post tang poetry jiancidian united nations* and others, his works fully express his personality as someone who is both contemporary and chinese, and someone with unique characteristics, which is very rare. but i discovered that after he went abroad, the situation changed. ink became a side-branch of his practice and installation became the main line. when he was abroad, his *united nations* work and his work dealing with placentas became the main focus of his practice and this change lasted until the new century. when he returned to china his creative direction took a turn. actually, speaking of his practice today, the focus seems to be the new chinese character ink works. in terms of methodology, his methodology comes from chinese folk culture. in guangdong province up until chinese new year, people will combine different auspicious characters together, for instance with the phrases like zhao cai jin

是在宣紙上寫；有的是刻在碑上；有的是刻在石頭；有的是做在霓虹燈上。但是這個方法論是很清晰的，這和他在美國時以做裝置為主，這個方向做了非常大的調整，不同的文化情景中，藝術家調整他的創作方式還是蠻有意思的。另外跟他同時的還有徐冰，徐冰其實是做漢字藝術比他要晚一些，88 年徐冰才開始做的，但是徐冰也到國外去也做裝置，徐冰的策略跟他的文化策略是不一樣的：他從 88 年開始不管做裝置還是做甚麼，漢字一直是主線，這跟谷老師的方案稍稍有點不同，是蠻有意思，這兩個藝術家是可以做對比研究。今天王廣義提議，合美術館以後可以把徐冰和谷文達兩個人在一起做一個展覽，這是一個調侃的意味，但是這兩個人確實是值得我們研究的。

謝謝大家！

主持人：非常感謝各位發言的嘉賓，特別是我們特邀的嘉賓 brian kennedy 先生，還有黃館長親自壓陣，另外還有各位評論家和媒體人，讓我們在谷文達先生的展覽開幕之前有一個預熱，是對谷文達先生藝術總體的描述或者一個梳理、一個評價。最後我們還是期待展覽的正式開幕，開幕式在 4 點半，也希望在座各位聽眾能夠繼續參加開幕式，再次感謝合美術館和谷文達工作室的邀請和預祝谷文達先生展覽圓滿成功，研討會到此結束。謝謝大家！

bao(bring in wealth and treasure), or nian nian you yu(every year have enough things to spend), these individual characters will be combined into a single character. so gu wenda's methodology likely comes from chinese folk culture. after this discovery, he transformed it into *jiancidian* a series that contains a large number of works. changing this methodology, he just applied it to different kinds of mediums, writing it on xuan paper, carving it onto stone steles, or stones, or using it to create works with neon lights. but his methodology was always very clear and this was a large adjustment from his us phase of installation work. it's very interesting watching artists adjust their creative methodology according to different cultural environments. at the same time, there was also xu bing. xu bing actually began making work with chinese characters later than gu wenda, starting in 1988. but xu bing also started to make installations when he went abroad. xu bing's strategy differed from his cultural strategy. xu bing began in '88 but whether he was making installations or other kinds of work, characters made up the main theme of his practice. this was slightly different from gu wenda's approach. it's really interesting. these two artists would make a great comparative study. today wang guangyi suggested that united art museum, should make an exhibition of gu wenda and xu bing. he said this in a tongue-in-cheek manner, but i think it's honestly worth researching.

thank you, everyone!

moderator: thank you so much to our honorable speakers, especially to brian kennedy, and also director huang for his personal support and also to the various critics and media who helped us with the lead up to gu wenda's exhibition, to tease out the details of the entirety of an artist's practice and provide an analysis. finally, we are all very much looking forward to the official opening of the show and would like to thank once more the united art museum and gu wenda studio and to wish gu wenda great success in this exhibition. the symposium will thus conclude. thank-you everyone!

嘉　賓　簡　介

GUEST PROFILE

張子康

現任中央美術學院美術館館長，教授，博士生導師，《美術館》雜誌主編。1996 年至今，主持策劃、編輯出版各類文學、藝術圖書千餘冊，多次榮獲國家級圖書獎項。

王端廷

1961 年生，湖北蘄春人，當代中國藝術評論家，西方美術史研究學者。中國藝術研究院美術研究所外國美術研究室主任，研究員。中國藝術研究院研究生院美術系教授，研究生導師。《美術觀察》雜誌編委。

孫振華

出生於湖北省荊州市。中國美術學院博士、中國美術學院雕塑系教授、博士生導師；中央美術學院客座教授、碩士研究生導師、深圳雕塑院院長。

徐可

文學碩士，上海書畫出版社副總編輯，《藝術當代》主編，雅昌藝術網 AAC 藝術中國顧問委員會成員。深耕當代藝術媒體前沿多年。

孟堯

藝術媒體人，1982 年生於安徽。2010 年碩士畢業於南京藝術學院美術學院。江蘇美術出版社《畫刊》主編、策展人。

嚴虹

嚴虹，筆名水果。作家、資深媒體人，湖北省作家協會會員。曾出版小說、散文。先後曾分別供職於多家藝術雜誌。

zhang zikang

the director of the cafa art museum, a professor and doctoral supervisor at cafa, and the editor in chief of *art museum* magazine. since 1996, he has been responsible for the planning, editing and publishing of more than 1000 volumes of various literature and art books, and has won many national book awards.

wang duanting

born in qichun county, hubei in 1961, wang duanting is a chinese contemporary art critic and a scholar of western art history. Wang duanting is the director and a fellow of the foreign art center in the arts institute of the chinese national academy of arts. he is also a professor and thesis advisor for ma students in the art department of the chinese national academy of arts and is a member of the editorial board of *art observation*.

sun zhenhua

born in jingzhou, hubei province, sun zhenzhua is a professor and thesis advisor in the sculpture department of the china academy of art. he also is a visiting professor at the china academy of fine arts, a graduate thesis advisor, and the dean of shenzhen sculpture academy.

xu ke

with a masters of arts, xu ke is the deputy editor of the shanghai fine arts publishing house, the editor in chief of *art china*, and a member of the advisory board committee of artron's art award china (aac). xu ke has been deeply involved in and at the forefront of chinese contemporary art for many years.

meng yao

a consistent member of the art media, meng yao was born in anhui in 1982, and graduated with a masters' degree from the school of fine arts at nanjing university of the arts. meng yao is a curator and the editor in chief of *art monthly*, published by jiangsu fine arts publishing house.

yan hong

who goes by the pen name "fruit" is an author, veteran media personality, and member of the hubei province writer's association. yan hong has published short stories and essays, working for a number of art magazines.

年表、研討會、後記（叁）：
後記

CHRONOLOGY, SYMPOSIUM AND POSTSCRIPT 3:
postscript

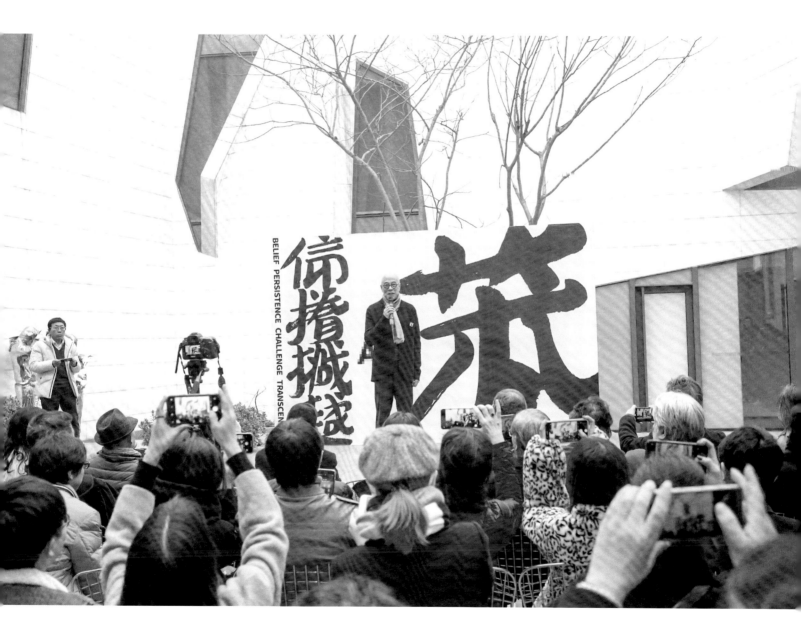

《藝術》回顧展大事記

TIMELINE OF THE RETROSPECTIVE *ART*

2017

1 月 10 日　谷文達工作室團隊至合美術館現場考察

2 月 13 日　合美術館執行館長魯虹到訪谷文達上海工作室

7 月 25 日　藝術家谷文達及團隊到合美術館現場討論展覽事宜

2019

6 月 12 日　合美術館館長黃立平、執行館長魯虹及團隊到訪谷文達上海工作室

9 月 25 日　藝術家谷文達及團隊與合美術館團隊進行現場籌備會議

11-12 月　11 月 24 日起，參展作品陸續啟運 11 月 26 日至 12 月 14 日佈展

12 月 15 日　開幕，展期為 2019 年 12 月 15 日至 2020 年 5 月 15 日

2020

1 月 21 日　合美術館第一次發佈的春節閉館通知為 1 月 22 日至 2 月 3 日

1 月 23 日　10 時起，武漢封城

1 月 28 日　合美術館第二次發佈通知繼續閉館，開館時間另行通知

6 月 20 日　合美術館發佈開館通知，6 月 23 日重新開放，展覽延期至 8 月 15 日

8 月 26 日　合美術館發佈通知，展覽延期至 9 月 13 日

9 月 11 至 17 日　撤展

2017

january 10　gu wenda'studio director took a site visit to the united art museum in wuhan

february 13　executive director of united art museum lu hong visited gu wenda'studio in shanghai

july 25　the artist gu wenda and his team arrived at united art museum to discuss the exhibition

2019

june 12　the director of united art museum huang liping, executive director lu hong and museum team visited gu wenda'studio in shanghai

september 25　the artist gu wenda and his team held the meeting on preparing the exhibition with the team of the museum on site

november 24　the artworks started to be shipped

november 26　to december 14, installation of the exhibition

december 15　the opening of exhibition, and exhibition scheduled would open from december 15th, 2019 to may 15th, 2020

2020

january 21　museum announced that the museum would be closed from january 22nd to february 3rd because of the chinese new year & spring festival

january 23　10:00 am, the lockdown of wuhan city was announced

january 28　museum made a second announcement on closing, and the reopening time was to be announced

june 20　museum announced that it would reopen on june 23rd and the exhibition extended until august 15th 2019

august 26　museum announced that the exhibition would extend until september 13th 2019

september 11 to september 17　deinstallation the exhibition

新冠疫情武漢封城之前：
2019 年 9 月底合美術館執行館長魯虹與藝術家谷文達在武漢合美術館廣場上討論《藝術》的佈展情況

before wuhan city closed for covid 19 pandemic:
executive director mr. lu hong and artist gu wenda are discussing the installation of *art* in the square of wuhan united art museum late sept. 2019

新冠疫情武漢封城之前：
2019 年 12 月初在合美術館的《藝術》佈展中

before wuhan city closed for covid 19 pandemic:
the installation of *art* at the wuhan the united art museum in early december, 2019

新冠疫情解禁後：
2020 年 6 月 23 日在武漢合美術館的《藝術》重見天日，觀眾陸陸續續前來參觀展覽

after wuhan re-opened following the lockdown:
people started to visit the united art museum. executive director mr. lu hong of the wuhan the united art museum discussing gu wenda's works with the audience late june 2020

開 啟 知 性 時 代

谷文達

THE BEGINNING OF AN INTELLIGENT ERA

gu wenda

引子……

庚子年貳月初陸，已整整壹個月了。這叁仟萬人口的遠東最大城市，都「宅」起了「禁城夢遊」；「宅」確實成了這些天之熱搜詞，「宅人」就醬紫上了億啊！

曾經是旗袍長衫交相輝映西服革履的拾里洋場，上海這個不夜城，現身說法諸葛之空城計了。fyodor dostoevsky（費奧多爾・杜斯妥也夫斯基）彼得堡之《白夜》裏的《罪與罰》，喪失父母的娜思金卡，憑夢幻邂逅房客也僅肆個夜晚的心路歷程。可以想像，這是壹整月的淪落成仟萬「靜宅謐居」的白夜空城了。

不甘淪為孤寂孤癖之「宅男」，日均行萬步開外，至庚子年叁月叁拾，步行壹佰萬步，累計捌佰餘公里。好狠，哇塞！

INTRODUCTION

it's been a whole month since february touched down in the year of gengzi (i.e. 2020) — already a whole month now. all the residents in the homes in this "forbidden city" of 30 million people, the largest in the far east, have become "sleepwalkers" and the word " 宅 "(zhaior "home") has actually become a very hot search word on the internet.

once shanghai was filled with a dazzling contrast of qipaos and cheongsams changshans (a long robe worn by men) and western shoes trotted through the bustling metropolis. old shanghai was filled with western adventurers, a city that never slept. but speaking from experience, i would say that it was more like zhuge liang and his use of the empty fort strategy (whereby the enemy is deceived into thinking that a fort is full of traps and an ambush is imminent and thus turns tail and flees). in dostoevsky's st. petersburg as depicted in the novel *white nights* and *crime and punishment*, nastenka, who has lost her mother and her father, relies on dreams to take her on an emotional journey over the course of four nights. we can see that this whole month has reduced tens of thousands of households into "tranquil homes and silent residences, " "white nights" in empty cities.

760

焦心的朋友，略帶恐懼地關心：「你在馬路上走的？」

我和「宅民」一樣怕死。在人頭攢動的「宅區」，你以為呢？在脫口罩的家中，這不就是張醫師之一句金言：家裏中招最為頻繁……郵輪告急、養老院告急、監獄告急、勞工蝸居告急、貧民窟告急、羅斯福號和戴高樂號告急了，都不是「宅居」麼？

貧困……密集……非流動……接觸！

抉擇了分析與知性，才會目明耳清。叁年前伊始，本人便無壹次出門不戴口罩了；不是先知，卻是為了自律於己，得益於他人；不放毒亦不受毒，是為我之行動準則。朋友以為我潔癖；如今呢？大眾多壹點如此想明白，想必不會再有地獄般的江漢了，不是嗎？

「宅」是壹把雙刃劍，壹刃人均素質堪憂；貳刃懶政制度缺陷；社會意識與知性普遍低迷。恐疫情爆發之萬不得已必要措舉，「封」創造奇跡，亦損失慘重。很難相信，丟了多少億，換來了多少億「宅民」？

unwilling to be a lonely eccentric "homebody," i averaged over 10000 steps a day reaching a million steps by march 30, 2020, or over 800 kilometers. such determination. wow!

some friends asked anxiously, "you were out walking on the road?"

i am just as afraid of death as the "homebodies." but these "residential communities" with people bumping into each other, what do you think? taking off masks in the home? is it not precisely the prescient remarks of dr. zhang, revealed that the disease is most often caught at home, from the critical emergency situations on cruise lines to seniors' homes, to prisons, to worker's barracks, slums, the aircraft carrier u.s.s. theodore roosevelt and the charles de gaulle aircraft carrier.

impoverished . . . dense . . . stagnant . . . contact!

only by choosing to use your powers of analysis and intellect can you see clearly and hear acutely. starting three years ago, not once did i open the door to go out without wearing a mask. it's not that i was some kind of prophet, rather it was a form of self-discipline, for the benefit of myself and others, to neither spread nor contract anything. this became a kind of code of conduct for me. my friends thought i was an obsessive germophobe, but now? people are starting to understand, and presumably, we won't see another event such as the hellish situation of jianghan district in wuhan . . . right?

"zhai" or home is a double-edged sword. one edge is that the populace has a bleak disposition; the other side is represented by the failings of the sluggish political system. social consciousness and intelligence seem to be in a slump. the last resort measure of the "lockdown" worked wonders to contain the outbreak lead to great losses. it's hard to imagine how many hundreds of millions of dollars has been lost in exchange for billions of "homebodies".

乙亥冬月貳拾那天……

2019 年 12 月 15 日的午餐，記得在武漢合美術館佈展《藝術》，壹次黃立平館長與佈展團隊晚餐，姚總和魯館一起進餐。午餐是壹大圓桌，武漢經典菜肴琳琅滿目。大家夥在《藝術》開幕之前吃到熱氣蒸騰。不要忘記那是在 2019 年 12 月 15 日，離乙亥年臘月初壹僅拾天之隔！合美術館熙熙攘攘、熱情洋溢，可謂人傑地靈，《藝術的故事》滔滔不絕，《聯合國 —— 血肉長城》裏壹仟伍佰枚實心人髮磚凝固了兩佰萬人的頭髮！」，「啊哦！這大型身體材質的藝術聚集了全武漢人口的伍分之壹，哇塞！」

此時，卻有消息傳來：武漢出現了兩例異形肺炎……

口罩 phenomenon（現象）……

就像宅 less 先生的名字，我戴口罩從嚴從密，出門必戴口罩已逾叄年，不是新冠肺炎來襲，才被動戴起方寸應急。未逾兩周之前，我仍在銀座閒暇，東瀛人面上口罩均嚴謹整潔統壹……

口罩態度未涼，壹則口罩市場動態，飛沙走石……

紹興曾是紡織業翹楚，河橋面料企卻發了疫情之爆財。「熔噴布從壹萬多元壹噸暴漲至叄拾伍萬元壹噸；無紡布也飛漲了拾幾倍！」

ON THE 20TH DAY OF THE 11TH LUNAR MONTH OF THE YIHAI YEAR

at lunch on december 15, 2019, i remember installing the show *art* at the united art museum in wuhan, and having dinner with huang liping the museum's director, and his team, director yao and curator lu. lunch was at a large round table and featured a dazzling array of classic wuhan dishes. all of our friends were tucking into the steaming dishes before the opening. do not forget this was december 15th, 2019, only ten days away from the first day of the lunar month of the year of yihai! united art museum was bustling, brimming with enthusiasm. it was, as the saying goes, a case of a fair place that produces extraordinary people. my exhibition *a story of art* poured out words in a steady flow, in *united nations—great wall of blood and flesh* there were 1500 congealed solid bricks of human hair, solidified from the hair of two million people!" "wow!" this large-scale art of bodily materials gathered a fifth of the population of wuhan, my god!"

at that time the news came out: wuhan had encountered two cases of a form of atypical pneumonia.

the mask phenomenon . . .

just like the name of mr. "zhai-less" (mr. outdoorsy), i had been wearing a dense mask three years prior to the outbreak. it was not only because of the arrival of the coronavirus, that i passively stuck on a few square inches of fabric as an emergency measure. two weeks earlier, i was in ginza on holiday, wearing my mask along with the careful and tidy japanese . . .

the attitude of mask wearers is not one of coldness, but the market for masks was in a frenzy.

shaoxing was once a pre-eminent hub of textile production, but there was an outbreak in the textile industry in heqiao. the price for meltblown fabrics surged from 10,000 rmb a ton to 35,000 a ton. the price of unwoven fabrics increased more than tenfold.

「才幾拾倍？」我裝作不以為然，有意打岔。

我進了公寓電梯，跟着的兩位喉嚨浜響，即刻令人不適；壹臉口罩歪歪扭扭，「我們正在招聘做過口罩的人……」「怎麼你做口罩啦？」「昨天淘到兩台做口罩機器，還不知道能不能做出口罩來。」「希望你能賺壹筆」。我對自己喃喃：倒楣，怪不得不靠譜的口罩伍花捌門都貼上嘴臉了！瘟疫裏還在出這樣的人「豺」。電梯總算到了他們該下的，我長舒壹口氣，心裏卻也暗暗僥倖，這兩個瘟神總算下了電梯！

我戴了叁年口罩，從未有異樣感；這次口罩真是徹底改變了我。兩個月後的壹天，精確說吧，伍天後武漢就會解封。但如何才可解封病毒侵入後的心理？今天，仕滬上 m50，網媒 vantage 來做採訪，談笑風生中暗波湧動……被病毒 bleached（浸染）後之心理狀態，會久久殘留……兩小時的採訪，不戴口罩，忽然面對捌位口罩男女，下意識地反覆掠過壹種不可言狀的抑鬱與困擾，淡淡的距離與孤寂，靜謐的驚心……

宅 less 先生之 keep walking……

早餐後，嚴嚴實實地戴好口罩；沐浴着太陽之生命力，壹路朝陽，步履在清空冷峻的大街上，冷颼颼的，沒人兒車兒的，直感覺末日了黃昏；這兒無毒無菌，是唯壹的 comfort（慰藉）。

"only ten times," i said in mock disagreement, having an inclination to interrupt.

i entered the elevator of the building, two person following talked loudly and immediately felt uncomfortable; one mask was twisted and askew, "we are currently advertising for people who know how to make masks . . .," "why are you making masks?" "yesterday i found some mask-making machines, but i am not sure if they can make masks for export." "i hope you can make some coin." i murmured to myself: "how unfortunate that all kinds of masks are stuck to our cheeks." this plague also brought out its fair share of "jackals." the elevator finally arrived at their floor and i breathed a sigh of relief. as the elevator closed its doors, i thought to myself how lucky that these plague demons had finally gotten off the elevator.

in three years of wearing a mask, i never had any unusual sensations of feelings: but this time the mask changed me in a very absolute way. two months later or let's be more precise, five days later, wuhan would open up again, but how to open up again after the virus has already invaded our consciousness? today at m50 in shanghai, the internet publication *vantage* came to interview me and while we were chatting and laughing merrily, some dark waves began to surge. after having my mental condition bleached by the virus, it was clear that this feeling would last for a while. in the two-hour interview, not wearing a mask, i was facing eight masked men and women, subconsciously again and again a sense of depression & obsession swept past me as i spoke about the distance & loneliness, a kind of quiet shock...

mr. zhai-less, keep walking . . .

after breakfast, i secure my mask tight and fast around my face; and bathe myself in the life-giving rays of the sun. facing the sun the whole journey, i walked through the empty street, noting the chilling lack of cars, and feeling that twilight brings the end of the day; here the lack of virus is the only comfort.

surprisingly while taking these 18576 steps, on the tenth day of the gengzi year, i found that this chinese new year was tinged with a chill that we've never seen before.

奇異的壹萬捌仟伍佰柒拾陸步，庚子年正月初拾，這是有生以來不一樣的「寒冷」過年。

沿陝西路直上，到了南京西路口，壹種幸福感油然而生。畢竟共和國第壹商業街，從未有過的獨享！南京西路右拐便走進了食街吳江小道；昔日門庭若市，熙熙攘攘的圖景不見了：環顧肆下，行人寥寥無幾。不在乎她了，我喃喃自說自話。小食街的盡頭的開闊地便是石「庫」門路的興業太古匯；好大壹個 pacific place（嘉里中心），春節喜氣洋洋的樂聲依然，卻也同樣空無壹人。眼下就是潤康村了，櫻花開了，錦鯉們見了我都游過來，「魚」戲弄的水聲，彷彿要告訴我，「主人，你的好年有魚！」

中午時分的靜安寺，本該是川流不息的職業人的 business lunch hour（商務午餐時間），也是燒香客爭先恐後、嘈雜紛陳之時段，現在靜寂到了聆聽我自個兒腳步聲聲和她們的空曠回音……我正走在空曠的大街上啊！

宅 less 先生，keep walking……

從北京西路進入泰興路，拾伍分鐘的步子，來到蘇州河邊。昨晚來了冷空氣，武漢下了冰雹，且雷電交加，抗疫和市民遭到莫大的困苦。一路靜悄悄的思緒，太陽知道此刻除了新冠毒，大家需要滿心歡喜的陽光普照。自北京路、泰興路至蘇州河，除去冷峻的現實，壹路乾淨到我心裏發慌，堪比東

along shaanxi road to the corner of nanjing west road, i felt a sense of happiness suddenly emerging. after all, it was the first major commercial street after the founding of the republic, yet i have never had the chance to enjoy it alone. turning right off of nanjing road, i walked towards a small alley, the wujiang road food street, which was in former times always heaving with diners and shoppers wandering about, yet today there was scant trace of this liveliness. looking around in vain i could find very few pedestrians. without caring, i muttered to myself. at the other end of the food street was a stone "storehouse" door "shikumen" style mixed-used development hkri taikoo hui. another big pacific place, which was full of joyous chinese new year music, but at the same time it was empty of people. the scene before me was of runkang cun, with cherry blossoms in bloom and the koi all swam over when they saw me. the "fish" were swishing around in the water as if teasing me saying, "master, you will have great fortune in this good year."

at noon at jing'an temple, should have seen an endless flow of professionals having business lunches, or crowds of faithful scrambling to be the first to burn incense, a noisy and frenetic time of day, but jing'an temple had become a place to listen to the sound of my own footsteps and their empty echoes through the plaza . . . i was in a completely empty street!

mr. "zhai-less," keeps walking . . .

from beijing west road, i entered taixing road, and walked for about 15 minutes, towards the edge of the suzhou creek. yesterday night the cold air came blowing in, and wuhan was assaulted by hail and lightning, causing great hardships for the citizens and those fighting the epidemic. all along the way, my train of thought quietly wandered, the sun was aware that despite the coronavirus everyone yearned for its warmth to fill their hearts full of joy. from beijing road to taixing road to the suzhou creek, if we remove the cold reality, the clean streets swept my heart — it was similar to tokyo. following the street along the river, i observed the quiet and charming scenes of the groups of buildings in the style of architecture which dominated after the reform and opening-up which were much more

京了。沿街沿河，街景靜謐美麗，改革開放後期的嶄新建築群也漂亮多了，原來人群密集的習性髒了市井。從西康路橋到到潤康樓，再從太古匯到海內外之著名 m50，壹萬壹仟伍佰步＋工作室回家，滿滿的今日壹萬伍仟步的目標圓滿實現，no more no less（剛剛好）！

沿常德路南上，沿共和國第壹商業街向東至近成都路的潤康村⋯⋯而後依原路返回。壹路從未有過的冷峻，如行走在空間站。

空曠在基本無人區的繁華南京路，我沉默的直覺，唯壹感知真切的是，人是髒的，人集聚和集居的地方⋯⋯舉城沒有意識到的，這些天裏，在大街孤獨漫步，比叁人口家裏，或稠密居住社區，或許更安全。

道理是有悖論的，這便是我每天走步的收穫⋯⋯

另類感染⋯⋯

今天是 2 月 17 日，回滬第拾伍天，阿姨小吳去了社區辦事處取了出入證，阿姨解禁了，很高興可以吃壹頓油鍋炒菜了。自 1 月 29 日到了海上禁城，也只上過壹次館子 —— 在波特曼的越南河粉鋪。沒有吃過壹盤炒菜，吃的都是懶漢的蒸煮，倒也物材之原質原汁原味。

我進嘉里中心直到壹入流的咖啡鋪，經過兩次體溫「槍擊」。映入眼簾的是服務生手指壓着杯蓋喝口

beautiful, than the scenes of people densely packed into dirty market places. from the bridge at xikang road towards the runkang building, from hkri taikoo hui to m50, a place which is renowned both at home and abroad, it was 11500 steps plus the studio to home, today's goal of 15000 steps was fully realized, no more no less!

going south along changde road, to the first commercial street in the republican period moving east towards chengdu road and runkang village . . . before returning to trace my footsteps. this journey has never before felt so cold and desolate, like walking through the international space station.

in the emptiness in the no-man's land of the normally bustling nanjing east road, my silent intuition invoked the distinct perception that people are dirty, as are the places where people gather and live together . . . but what the entire city did not realize, was that these days, a solitary walk on a big street, was a safer thing to do than to stay cramped in a home with three people, or a densely-packed residential community.

there is a certain paradox contained within this argument and this is what i discovered through my daily walks.

AN UNCONVENTIONAL INFECTION

today is february 17, the fifteenth day since i've returned to shanghai. my housekeeper xiao wu went to the district office to apply for an entry pass. housekeepers are now allowed to come in. i am happy to be able to eat a plate of stir-fried food. since arriving in the "forbidden city of shanghai" on january 29, i've only once been to a restaurant, a pho shop in the portman ritz-carlton. i've not eaten any stir-fried food, just a few dishes which i lazily boiled or steamed, which allowed me to taste the original textures, juices, and flavors of the raw materials.

i wandered into the kerry center until i found a coffee shop, encountering two "thermometer guns" along the way. my eyes were greeted with the sight of a server pressing their finger on the lid of a disposable coffee cup. how is one supposed to be

的杯杯外賣，怎麼可以放心？自從外賣發明以來，潔癖慎重的我，從未叫來外賣的⋯⋯

呿喝着的服務生：「請問要甚麼？」

「我要壹中杯美式，加熱牛奶；不要馬克杯，紙杯，不要蓋子。」

「好的」

我看到服務員摸着紙杯沿給我咖啡。我便說道：「既然你們認真，進商場量體溫，進店再量，就要衛生配套，請手指不要碰紙杯口，謝謝！」

「抱歉！好的，給你換壹杯」⋯⋯「謝謝！」

「剛才去買酒精，結賬的時候老闆問我是不是肺炎，我說不是，她說記得我是肺炎，我強調說我不是肺炎，她說報手機號就知道我是不是肺炎，是肺炎能打折，還能積分。我說：請說好你的普通話，尤其在這個時候⋯⋯是『會員』」打開手機，「肺」來壹條如此微信，讀來神情恍惚，我便回覆道：「天那！病毒能通過手機網絡傳播，柒拾餘億可都要中招了，病毒能做到嗎？」

宅 less 先生， keep walking ⋯⋯

壹路吃着冰淇淋，壹路數落着：

原來小食街吳江路上以黃色咖啡豆為 logo 的 doutor 鋪子是我常光顧的銀座流行的小咖啡連鎖

reassured by this? ever since take-out became available, i the fastidious germophobe, have never once ordered takeout. . . .

the server cried out: "what would you like?"

"i would like an americano with milk. i don't want a mug, but a paper cup and no lid."

"ok."

i saw the server touch the edge of the paper cup as she handed me the coffee. i spoke to her plainly, "since you are all very diligent, and we need to have our temperatures taken when we enter the shopping center, and then once again when we enter the shop, and you are all wearing your ppe, please be careful not to touch the rim of the cup. thanks!"

"i'm so sorry! okay, i will give you a new cup" . . . "thanks!"

"i just bought some rubbing alcohol, and as i was paying, the store owner asked me if it was pneumonia, i said, it wasn't. she said she remembered that i had pneumonia. i repeated that no, i did not have pneumonia. she said that if i gave her my mobile phone number she could check if i had pneumonia. if you have pneumonia, there is a discount, and you can earn points. i said: "please speak mandarin, especially at this time . . . i am a 'member.'" turning on my phone, i noticed a wechat message with the word (pneumonia) and read it in a state of trance and replied: "god! if this virus can be transmitted through the mobile phone network, then it will claim more than seven billion lives, can the virus do this?"

mr. zhai-less, keep walking . . .

as i walked eating my ice cream, i thought of all the examples:

the doutor shop on the wujiang lu with the yellow coffee bean logo, which was a popular coffee chain i visited while in ginza. the taikoo hui restaurants were all closed until the 9th, only jade

鋪子。興業太古匯的餐廳都關門到 9 日重開門，只有翠園燈火通明門可羅雀……

延南京西路向西回走，在波特曼的 pho 越南河粉，要來壹份牛肉河粉……不少西人，壹家子的都有，他們有些並沒戴 3M 或 N95，也許他們心裏更清楚 what has happened（發生了甚麼）……

從上海展覽中心向左兩個街口，老遠就見壹老夥計吆喝着「鳳陽燒餅，不好吃不要錢！」我的肚子似乎又餓起慌來，「要等多長時間？」不少顧客圍着爐子。「肆分鐘大概」「好，我要壹隻蔥香的」，「好嘞！」北京路西康路是個安靜美麗的街口，還能隱隱約約見着舊上海的風流餘韻。叁平方米的餅鋪，傳統爐子裏烤出來即吃，比啥麵包都好吃，「喔唷！儂看，只要肆塊洋甸。給朋友發去壹張現吃鳳陽燒餅的照片饞佬伊啦！」「嗯，當然好吃，新鮮就是最好，所以我每次南通都去買小時候吃的類似汽油桶爐子裏的燒餅，我和我媽站在爐子邊上等着買了就吃。」朋友即刻微來。「市井體驗吧，老百姓的生活都是這樣的」，「洋麵包要拾伍塊到伍拾塊不等，真沒意思」。「壹隻肆塊洋甸的燒餅，滿滿的人情味，這才 doubled（加倍了）」，「sure（當然）」……

「我秘書已經刷爆他信用卡了！去年 12 月集團就已經破產，去年壹年零玖個月都在欠薪過日子，美術館靠自己的收入在 12 月底給團隊補上的欠薪好讓大家過年……現在不能開工，叁個月美術館沒有收入，我也愁！」

garden, with its bright lights was open but the visitors were few and far between.

going back west along nanjing west road at the vietnamese pho restaurant at the portman ritz-carlton. i wanted to get a plate of beef pho, there were a lot of westerners there a whole family. there were some who were not wearing 3m or n95 masks, maybe in their hearts they were more aware of what has happened . . .

from shanghai exhibition center, going left two blocks, away, i saw an old fellow shouting, "fengyang flatbreads, if they don't taste good, no need to pay!" my stomach grumbled loudly with hunger, "how long is the wait?," as there were quite a few customers waiting around the stove. "about four minutes," "ok," "i want a scallion one," "okay!" beijing west road is a pretty corner in jing'an district, where we can still see a few traces of the lingering charm of old shanghai. a three-square-meter flatbread stall with a traditional stove baking up snacks to eat is so much better than any bread, "oh look, only four rmb a pancake. send your friends a picture of this freshly eaten pancake, you hungry guy!" "yes, of course, it's tasty. they are the best when they're fresh. so every time i go to nantong, i buy the kind of oil-barrel stove from our childhood and use it to bake the flatbreads. my mother and i would stand by the stove and wait to buy them and eat them immediately." friends would come immediately "the marketplace experience, this is what life is like for everyday people," "western-style bread ranges from 15-50rmb, and it's not all that good." "a four-rmb scallion flatbread, is full of the flavour of human goodness, this is doubled," "sure" . . .

"my secretary has already maxed out her credit card! last december the conglomerate went bankrupt, and since september employees have been living month to month. the museum has had to rely on its own income since the end of september, to give the team a salary to help them with a stipend to celebrate the new year festival . . . there is no way to start since the museum hasn't had any income for the past three months. i am also quite worried."

「經濟貧窮與精神貧困，卻戴着滯重而鈣化的 materialistic（唯物主義的）腦漿，裹在糖衣裹泡糖水裹幾代人最無用的秉性。人類和未來學家尤瓦爾・赫拉利先生《人類簡史》裹，他稱之為的『無用階級』」；「亦是美國國家安全顧問布熱津斯基先生的『奶頭樂（tittytainment）』之原型！」在共和國這幾代人裏早已徹頭徹尾地現實了。

「你壹人之力無法改變的，也只能隨波逐流，因為你改變不了別人，改變不了社會。學會生存，至少你比我們自由。」這位老同學開腔略帶着體溫。「對的，我以藝術開化人的知性」我附和着。

共和國第壹商業街上最佳廣告域取而代之了疫情裏之標語牌，可想而知「宅」了廣告背後幾拾乃至於上佰的供應商鏈呢？

到了北京西路新閘路口，買了壹個葱油餅加蛋，老長的隊等葱油餅出鍋。

「偶爾吃吃百姓的食物（人間煙火）」，朋友在微信裏寫道。

買葱油餅的已經排隊了，「總算有點生意了。這些天無人問津，生意怎麼做？唉！以前長串串排隊買我們的葱油餅」，做餅的抱怨着。

排隊買餅的大都在抱怨生意做不下去了……「可不是嗎？我這餅鋪在公廁邊走道，房租是壹萬貳壹月！」我打量了壹下，餅鋪只有伍個平米。

economic poverty and spiritual poverty, has meddled with a generation, sugar coating it and wrapping it in bubble-gum, creating useless generations with sluggish and calcified materialistic brains. a scholar of humanities and a futurist, yuval noah harari writes about this in *sapiens: a brief history of humankind*, he calls it the "useless class;" "which also follows the prototype of 'tittytainment,' as coined by former american national security advisor mr. brzezinski," a phenomena which has already been realized through and through in the people's republic of china.

"this is something that you cannot change as an individual. you can only go with the flow, because you cannot change other people or society. learn to exist, at least you have more freedom than we do," this old classmate spoke with a slight temperature, "yes. i use art to open up people's minds," i chimed in.

the best advertisements area on the no. 1 commercial street in china have been replaced by signs featuring slogans pertaining to the epidemic. one can well imagine how many hundreds of supply chains lie behind this advertisement for "zhai/home."

at the corner of beijing west road and xinzha road, i bought a scallion pancake with an egg. a long line waited for the pancakes to be brought from the wok.

"occasionally eating the food of common people (only gods need not eat food.)," a friend commented on wechat.

people have already started to line up for scallion pancakes, "finally a little bit of business. these days nobody showed any interest. how am i supposed to make a living? ai! before there were long lines to buy our pancakes," he grumbled as he continued flipping pancakes.

lining up for pancakes i saw most of the owners grumbling that there was no way to make money . . . "but that's how it is right? my stall is in an alley with a public bathroom, but the rent is 12000 rmb a month. eyeing it up, i saw that the stall was only 5 square meters.

「肯定的！說是『復工』，原料誰供應？產品誰來買？」

「大家都撐不下去了⋯⋯」在電視台《紀實人文》頻道的編導喃喃地說。

「你在馬路上走的？」

「對啊，走了壹個月零兩天了，累計叄拾玖萬步了，等於叄佰貳拾伍公里；還是要繼續走下去，所以今天又走了壹萬柒仟伍佰步，活下去⋯⋯」

我，宅 less 先生，keep walking⋯⋯

逃逸戈多⋯⋯

我不信仰任何宗教，不信仰人，我只信仰宇宙自然神。在我的思辨裏，自我不斷清明，馬克思主義的理想主義與實用主義的資本主義，平衡這兩極的是儒家的中庸之道。來到這個世界，我沒有選擇的餘地；這是我兩棲時代背景和生活經歷給予的選擇。

我近貳拾多年已不太讀書，我相信生活是真實，體驗與知性，走着瞧，mr.keep walking！

記得法國文豪普魯斯特，過於敏感性的《年華》，在純氧空間裏寫成，哮喘不治是免疫力的崩潰，還有羅曼羅蘭＆鮑伊斯⋯⋯好像我們正在爆發中的病毒⋯⋯

我呢？叄拾年不治的哮喘，移居紐約後煙消雲散，曙光初照。

"for sure! they say we are 'returning to work,' but who is producing the raw materials, and who is buying the products?"

"people can't hold on anymore. . . " the director of the tv show "humanities documentaries" muttered.

"you were walking on the road?"

"yes, it's been a month and two days, and 390000 steps, 325 kilometers; i need to keep on going, so today i walked another 17500 and still surviving . . ."

me, mr. zhai-less, must keep walking . . .

ESCAPING GODOT

i don't believe in any religion. i don't believe in any person. i only believe in the natural gods of the universe. i speculate that the self must be continuously ordered and sober, a balance between the marxist idealism and utilitarian capitalism, these two extremes represent the confucian golden mean. we are given little leeway in entering this word; these are choices given to us by the two eras which impacted our backgrounds and life experience.

these past twenty years, i've not been reading too many books. i believe that life is real, experiences&intelligence. i keep walking and looking, mr. keeps walking!

i remember the french writer proust, and his oversensitive "remembrances of things past," written in the space of pure oxygen, with a collapsed immune system and incurable asthma, and then there was romain roland, and boyce . . . it seems that we are truly in the throes of an epidemic ...

and me? with my 30 years of incurable asthma, as soon as i moved to new york, the smoke dissipated and the sun began to shine.

我一直無法理解，人們更迫切需要在疫情裏依靠歷史上的 parallels（相似之處），似乎是心理上的靈丹妙藥，曾經的災難對於今天之落難，就像煉獄彼岸的避風港與求生島。真切記述了 17 世紀黑死病流行的社會，法國加繆之《鼠疫》；英人丹尼爾‧笛福的《瘟疫年紀事》逼真地描寫了 1665 年大瘟疫襲擊下的倫敦；義大利作家曼佐尼小說《約婚夫婦》在 17 世紀米蘭暴動、叄拾年戰爭與其瘟疫之背景；在新冠病毒侵蝕中走俏的書籍，售罄並且添印。

《首都感染》更為直觀當今之疫情。高嶋哲夫的科幻長篇，故事中國某年主持世足賽，同時卻在距離賽場仟里之外的雲南邊境，流感爆發，死亡率疾速攀升，政府竭盡全力，且尚未阻止病毒傳播海外。日府應急全面疫檢，東京都內，仍然出了患者，危在旦夕，首相引爆史無前例的東京封鎖作戰……粉絲數在東瀛社交媒體上壹路飆升。

「災後文學」將在新冠病毒式微中大行其道。疫情之下，逝者冤魂不散、社會與人性羈絆，自然與人的 reorder（重新排序），新冠病毒試圖清理根源性問題等等。

「導演，請我來做你讓我主演獨幕話劇《逃逸戈多》，一直去體驗，卻沒有看到劇本和台詞，我走了好多天，我方從夢裏驚醒……忽然明白了，就是將傳統裏跑龍套的角色來演主角。除了主角的我，大家都有台詞，但我並不知道 hes & hers 會說啥，我的台詞是我現場對大家所說的立刻反應。」

i have never understood, the urgent need to rely on the historical parallels of past pandemics, as some kind of psychological panacea, the catastrophes of the past and the disasters of today, are seen as safe havens or deserted islands in the middle of a sea of purgatory. camus' *the plague* was a true account of french society during the black death in the 17th century, and daniel defoe's *a journal of the plague year*, describes in realistic detail the great plague which struck london in 1665. *the betrothed,* by italian writer alessandro manzoni is set against the backdrop of thirty years of war and plague in milan, during the insurrection in the 17th century. these books sold well during the corona epidemic and were sold out and subsequently reprinted.

the pandemic offered a more intuitive take on the epidemic. in tetsuo takashima's voluminous science fiction book, china is hosting a football competition, at the same time 1,000 miles away on the yunnan border, a pandemic breaks out. as the death toll rises, the government does its best to stop the spread of the virus overseas. despite the emergency epidemic detection system and extensive quarantine, enforced by the japanese government, there is still one patient. the japanese prime minister orders an unprecedented blockade of the tokyo streets . . . with the number of fans on social media continuously rising.

"post-disaster literature" enjoyed great popularity during the decline of the coronavirus. under the epidemic, the spirits of those who were wrongly killed do not wander, society and human feelings are constricted. the re-ordering of man and nature is occurring as coronavirus tries to clean up the roots of the problem etc.

"director, you asked me if i wanted to play the lead role in a one-act play, *escaping godot.* i went to go and experience it, yet i never saw any script or lines. i walked for many days and then awoke from my dream . . . i suddenly understood that it was the tradition of using a bit-part actor to play the main character. besides me as the main character, everyone else had lines, but i didn't know what the hes&hers were saying. my lines said on stage were absolutely situated according to the lines delivered by the other players on the live stage.

今天是貳月初捌了，叁月的第壹個周日。似乎感覺城市在復甦當兒了。

「坐滿了，有壹個帶菌的怎麼辦？」，在興業太古匯的我，從窗外向 chikalicious 甜品 café（咖啡廳）裏瞧了瞧，帶着慌亂的神情。

「你還是回家吃飯吧」。

上海寧陸陸續續在南京路上佰年鋪子沈大成外排起隊來，斜對門之上海美髮店人頭攢動，忙到不亦樂乎。我看着覺得慌張。

起初我總有點納悶，行人都出奇地乖巧，因不符大陸人之搶步習慣，我佰思不得其解；忽然今天我從我自己的行為中恍然大悟！眼睛對視着，停滯的秒殺，夾雜着壹種疑慮，空曠到了窒息……撲通撲通心跳出了喉嚨，柒上捌下，她離我仍有半個街口正朝我走來……我窺視前後，是否有車駛來，我心裏有數，也有準備，她沒戴口罩，我認出來了，她昨晚從漢口來，她是壹受新冠肺炎的感染者，上海警方正在追尋她……我的手臂上犯起了雞皮疙瘩，不敢細想中毛骨悚然。

她徑直衝着我來了，快步如飛。

空空蕩蕩的馬路，她的腳步聲踩出了壹連串的回音……

我乘馬路上壹輛救命車呼叫着飛馳而來，立刻快跑幾步穿過馬路，救命車幾乎擦身而過……我喘氣間

today is the eighth day in the second lunar month, the first sunday in march. it almost feels like the moment when the city is coming back to life.

"establishments are fully booked, but what happens if there is a carrier?," i thought with an alarmed expression, looking in at the chikalicious dessert café in taikoo hui.

"better to go and eat dinner at home."

at the 100-year-old shop nongdacheng on nanjing lu, shanghainese were continuously lining up. nongdacheng was right across from a sea of bobbing heads at the shanghai meifadian salon, which was doing a roaring business. i watched on as panic brewed in my mind.

initially, i always wondered why the pedestrians were all so surprisingly well behaved, not in the usual fast pace of mainlanders. i was baffled; but today, it suddenly dawned on me through observing my own behavior! eyes watching, a stagnant instant kill, mixed with doubt and suffocating emptiness, my heart was beating in my throat, completely unsettled. still, half a block away from me, she turned towards me . . . i looked back and forth. is there a car coming? in my heart, i knew the score and had fully prepared myself. she was not wearing a mask. i recognized her. she came last night from hankou. she was a carrier of the coronavirus. the shanghai police were looking for her . . . there were goosebumps on my arms, and i dare not think too much or else my blood would run cold.

she headed straight for me with flying steps.

on the empty road, the sounds of her footsteps left behind them a line of echoes.

on the road, an ambulance siren came roaring up and i immediately ran a few paces across the road. the ambulance almost side-swiped me . . . gasping for air, i searched back across the street and suddenly she was gone . . . again my blood ran cold a cold sweat began to form on my forehead. where did she

定睛朝馬路對過搜尋，她突然消失了……又壹次感到毛骨悚然，額頭上冒出了冷汗……她在哪裏，我就像得了新冠肺炎般感到窒息……我注目肆周：朝我走來的帶毒者，是否是我的心理幻覺？從未有過地感到人怕人了？此刻忽然感覺不好，壹位不斷咳嗽的行人從我背後擦肩而過，在我跟前忽然倒地後便紋絲不動了……我不由自主地寒戰和哆嗦起來！發愣中的我本能地飛快跑起來，壹口氣跑了近拾個街口才停下來，我瞠目結舌……

斷斷續續地對着 911 呼喊剛才有人倒地！

我匆匆忙打開手機，接着打開自拍，瞧着手機裏的我，怎麽都覺得模糊不清，神經症了……

幾輛救命車警笛聲劃破寂靜的暮色，如夢初醒的我，拖着疲憊的心到了家中……

滴零零……滴零零……嚇了我壹跳。手機驚醒了我，忙亂中打開了手機，朋友在錄音裏說：「上海寧要注意了，防疫形勢跌宕起伏，不能掉以輕心。壹大波所謂浙江在歐洲各國的愛國華僑已經潛入上海了而不是浙江，因為上海有更好的生活環境和醫療條件，後續更多的以溫州人為主的還在趕往上海的路上呢，希望這批絕大多數靠偷渡去歐洲的外籍華僑能主動到上海的居委會和社區如實申報想都不要想，他們秘密潛入上海各個角落投親靠友，正好趕上上海各個社區開始管理漸漸放鬆的時機隱匿下來，身體沒事就出來逛個街進個超市，發病

go? it was as if i was being suffocated by the coronavirus . . . i looked all around. was the carrier which was walking towards me only a hallucination? has there never been a time when people feared other people? at that moment, i suddenly felt bad. a pedestrian who would not stop coughing came from behind me and brushed my shoulder, and suddenly fell down in front of me motionless . . . i broke into involuntary shivers and still in a daze i broke into a run. and ran a full ten blocks in the space of a breath before stopping. i was dumbfounded.

i called intermittently for 911 that someone had just fallen on the ground.

i hurriedly picked up my phone and opened up the selfie function. the image i saw looking back at me looked blurry and neurotic.

the sounds of two ambulance sirens cut through the stillness of the twilight. i awoke as if from a dream, dragging my exhausted heart towards home . . .

ring . . . ring . . . jumping out of my skin. i was awoken by my mobile phone. picking up the phone, i noticed that a friend had sent a message. "shanghai people need to watch out. the challenge of epidemic prevention cannot be taken lightly. despite the ups and downs, we cannot let down our guard. a wave of so-called patriotic overseas chinese from zhejiang have come to shanghai rather than zhejiang because shanghai has a higher standard of living and better hospitals. after, there will be more wenzhounese who will set off on the road to shanghai. i hope that the majority of those overseas chinese, from europe, these foreign nationals will proactively register with their neighborhood committees and districts, rather than hiding themselves in various corners of the city with relatives or friends. it is precisely at this moment when various shanghai district and neighborhood committees have started to gradually relax their control of the situation that there is now an opportunity for these individuals to conceal themselves. if you feel fine and go out strolling, and then you go into a supermarket, then there is no way to help you if you fall ill. in any case, the government

了就兩手壹攤，反正政府包治包吃，還可以點菜，算盤打的精着呢，別指望他們會自覺居家隔離拾肆天，有這個自覺就根本不需要跑回來了，呆在義大利就可以做到，極端自私，所以現在更危險。現在歐洲回來的等同武漢回來的，你不知道社區和超市裏面擦身而過的人是不是這批人裏面的壹個，而且從這件事情來看浦東機場防控形同虛設，所以不要出門不要出門不要出門！看到新聞裏生病痊癒後遭歧視也蠻嚇人啊，這決不是以小人之心度君子之腹呀！重視起來，摒牢！」

「摒牢！」這句上海切口（俚語）很有表現力，但只有肺功能健全個寧，才「摒得牢！」可憐新冠肺重症者「摒勿牢」，只能等死。

人類之基因鏈發展已經複雜到了如此脆弱、僅要壹個錯連結便置於死地。好羨慕單細胞生物，是最完美的！

在空曠的大街上，怎麼都看不到壹個人影，我有點失魂落魄地趕回了家。接下來的幾天裏，我每天的步行，無論前面有人或有人朝我走來，我老遠就穿馬路避開。不得不說是疫情的爆發引起了心理恐慌症了。

至今沒有藥物治療的，疫苗還很遙遠。新冠肺炎患者「治癒」的，實際上是患者的免疫力抵抗所致，而住院過程中服用中藥提高了免疫力而治癒的是符合邏輯的。藥物研發的速度卻永遠比不上病毒

guarantees a cure and also food. you can even order what dishes you want. the abacus is very precise, don't count on the fact that people will stay at home in quarantine for fourteen days. with this knowledge, there is basically no need to come running back. you can do it in italy. it is extremely self-centered, and now it is more dangerous. those now coming from europe, are like those coming from wuhan. you don't know if those people you bump into in your residential community or your supermarket are from this group of people. and from this standpoint, the epidemic control methods at pudong airport are of practically no use. so don't go out. don't go out. don't go out. it is also very scary to see the discrimination against those who have gotten sick and recovered on the news. is this not gauging the heart of a person with integrity by your own corrupt and dishonest standards? pay attention, stand up and hold tight!"

"hold tight!" this shanghainese slang has a certain power of expression, but it's only with healthy functioning lungs can everyone "hold tight." those who are severely ill with coronavirus will "not hold tight," and all they can do is wait to die.

the development of human dna has become so complex and fragile that all we need is one faulty link for it to meet its death. i really envy unicellular organisms; they are the most perfect.

why do we always see our shadow on the empty street? driven to distraction i rushed back home. in the days that followed, i walked every day, no matter if there was someone in front of me or someone coming towards me, i always crossed the road to avoid them. i can't help but admit, the pandemic triggered in me a kind of psychological panic disorder.

so far there is no medicine to cure it. the vaccine is still far away. the patients of coronavirus actually cure themselves through their own immune systems. all the medicines used in the hospitals follow the logic of improving the patient's immune system. the speed at which new medications are developed can never out-pace the mutation of the virus and its rates of reproduction, and the new vaccinations and antibiotics only induced the virus' powers of mutation and survival. we waited in

變異和加快繁殖的速度；新疫苗和抗生素的使用卻誘發和促進了病毒求生變異的能力。最後等待新藥實質上變成了「等待戈多」，永遠實現不了的枉費心機。最後的堡壘和防線只剩下了每個個體自身的防疫系統 —— 免疫力。而中藥的調理人之免疫力，卻為關鍵了

我耳朵裏轟然壹聲，「你看看對面過來的行人見了你也是否避開你走到馬路對面了？」

竟然如此怕起人來，「逃逸戈多」

……

開啟知性時代……

我一直以為最好的是錢先生的《圍城》。至於《管錐編》&《談藝錄》等僅止於知識類編及工具書，而不具美學的拓展和建樹，儘管卓顯她們極為艱辛書記勞動。在民國與共和國早期，粗糙而原始的西方文明引薦，對於未脫文盲的社會，確實是壹輪明月清風般通透人心。

《圍城》與疫情說、有否仟絲萬縷？

疫情深重，網上火了。層出不窮之歇斯底里，意識形態成了壹片火海；批評、指責，甚至謾罵聲慷慨激越，良莠不齊且魚目混珠，漫天假新聞與標題黨；包括名目繁多的「紀實」日誌，我幾乎壹概不窺罷，原因是大抵出於半農耕文化與半知性，對當代國際政軍經之盲目偏執反應罷……

vain for this thing which never arrived. in the end, the line of defense and the survival of the fortress relies on the individual's immune system—immunity. but chinese medicine which tries to alter one's immune system is the key.

all of a sudden, there was a roar in my ear, "you see the pedestrian across from you who saw you coming? did they not also cross the road to avoid you?"

to go as far as to be afraid of people, "escaping godot."

...

THE BEGINNING OF THE INTELLIGENT ERA

i always thought that mr. qian's best book was *fortress besieged*. as for *limited views & on the art of poetry*, these are merely knowledge and reference books, without aesthetic explorations or contributions, even though we should acknowledge the hardship and labour of the scribes. in earlier min and the early years of the republic, these crude and primitive introductions to western civilization were for this formerly illiterate society were like a bright moon and a cool breeze blowing through the hearts of people.

are the *fortress besieged* and the pandemic inextricably linked?

as the pandemic deepened, the internet became fired up. it produced an endless stream of hysteria and ideology lit up into a sea of flames. criticism&censorship were amplified to the point of loud impassioned invective. the weeds and the seedlings became mixed up and the eyes of fish were passed off as pearls, with boundless piles of fake news and clickbait, and people publishing every kind of documentary daily journal under the sun. i barely paid attention to it. the roots of this phenomenon lie in this culture which is half-agricultural & half-intellectual, combined with a blind paranoia towards international political and military affairs.

盲目偏執反應與熱火朝天幹仗，正好比《圍城》之城裏城外兩撥人，生活在城牆壹面的現實裏，卻都拿着書本宣讀城牆另壹面的羅曼蒂克！錢先生沒有想像罷：然而兩邊的人們都各自覺得不可忍之現實水深火熱，欲望奮力推倒城牆。壹天圍城轟然坍塌，牆兩面的人們都迫不及待跑向原來城牆的另壹頭。面面相覷，不僅牆對面的「桃花源」無影無蹤，也不是甚麼「新大陸」，許久年的壹枕黃粱，頓時灰飛煙滅，頹廢 becoming pervasive（無處不在）⋯⋯

本來人性在多次運動中除了共性與絕跡私有；如今的世道矯枉過正，無論白貓黑貓，從自我與自由的意義曲解到了個性膨脹，最後墮落到了毫無底線之自私自利，迷失的個人價值觀！如今的疫情，卻給這樣的壹種人性社會似乎以更冠冕堂皇的理由，人性的危機從曲解的 independence+libration+freedom（獨立＋解放＋自由）遇到了原本壹盤散沙，新冠之疫情再雪上加霜了宅起了抑鬱、自閉和孤獨。新自由主義都已到了崩潰邊緣、經壽終正寢是遲早罷。

一位朋友轉發了警民告示，國門關了！「緊要關頭才 just arrived（姍姍來遲），上海不太平，海關吃緊，守住國門壹戰從壹天前已拉開帷幕；肆國航班壹個不漏地強制性機場臨近酒店拾肆天關緊閉。本國內航班自覺回家隔離。市府海關調兵遣將兩佰員，兵臨城下；候機室輪番加班，更有海關長高榮坤、機場海關關長無論正副，貳拾肆小時入駐候機室。市府聲明，疏漏壹位，格殺勿論！本禮拜航

this reaction of blind paranoia and these frenzied quarrels are exactly like the two groups of people living inside and outside the city walls in *fortress besieged*. those living within the reality of one side of the wall are all reading books that romanticize those on the other side of the wall. one day the besieged city collapses, and the people on either side of the wall cannot wait to run to the other side of the wall. gazing helplessly at each other, they realize that the peach blossom spring on the other side of the wall is nowhere to be seen, and there is certainly no "new world" to discover. the dream of golden millet went up in smoke and a sense of depression was becoming pervasive

originally humanity has experienced many movements, except commonality&the extinction of the private — like today when we see an overcorrection of the ways of the world, no matter if it's a black cat or white cat, from misinterpretations of the meaning of "ego," and "freedom," and finally to the expansion of individuality which has degenerated into a bottomless kind of selfishness and the loss of individual values! this kind of epidemic seems to have made human society even more highfalutin and pretentious. the crisis of humanity has been misinterpreted as an equation of independence + liberation + freedom which has caused us to entered into a state of disunity. the pandemic has been one disaster after another and the "zhai" aspect of the pandemic has brought depression, shut-in behavior, and loneliness. neoliberalism is already at the brink of collapse and will come to the end of its life sooner or later.

a friend forwarded me a notice from the police, the country has closed its doors! "a critical juncture just arrived. shanghai is not very peaceful and the customs bureau is cracking down. the war to defend the nation began a day ago. passengers from flights from four different countries will be forced into a mandatory quarantine of 14 days in a hotel near the airport. for domestic flights, passengers have the choice of quarantining at home. the municipal customs bureau dispatched 200 troops as the city is under siege. the troops have been working overtime in shifts, from customs chief gao rongkun, to the airport customs officers, from the deputies and chiefs, who have occupied the terminal 24 hours a day. the city government dictates that if one gets

班絡繹不絕，每天送來「瘟神」不下兩仟。下禮拜伊始，廣州與杭州機場將關閉，航班都需降落浦東機場，如臨大敵。

mr. 宅 less 忽然被隨之而來的逆向封城給宅住了！這壹個半月的宅 less，近陸佰公里之 keep walking，卻被宅進了城裏，近期的 activities 英特納雄耐爾 ly are all cancelled。

這或許是壹篇身臨其境之災中寫下的「災後文學」。

「經院式的『形而上』從黑格爾 post 那時已酒醒了！不是嗎？」「當地語系化和本土化之 life & living environment（生存與居住環境）至上，這才是 ʹpost-colonialʹ（後殖民時代）── ʹpost-internationalʹ（後國際時代）時代之形而上！」「ʹpost-industrialʹ 到了 ai 的第壹個字是甚麼東東？」「啊！是『人』嘛，哇塞！對了！life & living environment，壹大圈之形而上，操啥兜來兜去的，說的簡單明了，終究是生命與生存嗎？」

昨天出現叄個非常不好的事件。第壹：病毒基因突變，可導致至今藥物和疫苗研究功虧壹簣。第貳：確認病毒攻擊神經系統和各個內臟，病毒殺傷力不僅是肺，而是全面攻擊，新冠肺炎的名稱都不準確了。第叄：昨天壹輕症患者出院突然復發然後快速死亡，兩次檢查陰性出院後死亡，證明檢測可能失效，出院病人有繼續傳染病毒。綜合分析，形勢不容樂觀，大家戒備，絕不抱有僥倖心理。海外病例激增，天氣多變，人員流動增多，病毒傳播的幾率仍然非常高。

through, one will be killed on the spot. the endless stream of flights this week, has brought in over 2000 "gods of plague." starting next week both guangzhou and hangzhou airports will be closed. the flights must stop at shanghai pudong airport as if being stared down by a formidable foe.

suddenly, mr. zhai-less, in this reversed lockdown of a city was given a home. this past month, mr. zhai-less, in his 600 kilometers of "keep walking," was by the process of "zhai-ing" or "home-ing" was moved into the city. all international activities are canceled.

perhaps this is a piece of "post-catastrophe literature" written by someone present on the scene.

"the academic style 'metaphysical' character comes from hegel post, by that time i was already sober! isn't that right?" "a localized life&living environment is paramount. this is the true metaphysical 'post-colonial and 'post-international' era." in terms of "'post-industrial', what is the first character in the chinese word for ai?" "ah, well it's ren for "human"! wow! that's right! life&living environments exist within the big circle that is metaphysics, what is circulating, going back and forth, to put it simply, is it not life and survival?"

yesterday three very bad events occurred: first: the genes of the virus mutated, this could mean that the drugs and vaccines currently being researched may fail. the second: doctors have confirmed that the virus attacks the nervous system and internal organs, and is not just lethal to the lungs but a wholesale attack on the body. thus, the new coronavirus pneumonia is incorrectly named. the third: yesterday a patient with a mild case suddenly relapsed and died. the patient had tested negative twice but when he left the hospital he died. this is proof that the tests can fail and that after leaving the hospital patients can continue to carry the virus. in a comprehensive analysis, the situation is not optimistic, everyone needs to be on guard and we should never trust our luck. there has been a surge of cases overseas. the weather is unpredictable and people are moving about more — the rate of transmission is still very high.

人類以為人類總有能力最終會對過去了災難作深刻、全面而又富有前瞻性的理性分析，事與願違，這倒是合理的推測？

《狂人日記》& don·quixote（《堂吉訶德》），絕無想像到今天的貪婪和瘋狂！古訓海枯石爛，地球上的 futurists（未來主義者）相信人類可以告別死亡而 live forever（獲得永生）；佰倍於光速的東東，卻不想想，可以載幾團肉的生物生命體流浪地球，到黑洞之邊緣生存？不久改口了，說了宇宙黑洞有無邊境？縱然這些都僅僅為遐想，也真讓人肅然起敬的！自然莊稼困於雜草與蟲災，轉基因物種卻聲稱，沒有雜草，蟲也不吃；話音未落，這裏長出比莊稼還高的 super weeds（超級雜草），那兒出現了 super bugs（超級蟲子）！她們太富有生命力和免疫力了，居然使農藥和 bug killer（殺蟲劑）迷失了。愛因斯坦曾擔憂的蜜蜂滅絕了，人類只能存活柒天！愛因斯坦的驚歎之本身，是否是壹悖論呢？蜜蜂漫長的絕跡過程，是蜜蜂變異成另類「🐝」，或寄生於其他生命體中，從而再現成我們並不認識的「🐝」新生代呢？我不是專家，而只有細嚼慢咽我看到聽到之 phenomenons（現象）之後的奇思妙想？我聽着專家們歡呼霍亂和 sars 終於絕跡了！可是，如果邏輯上假設「🐝」，悖論成立，那麼病毒霍亂和 sars 似乎並沒有絕跡，卻衍生出了她們的超級後代 coronavirus！而我們幼稚的科學不可能發現她們 dna 變異密碼？我想着想着，跌入談虎色變。ayaya！壹團團肉身的人類，卻想要與天公比美。

humankind always thinks that it will have the power to do a profound, comprehensive, rich, forward-thinking, and rational analysis of catastrophes, but things often turn out the opposite of what we would like. is this not a reasonable speculation?

mad man's diary & *don quixote* could absolutely not have imagined the avarice and insanity we see today! despite the old adage "even if the seas run dry and the rocks crumble" (i.e. until the end of time), the futurists on the earth believe that humanity can bid farewell to death and live forever. they imagine things a hundred times the speed of light, but what they don't think about is whether these chunks of meat, these biological life forms which wander the earth could survive on the edge of a black hole. will they will soon change their tune and say that the black hole has no boundary? though this is still in the realm of fantasy, it is still very awe-inspiring. natural crops are plagued by weeds and pests, yet it's claimed that gmo species do not suffer from weeds and are not eaten by pests, but just as one has barely finished the sentence, super-weeds, bigger than the original crops begin to grow. and then following them are superbugs! they are full of vitality with a powerful immunity, actually, it's the pesticides and bug killers who have lost. einstein once said, that if bees went extinct, humans would only live seven days. but is einstein's statement itself not a paradox? in the long process of bee extinction, it was the bees that created species variation and different types of "🐝" or parasitized themselves with other life forms, to once again become a new and unrecognizable generation of "🐝." i am not an expert and it's only by chewing carefully and slowly digesting these phenomena that i can see and hear their curious whimsy. i heard the experts say that cholera and sars have finally been eradicated! but, if we follow the logic of the bees, it's not that sars and cholera are extinct, but rather they have evolved into a super descendant coronavirus! and our immature science has yet to discover the code which dictates the mutation of its dna. i turn pale just thinking of such a beast. oh my god! oh my god! humanity with our round fleshy bodies, yet we try to compare ourselves with the rulers of heaven.

世界瘋了，人類瘋了……．

前天病毒家族的戰績到了捌拾叁萬確診肆萬死亡！僅僅兩天之隔，已逾玖拾壹萬死亡肆萬伍仟，又隔了數日，病毒家族戰績到了貳佰伍拾萬進了煉獄，拾捌萬化作青煙。

今天統計感染數不重要了，請不要盲目機械地談論精準資料，精準計算，不存在任何實質意義。國情不同，「精準」的意義不同，資料的合目的性才是最本質的訴求，智慧的運用計算。如果以無症輕症肺炎全數，對拾叁億人口來說將會草木皆兵，醫院與醫療會被衝垮。需要根據國情，理性、知性、智慧地分析計算運用計算，和佰姓的素質等等。這就是為何中國運用計算成功，義大利運用計算失敗，不知有多少也許上了億的無症狀或輕症沒有檢測的，重要的是死亡數，更重要的是第叁波可能爆發的是東南亞與印度。東南亞和印度之後呢？還有非洲！人們乾等她們的第貳波第叁波……常態化裏隱隱約約，又孕育着壹場更狡猾毒辣的病毒風暴，山雨欲來風滿樓。

這麼多的天災人禍，多少生物從這個小球上消失了？多少 species（物種）漸行漸遠，幾近頻臨滅絕，何況更脆弱易碎之人類？天象裏，無止境的貪慾是功虧壹簣，我們不是整天科學嗎？coefficient of thermal expansion（熱脹冷縮），貪婪成性的膨脹系數就是宿命兆頭。

the world has gone crazy. humanity has lost its mind.

yesterday, the virus and its kin infected 83 million people killing 40000. in the space of two days, it infected more than 910000 with 45000 deaths. a few days later, the virus family sent 2500000 to purgatory, and 180000 were transformed into green smoke.

the case count for today is not important. please don't talk blindly about the precision of the data; the accuracy of the calculations has no inherent meaning. different countries facing different conditions have different meanings of the word precision, but the combination of different kinds of data is the most useful pursuit — an intelligent use of analysis and computation. if we count every person with no symptoms or mild symptoms then all 1.3 billion of us will find ourselves plagued with imaginary fears, and our hospitals and our health will shatter to pieces. we need to rationally, knowledgeably, and intelligently analyse the way we use data in accordance with the conditions in the country and the habits and attitudes of the people. this is why china has been successful in using data and italy has failed. who knows how many hundreds of millions of people with no symptoms or mild symptoms have not been tested? what is important is the number of deaths, and what is more important is the third wave which is erupting in southeast asia and india. and after southeast asia, there is still africa. people are willing to wait for the second wave or a third wave, then normalization seems like a vague thing on the horizon, then suddenly it gives birth to a cunning and diabolical new strain which erupts again —the rising wind foreshadowing another catastrophic storm.

so many natural and man-made catastrophes. how many creatures have disappeared from our small globe? how many species are gradually fading away? and of those which have recently faced impending extinction, which ones are more fragile than humankind? this rapacious greed that dominates the globe which will result in absolute ruin, all the want of a few dollars. are we not thoroughly scientific? the coefficient of thermal expansion and the swelling coefficient of rapacious greed seem like ominous karmic omens.

病毒的智慧遠遠走在了我們的前方，當你還未能接近，她就變了，變得你再也認不得了……

宅 less 先生，既成事實了，我們還能走多久？

從 sars 到她之新生代 coronavirus，短短數年，病毒家族旅行到了貳佰零伍個國度，人類智慧只能望洋興歎！

我，宅 less 先生， keep walking……

聯合國……

諾姆‧喬姆斯基（noam chomsky）的語言哲學的句法結構可否 multiply（應用）到社會結構上去，他的長壽與其經歷，談到的是已經變為傳統了的 n-war 與 global warming（全球變暖）已經逼近到了邊緣，他幾乎忘卻了採訪的時間在幾乎是壹場更為嚴峻之 bio-war 之刻。

齊澤克發聲：「可悲的事實，我們需要壹場災難」，「這意味着我們不能再像以前那樣壹意孤行，是時候進行根本性的變革了。」

捌拾年代末啟動的、在 new world order（新的世界秩序）下的 internationalism（國際主義）走過了肆拾年的路程。我們大致可以清晰地見證其前兩個階段；但在新冠肺炎疫情中走進了她之叄階段。壹階段導致不同文明與人種之身份危機；貳階段化身份危機於本土化 localized internationalism（本土化的國際主義）的身份重建；第叄階段分崩離析，各行其道，等待戈多……

the intelligence of the virus is far ahead of us. when you see it in front of you unable to catch up to it, suddenly it transforms into something you do not recognize.

the situation of mr. zhai-less is a fait accompli. how much further can we go?

from sars to its descendant coronavirus, only a few years have elapsed. the family lineage has spread to 105 countries. human intelligence can only occupy itself with bemoaning its insignificance.

i, mr. zhai-less, keep walking...

THE UNITED NATIONS...

can the syntactic structures of the philosophy of linguist noam chomsky be applied to social structures? in talking about his long life and experience, he discusses how we have already approached the edge of n-war and global warming, but what he forgets is that at the time that the interview was conducted an even more severe biological war was in progress.

zizek said, "the lamentable fact is that we need a catastrophe," "this implies that we can no longer obstinately insist on having our own way. at this point, it will be time for fundamental change."

we have already experienced 40 years of the internationalism of the new world order which was initiated in the late 80s. we have witnessed approximately two stages, but have entered into the third stage with the arrival of the coronavirus. the first stage resulted in a crisis of culture and ethnicity; the second stage was a reconstruction of identity crises and a localized international identity; the third stage was a complete disintegration where each followed its own path, *waiting for godot . . .*

人沒有了，資本毫無意義，一切都灰飛煙滅……

in the deepest moment of human crisis，BBC televised「the china greatest poet 杜甫」(在人類危機最深重的時刻，英國廣播公司轉播了《中國最偉大的詩人杜甫》)，杜甫不只是壹位偉大詩人，還是良知的守護者「文章千古事，得失寸心知」。新冠疫情之中，杜甫憂國憂民的詩篇，將在更廣闊的世界流傳。儘管漸行漸遠的 traditional idealism (傳統理想主義)，可能出現的分離主義，杜甫的詩會持續激發人類 realistic (切實的) 患難與共。

壹，另壹種人類大同，步履蹣跚已很久了，理想主義與烏托邦的 internationalism (國際主義)，羅曼蒂克式之專制與統治搖搖欲墜，已近乎煙消雲散，取而代之的是現實裏共同命運的人類大同。貳，可持續性發展。否則人類會在 2040 年代遇到她不能逆轉生還的大自然的逐客令，而首當其衝的是所謂對以往 developments (發展) 的亡羊補牢，面臨大自然的報復，從而規範人類之行為。

作為藝術家，我信奉自然神。浩瀚無垠的自然輪迴規則裏，地球人類的唯壹途徑是和平與融合，《聯合國》藝術計劃可謂是超驗了當下，預期了後新冠病毒時期之所需。「全主義藝術」的幾個核心理念法則：第壹，宇宙萬物無原創，只有延續、發展和輪迴；第貳，可持續性是終極美學；第叁，localized (本土化) 現實裏之大同；第肆，引導是最好的批評。核心形式意義：當代、極致、歷史、傳承。

there are no "people" and capitalism is meaningless. what's left is smoke and ashes . . .

in the deepest moment of human crisis, bbc televised "china's greatest poet, dufu." dufu is not only one of the greatest poets, but he is also a guardian of social conscience, "good writing may last a thousand years, but the heart of the author knows distinctly the ups and downs . . . amidst the coronavirus, du fu's poems show his concern for the country and the people were circulating in the world at large. despite the fading of traditional idealism and the potential of separatism, du fu consistently provides stimulation for humanity's reality, through thick and thin.

first, another kind of great harmony or perfect human society: hobbling along for quite some time now, idealism&utopian internationalism, a romantic despotism&domination tottering on the verge of collapse, has nearly vanished into smoke, replaced by this brotherhood of humanity, which in reality will share the same fate. second, sustainable development. otherwise, is it possible that by 2040 humankind will face such a blowback from nature that it will be time for the guests to be turned out from the house? first, we will bear the brunt of these developments, the consequences of locking the stable gate after the horse has already bolted, but will the revenge doled out by nature, regulate human behaviour.

as an artist, i believe in the gods of nature. in the vast and boundless natural laws of reincarnation. the only path for mankind is peace and integration. the *united nations* art project can be described as a project which transcends the present, a project which predicted the needs of a post-coronavirus condition. the central principles and concepts of "artwholeism" are as follows: first, all the creatures in the universe have no originality, there is only continuation, development, and transmigration. second, sustainability is the ultimate aesthetics. third, the ideal of a perfect society lies within a localized reality. fourth, guidance is the best form of criticism. the core formal meaning lies in: contemporaneity, perfection | history | a continuation of tradition.

僅僅叁拾年前後興盛的新 internationalism（國際主義），疾速化為傳統而壽終正寢。但與之伴隨而來的數碼世界性連結，和新冠疫情催生了嶄新的 localized 英特納雄耐爾（本土化的國際主義），現實取而代之了原來就虛設的人類大同。我們不可能，也不可以持續 traditional internationalism（傳統的國際主義），我們亦不可能重蹈 separation（分離）。

believe it or not（相信與否），後疫情時代開啟了物理上的地域主義 localization（本土化），史無前例的互聯網人類大同，是無法阻擋的「可以燎原」，除非到壹天，病毒可以先進到通過互聯網而傳播而感染！

尾聲

我無動於衷這一切啊，出於無可奈何。當時間流逝，她會告訴你相對真實的發生的故事，但那時已晚了，真實與否有何意義呢？除了挽回不了的痛楚，你再看看與時的世界，她依然覆轍同樣的故事。人世間只有兩件事：壹是人本，壹是資本。當人本為主，人命關天；當資本為重，草菅人命。平衡與和諧人本同資本，是難以完美的事兒了。當資本崇尚大自然，當資本備至人本，這才會是好的人類與社會。

4 月 18 日壹則新聞如是說，來自德國病理學家和法醫學家 prof. klaus püschel 宣佈壹個新發現：通過屍檢發現，「絕大部分死於新冠病毒的人，都是本來就不久於人世的人」。健康人不必恐懼。感染

only thirty years more or less since the arrival of a prosperous new internationalism, and tradition is now lying in its death bed, ready to meet its maker. but following these digital international linkages, and the new localized inter"net"ionalism which was born of the coronavirus epidemic. reality has superseded the original "great unity" (perfect society) of humanity, which was really just a great unity in name only. we cannot, and we can no longer sustain traditional internationalism, nor can we follow the ill-advised path of separation and isolation.

believe it or not, in post-pandemic times, a form of physical regional localization will emerge, an unprecedented great harmony of humanity on the internet, like an irresistible force or a single spark which ignites a prairie fire — unless one day, the virus can progress to the point which it can transmit the infection through the internet.

EPILOGUE

because there is no way out, i am unmoved and indifferent to everything. but as time passes, she tells you a relatively true account of what has happened. but by that time, it is too late but what is the meaning of true and false anyway? besides the irretrievable pain, if you look at time's world, she continues to follow the same path of ruin. in this world, there are only two things: one is humanism, the other is capitalism. of course, humanism is the priority — human life is of supreme importance. but when capitalism is valued above everything else, there is a disregard for human life. it's difficult to have a perfect fusion of balance&harmony&capitalism. but when capitalism can learn to hold nature in high esteem, when capital can value human life, only then can we have a good&humanistic society.

on april 18, the news reported a new discovery by german pathologist and forensic scientist prof. klaus püschel. the pathologist and forensic scientist reported that through autopsies he had discovered, that "most of the patients who died of coronavirus, were already close to death." healthy people needn't fear. for those infected by the coronavirus, the development of the disease is determined by underlying

上新冠病毒，自身攜帶之基礎病，決定病情之發展。其中之兇險詭異與深不可測，應該是昭然若揭的了。病毒或許就是大自然制約人類貪婪成性之機制。

建築界對黑川紀章先生之讚譽，莫過於他的「新陳代謝」理論，而全主義藝術（artwholeism），大有異曲同工，「基因 & 蛻變」卻更為鮮明，點明了存在與發展之本質。佛學輪迴說之宏遠，原創論之淺近。「基因 & 蛻變」無源頭亦無原創，是無限迴圈輪迴中之 continuation & extension（延續與延伸）。我們在疫情裏繼續 johnny walker（尊尼獲加）的 mr. 威士「忌」之 keep walking ……

唐宋元明清至民國與共和國，沒有壹個朝代可以拖垮這個文明；近代史上，外力亦無能為力這壹文明。曾記否，從太平天國到伍肆，造反派、改革派，當然還有顛覆派，洋洋大觀，這壹文明卻根本當你們杞人憂天而無動於衷。壹個這樣的文明，有她自身之命運邏輯、規律與進程。在人類史上，沒有像這樣壹個文明未曾死去過，但她多災多難，她或許仍將繼續災難深重，但她必將永恆……這壹文明從來就不強悍，也沒結怨家結仇敵，她的中庸，恰恰就是這個文明不會被終止和能延續的充足理由。

「我們工作室可沒有停過啊！一直持續性地發展」我頓了頓，「記得我的《藝術》回顧展開幕之刻，那是在 2019 年 12 月 15 日，離庚子年臘月初壹僅拾

conditions. among the dangerous, strange&unfathomable situation, something became abundantly clear. perhaps the virus was a mechanism of nature that emerged to restrict human greed.

the praise in the architecture world for mr. kisho kurokawa is nothing more than his theory of the metabolist movement, but artwholeism is a different approach that achieves similar results. "dna and metamorphosis" is even more distinct, illuminating the innate characteristics of existence and human development. buddhist theories of reincarnation are vast and far-reaching; theories of original creation are near and shallow. with "dna&metamorphosis," there is no original source and no original creation; it's an infinite cycle of continuation&extension. during the pandemic, we swallowed our fear bolstered by a shot of our own courage, striding with confidence like mr. johnny walker.

from the tang, song, yuan, ming, and qing up until the republican era and the communist era, no dynasty could drag this civilization down; in modern history there were no foreign powers who could suppress this civilization. do you remember from the taiping rebellion, to the may fourth movement, to the zaofanpai (rebel factions of the cultural revolution), to the reformists, to the subversives, spectacular and imposing, this civilization is not like chicken little who feared the sky was falling at every little crisis, rather she remained aloof and indifferent to the twists and turns of history. the fate of this kind of civilization is determined by its own logic, rules, and progression. in the course of human history, there has never been a civilization such as this that has never died, but which has been plagued by so many misfortunes. even though she still continues to be stricken by disasters, her power is everlasting. this civilization has never played the tough guy, and it has not ever attempted to incur hatred from enemies, it is this doctrine of the golden mean which is the reason she hasn't been snuffed out and continues to exist today.

"our studio hasn't stopped! it has always been continually developing," i paused for a minute, "remembering the opening day of *art* on december 15, 2019 only ten days from the first day

天之隔！卻在人流雲集熱情洋溢裏得知：就是那天，武漢出現了兩位患了異形肺炎⋯⋯」「我的展覽剛開講《藝術的故事》，我已經到了洛杉磯 lacma 藝術博物館做《聯合國 —— 美國密碼》主題演講和討論。助手們呢？她們在洛杉磯郡立藝術博物館卸裝《聯合國 —— 美國密碼》，並移師芝加哥，疫情蔓延裏《聯合國 —— 美國密碼》照樣伍彩繽紛，亮麗在彼岸。」

「我們又拿下了壹城，桃園市立美術館永久收藏了大地藝術儒石陣《碑林捌系 —— 先師碑》。位於曲阜碑刻工作室亦在同時竣工杭州灣新區碑林。」我沒有停歇，當人性遭遇嚴峻挑戰壹刻，藝術家應盡微薄之力，奮力疾書《簡詞典 —— 風雨同舟》捐助抗疾，這是責任之擔當，也是對疫情之回應！

順應天象巡迴，keep walking，walking in 大自然（繼續走，在大自然中行走），人工智慧遠遠比不上超級昆蟲雜草病毒 ai（人工智能），人類貪婪成性再不聽從自然的回應，2040 年時的災難就很難躲過去了！

「長壽的關鍵字是 sustainability（可持續）」

「可持續，與長壽有必然？」「也就是說，你的思維和行為均可持續了，你的身體也就會 sustainable 了⋯⋯」，「哇塞！對的，不就是如此長壽說！」

將來的人間天堂，是在那些可持續發展的，高瞻遠矚之 slow living（慢生活）的地方⋯⋯

of the gengzi year! with a stream of people enthusiastically crowding around: it was precisely that day that the first two cases of atypical pneumonia were discovered in wuhan . . .” my exhibition *a story of art* had just opened and i had just arrived at lacma in los angeles to give a keynote speech on *united nations- american code.* my assistants? they moved my work *united nations- american code* from lacma to chicago, as the outbreak spread *united nations- american code* installing it according to the same model, bright and colorful, beautiful and graceful on the opposite shore.

“we also captured another city, the taoyuan museum of fine arts, had long been collecting my land art stonehenge of *patron saint steles* forest of stone steles serise 8. situated in qufu, the stone-carving studio finished the stone steles for the hangzhou bay new zone.” i didn’t stop, but there was a moment when humanity encounters challenges and artists need to take to weibo and tweet. sparing no effort to write quickly, i donated *jianceidian-stand together* to the pandemic. this is a responsibility i assumed and also a response to the pandemic.

keeping to the habit of my celestial orbit, i continued to make the rounds, kept walking, walking in nature. human intelligence cannot compete with the ai of a superbug, superweed, or virus. if human greed does not listen to the response we’ve had from nature, it will be very difficult to avoid the impending extinction in 2040.

“the key word of longevity is sustainability.”

“but are sustainability and longevity inevitable?” “that is to say if your thoughts and behaviors sustainable on average, your body can also be sustainable . . .,” “wow!” that’s right, isn’t this precisely what longevity means!”

the “heaven on earth” of the future, will exist within those places which have great foresight and espouse slow living . . .

記得威士「忌」流行的廣告是壹位戴着禮帽，着壹身 tuxedo（燕尾服）的威士名叫 mr. 忌；mr. 忌先生不要坐宅，就像 mr. 宅 less，johnny walker，keep walking

人類學會慢走，才漫步長壽⋯⋯

（於 2020 年 1 月底至 4 月初）

just remember that in the popular commercial for johnny walker mr. whiskey (johnny walker), he is wearing a tuxedo, yet the chinese name for whiskey includes the character " 忌 *ji*" which implies notions of fear, taboo, and prohibition. mr. ji does not want to stay home. he is just like mr. zhai-less, johnny walker keeps walking.

humanity will slowly stroll along, only if we walk slowly will we be able to enjoy a long life.

end of january-beginning of april, 2020

記得威士「忌」流行的廣告是壹位戴着禮帽，着壹

身 tuxedo（燕尾服）的威士名叫 mr. 忌；mr. 宅 less，johnny walker，keep walking

just remember that in the popular commercial for johnny walker mr. whiskey (johnny walker), he is wearing a tuxedo, yet the chinese name for whiskey includes the character " 忌 *ji*" which implies notions of fear, taboo, and prohibition. mr. ji does not want to stay home. he is just like mr. zhai-less, johnny walker keeps walking.

責任編輯： 錢舒文
排　　版： 周　榮
責任校對： 趙會明
印　　務： 龍寶祺

藝術
ART

藝術的故事（全二冊）
A STORY OF ART

作　　者： 谷文達工作室

出　　版： 商務印書館（香港）有限公司
香港筲箕灣耀興道 3 號東匯廣場 8 樓
http://www.commercialpress.com.hk

發　　行： 香港聯合書刊物流有限公司
香港新界荃灣德士古道 220-248 號荃灣工業中心 16 樓

印　　刷： 深圳中華商務聯合印刷有限公司
深圳市龍崗區平湖鎮春湖工業區中華商務印刷大廈

版　　次： 2023 年 6 月第 1 版第 1 次印刷
© 2023 商務印書館（香港）有限公司

ISBN 978 962 07 6710 4

Printed in Hong Kong

凡例：為呈現作者谷文達之藝術面貌，其所著之中文文章及圖片說明等文稿中，表達數字含義的「一」「二」「三」……「十」「百」「千」等中文數字，將以「壹」「貳」「叁」……「拾」「佰」「仟」等大寫中國字收錄，其他作者所著文章，不作此修改；全書英文內容全小楷，句首不大楷。

藝　術
ART

藝術家：谷文達
artist: gu wenda

主辦單位：合美術館
organizer: united art museum

展覽地點：合美術館（武漢市洪山區野芷湖西路 16 號）
exhibition place: united art museum (no.16,
yezhihu west road, hongshan section, wuhan)

展覽時間：2019 年 12 月 15 日—— 2020 年 9 月 13 日
exhibition time: dec 15th 2019-sep 13th, 2020

開幕時間：2019 年 12 月 15 日 15:00
opening time: 15:00 dec 15th, 2019

出品人：黃立平（館長）
producer: huang liping

學術主持：沈語冰
academic director: shen yubing

策展人：布萊恩·甘迺迪　魯　虹（執行館長）
curator: brian kennedy, lu hong

策展助理：艾小錚 李軼睿
curator assistant: ai xiaozheng, mandy lee

合美術館展覽委員會：
黃立平　魯　虹　姚　華　甘行松　李　紅
洪　鎂　艾小錚　王瑋琪　孫江舒　胡　露
exhibition committee of united art museum:
huang liping, lu hong, yao hua, gan xingsong,
li hong, hong mei, ai xiaozheng, wang weiqi,
sun jiangshu, hu lu

展覽總負責：湯　華
gu wenda' studio director: linda tang

展覽負責：李軼睿
exhibition manager: mandy lee

展覽及助理團隊：湯　華　李軼睿　宋小平　張珊珊
沈清鈺　金怡婷　陳丹青
exhibition & assistant staff from gu
wenda' studio: linda tang, mandy lee, song
xiaoping, zhang shanshan, janine shen,
isabella jin, narcissus chen

展覽及視覺設計：
exhibition & visual design: design origin

文獻整理：谷文達工作室
documentation organizing: gu wenda' studio

英文翻譯及校對：林白麗
translator & proofreading: rebecca catching

主編：沈語冰
chief editor: shen yubing

執行主編：湯　華　李軼睿
executive editors: linda tang, mandy lee

攝影：馮曉天　孔　濤　馬丁·舒勒
photographer: feng xiaotian, kong tao,
martin schoeller